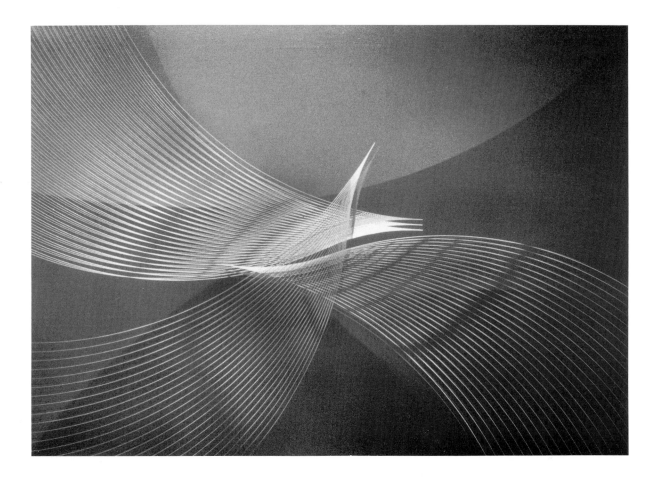

Exhibitions at the
Organization of American States
1965 -1985

Edited by
Annick Sanjurjo

The Scarecrow Press, Inc.
Metuchen, N.J., & London
1993

Frontispiece: Painting By Eduardo Mac Entyre, *Tres encuentros luminosos* (Three Luminous Encounters), 1987, 39½×27½. Collection of A. & A. J. Casciero.

British Library Cataloguing-in-Publication data available

Library of Congress Cataloging-in-Publication Data

Contemporary Latin American artists : exhibitions at the Organization
of American States 1965-1985 / edited by Annick Sanjurjo.
 p. cm.
 Includes indexes.
 ISBN 0-8108-2644-5 (acid-free paper)
 1. Art, Latin American--Exhibitions. 2. Art, Modern--20th
century--Latin America--Exhibitions. I. Sanjurjo, Annick.
II. Organization of American States.
N6502.5.C66 1993
709'.8'074753--dc20 92-40524

TABLE OF CONTENTS

FOREWORD

When I assumed the functions of Specialist in Art of the Division of Intellectual Cooperation of the Organization of American States in 1945, then the Pan American Union, there were activities promoting the Latin American culture and the doors of the institution were open to artists who wanted to exhibit their works there. Based on this premise, I decided to establish the program of temporary exhibitions of art. That program consisted of monthly exhibits by yet unknown but meritorious artists. One of the first to exhibit under this program was the then young Venezuelan painter Héctor Poleo, today considered a master. Poleo humorously recalls that he had to bring his own hammer and nails to hang his paintings!

This incident is but one example that there was never sufficient funding for the required task and neither was there unanimous support from the delegates of the member countries. My objective to promote the art of Latin America and the Caribbean outside of its parochial sphere was nevertheless clear and strong. I was committed to gaining respect for our art. The only self-imposed prerequisite guiding my selections for exhibitions was the quality with which each artist was able to translate an aesthetic message as a member of the Latin American culture.

Too frequently I was asked where could I possibly find enough artists to keep this program going on. Undoubtedly, this question reflects a reality: Latin American art was, and to a certain degree still is, a forgotten art. With my unwavering faith in art, I repeatedly answered that there are, and always will be, artists who in one way or another will communicate through a chosen medium their feelings and the feelings of their communities in spite of economic problems and the indifference of local institutions. In Latin America, as in any other place, there are very many talented people. It would be impossible to enumerate them all. By now, many of these individuals have achieved, and many more will continue to achieve, recognition, but they do it through their own effort, without hope or support as if doomed to accept an inexorable destiny.

In retrospect, as I reflect on my own contribution, I realize that more could have been done. It is like wanting to develop an airplane factory and ending up with a bicycle shop. One always wants to have what one loves the most to be appreciated and unconditionally supported by everyone, in this particular case, especially by the political institutions that purport to serve that cause. Reality is at times disheartening.

However, as regards the art from our hemisphere, I am thoroughly optimistic. There are those who do not yet acknowledge the existence of a clearly identifiable Latin American form of expression. This point, however, is open to debate. It is true that Latin American art appeared on the international scene rather late. Nevertheless, since the beginning of this century, it has advanced with gigantic strides. There are already many internationally recognized maestros. They are the ones who have created, almost in a vacuum, a history of the art of Latin America. They combined universal aesthetics with transformed elements of a surviving heritage, long forgotten or neglected by most. They shaped new cultural prototypes by reinterpreting the traditions of other ethnic groups who settled in the new lands. By drawing on diverse and at times even antagonistic physical and spiritual geographies, our artists have set milestones and have defined our art. They have done it by using a diversity of expressions as a testimony of an honest and difficult search within the varied cultural spectrum of our hemisphere.

To promote this art still in its developing stages, first it was necessary "to discover" what each country had to offer. There was a need to set marks and develop criteria. That was a very rewarding task for me. It is just as gratifying for me to see the unflagging search of our artists to be the *raison d'être* of this publication. This publication documents the history of the birth of Latin American modern art, and gives evidence of its worth and strength.

This publication is also positive proof for the skeptics that the then incipient program of monthly exhibitions was well worth it. Although not everyone who exhibited in the monthly temporary program is now a well-established artist, there are many who have acquired international recognition. I believe that for many artists, to be selected for the monthly exhibition program was to climb to the first rung in the success ladder. Many among them sacrificed their international renown by remaining in their own countries to foster the development of a new local art. Many others moved on looking for new horizons and triumphed in the international arena.

This publication should also be a source of pride for the Organization of American States, and stimulate the Organization to be the beacon by which our cultural achievements are illuminated.

Many years of dedicated and difficult labor have elapsed since 1945. They were years filled with many other related activities: conferences, lectures, traveling exhibitions within the United States and throughout the world, production of films and media materials, establishment of an archive of artists for more in-depth information about our art, attempts to create museums in many of our communities. They were years filled with both frustration and satisfaction, but above all, with an intense and honest search for quality art conveying the essence of the Latin American and Caribbean community.

Many years also elapsed before the Council of the Organization of American States assigned me to select and acquire art works to develop a collection that eventually was to become the permanent collection of the Museum of Modern Art of Latin America inaugurated in 1976 under my direction.

I am personally content with the achievements to date, but much remains to be done. My hope is that this important publication may awaken the enthusiasm in those who are in the position to support and foster cultural and artistic endeavors and that it fortifies their commitment. Our artists deserve it. They forge and shape our culture. They carry the torch outside of our regional boundaries and keep alive the flame of our Latin American essence. This compilation of catalogues is a tribute to them because they are the real authors.

José Gómez-Sicre

PREFACE

Since the beginning of my tenure as the archivist for the Museum of Modern Art of Latin America of the Organization of American States (1978-1989), small folded pages came across my desk sporadically. They noted an exhibition of a Latin American or a Caribbean artist in some room of the OAS, and I filed them without much notice.

Over time, however, I realized that I spent many hours searching for answers, sometimes unsuccessfully, in these unpretentious, colorless pages in order to respond to hundreds of calls and letters of inquiry from students, researchers, collectors, museums, art galleries, or simply, lovers of Latin American art.

It was around 1984 when, within the limits of my possibilities, I began to develop an index of those artists who had exhibited at the OAS. The results, then still unfinished, were astonishing. There was the history of the artistic happenings of an entire continent since the turn of the century! Immediately, I decided that it was well worthwhile to compile the catalogues of the exhibitions, even though I had to do it on my own time.

These exhibits were important not only because they included most of the artists that today are regarded as the masters or precursors of modern Latin American or Caribbean art (sometimes even before they were recognized in their own countries), but, moreover, because they documented the history of a crucial moment in the evolvement of an original art within the international art context: the birth of modern Latin American art.

They were a record of approximately 750 exhibitions including more than 2,000 artists spanning almost a half century, from 1941 until the end of 1985. Due to the size of the work, it was necessary to divide the publication into two volumes.

The present volume includes about 380 exhibitions of about 1,000 artists held during the period 1965-1985. This register of the uninterrupted work of the OAS in promoting the plastic arts of Latin America has several purposes. It is a sort of encyclopedia of Latin American and Caribbean artists who, observing their own still unknown and at times even rejected local cultures, have been able to reinterpret them in works of extraordinary quality. It is one of the few records in the English language providing information about Latin American artists who have exhibited in the United States, and it is, therefore, a rich and unique reference source.

This publication is also a recognition of the work of the late, well-known critic and Latin American art expert, José Gómez-Sicre, who from the 1940s until 1983, as Director of the Audiovisual Unit first, and the Museum of Modern Art of Latin America later, provided continuity in the temporary exhibitions program with a fervent and unmitigated faith in the art of his continent. He is the real author of these pages, since he was responsible for selecting the majority of these exhibitions and of writing most of the catalogues' notes. To him goes my appreciation for the clarifications he provided me when I needed them.

EDITORIAL METHOD

All the catalogues have been faithfully compiled and arranged in chronological order, which is the reason for having some American, Canadian, and European artists included in this publication.

The changes introduced were dictated by the need to add clarity to the texts and to correct all data. Although the majority of the comments were conceived by Mr. José Gómez-Sicre (signed *J.G-S.* in the catalogues), some were written by other persons, most of them in Spanish, and translated by different translators. This accounts for the diversity of styles.

Many artists' *curricula vitae* were missing, particularly in group exhibitions. Whenever that was the case, they have been added following the list of works exhibited, under **Biographical Notes**, whereas the original catalogues used **About the Artist,** or some other heading for this section. To keep the unity of the work, the *vitae* added were completed up to the date of that particular exhibition. No additional information was added for artists not from Latin America or the Caribbean.

Dates of birth have been carefully checked and corrected, when necessary, in accordance with forms signed by the artists. In some other cases the information was taken from other catalogues or publications, including newspaper clippings.

Whenever a catalogue was missing, the Press Release for that particular exhibition was used. Two catalogues of exhibitions that have not been held were included, as they were part of a planned schedule.

A list of the works exhibited has been added when it was missing from the original catalogue, and some others have been corrected in accordance with the list used during the exhibition. Titles of the works were kept in the language in which the artists originally named them. The English translation appears in italics in parentheses when it was given in the original catalogue, or in regular typeface when it was done by me.

To facilitate the use of this volume, two indexes were added: an Index of Artists and an Index of Exhibitions by Country. The first records the name of all the exhibitors in alphabetical order, followed by date of birth and death, and media. As all these shows are listed in the book in chronological order, instead of page numbers, it has been considered more useful to indicate the dates of the exhibitions. A date in italics means that it is an individual exhibition or that information on the artist can be found there. Due to the fact that some of these artists were exhibited prior to 1965, and therefore, no curricula vitae existed for them in the present volume, information on that artist was added in the Appendix. This is indicated by an (A) after the date of the exhibition.

The Index by Country lists the exhibitions held by artists of that particular country or in which they have participated; therefore, one group exhibition may appear under several countries.

To avoid confusion, last names such as Di Cavalcanti, de Szyszlo, de la Rosa, and other similar ones, appear under Cavalcanti, Szyszlo, or Rosa. It is also appropriate to keep in mind that it is customary in Latin America to use the father's last name followed by the mother's last name, i.e., Ramírez Villamizar or Roca Rey. In the Index, they are listed under Ramírez or Roca.

ACKNOWLEDGEMENTS

My sincere appreciation to all the persons who have graciously given their time and knowledge to make this publication possible:

The Friends of the Art Museum of the Americas, whose contribution made it possible to start this project;

Ms. Leslie Judd Ahlander, art critic, and one of the first to show Latin American artists at the OAS, who shared some of the missing catalogues;

Ms. Adelfa Fernández, OAS editor, who helped with language problems and editing on her own time;

Mr. Juan Carlos Gómez, whose computer knowledge solved some problems when this project started;

Mr. Tom Kelly for his editing assistance;

Ms. Travis Kranz, whose interest and professional help was valuable during her one-year internship at the Museum;

Ms. Alicia Maldonado, who did an excellent initial typing job; and

Mr. Albert J. Casciero, without whose help and expertise this publication would have never been a reality.

Annick Sanjurjo

EXHIBITIONS

YEAR 1965

January 7 - 25, 1965

RENE MORON OF ARGENTINA: OILS

In a southern district of Buenos Aires, far from the elegance and bustle of the center of that great capital, there is a run-down house in which some of the most interesting of contemporary Argentine art is being produced. The young painters and sculptors whose activities it shelters share its expenses, but maintain separate studios; while they call themselves the *Grupo del Sur* (Southern Group), each follows an independent trend. One by one they have been attaining renown: the names of Carlos Cañás, Aníbal Carreño, Ezequiel Linares, Mario Loza, and Pérez Román figure prominently in artistic discussions; work by the sculptor Leo Vinci was exhibited at the Pan American Union in 1963. Now still another member of the group, the painter René Morón, is being presented to the Washington public.

Morón was born in San Antonio Oeste, Argentina, in 1929. He attended the Manuel Belgrano School of Fine Arts in Buenos Aires for a few years. After working and exhibiting independently, he joined the *Grupo del Sur* with which he has appeared regularly since 1960, taking part in seven shows in Argentina and one in Brazil. Since 1948 he has been included in group exhibitions of Argentine art in Tokyo, Rome, Mexico City, Rio de Janeiro, Stockholm, Lima, and Santiago de Chile. He has painted murals for several government buildings in Argentina, and oils by him are to be found in the collections of four of that country's museums.

Morón's exclusive representative is the Galería Rubbers of Buenos Aires, where he has had several individual presentations.

CATALOGUE

Oils on Canvas, 1963 and 1964

1. *Thistles in Bloom*
2. *Crucifixión (Crucifixion)*
3. *Imágenes (Images)*
4. *Bird and Nest*
5. *Nests and Birds*
6-11. *Southern Birds Series*
12. *Nest*
13. *Iguana*
14. *Cardo (Thistle)*
15. *Compass Constellation*
16. *The Nest*
17. *Constelación el Centauro (The Centaur Constellation)*
18. *Vía láctea (Milky Way)*
19. *Spacial Integration*
20. *Aerolite*
21. *Spacial Disintegration*
22. *Element into the Space*
23. *The Wolf Constellation*

24. *Aerolite Reflection*
25. *Constelación Cruz del Sur (Southern Cross Constellation)*
26. *Búho (Owl)*
27. *Triángulo austral (Austral Triangle Constellation)*
28. *Spacial Ship*
29. *Chaos*
30. *Constelación Escorpión (The Scorpion Constellation)*
31. *Búho (Owl) II*
32. *Partridge*
33. *The Wolf and the Centaur*

January 29 - February 14, 1965

GUILLERMO NUÑEZ OF CHILE: OILS

While the Chilean Guillermo Núñez has devoted the bulk of his time in recent years to stage design, he has pursued a career in painting to such good effect that in 1963 he won the Grand Prize in a contest organized by the Pacific Mining Company, and last December he was awarded First Prize in the *Esso Salon of Young Artists* sponsored by the Organization of American States and the Esso Standard Oil Company. On a vaguely figurative basis he has evolved a solid and refreshingly novel approach to abstraction, one which might perhaps be termed biological symbolism. Evidencing vivid imagination and a strong power of invention, his fantasies at the same time exhibit a masterful command of color and technique and perfection of balance.

Núñez was born in Santiago, Chile, in 1930. After studying at the National University's School of Fine Arts, in 1953 he went to Paris where for two years he attended the open courses at the Grande Chaumière. From 1959 to 1961 he studied stage design at the Caroline University in Prague. His maquettes and sketches of stage settings for dramas, operas, and ballets have been used with great success in Chile; his paintings have been included in numerous exhibitions of Chilean art organized for presentation abroad--in Brazil, Peru, and the United States. Núñez currently resides in New York, and it was there that he painted the majority of the works here on view in this, his first exhibit in the Washington area. Last year he had a one-man show in Santiago at the Marta Faz Gallery, which is his exclusive representative in Chile and throughout Latin America.

CATALOGUE

Oils

1. *Cuando un enano se sube sobre otros forman una torre (When One Dwarf Jumps atop Another They Create a Tower)*, 1964, 60 x 49 1/4"
2. *Algo ocurre en el aire (There Is Something in the Wind)*, 1964, 62 x 48"
3. *¡Grita, Asturias! (Shout, Asturias!)*, 1964, 47 x 63"
4. *Saber del dolor (To Know about Sorrow)*, 1964, 48 1/2 x 62 1/2"
5. *Voces, silencios, aullidos escondidos (Occult Voices, Silences, Screams)*, 1964, 39 x 55"
6. *Vendrían después los ríos (Later the Rivers Would Flow)*, 1964, 49 1/4 x 60"
7. *Se disputan con ira (They Argue Angrily)*, 1964, 49 1/4 x 60"
8. *Rompe el gran secreto (Break the Great Secret)*, 1964, 49 1/4 x 60"
9. *Canción de Asturias (Song from Asturias)*, 1964, 36 x 25 6/8"
10. *Pacha Mama abre el surco (Pacha Mama Opens the Furrow)*, 1964, 25 6/8 x 36"
11. *Los cría uno mismo (We Raise Them Ourselves)*, 1965, 50 x 72"
12. *Aún en mis sueños (Still in My Dreams)*, 1965, 50 x 72"
13. *Los sueños de la gente (The People's Dream)*, 1964, 38 1/4 x 48"
14. *Sin título (Untitled) I*, 1964, 30 x 40"
15. *Sin título (Untitled) II*, 1964, 30 x 40"
16. *Sin título (Untitled) III*, 1964, 30 x 40"
17-18. Drawings,[1] 1964, 20 x 26"

[1] Also exhibited but not included in the original catalogue. Titles are unavailable. *--Ed.*

February 16 - March 8, 1965

RICARDO MACHADO OF ARGENTINA: OILS

In Latin America one occasionally encounters an artist who has managed to combine a career in the creative field with one in a very different area of endeavor, achieving a high professional level in both. Such is the case of Ricardo Machado, one of the most promising painters to appear in Argentina in recent years. Under the stage name of Ricardo Lavié, he is, and has been for some time, one of his country's most popular actors of the legitimate theater, cinema, radio, and television. Nevertheless, despite multiple performing commitments, he has been steadily active with the brush, winning a large measure of critical acclaim. His free handling of color, his ingenious treatment of subject matter, and the poetic touch which he imparts to his work make of it an important contribution to contemporary Argentine art.

Machado was born in Buenos Aires in 1923. Though he early showed talent as a draftsman, the stage called him as an adolescent and he soon established himself as a professional actor. In the 1950s, however, the urge to paint came upon him and it was not long before he had compositions accepted by local and national salons. With this encouragement, he decided to further his progress by professional training, joining the workshop of the well-known artist Leopoldo Presas in 1958. A scant year later he was rewarded by first prizes at several provincial salons and at the 1960 National Salon he received an Honorable Mention. He has participated in several important group exhibitions and in 1963 he had his first, and up to the present his only, one-man show at the Rubbers Gallery in Buenos Aires. It is with the cooperation of that gallery, which is his sole agent, that this, his first individual presentation abroad, has been arranged.

Ricardo Machado has just finished a season in the Argentine capital as leading man in the Paulina Singerman stock company. He is currently featured on Buenos Aires Channel 7 in a popular television series, from which he has obtained a temporary release to attend his exhibition in Washington.

CATALOGUE

Oils

1. *Something Look*s
2. *Inward*
3. *Búho (Owl)*, 1964, 100 x 70 cm.
4. *Cálido (Warm)*, 1964, 100 x 70 cm.
5. *Habitado (Inhabited)*, 1964, 100 x 60 cm.
6. *Agudo (Keen-Edged)*, 1965, 70 x 70 cm.
7. *Rojo (Red)*, 1964, 70 x 70 cm.
8. *Insecto (Insect)*, 1964, 70 x 70 cm.
9. *Celular (Cellular)*, 1964, 50 x 60 cm.
10. *Pájaro (Bird)*, 1964, 100 x 60 cm.
11. *Gestación (Gestation)*, 1964, 100 x 70 cm.
12. *Habitable*, 1964, 100 x 70 cm.
13. *Acuátil (Aquatic)*, 1964, 100 x 70 cm.
14. *Itinerario verde (Green Itinerary)*, 1965, 100 x 70 cm.
15. *Bicho (Vermin)*, 1964, 100 x 70 cm.
16. *Introito rojo (Red Prologue)*, 1965, 100 x 70 cm.
17. *Rojo tenaz (Tenacious Red)*, 1964, 120 x 120 cm.
18. *Peñasco azul (Blue Rock)*, 1964, 120 x 120 cm.
19. *Júbilo (Glee)*, 1964, 120 x 120 cm.
20. *Ser (To Be)*, 1964, 120 x 120 cm.
21. *Vital*, 1964, 120 x 120 cm.
22. *Impromptu*, 1964, 120 x 120 cm.
23. *Metamorfosis (Metamorphosis)*, 1964, 150 x 100 cm.
24. *Imagen (Image)*, 1964, 150 x 80 cm.
25. *Presencia (Presence)*, 1964, 150 x 80 cm.
26. *Alguien (Somebody)*, 1964, 150 x 100 cm.

March 9 - 29, 1965

EFRAIN RECINOS OF GUATEMALA: OILS

The most flourishing trend in present-day Guatemalan art is that which consists in the integration of painting and sculpture with architecture, without subordination of one element to the other. The trend was initiated by the country's greatest living artist, Carlos Mérida, in a remarkable series of mosaic murals in which his contemporary interpretation of the ancient Mayan sense of form has resulted in the creation of a new plastic language. Mérida's example has been an inspiration to many later artists who have neither copied his work nor acknowledged his influence, but for whom he has opened the way to public acceptance.

An outstanding figure in this younger generation is Efraín Recinos, an architectural engineer who has recently begun to express himself through the media of painting and sculpture.

Born in 1932, Recinos studied engineering and architecture and provided the plans for a number of important constructions in his country. His latest design, prepared in cooperation with other Guatemalan architects, is for the new national theater to be erected in the capital. As a painter and sculptor, he is self-taught; his most important creation being a gigantic mural in relief which forms the facade of a large bank currently under construction in Guatemala City. For his contribution in this area Recinos won First Prize in the National Art Salon held in his country last December. As a painter he was awarded First Prize in the *Esso Salon of Young Artists* of Latin America in El Salvador, and he represented his country in group shows presented at the Berlin Fair and the New York World's Fair. Recinos is responsible for several monuments in public parks and has been active in the fields of book illustration and stage design.

The present exhibition is the first individual presentation of Recinos's work to be given anywhere.

CATALOGUE

Oils

1. *La caza de brujas (The House of Witches)*[1]
2. *El poema olvidado (The Forgotten Poem)*
3. *Fiesta dorada (Gilded Feast)*
4. *La hora de las ninfas (The Hour of the Nymphs)*
5. *Vidas paralelas (Parallel Lives)*
6. *La ciudad del poeta (The City of the Poet)*
7. *Personaje de los bosques (Forest Personage)*
8. *El árbol que piensa (The Tree That Thinks)*
9. *El maizal de Vicente (Vincent's Corn Field)*
10. *Héroe nocturno (Nocturnal Hero)*
11. *Romance de los tenebrosos (Tenebrous Romance)*
12. *Cabalgata de las brujas (Witches' Cavalcade)*
13. *El baile de los muertos (The Dance of the Dead)*
14. *Noche de sortilegio (Night of the Sorcerer)*
15. *Las bodas del diablo (The Weddings of the Devil)*
16. *El tango del diablo (The Tango of the Devil)*
17. *Noche de volcanes (The Night of the Volcanos)*
18. *La selva mágica (The Magic Forest)*
19. *La canción de la heroína (The Song of the Heroine)*

[1] Literal translation of this title is "The Hunt of Witches." --*Ed.*

CARLOS POVEDA OF COSTA RICA: DRAWINGS

Of all forms of artistic activity, drawing is, in all probability, the most widely practiced in Latin America. A highly intellectual exercise, it presupposes an ability to seize upon the essential structure of a composition--an ability the development of which is of fundamental importance to all branches of art, from painting to sculpture and architecture. It is doubtless for this reason that Ingres, one of the greatest draftsmen in history, spoke of good drawing as representing the "probity of art."

While the case is not uncommon in Latin America of the painter or sculptor who has found in drawing an effective means of expression and has practiced it as a rewarding sideline, for the most part it has been assigned a subordinate position, as a preparatory step toward work in another medium or as a means of noting ideas for later elaboration. Very seldom was it pursued as an end in itself in the nineteenth century and the early years of our own. Of late, however, artists have arisen who are making a career of drawing, a notable example being the young Mexican José Luis Cuevas, whose work in this field has won him worldwide renown.

Though all the art schools of Latin America give intensive instruction in drawing, there are many self-taught artists who have achieved a high level of expression in the medium. Such a case is that of Carlos Poveda, born in San José, Costa Rica, in 1940. He has had no formal training other than that in the mechanical renderings he was called to produce as a student of combustion engines. He soon abandoned blueprints of motors to devote his time to sketching in a free but disciplined manner, to such good effect that he is today considered one of the most prominent figures in the younger generation of artists in Latin America. In 1960 he won First Prize in a contest in vignette illustration sponsored by a Costa Rican publishing house. His first experience as an exhibitor came through participation in a group show of Costa Rican artists held under the auspices of UNESCO in 1962. The same year he joined the Group of Eight in an open-air exhibit in San José. In 1963 his first one-man show was presented at the Costa Rican-North American Cultural Institute in the same city. His compositions were also included in a selection of works by the Group of Eight sent to Bogotá, Colombia, where they evoked favorable critical reaction In January 1964 Poveda came to Washington in charge of the exhibition *Modern Artists of Costa Rica*, presented at the Pan American Union. His own contributions to that exhibition were well received by critics and public alike. At its close he returned to Costa Rica for his second one-man show, held under the auspices of the Ministry of Education; then he came back to the United States, where he has participated in a number of group shows. Among them was that presented at the Central America and Panama Pavilion of the New York World's Fair. His works also figured in the exhibition at the Berlin Fair.

On the occasion of the Costa Rican exhibit at the Pan American Union, the critic Leslie Judd Ahlander wrote in the *Washington Post* that Poveda's drawings showed "subtle and varied textures and a strong, sculptural sense of form." José Luis Cuevas has said of his colleague: "In Poveda we find an artist who really knows the deepest value of line--by itself and in relation to volume and space."

Carlos Poveda is scheduled for a series of one-man shows in South America this year and next. This, however, is his first individual presentation outside of Costa Rica. *--J.G-S.*

CATALOGUE

Drawings

 1. *Figura sentada (Seated Figure)*
 2. *Reclined Man*
 3. *Man with High Cap*
 4. *Sketch*
 5. *Obispo (Bishop)*
 6. *Finger Counting*
 7. *Fish I*
 8. *Estudio de figuras (Figure Studies)*
 9. *Rata (Rat)*, 1964, pen and ink on paper, 12 1/2 x 23"
10. *Amitiés dangereuses I* (Dangerous Friendships I)

11. *Amitiés dangereuses II* (Dangerous Friendships II)
12. *Old Man*
13. *Head*
14. *Portrait with Bottles*
15. *Girl with Open Legs*
16. *El glotón (Glutton)*
17. *The Fall*
18. *El poeta (The Poet)*
19. *Head of a Woman*
20. *Embracing Figures*
21. *El abogado (The Lawyer)*
22. *Sitting Woman*
23. *Head*
24. *Child Eater*
25. *Perfil (Profile)*
26. *Fish II*
27. *Wanted to Surprise You*
28. *After the Deluge*
29. *My Cousin*
30. *Nacimiento (Birth)*
31. *Fly Man*
32. *The Doctor*
33. *La espera (The Wait)*
34. *The Dream*
35. *The Clown*
36. *Kneeling Woman*
37. *Prayer*
38. *The Observer*
39. *Seated Child*
40. *Sketch*

Works by Carlos Poveda are to be found in the following public collections:

The Museum of Modern Art, New York; the Permanent Collection of Latin American Art of the Pan American Union and the Art Collection of the Inter-American Development Bank, Staff Association, Washington, D.C.; the Collection of Latin American Art of Esso Standard Oil, Coral Gables; the Permanent Collection of the Ministry of Education, the Art Collection of the Central Bank of Costa Rica, and the Art Collection of the Costa Rican-North American Cultural Institute, San José.

They are also to be found in the following private collections:

Rabbi and Mrs. E. Allen, Mr. and Mrs. Diego Arria, Mr. and Mrs. David Berler, Mr. and Mrs. Walter Brandt, Dr. Humberto Calamari, Ambassador Representative of Panama to the Council of the OAS, Dr. Gerhard Cotts, Mr. and Mrs. Leon Dediot, Mr. and Mrs. Douty, Miss Betty Foy, Rabbi and Mrs. Emmanuel Frank, Mr. and Mrs. McKenzie Gordon, Mr. and Mrs. Enrique Govantes, Mr. and Mrs. Samuel Greenbaum, Mr. Ernesto Guarro, Mr. David Harrison, Mr. and Mrs. John Karkashian, Mr. and Mrs. Stuart Kornfeld, Mr. and Mrs. Harry Kronstad, Mr. and Mrs. Alvaro López, Mr. and Mrs. Antonio Lulli, Mr. Ned Manaschil, Mr. Juan Mathé, Mr. James Merkangas, Mr. Julio Mestre, Mr. Raúl Nass, Mrs. Newburger, Mr. and Mrs. Alfonso Perea, Mr. and Mrs. Harvey Perloff, Mr. Benoist Ravenel, Mr. and Mrs. Rodolfo Ricagno, Mr. and Mrs. Lee Rubinstein, the Secretary of State and Mrs. Rusk, Mr. Rafael Sardá, Dr. James E. Scott, Mr. and Mrs. Gabriel Schwartz, Mr. Clemente Segovia, Mr. and Mrs. Michael Sinberkoff, Mr. and Mrs. Junio Solano, the Ambassador of Venezuela and Mrs. Tejera París, Dr. and Mrs. Stanley Tempchin, Mr. Clarence Vandegrift, Mr. Gerardo Wills, all of them in Washington, D.C.; Mr. Kurt Backmann and Mr. and Mrs. Irwin Hersey, New York; Mrs. Ruth Berenstein, Baltimore; Mr. Alejandro Sarria, Denver; Prof. and Mrs. K.W. Wilbur, Raleigh; Mr. Roberto Estopiñán, Miami; Mr. and Mrs. Ricardo Machado and Mr. and Mrs. René Morón, Buenos Aires; Mr. Arturo Echeverría, Dr. and Mrs. Werner Oeschler, and Mr. and Mrs. Samuel Rowinsky, San José (Costa Rica); Mr. and Mrs. Harold Fonseca, Tegucigalpa; Mr. and Mrs. Bernardo Bermúdez and Mr. Víctor Roy Parro, Caracas.

April 1 - 18, 1965

RACHEL STROSBERG OF BRAZIL: ETCHINGS

Rachel Strosberg was born in the State of Guanabara in 1927. She studied engraving with Goeldi as well as with Friedlaender at the workshop of the Museum of Modern Art in Rio de Janeiro. She first exhibited in 1955 at the Fifth Salon of Fine Arts of Bahia. Since then, she has had several individual exhibitions and has taken part in group shows, including one held at the Museum of Modern Art of Rio de Janeiro and the Brazilian-North American Cultural Institute of Belo Horizonte. She was also one of her country's representatives in the exhibition *Art of America and Spain*, organized by the Institute of Hispanic Culture in Madrid, 1963.

CATALOGUE

Etchings

1. *Birds*
2. *Birds and Flowers*
3-4. *Composição (Composition)*
5. *Galos (Cocks)*
6. *Composição (Composition)*
7. *Composition with Flower*
8-14. *Composição (Composition)*
15. *Ouro Preto*
16. *Pássaros (Birds)*
17. *Galos (Cocks)*
18. *Peixe (Fish)*
19. *Galos (Cocks)*
20. *Peixe (Fish)*
21. *Pássaros (Birds)*
22. *Pássaro (Bird)*
23. *Bird and Moon*
24-25. *Pássaro (Bird)*
26-27. *Galos (Cocks)*

April 1 - 18, 1965

JAPANESE ARTISTS OF BRAZIL

Four years ago the Pan American Union presented, as a special event commemorating Pan American Week, an exhibition of works executed by artists of Japanese descent, born or residing in Latin America. The sole representative of Brazil, Manabu Mabe, met with great popular and critical success, later confirmed by an individual presentation of his compositions.

Mabe is not Brazil's only artist of Japanese origin, however. The Japanese population of Brazil, largely concentrated in the State of São Paulo, is second only to that of Japan itself. As in the case of immigrants of other nationalities, the Japanese have found in Brazil a milieu favorable to their cultural development. The warmth, generosity, and open-mindedness of the Brazilians have facilitated the introduction of foreign concepts and tastes, while at the same time the strength of their own long-established, deeply rooted cultural tradition has produced modifications in the extraneous elements, resulting in distinctly novel manifestations of creative talent. Thus, a nation whose culture already represents a fusion of European, American, and African factors is now in the process of enriching itself through the assimilation of Asian refinements.

The group of Japanese-Brazilian artists currently presented came into being some thirty years ago. Known as SEIBI, from the Japanese abbreviation for São Paulo Plastic Arts Club, it held its first exhibition in 1938. Activities were interrupted during World War II and were not resumed until 1947. SEIBI does not represent any

particular school: it brings together practitioners of both figurative and abstract trends. Although membership numbers over thirty, only ten artists are represented in the current show, which, following the presentation at the Pan American Union, will be sent to the West Coast and then to Japan for exposition. With the exception of Manabu Mabe, who is well known in this area, none of the participating artists has previously exhibited in Washington, D.C.

CATALOGUE

Paintings and Sculptures

Tikashi Fukushima
 1. *Remembrance*
 2. *Vento de outono (Autumn Wind)*
 3. *Native Country*
 4. *Idol*
 5. *Tropical*

Tomoo Handa
 6. *Buritis Tribe in the Mato Grosso*
 7. *Main-Stream*
 8. *Pines*
 9. *Gully*
10. *Highland Landscape*

Manabu Mabe
11. *Festival of Ecuador*
12. *The Wind*
13. *A Sign of Summer*
14. *Birth of Venus*

Tomie Ohtake
15. *Vermillion*
16. *Brown*
17. *Blue*
18. *White on Black*

Flavio Shiro
19. *Triptyque (Triptych)*, 1964, oil on canvas, 162 x 73 cm.
20. *Ascension*, 1964-65, oil on canvas, 83 x 180 cm.
21. *Alba (Dawn)*, 1965, oil on canvas, 192 x 56 1/2 cm.
22. *Fenêtre d'avenir (Window to the Future)*, 1965, oil on canvas, 192 x 55 1/2 cm.
23. *L'oeil de boeuf (Eye of the Ox)*, oil on canvas, 80 x 98 cm. (oval)

Yoshiya Takaoka
24. *Um trecho de boulevard, Paris (A Scene of Montparnasse)*. Coll. of the Nippo-Brazilian Cultural Center
25. *Barcas à Ponte de Bercy, Paris (Boats at Bercy Bridge)*. Coll. Dr. Takaoka
26. *Igreja do Pilar (Pilar Church)*, Ouro Preto. Coll. Dr. Rubens Cascardi
27. *Ponta d'Areia (Sand Point)*, Niteroi. Coll. Dr. Nelson Souza Campos
28. *Figura (Figure)*

Yuji Tamaki
29. *Paisagem (Landscape) I*
30. *Paisagem (Landscape) II*
31. *Paisagem (Landscape) III*
32. *Paisagem (Landscape) IV*
33. *Paisagem (Landscape) V*

Shigeto Tanaka
34. *Iguaçu Falls I*
35. *Iguaçu Falls II*
36. *Iguaçu Falls III*
37. *Iguaçu Falls IV*
38. *Squall in Mato Grosso*

Masumi Tsuchimoto
39. *Obra (Composition) I*, bronze
40. *Obra (Composition) II*, bronze
41. *Obra (Composition) III*, bronze
42. *Obra (Composition) IV*, bronze
43. *Obra (Composition) V*, bronze

Kazuo Wakabayashi
44. *Emerald Composition*
45. *Brown*
46. *Composition in Green*
47. *Composition in White*
48. *Composition in Green with White*

ABOUT THE ARTISTS

FUKUSHIMA, Tikashi. Born in Fukushima, Japan, in 1920, traveled to Brazil in 1940. He studied in Rio de Janeiro with the painter Tadashi Kaminagai. Has participated in the First, Third, Sixth, and Seventh São Paulo Biennial. Among other awards he has won the Grand Medal of Honor of the Salon of Japanese Painters in 1958; the Medal of Honor of the São Paulo Museum of Modern Art in 1959, and the First Prize in the Minas Gerais Salon in 1961.

HANDA, Tomoo. Born in Tochigi-Ken, Japan, in 1906, arrived in Brazil in 1917. Handa began his formal art education at the School of Fine Arts of São Paulo and is one of the charter members of SEIBI. He traveled to Japan in 1956, where he studied classical Japanese art.

MABE, Manabu. Born in Kumamoto, Japan, in 1924, immigrated to Brazil in 1934, where his artistic career has been rapid and brilliant and he is today considered one of the outstanding artists of Latin America. He has won, among many other awards, the First Prize in the Fifth São Paulo Biennial, 1959; First Prize in the First Biennial of Young Artists in Paris, 1959; First Prize in the Thirtieth Biennial of Venice, 1960; and First Prize in the First American Biennial of Art in Córdoba (Argentina), 1962. He has exhibited throughout Latin America, Europe, and the United States, where he is also included in several museum collections. Mabe held a one-man show at the Pan American Union in 1962. He is a Brazilian citizen.

OHTAKE, Tomie. Born in Kyoto, Japan, in 1913, immigrated to Brazil thirty years ago. She did not begin painting until 1952; since, has exhibited in the Museum of Modern Art in São Paulo, winning its Grand Medal of Honor. She has also exhibited in the American Biennial of Art in Córdoba (Argentina), and the group show of *Brazilian Art* at the Royal College of Arts, London (England).

SHIRO, Flavio. Born in Sapporo, Hokkaido, Japan, in 1928, arrived in Brazil with his family when he was three years old. Studied both in Brazil and Europe, where he has exhibited in both group and one-man shows, winning the Prize for Painting in the Biennial of Paris in 1961.

TAKAOKA, Yoshiya. Born in 1910 in Tokyo, Japan, immigrated to Brazil when he was fourteen. He exhibited for the first time in 1937, and was one of the organizers of SEIBI. Takaoka has exhibited both in group and one-man shows in South America, Europe, and Japan.

TAMAKI, Yuji. Born in Fukui, Japan, in 1916, arrived in Brazil in 1930. Began painting five years later, when he studied with Bruno Rechowski.

TANAKA, Shigeto. Born in Japan in 1910, arrived in Brazil in 1931 where he began his studies the following year at the School of Fine Arts of São Paulo. He has exhibited frequently in Brazil where he has been awarded several major prizes.

TSUCHIMOTO, Masumi. Sculptor born in Gifu-Ken, Japan, in 1934. There he studied ceramics prior to moving to Kyoto where he perfected his art. His work was shown in various group shows, winning several prizes, among them the Medal of Honor for Japanese Artists and the Third Prize in the *Esso Salon of Young Artists* in Rio de Janeiro this year.

WAKABAYASHI, Kazuo. Born in 1931 in Kobe, Japan, where he studied art. Since his arrival in Brazil he has exhibited, among other places, at the Museum of Modern Art of São Paulo, the Seventh São Paulo Biennial, as well as with the Nippo-Brazilian group at the Museum of Modern Art in Rio de Janeiro.

April 21 - May 18, 1965

ESSO SALON OF YOUNG ARTISTS [1]
Exhibition sponsored by the Pan American Union and Esso Standard Oil Company

The White House
Washington

March 29, 1965

Dear Mr. Mora:

I am most pleased to hear of the Art Festival which is being sponsored jointly by the Pan American Union and the Esso companies throughout Latin America.

The Esso Salon of Young Artists, which you will open at the Pan American Union on April 21 in commemoration of the 75th Anniversary of the inter-American system, will be a cultural achievement and an inspiration to all of us who seek to promote through the arts a deeper and richer understanding among our peoples.

I know that our citizens will welcome this opportunity to view the artistic achievements of our neighbors to the south.

It is heartening also that the Pan American Union and a private company have joined forces to make this festival possible, for it is through this type of dedicated partnership that our hemisphere will grow in strength and freedom. I congratulate the sponsors and the young artists whose works are being exhibited, and wish them every success.

Sincerely,

(Signed) Mrs. Lyndon B. Johnson

His Excellency
José A. Mora
Secretary General of the
Organization of American States
Pan American Union
Washington, D.C.

[1] The winners of the Grand Prizes at the *Esso Salon of Young Artists* in Washington, D.C., were Rogelio Polesello of Argentina (for painting) and Hermann Guggiari of Paraguay (for sculpture). Honorable Mentions were also awarded to the following artists: Fernando Botero of Colombia, Ernesto Cristiani of Uruguay, Mortès Mérisier of Haiti, Fernando de Szyszlo of Peru, all of them for painting; Tomás Batista of Puerto Rico and Alberto Guzmán of Peru, both for sculpture. --*Ed.*

INTRODUCTION

Few are the skeptics who would venture to express doubts today that Latin America possesses--as an obvious reality--a vigorous art of its own. It derives from the most heterogeneous of elements, at times not only dissimilar but in conflict with one another; yet it has fused those elements into a recognizable whole and ranks as one of the outstanding cultural manifestations of our hemisphere. I am among those who have believed in its power, its significance, and its viability for twenty or perhaps thirty years.

The incongruities in the conglomerate known as present-day Latin American art are the result of varying approaches, unrelated in time and space. These approaches can be grouped in several general categories. There is, for example, the movement of the nationalist type, confined within political frontiers but rich in life. There is the occasional school whose doctrine is bearing fruit in the appearance of new artists. There are also groups struggling feverishly and with tenacity against the ignorance or incomprehension of the milieu in which they find themselves, striving to bring to realization well-directed, healthy plastic concepts. And there is the random visionary, the artistic free shooter as it were. These--not to go into the names of individual persons or places--are the elements underlying a cultural phenomenon which is winning increasing recognition on the international scene.

Every creation, however, represents the concept or act of an individual. Movements and schools are produced by independent artists whose ideas converge into a more or less well-defined trend of common activity. In other cases, the artist pursues his path alone, isolated from an unpropitious or even hostile milieu. A prophet without honor in his own time, soon afterwards he finds fame and followers.

The figures who, individually or collectively, contributed to the genesis of modern Latin American art were born in the past century or at the beginning of the present one. Many are now dead. Those still surviving have entered their sixties and in some cases are approaching seventy. In exemplary fashion, they laid foundations, opened new paths, did away with outworn modes, rounded out new ideas, and gave direction to divergent trends. It was they who sowed the seed which has flowered into the Latin American art of today.

The existence of that art is a fact. There are incongruities, as I said before--any attempt to deny this would denote either a singular lack of perception or snobbery of the most artificial sort. Perhaps the dissimilarity of approach, occasioned by differences of circumstance, is precisely that art's chief merit; it gives it the rich variety which constitutes its greatest attraction.

It can be said without hesitation that Latin America is contributing lasting values to the history of art. Nevertheless, many texts which presume to cover the subject treat that area with indifference or neglect. I have in mind particularly texts written in the Old World, in which, if America figures at all--and seldom is this the case--it is represented by artifacts of the period prior to the Discovery. Until very recently, moreover, those artifacts were considered mere curiosities. Such interest was held to be purely scientific: they were consigned to the dusty shelves of museums of anthropology and ethnology, passed over in total ignorance of the art of exotic latitudes.

For more than forty years now, from Mexico to Patagonia, a series of positive achievements has been registered in the field of plastic development, to the extent that the unbelievers of yesterday are now filled with wonder at the end product of processes they could not perceive when they were happening before their very eyes. To establish a continuity, it was necessary to prove that the artists classified as precursors had indeed opened the way to those who came after them, particularly the generation of today.

It was thus that this contest came about. One day International Petroleum, one of the Esso companies operating in Latin America, came to me with the germ of an idea, for whose development they sought to draw on the experience of the Pan American Union's Division of Visual Arts--an experience which represented some twenty consecutive years of collecting first-hand information on Latin American art. The idea was that of a contest for young painters and sculptors of the lands to the south of the United States. I seized at once the significance of the plan and the many positive benefits it offered. In two or three conversations we worked out almost all the details.

The first thought that occurred to me was the stimulus which such a contest could provide for the youth of Latin

America. Next, I thought of the possibilities which it offered for exploring the present state of art, within the confines of a generation that had not as yet attained the median age of creative maturity. Finally, I saw that it would also permit determining the existence of a tradition, of a descent from older artists, of a connection with those who had laid the foundations of modern art in the Americas.

Of singular significance was the fact that it was private industry--the capitalistic initiative of a free world--that was thus seeking to foster the things of the spirit by an undertaking of broad cultural repercussion. The financial support provided by the Standard Oil Company (New Jersey) is eloquent testimony of an understanding of the balance which should prevail between the practical and the aesthetic which too often escapes the upper echelons of economic power.

In short order the contests were organized, one by one, in those countries in which the affiliates of the sponsoring organization were prepared to lend immediate assistance. The youth of those countries responded, in all cases, in greater numbers than could have been expected in view of the limited time for the submission of entries.

Alongside names of note belonging to figures whose age permitted participation, there appeared many new and previously unknown ones. Some were honored with awards; others showed promise of winning distinction at later salons. Every trend in present-day art was represented by the works submitted for evaluation. The juries proceeded with both caution and vision in passing judgment. If they erred at any point, their margin of error was slight.

The results may here be appreciated as a whole. A fine balance has been struck: artistic probity has been rewarded; relative rank has been duly respected. Behind these compositions one can perceive the ferment of the youth of our hemisphere, who agreed to measure talents in fair combat, whose champions have now made themselves known. For those concerned with lasting values, the most significant lesson to be derived is that, with freedom of expression, with liberty to accept or reject direction, art continues its forward progress in the Americas. In the best tradition of the past, it confidently awaits the challenge of the future. --*J.G-S.*

JURY OF INTERNATIONAL SALON, WASHINGTON, D.C.

BARR, Jr. Alfred H. Born in Detroit, Michigan, in 1902. Founder of the Museum of Modern Art in New York and presently its director of collections, was educated at Princeton and Harvard universities, receiving his doctorate from the latter. He has been honored with degrees from many universities. Among the decorations he has received is the Order of Chevalier of the Legion of Honor of France. Dr. Barr is the author of numerous works, including *What Is Modern Art?*

GROSCHWITZ, Gustave von. Born in New York in 1906, studied at Columbia University and received a master's degree from New York University. After teaching art at Wesleyan University, he served as senior curator of the Cincinnati Art Museum and adjunct professor of art at the University of Cincinnati. He joined the Museum of Art at the Carnegie Institute in 1963, which he serves as director.

MESSER, Thomas M. Born in Bratislava, Czechoslovakia, in 1920. Came to the United States as an exchange student and graduated from Boston University. After service in the United States Army, he obtained a degree in fine arts from Harvard University. He resigned as director of the American Federation of Arts in 1956 to become director of the Institute of Contemporary Art in Boston. In 1961 he was named director of the Solomon R. Guggenheim Museum in New York.

PARTICIPATING NATIONAL INSTITUTIONS AND JURIES

ARGENTINA. Museo de Arte Moderno, Buenos Aires: José Gómez-Sicre, Hugo Parpagnoli, Samuel Oliver, Luis Jorge Duhalde, Amaya Hernández Rosselot.
BRAZIL. Museu de Arte Moderna, Rio de Janeiro: José Gómez-Sicre, Quirino Campofiorito, José Geraldo Vieira.
CENTRAL AMERICA AND PANAMA. Dirección General de Artes y Letras, San José; Dirección General de Bellas Artes y Biblioteca Nacional, San Salvador; Escuela de Artes Plásticas, Guatemala; Escuela Nacional de Bellas Artes, Tegucigalpa; Escuela Nacional de Bellas Artes, Managua; Instituto Panameño de Arte, Panama:

José Gómez-Sicre, Salvador Salazar Arrué (Salarrué), Frank Getlein.
CHILE. Museo Nacional de Bellas Artes, Santiago: José Gómez-Sicre, Camilo Mori, Antonio Romera.
COLOMBIA. Museo de Arte Moderno, Bogotá: Marta Traba, José Gómez-Sicre, Alejandro Obregón.
DOMINICAN REPUBLIC. Palacio Nacional de Bellas Artes, Santo Domingo: Selden Rodman, Jaime Colson.
HAITI. Institut Haïtien-Américain, Port-au-Prince: Selden Rodman, Madame Pierre Piallière.
MEXICO. Museo de Arte Moderno, Mexico City: Rafael Anzures, Justino Fernández, Carlos Orozco Romero, Rufino Tamayo.
PARAGUAY. Museo de Arte Moderno, Buenos Aires: José Gómez-Sicre, Hugo Parpagnoli, Samuel Oliver, Luis G. Benítez.
PERU. Instituto de Arte Contemporáneo, Lima: José Gómez-Sicre, Emily Genauer, Juan Manuel Ugarte Eléspuru.
PUERTO RICO. Instituto de Cultura Puertorriqueña: Mary Sayre Haverstock, Osiris Delgado, Julio Rosado del Valle.
URUGUAY. Museo de Arte Moderno, Buenos Aires: José Gómez-Sicre, Hugo Parpagnoli, Samuel Oliver, Enrique Gómez.
VENEZUELA. Museo de Bellas Artes, Caracas: Guillermo Meneses, José Gómez-Sicre, Pedro Vallenilla Echeverría.

ACKNOWLEDGEMENTS

The *Esso Salon of Young Artists* was sponsored by the following affiliates of Standard Oil Company (New Jersey) which operate in Latin America. ARGENTINA: Esso Sociedad Anónima Petrolera Argentina; BRAZIL: Esso Brasileira de Petróleo S.A.; CENTRAL AMERICA AND PANAMA: Esso Standard Oil S.A. Limited; CHILE: Esso Standard Oil Co. (Chile) S.A.C.; COLOMBIA: International Petroleum (Colombia) Ltd.; DOMINICAN REPUBLIC: Esso Standard Oil S.A. Limited; HAITI: Esso Standard Oil S.A. Limited; MEXICO: Esso Mexicana S.A. de C.V.; PARAGUAY: Esso Standard Paraguay S.A.; PERU: International Petroleum Company, Limited; PUERTO RICO: Esso Standard Oil Company (Puerto Rico); URUGUAY: Esso Standard Oil Co. (Uruguay) S.A.; VENEZUELA: Creole Petroleum Corp.

CATALOGUE

Painting, Drawing, Sculpture

Rodolfo Abularach (First Prize, Painting, Guatemala)
 1. *Untitled*, pen and ink drawing on paper

Olga Albizu (Second Prize, Painting, Puerto Rico)
 2. *Crecimiento (Growth)*, oil on canvas

Felipe Aldama (Second Prize, Sculpture, Argentina)
 3. *Destrucción (Destruction)*, wood and metal sculpture

Antonio Alvarado (First Prize, Painting, Panama)
 4. *Trópico (Tropics)*, oil on canvas

Gracia Barrios (Second Prize, Painting, Chile)
 5. *Figura (Figure) No. 2*, oil on wood

Tomás Batista (Second Prize, Sculpture, Puerto Rico)
 6. *Caracol (Snail)*, stone sculpture

Cándido Bidó (First Prize, Painting, Dominican Republic)
 7. *Almuerzo tardío (Late Lunch)*, oil on canvas

Fernando Botero (First Prize, Painting, Colombia)
 8. *Las frutas (Fruits)*, oil on canvas

Ary Brizzi (First Prize, Sculpture, Argentina)
9. *Proyección plana, tensión (Flat Projection, Tension)*, Plexiglass sculpture

Feliza Bursztyn (First Prize, Sculpture, Colombia)
10. *Chatarra (Scrap)*, metal sculpture

Carlos Cañas (First Prize, Painting, El Salvador)
11. *Unidad marcada (Defined Unity)*, mixed media on canvas

Francisco Cardona (Second Prize, Sculpture, Colombia)
12. *Mateo I*, metal sculpture

Lilia Carrillo (Second Prize, Painting, Mexico)
13. *Seradís*, oil on canvas

Guillermo Castaño (Second Prize, Sculpture, Mexico)
14. *Luzbel*, bronze sculpture

Sergio Castillo (Second Prize, Sculpture, Chile)
15. *Chuaqui*, metal sculpture

Víctor Chab (First Prize, Painting, Argentina)
16. *La sombra de una imagen (The Shadow of an Image)*, oil and collage

Carlos Colombino (First Prize, Painting, Paraguay)
17. *Yboty (Flower)*, painting on wood.

Ernesto Cristiani (First Prize, Painting, Uruguay)
18. *Figuras 20 (Figures 20)*, oil and collage

Ernesto Deira (First Prize, Painting, Argentina)
19. *En torno al pensamiento A-11 (Concerning Thought A-11)*, oil

Lionel Derenoncourt (First Prize, Painting, Haiti)
20. *Liberté (Liberty)*, oil on canvas

Juan Egenau Moore (First Prize, Sculpture, Chile)
21. *Ancestro (Ancestor)*, bronze sculpture

Lola Fernández (First Prize, Painting, Costa Rica)
22. *Petróleo 4 a.m. (Petroleum 4 A.M.)*, oil on canvas

Rafael Ferrer (First Prize, Sculpture, Puerto Rico)
23. *Cabeza-máscara grande (Head--Large Mask)*, iron sculpture

Fernando García Ponce (First Prize, Painting, Mexico)
24. *Pintura (Picture) No. 1*, oil on canvas

Marie-José Gardère (Second Prize, Painting, Haiti)
25. *L'oiseau noir (Black Bird)*, oil on canvas

Gelasio Giménez (Second Prize, Painting, Honduras)
26. *Variaciones sobre un tema (Variations on a Theme)*, oil on Masonite

Roberto González Goyri (First Prize, Sculpture, Guatemala)
27. *Toro (Bull)*, bronze sculpture

Hermann Guggiari (First Prize, Sculpture, Paraguay)
28. *Kennedy*, iron sculpture

Edgard Guinand (Second Prize, Sculpture, Venezuela)
29. *Manifestación en ruinas (Manifestation in Ruins)*, iron sculpture

Alberto Guzmán (Second Prize, Sculpture, Peru)
30. *Formas (Forms) No. 1*, bronze sculpture

Gilberto Hernández (First Prize, Painting, Dominican Republic)
31. *El ángel de las sombras luchando con el fuego (The Angel of Shadows Fighting Fire)*, oil on canvas

Luis Hernández Cruz (First Prize, Painting, Puerto Rico)
32. *Subsuelo (Subsoil)*, oil on canvas

Alvaro Herrán (Second Prize, Sculpture, Colombia)
33. *Relieve (Relief)*, metal sculpture

Francisco Hung (First Prize, Painting, Venezuela)
34. *Materias flotantes en un espacio (Materials Floating in Space)*, oil on canvas

Humberto Jaimes Sánchez (Second Prize, Painting, Venezuela)
35. *Los años treinta (The Thirties)*, oil on canvas

Domingo Liz (First Prize, Sculpture, Dominican Republic)
36. *Talla (Carving)*, wood sculpture

Arturo Luna (First Prize, Painting, Honduras)
37. *Ciudad desierta (Deserted City)*, mixed media

Mortès Mérisier (First Prize, Painting, Haiti)
38. *Diac sous Diac*, oil on canvas

Silvio Miranda (Second Prize, Painting, Nicaragua)
39. *La Sagrada Familia (The Holy Family)*, oil on canvas

Carlos Moya Barahona (Second Prize, Painting, Costa Rica)
40. *Drama lunar (Lunar Drama)*, mixed media on canvas

Guillermo Núñez (First Prize, Painting, Chile)
41. *Pintura (Painting) No. 1*, oil on canvas

Manuel Pereira (First Prize, Sculpture, Peru)
42. *Figura en descanso (Figure at Rest)*, bronze sculpture

Rogelio Polesello (Second Prize, Painting, Argentina)
43. *Faz A (Phase A)*, oil

Efraín Recinos (First Prize, Sculpture, Guatemala)
44. *Sirena en las nubes (Siren in the Clouds)*, bronze sculpture

Víctor Manuel Rodríguez Preza (Second Prize, Painting, El Salvador)
45. *Pintura A (Picture A)*, wash on cardboard

Hermenegildo Sábat (Second Prize, Painting, Uruguay)
46. *La señora Pérez el día que se casó con el señor Pérez (Mrs. Pérez the Day She Married Mr. Pérez)*, oil

Mauricio Salgueiro (First Prize, Sculpture, Brazil)
47. *Escultura (Sculpture) III*, bronze

Lotte Schulz (Second Prize, Painting, Paraguay)
48. *Pergamino (Parchment) No. 1*, dye on leather

Olivier Seguin (First Prize, Sculpture, Mexico)
49. *Brote (Sprout)*, stone sculpture

Orlando Sobalvarro (First Prize, Painting, Nicaragua)
50. *Verano (Summer)*, oil on Masonite

Ruisdael Suárez (Second Prize, Painting, Uruguay)
51. *Tres a la mesa (Three at the Table)*, oil and collage

Fernando de Szyszlo (First Prize, Painting, Peru)
52. *Huanacauri*, oil on canvas

Alberto Teixeira (First Prize, Painting, Brazil)
53. *Azul e amarelo contrastante (Contrasting Blue and Yellow)*, oil on canvas

Yutaka Toyota (Second Prize, Painting, Brazil)
54. *Caminho (The Road)*, oil on canvas

Guillermo Trujillo (Second Prize, Painting, Panama)
55. *Perfil y paisaje (Profile and Landscape)*, oil on canvas

Víctor Valera (First Prize, Sculpture, Venezuela)
56. *Abdalá el ángel (The Angel Abdala)*, metal sculpture

Nicolas Vlavianos (Second Prize, Sculpture, Brazil)
57. *O imortal (The Immortal)*, bronze sculpture

Daniel Yaya (Second Prize, Painting, Peru)
58. *Musical*, oil on canvas

Nirma Zárate (Second Prize, Painting, Colombia)
59. *Abstracción (Abstraction) No. 5*, oil on canvas

BIOGRAPHIES OF ARTISTS

ABULARACH, Rodolfo. Was born in Guatemala in 1933. Studied architecture and later painting in Pasadena (California), and in Mexico City. After a period of work and exhibits in his own country, he returned to the United States on several fellowships. Abularach has presented six one-man exhibitions and has appeared in twenty group shows. His work is represented in the Museum of Modern Art in New York, as well as in public collections in Washington, Guatemala City, and La Paz. Abularach now lives in New York.

ALBIZU, Olga. Was born in Ponce, Puerto Rico, in 1924. She obtained her bachelor's degree at the University of Puerto Rico and studied painting at the Art Students League in New York, the Grande Chaumière Academy in Paris, and the School of Fine Arts in Florence. Miss Albizu has had one-man shows in the leading galleries of San Juan, Washington, New York, and other United States cities. She participated in the First Biennial of Mexico. Her works are found in private collections in Puerto Rico, the United States, and Israel.

ALDAMA, Felipe. Was born in Asunción, Paraguay, in 1932. Has had numerous one-man exhibits in the major cities of Argentina. He won First Prize in Sculpture in the thirty-eighth Salon of Plastic Artists in Santa Fe and the First Prize in Sculpture of the National Arts Fund, among many important artistic distinctions. Lives in Argentina.

ALVARADO, Antonio. Was born in Le Havre, France, in 1938 and has lived in Panama since early youth. He studied for several years with the painter Alberto Dutary. In 1963 he received First Prize in the Salon of Plastic Arts of the Panamanian Art Institute, and the following year had his first one-man exhibit there. His works appear in private collections in Panama, the Dominican Republic, Colombia, and the United States.

BARRIOS, Gracia. Was born in Santiago, Chile, in 1927. Teaches at the School of Fine Arts in Santiago and has participated with distinction in biennials in São Paulo (First and Second), Paris (Second), Mexico, and Córdoba (Argentina). She has had individual shows in Santiago (Chile) and Barcelona (Spain). Miss Barrios has won prizes for drawing and painting at official exhibitions in Chile. Her works are seen in the Museum of Contemporary Art of Santiago and in official collections in Caracas and Barcelona (Spain).

BATISTA, Tomás. Was born in Luquillo, Puerto Rico, in 1935. He received a scholarship from the Institute of Puerto Rican Culture and studied in San Juan (Puerto Rico) and Mexico City. A fellowship from the Guggenheim Foundation allowed him to continue his studies in New York. Batista has had one-man shows at the Institute, the Ateneo, and the University of Puerto Rico. His works have been seen in many group shows and are part of several public collections in San Juan.

BIDO, Cándido. Was born in Bonao, Dominican Republic, in 1936. Studied at the School of Fine Arts of his country, where he won a prize in painting in 1962. He has had several individual shows and has participated in national salons, among them the Eleventh Biennial of Plastic Arts. His work is represented in the Gallery of Fine Arts in Santo Domingo and in private collections. Bidó teaches at the School of Fine Arts in Santo Domingo.

BOTERO, Fernando. Was born in Medellín, Colombia, in 1932. Studied in his native Colombia and later in Italy, France, and Spain. In addition to eight individual shows in Bogotá, Mexico City, and Washington, D.C., his work has appeared in many important exhibitions in New York, Venice, São Paulo, Barcelona (Spain), Baltimore, Dayton, Dallas, Bogotá, and Barranquilla. Botero has received eight major prizes, including awards at the Barcelona Biennial (Spain) and the Guggenheim Museum, and the National Art Prize in Colombia.

BRIZZI, Ary. Was born in Argentina in 1930. Painter, sculptor, and designer, studied at the National School of Fine Arts and the Ernesto de la Cárcova School of Buenos Aires. He has traveled extensively in Latin America and the United States. Brizzi's work has become known through group and individual exhibits in New York, Paris, Lima, and other cities. By popular vote he was awarded the First Prize at the *Young Argentine Painters* exhibit of 1952 and was similarly honored in the First Salon of Modern Art, both in Buenos Aires.

BURSZTYN, Feliza. Was born in Bogotá, Colombia, in 1934. She studied first at the Art Students League in New York and later at the workshop of O. Zadkine in the Grande Chaumière Academy in Paris. Miss Bursztyn had individual exhibits in Bogotá in 1958 and 1961 and each year since 1962 has been included in the National Salon of that city.

CAÑAS, Carlos. Was born in San Salvador, El Salvador, in 1924. Studied at the National School of Fine Arts of that city, completing his artistic training in Madrid on scholarships awarded by his government and by the Institute of Hispanic Culture. He has exhibited in Spain (Madrid and Santander), Germany, and El Salvador. Cañas has also participated in biennials in Madrid, Paris, and Mexico. In addition to teaching in the School of Architecture in San Salvador, he has had experience as a set designer.

CARDONA, Francisco. Was born in Aguadas, Colombia, in 1937. Between 1955 and 1961 he studied painting at the School of Fine Arts in Bogotá. In recent years his works have appeared in major exhibitions in the Colombian cities of Bogotá, Cali, and Ibagué. Cardona has also had shows in Bogotá, Cali, and Cartago, and in 1961 he won the First Prize in Sculpture at the Francisco A. Cano Salon of Cali.

CARRILLO, Lilia. Was born in Mexico in 1929. Studied painting in Mexico and later at the Grande Chaumière Academy in Paris. She holds the degree of Master of Plastic Arts and teaches at the National Institute of Fine Arts in Mexico City. Miss Carrillo is also a designer of tapestry. She has had eight one-man shows in Mexico City, Lima, Washington, D.C., and Paris. Among the twenty exhibitions in which she has participated are those held in Mexico, Paris, Jerusalem, as well as other cities in Brazil, Chile, and the United States.

CASTAÑO, Guillermo. Was born in Mexico in 1938. Studied in the National School of Plastic Arts and the

Academy of San Carlos in Mexico City. He has participated in a number of collective exhibitions in Mexico, among them, Art Gallery of Monterrey, 1958; Home Fair, 1963; the Gallery of the Cooperative Development Bank, 1963; and the First Cultural Fair of Tlaxcala, 1963. He has also participated in the *Mexican Tourist Promotion Exposition* held in New York City in 1963.

CASTILLO, Sergio. Was born in Chile in 1925. Studied sculpture in the School of Fine Arts and the Julian Academy of Paris, as well as in the School of Fine Arts of the University of Chile. He has participated in major international exhibitions in Rome (Gold Medal), São Paulo, and Paris. He has had one-man shows in Rome, New York, Lima, Washington, and Santiago. Castillo has won four first prizes in his own country, including the National Critics' Award, in 1964, for the best work of art of the year.

CHAB, Víctor. Was born in Argentina in 1930. Has had both collective and one-man exhibits in Washington, Mexico, Brussels, Montevideo, Punta del Este, Saigon, Rio de Janeiro, New York, Jakarta, Paris, Caracas, Berlin, Minneapolis, and other cities. Chab has exhibited in the Venice Biennial, 1956 and 1964; the Berlin International Fair, 1964; and the Museum of Modern Art of Paris, 1963. He was awarded the Silver Medal in the Universal Exposition of Brussels, 1961, among other important prizes.

COLOMBINO, Carlos. Was born in Concepción, Paraguay, in 1937. Has been exhibiting in his country since 1956. Has participated twice in the Biennial of São Paulo and in collective exhibits in Madrid, Barcelona, Salamanca, Rome, Naples, Bern, Berlin, Lisbon, and Dallas. Individually, his work has been shown in the Ateneo of Madrid and will appear in the Lambert Gallery of Paris and in Panama. He won the Painting Prize in the *Art of America and Spain* exhibit, Madrid, 1963. Colombino's works are in collections in Paraguay, Argentina, Spain, and the United States.

CRISTIANI, Ernesto. Was born in Montevideo, Uruguay, in 1928. Studied in the studios of Vicente Martín, Eduardo Amézaga, and Lino Dinetto in that city. He has had individual shows in Montevideo and has participated in Uruguayan group exhibitions. Among the prizes Cristiani has won are an Honorable Mention in the Salon of Arts and Letters of Punta del Este, 1964, and the Grand Prize in Painting at the Bicentennial Art Salon in Montevideo, 1964.

DEIRA, Ernesto. Was born in Buenos Aires, Argentina, in 1928. He is a lawyer. Studied art in Buenos Aires and received a fellowship from the National Arts Fund. He has had individual showings in Buenos Aires and Washington and has participated in numerous exhibitions in Argentina as well as in Paris, Madrid, Rome, Bern, Naples, Bonn, Berlin, Saigon, Rio de Janeiro, Caracas, Bogotá, New York, and Austin. He won the Losada Prize in the Salon of Watercolorists and Engravers in 1958.

DERENONCOURT, Lionel. Was born in Port-au-Prince, Haiti, 1945. He is a senior high school student and hopes to become an architect. He is completely self-taught in art. The Esso competition, in which he won first honors with his work called *Liberté*, not only is the first in which he has participated, but it has given him an opportunity to exhibit in Haiti and abroad.

EGENAU MOORE, Juan. Was born in Santiago, Chile, in 1927. Studied architecture at the Catholic University of Santiago. In 1948 he entered the School of Fine Arts of the University of Chile. A fellowship enabled him to study to be a goldsmith and silversmith in the School of Porta Romana in Florence. Since 1952 Egenau has been awarded eight first prizes in the most important salons of Chile in sculpture, engraving, and applied arts, among them, the National Critics' Award for 1958.

FERNANDEZ, Lola. Was born in Colombia, 1926. Studied in San José (Costa Rica), as well as in Bogotá and Florence (Italy), where she was awarded the *laurea in pittura*. She has traveled extensively in the United States, Europe, and the Middle and the Far East. Ms. Fernández has exhibited in Paris, Mexico City, San José (Costa Rica), London, Bogotá, Santiago (Chile), Panama City, Guatemala City, Venice, Rome, Milan, Florence, and cities in the United States. She is part of the New Vision group of London and of the Group of Eight in San José, Costa Rica. Ms. Fernández is married to the painter Jean Guillermet and lives and teaches art in San José, Costa Rica.

FERRER, Rafael. Was born in San Juan, Puerto Rico, in 1933. Studied at the universities of Syracuse (New York) and Puerto Rico. He has held one-man exhibits at the latter in 1956, 1961, and 1964. In 1964 Ferrer also

participated in the *International Exposition* of the Washington Square Galleries in New York. His works are part of the permanent collections of the Museum of the University of Puerto Rico and the Ponce Museum.

GARCIA PONCE, Fernando. Born in Mérida, Mexico, in 1933. Studied architecture at the National University of Mexico and art in the workshop of Enrique Climent. Between 1956 and 1961, he traveled and studied in the United States and Europe. Since his first individual exhibit in Mexico, 1959, García Ponce has had no fewer than fifteen exhibits--both individual and group--in Mexico City, Mérida, Acapulco, Paris, Madrid, and other European capitals. He has won two prizes in art competitions in his country.

GARDERE, Marie-José. Born in Haiti in 1931, was educated in Haiti and Canada. Her first art lessons were at the Centre d'Art in Port-au-Prince, followed by studies at the Elmwood School in Ottawa. Mme. Gardère participated in her first group shows at the Alliance Française, 1963, and the Centre d'Art, 1964, both in Port-au-Prince. Mme. Gardère has traveled widely in the Caribbean area, Europe, and North America, and has exhibited in New York, Montreal, and San Juan (Puerto Rico).

GIMENEZ, Gelasio. A naturalized citizen of Honduras, was born in Cienfuegos, Cuba, in 1926 and studied at the Academy of Fine Arts in Havana. He has had individual exhibits in Havana, Mexico City, San Salvador, and Tegucigalpa. Some of his sculptures are found in public places in Havana. As a painter, Giménez won Second Prize in the last Annual Salon of the Honduran Institute of Inter-American Culture.

GONZALEZ GOYRI, Roberto. Born in Guatemala in 1924, studied art in his own country and later in New York. He has exhibited in Guatemala, the United States, Costa Rica, Panama, Venezuela, Ecuador, Mexico, France, and Switzerland. González Goyri was invited to participate in the Twenty-third Venice Biennial and in 1952 was a finalist in a worldwide art competition held in London. His work is found in the Museum of Modern Art in New York, and his sculptures and murals adorn public buildings in Guatemala.

GUGGIARI, Hermann. Was born in Asunción, Paraguay, in 1924. Studied engineering and later art in Buenos Aires. He has participated in several exhibitions in Asunción and in three biennials in São Paulo, in one of which he won a Silver Medal. He has won first prizes in six art competitions in his country. Guggiari designed a monument to Carlos Antonio López, 1962. Recently he visited the United States as a guest of the State Department.

GUINAND, Edgard. Was born in Caracas, Venezuela, in 1943 and now studies there at the School of Fine Arts. In 1963-64 he was invited to pursue special studies with the sculptor Kenneth Armitage in Caracas, under a fellowship from the Neumann Foundation. Guinand has taken part in all official Venezuelan salons since 1962 and has had eight shows in the principal galleries and museums of Caracas. In 1964 he won the Rotary Club Prize of the Salon D'Empaire in the Venezuelan capital.

GUZMAN, Alberto. Born in Talara, Peru, in 1927. Graduated with honors from the School of Fine Arts of Lima in 1956. He has taken part in many group exhibits in Lima and other Peruvian cities. In 1959 Guzmán won the National Sculpture Prize and obtained a fellowship from the French government to study in Paris. He has participated in the Paris Biennial and the exhibit *Treasures of Peru* in the Petit Palais, the Biennial of Sculpture in Antwerp, the International Salon of the Rodin Museum of Paris, and many other important events. Guzmán lives in Paris.

HERNANDEZ, Gilberto. Was born in Bani, Dominican Republic, in 1924. At the age of twenty-one he graduated from the National School of Fine Arts of his country, of which he is presently the director. He won First and Second Prize in Painting in the Dominican Republic Biennial of 1952 and 1958, among many other awards. Besides holding one-man shows in Santo Domingo and Caracas, Hernández has participated in international exhibitions in the United States, France, Spain, Mexico, Brazil, Colombia, and Venezuela.

HERNANDEZ CRUZ, Luis. Was born in San Juan, Puerto Rico, in 1936 and in 1959 graduated with a Master of Arts degree from the American University in Washington, D.C. He has had many one-man shows in Puerto Rico, and his work appeared in the exhibit *Art of America and Spain* held in Madrid in 1963. Hernández has won three first prizes in competitions in Puerto Rico and his paintings figure in important collections in the island.

HERRAN, Alvaro. Was born in Cali, Colombia, in 1937. His work has appeared in exhibits in such Colombian

cities as Bogotá, Cali, Barranquilla, Pereira, and Cúcuta, as well as in the Córdoba (Argentina) Biennial and other competitions. He has also held six one-man exhibits in Bogotá and in 1964 received an award in the Annual Art Salon of that capital. Herrán has executed murals in Colombia, and his works appear in public collections in Bogotá, Cali, Mexico City, Stockholm, and Yale University in New Haven (Connecticut).

HUNG, Francisco. Was born in Hong Kong, in 1937. He studied at the School of Art in Maracaibo and at the Advanced School of Fine Arts in Paris. Besides individual shows in Maracaibo and Caracas, Hung has participated in all official Venezuelan salons since 1957, as well as in Venezuelan exhibits sent abroad. He won an Honorable Mention in the Third Paris Biennial, 1963; the Rome Prize at the 1964 Official Salon in Caracas; and seven other important prizes in Venezuela, including First Prize at the Official Venezuelan Salon of 1965. Lives in Venezuela.

JAIMES SANCHEZ, Humberto. Was born in San Cristóbal, Venezuela, in 1930. He studied at the School of Plastic Arts in Caracas, where he now teaches. Jaimes Sánchez has had individual exhibits in Caracas, Washington, D.C., and New York. He has taken part in other exhibits in Caracas, Houston, Dallas, Paris, Chicago, Pittsburgh, Barranquilla (Colombia), Lima, Santiago, Concepción (Chile), Montevideo, Baden-Baden, and several Swiss cities. He has won many national awards.

LIZ, Domingo. Was born in Santo Domingo, Dominican Republic, in 1931. He studied sculpture and painting in the National School of Fine Arts of that city. In the Dominican Republic Biennial of Plastic Arts he won Second Prize for Drawing in 1956 and the Second Prize for Sculpture in 1958. He has participated in numerous group shows, among them the *Caribbean Painting* exhibit at the University of Florida in Gainesville and others held in the Dominican Republic and abroad. Liz is a teacher at the National School of Fine Arts, and his work appears in many collections.

LUNA, Arturo. Was born in Santa Rita de Copán, Honduras, in 1926. He studied in Tegucigalpa and later in Italy on a Honduran government fellowship. For five years he worked at the Superior Institute of Ceramics in Faenza (Italy). Luna, who teaches in the School of Fine Arts of Tegucigalpa, has won gold medals for his work in Italy and Guatemala, as well as various prizes in Honduras. He has had five individual exhibits in Tegucigalpa and San Salvador and has taken part in group shows in Europe and America.

MERISIER, Mortès. Born in Port-au-Prince, Haiti, in 1925, Mérisier is both an electrician and furniture maker who has had no academic preparation or opportunities to participate in art competitions. Although he has held exhibits in the famous Haitian Centre d'Art, this is the first time he has competed and won a prize.

MIRANDA, Silvio. Was born in Nicaragua in 1948. He has studied in the School of Fine Arts of Managua since 1958 on a merit scholarship of the Ministry of Education. He has participated in many expositions at the school, as well as in an exhibit of contemporary art held at the Praxis Gallery of Managua in 1964. Last year he won the Prize of the Republic of El Salvador in the Tenth National Cultural Competition. Miranda is not yet twenty years of age.

MOYA BARAHONA, Carlos. Was born in Cartago, Costa Rica, in 1925. He studied in the School of Fine Arts of San José (Costa Rica), the Fernando Academy and the Circle of Fine Arts in Madrid. He now teaches at the University of Costa Rica. In addition to a one-man show in San José, Moya has participated in group exhibits in Madrid, Washington, D.C., and New York. He was awarded a prize in the Floral Games of 1963 and his work appears in the government permanent collection in San José.

NUÑEZ, Guillermo. Born in Santiago, Chile, in 1930. He studied there as well as in Paris and Prague. He has had individual exhibitions in Santiago, Washington, D.C., and at Cornell University in Ithaca. Has been included in other shows in Santiago, Lima, Mexico, Caracas, Rio de Janeiro, Washington, D.C., and New York. He was selected to participate in the Chilean exhibits at the Third Paris Biennial, the Second Córdoba (Argentina) Biennial, and the Seventh São Paulo Biennial. Núñez won the Acero del Pacífico Grand Prize in Santiago, 1963, and his work is represented in museums and collections in Chile, Germany, Argentina, Brazil, Spain, the United States, France, and Peru.

PEREIRA, Manuel. Born in Cajamarca, Peru, in 1935, Pereira is a self-taught painter and sculptor who has been showing his works in the principal salons of Lima since 1957. In 1962 he offered a one-man exhibit in his native

Cajamarca. Pereira worked in 1964 on the award-winning project for a monument to the Peruvian poet César Vallejo. His works are found in private collections in Peru and abroad.

POLESELLO, Rogelio. Born in Buenos Aires, Argentina, in 1939. He studied at the School of Fine Arts in the Argentine capital. Polesello has had one-man shows in Buenos Aires, Washington, D.C., Lima, and Bogotá. He has participated in important group exhibitions in Washington, D.C., Dallas, Lima, Rio de Janeiro, Paris, and other cities. Among the awards received by Polesello in Buenos Aires are the Losada Prize, Annual Art Salon, 1959; First Honorable Mention, De Ridder Competition, 1959; Honorable Mention, Ver y Estimar Prize Salon, 1960; and First Prize, Israel Office of Tourism Salon, 1963.

RECINOS, Efraín. Born in Quezaltenango, Guatemala, in 1932. Recinos is an architect, painter, and sculptor whose design for the new National Theater of Guatemala is an outstanding example of integration in the plastic arts. He has had many one-man shows in his country and has executed several bas-reliefs on public buildings. Among the prizes he has won is First Prize in Painting at the Cultural Competition in El Salvador, 1964.

RODRIGUEZ PREZA, Víctor Manuel. Was born in San Salvador, El Salvador, in 1936. In that city he began his art studies, continuing his training in Madrid. Rodríguez held individual shows in El Salvador and Europe. He has participated in numerous exhibits in Bogotá, Paris, Vienna, Santiago, Guatemala City, San Salvador, Madrid, and New York. He is a professor of plastic arts in San Salvador.

SABAT, Hermenegildo. Was born in Montevideo, Uruguay, in 1933. After studying architecture, he began working as a draftsman and designer for Uruguayan newspapers and magazines. His drawings and posters have been reproduced in the German magazine *Gebrauchsgraphik*, the *Graphis Annual* of Switzerland, and in publications in Argentina, Brazil, the United States, and France. Sábat has exhibited in Uruguay and in the Second Córdoba (Argentina) Biennial. His works are found in collections in Uruguay, Argentina, Brazil, Colombia, and the United States.

SALGUEIRO, Mauricio. Was born in Vitória, Espírito Santo, Brazil, in 1930. He studied at the National School of Fine Arts in Rio de Janeiro. Among the exhibits in which he has participated in Rio de Janeiro are: National Salon of Fine Arts (Silver Medal in 1953 and 1957), Municipal Salon of Fine Arts (Silver Medal in 1955), and the National School of Fine Arts (Silver Medal in 1956 and Gold Medal in 1957). In 1960 Salgueiro was awarded the National Prize in Sculpture at the First Salon of Modern Art in Brasília and a trip abroad granted by the National School of Fine Arts.

SCHULZ, Lotte. Born in Encarnación, Paraguay, in 1925, Schulz is self-taught. Her paintings and sculptures have appeared in exhibitions and competitions in Paraguay as well as in São Paulo, Buenos Aires, Lugano, Tokyo, Madrid, and Santiago. She has won an award in the *Religious Art Exhibition* of Asunción, 1956; a Gold Medal in the *La Razón* contest of Buenos Aires, 1960; and the Grand Prize of the National Arts Fund of Buenos Aires, 1960.

SEGUIN, Olivier. Was born in Montreuil, France, in 1927. He studied at the School of Fine Arts in Lille and Paris. In addition to several individual exhibits, he participated five times in the Autumn Salon in French Morocco. Since 1956 his work has become well known in Mexico, where he teaches art in the University of Guadalajara. Seguin has executed a number of public monuments and has participated in important national sculpture competitions. He has won seven prizes in art salons in Morocco and Mexico. Lives in Mexico since 1956.

SOBALVARRO, Orlando. Born in Nicaragua in 1943. Sobalvarro is a painter and sculptor who studied for seven years in the School of Fine Arts in Managua, where he won a merit scholarship from the Ministry of Education. Sobalvarro has taken part in many national exhibits, and his work has been seen in important shows in New York, Berlin, Kansas City, San Salvador, and other cities.

SUAREZ, Ruisdael. Was born in Montevideo, Uruguay, in 1929. He is a self-taught artist who has had many one-man exhibits in his own country and has participated in group shows in Uruguay and abroad. Among the prizes he has won in Montevideo are: Bank of the Republic, 1959; Second Prize in Engraving, National Salon, 1963; Juan B. Blanes Acquisition Prize, Municipal Salon, 1959 and 1962. He was also awarded the Governor of Tokyo Prize at the Fourth Tokyo Biennial of Engraving, 1964.

SZYSZLO, Fernando de. Was born in Lima, Peru, in 1925. He studied in the School of Plastic Arts of the Catholic University in Lima and later in France and Italy. He has participated in such important international exhibits as the Fourth and Fifth São Paulo Biennials, Twenty-third Venice Biennial, and the Pittsburgh and Guggenheim international exhibits. Szyszlo has had one-man shows in Lima, Paris, Florence, Washington, D.C., New York, Mexico City, Buenos Aires, Rio de Janeiro, São Paulo, Santiago, Bogotá, and Caracas.

TEIXEIRA, Alberto. Was born in São João do Estoril, Portugal, in 1925. He studied painting and design at the National Society of Fine Arts in Lisbon, but his most intense artistic activity has been carried on in São Paulo. Teixeira held his first show in Lisbon in 1950 and since 1952 he has participated in group exhibits in Brazil and has had one-man shows in Rio de Janeiro and São Paulo. His work was represented in the Second, Third, Fifth, and Seventh São Paulo Biennials, after which he lived and worked for a year in Paris. Teixeira won the Second Prize in the Leirner Prize competition of São Paulo. Teixeira has lived in Brazil since 1950.

TOYOTA, Yutaka. Was born in Yamagata, Japan, 1931. He studied at the School of Fine Arts in Tokyo. In 1958 he participated in the Yamagata Salon and the following year held a one-man show in Tokyo. In 1962 Toyota held an individual exhibition and participated in a group show in Buenos Aires. In Brazil Toyota has been represented in the Twelfth and Thirteenth Salons of Modern Art of São Paulo (Gold Medal in the former) in 1963 and 1964; Seventh São Paulo Biennial, National Salon of Rio de Janeiro and Curitiba Art Salon in 1963; Second Work Salon (Salão do Trabalho) of São Paulo (First Prize), and the group show *Arte no IAB*, Institute of Brazilian Architects, São Paulo, 1964. Toyota now lives in Brazil.

TRUJILLO, Guillermo. Was born in Horconcitos, Panama, in 1927. He graduated as an architect from the University of Panama. He studied painting at the San Fernando Academy in Madrid on a fellowship from the Institute of Hispanic Culture. Trujillo has exhibited in Panama City, Caracas, Washington, D.C., and Madrid and has participated in biennials in Barcelona, Madrid, Mexico City, and São Paulo (Honorable Mention, 1959). He has executed five murals in Panama.

VALERA, Víctor. Was born in Maracaibo, Venezuela, in 1927. He studied art there and in Caracas, continuing later his training in Paris with Dewasne, Vasarely, and Fernand Léger. Valera has had important one-man shows in Paris, Milan, and Madrid and has participated in a dozen exhibitions in Maracaibo, Caracas, Paris, and São Paulo. Between 1957 and 1963 he was awarded ten prizes in painting and sculpture in Venezuela and abroad, including the National Prize for Sculpture. His work is in many private collections in Venezuela.

VLAVIANOS, Nicolás. Was born in Athens, Greece, in 1929. After studying in his native city, he continued his training in Paris. Among the exhibits in which he has been represented are the Salon des Réalités Nouvelles, Paris; Fourth Pan-Hellenic Exhibition, Athens; Sixth and Seventh São Paulo Biennial; Salon de la Jeune Sculpture, Paris; *Group of New Forms*, Athens; and other group exhibitions in Israel (Jerusalem, Haifa, and Tel Aviv). Vlavianos settled in Brazil in 1960.

YAYA, Daniel. Born in Lima, Peru, in 1935. Graduated from the National School of Fine Arts of Lima with the Grand Prize of Honor and Gold Medal. He has taken part in many group exhibits in Peru, as well as in the Seventh São Paulo Biennial and the Second Córdoba (Argentina) Biennial. In 1964 Yaya presented his first personal show in Lima. He has won two prizes (1962 and 1963) in competitions organized by the Peruvian-North American Cultural Institute.

ZARATE, Nirma. Was born in Bogotá, Colombia, in 1936. She studied at the School of Fine Arts of the National University, later completing her training in the United States. Miss Zárate has had personal exhibits in Bogotá, Valparaíso, Buenos Aires, and Washington, D.C. She has taken part in seventeen group exhibits in Bogotá, Cali, Barranquilla, Buenos Aires, Córdoba (Argentina), and in Europe and the United States.

May 18 - June 9, 1965

NEW ART OF ARGENTINA [1]

An exhibition organized by the Walker Art Center, Minneapolis,
and the Visual Art Center, Instituto Torcuato Di Tella, Buenos Aires.

Walker Art Center
September 9 - October 11, 1964

The Akron Art Institute
October 25 - November 29, 1964

Atlanta Art Association
December 13, 1964 - January 17, 1965

The University Art Museum, University of Texas, Austin
February 7 - March 14, 1965

FOREWORD

In making selections and proposing groupings for this exhibition, *New Art of Argentina*, our objective was to present museum visitors in the United States with the most viable and stimulating aspects of current Argentine art. The foreign eye, by necessity, chooses works that show a relationship to the international idiom of contemporary art. In this respect Argentina, perhaps more than any other Latin American country, is highly susceptible to the winds of change and innovation. Artists in Argentina not only assimilate ideas and impulses from abroad, but have taken an active role in the promulgation and expansion of their own ideas. Their part in new directions and movements has been recognized by the international art world.

Since the nineteenth century, France has been the dominant taste-maker for painters and sculptors in Argentina, endowing them with a sense of order and clarity, a love for theory and experiment. Italy, through its gifted emigrants and its many cultural ties, accounts for a high degree of creative imagination and surprising versatility in Argentine art. The Germanic countries may have contributed some of their single-minded ideological pursuit and methodology in the elaboration of plastic principles. Contemporary Spain's effect on Argentine art is evidenced by a taste for violent, often ghoulish imagery, as well as for monochromatic, earthy painting surfaces. The common denominator of Latin American art, a death awareness, derived from both Indian and Spanish cultures, is less apparent in Argentine art. There is little of the self-consciously folkloric, and none has been included in this selection.

The "new" in Argentine art already has a noteworthy, young tradition. Argentina's involvement in the art activities of Western Europe, particularly those of France, dates back to the middle forties, when Kosice founded the *Madí* movement and Maldonado preached the gospel of Max Bill. The Bauhaus and De Stijl were their models and sources of inspiration. Concrete art was the watchword. Representatives of the *Madí* movement were shown at the Salon des Réalités Nouvelles in Paris in 1948, and Arden-Quin, one of *Madí*'s co-founders, directed a Paris chapter of that movement until 1953. From 1958 to the present, a similar extension of a French aesthetic *chapel* can be found in Julio Llinás's relentless promulgation of the *Phases* group. Le Parc's and Demarco's roles in the foundation of the *Groupe de Recherche d'Art Visuel* in 1960 constituted another example of the two-way exchange between the arts of Argentina and Western Europe. The 1946 publication in Buenos Aires of the *Manifiesto Blanco* by Argentine art's important innovator, Lucio Fontana, further illustrates how ideas of international effect have been launched from the banks of the River Plate. Because Fontana's work within the context of *spazialismo* has become an integral part of the living tradition of contemporary Italian art, we have decided against its inclusion in the present survey.

[1] This exhibition was shown at the Pan American Union under the auspices of the Embassy of Argentina, through the cooperation of the American Federation of Arts and Industrias Kaiser Argentina. *--Ed.*

Recent exhibitions of Latin American art in which Argentines were prominently included have established identity for that country's artistic expressions in the United States (notably, *South American Art Today*, organized by the Dallas Museum of Fine Arts in 1959, and *Latin America: New Departures*, organized by the Boston Institute of Contemporary Art in 1961). In these showings abstract art, the predominant trend from 1952 until the emergence of a new figuration in 1962, was featured in the works of such artists as Fernández Muro, Grilo, Ocampo, Pucciarelli, Sakai, and Testa. The geometrists and constructivists gained more acceptance for their work in Europe than in this country, where they were never more than incidentally included in exhibitions. The same applies for the *Phases* group, whose members, like the constructivists, had opportunities to exhibit their works in Paris, but not in the United States. An incipient familiarity with paintings of the new figuration was created through the efforts of the Visual Arts Division of the Pan American Union, in Washington, D.C. A breakthrough in the United States for this group, consisting of Deira, Macció, Noé, and de la Vega, came with their recent inclusion in the 1964 Guggenheim International Award exhibition, and they are now assuming status that was once solely the abstract painters' prerogative. A vanguard group, whose allegiances are divided between French *nouveau réalisme* and American pop art and whose reputation has not yet spread beyond Buenos Aires, is presented in the United States for the first time in this survey. Of the sculptors in the exhibition, those who live in Paris (Kosice, Penalba, and Di Teana) are in varying degrees known in this country. Their colleagues in Buenos Aires (Badii, Gerstein, and Iommi) may be unknown to the North American art audience, although they have exhibited in Venice and São Paulo biennials.

In 1959, Rafael Squirru, then Director of the Museo de Arte Moderno of Buenos Aires, stated that the Argentines were the least innocent people in the world, and that this fact was clearly illustrated by their art. If we interpret the word "innocent" as "naive," "steeped in isolation," and "parochial," then the statement most certainly holds true, particularly in 1964. It is unlikely, and of questionable desirability, that the many styles and idioms of contemporary art in Argentina will ever congeal into one national style. Such a monolithic expression is as unlikely there as it is in any other country involved in the complexities of modern times. The phenomenal migration which drains artists of talent from the Buenos Aires community at an alarming rate (thirteen Argentines in this exhibition presently live or work abroad) has at least one beneficial effect: it accelerates the internationalization of Argentine art and contributes to the art of other countries. Emigration, which used to be an escape and an indictment of the barrenness of the national climate, now takes on the positive quality of a search for new challenges, stylistic alignment, and companionship of ideas. With the increasing facilities of the capital city and the notable sophistication of its artistic climate, much that has been carried abroad will no doubt return to Argentina, fuller in fact and potential.

New Art of Argentina is the second in the Walker Art Center's series of exhibitions devoted to contemporary art in Latin America, the first being *New Art of Brazil* which, after its premiere here in 1962, was circulated nationally. In organizing the present exhibition, we had the support of the Walker Art Center Board of Directors and the invaluable sponsorship of the Instituto Torcuato Di Tella in Buenos Aires. The Instituto generously agreed, through its Executive Director, Enrique Oteiza, to assume responsibility for the assembly and shipping of all works of art coming from Buenos Aires, as well as for the printing and financing in part of a substantial catalogue. The Director of the Instituto Torcuato Di Tella's Visual Arts Center, Professor Jorge Romero Brest, and its Sub-Director, Samuel Paz, deserve our greatest thanks. In making the selections for this exhibition, we had the active assistance of Professor Romero Brest, formerly Director of the Museo Nacional de Bellas Artes and an acknowledged connoisseur of Argentine art. We had the good fortune of being accompanied in Buenos Aires in our visits to studios, galleries, museums, and private collections, by Samuel Paz, who also took care of numerous details pertaining to the exhibition and catalogue.

In Buenos Aires for assistance in meeting artists and seeing their works we are indebted to Hugo Parpagnoli, Director of the Museo de Arte Moderno, Samuel Oliver, Director of the Museo Nacional de Bellas Artes, and Mario Fano, Director of the Galería Lirolay. Ignacio Pirovano introduced us to the geometric artists, and Julio Llinás acquainted us with the *Phases* group. Guillermo Whitelow and Enzo Manichini of the Galería Bonino, Mrs. Blanca Sagazzola de Junerur, Director of the Galería Rioboo, and Natalio Jorge Povarche, Director of the Galería Rubbers, gave of their time and interest.

In the United States this project has been enthusiastically supported by the Embassy of the Argentine Republic, especially through the efforts of its First Secretary and Director of Cultural Affairs, Juan J. Mathé. The Embassy staff assisted with translations. We are particularly grateful to Mr. and Mrs. Alfredo Bonino of the Gallery Bonino in New York and to Rafael Squirru and Dr. José Gómez-Sicre of the Pan American Union in

Washington, D.C. Sr. Squirru, Director of the Department of Cultural Affairs, showed a special interest in this exhibition. Dr. Gómez-Sicre, Chief of the Visual Arts Division, generously made available to us the excellent resources of his office.

E.L.M.A. Argentine Shipping Lines deserves our warmest thanks for carrying this exhibition to and from the United States free of charge. --*Jan van der Marck*, Curator. *Suzanne Foley*, Associate Curator.

INTRODUCTION

It would be useless to search for a distinctive stylistic contribution from the Argentine art of the last 150 years. A national identity can develop in a country's art only when there is a free yet unified response by its artists to the country's spirit. Such an atmosphere can produce works of art which are dynamic, in a dialectic relationship with that spirit. Although Argentine art is still far from this position, our efforts to attain it continue.

Unfortunately, our artistic tradition was established by those generations whose concept of pictorial form was limited. They were unable to profit from past experience. Moreover, progress was slowed up by the affliction of positivistic philosophies which obscured rather than enlightened the creative mind.

The backwardness of Argentine art is understandable. Conservative elements have predominated since the beginning of the nineteenth century. The second-rate European artists who came to Argentina depicted the picturesque River Plate area in the styles of their native countries, thus imposing a naive, representational fold style upon those native-born artists who were trained at their sides, and disregarding the possibility of stylistic influence from the colonial environment. Consequently, as the Europeans continued to employ their traditional ideas and methods, the Argentines did likewise, but were only able to adapt these superficially. This resulted in paintings and prints based on forms which the mediocre of them rapidly converted into stereotypes.

Our artists' inferiority complex vis-à-vis Europe probably developed at this time, and it did not disappear as they visited Europe at the end of the nineteenth century. Were these artists impressed by French Impressionism or by its counterpart, the Macchiaioli art of Italy? Not at all. Unfortunately, they were attracted by European academicians and, therefore, painted in a neo-classical and naturalist manner. The subsequent generation of Argentine artists visiting Europe discovered the more progressive movements, but again adapted these superficially. There were a few notable exceptions, who, freed from the craft itself, sought to understand the new styles.

New directions finally appeared in the art of the twenties and thirties. How did these new currents develop? Certainly not in an overt manner, although the majority of Argentine painters and sculptors spent considerable time in Europe, particularly in France. Thus in Argentina there were almost no extensions of fauvism, cubism, surrealism or futurism. Most of our art was timid and lacking in nerve or vigor. Abstract artists were, so to speak, still in diapers. Consequently, the development of Argentine art was initially stunted by artists so conservative that they were unable to transcend a limited view. This was not caused by their being "Europeanized" but by their not being only fundamentally "Europeanized." It was caused at first by thoughtless rejection of new forms of expression, then by much belated, timid acceptance which led to a bastardization of the new forms. These generations should have realized the need to look inward as well as outward, for only by looking upon what truly exists can man himself exist. Instead, the belated new Argentine movements, in their spurious and adulterated development, barred the creative impulse from developing along its redemptive path.

The initially conservative art, inherited from European academic art, is to this day addressed to the large lay public of Argentina, while experimental art, also derived from an alien tradition, found a smaller, more discriminating, audience. It is impossible to successfully integrate the old and the new if they have nothing in common. The results are either sterility or chaos. Such were indeed the chaotic results of Argentine painting in the thirties and forties, a period during which not even art critics could distinguish clearly between paintings of the so-called "old school" and those of the "modern style." This "modern style," though widely discussed, was generally misunderstood, as the significance of its derivation from European fauvism was ignored. Almost none of the European innovators had been exhibited in Buenos Aires at that time.

Considering this lack of contact and understanding, how can we then explain that some of our painters and

sculptors did create fine works, and occasionally masterpieces? These were the products of isolated fires such as dare burn in the chilly atmosphere of repression. Sixteen years ago I expressed the thought in the first issue of the magazine *Ver y Estimar*:

> The worst calamity is the lack of a common emotional climate among the artists; the lack of a sort of intimacy among and within themselves. These conditions, if established, would lead the artist to a discovery of our national identity, via the individual vision, which paradoxically is the only way toward a sense of universal being.

I am glad to say, the situation has changed. By adopting a freer attitude toward art, our younger artists echo a spirit generated in other countries. Such rapprochement is possible in contemporary art. The difference between the art of our young generation and that in other countries might seem subtle. Even among us, some say there is actually no difference, but I disagree and say that indeed there is. Upon this certainty we base our optimism, strengthened by similar judgments of the foreign art critics who have visited us in recent years: Lionello Venturi, Giulio Carlo Argan, and Gillo Dorfless, from Italy; André Malraux, Jean Cassou, and Jacques Lassaigne, from France; Herbert Read, from Great Britain; Willem Sandberg, from Holland; and James Johnson Sweeney, from the United States.

Thus, the thankless but inevitable task of including some and excluding others is justified. It would be false to say that to our judgment the works of those less daring artists are worthless. Certain works have doubtless merit within the national milieu. The question of which works are of "national" and which of "international" merit constitutes a grave problem for those appointed to choose among them. Are different standards of judgment used? Should different criteria in a selection for the international milieu be followed? Indeed, such double standards must be considered. Many artists in our country, in spite of or because of inhibiting forces, have created significant works of art representing persons or places or expressing ideas or feelings from an Argentine point of view. However, it is not fair to demand of the foreign public an understanding of these indigenous concepts. The value of a work is not established by a mere comparison of formal elements, but rather by how intensely it evokes a freer and fresher vision. Since most works of national merit are more limited, the selection for an international audience must include works of broader vision.

The vigorous sweep of the new artistic movements through Europe and the United States vitally touches the activities of private galleries and museums, inciting the release of the creative spirit everywhere. This liberating process already manifested itself in one artistic trend within our own country. Our so-called geometrists are the heirs of the concrete group of the forties, which was the first frankly new school in the country. The concretists adhered strictly to European dogma, and this approach seemed to them, at the time, the only way to validly establish identity. Their followers, the geometrists, were possibly not better, but certainly much freer. Those in Buenos Aires, of which three are represented in the exhibition--Mac Entyre, Silva, and Vidal--are still in the process of cautious experimentation, whereas those Argentine artists in Paris work in the full self-confidence of creation. The latter group is represented in the exhibition by three painters: Demarco, Le Parc, Tomasello; and two sculptors: Di Teana and Kosice. These residents abroad are finding new redeeming exits from geometricism. This is also witnessed by the drawings of Magariños D., the only draftsman in the exhibition.

Before the present generation of geometrists, the work of the so-called abstract group was the dominant trend in the avant-garde movement. It should be noted that the term "abstract" under which we have grouped six young painters, Fernández Muro, Grilo, Ocampo, Pucciarelli, Sakai, and Testa, is rather imprecise. However, the impulse toward the experimental and the new keeps their work in the mainstream of international art. These artists transcend the national milieu and have been recognized at home and abroad. As a matter of fact, only one of the six, Testa, is presently living in Buenos Aires.

Very different from the above is the attitude of Borda, Chab, Peluffo, and Polesello, four representatives of the *Phases* group in Buenos Aires. They adhere to a broad and less dogmatic artistic theory than the Paris branch of this group, but to a theory nevertheless. According to it, they paint images in a more defined manner, in contrast to the abstract group, whose forms are not purposefully sought, but develop from a visionary view. The *Phases* painters, if not innovators as the others, are young, daring, and deserve to be included in this selection.

The geometrist, the abstract and the *Phases* painters use relatively conventional methods and media. The five neo-figurative painters included in this exhibition, Deira, Noé, Macció, de la Vega, and Seguí, though bowing

to tradition, by going beyond these conventions are far more courageous when it comes to the freeing or unblocking process described previously. Their works are of such merit that I believe they will eventually inherit the leading role now held by the abstract group. The Instituto Torcuato Di Tella awarded its International Prize in 1963 to one of these neo-figurative painters, Macció.

Antonio Berni (winner of the International Engraving Prize at the Thirty-first Biennial in Venice) in recent years has used as the protagonists of his collages two imaginary personages, the young boy, Juanito Laguna, and the courtesan, Ramona Montiel. They are as distinct personalities, I would say, as the artist himself, a strong partisan of *social realism*, who by working in a sort of understated realism created a *cause célèbre*. In looking at his collages made of various materials and objects with painted figures, we find not only lyrical satire but such an affirmation of the popular way of life as to indicate he still remains the realist of his earlier days.

Berni, Tomasello, and Polesello excepted, the painters in the groups already mentioned are men and women ranging in age from thirty to forty-two. However, the more avant-garde the group, the younger the age of its members. Although I would not define some of the most advanced or novel of these works as pop art, they are undoubtedly more startling than the rest. Among these young painters, Puzzovio, Minujín, and Santantonín have a Dada-like fascination with making objects out of common and perishable materials. Cancela and Squirru, whose art relates more to surrealism, also employ assemblage media but concentrate less on objects and more on the act of painting itself. All of these young artists are motivated by a free-wheeling spirit which will undoubtedly soon yield the rich fruits of artistic maturity. They are the leaders in freeing and unblocking creative forces in our country, essential for the formation of a national artistic style.

Unfortunately, the sculptors represented in the exhibition are few. These artists are older men and women and of greater international repute. Thus they are much less representative of the new liberating spirit embodied by the painters.

This exhibition was prepared with exemplary zeal by the Walker Art Center. I thank all those concerned with this project in the name of the Argentine artists and the Instituto Torcuato Di Tella. It is my sincere hope that these works will help toward establishing closer contacts between the peoples of our two amicable countries. --*Jorge Romero Brest*

CATALOGUE

Paintings and Drawings and Sculptures

Hugo R. Demarco
1. *Spatial Dynamics*, 1963, glass, Plexiglass, and metal, 35 3/8 x 35 3/8". Lent by Instituto Torcuato Di Tella, Buenos Aires

Julio Le Parc
2. *Continual Light*, 1963, metal and glass, 98 1/2 x 33 x 7 7/8". Lent by The Contemporaries, New York

Luis Tomasello
3. *Reflection No. 48*, 1960, wood, 48 x 31 1/2". Lent by Museo Nacional de Bellas Artes, Buenos Aires

Carlos Silva
4. *Untitled I*, 1963, oil on Masonite, 48 x 48"
5. *Untitled II*, 1963, oil on Masonite, 63 x 63"

Eduardo A. Mac Entyre
6. *Spatial Form*, 1961, oil on canvas, 38 x 55 1/2"
7. *Opposing Forms*, 1963, oil on canvas, 59 x 59"

Víctor Magariños D.
8. *No. 1*, 1962-63, ink, 10 x 12 1/4"
9. *No. 2*, 1962-63, ink, 8 3/4 x 11"
10. *No. 3*, 1962-63, ink, 12 1/4 x 9 7/8"

11. *No. 4*, 1962-63, ink, 10 x 12 1/4"
12. *No. 5*, 1962-63, ink, 12 1/4 x 10"
13. *No. 6*, 1962-63, ink, 11 3/8 x 9 1/8"
14. *No. 7*, 1962-63, ink, 10 x 12 1/4"
15. *No. 8*, 1962-63, ink, 12 1/4 x 10"
16. *No. 9*, 1962-63, ink, 10 x 12 1/4"
17. *No.10*, 1962-63, ink, 10 x 12 1/4"
18. *No.11*, 1962-63, ink, 10 x 12 1/4"
19. *No.12*, 1962-63, ink, 9 1/2 x 7 7/8"
20. *No.13*, 1962-63, ink, 10 x 12 1/4"
21. *No.14*, 1962-63, ink, 10 x 12 1/4"
22. *No.15*, 1962-63, ink, 10 x 12 1/4"
23. *No.16*, 1962-63, ink, 10 x 12 1/4"
24. *No.17*, 1962-63, ink, 9 1/2 x 9 1/8"
25. *No.18*, 1962-63, ink, 10 x 12 1/4"
26. *No.19*, 1962-63, ink and tempera, 10 x 12 1/4"
27. *No.20*, 1962-63, ink, 8 3/4 x 11"
28. *No.21*, 1962-63, ink, 12 1/4 x 10"
29. *No.22*, 1962-63, ink, 10 x 12 1/4"
30. *No.23*, 1962-63, ink, 10 x 12 1/4"
31. *No.24*, 1962-63, ink, 9 1/2 x 8 1/2"

Miguel Angel Vidal
32. *Square to the Infinite Power*, 1962, oil on canvas, 42 1/2 x 39 3/4"
33. *Forms in Movement*, 1963, oil on canvas, 23 1/2 x 23 1/2"

Sarah Grilo
34. *Green Wall*, 1963, oil on canvas, 69 x 63". Lent by Bianchini Gallery, New York
35. *January*, 1963, oil on canvas, 57 x 50". Lent by Bianchini Gallery, New York

José Antonio Fernández Muro
36. *Reflecting Surface*, 1962, oil and mixed media, 63 x 50". Lent by Galería Bonimo, New York
37. *Scarlet Medal*, 1963, oil and mixed media, 50 x 44". Lent by Galería Bonino, New York
38. *Water*, 1963, oil and mixed media, 50 x 44". Lent by Galería Bonino, New York

Miguel Ocampo
39. *Painting AAA$_1$/63*, 1963, oil on canvas, 63 x 51 1/4". Lent by Galería Bonino, Buenos Aires
40. *Painting AAA$_2$/63*, 1963, oil on canvas, 63 x 51 1/4". Lent by Galería Bonino, Buenos Aires

Kazuya Sakai
41. *Jyoshu's "Mu,"* 1963, acrylic and mixed media, 50 x 50"
42. *The Little Theater*, 1964, acrylic and mixed media, 50 x 50"

Clorindo Testa
43. *Circle IV*, 1963, oil on canvas, 39 3/8 x 39 3/8". Lent by Galería Bonino, Buenos Aires
44. *Interrupted Fringes*, 1963, oil on canvas, 51 x 51". Lent by Galería Bonino, Buenos Aires
45. *Vertical Fringes*, 1963, oil on canvas, 39 3/8 x 55". Lent by Galería Bonino, Buenos Aires

Mario Pucciarelli
46. *Alter Ego*, 1963, oil and mixed media, 57 1/2 x 45 1/4". Lent by Galería Bonino, Buenos Aires
47. *Baroque History*, 1963, oil and mixed media, 63 3/4 x 51". Lent by Galería Bonino, Buenos Aires
48. *Semi-Constructive Situation*, 1963, oil and mixed media, 45 1/4 x 57 1/2". Lent by Galería Bonino, Buenos
 Aires

Osvaldo Borda
49. *Entering the First Cycle*, 1963, oil on canvas, 78 3/4 x 78 3/4"
50. *Heliogabalo*, 1963, oil on canvas, 55 x 43 3/8"

Víctor Chab
51. *Untitled Painting I*, 1963, oil on canvas, 78 3/4 x 69"
52. *Untitled Painting II*, 1963, oil on canvas, 39 3/8 x 39 3/8"

Martha Peluffo
53. *Deserts of Idleness*, 1963, oil on canvas, 63 3/4 x 63 3/4"
54. *The New Era*, 1963, oil on canvas, 102 3/8 x 76 3/4"

Rogelio Polesello
55. *Ius Primae Noctis*, 1963, oil on canvas, 67 3/4 x 63 3/4"
56. *Vertical*, 1963, oil on canvas, 102 3/8 x 76 3/4"

Ernesto Deira
57. *Since Adam and Eve No.1*, 1963, oil on canvas, 76 3/4 x 102 3/8". Lent by Galería Bonino, Buenos Aires
58. *Since Adam and Eve No.2*, 1963, oil on canvas, 76 3/4 x 102 3/8". Lent by Galería Bonino, Buenos Aires
59. *The History of the Honorable Bolingbroke*, 1963, oil on canvas, 44 3/4 x 57 1/2". Lent by Galería Bonino, Buenos Aires

Rómulo Macció
60. *To Live: By Leaps and Bounds*, 1963, mixed media, 72 x 72". Lent by Galería Bonino, Buenos Aires
61. *To Live: For the Sake of Position*, 1963, mixed media, 72" diameter. Lent by Galería Bonino, Buenos Aires
62. *To Live: Squandered Time*, 1963, mixed media, 72" diameter. Lent by Galería Bonino, Buenos Aires
63. *To Live: Without a Guarantee*, 1963, mixed media, 72 x 72". Lent by Galería Bonino, Buenos Aires

Jorge de la Vega
64. *Schizoid Beast*, 1963, mixed media, 51 1/2 x 38 1/4". Lent by Galería Bonino, Buenos Aires
65. *The Memory of an Elephant*, 1963, mixed media, 102 3/8 x 76 3/4". Lent by Galería Bonino, Buenos Aires
66. *The Most Illustrious Day*, 1964, mixed media, 78 3/4 x 98 3/8". Lent by Galería Bonino, Buenos Aires

Luis Felipe Noé
67. *Closed by Sorcery*, 1963, mixed media, 78 3/4 x 98 3/8". Lent by Galería Bonino, Buenos Aires
68. *Fire at the Jockey Club*, 1963, mixed media, 78 3/4 x 59". Lent by Galería Bonino, Buenos Aires
69. *Self-Portrait*, 1963, mixed media, 59 x 118". Lent by Galería Bonino, Buenos Aires

Antonio Seguí
70. *My Anatomy Class*, 1963, oil on canvas, 98 3/8 x 78 3/4"
71. *The Christ Child*, 1963, oil on canvas, 32 x 39 1/2". Lent by Galería Bonino, Buenos Aires
72. *The Commanders*, 1963, oil on canvas, 76 3/4 x 51"
73. *The President of the Academy*, 1963, oil on canvas, 72 x 72"

Delia Sara Cancela
74. *Girls Don't Go Out Alone*, 1963, assemblage, 28 x 20"
75. *The Temptation of Mr. X*, 1963, assemblage, 35 1/2 x 28"

Carlos Squirru
76. *The Humid Shadow*, 1963, oil and collage on canvas, 31 x 19 5/8". Lent by Galería Bonino, Buenos Aires
77. *The Witches of Pneumonia*, 1963, oil and collage on canvas, 39 1/4 x 39 1/4". Lent by Galería Bonino, Buenos Aires

Delia Puzzovio
78. *A Load of Serious Smiles*, 1963, plaster and metal, 23 x 67 x 21"
79. *The Underwater Palmist*, 1963, plaster, rope, and metal, 28 x 28 x 28"

Marta Minujín
80. *The Plight of the Pillow*, 1961, painted pillows and cardboard, 60 x 48 x 17"
81. *Mattress*, 1964, painted fabric, 63 x 43"

Antonio Berni
82. *Juanito Laguna Helps His Mother*, 1961, oil and collage, 82 5/8 x 61"
83. *Juanito Laguna's Family on Sunday Morning*, 1961, oil and collage, 82 5/8 x 120"
84. *Ramona Montiel Faces Life*, 1963, collage, 28 x 16"
85. *Ramona Montiel in Private*, 1964, collage, 56 3/4 x 77 1/2"

Rubén Santantonín
86. *Untitled*, 1961, construction, 74 3/4 x 57"
87. *Untitled*, 1961, construction, 43 3/8 x 33 3/8"

Libero Badii
88. *Liberty*, 1961, bronze, 20" diameter
89. *Independence*, 1963, bronze, 76 1/2 x 19"

Noemí Gerstein
90. *The Big Bear*, 1962, brass and silver, 50 x 43 x 28"
91. *The Mandragore*, 1963, brass and silver, 21 x 19 1/2 x 13 1/2"

Ennio Iommi
92. *Triangular Form*, 1962, nickel and silver, 73 x 45 x 4"
93. *Spatial Volume*, 1963, stainless steel, 60 x 43 x 16"

Gyula Kosice
94. *Alternation of Form and Word*, 1960-62, aluminum, Plexiglass, and water, 50 x 51 x 31 1/2". Lent by Instituto
 Torcuato Di Tella, Buenos Aires

Alicia Penalba
95. *Incógnita (Incognita)*, 1961-62, bronze, 17" high. Lent by Marlborough-Gerson Gallery, New York

Marino Di Teana
96. *Universities*, 1963, stainless steel, 41 3/4 x 31 7/8 x 24 3/8"

ABOUT THE ARTISTS

BADII, Libero. Born 1916, Arezzo, Italy. Moved to Argentina, 1927. Worked in his father's studio, 1930-40. Studied in the evening at the Escuela de Artes Decorativas, Buenos Aires, 1934-39, and the Escuela Superior de Bellas Artes, Buenos Aires, 1941-44. Traveled on a fellowship to the north of Argentina, Bolivia, Peru, and Ecuador, 1945. Worked as an apprentice for sculptors in Buenos Aires, 1946-47. Traveled to Europe, 1948-49 and 1958-59. Won the Palanza Prize, Buenos Aires, 1959. Established his own studio, 1950. One-man exhibitions include: Galería Krayd, 1954-55; Galería Bonino, 1957; Museo Nacional de Bellas Artes (retrospective), 1962; Galería Witcomb, 1963, all in Buenos Aires. Group exhibitions include: Second and Fourth São Paulo Biennials, 1953 and 1957; Twenty-eighth Venice Biennial, 1956; *150 Years of Argentine Art*, Museo Nacional de Bellas Artes, Buenos Aires, 1960; *First International Exhibition of Modern Art*, Museo de Arte Moderno, Buenos Aires, 1960. His work is represented in the collections of the Museo Nacional de Bellas Artes, Instituto Torcuato Di Tella, and Teatro Municipal San Martín, all in Buenos Aires; and in private collections. Lives in Buenos Aires.

BERNI, Antonio. Born 1905, Rosario, Argentina. Studied in Europe on a fellowship awarded by the Jockey Club of Rosario and the Governor of Santa Fe, 1925. Lived in Paris until 1931 and studied with André Lhote and Othon Friesz. Was president of the Sociedad Argentina de Artistas Plásticos and professor of drawing at the Escuela Nacional de Bellas Artes, Buenos Aires. Did a study for the Argentine National Commission of Culture on "American and Pre-Colonial Art in the Americas," 1941. Has won many awards and prizes since 1925, including the International Prize for Print and Drawing at the Venice Biennial, 1962. First one-man exhibition was held in Rosario, 1921. Since that date he has exhibited regularly in Rosario, Buenos Aires, Montevideo, and Paris, as well as in Madrid, 1928; Warsaw, Berlin, and Bucharest, 1956; and Moscow, 1958. Most recently, in 1963, his graphic works were exhibited at the Galerie du Passeur in Paris and at the Henri Gallery, Alexandria (Virginia). Has participated in national and international exhibitions since 1925 in Buenos Aires, Montevideo, Santiago (Chile), São Paulo, Madrid, Paris, New York, and other cities in the United States. Recent group

exhibitions include: Fifth São Paulo Biennial, 1959; *First International Exhibition of Modern Art*, Museo de Arte Moderno, Buenos Aires, 1960; Thirty-first Venice Biennial, 1962; Salon de Mai, Paris, 1963; Salon Comparaisons, Musée National d'Art Moderne, Paris, 1963; Galerie Kajanovitch, Paris, 1963; *Argentine Art Today*, Musée National d'Art Moderne, Paris, 1963. His work is represented in the collections of the Museo Nacional de Bellas Artes and Museo de Arte Moderno, Buenos Aires; Museo de Bellas Artes de la Boca (Buenos Aires); Museo Nacional de Bellas Artes, Montevideo; and other museums and private collections in Argentina and abroad. Lives in Paris and Buenos Aires.

BORDA, Osvaldo. Born 1929, Buenos Aires. Self-taught as a painter, has exhibited since 1953. Received a fellowship to travel to Europe from the Dirección Nacional de Cultura de Santa Fe, 1959. One-man exhibitions: Galería O, Rosario, 1956; Galería Galatea, Buenos Aires, 1958-59; Galería Plástica, Buenos Aires, 1961-62; Galería Klee, Buenos Aires, 1963. Group exhibitions include: *Eight Young Painters*, Galería Krayd, Buenos Aires, 1953; *Five Painters*, Galería Peuser, Buenos Aires, 1956; *Seven Abstract Painters*, Galería Pizarro, Buenos Aires, 1957; *International Confrontation of Experimental and Avant-Garde Art*, Galería Van Riel, Buenos Aires, and Museo de Arte Moderno, Montevideo, 1958; Art Salon, Mar del Plata, 1959; *First Salon of Painting from the Río de la Plata*, Museo de Arte Moderno, Buenos Aires, 1959; *Boa-Phases Exhibition*, Museo Provincial de Bellas Artes, Santa Fe, 1959; Thirty-sixth Annual Salon and *Exhibition of Fellowship Winners at the Thirty-sixth Annual Salon*, Museo Provincial de Bellas Artes, Santa Fe, 1959; *Twenty Contemporary Argentine Painters*, Tel-Aviv Museum of Art (Israel), 1960, and Boulogne-sur-Mer, 1961; *Exposition Phases*, Galerie Saint-Laurent, Brussels, 1960; *First International Exhibition of Modern Art*, Museo de Arte Moderno, Buenos Aires, 1960; Ver y Estimar Salon, Galería Van Riel, 1960 and Museo Nacional de Bellas Artes, 1961 and 1962, both in Buenos Aires; *Exposition Phases*, Galerie Ranelagh, Paris, 1961; *Contemporary Argentine Art*, Museu de Arte Moderna, Rio de Janeiro, 1961; Instituto Torcuato Di Tella Prize Salon, Centro de Artes Visuales del Instituto Torcuato Di Tella, Buenos Aires, 1963; *South American Painting Today*, Bonn, 1963; *Phases International Exhibition*, Museo Nacional de Bellas Artes, Buenos Aires, 1963. Lives in Buenos Aires.

CANCELA, Delia Sara. Born 1940, Buenos Aires. Studied at the Escuela Nacional de Bellas Artes Manuel Belgrano and Escuela Nacional de Bellas Artes Prilidiano Pueyrredón with José Antonio Fernández Muro, Buenos Aires. Exhibitions: First Winter Salon, Buenos Aires, 1960; Ver y Estimar Salon, Museo Nacional de Bellas Artes, Buenos Aires, 1962-63; Salon Arte Nuevo, Museo de Arte Moderno, Buenos Aires, 1962; *Six Artists*, Galería Lirolay, Buenos Aires, 1964. Lives in Buenos Aires.

CHAB, Víctor. Born 1930, Buenos Aires. Self-taught as a painter. Taught painting at the Escuela Superior de Bellas Artes, Buenos Aires. Won several prizes, including a Silver Medal at the Brussels World's Fair, 1958. Has held fourteen one-man exhibitions in Buenos Aires since 1952. Had one-man show at Galería Arte Bella in Montevideo in 1956 and, most recently, at the Pan American Union, Washington, D.C., in 1964. Group exhibitions include: Twenty-eighth Venice Biennial, 1956; *Seven Abstract Painters*, Galería Pizarro, Buenos Aires, 1957; First Inter-American Art Biennial, Mexico City, 1958; Argentine Pavilion, World's Fair, Brussels, 1958; *International Confrontation of Experimental and Avant-Garde Art*, Galería Van Riel, Buenos Aires, and Museo de Arte Moderno, Montevideo, 1958; *International Exhibition*, Punta del Este, 1959; Río de la Plata Young Artists Biennial, Montevideo, 1959; *Boa-Phases Exhibition*, Museo Provincial de Bellas Artes, Santa Fe, 1959; *Panorama of Young Argentine Painting*, Museo Nacional de Arte Moderno, Mexico City, 1960; *Seventeen Painters of Argentina*, Pan American Union, Washington, D.C., 1960; Ver y Estimar Salon, Galería Van Riel, 1960, and Museo Nacional de Bellas Arte, 1961, both in Buenos Aires; *150 Years of Argentine Art*, Museo Nacional de Bellas Artes, Buenos Aires, 1960; *First International Exhibition of Modern Art*, Museo de Arte Moderno, Buenos Aires, 1960; *Fourteen Painters of the New Generation*, Galería Lirolay, Buenos Aires, 1960; *Contemporary Argentine Art*, Museu de Arte Moderna, Rio de Janeiro, 1961; Instituto Torcuato Di Tella Prize Salon, Museo Nacional de Bellas Artes, Buenos Aires, 1961; *Phases International Exhibition*, Museo Nacional de Bellas Artes, Buenos Aires, 1963; *Argentine Art Today*, Musée National d'Art Moderne, Paris, 1963; *Washington Collects Latin American Art*, American University, Washington, D.C., 1964. His works are in private collections in Argentina and abroad. Lives in Buenos Aires.

DEIRA, Ernesto. Born 1928, Buenos Aires. Educated at the Universidad de Buenos Aires, graduating with a law degree in 1950. Studied painting under Leopoldo Torres Agüero and Leopoldo Presas. Has exhibited since 1957. Traveled to Europe in 1953 and again in 1962 on a fellowship awarded by the National Fund for the Arts. Received the Losada Prize in the Watercolorists and Printmakers Salon, Buenos Aires, 1958. One-man exhibitions: Galería Witcomb, Buenos Aires, 1960; Galería Van Riel, Buenos Aires, 1961; Galería El Pórtico,

Buenos Aires, 1962; Galería Galatea, Buenos Aires, 1963; Pan American Union, Washington, D.C., 1964. Group exhibitions include: *First International Exhibition of Modern Art*, Museo de Arte Moderno, Buenos Aires, 1960; *Otra Figuración (Another Figuration)*, Galería Peuser, Buenos Aires, 1961; Museo de Bellas Artes, Tucumán, 1961; Ver y Estimar Salon, Museo Nacional de Bellas Artes, Buenos Aires, 1961; *International Exhibition of Modern Art*, Saigon, 1962; *Latin American Art*, Musée National d'Art Moderne, Paris, 1962; *Deira, Macció, Noé, de la Vega*, Galería Lirolay (drawings) and Galería Bonino (paintings), Buenos Aires, 1962; *Deira, Macció, Noé, de la Vega*, Museo Nacional de Bellas Artes in Buenos Aires and Galeria Bonino in Rio de Janeiro, 1963; *South American Art*, Museo de Arte Moderno, Caracas, 1963; Third Latin American Art Biennial of Colombia, Bogotá, 1963; *Art of America and Spain*, Instituto de Cultura Hispánica, Madrid and Barcelona (also shown in other European cities), 1963-64; *South American Painting Today*, Bonn, 1963; *Argentine Painting*, Museo de Arte Contemporáneo, Santiago (Chile), 1963; *Figuración Otra (Another Figuration)*, Museo Nacional de Bellas Artes, Montevideo, 1963; Instituto Torcuato Di Tella Prize Salon, Centro de Artes Visuales del Instituto Torcuato Di Tella, Buenos Aires, 1963; Guggenheim International Award, Solomon R. Guggenheim Museum, New York, 1964. His work is represented in the collections of the Museo de Arte Moderno, Buenos Aires; Museo Provincial de Bellas Artes, La Rioja and Tres Arroyos; Museo de Arte Moderno, Caracas. Lives in Buenos Aires.

DEMARCO, Hugo R. Born 1932, Buenos Aires. Studied at the Escuela de Bellas Artes Prilidiano Pueyrredón, and the Escuela Superior de Bellas Artes Ernesto de la Cárcova, Buenos Aires. Exhibited in Buenos Aires, 1956-59. Moved to Paris, 1959. Traveled on a French government fellowship, 1963-64. Participated in organization of *Groupe de Recherche d'Art Visuel*, Paris, 1960. Recent exhibitions include: Galerie Latino-Américaine, Brussels, 1960; *Groupe de Recherche d'Art Visuel*, Galerie Denise René, Paris, and Galeria Hybler, Copenhagen, 1961; *International Abstract Constructivist Art*, Galerie Denise René, Paris, 1962; *Thirty Argentines of the New Generation*, Galerie Creuze (Salle Balzac), Paris, 1962; Latin American Art, Musée National d'Art Moderne, Paris, 1962; *Nove Tendencije*, Gradska Galerija Savremene Umjetnosti, Zagreb, 1963; First International Salon of Pilot-Galleries, Musée Cantonal des Beaux-Arts, Lausanne, 1963; *Argentine Painting*, Museo de Arte Contemporáneo, Santiago (Chile), 1963; *Instituto Torcuato Di Tella Permanent Collection*, Buenos Aires, 1963; *Esquisse d'un Salon*, Galerie Denise René, Paris, and Galeria Hybler, Copenhagen, 1963; *From Concrete Art to the New Tendency -- Argentina 1944-1963*, Museo de Arte Moderno, Buenos Aires, 1963; *The Classic Spirit in 20th Century Art*, Sidney Janis Gallery, New York, 1964. His works are in the collections of the Instituto Torcuato Di Tella and Museo Nacional de Bellas Artes, Buenos Aires; and in private collections. Lives in Vaires-sur-Marne, France.

FERNANDEZ MURO, José Antonio. Born 1920, Madrid, Spain. Moved to Argentina, 1938. Lived in Madrid and Paris, 1948-50. Traveled in Europe and the United States on UNESCO fellowship to pursue museum studies, 1957-58. One-man exhibitions: Galería Witcomb, Buenos Aires, 1944 and 1946; Galería Bucholz, Madrid, 1948; Pan American Union, Washington, D.C., 1957; De Aenlle Gallery, New York, 1957; Galería Bonino, Buenos Aires, 1958, 1962; Museo Nacional de Bellas Artes, Buenos Aires, 1961; Andrew-Morris Gallery, New York, 1963; Galleria Pogliani, Rome, 1964. Group exhibitions include: *Group of Modern Artists*, Museu de Arte Moderna, Rio de Janeiro, and Stedelijk Museum, Amsterdam, 1953; Second International Contemporary Exhibition, New Delhi, 1953; Second and Sixth São Paulo Biennials, 1953 and 1961; Twenty-eighth Venice Biennial, 1956; *Fifty Years of Abstract Painting*, Galerie Creuze, Paris, 1957; Pittsburgh International, Carnegie Institute, 1958; Argentine Pavilion, World's Fair, Brussels, 1958; *The United States Collects Pan American Art*, Art Institute of Chicago, 1959; *South American Art Today*, Dallas Museum of Fine Arts, 1959; *Five Argentine Painters*, Museo Nacional de Bellas Artes, Buenos Aires, and Museu de Arte Moderna, Bahia, 1960; Guggenheim International Award, Solomon R. Guggenheim Museum, New York, 1960 and 1964; Institute Torcuato Di Tella Prize Salon, Museo Nacional de Bellas Artes, Buenos Aires, 1960; *First International Exhibition of Modern Art*, Museo de Arte Moderno, Buenos Aires, 1960; *Latin America: New Departures*, Institute of Contemporary Art, Boston, and Time and Life Building, New York, 1961; *From Concrete Art to the New Tendency -- Argentina 1944-1963*, Museo de Arte Moderno, Buenos Aires, 1963; *Art of America and Spain*, Instituto de Cultura Hispánica, Madrid and Barcelona (traveling in other European cities), 1963-64; *Argentine Painting*, Museo de Arte Contemporáneo, Santiago (Chile), 1963; *Two Sculptors -- Four Painters*, Galeria Bonino, New York, 1964; *Painters Resident in the United States from Latin America*, Institute of Contemporary Arts, Washington, D.C., 1964. His work is represented in the collections of the Museo Nacional de Bellas Artes and Instituto Torcuato Di Tella in Buenos Aires; Museo de Bellas Artes, Caracas; Stedelijk Museum, Amsterdam; Museum of Modern Art and the Ford Foundation in New York; Pan American Union, Washington, D.C.; Dallas Museum of Fine Arts; Oakland Art Museum (California); and in private collections. Has lived in New York since 1962.

GERSTEIN, Noemí. Born 1910, Buenos Aires. Studied sculpture with A. Bigatti in Buenos Aires and at the Académie de la Grande Chaumière (Atelier O. Zadkine) in Paris. Awarded a fellowship by the French government, 1950-51. Has shown in seven individual exhibitions in Buenos Aires and in Rosario between 1948 and 1958. Has exhibited in salons and group exhibitions in Buenos Aires since 1952. Selected to participate in the competition for the monument to the *Unknown Political Prisoner*, organized by the Institute of Contemporary Arts in London, 1954. Has received many awards and prizes since 1937. Individual exhibitions since 1958: Museo de Bellas Artes, Paraná, 1959; De Aenlle Gallery, New York, 1960; Pan American Union, Washington, D.C., 1960; Galleria Numero in Florence and Rome, 1961, and Prato, 1962. Recent group exhibitions include: *The Unknown Political Prisoner*, Tate Gallery, London, 1954; Twenty-eighth and Thirty-first Venice Biennials, 1956 and 1962; Second Hispanic American Biennial, Barcelona (Spain), 1957; Argentine Pavilion, World's Fair, Brussels, 1958; *Outdoor Sculpture*, Sociedad Argentina de Artistas Plásticos, Buenos Aires, 1960; *150 Years of Argentine Art*, Museo Nacional de Bellas Artes, Buenos Aires, 1960; *First International Exhibition of Modern Art*, Museo de Arte Moderno, Buenos Aires, 1960; International Exhibition of Contemporary Sculpture, Musée Rodin, Paris, 1961; *Contemporary Argentine Art*, Museu de Arte Moderna, Rio de Janeiro, 1961; *Modern Argentine Painting and Sculpture*, Institute of Contemporary Arts, London, 1961; Instituto Torcuato Di Tella Prize Salon, Museo Nacional de Bellas Artes, Buenos Aires, 1962; *Argentine Art Today*, Musée National d'Art Moderne, Paris, 1963. Her work is represented in the collections of the Museo Nacional de Bellas Artes, Museo de Arte Moderno, Instituto Torcuato Di Tella, Sociedad Hebraica Argentina, all in Buenos Aires; Museo Provincial de Bellas Artes in Paraná and Córdoba (Argentina), Museum of Modern Art, New York; Bazalel Museum of Fine Arts, Jerusalem; and other public and private collection in Argentina and abroad. Lives in Buenos Aires.

GRILO, Sarah. Born 1920, Buenos Aires. Studied in Buenos Aires; began painting, 1940. Lived in Madrid and Paris, 1948-50. Traveled in Europe and the United States, 1957-58. Awarded fellowship by John Guggenheim Memorial Foundation, 1962. Individual exhibitions: Galería Palma, Madrid, 1949; Galería Viau, Buenos Aires, 1950; Galería Krayd, Buenos Aires, 1955; Pan American Union, Washington, D.C., 1957; De Aenlle Gallery, New York, 1957; Galería Bonino, Buenos Aires, 1958 and 1961; Obelisk Gallery, Washington, D.C., 1963; Instituto de Arte Contemporáneo, Lima, 1963; Bianchini Gallery, New York, 1963. Group exhibitions include: *Group of Modern Artists*, Museu de Arte Moderna, Rio de Janeiro, and Stedelijk Museum, Amsterdam, 1953; Second International Contemporary Exhibition, New Delhi, 1953; Second and Sixth São Paulo Biennials, 1953 and 1961; Twenty-eighth Venice Biennial, 1956; Pittsburgh International, Carnegie Institute, 1958; Argentine Pavilion, World's Fair, Brussels, 1958; *The United States Collects Pan American Art*, Art Institute of Chicago, 1959; *South American Art Today*, Dallas Museum of Fine Arts, 1959; *First International Exhibition of Modern Art*, Museo de Arte Moderno, Buenos Aires, 1960; *Five Argentine Painters*, Museo Nacional de Bellas Artes, Buenos Aires, and Museu de Arte Moderna, Bahia, 1960; *150 Years of Argentine Art*, Museo Nacional de Bellas Artes, Buenos Aires, 1960; *Latin America: New Departures*, Institute of Contemporary Art, Boston, and Time and Life Building, New York, 1961; Instituto Torcuato Di Tella Prize Salon, Museo Nacional de Bellas Artes, Buenos Aires, 1961; *Argentine Painting*, Museo de Arte Contemporáneo, Santiago (Chile), 1963; *Art of America and Spain*, Instituto de Cultura Hispánica, Madrid and Barcelona (traveling in other European cities), 1963-64; *Painters Resident in the United States from Latin America*, Institute of Contemporary Arts, Washington, D.C., 1964. Her work is represented in the collections of the Museo Nacional de Bellas Artes and Museo Municipal in Buenos Aires; Museo Municipal, Córdoba (Argentina); Museo de Bellas Artes, Caracas; Museo de Cartagena de Indias, Cartagena (Colombia); Pan American Union, Washington, D.C.; Stedelijk Museum, Amsterdam; and in private collections. Has lived in New York since 1962.

IOMMI, Ennio. Born 1926, Rosario, Argentina. Worked in the studio of his father, a sculptor and engraver. Moved to Buenos Aires, 1939. Founding member of the group *Arte Concreto*, 1946. One-man exhibitions: Galería Pizarro, 1958; Galería Rubbers, 1962; Museo Nacional de Bellas Artes (retrospective), 1963, all in Buenos Aires. Group exhibitions include: *Argentine Painting and Sculpture of the Present Century*, Museo Nacional de Bellas Artes, Buenos Aires, 1952; *Argentine Modern Artists*, Museu de Arte Moderna, Rio de Janeiro, 1952; Second and Sixth São Paulo Biennials, 1953 and 1961; *Present Directions in Sculpture*, Galería Krayd, Buenos Aires, 1953; School of Architecture, Valparaíso, and Ministry of Education, Santiago (Chile), 1953; Argentine Pavilion, World's Fair, Brussels, 1958; *150 Years of Argentine Art*, Museo Nacional de Bellas Artes, Buenos Aires, 1960; *Concrete Art*, Helmhaus, Zurich, 1960; *Argentine Painting and Sculpture*, Scottish National Gallery of Modern Art, Edinburgh, 1961; *Contemporary Argentine Art*, Museu de Arte Moderna, Rio de Janeiro, 1961; *From Concrete Art to the New Tendency -- Argentina 1944-1963*, Museo de Arte Moderno, Buenos Aires, 1963. His work is represented in the collections of the Museo Nacional de Bellas Artes and Museo de Arte Moderno, both in Buenos Aires; Museu de Arte Moderna, Rio de Janeiro; and in private collections in Argentina and abroad.

Lives in Buenos Aires.

KOSICE, Gyula. Born 1924, Kosice, Czechoslovakia. Moved to Buenos Aires, 1928; became Argentine citizen. Published poetry and essays on aesthetics. Co-founder of the magazine *Arturo*, 1944, and *Arte Concreto Invención*, 1945. Founder of the group *Arte Madí*, 1946. Traveled to Paris on a French government fellowship, 1957. First hydraulic sculpture, 1957. Awarded the National Prize for Sculpture, Instituto Torcuato Di Tella, Buenos Aires, 1962. One-man exhibitions: Galería Pacífico, Buenos Aires, 1947; Galerie Denise René, Paris, 1960; Drian Galleries, London, 1960; Galería Bonino, Buenos Aires, 1960; Galerie L'Oeil, Paris, 1963. Included in over forty group exhibitions from 1944 to 1963 in Latin America and Europe, among which are: *Grupo Madí*, Salon des Réalités Nouvelles, Paris, 1948; Second and Fourth São Paulo Biennials, 1953 and 1957; Twenty-eighth Venice Biennial, 1956; *150 Years of Argentine Art*, Museo Nacional de Bellas Artes, Buenos Aires, 1960; *Concrete Art*, Helmhaus, Zurich, 1960; *Thirty Argentines of the New Generation*, Galerie Creuze (Salle Balzac), Paris, 1962; Instituto Torcuato Di Tella Prize Salon, Museo Nacional de Bellas Artes, Buenos Aires, 1962; Fourth Art Biennial, Palazzo del Kursal, San Marino (Italy), 1963; Salon of Young Sculpture, Musée Rodin, Paris, 1963; Salon des Réalités Nouvelles, Paris, 1963; *From Concrete Art to the New Tendency -- Argentina 1944-1963*, Museo de Arte Moderno, Buenos Aires, 1963; *Argentine Art Today*, Musée National d'Art Moderne, Paris, 1963. Lives in Paris.

LE PARC, Julio. Born 1928, Mendoza, Argentina. Studied painting and sculpture in Buenos Aires. Co-founder of *Groupe de Recherche d'Art Visuel*, Paris, 1960. Active participant in international movement *Nouvelles Tendences*. Recent exhibitions include: Fourth São Paulo Biennial, 1957; First Inter-American Art Biennial, Mexico City, 1958; Paris Biennial, Musée d'Art Moderne de la Ville de Paris, 1959, 1963; *150 Years of Argentine Art*, Museo Nacional de Bellas Artes, Buenos Aires, 1960; *Groupe de Recherche d'Art Visuel*, Galerie Denise René, Paris, and Galeria Hybler, Copenhagen, 1961; *Bewogen Beweging*, Stedelijk Museum, Amsterdam, and Modern Museet, Stockholm, 1961; Pittsburgh International, Carnegie Institute, 1961; *Nove Tendencije*, Gradska Galerija Savremene Umjetnosti, Zagreb, 1961 and 1963; *International Abstract Constructivist Art*, Galerie Denise René, Paris, 1961; *Thirty Argentines of the New Generation*, Galerie Creuze (Salle Balzac), Paris, 1962; *The Instability* (manifestation of the Groupe de Recherche d'Art Visuel), Maison des Beaux-Arts in Paris, Galleria del Gruppo Enne in Padua, Galleria Danese in Milan, and The Contemporaries in New York, 1962; Latin American Art, Musée National d'Art Moderne, Paris, 1962; *Contemporary Sculpture*, Musée du Havre, 1962; *Anti-Painting*, Hessenhuis, Antwerp, 1962; *Le Parc, Sobrino, Yvaral*, Galerie Aujourd'hui, Brussels, 1963; Salon des Comparaisons, Musée National d'Art Moderne, Paris, 1963; *Art Has Many Facets*, Museum of Fine Arts, Houston, 1963; *The Instability*, Museu de Arte Moderna, Rio de Janeiro, 1963; *Argentine Art Today*, Musée National d'Art Moderne, Paris, 1963; First International Salon of Pilot-Galleries, Musée Cantonal des Beaux-Arts, Lausanne, 1963; *From Concrete Art to the New Tendency -- Argentina 1944-1963*, Museo de Arte Moderno, Buenos Aires, 1963; *Le Parc, Sobrino*, Galerie Ad Libitum, Antwerp, 1964; *On the Move*, Howard Wise Gallery, New York, 1964. His works are in the collections of the Gradska Galerija Savremene Umjetnosti, Zagreb; Museum of Modern Art, New York; Isaac Delgado Museum of Art, New Orleans; and in private collections in Latin America, the United States, and Europe. Has resided in Paris since 1958.

MACCIO, Rómulo. Born 1931, Buenos Aires. Trained as a graphic artist by working in various advertising agencies, beginning in 1945. Self-taught painter, exhibited since 1956. Won several prizes, including the Second Prize awarded by the Instituto Torcuato Di Tella in 1961 and the International Prize awarded by the same institution in 1963. Traveled to Europe on a fellowship from the National Fund for the Arts, 1962. One-man exhibitions: Galería Galatea, 1956 and 1957; Galería Pizarro, 1958; Galería Witcomb, 1959 and 1960; Sociedad Hebraica Argentina, 1959; Galería Rubbers and Galería Van Riel, 1961; Galería Bonino, 1963, all of them in Buenos Aires. Recent group exhibitions include: *Boa-Phases Exhibition*, Santa Fe (Argentina), 1959; *Panorama of Young Argentine Painting*, Museo Nacional de Arte Moderno, Mexico City, 1960; Instituto Torcuato Di Tella Prize Salon, Museo Nacional de Bellas Artes, 1960 and 1961, and Centro de Artes Visuales del Instituto Torcuato Di Tella, 1963, both in Buenos Aires; Ver y Estimar Salon, Galería Van Riel, 1960, and Museo Nacional de Bellas Artes, 1961, both in Buenos Aires; *Seventeen Painters of Argentina*, Pan American Union, Washington, D.C., 1960; *150 Years of Argentine Painting*, Museo Nacional de Bellas Artes, Buenos Aires, 1960; *First International Exhibition of Modern Art*, Museo de Arte Moderno, Buenos Aires, 1960; *Modern Argentine Painting and Sculpture*, Institute of Contemporary Arts, London, 1961; Sixth São Paulo Biennial, 1961; *Contemporary Argentine Art*, Museu Arte Moderna, Rio de Janeiro, 1961; Paris Biennial, Musée d'Art Moderne de la Ville de Paris, 1961 and 1963; Thirty-first Venice Biennial, 1962; *Neo-Figurative Painting in Latin America*, Pan American Union, Washington, D.C., 1962; *Deira, Macció, Noé, de la Vega*, Galería Lirolay (drawings) and

Galería Bonino (paintings), Buenos Aires, 1962; *Deira, Macció, Noé, de la Vega*, Museo Nacional de Bellas Artes in Buenos Aires and Galería Bonino in Rio de Janeiro, 1963; *South American Painting Today*, Bonn (Germany), 1963; *Argentine Painting*, Museo de Arte Contemporáneo, Santiago (Chile), 1963; *Art of America and Spain*, Instituto de Cultura Hispánica, Madrid and Barcelona (also shown in other European cities), 1963-64; *Argentine Art Today*, Musée National d'Art Moderne, Paris, 1963; Guggenheim International Award, Solomon R. Guggenheim Museum, New York, 1964. His work is represented in the collections of the Museo Nacional de Bellas Artes, Museo de Arte Moderno, and Instituto Torcuato Di Tella, Buenos Aires; Museo Nacional de Bellas Artes, Caracas; Musée d'Art Moderne, Brussels; and in private collections. Lives in Buenos Aires.

MAC ENTYRE, Eduardo A. Born 1929, Buenos Aires. Trained as an industrial designer. Designed the daily *Arte y Crítica*, the magazine *AN*, as well as exhibition catalogues and books. Wrote the first manifesto of *Arte Generativo*. One-man exhibitions: Galería Rubbers, 1960, and Galería Peuser, 1961, both in Buenos Aires. Group exhibitions include: Salón Arte Nuevo, Galería Van Riel, Buenos Aires, 1956-59; *Non-Figurative Painters and Sculptors*, Asociación Estímulo de Bellas Artes, Buenos Aires, 1956; First Inter-American Art Biennial, Mexico City, 1958; *New Generations in Argentine Painting*, Galería Peuser, Buenos Aires, 1958; *Non-Figurative Art*, Museo de Arte Moderno, Buenos Aires, 1959; Art Salon, Mar del Plata, 1959; Ver y Estimar Salon, Galería Van Riel, 1960, and Museo Nacional de Bellas Artes, 1961, both in Buenos Aires; *150 Years of Argentine Art*, Museo Nacional de Bellas Artes, Buenos Aires, 1960; *First International Exhibition of Modern Art*, Museo de Arte Moderno, Buenos Aires, 1960; *Generative Art: Eduardo A. Mac Entyre and Miguel A. Vidal*, Galería Peuser (under the auspices of the Museo de Arte Moderno), Buenos Aires, 1960; Sixth São Paulo Biennial, 1961; *Contemporary Argentine Art*, Museu de Arte Moderna, Rio de Janeiro, 1961; *Modern Argentine Painting and Sculpture*, Institute of Contemporary Arts, London, 1961; *Generative Art: Mac Entyre and Vidal*, Museu de Arte Moderna, Rio de Janeiro, 1962; *Form and Space*, University of Chile, Santiago, 1963; *Argentine Painting*, Museo de Arte Contemporáneo, Santiago (Chile), 1963; *Eight Constructivist Artists*, Museo Nacional de Bellas Artes, Buenos Aires, 1963; *From Concrete Art to the New Tendencies -- Argentina 1944-1963*, Museo de Arte Moderno, Buenos Aires, 1963. His work is represented in the collections of the Museo de Arte Moderno, Buenos Aires; Museo de Bellas Artes, Córdoba (Argentina); Museu de Arte Moderna, Rio de Janeiro; Art Center of La Jolla (California); and in private collections in Argentina and abroad. Lives in Buenos Aires.

MAGARIÑOS D., Víctor. Born 1924, Lanús, Argentina. Studied at the Academia Nacional de Bellas Artes, winning the Enrique Prins Award of the Academia in 1947. Awarded a French government fellowship, 1951. President of the Argentine Committee of the International Association of Plastic Arts of UNESCO at its founding, 1959. Presently professor at the Escuela Nacional de Artes Visuales, Buenos Aires. One-man exhibitions: Galería Juan Cristóbal, 1950, and Instituto de Arte Moderno, 1951, both in Buenos Aires. Group exhibitions include: Second São Paulo Biennial, 1953; Twenty-eighth Venice Biennial, 1956; *From Concrete Art to the New Tendency --- Argentina 1944-1963*, Museo de Arte Moderno, Buenos Aires, 1963. Lives in Buenos Aires.

MINUJIN, Marta. Born 1941, Buenos Aires, Argentina. Studied at the Escuela Nacional de Bellas Artes Manuel Belgrado, Escuela Nacional de Bellas Artes Prilidiano Pueyrredón, and Escuela Superior de Bellas Artes Ernesto de la Cárcova, Buenos Aires. Lived in Paris 1961-1964. Individual exhibitions: Teatro Agon (drawings), 1959, and Galería Lirolay, 1961 and 1962, both in Buenos Aires. Group exhibitions include: Salón Estímulo, La Plata, 1957 and 1958; White and Black Salon, Córdoba (Argentina) and Buenos Aires, 1958; Art Salon, Mar del Plata, 1959 and 1960; Río de la Plata Salon of Modern Art, Mar del Plata and Buenos Aires, 1959; De Ridder Prize Salon, Galería Pizarro, Buenos Aires, 1959 and 1960; Salon de Arte Nuevo, Museo de Arte Moderno, Buenos Aires, 1960 and 1961; *Five Artists*, Galería Lirolay, Buenos Aires, 1961; *Collage Exhibition*, Galería Lirolay, Buenos Aires, 1961; Paris Biennial, Musée d'Art Moderne de la Ville de Paris, 1961; *Thirty Argentines of the New Generation*, Galerie Creuze (Salle Balzac), Paris, 1962; Young Sculpture Salon, Musée Rodin, Paris, 1962; *The Relief*, Galerie XXe. Siècle, Paris, 1962; Latin American Art, Musée d'Art Moderne, Paris, 1962; Ver y Estimar Salon, Museo Nacional de Bellas Artes, Buenos Aires, 1962; *Man Before Man*, Galería Florida (under the auspices of the Museo de Arte Moderno), Buenos Aires, 1962; Salon of Young Painting, Musée National d'Art Moderne, Paris, 1964; Salon Comparaisons, Musée National d'Art Moderne, Paris, 1964; *Autour du Jeu*, Galerie Ursula Girardon, Paris, 1964; *The Box and Its Content*, Galerie Le Gendre, Paris, 1964. Lives in Buenos Aires.

NOE, Luis Felipe. Born 1933, Buenos Aires. Studied painting with Horacio Butler in 1952. Wrote art criticism for *El Mundo* in 1956. Exhibited since 1957. Awarded a French government fellowship enabling him to live and paint in Paris, 1961. Won the National Prize awarded by the Instituto Torcuato Di Tella, Buenos Aires, 1963,

allowing him to travel to the United States in 1964. One-man exhibitions: Galería Witcomb, 1959; Galería Kala and Galería Van Riel, 1960; Galería Bonino, 1961, all in Buenos Aires. Recent group exhibitions include: *150 Years of Argentine Painting*, Museo Nacional de Bellas Artes, Buenos Aires, 1960; *First International Exhibition of Modern Art*, Museo de Arte Moderno, Buenos Aires, 1960; Ver y Estimar Salon, Galería Van Riel, 1960, and Museo Nacional de Bellas Artes, Buenos Aires, 1961, both in Buenos Aires; Instituto Torcuato Di Tella Prize Salon, Museo Nacional de Bellas Artes, 1960 and 1961, and Centro de Artes Visuales del Instituto Torcuato Di Tella, 1963, both in Buenos Aires; *Panorama of Young Argentine Painting*, Museo de Arte Moderno, Mexico City, 1960; Paris Biennial, Musée d'Art Moderne de la Ville de Paris, 1961; *Modern Argentine Painting and Sculpture*, Institute of Contemporary Arts, London, 1961; *Contemporary Argentine Art*, Museu de Arte Moderna, Rio de Janeiro, 1961; *Otra Figuración (Another Figuration)*, Galería Peuser, Buenos Aires, 1961; *Thirty Argentines of the New Generation*, Galerie Creuze (Salle Balzac), Paris, 1962; *Neo-Figurative Painting in Latin America*, Pan American Union, Washington, D.C., 1962; *Deira, Macció, Noé, de la Vega*, Galería Lirolay (drawings) and Galería Bonino (paintings), Buenos Aires, 1962; *Deira, Macció, Noé, de la Vega*, Museo Nacional de Bellas Artes, Buenos Aires, and Galería Bonino, Rio de Janeiro, 1963; *Figuración Otra (Another Figuration)*, Museo Nacional de Bellas Artes, Montevideo, 1963; *Argentine Painting*, Museo de Arte Contemporáneo, Santiago (Chile), 1963; *Art of America and Spain*, Instituto de Cultura Hispánica, Madrid and Barcelona (also shown in other European cities), 1963; *Argentine Art Today*, Musée National d'Art Moderne, Paris, 1963; Guggenheim International Award, Solomon R. Guggenheim Museum, New York, 1964; *Painters Resident in the United States from Latin America*, Institute of Contemporary Arts, Washington, D.C., 1964. His work is represented in the collections of the Museo Nacional de Bellas Artes, Museo de Arte Moderno, and Instituto Torcuato Di Tella in Buenos Aires, and in private collections. Lives in Buenos Aires.

OCAMPO, Miguel. Born 1922, Buenos Aires. Studied architecture; began painting in 1944. Traveled to Paris, 1949-50; lived in Rome as Cultural Attaché with the Argentine Embassy. Presently holds the same position in Paris. One-man exhibitions: Galerie Ariel, Paris, 1950; Instituto de Arte Moderno, Buenos Aires, 1950; Galería Bonino, Buenos Aires, 1952, 1958-60; Galería Krayd, Buenos Aires, 1954; Galleria La Tartaruga, Rome, 1958; De Aenlle Gallery, New York, 1958; Museu de Arte Moderna, Rio de Janeiro, 1959. Group exhibitions include: First, Second, and Sixth São Paulo Biennials, 1951, 1953, 1961; *Group of Modern Artists*, Museu de Arte Moderna, Rio de Janeiro, and Stedelijk Museum, Amsterdam, 1953; *Argentine Painting and Sculpture of the Present Century*, Museo Nacional de Bellas Artes, Buenos Aires (also shown in Chile, Peru, and Ecuador), 1953; Second International Contemporary Exhibition, New Delhi, 1953; Twenty-eighth Venice Biennial, 1956; *Fifty Years of Abstract Painting*, Galerie Creuze, Paris, 1957; Argentine Pavilion, World's Fair, Brussels, 1958; *South American Art Today*, Dallas Museum of Fine Arts, 1959; *Five Argentine Painters*, Museo Nacional de Bellas Artes, Buenos Aires, and Museu de Arte Moderna, Bahia, 1960; *First International Exhibition of Modern Art*, Museo de Arte Moderno, Buenos Aires, 1960; *Latin America: New Departures*, Institute of Contemporary Art, Boston, and Time and Life Building, New York, 1961; *Contemporary Argentine Art*, Museu de Arte Moderna, Rio de Janeiro, 1961; Latin American Art, Musée National d'Art Moderne, Paris, 1962; *Artists from Latin America*, Spoleto, 1963; *From Concrete Art to the New Tendency -- Argentina 1944-1963*, Museo de Arte Moderno, Buenos Aires, 1963; *Argentine Painting*, Museo de Arte Contemporáneo, Santiago (Chile), 1963; *Argentine Art Today*, Musée National d'Art Moderne, Paris, 1963. His work is represented in the collections of the Museo Nacional de Bellas Artes and Museo de Arte Moderno in Buenos Aires; Museu de Arte Moderna in Rio de Janeiro and Bahia; Museum of Modern Art, New York; and in private collections. Presently lives in Paris.

PELUFFO, Martha. Born 1931, Buenos Aires. Began exhibiting in 1952. Won several awards and prizes, including Purchase Prize at the Seventh São Paulo Biennial, 1963. Individual exhibitions: Galería Antú, Buenos Aires, 1952; Centro de Arquitectura, Córdoba (Argentina), 1954; Galería Galatea, Buenos Aires, 1957; Galería Pizarro, Buenos Aires, 1958 and 1959; Galería Nueva, Buenos Aires, 1962. Group exhibitions include: Salon Arte Nuevo, Galería Van Riel, Buenos Aires, 1955 and 1956; *Non-Figurative Art*, Museo Sívori, Buenos Aires, 1956; *Seven Abstract Painters*, Galería Pizarro, Buenos Aires, 1957; *International Confrontation of Experimental and Avant-Garde Art*, Galería Van Riel, Buenos Aires, and Museo de Arte Moderno, Montevideo, 1958; *Boa-Phases Exhibition*, Museo Provincial de Bellas Artes, Santa Fe, 1959; *Panorama of Young Argentine Painting*, Museo Nacional de Arte Moderno, Mexico City, 1960; *Seventeen Painters of Argentina*, Pan American Union, Washington, D.C., 1960; Ver y Estimar Salon, Galería Van Riel, 1960, and Museo Nacional de Bellas Artes, 1961, both in Buenos Aires; Art Salon, Mar del Plata, 1960; *150 Years of Argentine Painting*, Museo Nacional de Bellas Artes, Buenos Aires, 1960; *Exposition Phases*, Galerie Ranelagh, Paris, 1961; Paris Biennial, Musée d'Art Moderne de la Ville de Paris, 1961; *Four New Values in Argentine Painting*, Galería Bonino, Buenos Aires, 1961; *Contemporary Argentine Art*, Museu de Arte Moderna, Rio de Janeiro, 1961; Seventh São Paulo Biennial, 1963;

Phases International Exhibition, Museo Nacional de Bellas Artes, Buenos Aires, 1963; *Argentine Art Today*, Musée National d'Art Moderne, Paris, 1963. Her work is represented in museums and private collections in Argentina and abroad. Lives in Buenos Aires.

PENALBA, Alicia. Born 1918, San Pablo, Argentina. Moved to Buenos Aires, 1934. Studied at the Escuela Nacional de Bellas Artes and the Escuela Superior de Bellas Artes. Worked in advertising and illustrated children's books. Traveled to Paris on a French fellowship and studied at the Ecole Supérieure des Beaux-Arts and the Académie de la Grande Chaumière (Atelier O. Zadkine), 1950-52. Since 1945 has won several prizes and medals, including the First Prize in Sculpture at the Sixth São Paulo Biennial, 1961. Individual exhibitions: Galerie du Dragon, Paris, 1957; Galerie Claude Bernard, Paris, 1960; Otto Gerson Gallery, New York, 1960; Galerie Charles Lienhard, Zurich, 1961; Museu de Arte Moderna, Rio de Janeiro, 1962; Devorah Sherman Gallery, Chicago, 1962; Rijksmuseum Kröller-Müller, Otterlo, 1964. Group exhibitions include: Salon de Mai, Paris, 1952; Salon of Young Sculpture, Musée Rodin, Paris, 1952-57; Biennale Voor Beeldhouwkunst, Middelheimpark, Antwerp, 1953-55 and 1959-61; *Fifteen Sculptors*, Galerie Suzanne de Corninck, Paris, 1955; *International Exhibition of Sculpture* Musée Rodin, Paris, 1956; *Sculpture of Another Time*, Musée d'Angers, 1956, and Musée de Tours, 1957, both in France; Salon des Réalités Nouvelles, Paris, 1955-57 and 1963; *Sculptures and Drawings from Seven Sculptors*, Solomon R. Guggenheim Museum, New York, 1958; Pittsburgh International, Carnegie Institute, 1958; *International Sculpture*, Galerie Claude Bernard, Paris, 1958; Documenta II and III, Kassel, 1959 and 1964; *Three Sculptors from Paris*, Museum Haus Lange, Krefeld, 1959; *150 Years of Argentine Art*, Museo Nacional de Bellas Artes, Buenos Aires, 1960; Otto Gerson Gallery, New York, 1960; Sixth São Paulo Biennial, 1961; *Sculpture in the City*, Festival dei Due Mondi, Spoleto, 1962; *Modern Sculpture from the Joseph H. Hirshhorn Collection*, Solomon R. Guggenheim Museum, New York, 1962. Her work is represented in the collections of the Musée National d'Art Moderne, Paris; Musée de Tourcoing (France); Musée d'Art et d'Industrie, Saint-Etienne; Middelheimpark, Antwerp; Cleveland Museum of Art; Isaac Delgado Museum of Art, New Orleans; Handels-Hochscule, Saint Gall; and in private collections in the United States and Europe. Lives in Montrouge, France.

POLESELLO, Rogelio. Born 1939, Buenos Aires. Studied painting and graphic arts at the Escuela Nacional de Bellas Artes, Buenos Aires. Won prize offered for young artists of talent by Losada publishing house in 1959 and a similar award the following year. One-man exhibitions: Galería Peuser, Buenos Aires, 1959; Galería Pizarro, Buenos Aires, 1960; Galería Lirolay, Buenos Aires, 1961; Pan American Union, Washington, D.C., 1961; Galería Rubbers, Buenos Aires, 1962; Radio Municipal, Buenos Aires, 1963; Galería Rioboo, Buenos Aires, 1963. Group exhibitions include: Galería Galatea, Buenos Aires, 1958-59; Galería Pizarro, Buenos Aires, 1959; Galería Van Riel, Buenos Aires, 1959; *Drawings from Latin America*, Smithsonian Institution Traveling Exhibition (circulated in the United States), 1959-60; *South America Art Today*, Dallas Museum of Fine Arts, 1959; *Seventeen Painters of Argentina*, Pan American Union, Washington, D.C., 1960; *Panorama of Young Argentine Painting*, Museo Nacional de Arte Moderno, Mexico City, 1960; *150 Years of Argentine Art*, Museo Nacional de Bellas Artes, Buenos Aires, 1960; *First International Exhibition of Modern Art*, Museo de Arte Moderno, Buenos Aires, 1960; Ver y Estimar Salon, Galería Van Riel, 1960, and Museo Nacional de Bellas Artes, 1961, both in Buenos Aires; *Young Argentine Art*, Instituto de Arte Contemporáneo, Lima 1960; *Fourteen Painters of the New Generation*, Galería Lirolay, Buenos Aires, 1960; *Contemporary Argentine Art*, Museu de Arte Moderna, Rio de Janeiro, 1961; *From Concrete Art to the New Tendency -- Argentina 1944-1963*, Museo de Arte Moderno, Buenos Aires, 1963; Paris Biennial, Musée d'Art Moderne de la Ville de Paris, 1963; Instituto Torcuato Di Tella Prize Salon, Centro de Artes Visuales del Instituto Torcuato Di Tella, Buenos Aires, 1963; *Phases International Exhibition*, Museo Nacional de Bellas Artes, Buenos Aires, 1963. His work is represented in the collections of the Museo de Arte Moderno, Buenos Aires; Pan American Union, Washington D.C.; Museo Nacional de Bellas Artes, Caracas; and in private collections. Lives in Buenos Aires.

PUCCIARELLI, Mario. Born 1928, Buenos Aires. Studied with Vicente Forte and other Argentine painters. Lived in London, 1955-56. Won several awards and prizes, including the Instituto Torcuato Di Tella Prize, 1960, a travel grant to study in Rome. One-man exhibitions: Teatro Candilejas, Buenos Aires, 1957; Galería Galatea, Buenos Aires, 1958; Galería Pizarro, Buenos Aires, 1960; Galería Zaffaroni, Montevideo, 1960; Pan American Union, Washington, D.C., 1960; Galería Bonino, Buenos Aires, 1961 and 1962; Galleria Il Centro, Ischia (Italy), 1961; Galleria Pogliani, Rome, 1962 and 1963. Group exhibitions include: Chelsea Group of Artists, London, 1955; Salón Arte Nuevo, Galería Van Riel, Buenos Aires, 1958; *South American Art Today*, Dallas Museum of Fine Arts, 1959; Paris Biennial, Musée d'Art Moderne de la Ville de Paris, 1959; Biennial of Río de la Plata Young Art, Montevideo, 1959; *First International Exhibition of Modern Art*, Museo de Arte Moderno, Buenos

Aires, 1960; *150 Years of Argentine Art*, Museo Nacional de Bellas Artes, Buenos Aires, 1960; *Young Argentine Art*, Instituto de Arte Contemporáneo, Lima, 1960; Guggenheim International Award, Solomon R. Guggenheim Museum, New York, 1960; *Art and Future of Argentina*, Palazzo dell'Esposizione, Rome, 1960; Institute Torcuato Di Tella Prize Salon, Museo Nacional de Bellas Artes, 1960, and Centro de Artes Visuales del Instituto Torcuato di Tella, 1963, both in Buenos Aires; Autumn Salon, Rome, 1961; Sixth São Paulo Biennial, 1961; *Contemporary Argentine Art*, Museu de Arte Moderna, Rio de Janeiro, 1961; *Modern Argentine Painting and Sculpture*, Institute of Contemporary Arts, London, 1961; Thirty-first Venice Biennial, 1962; Festival dei Due Mondi, Spoleto (Italy), 1962; *Art of America and Spain*, Instituto de Cultura Hispánica, Madrid and Barcelona (also shown in other European cities), 1963-64; *Two Sculptors -- Four Painters*, Galería Bonino, New York, 1964. His work is represented in public and private collections in Argentina and abroad. Has lived in Rome since 1961.

PUZZOVIO, Delia. Born 1942, Buenos Aires. Studied under the surrealist painter Juan Batlle Planas, Buenos Aires. Received an award in Ver y Estimar Salon, Buenos Aires, 1963. Individual exhibitions: Galería Lirolay, 1961 and 1963, and Galería Arte Nueva, 1962, both in Buenos Aires. Group exhibitions include: *Five Painters*, Galería Lirolay, Buenos Aires, 1960; Museo Sívori, Buenos Aires, 1961; Seventh Autumn Salon, San Fernando (Argentina), 1961; *New Art Association*, Museo de Arte Moderno, Buenos Aires, 1961; Ver y Estimar Salon, Museo Nacional de Bellas Artes, Buenos Aires, 1962-63. Thirty-ninth Annual Salon, Santa Fe, 1962; *New Names in Argentine Art*, Embassy of the United States, Buenos Aires, 1962; *Man before Man*, Galería Florida (under the auspices of the Museo de Arte Moderno), Buenos Aires, 1962; *Art Today*, Galería Saber Vivir, Buenos Aires, 1962; *Things*, Galería Lirolay, Buenos Aires, 1964. Lives in Buenos Aires.

SAKAI, Kazuya. Born 1927, Buenos Aires, of Japanese parents. Educated in Japan, 1934-51. Former professor of oriental philosophy at the Universidad Nacional de Tucumán. Traslated Japanese literature into Spanish. Member of Orient-Occident Committee of the UNESCO in Argentina. Self-taught as a painter. Has had seven one-man exhibitions in Buenos Aires, 1952-57. Won several prizes, including the Gold Medal Award, World's Fair, Brussels, 1958. One-man exhibitions since 1958: Galería Bonino, Buenos Aires, 1958, 1959, and 1962; Galería Bonino, Rio de Janeiro, 1960; Galeria São Luiz, São Paulo, 1960; Instituto de Arte Contemporáneo, Lima, 1962; Martin Schweig Gallery, St. Louis (Missouri), 1963; the Cleveland Institute of Art, Cleveland (Ohio), 1963. Recent group exhibitions include: First Inter-American Art Biennial, Mexico City, 1958; Argentine Pavilion, World's Fair, Brussels, 1958; *South American Art Today*, Dallas Museum of Fine Arts, 1959; *White and Black*, Galerie Internationale d'Art Contemporain, Paris, 1960; *Five Argentine Painters*, Museo Nacional de Bellas Artes, and Museu de Arte Moderna, Bahia, 1960; *First International Exhibition of Modern Art*, Museo de Arte Moderno, Buenos Aires, 1960; *150 Years of Argentine Art*, Museo Nacional de Bellas Artes, Buenos Aires, 1960; Instituto Torcuato Di Tella Prize Salon, Museo Nacional de Bellas Artes, Buenos Aires, 1960-61; *Latin America: New Departures*, Institute of Contemporary Art, Boston, and Time and Life Building, New York, 1961; *Japanese Artists of the Americas*, Pan American Union, Washington, D.C., 1961; Sixth São Paulo Biennial, 1961; *Contemporary Argentine Art*, Museu de Arte Moderna, Rio de Janeiro, 1961; *Circle of Contemporary Art*, Musée des Beaux-Arts, Liège, 1961; Thirty-first Venice Biennial, 1962; *Art of America and Spain*, Instituto de Cultura Hispánica, Madrid and Barcelona (traveling in other European cities), 1963-64; *Painters Resident in the United States from Latin America*, Institute of Contemporary Arts, Washington, D.C., 1964. His work is represented in the collections of the Museo Nacional de Bellas Artes and Instituto Torcuato Di Tella, Buenos Aires; Museu de Arte Moderna, Bahia; Chase Manhattan Bank, New York; and in private collections. Has lived in New York since 1963.

SANTANTONIN, Rubén. Born 1919, Buenos Aires. Began his career as a self-taught artist in 1943. One-man exhibitions: Asociación Estímulo de Bellas Artes, 1958; Galería Van Riel, 1960, and Galería Lirolay, 1961, all in Buenos Aires. Group exhibitions include: Asociación Arte Nuevo, Salas Nacionales de Exposiciones and Museo de Arte Moderno, Buenos Aires, 1961; *Collage -- Thirteen Painters*, Galería Lirolay, Buenos Aires, 1962; Ver y Estimar Salon, Museo Nacional de Bellas Artes, Buenos Aires, 1962-63; *Man before Man*, Galería Florida (under the auspices of the Museo de Arte Moderno), Buenos Aires, 1962; *New Names in Argentine Art*, Embassy of the United States, Buenos Aires, 1962; Instituto Torcuato Di Tella Prize Salon, Centro de Artes Visuales del Instituto Torcuato Di Tella, Buenos Aires, 1963; Seventh São Paulo Biennial, 1963; *Argentine Art Today*, Musée National d'Art Moderne, Paris, 1963; *Six Artists*, Galería Lirolay, Buenos Aires, 1964. Lives in Buenos Aires.

SEGUI, Antonio. Born 1934, Córdoba, Argentina. Studied painting and sculpture in Argentina and later in Europe. Lived in Mexico, 1958-61. Won many awards and purchase prizes. One-man exhibitions: Galería Paideia, Córdoba, 1957; Galería Génova, Mexico City, 1958 and 1959; Museo de Arte, Quito, 1958; Museo Nacional de Bellas Artes, Guatemala City, 1958; Galería México, Mexico City, 1959; Bolles Gallery, San Francisco

(California), 1959; Galería El Pórtico, 1960, and Galería Witcomb, 1960-62, both in Buenos Aires; Instituto de Arte Contemporáneo, Lima, 1961; Ortiz Foundation, La Plata, 1961; Galería Lirolay, Buenos Aires, 1962; Museo Provincial de Bellas Artes, Córdoba, 1962; Galería Antígona, Buenos Aires, 1963. Recent group exhibitions include: National Salon of Córdoba, Museo Provicial de Bellas Artes, Córdoba, 1957 and 1962; National Salon of Tucumán, Museo Provincial de Bellas Artes, Tucumán, 1958; *Retrospective Exhibition of Mexican Painting*, University of Mexico, Mexico City, 1959; First Salon of Painting from the Río de la Plata, Museo de Arte Moderno, Buenos Aires, 1959; *The Woman in the New Figuration*, Galería Génova, Mexico City, 1960; *Painting Today*, Galería Glontz, Mexico City, 1960; *Contemporary Argentine Art*, Museu de Arte Moderna, Rio de Janeiro, 1961; Galería Galatea, Buenos Aires, 1961; Instituto Torcuato Di Tella Prize Salon, Museo Nacional de Bellas Artes, 1961, and Centro de Artes Visuales del Instituto Torcuato Di Tella, 1963, both in Buenos Aires; Art Salon, Mar del Plata, 1963; Paris Biennial, Musée d'Art Moderne de la Ville de Paris, 1963; *Art of America and Spain*, Instituto de Cultura Hispánica, Marid and Barcelona (also shown in other European cities), 1963; *Argentine Art Today*, Musée National d'Art Moderne, Paris, 1963. His work is represented in the collections of the Museo Nacional de Bellas Artes in Buenos Aires, Quito, and Guatemala City; Museum of Modern Art in Buenos Aires, Tokyo, Paris, Mexico City, and Tel Aviv; Instituto Torcuato Di Tella, Buenos Aires; Museum of Fine Arts in Tucumán, Córdoba, La Plata, and Pôrto Alegre (Brazil); Instituto de Arte Contemporáneo, Lima; Oakland Art Museum (California); and in private collections. Has lived in Paris since 1963.

SILVA, Carlos. Born 1930, Buenos Aires. Self-taught as a painter, has exhibited since 1955. Exhibitions include: Salon Arte Nuevo, Galería Van Riel, Buenos Aires, 1955-58; *Non-Figurative Art*, Museo Sívori, Buenos Aires, 1956; *Fourteen Abstract Painters*, Galería Galatea, Buenos Aires, 1957; *Non-Figurative Art*, Galería Pizarro, Buenos Aires, 1959; First Rio de la Plata Painting Salon, Museo de Arte Moderno, Buenos Aires, 1959; First Pan American Salon, Pôrto Alegre, 1959; *International Exhibition*, Punta del Este, 1959; *First International Exhibition of Modern Art*, Museo de Arte Moderno, Buenos Aires, 1960; Ver y Estimar Salon, Galería Van Riel, 1960, and Museo Nacional de Bellas Artes, 1961-62, both in Buenos Aires; Galería Witcomb, Buenos Aires, 1961; *Thirty Argentines of the New Generation*, Galerie Creuze (Salle Balzac), Paris, 1962; *Argentine Painting*, Museo de Arte Contemporáneo, Santiago (Chile), 1963; *Eight Constructivist Artists*; Museo Nacional de Bellas Artes, Buenos Aires, 1963; *From Concrete Art to the New Tendency -- Argentina 1944-1963*, Museo de Arte Moderno, Buenos Aires, 1963. His work is represented in the collection of the Museo de Arte Moderno, Buenos Aires, and in private collections. Lives in Buenos Aires.

SQUIRRU, Carlos. Born 1934, Buenos Aires. Studied with Robert Hale at the Art Students League, New York, 1957. Traveled in Europe, 1958. Awarded a fellowship by the Pratt Institute, New York, to study engraving and lithography, 1962. One-man exhibitions: Galería Bonino, Buenos Aires, 1960 and 1963; Hilda Carmel Gallery, New York, 1962; Galería Norte, Buenos Aires, 1963. Group exhibitions include: Ligoa Duncan Gallery, New York, 1957; Galería Sudamericana, New York, 1957 and 1962; *Recent American Acquisitions*, Museum of Modern Art, New York, 1957; *First International Exhibition of Modern Art*, Museo de Arte Moderno, Buenos Aires, 1960; *Contemporary Argentine Art*, Museu de Arte Moderna, Rio de Janeiro, 1961; Ver y Estimar Salon, Museo Nacional de Bellas Artes, Buenos Aires, 1963; *Art of America and Spain*, Instituto de Cultura Hispánica, Madrid and Barcelona (also shown in other European cities), 1963-64. His work is represented in the collections of the Museum of Modern Art, Brooklyn Museum, and Metropolitan Museum of Art in New York; Museo de Arte Moderno, Buenos Aires; and in private collections in Argentina and abroad. Lives in Buenos Aires.

TEANA, Marino Di. Born 1920, Teana, Italy. Served an apprenticeship in masonry; immigrated to Argentina, 1936. Began studying at the Technical School, but abandoned it to enter the Escuela Superior de Bellas Artes, from which he graduated in 1948. Left Argentina for Europe, first working with the Spanish sculptor Jorge de Oteiza in 1952, and then settling in Paris. Recent exhibitions include: *Four Artists*, Galerie Haut-Pavé, Paris, 1954; Salon of Young Sculpture, Musée Rodin, Paris, 1955, 1958-60. *International Exhibition of Sculpture*, Musée Rodin, Paris, 1956; Galerie Denise René, Paris, 1957; Salon Comparaisons, Musée National d'Art Moderne, Paris, 1957-60; Salon des Réalités Nouvelles, Paris, 1957-60; Städtische Kunsthalle, Recklinghausen, 1958; *Denise René Exposes*, Städtisches Museum, Leverkusen, 1959; *100 Sculptors from Daumier to Present Day*, Musée de Saint-Etienne, 1960; *150 Years of Argentine Art*, Museo Nacional de Bellas Artes, Buenos Aires, 1960; *International Group*, Musée des Beaux-Arts d'Ixelles (Brussels), Musée de Liège, and Musée de Bruges, 1960; Galerie Denise René (one-man exhibition), Paris, 1960; Biennale Voor Beeldhouwkunst, Middelheimpark, Antwerp, 1961; *Thirty Argentines from the New Generation*, Galerie Creuze (Salle Balzac), Paris, 1962. His work is represented in the collection of the Kunst Museum, Aarhus (Denmark), and in private collections in Europe and the Americas. Has lived in Paris since 1953.

TESTA, Clorindo. Born 1923, Naples, Italy. Moved to Argentina with his parents in 1924. Trained as an architect at the Universidad de Buenos Aires. Traveled to Spain and Italy, 1949-51. Awarded the First Prize in the *International Exhibition* in Punta del Este, 1959, and the First Prize of the Instituto Torcuato Di Tella, Buenos Aires, 1961. One-man exhibitions: Galería Van Riel, Buenos Aires, 1952 and 1953; Museo Municipal de Córdoba (Argentina), 1952; Galería Krayd, Buenos Aires, 1954; Galería Antígona, Buenos Aires, 1956, 1958; Galería Bonino, Buenos Aires, 1959, 1961, and 1963. Group exhibitions include: *Group of Modern Artists*, Museu de Arte Moderna, Rio de Janeiro, and Stedelijk Museum, Amsterdam, 1953; Twenty-eighth and Thirty-first Venice Biennials, 1956, 1962; Argentine Pavilion, World's Fair, Brussels, 1958; *South American Art Today*, Dallas Museum of Fine Arts, 1959; *International Exhibition*, Punta del Este (Uruguay), 1959; *First International Exhibition of Modern Art*, Museo de Arte Moderno, Buenos Aires, 1960; *150 Years of Argentine Art*, Museo Nacional de Bellas Artes, Buenos Aires, 1960; Guggenheim International Award, Solomon R. Guggenheim Museum, New York, 1960; *Five Argentine Painters*, Museo Nacional de Bellas Artes, Buenos Aires, and Museu de Arte Moderna, Bahia (Brazil), 1960; Instituto Torcuato Di Tella Prize Salon, Museo Nacional de Bellas Artes, 1961, and Centro de Artes Visuales del Instituto Torcuato Di Tella, 1963, both in Buenos Aires; Sixth São Paulo Biennial, 1961; *Latin America: New Departures*, Institute of Contemporary Art, Boston, and Time and Life Building, New York, 1961; *Art of America and Spain*, Instituto de Cultura Hispánica, Madrid and Barcelona (also shown in other European cities), 1963-64; *Argentine Art Today*, Musée National d'Art Moderne, Paris, 1963; *Argentine Painting*, Museo de Arte Contemporáneo, Santiago (Chile), 1963. His work is represented in the collections of the Museo Nacional de Bellas Artes, Museo de Arte Moderno, and Instituto Torcuato Di Tella, Buenos Aires; Museo Municipal, Córdoba (Argentina); Museo de Bellas Artes, Caracas; and in private collections. Lives in Buenos Aires.

TOMASELLO, Luis. Born 1915, La Plata, Argentina. Studied at the Escuela de Bellas Artes Prilidiano Pueyrredón, graduating in 1937, and at the Escuela Superior de Bellas Artes Ernesto de la Cárcova, Buenos Aires. Traveled in Europe, 1950-52. First exhibited in Buenos Aires, 1953. Founding member of the *Salon Arte Nuevo*, Buenos Aires, 1953. Recent one-man exhibitions: Museo Nacional de Bellas Artes, Buenos Aires, 1962; Galerie Denise René, Paris, 1962. Group exhibitions include: Salón Arte Nuevo, Galería Van Riel, Buenos Aires, 1955-56; *Abstract Art*, Galería Müller, Buenos Aires, 1955; *Non-Figurative Painters and Sculptors*, Asociación Estímulo de Bellas Artes, Buenos Aires, 1956; Salon des Réalités Nouvelles, Paris, 1959, 1961, 1963-64; *The Relief*, Galerie XXe. Siècle, Paris, 1960 and 1962; *Concrete Art*, Helmhaus, Zurich, 1960; *Construction and Geometry in Painting*, Galerie Chalette, New York and Paris (traveled to Contemporary Art Center in Cincinnati, Arts Club of Chicago, and Walker Art Center in Minneapolis), 1960; *Constructed Art*, Musée des Beaux-Art d'Ixelles in Brussels and Musée des Beaux-Art in Liège and Bruges, 1960; *Twenty Contemporary Argentine Painters*, Tel Aviv Museum of Art (Israel), 1960, and Boulogne-sur-Mer, 1961; Pittsburgh International, Carnegie Institute, 1961; *Bewogen Beweging*, Stedelijk Museum, Amsterdam, and Moderna Museet, Stockholm, 1961; *Structures*, Galerie Denise René, Paris, 1961; *Thirty Argentines of the New Generation*, Galerie Creuze (Salle Balzac), Paris, 1962; *Latin American Art*, Musée National d'Art Moderne, Paris, 1962; *Art Has Many Facets*, Museum of Fine Arts, Houston, 1963; First International Salon of Pilot-Galleries, Musée Cantonal des Beaux-Arts, Lausanne, 1963; *Nove Tendencije*, Gradska Galerija Savremene Umjetnosti, Zagreb, 1963; *Argentine Painting*, Museo de Arte Contemporáneo, Santiago (Chile), 1963; *Esquisse d'un Salon*, Galerie Denise René, Paris, and Galeria Hybler, Copenhagen, 1963; *From Concrete Art to the New Tendency -- Argentina 1944-1963*, Museo de Arte Moderno, Buenos Aires, 1963. His work is represented in the collections of the Museo Nacional de Bellas Artes and Museo de Arte Moderno, both in Buenos Aires; Carnegie Institute, Pittsburgh; and in private collections in Latin America, the United States, and Europe. Has lived in Paris since 1957.

VEGA, Jorge de la. Born 1930, Buenos Aires. Studied architecture for six years at the Universidad de Buenos Aires, where he now teaches art appreciation. Self-taught as a painter, has exhibited since 1946. Awarded fellowship from the National Fund for the Arts, permitting him to spend a year in Europe, 1962. One-man exhibitions: Banco Municipal, 1951; Galería Plástica, 1952; Galería Lirolay, 1961, all in Buenos Aires; and Pan American Union, Washington, D.C., 1963. Recent group exhibitions include: *Twelve Non-Figurative Painters*, Galería Peuser, Buenos Aires, 1957; *New Generations in Argentine Painting*, Galería Peuser, Buenos Aires, 1958; *150 Years of Argentine Painting*, Museo Nacional de Bellas Artes, Buenos Aires, 1960; *First International Exhibition of Modern Art*, Museo de Arte Moderno, Buenos Aires, 1960; Ver y Estimar Salon, Galería Van Riel, 1960, and Museo Nacional de Bellas Artes, 1961, both in Buenos Aires; Instituto Torcuato Di Tella Prize Salon, Museo Nacional de Bellas Artes, 1960-61, and Centro de Artes Visuales del Instituto Torcuato Di Tella, 1963, both in Buenos Aires; *Contemporary Argentine Art*, Museu de Arte Moderna, Rio de Janeiro, 1961; *Otra Figuración (Another Figuration)*, Galería Peuser, Buenos Aires, 1961; *Latin American Art*, Musée d'Art Moderne,

Paris, 1962; *Thirty Argentines of the New Generation*, Galerie Creuze (Salle Balzac), Paris, 1962; *Neo-Figurative Painting in Latin America*, Pan American Union, Washington, D.C., 1962; *Deira, Macció, Noé, de la Vega*, Galería Lirolay (drawings), and Galería Bonino (paintings), Buenos Aires, 1962; *Deira, Macció, Noé, de la Vega*, Museo Nacional de Bellas Artes, Buenos Aires, and Galeria Bonino, Rio de Janeiro, 1963; *Argentine Painting*, Museo de Arte Contemporáneo, Santiago (Chile), 1963; *Art of America and Spain*, Instituto de Cultura Hispánica, Madrid and Barcelona (also shown in other European cities), 1963-64; *Argentine Art Today*, Musée National d'Art Moderne, Paris, 1963; Guggenheim International Award, Solomon R. Guggenheim Museum, New York, 1964. His work is represented in the collections of the Museo Nacional de Bellas Artes and Museo de Arte Moderno, both in Buenos Aires; in other museums in the country and in private collections. Lives in Buenos Aires.

VIDAL, Miguel Angel. Born 1928, Buenos Aires. Graduated from the Academia Nacional de Bellas Artes, Buenos Aires. Participated in the publication of the first manifesto of *Arte Generativo* and collaborated in the direction of the magazine *AN*. Works as graphic designer as well as painter. Exhibitions include: Salón Arte Nuevo, Galería Van Riel, Buenos Aires, 1955-56, 1958-59; *Fourteen Abstract Painters*, Galería Galatea, Buenos Aires, 1957; *New Generations in Argentine Painting*, Galería Peuser, Buenos Aires, 1958; First Inter-American Art Biennial, Mexico City, 1958; Galería Rubbers (one-man exhibition), Buenos Aires, 1959; *First Pan American Salon*, Pôrto Alegre, 1959; Art Salon, Mar del Plata, 1959; *Non-Figurative Art*, Museo de Arte Moderno, Buenos Aires, 1959; *Panorama of Young Argentine Painting*, Museo Nacional de Arte Moderno, Mexico City, 1960; Ver y Estimar Salon, Galería Van Riel, 1960, and Museo Nacional de Bellas Artes, 1961, both in Buenos Aires; *First International Exhibition of Modern Art*, Museo de Arte Moderno, Buenos Aires, 1960; *Generative Art: Eduardo A. Mac Entyre and Miguel Angel Vidal*, Galería Peuser (under the auspices of the Museo de Arte Moderno), Buenos Aires, 1960; *Contemporary Modern Art*, Museu de Arte Moderna, Rio de Janeiro, 1961; *Modern Argentine Painting and Sculpture*, Institute of Contemporary Arts, London, 1961; Galería Witcomb, Buenos Aires, 1961; *Generative Art: Mac Entyre and Vidal*, Museu de Arte Moderna, Rio de Janeiro, 1962; *Argentina Painting Today*, Asociación Estímulo de Bellas Artes, Buenos Aires, 1962; *Form and Space*, University of Chile, Santiago, 1963; *Eight Constructivist Painters*, Museo Nacional de Bellas Artes, Buenos Aires, 1963; *Argentine Painting*, Museo de Arte Contemporáneo, Santiago (Chile), 1963; *From Concrete Art to the New Tendency -- Argentina 1944-1963*, Museo de Arte Moderno, Buenos Aires, 1963. His work is represented in the collections of the Museo de Arte Moderno, Buenos Aires; Museu de Arte Moderna, Rio de Janeiro; and private collections in Argentina and abroad. Lives in Buenos Aires.

May 21 - June 13, 1965

JULIO ROSADO DEL VALLE OF PUERTO RICO

Despite the political tie which has linked the island of Puerto Rico with the Anglo-Saxon world of the United States for over half a century, art in the Commonwealth--whether figurative or abstract--partakes today, as in the past, of the Latin American tradition. Graphics and architecture are the fields of greatest distinction in creative activity, but painting also is worthy of note. The outstanding figure in this last mentioned area, by reason both of seniority and of the high quality of his production, is Julio Rosado del Valle.

Rosado del Valle was born in Cataño, Puerto Rico, in 1922. He began to paint while a student at the high school in Bayamón, and it was there that he held his first one-man show in 1944. A year later he exhibited at the Puerto Rican Athenaeum in San Juan and initiated formal training with the Spanish painter Cristóbal Ruiz. In 1946 he journeyed to New York, where he studied for two years at the New School for Social Research with Cuban Mario Carreño and the Ecuadorian Camilo Egas. Upon the completion of these courses, Rosado del Valle traveled to Florence, Italy, where he attended classes at the School of Fine Arts, and later to Paris, where he observed current artistic movements. In 1958 he received a fellowship from the Guggenheim Foundation.

Since returning to Puerto Rico, Rosado del Valle has served as an art consultant to the Department of Education, for whose building he also executed a mural. He is a frequent exhibitor both on the island and in the mainland United States.

CATALOGUE

Oils

1. *Reflections*

2. *Naturaleza muerta (Still Life) I*
3. *Naturaleza muerta (Still Life) II*
4. *Naturaleza muerta (Still Life) III*
5. *Flores (Flowers)*
6. *Dry Leaves*
7. *Composition I*
8. *Composition II*

Drawings

1-21. *Untitled*

June 15 - 29, 1965

TWENTY SOUTH AMERICAN ARTISTS
FROM THE SECOND BIENAL AMERICANA DE ARTE
A selection by Lawrence Alloway, Paul Mills, and Robert Wool

With the ten South American countries--Argentina, Bolivia, Brazil, Colombia, Chile, Ecuador, Paraguay, Peru, Uruguay, and Venezuela--participating, the Second Bienal Americana de Arte opened at the University of Córdoba, Argentina, on September 25, 1964. The paintings had been chosen by a selection committee organized in each country.

A complete two-week program of cultural and artistic events took place concurrently with the Second Bienal Americana de Arte, ranging from the 130 male folkloric dancers of the Diablada Ferroviaria de Oruro (Bolivia) to various art shows of contemporary drawing, engraving, and sculpture, concerts and lectures. The Oakland Art Museum participated with a selection of paintings by Northern Californian post-abstract artists.

As a complement to the Bienal Americana de Arte, Industrias Kaiser Argentina, a private enterprise, sponsors national visual art shows in the intervening years for Argentine artists.

Twenty South American artists and their paintings were selected at the Second Bienal Americana de Arte by Mr. Lawrence Alloway, Curator of the Guggenheim Museum, Mr. Paul Mills, Curator of the Oakland Art Museum, and Mr. Robert Wool, President of the Inter-American Foundation for the Arts, for showing in the United States.

FOREWORD

The past five National Visual Art shows as well as the First Bienal Americana de Arte may make these words seem somewhat superfluous.

Having been able to join forces with the ten countries of South America for this Second Bienal strengthens our belief that we are all approaching a level of factual achievements, and that the people of our countries are ready to provide their generous support to any effort that tries to contribute to the development of human values and their expression.

I would like to express my sincere appreciation to all those who have helped us in making this objective possible.

This Second Bienal Americana de Arte could not have become the cultural event it is without the understanding and support we have received everywhere from governments as well as from private institutions.

We are convinced that in our constantly developing New World, fostering the international interchange of cultural values, both past and present, of our countries is more and more becoming part of our daily work. Art is one of the most important forces contributing to the strengthening of our social structures, and developing a free interchange of persons and ideas cannot help but make our common future better. This is the main motivating reason for Industrias Kaiser Argentina's sponsorship of the Bienal de Arte that, we hope, provides a stage for,

and is an expression of, the levels of cultural maturity attained by the people of South America. *--James F. McCloud*, President, Bienal Americana de Arte.

CATALOGUE

Jesús Soto
1. *Un bleu, quinze noirs (One Blue, Fifteen Blacks)*, 40 x 40"
2. *Inversion*, 28 x 19"
3. *Ecriture noire et argentée (Writing in Black and Silver)*, 80 x 26"

Eduardo Bonati
4. *Enorme signo (Enormous Sign)*, 38 x 61"

Jacobo Borges
5. *Continúa el espectáculo (The Show Goes On)*, triptych, 62 x 153"

Carlos Cruz-Diez
6. *Physichromie (Physiochrome) No. 114*, 56 x 27"

Ernesto Deira
7. *En torno al pensamiento A-9 (A Thought Around A-9)*, 76 x 63"

Jorge de la Vega
8. *Los músculos de la memoria (Memory Muscles)*, 51 x 76"
9. *Diario de Santos L'Ouverture (Diary of Toussaint L'Ouverture)*, 92 x 76"
10. *Pruebe de nuevo (Try Again)*, 51 x 76"

Fernando de Szyszlo
11. *Yana sunquo (Black Heart)*, 63 x 51"
12. *Paisaje ritual de Machu-Picchu (Machu-Picchu's Ritual Landscape) II*, 64 x 64"

José Gamarra
13. *Pintura (Painting) M 63509*, 59 x 47"

Alberto Gutiérrez
14. *Tres días en mayo (Three Days in May)*, 56 x 47"
15. *Summa V*, 56 x 47"

Arturo Kubotta
16. *Macrocosmos (Macrocosm)*, 59 x 80"
17. *Sinfonía pictórica (Pictorial Symphony)*, 59 x 59"

Gerd Leufert
18. *Hattan*, 50 x 50"
19. *Union Square 11*, 59 x 59"
20. *Union Square 14*, 59 x 59"

Rómulo Macció
21. *Vivía con prestigio (Living High)*, 68 x 68"

Eduardo Mac Entyre
22. *Pintura generativa (Generative Painting)*, 53 x 53"

Guillermo Núñez
23. *Ya no se puede descansar (Can Rest No Longer)*, 67 x 94"

Rogelio Polesello
24. *Todos los pasos (Every Step)*, 102 x 71"
25. *Iota,* 51 x 76"

Hermenegildo Sábat
26. *Torre Nilsson*, 59 x 59"

Antonio Seguí
27. *Caja con señores (Box with Gentlemen)*, 76 x 51"

Eugenio Téllez
28. *Le puit (The Well)*, 77 x 78"

Clorindo Testa
29. *Anotaciones en Machu-Picchu (Notes from Machu-Picchu)*, 59 x 59"

Nirma Zárate
30. *Variaciones sobre horizontal (Horizontal Variations)*, 60 x 48"

ABOUT THE ARTISTS

BONATI, Eduardo (Eduardo Martínez Bonati). Born in 1930 in Santiago, Chile. Studied at the University of Chile and Iowa State University. Has been awarded a Fulbright scholarship. Has attended the Paris Biennial, 1961; the Latin American Art Exhibit in Paris, 1962; the First Bienal Americana de Arte, Córdoba, 1962; the Sixth May Salon of Barcelona (Spain), 1962; the Seventh Biennial of São Paulo and exhibits in Germany during 1963 and 1964.

BORGES, Jacobo. Born in 1931 in Caracas, Venezuela. One-man exhibits in art galleries and Venezuelan museums; group exhibits at official Venezuelan art salons and abroad: in Brussels, Haifa, Paris, Mexico City, New York (including the Guggenheim Museum), and the Biennial of São Paulo and of Venice. Has been commissioned important stage designs, and worked on a mural for the Instituto Nacional de Canalización. His works can be found at the Museum of Fine Arts in Caracas and Mexico and in private collections. Awards include: Honorable Mention at the São Paulo Biennial, 1957; Honorable Mention at the Official Salon in Caracas, First Prize at the Arturo Michelena Art Salon in Valencia (Venezuela), and First Prize at the exhibition *Seven Venezuelan Painters* held at the Museum of Fine Arts in Curaçao, 1960; National Prize for Drawing at the Official Salon in Caracas, 1961; Esteban Frías Prize and Puebla de Bolívar Prize at the Twenty-third Official Salon in Caracas, 1962; National Prize for Painting at the Twenty-fourth Official Salon in Caracas, 1963.

CRUZ-DIEZ, Carlos. Born in 1923 in Caracas, Venezuela. Graduated as a professor of art from the School of Fine Arts. Has been active in publicity and as illustrator for the *El Nacional* newspaper. From 1958 to 1960 was assistant director and professor at the School of Fine Arts of Caracas and professor in typographic design in the Journalism School of the Central University of Venezuela. Held several one-man exhibitions in Caracas and Madrid and participated in group exhibitions, including the Second, Fourth, and Seventh São Paulo Biennials, the Thirty-first Venice Biennial, and other important exhibitions in Latin American countries, the United States, and Europe. Has been a resident of Paris since 1960.

DEIRA, Ernesto. Born in 1928 in Buenos Aires, Argentina. Attended the University of Buenos Aires, graduating as a lawyer in 1950. Apprenticeship was initiated in 1954 under Leopoldo Torres Agüero and Leopoldo Presas. Since 1957 has participated in group and one-man exhibitions in Buenos Aires and other cities in Argentina as well as abroad. Was invited to exhibit in the Acquarone and Ver y Estimar Prize competitions, 1961, and the Torcuato Di Tella shows, 1963 and 1964, all in Buenos Aires; the Guggenheim International Award in New York and the Pan American Union in Washington, D.C., 1964. His work is represented in the museums of La Rioja and Tres Arroyos, the Museum of Fine Arts of Buenos Aires, the Museum of Modern Art of Buenos Aires and Caracas, and the Permanent Collection of the Organization of American States. He was awarded the 1958 Losada Prize at the Watercolor and Engraving Salon of Buenos Aires. Has traveled throughout Europe under a National Arts Fund scholarship and visited the United States in 1964.

GAMARRA, José. Born in 1934 in Tacuarembó, Uruguay. Studied at the Montevideo Academy of Fine Arts. In 1959, through a Brazilian government grant, studied in Rio de Janeiro. Took up residence in São Paulo in 1960, where he taught art at the Armando Alvares Penteado Foundation. Traveled to Paris in 1963. Held one-man exhibits in Buenos Aires, São Paulo, Santiago de Chile, Montevideo. Participated in such group exhibitions as the First Bienal Americana de Arte, Córdoba; Young Artists Biennial in Montevideo and Paris, São Paulo Biennial as well as that of Tokyo and Venice, and other exhibits of similar importance. Awards: Brazil's Itamaraty Grant, 1959; Third Prize, First Bienal Americana de Arte, Córdoba, 1962; Third Prize, Young Artists Biennial, Montevideo, 1962; Prize for Painting, Young Artists Biennial, Paris, 1963. Also received several other awards at exhibits held in Uruguay and Brazil. Has lived in Paris since 1963.

GUTIERREZ, Alberto. Born in 1935, in Caldas, Armenia, Colombia. Studied at the University of Florida, thereafter in New York, Paris, and Amsterdam. Held one-man exhibits in Colombia, Copenhagen, Stockholm, Balearic Islands, and Miami; participated in thirty-seven group exhibits both in Colombia and foreign countries. Awards: Intercol National Prize at the Third Inter-American Annual Art Exhibition, Barranquilla, 1963; First National Award for Painting at the Fourth National Art Festival, Cali, 1964.

KUBOTTA, Arturo. Born in 1932 in Lima, Peru. Graduated in 1960 from the National Academy of Fine Arts of Peru with Grand Prize of Honor. Participated in numerous group exhibits in Peru and abroad: First and Second Paris Biennials, 1959 and 1961; *Peruvian Art*, Mexico City, 1960; *American Painting*, Santiago de Chile, 1961; *Young Peruvian Artists*, Pan American Union, Washington, D.C., 1961. Held one-man exhibitions at the Pan American Union, 1963, and in Chicago, 1963 and 1964.

LEUFERT, Gerd. Born in 1914 in Klaipeda, Lithuania. Studied in Europe and specialized at the Pratt Institute of New York and Iowa State University. Has held several important art-related positions and is currently curator of the Caracas Museum of Fine Arts. Has held eleven one-man shows in Caracas as well as in galleries in Germany, Colombia, and the United States. His participation in group exhibits has made his work known worldwide. Has recently participated in a show at the Madrid Museum of Contemporary Art, the New York World's Fair, and the *Magnet* exhibition at the Bonino Gallery of New York City. His works are in several private collections in Latin America, the United States, and Europe, as well as in New York and Venezuelan museums, while his graphic works are in the collections of the Pratt Institute, the Public Library, and the Museum of Modern Art in New York; in Basel, Switzerland; the Venezuelan Museum of Fine Arts, and the Library of Congress in Washington, D.C. Lives in Venezuela.

MACCIO, Rómulo. Born in 1931 in Buenos Aires. Self-taught. First exhibited in 1956, with nine subsequent one-man shows in Buenos Aires galleries. Has also participated in group exhibits both in his country and abroad: Bogotá, Buenos Aires, Caracas, Edinburgh, Stockholm, Lima, Mexico City, Montevideo, and New York City. Also participated in the Biennials of Paris, São Paulo, Venice, and Córdoba, and a number of other important exhibits. His work is to be found in the National Museum of Fine Arts in Buenos Aires and Caracas, Museum of Modern Art in Buenos Aires and Brussels, as well as the Guggenheim Collection. Awards: De Ridder Prize and Chantal Prize, 1959; Second Prize and Di Tella International Prize, Instituto Di Tella, 1961 and 1962, all of them in Buenos Aires; Fourth Prize, First Bienal Americana de Arte, Córdoba; and the Guggenheim Award, New York, 1964.

MAC ENTYRE, Eduardo. Painter, industrial designer, graphic artist, born in 1929 in Buenos Aires, Argentina. Participated in numerous group exhibits in his country and abroad. His work is represented in the Buenos Aires Museum of Modern Art, the Provincial Museum of Fine Arts in Córdoba, the Rio de Janeiro Museum of Modern Art, as well as in local and foreign private collections. Composer M. J. Etkin has written a piano score inspired by Mac Entyre's artistic creations. Participated in the First Biennial of Mexico, the Sixth Biennial of São Paulo, several exhibits in Sweden, and the First River Plate Biennial of Montevideo. Was a member of the International Jury Panel for the selection of the Seventh São Paulo Biennial poster in 1963.

NUÑEZ, Guillermo. Born in 1930 in Santiago, Chile. Participated in Chile's selection to the Third Paris Biennial and the Theatre Section of the Seventh São Paulo Biennial, 1963. Was awarded the Pacific Steel Prize for 1963 in Santiago. Professor of scenography at the Dramatic Art Academy of the University of Chile, has worked for the theatre, opera, and ballet as stage and costume designer. Has participated in individual and group exhibits in Chile as well as in Mexico, Oakland, Rio de Janeiro, and Washington, D.C. His works are at the Santiago Museum of Contemporary Art and private collections of Heinrich Lübke, Baron Toby von Schwiez, and others

in Germany, Argentina, Brazil, Spain, the United States, France, and Peru.

POLESELLO, Rogelio. Born in 1939 in Buenos Aires, Argentina. Graduated from the National Academy of Fine Arts in 1958. Career started in 1955 with an advertising agency. Presented his first graphic works in 1957. Held one-man shows in Buenos Aires and Washington, D.C., and participated in group exhibits in his country and abroad. He is represented in private collections in Germany, Buenos Aires, Montevideo, and Washington, D.C., as well as in art galleries of Buenos Aires, Caracas, and Washington, D.C. Awards: Losada Prize and First Mention at the De Ridder Prize Salon, 1959; Honor Sash at the Ver y Estimar Prize Contest, 1960; First Prize from the Israeli Tourist Bureau, 1963, all of them in Buenos Aires.

SABAT, Hermenegildo. Born in 1933 in Montevideo, Uruguay. Took up preparatory courses in architecture. In 1950 began his first graphic works. Traveled to the United States under a scholarship and stayed for four months. Has exhibited at Cine Club of Uruguay, Montevideo, 1958; Arts and Letters Center sponsored by *El País*, Montevideo, 1960; the Santos Dumont Building, Punta del Este, 1963; General Electric's Gallery, Montevideo, 1964.

SEGUI, Antonio. Born in 1934 in Córdoba, Argentina. Studied art in Argentina, Spain, and France. Held twenty-four one-man shows in his country, the Americas, and Europe. Participated in numerous group exhibits, including the Paris Biennial; *New Art of Argentina*, traveling in the United States; Pittsburgh International, Carnegie Institute; the Venice Biennial, and others. His latest individual exhibits took place in Paris and Turin. Won ten Argentine awards and two prizes at international contests. His works are in important art museums of Latin America, United States, and Europe, as well as in the Tokyo Museum of Modern Art.

SOTO, Jesús. Born in 1923 in Bolívar, Venezuela. Attended the Caracas Plastic Arts School from 1942 through 1947. Was director of the Maracaibo School of Fine Arts from 1947 through 1950. Has held one-man shows in Caracas and in European cities and has participated in important group exhibits, such as the 1957 and 1959 São Paulo Biennials, the 1958 and 1960 Venice Biennials, as well as other group shows held in European galleries and museums.

SZYSZLO, Fernando de. Born in 1925 in Lima, Perú. Participated in numerous group exhibits, including the Fourth and Fifth São Paulo Biennials, the 1958 Pittsburgh International, the Thirty-second Venice Biennial, and the 1964 Guggenheim International exhibit. Held one-man exhibits in Bogotá, Buenos Aires, Caracas, Florence, Lima, Mexico, New York, Paris, Rio de Janeiro, Santiago (Chile), São Paulo, and Washington, D.C. His work is represented at the Bogotá Museum of Modern Art, the Ithaca White Museum, Institute of Contemporary Art in Lima, Museum of Contemporary Art in Santiago (Chile), São Paulo Museum of Modern Art, and the Pan American Union Permanent Collection, Washington, D.C.

TELLEZ, Eugenio. Born in 1939 in Santiago, Chile. Worked from 1958 through 1959 at the Santiago Academy of Fine Arts. Traveled to Europe in 1960 and in 1962 was appointed assistant to S.W. Hayter at Atelier 17 in Paris, which he joined in 1960. His works are in the Museum of Modern Art of Amsterdam and New York, Oslo Museum, Musée de la Ville de Paris, as well as in the Paris National Library. Principal exhibits: *Young Artists*, Liberty Hall, Santiago (Chile), 1960; Second and Third Paris Biennials, 1961 and 1963; Institute of Modern Art, London, 1962; Latin American Art in Paris, Musée d'Art Moderne, Paris, 1962; A.A.A. Gallery, New York, 1962; the Bologna Museum (Italy), 1963. In 1964 participated in Salon des Réalités Nouvelles, Paris; Atelier 17 in Caracas; the Print Center in London; *Latin American Engraving*, Sudamericana Gallery, New York; and *Young Contemporary Engravers*, Musée d'Art Moderne, Paris.

TESTA, Clorindo. Born in Italy in 1923, he is an architect by profession. Has traveled throughout America, Europe, and the Orient. In Argentina he has held various one-man exhibitions. Participated in several group exhibits in Argentina and abroad. Highlights of his artistic career include: First Prize at the *International Exhibition* at Punta del Este, Uruguay, 1959; First Prize of the Institute Torcuato Di Tella, Buenos Aires, 1961; participation in the Guggenheim International Award, 1960; São Paulo Biennial, 1961; Venice Biennial, 1962; *Art of America and Spain*, Madrid and other European cities, 1963-64; and *Argentine Art*, Santiago (Chile) and Lima (Peru), 1963. Has lived in Argentina since 1924.

VEGA, Jorge de la. Born in 1930 in Buenos Aires, Argentina. Self-taught. Forsook his studies in architecture for painting. Has held individual exhibits since 1951 in Buenos Aires and at the Pan American Union,

Washington, in 1963. Has participated in group exhibits in Latin America, North America, and Europe. The group of artists consisting of himself, Deira, Macció, and Noé has been invited to the First Bienal Americana de Arte of Córdoba, the Pittsburgh International Triennial, as well as the Guggenheim International and the Torcuato Di Tella and Ver y Estimar Prize competitions. Traveled through Europe, living in Paris until 1962. Came to the United States in 1963 to attend his one-man exhibition at the Pan American Union in Washington, D.C.

ZARATE, Nirma. Born in 1936 in Bogotá, Colombia. In 1955 joined the Fine Arts Academy of the University of the Andes. Became a professor of drawing in 1958 at Bogotá's National Pedagogical Institute and participated in her first group exhibit the same year. In 1959 she entered the National University of Colombia and graduated in 1960 with a master's degree in painting. In 1961 she was commissioned by the National University of Colombia to foster cultural understanding among South American countries by traveling and holding exhibits in Argentina, Colombia, and Chile. Was selected in 1962 to join the *Colombian Art* exhibit which was sent to Europe, touring Germany, Spain, Italy, and Sweden. Has been awarded numerous special prizes at various group exhibits. Her works are in the Buenos Aires Modern Art Museum and other museums in Bogotá and Barranquilla, the Pan American Union in Washington, D.C., and in private collections of Argentina, Colombia, Chile, the United States, Israel, and Venezuela. She is currently a United States resident.

June 30 - July 18, 1965

COLONIAL ART OF PERU

A selection of paintings from the collection of His Excellency Celso Pastor,
Ambassador of Peru to the United States

In 1951 the Pan American Union's remodeled temporary-exhibit gallery was inaugurated with a presentation of selected items from the personal collection of the Ambassador of Peru to the United States, Fernando Berckemeyer--an exhibition indicative of the proprietor's special interest in the art of Spain.

His Excellency Celso Pastor, the present Peruvian Ambassador, like his predecessor, is the owner of a distinguished collection composed, however, of works by colonial artists of his own country. As part of this year's commemorations of the seventy-fifth anniversary of the establishment of the inter-American system, Ambassador Pastor has graciously permitted the showing of a selection of those works at the Pan American Union.

Colonial painting in Peru is largely identified with the so-called school of Cuzco, the most representative not only of that country but of all South America during the period of Spanish domination. It is not unnatural that in the years following the Conquest, Spanish artists and craftsmen whose careers had not proved lucrative in the Old World should have been attracted to the Inca capital, lured by the prospect of commissions payable in pure physical gold. Once creative activity had been initiated there, it continued unabated until the beginning of the nineteenth century, reaching its greatest intensity in the hundred and fifty years preceding the wars of independence: from the workshops of Cuzco there poured forth hundreds of canvases destined first for the churches of Peru and then for the Andean regions of Colombia and Venezuela. Indeed, during that period, Cuzco absorbed the major part of energy in painting in the whole northwestern quarter of the South American continent.

Ambassador Pastor began his collecting activities at the age of eighteen, as a law student at the Catholic University of Lima. Collecting may well be said to be in his blood. A collateral branch of his family, the de la Torres, long the owners of the celebrated "House of the Admiral" in Cuzco, a sixteenth-century palace built on Inca foundations, had filled it with a hoard of artistic treasures. In 1947, however, the palace was donated to the University of Cuzco and the collections were scattered by inheritance. A few of the works came into the hands of the future ambassador and helped both to mature his taste and to incline it toward art of the colonial period.

Any selection implies a judgment conditioned by the period in which the choice is made. In exercising the faculty granted me by Ambassador Pastor to separate a portion of his collection for public exhibition, I have, then, followed a criterion of my own time, settling upon those items which seemed to me most expressive from the viewpoint of present-day artistic sensitivity. I have intentionally avoided all slavish copies of European models by members of the Cuzco guilds, preferring canvases which openly transform those models, canvases which

represent interpretations rather than duplications of form, subject, and technique. In some instances one may speak of actual variations on a theme--variations that may attain the rank of metaphor. The exuberance of fantasy, refinement of detail, and eloquence of distortion which these works exhibit win for them entrance into the realm of poetry.

A variation in medium with which I have rounded out an exhibit otherwise devoted to oils is represented by a small relief carved in stone similar to alabaster, found in the region of Huamanga. Though the presentation is sculptural, the characteristics are those of the Cuzco school of painting.

Since the Cuzco guilds brought together Spanish instructors and Indian apprentices, in making the selection on view here, I have been inclined to pick works in which one can detect the presence of both ethnic elements. The union of Spanish realism with cryptic Indian symbolism is for many the fundamental characteristic of art of the colonial period in Latin America, and nowhere is it better illustrated than in painting of the school of Cuzco in the eighteenth century. As Ambassador Pastor has well said, that school, "like the Peruvian nation, represents the fusion of the Indian with the Spaniard, of paganism with Christianity."

On behalf of the Pan American Union I wish to express deepest appreciation to Ambassador Pastor, who has so generously contributed to the observances of three-quarters of a century of Pan Americanism by this loan of art, now shown publicly for the first time in the United States. --*J.G-S.*

CATALOGUE

It is very difficult to establish chronological attributions to the works; however the predominant style corresponds to the eighteenth century with the exception of No. 16, which might have been executed at a later date.

Oils on Canvas

1. *La Virgen de la Montera*
2. *La Virgen del Rosario*
3. *La Sagrada Familia*
4. *La Purísima*
5. *La Virgen de la Candelaria*
6. *La Virgen Niña de la Rueca*
7. *Santiago Apóstol*
8. *Barachiel*
9. *La Virgen Negra*
10. *La Virgen de la Candelaria y la Virgen del Rosario*
11. *Santa Rosa de Lima*
12. *La defensa del Santísimo Sacramento*
13. *San Francisco Javier*
14. *San Francisco de Asís*
15. *El Cristo de los Temblores*
16. *Captura de Atahualpa en los llanos de Cajamarca*
17. *La Virgen de Pomata*, carved stone of Huamanga
18. *Cristo cargando la cruz*

July 12 - 31, 1965

ABRAHAM PALATNIK OF BRAZIL: KINETIC EFFECTS IN ART

For many years Latin America has provided a fertile field for experimentation with different forms of abstract art. Several were practiced there with great intensity prior to achieving international consecration in the galleries of Paris and New York. Such, for example, was the case with the so-called op art, which enjoyed a great vogue in Venezuela and Brazil before spreading to the great world centers.

Movement has been a matter of preoccupation for a number of Latin American artists. Some have sought to

obtain kinetic effects by optical illusions. Others have created appearances of mobility by the use of contrasting media. Still others have resorted to energy created by motors or other mechanical devices.

Among a score of experimenters in this area in Brazil, an important place is occupied by Abraham Palatnik. Palatnik has produced an endless variety of effects of motion in his creations, from the illusions obtained from static elements employed in collage to actual moving flashes of electric light projected through transparent planes of color onto a screen in a dark chamber. Examples of these efforts constitute the present display of his work at the Pan American Union.

Palatnik was born in 1928 in the northeastern Brazilian city of Natal. He received an artistic and technical education in the Old World, attending art schools in Tel Aviv and Herzliya in Israel, and engaging in technological studies in Montefiori, Italy, celebrated as a center for instruction in internal combustion engines. He returned to Brazil in 1948 to work and carry out research and in the following year initiated his experiments with light. In 1951 he exhibited his first kinechromatic apparatus at the First São Paulo Biennial and received an Honorable Mention from the jury. Palatnik has since devoted himself to the development of new variations of his art, winning recognition in Brazil as a master thereof. An incidental offshoot of his activity was the invention and patenting of "Perfect Square," a mathematically based game which the author describes as one of "strategy and perception."

Palatnik has exhibited at the São Paulo Biennial on four occasions, 1951, 1955, 1957, 1959, and thrice at the National Salon in Rio de Janeiro, 1948, 1949, 1960, in addition to taking part in many group shows in Brazil. In Europe his works have been put on view at exhibitions in Munich and St. Gall (Switzerland), at the 1964 Venice Biennial, at the Denise René Gallery and the *Salon des Comparaisons* in Paris, and the Royal College of Art in London. In May 1965 he enjoyed a one-man show at the Brazilian Consulate in Munich, and works by him are currently on display at the Kunsthalle in Bern.

The present exhibition is Palatnik's first in the United States.

EXHIBITION LIST [1]

Progression Series, wood

1. *18-A*, 114 x 146 cm.
2. *19-A*, 140 x 134 cm.
3. *21-A*, 67 x 84 cm.
4. *22-A*, 58 x 77 cm.
5. *24-A*, 65 x 68 cm.
6. *26-A*, 59 x 72 cm.
7. *27-A*, 75 x 110 cm.
8. *28-A*, 133 x 125 cm.
9. *29-A*, 75 x 114 cm.
10. *38-A*, 120 x 122 cm.
11. *39-A*, 156 x 140 cm.
12. *40-A*, 127 x 140 cm.
13. *42-A*, 153 x 152 cm.
14. *43-A*, 96 x 96 cm.
15. *44-A*, 122 x 156 cm.
16. *45-A*, 110 x 127 cm.
17. *50-A*, 140 x 134 cm.
18. *53-A*, 72 x 77 cm.
19. *54-A*, 141 x 80 cm.
20. *55-A*, 145 x 130 cm.
21. *56-A*, 116 x 164 cm.
22. *57-A*, 43 x 44 cm.

[1] Not included in the original catalogue. --*Ed.*

23. *58-A*, 63 x 58 cm.

Kinechromatic Series, light

24. *C-29*, 70 x 110 x 20 cm.

July 20 - August 9, 1965

OSCAR PANTOJA OF BOLIVIA

Bolivian art has been characterized for over two decades by the ascendancy of Indian subjects and other folk motifs. Of late, however, certain figures have risen in revolt against this domination, taking a more creative approach, which has generally led them to abstract expressionism. Chief among these rebels are three outstanding painters: María Luisa Pacheco and Alfredo Da Silva, both of whom have exhibited at the Pan American Union, and Oscar Pantoja.

Pantoja's work is intensely lyric and rich in subtleties. It carries a suggestion of the incredibly beautiful Bolivian landscape--the contours of the land, the color of the earth, the gleam of its minerals; it exudes a mysterious atmosphere similar to that evoked by the pre-Columbian art of the remote past, as represented by the fascinating culture of Tiahuanaco; it conveys a sense of vibrancy, of fluidity, of gaseous expansion.

Born in Oruro, Bolivia, in 1925, Pantoja studied at the School of Fine Arts in La Paz, later at the School of Plastic Arts in Mexico City, where he lived and worked for eight years. During this period he was first inclined to painting of social content; eventually, he turned to abstraction.

Pantoja made his debut as an exhibitor at the Palace of Fine Arts in Mexico City in 1945. Since that time he has held numerous one-man shows in La Paz, 1950, 1951, 1953, 1958, and 1963; in Santiago de Chile, 1953; in Caracas, 1957, 1959, and 1963; and in Rio de Janeiro and Miami, 1961. He has participated in frequent group exhibitions in Argentina, Bolivia, Brazil, Chile, Mexico, and Uruguay. Pantoja's work was presented for the first time in the United States at the Galería Sudamericana in New York in 1959; this, however, is his first appearance at the Pan American Union.

CATALOGUE [1]

 1-12. Oil Paintings
13-20. Ink Drawings

August 10 - September 1, 1965

CARLOS GONZALO CAÑAS FROM EL SALVADOR: PAINTINGS

The beginnings of modern art in El Salvador date back less than twenty years, to the return from Europe of a number of young artists who had been sent there to study on official scholarships. They brought with them not only the latest techniques but also a new, less literal, more imaginative approach to the subject matter which their native land provided.

One of the youngest of the returning artists was Carlos Gonzalo Cañas, who has pursued his career with a high degree of seriousness, developing his expressionist tendencies from a figurative to a nonobjective manner. Originally characterized by intense distortion of the subject, his work is now marked by an informal treatment of textures and the use of neutral colors. His pigments, splashed on in thick impasto, produce rough surfaces suggestive of the lava deposits of Salvadorian volcanoes; they possibly reflect an unconscious influence of the

[1] Detailed titles are unavailable. --*Ed.*

native landscape upon his imagination.

Cañas was born in the capital, San Salvador, in 1924. After graduation from the National School of Graphic Arts in that city, he was sent to Madrid to further his studies in painting. He remained there from 1950 to 1957 and, upon the termination of his scholarship, traveled through North Africa, France, Germany, the Netherlands, Mexico, and various parts of Central America before taking up residence in his native El Salvador. He has held several official positions there in the artistic field; currently he is director of the School of Architecture of the National University.

Cañas has participated in numerous group exhibitions in Latin America, Europe, and Japan. He has enjoyed one-man shows not only in El Salvador but also in Spain (Madrid and Santander), Germany (Frankfurt and Hannover), and in Managua, Nicaragua. He has, moreover, received frequent national and international awards, among them the First Prize for Painting in the Salvadorian section of the *Esso Salon of Young Artists* of the Americas. The work which won for him this distinction was presented in the *Esso Salon* of finalists held at the Pan American Union in May of this year. Compositions by him are included in the selection from the Esso Standard Oil Company's permanent collection now on view at the Central American Pavilion in the New York World's Fair. The current presentation is Cañas's first one-man show in the United States.

CATALOGUE

Paintings, 1965

1. *Viejo madero vertical (Old Wood)*, 122 x 81 cm.
2. *Cornisa (Cornice)*, 81 1/2 x 122 cm.
3. *Dintel* (Lintel), 81 1/2 x 122 cm.
4. *Trono del guerrero (Warrior's Throne)*, 122 x 80 1/2 cm.
5. *Ciclo mágico (Magic Cycle)*, 122 x 81 cm.
6. *Responso de una rosa (Response of a Rose)*,[1] 81 x 122 cm.
7. *Descanso del guerrero (Warrior's Repose)*, 122 x 81.3 cm.
8. *Decididamente, joya (Decidedly, a Jewel)*, 122 x 81 cm.
9. *Penetración por la banda derecha (Penetration of the Left Side)*,[1] 102 x 77 cm.
10. *Nupcial (Nuptial) No. 1*, 122 x 81 1/2 cm.
11. *Nupcial (Nuptial) No. 2*, 122 x 82 cm.
12. *Condecoración para un militar centroamericano utópico (Medal for a Utopian Central American Military Man)*, 122 x 81 cm.
13. *Iluminada torre (Illuminated Tower)*, 122 x 81 cm.
14. *Arquitectura plena (Full Architecture)*, 122 x 81 cm.
15. *Ojo de puente (Eye of a Bridge)*, 77 x 102 cm.
16. *Suspendido tablero (Suspended Table)*,[1] 102 x 77 cm.
17. *De pronto, un niño descubre el castillo (Suddenly, a Child Discovers the Castle)*
18. *Cruz de mayo 1965 (Cross of May 1965)*, 102 x 77 cm.
19. *Insignia para un hombre triste (Sign for a Sad Man)*, 102 x 76 1/2 cm.
20. *Tema místico (Mystic Theme)*,[2] 122 x 80 1/2 cm.

September 2 - 22, 1965

TERESA CASANOVA: PAINTINGS AND ENGRAVINGS FROM VENEZUELA

A new personality, Teresa Casanova, has recently emerged in Venezuelan art among cultivators of abstract

[1] Literal translation of no. 6 is "A Rose's Prayer for the Dead;" of no. 9 is "Penetration by the Right Side;" of no. 16 is "Suspended Board." --*Ed.*

[2] Also exhibited but not included in the original catalogue. --*Ed.*

expressionism and is winning growing renown for her accomplishments in painting and, more particularly, engraving.

Miss Casanova was born in Caracas. She studied at the School of Plastic Arts in that city and later took courses in Bogotá given by the Peruvian-Colombian painter Armando Villegas. Still further study took her to Rome and the workshop of the Peruvian Jorge Piqueras. Upon returning to Venezuela, she turned to engraving, taking for her teacher in that technique Elisa Elvira Zuloaga, an artist whose work was recently presented at the Pan American Union.

Miss Casanova has participated in numerous salons in Caracas and other cities of Venezuela during the past decade. In 1961 her work was included in the São Paulo Biennial; this year it was exhibited in Belgium. Her sole individual exhibit to date took place at the Caracas Museum of Fine Arts. The current presentation is Miss Casanova's first in the United States.

CATALOGUE

Paintings

1. *Memorias de Adriano (Memories of Adrian)*
2. *Paisaje japonés (Japanese Landscape)*
3. *Sancho Panza*
4. *Nils*
5. *Bodegón 1920* (Still Life 1920)
6. *Bodegón 1925* (Still Life 1925)
7. *Bodegón 1930* (Still Life 1930)
8. *Serie del aventurero (Series of the Adventurer) I*
9. *Serie del aventurero (Series of the Adventurer) II*
10. *Serie del aventurero (Series of the Adventurer) III*
11. *Serie de la ciudad (Series of the City) I*
12. *Serie de la ciudad (Series of the City) II*

Engravings

1. *El grifo (The Griffin)*, 5/50
2. *Anunciación (Annunciation)*, artist's proof
3. *Cosmogonía (Cosmogony) I*, 4/15
4. *Cosmogonía (Cosmogony) II*, 1/15
5. *Caballo estelar (A Stellar Horse)*, 5/50
6. *Ci ritroviamo in una senda scura (We Shall Meet Again on a Dark Path)*, 2/15
7. *Ideas sobre Troya (Ideas About Troy)*, 6/20
8. *La vaca sobre la luna (The Cow on the Moon)*, 4/20
9. *Encima de la tierra (On Top of the Land)*, artist's proof
10. *Ollantaytambo*, 5/20
11. *Ollantaytambo*, artist's proof
12. *Hallazgo mítico (A Mythical Finding)*, 4/20
13. *La Torre de Babel (The Tower of Babel)*, 1/10
14. *Vibraciones (Vibrations)*, 1/10
15. *Gemini-2*, artist's proof

September 23 - October 12, 1965

JUAN DOWNEY OF CHILE

Despite his youth, the Chilean Juan Downey has already given evidence of a well-developed, many-sided talent for artistic creation. Born in Santiago in 1940, he published his first volume of verse at the early age of fifteen. A year later he enrolled in the School of Architecture of the Catholic University of Chile. While pursuing his

professional courses there, he took up the craft of engraving, studying at the workshop of his celebrated compatriot Nemesio Antúnez. Downey has remained active as a poet, architect, and engraver, and has engaged in painting as well, but of late he has concentrated his efforts on the field of the plastic arts.

Works by Downey have figured in national group exhibitions not only in his own country but also in Argentina, Canada, France, Spain, Switzerland, the United States, and Venezuela. Recently he was a participant in a special international exhibit of original graphics held in San Francisco. He has, in addition, had two one-man shows: the first at the Ministry of Education in Santiago in 1961; the second, the following year, at the Condal Gallery in Barcelona, Spain.

This year the artist has been studying in France, on a scholarship awarded him by the French government. There he prepared the works that appear in the current exhibition, marking his first presentation at the Pan American Union.

CATALOGUE

Oils

1. *Un cosmonauta sale del satélite (A Cosmonaut Leaves the Satellite)*, 195 x 130 cm.
2. *Despiértate (Wake Up)*, 195 x 130 cm.
3. *Multitud humana (Human Multitude)*, 195 x 130 cm.
4. *Evolución de un gran hombre (Evolution of a Grand Man)*, 195 x 130 cm.
5. *Dame la mano (Give Me Your Hand)*, 146 x 114 cm.
6. *Los marinos de Amsterdam (The Sailors of Amsterdam)*, 120 x 120 cm.
7. *Pasando un túnel (Passing by a Tunnel)*, 100 x 130 cm.
8. *El nudo de la vida (The Knot of Life)*, 116 x 89 cm.
9. *Joven parecido a Tarzán (A Young Man Who Looks Like Tarzan)*, 116 x 89 cm.
10. *Gimnastas (Gymnasts)*, 116 x 89 cm.
11. *La difícil relación humana (The Difficult Human Relationship)*, 116 x 89 cm.
12. *Mi cara durante un viaje en automóvil (My Face During a Journey by Automobile)*, 116 x 89 cm.
13. *Retrato de cuerpo entero (Full Portrait)*, 116 x 89 cm.
14. *Autorretrato (Self-Portrait)*, 100 x 81 cm.
15. *Un cuello y media cara (A Neck and Half of a Face)*, 100 x 81 cm.
16. *Maquinaria (Machinery)*, 81 x 65 cm.
17. *Luchadores griegos (Greek Wrestlers)*, 73 x 60 cm.
18. *Conoce a un cosmonauta (Meet a Cosmonaut)*, 80 x 160 cm.
19. *Lavatorio (Lavatory)*, 46 x 38 cm.

Oils and Collage

20. *Cara que cambia (A Face Changes)*, 46 x 33 cm.
21. *Ojo (Eye)*, 37 x 35 cm.

Etchings

22. *Le groupe (The Group)*, 1963
23. *Vivant (Lifelike)*, 1963
24. *Homme (Man)*, 1963
25. *Cucaracha (Cockroach)*, 1963
26. *Búscate (Search Yourself)*, 1963
27. *Intérieur (Interior)*, 1963
28. *Vif (Alive)*, 1963
29. *Forme (Form)*, 1963
30. *L'autre monde (The Other World)*, 1963
31. *Como un animal (Like an Animal)*, 1963
32. *Profondeur (Profundity)*, 1963
33. *Twice*, 1964

34. *Dedans (Inside)*, 1964
35. *Portrait du monsieur (Portrait of a Gentleman)*, 1964
36. *Le vrai monsieur (The Real Gentleman)*, 1964
37. *Retrato de un chileno (Portrait of a Chilean)*, 1964
38. *Succession*, 1963
39. *Put the Pieces of Life Together*, 1965
40. *The Creators of a New Universe*, 1965

October 13 - November 3, 1965

THE TANGO: OILS BY CARLOS CAÑAS OF ARGENTINA

Before dance rhythms of Cuban and, more recently, Brazilian origin made their triumphant invasion of the world's music halls, it was the Argentine tango that symbolized Latin America in foreign lands. So great was its popularity in the period from shortly before to shortly after World War I that those years became known as "the tango era." Today its success continues unabated in the land which gave it birth.

Like many other forms of popular music, the tango originated in the lower classes, among the inhabitants of what the Argentines call *los arrabales*. It soon made its way up the social scale, however, and its reflections began to appear in sculpture, painting, and the graphic arts. These manifestations were merely incidental, and the treatment was of the illustrative, academic type. In the paintings of Carlos Cañás, for the first time the tango is taken as a subject and given a serious interpretation, in which the rhythms of music are transmuted into visual forms. The artist's brushstrokes dance as it were across the canvas; austere, somber colors echo melancholy harmonies; highlights flash forth like a pulsating accent.

Cañás was born in a tenement-house district of Buenos Aires in 1928. There, in the Riachuelo section in which he lived later, in the quarter known as La Boca, and in suburban Avellaneda, he met the persons who provide the motifs of the tango. La Boca and Avellaneda are famous for their small bars and cafés, frequented by people who make a daily ritual of singing, listening, and dancing to the tango, which is for them both a mode of expression and a way of life.

Most of the paintings in the present show were executed in 1962, when the artist decided to give graphic form to the memories of his early years. Cañás has said of them:

> If these paintings are not the most profound of my work, they are at least the most deeply felt. I understand that my mission in painting is perhaps other than this, but I had the urge to produce this work. Rather than a concession to the public, it is a concession to myself.

Cañás graduated from the National School of Fine Arts in Buenos Aires in 1955. Since 1958 his compositions have figured in numerous national salons, where they have won him important awards. He has had one-man shows in both Argentina and Brazil; he was included in Argentine group exhibits sent to Mexico City and Rome in 1960; and he has participated in international exhibitions such as the Biennial of Young Artists, Paris, 1959 and 1961; the Saigon International Exhibition, 1962; and the *Art of America and Spain* exhibition presented in Madrid and other European cities in 1963. Last year his work went on view for the first time in the United States in a group show held at the Museum of Modern Art in Miami. Cañás is a member of the Buenos Aires *Grupo del Sur* (Southern Group), which includes René Morón and Leo Vinci, whose compositions were recently exhibited at the Pan American Union. The current show, exhibited in cooperation with the Rubbers Gallery in Buenos Aires, is Cañás's first presentation in the Washington area. --*J.G-S.*

CATALOGUE [1]

Oils

1. *Homenaje a Pichuco (Aníbal Troilo)* (Homage to Pichuco [Aníbal Troilo]), 195 x 130 cm.

[1] In the original catalogue the titles of the works appeared in Spanish only. Most of them are titles of tangos; therefore, an approximate translation is given here. --*Ed.*

2. *La cruzada* (The Crossed Step), 114 x 114 cm.
3. *En lo de Hansen* (At Hansen's House), 114 x 146 cm.
4. *La que nunca tuvo novio* (The Girl Who Never Had a Boy Friend), 114 x 146 cm.
5. *Imagen de tango A* (Tango Image A), 97 x 146 cm.
6. *Imagen de tango B* (Tango Image B), 97 x 146 cm.
7. *Rosendo Juárez, el pegador* (Rosendo Juárez, the Hitter), 97 x 130 cm.
8. *Muchachas de percal* (Girls in Percale), 97 x 130 cm.
9. *Cantor orillero* (Marginal Singer), 73 x 100 cm.
10. *A media luz los dos* (Both in Half Light), 73 x 100 cm.
11. *Bandoneón arrabalero* (Suburban Italian Accordion), 73 x 100 cm.
12. *Tango íntimo* (Intimate Tango), 45 x 60 cm.
13. *La sangre que buye con cada compás* (Blood Pulses with Each Beat), 45 x 60 cm.
14. *La Parda Filipina* (The Dark Filipina), 50 x 70 cm.
15. *La Flaca del Corralón* (The Corral's Skinny Girl), 50 x 70 cm.
16. *Romántica loca* (Crazy Romantic), 40 x 50 cm.
17. *El Cicatriz* (The Scarface), 40 x 50 cm.
18. *Compadrito de Palermo* (Bully from Palermo), 40 x 50 cm.
19. *Bocanegra* (Blackmouth), 40 x 50 cm.

October 13 - November 3, 1965

LILIAN GOMEZ MOLINA OF ARGENTINA: ENGRAVINGS

Although Buenos Aires, as the focal point of Argentine cultural life, is the undisputed art center of the Republic, the plastic arts are widely cultivated in the provinces. A particularly important nucleus of activity in all fields is constituted by the city of Córdoba. The seat of Argentina's oldest university, the possessor of a booming automobile and airplane industry, it has manifested its interest in the aesthetics by the establishment of a biennial art exhibition that draws entries from far and wide.

A local artist whose work is attracting increasing attention from the rest of the country is the engraver Lilián Gómez Molina. Born in Córdoba in 1926, she studied at the city's university and at the Academy of Fine Arts. She has had one-man shows in Buenos Aires and in other Argentine cities, and her entries in national salons have won her a number of important prizes. Abroad she exhibited with other Argentine engravers in New Delhi in 1961; she participated in the Tokyo Biennial in 1964, and in the Osaka exhibition in 1965. The current presentation is the artist's first exhibit at the Pan American Union.

CATALOGUE

1. *Lento* (Slow), copy no. 2, 1962, 22 x 53 cm.
2. *Primer movimiento* (First Movement), copy no. 3, 1963, 34 x 59 cm.
3. *Mosso*, copy no. 1, 1963, 29 x 54 cm.
4. *Dinámica de un tiempo musical* (Dynamic of a Musical Tempo), diptych, copy no. 2, 1964, 27 x 50 cm. (upper part); 27 x 51 cm. (lower part)
5. *Sonata*, copy no. 1, 1963, 28 x 62 1/2 cm.
6. *Sonatina*, copy no. 1, 1963, 34 1/2 x 40 cm.
7. *Continuidad espacial rítmica* (Rhythmic Spatial Continuity), diptych, copy no. 4, 1963, 29 x 48 cm. (upper part); 29 x 54 cm. (lower part)
8. *Doloroso* (Painful), copy no. 1, 1963, 29 x 48 cm.
9. *Integración gráfico-sonora* (Audio-Graphic Integration), copy no. 2, 1964, 33 x 58 cm.
10. *Concordancia sonora* (Concord of Sounds), copy no. 2, 1964, 33 x 52 cm.
11. *Frecuencia de sonidos parciales* (Frequency of Partial Sounds), copy no. 3, 1964, 32 x 56 cm.
12. *Arpegio* (Arpeggio), copy no. 1, 1963, 34 1/2 x 55 cm.
13. *Animato*, copy no. 2, 1963, 29 x 64 cm.

November 4 - 23, 1965

RAFAEL CORONEL OF MEXICO: OILS

Realism--tempered by varying degrees of subjectivity--has been the hallmark of art in Mexico from pre-Columbian times to the present day. Representation has been and remains the goal of creative activity in that country.

The world depicted by Rafael Coronel is one of twilight calm, far different from the turmoil and noonday brilliance of the painters of the Revolution. Only occasionally is the tranquillity of his canvases broken by an emotional brushstroke or by a violent splash wrought with the palette knife. The human figure in his rendering is quiet, static, void of either conflict or message. Without ever seeking to enter the realm of abstraction, Coronel has for fourteen years been evolving a style of his own, clearly in the Mexican tradition, and occasionally suggestive of the ancestors thereof, the painters of the Spanish school of the seventeenth century.

Rafael Coronel was born in 1932 in Zacatecas. After finishing his secondary education there he entered the local university, where he undertook the study of architecture. However, when his family moved to Mexico City in 1952, he abandoned architecture, enrolling in the School of Painting and Sculpture of the National Institute of Fine Arts. In that same year he won a contest for a scholarship which the school offered.

In 1960 a one-man show of Coronel's paintings was presented at the Palace of Fine Arts in Mexico City, and a year later he had an exhibition at the Forsythe Gallery in Ann Arbor, Michigan. In 1964 he was contracted to execute murals for the National Institute of Anthropology and History in the Mexican capital. In the course of the current year he held a highly successful one-man show at the Gallery of Mexican Art, which serves as his agent in Mexico City, and he was featured in the Mexican section at the Eighth São Paulo Biennial, where he obtained the Special Prize for Latin American Artists offered by Kaiser Industries. The current exhibition is the first presentation of the artist's work at the Pan American Union. --*J.G-S.*

CATALOGUE

Oils on Canvas, 1965

1. *Mi abuela (My Grandmother)*, 150 x 110 cm.
2. *El enano (The Midget)*, 120 x 90 cm.
3. *Mi abuela (My Grandmother) No. 2*, 150 x 110 cm.
4. *Mi abuela (My Grandmother) No. 3*, 130 x 90 cm.
5. *La santa loca (The Crazy Saint)*, 110 x 140 cm.
6. *Fogata apagada (A Fire Extinguished)*, 140 x 140 cm.
7. *Cuento al niño (A Story Told to the Child)*, 120 x 120 cm.
8. *Todos juntos (All Together)*, 140 x 140 cm.
9. *Martina*, 100 x 120 cm.
10. *Escena del circo (Circus Scene)*, 120 x 120 cm.
11. *El enano y la foca (The Midget and the Seal)*, 130 x 90 cm.
12. *De paseo (On a Walk)*, 120 x 120 cm.
13. *Perfil (Profile)*, 75 x 50 cm.
14. *Cabeza (Head) No. 1*, 50 x 50 cm.
15. *Cabeza (Head) No. 2*, 30 x 50 cm.
16. *Cabeza (Head) No. 3*, 45 x 80 cm.
17. *Cabeza (Head) No. 4*, 20 x 25 cm.
18. *Retrato de mi tía (Portrait of My Aunt)*, 90 x 45 cm.
19. *El niño de San Angel (The Child of San Angel)*, 125 x 90 cm.
20. *El organillero (The Organ Grinder)*, 90 x 90 cm.
21. *Retrato flash (Flash Portrait)*, 55 x 45 cm.
22. *Perfil (Profile) No. 2*
23. *Retrato (Portrait)*

November 4 - 23, 1965

NOE LEON OF COLOMBIA

Noé León was first presented at the Pan American Union in a group show entitled *Primitive Artists of the Americas* in 1963. At the time, I spoke of the tradition represented in that show as one of the oldest, strongest, and liveliest in the artistic repertory. Primitive or naive art, whether concerned with portraiture, the depiction of everyday objects and scenes, or the tracing of magic symbols, is a mode of expression which has resisted the impact of time, academic teaching, and the sophistications of culture.

About four years ago, during a visit to Colombia, I came upon Noé León selling little paintings to people passing through the streets of Barranquilla, the city in which he still resides. I discovered that he had been born in the town of Ocaña in 1907; that from 1924 to 1931 he had been a policeman; and that thereafter he had devoted himself entirely to painting, taking for models landscapes and romantic scenes which he found in magazines or on postcards, and translating them into his own highly personal idiom.

I suggested that he paint directly from nature, rather than copy reproductions. The suggestion was accepted, and the result has been a progressive improvement in the quality of León's work, which now reveals an impressive feeling for composition and great imagination with regard to subject. The colors are rich, varied, and bold, and the approach to detail is delightful. It is a significant guarantee of Leon's highly developed plastic sense that a majority of the collectors of his works are professional painters or art critics in Colombia.

This office has been instrumental in obtaining the inclusion of compositions by León in group exhibitions of primitive art held at the Museum of Art of La Jolla (California), at Duke University (Durham, North Carolina) and in Baden-Baden (Germany). In addition, there have been two one-man shows of his work in Bogotá at the Galería El Callejón, in 1964 and 1965, and one in Barranquilla, all of which were highly successful. This is Noé León's first individual presentation outside of Colombia. --*J.G-S.*

CATALOGUE

Paintings

Series of *The City of Barranquilla*

1. *Pueblo viejo* (Old Town)
2. *Plaza de Ciénaga* (Square of Ciénaga)
3. *Parada de buses* (Bus Stop)
4. *Fuente del Barrio Abajo* (Fountain of the Barrio Abajo)
5. *Calle de Usiacurí* (Street of Usiacurí)
6. *Siape*
7. *Tubará*
8. *Sabanilla*

Series of *The Forest*

1. *Mariposa y mono* (Butterfly and Monkey)
2. *Tigre malibu* (Malibu Tiger)
3. *Selva motilona* (Forest Motilona)
4. *Guazalé*
5. *Monos comiendo* (Monkeys Eating)
6. *Culebra cazando a un mono* (Snake Hunting a Monkey)
7. *Selva Orucué* (Forest Orucué)
8. *El Catatumbo*
9. *Tucán y mono* (Toucan and Monkey)
10. *Rendija en la selva* (Opening in the Forest)

Series of *The Magdalena River*

1. *El Cortizos*
2. *Colombia*
3. *El Canillo Torres*
4. *El Atlántico*
5. *El Valdivia en Plato*
6. *El Mercantil*

Series of *The Kites*

1. *Cepeda Ciénaga Cometa* (Cepeda Ciénaga Kite)
2. *Cometa Galapea* (Galapea Kite)
3. *Cometa en Manatí* (Kite in Manatí)
4. *Cometa y toches* (Kites and Birds)

November 24, 1965 - January 4, 1966

EMILIO RENART OF ARGENTINA: DRAWINGS

It was the "assemblage" which as an ultimate expression of collage served strongly for the emergence of what is known as pop art. Some artists didn't take pop art in its entirety but used it with freedom, producing objects with a strange and haunting meaning. This is what Emilio J. Renart has done during the past three years. His masterly treatment of the surfaces of new materials, the originality of his forms, and the queer expression of these objects which can be considered painting and sculpture simultaneously, constitute an important discovery in the new art trends of Latin America.

Unfortunately we are unable, because of lack of space in our exhibition hall and difficulties in transportation, to admire the large compositions or "monsters" which Renart has created. Therefore, we are presenting him in another media in which he excels: drawing.

Drawing is an art which Renart practices brilliantly. If this work is calmer than his fascinating "monsters," it is equally intriguing. In these refined and exquisite compositions, threads interweaving like strands of silk or human hair emerge from darker zones of free forms which can be considered the nucleus of every composition. Each thread flows miraculously in a different plane. When the lines are straight and cross each other, there is the same charm and the same definition of space as in the free lines. These lines and Renart's eye-catching concept of three-dimensional and aerial space constitute the purest elements. As is the case with the large, articulate, three-dimensional "monster" creations which we show here only in photography, these drawings represent the work of a genuine personality who has just emerged in the panorama of Latin American art.

Renart was born in Mendoza, Argentina, in 1925. Among the numerous salons of art in which he has participated are the *Premio Varig* at the Museum of Modern Art of Buenos Aires, 1961; Ver y Estimar Salon, 1962 and 1963; *Buenos Aires '64*, sponsored by the Pepsi-Cola Company, New York, 1964; Di Tella National Prize Salon, where he obtained a special prize, 1964; and the Georges Braque Prize Salon at the Museum of Modern Art of Buenos Aires, where he was awarded the First Prize for Drawing, 1965. The current exhibition is the first presentation of the artist's work at the Pan American Union. --*J.G-S.*

CATALOGUE [1]

1-30. Drawings

[1] Titles are unavailable. --*Ed.*

YEAR 1966

January 6 - 26, 1966

OILS BY GASTON ORELLANA OF CHILE

Three years ago the turbulent art scene of Madrid was further enlivened by the appearance of a group of young highly talented painters who took as their collective denomination the adjective *Hondo*, meaning "deep." They launched out in a variety of new directions, in daring statements of the most advanced artistic trends. Among the group was Gastón Orellana, a Chilean who has been living in Spain for seven years. Orellana's expression is highly personal: poetic and mysterious, his work reveals barely defined, nebulous forms traced in a suggestive monochrome. Spanish critics have been warm in their praise of his achievement.

Orellana was born in 1933 in Valparaíso, where he later studied at the Experimental School of Artistic Education. His first exhibition took place at the Chilean-American Institute in that same city when he was seventeen years old. He has since had one-man shows at the Chilean-British Institute, Santiago, 1954; the Institute of Contemporary Arts, Lima, 1957; the Pacific Gallery, Buenos Aires, 1959; the Institute of Hispanic Culture, Madrid, 1959; the Mayer Gallery, Madrid, 1960; the Dintel Gallery, Santander (Spain), 1960; and in Switzerland. In 1961 he exhibited with other artists of the *Hondo* group at the Neblí Gallery in Madrid. Examples of his work are to be found in numerous private collections in Latin America, the United States, and Europe. This is the first presentation of his work at the Pan American Union.

CATALOGUE

Oils

1. *Diálogo entre dos mujeres (Dialogue between Two Women)*
2. *Tragedia familiar (Familiar Tragedy)*
3. *Lavado de pelos (The Washing of Hair)*
4. *Alumbramiento (Childbirth)*
5. *Hacia los blancos vientos (Towards the White Winds)*
6. *Espejo encontrado en la tristeza (Mirror Found in Sadness)*
7. *Hasta las azules praderas (Till the Blue Prairies)*
8. *La columna solitaria (The Solitary Column)*
9. *Cabeza para conjurar maleficios (Head to Cast Out Bewitchments)*
10. *Hasta el cielo azul (Till the Blue Sky)*
11. *La noche del prestidigitador (The Night of the Magician)*
12. *Aguila sideral (Sidereal Eagle)*
13. *Cabeza sumergida (Submerged Head)*
14. *Llanto por el viejo (Tears for the Old Man)*
15. *A través de un espejo (Behind a Glass)*
16. *Advent*

January 18 - 25, 1966

ART OF THE AMERICAS
A selection of contemporary paintings and sculptures presented by the Pan American Union
in honor of the delegates to the Fourth Meeting of the Inter-American Cultural Council

In honor of the delegates to the Fourth Meeting of the Inter-American Cultural Council, a group of contemporary works by prominent artists of this hemisphere has been selected for exhibition. Many of the works belong to the Permanent Collection of the Pan American Union; some have been loaned especially for this

occasion by the artists or owners. The group offers a consistent view of the present trends of painting and sculpture in the Americas and constitutes a vigorous statement of what the American creator signifies, as a comparable value of modern art in today's world.

To all who have cooperated in making this show possible, the Division of Visual Arts of the Department of Cultural Affairs extends its gratitude. --*J.G-S.*

CATALOGUE

Painting, Drawing, Sculpture

Oscar Capristo (Argentina, 1921-)
1. *Círculos ausentes (Absent Circles)*, 1961, oil, 132 x 132 cm.

Víctor Chab (Argentina, 1930-)
2. *Collage No. 29*, 1964, mixed media

Raquel Forner (Argentina, 1902-)
3. *Astroseres negros (Black Astrobeings)*, 1961, oil on canvas, 47 x 47"

Alfredo Da Silva (Bolivia, 1936-)
4. *Equilibrium*, 1960, oil on paper

Manabu Mabe (Brazil, b. Japan, 1924-)
5. *Agonía (Agony)*, 1963, oil on canvas, 75 x 75"

Danilo Di Prete (Brazil, b. Italy, 1911-)
6. *Untitled*, 1962, oil on canvas

Cândido Portinari (Brazil, 1903-1962)
7. *Retorno da feira (Return from the Fair)*, 1940, oil on canvas, 39 x 31 1/2"

Raúl Valdivieso (Chile, 1931-)
8. *La serpiente emplumada (The Plumed Serpent)*, 1963, cast bronze, 19 x 44 x 8"

Guillermo Núñez (Chile, 1930-)
9. *Se disputan con ira (They Argue Angrily)*, 1964, oil, 40 x 60"

Roberto Matta (Chile, 1912-)
10. *Hermala 11*, 1948, oil on canvas, 50 x 57 1/2"

Edgar Negret (Colombia, 1920-)
11. *Aparato mágico (Magic Gadget)*, 1959, polychrome wood and aluminum, 19 x 35 x 20"

Carlos Poveda (Costa Rica, 1940-)
12. *Friso (Frieze)*, 1964, pen and ink on paper

Amelia Peláez (Cuba, 1897-)
13. *Waiting Lady*, 1944, gouache on paper, 39 x 29"

Darío Suro (Dominican Republic, 1917-)
14. *Optical Metamorphosis*, oil

Mauricio Aguilar (El Salvador, 1919-)
15. *Still Life with Fish*, oil on Masonite

César Valencia (Ecuador, 1918-)
16. *No. 2*, 1961, encaustic

Enrique Tábara (Ecuador, 1930-)
17. *Rivalidad ancestral (Ancestral Rivalry)*, oil

Carlos Mérida (Guatemala, 1891-)
18. *Púrpura de tormenta, Serie de los cielos de Tejas (Stormy Purple, Texas Skies Series)*, 1943, oil on canvas, 24 x 20"

Georges Liautaud (Haiti, 1899-)
19. *Crucifixion*, 1959, cut and forged oil drum metal, 46 x 30 x 9"

José Antonio Velásquez (Honduras, 1906-)
20. *San Antonio de Oriente*, 1957, oil on canvas, 26 x 37"

Rufino Tamayo (Mexico, 1899-)
21. *Hombre contemplando la luna (Man Contemplating the Moon)*, ca. 1955, lithograph, 21 x 16 1/2"

Rafael Coronel, (Mexico, 1932-)
22. *Todos juntos (All Together)*, 1965, oil on canvas, 140 x 140 cm.

José Clemente Orozco (Mexico, 1883-1949)
23. *Soldaderas*, oil

Armando Morales (Nicaragua, 1927-)
24. *Guerrillero muerto (Dead Guerrillero) VIII*, 1962, oil on canvas, 40 x 65"

Asilia Guillén, (Nicaragua, 1887-1964)
25. *Rafaela Herrera defendiendo el castillo contra los piratas (Rafaela Herrera Defends the Castle against the Pirates)*, 1962, oil on canvas, 25 x 38"

Guillermo Trujillo (Panama, 1927-)
26. *Figures*, mixed media

Carlos Colombino (Paraguay, 1937-)
27. *The Fish*, oil

Joaquín Roca Rey (Peru, 1923-)
28. *Maqueta para prisionero político desconocido (Study Figure for an Unknown Political Prisoner)*, 1952, bronze, 13 x 9 x 10"

Arturo Kubotta (Peru, 1932-)
29. *Endlessly Spacious*, 1962, oil on canvas, 30 x 32"

Robert Gates (United States, 1906-)
30. *Landscape*, oil

Jack Perlmutter (United States, 1920-)
31. *Eclipse*, oil

Ben Summerford, (United States, 1925-)
32. *Catalan Hill*, oil

Rafael Barradas (Uruguay, 1890-1929)
33. *Naturaleza muerta (Still Life)*, 1926-27, watercolor, 16 x 12"

Pedro Figari (Uruguay, 1861-1938)
34. *El patio (The Market Place)*, ca. 1935, oil on cardboard, 15 3/4 x 23 3/4"

Alejandro Otero (Venezuela, 1921-)
35. *Coloritmo (Colorrhythm) 34*, 1957-58, oil on board, 78 3/4 x 18 1/4"

BIOGRAPHICAL NOTE [1]

BARRADAS, Rafael. Painter, draftsman, caricaturist, illustrator, costume and set designer, born in Montevideo, 1890, where he died in 1929. The son of a painter, received drawing lessons from Spanish painter Vicente Casanova at age of seven. Began his art career as a caricaturist. Went to Europe in 1912 and settled in Spain, 1914-28, where he illustrated periodicals and books, designed theatrical sets and costumes for the Art Theatre of Madrid, and did most of his art work. Besides his paintings, left a great number of drawings and watercolors, including the *Montevidean Stamps Series*. Held individual exhibitions in Montevideo, Barcelona (Spain), Madrid, Buenos Aires. His work was included in official salons in Uruguay and Spain, and in international group shows in Paris, including the *International Exhibition of Modern Art*, UNESCO, Musée d'Art Moderne, 1946; São Paulo Biennial, 1951 and 1963 (special room); *First International Exhibition of Contemporary Painting*, Punta del Este, 1958 (special room); *Art of Latin America since Independence*, touring the United States, 1966-67. Was awarded Gold Medal and Honorable Mention, International Exhibition, Paris, 1925.

January 27 - February 14, 1966

MILNER CAJAHUARINGA OF PERU: OILS

The cause of modern art has been well served in Peru in recent years by the National School of Fine Arts in Lima: from it has come a group of talented young men who are contributing significantly to the development of promising new trends. Among the graduates is Milner, one of the finest of a generation of painters now in their thirties.

Born in Lima in 1932, José Milner Cajahuaringa--to give his full name--began the study of art in 1950. At the time he was also attracted by medicine and in 1952 he went to Argentina and enrolled in the Medical School of the University of Buenos Aires. In the end, interest in art proved stronger. Milner returned to Peru and in 1959 graduated from the National School of Fine Arts, where he had achieved a brilliant record. He has since received numerous awards as well as grants for the continuation of his studies.

In 1959 Milner exhibited in Mexico City and in the Biennial of Young Artists of Paris; in 1963 he was included in the exhibition *Art of America and Spain* in Madrid; he figured in the Peruvian section of the São Paulo Biennial in 1961, 1963, and 1965; and he was among the artists presented at the Second Kaiser Biennial in Córdoba, Argentina. Since 1958 he has had a total of eight one-man shows, held not only in Peru but also in Rio de Janeiro, Buenos Aires, and Madrid.

Work by Milner was included in a group exhibition of *Young Peruvian Artists* held at the Pan American Union in 1961. This, however, is the painter's first individual presentation in the United States.

CATALOGUE

Oils

1-18. *Untitled*

[1] Not included in the original catalogue. See Index of Artists for reference on those not listed here. *--Ed.*

February 15 - March 3, 1966

LEONCIO SAENZ OF NICARAGUA: DRAWINGS

Among painters who have come to the fore in Nicaragua in the last five years, Leoncio Sáenz stands out by reason of the unusual nature of his work in black and white.

Whereas black and white artists as a rule create on the basis of line, Sáenz approaches his medium from the viewpoint of mass. Like others of his generation, he has found inspiration in pre-Columbian statuary, which provides him with subject matter and serves as a point of departure for the invention of forms.

Born in Matagalpa, Nicaragua, in 1935, Sáenz studied at the School of Fine Arts in Managua under the guidance of its director, the painter Rodrigo Peñalba. He participated in all exhibitions organized by the School from 1953 to 1964. His compositions have been shown abroad at the Second Mexican Biennial, 1960; in the Latin American exhibit organized by the University of Kansas, 1962; at an exhibition in San Salvador, 1963; at the *Art of America and Spain* show in Madrid, 1963; and at the Berlin Fair, 1964. They were also included in the *Esso Collection of Central American Art* shown at the New York World's Fair in 1964. This same year Sáenz joined the group of artists who founded the Praxis Gallery in Managua, and he has since participated in all the Gallery's exhibits.

As in the case of Alejandro Aróstegui, whose compositions are simultaneously on view at the Pan American Union, this, the first presentation of Sáenz's work in Washington, has been rendered possible by the effective interest in the promotion of art taken by the President of Nicaragua, Dr. René Schick. --*J.G-S.*

CATALOGUE

Drawings

1. *Portrait of a Warrior*
2. *Priest*
3. *Magician*
4. *God of Fear*
5. *In a Past Age*
6. *Chorotega*
7. *Project for a Monument*
8. *Composition*
9. *Man and Weapon*
10. *Ghost*
11. *Slave*
12. *Lake Dweller*
13. *Message*
14. *Wrestler*
15. *Ancestor of Nicarao*
16. *Composition*

February 15 - March 3, 1966

ALEJANDRO AROSTEGUI OF NICARAGUA

"Fanciful and worth looking at twice" was the comment of the *New York Times* art critic John Canaday on the paintings of Alejandro Aróstegui, which figured in the *Esso Collection of Central American Art* shown at the New York World's Fair in 1964--the first time that the young Nicaraguan artist's work had appeared in an important exhibition in the United States.

Aróstegui was born in Bluefields, Nicaragua, in 1935. After studying at the National School of Fine Arts, he came to the United States in 1954 and enrolled in the School of Architecture of Tulane University in New Orleans. Deciding, however, that his creative efforts might be more profitably employed in painting, he transferred to the

Ringling School of Art in Sarasota, Florida in 1955 and continued there for two years. Having completed his basic study in the United States, he went to Europe for further training at the Academy of San Marco in Florence, 1958-59, and the School of Fine Arts in Paris, 1960-62. Thereafter he returned to his native country, whose influence is increasingly to be noted in his work, both in its subject matter--the Nicaraguan lakes and manifestations of local color--and in its spirit, a keen sense of drama being the dominant characteristic of his compositions.

In 1963 Aróstegui gathered together a number of young graduates of the National School of Fine Arts, an institution which had been instrumental in developing many of the new personalities who currently figure on the art scene in Nicaragua, to found in the capital city of Managua the Praxis Gallery, which has since proved to be a focal point of artistic activity in the country. Although it represents a purely private venture without official connection with the government, the President of Nicaragua, Dr. René Schick, conscious of the importance of this gallery as a center for the dissemination of new ideas, has provided it with a subsidy since 1964. It is the President's interest in the cause of modern art that has made the present exhibition possible: Dr. Schick not only facilitated the shipping of the works here exhibited but also the personal appearance of the artist.

Aróstegui's compositions possess great solidity and are highly personal in expression. As regards genre, the artist divides his efforts among figure paintings, landscapes, and still lifes. Human loneliness is a frequently recurring theme: man is depicted either in isolation or in contrast with the power of nature. The emaciated figures occasionally suggest ancient personages of pre-Columbian mythology. Aróstegui's palette leans toward muddy, neutral hues, perhaps inspired in the colors of Nicaragua's two great lakes.

Figures and landscape features are outlined in impasto, the artist making use of a textural clay to which at times he adds bones, shells, and stones, either singly or in combination. If there is a reminiscence of the forms of Giacometti or the textural qualities of Dubuffet, two points of departure for Aróstegui, the paintings are pervaded by the young Nicaraguan's own personality--one of the many which make the Latin American artistic scene one of the liveliest and most interesting of our days.

Aróstegui's compositions have been included in group shows in New York, Paris, Berlin, San Juan (Puerto Rico), San Salvador (El Salvador), and San José (Costa Rica). In his native Nicaragua the artist has participated in numerous group exhibitions and has enjoyed two one-man shows. This is his first presentation in Washington. --*J.G-S.*

CATALOGUE

1. *Alienado (Alienated)*, 1963
2. *Tríptico (Tripartite)*,[1] 1963
3. *Personajes lacustres (Lake Inhabitants)*, 1964
4. *Monstruo sagrado (Sacred Monster) No. 2*, 1964
5. *Lavanderas (Washerwomen)*, 1965
6. *Máscara (Mask)*, 1965
7. *Retrato de joven (Portrait of a Young Man)*, 1964
8. *Retrato de campesino (Portrait of a Peasant)*, 1964
9. *Paisaje lacustre (Lake Scene) No. 6*, 1965
10. *Basurero (Dump Yard) No. 3*, 1964
11. *El banquete (The Feast)*, 1965
12. *Basurero (Dump Yard) No. 4*, 1964
13. *Basurero (Dump Yard) No. 2*, 1964
14. *Paisaje lacustre (Lake Scene) No. 5*, 1965
15. *Naturaleza muerta (Still Life) No. 1*, 1965
16. *Vejez (Old Age)*, 1964
17. *Orígenes (Origins)*, 1964
18. *Paisaje lacustre (Lake Scene) No. 7*, 1965
19. *Naturaleza muerta (Still Life) No. 2*, 1965

[1] Literal translation of this title is "Triptych." --*Ed.*

20. *Recién nacido (Newborn)*, 1963
21. *Narizona (Big Nose Female)*, 1964
22. *Pequeño monstruo (Miniature Monster)*, 1964
23. *Títeres (Marionettes)*, 1964

March 4 - 21, 1966

CESAR IZQUIERDO OF GUATEMALA

One of the liveliest centers of artistic activity in Latin America today is the Praxis Gallery in Managua, Nicaragua. The Pan American Union has just exhibited compositions by two of the Gallery's Nicaraguan members, and it now takes pleasure in presenting the work of a Guatemalan associate, César Antonio Izquierdo.

Izquierdo was born in Santa Cruz del Quiché, Guatemala, in 1937. He received his basic artistic education in his country's National School of Fine Arts. Upon receipt of a scholarship for advanced training, he went at the age of nineteen to work under Rodrigo Peñalba at the National School of Fine Arts in Managua. Once he completed his studies, he elected to remain in Nicaragua, where he has played an active role in the country's artistic life, being, for example, one of the founders of the Praxis Gallery.

Izquierdo expresses an interest in pre-Columbian forms chiefly by means of a heavy impasto to which he imparts effects suggestive of the cryptic reliefs to be found on Mayan stelae. He exhibited in Guatemala even before moving to Nicaragua, and his works have been presented on a number of occasions in both countries. Since 1956 he has participated, along with other members of the Praxis group, in group shows in San Salvador (El Salvador), Mexico City, San Juan (Puerto Rico), San José (Costa Rica), New York, and Berlin. His compositions were among those in the *Esso Collection of Central American Art* exhibited at the New York World's Fair in 1964.

This is the first presentation of Izquierdo's work in the Washington area.

CATALOGUE

Paintings

1. *Muchacha de ayer (Girl of Yesterday)*
2. *Personajes de Cervantes (Characters from Cervantes)*
3. *Declamadora (Orator)*[1]
4. *Vestigios (Vestiges)*
5. *Paisaje (Landscape)*
6. *Huellas de un picnic (Evidences of a Picnic)*
7. *Nacimiento de un rey (Birth of a King)*
8. *Veraneo (Summer Tourist)*
9. *Flores tristes (Sad Flowers)*
10. *Bordadora de ilusiones (Maker of Illusions)*
11. *Cuna para niño muerto (Cradle for a Dead Child)*
12. *Milagro gris (Gray Miracle) No. 1*
13. *Milagro gris (Gray Miracle) No. 2*
14. *Milagro gris (Gray Miracle) No. 3*
15. *Sol (Sun)*
16. *Figura yacente (Figure in Repose)*
17. *Mesa de bohemio (Bohemian's Table)*
18. *Cuento (Story)*
19. *Conversación (Conversation)*
20. *La familia (The Family)*

[1] Literal translation of this title is "Reciter of Poetry." --*Ed.*

Drawings

1. *Llanto (Crying)*
2. *Miedo (Fear)*
3. *Huella (Prints)*
4. *Nostalgia*
5. *Maleficio (Spell)*
6. *Profanación (Desecration)*
7. *Bosque (Forest)*
8. *Guerrillero (Guerrilla Soldier)*
9. *Duelo (Duel)*
10. *Quijote (Quixote)*
11. *Lamento (Lament)*
12. *Penumbra (Dusk)*
13. *Pájaro herido (Wounded Bird)*
14. *Personaje (Character)*
15. *Dolor (Pain)*

March 23 - April 10, 1966

ALBERTO COLLIE OF VENEZUELA: SCULPTURES [1]

Beginning in the nineteenth century, with the impressionists' studies of light and their attempts to capture its varying effects on canvas, an interplay between art and science has increasingly marked modern Western culture. It is an unending adventure in discovery, in which a development in one realm provides a worker in the other with an insight which, pursued, may lead to achievements of unsuspected significance. Mechanical structures and scientific apparatus may suggest forms that had hitherto escaped the eye of artists; in turn, the artists' plastic conceptions, seemingly without utilitarian application, may prove of practical value in engineering and industrial design. Notable expression was given to this theme by St. John Perse, who formulated in his Nobel Prize acceptance speech in 1960 the thesis that poetry is a forerunner of modern science.

Now there has come from Latin America a man who is perhaps the first to base experimentation in sculpture on application of the laws of physics. Alberto Collie has given a new facet to three-dimensional form by suspending his compositions in space, without visible support. This magic effect of levitation, of apparent defiance of the law of gravity, is achieved by the use of magnetic force. The forms of Collie's creation generally embody the curve in one or more of its aspects. Thus, viewed from a distance the bases of Collie's constructions may appear rectangular, but a closer approach reveals them to be cylinders. In their elementary purity, the compositions are reminiscent of the simplicity of Brancusi, who may be considered the major influence on the young Latin American. As for materials, Collie uses such metals as aluminum, magnesium, beryllium, and titanium. He sends his designs to a Boston factory which makes radar and other scientific apparatus for submarines; there, under the supervision of electronic technicians, the parts of the composition are constructed and tested before shipment to the artist for assembly in his studio.

Collie was born in 1939 in Caracas, Venezuela. On completing secondary school he began private study in art and continued his formal education at Boston University, working toward a degree in landscape architecture. Currently, he is enrolled in the Graduate School of Design at Harvard University and manifests an increasing interest in science and technology.

Examples of Collie's work are to be found in the Dallas Museum of Art, the Chrysler Museum (Provincetown, Massachusetts), and in many important private collections in the United States. Collie has participated in group shows both in Venezuela and in the United States (Albany, Berkeley, Boston, New York, San Francisco). In 1964 he was invited to participate in the Pittsburgh International, organized by the Carnegie Institute. One-man shows

[1] The list of works exhibited is unavailable. --*Ed.*

of his compositions have been given at the Atelier Chapman Kelly Gallery in Dallas, 1963; at the Comara Gallery in Los Angeles, 1964; and at the Nordness Gallery in New York, 1964. In an extensive review of the last-mentioned exhibit, the *New York Times* commented: "The sight of a major law broken before one's eyes opens the door to possibilities that capsize one's view of the world." *Time* magazine celebrated the achievement, saying: "Collie's spatial-absolutes represent a marriage of technology and art, but science is clearly the stronger partner," and it qualified the effect of the sculptures as "playful and magical."

A limited number of Collie's works have been given a private showing at the residence of the Ambassador of Venezuela; this, however, is the first public presentation of his sculptures in the Washington area.

We want to express our appreciation to the Nordness Gallery for their cooperation in presenting the show. --*J.G-S*.

March 23 - April 10, 1966

CARLOS EDUARDO PUCHE OF VENEZUELA: IMAGE-OBJECTS [1]

One of the developments to which complete freedom of artistic expression has led since cubism and dadaism is the use of odds and ends to create an object which, though neither a picture nor a sculpture in the traditional sense, partakes of elements of both and possesses intrinsic plastic value--that aura or inner significance which is characteristic of the true work of art. Similarly adventurous paths have been taken in photography: the mechanical possibilities of the lens have been explored as have chemical reactions on paper and negatives. Painters and sculptors have had resort to the photograph as a point of departure for their creative efforts, using the camera to record nature, to eliminate, to compose.

Carlos Puche introduces a new note, seeking to combine the arts of collage and photography in a marriage of reality and the image of reality--the object in itself and its likeness as captured by the lens. This double presentation leaves the viewer faced with an enigma: which is the more important element in the composition, the object or its photographic echo? A further dimension is added by the shadow which the former projects on the latter--a shadow which may also impart the element of movement if there is variation in the source of light. Object, image, shadow, and movement: these are the four essential elements of Puche's work.

Carlos Eduardo Puche, the originator of this new form of plastic expression, is director of the photographic laboratory of the Department of Metallurgical Engineering at the Central University of Venezuela in Caracas, and is currently specializing in microphotography of opaque objects. He was born in Caracas in 1923 and studied physics and mathematical sciences at the institution of whose faculty he is now a member. His experimentation, the result of which we are now exhibiting, began in 1961. He has participated in group shows in Caracas and early this year had a one-man exhibit at that city's Museum of Fine Arts. This is the first presentation of Puche's work in Washington. --*J.G-S*.

April 11 - May 9, 1966

NEW ARCHITECTURE IN MEXICO

Mexico has been a trailblazer in many aspects of the advance of modern art in the Americas, a good example being provided by the activity of the mural painters of the Mexican Revolution. While that activity bore a significant relationship to architecture, the latter art did not undergo the rapid evolution which took place in painting. Building is of necessity a more deliberate operation, and architectural design is perhaps the most complex of the arts in that it may incorporate graphic and sculptural elements and that it must give due consideration to matters of function.

[1] The artist calls his compositions *objeto-grafías* (object-graphs). The list of works exhibited is unavailable. --*Ed*.

If architecture's advance is then relatively slow, in the case of Mexico it has been steady and sure, and today Mexican work in building design evidences a maturity which assigns the country a place of first rank in the Americas. Its professionals have had to consider not only the purely creative aspects of design, but also difficulties deriving from the land, of which seismic problems are by no means the least. At times, as in the case of the Pedregal de San Angel, they have been able to take advantage of accidental features of the terrain to achieve strikingly original effects. The intrinsic nobility and grandeur that characterize their work, however, are to some degree a heritage from the pre-Hispanic past.

The present exhibition of photographs constitutes a digest of the recent activity of thirty-one architects of prime significance. Presented in commemoration of Pan American Week, the exhibit was organized by the National Institute of Fine Arts of Mexico, working through its Department of Architecture and the Mexican Architects Association. The Pan American Union takes this occasion to express its special appreciation to José Luis Martínez, Director General of the Institute, and to Ruth Rivera, Head of the Department of Architecture, for the important role they played in selecting and assembling the material here on view. *--J.G-S.*

Modern architecture in Mexico was born as a reflection of a social battle that brought to the fore a new way of understanding man and, consequently, his necessities and his shelter.

The revalorization of the Mexican man was projected in all social orders. Thus in the arts, architecture joined with the plastic movement to become a part of mural painting. By the force of its impulse, this painting went on to cover the walls of existing buildings: colonial churches; public, administrative, and social service buildings; auditoriums, etc. Finally a stage begins of rational construction of proper sites for government programs, derived from research and analysis of purely architectural problems that will definitively include those elements used to project an aesthetic message. Thus the new schools, hospitals, public meeting centers, housing units, athletic and learning centers will always be, in our country, a part of the development of sculpture and painting, following the traditions and aesthetic constants manifested in the pre-Hispanic, colonial, and neoclassical architecture.

We live in the peace of our Revolution and there our Cultural Renaissance has been made possible. In this fundamentally nationalistic stage, architecture shares the universal technological points of view: the techniques, materials, concepts, building methods, programming, and planification are common to all countries. Nevertheless, in its aesthetic accents, it will at times lean towards realistic or figurative currents and, at others, towards cubism or abstractionism.

It can be ascertained that within these four aesthetic currents, the production of our architects come to possess personality, and their imagination creates original results.

This exhibition of the Mexican Architects Association has been organized by the National Institute of Fine Arts, through its Department of Architecture, and the Mexican Architects Association. It will allow the visitors to share ideas with the creators about their interpretation of man's multiple problems in Mexico's environment. From this dialogue they will deduce how, in architecture, man is important organically speaking. Our architects have not only provided him with useful spaces and healthy, comfortable areas but, fundamentally, he has been conceived as the heir of an aesthetic tradition for whom texture, color, light, urban landscape, and the possibility of his integration with nature serve as spiritual nourishment.[1] *--Ruth Rivera*, Architect.

LIST OF ARCHITECTS AND THEIR WORKS

Photographs

Salvador de Alba
 1. *Escuela Normal Regional en Ciudad Guzmán* (Regional Normal School in Ciudad Guzmán), Jalisco

[1] The text by Ruth Rivera appeared in Spanish in the original catalogue. It was translated by Rodrigo Alba. *--Ed.*

Augusto H. Alvarez
2. *Universidad Iberoamericana* (Spanish-American University)

Joaquín Alvarez Ordóñez
3. *Centro Cívico de Campeche* (Civic Center of Campeche)

Francisco Artigas
4. *Casa habitación* (Apartment Building)

Raúl Cacho
5. *Ciudad Industrial en Cuernavaca* (Industrial City in Cuernavaca), Morelos

Félix Candela
6. *Iglesia de la Medalla Milagrosa* (Church of the Miraculous Virgin)

Eric Coufal
7. *Banco de Bajío* (Bajío Bank), Guadalajara, Jalisco

Enrique Carral
8. *Centro Comercial Manacar* (Manacar Shopping Center)

Alejandro Caso
9. *Instituto Nacional Indigenista* (National Institute for Indian Studies)

Enrique Castañeda Tamborrel
10. *Casa habitación* (Apartment Building)

Agustín Hernández
11. *Edificio Tokio* (Tokyo Building)

Enrique Landa
12. *Unidad de Servicios Médicos del I.S.S.S.T.E* (Medical Services Unit of the I.S.S.S.T.E.)

Ricardo Legorreta
13. *Fábricas Automex* (Automex Factories)

René Martínez Ostos
14. *Edificio de Oficinas del I.S.S.S.T.E.* (Office Building of the I.S.S.S.T.E.)

Héctor Mestre and Manuel de la Colina
15. *Edificios de Seguros La Comercial* (La Comercial Insurance Building)

Enrique de la Mora y Palomar
16. *Iglesia El Altillo* (El Altillo Church)

Mario Pani
17. *Unidad Nonoalco Tlatelolco* (Nonoalco Tlatelolco Unit)

Enrique del Moral
18. *Oficinas del Departamento del Distrito Federal* (Offices of the Federal District Department)

Manuel Parra
19. *Casa habitación* (Apartment Building)

Reynaldo Pérez Rayón
20. *Unidad Profesional I.P.N. Zacatenco* (Professional Unit, I.P.N., Zacatenco)

Alejandro Prieto
21. *Unidad vacacional para los trabajadores del I.M.S.S.* (Workers' Vacation Unit of the I.M.S.S.)

Pedro Ramírez Vázquez and Rafael Mijares
22. *Museo Nacional de Antropología* (National Museum of Anthropology)

Guillermo Rossel de la Lama and Manuel La Rosa
23. *Puerta Fronteriza de Tijuana* (Frontier Door in Tijuana)

Joaquín Sánchez Hidalgo
24. *Hospital del I.M.S.S.*

José Villagrán García and Juan Sordo Madaleno
25. *Hotel María Isabel*

Enrique Yáñez de la Fuente
26. *Centro Méduci de la Ciudad de México* (Medical Center of Mexico City)

Alejandro Zohn
27. *Unidad Deportiva en Guadalajara, Jalisco* (Sports Unit in Guadalajara, Jalisco)

May 10 - 23, 1966

ROSINA BECKER DO VALLE OF BRAZIL

Rosina Becker do Valle expresses an attitude that is unsophisticated and angelical; her world is that of the naive painter--a world that perhaps belongs to a privileged few who have been able to preserve the untouched humor and eternal laughter of childhood. Her work portrays with grace and spontaneity a true reflection of Brazil in its popular aspects: the gaiety of the Carioca slums, the cockfights, the folklore of the dances and the rhythmic vibrations, the richness of the forest and its inhabitants--Paradise before the serpent brought the apple. She could be placed beside other outstanding naive artists of the Americas, such as Asilia Guillén of Nicaragua, Noé León of Colombia, Antonio Velásquez of Honduras, and Préfète Duffaut of Haiti.

The artist has said:

> I paint whenever I have the desire and the *gusto*. I wanted to paint when I was a child, but a teacher refused to instruct me. I did not learn to paint; I merely paint what I feel. To be able to sense the poetry that exists in the simple things constitutes a satisfaction for me, and to be able to put that on canvas is complete happiness.

This exhibition at the Pan American Union is the first presented by Rosina Becker do Valle outside Brazil.

EXHIBITION LIST [1]

Oils

1. *Futebol* (Soccer), 1961, 102 x 122 cm.
2. *Amalá na Macaia*, 1966, 130 x 97 cm.
3. *Briga de galo* (Cock Fight), 1966, 130 x 97 cm.
4. *Parque de diversões* (Amusement Park), 1966, 73 x 92 cm.
5. *Capoeira* (Wood Dweller), 1966, 73 x 92 cm.
6. *Baianas de candomblé*, 1966, 73 x 92 cm.

[1] Not included in the original catalogue. --*Ed.*

7. *Veados na floresta* (Deer in the Wood), 1966, 60 x 116 cm.
8. *Presente a Janaína* (A Present for Janaína), 1966, 55 x 114 cm.
9. *Homenagem a Iemanjá* (Homage to Iemanjá), 1966, 55 x 114 cm.
10. *Floresta* (Woods), 1966, 73 x 92 cm.
11. *Bumba meu boi* (Brazilian Popular Dance), 1966, 92 x 73 cm.
12. *Afoxé*, 1966, 81 x 65 cm.
13. *Malhação de Judas* (The Evil of Judas), 1966, 81 x 65 cm.
14. *Circo* (Circus), 1966, 60 x 73 cm.
15. *Festa da Penha* (Party at the Penha), 1966, 60 x 73 cm.
16. *Floresta* (Woods), 1966, 54 x 65 cm.
17. *Homenagem a Iemanjá* (Homage to Iemanjá), 1965, 54 x 65 cm.
18. *Omulu*, 1966, 73 x 50 cm.
19. *Pastorinhas* (Little Shepherds), 1966, 73 x 54 cm.
20. *Boi mamão*, 1966, 61 x 50 cm.
21. *Briga de galo* (Cock Fight), 1966, 50 x 61 cm.
22. *Jardim zoológico* (Zoo), 1966, 46 x 61 cm.
23. *Veado* (Deer), 1966, 61 x 38 cm.
24. *Nossa Senhora do Rosário* (Our Lady of the Rosary), 1966, 55 x 46 cm.
25. *Caboclinhos* (Mestizo Boys), 1966, 55 x 46 cm.
26. *Folia de Reis*, 1966, 55 x 46 cm.
27. *Santo* (Saint), 1966, 55 x 33 cm.
28. *Praia* (Beach), 1965, 46 x 55 cm.
29. *Morro* (Hill), 1966, 52 x 63 cm.
30. *Figura de folclore* (Folklore Figure), 1966, 75 x 42 cm.
31. *Iemanjá*, 1966, 55 x 46 cm.

May 23 - June 12, 1966

ALDO OF ARGENTINA [1]

Unlike the case of the performing arts, or that of music or even literature viewed as composition, the history of the plastic arts is relatively void of instances of precocious genius. In all parts of the world children tend to express themselves after the same fashion, with a spontaneity and boldness of color which offer a certain charm, but always with results that are instantly recognizable as "children's art." There have, however, been cases in Latin America of children who have taken up art with an approach approximating that of adults. The well-known Mexican draftsman José Luis Cuevas when only ten years old produced traumatic drawings that are surprisingly mature in their characteristics, and the work of his later teens could be taken for that of a man in his forties. Currently there is the case of the young Uruguayan Carlitos Sgarbi, who at the age of twelve is exhibiting in Belgium and France.

The Pan American Union is presenting the work of Aldo Franceschini, by now a veteran painter and designer, whose professional career dates back to 1953, when, aged eight, he won First Prize in a book illustration contest sponsored by the Kraft publishing concern of Buenos Aires. Born in Mendoza, Argentina, in 1945, the son of a competent painter and a poet, Aldo was constantly surrounded by professionals and had little contact with those of his own age. He traveled with his parents throughout South America and in 1957 he moved with them to Europe. There he studied in Spain, Italy, and France, and in the last mentioned country he presently resides.

When less than twelve years old, Aldo took his watercolors and gouaches to the sidewalk cafés of the Latin Quarter of Paris, near Saint-Germain-des-Prés, and there he sold them to admirers astonished by the maturity of his productions. In 1959 he held his first one-man show in the French capital, and the same year he won First Prize for Painting in a contest sponsored by the Renault auto works. In 1960 he returned to Argentina for an individual exhibition at the Buenos Aires Museum of Modern Art. Since 1961 he has exhibited in Brazil, France,

[1] The list of works exhibited is unavailable. --*Ed.*

and Germany. His compositions have been included in numerous collections in the Americas, Europe, and Japan. The artist is currently on his first visit to the United States, and this exhibit at the Pan American Union is the first formal presentation of his work in this country. *--J.G-S.*

May 24 - June 12, 1966

BERTHA RAPPAPORT OF ARGENTINA

Bertha Rappaport provides a conspicuous example of the experimentalist in the plastic arts, by virtue of her work in a variety of media and modes of expression.

Born in Buenos Aires in 1919, she has long been active on the artistic scene in Argentina, holding individual exhibits, participating in group shows, and winning a number of distinctions, including Honorable Mention at the Braque Award exhibition. Two years ago she took part in the exhibition *Buenos Aires '64*, presented at the Pepsi-Cola Salon in New York. Her most recent exhibits were held at the Lirolay Gallery and the Argentine Center for Cultural Freedom, both in Buenos Aires. The works now on view are those which figured in those presentations. Other examples are to be found in the private collection of the Buenos Aires Museum of Modern Art.

In the past few months, Miss Rappaport has been pursuing her career in Israel and Paris. This is her first presentation at the Pan American Union.

CATALOGUE

Oils

1. *Espacio sideral (Sidereal Space)*, oil on bristol paper, 135 x 135 cm.
2. *Espacio sideral (Sidereal Space) No. 2*, oil on bristol paper, 135 x 135 cm.
3. *Carnaval en Rio (Carnival in Rio) No. 1*, oil on bristol paper and aluminum, 102 x 120 cm.
4. *Carnaval en Rio (Carnival in Rio), No. 2*, oil on bristol paper and aluminum, 119 x 87 cm.
5. *Melodía (Melody)*, oil on bristol paper and aluminum, 125 x 90 cm.
6. *Melodía en verde (Melody in Green)*, oil on bristol paper and aluminum, 100 x 75 cm.
7. *Torbellino (Whirlwind)*, oil on bristol paper and aluminum, 125 x 100 cm.
8. *Rombos (Rhomboid)*, oil on bristol paper and aluminum, 100 x 134 cm.
9. *Rombos espaciales (Spatial Rhomboid)*, oil on bristol paper and aluminum, 135 x 85 cm.
10. *Rombo negro (Black Rhomboid)*, oil on bristol paper and aluminum, 100 x 65 cm.
11. *Infinito (Infinite)*, oil on bristol paper and aluminum, 150 x 80 cm.
12. *Ves (You See)*, oil on bristol paper, 125 x 90 cm.

June 13 - 28, 1966

OLGA ALBIZU OF PUERTO RICO

The work of Puerto Rican Olga Albizu is largely associated in the public mind with *bossa nova*, the Brazilian musical style which has attained such wide popularity in recent years both in the United States and elsewhere. Beginning with the first successes of João Gilberto and Stan Getz, oils of her authorship have decorated the jackets of the albums they have recorded for Verve and RCA Victor. *Green No. 9*, included in the current exhibition, was used for the cover of the most recent Gilberto-Getz release, for example. The association is not accidental: the flat splashes of pure color, rhythmically distributed across the surfaces, while in no sense a literal translation of musical ideas, are nonetheless suggestive of syncopation.

Born in Ponce, 1924, Olga Albizu attended the University of Puerto Rico, obtaining her B.A. in 1945. During her last year there, she studied with the well-known painter Esteban Vicente. In 1948 a graduate scholarship from the University enabled her to continue her training in New York, at the private studio of Hans Hoffman. Later

she enrolled in the Art Students League, where she worked with Morris Kantor, Holty, and Vaclav Vytalicil. In 1951 and 1952 she studied in the Académie de la Grande Chaumière in Paris and the Academy of Fine Arts in Florence.

Last year Miss Albizu won the Second Prize for Painting at the *Esso Salon of Young Artists* in Puerto Rico, and her work was featured at the RCA Pavilion in the New York World's Fair. She has participated in numerous group shows in both Puerto Rico and in the continental United States. Her first individual exhibit took place in New York in 1956; her first in her native island was held in 1958. Examples of her work are to be found in many collections, public and private, in the continental United States, Puerto Rico, and Israel. *--J.G-S.*

CATALOGUE

Paintings

1. *Red No. 4*
2. *Ocher No. 12*
3. *Yellow No. 11*
4. *Blue No. 1*
5. *Red No. 7*
6. *Green No. 9*
7. *Yellow No. 3*
8. *Orange No. 8*
9. *Green No. 10*
10. *Blue No. 6*
11. *Gray No. 2*
12. *White No. 5*

June 13 - 28, 1966

RAFAEL FERRER OF PUERTO RICO

Several months ago, a group of sculptures by Rafael Ferrer was exhibited with great success at the Institute of Puerto Rican Culture in San Juan. The presentation constituted as it were a preview, for the show had been organized with a view to this, Ferrer's debut at the Pan American Union.

The works now on display are primarily adaptations of machinery to human form: typewriters and adding machines have been endowed with poetic wit and charm. They represent, however, a criticism of the mechanized attitudes assumed by human beings under the impact of an increasingly mechanical civilization.

Born in Santurce, Puerto Rico, in 1933, Rafael Ferrer is a member of a family of artists, the best known of whom is his older brother José Ferrer, one of the most distinguished figures of the stage and screen today. From an early age Rafael showed an inclination to self-expression both through the visual arts and through music, evidencing sufficient talent in the latter field to have been accepted into a jazz orchestra in Puerto Rico. Priority, however, has been assigned to the former. In 1952 Ferrer abandoned his studies at Syracuse University in order to devote full time to art. Returning to his native island, he worked with the painter E.F. Granell, a member of the faculty of the local university. It was Granell who introduced Ferrer to the leader of the main trend in surrealism, the French poet André Breton. Ferrer went to Europe for a season, then spent five years in New York, and since has resided in Puerto Rico, alternating activity as a musician with his work as a draftsman, painter, and sculptor.

Rafael Ferrer first presented his compositions to the public at the University of Puerto Rico in 1958. He has participated in numerous group shows in the island and in the continental United States. Last year he received the First Prize for Sculpture at the *Esso Salon of Young Artists* in Puerto Rico. His first one-man sculpture show took place in 1965 at La Casa del Arte in San Juan, and he exhibited at the same gallery again this year, after the presentation at the Institute of Puerto Rico Culture. Examples of his work are to be found in numerous collections, public and private, among others those of the Institute of Culture, the University of Puerto Rico, the

Ponce Museum, and the Esso Standard Oil Company.

We wish to express appreciation to the Institute of Puerto Rican Culture in San Juan for its cooperation in presenting this exhibition. --*J.G-S.*

CATALOGUE

Sculpture

1. *Alias*
2. *Mykonos*
3. *Superman*
4. *Sourire* (Smile)
5. *Voyeur*
6. *Not for War*
7. *A New Sign I*
8. *A New Sign II*
9. *More of the Same Shame*
10. *The Thinker after Rodin*
11. *Mr. Cool I*
12. *Mr. Cool II*
13. *The New Think*
14. *Are All Young Executives Doomed?*
15. *Para Alberto Giacometti* (For Albert Giacometti) I
16. *Para Alberto Giacometti* (For Albert Giacometti) II
17. *You BM*
18. *She BM*
19. *They BM*
20. *Three Times a Day*
21. *Untitled*

June 29 - July 18, 1966

GITI NEUMAN OF ECUADOR

Giti Neuman is representative of contemporary figurative painters in Ecuador. Incisive and solid delineation of forms, dramatic distortion, color, and thick impasto make her work distinctively Ecuadorian.

Miss Neuman was born in Prague in 1941 and, as a child, moved to Ecuador where she acquired Ecuadorian nationality. She studied at the Academy of the Association of Plastic Arts in Quito under the direction of Leonardo Tejada, Lloyd Wulf, Jaime Valencia, and Alberto Coloma. Since 1961 she has held nine solo shows throughout Ecuador and in West Germany. She has participated in numerous group exhibitions in Ecuador, England, and Germany and in 1963 was selected to represent her country in the Paris Biennial. Miss Neuman also has served as coordinator for exhibitions of Ecuadorian art in Germany and England.

This is the first presentation of her work at the Pan American Union.

CATALOGUE

Paintings

1. *Composición (Composition) I*
2. *Composición (Composition) II*
3. *Gótico (Gothic) I*
4. *Gótico (Gothic) II*
5. *Gótico (Gothic) III*

6. *White Trees*
7. *Reflections*
8. *Glasses*
9. *El árbol (Tree)*
10. *Reminiscencias (Reminiscence)*
11. *Indian*
12. *Chola* (Mestizo Woman)
13. *Cabezas (Heads)*
14. *Fire Ball*
15. *I Love America*
16. *Silhouette of a Laughing City*
17. *Cristo (Christ)*
18. *Evening*
19. *Rocas (Rocks)*
20. *Roots*

July 20 - August 22, 1966

CARLOS COLOMBINO OF PARAGUAY

A place apart in contemporary artistic activity must be assigned to the Paraguayan Carlos Colombino, who works in a medium of his own invention, termed by him *xilo-painting*.

The name derives from the fact that the base of Colombino's compositions is wood. The artist initiates his labor as if aiming to produce a large woodcut: he takes a thick plank of plywood and works it with the usual tools of the engraver. Instead of inking the surface and running off prints, however, he tints or dyes it with a variety of colors, which stain the rough cuts made by the burin and penetrate well into the fiber. Taking full advantage of accidents in the texture, Colombino creates intricate patterns from which mysterious ghost-like forms loom forth in effects of striking and highly appealing originality.

The artist was born in Concepción, Paraguay, in 1937. Self-taught, he held his first one-man show in Asunción in 1956, later participating in the Biennial of São Paulo and of Paris, and in the South American exhibit presented at the Dallas Museum of Fine Arts in 1959. In 1965 the Ismos Gallery in Buenos Aires featured an individual presentation of his work, and the compositions currently on view stem from two one-man shows Colombino gave in Asunción earlier this year.

Colombino has studied architecture, has illustrated a number of books, and has undertaken stage design on several occasions. His new technique, which he began to employ in 1963, has led him to significant achievements as a graphic artist. His contribution to the exhibit *Art of Spain and America*, held in Madrid in 1963, won him a scholarship from the Spanish government; in 1965 he obtained First Prize in the Paraguayan section of the *Esso Salon of Young Artists*; and recently he was the recipient of a special award for a mural in Asunción.

Presently, Carlos Colombino is traveling in this country at the invitation of the Department of State. This is his first exhibition in the United States.

CATALOGUE

Xilo-Painting

1. *Ita (Stone)*, 1965, 160 x 160 cm.
2. *Cuerpo extraño* (Strange Body), 1965, 160 x 110 cm.
3. *Esbozo para un hombre aniquilado* (Sketch for an Annihilated Man), 1965, 160 x 160 cm.
4. *Icaro, o la imagen de mi pueblo (Icarus, or the Image of My People)*, 1966, 160 x 160 cm.
5. *Kuñakue* (Ex-Woman), 1966, 160 x 60 cm.
6. *Karaikue* (Ex-Man), 1966, 160 x 60 cm.
7. *Te'ongue* (Corpse), 1966, 210 x 120 cm.

8. *Muerto* (Dead), 1966, 160 x 140 cm.
9. *Grupo* (Group), 1966, 160 x 160 cm.
10. *Manos* (Hands), 1966, 160 x 160 cm.
11. *Crecimiento* (Growth), 1966, 160 x 105 cm.
12. *Máscaras* (Masks), 1966, 160 x 83 cm.
13. *Espantapájaros* (Scarecrows), 1966
14. *Paraguay I*, 1966, 160 x 140 cm.
15. *Paraguay II: Mariscal del Aire* (Paraguay II: Marshal of the Air), 1966, 160 x 120 cm.
16. *Mitakuña* (Girl), 1966, 160 x 60 cm.
17. *Olga*, 1966, 140 x 100 cm.
18. *Máscara* (Mask), 1966
19. *La presa* (The Prisoner), 1966, 160 x 120 cm.

Ten woodcuts by Colombino are also exhibited in the Print Gallery[1]

August 23 - September 13, 1966

MEXICAN PRINTS: UNIVERSITY OF GUANAJUATO

Engraving, in its various modes, has been practiced in the Western Hemisphere since earliest colonial times. The first flowering of the graphic arts took place in Mexico and the tradition, once initiated, has been carried on to our own day, when the country may be said to have developed a style peculiarly its own. Although artistic activity has always centered on the capital, recently many lesser cities have become nuclei of creative endeavor, one of them being the picturesque old silver-mining town of Guanajuato.

The Art Workshop of the University of Guanajuato, under the direction of Jesús Gallardo, has evolved into an important focus of print production: works originating in the school are gaining an ever-wider reputation, both in Mexico and abroad. The present exhibition, composed by Professor Gallardo and six of his students, was shown earlier this year at the Contemporary Arts Gallery of New York University and is clear proof of the high professional level of work that is being accomplished.

We wish to acknowledge the cooperation of the Mexican National Tourist Council in New York which is responsible for circulating this exhibition. *--J.G-S.*

CATALOGUE

Prints

Thelma Cortés
1. *Almost Out of Heaven*
2. *Kid and Cat*
3. *Pedrito*
4. *Job*

Esthela Gutiérrez
5. *Deep Waters*
6. *Narrow Street*

Roberto González
7. *Warriors*
8. *Guanajuato*

[1] The titles of these woodcuts are unavailable. *--Ed.*

Francisco Patlán
 9. *The Pears*
10. *Girl*

Rubén Resendiz
11. *Miner*

Lourdes Luna
12. *Bird Seller*

Jesús Gallardo
13. *Man's Triptych*
14. *Solitude*
15. *Dog*
16. *Reminiscence of Guanajuato*
17. *Old Walls*
18. *Resignation*
19. *Night Landscape*
20. *Wall*

BIOGRAPHICAL NOTES [1]

All the artists exhibiting here are printmakers born in Mexico. At present, they are studying at the Art Workshop of the University of Guanajuato, under the direction of Jesús Gallardo. They participated in the exhibitions presented by the University in Guanajuato and Mexico City, and in Seattle, Denver, Eugene, and New York City.

GALLARDO, Jesús. Painter, draftsman, printmaker, born in León, Guanajuato, 1931. Studied at the Escuela Nacional de Artes Plásticas, Universidad Nacional, Mexico City, graduating in 1963. Since 1952 teaches at the University of Guanajuato, where he is at present the director of the Fine Arts Department and professor of drawing at the School of Architecture. Since 1956 has held individual exhibitions in Mexico and the United States. Participated in group shows in Mexico, Colombia, Chile, Ecuador, Peru, Haiti, Czechoslovakia, Bolivia, Uruguay, and the United States.

August 23 - September 13, 1966

HECTOR NAVARRO OF MEXICO

It is a sign of the increasing maturity of Latin American artistic life that in countries in which activity is most intense it is by no means confined to the capital cities, which tend to exercise a monopoly in cultural matters, but is highly developed in provincial centers as well. Thus, despite the dynamic attraction of Mexico City and the opportunities afforded by its many galleries and museums, there are a number of secondary focuses of creative activity in Mexico, each with a group of artists of demonstrable quality who do not present themselves in the capital until they have attained maturity of expression. The two exhibitions currently on view at the Pan American Union--graphics originating in the Art Workshop of the University of Guanajuato and compositions by the Guadalajara painter Héctor Navarro--are good examples of the level of artistic endeavor in the Mexican states.

Navarro was born in Guadalajara in 1937. He received his education, both general and artistic, in that city, and it is there that he has begun to make himself felt as a professional of distinction. Except for a presentation at the Proteo Gallery in the capital in 1961, all Navarro's one-man shows in Mexico to date--now totaling seven--have been held in his birthplace. Examples of his work have, however, figured frequently in group shows, both in Mexico and in the United States. In 1963 and 1965 Navarro received important awards in Guadalajara.

[1] Not included in the original catalogue. --*Ed.*

Although he has studied architecture and is competent in both industrial and stage design, Navarro directs his main effort to painting and drawing, media in which he has gradually developed a personal mode of expression. While his frequent use of gold leaf is reminiscent of the image-making techniques of colonial days, his use of free form and the subtle insinuation of subject matter place him clearly in the panorama of contemporary art.

This is the first individual presentation of Héctor Navarro's compositions in the United States. *--J.G-S.*

CATALOGUE

Acrylics on Canvas

1. *Mensaje de Marte (Message from Mars)*, 1965, 150 x 150 cm.
2. *Astronauta (Astronaut)*, 1966, 120 x 150 cm.
3. *Insecto (Insect)*, 1966, 150 x 150 cm.
4. *Joven ex-soldado (Young Ex-Soldier)*, 1966, 100 x 120 cm.
5. *Pez viejo (Old Fish)*, 1964, 105 x 125 cm.
6. *América antigua (Old America)*, 1965, 105 x 125 cm.
7. *Homenaje a Vesalio (Homage to Vesalius)*, 1964, 150 x 150 cm.
8. *Pez tragón (Gluttonous Fish)*, 1966, 100 x 120 cm.
9. *Draco*, 1966, 100 x 120 cm.
10. *Altar mágico (Magic Altar)*, 1966, 100 x 120 cm.
11. *Personaje (Personage)*, 1966, 80 x 100 cm.
12. *Venus*, 1966, 80 x 100 cm.
13. *Monólogo (Monologue)*, 1966, 80 x 100 cm.
14. *Interferencia (Interference)*, 1965, 80 x 100 cm.
15. *Paisaje (Landscape)*, 1966, 120 x 150 cm.

September 16 - October 2, 1966

MAURICIO AGUILAR OF EL SALVADOR: PAINTINGS

It is a generally accepted view that the great revolutionary in art is the man who is permanently wedded to a single concept--one that dominates his mature production to the point of obsession. In this pursuit of the *idée fixe* or in his dedication to a single procedure he may even come to be termed a visionary.

Such is the case with Mauricio Aguilar, an artist who for many years has devoted himself to a proposition which provides the constant motivation for his creative activity. For Aguilar, light is a force which destroys objects, yet at the same time provides their sole support in space. Subject matter in his fairylike paintings is a mere allusion, a pretext for demonstrating his besetting notion: a glass, a bottle, a fish is but a pure form which, dissolved in light, will give an indication of space and monumental projection. In Aguilar's case, space is treated two-dimensionally; the effect of volume is sought on only rare occasions. Sometimes the surface of a painting is covered with a single hue, as in the case of Aguilar's renderings of Salvadorian volcanoes, the outline of which is indicated by a mere incision in the heavy impasto.

Mauricio Aguilar was born in San Salvador in 1919. As a child he was taken to Paris and there, at the age of fifteen, he was admitted to he workshop of Christian Bérard. Later he attended the Académie Julian, located in the same city. For some ten years now he has been living in his native country, occupying a secluded residence on top of a hill on the outskirts of San Salvador, and making periodic trips to New York and Europe. As a rule, he has refused to make public exhibition of his work, though he has participated in a few group shows in Paris and New York and held a one-man exhibit in the latter city in 1949 at the Iolas Gallery. While he works continuously, he usually destroys the product of his intense creative activity.

At my insistence, in December of last year the artist exhibited a number of the paintings which he thought worthy of preservation at the Forma Gallery in San Salvador, this being the first public presentation of his work in his own country. A selection has been made from the works shown on that occasion and constitutes the present exhibit.

Another group of works will be displayed at the Catherine Viviano Gallery in New York later this season. --*J.G-S.*

CATALOGUE

The paintings in this exhibition, all executed in oil on Masonite, are based upon the following themes:

1. Bottles and Glasses
2. Glasses
3. Large Bottle
4. Fish
5. Coffee Grinder
6. Volcano

EXHIBITION LIST [1]

Oils on Masonite

1. *Pescados (Fish)*
2. *Volcán (Volcano) I*
3. *Glasses in Green*
4. *Large Blue Bottle*
5. *Bottle and Glasses in Blue*
6. *Glasses on White*
7. *Large Bottle in Pale Blue*
8. *Coffee Grinder I*
9. *Bottles and Glasses in White*
10. *Volcano II*
11. *Large Bottle in White*
12. *Fish, Glass, and Lemon*
13. *Large Bottle on Red*
14. *Glasses on Green*
15. *Large Bottle in Green*
16. *Bottles and Glass*
17. *Coffee Grinder II*
18. *Bottles and Glass*

September 16 - October 2, 1966

MANUEL AND RENE PEREIRA OF PERU: SCULPTURES

It is a rare occurrence to find two members of one family engaged in the same line of artistic endeavor and following a similar line of development. Such, however, is the case with the Peruvians Manuel and René Pereira, both of whom have practiced painting from time to time but devote their major efforts to sculpture. So close is their association that they not merely share their workshop, tools, and materials but even occasionally collaborate in the execution of an important piece, as in the instance of their prize-winning design for a monument to the poet César Vallejo. Most of their works, however, are independent, representing individual artistic concepts.

The brothers were born in Cajamarca, Peru--Manuel in 1935, and René in 1937. While Manuel tends to follow the line of geometric abstraction, René occasionally treats the human figure or finds a motif in some other aspect of ambient reality. Both took part in the *Esso Salon of Young Artists* held in Peru in 1964; Manuel's entry won the First Prize for sculpture whereas René's took the First Acquisition Prize. The Pereiras participate only rarely

[1] Not included in the original catalogue. --*Ed.*

in national exhibitions, but their works have figured in group shows in Lima and other Peruvian cities, likewise in Mexico. Manuel presented a one-man show in Cajamarca in 1962; René has held two individual exhibits in Lima and one in Cuzco. This is their first dual presentation in the United States. *--J.G-S.*

CATALOGUE

Sculpture

Manuel Pereira
Serie de las columnas espaciales (Spatial Columns Series)[1]

René Pereira
Serie de los nuevos dólmenes (New Dolmens Series)[1]

October 3 - 19, 1966

ERNESTO BARREDA OF CHILE: PAINTINGS

In the varied panorama of contemporary Chilean art, with its broad spectrum of tendencies and modes of expression, an outstanding figure is that of painter and architect Ernesto Barreda.

Contrary to the prevalent trend in recent years toward abstraction, Barreda's compositions have kept a firm basis in reality. His inspiration has ranged from doors and windows, through the popular arts of southern Chile and religious themes, to walls, furniture, and statues, always with an emphasis on static qualities. Barreda's realism seeks to go beyond outward appearance, to discover the essence of matter. Every detail that suggests a penetration beneath the surface is brought out with care. Wood, for example, appears with its fibers clearly exposed, eaten by termites, or softly weathered by age; walls exhibit the cracks occasioned by settling, the holes worn by nails and hooks. A romantic aura of loneliness and decay exudes from every composition.

Barreda was born in Paris in 1927, but was taken to Chile while still a child. He attended the Catholic University in Santiago, receiving a degree in architecture in 1952. Previous to graduation he had spent a year in his birthplace studying not only his chosen profession but drawing as well, and as early as 1947 he had presented a one-man show of his paintings at the Neira Bookshop in Santiago. In the years since that time, he has held seven additional individual exhibitions of his work in Chile, two in Buenos Aires (at the Van Riel Gallery in 1958 and the Bonino Gallery in 1965), and two in New York (at the Alexander Iolas Gallery in 1960 and 1962). He has taken part in numerous group shows in Latin America, the United States, France, and Spain. Public collections possessing examples of his work are those of the Oakland Museum of California; the Museum of Contemporary Art of Santiago in Chile; and the Chase Manhattan Bank of New York. The current exhibit at the Pan American Union is the first presentation of the art of Barreda in the Washington area. *--J.G-S.*

CATALOGUE

Paintings

1. *Four Chairs*
2. *Mannequins*
3. *Muro (Wall) I*
4. *Muro (Wall) II*
5. *Dark Patio*
6. *Sol y sombra (Sun and Shade)*
7. *And Now What Do We Do?*
8. *La Pampa*

[1] The titles of the works exhibited are unavailable. *--Ed.*

9. *Domingo (Sunday)*
10. *Jar*
11. *Whites*
12. *Postigo* (Shutter)
13. *Muro (Wall) IV*
14. *Muro (Wall) V*
15. *Muro (Wall) VI*

October 3 - 19, 1966

MARIA FREIRE AND JOSE PEDRO COSTIGLIOLO OF URUGUAY

Two important artists from Uruguay, María Freire and José Pedro Costigliolo, are presenting a series of gouaches in the Graphic Arts Gallery of the Pan American Union. Both artists tend towards abstraction but base their work on solid, geometrical forms which lend a certain decorative quality.

María Freire was born in Montevideo in 1919, and studied at the Fine Arts Circle and the Art School of the University of Workers in that city. José Pedro Costigliolo, who was born in 1902, also attended the Fine Arts Circle. Although the two artists occasionally exhibit individually, they began showing their works simultaneously in 1956. In Latin America they have held exhibitions in Montevideo, São Paulo, and Rio de Janeiro; in Europe they have exhibited in Madrid and Brussels. Both have participated in numerous group shows throughout Latin America and this year took part in the Venice Biennial. Among public collections, the artists are represented in the National Museum of Fine Arts and the Municipal Museum of Montevideo, the Museum of Modern Art of São Paulo, the Museum of Modern Art of Rio de Janeiro, and the Museum of Contemporary Art of Madrid. This is the first presentation of their work in the United States.

CATALOGUE

María Freire
1-10. Gouaches[1]

José Pedro Costigliolo
1-10. Gouaches[1]

October 25 - November 16, 1966

VENEZUELAN PAINTING TODAY

Under the auspices of the Neumann Foundation of Caracas, this collection of contemporary art of Venezuela is being presented for the first time in the Washington area. The collection is composed of a cross-section of works, comprehending the most representative tendencies in the realms of abstract and figurative painting.

Since its inception in Venezuela in 1945, modern art in its most radical forms has had the rare advantage of enthusiastic public response. The artists have exhibited widely in their native country, the United States, and Europe, and their works are to be found in numerous important public and private collections of art. Most of the artists have studied independently or in art workshops in Paris, and some continue to live in the French capital.

Prior to its arrival in the United States, the collection had an extensive tour of galleries and museums in Germany. Recently, it was displayed at the Brooks Memorial Art Gallery in Memphis, Tennessee. Because of space limitations in the gallery of the Pan American Union, several works of each of the artists represented in

[1] The titles of the works exhibited are unavailable. --*Ed*.

the collection have been omitted.

CATALOGUE

Jacobo Borges (Caracas, 1931-)
 1. *Shameless Subject*, 100 x 80 cm.
 2. *Alone Forever*, 100 x 80 cm.
 3. *All Has Ended*, 100 x 80 cm.
 4. *High Financing*, 300 x 150 cm.

Carlos Cruz-Diez (Caracas, 1923-)
 5. *Physichromie 133*, 25 x 126 cm.
 6. *Physichromie 137*, 84 x 107 cm.
 7. *Physichromie 139*, 85 x 61 cm.
 8. *Physichromie 140*, 85 x 62 cm.
 9. *Physichromie 142*, 61 x 71 cm.

Elsa Gramcko (Puerto Cabello, Venezuela, 1925-)
10. . . . *He Ordered the Darkness and the Darkness Came*, 75 x 55 cm.
11. . . . *Small Space of Time*, 75 x 50 cm.
12. *Sketch for a Monument*, 90 x 63 cm.
13. . . . *and the Man Remembered All That He Had Forgotten*, 85 x 55 cm.
14. *Remembrance*, 75 x 55 cm.

Luis Guevara Moreno (Valencia, Venezuela, 1926-)
15. *Project for a Monument*, 146 x 80 cm.
16. *Seascape*, 116 x 81 cm.
17. *Group*, 146 x 115 cm.
18. *The Rider and the Morning*, 120 x 100 cm.
19. *Portrait*, 131 x 89 cm.

Francisco Hung (Canton, China, 1937-)
20. *Painting No. 1*, 146 x 97 cm.
21. *Painting No. 2*, 146 x 97 cm.
22. *Painting No. 3*, 146 x 97 cm.
23. *Painting No. 4*, 146 x 97 cm.
24. *Painting No. 5*, 146 x 228 cm.

Humberto Jaimes (San Cristóbal, Venezuela, 1930-)
25. *Paper Generalstaff*, 50 x 35 cm.
26. *The Thirtieth Year*, 116 x 90 cm.
27. *All Is Repeated*, 116 x 100 cm.
28. *In the Year 34*, 146 x 110 cm.

Alejandro Otero (El Manteco, Venezuela, 1921-)
29. *17 rue de Vaugirard*, 48 x 31 cm.
30. *Siège de Lyon (Siege of Lyon)*, 45 x 41 cm.
31. *Figueras-Vendrelle*, 32 x 27 cm.
32. *Chinablau (Blue China, Korean Silk)*, 77 x 44 cm.

Mercedes Pardo (Caracas, Venezuela, 1922-)
33. *Café de Paris (Café of Paris)*, 73 x 90 cm.
34. *Boutique*, 73 x 105 cm.
35. *Ese mirífico mundo (This Magnificent World)*, 90 x 120 cm.
36. *Brujas del norte (Witches of the North)*, 90 x 120 cm.
37. *L'oeil (The Eye)*, 90 x 120 cm.

Héctor Poleo (Caracas, 1918-)
38. *Le ciel aride (The Arid Sky)*, 130 x 130 cm.
39. *La rose (The Rose)*, 92 x 73 cm.
40. *Les amants (The Lovers)*, 100 x 81 cm.
41. *De la terre à la terre (From the Earth to the Earth)*, 116 x 89 cm.
42. *Celle que mon coeur a pris (That Is My Heart)*,[1] 100 x 81 cm.

Luisa Richter (Besigheim, Germany, 1928-)
43. *Poor People*, 140 x 100 cm.
44. *Clan*, 130 x 97 cm.
45. *Kybele*, 160 x 100 cm.
46. *Seat*, 122 x 81 cm.
47. *Figure, Time, Landscape*, 160 x 100 cm.

Jesús Soto (Bolívar, Venezuela, 1923-)
48. *Vibration horizontale-verticale (Horizontal-Vertical Vibration)*, 54 x 56 cm.
49. *Vibration rouge et noire (Red and Black Vibration)*, 108 x 108 cm.
50. *Vibration quasi-immatérielle (Quasi-Immaterial Vibration)*, 160 x 58 cm.
51. *Vibration ligne libre (Free Line Vibration)*, 70 x 89 cm.
52. *Vibración quebrada (Broken Vibration)*, 172 x 102 cm.

Oswaldo Vigas (Valencia, Venezuela, 1926-)
53. *Eye of the Lance*, 130 x 162 cm.
54. *Orinoco*, 130 x 162 cm.
55. *Large Form*, 130 x 162 cm.
56. *Devil*, 100 x 100 cm.
57. *Geminis*, 100 x 100 cm.

BIOGRAPHICAL NOTES [2]

BORGES, Jacobo. Painter, draftsman, set designer, born in Caracas, 1931. Studied at the Escuela de Artes Plásticas y Aplicadas, Caracas, 1949-51, and worked at the Taller Libre de Arte, Caracas, 1951. Traveled to Paris, under a scholarship, 1952, where he remained until 1956. Did numerous set designs for plays by Camus, Tennessee Williams, García Lorca, and others. Held individual exhibitions in Venezuela, including the Museo de Bellas Artes, Caracas, 1956. Since 1951 has participated in national salons, Venezuelan exhibitions abroad, and international group shows, including Salon des Jeunes, Paris, 1952; Biennial of São Paulo, 1957, 1963-65; Biennial of Venice, 1958; Biennial of Córdoba (Argentina), 1964; World's Fair, Brussels, 1958; Guggenheim International, New York, and inaugural exhibition of the Museo of Arte Moderno, Bogotá, 1964. Was awarded Honorable Mention, São Paulo Biennial, 1957, and numerous national prizes, including the National Prize for Drawing and the National Prize for Painting, Official Salons, 1961, 1963.

RICHTER, Luisa. Painter, draftsman, printmaker, born in Germany, 1928. Studied at the Independent Academy and the National Academy of Fine Arts, with Willy Braumeister, Stuttgart. Held individual exhibitions in Caracas, including the Museo de Bellas Artes, 1959, 1964-65, and in Bogotá. Participated in group exhibitions in Germany and France; Venezuelan salons and group shows in Maracaibo, Caracas, New York, Jerusalem, Tel Aviv, Haifa, Lima, Montevideo, Santiago de Chile, and Bogotá; and international exhibitions such as *Suedamerikanische Malerie von Hute* held in Berlin and Baden-Baden, the 1964 Biennial of Cordoba (Argentina), and *Braniff Collection*, University of Texas, 1965. Won several awards, including Kunstpreis der Jugend, Germany, 1952, and the Prize for Drawing, Museo de Bellas Artes, Caracas, 1963.

[1] Literal translation of this title is "She Whom My Heart Has Taken." --*Ed.*

[2] Not included in the original catalogue. See Index of Artists for reference on those not listed here. --*Ed.*

November 22, 1966 - January 3, 1967

CONTEMPORARY ART OF PARAGUAY

In 1964, at the Second Biennial of American Art, sponsored by Kaiser Industries in Argentina, great attention was attracted by the work of a group of young artists from Paraguay, for it showed a boldness and sureness of expression not as a rule associated with that country. Previously, artistic production had been romantic in approach and had tended toward the descriptive, dwelling by preference on themes that were national in flavor. Exceptions were constituted by the compositions of Carlos Colombino and Hermann Guggiari, each of whom had developed a mature, personal style which established him as a figure on both the national and international art scenes. Colombino had indeed developed a wholly new mode of expression with his handsome plywood carvings. A selection of these was presented at the Pan American Union in July of this year--the first exhibition devoted entirely to Paraguayan art to have been shown in the Washington area. It is a natural consequence of the success of that event that it should be followed up with a group exhibit of the works of the young artists who aroused interest at the Kaiser Biennial.

Responsibility for the organization of the present show lies with the Museum of Modern Art of Asunción, which was founded two years ago with a view to collecting and bringing to public attention the work of local artists of the rising generation and which has been instrumental in promoting exhibits of their production abroad. Owing to limitations of space, the Pan American Union is unable to display the works of all the artists at this time; however, a second exhibition, featuring the remainder of the artists represented, will be given next year.

Appreciation is expressed to the Esso Standard Oil Company for having the exhibit packed and shipped to the United States. --*J.G-S.*

CATALOGUE

Paintings and Prints

Michael Burt
 1. *El corazón de la ciudad (The Heart of the City)*, acrylic on hardboard, 122 x 122 cm.
 2. *Pequeño núcleo urbano (Small Urban Nucleus)*, acrylic on hardboard, 122 x 122 cm.

Leonor Cecotto
 3. *Penetrar el silencio (Penetrating the Silence)*, woodcut, 54 x 65 cm.
 4. *Acercarse al mañana (Close to Morning)*,[1] woodcut, 54 x 65 cm.
 5. *Vivir hoy, morir mañana (To Live Today, to Die Tomorrow)*, woodcut, 67 x 52 cm.
 6. *Final (The End)*, woodcut, 67 x 52 cm.
 7. *Tiempo y distancia (Time and Distance)*, woodcut, 64 x 54 cm.

Pedro Di Lascio
 8. *Paisaje (Landscape)*, oil on canvas, 70 x 70 cm.
 9. *Naturaleza muerta (Natural Death)*,[1] oil on canvas, 70 x 100 cm.

Ida Talavera de Fracchia
10. *Pintura (Painting) I*, oil on canvas, 80 x 100 cm.
11. *Pintura (Painting) II*, oil on canvas, 70 x 100 cm.

Hugo González Frutos
12. *Tema de la araña loca (Theme of the Crazy Spider) I*, synthetic enamel on canvas, 70 x 100 cm.
13. *Tema de la araña loca (Theme of the Crazy Spider) II*, synthetic enamel on canvas, 70 x 100 cm.

Hermann Guggiari
14. *Sculpture in Iron*

[1] Literal translation of no. 4 is "Getting Closer to the Future," and of no. 9 is "Still Life." --*Ed.*

Edith Jiménez
15. *Estudio (Study) No. 3*, oil on canvas, 85 x 130 cm.
16. *Estudio (Study) No. 5*, oil on canvas, 85 x 130 cm.
17. *Xilografía (Woodcut) No. 70*, 74 x 28 cm.
18. *Xilografía (Woodcut) No. 76*, 46 x 100 cm.
19. *Xilografía (Woodcut) No. 77*, 46 x 100 cm.
20. *Xilografía (Woodcut) No. 78*, 100 x 120 cm.
21. *Xilografía (Woodcut) No. 79*, 100 x 120 cm.

Guillermo Ketterer
22. *Anahí: leyenda de la flor del ceibo (Anahí: Legend of the Ceiba Flower)*, collage and oil on canvas, 90 x 120 cm.
23. *Ypacaraí: leyenda del lago azul (Ypacaraí: Legend of the Blue Lake)*, collage and oil on canvas, 90 x 120 cm.

Laura Márquez
24. *Oleo (Oil) I*, oil on canvas, 200 x 200 cm.
25. *Oleo (Oil) II*, oil on canvas, 120 x 120 cm.
26. *Oleo (Oil) III*, oil on canvas, 120 x 120 cm.

William Riquelme
27. *Diseño (Drawing) I*, ink and wax on paper, 19 x 35 cm.
28. *Diseño (Drawing) II*, ink and wax on paper, 19 x 44 cm.
29. *Diseño (Drawing) III*, ink and wax on paper, 22 x 48 cm.
30. *Diseño (Drawing) IV*, ink and wax on paper, 22 x 45 cm.
31. *Diseño (Drawing) V*, ink and wax on paper, 26 x 45 cm.

Angel Yegros
32. *Icono (Icon) I*, metal on wood, 70 x 70 cm.
33. *Icono (Icon) II*, metal on wood, 70 x 170 cm.

Ricardo Yustman
34. *Némesis (Nemesis) I*, oil on relief, 70 x 100 cm.
35. *Némesis (Nemesis) II*, oil on relief, 70 x 100 cm.

Alberto Miltos
36. *Venus*, 170 x 200 cm.

BIOGRAPHICAL NOTES [1]

BURT, Michael. Painter, born in Asunción, 1931. Graduated as an architect in Brazil, where he also studied painting and ceramics. Lived in the United States as a teenager and in Brazil, 1955-59. In 1963 abandoned ceramics to take up painting exclusively. Co-founder of the Museo de Arte Moderno, Asunción, 1965. Held individual exhibitions in Asunción since 1962. Participated in national and international group shows including *Arte Moderno del Paraguay*, a retrospective exhibit, Asunción, 1964; Biennial of São Paulo, 1965, and Biennial of Córdoba (Argentina), 1966.

CECCOTO, Leonor. Painter, printmaker, born in Formosa, Argentina, 1920. Studied drawing and painting with Eugene Charles and João Rossi, Asunción. Member of the *Grupo de Arte Nuevo*, 1953; founding member of the Museo de Arte Moderno, Asunción, 1965. Since 1951 has exhibited in Asunción and participated, among other international exhibitions, in the following biennials: Mexico, 1958; São Paulo, 1963, 1965; Tokyo, 1964; Santiago de Chile, 1965; Lugano, 1966. Was awarded several awards, including First Prize for Print, Plastic Arts Contest, Asunción, 1966. Has lived in Asunción since childhood.

[1] Not included in the original catalogue. See Index of Artists for reference on those not listed here. *--Ed.*

GONZALEZ FRUTOS, Hugo. Painter, born in Asunción, 1940. Presently is studying Fine Arts in Buenos Aires. Founding member of the Museum of Modern Art, 1965. Exhibited in Asunción, Buenos Aires, and the São Paulo Biennial, 1965.

JIMENEZ, Edith. Painter, draftsman, printmaker, born in Asunción, 1925. Studied drawing and painting in Asunción with Jaime Bestard and in 1956 with Livio Abramo; and at the Museu de Arte Moderna, São Paulo, through a Brazilian fellowship, 1958-60. Invited by the Department of State, traveled in the United States, 1965. Member of the *Grupo de Arte Nuevo*, 1953; founding member of the Museo de Arte Moderno, 1965; at present is a professor at the Printing Workshop of the Brazilian Cultural Institute, and directs her own Children's Art Workshop in Asunción. Since 1952 has held individual exhibitions in Asunción, including the first individual print exhibit in the country, 1960. Participated in national and international shows such as the Biennial of São Paulo, 1953 and 1961-65; Print Biennial of Tokyo, 1964; *Art of America and Spain*, Madrid, circulating in Europe, 1963-64; and Latin American exhibitions in the United States. Won many national and international prizes, including Gold Medal, *First Latin American Print Exhibition*, Buenos Aires, 1960; Honor Mention, Biennial of São Paulo, 1961 and 1965; Honor Mention, Print Biennial, Santiago (Chile), 1963; Kennedy First Prize for Painting, Asunción, 1964.

KETTERER, Guillermo. Painter, born in Paraguay, 1910. Studied in Buenos Aires and under Héctor Da Ponte in Asunción. Traveled in the United States, invited by the Department of State, 1966. Member of the *Centro de Artistas Plásticos del Paraguay*, 1955-1960; founding member of the Museo de Arte Moderno, 1965. Held individual exhibitions in Asunción. Participated in national and international shows, including the Biennial of Barcelona (Spain) in 1955 and the Biennial of São Paulo, 1961-65. Was awarded a Silver Medal, Autumn Salon, Asunción, 1951, among other prizes.

LASCIO, Pedro Di. Painter, born in Asunción, 1906. Studied in Asunción with Jaime Bestard and Ofelia Echagüe Vera at the Ateneo Paraguayo and under the Brazilian artist João Rossi. Traveled in Brazil, Uruguay, and Argentina. Founding member of the Museo de Arte Moderno, Asunción, 1965, exhibited in individual and group shows in Asunción. Participated in international exhibitions, including the *Inter-American Exhibition*, Caracas, 1954; the Biennials of São Paulo, 1957 and 1961-65; the Inter-American Biennial of Mexico, 1958; and the American Biennial of Córdoba (Argentina), 1964-66. Was awarded First Prize for Painting, Plastic Arts Contest, Asunción, 1964, and a Mention at the Grand Prize of Monaco exhibit, 1965.

MARQUEZ, Laura. Painter, sculptress, born in Asunción, 1929. Studied in Buenos Aires at the Manuel Belgrano, Prilidiano Pueyrredón, and Ernesto de la Cárcova Schools of Fine Arts, 1950-60. Founding member of the Museo de Arte Moderno, Asunción, 1965. Since 1959 has held individual exhibitions in Asunción. Participated in group exhibitions, mainly in Paraguay, Argentina, and Brazil, such as the Biennials of São Paulo, 1959-61 and 1965, and the American Biennial of Córdoba (Argentina), 1964. Won the First Prize for Mural, Asunción, 1961, and in 1963-64 was the recipient of a scholarship granted by the Argentine National Fund for the Arts.

MILTOS, Alberto. Painter, draftsman, printmaker, born in Concepción, Paraguay, 1941. Self-taught as an artist, has exhibited since 1960 mainly in Paraguay. Won First Prize (Gold Medal), Plastic Arts Contest, Asunción, 1965.

RIQUELME, William. Painter, draftsman, born in Asunción, 1944. Studied architecture. Co-founder of the group *Los novísimos*, 1964 and founding member of the Museo de Arte Moderno, Asunción, 1965. Since 1962 has exhibited in national and international shows, including the American Biennial of Córdoba (Argentina), 1964, and the São Paulo Biennial, 1965. Won the Kennedy Prize for Painting, and the First Tayi Prize, Asunción, 1966.

TALAVERA DE FRACCHIA, Ida. Painter, poetess, born in Asunción. Held her first individual show in July 1966. Since 1965 has participated in four group shows in Asunción.

YEGROS, Angel. Painter, printmaker, born in Asunción, 1943. Studied printmaking at the Taller Julián de la Herrería under Livio Abramo, Asunción. Co-founder of the group *Los novísimos*, 1964. Since then, has exhibited in national group exhibitions and participated in the Biennial of Córdoba (Argentina), 1964.

YUSTMAN, Ricardo. Painter, born in San Juan, Argentina, 1942. Self-taught as a painter, studied architecture for three years. Since 1965 has exhibited in national shows and participated in the Biennial of São Paulo, 1965, and the American Biennial of Córdoba (Argentina), 1966. Has lived in Asunción since 1950.

YEAR 1967

CARMEN GRACIA OF ARGENTINA

A surprisingly large number of Latin Americans who have lately won international reputation in the field of graphic arts have received training and orientation at the Paris workshop known as Atelier 17, directed by the English engraver Stanley William Hayter. One such is the Argentine Carmen Gracia who, with the present exhibition, is making her first appearance at the Pan American Union.

Born in the city of Mendoza, Miss Gracia initiated her study of art there and continued, beginning in 1960, at Atelier 17. In 1965 she enrolled at the Slade School in London for advanced training, and by the end of that year was in a position to give a course in metal engraving at the Cooperative Society of Portuguese Engravers in Lisbon, under the auspices of the Gulbenkian Foundation.

Miss Gracia began exhibiting with others of the Atelier 17 group in 1962, their work being presented in Copenhagen, Oslo, Paris, Helsinki, Stockholm, London, Tokyo, Caracas, and several cities of Canada. She has participated in numerous international salons, among others the International Exhibit of Engraving, Ljubljana, Yugoslavia, 1963 and 1965; the Northwest Printmakers International Exhibition, Seattle Museum of Art, 1964 and 1965; the International Exhibition of the California Society of Etchers, San Francisco, 1964; and the Eleventh Annual Exhibition of Latin American Prints, Galería Sudamericana, New York, 1965. In addition, she has had four individual presentations of her work in London and Lisbon, and is represented in such important collections as those of the Slade School and the Victoria and Albert Museum in London, the National Library and the Municipal Museum of Paris, and the Museum of Contemporary Art in Skopje, Yugoslavia. --*J.G-S.*

CATALOGUE

Graphics

1. *Autoportrait (Self-Portrait)*, 2/20
2. *Le Saint Esprit (The Great Spirit Saint)*,[1] 4/20
3. *Voyage*, 2/20
4. *Bishop*, 2/20, 1965, color etching
5. *British Isles*, 5/20
6. *Knight Errant*, 3/20, 1965, etching
7. *Yule*, 2/20
8. *Cortège funèbre (Funeral Cortege)*, 8/20
9. *Défaites (Defeats)*, 3/20
10. *Dieu (God)*, 5/20
11. *Affiche Carmen (Carmen)*, 3/10
12. *Maison clôse (Closed house)*, 5/20
13. *Por la calle del Tajo Barajo (Through the Street of Tajo Barajo)*, 3/20
14. *Caballo y caballero (Horse and Horseman)*, 2/10
15. *Metro Gaieté (Metro Escapades)*, 2/20
16. *Retrato del bisabuelo (Portrait of Great-Grandmother)*,[1] 7/20
17. *La charrette des enfers (The Wheelbarrow of Hades)*, 9/20
18. *Noon*, 1/20
19. *La pêche miraculeuse (The Miraculous Fish)*, artist's proof

[1] Literal translation of no. 2 is "The Holy Spirit" and of no. 16 is "Portrait of Great-Grandfather." --*Ed.*

20. *Nôces (Nights),*[1] artist's proof
21. *Pot de chambre (Chamberpot),* artist's proof
22. *Poème de Socrates Cobas (Poem of Socrates),* 2/14
23. *Nouveau né (Newborn),* 5/20
24. *Revolution,* 9/15
25. *Le premier roi et la première reine (The First King and the First Queen),* 1/10
26. *Le sens mexicain de la mort (The Mexican Sense of Death),* 3/20

January 4 - 31, 1967

BERTA GUIDO OF ARGENTINA

Of all the American republics, Argentina has perhaps the greatest number of women actively engaged in artistic production, particularly in the fields of painting and sculpture. An outstanding figure in their ranks is that of Berta Guido, whose oils are continually marked by a subtle fluctuation between abstraction and reality.

Born in Rosario in 1930, Miss Guido is but one of several members of her family who have connections with the arts. Her father was a highly respected architect and art historian; her sister Beatriz is a writer and author of *La caída (The Fall)* on which Berta collaborated as illustrator.

Miss Guido studied under Adolfo de Ferraris at the Ernesto de la Cárcova School of Fine Arts of the University of the Littoral, and later became a professor at that institution. She has exhibited extensively in the River Plate region; her individual presentations include the ones at the Rubbers Gallery in Buenos Aires and the Moretty Gallery in Montevideo, both of which took place in 1959. In recent years she has been the recipient of a number of national awards.

This is the first exhibition of the paintings of Berta Guido to be given in the Washington area. *--J.G-S.*

CATALOGUE

Paintings

1. *Que mira mi ojo sudamericano sólo veo este color (Whatever My South American Eye Looks at Is Seen in This Color),* 228 x 162 cm.
2. *Amor 33 (Love 33),*[2] 178 x 146 cm.
3. *Rojo sobre rojo (Red on Red),* 228 x 162 cm.
4. *Ir a la muerte en coche (Going towards Death in a Car),*[2] 195 x 130 cm.
5. *Al horizonte de un suburbio (Upon the Horizon of a Suburb),* 195 x 130 cm.
6. *Rayuela,*[2] 195 x 130 cm.
7. *Ya muerto, ya de pie, ya inmortal, ya fantasma (Now Dead, Now Alive, Now Immortal, Now Ghostly),* 178 x 46 cm.
8. *Esquina rosada (Pink Corner),*[2] 165 x 180 cm.
9. *Dimensión No. 1,* 130 x 81 cm.
10. *Lavalle duerme antes de morir (Lavalle Sleeps before Dying),*[2] 165 x 180 cm.
11. *America No. 1,* 110 x 130 cm.
12. *America No. 2,* 110 x 130 cm.
13. *Serie América (American Series) I,* 50 x 73 cm.
14. *Serie América (American Series) II,* 50 x 73 cm.
15. *Serie América (American Series) III,* 50 x 73 cm.

[1] Literal translation of this title is "Wedding." *--Ed.*

[2] These works were inspired by novels and short stories of the following Argentine authors: no. 2, Rafael Squirru; nos. 4 and 8, Jorge Luis Borges; no. 6, Julio Cortázar; no. 10, Ernesto Sábato.

16. *Serie América (American Series) IV*, 50 x 73 cm.
17. *Soles de América (Suns of America)*, 38 x 73 cm.
18. *Soles de América (Suns of America)*, 38 x 73 cm.
19. *Pintura (Painting)*, 73 x 130 cm.
20. *Lunas de América (Moons of America)*, 70 x 50 cm.
21. *Lunas de América (Moons of America)*, 70 x 50 cm.
22. *Dimensión (Dimension) No. 1*, 116 x 54 cm.
23. *Dimensión (Dimension) No. 2*, 116 x 54 cm.
24. *Pintura en rojo (Painting in Red)*, 116 x 54 cm.
25. *La pampa en los zaguanes (The Pampa in the Vestibules)*, 130 x 97 cm.
26. *Pintura en azules (Painting in Blues)*, 81 x 65 cm.
27. *Serie América (American Series)*, 50 x 73 cm.
28. *Serie América (American Series)*, 50 x 73 cm.
29. *Pintura (Painting)*, 116 x 54 cm.
30. *Pintura (Painting)*, 116 x 54 cm.

January 24 - February 15, 1967

MYRA LANDAU OF BRAZIL

Graphic art in Brazil is traditionally of high quality as regards both style and technique. A good example of the level of Brazilian production is provided by the current exhibit at the Pan American Union, which features a selection of prints by the artist Myra Landau.

Though she has now been a Brazilian citizen for some two decades, Miss Landau was originally a native of Romania, a country which she left during World War II. Before coming to South America, she studied in London and Paris, but it was in Rio de Janeiro that she received her secondary education, majoring in chemistry. It was there too that, about the same time, she took up the graphic arts, receiving guidance from the well-known engraver Oswaldo Goeldi. Soon she was exhibiting both in Brazil and in other countries of Latin America. Since 1954 she has had ten individual shows: these took place in Buenos Aires (Müller Gallery), Rio de Janeiro (Petite Gallery, OCA Gallery, Piccola Gallery), São Paulo (Michel Veber Gallery of Modern Art), Mexico City (Juan Martín Gallery, Antonio Souza Gallery, Pecanins Gallery), and San Antonio, Texas (Men of Art Guild Galleries).

Miss Landau currently resides in Mexico. The present exhibition is the first of her work to be given in the Washington area. --*J.G-S*.

EXHIBITION LIST [1]

Engravings, 1956-1966

1. *Favela* (Slum)
2. *Velhinha* (Old Little Lady)
3. *Rio*
4. *Rio antigo* (Old Rio de Janeiro)
5. *Tronco* (Trunk)
6-8. *Casas* (Houses)
9. *Campos do Jordão*
10. *Cabo Frio*
11. *Igreja na noite* (Church at Night)
12. *Feira* (Fair)

[1] Not included in the original catalogue. The original catalogue indicates that twenty-four engravings were exhibited on this occasion; since they were not identified, the list of the titles sent by the artist for this exhibition is reproduced here in its entirety. --*Ed*.

13-17. *Positano*
 18. *Piazza* (Square)
19-20. *Capri*
 21. *Capri sotto la luna* (Capri under the Moon)
 22. *Lua nova* (New Moon)
 23. *Lua quebrada* (Broken Moon)
 24. *Mar* (Sea)
 25. *Floresta* (Woods)
 26. *Xochimilco*
 27. *Taxco*
 28. *Tu cruz (Your Cross)*
 29. *Nosostros (We)*
 30. *Pared con hojas (Wall with Leaves)*
 31. *Hoja en la pared (Leaf on the Wall)*
 32. *Kakemono*
 33. *Detrás del mundo (Behind the World)*
 34. *Fuego fatuo (Ignis Fatuus)*
 35. *Llaga de metal (Metal Wound)*
 36. *Cicatrices (Scars)*
37-48. *Composición (Composition) Nos. 1, 2, 3, 4, 5, 6, 7, 8, 9, 10, 11, 12*

January 24 - February 15, 1967

WEGA NERY OF BRAZIL

Visitors to the Seventh São Paulo Biennial, in 1963, were filled with surprise when they came upon the work of the Brazilian Wega Nery. The huge, handsome canvases glowed with color; the expression, fluctuating between abstract and figurative, bore the stamp of an original personality. Long years of study and artistic endeavor were finally rewarded when Wega was assigned the Biennial's First Acquisition Prize and a room apart for the presentation of her compositions.

Wega Nery was born in 1913 at Corumbá, in the remote Brazilian state of Mato Grosso. At an early age she undertook study at the School of Fine Arts in São Paulo, and gradually her paintings began to appear in exhibitions held throughout the country. She enjoyed individual presentations in Rio de Janeiro, São Paulo, Montevideo, and Buenos Aires and has participated in six of the eight São Paulo Biennials, being awarded the National Prize for Design in 1957. She had previously received the Bronze Medal at the National Salon in Rio in 1950. Last year she gave a special exhibition at the Museum of Modern Art in that city, as part of the celebration of the former capital's fourth centennial.

This is the first presentation of paintings by Wega Nery in the United States. *--J.G-S.*

CATALOGUE

1-25. Oils[1]

[1] The list of works sent by the artist for this exhibition includes 108 oils and drawings executed between 1950 and 1965. Since the original catalogue indicates that only twenty-five oils were exhibited, no detailed exhibition list is provided. *--Ed.*

March 15 - April 10, 1967

EDUARDO MAC ENTYRE OF ARGENTINA

In the vast realm of abstraction in the plastic arts during the past fifteen years, there has been a gradual development toward op art, a non-representational art based on geometrical forms. The approach is kinetic rather than static, producing optical phenomena that give lasting effects, including vibration, expansion, and the illusion of volume and space.

Artists in Argentina were among the first to respond strongly to abstract art, and they have been no less receptive to op art. Eduardo Mac Entyre, the artist now presented, has been working in this field for more than ten years. His manipulation of op art has been sustained by a kind of calligraphy--the ruler and compass are used to trace on dark surfaces very thin lines generally in repeated circles that intersect. As the lines cut each other they build a subtle but vibrant web from which evolve movement and volume. The contrast of colors, the meticulous lines, the purity of the geometrical shapes create clear, weightless, luminous forms. A suggestion of iridescence emerges to take away from the composition the solidity implied in three-dimensional forms, affording an element of surprise.

Eduardo Mac Entyre was born in Buenos Aires in 1929. He is a self-taught painter who has worked as both an industrial and graphic designer. Mac Entyre presented his first one-man show in Buenos Aires in 1960 at the Rubbers Gallery, and his most recent exhibition was held at the Bonino Gallery in the same city in 1965. The artist has participated in numerous national salons, including the two Córdoba Biennials. Since 1960 he has exhibited in Mexico, Uruguay, Brazil, Venezuela, England, Scotland, Sweden, and the United States. Among public collections that include Mac Entyre's work are: the Museum of Modern Art and the National Museum of Fine Art Arts, Buenos Aires; the Museum of Modern Art, Rio de Janeiro; and the Museum of Modern Art, New York. He is represented in numerous important private collections both in the United States and abroad.

The work of Eduardo Mac Entyre was presented in a group show of Argentine artists at the Pan American Union several years ago. The current exhibit, however, is his first one-man show in the United States. --*J.G-S.*

CATALOGUE

Paintings

1-20. *Pintura generativa (Generative Painting) Nos. 1, 5, 6, 8, 13, 17, 23, 24, 25, 26, 27, 28, 29, 30, 31, 32, 33, 34, 35, 37*

April 13 - 30, 1967

FOLK ART OF PERU [1]

Few countries in the world can boast a centuries-old tradition in the production of folk arts and crafts as can Peru and Mexico, and certainly there is not elsewhere the variety of expression found in these two countries. The territory that the Spaniards conquered was the home of a vast number of cultures, each with a unique style manifested in the ornamentation of objects of ritual and daily use. The decoration of objects is always an indication of an advanced cultural stage, of a degree of historical and social maturity. The indigenous styles merged with the European after the arrival of the Spaniards. Technique suffered with hybridization, especially in ceramics and textiles in which the native craftsmen had attained a degree of excellence unequaled in the world of the time. Jewelry and sculpture admitted certain ideas and procedures to advantage. Perhaps one of the more significant contributions of the Europeans was the introduction of certain animals such as the cow and the horse, which were immediately integrated into the realm of the arts and crafts.

[1] The list of works exhibited is unavailable. The photographs of objects and scenes also included in this exhibition were taken by the Peruvian photographer José Casals. --*Ed.*

This exhibit of folk arts and crafts was prepared by His Excellency Celso Pastor, Ambassador of Peru to the United States, and the Department of Culture, Education, and Tourism of the Embassy of Peru. It is composed entirely of contemporary objects, and although it does not pretend to be exhaustive, the exhibit provides a valid idea of the work being accomplished today.

The ceramics of Pucará and Ayacucho, including the bulls, horses, and miniature Catholic churches and chapels, are testimony to the skill of the pottery makers of Peru. Although the pre-Columbian textiles have no equivalent, the present work does retain much of the variety and grandiosity of the earlier textiles.

The texture and quality are perhaps a reflection of the country's ability to supply cotton and wool to the craftsmen in abundance. The alabaster carvings of Huamanga are extremely delicate and eminently European in conception. The fascinating engraved gourds of Huancayo, Ayacucho, and Lambayeque, relating stories in a sequence not unlike that seen in the comic strips, represent an old craft that has no parallel in the rest of America. Work with silver and gold has gained the least in terms of new form and technique, possibly because the jewelers are distracted by the intrinsic value of the metals. Basketry is another very delicate and ancient craft that has changed little through the centuries.

Finally, there is the unique tradition of the *retablo*, a miniature altar piece, roughly conceived, with a wood surface painted in a dull color. Formed usually by a central body of some depth, with two doors which open like wings, the *retablo* contains a scene of the life of Christ. The scene is represented by three-dimensional figures of Peruvian animals and humans, minute in size, made of plaster or ceramic which is brilliantly decorated with enamel. The tradition, of course, is in the direct line of Christianity, from the icons of Eastern Europe, with a certain similarity to the Byzantine altar pieces of Ethiopia. The *retablo* tells a transcendental story in the most simple and direct manner, with a charm that is inherent in a primitive people.

The present exhibit of arts and crafts of Peru is definite proof of the permanence of the creative talent for the plastic arts possessed by the people of the Americas. *--J.G-S.*

This exhibition is composed of works from the following regions of Peru:
Cuzco, Puno, Ayacucho, Junín, Lambayeque, Lima, Cajamarca, Río Ucayali (Loreto), Ancash, and Huancayo.

ACKNOWLEDGEMENTS

We wish to acknowledge appreciation to the following for their cooperation in the presentation of this exhibition:

Violeta Correa Miller; Elvira Luza; Mrs. David F. Phillips; Antonio Lulli, Minister Counselor of the Embassy of Peru; and Alfonso Espinosa, Cultural Counselor of the Embassy of Peru; also, the Department of Culture and Information of the Peruvian Ministry of Foreign Relations, the Peruvian Tourist Corporation, the Industrial Bank of Peru, the Credit Bank of Peru, the Smithsonian Institution, the Peruvian Airlines, and Braniff International.

May 1 - 22, 1967

ALDO BIGLIONE OF ARGENTINA

Concurrent with the Third Kaiser Biennial of American Art held last year in Córdoba, Argentina, was the Second Salon of University Graphic Arts. For the latter, the Division of Visual Arts offered a prize consisting of the opportunity for an artist selected by the jury to exhibit at the Pan American Union. The recipient of the award was Aldo Biglione, a graduate of the University of Tucumán and of the School of Fine Arts of Buenos Aires.

Biglione was born in Cañada Rosquín, Province of Santa Fe, Argentina, in 1929. He has participated in several group exhibitions, including the National Salon of Engravers held in Havana, Cuba, in 1965. Currently he is represented in an exhibition of Argentine art which is touring the European capitals. The artist has presented one-man shows in the Galería Klee and the Galería Siglo XX, both in Buenos Aires, and another in the Galería La Siringa in Neuquén, Argentina. His work is in several museums and private collections in his native country.

This is the first exhibition of the graphics of Aldo Biglione in the United States. *--J.G-S.*

CATALOGUE [1]

Graphics

Serie vivir de segunda (Second Class Living Series), 1964

1. *Chicos y pájaros* (Children and Birds), 1/25, color etching
2. *Villa Miseria* (Shantytown), 3/25, woodcut
3. *Los que siguen esperando* (Those Who Keep Waiting), 3/25, etching
4. *Los que fueron postergados* (Those Who Were Left Behind), 2/25, etching
5. *Ilusión y frustraciones* (Illusion and Frustrations), 1/25, etching
6. *Los de la música negra* (Those of the Black Music), 7/25, etching

Serie sobre poemas de A. Tejada Gómez (Themes on the Poems by A. Tejada Gómez Series), 1965

7. *Desalojaron a Pedro Changa* (Pedro Changa Has Been Evicted), 1/25, etching
8. *Muchos globos para los hijos de Pedro Changa* (Many Balloons for Pedro Changa's Children), 5/25, color metal
9. *Pedro Changa y su familia* (Pedro Changa and His Family), 3/25, etching and soft varnish

Serie de los músicos (The Musicians Series), 1965, etching

10. *Milonga en el conventillo* (Milonga in the Tenement House),[2] 1/25
11. *Fuellerías* (Blower Makers), 7/25
12. *Después de la milonga* (After the Milonga),[2] 4/25
13. *Milonga en camiseta* (Milonga in T-Shirt),[2] 1/25

Serie de mitos, leyendas y costumbres (Myths, Legends, and Customs Series)

14. *Consultorio de la curandera* (The Quack's Office), 1/25, 1965, etching
15. *Yerba de pollo p'al empacho* (Chicken Herb for Stomach-Ache), 1966, color metal
16. *Tirando las cartas* (Card Fortune Telling), 1/25, 1966, etching
17. *El mal de ojo* (Evil Eye), 1/25, 1965, woodcut

Serie de juego de chicos (Children's Games Series), 1966, color metal

18. *Tocando quenas* (Playing the Quena), 13/25
19. *Cuentos del viejo guerrero* (Old Warrior's Stories), 1/25

Serie de la vida y el amor (Life and Love Series), 1966, color metal

20. *Y van cuatro lunas* (And Four Moons Have Passed), 2/35
21. *Riña de gallos* (Cockfight), 1/35

Serie del compadre (The Godfather Series), 1966, color metal

22. *Salió a vivir la noche* (He Went Out to Live the Night), 1/25
23. *Viviendo la noche* (Living the Night), 2/25
24. *Se incendió el compadre* (The Godfather Set on Fire), 1/25
25. *Zamba de noche y luna* (Zamba of Night and Moon), 1/25

[1] The original catalogue only listed the series' titles. --*Ed.*

[2] *Milonga* is a popular Argentine rhythm but it also refers to a dancing party. --*Ed.*

May 1 - 22, 1967

ESTUARDO MALDONADO OF ECUADOR

In the art of Ecuador there is a prominent trend, initiated by the painters Aníbal Villacís and Enrique Tábara, in which pre-Columbian forms and textures are incorporated into abstract art through the use of new techniques. Estuardo Maldonado is one of the young artists who has followed this current most successfully. With subtlety and imagination he has adapted the masks, stone slabs, seals, and reliefs of the early craftsmen to his own paintings which are executed in today's media.

Estuardo Maldonado was born in Pintag, Ecuador, in 1928. From 1947 until 1953, he studied at the School of Fine Arts of Guayaquil. In 1957 the Ecuadorian government awarded him a scholarship to continue his studies in Italy. There he attended the Academy of Fine Arts in Rome, studying with the sculptor Pericle Fazini and later with the painter Franco Gentilini. At the same time, Maldonado took special courses in the graphic arts, ceramics, and mosaic at other institutions.

Maldonado presented his first one-man show in Portoviejo, Ecuador, in 1952. Since that time he has held solo exhibits in numerous galleries in Rome, including the Galleria Scorpio, the Galleria Il Bilico, and the Galleria Carpine, and in his native country. His paintings have been included in approximately twenty group exhibits in Italy and Ecuador. In 1966 the artist participated in the Venice Biennial as a representative of Ecuador.

The work of Estuardo Maldonado is in public galleries in Guayaquil and Quito and in the collections of the Academy of Fine Arts, the Gallery of Modern Art, and the National Academy of San Giacomo in Rome. He is represented in private collections in Latin America, Europe, and Japan.

This is the first exhibit of paintings by Estuardo Maldonado in the United States. *--J.G-S.*

CATALOGUE

Paintings[1]

1. *Superficie contraste (Surface Contrast)*, 1965
2. *Espacial verderojo (Spatial Green-Red)*, 1965
3. *Constelación (Constellation)*, 1965
4. *Recuerdo de una imagen (Memory of an Image)*, 1965
5. *Grupo (Group)*, 1964
6. *Superficie rosada (Pink Surface)*, 1966
7. *Espacial bleu (Spatial Blue)*, 1965
8. *Superficie contínua (Continued Surface)*, 1965
9. *Coloquio (Colloquialism)*, 1966
10. *Espacio y tiempo (Space and Time)*, 1965
11. *Recuerdo de una imagen (Memory of an Image)*, 1965
12. *Recuerdo de formas (Memory of Forms)*, 1965
13. *Personajes (Characters)*, 1965
14. *Estructura ocre (Ocher Structure)*, 1965
15. *Precolombiano (Pre-Columbian)*, 1965
16. *La noche (Night)*, 1967
17. *Tridimensional (Three-dimensional)*, 1967
18. *Estructura verde violeta (Green-Violet Structure)*, 1967
19. *Forma (Form)*, 1966
20. *Estructura gris (Gray Structure)*, 1967
21. *Imagen lunar (Lunar Image)*, 1967
22. *Personajes oro (Gold People)*, 1966

[1] All paintings above are encaustic, except for no. 5 which is an oil. *--Ed.*

23. *Composición oval (Oval Composition)*, 1966
24. *Composición azul violeta (Blue-Violet Composition)*, 1966
25. *Dinámica circular (Dynamic Circle)*, 1967

May 23 - June 14, 1967

DALIA ANTONINA OF BRAZIL

One of the outstanding personalities working in the plastic arts in Brazil is Dália Antonina, whose paintings were recently exhibited at the Brazilian-American Cultural Institute in Washington.

Dália Antonina was born in the State of Minas Gerais, Brazil, in 1918, but has been living in Rio de Janeiro since she was very young. From 1938 to 1948 she studied drawing and painting with Cândido Portinari and Tomás Santa Rosa, major figures in the modern art of Brazil. Later in her career the artist attended the New York School of Interior Design.

The paintings of Dália Antonina have been exhibited in individual and group shows in Rio de Janeiro (Ministry of Education and Culture, 1950; Atelier Gallery, 1957; Oca Gallery, 1960; Montmartre Gallery, 1960 and 1966), Belo Horizonte (Thomas Jefferson Gallery, 1954), New York (Brazilian Center of New York, 1960), São Paulo (Mobilínea Gallery, 1964), London (SEPRO Gallery, 1964), and Lisbon (Palácio da Foz, 1964).

This is the first exhibition of the works of Dália Antonina to be presented at the Pan American Union.

CATALOGUE

Paintings

1. *The Gates of Hell*
2. *Struggle Between Good and Evil*
3. *Transfiguration*
4. *Victory*
5. *Resurrection*
6. *Guardian Angel*
7. *Hallelujah*
8. *Infinite Repentance*
9. *Fallen Angel*
10. *Purgatory*
11. *Melancholy*

May 23 - June 14, 1967

RAUL PORTO OF BRAZIL

Raul Porto is a young artist who has gradually come to the fore in Brazil. Although he has continually sought new means of expression, he has kept strong links with tradition. A certain austere quality makes Porto's work easily identifiable, as is apparent in his current paintings in oil and collage.

Raul Porto was born in Dois Córregos, State of São Paulo, Brazil, in 1936. He is a self-taught artist who became interested in art at a young age. For two years Porto was director of a small commercial gallery, and presently he is the director of the Department of Painting of the Center of Arts, Letters, and Sciences in São Paulo. Porto has participated in numerous group shows, including the Fifth, Seventh, and Eighth São Paulo Biennials. In 1965 the artist won a Purchase Prize for Brazil at the *Esso Salon of Young Artists*. In the same year he held his first one-man show in Lima, Peru, at the Brazilian Studies Center. Last year Porto was represented in a group show of Brazilian art that was exhibited in Japan. His works are in the collections of the Museum of Modern Art of

Rio de Janeiro, the Museum of Art of Paraná, and the Museum of Contemporary Art of São Paulo.

This is the first exhibition of the works of Raul Porto in the United States. --*J.G-S.*

CATALOGUE

1-25. Paintings and collages[1]

June 15 - July 9, 1967

ARNALDO COEN OF MEXICO

In the four years since he first appeared on the Mexican art scene, Arnaldo Coen has established himself as an outstanding personality among painters who have broken with their country's well-established tradition of social realism. Self-taught, for several years prior to his debut in a group exhibit at the Israeli Sports Center Gallery in Mexico City in 1963, he had been seeking to develop a technique and characteristics of his own. He has by now achieved a style marked by strong imagination and a subtle handling of color.

Coen's initial appearance was followed the same year by two one-man shows, likewise in the Mexican capital, at the Mer-Kup and Novedades galleries. Further individual presentations took place in 1964 and 1965 at the Juan Martín Gallery, which serves as the artist's representative. At the same time Coen has participated in a number of important group exhibitions, among others the *Esso Salon of Young Artists* in Mexico City, the Fourth Biennial of Young Artists in Paris, and a show of self-portraits organized by the Museum of Modern Art in Mexico, all in 1965. Last year he was also invited by his country's National Institute of Fine Arts to take part in an exhibit entitled *Confrontation '66.*

Though still in his twenties--he was born in Mexico City in 1940--Arnaldo Coen has already met with a large measure of success: his paintings hang not only in numerous private collections in the United States and Mexico, but also in the Museum of Modern Art in Mexico City, the Union Court Gallery in San Francisco, the Suneson Gallery in Nuevo Laredo (Mexico), and the Carlota Gallery in Tijuana (Mexico). This year he was honored by a grant from the French government which will take him to Paris for study and further painting after his presentation at the Pan American Union.

We wish to acknowledge the cooperation of the Juan Martín Gallery in making this exhibit possible. --*J.G-S.*

CATALOGUE

Oils on Canvas

 1. *Angel del sueño (Dream Angel),* 75 x 60 cm.
 2. *Criatura de persistencia (Creature of Persistence),* 60 x 45 cm.
 3. *Nueva noche (New Night),* 45 x 60 cm.
 4. *Hora de tierra (Hour of Earth),* 90 x 70 cm.
 5. *Olas heridas (Wounded Waves),* 95 x 75 cm.
 6. *Materia radiante (Radiant Material),* 110 x 70 cm.
 7. *Tu espuma negra (Black Foam),* 110 x 80 cm.
 8. *Barrida por los sueños (Swept Through Dreams),* 80 x 130 cm.
 9. *Menos el hombre (Except for Man),* 130 x 80 cm.
10. *Color desnudo (Naked Color),* 80 x 125 cm.
11. *Heridas espaciales (Spatial Wounds),* 80 x 125 cm.
12. *Polvo luminoso (Luminous Dust),* 90 x 120 cm.
13. *Sexos diferentes (Different Sexes),* 90 x 120 cm.

[1] Titles are unavailable. --*Ed.*

14. *Hacia vivir (Towards Living)*, 90 x 120 cm.
15. *Se juntó en la tierra (Joined on Earth)*, 110 x 150 cm.

June 15 - July 10, 1967

INLAYS ON AMATE BARK BY CAMILA HERNANDEZ OF MEXICO

An impelling force in the work of many artists of the twentieth century has been the urge to depict human beings, objects, and their environments in the simplest manner possible, with complete freedom of line, uninhibited by convention of any sort. The ideal has been to execute a composition with the innocent naivete of a child or a primitive adult. The importance of this drive may be judged from the extent to which it manifests itself in the work of such major figures as Picasso, Miró, Klee, and Dubuffet.

An outstanding example of the type of primitive art whose qualities they sought to reproduce is furnished by the compositions on bark by Camila Hernández, an Otomí Indian woman of Mexico. Unhampered by preconceptions of any sort, she produces compositions of exquisite simplicity, reminiscent of early cave drawings, exhibiting a fine selection of detail and a strong awareness of space.

Doña Camila lives in San Pablito, a village on the slopes of the Witch's Mountain, a peak of the Sierra Madre in the State of Puebla. There is evidence that, like some others of her tribe, she is a *curandera*, or medicine woman. As members of most Mexican Indian societies have done since pre-Hispanic times, the Otomí use the bark of the amate tree to produce a rich-textured paper that is used for magical as well as utilitarian purposes. In the former case, images are cut from the paper and endowed with powers of good and evil, depending on the spell cast by the medicine woman. There is but a limited range of color in the bark, from pale honey to dark brown; images cut from dark paper naturally symbolize evil, the lighter paper being reserved for the forces of good.

Sondra Battist, an American artist and art instructor who has loaned a selection of Doña Camila's compositions for the present exhibition, describes the technique used as follows:

> The bark has been stripped from the trees, and the sap-rich inner fibers have been separated from the outer bark. Doña Camila soaks the fibers in a nearby stream to remove the sap: the fibers that are for future use are dried and preserved. She will now boil the fibers in ash or lime-filled water where corn has previously been soaked. The mixture must boil for three to six hours. She rinses the fibers in clean water and places them in a water-filled wooden bowl called a *batea*. The softened fibers wait for her nimble fingers. She carefully selects the color of the fibers she will use, since the choice greatly influences the finished product. . . . After making her selection Doña Camila forms the strips of wet fiber into a rectangular pattern on a wooden board. This determines the ultimate size of the finished paper. With a stone bark beater in her hand she mashes the fibers and spreads them. Onto this foundation she incorporates her wonderful intuitive creations, depicting both real and imagined life forms. Utilizing the various textures and tonalities of the available fibers, she works her creations into the wet sheet. Skillfully she macerates the fibers against the board with the grooved beater until they are felted together to form a comparatively smooth surface. The completed work is then placed in the hot sun to dry. --*Américas*, May 1967.

This is the first presentation of the works of Doña Camila Hernández in the United States. --*J.G-S.*

CATALOGUE

Compositions in the exhibition are based on the following subjects:

1. Birds
2. Bulls
3. Floral Arrangement
4. Fish

5. Sun
6. Bean Dolls
7. Animal Groups

June 21 - September 20, 1967

SERGIO CASTILLO OF CHILE: OUTDOOR SCULPTURES

Since completion in 1910, the Pan American Union building and its Aztec garden have formed a center of attraction not only for visitors to Washington but also for residents of the city. This year, using the garden for a background, the Pan American Union is initiating a series of sculpture exhibitions, to be presented annually during the summer months. The sculptures, although they could be displayed inside, are designed for an outdoor setting--for parks and gardens, the approach to buildings, or even urban street corners--where they can be seen enhanced by natural light, vegetation, and direct contact with the movements of everyday life. Such works must not merely be weather-resistant, but must possess a certain grandeur, self-definitive form and volume, and strength to endure the effects of an ever-changing focus of sunlight on the surface without loss of value or interest. It is a case of what might be called sculpture in its purest form.

Opening this series of exhibits is the Chilean Sergio Castillo, a sculptor who has already attained a high reputation in his own country and elsewhere. Castillo has had fourteen one-man shows in Santiago, Lima, Paris, Rome, New York, and Washington. In 1962 a selection of his smaller sculptures was presented in the main gallery of the Pan American Union.

Castillo was born in Santiago in 1925. From 1948 to 1950 he studied at the School of Fine Arts and the Académie Julian in Paris, returning to his own country in 1952. He then enrolled in the School of Fine Arts of the University of Chile, remaining until 1956. He has won eleven prizes in salons and competitions in Chile, one of the most important being that given by Esso in 1964. Sculptures by Castillo are on display, both indoors and outdoors, in Chile and in New York, in banks, schools, and public office buildings. Small examples of his work are included in private collections in the United States, Latin America, Spain, France, Italy, and Sweden. Castillo is also represented in museum collections in Chile, Venezuela, and Peru.

The current exhibition, opening on the first day of summer, will close September 20. --*J.G-S.*

CATALOGUE

Outdoor Sculptures[1]

 1. *Puerta de la percepción (Door of Perception)*
 2. *Explosión (Explosion)*
 3. *Onda lunar (Lunar Wave)*
 4. *Guerrero (Warrior)*
 5. *Totem*
 6. *Templo (Temple)*
 7. *Hippie*
 8. *Ritmos (Rhythms)*
 9. *Torre de Babel (Tower of Babel)*
10. *Jangada (Raft)*
11. *Pachamama*
12. *Chuqui*
13. *Templo del Sol (The Sun Temple)*
14. *Kay Kay Villu*
15. *Entre Soles (Between Suns)*

[1] Nos. 13-21 were also exhibited although not included in the original catalogue. --*Ed.*

16. *Ho-Oh Sin*
17. *Pillán*
18. *Nacimiento (Birth)*
19. *Desarrollo horizontal (Horizontal Development)*
20. *Pequeña explosión (Small Explosion)*
21. *Blow-Up*

July 11 - August 7, 1967

MARIA SEÑERIZ OF PUERTO RICO: CARDBOARD RELIEFS

While there has been a tendency among certain Puerto Rican artists to look to the Mexican muralists for inspiration, the style and techniques of those masters have been adapted to suit the islanders' needs for personal expression. Such, for example, has been the case with María Señeriz, although her work at present shows only slight traces of Mexican influences.

María Rodríguez Señeriz was born in Río Piedras, Puerto Rico, in 1929. She began her art studies in 1949 at the University of Puerto Rico, continuing them at the Art Students League in New York the following year. Thereafter she studied at the Academy of Fine Arts in Florence, the Grande Chaumière in Paris, the Academy of San Fernando in Madrid, and the School of Painting and Sculpture of the National Institute of Fine Arts in Mexico City. Miss Señeriz has worked in the media of painting, drawing, and sculpture and has recently completed the series of polychrome cardboard reliefs which constitute the present exhibition--her first at the Pan American Union.

Miss Señeriz has had individual shows at the Gallery of the Art Students League, 1950; the Museum of the University of Puerto Rico, 1950, 1962, and 1965; the Palazzo Davanzati in Florence, 1951; and the Ogunquit Art Center in Maine, 1957. Works by her have been included in group shows in New York and Mexico and are to be found in public and private collections in Puerto Rico and the continental United States.

CATALOGUE

Polychrome Cardboard Reliefs

1. *Antillean Venus*
2. *José with His Cherished Transistor Radio*
3. *Head*
4. *Happy Smoker*
5. *Construction Worker*
6. *Girl in Mini-Skirt*
7. *Smiling Boy*
8. *Nude*
9. *Farmer*

Drawings for Relief Sculptures

10. *Cocktail Time*
11. *Woman's Head*
12. *Nude*
13. *Girl in Mini-Skirt No. 1*
14. *Girl in Mini-Skirt No. 2*
15. *Eternal Struggle*

August 21 - September 15, 1967

CHACON OF VENEZUELA: THE PLANETS

Of all Latin American artists, the Venezuelans are perhaps the most given to experimentation. They are constantly in search of new techniques and drive to expand the dimensions of familiar media. The country rewards their efforts by supporting even the most radical ventures of the avant-garde in the plastic arts.

Characteristic of this pioneering spirit is Luis A. Chacón, who for some years has been exploring the possibilities of the graphic arts. Breaking the bounds of tradition, he has created what he calls object-engravings. Under the generic title of *The Planets*, Chacón's object-engraving generally consists of an engraved circle of metallic foil (copper, aluminum, or zinc being most frequently used), mounted on another, more widely extending engraved surface. The combination is encased in a box which both serves as a frame and constitutes a part of the composition. Single colors dominate, as a rule, and are explored in all their contrasts and variations.

Chacón was born in Maracaibo in 1927. He began his studies of art while still in secondary school and continued them at the Cristóbal Rojas School of Fine Arts in Caracas. From 1946 to 1951 he lived in Spain, taking summer courses at the School of Fine Arts of Barcelona and at the institution known as La Lonja.

The artist has had one-man shows in Barcelona, Brussels, Madrid, Rotterdam, and in his own country at the Fine Arts Center of Maracaibo, at the Museum of Fine Arts, and Galería G in Caracas. Since 1950 he has taken part in group shows in Argentina, Belgium, Chile, Italy, the Netherlands, Norway, Poland, and Yugoslavia, as well as in his native Venezuela. In 1968 he is to exhibit at the Skopje Museum in Yugoslavia and the Dalarnas Museum in Falun, Sweden. Examples of his work are to be found in both public and private collections in Europe, the United States, and Latin America.

This is the first presentation of Chacón's compositions in the Pan American Union. --*J.G-S.*

CATALOGUE

Object-Engravings

1-20. *Serie de los planetas (The Planets Series)*[1]

September 18 - October 8, 1967

CONTEMPORARY ART OF CHILE

This exhibit represents a part of what is being accomplished in Chile by young men and women who are striving to find an authentic artistic expression through different forms and techniques. With their imagination and sensitivity these artists are able to create an image of Chile beyond any frontier, thus serving their country in a unique way.

We are very happy to present this exhibition of Chilean contemporary art on the occasion of the celebration of the 157th Anniversary of the Independence of Chile. --*Radomiro Tomic*, Ambassador of Chile; *Alejandro Magnet*, Ambassador Representative of Chile to the Organization of American States.

The University of Chile, with the cooperation of the University of California and support from the Ford Foundation, last year organized an exhibition of contemporary Chilean art which circulated on the west coast of the United States. A selection of works from this collection is now presented at the Pan American Union under the auspices of Their Excellencies Alejandro Magnet, Ambassador Representative of Chile on the Council

[1] The list of works sent by the artist for this exhibition includes twenty engravings belonging to *The Planet Series*, with a description of each, but no titles. --*Ed.*

of the Organization of American States, and Radomiro Tomic, Ambassador of Chile to the United States of America.

Whereas in years past Chilean artists tended toward the academic and the descriptive, more recently they have exhibited great imagination and inventiveness. In all media--painting, sculpture, graphics--they evidence brilliant technique, based on sound knowledge and strict discipline. The current exhibit comprises works by a number of figures of distinction not only in their native land but throughout Latin America. --*J.G-S.*

CATALOGUE

Paintings

Nemesio Antúnez
1. *Cordillera adentro (Within the Mountains)*, 1962, 98 x 130 cm.

Federico Assler
2. *Insistently In*

José Balmes
3. *Peace*

Ernesto Barreda
4. *La ventana (Window)*

Gracia Barrios
5. *Figuration 22*

Enrique Castro-Cid
6. *Dead People*

Delia del Carril
7. *Horse*

Jorge Elliott
8. *Landscape in Central Chile*

Celina Gálvez
9. *Wings at Dawn*

Jaime González
10. *Towards the Hills*

Patricia Israel
11. *The Raped Moon*

Rebeca León
12. *Space II*

Luis Mandiola
13. *Composition in Metals*

Roberto Matta
14. *Spring*

Sergio Montecino
15. *Landscape of Chiloé*

Guillermo Núñez
16. *Letter for the Thirtieth Century*

Consuelo Orb
17. *Vase*

Rodolfo Opazo
18. *Waiting Room*

Carlos Ortúzar
19. *A Character from Choapa*

Eduardo Pérez
20. *Cayapu from the Andes*

Bernal Ponce
21. *Opening 2*

Israel Roa
22. *Sky*

Ramón Vergara Grez
23. *Untitled*

Dolores Walker
24. *A Monstrous Language*

Ricardo Yrarrázaval
25. *Figure Change I*

Enrique Zañartu
26. *The Beachcomber*

Sculptures

Felipe Castillo
27. *Mask*

Sergio Castillo
28. *Untitled*

Juan Downey
29. *Nostalgic Thing*

Juan Egenau
30. *Composition I*

Lily Garafulic
31. *Torso*

Sergio Mallol
32. *Chess Pieces*

Luis Mandiola
33. *Ceramic I*

Ricardo Mesa
34. *Feminine*

Raúl Valdivieso
35. *The Seed*

Matías Vial
36. *Bronze Figure*

Rosa Vicuña
37. *Witch Musician I*

Engravings

Roser Bru
38. *Man on Earth*

Delia del Carril
39. *Idol and Pain*

Jaime Cruz
40. *Mutation*

Santos Chávez
41. *Spring*

Juana Lecaros
42. *Women by a Mill*

Eduardo Pérez
43. *Torso*

María Luisa Señoret
44. *Women*

Mario Toral
45. *Totem 2*

Eduardo Vilches
46. *Untitled*

Bob Borowicz
47. *Nude 2*

BIOGRAPHICAL NOTES [1]

ASSLER, Federico. Painter, muralist, set and costume designer, architect, born in Santiago, Chile, 1929. Studied painting and drawing at the School of Fine Arts, Viña del Mar; architecture at the Catholic University, Valparaíso. In Santiago, has worked as a curator, Museum of Contemporary Art, University of Chile, since 1964; executed wall reliefs for an industrial building, 1965; created set and costume designs for Stravinsky's *The Fire Bird*, National Ballet, 1966; and since 1959 has held individual exhibitions. Participated in national and international group shows, including *Abstract Art*, Museo de Arte Contemporáneo, Santiago, 1960; Biennial of Paris, 1963, and São Paulo, 1967; *Art of Latin America since Independence*, Yale University and Texas University,

[1] Not included in the original catalogue. See Index of Artists for reference on those not listed here. *--Ed.*

circulating in the United States, 1966-67; and other exhibitions in the United States and Mexico. Won several national awards and the Government of Córdoba Prize (Argentina), Third American Biennial of Art, 1966.

BALMES, José. Painter, illustrator, born in Barcelona, Spain, 1927. Graduated from the School of Fine Arts, Santiago, 1949, under the direction of Pablo Burchard and Gustavo Carrasco. Traveled in Italy, France, and Spain through a University of Chile scholarship, 1954-56. At present, is a professor of painting and composition, University of Chile. Illustrated several books. Member of the *Grupo Signo*, Spain, with whom he exhibited in Madrid and Barcelona, 1962. Held individual exhibitions in Santiago, Buenos Aires, and Barcelona. Participated in national salons and international shows, including the Biennial of São Paulo, 1951-53, 1957-59, and 1965; Biennial of Mexico, 1958-60; Salon de Mai in Barcelona, 1962. Was awarded First Prize, National Salon of Santiago, 1958 and 1963; Prize B, Youth Biennial, Paris, 1961, among other prizes. Lives in Chile and is a Chilean citizen.

BOROWICZ, Bob. Graphic artist, photographer, born in Poland, 1922. Studied photography in Vienna. Took it up professionally ten years ago and at present teaches photography at the Catholic University, Santiago. Held individual exhibitions in Santiago. Participated in national salons and international group shows in Latin America, the United States, and Europe. Was awarded Gold Medal, Baltimore Museum of Art; Medal of the City of Antwerp, Belgium; Grand Prize Bernardo O'Higgins, Santiago; and special awards in the São Paulo Biennial and in Milan (Italy). Lives in Chile.

BRU, Roser. Painter, draftsman, printmaker, born in Barcelona, Spain, 1923. In Santiago, graduated from the School of Fine Arts of the University of Chile and worked at the Taller 99, a cooperative print workshop of the Catholic University. Since 1955 has held individual exhibitions in Santiago, Buenos Aires, and Barcelona. Participated in national and international group shows, including the Biennial of São Paulo, 1957 and 1963; Biennial of Mexico, 1958-60; Biennial of Tokyo, 1960; Biennial of Córdoba (Argentina), 1962-66; Biennial of Santiago de Chile, 1963-65; *Art of Latin America since Independence*, Yale University and Texas University, circulating in the United States, 1966-67. Was awarded First Prize at the 1956 and 1961 National Salon and at the Second Print Biennial, 1965, both in Santiago. Has lived in Chile since 1939 and is a Chilean citizen.

CARRIL, Delia del. Painter, draftsman, printmaker, born in Saladillo, Buenos Aires, Argentina, 1886. Studied with André Lhote and Fernand Léger and later on, in 1954-55 and 1961, with Stanley W. Hayter in Paris and with Nemesio Antúnez in Santiago (Chile), 1958. Member of the Taller 99 of the Catholic University in Santiago, participated in its group exhibitions. In 1954 took up printmaking exclusively. Since 1960 has held individual exhibitions in Santiago, Buenos Aires, Paris, Moscow. Participated in national and international shows such as the Biennial of Santiago de Chile, 1963, and the Biennial of Córdoba (Argentina), 1966; *Art of Latin America since Independence*, Yale University and Texas University, circulating in the United States, 1966-67; International Show of Engraving, Vancouver, 1967. Took up residence in Santiago de Chile in 1937.

CASTILLO, Felipe. Sculptor, born in Santiago, Chile, 1931. Studied at the School of Fine Arts, University of Chile, Santiago, 1953; Ecole des Beaux-Arts, Paris, 1960. Held one individual exhibition in Santiago, 1966. Participated in national salons and the Chilean art exhibit held at the University of California, Los Angeles, 1963. Was awarded prizes in Santiago, 1966, and at the Summer Salon of Viña del Mar, 1967.

CHAVEZ, Santos. Graphic artist, born in Canihual, Arauco, Chile, 1934. Studied in Chile at the Sociedad de Bellas Artes, Concepción, 1955-60; Taller 99, Catholic University, under Nemesio Antúnez, Santiago, 1961-62; Print Workshop, School of Applied Arts, University of Chile, Santiago, 1963-66. Held individual exhibitions in Concepción, Santiago, and Buenos Aires. Participated in national and international shows, including the American Biennial of Print, Santiago, 1963-65; *Art of Latin America since Independence*, Yale University and Texas University, circulating in the United States, 1966-67; International Show of Engraving, Vancouver, 1967; and other group shows in Cuba, the United States, and Yugoslavia. Was awarded the Andrés Bello Prize, Official Salon, Santiago, 1966.

CRUZ, Jaime. Painter, printmaker, born in Concepción, Chile, 1934. In Santiago, graduated from the School of Fine Arts of the University of Chile and worked at the Taller 99 of the Catholic University; also studied in Brazil, under a Brazilian scholarship, 1963. Held individual exhibitions in Santiago, Valparaíso, and Concepción. Published a portfolio of his work in Rosario (Argentina), 1966. Participated in national salons and international group exhibitions, including the Fifth International Biennial of Prints, Tokyo, 1966. Won first prizes for drawing

and prints at national salons in Valparaíso, 1963, and Santiago, 1965.

ELLIOTT, Jorge. Painter, author, theatre director, born in Iquique, Chile, 1916. Studied with Arturo Gordon at the School of Fine Arts in Viña del Mar and under the English painter John Duguid. Graduated from the Chilean Naval Academy; worked for Panagra, traveling all over South America; published an anthology of Chilean modern poetry; under a Hispanic Council scholarship, lived in England, 1946-48, studying English literature and lecturing in different universities; was a John Hay Whitney visiting professor in the United States and taught at the University of Wisconsin, 1958; professor of literature as well as of history of art which he taught at the School of Fine Arts in Concepción, where he also founded and directed the University Theatre. At present is the director of the Institute of Visual Arts at the University of Chile. Held individual exhibitions in Concepción and Santiago (Chile), New York, Appleton (Wisconsin), and London. Participated in national and international shows in England and the United States. Was awarded prizes in national salons, including First Prize, Summer Salon of Viña del Mar, 1964.

GALVEZ, Celina. Painter, draftsman, born in Santiago, Chile, 1936. Studied at the School of Fine Arts, University of Chile. Since 1959 has held individual exhibitions in Santiago and participated in national salons and group exhibitions abroad, including *Exposición Hispanoamericana*, Montevideo, 1966; and *Chilean Painters*, Lima, 1965, and New York and California, 1966-67. Won prizes in national salons, 1963 and 1965.

GARAFULIC, Lily. Sculptress, printmaker, born in Antofagasta, Chile, 1914. Studied at the School of Fine Arts, University of Chile. Has been a Guggenheim scholar, 1944-45, and worked with José de Creeft and Stanley W. Hayter in New York. Through a scholarship granted by the University of Chile, where she is a professor at the School of Fine Arts, studied mosaic art in Europe and the Near East, 1957. Has held individual exhibitions in Santiago since 1944. Participated in national salons and Chilean art exhibitions in Argentina, Colombia, and the United States; São Paulo Biennial, 1951-53, 1957, and 1963. Won numerous awards including first prizes in national salons.

GONZALEZ, Jaime. Painter, architect, born in Santiago, Chile, 1934. Graduated from the School of Architecture of the Catholic University, where he is currently a professor of painting. Studied art at the School of Fine Arts, University of Chile. Held individual exhibitions in Santiago. Participated in national salons and international shows, including *Chilean Art*, Museum of Modern Art in Rio de Janeiro and Buenos Aires, 1961; Biennial of Córdoba (Argentina), 1962; *Art of America and Spain*, Instituto de Cultura Hispánica, Madrid, touring Europe, 1963-1964; *Art of Latin America since Independence*, Yale University and Texas University, circulating in the United States, 1966-67. Was awarded prizes in national salons.

ISRAEL, Patricia. Painter, printmaker, born in Temuco, Chile, 1939. Studied in Santiago (Chile) at the Academia Tótila Albert, 1950-51; School of Fine Arts, University of Chile, 1958-63, under Eduardo Bonati, José Balmes, and others. Held individual exhibitions in Washington, D.C., 1963, and Santiago, 1966. Participated in national salons; Biennial of Santiago de Chile, 1963-65; and the American Art Biennial of Córdoba (Argentina), 1966. Was awarded several prizes in national salons, including First Prize for Painting, 1962, and the Maruja Burchard Prize, 1966.

LECAROS, Juana. Painter, draftsman, printmaker, born in Santiago, Chile, 1920. Studied at the School of Fine Arts, University of Chile. Currently is a professor of plastic arts, Catholic University. Since 1951 has held individual exhibitions in Santiago. Since 1952, in addition to the First Inter-American Biennial of Painting and Print, Mexico City, 1958, has participated in numerous Chilean group shows in Buenos Aires, Caracas, Washington, D.C., Lima, Rio de Janeiro, and New York.

LEON, Rebeca. Painter, draftsman, born in Chile, 1937. Studied at the School of Fine Arts, University of Chile in Santiago. Exhibited in individual and group shows in Santiago. Won several national awards, including the Drawing Award at the 1960 National Salon of Santiago and First Prize at the Summer Salon of Viña del Mar, 1961.

MALLOL, Sergio. Sculptor, born in Santiago, Chile, 1922. Studied at the School of Fine Arts of the University of Chile in Santiago and the Slade School of Fine Arts in London. Has been a British Council and a UNESCO scholar. Held individual exhibitions in Santiago. Participated in national and international exhibitions, including

the Sculpture Biennial of Santiago and the São Paulo Biennial, 1951-53 and 1959. Won several awards including first prizes at national salons in Santiago and Viña del Mar.

MANDIOLA, Luis. Painter, draftsman, printmaker, sculptor, ceramist, born in Santiago, Chile, 1934. Studied at the School of Fine Arts of the University of Chile and worked at the Taller 99 of the Catholic University. Held individual exhibitions in Santiago. Participated in group exhibitions in Chile, the United States, and Germany. Among other awards, won First Prize for Ceramics, Plastic Arts Fair, Santiago.

MESA, Ricardo. Sculptor, born in Cauquenes, Chile, 1931. Studied at the School of Fine Arts, University of Chile, Santiago; Istituto Statale d'Arte, Florence; Akademie der Bildenden Künste, Munich. Currently is a professor of sculpture at the University of Chile. Held one individual exhibition in Santiago. Participated in national salons and art salons of the Akademie der Bildenden Künste, Munich. Won several awards including First Prize, National Salon, 1960; First Prize for the Monument to Manuel Rodríguez; Special Award, International Competition, Monument Playa Girón, Cuba.

ORB, Consuelo. Painter, born in Santiago, Chile, 1942. Graduated from the School of Fine Arts, Catholic University of Santiago, 1962. Held one individual exhibition in Santiago, 1962. Participated in national salons and group shows abroad, including *Art of Latin America since Independence*, Yale University and Texas University, circulating in the United States, 1966-67. Won special awards at national salons, 1962, 1963, and 1965.

ORTUZAR, Carlos. Painter, sculptor, illustrator, born in Santiago, Chile, 1935. Studied at the School of Fine Arts of the University of Chile in Santiago. Illustrated *Arte de pájaros* by Pablo Neruda and other publications. Held individual exhibitions in Santiago. Since 1958 has participated in national salons; Biennial of Paris, 1961; Biennial of Córdoba (Argentina), 1962-64; Biennial of São Paulo, 1963; *Chilean Art*, Museum of Modern Art of Buenos Aires and Rio de Janeiro, 1961. Won several prizes at national salons and the First Prize for Painting, Plastic Arts Fair, Santiago, 1959.

PEREZ, Eduardo. Painter, draftsman, printmaker, born in Santiago, Chile, 1937. Studied architecture, University of Chile at Valparaíso; also studied art, School of Applied Arts, University of Chile in Santiago. Held individual exhibitions in Santiago and at the Museum of Modern Art of Rio de Janeiro, both in 1965. Participated in national salons and the American Biennial of Print, Santiago, 1963-65. Was awarded several prizes, including the Andrés Bello Award, National Salon, 1965.

PONCE, Bernal. Painter, printmaker, born in Valparaíso, Chile, 1938. Graduated as an architect, University of Chile in Santiago. Studied art under Hermosilla Alvarez in Valparaíso and at the School of Applied Arts, University of Chile in Santiago; worked at Stanley W. Hayter Workshop in Paris. Held individual exhibitions in Santiago, New York, Paris. His group exhibitions include Atelier 17 (Hayter's), Bologna and New York; São Paulo Biennial, 1963; *Art of Latin America since Independence*, Yale University and Texas University, circulating in the United States, 1966-67. Was awarded several prizes in Chile.

ROA, Israel. Painter, muralist, born in Angol, Chile, 1909. Studied at the School of Fine Arts, University of Chile, under Juan Francisco González; through a Humboldt scholarship, 1927, studied two years in Berlin. Also studied one year in Brazil. Traveled in Europe. At present is a professor at the University of Chile. Held numerous individual exhibitions in Santiago and abroad. Participated in national salons and Chilean and international exhibitions abroad, including Pittsburgh International, Pennsylvania, 1935; *Latin American Exhibition of Fine and Applied Art*, Riverside Museum, New York, 1939; *Golden Gate International Exposition*, San Francisco, 1940; Biennial of São Paulo, 1951-53; Biennial of Mexico, 1960; *Art of Latin America since Independence*, Yale University and Texas University, circulating in the United States, 1966-67. Won many awards, including first prizes for both painting and watercolor in national salons.

SEÑORET, María Luisa. Painter, printmaker, born in Viña del Mar, Chile, 1920. Studied at the School of Fine Arts, University of Chile; Académie de la Grande Chaumière and Ecole des Beaux-Arts, Paris; Academy of Fine Arts, Florence; Iowa State University, under Mauricio Lasansky; Otis Art Institute and University of California, Los Angeles. Held individual exhibitions in Chile and the United States. Exhibited in national salons; São Paulo Biennial, 1953; Third National Biennial of Print, Pasadena, and other group shows in Chile and the United States. Was awarded Prize for Painting, 1957, and First Prize for Engraving, 1963, at national salons.

VIAL, Matías. Sculptor, printmaker, born in Santiago, Chile, 1931. Studied at the School of Fine Arts, University of Chile in Santiago; Escuela Santa Isabel de Hungría, Seville; Iowa State University under Mauricio Lasansky. Held individual exhibitions in Santiago. Has exhibited in national salons since 1954; Biennial of Mexico and Tokyo, both in 1960; *Chilean Art*, Museum of Modern Art in Rio de Janeiro and Buenos Aires, 1961. Was awarded First Prize for Sculpture, National Salon, 1959, among other prizes.

VICUÑA, Rosa. Sculptress, born in Santiago, Chile, 1925. Studied at the School of Fine Arts of the University of Chile in Santiago and Columbia University in New York. Held individual exhibitions and participated in group shows in Santiago. Won several national awards including First Prize, Sculpture Biennial, Santiago, 1963, and First Prize for Sculpture, National Salon, 1965.

VILCHES, Eduardo. Printmaker, born in Concepción, Chile, 1932. Studied printmaking at Taller 99 of the Catholic University in Santiago, 1958-59, and Yale University, New Haven, 1960-61. Since 1962 has been a professor of printmaking, Catholic University. Held one individual exhibition in Santiago. Participated in Chilean exhibitions at the Museum of Modern Art of Rio de Janeiro and Buenos Aires, 1961; and in Mexico and Los Angeles, 1966; Biennial of Tokyo, 1962; Biennial of Santiago de Chile, 1963; Biennial of Ljubljana, 1963-67; Biennial of São Paulo, 1965; and Biennial of Krakow, 1966; *Contemporary South American Art*, Berlin, 1963; and *Art of Latin America since Independence*, Yale University and Texas University, circulating in the United States 1966-67.

WALKER, Dolores. Painter, draftsman, printmaker, born in Purén, Chile, 1931. Studied at the School of Fine Arts, University of Chile; School of Applied Arts, Prague, 1957. Traveled in France and Spain. Currently is a professor at the School of Fine Arts, University of Chile. Held one individual exhibition in Santiago. Participated in national salons; Biennial of Santiago de Chile, 1963-65; Biennial of Prague; exhibition of engravings in Madrid and *Chilean Painting* in Los Angeles, 1966. Was awarded prizes in national salons, including First Prize for Drawing.

October 10 - 29, 1967

CHONG NETO OF PANAMA: OILS AND DRAWINGS

An outstanding new personality in the panorama of Panamanian art is that of Manuel Chong Neto. The strong, almost monumental, sculptural forms that dominate his work are enhanced by his skill as a draftsman; painterly qualities are preserved by the softening of volume in a diffused twilight which renders contours all but imperceptible. Chong's palette is a subtly somber one; his compositions are pervaded by both mystery and humor.

Chong Neto was born in Panama City in 1927. Originally self-taught, he later studied for two years at the National School of Plastic Arts of the University of Mexico. Since 1959 he has held six one-man shows in his native country, two of them (1965, 1966) under the auspices of the Panamanian Institute of Art. Examples of his work have figured in group shows throughout Latin America and were included in the Panamanian section of the Eighth São Paulo Biennial.

This is the first presentation of the work of Manuel Chong Neto in the United States.--*J.G-S.*

CATALOGUE

Oils

1. *Rostros contemplando un suceso (Human Faces Contemplating a Happening)*
2. *Aguacates (Avocados)*

3. *Bodegón gris de los pescados (Fishermen's Blue Tavern)*[1]
4. *Placidez rosa (Pink Serenity)*
5. *Pargos colorados (Colored Porgy)*[1]
6. *Dama de la noche (Lady of the Night)*
7. *Dama en cuclillas (Lady Crouching)*
8. *Espera en rojos (Wait in Reds)*
9. *Muñeca y perro negro (Doll and Black Dog)*
10. *Casa suburbana (Suburban House)*
11. *Telepersonajes: dos villanos y una dama (Television Characters: Two Villans and a Lady)*
12. *Bodegón con calavera (Tavern with Skull)*[1]
13. *Alegre dama del vestido verde (Happy Lady Dressed in Green)*
14. *Oligarca (Oligarch)*
15. *Pescados gordos (Fat Fish)*
16. *Dama en grises (Lady in Grays)*
17. *Pareja vestida de negro (Couple Dressed in Black)*, 1967, oil on canvas, 48 x 33"
18. *Torso*
19. *Desnudo (Nude)*
20. *Seres que vegetan (Beings That Vegetate)*
21. *Tres mujeres (Three Women)*
22. *Dama con guantes verdes (Lady with Green Gloves)*
23. *Pareja (Couple)*
24. *Pequeña dama en rojo (Small Lady in Red)*
25. *Laxitud (Laxity)*

1-20. Drawings[2]

October 30 - November 19, 1967

PEREZ CELIS OF ARGENTINA

The art of America's pre-Columbian past has become in the mid-twentieth century a living force, influencing painters and sculptors of a number of Latin American countries in widely varying ways. In the case of the Argentine Pérez Celis, his aim is neither to copy the patterns characterizing the early Indian cultures nor to adopt the solutions reached by ancient artists, but to recapture the sense or spirit of form which their work displays. Pérez Celis's paintings, with their brilliant colors and calligraphic designs, reflect no given work, period, or culture; they are, rather, well-calculated studies of the resources which pre-Columbian art offers for development.

Pérez Celis was born in Buenos Aires in 1939. Self-taught, he has been exhibiting publicly since 1956. He has had nine one-man shows in the Argentine capital, including an exhibition of tapestries, and one in Lima at the Institute of Contemporary Art, 1964. He has also participated in thirty-six group shows, in Argentina, Japan, Peru, and Spain. Examples of his work are to be found in the Museum of Modern Art of Bogotá, Buenos Aires, and New York, and in numerous other collections, public and private.

This is the first presentation of the compositions of Pérez Celis in the Washington area, and the artist's first one-man show in the United States. --*J.G-S.*

[1] Although *bodegón* also means "tavern", in art it is usually translated as "still life." Therefore, literal translation of no. 3 is "Still Life with Fish" and of no. 12 is "Still Life with Skull." Literal translation of no. 5 is Red Porgy." --*Ed.*

[2] Titles are unavailable.--*Ed.*

CATALOGUE

Paintings

1. *Cruz al tiempo (Timely Cross)*, 40 x 50 cm.
2. *Vuelo cósmico (Cosmic Flight)*, 91 x 50 cm.
3. *Fruto-átomo (Fruit-Atom)*, 50 x 60 cm.
4. *Cruz-vuelo-tiempo (Cross-Flight-Time)*, 60 x 70 cm.
5. *Cruz-tiempo (Cross-Time)*, 60 x 70 cm.
6. *Los hermanos sean unidos (Brothers Should Be United)*, 60 x 70 cm.
7. *Serpiente y tiempo (Serpent and Time)*, 60 x 70 cm.
8. *Máscara y tiempo (Mask and Time)*, 60 x 70 cm.
9. *Serie de la misa criolla (From the Series of the Creole Mass)*
10. *Mano productiva (Productive Hand)*, 73 x 92 cm.
11. *Vuelo (Flight)*, 73 x 92 cm.
12. *La serpiente y la cruz (The Serpent and the Cross)*, 90 x 110 cm.
13. *Bomba cristianizada (Christianized Bomb)*, 90 x 100 cm.
14. *De la tierra cósmica (From the Cosmic Earth)*, 100 x 120 cm.
15. *Ante la bomba (Before the Bomb)*, 90 x 120 cm.
16. *Bomba para todos (Bomb for Everybody)*, 90 x 120 cm.
17. *Bomba constructiva (Constructive Bomb)*, 90 x 120 cm.
18. *Serpiente y átomo (Serpent and Atom)*, 120 x 150 cms.
19. *Crucifixión dinámica (Dynamic Crucifixion)*, 120 x 150 cm.
20. *Serpiente y vuelo (Serpent and Flight)*, 150 x 150 cm.
21. *Mano al tiempo (Handling of Time)*, 132 x 162 cm.
22. *Escarabajo emplumado (Plumed Scarab)*, 132 x 162 cm.

Drawings[1]

October 30 - November 19, 1967

STEKELMAN OF ARGENTINA

Though a native of Argentina, Juan Carlos Stekelman has in recent years been pursuing his career as a graphic artist in the United States, making his home in New York. Born in Buenos Aires in 1936, he initiated his professional education at the Manuel Belgrano National School of Visual Arts, specializing in woodcut. He readily achieved success, obtaining a number of scholarships for advanced study. Since 1963 he has had three one-man shows in Argentina, and his graphics have been included in group exhibitions in both South America and the United States.

This is the first presentation of the work of Juan Carlos Stekelman in the Washington area.

CATALOGUE

Prints and Drawings

1. *Three Figures*, linocut, 14 x 20"
2. *Woman*, linocut, 17 x 24"
3. *Watusi Dancer*, linocut, 7 1/2 x 11"
4. *Unassembled Man*, linocut, 19 x 20"
5. *Dancing Girl*, linocut, 9 x 16"
6. *The Girl of the Kites*, linocut, 15 x 20"

[1] Titles are unavailable. --*Ed.*

7. *Spring*, linocut, 14 x 12"
8. *Happy Woman*, linocut, 15 x 20"
9. *Beach Party*, linocut, 15 x 14"
10. *Face,* linocut, 12 x 20"
11. *Face and Star*, linocut, 18 x 15"
12. *Smiling Face*, drawing, 19 x 16"
13. *Face in a Dream,* drawing, 14 1/2 x 23"
14. *The Red Flowers*, drawing, 22 x 11 1/2"
15. *Portrait*, drawing, 17 x 22"
16. *Man with a Hat*, drawing, 20 x 22"
17. *Scared Girl*, linocut, 22 x 14"

November 16 - December 4, 1967

PIÑEROSS OF COLOMBIA

The paintings of the Colombian Jorge Piñeross, who has lived in Spain for a number of years, reflect the expression and spirit that are traditionally linked with Spanish art. This is particularly evident in the use of austere and somber color and the detailed vision of imaginative forms.

Jorge Piñeross was born in Bogotá in 1929. In 1949 he went to Spain, where he is currently a resident, and enrolled for a year in the San Fernando Academy of Fine Arts in Madrid. He has held three one-man shows in his native country since 1953 as well as six in Spain, the most recent being at the Neblí Gallery in Madrid during the early part of this year. He has been represented in numerous group exhibits in Colombia, Spain, Italy, and Germany. This year the artist was awarded First Prize for Painting in the exhibition *Painters of America and the Philippines*, held in Madrid.

This is the first presentation of the work of Jorge Piñeross in the United States. *--J.G-S.*

CATALOGUE

Paintings

1. *Transmutación vegetal (Vegetal Transmutation)*, 182 x 114 cm.
2. *Vibración estructurada (Structured Vibration)*, 100 x 81 cm.
3. *Curva de la biósfera (Curve of the Biosphere)*, 150 x 105 cm.
4. *Espacios intercelulares (Intercellular Spaces)*, 100 x 81 cm.
5. *Evolución (Evolution)*, 162 x 114 cm.
6. *Construcción celular (Cellular Construction)*, 130 x 81 cm.
7. *Crecimiento articulado (Articulated Growth)*, 1957, mixed media, 162 x 114 cm.
8. *Xilema (Xylem)*, 150 x 90 cm.
9. *Núcleo cósmico (Cosmic Nucleus)*, 100 x 81 cm.
10. *Puntuaciones vegetales (Vegetal Punctuations)*, 150 x 105 cm.
11. *Entrenudo cortical (Vigorous Cortex)*, 130 x 81 cm.
12. *Células organizadas (Organized Cells)*, 1967, acrylic, 100 x 73 cm.
13. *Germinación espacial (Spatial Germination)*, 130 x 97 cm.
14. *Embrión (Embryo)*, 100 x 73 cm.
15. *Progresión cósmico-vegetal (Cosmic-Vegetal Progression)*, 182 x 100 cm.
16. *Abertura profunda (Fissure)*, 130 x 81 cm.
17. *Ordenación dinámica (Dynamic Order)*, 150 x 90 cm.
18. *Tejido y corteza (Tissue and Cortex)*, 100 x 73 cm.
19. *Estructura vegetal (Vegetal Structure)*, 182 x 114 cm.

November 16 - December 4, 1967

EDGAR TAFUR

Edgar Tafur is only one of the members of his family dedicated to the arts, his sister Alicia being an equally well recognized figure in the field of sculpture. Tafur, who was born in Cali, Colombia, in 1929, began studying architecture at the University of the Andes in Bogotá. Fourteen years ago, he came to the United States where he enrolled at the University of Florida and directed his interest toward sculpture. He later continued his studies at the University of Cincinnati, where he is currently professor of art.

Tafur has held several one-man shows and participated in numerous group exhibitions in the United States and Canada. His work, generally executed in metal that is either cast or welded, follows current trends of expressionism, and examples, in the form of three-dimensional sculptures, wall reliefs, and fountains, can be found in public buildings and gardens in the mid-western and eastern sections of the United States.

Robert Ayre, reviewing Tafur's work for the *Montreal Star*, comments: "The word for Tafur is gaiety. Humor, wit, lyricism, and information are combined with an essential tact and modesty and carried out with a technical skill."

This is the first presentation of the work of Edgar Tafur in the Washington area. *--J.G-S.*

CATALOGUE

Sculptures

1. *Columna (Column) No. 1*, 16 x 15"
2. *Columna (Column) No. 2*, 16 x 15"
3. *Columna (Column) No. 3*, 13 x 5"
4. *Columna (Column) No. 4*, 14 x 5"
5. *Columna (Column) No. 5*, 14 x 5"
6. *Columna (Column) No. 6*, 16 x 5"
7. *Columna (Column) No. 7*, 16 x 5"
8. *Columna (Column) No. 8*, 15 x 5"
9. *Columna (Column) No. 9*, 17 x 5"
10. *Columna (Column) No. 10*, 24 x 8"
11. *Dodecaedro (Dodecahedron)*, 5 x 22 x 22"
12. *Acuático (Aquatic)*, 10 x 5"
13. *Forma libre (Free Form)*, 36" x 4'
14. *Cúbico (Cubic)*, 14 x 14 x 14"
15. *Equilibrio (Equilibrium)*, 36 x 22 x 22"
16. *Eco (Echo)*, 8 x 8"

December 5, 1967 - January 1, 1968

OSCAR MERALDI OF URUGUAY

Following the tradition of realism in Uruguayan art, the subjects or themes of Oscar Meraldi's paintings range from portraits of famous personalities to port scenes.

Born in Montevideo in 1932, Meraldi entered the National School of Fine Arts in 1956, interrupting his studies there in 1958 to focus his attention on pre-Columbian and colonial art in Peru and Bolivia. In 1962 he was awarded a scholarship to study in Argentina, and in 1965 he concentrated on colonial and present-day art in Brazil. Last year Meraldi traveled and exhibited in Mexico, Central America, Europe, and the Near East. His most recent show was held in the Mexican Art Gallery in San Antonio, Texas, September 1967. Paintings by Meraldi are included in private and public collections in the United States and Latin America.

This is the first presentation of the work of Meraldi in the Pan American Union.

CATALOGUE

Paintings

1. *Cézanne*
2. *Figure*
3. *Figures*
4. *Composition*
5. *Still Life*
6. *Figure*
7. *Figures*
8. *Figure*
9. *Port 16*
10. *Port 65*
11. *Figure*
12. *Figure*
13. *Figure*
14. *Port 4*
15. *Port 5*
16. *Figures*
17. *Structure*
18. *Port 067*
19. *Port 14*
20. *Structure*

December 5, 1967 - January 1, 1968

FERNANDO MONTES OF BOLIVIA

Although he has lived in Europe for many years, Fernando Montes finds the themes for his paintings in the people and landscape of his native Bolivia.

Born in 1930 in La Paz, Montes first studied art in Buenos Aires and later in Santiago. In 1959 he was granted a scholarship by the Spanish government to study for two years in Madrid's San Fernando Academy of Fine Arts. He then moved to London where he has lived since 1961.

Fernando Montes has presented four one-man shows, including an exhibition at the St. Martin's Gallery in London, 1965, and another at the Charles Barzansky Gallery in New York, 1966. In 1959 he represented Bolivia at the Fifth São Paulo Biennial. He has participated in group shows in both Spain and England, and recently exhibited at the Royal Society of Portrait Painters in London.

This is the first exhibition of his paintings in the Washington area.

CATALOGUE

Oil on Canvas

1. *Mirando el horizonte (Watching the Horizon)*, 26 x 38 1/2"
2. *Caminando con el niño (Walking with the Child)*, 31 x 21"
3. *Descansando (Resting)*, 37 x 30"
4. *Pobre (Poor Woman)*, 24 x 30"
5. *En el templo (At the Church)*, 16 x 20"
6. *Después de trabajar (After Work)*
7. *Tejiendo en la tarde (Weaving in the Evening)*, 28 1/2 x 38 1/2"

8. *En un mercado (In a Market)*, 36 x 28 1/2"
9. *Finca al atardecer (Farm in the Evening)*, 49 x 36"
10. *Paisaje del lago (Landscape by the Lake)*, 41 x 55"
11. *Dos figuras al amanecer (Two Figures at Daybreak)*, 30 x 40"
12. *Mujeres aymarás (Aymara Women)*, 47 x 50"
13. *Día gris en los Andes (Gray Day in the Andes)*, 30 x 40"
14. *Pueblo en la montaña (Village in the Mountain)*, 22 x 25"
15. *Tres figuras (Three Figures)*, 16 x 20"
16. *Chola sentada (Chola Seated)*,[1] 17 x 15"
17. *Músicos (Musicians)*, 18 x 15"
18. *Sicuris y bombos (Sicuris and Drums)*,[2] 26 x 22"
19. *Grupo de aymarás (Aymara Group)*, 47 x 30"
20. *Paisaje del valle (Valley Landscape)*, 23 x 19"
21. *Casas de los Andes (Houses in the Andes)*, 22 x 25"
22. *Mujeres del altiplano (Women of the Altiplano)*
23. *Sembrado (Sowing)*
24. *Chipayas*

[1] Literal translation of *chola* is "mestizo woman." --*Ed.*

[2] A *sicuri, sikuri,* or *siku* is a panpipe. --*Ed.*

YEAR 1968

January 14 - 27, 1968

A PARTICULAR PORTION OF EARTH

An exhibition of the work of four painters of the Texas landscape and two sculptors in honor of the Organization of American States, and in the spirit of HemisFair, 1968, under the auspices of the Texas State Society of Washington, D.C., and its President, The Honorable J.J. Pickle, United States Representative from the Tenth Texas District, and the other officers and members of the Society.

INTRODUCTION

An exhibition is a visual library. Art objects permit one to see even familiar sights as something new. We look at art not to confirm our own vision but to broaden it. The familiar becomes art only if the hand and mind of the artist have added something which has not been noted before.

The four painters and two sculptors whose work is shown in this exhibition, all artists of maturity, belong generally to the same generation. The paintings, done over a period of twenty-five years, are of the Texas landscape. A small exhibition can do little more than suggest the excessive variety and exaggerations of this landscape. Missing here are the primeval tangle of the Big Thicket, the 360-degree horizon of the Llano Estacado, and many another smaller prairie, slow stream or stand of pine. What is shown is how the painters felt about the sea, jagged mountains, grasslands, cactus, palmettos, rocks, mesquite and pecan trees, rivers, thistles, and abandoned forts.

Otis Dozier has a naturalist's love for the earth, what it grows and what lives on it. He looks at a landscape and selects elements from it, a plant, rocks, a bird. He shows them in close-up: the landscape as still life.

Everett Spruce first recorded the elements of the landscape as brutal components, definitely and defiantly divided from each other. Later trees, rocks, and briars lose their divisions. Each becomes a part of the other. When Spruce records the Big Bend country it is not a lonely view. Each bush, tree, mountain, and cloud retains a part of the passion with which it was painted. The landscape is exploding.

William Lester's landscapes show rugged land, irregular, geometric hunks and layers of rock piled up into mountains and cliffs. The country has a builded look; Lester's landscapes are architectonic.

Loren Mozley looks at the landscape more closely than Lester and Spruce but from farther away than Dozier. Mozley is close enough for exquisite clarity but far enough away for the painter's symbols for reflections in water and leaves to create abstract patterns of color, not the least important of which are the blue-violet shadows creating zigzag spaces between rocks or cactus pads. The landscapes of Mozley are poetic geometry.

Two pieces of sculpture are included in the exhibition as essential parts of the Texas ambiance: a bronze steer by Charles Umlauf and a sleeping calf in limestone by Evaline Sellors. Until the most recent generation, domestic animals were a part of all Texans' visual environment. The form of animals has always attracted sculptors. Umlauf's lowing steer is made up of many curving forms. By accentuating the curving parts of the steer in motion, he has made graceful an animal that usually appears clumsy.

Miss Sellor's sleeping calf represents another approach to curves. While Umlauf's steer was built up in clay and later cast in bronze, the calf was locked within a piece of stone. The sculptress freed the calf by cutting away the superfluous parts. In doing this she maintained the solid character of the original rock and yet defined the calf.

Lloyd Goodrich, formerly Director of the Whitney Museum of American Art, in speaking of the work of these artists, said their "traits are not the outgrowth of the conscious regionalist creed and have no element of

chauvinism, as with the earlier regionalists. Rather, they are the natural and inevitable expression of artists long identified with a particular portion on the earth, and recording what they feel about its life and landscape." --*Sam Cantey III.*

ACKNOWLEDGEMENTS

The co-sponsor of the exhibition is the Texas Fine Arts Commission of which Mr. Theodore Strauss is chairman.

On behalf of the commission, the committee which chose the items and organized the exhibition was composed of:

Miss Ann Holmes, Fine Arts Critic, The *Houston Chronicle*; Member of the Advisory Council, College of Fine Arts, The University of Texas.

Mr. John Palmer Leeper, Director, The McNay Art Institute, San Antonio.

Dr. Donald Weismann, University Professor in the Arts, Humanities Research Center, The University of Texas, Austin; Member of the National Council on the Arts.

Mr. Sam Cantey III, Vice President, The First National Bank of Fort Worth; Past President, The Fort Worth Art Association; Founding Chairman, The Advisory Council, College of Fine Arts, The University of Texas.

The exhibition has been installed by Mr. José Gómez-Sicre, Chief, and his staff, Division of Visual Arts, Pan American Union, Washington, D.C.

This catalogue was designed by Bill Daniels of Susan Crane Packaging, Inc.

CATALOGUE

Painting

Otis Dozier
1. *Cactus and Crow*, 1947, oil on canvas, 24 x 48". Lent by The Dallas Museum of Fine Arts
2. *Summer*, 1954, oil on pressed wood, 30 x 48". Lent by The Witte Memorial Museum, San Antonio
3. *Tropical Pattern*, 1955, oil on canvas, 30 x 40". Lent by The Fort Worth Art Center Museum, The William Edrington Scott Collection
4. *Southwest Landscape*, 1958, oil on canvas, 24 x 48". Lent by The Fort Worth Art Center Museum, The Champlin Petroleum Company Collection
5. *Autumn Plants*, 1960, oil on Masonite, 24 x 29 3/4". Lent by The Fort Worth Art Center Museum, The Dr. and Mrs. John Swanson Collection

William Lester
6. *Mesquite Tree*, 1944, oil on board, 24 x 30". Lent by The Museum of Fine Arts, Houston, gift of the Marquis and Marquise d'Oyley
7. *White Cliffs*, 1948, oil on canvas, 24 x 30". Lent by The University of Texas Art Museum, The D.D. Feldman Collection
8. *Old Fort Davis*, 1949, oil on Masonite, 24 x 34". Lent by The Dallas Museum of Fine Arts
9. *Near Terlingua*, 1950, oil on Masonite, 24 x 36". Lent by The Fort Worth Art Center Museum, The Champlin Petroleum Company Collection
10. *Three Peaks*, 1956 (?), oil on Masonite, 30 x 43 3/4". Lent by The Dallas Museum of Fine Arts

Loren Mozley
11. *Big Pecans*, ca. 1952, oil, 30 x 24". Lent by the artist
12. *Pedernales Crossing, Cypress and Rocks*, 1959, oil on canvas, 40 x 48". Lent by the artist
13. *Pedernales Study*, 1959, oil on canvas, 16 x 20". Lent by the artist
14. *Village Beside the Highway*, 1963 (?), oil on canvas, 18 x 24". Lent by The Whitte Memorial Museum, San Antonio

15. *Green Landscape*, 1966, oil, 30 x 40". Lent by the artist
16. *Rocky Hillside*, 1966, oil, 30 x 40". Lent by the artist

Everett Spruce
17. *Green Hillside*, 1942, oil on Masonite, 16 x 24". Lent by The Museum of Fine Arts, Houston, gift from Friends of Art
18. *Autumn Landscape*, 1955, oil on Masonite, 36 x 30". Lent by The Dallas Museum of Fine Arts
19. *Rio Grande*, 1958, oil on Masonite, 30 x 40". Lent by The Fort Worth Art Center Museum, The Champlin Petroleum Company Collection
20. *The Cliff*, ca. 1959, oil on Masonite, 19 3/4 x 23 3/4". Lent by The University of Texas Museum, The D.D. Feldman Collection
21. *Wave Breaking*, 1959, oil on canvas, 30 x 40". Lent by The Whitte Memorial Museum, San Antonio
22. *Pecos*, oil on Masonite, 30 x 36". Lent by The Marion Koogler McNay Art Institute, San Antonio, bequest of Mrs. John W. Todd

Sculpture

Evaline Sellors
23. *Winter*, 1947, limestone, 5 1/4" high. Lent by The Fort Worth Art Center Museum

Charles Umlauf
24. *Steer*, 1951, bronze, 22" high. Lent by The Fort Worth Art Center Museum, gift of M. Knoedler and Company

BIOGRAPHICAL NOTES

DOZIER, Otis. Born in Forney, Texas, lives in Dallas. Taught at Colorado Springs Fine Art Center and since 1945 has taught at Southern Methodist University and the Dallas Museum School. He studied with Boardman Robinson. His work has been included in group exhibitions in San Francisco and in New York at the Museum of Modern Art, Metropolitan Museum, and Knoedler's. He has had one-man exhibitions in the museums of Fort Worth, Dallas, San Antonio, and at the University of Texas. Numerous awards in *Texas Annual* exhibitions. His work is presented regularly at the Nye Gallery in Dallas. His work is owned by the museums of Dallas, Fort Worth, Houston, San Antonio, Denver, Newark, Colorado Springs, and by several university art museums and many private collectors. He did murals for four post offices under the auspices of Public Works Art Project.

LESTER, William. Born in Graham, Texas, lives in Austin and is a professor of art at the University of Texas. He studied with Alexander Hogue in 1928 and Thomas Stell in 1930-32. He has had one-man exhibitions at the Dallas Museum, the Elizabeth Ney Museum and Laguna Gloria Gallery at Austin, Fort Worth Art Center Museum, the art department of several universities and the Passedoit Gallery in New York. Represented regularly in group exhibitions in Texas and the Southwest. Important purchase awards in *Texas Annual* exhibitions. Has been in exhibitions at the Denver Art Museum, the Virginia Biennial, the 1939 New York World's Fair, the National Academy, the Pennsylvania Academy, the Palace of the Legion of Honor in San Francisco, and others. Lester's paintings are owned by the museums of Dallas, Houston, Fort Worth, Metropolitan Museum in New York, Pennsylvania Academy of Fine Arts, and in many private collections.

MOZLEY, Loren. Born in Brookport, Illinois, brought up in New Mexico. Professor of art at the University of Texas. He studied at the University of New Mexico and pursued independent study in France and Italy. He has taught at the University of New Mexico and the National University of Mexico (Profesor extraordinario). He has exhibited in numerous regional and national exhibitions. A First Prize and other awards in *Texas Annual* exhibitions. His work is owned by Texas museums and by many private collectors. He has written on diverse subjects: "Yankee Artist," a portrait of John Marin, "The Colonial Churches," and "A Note on José Guadalupe Posada."

SELLORS, Evaline. Born and lives in Fort Worth, teaches in the schools of The Fort Worth Art Center Museum and the Dallas Museum of Fine Arts. Studied at the Pennsylvania Academy of Fine Arts under Charles Grafley and Albert Laessle; received two Cresson traveling scholarships to study abroad. More recently with Marguerite Wildenhain. She has exhibited at the Carnegie Institute in Pittsburgh, the De Young in San Francisco, the Denver Art Museum, at Knoedler's in New York, and in many traveling exhibitions. Received a Merit Award

for the Southwestern Region in the exhibition *U.S.A. '66* at the Craft Museum in New York. Her work is represented in the collections of the Dallas Museum of Fine Arts and Fort Worth Art Center Museum; bronze and stone sculptures, as well as ceramic work, are found in many private collections.

SPRUCE, Everett. Born near Conway, Arkansas, lives in Austin and is professor of art at the University of Texas. He studied at the Dallas Art Institute under Olin Travis and Thomas M. Stell. One-man exhibitions at museums in Dallas, San Antonio, Santa Barbara, the Arts Club in Washington, D.C., and the Hudson D. Walker, Mortimer Brandt, and Levitt Galleries in New York. A retrospective one-man exhibition was circulated nationally by the American Federation of Arts. Has participated in group exhibitions in museums in Kansas City, San Francisco, Chicago, Worcester, Denver, Dallas, Fort Worth, Houston, San Antonio. His work is owned by museums in Baltimore, San Francisco, Colorado Springs, Dallas, Fort Worth, Houston, San Antonio, New Orleans, Des Moines, Wichita, Kansas City, Newark, and by the Metropolitan Museum, the Whitney Museum, and the Museum of Modern Art in New York, and the Museu de Arte Moderna in Rio de Janeiro.

UMLAUF, Charles. Born in South Haven, Michigan, brought up in Chicago, lives in Austin. Professor of art of the University of Texas. Earned his first scholarship to the Art Institute of Chicago at the age of ten. Recently pursued independent study in Italy. Has had twenty-five one-man shows, four of which were in New York and one in Florence. He exhibits regularly in regional and national exhibitions of sculpture and ceramics. The International Religious Biennial sponsored by the United States Information Agency included his work, the exhibition originated in Salzburg and was shown in three places in Germany, three in Spain, and two in England. Commissioned to do work for the cities of Lubbock and Dallas and for the facade of the Witte Memorial Museum in San Antonio. Examples of his sculpture are found in the museums of Santa Barbara, Fort Worth, Houston, Dallas, San Antonio, Wichita, El Paso, Oklahoma City, and the Metropolitan Museum of New York. Work is owned by such private collectors as Edward G. Robinson, Ted Weiner, Ruth Carter Johnson, Robert Straus, Percy Selden, T.D. Hanley, and Robert Beverly Hale.

January 26 - February 19, 1968

HECTOR BORLA OF ARGENTINA: DRAWINGS

One of the outstanding personalities in contemporary Argentine graphic arts is that of Héctor Borla. Working in black and white, using a strong, fine line, he converts what could be mere illustration into highly sensitive forms, treating figures with a sense of humor that borders on caricature.

Borla was born in Santa Fe in 1947. In 1961 he obtained a scholarship from the National Fund for the Arts that enabled him to establish himself in Buenos Aires. He has since pursued an active professional career. He has participated in numerous national salons, winning several awards. He has taken part in Argentine group shows abroad, his compositions having thus far been presented in Germany, Italy, Spain, and the United States. In addition, since 1960 he has had seven one-man shows. Examples of his work are to be found in the Institute of Hispanic Culture in Madrid, the University of Texas Museum, the Brooklyn Museum, the Braniff International Collection, as well as in museums in Argentina.

This is the first presentation of the art of Héctor Borla in Washington. *--J.G-S*.

CATALOGUE

Drawings

1. *Mesa redonda (Round Table)*, 35 x 45 cm.
2. *Arco satánico (Satanic Ring)*, 35 x 45 cm.
3. *Himno celestial (Celestial Hymn)*, 35 x 45 cm.
4. *Ida y vuelta (Round Trip)*, 35 x 45 cm.
5. *Spring*, 35 x 45 cm.
6. *Sin salida (No Exit)*, 35 x 45 cm.
7. *El sueño de la razón produce monstruos, Goya* (The Dream of Reason Produces Monsters, Goya), 35 x 45 cm.

8. *Por sobre todos (Above All)*, 35 x 45 cm.
9. *Púlpito (Pulpit)*, 35 x 45 cm.
10. *Al cielo llegan los buenos (Heaven Is for the Good)*, 35 x 45 cm.
11. *Bien vs. mal (Good vs. Evil)*, 35 x 45 cm.
12. *Mens sana in corpore sano*, 35 x 45 cm.
13. *El último viaje (The Last Trip)*, 35 x 45 cm.
14. *La despedida (Farewell)*, 35 x 45 cm.
15. *El rendiconto*, 35 x 45 cm.
16. *El exorcismo (Exorcism)*, 24 x 30 cm.
17. *Paseo matinal (Morning Stroll)*, 23 x 26 cm.
18. *Los saludos (Greetings)*, 20 x 20 cm.
19. *Comfort*, 35 x 45 cm.
20. *The Rockettes' New Dance*, 35 x 45 cm.

January 26 - February 19, 1968

SUPISICHE OF ARGENTINA

Although one of the world's major cultural centers and the focal point of artistic endeavor in Argentina, Buenos Aires is far from absorbing all the creative energies of the country. While the pace of activity is slower in the provinces, such cities as Córdoba, Mendoza, Rosario, and Santa Fe are strong in their support of artists, art schools, galleries, and museums.

The current exhibition at the Pan American Union of the works of Ricardo Supisiche affords a view of a master artist thoroughly identified with the Argentine interior. The region along the Paraná River known as *el Litoral* forms what might be called "Supisiche territory," for it is in the flat, reddish plains and the people who live on them that he finds the subject matter for his paintings. The depiction is not literal. Supisiche has a schematic, idealistic sense of realism: he reduces his subjects to their essential elements, converting them into symbols of true plastic value. With subtle brushstrokes, using a palette approaching monochrome, he produces canvases in which lonely figures of persons, houses, and boats diffuse into misty, flat surroundings.

Ricardo Supisiche was born in Santa Fe in 1912 and only rarely has he traveled outside his native region, a brief visit to Italy being his major excursion. Although he studied drawing at a local academy, he is essentially a self-taught painter who has devoted his entire life to art.

His first one-man show took place at a flower shop in Santa Fe in 1937. Since that time he has had no fewer than thirty-four individual presentations in galleries and museums throughout Argentina, the last three at the Rubbers Gallery in Buenos Aires, which acts as his representative. Since 1942 he has participated in fifty-four important group exhibitions, not only in Argentina but in Guatemala, Honduras, Mexico, Nicaragua, and Uruguay, and he has won thirty-three awards in competitions. Examples of his work may be found in a number of Argentine museums and in private collections both in his native land and in the United States.

This is Supisiche's first one-man show outside Argentina. --*J.G-S.*

CATALOGUE

Oils

1. *La tormenta (The Torment)*,[1] 50 x 75 cm.
2. *La negra (The Negro Woman)*, 50 x 75 cm.
3. *El cajón (The Box)*, 50 x 75 cm.
4. *Figuras en la mañana (Figures in the Morning)*, 50 x 75 cm.

[1] Literal translation of this title is "The Storm." --*Ed.*

5. *La casa de Don Astrada (The House of Don Astrada)*, 70 x 100 cm.
6. *Viejas conversando (Old Women Talking)*, 50 x 75 cm.
7. *El cajón (The Box)*, 50 x 75 cm.
8. *Dos mujeres hablando (Two Women Talking)*, 50 x 75 cm.
9. *El trapo gris (The Gray Rag)*, 50 x 75 cm.
10. *Mujer en la soledad (Woman in Solitude)*, 50 x 75 cm.
11. *Pescador con sombrero (Fisherman with Hat)*, 50 x 75 cm.
12. *La mesa roja (The Red Table)*, 50 x 75 cm.
13. *Pescador (Fisherman)*, 50 x 75 cm.
14. *Tres mujeres en el paisaje (Three Women in the Plains)*,[1] 50 x 75 cm.
15. *Mujeres y cajones (Women and Boxes)*, 50 x 75 cm.
16. *El manto negro (The Black Cape)*, 50 x 75 cm.
17. *El pozo (The Well)*, 50 x 75 cm.
18. *Mujer frente a su rancho (Woman in Front of a Ranch)*,[1] 50 x 75 cm.
19. *Dos mujeres y un charco (Two Women and a Puddle)*, 70 x 100 cm.
20. *La pareja vieja (The Old Couple)*, 70 x 100 cm.

January 26 - February 19, 1968

LEOPOLDO PRESAS

Between the pioneer generation that laid the foundations of modern art in Argentina and the vanguard of today, which has introduced the most progressive trends in abstraction into the country, there comes a generation, now in its fifties, whose members--despite long years of patient effort--have only recently come to the fore and begun to receive the recognition that is their due. Prominent in this group are the figures of Vicente Forte, Julio Barragán, Ideal Sánchez, Bruno Vernier, and Leopoldo Presas. Presas, whose work is currently being exhibited, has won wide acceptance in the past decade and takes his place among the most brilliant of his contemporaries.

Viewed in retrospect, Presas's work evidences his total dedication to expressionism. It shows a continuous striving at psychological interpretation of the model, at conveying inner feeling or mood. It makes constant use of distortion, of vivid color applied in splashes, of vibration of the brushstroke, of interplay of light and shadow. Social comment makes a not infrequent appearance in Presas's work: there are irreverent references to historical personages and events, and basic matters of faith receive acid treatment, as evidenced by his handling of themes from the Old Testament.

Born in Buenos Aires in 1915, Leopoldo Presas attended the National Academy of Fine Arts for three years and later pursued his studies with the painter Lino E. Spilimbergo. In 1939 he exhibited for the first time, with the group known as *Orion*. His first one-man show took place in Buenos Aires in 1946. Since that time he has had a number of others, for the most part in his native country. The first in the United States was held at the Zegrí Gallery in New York in 1956; the second, a retrospective show of his work, at the Huntington Hartford Gallery of Modern Art of New York in November, 1967. The current presentation consists of a selection of works from the last-mentioned exhibition.

In a book entitled simply *Presas* (Buenos Aires, El Mangrullo, 1967), Rafael Squirru, Director of the Department of Cultural Affairs of the Pan American Union, wrote:

> The painting of Presas transcends the bounds of elegance, for beauty is something different from, and more profound than, mere prettiness. Despite the Italian approach Presas has taken to painting, the essentially Hispanic character of his art can easily prove a stumbling block to the sophisticated. His work has the nobility of a bull engaged in a headlong charge; it is rich in the same symbolic beauty as that scarcely to be termed pretty beast.

This is Presas's first individual presentation in the Pan American Union. *--J.G-S.*

[1] Literal translation of no. 14 is "Three Women in the Landscape;" and of no. 18, "Woman in Front of Her Hut." *--Ed.*

EXHIBITION LIST [1]

1. *¿Eli Eli Lama Sabachtani? Díos mío* (Eli Eli Lama Sabachtani? My God)
2. *El personaje (Character)*, from the *The Fat People Series*
3. *Procesión (Procession)*
4. *Composición con dos figuras (Composition with Two Figures)*
5. *The Poet and the Lady*
6. *Tango*
7. *Puerto (Port)*
8. *Composición (Composition)*
9. *Puerto (Port) No. 6*
10. *Virgen de las flores (Virgin of the Flowers)*
11. *Bethrodal*
12. *Saintly Prophets*
13. *The Professor and His Students*
14. *Autorretrato (Self-Portrait)*
15. *Elsa*
16. *El cerdo y su amante (The Pig and His Mistress)*
17. *Composición (Composition) No. 1*
18. *Composición (Composition) No. 2*
19. *Reyes de la podredumbre (Kings of Destitution)*
20. *Puerto (Port) No. 5*
21. *Dos figuras (Two Figures)*
22. *Composición (Composition) No. 3*
23. *Puerto (Port) No. 4*
24. *Puerto (Port) F*
25. *Desnudo (Nude)*
26. *Paisaje lunar (Lunar Landscape)*
27. *Figura (Figure)*
28. *La muchacha y el cerdo (The Girl and the Pig)*

February 20 - March 10, 1968

JOSE CASALS: PHOTOGRAPHS OF PERU [2]

Following the path taken by the plastic arts, photography in Latin America has turned toward a variety of basic realism in which the romantic or sentimental is abandoned for the strictly documentary, at times even the crude or the macabre. Latin America is in a ferment of economic and social development: sharp contrasts are everywhere evident in the manner of living and the appearance of the people of the area. These contrasts are put to advantage by the present generation of photographers. Adhering to rigid concepts of composition, striving for psychological penetration of the subject, which they render in harshly naturalistic terms, they often achieve a pungent satire, at times marked by dramatic or even tragic overtones. Their work, of high artistic merit, bears a distinctly Latin American imprint.

The Peruvian photographer José Casals has been active in a variety of fields--illustration, portraiture, fashion poses, and advertising and industrial work. No matter what the assignment, he always combines the greatest of technical proficiency with keen perception of the inherent artistic qualities of the subject.

Casals was born in Santiago, Chile, in 1931. For fourteen years he studied music, but in 1956 he took up photography with a view to a career in that field. Attracted by the subject matter afforded by the neighboring

[1] Not included in the original catalogue. --*Ed.*

[2] The list of works exhibited is unavailable. --*Ed.*

country of Peru, he established his studio there. He has participated in a number of group shows in his new homeland, including one at the Lima Museum of Art in 1963. His first one-man show took place at the Institute of Contemporary Art in the Peruvian capital in 1961. The following year he exhibited at the Gallery in the Pepsi-Cola Building in New York and figured in the photographic section of the Paris Biennial. In 1966 and 1967 his color reproductions of Peruvian folk art accompanied an exhibit of these objects that appeared at the Pan American Union and at the Los Angeles County Fair.

This is the first individual presentation of Casals's work in the Washington area. *--J.G-S.*

February 20 - March 10, 1968

SHINKI OF PERU

In that middle generation of artists who laid the foundations of modern art in Peru a leading personality is the Japanese-descent painter Shinki. His Oriental heritage is apparent in a delicacy and balance of subtly suggested forms. At the same time, evidencing the influence of the Latin American milieu, the forms in question are often reminiscent of pre-Columbian Indian motifs. The fusion of two widely separated cultures, as exemplified by the work of Shinki and other artists of Nipponese ancestry, both in Peru and in Brazil and other Latin American countries, constitutes a curious and distinctive variety of plastic abstraction.

Venancio Shinki was born in Lima in 1932. His formal education was obtained at the National School of Fine Arts, one of the outstanding teaching institutions in its field in South America. In accordance with its system, Shinki worked for two-year periods in the studios of leading artists of the country--in his case Alberto Dávila, Sabino Springett, and Ugarte Eléspuru. Graduating with honors, in 1963 he made his professional debut with a one-man show at the Art Center Gallery in Lima. Since that date he has had no fewer than six individual exhibitions at the most important galleries in that capital, among them two at the Institute of Contemporary Art, 1965-1966. Shinki participated in the Biennial of São Paulo, 1963, and of Córdoba, Argentina, 1964, and he has been represented in group shows of Peruvian art in Argentina, Chile, Colombia, Ecuador, and the United States--at the Corcoran Gallery of Art in Washington, the Philadelphia Civic Center Museum, and the IBM Gallery in New York, 1966 and 1967. He has won seven prizes, and examples of his work are to be found in numerous collections, private and public, in his native land.

This is the first individual presentation of the paintings of Shinki in the United States. *--J.G-S.*

CATALOGUE

Paintings

1. *Tierras de bien (Good Earth)*
2. *Encuentro (Meeting)*
3. *Viejo grande (Grand Old Man)*
4. *Gris (Gray)*
5. *Idolo (Idol)*
6. *Valle (Valley)*
7. *Procesión (Procession)*
8. *Araya*
9. *Chimucapac*
10. *Fardos (Bundle)*
11. *¿Adónde? (Where?)*
12. *Tumulto (Tumult)*
13. *Misa grande (Great Mass)*
14. *Sombra cálida fría (Warm Shade and Cold)*[1]

[1] Literal translation of this title is "Cold Warm Shade." *--Ed.*

15. *Vino (Wine)*
16. *Vieja, adiós (Goodbye, Old Lady)*
17. *Chancay*
18. *Primavera dentro (Spring Inside)*
19. *Castillo (Castle)*
20. *Mesa grande (Big Table)*

March 21 - 30, 1968

FLORIDA 17 [1]

When we want to learn about ancient Greece, we look first at her works of art. The same is true for Renaissance Italy or eighteenth century France. For we know from experience that the artist, whether he creates a perfect square or a Sistine ceiling, records his interactions with the realities and ideals of his time and consequently gives us a key to understanding those realities and ideals.

What we learn about Florida from this exhibition of seventeen leading artists of this state is not generally known; that is, that in addition to being a Land of Enchantment, Florida is a Land of Reality, grappling with the practical, philosophic, and aesthetic problems of contemporary life. The works of art indicate that foremost among these are the meaning of the human being in the contemporary world and the pre-eminence of technological over humanistic values.

Eight of the artists use the human figure. Significant, even astonishing, are the elements which their figures have in common. They are unsubstantial, often faceless, sometimes even headless, never identifiable as individual personalities. They occupy a space which is, like the figures themselves, not rationalized, but immeasurable. Integers among integers, subject to forces beyond their control, they represent the antithesis of the privileged and cultivated humanist man who was the ideal from the fifteenth to the twentieth century. Humanist man was conceived as the center and measure of all creation. He was endowed with will and reason by which he could control his passions and a considerable share of his destiny. Through the tools of his intellect--mathematics, science, and philosophy--he was convinced he could control nature. His actions were purposeful and meaningful. His space was limited and measurable. He was personified in rules, heroes, and thinkers who became models of human conduct.

Many of the bases of the classical humanist conception of man have been challenged by modern learning: by philosophy which defines man as a purely finite being; by biology which sees him as part of nature related to lemurs and mushrooms; by psychology which emphasizes the role of the irrational, the emotions, and the unconscious; by political science which accords human rights to barbarians as well as to civilized man; by mathematics which recognizes the insolubility of certain problems, to cite only a few.

Artists like Covington, Deshaies, Lotz, Massin, Rampolla, Rubadoux, Saff, and Williams are, each in his own way, still in the process of destroying the traditional image and of exploring and giving form to newly recognized aspects of man. Out of this exploration may eventually arise the image of a new humanist man adapted to a democratic, technological, mass civilization; but that day has not yet come.

Quite the opposite are the four nonobjective artists--Cox, Leeper, Manley, and Naylor--who optimistically embrace modern technology. They are not concerned with what they consider rather academic problems of human form and meaning, but enthusiastically create objects of beauty for the eye attuned to pure geometry or its engineering and mechanical applications. Using the tools, methods, and materials of modern technology, they create forms and relationships which in many cases could not have been made earlier. The artists of the early Renaissance were so enamored of mathematics and perspective that the story is told that Piero della Francesca's wife found him sitting up in bed in the middle of the night muttering: "Che bella cosa è la prospettiva." These

[1] This exhibition was presented by the Division of Visual Arts of the Department of Cultural Affairs, Pan American Union, and the Florida Development Commission. --*Ed.*

young artists, convinced that they have found the means of creating the visual world of the future, might well paraphrase Piero in declaiming: "What a beautiful thing is technology."

There are other artists in the exhibition with uniquely individual concerns. Solomon is the only artist immersed in Florida land and seascape, light and color from which he extracts his bold but simple segments of experience. Voelz has such a deep affinity for nature that even his metal and wood construction seems organic rather than technological and his thunderbird takes its place in a long American tradition. Zerbe concentrates on the aesthetic experience of rich surface pattern. Voichysonk creates a surrealist physiology. Pachner pours out his intense feelings in a landscape in which serenity and order are disturbed by portentous flame-like movements--a microcosm of the twentieth century world ceaselessly disturbed by real and impending crises.

The deep involvement of these artists with the realities of contemporary life implies that a large segment of Florida's population is equally involved. This, added to a favorable natural environment, an expanding professional population and rapid growth in higher education and technology, offer great hope that Florida may be a major center of creative civilization in the century to come. --*Kenneth Donahue*, Director, Los Angeles County Museum of Art.

ACKNOWLEDGEMENTS

The Florida Development Commission deeply appreciates the hospitality of the Pan American Union and the enthusiastic support of Dr. José A. Mora, Dr. Rafael Squirru, Dr. José Gómez-Sicre, Ramón G. Osuna, and their able staff. In arranging for the exhibition, the Commission was graciously assisted by Ambassador Sol Linowitz and Representative Don Fuqua of Florida's Second Congressional District. To Ernest Evans goes the Commission's special thanks.

The members of the Selection Committee--James R. Camp, Roy C. Craven, Jr., Dr. August Freundlich, Karl R. Nickel, and Richard L. Puckett--contributed generously in both time and effort. Without their professional advice and experienced counsel, the exhibition would not have been possible. To Kenneth Donahue, formerly Director of Florida's John and Mable Ringling Museum of Art, the Commission extends its thanks for the excellent introduction.

CATALOGUE

Painting, Drawing, and Sculpture

Harrison W. Covington
 1. *Cloaked Figure II*, acrylic and wood collage, 65 1/2 x 52". Collection of Mr. and Mrs. Henry Gardner, Tampa
 2. *Grey Man*, acrylic and marble dust, 65 x 51"

Ernest L. Cox
 3. *Slab II*, metal sculpture, 22 x 10 x 4"
 4. *Untitled No. 25*, welded steel sculpture, 24 x 34"

Arthur Deshaies
 5. *Mr. Kennedy Hello Miss Liberty*, relief engraving with acrylic, 42 x 29"
 6. *Sweep or Roll, Mr. Lincoln*, relief engraving with acrylic, 42 x 29"

Doris Leeper
 7. *Red Column*, enamel on plywood, 7 1/2' height x 17 1/2" square
 8. *Five Across Four Down*, enamel on plywood, 70 x 87 1/2"

Steven D. Lotz
 9. *Homage to Gary Downing*, diptych, white chalk and spray paint on black paper, 96 1/2 x 31"
10. *Three Untitled Drawings*, white chalk and spray paint on black paper, 96 1/2 x 31"

Bryn J. Manley
11. *This Time Gently*, shaped lithograph in Plexiglas box, 28 x 21 x 9 1/2"
12. *The Game on the Hill*, shaped lithograph in Plexiglas box, 28 x 21 x 7"

Eugene Massin
13. *Two Runners*, acrylic on canvas, 73 x 61"
14. *The Bathers*, acrylic on canvas, 64 x 98"

J. Geoffrey Naylor
15. *Catafalque*, aluminum and Formica, 8'6" x 10' x 1'6"

William Pachner
16. *Landscape of Crisis*, oil on canvas, 53 x 78"
17. *Large Summer Landscape*, oil on canvas

Frank Rampolla
18. *Tableau: The Actors*, oil on Masonite with paper collage, 84 x 96"
19. *Scherzo quasi una fantasia*, oil on canvas, 60 x 80"

Craig Rubadoux
20. *3*, oil on Masonite, 96 x 48"
21. *Start*, oil on Masonite, 96 x 48"

Donald J. Saff
22. *An American Lover*, drawing, 32 x 37"
23. *Paradise Lost No. 10*, drawing, 32 x 37"

Syd Solomon
24. *Shoremark*, oil on Masonite, 48 x 45"
25. *Beck and Call*, oil on Masonite, 40 x 40"

Bernard F. Voichysonk
26. *Untitled*, oil, 7 1/2' x 5'. Collection of Mr. and Mrs. Jerry Uelsmann, Gainesville
27. *Untitled*, oil, approx. 6 1/2' x 48"

Vernon Voelz
28. *Thunderbird*, metal sculpture, 8' x approx. 54" (wingspread)
29. *In and Out*, metal sculpture, brass, 13 x 10 x 10"

Hiram D. Williams
30. *Running Man No. 1*, oil on canvas, 73 x 88"
31. *Smiling Man*, mixed media, 52 x 46"

Karl L. Zerbe
32. *Philodendron*, collage of leaves and plastic, 73 x 37"
33. *Favela No. 3*, brocade collage with acrylic, 52 x 62"

ABOUT THE ARTISTS

COVINGTON, Harrison W. A native Floridian (Plant City), the artist received his B.F.A. with honors from the University of Florida and his M.F.A. from the same institution. He has also studied in New York, Europe, and Mexico. Covington's work has been exhibited at museums throughout the United States and was included in *Painting USA* by the Museum of Modern Art. He was included in three annual exhibitions of contemporary American painting of the Society of Four Arts in Palm Beach. The artist has had over seventeen one-man shows in New York and Florida and participated in various major invitationals. The recipient of a Guggenheim Fellowship, a Sloan Foundation grant, and a summer research grant, the Florida artist has won over fourteen awards in competitive exhibitions. Major purchasers have been the Jacksonville Art Museum, the Mead Paper Company, Massachusetts State College, John and Mable Ringling Museum of Art, Herron Museum of Art, and many other institutions and private collectors. At present Covington is associate dean of the Division of Fine Arts at the University of South Florida at Tampa. He is represented by the Group Gallery in Jacksonville, the Harmon Gallery of Naples, and the Oehlschlaeger Gallery of Sarasota.

COX, Ernest L. One of many outstanding young artists who have moved to Florida in recent years, Cox was born in Wilmington, North Carolina. He received his B.F.A. from the College of William and Mary and his M.F.A. in sculpture from Cranbrook Academy of Art. He has participated in Florida invitationals since 1961 and prior to that in resident exhibitions in North Carolina and Michigan. Cox's reputation has developed quickly within Florida with a two-man show at the Jacksonville Art Museum, one-man shows at the universities of Tampa, Jacksonville, and South Florida. He has been accepted in all the Florida State Fair Fine Arts Exhibitions since 1963 and been a prize winner in sculpture two times. Regionally he has been included in the Southeastern Annual of the High Museum of Atlanta the past three years. Major purchases of Cox's sculpture have been made by a number of Florida institutions and private collectors. In Washington, a Cox sculpture is in the Federal Deposit Insurance Corporation building. Presently, Ernest Cox is an assistant professor of art at the University of South Florida in Tampa. He is represented by the Group Gallery of Jacksonville.

DESHAIES, Arthur. Born in Providence, Rhode Island, the artist began on his own to make prints at age ten. He is still independent and innovative, breaking traditional concepts and barriers in the print medium. Deshaies studied at Cooper Union Art School, Rhode Island School of Design, and Indiana University, having taught at the latter two as well as the Pratt Institute in Brooklyn and the Pratt Graphic Art Center. He has been visiting artist and lecturer at a number of schools in the East and South. He has participated in practically every national and international print exhibition, including invitationals organized by the Brooklyn Museum, the Museum of Modern Art, Whitney Museum of American Art, the Smithsonian Institution, American Federation of Arts, the United States Information Agency, and other notable institutions. Deshaies's work has been purchased by major museums of the United States, Europe, South America, India, Australia, and private collectors throughout the world. He has received a Fulbright grant, MacDowell Colony Fellowship, Yaddo Fellowship, Tiffany Foundation Award, and Guggenheim Foundation grant. In a recent two year period Deshaies's prints were shown in thirty-six major exhibitions, including five one-man shows, one at the Whitney. At present he is working on a one-man show to circulate among four California institutions. Since 1963 the artist has been associate professor of art at Florida State University at Tallahassee. He is represented by LeMoyne Art Foundation of Tallahassee, St. Armands Gallery in Sarasota, and the Group Gallery in Jacksonville.

LEEPER, Doris. Another Carolinian now at home in Florida, Doris Leeper was born in Charlotte and received a bachelor of arts degree in art history from Duke University. Except for two studio courses during her undergraduate years, she has developed her talent without formal instruction. Her work has been included in the Hunter Gallery Annual, 1964, 1966, and 1967, the Society of Four Arts Annual Contemporary American Painting Exhibition every year since 1962; the National Small Painting Biennial at Purdue University, 1964 and 1966; the High Museum's Southeastern Annual, 1965 and 1967; Jacksonville's Southeastern Painting Biennial, 1965 and 1967; and the Butler Institute's American Art Mid-Year Annual, 1966 and 1967. She has had two-man shows at the Mint Museum in Charlotte, North Carolina, and the Columbia Museum of Art in Columbia, South Carolina. Her New York representative, Bertha Schaefer, has presented a one-man show in 1967, and the artist is currently working for coming one-man exhibitions at Chattanooga's Hunter Gallery of Art and the Mint Museum. Among her awards and prizes, Miss Leeper won the Florida State Fair Annual Fine Arts Exhibition in 1966, and the Jacksonville Southeastern Competition in 1967. Other awards include the Second Prize in a national drawing competition of Gallery Arkep, and a special award from the Hunter. Miss Leeper maintains a studio on Indian River Lagoon south of New Smyrna Beach and just north of the Cape Kennedy spaceport. In Florida she is represented by the Group Gallery of Jacksonville.

LOTZ, Steven D. One of the younger artists represented in this exhibition, Steve Lotz was born in Los Angeles and received his bachelor of arts degree from the University of California at Los Angeles. He received his M.F.A. from the University of Florida where he studied under Hiram Williams, another artist in this exhibition. Lotz, who teaches drawing, painting, and printmaking at Jacksonville University, and his wife spent the 1965-66 school year in Europe where he studied graphics at the Akademie der Bildenden Künste in Vienna, Austria. His work has been shown by the 10/4 Group Gallery in New York. The Cummer Gallery of Art in Jacksonville invited Lotz to exhibit in the *Young American Realists* show it organized in 1963. He was honored with a two-man show by Jacksonville University in 1965, and won First Prize in the Southeastern Painting Competition sponsored by the Jacksonville Arts Festival that same year. Purchases have been made by some of Florida's most astute private collectors. Along with sculptors Ernest Cox and Geoffrey Naylor in this exhibition, his work was recently featured in a four-man show at the Group Gallery of Jacksonville which represents the artist in Florida.

MANLEY, Bryn J. One of two English-born artists in this exhibition now living, teaching, and working in Florida,

Bryn Manley studied at Hornsey College of Art and the Royal College of Art, both in his native city of London. His exhibitions on both sides of the Atlantic are impressive. His work was included in the *The Young Contemporaries* and *The Graven Image*, organized by the British Ministry of Education. He was one the *Three Young Painters* in the Imperial College exhibition and has been exhibited by the Victoria and Albert Museum and the Manchester Art Gallery. On this side of the Atlantic he was included in the *National Print Show* at the Brooklyn Museum and a similarly entitled show in Potsdam, New York. The Finger Lakes Annual, Buffalo Regional, and *New York State Faculty* show have included his work. He is also featured in a show entitled *Young English Painters* now touring the United States. In England his work has been purchased by the Manchester Art Gallery, the Victoria and Albert Museum, and distinguished private collectors. He is affiliated with the Associated American Artists in New York City and is represented by the Schuman Gallery of Rochester. Manley is assistant professor of graphics at the University of South Florida in Tampa.

MASSIN, Eugene. Born in Galveston, educated at the Art Institute of Chicago and University of Chicago, Eugene Massin has lived in the Miami area since 1950. Massin's work has been shown at the Metropolitan Museum of Art, the Whitney Museum of American Art, John and Mable Ringling Museum of Art, and featured in an American Federation of Arts traveling exhibition of four Florida artists. The Joe and Emily Lowe Art Gallery held a major Massin show in 1967. The artist's work is included in the collection of Brandeis University, Lowe Gallery, Ringling Museum, Norton Gallery, and Jacksonville Art Museum. Among private collections, he is represented in the Gardiner Cowles, Bocour, Gimbel, Burdine, and Horowitz collections. He recently completed a mural for the Cafritz Company building in Washington, D.C. Formerly on the art faculty of the University of Wisconsin, Massin is a professor of art at the University of Miami in Coral Gables. He is represented by the Berenson Gallery of Bay Harbour Isles in the greater Miami area.

NAYLOR, J. Geoffrey. Naylor was born in Morecambe, England, and studied at the Lancaster College of Arts, Leeds College of Art, and London University where he received his teaching diploma. His M.F.A. degree is from the University of Illinois. His work has been exhibited both here and abroad including the Florida Sculptors Exhibition, Florida State University invitational in 1962, the Kornblee Gallery in New York, the Isaac Delgado Museum of Art in New Orleans, a 1963 invitational at the University of Manchester, and the Jacksonville Arts Festival invitational in 1964. He has had one-man shows at the Group Gallery in Jacksonville, Alabama State College, and the Micanopy Art Center. He was recently featured with two other artists in an exhibition at the Group Gallery which represents him. Naylor attended the University of Illinois on a Fulbright award and at present holds a National Foundation for the Arts grant, one of only four awarded in the Southeast. The artist is an assistant professor of art at the University of Florida.

PACHNER, William. Born in Czechoslovakia, educated at Kunstgewerbeschule in Vienna, Pachner came to the United States in 1935. He worked as a successful art director and illustrator for top magazines before turning to serious painting following World War II. In 1951 he came to Florida as an instructor for the Florida Gulf Coast Art Center. He has exhibited at the Whitney Museum of American Art, National Academy of Arts and Letters, Corcoran Biennial, Carnegie Invitational, Pennsylvania Academy of Fine Arts, Detroit Institute of Fine Arts, and the New York World's Fair Fine Arts Exhibition in 1964-65 as well as the Florida Pavilion at the fair. Pachner has had about ten one-man shows in both New York and Florida. His one-man retrospective was circulated nationally by the American Federation of Arts and he represented Florida in the Governors' National Art Exhibition entitled *50 Artists from 50 States*. Winner of two Ford Foundation grants, a Guggenheim Fellowship and an American Academy of Arts and Letters grant, the artist has for the past ten years conducted painting classes in his own studio in Clearwater. He is represented by St. Armands Gallery of Sarasota, Sindelir Gallery in Coral Gables, and Krasner Gallery in New York City.

RAMPOLLA, Frank. The artist was born in New York and studied at the Art Students League and the Cooper Union School of Art in his native city. He received his B.F.A. degree from Boston University, magna cum laude, in 1959 and won the Grand Prize of the Friends of Arts of the University that same year. Rampolla's work has been included in exhibitions organized by East End Gallery, Provincetown; Nixon Art Foundation Galleries, New Orleans; Sarasota Art Association; Ringling Museum of Art; Mead's Painting of the Year show, 1963; Associated American Artists, New York City; University of Tampa; Columbia Museum of Art, Columbia, South Carolina; and M. Knoedler, New York City. He was a First Prize winner at the Florida State Fair Fine Arts Exhibition in 1962. One-man exhibitions include Fleischman Gallery, New York City; Center Gallery, Sarasota; Gladstone Gallery, Woodstock, New York; St. Armands Gallery, Sarasota; Sindelir Gallery, Coral Gables; and Theatre Gallery, University of South Florida, Tampa. Ringling Museum and New College of Sarasota have made

collection purchases along with the Mead Paper Company. Since 1960 Rampolla has taught painting, drawing, color, and design at the Ringling School of Art in Sarasota. He is represented by St. Armands Gallery of Sarasota and Sindelir Gallery in Coral Gables.

RUBADOUX, Craig. Though born in Rochester, New York, Rubadoux has lived in Sarasota since he was eight years old and was educated in Sarasota public schools. While Sarasota has remained his home base, he has traveled widely in Holland, France, Belgium, Italy, North Africa, and Spain, having exhibited in Málaga and Madrid in the latter nation. As an artist he is largely self-taught. His exhibitions include a traveling show organized by Ringling Museum of Art, the Charles Lamont Gallery in Coral Gables and this year a one-man at St. Armands, his Sarasota gallery. Rubadoux's recent awards include the Four Arts Society of Palm Beach, the Florida State Fair award, and first prizes in the Manatee Art League and Sarasota Art Association. He is represented in the Ringling Museum of Art, the High Museum of Atlanta, the Guggenheim Museum of New York, and in private collections both here and abroad. In addition to St. Armands Gallery, the artist is affiliated with the Polari Gallery of Woodstock, New York, and the Sindelir Gallery in Coral Gables.

SAFF. Donald J. Saff was born in Brooklyn, received his B.A. degree from Queens College of the City University of New York, his M.A. degree from Columbia University, M.F.A. from Pratt Institute, and an Ed.D. from Columbia University Teachers College. In 1965 he studied at Istituto Statale di Belle Arti in Italy under a Fulbright grant. He has had one-man shows at the 80th Street Gallery, Martin Gallery, and the Pratt Institute in New York City; La Colomba Gallery of Bologna and Galleria Accademia of Rome in Italy; the Exeter-Lamont Gallery in New Hampshire; St. Armands Gallery, University of South Florida, and LeMoyne Art Foundation in Florida. In addition to the Fulbright, Saff has been awarded a Yaddo Fellowship, the Patrick Gavin Memorial Prize of the Boston Printmaking Association, and a commission from the International Graphic Arts Society. Major purchases and collections include the Museum of Modern Art, Metropolitan Museum of Art, Fogg Museum at Harvard University, Museum of Fine Arts of Boston, Museum of Graphic Arts, Lessing Rosenwald Collection, the Brooklyn Museum, Syracuse University Art Collection, the Library of Congress, New York University Art Collection, the Philadelphia Museum, and the Nelson Rockefeller Collection. Dr. Saff is chairman of the Department of Visual Arts at the University of South Florida. In Florida he is represented by St. Armands Gallery of Sarasota, the Group Gallery of Jacksonville, and LeMoyne Art Foundation in Tallahassee. Other gallery affiliations are Martin, Byron, and Allan Stone Galleries in New York City; La Colomba Gallery in Bologna; and the Galleria Accademia in Rome.

SOLOMON, Syd. Of Hungarian parentage, Solomon was born in Uniontown, Pennsylvania. He feels direct experience has been his major training though he studied at the Art Institute of Chicago and Ecole des Beaux-Arts in Paris for short periods. He was a newspaper artist prior to serving five years in the Army as a reconnaissance man during World War II. In 1954 he was chosen as one of "27 Americans with a Future" by *Art in America* magazine and has had many one-man shows in New York and Israel, including the Associated American Artists Gallery in New York. He is a faculty member of the Famous Artists School and has taught at the Pittsburgh Art Institute. Probably more than any other artist, Solomon has been a developing force for culture in his home community, Sarasota. Since moving there in 1946, he has consistently worked with local and state art institutions and cultural organizations to set standards of excellence equal to or above those in any part of the country. For many years, Solomon was director of his own Sarasota School of Art and more recently has been associated with the innovative creative arts program of New College. The artist is represented by Berenson Gallery in the Miami area, the Group Gallery in Jacksonville, and Saidenberg in New York.

VOELZ, Vernon. Born in Kenosha, Wisconsin, studied at the Art Institute of Chicago, moved to Sarasota in 1954, but the greatest effect on the artist and his work is the period he served in the Far East in World War II. The Oriental influence was profound and led him to spend a year working for the Baha'i faith in Rio de Janeiro. His work has been exhibited at the Jacksonville Art Museum, University of South Florida, Manatee Art League, University of Tampa, Loft Gallery of Coral Gables, Cummer Art Gallery, Florida State University, and the Columbia Museum of Art in South Carolina. Since 1962 he has had annual one-man shows at St. Armands Gallery in Sarasota and in 1965 was honored by a one-man show at the University of South Florida. He won the George Brown Foreign Traveling Fellowship from the Art Institute of Chicago and has been a consistent winner of prizes and awards in Florida shows. His work has been purchased by institutions in his home area of Florida and by many significant private collectors. Voelz has maintained a studio in Sarasota and has sculpted seriously from 1956. He is represented in Florida by St. Armands Gallery in his home town.

VOICHYSONK, Bernard F. The artist was born in Buffalo, New York, attended the Whitney School of Art in New Haven, and earned both his B.F.A. and M.F.A. degrees from Yale University where he was a student of Joseph Albers and held a teaching fellowship. He exhibited in the Yale Art Gallery as a student and also in the New Haven Arts Festival, winning the Best of Show Award in 1958. His works have also been shown in various exhibitions, including those at the Society of Four Arts in Palm Beach, the Sarasota Art Association, the University of Florida, the Florida State Fair Fine Arts Exhibition, the Jacksonville Arts Festival, and Clemson College in South Carolina. One of Voichysonk's paintings was included in the art exhibition in the Florida Pavilion of the New York World's Fair in 1964. He is currently an assistant professor of architecture at the University of Florida and is affiliated with the Micanopy Art Center near Gainesville.

WILLIAMS, Hiram D. Born in Indianapolis, Indiana, Williams attended Lycoming College in Williamsport, Pennsylvania, and the Arts Student League in New York City. He received his B.S. and M.Ed. degrees from Pennsylvania State University. He has worked as a freelance magazine illustrator, art supervisor in the Delaware public schools, and taught art at Pennsylvania State University, University of Southern California, and University of Texas, prior to moving to Florida in 1960. His works have been exhibited in leading museums and galleries, including the Museum of Modern Art, the Whitney Museum of American Art, the Corcoran Gallery of Art, and the Pennsylvania Academy. Special exhibitions include the American Federation of Arts *Survey of Texas Painting* and the Museum of Modern Art's *Painting USA: The Figure*. One-man shows have been staged at the Landau Gallery of Los Angeles, the Nordness Gallery in New York, and the Nye Gallery and the Chapman Kelley Gallery of Dallas. Among his many prizes and awards are two first prizes from the Annual Oil Show of Wilmington, Delaware; the Texas State Fair; the Feldman Award (three times); and the Texas Fine Arts Association. He has also received a research grant and a Guggenheim Fellowship. Williams is included in the collections of the Museum of Modern Art, the Corcoran Gallery of Art, the Allentown Museum of Art, the Pennsylvania Academy, the Johnson Wax Collection of American Art, the Whitney Museum of American Art, the Sheldon Memorial Art Gallery, and the Milwaukee Art Center. He is an associate professor of art at the University of Florida and is represented in Florida by the Harmon Gallery of Naples. Nordness is his New York representative and Chapman Kelley Gallery represents him in Dallas.

ZERBE, Karl L. Last year, Karl Zerbe was honored by his one hundredth one-man show. His first was held at the Gurlitt Gallery of Berlin in 1922. The German-born artist studied at the Debschitz School under Josef Eberz and was considered a rising young artist in his native land when he came to the United States in 1935. A painting of his, acquired by the Nation-Galerie in Berlin in 1932, was destroyed and his work denounced by the Nazis in 1937. Among his one-man shows are Marie Sterner Galleries, Harvard University (three), Grace Horne Galleries of Boston (four), Art Institute of Chicago, Detroit Institute of Art, Nordness Gallery (four), Museum of Modern Art of Rio de Janeiro, Ringling Museum of Art, LeMoyne Art Foundation of Tallahassee, and St. Armands Gallery of Sarasota which staged the one hundredth. Two retrospectives, one by the Institute of Contemporary Art of Boston, 1951-52, and one by the American Federation of Arts, 1961-62, have been circulated nationally. Zerbe has won major awards and prizes from the Institute of Contemporary Art in Boston, the Art Institute of Chicago, the Carnegie Institute, the Boston Arts Festival, and the University of Illinois. His work is in the collections of the Museum of Modern Art, the Metropolitan Museum of Art, the Whitney Museum of American Art, Detroit Institute of Arts, and many other leading Institutions as well as private collections. Since 1954 he has been professor of art at Florida State University. He is affiliated with LeMoyne Art Foundation of Tallahassee, the Group Gallery of Jacksonville, and St. Armands in Sarasota. His out-of-state representatives are Nordness in New York, Mirski Gallery in Boston, and Fischman-Weiner Gallery in Philadelphia.

March 19 - April 10, 1968

MARGARET OF ARGENTINA

A newly emerged name in Argentine art is that of draftsman Margaret Collazo. Born in New Jersey in 1931, she moved to Argentina at an early age, became a naturalized citizen and has lived there since. She has been a practicing artist since her graduation from the Pueyrredón School of Fine Arts in 1961.

Miss Collazo held her first exhibit in the Ver y Estimar Salon of Buenos Aires in 1960, and later that year her first foreign exhibition took place in the Arts and Letters Center of Montevideo.

She has taken part in many exhibitions in Argentina. In 1965 she exhibited at the Foussat Gallery in New York City and at the Institute of Hispanic Culture in Madrid.

This is Miss Collazo's first show in the Washington area. *--J.G-S.*

CATALOGUE

Drawings

1. *¿Por qué nos miran? (Why Do They Look at Us?)*
2. *¿Qué postre comeremos? (What Dessert Shall We Eat?)*
3. *Ico-ico*
4. *Cuando se duerme... (When One Sleeps . . .)*
5. *¿Te resbalastes mamá? (Did You Slip, Mother?)*
6. *Hola, mamita! (Hi . . . Mom!)*
7. *¿Verdad que es lindo? (Is It Not Beautiful?)*
8. *¿Por qué se ríen? (Why Do They Laugh?)*
9. *Cuando sea grande... (When He Grows Up . . .)*
10. *¿Mamá, estás triste? (Mother, Are You Sad?)*
11. *¿Por qué me miras? (Why Do You Look at Me?)*
12. *¿Por qué lo llamas así? (Why Do You Call It Like That?)*
13. *¿Por qué no me dejas hablar? (Why Don't You Let Me Speak?)*
14. *¿Por qué juegan? (Why Do They Play?)*
15. *¿Por qué te llaman Moñito? (How Do They Call You?)*[1]
16. *Moñito verde (Green Bow)*
17. *¿Estaba rico el postre? (Was the Dessert Good?)*
18. *Moñito negro (Black Bow)*
19. *Pecosa (Freckles)*

April 16 - 28, 1968

ALICIA CAJIAO OF COLOMBIA: PAINTINGS

Alicia Cajiao was born in Colombia and studied at the School of Fine Arts of the National University in Bogotá. She continued her studies at the Art Students League in New York, where she worked with Morris Kantor, and at the Julian Academy in Paris.

She has presented individual shows in the National Library in Bogotá in 1942 and 1944, the Conservatory of Cali in 1943, the British-Colombian Institute in Medellín in 1945, and the National Museum in Bogotá in 1966.

Miss Cajiao held her first individual show in the United States in New York in 1957. This is the first presentation of her paintings in the Pan American Union.

CATALOGUE

Paintings

1. *Reflections*
2. *Primavera (Spring)*
3. *Otoño (Fall)*
4. *Composición (Composition)*
5. *Forest in the Spring*

[1] Literal translation of this title is "Why Do They Call You Little Bow?" *--Ed.*

 6. *Autumn Array*
 7. *Tall Birches*
 8. *Park at Dusk*
 9. *Holly Hocks*
 10. *Trees*
 11. *Café*
 12. *Japanese Garden*
 13. *Appalachian*
 14. *Tres hermanas (Three Sisters)*
 15. *Fight Red-Blue-Black*
 16. *Cocks Blue and White*
 17. *Casino*

April 16 - 28, 1968

MARLENE HOFFMAN OF COLOMBIA: TEXTILES

The craftsmen of pre-Columbian Latin America had a distinguished and elegant approach to form and texture that is clearly evident in their work in gold and silver, and particularly in their textiles. Weaving is an ageless craft that has continued through the centuries, but its strongest revival has taken place in recent years in the Andean countries where it first began to flourish. If the processes or techniques have changed little, the spirit has become sophisticated and international.

One of the most serious and accomplished personalities in the field of contemporary weaving is Marlene Hoffman. The inventiveness of her forms, the delicate interplay of colors, the clarity of her style, all combine to create work of extraordinarily high quality.

Miss Hoffman was born in Barranquilla, Colombia, in 1934 and completed studies in architectural composition and drawing in the Colegio Mayor de Cundinamarca. From 1953 to 1954 she studied painting and sculpture in the National University's School of Fine Arts. In 1955 she came to the United States to attend the Cranbrook Academy of Art, Bloomfield Hills, Michigan, and to specialize in the design of fabrics and jewelry. In 1964 Miss Hoffman studied in Germany, and the following year she spent working in the studio of Dora Jung in Finland. Since 1963 Miss Hoffman's work has been included in group shows in Bogotá, Medellín, and Cali, and in Berlin, Germany. Last year she was invited to participate in an international exhibition at the Museum of Modern Art in New York. She has held individual shows in Colombia and Germany. Works by Miss Hoffman are included in private collections in Colombia, Germany, Spain, and the Museum of Modern Art in Bogotá.

This exhibition, coinciding with the celebration of Pan American Week, is the first presentation of her work in the Washington area. *--J.G-S.*

CATALOGUE

Tapestries, Hand-Spun and Handwoven Wool

 1. *Tú y yo (You and I)*, hand-knotted, 200 x 250 cm.
 2. *Curaçao*
 3. *Gato en el paraíso (Cat in Paradise)*
 4. *Geometría en crudo (Geometry in Naturals)*
 5. *Geometría en azules (Geometry in Blues)*
 6. *Voodoo*
 7. *En busca de espacio (Search for Space)*
 8. *La pluma (The Feather)*
 9. *Shuttle*
 10. *Sementera del indio (Indian's Plot)*
 11. *Villa Mairea*
 12. *The Fox*

Hangings

13. *The Process*
14. *Bochica*
15. *Tisquesusa*

April 29 - May 22, 1968

TOMIE OHTAKE OF BRAZIL: OILS

In the Pan American Union's program of exhibitions, a certain emphasis has been placed on the presentation of artists whose works are not entirely identified or associated with Western culture. This is particularly relevant in the case of a number of artists of Japanese origin who form a vigorously active group in São Paulo. It should be noted, perhaps, that the Japanese population of Brazil, largely concentrated in the State of São Paulo, is second only to that of Japan itself. These artists have contributed strongly to the trend of abstract painting, influencing not only Brazilian painters but artists of other nationalities as well.

Three years ago the Pan American Union presented a comprehensive group show entitled *Japanese Artists of Brazil*. In the introductory remarks of the catalogue, I stated: "The warmth, generosity, and open-mindedness of the Brazilians have facilitated the introduction of foreign concepts and tastes, while at the same time the strength of their [the Japanese] own long-established, deeply rooted cultural tradition has produced modifications in the extraneous elements, resulting in distinctly novel manifestations of creative talent. Thus, a nation whose culture already represents a fusion of European, American, and African factors is now in the process of enriching itself through the assimilation of Asian refinements." That exhibition marked the first appearance of the work of Tomie Ohtake in the United States.

Miss Ohtake was born in Kyoto, Japan, in 1913 and moved to Brazil in 1935, proudly adopting the nationality of that country. After having reared a family--she is the mother of a prominent Brazilian architect--she became seriously involved in painting.

Miss Ohtake's expression is direct. Using wide zones of almost pure color, she creates overwhelmingly strong forms, and there is a delightful sense of texture which enhances the brilliance of her palette.

Since the beginning of her career in 1952, she has held four solo exhibits--two at the Museum of Modern Art in São Paulo, 1957 and 1961. She has participated in group exhibits in Argentina, Nicaragua, Colombia, Japan, England, Austria, and the United States and was represented in the last four São Paulo Biennials. She has also obtained several important awards. Her work is included in more than nine museum collections in Brazil and in many private collections in the United States, Japan, and Germany. Among the most important are those of David Rockefeller (New York) and Walter Gross (Lima).

The current exhibition is her first individual show in the United States. *--J.G-S.*

CATALOGUE

Paintings, 1968

1. *Pintura (Painting)*, 135 x 135 cm.
2. *Pintura (Painting)*, 156 x 117 cm.
3. *Pintura (Painting)*, 105 x 156 cm.
4. *Pintura (Painting)*, 156 x 117 cm.
5. *Pintura (Painting)*, 156 x 105 cm.
6. *Pintura (Painting)*, 135 x 110 cm.
7. *Pintura (Painting)*, 135 x 100 cm.
8. *Pintura (Painting)*, 75 x 135 cm.
9. *Pintura (Painting)*, 135 x 75 cm.
10. *Pintura (Painting)*, 135 x 56 cm.

11. *Pintura (Painting)*, 100 x 135 cm.
12. *Pintura (Painting)*, 135 x 110 cm.
13. *Pintura (Painting)*, 100 x 120 cm.
14. *Pintura (Painting)*, 135 x 55 cm.
15. *Pintura (Painting)*, 135 x 100 cm.
16. *Pintura (Painting)*, 135 x 100 cm.
17. *Pintura (Painting)*, 130 x 110 cm.
18. *Pintura (Painting)*, 135 x 100 cm.
19. *Pintura (Painting)*, 135 x 110 cm.
20. *Pintura (Painting)*, 130 x 130 cm.
21. *Pintura (Painting)*, 135 x 70 cm.

May 24 - June 11, 1968

CARLOS SCANNAPIECO OF ARGENTINA

Carlos Scannapieco was born in Buenos Aires in 1940 and began to study graphic arts nine years ago, first attending the Manuel Belgrano National School of Visual Arts and later taking specialized courses at other institutions. Since 1960 he has held six one-man shows in the Argentine capital as well as four shows in the country's interior. He has participated in numerous group exhibitions and national salons in Argentina, Colombia, Spain, Brazil, India, and Japan and has been awarded several prizes. Scannapieco's works are included in museum collections in Argentina, Paraguay (the Museum of Modern Art), and Peru (the Museum of Contemporary Art in Lima).

This exhibition, sponsored by the Museum of Coronel Pringles in Buenos Aires, is Scannapieco's first presentation in the United States.

CATALOGUE

Linoleum Cuts

1. *Leaf*
2. *Two Forms*
3. *Cemetery*
4. *Rugby*
5. *Lathe*
6. *Clutch*
7. *Ford T, de la serie de las ruedas (Ford T, from the Wheels Series)*, artist's proof

Etchings

De la serie del mar (From the Series of the Sea), 1966, artist's proof

8. *Quetodonte I*
9. *¡Si! (Yes!)*
10. *Rodaballo (Flounder) I*
11. *Trionice*
12. *Rodaballo (Flounder) II*
13. *Rodaballo (Flounder)*
14. *Quetodonte*
15. *Quetodonte II*

May 24 - June 12, 1968

HANDWOVEN ARGENTINE CARPETS
WITH DESIGNS OF ARGENTINE ARTISTS BY DANDOLO AND PRIMI [1]
A Smithsonian Institution Traveling Exhibition

FOREWORD

Something quite extraordinary is happening today in Argentina.

The creative energies of the country have for some time been channelled into the world of vision in the literary sense of the word.

National talent has exploded through images of increasing sophistication and depth. Proof of this lies in the fact that in the last decade Argentine artists have won major prizes in international competitions such as Venice and São Paulo in the different categories of artistic achievement: engraving, sculpture, and painting. Surely this must be more than mere chance. Keeping these antecedents in mind, it should not surprise us that alert and shrewd executives like those of the firm Dandolo & Primi should start producing results as a consequence of awareness of the facts revealed in my opening statement. Only that here is not where the story ends but where the story begins. Argentina, like many Latin American countries, has a long and magnificent tradition in the ancient crafts such as weaving. It is not surprising then that the creative bloom should find communication with the ageless art of our weavers. This is what has happened and this is what this exhibition of carpets is out to prove. Let me simply add that in a paradoxical way the re-discovery of these ancient crafts in the age of automation becomes doubly significant. As man has more time for himself while the machine does his work, he will feel increasingly compelled to the task of revealing the creative aspects of his nature. The message revealed through these carpets is one of the possible answers for a happier man in a happier future.

By way of presentation, a few remarks about the artists that are here represented.

Alberto Churba, who belongs to a refined tradition of op art, obtains color effects and sensations that as yet have not been matched by his predecessors. A wonderful thing about his achievements is that his carpets remain carpets; Alicia Silman drinks from the fountains of pre-Columbian motives adding the archaic flavor to her creations; Carlos Cañás, a painter of renown, has proved how classical and Spanish sensibility for form can find its way into modernity without losing the majesty of tradition; Rogelio Polesello gives a vision of speed that makes his carpet almost the one of magical legend, capable of transporting us to any corner of the earth; Josefina Robirosa blends elegance and good taste with a truly beautiful display of energy; Aníbal Carreño appears to have brought up to date the imagination of the Orient and gives us a carpet upon which meditation will become an easier task; María Elisa de la Fuente has turned the carpet into the skin of a dragon that will help bring fantasy into the room. --*Rafael Squirru*, Director of the Department of Cultural Affairs, Pan American Union.

ABOUT THE ARTISTS

CAÑAS, Carlos. Born in Buenos Aires, November 19, 1928. He graduated from the Prilidiano Pueyrredón National School of Fine Arts of Buenos Aires in 1951, and mastered at the Ernesto de la Cárcova Superior School of Fine Arts in 1955, also in Buenos Aires. He belongs to the group called *Grupo del Sur* (Southern Group) together with the painter Aníbal Carreño and the sculptor Leo Vinci. He traveled as part of his studies, first to the interior of the country and then abroad. In 1961 he obtained a scholarship through the National Funds for the Arts to go to Europe and visited Italy, Switzerland, France, and Spain; on his way back he visited Brazil at an invitation of the Argentine Embassy in Rio. He has exhibited his work from 1959 to 1965 in Paris, Mexico City, Rio de Janeiro, Washington, Miami, Madrid, and Saigon and has obtained important prizes in Buenos Aires.

CARREÑO, Aníbal. Born in Buenos Aires in 1930, he studied under Adolfo De Ferrari and has been exhibiting his paintings since 1957. In 1959 he began exhibiting in the *Grupo del Sur* (Southern Group); he showed at the

[1] No exhibition list is available. --*Ed*.

Fourth and Sixth Biennials of São Paulo, at the exhibition of *Contemporary Argentine Art* in Paris, and at the exhibition of *Art of America and Spain* in Madrid and other European cities, 1963-64. He has held his one-man shows at the Nueva Van Riel and Rubbers galleries in Buenos Aires. His awards include the Ver y Estimar (See and Appreciate) Prize of Honor; the De Ridder Prize and Consagración (Consecration) Prize, the latter awarded by the critics; and First Prize at the Salon in Azul, Province of Buenos Aires.

CHURBA, Alberto. Was born in Buenos Aires in 1933; he graduated from the School of Visual Arts in 1955. From 1955 to 1957 he worked on ceramics and made several murals and pieces of craft work. In 1958 he opened in Buenos Aires the CH Center of Art and Design; the same year he exhibited craft works in Finland, Denmark, Sweden, and Japan. In 1964 he was awarded prizes for textile designs by the CIDI (Industrial Design Center) and held a one-man exhibition of textiles and tapestries at the Torcuato Di Tella Institute in Buenos Aires. In 1965 he exhibited crystal, furniture, carpets, and textiles at the Buenos Aires Museum of Modern Art. In 1965 Churba obtained the Solid Copper First Prize granted by the CIDI for design of filing cabinets and desks.

FUENTE, María Elisa de la. Was born in Buenos Aires, where she studied at the Prilidiano Pueyrredón National School of Fine Arts. After studies of plastic composition, she held a number of exhibitions of her work in the interior of the country. At present she is working in graphic design. Her artistic creations, based on photographic experience, are really original. She was awarded an important prize at the Dandolo & Primi Contest of Cartons for Carpets in 1963.

POLESELLO, Rogelio. Born in Buenos Aires in 1939, graduated from the National School of Fine Arts in 1958. He has held one-man exhibitions at the Peuser, Pizarro, Lirolay, Rubbers, and Argentine Jewish Society galleries in Buenos Aires. In Latin America his works were shown in Mexico, Peru, Brazil, and Venezuela; in the United States, besides the Pan American Union in Washington, D.C., in Alabama, Baltimore, Connecticut, Dallas, Nebraska, Milwaukee, Minneapolis, and Virginia. Europe knows him from the Third Biennial of Paris and the Latin American Congress in Berlin. He is included in such important collections as the Buenos Aires Museum of Modern Art, the Caracas Fine Arts Museum, the Pan American Union, the Esso Collection in Buenos Aires, the Nessler Collection in Germany, and the Vance Kirkland Collection in Colorado, United States. His awards include the Losada Prize, 1959; the Sash of Honor at the Ver y Estimar (See and Appreciate) Salon, 1960; and Honorable Mention at the De Ridder Salon of 1959. Abroad he won First Prize at the *Esso Salon of Young Artists* in Washington, D.C., in 1965, and a First Prize from the Israeli Tourist Office Exhibition in 1963.

ROBIROSA, Josefina. Born in Buenos Aires in 1932, she has held solo exhibitions of her own paintings in the Fine Arts Museum in Córdoba (Argentina) in 1957, at the Bonino Gallery of Buenos Aires in 1959 and 1964, and at the North Gallery in Martínez (Buenos Aires) in 1963. She also held individual exhibitions of tapestry in 1964 at the Museum of Modern Art in Buenos Aires and in 1965 at the Witcomb Gallery also in Buenos Aires. Her paintings, tapestries, bas-reliefs, and murals have been shown abroad in São Paulo in 1957, in New York in 1964 at the Pepsi-Cola exhibition organized by the Museum of Modern Art, and in 1966 she exhibited her work in New York and Houston.

SILMAN, Alicia. Born in Buenos Aires in May 1930, she graduated from the Fernando Fader School of Decorative Arts. She also studied sculpture at the Ernesto de la Cárcova Superior School of Fine Arts and design with Professor Cartier. She is presently studying anthropology at the School of Philosophy and Letters of the University of Buenos Aires. Miss Silman has created since 1957 a series of designs for carpets with motifs of native inspiration. In 1958 her carpets were exhibited at the Brussels World Fair and later on in Berlin and Stockholm. In 1959 they were exhibited at Radio Nacional in Córdoba (Argentina). In 1963 she won a scholarship from the National Foundation for the Arts to compile decorative folk motifs, and the same year she obtained an important prize in the Dandolo & Primi Carpet Design Competition. In 1964 she exhibited sculptures at the SAAP (Argentine Society of Plastic Artists) in Buenos Aires.

June 13 - 29, 1968

RICARDO MORALES OF COSTA RICA

After a long tradition of conservatism, several years ago Costa Rican artists began to reflect the influence of modern art trends, including abstraction, geometric or informal art, and expressionism. The latter was

characterized by the use of quiet, somber colors. Among the first exponents of the new trends were a number of painters, sculptors, and draftsmen who called themselves the *Totem Group*, and one of the fresher personalities to appear within that group was painter Ricardo Morales.

Morales, who was born in San José in 1935, studied in the private workshop Casa del Artista (House of the Artist). For two consecutive years he was awarded the School's First Prize for Painting. In 1960 he continued his studies in Mexico. Since 1961 he has exhibited individually and with the Totem Group in Costa Rica, Honduras, and El Salvador. Last year he toured the museums of this country at the invitation of the United States Department of State and later returned to exhibit in Las Manos Gallery in Dallas.

This is his first presentation in the Washington area.

EXHIBITION LIST [1]

Paintings

1. *El potrero* (Pastureland)
2. *Volcán Irazú* (Irazú Volcano)
3. *Amanecer* (Dawn)
4. *Rancho redondo* (Round Hut)
5. *La cabaña* (Cabin)
6. *Colonia* (Colony)
7. *El Alto de Ipis*
8. *Hombre viejo* (Old Man)
9. *Niebla* (Fog)
10. *Purral*
11. *Limones* (Lemons)
12. *Tarde* (Afternoon)
13. *Más tarde* (Later)
14. *Montaña, Canal 6* (Mountain, Channel 6)
15. *El pastizal* (Pastureland)
16. *El grillo estilizado* (Stylized Cricket)
17. *Arboles* (Trees) *No. 1*
18. *Arboles* (Trees) *No. 2*
19. *Camino* (Road)
20. *Filósofo* (Philosopher)
21. *Chorotega*
22. *Verano en la tarde* (Summer in the Afternoon)
23. *El itabo* (Iucca elephantipes)
24. *Camino tronchado* (End of the Road)
25. *Crítico* (Critic)
26. *Accidente* (Accident)
27. *Casa vieja* (Old House)
28. *Camino al rancho redondo* (Road to the Round Hut)
29. *El Bajillo*
30. *Apunte de paisaje* (Sketch for a Landscape)
31. *Flores* (Flowers)
32. *Hortaliza* (Vegetable)
33. *Las palmas* (Palm Trees)
34. *Los cerros* (Hills)
35. *El tomatal* (Tomato Plantation)
36. *Vista aérea* (Aerial View)

[1] The original catalogue indicates that twenty paintings were exhibited on this occasion; since they were not identified, the list of titles sent by the artist for this exhibition is reproduced here in its entirety. --*Ed.*

July 8 - August 23, 1968

LANDSCAPE ARCHITECTURE IN VENEZUELA
BY FERNANDO TABORA AND J. GODFREY STODDART

It is only during the last thirty years that the specialized field of landscape architecture has had active participation in the area of construction, and its starting point was the new architectural movement in Brazil whose beginnings date back to roughly 1936. The first and foremost figure in landscape architecture in Brazil, as he is indeed throughout the Americas, is Roberto Burle Marx, who opened up new possibilities in this field in America. He has attained universal prestige for his original approach in utilizing plants and in making the most of the existing irregularities of the terrain as well as for the bold strength of his designs. In addition, he takes advantage of the vegetation peculiar to each place and does not need to resort to imported botanical species for his effects.

In 1954 a general exhibition of Burle Marx's best work was presented by the Pan American Union, the first time it had been seen in the United States. Following up this show, which was circulated to many parts of the country by the Smithsonian Institution, two young architects who have been associated for several years with the Burle Marx studio in Rio de Janeiro are now presenting selected examples of their work, done mainly in Venezuela.

Fernando Tabora, born in Santiago, Chile, in 1927, studied architecture at the Catholic University in that capital city, graduating in 1955. He had already become associated with the Burle Marx studio in Rio in 1954 and spent three years there working on a number of landscape architecture projects in Brazil. In 1956 he took up residence in Venezuela, where he developed the work that led to the present show, in association with the English architect J. Godfrey Stoddart.

Stoddart, born in London in 1929, obtained his degree in architecture in that city in 1953. In 1954 he went to Brazil and joined the studio of Burle Marx, working in close collaboration with him and with Tabora. Work by both Stoddart and Tabora is included in this exhibition. Both architects now also teach at the Central University of Venezuela.

The show presented here was first seen two months ago in Montreal, Canada, during a specialized congress on the subject of landscape architecture. This is the first time it is being exhibited in the United States. *--J.G-S.*

CATALOGUE

Landscape Architecture Photographs

Panel No. 1. *Jesús Enrique Lossada Park*
Panel No. 2. *Punta Vista Park*
Panel No. 3. *Plan of Punta Vista Park*
Panel No. 4. *Gardens of the Central Bank of Venezuela*
Panel No. 5. *Residential Garden*
Panel No. 6. *Garden-Lake*
Panel No. 7. *House and Garden*
Panel No. 8. *Garden in Caracas*
Panel No. 9. *Large Landscaped Plaza*
Panel No.10. *Green Spaces*
Panel No.11. *Bull Ring*
Panel No.12. *Landscaping around the Bull Ring*
Panel No.13. *Centro Simón Bolívar*
Panel No.14. *Plaza Diego Ibarra*
Panel No.15. *El Conde*

July 11 - 29, 1968

LUIS HERNANDEZ CRUZ AND RAFAEL VILLAMIL OF PUERTO RICO [1]

RAFAEL VILLAMIL

Among Latin American architects it is not uncommon to find people who practice other arts as well. One of those with parallel careers is Rafael Villamil who was born in Santurce, Puerto Rico, in 1934, and received a degree in architecture from Georgia Institute of Technology. A few years ago he began to divide his creative activity equally between architecture and a trend in the plastic arts that gives equivalent emphasis to painting and to sculpture. His use of collage, the intensely raw colors of his palette, and the letters, inscriptions, numbers, and other added elements, place him within the current known as pop art.

Villamil has had exhibits at the University of Puerto Rico at Río Piedras and in Philadelphia where he is now living, at the Peale Gallery of the Pennsylvania Academy of Fine Arts, the Makler Gallery, the Art Council Gallery, and the Museum of the Philadelphia Civic Center. His work has also been shown at the Gallery of the School of Visual Arts in New York. This is the first Washington presentation of the young Puerto Rican artist's work.

CATALOGUE

Collages

1. *Englishmen scoffed as always at a new thing, but Fernando was not English*, 1965
2. *Yes, it was not sad, but . . . but . . .* , 1965-1968
3. *Smart affairs move inland*, 1966-1968
4. *How many wives are sacrificed every night?* 1967-1968
5. *For many unknown little friends, including Mónica*, 1965-1966
6. *A reconstruction of the battle between government forces under the Duke of Cumberland and the Scottish Jacobites as led by Bonnie Prince Charles*, 1965
7. *Stoccatta, Mandritto, and Stragazzone came quick and clean to his hard young muscles*, 1965

LUIS HERNANDEZ CRUZ

The work of the Puerto Rican painter Hernández Cruz has always stayed within the nonfigurative trend. At times he has dealt with free forms, full of color, at other times with geometric shapes, in black and white. In either case he can be considered an experimentalist who has for years contributed to enlivening the art of the island. His most recent experiments are summarized in the following paragraph from an essay on his work by the Spanish writer and critic Angel Crespo:

> The intent is to create an environment (not an architectonic one, as fundamentally architecture relates only to rational spaces, and its greatness as well as its limitations derive from its immediately utilitarian ends) capable of modifying our perception of time and space through visual stimuli. This is something achieved until now only by music, through auditory stimuli.

Luis Hernández Cruz was born in San Juan, Puerto Rico, in 1936. He is self-taught. He has had individual exhibits since 1961, the year of his debut at the Campeche Gallery in San Juan. Over the succeeding years his work has been shown at the Institute of Puerto Rican Culture in 1962 and 1965, at the First Federal Gallery in Santurce in 1963, and in 1964 at the Museum of the University of Puerto Rico. The San Juan gallery that represents him, La Casa del Arte, showed his paintings in 1966. Now he has just finished his first one-man exhibit

[1] This exhibition was cancelled when a Pan American Union official found objectionable that paintings of nude men and women (collages by Rafael Villamil) were to be shown at the Pan American Union Gallery. Luis Hernández Cruz withdrew his works as well in a display of solidarity. This catalogue was therefore never distributed. --*Ed.*

abroad, at the Institute of Hispanic Culture in Madrid.

Hernández Cruz has also participated in numerous group shows in Puerto Rico and elsewhere. After winning an award in the *Esso Salon of Young Artists* on the island, his work was included in the final exhibit in Washington, D.C., in 1965. He has also been represented in group shows in New York, Madrid, Mexico City, Caracas, and Cali and has won a number of first and second places in various contests.

This is the first one-man show Hernández Cruz has had on the United States mainland.

CATALOGUE

Paintings

1. *Combinación de pirámides (Combination of Pyramids) I*
2. *Combinación de pirámides (Combination of Pyramids) II*
3. *Diamante violeta (Violet Diamond)*
4. *Franjas amarillas (Yellow Stripes)*
5. *Verde y marrón opuestos (Counterpoint of Green and Brown)*
6. *Rojo y gris alternados (Alternating Red and Gray)*
7. *Anaranjado en valor mínimo (Orange Decreasing)*
8. *Proyección horizontal de una pirámide alargada (Horizontal Projection of an Elongated Pyramid)*
9. *Formas en relación de grises (Related Grays)*
10. *Pirámide espaciada e invertida (Upside Down Pyramid)*

August 2 - 26, 1968

BELAUNZARAN OF MEXICO

Carlos Belaunzarán, one of the stronger young personalities to have appeared in Mexico's art world recently, works within the realm of abstraction, conserving only a reminiscence of figuration or representational form. In the case of the paintings presently on exhibit, insects have served as the basis for his abstraction. His line follows the baroque tradition, and color--sometimes applied to create transparent layers, sometimes used seemingly by accident--plays a prominent role in his creation of form and space.

Born in Guanajuato in 1940, Belaunzarán first began to paint at the age of twelve, studying under Ramón Alva de la Canal in Jalapa. In 1958 he attended the Academy of San Carlos in Mexico City and later the National University of Mexico, where he studied art history, sociology, philosophy, aesthetics, and drama. He has participated in numerous group shows since 1964, including two exhibitions in Mexico's Museum of Modern Art and another in the Palace of Fine Arts. Last year he was represented in group shows in Hanover, Houston, Caracas, and Montreal. In 1966 he held his first one-man show in the Galería Mexicana de Arte Tianquiztli, which also acts as his agent in Mexico City.

This is the first presentation of the work of Belaunzarán in the Washington area. --*J.G-S.*

CATALOGUE

Oils

1. *Insecto bajo el agua (Insect under Water)*, oil on canvas, 85 x 100 cm.
2. *Insecto geómetra (Geometrician Insect)*, oil on canvas, 45 x 50 cm.
3. *Acrobacia (Acrobatics)*, oil on canvas, 70 x 90 cm.
4. *Ascención (Ascension)*, oil on canvas, 55 x 85 cm.
5. *Insecto en rojo (Insect in Red)*, oil on Masonite, 72 x 61 1/2 cm.
6. *Insecto en violeta (Insect in Violet)*, oil on Masonite, 56 x 60 1/2 cm.
7. *Conflicto (Conflict)*, oil on Masonite, 61 1/2 x 40 cm.
8. *Trayectoria (Trajectory)*, oil on canvas, 60 x 50 cm.

9. *Imagen luminosa (Brilliant Image)*, oil on Masonite, 30 x 35 cm.
10. *Lugar de recreo (Amusement Spot)*, oil on Masonite, 30 1/2 x 22 cm.
11. *Casa de insecto (Insect House)*
12. *Danza (Dance)*, oil on canvas, 60 x 90 cm.
13. *Larga espera (Long Wait)*, oil on Masonite, 72 x 61 1/2 cm.

Collage on Bristol Cardboard

14. *Campo de aterrizaje (Landing Field)*
15. *Casa de insecto (Insect House)*
16. *Jardín (Garden)*, 48 x 38 cm.
17. *Escondite (Hiding Place)*, 36 x 45 cm.
18. *Selva (Forest)*, 64 x 49 cm.
19. *Punto de reunión (Meeting Point)*, 64 x 49 cm.
20. *Punto de equilibrio (Equilibrium Point)*, 47 x 30 cm.
21. *Formas de primavera (Forms of Spring)*
22. *Encuentro inesperado (Unexpected Meeting)*, 48 x 41 cm.
23. *Juego sencillo (Simple Game)*, 34 x 47 cm.
24. *Hipérbole (Hyperbole)*, 48 x 36 cm.

August 2 - 26, 1968

FILCER OF MEXICO

Like other Mexican painters of his generation, Luis Filcer focuses his attention on the representation of the human figure, which he treats in the expressionistic tradition, with a simplification of form.

Born in 1927 in Ukraine, Filcer became a Mexican citizen more than twenty years ago. He first studied at the Academy of San Carlos in Mexico City and later in Paris, Rome, and Amsterdam. His work has been included in group exhibitions in Mexico City, Rome, Santiago, Tokyo, Amsterdam, and in several cities in the United States. He has held numerous one-man shows in this country--at the Hispanic-American Institute, New York, 1962; the Sausalito Art Gallery, San Francisco, 1962; the Jewish Community Center, San Diego, 1963; the AFA Gallery, Carmel, California, 1963; the World House Galleries, New York, 1966; and the Carter Gallery, Los Angeles, 1966, as well as in Mexico, Holland, Belgium, and Israel.

This is the first presentation of Filcer's work in the Washington area.

CATALOGUE

Acrylics

1. *Corrida*, 1964, 70 x 100 cm.
2. *General Macho*, 1965, 90 x 110 cm.
3. *Conversación (Conversation)*, 1967, 100 x 100 cm.
4. *El acusado (The Accused)*, 1966, 90 x 120 cm.
5. *Hamlet*, 1967, 100 x 100 cm.
6. *Máscaras (Masks)*, 1965, 75 x 85 cm.
7. *La ventana (The Window)*, 1967, 100 x 100 cm.
8. *Bufón (Buffoon)*, 1967, 90 x 120 cm.
9. *Pensador (Thinker)*, 1966, 45 x 50 cm.
10. *Las viejas (The Old Women)*, 1967, 60 x 110 cm.
11. *El sillón (The Seat)*, 1966, 95 x 120 cm.
12. *El uniforme (The Uniform)*, 1965, 75 x 85 cm.

August 23 - September 12, 1968

NELIA LICENZIATO OF ARGENTINA

Nelia Lincenziato began painting more than ten years ago and recently has concentrated her efforts largely on the application and use of new materials on canvas. In the tradition of Argentine painter Raquel Forner, Miss Lincenziato bases her subject matter primarily on the activities of the astronaut in space.

Miss Licenziato was born in Buenos Aires in 1936 and studied painting and graphics in the National School of Fine Arts there. She has been awarded scholarships for advanced studies by the governments of both Argentina and Brazil. Her first solo show was presented in Viña del Mar (Chile) in 1958. Since that time she has held six individual exhibitions in Buenos Aires and has participated in national and international shows in Argentina, Chile, and Japan. Her work is included in several important public collections in Buenos Aires.

This is the first presentation of Miss Licenziato's paintings in the United States.

CATALOGUE

Paintings

1. *El profeta (The Prophet)*, enamel and glass, 98 x 245 cm.
2. *Ser de un mundo radioactivo (Being from a Radioactive World)*, enamel and glass, 122 x 245 cm.
3. *El astroconquistador (The Astro-Conquistador)*, enamel and glass, 80 x 183 cm.
4. *Un enigma (An Enigma)*, enamel and glass, 40 x 240 cm.
5. *El último terrestre (The Last World)*,[1] enamel and glass, 80 x 183 cm.
6. *Ser mágico (Magic Being)*, enamel and glass, 80 x 183 cm.
7. *De profundis. Homenaje al cosmo-héroe (De Profundis. Homage to the Cosmo-Hero)*, enamel and glass, 183 x 356 cm.
8. *Una cara para el espacio (A Face for Space)*, acrylic and glass, 150 x 170 cm.
9. *Robot-ser (Robot-Being)*, enamel and glass, 60 x 178 cm.
10. *Los que vieron el átomo (Those Who Saw the Atom)*, enamel and Pyrex, 90 x 85 cm.
11. *Espectros (Specters)*, enamel and Pyrex, 60 x 150 cm.
12. *Mutante (Mutant)*, enamel and glass, 40 x 69 cm.
13. *Seres astrales (Astral Beings)*, Pyrex and glass, 180 x 240 cm.
14. *El clamor (The Clamor)*, Pyrex and glass, 80 x 90 cm.
15. *Cosmo-robot (Cosmo-Robot)*, iron and glass, 110 x 230 cm.
16. *Personaje lunar (Lunar Personality)*, Pyrex and glass, 50 x 60 cm.
17. *Tiempo de mutantes (Time of Mutants)*, enamel and glass, 22 x 45 cm.
18. *Hijos del siglo (Son of the Century)*, glass and Pyrex, 37 x 65 cm.
19. *Urano (Uranus)*, iron and glass, 40 x 140 cm.
20. *Los que no olvidan (Those Who Do Not Forget)*, enamel and glass, 36 x 40 cm.
21. *El portador de enigmas (The Bearer of Enigmas)*, iron and glass, 140 x 220 cm.
22. *Mutante alado (Winged Mutant)*, enamel and glass, 28 x 45 cm.
23. *Lunautas (Moonauts)*, Pyrex and glass, 50 x 60 cm.
24. *Cosmo-espectros (Cosmo-Specters)*, Pyrex and glass, 60 x 183 cm.
25. *El grito (The Scream)*, acrylic and glass, 150 x 170 cm.

September 13 - 23, 1968

RUDY AYOROA OF BOLIVIA

For many years, there have been Latin American artists who have tried to give a creative or imaginative

[1] Literal translation of this title is "The Last Terrestrial." --*Ed.*

interpretation of the cosmic world--each following his own different concept, but not necessarily ignoring or excluding a careful analysis of certain scientifically known elements.

In Argentina, Raquel Forner offers in her painting of the last five years her own very subjective, expressionistic version of the world of space flights and forms related to sidereal bodies. Equally interested in the cosmic world is David Manzur of Colombia, who during the last few years has been engaged in deciphering the universe morphologically. Manzur, however, uses an objective approach, basing his work on images seen through a powerful telescope that he keeps in his studio. There is a richness in his painting that is enhanced by the addition of various materials on the picture plane and a new cartography of lines, circles, and forms outlined on an intense blue.

The Bolivian painter Alfredo Da Silva is now in a phase of attempting to describe the interplanetary world using thick relief and intricate, romantic forms. His fellow countryman, Rudy Ayoroa, interpreting the world of outer space by still another means, goes away from painting toward relief or sculpture dependent on the kinetic laws that rule the universe. Combining electronics and sound, his spatial constructions offer a fascinating vision of light, movement, and transparent forms.

Ayoroa's interest in this theme dates back to his earliest work based on the Bolivian highlands, which later developed into a concern with painting executed on the geometric picture plane, and finally into these experimentations in the darkroom, where working with lights, forms, and colors he was allowed to present a small-scaled vision of the spatial world. What one might find entertaining or curious about his constructions is secondary to their strong plastic or artistic value.

Rudy Ayoroa was born in La Paz in 1927 and studied at the Academy of Fine Arts of Cochabamba in 1945 and 1946. For the next three years, he attended the National University of Buenos Aires where he studied architecture. He continued to live in Argentina until 1965, during that time exhibiting with the *Madí Group* in several important Buenos Aries galleries and holding two one-man shows in his native Bolivia. In 1965 he moved to Washington, D.C., where he now works as an architect and interior decorator. His strong intuition of the abstract and his devotion to the mysteries of the cosmos are given expression in the works with which he continues to experiment in his studio.

This is the artist's first one-man exhibition in the United States. *--J.G-S.*

EXHIBITION LIST [1]

Kinetic Constructions

1. *RAMPA-64*
2. *AL-36*
3. *ISI-56*
4. *DJU = OM*
5. *3 : 5 = OM*
6. *SA+LE+2RO = 2.008*
7. *IS+RU = 2.008*
8. *ERI-68*
9. *ES-54*
10. *SQ-33*

Drawings[2]

[1] Not included in the original catalogue. *--Ed.*

[2] Titles are unavailable. *--Ed.*

September 18, 1968

PAINTINGS, DRAWINGS, ENGRAVINGS, AND SCULPTURES OF CHILE [1]

Chile is suffering this year from the most devastating drought it has known in a history so wrought with catastrophes. Chileans have learned to be hard and enduring. Yet, it is sad to think that the wind that ruffles our flags and flies the kites up to the sky will blow over a parched countryside in this month of September in which we celebrate the 158th anniversary of our Independence. The folksingers will continue to sing their ballads of clear waters, even when sorely deprived of it.

This drought, more destructive than an earthquake, has forced the government and the people of Chile to take severe measures to reduce expenditures. The Ministry of Foreign Affairs has instructed its Missions abroad to cancel the receptions usually held to celebrate the anniversary of our Independence. However, cultural events have been prepared for the occasion. Chileans will be able to meet and bring closer to them the image of the distant homeland.

All Chileans are invited to attend the celebration of these cultural events, as well as all our friends from the United States and from other countries represented in Washington, D.C.

EXHIBITION LIST [incomplete]

Paintings, Drawings, Engravings, and Sculptures

Nemesio Antúnez
 1. *N.Y., N.Y. 10003*, 1968, oil
 2. *N.Y., N.Y. 10013*, 1968, oil
 3. *N.Y., N.Y. 10012*, 1968, oil
 4. *N.Y., N.Y. 10009*, 1968, oil
 5. *N.Y., N.Y. 10030*, 1968, oil
 6. *N.Y., N.Y., Highway*

Sergio Castillo

Enrique Castro-Cid
 1. *No. 13380-D*, drawing
 2. *No. 13389-D*, drawing
 3. *No. 13390-D*, drawing
 4. *No. 12991-D*, drawing
 5. *No. 13379-D*, drawing

Juan Downey

Ernesto Fontecilla
 1. *Algunas nostalgias* (Some Longings)
 2. *Geometría* (Geometry)
 3. *Comunicaciones* (Communications)
 4. *Retrato de G. y la naturaleza* (Portrait of G. and Nature)
 5. *Enfermedad* (Sickness)
 6-7. *Drawings I, II, III*

[1] This exhibition was part of a program of eight cultural events organized by the Embassy of Chile, in celebration of the 158th anniversary of the Independence of Chile. It was open to the public for one week, sponsored by the Embassy of Chile and the Chilean Delegation to the OAS. No catalogue was issued. The text and Biographical Notes were taken from the Program of Events. A list of works by Nemesio Antúnez, Enrique Castro-Cid, and Ernesto Fontecilla was found in the exhibition files, but no list of works is available for the other artists. --*Ed.*

Roberto Matta

Santos Chávez

Raúl Valdivieso

BIOGRAPHICAL NOTES

ANTUNEZ, Nemesio. Born in Santiago, Chile, in 1918, studied architecture in Chile and in the United States. Painter, engraver, and muralist, he now lives in New York where he holds the position of Cultural Attaché to the Embassy of Chile.

CASTILLO, Sergio. Born in Santiago, Chile, in 1925, has exhibited his work in France, Latin America, and the United States. He is at present a professor at the Art School of the Catholic University in Chile.

CASTRO-CID, Enrique. Born in Rancagua, Chile, in 1937, studied at the School of Fine Arts in Santiago. Has lived in the United States since 1962.

CHAVEZ, Santos. Born in Canihual, Arauco, Chile, in 1934, studied at the Art School of Concepción and at the Taller 99 of the Catholic University in Santiago. He traveled to Mexico and the United States in 1967.

DOWNEY, Juan. Born in Santiago, Chile, in 1940, studied architecture in Chile on a scholarship. Lived in France from 1964 through 1965. He now lives in Washington and teaches at the Corcoran Institute of Art.

FONTECILLA, Ernesto. Born in Santiago, Chile, in 1938, studied architecture and is now living in the United States under a scholarship.

MATTA, Roberto. Born in Santiago, Chile, in 1912, studied architecture in Chile and then in Paris with Le Corbusier. He came to New York in 1941, during the World War II, with the group of European artists in exile: Miró, Tanguy, Chagall, Mondrian. He actively participated in the creation of the School of New York, with Polloch, De Kooning, and Motherwell. He now lives in Paris.

VALDIVIESO, Raúl. Born in Chile in 1931, has exhibited in Europe and the United States.

September 25 - October 10, 1968

CARLOS DAVILA OF PERU

Carlos Dávila, his father Alberto, and brother Jaime are all painters, and together they form a stronghold in the panorama of contemporary Peruvian art, each having taken his own direction. Carlos is engaged in an austere world where forms have been simplified and each element is easily identifiable, precisely defined. Color has been eliminated, with all the forms being grounded in pure white. If there is a certain austerity in his work, there is also wit, as evidenced in his association of the names of the planets with objects of everyday use.

Carlos Dávila was born in Lima in 1935 and studied at the National School of Fine Arts, graduating in 1962. In 1963 he took part in the restoration of archaeological monuments in Chanchán, near Trujillo, Peru. Since 1962 he has held nine one-man shows in his native country, most recently in Lima's Institute of Contemporary Art and two in the United States (Miami Museum of Modern Art and the Art Gallery of Fort Lauderdale, 1966). He has participated in group shows in Peru, Chile, and France. His paintings are in the public collections of the Foundation for the Arts, the Credit Bank of Peru, and International Petroleum Company, all in Lima, and in the Miami Museum of Modern Art and Fort Lauderdale's Art Gallery. He is also represented in numerous private collections both in Peru and the United States.

This is the first presentation of the paintings of Carlos Dávila in Washington. --*J.G.S.*

CATALOGUE

Acrylics on Wood

1. *Alfa*, 90 x 80 cm.
2. *Orion*, 90 x 80 cm.
3. *Venus*, 90 x 80 cm.
4. *Saturno (Saturn)*, 90 x 80 cm.
5. *Magnetic*, 90 x 80 cm.
6. *Static*, 90 x 80 cm.
7. *Marte (Mars)*, 90 x 80 cm.
8. *Jupiter*, 90 x 80 cm.
9. *Plutón (Pluto)*, 90 x 80 cm.
10. *Acuario (Aquarius)*, 122 x 100 cm.
11. *Delta*, 122 x 100 cm.
12. *Omega*, 122 x 100 cm.
13. *Sirio (Sirius)*, 122 x 100 cm.
14. *Beta*, 122 x 100 cm.

October 10 - 29, 1968

CARRASCO OF BOLIVIA

Jorge Carrasco, who is exhibiting for the first time in Washington, belongs to the Núñez del Prado family which has been prominent in the Bolivian art world for many years. Born in La Paz in 1919, Carrasco studied both in the capital's School of Plastic Arts, 1942-1943, and the Academy of Arts in Vienna (Austria), 1954. Since 1943 he has held one-man shows in La Paz, Lima, Caracas, Quito, Guayaquil, Paris, Zurich, and London. He participated in the São Paulo Biennial in 1951 and 1953, and some years later in the Biennial of Córdoba and of Havana. His work is in the collections of the Casa de la Cultura in Guayaquil and Quito, the Museum of Modern Art in Rio de Janeiro, and the National Museum in La Paz.

Six of the paintings currently on exhibit are from the collection of Erik A. R. Haldane (Washington, D.C.).

CATALOGUE

Paintings

1. *Rotación (Rotation)*, 1967, lacquer on canvas, 150 x 130 cm.
2. *Expansión cósmica (Cosmic Expansion)*, 1967, lacquer on canvas, 150 x 130 cm.
3. *Energía creadora (Creative Energy)*, 1967, lacquer on canvas, 91 x 72 cm.
4. *Atmósfera en Saturno (Atmosphere on Saturn)*, 1964, oil on canvas, 81 x 65 cm.
5. *Allá en el tiempo (There in Time)*, 1964, oil on canvas, 98 x 73 cm.
6. *Mensaje cósmico (Cosmic Message)*, 1964, oil on canvas, 98 x 73 cm.
7. *Espacio sin peso (Weightless Space)*, 1964, oil on canvas, 99 x 72 cm.
8. *Atmósfera del Sol (Atmosphere of the Sun)*, 1967, lacquer on wood, 65 x 45 cm.
9. *Visión en el espacio (Vision in Space)*, 1967, oil on canvas, 60 x 73 cm.
10. *Campo magnético (Magnetic Field)*, 1967, lacquer on canvas, 98 x 73 cm.
11. *Comienzo de la creación (Beginning of Creation)*, 1967, lacquer on canvas, 98 x 73 cm.
12. *Puesta del Sol en el espacio (Door to the Sun)*,[1] 1967, lacquer on canvas, 98 x 73 cm.
13. *¡Nada más! (Nothing More!)*, 1964
14. *Sagrado fundamental (Sacred Fundamental)*, 1964
15. *Organismo con posibilidad metafísica (Organism with Metaphysical Possibility)*, 1964

[1] Literal translation of this title is "Sunset in Space." --*Ed*.

16. *Espacio onírico (Oneiric Space)*, 1965
17. *Elemento de la Vía Láctea (Element of the Milky Way)*, 1966
18. *Fragmento cósmico (Cosmic Fragment)*, 1964

October 30 - November 20, 1968

LOLA FERNANDEZ OF COSTA RICA

Lola Fernández Caballero was born in Cartagena, Colombia, in 1926, but moved to Costa Rica at an early age and there established a reputation as one of the foremost painters of that country. She first studied at the School of Fine Arts of the University of Costa Rica and later, in 1949, returned to Colombia to study for two years at the National University of Bogotá. In 1954 she went to Italy, where she attended the Academy of Fine Arts in Florence and remained there until 1957, working and traveling throughout Europe, the Middle East, and Morocco. After a year in Costa Rica, she again went to Europe in 1958 and consequently was invited to join an international group of artists, *New Vision*, which was formed in London and exhibited primarily in the larger cities of Great Britain. In 1959 she was appointed professor of art at the University of Costa Rica, but two years later she went to the Far East on a UNESCO scholarship. This trip, concentrating on Japan and India but including Formosa, Hong Kong, Thailand, and Burma, was to be a landmark in her professional career.

Since her study of the art forms of the Far East, her basic expression has been oriental in flavor, and for that reason she falls in a unique category for a Latin American artist. The Asian influence is evident in her open forms, the delicate application of pigment, the veiled transparencies, and the asymmetrical composition of her paintings.

The artist held her first individual show in 1957 in the Bernard Chêne Gallery in Paris. She has participated in numerous group shows, including the *Esso Salon of Young Artists* in which she was awarded First Prize for Painting in Costa Rica, Esso's Central American exhibition at the New York World's Fair of 1964-65, *New Names in Latin American Painting* in Berlin, the Latin American exhibition presented at the Pepsi-Cola Gallery in New York, and two exhibits in *Homage to Rubén Darío* presented in Managua and Mayagüez. This year she participated in the Coltejer Salon in Medellín and in a group exhibition at the National Museum of San José (Costa Rica).

Her paintings are in numerous collections in this country, Europe, and Latin America.

This is the artist's first individual show in the United States. --*J.G-S.*

CATALOGUE

Paintings

1. *Tarantula*
2. *The Message of the God*
3. *Drifting*
4. *November*
5. *Return of the Ancestor*
6. *Kalimpong*
7. *Blood of Pigeon*
8. *Deity*
9. *Instrument of Dreams*
10. *Mandrágora (Mandragora)*
11. *Ming*
12. *Mask of Kashmir*
13. *My Dream of Lhasa I*
14. *My Dream of Lhasa II*
15. *Takarasuka*
16. *Vision of Himalaya*
17. *Sacred Mantis*
18. *Kowloon*

November 21 - December 10, 1968

SONIA EBLING

A major concern of many present-day artists is the exploration of new materials, the addition of alien elements to the traditional, or the use of materials which are not generally considered to be applicable to the plastic arts. Sonia Ebling works with cement. While still in liquid form the cement is mixed with oxide pigments, as is done in the fresco procedure, but in this case vegetable fibers are added for reinforcement. The surface is later polished and finished with different kinds of files but still retains a rough texture. The final form, belonging to the realms of both painting and sculpture, is durable and adaptable to both interior and exterior settings.

Miss Ebling was born in the State of Rio Grande do Sul, Brazil, in 1926. From 1944 to 1951 she studied in the School of Fine Arts there and in Rio de Janeiro. She later continued her studies in the Paris workshop of the sculptor Zadkine. She has participated in numerous group exhibitions in Rio de Janeiro, Pôrto Alegre, Brasília, Paris, Berlin, and Oldenburg. This year she executed a relief for the Palácio dos Arcos, headquarters of Itamaraty, the Ministry of Foreign Affairs, in Brasília.

This is the artist's first presentation in the United States.

CATALOGUE

1. *Choque de esferas (Crash of the Spheres)*, 100 x 100 cm.
2. *Outono (Autumn)*, 75 x 50 cm.
3. *Momento (Moment)*, 75 x 50 cm.
4. *Dracena*, 100 x 25 cm.
5. *Galax (Galaxy)*, 100 x 25 cm.
6. *Esmeralda (Emerald)*, 75 x 75 cm.
7. *Paisagem da Lua (Landscape of the Moon)*, 75 x 75 cm.
8. *Secular*, 75 x 50 cm.
9. *Via-láctea (Milky Way)*, 100 x 50 cm.
10. *Albatroz (Albatross)*, 125 x 25 cm.
11. *Labareda (Flame)*, 125 x 25 cm.
12. *Mesquita (Mosque)*, 125 x 25 cm.
13. *Danubio (Danube)*, 100 x 25 cm.
14. *Bodas de sangre (Blood Wedding)*, 75 x 50 cm.
15. *Time Out*, 75 x 50 cm.

November 26, 1968 - January 10, 1969

PHOTOGRAPHS AND OBJECTS FROM EASTER ISLAND [1]

EXHIBITION LIST

Photographs

1. *Oronco: The Rano Kau Volcano*
2. *Oronco: Islands of Motuiti and Motu Kaokao*

[1] No catalogue is available for this exhibit which included forty objects lent by the Smithsonian Institution, books on Easter Island lent by the Organization of American States' Columbus Memorial Library, and the color and black and white photographs taken by Ramón G. Osuna and listed here. At the opening of this show, the following events also took place: (1) Inauguration of an authentic Easter Island *Mohai*--monolithic head--placed in front of the Organization of American States building. (2) Premiere of the film *Easter Island*, shot in December 1966, color, 25 minutes, produced by the Division of Cultural Affairs of the Organization and the Chilean government. This exhibit was later circulated for two years in the United States by the Smithsonian Institution. *--Ed*.

3. *Oronco: Cliffs*
4. *Oronco: Detail of Petroglyph*
5. *Slope and Lake near Puna Pau*
6. *Oronco: Dwellings of King and His Court*
7. *Rano Raraku: Volcano in the Distance*
8. *Rano Raraku: Crater with Totora Plant*
9. *Rano Raraku: Detail of the Totora*
10. *Vinatea: Sheep Shearing*
11. *Vinapu: Masonry of Ahu Resembling Masonry of the Inca Walls in Machu Picchu*
12. *Totora Boat with Three Masts Resembling Boats Constructed by South American Indians*
13. *Hanga Roa: Port for Small Fishing Boats*
14. *Moai on Slopes of Rano Raraku*
15. *Oronco: Inside the Crater of Rano Kau*
16. *View of Island and Coast*

The Island Population and Fauna

17. *Father Sebastian Englert*
18. *Chilean Couple*
19. *Nuns from Chile*
20. *Sunday Mass*
21. *Night Fishing*
22. *Children Dancing on Anakena Beach*
23. *Horses Imported from Tahiti*
24. *Falcon Imported from Chile*
25. *Ahu or Altar Erected by William Mulloy and Gonzalo Figueroa*
26. *Detail of Ahu*
27. *Detail of Ahu*
28. *View from the Rano Raraku Volcano Showing Eucalyptus Trees in the Distance*
29. *Rano Raraku: Inside the Quarry*
30. *Rano Raraku: Outside the Quarry*
31. *Rano Raraku: Slopes of the Crater with Moai or Statues*
32. *Rano Raraku: Quarry with Figures Still Attached to the Rock*
33. *Moai Resembling Tiahuanacan Monoliths of Bolivia*
34. *Easter Islanders of the 18th Century as Seen by European Engravers of That Period*

BIOGRAPHICAL NOTE

OSUNA, Ramón G. Photographer, born in Havana, Cuba, 1937. Although he graduated from the Santo Tomás School of Law in Havana, 1960, his main interest has always remained in art related activities. Was assistant to the director of the National Museum in Havana, 1959-60. Presently is the assistant director of the Visual Arts Division, Organization of American States, where he has organized Latin American exhibits and has been the photographer for several of the films produced by that division. Has lived in the United States since 1960.

December 10, 1968 - January 6, 1969

SOLA FRANCO OF ECUADOR

Eduardo Solá Franco was born in Guayaquil, Ecuador, in 1915. He first studied art in the workshop of the Spanish painter López Morello in Barcelona (Spain), 1930. Three years later he returned to Ecuador, where he studied in the School of Fine Arts of Quito. In 1936 he was awarded scholarships to attend the Grand Central School of Art and the New School of Social Research in New York, and the next year was awarded another scholarship to attend the Academy of Art in Warsaw, Poland. He also studied at the Art Students League in New York, the de Puig Academy of Buenos Aries, and the Gambacciani Academy in Florence. In 1947 he attended sessions at the Grande Chaumière in Paris.

Since 1938 Solá Franco has held one-man shows in Guayaquil, Lima, Buenos Aires, Quito, Santiago, New York, Paris, Barcelona, Rome, Madrid, and in Bermuda. He participated in the Madrid Biennial in 1951 and in the Venice Biennial in 1966. His paintings are included in private collections in Italy, France, Spain, and Peru.

This is the artist's first presentation in the Washington area.

CATALOGUE

Paintings

1. *Edipo y la esfinge (Oedipus and the Sphinx)*
2. *Juego de masacre (Massacre Game)*
3. *Angel vengador (The Avenging Angel)*
4. *Maremoto(Tidal Wave)*[1]
5. *Imágenes de un verano (Images of Summer)*
6. *El ruido (The Noise)*
7. *Film alemán (German Film)*, 1927
8. *Llegaron las ostras (The Oysters Arrived)*
9. *Equilibrio difícil (Difficult Equilibrium)*
10. *Negativo de Dorian Gray (Negative of Dorian Gray)*
11. *Cámara oscura: los Romanovs (Dark Camera: The Romanovs)*
12. *Cámara oscura: los Borbones (Dark Camera: The Bourbons)*
13. *Cámara oscura: Retrato de desconocida (Dark Camera: Portrait of an Unknown)*
14. *Linterna mágica (Magic Lantern)*
15. *Ciudad crujiente (Creaking City)*
16. *Otro nacimiento de Venus (Another Birth of Venus)*
17. *Comienza el diluvio (The Flood Begins)*
18. *Diversiones (Diversions)*

[1] Literal translation of this title is "Seaquake." --*Ed*.

YEAR 1969

January 7 - 22, 1969

PARADA OF BOLIVIA

Abstract art in Bolivia follows two directions: one is expressionistic in aim, informalistic, generally a free or non-literal description of Bolivia itself; the other, geometric with hard-edge forms and flat, smooth painting. Color is generally somber and austere. Both can be related to the country of origin, if only because they echo the transparent atmosphere and the vastness of the highlands.

Domingo Parada is representative of the geometric trend. Born in Sucre, Bolivia, in 1941, he studied there in the School of Plastic Arts of the University of San Francisco Xavier, graduating in 1961. In 1964 he studied painting with Ivan Serpa at the Museum of Modern Art in Rio de Janeiro. He has exhibited extensively in his native country since 1957 and in 1966 represented Bolivia at the Third American Biennial of Art in Córdoba, Argentina. That same year he also exhibited in the Ilary Gallery in Asunción, Paraguay.

In 1967 the artist moved to Chicago, Illinois, where he has presented three shows, the most recent at Chicago State College, May 1968. He has been awarded several prizes in Bolivia and Brazil. Paintings by Parada are in museum and private collections in Bolivia, Brazil, Argentina, Chile, Peru, Germany, Japan, Paraguay, the Dominican Republic, and the United States.

This is the first presentation of Domingo Parada's work in the Washington area. --*J.G-S.*

CATALOGUE

Oils

1-16. *Untitled*

January 23 - February 12, 1969

ALIRIO RODRIGUEZ OF VENEZUELA

For almost twenty years geometric abstraction has been the prevalent trend in Venezuelan art. However, there has also been a tendency toward non-representational, informalist art, which is subjective and expressionistic. This has recently evolved into a humanistic, neo-figurative expression, with the human form, human attitudes and emotions becoming the focal points.

Alirio Rodríguez takes individual emotions and features of the human face or body separately and exaggerates them to express human loneliness, pathos, and tragedy much in the same way that the early nineteenth century caricaturists, for example, drew enlarged heads on diminutive bodies to focus on some particularly humorous aspect of the subject. He avoids repetition and the conventional by alternating emphasis or use of different elements such as foreshortening of the form, tension, and color.

Rodríguez was born in El Callao, State of Bolívar, Venezuela, in 1934. In 1958 he was awarded a four-year scholarship to study at the Institute of Art in Rome. He returned to Caracas in 1962 to study at the School of Fine Arts. Since 1957 he has held ten one-man shows in his native country and one in Rome. He has participated in group shows in Venezuela, Colombia, Peru, Chile, Argentina, France, and Italy and has won numerous awards in national competitions.

Rodríguez, who in his own way is a forerunner in Venezuelan neo-figurative art, is exhibiting for the first time in the United States. We gratefully acknowledge the cooperation of the National Institute of Culture and Fine Arts in Caracas for having made this exhibition possible. --*J.G-S.*

CATALOGUE

Oils

1. *Sobre el vacío (In the Emptiness)*
2. *Cargador de recuerdos (Carrier of Memories)*
3. *Proposición de una cabeza a la velocidad del rojo (Proposition of a Head at the Velocity of Red)*
4. *Oferente (Offering)*
5. *Transfiguración de un ser (Transfiguration of a Being)*
6. *Hombre con camisa de fuerza (Man with a Strait Jacket)*
7. *Juez (Judge)*
8. *Filósofo (Philosopher)*
9. *Personaje (Personage) I*
10. *Personaje (Personage) II*

Ink Drawings[1]

1. *Estudio (Study) I*
2. *El prócer (Forefather)*
3. *Retrato de un hongo (Portrait of a Mushroom)*
4. *Hubo una vez un rey... (Once Upon a Time There Was a King . . .)*
5. *Monumento (Monument) I*
6. *Bicéfalo (Bicephalous) I*
7. *Bicéfalo (Bicephalous) II*
8. *La tapa de los sesos (Top of the Shell)*[2]
9. *Estudio sobre aparecidos en un hongo (Study on Ghosts in a Mushroom)*
10. *En el vacío, estudio tridimensional (In the Void, Three-Dimensional Study)*
11. *Vigía (Watchman)*
12. *Monumento (Monument) II*
13. *Perfil (Profile)*
14. *Bicéfalo (Bicephalous) III*
15. *Estudio (Study) II*
16. *Estudio tridimensional (Three-Dimensional Study)*
17. *Hacia otra galaxia (Towards Another Galaxy)*
18. *Hacia otra dimensión (Towards Another Dimension)*
19. *Monumento, bailarinas (Monument, Ballerinas)*
20. *La cortina (Curtain)*

February 13 - March 5, 1969

OSVALDO BORDA OF ARGENTINA

Unlike many of his fellow artists in Argentina, Osvaldo Borda is not experimenting with the extra-pictorial; rather, he continues to use traditional materials--paint, brush, and canvas--and works within one of the most advanced trends in Argentine art. His static, stiff, dry forms are expressive of the space age. But the meaning of the forms aside, Borda's is the work of a great colorist, as evidenced by his way of inter-mixing colors and the

[1] The titles of these drawings did not appear in the original catalogue. --*Ed.*

[2] Literal translation of this title is "The Cover of the Brain." --*Ed.*

dexterity with which he handles a harsh palette.

Borda was born in Loma de Zamora, Province of Buenos Aires, in 1929 and has been a professional artist for more than fifteen years. With the exception of his association with the *Phases Group* in 1960 and 1964 while working on a scholarship in Paris, he considers himself a self-taught artist. From 1956 to 1968 he held fourteen one-man shows in Argentina. He has participated in group shows in Paris, Tel Aviv, Brussels, Bonn, Berlin, São Paulo, Bogotá, Caracas, Mexico City, Buenos Aires, San Juan, Minneapolis, and Boston. He has won four important awards, including the Georges Braque Prize given by the Embassy of France.

This is Borda's first one-man show in the United States. --*J.G-S.*

LIST OF WORKS [1]

Oils on Canvas

1. *Hermético (Hermetic)*, 1968, 30 x 40 cm.
2. *Los prisioneros (The Prisoners)*, 1967, 114 x 162 cm.
3. *Los autómatas (The Automatons)*, 1968, 80 x 100 cm.
4. *Sin nombre, sin edad (Without Name, Without Age)*, 1967
5. *Personaje de una incierta edad (Personage of an Uncertain Age)*, 1967, 60 x 90 cm.
6. *Otros seres (Other Beings) I*, 1966, 70 x 100 cm.
7. *Otros seres (Other Beings) II*, 1966, 70 x 100 cm.
8. *Enigmático (Enigmatic)*, 1968, 80 x 100 cm.
9. *Clasificados (Classified)*, 1968, 70 x 100 cm.
10. *Los sobrevivientes (The Survivors)*, 1966, 144 x 145 cm.
11. *Viajeros de lo desconocido (Travelers from the Unknown)*, 1967, 150 x 180 cm.
12. *Los visitantes (The Visitors)*, 1968, 150 x 180 cm.

Drawings, black and white and color [2]

February 13 - March 5, 1969

GERO OF ARGENTINA

I have known the sculptor Julio Gero for the last twenty years and have seen him struggle from what could be considered his beginnings as an original creator of forms to his maturity of today.

In a subtle and mysterious way the rotund images of the master Fernand Léger become part of the deceptively eerie forms of Gero, who is a disciple and admirer of Léger. In the structural world of Gero, the sensation of volume which Léger expressed in pictorial language has been penetrated by space. But it would be a mistake to ignore the presence and weight of volume, and even mass, which characterizes Gero's work.

After Gabo's discovery, the sensation of weight needs no longer be achieved solely through an impenetrable block of marble or granite. It is enough to point to the outline of a weighty structure and allow the imagination to fill in the gaps. This allows more lyrical interplay between fancy and the more rigid laws of geometry. It is this lyrical quality that animates the work of Gero. In the hard discipline of his art, Gero has grown to this type of authority and deserves to be called a master in his own right.

We would hope that the beauty he has rescued after so many years of toil and incorruptible faith will be able to transmit its message to the alert vision of the American public and critics.

[1] Not included in the original catalogue. --*Ed.*

[2] Titles are unavailable. --*Ed.*

Julio Gero was born in Arad, Hungary, in 1910. He began his studies at the School of Fine Arts in Budapest and in 1938 went to Paris where he studied under Jean Boucher at the Fine Arts School. In 1940 he moved to Argentina and became a citizen of the country. Presently, Gero is titular professor of sculpture at the School of Fine Arts in Buenos Aires. He has exhibited extensively, both in one-man and group shows, in Argentina, Brazil, France, and recently in the United States. In 1964 he represented Argentina in the sculpture exhibit at the Venice Biennial. Works by Gero are included in the collection of the Museum of Modern Art in Buenos Aires, Rio de Janeiro, and Asunción and in the Fine Arts Museum in Paris.

This is Gero's first exhibition in the Washington area. --*Rafael Squirru*, Director, Department of Cultural Affairs, Organization of American States.

CATALOGUE

1. *Acróbatas (Acrobats)*
2. *Concordia (Concord, Autonomous City)*
3. *Concordia (Concord) No. 2*
4. *Dragón (Dragon)*
5. *Fuga (Fugue)*
6. *Medusa*
7. *Osiris*
8. *Orpheus*
9. *Pegasus*
10. *Pierrette*
11. *Modular No. 1*
12. *Modular No. 2*
13. *Saturno (Saturn)*
14. *Totem*
15. *Victoria (Victory)*
16. *Icarus*

March 6 - 25, 1969

BEATRIX BRICEÑO OF PANAMA

Contrary to the trend of dramatic expressionism which is predominant in present-day Panamanian art, Beatrix Briceño's paintings are characterized by a personal charm--a humorous and magic conception of reality, almost as if seen through primitive eyes. In this respect she might be linked to magic realism, to the vast world of fantasy created by René Magritte. The impossible, the coincidental, and the simple mutation in the order of reality achieve poetic significance through a simple, direct technique reminiscent of the delightful touch of the naive painters.

Born in London in 1911, Beatrix Briceño moved to Panama where she became a citizen in 1943 and reared a family. She began her art studies at the University of Panama in 1956 and in 1958 moved to Rio de Janeiro to enroll in the workshop of painter Frank Schaeffer. During her two-year stay in Brazil, she held her first individual show and participated in a group exhibit. Since that time she has had nine individual exhibits in Panama and the Canal Zone and has participated in group shows in Panama, Brazil, Colombia, and El Salvador. Her work was first presented in the United States in the Panama Pavilion at HemisFair 1968 in San Antonio, Texas.

This is the artist's first individual presentation in the United States. --*J.G-S.*

CATALOGUE

Paintings

1. *Red Ball*
2. *Still Life*

3. *Genesis*
4. *Cherries*
5. *Pink Vanity*
6. *Tea*
7. *Breeze*
8. *Foot*
9. *Apples*
10. *Assassination*
11. *Cushions*
12. *Luigi*
13. *Cerebral Topography*
14. *Magic Tree Box*
15. *Conversation*
16. *Factory*
17. *The Dollies*
18. *One Way*
19. *Filial Love*
20. *The Repossessed*

March 26 - April 12, 1969

HERRERA GUEVARA OF CHILE, 1891-1945

For almost twenty years Santiago's cafés, theaters, and art galleries were the regular haunts of a tall, wig-wearing Oscar Wilde-type character named Luis Herrera Guevara. If he created a sensation with his wigs, which were blonde, black, brown, or red according to the season of the year, he also inspired admiration because he was an unmistakably talented painter. Time has enlarged the legend of the man, and the importance of his work is now being fully considered. He is Chile's best naive painter, and his work is sought after by collectors both in his native country and abroad.

Born in Santiago in 1891, Herrera Guevara studied law at the insistence of his father and in 1920 began to practice professionally. But his natural instinct for drawing and painting and his feverish dedication to his art finally led him to put aside his law career and convert his office into a studio. His style and technique are genuinely naive, with two-dimensional perspective and attention to minute detail, and, as is characteristic of all primitive painting, his work has an innocent charm and delightful shortcomings. Several of his compositions with intentional splashes of thick pigment are reminiscent of Matisse, whose work he had seen in reproductions. Certainly, however, the greater part of his work links him with the masters of naive painting.

Herrera Guevara first exhibited his paintings in 1930 in the Open Salon of Valparaíso. He held only three one-man shows during his lifetime--two in Santiago and another in 1943 in New York's Durlacher Brothers Gallery. The New York show attracted the attention of art critics of major magazines and newspapers such as *Time, Art News*, and the *New York Times*. Henry McBride, then critic for the *New York Sun*, noted that Herrera Guevara was recognized as a Chilean Rousseau in his own country, though lacking the touches of "romantic yearning that made the original Rousseau." McBride found a hearty feeling, a "devil-may-care, something of the earthquake rhythm" in the artist's style and commented that he could not imagine that he had ever heard the word "defeatism."

The New York presentation was due in great part to the interest of René d'Harnoncourt, who first introduced Lincoln Kirstein to Herrera Guevara's work. Two of these paintings that Kirstein brought back from Chile are still in the collection of New York's Museum of Modern Art. Another of the few collections in this country with a painting by Herrera Guevara is the Rhode Island Museum of Art's Nancy Sayles Collection of Latin American Art.

This exhibition is the first since Herrera Guevara's death in 1945 and was made possible with the loan of the collection of Chilean painter Alvaro de Silva, to whom we wish to express our gratitude. Information for the catalogue is based on the book *Herrera Guevara* by Antonio R. Romera, the first biography and critical appraisal

of the artist's work, published by the University of Chile in 1958. *--J.G-S.*

CATALOGUE

Paintings

1. *La tenista (The Tennis Player)*
2. *Avenida (Avenue)*
3. *Nueva York (New York)*
4. *Amor de paso (Fickle Love)*
5. *La Moneda, Casa de Gobierno de Chile*
6. *Congreso de Chile (Congress of Chile)*
7. *Frutera con higos (Fruit Basket with Figs)*
8. *Avenida Bellavista*
9. *Paracaidistas (Parachutists)*
10. *Esquina verde de Valparaíso (Green Corner of Valparaíso)*
11. *Plaza Baquedano*
12. *Plaza de Iquique*
13. *La cantinera (The Bar Maid)*
14. *Pedro de Valdivia*
15. *Autorretrato (Self-Portrait)*
16. *Príncipe de la Iglesia (Prince of the Church)*
17. *Primavera en Santiago (Spring in Santiago)*
18. *Paseo en bote (Boating Ride)*
19. *Penitente (Penitent)*
20. *La Unión de Valparaíso (The Union of Valparaíso)*
21. *Góndola acolchada (Cushioned Gondola)*

April 13 - 30, 1969

ARTS OF THE CUNA INDIANS
A loan exhibition from the F. Louis Hoover Collection of Cuna Art

Photos of San Blas by F. Louis Hoover
Photos of *molas* by Illinois State University Photographic Service

FOREWORD

For more than twenty years, the Division of Visual Arts has attempted to give the North American public the widest view possible of the cultural expressions of the Latin American countries, including not only the fine arts of painting and sculpture but also the so-called popular arts and crafts which belong in the realm of folklore. One of the most imaginative and charming of the popular arts is the *mola*, with its cryptic patterns and overlapping planes of bright, pure color. Made by the Cuna Indian women and used as the back and front of a blouse, the *mola* has attracted the attention of not only collectors of folk art but also such renowned fashion designers as Balenciaga.

This exhibit, in celebration of Pan American Week, provides a comprehensive view of the art created by the Cuna Indians, including both *molas* and carved wooden figures, and consists entirely of pieces belonging to the collection of F. Louis Hoover, professor of art at Illinois State University. Part of this collection was shown last year in New York City's Center for Inter-American Relations. We wish to express our sincere gratitude to Mr. Hoover for having made this exhibition possible. *--J.G-S.*

ARTS OF THE CUNA INDIANS

The fine reception given our collection of Cuna art in New York City a few months ago has encouraged us to make available selections of representative Cuna art objects to other museums and galleries from time to time.

The *New York Times* art critic, John Canaday, began his review with ". . . an enthusiastic send-off to a new exhibition at the Center for Inter-American Relations called *Molas from the San Blas Islands, Panama*. It is a very good show." Later, Canaday referred to the fabric designs as "folk art of a superior kind . . . , often works of fine art in a living form . . . ," and concluded by saying: "What I don't quite understand is how this material can have remained undiscovered, or at least unexploited, during the forty or fifty years during which so many so-called primitive arts, including the sculpture of tribal Africa, have been taken away from the anthropologists by the aestheticians."

In some ways this exhibition sponsored by the Pan American Union is more comprehensive than that held in New York. More than half the *molas* are being shown for the first time. The addition of the *uchus*--those unique little figures carved from native hardwood and used by medicine men to cure various ills--along with the exotic necklaces of wild boars' teeth, bird bones, shells, and seeds give the viewer a more comprehensive idea of the artistic traditions and contributions of the Cuna people.

It might be observed that Mrs. Hoover and I are attempting to collect and preserve primarily the older examples of Cuna art. On our trips to the San Blas Islands we have centered our efforts on the farther-out islands in the area of Achatupo, Mamitupo, Ustupo, Mulatupo, and on down the coast as far as Puerto Obaldía on the Colombian border. Numerous individuals have contributed to making these expeditions successful, but special appreciation must be given to Mr. W.D. Barton without whose personal interest and assistance the development of such a comprehensive collection would have been most difficult indeed. It is our hope that a Cuna art center may be established which will be suitable for housing and preserving art objects. At that time this basic collection of Cuna art will be returned to the Cuna people for future research and study regarding their cultural heritage.

History

In all there are some three hundred and sixty islands which extend along the Atlantic coastline of Panama. The Cuna Indians live primarily in very crowded villages on approximately forty of these islands.

Known also as the San Blas or Tule Indians, some anthropologists believe the race originally migrated from Southeast Asia as long ago as 4000 B.C. In this case, they would have brought with them cultures similar to those of protoliterate Mesopotamia and pre-dynastic Egypt. They may also have maintained trade contacts with their parent cultures for long periods of time. If this were true, it might account for some of the beliefs which we find today among the Cunas as well as certain visual symbols found in their art expressions and picture writing.

For the present this can only be conjecture, but we do know that the Cuna culture contains some of the oldest and most widely distributed traditions of mankind. In *Secrets of the Cuna Earthmother*, Clyde Keeler states: ". . . if you want to know the original meanings of symbols in the ancient Ishtar religion of Babylon, you may . . . ask a medicine man of San Blas."

In our own research we have found designs and subjects on some of the older *molas* which are remarkably similar to designs found on objects dating from the third millennium B.C. These include the use of both animal and human forms flanking a tree (nos. 31 and 32), a double-headed, winged dragon (no. 7), heroes battling a variety of vicious monsters (no. 8), and demonic combinations of animals and man (nos. 39 and 43).

While some educated Cunas may agree to the possibility of trade and cultural contacts with Asia several thousands of years ago, most Cunas seem to believe that their own origins were in the mountainous regions of the Panamanian mainland. And we should not overlook the fact that some objects have been found in the Puerto Obaldía area which, by means of carbon dating, indicate their use at approximately 3000 B.C. Physically, the Cunas we know today have a strong resemblance to the Maya Indians. They are short in stature with well developed necks and shoulders and rather short legs and small feet.

Regardless of their origin, there seems to be some agreement that certain Cuna groups migrated from the Pacific to the Atlantic side of the Isthmus during the sixteenth and early seventeenth centuries. However, some Cunas undoubtedly remained on the Pacific side until the time of Lionel Wafer in the second half of the seventeenth century.

It was during the years in which the Cunas colonized certain parts of the Caribbean coast of the Isthmus that

they became a sea-minded people. There is no known record of Indians living on the San Blas Islands until about 1850.

Today the Cuna Indians are divided into two groups: the sea-going people who inhabit the islands and the adjacent coast of Panama, with whom this exhibition deals, and the mountain Cunas who speak the same language and share many of the same customs as the island Cunas, although somewhat different in temperament.

It should be noted that the Choco Indians also have lived for many years in the area of the Isthmus known as Darién. However, the Chocoes seem to be more like the native Indians of the Republic of Colombia in their language, physical appearance, and customs. Apparently the Chocoes and the Cunas have lived for centuries side by side without inter-marriage and without adopting a similar culture. On the other hand, the Chocoes have mingled their blood with that of Negroes since the first days of the *Cimarrones*. They now live primarily along the Pacific shores of Panama and along the banks of rivers flowing into the Pacific.

In considering the historical, religious, and cultural development of the Cunas, it must be kept in mind that they have been influenced by Europeans for more than four hundred years. Rodrigo de Bastidas and Alonso de Ojeda have been credited with having first discovered the Atlantic coast of the Isthmus about 1501. Apparently no attempt at landing was made until Columbus, on his last voyage, established a small colony on the Belén River. This was soon destroyed by a local war-like chief. Columbus continued down the coast and discovered the harbor of Porto Bello and the Mulatas Archipelago, which he called Islas Bergas.

Later, in the region around the Gulf of Uraba, Rodrigo de Bastidas is said to have encountered the Cuevas, a people possibly related to the Cunas. He also found large quantities of gold and pearls. This was probably the beginning of the insatiable lust for gold which brought treachery and death to hundreds of thousands of Indians during the next three centuries.

Numerous efforts were made by the Spaniards and other European groups during the seventeenth and eighteenth centuries to subdue the Cunas. In this they were unsuccessful, although many thousands of Indians were massacred. At the time of the first Spanish settlements, the Indian population of Darién was variously calculated at between 300,000 and 800,000. Today, the total Cuna population has been estimated at about 20,000.

In the nineteenth century work on the Panama Canal had a major effect on all Panamanian affairs. Both the Cunas and Chocoes came into contact with French, English, and American engineers, but there was no special trouble except that permission to cross Cuna territory was occasionally refused.

When Spain lost her colonies in South America, the Isthmus of Panama came under the rule of Colombia, but efforts on the part of the Colombians to subdue the Cunas were unsuccessful.

When Panama declared its independence in 1904, a large portion of Cuna land came under Panamanian domination. At first, many Cunas wanted to become Colombian citizens, and for a period of time they flew the Colombian flag. But Colombia was in no position to defy the new Republic of Panama.

In 1925 the Cunas proclaimed the independent Republic of Tule whose flag was a blue swastika on a field of orange with a border of red. This was a most unsuccessful venture, and a great number of lives were lost. Relations remained strained until a final agreement was reached in the legal establishment of an area of land designated specifically for the Cunas by the Panamanian National Assembly in 1938. This was reaffirmed in 1953.

Today the boundary lines of the Cuna Indians are well established. Panamanian government offices have been set up on the island of Porvenir in Mandinga Bay with a resident *intendente* having the official title of Governor of San Blas.

Traditionally, the Cunas were ruled by three chiefs known as caciques. Today Panamanian law recognizes the tribes in line with the Organization Charter of the Cuna Tribe. Under the new law, the various chiefs of Indian villages are paid a modest monthly salary for cooperating with the Panamanian authorities and are expected to help keep law and order throughout the islands.

Religion and Mythology

The Cuna's conception of God is not very different from that of the Old Testament. This includes the belief that many years ago God became displeased with his people and punished them by sending a great flood which destroyed almost everything on earth. However, while the Cunas believe that God was responsible for the creation of all things, He is not a deity to whom they pray or to whom they make sacrifices of any kind.

They believe that man has a soul. They also believe that the world is full of demons, monsters, and spirits, both good and bad. Most objects such as trees and rocks also contain spirits, and it is believed that evil spirits sometimes make men ill. When this happens, a medicine man is called in to fight them.

The Cunas believe there is a heaven where the good will be rewarded. Evil-doers get to heaven also, but it may take them longer to make the trip because they will be punished for all their past sins along the way. The Cunas believe that there are sixteen layers to the universe aside from the earth's surface: eight layers to heaven and eight layers to the underworld. The chief of the evil spirits lives on the fourth layer of the underworld through which the souls of all men must journey on their way to heaven.

Thus, there are many "spirit worlds" or realms in which spirits may live. When any of the spirits are disturbed or become angry, they may attack a person and cast a spell upon him which results in sickness. This fear of disembodied spirits may be one reason why the Cunas seem to prefer to live in crowded island villages; they may feel safer when they are close to their fellow man than when alone.

Death comes to a person when his soul or spirit has been separated from him for such a long time that it becomes lost and the body can no longer function without it. It is the task of the medicine man to use all the devices he knows to bring back the lost spirit. Among these devices are chants, medicinal herbs, and the very powerful fumes of burning hot peppers. Carved wooden figures called *uchus* are placed around the bed of the patient and play an important role in certain rituals. Also among the medicine man's aids is the *akuanusa*, a rare and very powerful stone which is said to always remain cold. It is used in bringing down high fever.

There are certain Cuna leaders who are the most learned and informed regarding the Cuna culture. These are the *neles* (wise men), the *kantules* (medicine men), and the *nappa taketis* (morticians).

Knowledge concerning certain aspects of the Cuna culture is limited to particular individuals, since apparently no person presumes to know all the secrets of the culture. It is not unusual to receive conflicting opinions about social and cultural customs. Some of this discrepancy may be due to honest differences of opinion. After all, none of it has even been written down by a Cuna, since the language, except for picture writing, was never a written one. Or the discrepancy may be an effort to keep the inquirer away from the truth, for the Cuna considers many of his customs and beliefs too sacred to discuss them with a white man. Thus, many facts about the Cuna culture are kept secret, and not only from the outsider. The average Cuna may never know the real meaning of certain sacred religious chants which are filled with symbolic references.

This secretiveness extends to various aspects of daily life, including sex. In the past, it has not been unusual for young people to reach the age of marriage and still be quite innocent regarding conception and birth. It is little wonder, therefore, that obvious sexual symbols seldom appear in the Cuna's visual arts. And yet there seems to be some evidence that much of their basic religious and cultural beliefs derive from ancient fertility cults.

As far as we know today, the Cuna religion is based upon a belief in the sacred Earth-Mother. This, one of the earliest and most primitive of all religions, has been found in all parts of the world. For the Cunas, the Earth-Mother represents the great cosmic womb from which comes all life. She is called *Olokukurtilisoop*, and is sometimes referred to as the Giant Blue Butterfly Lady. Her divine symbol is the moon. Her son is *Olowaipipilele*, the Sun-God, who also became her consort.

The Tree of Life, like the Earth-Mother, is a religious symbol of fertility and reproduction which comes from the ancient Near East in an unbroken tradition. It has been found in some of the earliest Sumerian art and continues through the history of Mesopotamian art. It was prominent in Assyrian friezes of the first millennium B.C. and is described in the Bible in the books of Genesis and Revelations. The Tree of Life is found in a variety of visual and symbolic forms in both picture writing and other visual arts of the Cuna Indians. Their name for

it is *Paluwala*.

There are numerous other religious symbols used by the Cunas which have ancient traditions. One example is the snake which may be the sacred phallic symbol of the Sun-God's creative power.

Social and Political Customs

Cuna life is based upon a matriarchal system. The woman is not only well respected, but to a large extent controls the destiny of her family. The family units which live within a house are all related by marriage to a lineage of women. Thus, when a young man marries, he and all his earthly possessions move into the home of his bride.

In spite of this emphasis upon female lineage, the oldest male in each household is regarded as its head. In case of death, authority goes to the eldest son-in-law of the several families which may reside under the same roof.

By tradition marriage has seldom been the result of courtship. When an adolescent girl's mother and father decide that she is ready for marriage, they choose a young man who they think will make her a good husband. A consultation is held between the father of the girl and the father of the boy. If both are in agreement, plans for the marriage are made without consulting or discussing the matter with the young couple.

Individual problems which occur in the village are dealt with promptly, fairly, and decisively in the council hall by duly elected village officials. Although three major Cuna caciques are elected to rule over the Cuna people, each village has its own group of *saiklas*, elected for life but remaining in office only for as long as their decisions are considered wise. On the death of a *saikla* or cacique, a person is elected who has already proved himself to his people over a period of many years. To the writer's knowledge, there are no young *saiklas* or caciques.

Each village has a council hall, generally a very large building with thatched roof and a dirt floor. In the center are hammocks in which the several *saiklas* or caciques may lounge and smoke their pipes during sessions of the council. Other members of the village, usually men, sit on benches facing the hammocks. In council, which is in session almost every evening, all decisions regarding village matters are discussed and settled. If a visitor comes to the village, especially one who is not a Cuna, he is taken to the council hall, presented to the *saikla*, and requested (and expected) to state his business. Usually he is well received by the members of the village.

Generally speaking, life in the typical Cuna village has changed little over the years. Every day the women paddle their dugout canoes, called *cayucas*, to mainland rivers for drinking water. The men may go the mainland to work on their farms or into the jungle for fresh fruit. Usually they are back home by early afternoon and may spend the rest of the day fishing.

When a man dies, he is buried in the family plot of the village cemetery. This is usually located along the banks of a mainland river. A hammock is hung from two poles which have been set in a pit. After burial in the hammock, the pit is covered with a roof of thatch. Containers of food and water are placed nearby for the deceased to use until his soul reaches heaven.

Of considerable interest is the fact that no system of phonetic writing was developed by the Cunas. There was no calendar or written dates. However, the Cunas did develop a method of picture writing which most of the early explorers mention in their writings. Many examples of this writing have been assembled and translated with the assistance of educated Cunas such as Rubén Pérez Kantule. A collection of Cuna picture writing is in the Göteborg Museum, Sweden.

The writer has talked with a Cuna chanter who showed him books of picture writing telling the story of chants used in certain ceremonies. The chanter admitted that no younger Cuna men were interested in taking the time to learn them, and that when he dies these particular chants would probably die with him.

Dress

With regard to clothing, it appears that woven apparel, with the possible exception of loincloths, made its appearance only within the last several hundred years. The early explorers generally referred to the Indians as

naked. Interesting exceptions were a man's penis cover of gold as well as golden nose rings, so large that they had to be lifted or removed in order to eat. Nele de Kantule of Ustupo, one of the wisest of Cuna men, is said to have stated that, as a child, he could remember seeing old men with the septum of their noses perforated for nose rings much like those worn by Cuna women today.

Several explorers describe the Indians as body painters, and apparently the custom of binding the arms and legs tightly with long strands of beads is a very old one.

We do not know the origin of the *mola*, and we have few, if any, clues to its development. From the available evidence, it appears that a painted loin cloth called a *picha makkalet* was possibly the intermediate step between body painting and the brightly colored, stitched *molas* we know today.

Necklaces of animal teeth, coral, shell, seeds, and, more recently, glass beads and pierced coins have for many years decorated the throats of women. It is not unusual to see a Cuna woman with twenty or more strands piled high around her neck. (In contrast, a string of animal teeth is often the only thing worn by little boys.) Even more eye-catching are the huge golden breast plates and circular earrings which are the desire of every Cuna female.

But the brilliantly colored *mola* is the glory of every Cuna woman. She may work as many as six weeks on each of the two panels which form the front and back of her blouse, and they may contain as many as ten or twelve colors. The predominant color is usually red, which may match the color of her cheeks if she has painted them with round circles of *mageba*, a red pigment.

If we establish categories of *mola* designs based upon content, certain ones may be identified as purely decorative with, apparently, no special meaning. But it seems unlikely that certain motifs were repeated for many centuries, and in many parts of the world, simply because aesthetic sensibilities hungered for a specific decorative expression.

This exhibition and catalogue make no attempt to provide answers, but to question and suggest possibilities for future research. The titles given the *molas* are primarily descriptive for purposes of identification. However, some suggest meanings which are based upon discussions with Cunas, or with other persons familiar with their culture, as well as an examination of certain symbols used in other cultures, especially those of ancient Near East cults.

We might tentatively divide *molas* into three groups by content: (1) celebrations of current events; (2) religious and mythological themes; and (3) abstractions which may or may not have implied meanings.

Technically the *molas* involve both appliqué and a reverse appliqué type of sewing, a combination of methods that we now refer to as "multipliqué." There are several variations that occur on a relatively consistent basis. The first of these, exemplified by no. 22, *Two Pelicans*, is a "bar and grid" pattern in which the fabric has been cut and sewn to form a pattern of parallel lines often juxtaposed at right angles. Then, an emphasis on linear quality and a limitation to essentially two colors, as in no. 13, *Man, Birds, and Animals*, may be referred to as a "linear duotone." Finally, the addition of embroidery after all the parts of the *mola* have been stitched down, as in no. 26, *Sea Creatures*, may be called "embroidered multipliqué."

Besides the highly developed fabric designs produced by Cuna women, a fine sculptural quality may be seen in some of the small *uchus* carved from native hardwood by Cuna men. Although used by medicine men in curing ills, they are also owned by individual families for whom they may serve as protectors from evil spirits. Occasionally quite large *uchus* are carved from softwood such as balsa. These may be used on special occasions to rid an island of devils or evil spirits, but unless they prove to be unusually powerful, apparently they lose their significance and are not kept after they have served their purpose. Unusually powerful *uchus* are sometimes kept in the council house to be used in time of great need. However, these large *uchus* of softwood seldom have the fine sculptural qualities to be found in the smaller hardwood examples.

There is some basket weaving; however, little of it involves pattern weaving. Occasionally we find a woven mat which contains a pattern in which figures and animals appear.

Elaborate necklaces of multiple rows of animal teeth are rather common, as are necklaces of shells and seeds.

Of special interest, but almost extinct, are the necklaces made of pelican wing bones, each bone of which is drilled with holes along the side and a bit of pitch is placed in one end for a mouth piece so that the entire wing bone may serve as a flute. Such a necklace may have as many as a dozen wing bone flutes and in past years was used only for special ceremonies.

Handmade pottery is almost unknown in the San Blas today except for an occasional figurative receptacle used for burning incense by medicine men. Panpipes and flutes made of reed, as well as gourd rattles, are among the few musical instruments. The pipes are still used today to accompany the Cunas in their folk-like dances.
--*F. Louis Hoover*, Professor of Art, Illinois State University, Normal, Illinois.

CATALOGUE

Molas

1. *Four Figures* (Island of Nargana)
2. *Pregnant Figure* (Island of Irgandi)
3. *Stylized Cat* (Tigre Island)
4. *Two Figures* (Island of Ustupo)
5. *Linear Design* (Island of Ustupo)
6. *Jungle God* (Island of Ailigandi)
7. *Double-Headed, Winged Dragon* (Island of Ailigandi)
8. *Hero Fighting Monster* (Island of Tualo)
9. *Totems* (Island of Nargana)
10. *Dragon* (Island of Nargana)
11. *Birds and Animals* (Island of Idagandi)
12. *Four Ovals* (Island of Playón Chico)
13. *Man, Birds, and Animals* (Tigre Island)
14. *Weaving Beaters* (Island of Mamitupo)
15. *Heavenly Maze* (Island of Mamitupo)
16. *Making Chicha* (Island of Mamitupo)
17. *Heavenly Maze* (Village of Armilla)
18. *Abstract Figure* (Isla Pino)
19. *Abstract Figure* (Island of Ustupo)
20. *Tree and Animal Forms* (Island of Achatupo)
21. *Three Abstract Figures* (Island of Achatupo)
22. *Two Pelicans* (Island of Ustupo)
23. *Leaf Forms* (Island of Ustupo)
24. *Figures Enclosed* (Village of Mansucum)
25. *Turtles* (Island of Ustupo)
26. *Sea Creatures* (Island of Achatupo)
27. *Flower Motif* (Island of Ailigandi)
28. *Yellow Christ* (Island of Ailigandi)
29. *Iguanas* (Island of Tualo)
30. *Three Figures* (Island of Tualo)
31. *Animals Flanking Tree of Life* (Island of Ailigandi)
32. *Two Coati Mundis* (Island of Mulatupo)
33. *Circle Design* (Island of Ustupo)
34. *Monkeys* (Island of Mamitupo)
35. *Enclosed Rabbit* (Island of Achatupo)
36. *Man Spearing Manta Ray* (Island of Tualo)
37. *Birds and Frogs* (Island of Ailigandi)
38. *Heavenly Maze: Modern Variation* (Island of Ailigandi)
39. *Demon* (Island of Mulatupo)
40. *Skeleton* (Island of Mulatupo)
41. *Man Riding Animal* (Island of Achatupo)
42. *Two Figures* (Island of Achatupo)
43. *Male Monster* (Village of Mansucum)

44. *Kneeling Figures* (Island of Ustupo)
45. *Sea Horses* (Island of Achatupo)
46. *Four Figures* (Island of Ustupo)
47. *The Medicine Man* (Island of Mamitupo)
48. *Devils of Death* (Island of Tualo)
49. *Two Crocodiles* (Island of Tualo)
50. *The Goldsmiths*, a complete blouse (Island of Achatupo)

Uchus

51. *Female Figure* (Island of Achatupo)
52. *Female Figure* (Island of Achatupo)
53. *Male Figure* (Island of Achatupo)
54. *Male Figure* (Island of Ustupo)
55. *Male Figure* (Island of Ustupo)
56. *Male Figure* (Island of Ustupo)
57. *Male Figure* (Island of Ustupo)
58. *Female Figure* (Island of Mamitupo)
59. *Male Figure* (Island of Ustupo)
60. *Three Figures* (Isla Pino)
61. *Male Figure* (Island of Ustupo)
62. *Female Figure* (Island of Achatupo)

Necklaces and Musical Instruments

63. *Necklace of Seeds* (Island of Achatupo)
64. *Necklace of Wild Boar's Teeth* (Island of Ustupo)
65. *Necklace of Seeds* (Island of Wichubuala)
66. *Necklace of Camphor Wood* (Island of Tualo)
67. *Necklace of Ginger* (Island of Mamitupo)
68. *Necklace of Seeds and Teeth* (Island of Achatupo)
69. *Necklace of Pelican Wing Bones* (Island of Ustupo)
70. *Panpipes of Reed* (Island of Ailigandi)

April 13 - 30, 1969

TAPESTRIES BASED ON THE *MOLA*
DESIGNED BY GUILLERMO TRUJILLO
EXECUTED BY ODERAY OBALDIA

The *mola* is one of the purest and most exquisite popular art forms in Latin America, produced only by the Cuna Indian women of Panama's San Blas Islands. Although subjects or forms may be repeated, there are always slight variations, and each *mola* is unique. Several years ago the Panamanian painter and architect Guillermo Trujillo became interested in applying the techniques employed in making *molas* to tapestries, enlarging the traditional cotton cloth blouse-fronts to majestic proportions. With the help of his assistant Oderay Obaldía, who is a native of the San Blas Islands, Trujillo has been able to maintain the purity of the original craft in his new medium, successfully capturing the elements which give the *molas* their strength and impact. Although his approach is more sophisticated and intellectual, he keeps the same magnificent, overlapping colors, the sense of the patterns intuitively conceived by the Indian women, and the rigorous discipline of technique.

Trujillo was born in Horconcitos, Panama, in 1927 and for many years has been on the faculty of the School of Architecture of the University of Panama. He has won numerous awards in international competitions for both his paintings and his designs for landscape architecture and has exhibited extensively in Latin America and Europe. The artist's first presentation was in 1961, when he exhibited paintings here at the Pan American Union.
--*J.G-S.*

CATALOGUE

1-13. Tapestry[1]

May 1 - 22, 1969

CARLOS SALATINO OF ARGENTINA

One of the younger Argentine personalities emerging in the art world is Carlos Alberto Salatino, who has produced the greater part of his work during the past seven years while living in Washington, D.C. Although his first paintings were expressionistic and almost romantic in mood, concentrating on tension and dramatic effects, he has gradually begun to paint in the op art trend so successfully initiated by Victor Vasarely. Using acrylic and collage, he combines and arranges pure geometric elements in such a way as to create luminosity and vibration or a twinkling effect.

Born in Buenos Aires in 1939, Salatino attended the National School of Fine Arts there from 1955 to 1959 and later began to exhibit in group shows in Argentina. In 1962 he came to Washington, D.C., where he eventually enrolled in the Corcoran School of Art, studying under the Washington painter Tom Downing. In 1967 and 1968 he held one-man exhibitions in Madrid's Institute of Hispanic Culture and in the House of the Americas in Granada. Paintings by Salatino are in the collection of the Museum of the Americas in Madrid and in private collections in South America, the United States, Europe, and Puerto Rico. In June he will exhibit in the recently established Foundation for the Arts in San Juan, Puerto Rico.

This is Salatino's first one-man exhibition in the United States. *--J.G-S.*

CATALOGUE

Acrylic and Collage

1. *Bastion*
2. *Exact Lighthouse*
3. *Homenaje a André Malraux (Homage to André Malraux)*
4. *The Last Bivouac*
5. *Beyond Any Doubt*
6. *Final Octagon*
7. *Warp*
8. *Nostalgia for the North*
9. *Childhood*
10. *Horizon*

May 27 - June 17, 1969

TSUCHIMOTO OF BRAZIL: SCULPTURES

The most outstanding sculptor in the São Paulo Plastic Arts Club, or SEIBI, is Masumi Tsuchimoto. His work, like that of his Nippo-Brazilian colleagues, reflects his native culture, especially evident in his conception of form and technique; it is most closely related to ancient Japanese art, which is less literary and descriptive than the art of the last four centuries but more significant in terms of form. Tsuchimoto is also a highly skilled craftsman who devotes much of his time to ceramics.

Born in Gifu-Kem, Japan, in 1934, Tsuchimoto studied there for three years in the School of Fine Arts. Later

[1] Titles are unavailable. *--Ed.*

he went to Kyoto where he studied for six years with the sculptor Uno Sana. Before moving to Brazil in 1959 where he became a naturalized citizen, he participated in several group shows in Japan and held a one-man exhibition in Tokyo. Tsuchimoto has exhibited extensively in Brazil, including participation in three São Paulo Biennials. In 1965 his work was included in the Pan American Union exhibition *Japanese Artists of Brazil*. That same year he was awarded Honorable Mention in the *Esso Salon of Young Artists*. Twice he has been given the Gold Medal awarded by the Japanese colony in São Paulo. His most recent one-man exhibit was held at São Paulo's Astréia Gallery.

This is Tsuchimoto's first individual presentation in the United States. --*J.G-S*.

EXHIBITION LIST [1]

1. *Ruido e pensamento* (Noise and Thinking)
2. *Vento e pensamento* (Wind and Thinking)
3. *Um homem* (A Man)
4. *Eu* (I)
5. *Amigos* (Friends)
6. *Senhorita* (Miss)
7. *Uma senhora* (A Woman)
8. *Pessoa que ganhou* (Winner)
9. *Venda* (Sale)
10. *Pensamento e andar* (Thinking and Walking)
11. *Ove resco*
12. *Num cantinho* (In a Corner)
13. *Partir* (To Leave)
14. *Uma pessoa* (A Person)
15. *Pessoa con chifre* (Person with Horn)

May 27 - June 17, 1969

WAKABAYASHI OF BRAZIL: PAINTINGS

During the past eight years the Pan American Union periodically has presented the work of Latin American artists of Japanese origin. Most have been from Brazil, which has the largest Japanese population outside of Japan itself. Art being the natural consequence of Japanese education, they have contributed significantly to the cultural environment of their adopted country.

The São Paulo Plastic Arts Club, or SEIBI, which has been in existence for more than thirty years, has had a fundamental role in the development and promotion of the Nippo-Brazilian artists. Among the members of SEIBI who have held shows at the Pan American Union are the painters Manabu Mabe and Tomie Ohtake, as well as eight artists who were included in a group exhibition of Nippo-Brazilian art here in 1965. One of the group who has since become one of the most outstanding artists in Brazil is Kazuo Wakabayashi.

Wakabayashi's paintings are highly refined, with strange depths of color, unexpected variations in texture, and mysterious, cryptic forms. The oriental spirit is reflected in the harmonious structural strength of his work, which is directly related to Japanese calligraphy.

Born in Kobe, Japan, in 1931, Wakabayashi studied at the NIKKI School of Fine Arts from 1947 to 1950. He has participated in numerous group shows in Japan and Brazil and in 1965 exhibited in a group show of Brazilian art at New York City's Rockefeller Center. He has presented five one-man exhibits in Tokyo, Kobe, and São Paulo, the most recent in 1968 at the Astréia Gallery in São Paulo. In 1967 Wakabayashi was awarded an Acquisition Prize at the Ninth São Paulo Biennial. Currently his work is included in an extensive exhibition of

[1] Not included in the original catalogue. --*Ed*.

Brazilian art which is being circulated throughout Latin America.

This is the artist's first one-man exhibition in the United States. --*J.G-S.*

EXHIBITION LIST [1]

1. *Composição amarela (Yellow Composition)*
2. *Composição azul (Blue Composition)*
3. *Vermelho (Vermilion) I*
4. *Composição verde (Green Composition)*
5. *Branco (White)*
6. *Vermelho fundo escuro (Vermilion Dark Background)*
7. *Azul fundo escuro (Blue Dark Background)*
8. *Composição vermelha (Vermilion Composition) I*
9. *Composição azul (Blue Composition) II*
10. *Amarelo (Yellow)*
11. *Composição vermelha (Vermilion Composition) II*
12. *Preto (Black)*
13. *Vermelho (Vermilion) II*

June 18 - July 9, 1969

GILBERTO ALMEIDA OF ECUADOR

Gilberto Almeida is one of Ecuador's most prominent artists. Having experimented with various materials and media, he has in recent years devoted most of his time to drawing. His compositions in pen and ink are baroque and expressionistic in tone, tending toward the dramatic; his approach toward subject matter is purely intellectual.

Gilberto was born in 1928 in San Antonio, Ecuador, and studied at the School of Fine Arts of Quito from 1953 to 1957. Since that time he has held ten one-man shows in Ecuador, Chile, and Argentina and participated in group shows throughout South America, including the Biennial of São Paulo and Córdoba (Argentina). He has won eleven prizes and is represented in important public and private collections in Ecuador and the United States. In 1967 Gilberto was invited by the U.S. Department of State to tour museums and art schools in this country.

This is the artist's first exhibition in the United States. --*J.G-S.*

CATALOGUE

Drawings

1. *The Big Chair*
2. *On Business*
3. *A Miniskirt*
4. *Abduction*
5. *Badman Putting on His Pants*
6. *Sergeant*
7. *Good Fences Make Good Neighbors*
8. *The Bench*
9. *Military Man with Doves*
10. *The Rivals*
11. *Dialogue*

[1] Not included in the original catalogue. --*Ed.*

12. *Lost Objects*
13. *The Sidewalk*
14. *The Wall*
15. *Porter*
16. *Soldiers and Horses*
17. *Traffic*
18. *Football Players*
19. *Porters*
20. *Kites*
21. *Woman Putting on Tights*
22. *Cat*
23. *Cat and Mouse*
24. *Dogs*
25. *A General*
26. *At the Hairdresser*
27. *Café Costa, Guayaquil*
28. *Our Father, the Generalissimo*
29. *Dancer of Ecuador*
30. *The Messenger*
31. *Song*
32. *Houses in Guayaquil*

June 18 - July 9, 1969

VIEWS OF ECUADOR: PHOTOGRAPHS BY GUILLERMO PROAÑO MORENO

Ecuador, with its lush tropical jungles, seashore, and austere highlands, offers such spectacular natural beauty to the photographer that he is often tempted to focus only on that aspect of the country. Ecuadorian-born Guillermo Proaño Moreno, however, attempts to resist the dramatic attractions and reveal his country in its most intimate aspects, focusing on the familiar, everyday scenes.

Born in Cotacachi in 1915, Proaño Moreno studied for one year at the New York Institute of Photography and currently is a resident of the United States. He held his first one-man exhibit in 1966 in Dearborn, Michigan, and another in 1967 in New York City. He has participated in numerous national and international salons and has been awarded several prizes. The photographs included in this exhibition were made during recent trips to his native country. *--J.G-S.*

CATALOGUE

1. *Amateur Photographer*
2. *Caretaker*
3. *Flock*
4. *San Juan Hill*
5. *Coquetting*
6. *Washing the Corn*
7. *Returning Home*
8. *Calle de la Ronda*
9. *Spanish Lane*
10. *Quito's White Lily*
11. *A View of Guápulo from Hotel Quito*
12. *Sundown in Cotacachi*
13. *Stone Cutter*
14. *Quito's Cathedral Tower*
15. *Fatherly Blessing*
16. *Presidential Palace*

17. *Return from the Fair*
18. *Monument to Simón Bolívar*
19. *Shepherdess*
20. *Farm of Ocampo*
21. *Defeated Spain*
22. *Checking the Lesson*
23. *Resident of La Ronda*
24. *Inspection of His Kingdom*
25. *Mount Pichincha*

July 14 - August 5, 1969

MANUEL CANTOR OF COLOMBIA

One of the most talented personalities emerging in the mainstream of modern art in Colombia is Manuel Cantor, who is both a painter and draftsman. His work is characterized by an unusual suggestion of corresponding elements in landscape and the human anatomy or what might be called an orographic approach to the human form, treated in painting with thick impasto applied on a flat surface of brilliant color and in drawing with heavy, invariable, firm strokes.

Cantor was born in Cúcuta in 1939 and studied there for one year at the Casa de la Cultura. He attended the School of Fine Arts of the National University in Bogotá from 1963 to 1967. Since 1965 he has held six one-man exhibitions and participated in numerous group shows.

This exhibition, consisting of drawings, is the artist's first presentation in the United States. *--J.G-S.*

CATALOGUE

1-20. Ink Drawings[1]

July 14 - August 5, 1969

FANNY SANIN OF COLOMBIA: PAINTINGS

Fanny Sanín's paintings, executed with imagination and precision, follow the geometric trend in Colombian art. Born in Bogotá in 1935, she attended the School of Fine Arts of the University of the Andes from 1956 to 1960, afterwards studying for one year with the painter Armando Villegas. From 1962 to 1963 she attended the Graduate School of Art at the University of Illinois. In 1967 she attended London's Central School and the Chelsea School of Art, taking special courses in the graphic arts.

Miss Sanín has had one-man exhibitions in Monterrey (Modern Art Gallery, 1964), Mexico City (Turok-Wasserman Gallery and Casa del Lago Gallery, 1965), Bogotá (Museum of Modern Art, 1965; Colseguros Gallery, 1966), and Caracas (Museum of Fine Arts, 1967). She has participated in numerous group exhibitions, including the *Esso Salon of Young Artists* in Bogotá, 1964; the First Latin American Salon sponsored by the National Institute of Culture and Fine Arts in Caracas, 1967; and the First Hispanic-American Biennial of Art in Medellín, 1968. While in London, she presented an individual exhibition in the A.I.A. Gallery and was presented in the exhibition *Trends 1968* in the FBA Galleries. Her work is included in the collections of the Museum of Modern Art and the Museum of Contemporary Art in Bogotá, the Museum of Fine Arts of Caracas, and in private collections in Mexico, Venezuela, Colombia, and the United States.

This is the first presentation of her paintings in Washington. *--J.G-S.*

[1] Titles are unavailable. *--Ed.*

EXHIBITION LIST [1]

Oils on Canvas

1. *Oil No. 6*, 1968
2. *Oil No. 2*, 1969, 175 x 135 cm.
3. *Oil No. 3*, 1969, 175 x 140 cm.
4. *Oil No. 4*, 1969, 175 x 160 cm.
5. *Oil No. 5*, 1969, 170 x 140 cm.
6. *Oil No. 6*, 1969, 170 x 170 cm.
7. *Oil No. 7*, 1969, 175 x 165 cm.
8. *Oil No. 7*, 1968
9. *Oil No. 9*, 1968

August 7 - 31, 1969

CARLOS VASQUEZ OF CHILE

Carlos Vásquez is a young painter who has evolved in accordance with the different trends of contemporary expression in his native country, finally having arrived at his own personal language with free, imaginative forms that are set or suspended in space.

Vásquez was born in Antofagasta, Chile, in 1931 and began his art studies with the painter Pedro Luna. In 1955 he attended the Renoir Academy and for the next two years studied at the School of Fine Arts of the University of Chile in Santiago. In 1960 he studied at the Institute of Hispanic Culture in Madrid. Vásquez has had one-man exhibitions in Santiago (Chilean-British Institute of Culture, 1958; Sala Quintana, 1959; Sala Libertad, 1962; Casa de la Cultura, 1969), Buenos Aires, and Barcelona (Spain). He has participated in ten group exhibits and has been awarded several prizes.

This is the first presentation of Vásquez's paintings in the United States. *--J.G-S.*

CATALOGUE

Oils on Canvas

Serie de las situaciones (Situations Series)
1. *Situación (Situation) No. 1*, 100 x 100 cm.
2. *Situación (Situation) No. 2*, 129 x 94 cm.
3. *Situación (Situation) No. 4*, 100 x 75 cm.
4. *Situación (Situation) No. 5*, 70 x 150 cm.
5. *Situación (Situation) No. 6*, 100 x 130 cm.
6. *Situación (Situation) No. 8*, 38 x 42 cm.
7. *Situación (Situation) No. 9*, 65 x 100 cm.
8. *Situación (Situation) No. 10*, 65 x 100 cm.
9. *Situación (Situation) No. 15*, 100 x 150 cm.
10. *Situación (Situation) No. 16*, 100 x 150 cm.
11. *Situación (Situation) No. 17*, 150 x 150 cm.
12. *Situación (Situation) No. 18*, 150 x 140 cm.
13. *Situación (Situation) No. 19*, 100 x 130 cm.
14. *Situación (Situation) No. 20*, 100 x 130 cm.
15. *Situación (Situation) No. 21*, 100 x 130 cm.
16. *Situación (Situation) No. 22*, 80 x 130 cm.
17. *Situación (Situation) No. 23*, 90 x 130 cm.

[1] Not included in the original catalogue. *--Ed.*

August 7 - 31, 1969

VIEWS OF CHILE: PHOTOGRAPHS BY MARCELO MONTEALEGRE [1]

The transitions in the Chilean landscape (from plains and mountain ranges to the long coastline), the variety of flora and fauna, and the Chilean people themselves are an exciting challenge to the photographer. Chilean-born Marcelo Montealegre, after traveling throughout South America, returned to his native country and produced the series of photographs which are currently on exhibit.

A self-taught artist, Montealegre was born in Puerto Montt in 1936 and is now living in New York. He has devoted his time primarily to journalistic photography. This is the first exhibition of his work in Washington.

September 3 - 25, 1969

DINO ARANDA OF NICARAGUA

Of the Central American republics, Nicaragua has produced the largest number of artists of importance, due largely to the efforts of Rodrigo Peñalba, Director of Managua's National School of Fine Arts. For more than twenty years Peñalba has demanded a high standard of quality from his students, at the same time encouraging each to follow his own direction and discover his own definition of plastic values. One of his former students who has since gone on to win an international reputation is Armando Morales. Dino Aranda belongs to a younger generation, the last to have benefited from Peñalba's teaching.

As a painter Aranda is an outstanding colorist. He is equally talented as a draftsman, with fluent lines that vigorously describe his subject.

Born in Managua in 1945, Aranda studied at the National School of Fine Arts from 1957 to 1963 and was a member of the *Praxis Gallery Group* until 1965, when he came to Washington, D.C., to study at the Corcoran School of Art. He has held one-man exhibits at the Praxis Gallery in Managua and the Oklahoma National Bank in Norman. His work has also been included in group exhibitions at the Central American Pavilion of the New York World's Fair, 1964; the Berlin Fair, 1964-65; the Butler Institute of Art in Youngstown, Ohio, 1966; the Oak Ridge Community Art Center, Tennessee, 1966; and the Corcoran Gallery of Art, 1966.

This is the artist's first one-man show in the Washington area. --*J.G-S*.

CATALOGUE

1-16. Oils [2]

Drawings [2]

September 25 - October 14, 1969

ALBERTO TEIXEIRA OF BRAZIL

Although he had been a mature painter for many years, Alberto Teixeira first won the acclaim of critics and the public when he was awarded First Prize in Brazil's *Esso Salon of Young Artists* in 1964, emerging as an outstanding colorist with a firm handling of pigment and impasto and a simple, direct concept of abstract expression.

[1] The list of works exhibited is unavailable. --*Ed*.

[2] The titles of the works exhibited are unavailable. --*Ed*.

Teixeira was born in 1925 in São João do Estoril, Portugal, but has been a Brazilian citizen for almost twenty years. He began to study art at the National Society of Fine Arts in Lisbon in 1947 and after moving to Brazil continued his studies with the painter Sanson Flexor in São Paulo, 1952-1955. Early in his career he advocated a figurative expression, which under Flexor was to be rejected for pure geometric abstraction. The rigidity of the geometric concept later caused him to seek a freer expression, resulting in a loose, vibrating abstraction.

Teixeira has held one man-exhibits in São Paulo's Antigo-Novo Gallery, 1960; São Luiz Gallery, 1963; and Seta Gallery, 1966. He has been a frequent participant in the São Paulo Biennial and has exhibited his work abroad in group shows of Brazilian art.

This is the artist's first one-man exhibition in the United States. --*J.G-S.*

CATALOGUE

Paintings

1. *Formas contrastantes (Contrasting Forms)*, 92 x 60 cm.
2. *Formas contrastantes (Contrasting Forms)*, 60 x 50 cm.
3. *Pequeno verde e amarelo contrastante (Contrasting Green and Yellow)*, 60 x 50 cm.
4. *Carnaval (Carnival)*, 92 x 92 cm.
5. *Engrenagem (Intertwining)*, 92 x 92 cm.
6. *Conexões (Connections)*, 100 x 81 cm.
7. *Roda-viva (Live Wheel)*, 146 x 89 cm.
8. *Meditação (Meditation)*, 114 x 89 cm.
9. *Caminhos (Roads)*, 92 x 92 cm.
10. *Movimento curvilíneo (Curvilinear Movement)*, 73 x 100 cm.
11. *Campos contrastantes (Contrasting Fields)*, 146 x 89 cm.
12. *Torrente azul (Blue Fall)*, 81 x 81 cm.
13. *Contra o azul claro (Against a Light Blue)*, 81 x 81 cm.
14. *Planos contrastantes (Contrasting Planes)*, 92 x 60 cm.

October 15 - November 5, 1969

BENEDIT OF ARGENTINA

Fantasy has pervaded the paintings of Benedit since he began his career as an artist more than ten years ago. His earliest work was characterized by an intriguing personal conception of forms obtained as the result of assembling seemingly unrelated elements to depict what he intended to represent, reminiscent in certain aspects of the work of the mannerist Arcimboldo, who combined carefully painted vegetable forms to portray the human form. As was the case with his earlier work, Benedit's painting today is representational and highly articulate, not unlike serious illustrations for fables or fairy tales but with a definite sense of humor. Perhaps the most significant development in recent years is his use of a rich palette, which provides a contrast to his previous grayish monochrome painting.

Born in Buenos Aires in 1937, Luis Fernando Benedit is a self-taught painter and a professional architect. From 1964 to 1965 he studied architecture in Spain and later in Rome, landscape architecture and industrial design. He has had six one-man exhibits in Buenos Aires (Lirolay Gallery, 1961, 1962, 1964; Rubbers Gallery, 1963, 1967, 1968) and three in Europe (Europe Gallery and Creuze Gallery, Paris, 1965; La Balance Gallery, Brussels, 1966). He has participated in group exhibitions in Lima, Caracas, Santiago, Buenos Aires, Paris, Rome, and New York. In Argentina, Benedit has twice received the Braque Prize, 1964 and 1966, and was awarded the Torcuato Di Tella Prize in 1966. Paintings by the artist are in the collections of the Museum of Modern Art in New York and Buenos Aires, the Braniff Collection, the University of Texas Museum, the Museum of Fine Arts of La Plata (Argentina), and the Museum of the Rhode Island School of Design.

This is Benedit's first one-man exhibition in the United States. --*J.G-S.*

CATALOGUE

Oil and Enamel on Canvas

1. *Fútbol mecánico (Mechanical Football)*,[1] 146 x 114 cm.
2. *El hambre sin solución (The Hunger without Solution)*, 146 x 114 cm.
3. *La misteriosa vida rural (The Mysterious Rural Life)*, 146 x 114 cm.
4. *La casa del Profesor Fracasi (House of Professor Fracasi)*, 146 x 114 cm.
5. *La última ascensión (The Last Ascencion)*, 130 x 96 cm.
6. *Super XX*, 130 x 96 cm.
7. *La tercera fuga (The Third Flight)*, 130 x 96 cm.
8. *Mi casa africana (My African House)*, 130 x 96 cm.
9. *S.O.S.*, 66 x 54 cm.
10. *Arquitectura (Architecture) 677/66*, 66 x 54 cm.
11. *Cuento con conejo (Story with Rabbit)*, 55 x 46 cm.
12. *Nuevo proyectil (New Projectile)*, 55 x 46 cm.
13. *Nuestros gatoveros (Our Gatoveros)*,[1] 55 x 46 cm.
14. *La riqueza nacional (The National Wealth)*, 55 x 46 cm.

Enamel on Paper

15. *El gran pomo (The Great Bottle)*, 50 x 70 cm.
16. *Coniglio a la cacciatore*, 50 x 70 cm.
17. *Util diálogo (Useful Dialogue)*, 50 x 70 cm.
18. *Corte transversal (Transversal Cut)*, 50 x 70 cm.
19. *La casa de Caifás (The House of Caiphas) 69*, 50 x 70 cm.
20. *El buen pastor (The Good Shepherd)*, 50 x 70 cm.
21. *El gran serrucho (The Great Saw)*, 50 x 70 cm.
22. *El distendedor (The Swindler)*, 50 x 70 cm.
23. *Mi nueva especie (My New Species)*, 50 x 70 cm.
24. *Alcancia magnum* (Magnum Money Box), 50 x 70 cm.
25. *Los almirantes (The Admirals)*, 50 x 70 cm.
26. *Arriba-abajo (Up-Down)*, 50 x 70 cm.

November 6 - 24, 1969

FLOWERS AND BUTTERFLIES BY LUIS CRESPO OF ECUADOR

Beginning with an indigenous expressionistic approach and later adhering to the highly realistic, Luis Crespo's current work follows the contemporary bi-dimensional conception of art in its flatness, with a realism intensified by the use of brilliant, almost raw pigments often applied in rich impasto.

Born in 1911 in Cuenca, Ecuador, Crespo first studied there at the School of Fine Arts and later in Quito. In 1930 he was awarded a scholarship by the Ecuadorian government to study in Paris, where he attended the Grande Chaumière Academy, and in Madrid, where he attended classes at the San Fernando Academy. The Spanish government extended his scholarship for two years, allowing him to continue his studies with Eduardo Chicarro. After having spent six years in Europe, he returned to Latin America and in 1939 came to live in the United States.

Crespo has had one-man exhibitions at George Washington University, 1957; the Parish House of St. John's Church in Washington, D.C., 1960; and the Bloomfield School in Charlottesville, Virginia, 1967. He has

[1] Literal translation of no. 1 is "Mechanical Soccer." Although *gatoveros* of title no. 13 does not exist in the Spanish dictionary, *gato* means "cat" and *overo* means "of a golden color." --*Ed.*

participated in group exhibitions in Quito and Madrid and has been awarded several prizes. In 1934, when Crespo was awarded Second Prize in Spain's Autumn Salon, José Francés, art critic for the *Noticiero Universal*, commented that he was an artist of "solid culture and preparation, whose still lifes were the most outstanding in the exhibit."

The artist is represented in the collections of Johns Hopkins University, George Washington University, and the Museo Taurino in Lima, Peru. One of his paintings hangs in the Pan American Union's Columbus Room. *--J.G-S.*

CATALOGUE

Oil on Canvas

1. *Lyrical Song to the New Generation*
2. *Three Roses in a Blue Vase*
3. *Yellow and Coral Glow*
4. *Copper, Oranges, Lavenders*
5. *Sevillana (Sevillan Woman)*
6. *Granadina (Woman from Granada)*
7. *Bahía de Guayaquil (Guayaquil Bay)*
8. *Diablitos (Little Devils)*
9. *Red Flowers on an Inca Cloth*
10. *La línea del ecuador (The Equator Line)*, 1966, 162 x 97 cm.
11. *Yellow Callas and Song*
12. *Psychedelia nordica*
13. *Reina gitana (Gypsy Queen)*, 1965, 92 x 123 cm.
14. *Mariposa de Veragua (Butterfly of Veragua)*
15. *The Blue Queen*
16. *Excelsior, Gold, Magenta, Blue*
17. *Hail to the Sun*
18. *Blue Vase, Reds on Gold*
19. *Yellow Marigolds on Magenta and Blue Cloth*
20. *Sunflowers*
21. *Amapolas*
22. *Mayagüez*
23. *Basket of Flowers*
24. *Diálogo de primavera en los Andes (Spring Dialogue in the Andes)*, 1966, 117 x 88 cm.
25. *Yellow Flowers on an Inca Cloth*

November 6 - 24, 1969

JOSE RICARDO ETCHEVERRY OF CHILE

José Ricardo Etcheverry is an emerging young artist working in the field of graphics. Born in Santiago in 1947, he attended the Catholic University of Chile and the School of Fine Arts of the University of Chile from 1965 to 1967. The following year he was awarded a scholarship to study at the School of Fine Arts in Paris and later attended the graphic workshop at the Museum of Modern Art in Rio de Janeiro. He has had three one-man exhibitions in Santiago and has participated in several group shows in the interior of Chile.

This is Etcheverry's first exhibition in the United States.

CATALOGUE

1-12. Graphics[1]

[1] Titles are unavailable. *--Ed.*

November 25 - December 9, 1969

IVAN FREITAS OF BRAZIL

A self-taught painter, Ivan Freitas has consistently explored new possibilities of form and media. His current production follows an abstract, geometric line in contrast to his earlier informalist painting.

Born in 1932 in João Pessoa, State of Paraíba, Brazil, he had his first one-man exhibition there in 1957. Since that time he has had individual shows at the Museum of Modern Art in Bahia in 1961, in Rio de Janeiro at the Barcinsky Gallery in 1962, 1963, and 1964, at the Relevo Gallery in 1966, and at the Santa Rosa Gallery, 1967. He has participated in group exhibitions in London, Naples, Madrid, Buenos Aires, Valparaíso, Santiago, Rio, and São Paulo. He was represented at the São Paulo Biennial in 1961, 1963 and 1965 and the Paris Biennial in 1963. Since 1968 he has been working and living in New York. Paintings by Freitas are in the collections of the Museum of Modern Art in Rio de Janeiro and the University of Texas Art Museum in Austin, as well as in numerous private collections.

This is the artist's first presentation in the United States. *--J.G-S.*

CATALOGUE

Paintings

1. *Emissão (Emission)*, 1969, oil on canvas, 44 x 53"
2. *O sinal (The Signal)*, 1969, oil on canvas, 44 x 53"
3. *Hora azul (Blue Hour)*, 1969, oil on canvas, 42 x 50"
4. *O mapa (The Map)*, 1969, oil on canvas, 26 x 40"
5. *Tensão (Tension)*, 1969, oil on canvas, 30 x 40"
6. *Painel de contrôle (Control Panel)*, 1968, oil on canvas, 18 x 25"
7. *O sinal azul (Blue Signal)*, 1968, oil on canvas, 18 x 22"
8. *Face mecânica (Mechanical Phase)*, 1969, oil on canvas, 20 x 24"
9. *Face azul (Blue Phase)*, 1969, oil on canvas, 16 x 20"
10. *Comporta da luz (Light Hatch)*, 1969, acrylic, 22 x 28"
11. *Conexão (Connection) I*, 1969, acrylic, 20 x 30"
12. *Paisagem tensa (Tense Landscape)*, 1969, acrylic, 19 x 28"
13. *Miragem (Mirage)*, 1969, acrylic, 20 x 30"
14. *Conexão (Connection) II*, 1969, acrylic, 18 x 28"
15. *Face mecânica (Mechanical Phase) II*, 1969, acrylic, 20 x 30"
16. *Face mecânica (Mechanical Phase) III*, 1969, acrylic, 20 x 30"
17. *Face mecânica (Mechanical Phase) IV*, 1969, acrylic, 20 x 30"
18. *Face mecânica (Mechanical Phase) V*, 1969, acrylic, 20 x 30"

19-22. *Mapa da memória (Memory Box) I, II, III, IV,*[1] acrylic, 10 x 11"

[1] Also exhibited but not included in the original catalogue. Literal translation of this title is "Memory Map." *--Ed.*

December 9, 1969 - January 6, 1970

MIGUEL OCAMPO OF ARGENTINA

In 1950, when the geometric trend was beginning to emerge in Europe, a group of Argentine painters influenced by the movement abandoned the figurative trend and began to produce non-objective works. The members of the group, all of whom can be considered masters of abstract art in their country as well as important figures in the international art world, were José Antonio Fernández Muro, Sarah Grilo, Tomás Maldonado, Kasuya Sakai, Clorindo Testa, and Miguel Ocampo. Testa and Ocampo were professional architects as well as painters, and the former was to abandon painting a few years ago to return to architecture. The one common denominator uniting the group was their concern with non-objectivity; otherwise, each expressed his ideas in his own individual language. In spite of the widespread return to figurative art in recent years, all of these artists have adhered to their roots and matured accordingly.

Ocampo's paintings are characterized by large planes of sprayed pigment divided by sharp edges, always with a sense of volume, depth in space, and a lyrical control of the balance in the total arrangement of the surface. The transparent quality of his work is obtained by the use of an airbrush.

Ocampo was born in Buenos Aires in 1922 and attended the National University there. He has had one-man exhibits in Buenos Aires (Institute of Modern Art, 1950; Bonino Gallery, 1952, 1956, 1959, 1960; Krayd Gallery, 1954; El Taller Gallery, 1967, 1968), Paris (Ariel Gallery, 1950; Paul Facchetti Gallery, 1966), Rome (La Tartaruga Gallery, 1956), New York (De Aenlle Gallery, 1958), Rio de Janeiro (Museum of Modern Art, 1959), and Montevideo. In the United States his work has been included in group exhibits at the National Gallery of Art, Washington, D.C., 1956; the Dallas Museum of Fine Arts, 1959; the Chicago Art Institute, 1959; the Walker Art Center in Minneapolis, 1964; the Akron Art Institute, Ohio, 1964; the Atlanta Art Association, 1965; the University of Texas Art Museum, Austin, 1965; and the exhibition *Latin America: New Departures*, which was shown in Boston and New York in 1961. Ocampo has also participated in the Venice Biennial, 1956; the São Paulo Biennial, 1953; and the Festival of Two Worlds in Spoleto, Italy, 1963.

Works by the artist are in the public collections of the National Museum of Fine Arts and the Torcuato Di Tella Foundation in Buenos Aires; the Museum of Modern Art in Buenos Aires, New York, and Rio de Janeiro; and the Pasadena Art Museum. He is represented in numerous private collections in Latin America, Europe, and the United States, including those of Governor and Mrs. Nelson Rockefeller, Senator and Mrs. Jacob Javits, and Mr. and Mrs. Isaac Stern.

This is Ocampo's first one-man exhibit in the Washington area. --*J.G-S.*

CATALOGUE

1-18. Paintings[1]

December 9, 1969 - January 10, 1970

PATRICK VILAIRE OF HAITI

During a recent trip to Haiti, Lois Pierre-Noël, Professor of Art at Howard University, discovered the work of young Haitian painter Patrick Vilaire. Although the art produced on the island is almost exclusively primitive, Vilaire uses diverse elements and symbols--some undoubtedly related to African mythology--to create a bizarre world that is his own. The high quality of his work, almost all in black and white with occasional coffee-colored touches that he achieves by using--appropriately--coffee, indicates a brilliant career.

Born in Port-au-Prince in 1942, Vilaire began to study drawing with Bernard Wah at the Ramponeau Gallery

[1] Titles are unavailable. --*Ed.*

in 1955. By 1959 he was exhibiting in group shows in Haiti and Switzerland. He is one of the founders of the Museum of Ceramic Art in Haiti and has taught there, as well as at Holy Trinity College. While he has participated in numerous group shows outside Port-au-Prince, including an exhibit at Howard University in 1965 and the First World Festival of Negro Arts in Dakar in 1966, this is the artist's first one-man exhibition.

We wish to express our gratitude to Dr. Pierre-Noël for introducing Vilaire's work to us. *--J.G-S.*

CATALOGUE

Black and White Washes

1. *1990*
2. *Demande* (Request)
3. *Métamorphose* (Metamorphosis)
4. *Soleil* (Sun)
5. *Amour* (Love)
6. *Pollution*
7. *Femme* (Woman)
8. *Symphonie* (Symphony)
9. *Dans la fumée* (In the Smoke)
10. *Merveilleux* (Marvelous)
11. *Sein au soleil* (Breast under the Sun)
12. *Chat* (Cat)
13. *Rêve* (Dream)
14. *Omega*
15. *Cri* (Cry)
16. *Eté* (Summer)
17. *Trajectoire* (Trajectory)

YEAR 1970

January 12 - 28, 1970

CAÑAS HERRERA OF EL SALVADOR

Diminutive human figures are introduced into delicately diffused atmospheres in the work of Benjamín Cañas Herrera of El Salvador. He has a poetic approach to painting and drawing in which elements of reality are combined with a basic abstract sense of composition and space. All of his forms maintain a tie with the pre-Columbian past. If there is a precedent for such work in Central American art, it is to be found in the paintings of Guatemalan artist Carlos Mérida.

Born in 1933, Cañas Herrera studied architecture and painting at the National University of El Salvador. He held his first one-man show in San Salvador in 1964 at the Inter-Continental Hotel and has participated in numerous group exhibits of Salvadorian art. He was represented twice in the São Paulo Biennial, in 1967 and 1969, at the Paris Biennial of 1967, and the Colombian Biennial held in Medellín in 1968. Works by the artist are in public and private collections in El Salvador and Switzerland. Several years ago he was commissioned to design the stained glass windows in the Temple of the Sacred Heart in Guatemala City.

This is Cañas Herrera's first exhibit in the United States. --*J.G-S.*

CATALOGUE

1-12. Oils[1]
13-20. Drawings[1]

January 29 - February 23, 1970

NOUGUES OF ARGENTINA: DRAWINGS [2]

A profound sense of humor and imagination pervades the work of Argentine draftsman Isaías Nougués. With lines extending in a constant curve, defining large masses and interlocking them, his drawings seem at times to be first sketches for sculpture. Commenting on Nougués's most recent work, Ernesto Ramallo, critic for *La Prensa* in Buenos Aires, said: "The artist has made extraordinary progress, treating his subject with less timidity and a more open line, giving a certain flesh and solidity to his figures."

A self-taught artist and professional architect, Nougués was born in Tucumán in 1930. He has had nine one-man shows in Argentina, the first in Buenos Aires in 1964, and has participated in group exhibits throughout the country. Works by the artist are in the collections of the National University of Tucumán and the Cultural Council of the same city.

This is Nougués's first exhibition in the United States. --*J.G-S.*

[1] Titles are unavailable. --*Ed.*

[2] The list of the works exhibited is unavailable. --*Ed.*

January 29 - February 23, 1970

BRIZZI OF ARGENTINA

In Buenos Aires it is not unusual to find groups of artists working together as a team, pursuing their ends by different means but united by a common concept. Such is the case with the group made up of Eduardo Mac Entyre, Miguel Angel Vidal, and Ary Brizzi, all of whom can be considered young masters of the optical-geometric trend in Argentine art. Each achieves purity of line, luminosity, and kinetic effects of vibration and expansion.

Ary Brizzi works indiscriminately on the flat surface of the canvas and with three-dimensional, transparent plastic materials. With compositions in either medium, he shows great power of invention, a sense of the poetic, and dexterity in the handling of his materials. The maturity of his work has been reached through a careful, valid process of systematic study and investigation.

Born in 1930 in Avellaneda, Buenos Aires Province, Brizzi studied at the Manuel Belgrano National School of Fine Arts and the Ernesto de la Cárcova School of Fine Arts, graduating to become a professor of drawing and mural decoration. After having visited various countries in South America during the early 1950s, he came to the United States for the first time in 1959 to direct the construction of the Argentine Pavilion at the U.S. World Trade Fair. Brizzi has had four one-man shows in his native country, the most recent last year at the Bonino Gallery in Buenos Aires. He has participated in more than fifty group exhibits in Argentina and has been represented in fifteen major national and international exhibits abroad, including the *Esso Salon of Young Artists*, Washington, 1965; the São Paulo Biennial, 1965; the exhibit *Beyond Geometry*, New York, 1968; and the Quito Biennial, 1968, where he was awarded First Prize. Brizzi has been the recipient of numerous prizes in his own country, including first prizes for sculpture at the Argentine competition of the *Esso Salon*, 1964, the exhibit *Plastic with Plastics*, 1966, and the Córdoba Salon of Modern Art, 1969. In 1968 he was awarded prizes in Lima and Cali (Colombia) as well as in Quito.

Works by the artist are in the collections of the Museum of Modern Art in Buenos Aires and New York; the National Museum of Fine Arts in Buenos Aires; the IBM and Esso collections of Latin American art, and the Albright-Knox Gallery in Buffalo, New York. He is represented in private collections throughout South America and the United States. Although his work has been included in group exhibits in this country, this is Brizzi's first one-man presentation here. *--J.G-S.*

CATALOGUE

Acrylics
1. *Estudio (Study)*, 40 x 40 cm.
2. *Estudio (Study)*, 40 x 40 cm.
3. *Dominante (Dominant) No. 5*, 60 x 60 cm.
4. *Cuasar (Quasar) No. 2*, 60 x 60 cm.
5. *Dominante (Dominant) No. 19*, 80 x 80 cm.
6. *Dominante (Dominant) No. 20*, 80 x 80 cm.
7. *Biacción (Bi-Action) No. 2*, 80 x 80 cm.
8. *Dominante (Dominant) No. 16*, 80 x 80 cm.
9. *Dominante (Dominant) No. 7*, 100 x 100 cm.
10. *Dominante (Dominant) No. 14*, 100 x 100 cm.
11. *Confluencias (Confluences) No. 5*, 100 x 100 cm.
12. *Dominante (Dominant) No. 15*, 100 x 100 cm.
13. *Dominante (Dominant) No. 17*, 100 x 100 cm.
14. *Confluencias (Confluences) No. 3*, 100 x 100 cm.
15. *Dominante (Dominant) No. 18*, 100 x 100 cm.
16. *Interacción (Interaction) No. 10*, 100 x 100 cm.
17. *Confluencias (Confluences) No. 7*, 120 x 120 cm.
18. *Interacción (Interaction) No. 1*, 120 x 120 cm.
19. *Interacción (Interaction) No. 4*, 120 x 120 cm.
20. *Gradiva*, 60 x 120 cm.

21. *Variante (Variant) No. 2*, collage, polystyrene, and acrylic on wood, 60 x 60 x .05 cm.
22. *Interacción (Interaction)*, acrylic sculpture, 77 x 62 x 13 cm.

February 24 - March 23, 1970

OLGA DONDE OF MEXICO

The still life, especially the still life with fruits and vegetables, has long been a subject treated by Mexican artists, beginning with the ancient sculptors before the Conquest and continuing with the painters of the colonial and contemporary periods. Perhaps this interest is due in part to the fact that Mexico has always been a rich, fertile land in which a wide variety of plants flourishes, and that since the earliest time vegetable life has been considered significant not only in a practical sense but in the realm of mythology.

Olga Dondé, too, treats the still life but in her own unique manner, which is related to magic realism. Taking a simple fruit or vegetable and conceiving it in minute detail, she enhances the fruit or a fragment of it, giving it an external characterization. A papaya with seeds, a half-peeled banana, or a clove of garlic is raised to a state of grandeur. Isolated in an almost empty space, it is projected into the infinite. In spite of the sizes of the paintings, which tend toward the miniature, none of the impact is lost.

A self-taught painter, Olga Dondé was born in Mexico City in 1935 and has been involved in the art world for several years both as a painter and as owner of the Gallery 33. She had her first solo exhibit last year at the National Museum of Querétaro in Mexico. Her works have been included in group exhibits in Mexico (Palace of Fine Arts, Mexico City, 1968) and the United States (Carroll Reece Museum, Johnson City, Tennessee, 1969).

This is Miss Dondé's first individual exhibition in this country. --*J.G-S.*

CATALOGUE

Oils on Masonite

1. *Jitomates (Tomatoes)*, 31 x 22 1/2 cm.
2. *Toronja (Grapefruit)*, 30 x 39 1/2 cm.
3. *Nueces (Nuts)*, 31 x 35 cm.
4. *Manzanas (Apples)*, 40 x 29 1/2 cm.
5. *Cacahuete (Peanut)*, 20 x 30 cm.
6. *Pan (Bread)*, 29 1/2 x 19 1/2 cm.
7. *Papaya*, 39 1/2 x 29 1/2 cm.
8. *Chico-zapotes (Little Sapotes)*,[1] 50 x 25 cm.
9. *Aguacate (Avocado)*, 40 x 30 cm.
10. *Higos (Figs)*, 43 x 28 1/2 cm.
11. *Cerezas en paja verde (Cherries in Green Shucks)*, 43 x 28 cm.
12. *Chirimoya (Cherimoya)*, 39 1/2 x 29 1/2 cm.
13. *Plátano maduro (Ripe Banana)*, 20 x 30 cm.
14. *Ajo (Garlic)*, 30 x 20 cm.
15. *Fresa (Strawberry)*, 40 x 30 cm.
16. *Limones (Lemons)*, 25 1/2 x 20 1/2 cm.
17. *Gajos de mandarina (Mandarin Sections)*, 25 x 20 cm.
18. *Wanted* (in collaboration with José Luis Cuevas), 60 x 40 cm.
19. *Mandarina (Mandarin Orange)*, 40 x 30 cm.
20. *Nueces y carta de Cuevas (Walnuts and Letter from Cuevas)*, 40 x 30 cm.
21. *Chícharo (Pea)*, 20 x 25 cm.
22. *Mamey*, 25 x 20 cm.

[1] Literal translation of this title is "Sapodilla." --*Ed.*

23. *Cuarzo de amatista (Amethyst Quartz)*, 20 x 25 cm.
24. *El tornillo (The Screw)*, 25 x 20 cm.
25. *Membrillos (Quinces)*, 40 x 60 cm.
26. *Calabaza (Pumpkin)*, 60 x 40 cm.
27. *Duraznos (Peaches)*, 25 1/2 x 20 1/2 cm.
28. *Granada (Pomegranate)*, 25 x 20 cm.

February 24 - March 23, 1970

ORTIZ MONASTERIO OF MEXICO

Throughout all periods of Mexican history, the spirit of the Mexican people has been expressed most explicitly through the art of sculpture. In present-day art the work of Luis Ortiz Monasterio, who might be considered the father of modern sculpture in Mexico, is perhaps the most representative example of this tradition. Blending past and present, combining pre-Columbian elements with the simplifications of contemporary sculpture, he converts his art into an international language. Although only his small-scale works are presented in this exhibition, they are sufficient to provide us with the essence of his ideas.

Born in Mexico City in 1906, Ortiz Monasterio studied at the Academy of San Carlos from 1920 to 1924. From 1924 to 1930 he resided in California where he presented his first one-man exhibition. In Mexico City he has had one-man shows at the Palace of Fine Arts, 1931; the Gallery of Mexican Art, 1935 and 1959; and the National University of Mexico. In the United States he has exhibited at the Book Shop Art Gallery in Los Angeles, 1929; Gump's Art Gallery in San Francisco, 1930; and the Betty Parsons Gallery in New York City, 1950. In 1949 he participated in the *International Exhibition of Sculpture* at the Philadelphia Museum of Art.

More than ten public monuments executed by the artist are to be found in Mexico City, including the monument of Nezahualcoytl in Chapultepec Park; sculptures, fountains, and the portico for the Civic Plaza Theater; and a fountain for the National Medical Center. In 1967 he created a bust of the Mexican educator Justo Sierra, which now stands in the Plaza of the Americas in Paris, and in 1969 a bust of the Mexican poet Amado Nervo, which is in Montevideo, Uruguay.

Smaller works by the artist are included in the collections of the Philadelphia Museum of Art, the National School of Mexico, and the Museum of Modern Art in Mexico City as well as in numerous private collections in his native country and the United States.

This is the first presentation of his work in the Washington area. *--J.G-S.*

CATALOGUE

Bronze Sculptures[1]

1. *Composición (Composition) No. 1*, 32 x 25 x 9"
2. *Composición (Composition) No. 2*, 20 x 15 x 5"
3. *Composición (Composition) No. 3*, 16 1/2 x 10 1/2 x 5 1/2"
4. *Composición (Composition) No. 4*, 17 x 13 x 7"
5. *Composición (Composition) No. 5*, 16 x 13 1/2 x 4 1/2"
6. *Composición (Composition) No. 6*, 13 1/2 x 18 x 6 1/2"
7. *Composición (Composition) No. 7*, 17 x 14 x 5"
8. *Standing Figure*, 16 1/2 x 12 x 6"
9. *Figura sentada (Seated Figure)*, 17 x 13 x 5"
10. *Dos figuras (Two Figures)*, 17 x 15 x 7 1/2"
11. *Mother and Child*, 24 1/2 x 18 x 9"

[1] Measurements include the sculpture's base. *--Ed.*

12. *Calaveras (Skulls)*, 16 x 13 x 5"
13. *Venus con máscaras (Venus with Masks)*, 16 1/2 x 11 1/2 x 5"
14. *Old Fashioned Girl*, 19 x 5 x 2 1/2"
15. *Cohete espacial (Space Rocket)*, 36 x 12 x 9"

March 24 - April 12, 1970

GERARDO CABALLERO OF COLOMBIA

This one-man exhibit is a first for Gerardo Caballero--and for the OAS General Secretariat as well since it is customary to show works by artists who have already made their debut in Latin America. Caballero's drawings hang in no museum collections, and few people have ever seen them. They are owned only by a handful of his fellow students.

Born in Bugalagrande, Valle del Cauca, Colombia, in 1938, Caballero began to draw at the age of five. After finishing his high school studies there, he went to Bogotá where he worked as an accountant and continued to devote his spare time to art. In 1967 he enrolled in the David Manzur School of Art, where he was a student until June 1969. While in Bogotá to give a series of lectures at the School, I had the opportunity to meet Caballero and was convinced that he was approaching drawing as an art, as an end in itself rather than as a means to an end. I promised him that within a two-year period, if he continued to progress, he would exhibit at the OAS General Secretariat. Meanwhile, he offered to decline invitations during that time to exhibit in Colombia or elsewhere. Last year Caballero prepared a collection of drawings from which David Manzur and I selected the thirty examples that make up the current exhibition.

Since I have known Caballero I have watched his development closely. He has progressively disciplined his dexterity with pen, brush, and pencil, to the point that he obtains meaning from line itself. Each of the drawings exhibited is characterized by a fluency of line, strong, vibrant strokes, and a definite sense of mood and expression. All are refined examples of his psychological penetration of the subject.

For Caballero this marks the beginning of his professional career. Another name is added not only to the panorama of Colombian art but also to the increasing number of excellent draftsmen who are appearing throughout Latin America. *--J.G-S.*

CATALOGUE

Drawings

1. *Family*
2. *Grupo (Group)*
3. *The Artist's Mother*
4. *Pareja (The Couple) I*
5. *Julio*
6. *Physician I*
7. *The Couple II*
8. *Wrestler*
9. *Man and Animals*
10. *Trio*
11. *Pigeons*
12. *Mythical Figure I*
13. *Mythical Figure II*
14. *Mythical Figure III*
15. *Personages*
16. *Seated Man*
17. *Physician II*
18. *Physician III*

19. *Man and Dog*
20. *Mother I*
21. *Three Girls*
22. *La mujer (Woman)*
23. *Carlos*
24. *Peasant*
25. *Man Crouching*
26. *Mother II*
27. *Resting Model*
28. *Physician IV*
29. *Profile*
30. *Surgery Assistant*

April 12 - May 4, 1970

CHILEAN FOLK ARTS

To all of us, Chile is a land of minerals and fertilizers. To many, it is the greatest wine producing region in the Americas. Its wines and fruits, for example, are found even in the most unexpected corners of the United States and Latin America, and there is no way to ignore them. For a select minority who know much of literature, it is a land of poets, who sometimes attain universal recognition. For those who visit the country, in addition to all the preceding bits of knowledge, Chile has the most exquisite and varied sea food in the world. But those of us who visit Chile frequently also find artists and artisans of such stature that they can compete successfully with the best of the hemisphere.

Few, very few people, other than Chileans, are aware of certain popular arts of legitimate value and interest. The shops in Santiago and Valparaíso that specialize in articles for tourists often miss the mark with their merchandise, and offer travelers, for souvenirs, poorly designed copper pieces, conventional or run off the assembly line, and fake carvings of wood or stone, which are said to come from Easter Island but have usually been made in Valparaíso in large quantities, without the slightest attempt to cover up the falsification.

In light of this, those who like art should not visit Santiago without climbing Santa Lucía Hill to see the Folk Arts Museum. They may well be surprised at the selection showing the development of the folk artist in the aesthetic sense. There the visitor can get a detailed view of the popular arts of the country, some of whose traditions date back to pre-Conquest times. It is an austere, carefully selected collection, of specific and exemplary value in showing the sensitivity of a people in fashioning their utilitarian objects.

Although copper is the most abundant product of the Chilean earth, it is not the material most often used; in fact, it could almost be said that it is the least or most poorly used. Indeed, pottery, textiles, and silverwork are the categories that account for most of the objects and yield the works of highest quality.

The most characteristic pottery produced in the country is black, and possibly has its origin in the spread of Peruvian cultural influences before the Discovery. The people of Chavín, Paracas, and Chimú made black pottery, with some variations. There is no doubt that the general Andean techniques and skills reached the territory that today is Chile. Chilean popular ceramics in black have continued to maintain their lustrous finish, sometimes perforated, their incisions or ornamentations reinforced with white, and the humor of their themes, preferably animals or the more recent *campesino* figures on horseback or playing the guitar, or both. A frequent characteristic is the fact that they are still modeled without the potter's wheel, entirely by hand, with surprising dexterity on the part of the potters, who are almost exclusively women.

South of Santiago, in the Province of Ñuble, not far from Chillán, its capital, is the village of Quinchamalí which, along with the village of Florida, continues the black pottery tradition with an excellence of form and an originality seldom seen in popular Latin American ceramics. In addition to the workshops, where important pieces can be purchased, the Chillán market offers the visitor the greatest abundance and variety. As the center of a region particularly rich in popular expression, Chillán also offers us the possibility of acquiring the splendorous spurs of the *huasos* (cowboys) of Chillán, the basketwork, the textiles, and the other superior

manifestations of Chilean craftsmanship.

In Santiago Province, half an hour from the capital, is the town of Pomaire, perhaps the best-known pottery center of the region, which includes also the villages of Malloco, Pueblo de Indios, and Talagante--the latter known for its colorful figures of rosy-cheeked men and women on horseback under an open parasol. Pomaire is, nonetheless, the most visited, and although the affluence of tourists could be a negative factor in the preservation of forms and traditions, the technique and the ideas continue unaltered and with considerable beauty. Pomaire ware is primarily utilitarian, and while an object may appear to be a sheep, or a rooster, or a fat woman, it will probably turn out to be a pitcher or a sugar bowl. The pottery is traditionally the color of red clay, but in recent years a dark brown glaze has been added, with great public acceptance, and the red objects are becoming increasingly scarce. Many Chilean families use dinnerware from Pomaire in their homes. Although there are a few individuals who specialize in making graceful figurines, most of the villagers are engaged in turning out pots and plates and bowls, whose simplicity of design and careful finish have made them much sought after. A visit to each of the humble factory-homes of the dusty, peaceful town is an unforgettable experience for the folk arts *aficionado*.

The twenty-six-hundred mile length of this vertical country is for the most part fertile in folk arts. These traditions, as a way of life, suffer the competition of the diverse industries of the country that are encouraging more and more artisans to give up their art and accept better paying jobs. This factor also tends to make hand work requiring many hours of labor notably more expensive.

Generally speaking, textiles are one of the great surprises that the Chilean artisan reserves for the visitor searching for the creative essence of this people. The center of greatest purity of execution is perhaps Chiloé Province, in the south, composed of the archipelago of the same name. In addition to the basketwork, original and strong, the Chilote is an outstanding creator of ponchos, rugs, and garments woven in wool with a magnificent richness of motifs and a unique concept of color that make the textiles of Chiloé highly prized by the initiated. Geometric forms prevail, along with the very characteristic sense of color. The ponchos known as *choapinos*, which are produced by the Araucanian Indians and their descendants, are an example of a chromatic sobriety that has few equivalents in the rest of the indigenous arts of Latin America. The Araucanians, in addition, have throughout the centuries handed down their methods of making silver jewelry, which is conceived with a sense of synthesis and marked by the same expressive rigor as their textiles. Similarly, the wood carvings with which the Araucanians marked their sepulchers have survived in their stepped forms, which are repeated in many wooden utensils, gigantic spoons and forks of monumental aspirations.

The arts of basketry and the weaving of wicker figures of animals and people are practiced widely throughout the country, even in the capital city. In addition to wicker, people weave the *copihue* (the national flower), *coirón* (a grassy herb), and wheat chaff in the rural zone, in which the Chilean of Spanish origin, especially Basque, is foremost. There, where cattle abound, horns are used in the making of various objects, occasionally of brutal aspect.

Experience indicates that when a country's national or foreign tourism increases, its traditions suffer from, accommodate themselves to, or are conquered by the contact with other forms of expression. The only way to guarantee that folk arts, and folkways in general, conserve their purity and develop only in a firm, progressive sense, without having the aesthetic manifestations of the people depart from tradition, is to place them under the control of watchful institutions that guarantee a market or a compensation for the products. Neither necessity nor profit incentive can then subvert or diminish the feeling of the arts of our peoples. Years ago, Mexico began the task of protecting its folk arts and has managed, despite the constant influx of tourists, to conserve their purity in many sectors by providing a common market in Mexico City: the Museum of Folk Arts. Brazil's Ministry of Agriculture has a department in charge of indigenous crafts and of maintaining the forms of Indian life. Generally speaking, the requirement of greatest importance is that such vigilant institutions be the major market as well, so that the artisan will not suffer fluctuations in tourism and subsequent economic ups and downs.

Chile now has three agencies for the protection of popular arts and industries: the Technical Cooperation Service of the Chilean Development Corporation (CORFO), the Institute of Farm Development, and the Coordinating Office of the Center for Mothers (CEMA). All pursue the central goal of protecting the Chilean craftsman, be it by founding cooperatives, by grouping the artisans, or by aiding them with loans for production. The agencies

are the best stimulus for the diversification of markets within the country and outside it, stimulating participation in fairs, expositions, and competitions that give incentive for production. The greatest effort, nevertheless, is that carried out by CEMA. Not far from the commercial sector of Santiago, at number 439 of Nataniel Street, an old mansion serves as the CEMA gallery or exhibit salon, where members of the rural centers can show their works on a permanent basis, with the gallery acting as a distribution center for them. CEMA buys the works at fair prices and receives a small profit from their sale, which permits the continuation of its efforts, paying the rent and the employees' salaries. Similar headquarters are projected for other regions of the country, in order to increase the market for folk art. As most of the works are by women, the objects that CEMA supervises and distributes are a constant source of income for the Chilean woman who works as an artisan. CEMA buys all the production offered, provided that it meets the Office's rigid standards of quality.

On my visits to the Santiago Center I was able to ascertain, to the great satisfaction of those of us who are interested in the survival of the folk arts of our peoples, that the greater part of the buyers were Chilean. Domestic consumption of national arts and industries is a guarantee to keep them free of the economic fluctuations that come with waves of tourism, and to avoid the painful confrontation of "dead time," the season when foreign visitors are scarce. Aside from that, it is a guarantee that there will be neither intrusions of outside taste nor variations dangerous to the integrity of the traditions and styles.

CEMA's technicians make sure the material maintains the indispensable uniformity, the finish, and the purity of its expression. There are rooms in which the textiles of the country are shown, as well as others for regional ceramics, stone carvings, baskets and objects of wood and wicker, objects of copper and iron--in short, a compendium of everything the Chilean has known how to construct with his hands to prolong the life of the traditions, of the cultural encounters, of the base of human talent for invention and ornamentation, in order to keep alive the strongest testimonial to a nation's reason for being. --*J.G-S.* Reprint of "From Chilean Hands," *Américas*, April 1970, Vol.22, No.4, pp.21-26.

CATALOGUE

Salar de Atacama (Desert Region)
 Textiles and stone carvings, Toconao
 Textiles, Caspana

Vallenar
 Ritos (knot weavings)

Chapilca (Valle de Elqui)
 Ponchos, by Rosa Hualquimir
 Frazadas (blankets), by Leoncia Valenzuela
 Alforjas (wool saddlebags), by Leoncia Valenzuela

Santiago
 Wicker birds, by Manzanito
 Horn carts, by Raúl Pizarro

Pomaire
 Pottery stove and pans, by Etelvina Gaete
 Cut pottery bowls, by Amelia Muñoz

Doñihué
 Chamanto (large poncho), by Yolanda Bravo

Rari
 Textiles

Pilén de Cauquenes
 Pottery, by Rosita Alarcón and Edita Bravo

Quinchamalí
 Pottery, by Praxedes Caro, Juana Romero, and the Garcías

Hualqui
 Reed basketwork, by Ana Rita Alvarez

Cautín
 Ponchos (blankets)
 Manta (cloak)
 Llamas (rugs)
 Pottery
 Jewelry
 Stone, wood, and horn carvings

Alepue-Mehuín
 Vine weavings

Chiloé
 Basketwork
 Garments worn by the *huaso* or Chilean cowboy

May 5 - 27, 1970

GATTO OF ARGENTINA

In reviewing a recent exhibition of paintings by Domingo Gatto, Ernesto Ramallo, art critic for the Buenos Aires *La Prensa*, commented: "Unlike most of his contemporaries, Gatto shows us his findings rather than his search." There is indeed a maturity in the work of this artist that places him among the best of the young Argentine painters. His canvases are evidence of the art that can be produced when imagination is combined with technical knowledge and skill. The schematically rendered still lifes, at once figurative and expressionistic, are treated with a subtlety that lends a poetic sense to the objects depicted. Undoubtedly, Gatto can be considered as one of the major artists in the realm of neofigurativism not only in Argentina but in all South America.

Born in Buenos Aires in 1935, Gatto studied at the National Academy of Fine Arts and attracted the attention of critics and collectors in 1959, when he first began to participate in local and national exhibitions. He has some fifteen awards, including First Prize at the Salon of the Argentine Institute of Graphic Arts in 1967, and the Grand Prize of Honor at the Manuel Belgrano Municipal Salon of Plastic Arts, 1968. He has had eleven one-man exhibitions in Argentina, the first at the Rubbers Gallery in Buenos Aires in 1962. Last year he exhibited at the Argentine House in Jerusalem and later toured various European countries while on a fellowship granted him by the Israeli government. Upon his return to Argentina, he had a one-man show at the Attica Gallery in Olivos, a suburb of Buenos Aires, in which he exhibited many of the paintings currently on display. His work has previously been exhibited in this country only at the Carrol Reece Museum of Art in Johnson City, Tennessee, 1969.

Paintings by Gatto are in the collections of the Museum of Modern Art in Buenos Aires, the Emilio Caraffa Museum in Córdoba, the Argentine-Israeli Department of Tourism, and in important private collections in Argentina and Europe.

This is the artist's first one-man show in the United States. --*J.G-S.*

CATALOGUE

Oils

 1. *Sobre la tierra (On the Earth)*, 100 x 100 cm.
 2. *La dama romana (Roman Lady)*, 120 x 100 cm.

3. *La modelo (Model)*, 100 x 100 cm.
4. *Pecera y frutas (Fishbowl and Fruit)*, 100 x 100 cm.
5. *Reminiscencias (Reminiscences)*, 100 x 100 cm.
6. *Mesa con elementos (Table with Objects)*, 80 x 60 cm.
7. *La mesa blanca (White Table)*, 110 x 80 cm.
8. *De la tierra (From Earth)*, 80 x 60 cm.
9. *Elementos arcaicos (Archaic Elements)*, 60 x 40 cm.
10. *Paisaje del hombre actual (Landscape for Today's Man)*, 60 x 35 cm.
11. *Pampa*, 50 x 35 cm.
12. *Frutas (Fruits)*, 40 x 40 cm.
13. *Sugerencias (Suggestions)*, 40 x 40 cm.
14. *La mesa negra (Black Table)*, 40 x 40 cm.
15. *Interior*, 45 x 27 cm.
16. *Elementos (Elements)*, 40 x 30 cm.
17. *El pez dorado (Goldfish)*, 35 x 30 cm.
18. *Paisaje y frutas (Landscape and Fruits) I*, 35 x 30 cm.
19. *Paisaje y frutas (Landscape and Fruits) II*, 35 x 26 cm.
20. *Paisaje ocre (Landscape in Ocher)*, 30 x 27 cm.
21. *Paisaje (Landscape)*, 31 x 26 cm.
22. *Juanita*, 31 x 26 cm.
23. *Intimidad (Intimacy)*, 25 x 20 cm.
24. *Paisaje (Landscape)*, 25 x 20 cm.

May 27 - June 21, 1970

ANTONIETA FIGUEROA OF MEXICO

Another painter making her debut at the Organization of American States this season is the versatile María Antonieta Flores de Figueroa. Although she has been studying art for many years, Miss Figueroa has been reluctant to exhibit publicly until now. When I was in Mexico several years ago, actress Dolores del Rio invited me to visit the artist's studio, and I was interested to find in her paintings a subtle handling of color, particularly evident in her still lifes and landscapes, and a delicate, feminine trace that gives a feeling of intimacy to her work. At that time she was asked to make her first professional appearance as an artist at the OAS, and a selection of paintings, drawings, and batiks from different periods was set aside to be supplemented with later works.

Miss Figueroa, who is the wife of internationally known cinematographer Gabriel Figueroa, was born in Mexico City in 1931. She studied interior decoration at the University of Motolinía from 1946 to 1959 and for the next three years attended the Esmeralda School of Plastic Arts. From 1959 to 1962 she studied with Mexican painter Carlos Orozco Romero. For the past seven years she has studied painting and art history with Jacqueline Larralde de Sáenz and Lucinda Uorusti.

Although none of her pieces is in a public collection thus far, Miss Figueroa is represented in private collections in Mexico and the United States. --*J.G-S.*
CATALOGUE

Oils and Acrylics

1. *Desnudo amarillo (Yellow Nude)*, mixed media, 39 5/8 x 27 5/8"
2. *Paisaje azul (Blue Landscape)*, mixed media, 47 x 31 5/8"
3. *Naturaleza roja (Red Still Life)*, mixed media, 23 5/8 x 19 5/8"
4. *Naturaleza azul (Blue Still Life) I*, mixed media, 23 5/8 x 29 5/8"
5. *Naturaleza azul (Blue Still Life) II*, oil, 27 5/8 x 19 5/8"
6. *Cuernavaca*, acrylic, 19 5/8 x 16"
7. *Pequeña casa (Small House)*, oil, 19 5/8 x 16"
8. *Cabeza en blanco (Head in White)*, oil, 13 5/8 x 19 5/8"
9. *Figuras rojas (Red Figures)*, mixed media, 17 5/8 x 21 5/8"

10. *Flores amarillas (Yellow Flowers)*, mixed media, 16 x 19 5/8"
11. *Flores naranja (Orange Flowers)*, mixed media, 25 5/8 x 18"
12. *Retrato de Dolores (Portrait of Dolores)*, mixed media
13. *Paisaje blanco (White Landscape)*, acrylic, 37 5/8 x 29 5/8"
14. *Naturaleza fría (Cold Still Life)*, oil, 16 x 12"
15. *Paisaje amarillo (Yellow Landscape)*, mixed media, 16 x 19 5/8"
16. *Peras (Pears)*, oil, 5 5/8 x 7"
17. *Flores solferinas (Red Flowers)*, mixed media, 29 5/8 x 23 5/8"
18. *Portrait of Mrs. Oscar Gerber*

Batiks

19. *Tehuantepec*, inks, 16 x 12 5/8"
20. *Jarrones (Jugs)*, inks, 14 5/8 x 12 5/8"
21. *Rítmicas (Rhythmic)*, inks, 10 5/8 x 8 2/8"
22. *Jarrón de flores (Jar with Flowers)*, inks, 8 x 10"
23. *Naturaleza (Still Life)*, inks, 10 5/8 x 8 2/8"
24. *Cuento (Story)*, inks, 10 5/8 x 8 2/8"
25. *Peras (Pears)*, inks, 10 5/8 x 8 2/8"

Drawings

26. *Jarrón de flores (Jar with Flowers)*, pencil, 7 x 10"
27. *Estilización (Stylization)*, pencil, 10 x 7"
28. *Castillo (Castle)*, pencil, 10 x 8"
29. *Botellas (Bottles)*, 11 5/8 x 8 2/8"
30. *Autorretrato (Self-Portrait)*, charcoal, 12 x 14 5/8"
31. *Retrato de Gabriel (Portrait of Gabriel)*, charcoal, 10 5/8 x 10 5/8"
32. *Del mar (From the Sea)*, mixed media, 19 5/8 x 12 5/8"

Monotypes

33. *Figuras desnudas (Nude Figures)*, 9 x 12"
34. *Figura (Figure)*, 14 x 9"
35. *Paisaje (Landscape)*, 12 x 8 5/8"

June 18 - July 19, 1970

FELIX ARAUZ OF ECUADOR

Félix Aráuz's work is linked to the expressionist trend that is predominant in modern Ecuadorian art, but, more specifically, he can be considered an exponent of the international direction known as *art brut*. One of the most outstanding young personalities to have appeared in his country in recent years, Aráuz obtains a certain dramatic force in his paintings through the use of loose brush strokes and elaborate color. His simplified shapes are undoubtedly inspired by the primitive forms characteristic of the Indian and African cultures as represented in contemporary Ecuador.

Born in Guayaquil in 1935, Aráuz studied at the Municipal School of Fine Arts there. Prior to his graduation in 1964, he had already had three one-man shows in Guayaquil and Quito. Since that time he has had six other exhibits in the same cities. He has participated in numerous group exhibitions, including a show that was presented at the Zegrí Gallery in New York last year, and has been awarded four national prizes. The artist is represented in the Casa de la Cultura Museum in Guayaquil and in private collections in Guayaquil, Quito, Bogotá, New York, and Washington, D.C.

This is Aráuz's first one-man exhibit in the United States. *--J.G-S.*

CATALOGUE

Paintings

1-25. Mixed media[1]

July 22 - August 19, 1970

RUIZ MATUTE OF HONDURAS

Of those artists in Honduras whose work can be considered sophisticated as opposed to naive, one of the most accomplished is Miguel Angel Ruiz Matute. Ruiz Matute has reached his present stage of maturity in painting through years of study in Honduras, Mexico, the United States, and Spain. His work is being presented for the first time in the United States under the patronage of the First Lady of Honduras, Mrs. Gloria de López Arellano.

Born in San Pedro Sula in 1928, Ruiz Matute began his study of art at the National School of Fine Arts in Tegucigalpa in 1941. From 1948 to 1951 he studied painting and engraving at the San Carlos Academy in Mexico City, after which he traveled extensively through the United States to visit museums. Returning to Mexico City in 1952, he assisted the artist and architect Juan O'Gorman in completing the murals for the library at the National University of Mexico and later worked with Diego Rivera on the mural for the Los Insurgentes Theater. In 1953 he returned to Honduras to teach drawing. The following year he moved to Spain, where he still lives, and studied restoration of painting at the Royal Academy of San Fernando in Madrid.

The artist has had fourteen one-man shows in Tegucigalpa, Mexico City, San José (Costa Rica), Madrid, West Berlin, and Deauville (France) and has participated in numerous group shows in Mexico and Spain. He has been awarded a number of prizes and scholarships, including a UNESCO scholarship to study and travel in Central Europe and the Middle East in 1960. --*J.G-S.*

CATALOGUE

Oils on Canvas

1. *La familia (The Family)*, 131 x 90 cm.
2. *Después del pecado (After Sin)*, 131 x 90 cm.
3. *Composición (Composition) I*, 121 x 96 cm.
4. *Composición (Composition II*, 120 x 91 cm.
5. *La toilette (Toilette) I*, 101 x 82 cm.
6. *Lanzando el peso (Throwing the Weight)*, 106 x 83 cm.
7. *Bodegón (Still Life) I*, 101 x 78 cm.
8. *Bodegón (Still Life) II*, 101 x 76 cm.
9. *Bodegón (Still Life) III*, 92 x 66 cm.
10. *Bodegón (Still Life) IV*, 91 x 61 cm.
11. *Bodegón (Still Life) V*, 101 x 52 cm.
12. *Bodegón (Still Life) VI*, 82 x 66 cm.
13. *Bodegón (Still Life) VII*, 86 x 41 cm.
14. *Bodegón (Still Life) VIII*, 82 x 67 cm.
15. *Bodegón (Still Life) IX*, 82 x 38 cm.
16. *Bodegón (Still Life) X*, 66 x 55 cm.
17. *Bodegón (Still Life) XI*, 71 x 31 cm.
18. *Bodegón (Still Life) XII*, 70 x 30 cm.
19. *Pescadores (Fishermen)*, 101 x 82 cm.

[1] Titles are unavailable. --*Ed.*

20. *Fontaneros (Fountains)*, 101 x 82 cm.
21. *Intimo (Intimate)*, 101 x 82 cm.
22. *Maternidad (Maternity)*, 92 x 74 cm.
23. *La toilette (Toilette) II*, 92 x 68 cm.
24. *Desnudo (Nude) I*, 101 x 62 cm.
25. *Desnudo (Nude) II*, 67 x 48 cm.
26. *Desnudo (Nude) III*, 62 x 39 cm.
27. *Retrato (Portrait)*, 81 x 61 cm.
28. *Músico (Musician)*, 68 x 56 cm.

August 20 - September 16, 1970

WOOD CARVINGS OF ECUADOR: JORGE RIVADENEIRA

During the colonial era, Ecuador was a distinguished center for the production of fine wood carvings, almost always of a religious nature. Although practice of the craft declined over the years, there are still a number of isolated artisans who have kept the tradition alive. Among them is Jorge Rivadeneira Almeida, who learned the craft in his father's studio where he began to work at the age of fifteen.

Born in 1935 in San Antonio, Ecuador, Rivadeneira received a grant from the OAS in 1966 to study wood carving at the School of Fine Arts of the National University of Mexico. After having his first one-man exhibition in Mexico City, he returned to Ecuador in 1968 to exhibit at the Museum of Colonial Art in Quito. The same year he exhibited in his native city. He has participated in numerous exhibitions of arts and crafts in both Ecuador and Mexico and has been awarded several prizes, including a Gold Medal by the Casa de la Cultura in Quito in 1969.

This is the first presentation of Rivadeneira's work in the United States.

CATALOGUE

Modern Wood Reliefs

1. *Cristo negro (Black Christ)*
2. *Génesis (Genesis)*
3. *Gérmenes (Germs)*
4. *Cascada (Cascade)*
5. *Remolino (Torment)*[1]
6. *Sol negro (Black Sun)*
7. *Evolución (Evolution)*
8. *Ocaso (Dusk)*
9. *La familia (The Family)*
10. *Otoño de la vida (Autumn of Life)*
11. *Desconcierto social (Social Disorder)*
12. *Desintegración (Disintegration)*

Modern Sculptures

13. *Senectud (Senility)*
14. *Maternidad (Maternity)*
15. *Mujer en reposo (Woman in Repose)*
16. *Elevación (Elevation)*
17. *Valet*

[1] Literal translation of these titles is: no. 5, "Whirl;" no.18, "Foreshortening of a Woman." --*Ed.*

18. *Escorzo de mujer (Indignation of Woman)*[1]
19. *Meditación (Meditation)*
20. *Estilización de mujer (Stylization of Woman)*
21. *Composición (Composition)*
22. *Formas (Forms)*

Baroque Carvings

23. *Composición barroca (Baroque Composition)*
24. *Composición ornamental (Ornamental Composition)*
25. *Quito colonial (Colonial Quito)*
26. *Quito interpretación (Quito Interpretation)*
27. *Motivo ornamental (Ornamental Motive)*
28. *Talla barroca (Baroque Carving)*

Reliefs of Pre-Columbian Motif

29. *Sol inca (Inca Sun)*
30. *Danzantes (Dancers)*
31. *Danza ritual (Ritual Dance)*[1]
32. *Símbolo incaico (Inca Symbol)*
33. *Composición precolombina (Pre-Columbian Composition)*

September 17 - October 13, 1970

VICENTE CARNEIRO OF BRAZIL

Among the many artists in Brazil who continue to paint in the informalist tradition is Vicente Carneiro. Carneiro works carefully, using small brushstrokes to form unusual shapes and occasionally taking advantage of the accidental.

Born in Fortaleza, Ceará, Brazil, in 1927, Carneiro studied at the National Schools of Fine Arts and Architecture at the University of Brazil in Rio de Janeiro. He is currently on the staff of the Brazilian-American Cultural Institute in Washington, D.C. The artist has participated in several group exhibitions and has had four one-man shows in the United States, including an exhibition at the Inter-American Development Bank in 1968. His paintings are in numerous private collections in Washington and the surrounding area.

CATALOGUE

Paintings

1. *Man's Divine Creation*
2. *Lost Civilization*
3. *Conquistador's Dream*
4. *Reflection in the Sea*
5. *A Dream in Autumn*
6. *Goodbye, Nature*
7. *Sea Melody*
8. *Gothic Fate*
9. *Amazon Sunrise*
10. *Red Passion*

[1] Not included in the original catalogue but also exhibited. --*Ed.*

11. *Tropical Paradise*
12. *Blues Fugue*
13. *Genesis II*
14. *Sunshine*
15. *Sun Island*
16. *The Gate of Life*
17. *Satisfied Curiosity*
18. *Turmoil*
19. *My Life*
20. *Artist's Liberation*

October 14 - November 9, 1970

GONZALO RIBERO OF BOLIVIA

This exhibition introduces the work of a young Bolivian artist, Gonzalo Ribero, who had most of his formal training in Brazil. Born in Cochabamba in 1942, Ribero attended classes at the Academy of Fine Arts there and in 1961 enrolled in the School of Architecture at MacKenzie University in São Paulo, graduating in 1965. During that time he also studied drawing and painting at the Penteado Foundation and the Paulist Association of Fine Arts. In 1963, 1964, and 1965 he studied privately with the artists Yutaka Toyota, Ubirajara Ribeiro, and Wesley Duke Lee. Ribero has participated in numerous group exhibits in Bolivia and Brazil and has been awarded several prizes. Since 1966 he has had one-man shows in São Paulo, La Paz, and Cochabamba.

Ribero's paintings present a simplified interpretation of aspects of colonial Bolivia.

CATALOGUE

Paintings

1. *Transformación de la tierra (Transformation of the Earth)*
2. *Soledad (Solitude)*
3. *Reminiscencias (Reminiscences)*
4. *Encuentro con el pasado (Encounter with the Past)*
5. *Oración mestiza (Mestizo Prayer)*
6. *Trinos en la tarde (Trills in the Afternoon)*
7. *Sobrevivencia (Survival)*
8. *Vestigios (Vestiges)*
9. *Muro de silencio (Wall of Silence)*
10. *Cántico de paz (Song of Peace)*
11. *Introspección (Introspection)*
12. *Todos santos (All Saints)*
13. *Muro (Wall)*
14. *Rincón (Corner)*
15. *Cocina (Kitchen)*
16. *La pila (The Pile)*
17. *Oratorio (Oratorio)*
18. *Batán (Loom)*
19. *Restos (Remains)*
20. *Paraje de oración (Place of Prayer)*
21. *Refugio (Refuge)*
22. *Fragmento (Fragment)*
23. *Fábula del espacio (Fable of Space) I*
24. *Fábula del espacio (Fable of Space) II*
25. *Resplandor (Splendor)*
26. *Entrada al silencio (Entrance to Silence)*
27. *Refugio de los dioses (Refuge of the Gods)*

28. *Residuos en el tiempo (Residuals in Time)*
29. *Invitación al infinito (Invitation to the Infinite)*
30. *Retiros en la soledad (Seclusion)*

November 13 - December 9, 1970

CIRO PALACIOS OF PERU

The young Peruvian artist Ciro Palacios embarked on his professional career only in 1967, after graduating from the School of Fine Arts of the Catholic University in Lima. In spite of the brevity of his experience, he has already represented Peru in numerous international exhibitions, including the Biennial of Art in Ibiza, Spain, 1968; the Tenth São Paulo Biennial, 1969; and the Second Coltejer Biennial in Medellín, Colombia, 1970. He has had one-man shows at the Culture and Liberty Gallery, 1968; Carlos Rodríguez Gallery, 1969; and Trapecio, 1970, all in Lima, and will exhibit next year in Buenos Aires and São Paulo.

In addition to his studies at the Catholic University, Palacios has worked under the tutelage of the well-known Peruvian painter Fernando de Szyszlo, who not only gave him technical training but influenced his serious approach to art. Departing from painting in the traditional sense, he creates austere, monochrome works that combine elements of both painting and sculpture.

In 1968 Palacios was awarded First Prize at the Fifth Salon of Art sponsored by San Marcos University, the Grand Prize at the American Festival of Painting in Lima, and the Critics' Prize at the Ibiza Biennial. One of his works stood at the entrance to the Peruvian Pavilion at Expo '70 in Osaka.

This is the first presentation of the artist in the United States. --*J.G-S.*

CATALOGUE

Paintings

1. *Estructura blanca alfa (White Alpha Structure)*
2. *Estructura blanca beta (White Beta Structure)*
3. *Estructura blanca gama (White Gamma Structure)*
4. *Volumen (Volume) X*
5. *Volumen (Volume) Y*
6. *Volumen (Volume) W*
7. *Cubo (Cube) Z*

Drawings

 8. *Tono omos (Omos Tone)*
 9. *Tono omicron (Omicron Tone)*
10. *Tono ípsilon (Upsilon Tone)*
11. *Tono sigmar (Sigmar Tone)*
12. *Tono tetra (Tetra Tone)*
13. *Tono quella (Quella Tone)*
14. *Tono eta (Eta Tone)*
15. *Tono kappa (Kappa Tone)*
16. *Tono karma (Karma Tone)*
17. *Tono krishna (Krishna Tone)*

November 13 - December 9, 1970

EDUARDO MOLL OF PERU

Eleven years ago the Peruvian Eduardo Moll was introduced at the OAS gallery as a painter, yet it was almost as if he were attempting to approach art through graphics in his abstract expressionist paintings dominated by blacks and whites. Today Moll is dedicated almost solely to the graphic arts, and it is fitting that he be presented again to the Washington public in his new role.

Born in Leipzig, Germany, in 1929, Moll lived in Peru until recently and is citizen of that country. While studying chemical engineering at the University of San Marcos in Lima, he took courses at the National School of Fine Arts and later went to France and Germany to continue his art studies. Since 1951 he has had more than twenty one-man shows and has participated in numerous important group exhibits in Latin America, Europe, the United States, Iceland, and Japan. At the time of his exhibit here in 1959, he was teaching experimental art courses at the Lima penitentiary. Moll currently lives in Munich, where he had a one-man show this year. *--J.G-S.*

CATALOGUE

Graphics

1. *Tutumanta*
2. *Sacha*
3. *Jesana*
4. *Runapa*
5. *Venus*
6. *Cotahuasi*
7. *Itana*
8. *Apurimak*
9. *Karva*
10. *Kimsa*
11. *Munay*
12. *Isakai*
13. *Munani*
14. *Kita-Urpi*
15. *Pumatambo*
16. *Rumi-Chaka*
17. *Taitaikip*
18. *Machay*

December 11, 1970 - January 6, 1971

CREATIVE STITCHERY ON HAND-WOVEN TEXTILES FROM BOLIVIA
BY NANCY HEMENWAY

While living in Bolivia where her husband was assigned to the United States Embassy, Nancy Hemenway Barton became interested in applying methods of creative stitchery to native hand-woven fabrics. Using a combination of collage and embroidery, she originated the medium she calls "bayatage." The motifs that appear in her work are inspired by ancient pre-Columbian designs.

Nancy Hemenway is a graduate of Wheaton College, Columbia University, and the Art Students League of New York. She has participated in exhibitions in the United States and Mexico and has had one-man shows at Wheaton College's Watson Gallery of Art, 1963; the National Museum of Art in La Paz, Bolivia, 1968; the Bola Gallery in Mexico City, 1970; and the Municipal Gallery in Guadalajara, 1970.

EXHIBITION LIST[1]

Bayatages

1. *Presagio* (Presage) I
2. *Presagio* (Presage) II
3. *Cangrejo (Crab)*
4. *Trucha* (Trout)
5. *Niño del mar* (Boy of the Sea)
6. *Cuatro inocentes* (Four Innocents)
7. *Cardenales* (Cardinals)
8. *Orza* (Jar)
9. *La red* (The Net)
10. *Tesoro chimú* (Chimú Treasure)
11. *Jaguar*
12. *En memoria* (In Memory)
13. *Mensaje enigmático* (Enigmatic Message)
14. *Keru* (Children)
15. *Hijos de la selva* (Sons of the Forest)
16. *Señuelos* (Decoys)
17. *Cóndores* (Condors)
18. *Encaje del mar* (Sea Lace)
19. *Llamero* (Llama Keeper)
20. *Amuleto* (Amulet)
21. *Maternidad* (Maternity)
22. *Corredores*
23. *Figura antropomórfica* (Anthropomorphic Figure)
24. *Pampa*
25. *Colibrí* (Hummingbird)
26. *Fragmento* (Fragment)
27. *Fish*
28. *Cosecha del Lago Titicaca* (Harvest of the Titicaca Lake)
29. *Tesoro chimú II* (Chimú Treasure II)

[1] Not included in the original catalogue. --*Ed.*

YEAR 1971

RAUL FRIAS AYERZA OF ARGENTINA

Raúl Frías Ayerza, who was born in Buenos Aires in 1911, has been known primarily as an outstanding businessman and sportsman. He began to paint at the age of fourteen but did not exhibit professionally until 1969, when he had a one-man show at the Van Riel Gallery in Buenos Aires. The well-known Argentine critic Córdova Iturburu has described him as "a gifted artist with a vibrant, personal expression and a pictorial vocabulary that has multiple possibilities." In 1970 Frías had a one-man show in Mar del Plata and participated in several group exhibitions in Argentina. He was also represented in an exhibition of important Argentine art that was shown recently at the Albright-Knox Gallery in Buffalo, New York.

This is the first presentation of his work in Washington, D.C.

CATALOGUE

Paintings

1. *Plenitud* (Plenitude)
2. *Pasividad* (Passivity)
3. *Electronicolor*
4. *Galaxia* (Galaxy)
5. *Conjugación armoniosa* (Harmonious Conjugation)
6. *Cauce del color* (Color-Course)
7. *Saeta 71* (Dart 71)
8. *Sinfonía estelar* (Sidereal Symphony)
9. *Mundo de nadie* (Nobody's World)
10. *Misterio del color* (Mystery of Color)
11. *Color de penumbra* (Shadowy Color)
12. *Ritmo coloranológico* (Coloranologic Rhythm)
13. *Nueva cromática* (New Chromatism)
14. *Sintonía* (Tuning)
15. *Vocación del fuego* (Fire Vocation)
16. *Reflejo anímico* (Spiritual Reflex)
17. *Profundidades del mundo* (Depths of the World)
18. *Matiz de oscuridad* (Darkness Hue)
19. *Alegría del color* (Gaiety of Color)
20. *Penitentes* (Penitents)
21. *Atavismo* (Atavism)
22. *Euforia* (Euphoria)
23. *Futuramen*
24. *Prisionera* (Woman Prisoner)
25. *Vida en materia* (Life in Matter)
26. *Otro mundo* (Another World)
27. *Misteriosidad* (Mysteriousness)
28. *Olimpo* (Olympus)
29. *Vibrante* (Vibrant)
30. *Egoencia*

January 22 - February 13, 1971

JOSEPH JEAN-GILLES OF HAITI

Lacking an academic tradition, Haitian art has been dominated by the naive or primitive trend, with its candor and charming shortcomings. Although Joseph Jean-Gilles adheres to many elements that characterize primitive painting--two-dimensional rendering, brilliant color, selection of his country's people and landscape for subject matter, and a certain innocence of vision--he has reached a more advanced stage that is most evident in the luminosity that pervades his paintings and the astonishing precision with which the various elements are interwoven, particularly in the still lifes and works in which crowds appear. Even his color seems to have added intensity, in spite of the fact that he has been living in New York for several years, far removed from the tropics.

Jean-Gilles was born in Hinche, Haiti, in 1943 and attended the workshop of the Centre d'Art in Port-au-Prince, the first institution that brought Haiti's artists together. He has participated in numerous group shows in this country, among them exhibitions at the Penthouse Gallery of the Museum of Modern Art in New York, 1965; the Inter-American Development Bank in Washington, D.C., 1966; and the Brooklyn Museum, New York, 1969.

This is his first one-man exhibit in the United States. --*J.G-S.*

CATALOGUE

1. *Coumbite (Collective Farming)*, 24 x 30"
2. *Cérémonie Canzo (Voodoo Initiation Rites)*, 24 x 30"
3. *Marché St. Martin* (St. Martin Market), 24 x 30"
4. *Récolte de riz à Dessalines (Rice Harvest at Dessalines)*, 24 x 30"
5. *Vallée des rêves (Valley of Dreams)*, 30 x 40"
6. *Bassin Zime*, 24 x 30"
7. *La pêche (Fishing)*, 24 x 30"
8. *L'arbre d'abondance (Tree of Plenty)*, 24 x 36"
9. *Nature morte (Still Life)*, 20 x 24"
10. *Le passage (The Passage)*, 20 x 24"
11. *Le chemin de la vie (The Road of Life)*, 24 x 40"

February 16 - March 4, 1971

ELMAR ROJAS OF GUATEMALA

Because of geographical proximity, Guatemalan artists have often been influenced by movements that began in Mexico. By no means has this resulted in a literal adoption of concepts or formulas but, rather, has provided a stimulus for constant exploration and renewal, subsequently strengthening the quality of Guatemalan art. Carlos Mérida, one of Latin America's most important twentieth century masters, has spent most of his life in Mexico but is Guatemalan by birth, and it is to him as an individual painter that the new generation is most indebted for having pioneered an approach to art that is vigorous, imaginative, and alive.

Elmar Rojas, undoubtedly one of the most outstanding young Guatemalan artists as well as a promising figure in Latin American art as a whole, was born in Guatemala City in 1937. He graduated from the National School of Fine Arts and the University of San Carlos in 1959 with a degree in architecture. In 1960 he was invited by the U.S. Department of State to visit museums in this country. In 1963 and 1964 he held fellowships at the Pietro Vanucci Academy of Art in Italy and the Academy of Decorative Arts in Paris.

Although a practicing architect, Rojas devotes most of his time to painting. His work is characterized by a sensitive handling of transparent color and subtle brushwork. Essentially figurative, his compositions are balanced with abstract zones of color, reminding one that his work was once exclusively abstract.

Rojas has had one-man shows in Guatemala, Panama, Spain, and Italy, and has participated in group exhibitions in the same countries as well as in Mexico, Costa Rica, El Salvador, Switzerland, and the United States. He has

been awarded a score of prizes, including Honorable Mention in 1969 at the International Festival of Painting in Cagnes-sur-Mer, France, and is represented in important public and private collections in Central America, Europe, and the United States. In 1969 he founded Guatemala City's Vértebra Gallery, with the painters Roberto Cabrera and Marcos Quiroa.

This is his first one-man show in the United States. --*J.G-S.*

EXHIBITION LIST [1]

Paintings

Serie Guatemala, fisonomía de la realidad (Guatemala, Appearance of Reality Series)

1. *El coleccionista* (The Collector), 82 x 122 cm.
2. *El gran señor* (The Grand Man), 122 x 146 cm.
3. *El Señor Caudillo*, 112 x 146 cm.
4. *Faustino*, 95 x 122 cm.
5. *El Comisionado* (Commissioner), 95 x 122 cm.
6. *El soldado* (The Soldier), 82 x 122 cm.
7. *La ascención de los mártires* (The Ascension of the Martyrs), 95 x 122 cm.
8. *El gran poderoso* (The Grand Powerful), 95 x 122 cm.
9. *Los ahogados* (The Drowned), 122 x 146 cm.

Serie Guatemala, fisonomía de la esperanza (Guatemala, Appearance of Hope Series)

10. *La ronda de los mártires* (Circle of Martyrs), 95 x 122 cm.
11. *Los viejos victoriosos* (The Old Victorious Men), 95 x 122 cm.
12. *El hombre volcán* (The Volcano Man), 46 x 61 cm.
13-16. *Los recuperados* (The Recovered), 46 x 61 cm.
17. *Adiós a mi pueblo* (Farewell to My People), 95 x 122 cm.
18-32. *Serie de los temas de una época (Themes of an Era Series)*,[2] 15 x 22 cm.

March 5 - 24, 1971

BRUNO VENIER OF ARGENTINA

Bruno Venier is of that generation of artists, all now between the ages of forty and sixty, who were the first modern painters to attempt to express reality in terms of their Argentine nationality. They found their subjects among the people on the streets and in the bars and cafés, where singing, listening to, and dancing the tango is an everyday ritual, and endowed them with poetry.

As an artist and professor, Venier has had substantial influence on present-day Argentine painting and is considered one of the most important personalities of his time. His work is characterized by dynamic forms, vivacity of color, rich, textural impasto, and nervous brushstrokes that condense and synthesize all the elements in a pictorial shorthand.

Born in Italy in 1914, Venier has lived in Buenos Aires since childhood and is an Argentine citizen. He graduated in 1935 from the National School of Fine Arts, where he now teaches, and later studied at the workshops of André Lhote in Paris and Lino Spilimbergo in Buenos Aires. He is represented in more than a dozen museum collections in Argentina and in private collections there and in Spain, Venezuela, and the United States. Venier

[1] The original catalogue only included the series titles. --*Ed.*

[2] Detailed titles are unavailable. --*Ed.*

has had more than twenty one-man shows and has participated in group exhibits in Argentina, Brazil, Mexico, Spain, and India.

Among his many awards is First Prize at the National Salon of Painting in Buenos Aires in 1962.

This is the first presentation of the work of Bruno Venier in the United States. *--J.G-S.*

CATALOGUE

Oils

1. *Claro de luna: paisaje del Tigre* (Moonlight: Landscape of El Tigre), 30 x 40 cm.
2. *Músicos en azul* (Musicians in Blue), 35 x 40 cm.
3. *Músicos en rojo* (Musicians in Red), 35 x 40 cm.
4. *Músicos en verde* (Musicians in Green), 35 x 40 cm.
5. *Tango de mi flor* (Wonderful Tango), 35 x 40 cm.
6. *Tango Bar*, 40 x 50 cm.
7. *Río Capitán* (Capitán River), 30 x 50 cm.
8. *Tigre en verde* (Tiger in Green), 35 x 55 cm.
9. *Jovencita con gallo* (Girl with Rooster), 40 x 70 cm.
10. *Naturaleza muerta: sinfonía en azul* (Still Life: Symphony in Blue), 50 x 60 cm.
11. *Naturaleza muerta: sinfonía en amarillo* (Still Life: Symphony in Yellow), 50 x 60 cm.
12. *Verdeando: paisaje del Tigre* (Getting Green: Landscape of El Tigre), 60 x 60 cm.
13. *Paisaje: luz de luna* (Landscape: Moonlight), 60 x 60 cm.
14. *Luz de atardecer* (Sunset Light), 60 x 60 cm.
15. *Orquesta* (Orchestra), 60 x 70 cm.
16. *Naturaleza muerta sobre fondo azul* (Still Life on Blue Background), 60 x 80 cm.
17. *Naturaleza muerta en rojo* (Still Life in Red), 60 x 80 cm.
18. *Naturaleza muerta en naranja* (Still Life in Orange), 60 x 80 cm.
19. *Naturaleza muerta a contraluz* (Backlit Still Life), 60 x 90 cm.
20. *Gallo en rojo* (Rooster in Red), 70 x 80 cm.
21. *Tango canyengue* (Showy Tango), 80 x 80 cm.
22. *Tango con cortada* (Tango with Cross Step), 80 x 80 cm.
23. *Serenata* (Serenade), 90 x 90 cm.
24. *Arlequín en verde* (Harlequin in Green), 70 x 120 cm.
25. *Arlequín en rosa* (Harlequin in Pink), 65 x 120 cm.
26. *Arlequín en rojo* (Harlequin in Red), 70 x 100 cm.
27. *El molinillo* (Small Mill), 80 x 100 cm.
28. *El pescado* (Fish), 70 x 100 cm.

March 25 - April 9, 1971

ADELA VARGAS AND ALBERTO YCAZA OF NICARAGUA: PAINTINGS

This is the first exhibit at the OAS in which the works of a mother and son are being shown together, and, contrary to what is commonly true among families with an artistic tradition, it was the son--not the mother-- who first began to paint.

Born in 1911 in Granada, Nicaragua, Adela Vargas de Ycaza started painting as a hobby more than five years ago, when her son Alberto gave her oils, brushes, and a canvas. There is a captivating freshness and spontaneity in her expression. With an intricate, baroque sense of space, she fills every inch of the canvas with doves, daisies, lions, and fairies--all familiar references in the verses of the well-known Nicaraguan poet Rubén Darío. I was first introduced to Mrs. Ycaza and her work by Alberto when in Nicaragua to attend the opening of the Rubén Darío Festival in 1967. Although she had become known in Managua's art circle, she had never exhibited her work professionally. I recommended that she be invited to participate in the painting competition that was a part

of the Festival and, subsequently, she was asked to submit paintings for both the São Paulo Biennial of 1967 and the Second Lima Biennial of 1968. The painting that was shown at the Rubén Darío Festival is now in the collection of the First Lady of Nicaragua, Mrs. Hope Somoza.

Born in León, Nicaragua, in 1945, Alberto Ycaza is already a nationally recognized playwright and stage director. He studied art briefly at the National School of Fine Arts in Managua and later studied drama at the Institute of Hispanic Culture in Madrid, 1963-1964. Although he has not abandoned the theater, he has given priority to painting during the past two years. Unlike that of his mother, Alberto's work has overtones of social comment, focusing on themes of the contemporary world. His figures are rendered expressionistically, surrounded by a dark, almost monochrome atmosphere in which color emerges only as an accent. Since 1964 Alberto has participated in several group exhibits and has had two one-man shows at the National School of Fine Arts in Managua, 1963 and 1965.--*J.G-S.*

CATALOGUE

Paintings

Adela Vargas

1. *Popol Vuh*
2. *Lavanderas nocturnas (Nocturnal Laundrywomen)*
3. *Génesis (Genesis)*
4. *El rey burgués (The Bourgeois King)*
5. *Sonatina*
6. *En el portal del Señor (In the Door of the Lord)*
7. *Leyenda de la Peña del Tigre (Legend of the Peña del Tigre)*, 1970, oil on canvas, 15 1/2 x 19"
8. *Una boda en el campo (Country Wedding)*
9. *Feria en Subtiava (Fair in Subtiava)*
10. *Claro de luna (Moonlight)*
11. *Erupción del Cerro Negro (Eruption of Cerro Negro)*

Alberto Ycaza

Retratos históricos de la Sagrada Familia (Historical Portraits of the Sacred Family)

1. *No tendrás otros dioses delante de mí (Thou shalt not have other gods before Me)*
2. *No tomarás el nombre de Dios en vano (Thou shalt not take the name of the Lord thy God in vain)*
3. *Santificarás el sábado (Keep the Sabbath day holy)*
4. *Honra a tu padre y a tu madre (Honor thy father and thy mother)*
5. *No matarás (Thou shalt not kill)*
6. *No fornicarás (Thou shalt not commit adultery)*
7. *No hurtarás (Thou shalt not steal)*
8. *No dirás contra tu prójimo falso testimonio (Thou shalt not bear false witness against thy neighbor)*
9. *No desearás la mujer de tu prójimo (Thou shalt not covet thy neighbor's wife)*
10. *No codiciarás los bienes de tu prójimo (Thou shalt not covet thy neighbor's goods)*

April 10 - 30, 1971

PRE-COLUMBIAN ART OF COSTA RICA IN WASHINGTON COLLECTIONS

Costa Rica, in the middle zone of Central America, has a cultural and historical unity with Nicaragua and Panama as yet not the object of the detailed study given other areas, especially the northern region of Central America, where the great Maya culture flourished.

Archaeologists Jorge A. Lines and Doris Stone have dedicated much fruitful effort to the study of the remote

past of Costa Rica, but publications are not abundant, and there is still much about the people of the region, their customs, and their art that remains in obscurity. Perhaps that is precisely why Costa Rica holds such fascination for collectors and lovers of ancient American art.

In accordance with the discoveries and studies of those archaeologists, Costa Rica can be considered the "epicenter" of the region from an artistic point of view. From the north through Nicaragua came the influence of the Maya and the Olmec; from the south through Panama, the accents and cultural expressions of the Chibcha and Agustín cultures of Colombia.

Once excavation is completed, one must rely on morphology, accents of expression, and techniques of execution to trace cultural links hypothetically. It is thus that art serves archaeology. Seeing the magnificent monoliths of Easter Island and analyzing their physical characteristics reminded me of certain Costa Rican Huétar figures. In spite of the fact that the statues of Easter Island were executed seven centuries later and that they are much larger than the largest Huétar figures, one can engage in a sustained hypothesis on the basis of their similarity alone. Did the Huétar make excursions through the South Pacific as did the Tiahuanacan or the Inca? Little is known, but the statues and the formal affinities remain, and the doubts may someday lead to investigation and confirmation of facts. Other similarities can be found in certain forms and plastic solutions of the huge sculptures at San Agustín, which also served as models for other cultures throughout South America.

Costa Rica was inhabited by three important cultural groups prior to the arrival of the Spaniards. The Chorotega, which shared affinities with the Maya, had its center in the northwestern region and is perhaps the oldest of the cultural complex. Besides having developed an orange ceramic decorated with highly expressive animal figures and deities, the Chorotega used a mysterious, virtuoso technique to carve jade and stone. The green jade carvings have something of the strength and simplicity characteristic of the Olmec. Jade being a material of exceptional hardness, it is an enigma how these pieces were executed and polished by men who did not yet have metal tools. Also characteristic of the culture are the *metates* or tripod corn grinders often seen with the head and tail of a jaguar. The concaveness of the bowl, the richness of detail in the treatment of the stone, and the rhythm of the pieces as a whole make these utilitarian objects, which may also have been used for religious purposes, excellent examples of the extremely refined craftsmanship of the ancient sculptors.

The Huétar occupied the largest part of the territory, including the central zone and extending along most of the Caribbean coast and a large part of the Pacific coast of the country. The Huétar were primarily stone carvers. The volcanic stone almost always was left with a rough surface, polished only enough to erase the traces of the blows made with the tools. Sometimes the sculptor insinuated an adornment on the waist of the *guerrero*, or warrior figure, or traced hair or decoration on the head; but in spite of these refinements, essentially the stone remained rough. Although careful attention was given to correct anatomy in reproducing heads and bodies, the extremities were expressed in simple tubular shapes. The single heads, the *metates* decorated with small human or animal forms, the circular *metates*, the large baroque altars, the *guerreros* who customarily decapitated their enemy and carried his head in their hands, all are executed with sculptural principles of surprising maturity.

Although the Brunca (Brunka or Boruca) culture bears a close formal relationship with the Huétar, especially as evidenced in the work in carved volcanic stone, there are certain characteristics that differentiate them. When the ceramics are examined, especially the tripod incensories ornamented with animals, Brunca art acquires its own stamp. The Bruncas were located in the southwestern part of the country on the Pacific and received by way of Panama a direct influence of the cultures from the south--especially the Coclé and, further down, the Chibcha, Quimbaya, and Agustín. The popular use of gold as ornament and as a means of plastic expression can be traced along that southern route. In quality and strength of expression and technique Brunca goldwork is easily comparable to that coming from the original sources in Colombia and Peru. The Brunca delighted in portraying animal forms both in gold and in stone, the latter being treated as a mass, and often used animal forms as relief or incised decoration on clay vessels.

In spite of the influences exerted upon the Costa Rican cultures from north and south, each had its own distinguishing characteristics. They had in common a rich imagination and expressive power, sure command of technique, and a skill in modelling and carving that the serious scholar of ancient American art cannot afford to overlook.

To avoid confusion brought about by technical nomenclature that distinguishes variants within a culture, the

classification has been limited to the three general cultural groups, appropriating to each the name of the place inhabited. It is hoped that in this way the layman will more easily comprehend and be able to identify the pieces for himself. --*J.G-S.*

ACKNOWLEDGEMENTS

This exhibition is being presented in celebration of the one-hundred and fiftieth anniversary of the Independence of Costa Rica and Pan American Week. The exhibit has been organized by the Division of Visual Arts with the invaluable cooperation of Mrs. Mirtha Virginia de Perea. We wish to extend our warm appreciation to the generous lenders and acknowledge the contributions of United Brands Company of New York, the National Geographic Society, and the Smithsonian Institution.

LENDERS TO THE EXHIBITION

Mr. and Mrs. Roberto Aragón, Mr. Ricardo Aued, Mr. and Mrs. John Balenger, Mr. and Mrs. Edward Bou, Mrs. Poe Burling, Miss Dina Dellalé, Mr. and Mrs. Sam Di Maria, Mr. and Mrs. Guillermo Espinosa, Mr. and Mrs. Alberto García-Dobles, Mr. and Mrs. Robert Gates, Mr. and Mrs. Louis Gotthold, Mr. and Mrs. David Harrison, Mr. and Mrs. Winslow Hatch, Mr. Manuel Hidalgo, Mrs. James Johnston, The Honorable and Mrs. Sol Linowitz, Mr. and Mrs. David Lloyd Kreeger, Mr. and Mrs. Joel J. Lloyd, Mr. and Mrs. Alvaro López, Mr. and Mrs. Robert Magis, Mr. and Mrs. William S. Paddock, Mr. and Mrs. Alfonso Perea, Miss Ana María Perera, Mr. and Mrs. John Perkey, Mr. Michael Skol, The Honorable and Mrs. Raymond Telles, Dr. James Scott, The Honorable and Mrs. T. Graydon Upton, Mr. and Mrs. Fred Ward, Mr. Sigfrido Wolf, H.E. Ambassador and Mrs. Rafael Alberto Zúñiga.

CATALOGUE

Huétar

1. Fragment of a weapon or instrument in form of toucan, stone
2. Grinder, stone
3. Tray, stone
4. Sphere, stone
5. *Metate* with jaguar form, stone
6. *Metate* with two jaguar heads, stone
7. Jaguar jar, ceramic
8. Turtle man *metate*, stone
9. Multifaceted *metate*, stone
10. Warrior with two heads and monkey on his shoulder, stone
11. Monkey with long tail, stone
12. Circular *metate* with animals, stone
13. Quadrangular *metate* with human figures, stone
14. Vessel with incised turtle, ceramic
15. Zoomorphic vessel, ceramic
16. Coiled snake, ceramic
17. Owl vessel, ceramic
18. *Chicha* drinker, stone
19. Square *metate* with two jaguars, stone
20. Warrior with trophy head, stone
21. Zoomorphic incensory with tripod base, ceramic
22. Tripod incensory, ceramic
23. Jade
24. *Metate*, stone
25. *Sukia*, stone
26. Warrior, stone
27. Fertility goddess, stone
28. Fertility figure, stone
29. Lizard, stone

30. Vessel with two jaguar heads, ceramic
31. Crouching man, stone
32. Lizard, ceramic
33. Tripod *metate* with hammer, stone
34. Tray with circular tail, stone
35. Jaguar, stone
36. Head with crown, stone
37. Feminine figure, stone
38. Feminine torso, stone
39. Warrior figure, stone
40. *Metate* handle, stone
41. Large warrior with trophy head, stone
42. Two idols, stone
43. Feminine idol, stone
44. Warrior idol, stone

Chorotega

45. Polychromed vessel in form of jaguar, ceramic
46. Double figure of anthills, ceramic
47. Polychromed vessel, ceramic
48. Polychromed vessel, ceramic
49. Tripod vessel, ceramic
50. Jaguar *metate*, stone
51. Tripod vessel with monkey inside, ceramic
52. Vessel with serpent decorating round base, ceramic
53. Jaguar vessel, ceramic
54. Jaguar jar, ceramic
55. Tripod vessel, ceramic
56. Small tripod, stone
57. Vessel, ceramic
58. Decorated vessel, ceramic
59. Jaguar incensory, ceramic

Brunca

60. Tripod incensory with armadillos, ceramic
61. Vessel with narrow neck decorated with double face, ceramic
62. Marine bird, ceramic
63. Tripod vessel decorated with circular feet, ceramic
64. Circular vessel in form of lizard eating two small animals, ceramic
65. Figure, stone
66. Figure, stone
67. Figure with crossed arms, stone
68. Vessel with monkeys, ceramic
69. Tripod incensory, ceramic
70. Jaguar *metate*, stone
71. Tripod incensory, ceramic
72. Vessel with birds on rim, ceramic
73. *Metate*, stone
74. Brunka family figurines, ceramic
75. Vessel with zoomorphic handle, ceramic
76. Tripod with deer figures, ceramic
77. Portion of woman's face, ceramic
78. Carving on coffee-colored, stone
79. Pre-historic animal figure, ceramic
80. *Metate* with bird figures on base, stone
81. Male figure with bird in his hand, ceramic

May 5 - 23, 1971

TAPESTRY WORKSHOP NICOLA-DOUCHEZ OF SÃO PAULO, BRAZIL

Norberto Nicola and Jacques Douchez were first associated in 1954 when both were members of the Abstract Workshop in São Paulo. As painters they exhibited with others of the group until 1959, when they separated to establish their tapestry workshop. The following year they toured and studied the great tapestry centers of Europe, returning to Brazil in 1961 to participate in their first group show in Belo Horizonte's Museum of Modern Art.

Until recent years, tapestry was thought of in terms of a flat plane generally intended for a floor or wall. Nicola and Douchez, who often share both the design and execution of their work, have departed from tradition to create multi-dimensional woven forms. Wool is sometimes combined with wood or another material to create rich, textural variety, and open and closed spaces are alternated to give a sense of volume.

Nicola, who was born in São Paulo in 1930, and Douchez, born in Mâcon, France, in 1921, have exhibited in group shows in Brazil, Uruguay, Argentina, England, and France. They have had individual shows in São Paulo, Rio de Janeiro, Montevideo, Lima, Santiago, and Mexico City, and last year represented Brazil at Expo 70 in Osaka, Japan. Among the books in which mention of their work appears are *The Art of Tapestry* by Pierre Verle, *Crafts of the Modern World* by Aileen Webb, and *Profile of the New Brazilian Art* by P.M. Bardi.

This is the first presentation of their work in the United States. *--J.G-S.*

CATALOGUE

Tapestry

1. *Estandarte (Standard)*, 268 x 140 cm.
2. *Forma alada (Winged Form)*, 160 x 190 cm.
3. *Verde e amarelo (Green and Yellow)*, 235 x 110 cm.
4. *Corda azul (Blue Cord)*, 200 x 220 cm.
5. *Exorcismo (Exorcism)*, 200 x 198 cm.
6. *Fausto (Faust)*, 265 x 119 cm.
7. *Queda azul (Blue Fall)*, 290 x 187 cm.
8. *Rede azul (Blue Net)*, 160 x 118 cm.

May 5 - 23, 1971

ODETTO GUERSONI OF BRAZIL: WOODCUTS

Traditionally, Brazilian artists have excelled in all printmaking techniques, thus making that country the most important center for the production of the graphic arts in Latin America. Among the most accomplished of those artists is Odetto Guersoni, whose work is being presented for the first time in Washington. A specialist in woodcuts, Guersoni achieves an impressive solidity using simple abstract designs.

Born in São Paulo in 1924, Guersoni attended the School of Fine Arts and Crafts there from 1938 to 1942 and in 1947 studied in Paris with René Cottet and Stanley W. Hayter. He has had more than thirteen one-man shows, including an exhibit at the Museum of Modern Art in Rio de Janeiro in 1961. He has participated in group exhibits in Paris, London, Lugano, Zürich, Berlin, Dresden, Tel Aviv, Tokyo, São Paulo, Rio de Janeiro, Quito, Milwaukee, New York, and San Francisco and this year will be represented at the International Print Biennial in Ljubljana, Yugoslavia. Guersoni has been awarded numerous prizes in Brazil, and his work is included in the collections of all the country's major museums. *--J.G-S.*

CATALOGUE

Woodcuts

1. *Jogo de cruzes (Game of Crosses) VI*

2. *Jogo das formas (Game of Shapes) III*
3. *Jogo das formas (Game of Shapes) XIV*
4. *Jogo das formas (Game of Shapes) XVII*
5. *Jogo das formas (Game of Shapes) XXX*
6. *Formas justapostas (Juxtaposition of Shapes) IV*
7. *Formas justapostas (Juxtaposition of Shapes) V*
8. *Formas justapostas (Juxtaposition of Shapes) IX*
9. *Formas justapostas (Juxtaposition of Shapes) XV*
10. *Formas justapostas (Juxtaposition of Shapes) XX*
11. *Formas justapostas (Juxtaposition of Shapes) XXIV*
12. *Formas justapostas (Juxtaposition of Shapes) XXXII*
13. *Formas justapostas (Juxtaposition of Shapes) XXXIII*
14. *Formas justapostas (Juxtaposition of Shapes) XXXIV*
15. *Formas justapostas (Juxtaposition of Shapes) XXXV*
16. *Justaposição, em relevo (Juxtaposition, in Relief) I*

June 2 - 20, 1971

THREE ARTISTS OF PERU: BURELA, CONDESO, RAMIREZ

This exhibition unites three young Peruvian artists who currently live in the United States and Canada. All were born in Lima and graduated from different art schools in Peru. Aida Burela and Eduardo Ramírez are painters, while Orlando Condeso is a printmaker; each follows a different tendency of expression. All began exhibiting their works in Lima in 1966.

Aida Burela, who now lives in Texas, was born in 1934. She has had four one-man shows in Texas, including exhibits at the University of Texas at Dallas, 1969 and 1970, and has participated in twelve group exhibits in Texas and Peru. She has been awarded several prizes in community art shows.

Eduardo Ramírez was born in 1945 and resides in Montreal, Canada. Last year he had three one-man exhibits in Texas. His work has been included in group shows in Lima at the Institute of Contemporary Art, 1965, 1966 and 1967; the Museum of Art, 1968; and the Peruvian-North American Institute, 1968; as well as in the United States.

Born in 1947, Orlando Condeso lives in New York. Prior to coming to the United States, he taught printmaking at the National School of Engineering and at Catholic University in Lima. Condeso has participated in twenty-four group exhibits in Peru, Chile, Puerto Rico, Cuba, and Spain and has been awarded prizes, including First Prize at the National Print Contest in Lima, 1970, and participated in the award given to the Best Foreign Collection at the Third International Biennial of Art in Ibiza, Spain. Works by the artist are included in the public collections of Braniff International and the Peruvian-North American Institute as well as in numerous private collections.

This is the first presentation of the work of these artists in the Washington area.

EXHIBITION LIST [1]

Aida Burela

Collages

1. *Shape of a Head on the Dark Waters*
2. *There Were Four Beating Wings*

[1] Not included in the original catalogue. --*Ed.*

3. *The City of the One Thousand Dreams*
4. *Reflections*
5. *Learn the Taste of Pride*
6. *The Cheating Look*
7. *Hiroshima, mon amour*
8. *Who Is on My Side, Who?*
9. *Sequence*
10. *Mahia*
11. *Footsteps under the Pier*
12. *Any Where, Any Place*
13. *From My Memories, Sad Brother*
14. *The Original Is in France*

Orlando Condeso

Paintings

1. *In the Cold Nights of Endless . . .*
2. *I Remember My First Lie That . . .*
3. *I Remember an Infinite Emptiness . . .*
4. *I Remember the Slave Girl . . .*
5. *I Remember the Dim Downs . . .*
6. *And a Fossil Looking At . . .*
7 *Each One with His Inner . . .*
8. *5,000,000 Years Trying To . . .*
9. *And Everyone Can See . . .*
10. *I Remember My Father's Lingering . . .*
11. *I Remember the World That One . . .*
12. *I Remember Those Cold Mornings . . .*
13. *I Remember a Stoned Bird . . .*

Eduardo Ramírez

Paintings

1. *Paccari Tambo Wall*
2. *Ya que viene del azul* (Since It Comes from Blue)
3. *Un distante silencio* (A Distant Silence)
4. *Feather Shawl*
5. *Fluir, fluir, siempre, interminablemente* (Flowing, Flowing, Always, Endlessly)
6. *Ollantaytambo*
7. *Consumación y posesión* (Consummation and Possession)
8. *Será por ser* (It Will Be)
9. *Sin volver la mirada* (Without Looking Back)
10. *Inti Raymi*
11. *Circulación ilimitada* (Unrestrained Circulation)
12. *Nunca fuimos, nunca somos* (We Never Were, We Never Are)
13. *A mi modo* (In My Way)
14. *Divagaciones en blanco* (Digressions in White)
15. *Fiebre de los días idos* (Fever of the Days Gone)
16. *No está perdido ni olvidado* (It Is Neither Lost nor Forgotten)
17. *Cordura diáfana* (Transparent Sanity)
18. *A mi vida misma* (To My Own Life)

July 8 - 31, 1971

TAPESTRIES FROM BOLIVIA BY DANIEL VEGA DE LA TORRE

It is not surprising that Bolivia, with a wealth of wools from the alpaca, llama, sheep, and vicuña, produces some of the most select textiles to be found in South America. Although the inhabitants of pre-Columbian Bolivia produced textiles with exquisite designs, only in recent years have contemporary artists begun to explore the possibilities with tapestry-making. Among the most outstanding of these artists is Daniel Vega de la Torre. Combining various wools, which are left in their natural colors and woven by hand on Indian looms, he creates motifs that while modern are sometimes reminiscent of pre-Columbian forms or of features in the Bolivian landscape.

Vega de la Torre, who signs his work as Danny, was born in Oruro, Bolivia, in 1932 and studied at the Institute of Art and Decoration in São Paulo, Brazil. After completing his studies and working for several years in Brazil, he returned to Bolivia to establish a tapestry workshop. He has had several one-man shows, including an exhibit at the First National City Bank in La Paz in 1969, and participated in group exhibitions in Bolivia. Illustrations of his tapestries appeared in the 1970/71 edition of *Decorative Art*, published in London, England.

This is the first presentation of his work in the United States. *--J.G-S.*

CATALOGUE

Handwoven Wool Tapestry

1. *Ovejeros (Shepherds)*, about 320 x 280 cm.
2. *Cementerio indio (Indian Cemetery)*, about 150 x 200 cm.
3. *Llamas*, about 220 x 330 cm.
4. *Altiplano (Highland)*, about 280 x 280 cm.
5. *Vicuñas*, about 100 x 200 cm.
6. *Valle de la luna (Valley of the Moon)*, about 150 x 150 cm.
7. *Ollas (Pots)*, about 150 x 150 cm.
8. *Sol en la montaña (Sun on the Mountain)*, about 100 x 140 cm.
9. *Pisadas (Footprints)*, about 150 x 150 cm.
10. *Figuras (Figures)*, about 90 x 120 cm.

August 5 - 31, 1971

RAUL MARROQUIN OF COLOMBIA

Raúl Marroquín is a new personality in the Colombian art world. An experimentalist, he has worked in various media, including painting, drawing, and sculpture as well as film, in each employing new techniques and materials. In this exhibition he is presenting a series of drawings and sculptures or constructions based on an imaginary interpretation of aspects of the pre-Columbian culture of San Agustín.

Marroquín was born in Bogotá in 1948 and studied there at the National School of Fine Arts. Since 1965 he has had five one-man shows in Medellín, Bogotá, and Caracas and has participated in numerous group shows in Colombia. He has been awarded several prizes, including First Prize for Drawing at the Salon of Young Artists of Medellín in 1968. He currently teaches at the art workshop of the Minuto de Dios Museum of Contemporary Art in Bogotá.

This is the artist's first appearance in the United States. *--J.G-S.*

CATALOGUE

Interpretations of San Agustín

1-20. Drawings[1]
1-10. Constructions[1]

September 1 - 25, 1971

PILAR CASTAÑEDA OF MEXICO

Pilar Castañeda paints still lifes and rural and urban landscapes that have little or no relation to the social and national themes that once characterized Mexican art. Her technical skills are evident in her handling of paint applied in thick impasto to create subtle transparencies, and her use of color, although brilliant, is treated in terms of tonality rather than contrast.

Born in Mexico City in 1941, Miss Castañeda is a relatively new personality in the Mexican art world. From 1958 to 1965 she studied privately and at the National School of Plastic Arts under artists such as Antonio Rodríguez Luna and Francisco Moreno Capdevila. She has had five solo shows in Mexico, and has participated in numerous group shows in Mexico, Chile, Israel, Canada, and the United States, including the exhibition *Contemporary Mexican Painting* presented at the Mexican National Museum of Modern Art as a part of the cultural program of the Olympic Games in 1968. She has also been awarded several prizes, among them the First Prize for Painting given by the National School of Plastic Arts in 1964.

This is her first solo exhibition in the United States.

CATALOGUE

Oils

1. *Autorretrato (Self-Portrait)*, 40 x 50 cm.
2. *Sueño (Dream)*, 50 x 60 cm.
3. *Crepúsculo (Crepuscule)*, 50 x 60 cm.
4. *Geometría natural (Natural Geometry)*, 40 x 70 cm.
5. *Penumbra*, 40 x 70 cm.
6. *Al alba (Daybreak)*, 60 x 80 cm.
7. *Terremoto (Earthquake)*, 55 x 105 cm.
8. *Campiña (Field)*, 70 x 90 cm.
9. *Amarillo y blanco (Yellow and White)*, 70 x 95 cm.
10. *Velas (Candles)*, 70 x 95 cm.
11. *La cinematografía (Cinematography)*, 70 x 100 cm.
12. *El ramo atómico (The Atomic Field)*, 70 x 100 cm.
13. *Estallido floral (Floral Outburst)*, 70 x 100 cm.
14. *Ojos vigilantes (Watchful Eyes)*, 90 x 130 cm.
15. *Explosión demográfica (Demographic Explosion)*, 90 x 150 cm.
16. *Peras (Pears)*[2]
17. *Calabaza (Squash)*[2]
18. *Bananas*[2]

[1] Titles are unavailable. --*Ed*.

[2] Also exhibited but not included in the original catalogue. --*Ed*.

September 23 - October 12, 1971

THE BANANA: VARIATIONS IN OIL
BY ANTONIO HENRIQUE AMARAL OF BRAZIL

Last month Antônio Henrique Amaral was the recipient of one of the most coveted prizes awarded annually by the National Salon of Modern Art in Rio de Janeiro. The award was presented to him for his paintings based on the banana. Since Brazil's economy still relies heavily on the exportation of agricultural products, especially the banana, of which there are more than a dozen varieties, it somehow seems appropriate that one of the country's most outstanding artists has chosen the banana as his subject. Amaral has explained that he sees the fruit as a "symbol of Brazil," furthermore, he sees his rendering of the banana in all its monumentality as representing a break with the vanguard movements of Europe and the United States, giving to Brazil a kind of national expression of its own.

A leading proponent of the neofigurative direction in Brazilian art, Amaral began painting bananas in 1968, using the *banana da terra* as his model. He approaches his subject through abstraction, rendering close-ups of the fruit itself, the stems, and often including parts of the plant as might be seen from various perspectives. His colors are austere, his forms monumental but simple.

Born in São Paulo in 1935, Amaral is a self-taught painter who, until 1967, devoted his efforts entirely to the graphic arts. In 1955 he studied drawing with Roberto Sambennet at São Paulo's Museum of Modern Art and in 1957 took a course in engraving with Livio Abramo. In 1959 he studied briefly at the Pratt Graphic Arts Center in New York under Shiko Munakata.

From 1958 to 1963 Amaral had eight one-man shows in which he exhibited graphic arts--linoleum cuts, woodcuts, and drawings--including an exhibit at the OAS in 1959 that was his first appearance in the United States. Since that time he has had nine solo painting exhibitions, the most recent at the Bonino Gallery in Rio de Janeiro. He has participated regularly in the São Paulo Biennial since 1963 and has been represented in group shows in Argentina, Brazil, Chile, Cuba, Puerto Rico, France, Germany, and England. Works by the artist are included in numerous public collections, among them the collections of the Museum of Bahia, the Institute of Modern Art of Chile, the Rhode Island Museum of Art, and the Museum of Art of Belo Horizonte. He is also represented in important private collections in Chile, Brazil, Argentina, and the United States and has been awarded some twenty prizes for both painting and the graphic arts.

This is his second appearance at the OAS and the first exhibition of his paintings in the United States. --*J.G-S.*

CATALOGUE

Paintings

1. *Penca em detalhe (Detail of a Bunch)*, 1971, 80 x 130 cm.
2. *Maduras (Ripe Bananas)*, 1971, 80 x 130 cm.
3. *Quasi podres (Overripe Bananas)*, 1971, 80 x 130 cm.
4. *Brasiliana em verde (Brasiliana in Green)*, 1971, 100 x 65 cm.
5. *Cacho pendente (Hanging Bunch)*, 1971, 100 x 65 cm.
6. *Apodrecidas (Rotting Bananas)*, 65 x 100 cm.
7. *As três últimas (The Last Three)*, 1971, 100 x 65 cm.
8. *Penca de dúzia (A Dozen)*, 1971, 73 x 100 cm.
9. *De cima, o cacho (Bunch from an Aerial View)*, 1971, 73 x 100 cm.
10. *Grande penca (Big Bunch)*, 1970, 130 x 170 cm.
11. *Bananas da terra, no prato (Banana da Terra on a Plate)*, 1970, 130 x 170 cm.
12. *Suspensas, no azul (Suspended in Blue)*, 1970, 60 x 80 cm.
13. *Face à face (Face to Face)*, 65 x 100 cm.
14. *Grande cacho (Big Bunch)*, 130 x 170 cm.
15. *Penca no prato (Bananas on a Plate)*, 1970, 130 x 170 cm.
16. *No prato, só (Alone on a Plate)*, 1970, 130 x 170 cm.
17. *Sobre fundo verde (On a Green Background)*, 1971, 80 x 130 cm.

18. *Conjunto sobre amarelo (Bunch on a Yellow Background)*, 1971, 65 x 100 cm.
19. *Bananas reclinadas (Reclining Bananas)*, 1971, 80 x 170 cm.
20. *A banana (Banana)*, 1971, 80 x 130 cm.
21. *Podres (Rotting Bananas)*, 1971, 85 x 130 cm.
22. *Ruptura umbilical (Umbilical Rupture)*, 1970, 60 x 80 cm.
23. *Podre pequena, no prato (Small Rotting Banana on a Plate)*, 1970, 65 x 100 cm.
24. *Penca simétrica, fundo verde (Symmetrical Bunch with Green Background)*, 1970, 100 x 65 cm.
25. *Uma sobre a outra (One Above Another)*, 1971, 80 x 100 cm.

September 23 - October 12, 1971

OLGA LEBEDEFF OF BRAZIL

Following the tradition of showing graphic art together with painting or sculpture by artists from the same country, the OAS is currently exhibiting the woodcuts of Olga Lebedeff in the Print Gallery. Miss Lebedeff follows a long line of Brazilian printmakers who have been introduced to the Washington public through the OAS, including, among others, Marcelo Grassmann, Roberto De Lamônica, Fayga Ostrower, Odetto Guersoni, and Arthur Luiz Piza.

Born in 1933 in Livramento, Rio Grande do Sul, Miss Lebedeff studied under the well-known Brazilian artists Edith Behring, José Assumpção Souza, and Oswaldo Goeldi. Last year she studied briefly at Indiana State University. She has had several solo shows, including an exhibit at the Picolla Gallery in Rio de Janeiro in 1969, and has been represented in group exhibits in Argentina, Brazil, the United States, and England. Works by Miss Lebedeff are included in the collections of the Museum of Art of São Paulo and the Pampulha Art Museum in Belo Horizonte as well as in private collections in Brazil and abroad.

This is her first solo exhibition in the United States. *--J.G-S.*

CATALOGUE

Graphics

1. *Quo vadis*, 1/20
2. *Duas figuras em diálogo (Two Figures in Dialogue)*
3. *Evolução (Evolution)*, 1/20
4. *Germinação (Germination)*, 1/20
5. *Expansão e conquista (Expansion and Conquest)*, 6/10
6. *Contemplação (Contemplation)*, 2/10
7. *Embrião dissolução (Embryonic Dissolution)*, 1/15
8. *Geração anti-geração (Generation Anti-Generation)*, 3/20
9. *Germinação (Germination) III*, 1/20
10. *Meditação (Meditation)*, 1/20

October 14 - November 1, 1971

NELLY FREIRE OF ARGENTINA

The art of drawing was considered for many years as necessary but subservient to the arts of painting and sculpting. The internationally known Mexican artist José Luis Cuevas, who was introduced through the OAS some fifteen years ago, was one of the first to take part in the revival of drawing as an art in itself. There is a remarkable number of young artists today who, like Cuevas, specialize in drawing, perhaps as a reaction against the current trend toward experimentation and disrespect for discipline that seems to jeopardize the existence of art as a serious means of communication.

The drawings of Nelly Freire are vibrant and eloquent examples of fine draftsmanship. Her work is characterized

by a certain sobriety and dramatic quality that reflect the early guidance of her teachers Vicente Puig, Carlos Alonso, and Lajos Szalay, all accomplished draftsmen who work in the expressionistic language preferred by so many of today's artists concerned with man's search for his identity. Miss Freire concentrates on the pure graphic value of line, leaving it precise and clean. She makes no attempt to define volume but, rather, implies it, sometimes using contrasting splashes of black and white. Her figures are serene and motionless, pathetic or tragic perhaps but never oppressive, suggestive of moods but never literary.

Nelly Freire was born in Villa Angela in the Province of Chaco, Argentina, in 1933 and studied drawing with Puig, Alonso, and Szalay from 1952 to 1958, while at the same time working toward a degree in education, which she completed in 1959. She also took courses in painting from Leopoldo Presas. From 1954 to 1965 she was director of the Antígona Gallery in Buenos Aires and headed a children's art workshop there. She has had six solo shows since 1964, including exhibits at the Lirolay Gallery, 1966, and the Atica Gallery, 1969, both in Buenos Aires. She has participated in numerous national salons. This year she was awarded the Grand Prize for Drawing at the Manuel Belgrano Municipal Salon. Her work is represented in public and private collections in Argentina, Peru, and the United States.

This is her first exhibition in this country. --*J.G-S.*

CATALOGUE

1-30. Drawings[1]

November 5 - 22, 1971

HERMAN BRAUN OF PERU

Last spring Herman Braun made his United States debut at the Lerner-Misrachi Gallery in New York City with the exhibition *Velásquez, Manet, Cézanne, and Picasso Revised*. The current exhibit consists of a selection of those paintings, with the addition of several new works from the series, and represents the artist's first appearance in the Washington area.

Braun conceives of his work in terms of a "new reality" --a reality opposed to but extracted from the traditional reality represented by the works of the aforementioned masters, whose paintings he modifies or transforms. He has explained that his intention is twofold:

> The first is purely pictorial. Each painting in a series constitutes an independent plastic and pictorial entity. But I am also trying to give a sensation of movement, both in the objective representation of the subject of each painting and throughout the series as a whole, in order to stimulate the observer's imagination and so invite his participation. Secondly, I want to remove the mystery. I chose the works of Velásquez, Manet, Cézanne, and Picasso partly because of personal affinities, but mainly because they are universally known. I want to make them the commonplace, so as to liberate the critical faculties of the uninitiated observer and help free him from the inhibitions created by the educational and informative system of the plastic arts--a system which demands blind acceptance of "historical truths."

Braun was born in Lima, Peru, in 1933 and studied there at the School of Fine Arts. Besides painting, he is actively engaged in the design of architectural interiors and furniture and in 1960 was awarded First Prize for the design of an open-air theater in Lima. He has lived in Paris since 1952, but frequently returns to Peru where he has exhibited and taught. He has had more than seven one-man shows, including two exhibits at the Gallery 9 in Paris, 1969 and 1970; others in Lima (Institute of Contemporary Art, 1966; Carlos Rodríguez Gallery, 1970); La Chaux-de-Fonds, Switzerland; and New York. He has participated in important group exhibitions in Peru, France, Italy, England, Norway, Denmark, and Sweden and in 1972 will take part in the Coltejer Biennial in

[1] Titles are unavailable. --*Ed.*

Medellín, Colombia.

Braun's interpretations of masterpieces are fresh and imaginative, sometimes serious, sometimes amusing. *New York Times* art critic John Canaday has remarked: "He has a sharp perception of styles and a clever hand at imitating or burlesquing them." His drawing is clearly expert and highly powerful, his palette brilliant.

The artist is represented in public and private collections in Latin America, Europe, and the United States, including the Museum of Modern Art of Paris. --*J.G-S.*

EXHIBITION LIST [1]

Paintings

 1-16. *Meninas Series*, 39 x 39"
 17. *Meninas Series*, 78.5 x 70.5"
18-19. *Picasso Diptych*, 76 x 51" each
 20. *Deux portraits au verre de vin (Two Portraits with a Glass of Wine)*, 64 x 51"
21-23. *Cézanne Triptych: Affaire de pomme (Apple Business)*, 76.5 x 76.5" each
24-27. *Manet Series: Déjeuner sur l'herbe*, lithograph, artist's proof

November 22 - December 10, 1971

ROBERTO MORASSI OF URUGUAY

Roberto Morassi began his artistic career as a painter and photographer in 1943. It was not until some twenty years later that he began to work with sculpture and this year, after more than fifteen one-man shows and participation in approximately thirty group exhibitions, he was awarded First Prize for Sculpture at the National Salon of Plastic Arts in Montevideo.

Morassi creates what he calls *oscilantes* or sculptures in motion, following the concepts of Alexander Calder. He works exclusively in metal, generally steel, the only material that allows him "to draw or define line in space and at the same time create dynamic volumes." His production is stylistically eclectic--some forms are abstract, others are naturalistic.

Born in Montevideo in 1918, Morassi attended the National School of Fine Arts and in 1941 studied painting at the workshop of the Uruguayan master Joaquín Torres-García. He has had one-man shows in Argentina, Paraguay, and Uruguay and has participated in numerous group exhibitions, including the Third International Exhibition of Contemporary Sculpture at the Rodin Museum in Paris, 1966. His work is represented in collections in Europe, Latin America, and the United States.

This is his first one-man show in this country. --*J.G-S.*

EXHIBITION LIST [2]

Metal Sculpture

1. *Orbital*
2. *Plea*
3. *Corimbo*
4. *Restlessness*

[1] Not included in the original catalogue. --*Ed.*

[2] Not included in the original catalogue. --*Ed.*

5. *Espirales flotantes (Floating Spirals)*
6. *Cadena de arcos (Chain of Arches)*
7. *Sprouts*
8. *Aggressive Equilibrium*
9. *Penetración (Penetration)*
10. *Espiral en vuelo (Spiral in Flight)*
11. *Gravedad (Gravity)*
12. *Energía contenida (Contained Energy)*
13. *Ritmo elíptico (Elliptical Rhythm)*
14. *Turn*
15. *Masculino-femenino (Masculine-Feminine)*
16. *Espiral danzante (Dancing Spiral)*
17. *Forma sinuosa (Sinuous Form)*
18. *Llamas (Flames)*
19. *Círculos en un arco (Circles in an Arch)*
20. *Rotación (Rotation)*
21. *Ritmos combinados (Combined Rhythms)*
22. *Oscilación ondulada (Undulated Oscillation)*

December 10, 1971 - January 4, 1972

SANTIAGO ALEGRIA AND ALFONSO D'ALBORA CORREA OF CHILE

To Santiago Alegría, Chile is a country of damp skies and traveling clouds, of twisted trees in the lonely stretches of the south, of northern beaches barely touched by a sea that urges on subtle burros, slow wagons, distant shellfish gatherers. It is also the land of the *huaso*, vibrant with poplars, larches, and *coihués*, while it sinks its roots in furrows and estuaries.

Alegría is a painter of proletarian lateeners, rigging, masts, and red metals, of shadows in the water and pensive horses at low tide at Angelmó, of the canals and islands in the region of Chiloé, of baroque araucarias, of insistent rains and old doors, of rough hills, and of country people moving toward green, blue, gray horizons.

In painting, Santiago Alegría caresses his country, sings to it, and illuminates it with his swift brushes. There is no *cordillera* more snow-covered than his Chilean Andes, nor muleteers more certain of their way in their desolate abysses. A painter of the blessings of Chile converted by an act of magic into paintings of lights, blots, reflections, and skies, Santiago Alegría joyfully builds a country that is reborn every day, like a flower, in his hands.

Santiago Alegría was born in Santiago, Chile, and studied at the Academy of Humanities and the School of Arts and Crafts. He has exhibited with success in Chile and elsewhere and has been the recipient of awards in Viña del Mar and at the Fair of Plastic Arts in Santiago. This year the Municipality of Santiago conferred upon him the Medal of the City for his continued and brilliant artistic career.

In the work of the fingers of Alfonso D'Albora Correa the Chileans are learning to experience the touch that makes them eternal, the single act in the red consistency of a terra-cotta miraculously captured in the moment of creation and re-creation, subtle and powerful at the same time, fragile as a snapshot in blood, an overturning of reality reflected in itself.

Here are the skies, the signs, and the marks, the destinies and delays of a country in miniature, rendered motionless for an instant, afterwards to take on a new movement that is secret, inner, continuous.

A ceramist of ardent clay feeling its occult forces, in careful and masterly work, letting the earth show its essences in the fires of a sorcerer's oven, D'Albora Correa is the molder of the dynamism of Chile. With his strong fingers he governs and presides over a silent and magical kingdom of clay.

Alfonso D'Albora Correa was born in Valparaíso in 1927 and studied at the Academy of Humanities and the

School of Applied Arts. He has received numerous awards and unanimous praise from Chilean critics. In 1963 he received First Prize at the Third Municipal Fair of Plastic Arts. --*Fernando Alegría*, Cultural Attaché, Embassy of Chile

CATALOGUE

Santiago Alegría

Watercolors

1. *Licanray*, Villarrica
2. *Lago (Lake)*, Villarrica
3. *Salto del Laja*, Los Angeles
4. *Angelmó*, Puerto Montt
5. *Castro*, Chiloé
6. *Río Valdivia (Valdivia River)*, Valdivia
7. *El ovejero (The Shepherd)*, Punta Arenas
8. *Quisco Sur*, El Quisco
9. *Día de lluvia en el sur (Rainy Day in the South)*
10. *La carreta (The Cart)*, Mehuín
11. *Viejo portón (Old Door)*, Colina
12. *Pescadores (Fishermen)*, Los Vilos
13. *Barcas en Angelmó (Boats in Angelmó)*, Puerto Montt
14. *El arriero (The Muleteer)*, Cordillera de los Andes
15. *Callejón San José (San José Street)*, Santiago
16. *Río Mapocho (Mapocho River)*, Santiago
17. *Araucarias*, Volcán Llaima (Llaima Volcano)
18. *Castro*, Chiloé
19. *Cerro de Valparaíso (Hills of Valparaíso)*
20. *Lago Llanquihue (Lake Llanquihue)*, Volcán Osorno (Osorno Volcano)
21. *Ranchos nevados (Snowy Ranches)*, Vitacura, Santiago
22. *Cajón del Maipo*, Puente Alto
23. *Barcas en el Canal de Tenglo (Boats in Tenglo Canal)*
24. *La lavandera (The Washerwoman)*, Temuco
25. *Burrero en las playas de Tongoy (Burro Keeper on Tongoy Beach)*
26. *Punta Arenas*
27. *Faluchos en Calbuco (Boats in Calbuco)*
28. *Osorno*
29. *El estero (The Matting)*,[1] Temuco
30. *Pescadores (Fishermen)*, Chiloé

Alfonso D'Albora

Terra-Cottas

1. *Felicidad a pleno sol (Sunlight Happiness)*
2. *Alegría triste (Mournful Joy)*
3. *El payaso Marianelo (Marianello the Clown)*
4. *Ladrón de huevos (Egg Thief)*
5. *¡Cuidado con las espinas! (Look for the Thorns!)*
6. *Juglar en verde y oro (Joker in Green and Gold)*
7. *Joven organillero (Young Organ Player)*
8. *Abuelo chacarero (Grandfather Farmer)*
9. *Desgranando mazorcas (Beating the Ears of Corn)*

[1] Translation of this title in Bolivia is "The Stream." --*Ed.*

10. *¡Pilla el pájaro! (Get the Bird!)*
11. *La gitana vendedora de braseros (The Gypsy Fire-Pan Seller)*
12. *Músico callejero (Street Musician)*
13. *Vendedor de tortillas (Bread Seller)*[1]
14. *El gozador de vinos (The Wine Connoisseur)*
15. *Travesura en el circo (A Joke in the Circus)*
16. *¿Se sirve un matecito? (Care for a Mate?)*
17. *Adivinadora de fortuna (Fortune-Teller)*
18. *Chismosas (Gossipers)*
19. *El zapatero (The Shoemaker)*
20. *Amigas (Friends)*
21. *El final del camino (End of the Road)*
22. *Guitarra chilena (Chilean Guitar)*

[1] Literal translation of this title is "Tortilla Seller." --*Ed*.

YEAR 1972

MARIA ELENA DELGADO OF MEXICO

During the seventeen years in which she has figured in the panorama of Mexican art, María Elena Delgado has had seven solo shows in Mexico and two in the United States and Canada, and has been represented in group exhibits in those countries as well as in Switzerland. Her sculptures are in several theaters in Monterrey and in private collections in the United States and Mexico, including that of the President of Mexico, His Excellency Luis Echeverría.

Although she has worked with wood, metals, and marble, Miss Delgado in recent years has shown a decided preference for volcanic stone. She has a keen awareness of contemporary trends in sculpture and much of her early work reflects a particularly strong interest in the forms of Brancusi and Arp.

Born in Monclova, Coahuila, Mexico, in 1921, Miss Delgado began studying art at the age of eleven. Among the galleries and museums in which her work has been exhibited are the Regional Institute of Fine Arts, Acapulco, 1958; the Museum of Art, Juárez, 1969; and the Welna Gallery, Chicago, Illinois, 1969. In 1964 her work was included in an exhibit at the Mexican Pavilion of the New York World's Fair, and in 1968 she participated in the cultural program of the Olympic Games.

This show is being presented with the cooperation of Mexico's Secretariat of Foreign Affairs and marks the artist's first appearance in Washington. --*J.G-S.*

EXHIBITION LIST [1]

Sculptures

1. *Impetu (Impetus)*, white onyx
2. *Ovulo (Ovule)*, black marble
3. *Maternidad (Motherhood) I*, green marble
4. *Protección (Protection)*, bronze
5. *Pareja (Couple)*, bronze
6. *Ballet acuático (Aquatic Ballet)*, bronze
7. *Mujer sentada (Seated Woman)*, bronze
8. *Extasis (Ecstasy)*, bronze
9. *Ovulación (Ovulation) II*, black marble
10. *Despertar (Awakening)*, orange onyx
11. *Maternidad (Motherhood) V*, green marble
12. *Maternidad (Motherhood) III*, lemon onyx
13. *Torso*, orange onyx
14. *Venus II*, white onyx
15. *Idilio (Idyl)*, lemon onyx
16. *Eros III*, black marble
17. *Ovulación estelar (Stellar Ovulation)*, white onyx
18. *Fusión (Fusion)*, black marble
19. *Ovulación (Ovulation) III*, black marble

[1] The list here reproduced--not included in the original catalogue--was sent by the artist for this exhibition, but there is no indication that all of the pieces were actually exhibited. --*Ed.*

20. *Pia*, white onyx
21. *Ovulación (Ovulation) I*, lemon onyx
22. *Madre tierra (Mother Earth)*, lemon onyx
23. *Venus II*, black marble
24. *Ballet acuático (Aquatic Ballet)*, white marble
25. *Eros*, black marble
26. *Ventana al universo (Window to the Universe)*, black marble
27. *Elevación II (Elevation) II*, white marble
28. *Elevación (Elevation) I*, black marble
29. *Piedra al sol (Stone of the Sun)*

January 5 - 23, 1972

MEXICO: PHOTOS BY HECTOR GARCIA

Mexico has a tradition of artistic photography that dates to the beginning of this century. The first great advances were made during the decade of the 1920s and coincided with the birth of the new expression in the plastic arts. That tradition, which might be called a "national style," has brought international acclaim to Mexican photographers in both the still and motion picture categories.

Among the most prominent of today's still photographers is Héctor García. His work clearly reflects his heritage--compositions marked by a certain sense of tension, a clever combination of pathos and humor, and strong overtones of social comment.

Born in Mexico City in 1923, García came to the United States as a laborer during World War II and used his wages to study photography in New York. In 1946 he returned to Mexico and entered the Academy of Cinematographic Arts, which was under the direction of the two greatest Mexican photographers of all time, Manuel Alvarez Bravo (stills) and Gabriel Figueroa (motion pictures). For the past twenty-eight years he has worked on a free-lance basis for numerous magazines and newspapers and has been awarded many prizes, including a scholarship from UNESCO to study in Paris, 1964, and another to study in Lebanon, 1969. In 1968 he received a prize for his contribution to the film program of the Olympic Games. He has had eighteen one-man shows in Mexico and abroad (Paris, Madrid, Beirut), and in October 1971 opened a show in New York under the auspices of His Excellency Luis Echeverría, President of Mexico. A selection of those works makes up the current exhibit, which will be shown in Chicago, San Francisco, Los Angeles, San Antonio, and Dallas later this year.

The late Diego Rivera commented:

> We may say that Héctor García is an excellent artist who expresses with emotion a great sense of beauty and of balance, a profound sensitivity and a deep understanding of the life around him.

This show, which is being presented with the assistance of the Secretariat of the Presidency of Mexico, is the artist's first in Washington. --*J.G-S.*

EXHIBITION LIST [1]

Photographs

1. *La venta de los dioses I* (Sale of Gods I)
2. *La venta de los dioses II* (Sale of Gods II)

[1] The list here reproduced--not included in the original catalogue--was sent by the artist for this exhibition, but there is no indication that all of these photographs were actually exhibited. --*Ed.*

3. *La venta de los dioses III* (Sale of Gods III)
4. *Bambi*
5. *El que hambre tiene* (The Hungry One)
6. *Scarolo*
7. *La sangre de "O"* (Blood of "O")
8. *Cartucho quemado* (Fired Shell)
9. *Puente al sol* (Bridge under the Sun)
10. *Sancho*
11. *Daca la pata* (Give Me the Leg)
12. *Haciendo al hombre* (Making a Man)
13. *Las chinas* (The Chinese Women)
14. *La casa del venadito* (The House of the Little Deer)
15. *Vientre de concreto* (Concrete Womb)
16. *La eterna víctima* (Eternal Victim)
17. *Homicidio* (Homicide)
18. *Del plato a la boca* (From Dish to Mouth)
19. *Gato negro* (Black Cat)
20. *Le pisaron la cola* (They Stepped on His Tail)
21. *Los bien amados* (The Loved Ones)
22. *La llamarada encarcelada* (Imprisoned Flame)
23. *Orozco*
24. *Diego Rivera y sus Judas* (Diego Rivera and His Judas)
25. *Semana Santa I* (Holy Week I)
26. *Semana Santa II* (Holy Week II)
27. *Semana Santa III* (Holy Week III)
28. *Semana Santa IV* (Holy Week IV)
29. *Uzumacinta*
30. *Bonampak*
31. *El sueño de las lanzas* (Dream of Spears)
32. *El templo de la cruz foliada* (The Temple of the Leafy Cross)
33. *Para dos* (For Two)
34. *Por los vinos* (To the Wines)
35. *Apártame un cacho* (Keep a Piece for Me)
36. *Se querían* (They Loved Each Other)
37. *Penagos*
38. *De qué te ríes* (Why Do You Laugh?)
39. *El ídolo del bigote* (The Idol of the Mustache)
40. *En la sombra está el tigre* (The Tiger Is in the Shadow)
41. *Spaguetti*
42. *Muchas deudas* (Many Debts)
43. *La Carmelia*
44. *Brujería electrónica* (Electronic Sorcery)
45. *Bendita sed* (Holy Thirst)
46. *Pentagrama fatal* (Fatal Musical Staff)
47. *A dónde irán a dar* (Where Are They Going to End?)
48. *La carga del hombre* (The Man's Load)
49. *Nunca se acaba* (It Never Ends)
50. *El pavo real* (Peacock)

January 24 - February 15, 1972

ENGRAVINGS BY RUTH BESS OF BRAZIL

In number and quality of production, Brazilian artists indisputably take the lead in the field of graphic arts in South America. Ruth Bess, whose work is being exhibited in the Washington area for the first time, can be considered among the top-ranking engravers, not only because of the excellence of her craftsmanship, but also

because of her highly original interpretation of Brazilian fauna. Unlike the artist who paints or draws for the natural historian, she gives free rein to her imagination in the treatment of her subject matter, so that one animal inexplicably becomes a herd or a fetus in the form of a full-grown animal appears inside the mother's womb. Her forms are often reminiscent of the cave drawings of prehistoric times.

Ruth Bess was born in Hamburg, Germany, in 1924 and studied there at the Academy of Fine Arts and at the Ecole Paul Colin in Paris. In 1964 she studied engraving at the Museum of Modern Art in Rio de Janeiro. Before moving to Brazil, where she now lives, she spent several years in Venezuela as a magazine illustrator and free-lance artist.

The artist has represented Brazil in international exhibitions in Argentina, Colombia, Ecuador, Panama, Peru, Puerto Rico, England, Italy, Spain, Portugal, Switzerland, Holland, Poland, Israel, Japan, and the United States. Her work is included in private collections in those countries as well as in important collections such as the Museum of Modern Art in New York, the Museum of Modern Art in Rio de Janeiro, the Museum of Contemporary Art in Skopje, Yugoslavia, and the Uffizi Palace collection of design and engraving in Florence, Italy. She has been awarded six prizes in Brazil and several international prizes, including the Gold Medal at the Third International Biennial of Graphic Arts in Florence, 1970. *--J.G-S.*

CATALOGUE

Prints: Etchings, Aquatints, Reliefs

1. *Tatu Torre (Tatu Tower)*,[1] 1968, 3/15, 30 x 60 cm.
2. *Blow-Up I*, 1968, artist proof V, 45 x 60 cm.
3. *Blow-Up II*, 1968, 3/15, 40 x 56 cm.
4. *Album de familia (Family Album)*, 1968, 6/15, 40 x 60 cm.
5. *Hereditariedade (Inheritance)*, 1968, 7/20, 40 x 60 cm.
6. *Tapir rebelde (Rebellious Tapir)*, 13/15, 1969, 34 x 70 cm.
7. *Tatu Puzzle*,[1] 1969, 10/15, 59 x 49 cm.
8. *Jacaré folha (Jacaré Leaf)*,[2] 1969, 9/15, 70 x 51 cm.
9. *Folha playground (Playground Leaf)*, 1969, 3/15, 70 x 51 cm.
10. *Ovelha negra (Black Sheep)*, 1969, 14/15, 40 x 67 cm.
11. *Ciranda dos carneiros (Merry-Go-Round of Sheep)*, 1970, 7/15, 50 x 60 cm.
12. *Sonho da preguiça (Sloth's Dream)* 1971, 9/35, 40 x 70 cm.
13. *Tatu mãe (Tatu Mother)*, 1971, 5/40, 46 x 68 cm.
14. *Preguiça demais (Too Many Sloths)*, 1971, 4/40, 66 x 35 cm.
15. *Tapir comendo uma folha (Tapir Eating a Leaf)* 1967, 11/15, 20 x 60 cm.
16. *Tatu folha (Tatu Leaf)*, 1967, 11/15, 30 x 45 cm.
17. *Tapir metamorfose (Metamorphosis of a Tapir)*, 1967, 13/15, 30 x 60 cm.
18. *Tapir livro (Tapir Book)*, 1967, 12/15, 30 x 40 cm.
19. *Antas (Elks)*, 1967, 11/15, 30 x 45 cm.
20. *Tatu bola (Tatu Ball)*, 1967, 10/15, 49 x 27 cm.
21. *Tatu*, 1967, 11/15, 25 x 35 cm.
22. *Tatu sesta (Tatu Basket)*,[3] 1967, 8/15, 30 x 42 cm.

January 24 - February 15, 1972

TOYOTA OF BRAZIL

Various cultures have at different times influenced South American art, but in present times none has so great

[1] Literal translation of *tatu* is "armadillo." *--Ed.*

[2] Literal translation of *jacaré* is "alligator." *--Ed.*

[3] Literal translation of this title is "Armadillo Nap." *--Ed.*

an impact as that of the Japanese in Brazil. Many Nippo-Brazilian artists were born in Japan and moved to Brazil at an early age, while others were born in Brazil of Japanese parentage; most live in the State of São Paulo, where the Japanese population is centered, and are members of the São Paulo Plastic Arts Club, or SEIBI, which has had a fundamental role in the development and promotion of the Nippo-Brazilian artists.

If the work of Brazilian artists has acquired a certain Japanese sensitivity, the work of the Japanese has taken on characteristics of the Brazilian culture which serve to enhance and strengthen it. This hybridization has enriched the quality of both and might even be said to have become a trend in itself.

The Nippo-Brazilian artists excel in all media and directions, from ultra-realism to the most advanced forms of experimentation in kinetic art. If there are any common denominators in Nippo-Brazilian art they are to be found in the extraordinary sense of space and the pure, clean quality of the craftsmanship.

Toyota is an example of an artist whose work has evolved gradually and conservatively from painting to experimentation with "objects" and the proposal of progressive ideas concerned with the reflection and multiplication of images.

Born in Yamagata, Japan, in 1931, Toyota studied art at the University of Tokyo and later was professor of industrial design at the Institute of Small Industries in Shizuoka, 1955-1957. He has lived in Brazil since 1959 and has represented the country in more than ten international exhibitions during the past decade, as well as having participated in numerous national shows. He has had twenty one-man shows, including exhibits at the Museum of Modern Art in Pôrto Alegre, the Astréia and Bonino Galleries in Brazil, and in several cities in Italy.

Toyota has been the recipient of a number of important awards, among them Second Prize in the *Esso Salon of Young Artists*, the Grand Prize at the Second Biennial of Bahia, and the Bank of Boston Prize awarded at the São Paulo Biennial in 1969. His work is included in museum collections in Brazil, Italy, Colombia, Yugoslavia, Denmark, and Australia.

This is his first exhibition in the United States. --*J.G-S.*

CATALOGUE

Paintings

1. *Espaço positivo-negativo (Positive-Negative Space)*, 95 x 110 cm.
2. *Espaço contraste (Contrasting Space)*, 110 x 110 cm.
3. *Espaço infinito, quarta dimensão (Infinite Space, Fourth Dimension)*, 110 x 110 cm.
4. *Harmonia de vida, positivo e negativo (Harmony of Life, Positive and Negative)*, 110 x 110 cm.
5. *Espaço negativo (Negative Space)*, 95 x 110 cm.
6. *Espaço infinito (Infinite Space)*, 110 x 110 cm.

Objects

1. *Espaço infinito (Infinite Space) I*, 75 x 47 cm.
2. *Espaço infinito (Infinite Space) II*, 75 x 47 cm.
3. *Espaço contraste (Contrasting Space)*, 75 x 47 cm.
4. *Quarta dimensão (Fourth Dimension)*, 75 x 47 cm.
5. *Espaço dimensional (Dimensional Space)*, 75 x 47 cm.
6. *Espaço dimensional (Dimensional Space) I*, 55 x 35 cm.
7. *Quarta dimensão (Fourth Dimension) I*, 55 x 35 cm.
8. *Espaço negativo (Negative Space) I*, 55 x 35 cm.
9. *Espaço infinito (Infinite Space) III*, 55 x 35 cm.
10. *Espaço infinito (Infinite Space) IV*, 55 x 35 cm.
11. *Espaço positivo-negativo (Positive-Negative Space)*, 55 x 35 cm.
12. *Espaço negativo (Negative Space) II*, 55 x 35 cm.
13. *Espaço contraste (Contrasting Space) I*, 55 x 35 cm.
14. *Espaço negativo (Negative Space) III*, 55 x 35 cm.
15. *Espaço negativo (Negative Space) IV*, 55 x 35 cm.
16. *Espaço negativo (Negative Space) V*, 55 x 35 cm.

February 17 - March 9, 1972

DE FERRARI OF ARGENTINA

Today the art movement in Argentina is possibly the most diverse, most highly developed, and the most exciting in the whole of Latin America. Almost needless to say, it is also the most highly respected on an international scale. The OAS has introduced not only those artists who work in the most advanced trends, but also the more conservative artists whose work is the very foundation of contemporary Argentine art.

Although he is an artist of great significance, Adolfo De Ferrari is known primarily to a small, select group of collectors, students, and those familiar with the history of contemporary Argentine art. He has devoted more than fifty years to painting and the teaching of art, and it is largely due to the intensity of his efforts that artists such as Carlos Cañás, Leo Vinci, and Aníbal Carreño, among many others, enjoy national prominence. But his importance does not stop there, for his work and teaching continue to serve the new generation, opening new routes of expression and instilling a profound respect for craftsmanship.

Born in Buenos Aires in 1898, De Ferrari studied there at the Ernesto de la Cárcova School of Fine Arts and, later, at the National Academy of Fine Arts where he has taught for many years. In 1929 he studied with André Lhote and Othon Friesz in Paris and in 1931 attended classes at the workshop of Felipe Carenna in Italy. Nine years later he was awarded a scholarship to return to Europe for extensive research on the Italian primitives.

De Ferrari has participated in more than thirty group shows in Buenos Aires, São Paulo, Havana, Paris, Barcelona, New York, and San Francisco, but he has had only two one-man shows, both in Buenos Aires (Javier Gallery in 1968 and Rodrigo Carmona Gallery in 1970). The limited number of one-man exhibits is due largely to the fact that he works quite slowly and sells most of his paintings privately immediately upon completion. The current exhibition is made up of works from an early period in private collections as well as paintings he has completed within the past three years. Paintings by De Ferrari are in private collections in Argentina, Brazil, Venezuela, and the United States and in museum collections in Argentina and Italy.

His work is characterized by an extraordinary craftsmanship, as evidenced in his careful handling of brushstrokes, patient construction of volumes and planes through transparencies of color, and the articulation of surfaces with a rich impasto. His compositions are intimate, alive, and contemporary in spirit.

This is the artist's third one-man show and his first appearance in the United States. --*J.G-S.*

CATALOGUE

Oils

1. *Torero (Bullfighter) I*, 1969, 38 x 60 cm.
2. *Torero (Bullfighter) II*, 1969, 82 1/2 x 53 1/2 cm.
3. *Torero (Bullfighter) III*, 1969, 60 x 90 cm.
4. *Suburbio en azul (Suburb in Blue)*, 1969, 50 x 80 cm.
5. *La costa (The Coast)*, 1967, 60 x 90 cm.
6. *Paisaje de campo (Country Landscape)*, 1967, 60 x 90 cm.
7. *Naturaleza muerta en ocres (Still Life in Ochers)*, 1970, 82 1/2 x 51 cm.
8. *Paisaje (Landscape): Villa Rosa*, 1969, 50 x 70 cm.
9. *Puerto (Port)*, 1968, 110 x 70 cm.
10. *Suburbio de Buenos Aires (Suburb of Buenos Aires)*, 1969, 60 x 100 cm.
11. *La actriz (The Actress)*, 1968, 50 x 80 cm.
12. *Paisaje del norte (Landscape of the North)*, 1968, 35 x 64 cm.
13. *Naturaleza muerta en verdes (Still Life in Greens)*, 1968, 60 x 100 cm.
14. *Figura de niño (Figure of a Child)*, 1969, 76 x 50 cm.
15. *La paloma (The Dove)*, 1971, 88 x 80 cm.
16. *Suburbio (Suburb)*, 1971, 100 x 60 cm.
17. *Flores (Flowers)*, 1954, 53 x 80 cm.
18. *Bodegón (Still Life)*, 1971, 90 x 70 cm.

March 10 - April 3, 1972

BERNARD DREYFUS OF NICARAGUA

Bernard Dreyfus is a young man who has only recently joined the artistic movement in his native country. Born in Managua in 1940, he began his studies in that capital and was later sent to France for secondary school. In France his interest in art awoke, and he began to study drawing and painting at the Charpentier Academy of Paris in 1958. Shortly afterward he attended the Colin Studio, also in France, and in 1960 he attended the Bournet Studio of Paris and Nice to study painting and ceramics.

Dreyfus came to the United States in 1961 to continue his studies at the Art Center College of Science of Los Angeles. While there he also completed research studies under the direction of Loser Feiter. In spite of the fact that he has resided in Paris for the past few years the artist has continued to visit Nicaragua periodically in order not to lose contact with the national artistic movement.

His work in the field of drawing, as in painting, follows an austere trend in forms and in color, presenting variations of a single theme in which the asymmetrical plane and kinetic composition are his chief concerns.

Dreyfus's first one-man show was held in 1960 at the Bournet Gallery in Nice. In 1964 he had another one-man show in Managua, and his last exhibit was held just three months ago at Viry-Chatillon in France.

Dreyfus has participated in group exhibits in Los Angeles; Brussels; Nanterre, France; San José, Costa Rica; and Managua. In 1961 he represented Nicaragua in the Autumn Salon in Paris and last year in the Seventh Paris Biennial.

Works by the artist are found in important private collections in France, Nicaragua, and the United States, and one of his most important works is in the Rubén Darío National Theater in Managua.

This is his first one-man show in the United States. --*J.G-S.*

CATALOGUE

Paintings

1-4. *Bienal de Paris (Paris Biennial) Nos. 1-4*
 5. *Vanves*
6-35. *Ivry Nos. 1-30*

April 3 - 26, 1972

GUAJIRO ART WORKSHOP OF MALI-MAI, VENEZUELA

The Guajiros inhabit what is known as the Guajira Peninsula in the northwestern region of Venezuela and the area extending northward beyond the frontier of Colombia. Their culture is unique, bearing little relation to the other Indian cultures of South America.

The Guajiro dresses with elegance and decorates his face, arms, and legs with beautiful designs in vivid colors. His dances are intricate and profoundly expressive. He excels as a craftsman, making jewelry, pottery, baskets, and wood carvings, but his imagination and skill are most amply demonstrated in his weavings.

In 1966, while visiting several Guajiro villages near Maracaibo in search of material for an exhibition of indigenous art for the Chiquinquirá Fair, Masula d'Empaire de Mannil came across the work of Luis Montiel, an exceptionally gifted weaver who until that time had limited his efforts to making saddle blankets and other small items with brightly colored flower and bird designs. At Mrs. Mannil's insistence and with her support, Montiel began to expand his production. In 1969 the first large scale exhibition of rugs and tapestries made by Montiel and his four assistants was shown at the Museum of Fine Arts in Caracas, creating a sensation among

collectors and critics. In 1970 the Center of Fine Arts in Maracaibo, one of the most important institutions in South America devoted to the promotion of popular arts, lent its support to Montiel, and the Ministry of Public Works of Venezuela aided with the construction of what is now called the Guajiro Art Workshop of Mali-Mai. This year the tapestries were exhibited for the first time outside of Venezuela at the National Museum of Fine Arts in San José, Costa Rica.

The Guajiro tapestries are made of cotton or wool, the latter being brought from the highlands of Venezuela and from other countries such as Chile and Peru. In spite of the fact that there is little color in the Guajiro region--a harsh land with no flowers, no fruit, and little rainfall--vibrant reds, pinks, purples, greens, blues, and yellows abound in these creations. Luis Montiel, who designs most of the works himself, has a preference for stylized birds and flowers, geometric forms, and symmetrical composition, yet he has never used a ruler or a compass. Although some find that the Guajiro tapestries bear a resemblance to a more sophisticated art, neither Montiel nor his fellow-workers has been outside the Guajiro region, with the exception of visits to Maracaibo and Caracas, and none had access to reproductions or designs of others. Even the needle used by the tapestry makers was invented in the Mali-Mai workshop.

By far the largest and most ambitious undertaking of Montiel and his associates is the stage curtain for the Theater of Maracaibo--a woven mural of monumental proportions, measuring approximately 50 x 23 feet. With the aid of the Center of Fine Arts, the Guajiro Art Workshop is acquiring new facilities and materials and training young craftsmen in an effort to keep alive the rich artistic and cultural tradition of the Guajiran region.

This exhibition, coinciding with Pan American Week and the Second Regular Session of the General Assembly of the Organization of American States, is the first presentation of these works in the United States.

We wish to acknowledge the invaluable cooperation of the Center of Fine Arts of Maracaibo, Mr. Oscar d'Empaire, and Mr. and Mrs. Harry Mannil. *--J.G-S.*

ARTICLES INCLUDED IN EXHIBITION

Rugs, tapestries, woven bags, belts, robes, beads, blankets, ponchos.

BIOGRAPHICAL NOTE [1]

MONTIEL, Luis. Tapestry designer and weaver born in 1914 in Laguna de Pájaros, La Guajira, Venezuela. Learned his craft from the indigenous tradition passed on to him by his mother and an uncle. Discovered by Mrs. Masula de Mannil on the occasion of the First Indian Craft Fair of La Chiquinquirá, she became his sponsor and with the help of the Fine Arts Center of Maracaibo, he founded his Guajiro Workshop in Mali-Mai in 1968, where he is helped by other local weavers. The 55 x 23' curtain of the Teatro de Bellas Artes of Maracaibo is considered to be Montiel's masterpiece. Held a one-man show at the Museo de Bellas Artes, Caracas, 1969.

May 2 - 21, 1972

LUIS ARATA OF ARGENTINA: EXPERIMENTS IN ALUMINUM

Luis Arata was born in Buenos Aires in 1925 and graduated from the University of Buenos Aires in 1947, with a degree in civil engineering. A self-taught artist, he first began to experiment with works in aluminum less than seven years ago. Using a burin-like instrument to engrave on flat aluminum sheets and taking advantage of certain inherent properties of the material, he creates moire-like patterns that change constantly in accordance with the position of the viewer. Although his earliest works are intended for hanging on the wall, the most recent are three-dimensional sculptures.

Samuel Oliver, director of Argentina's National Museum of Fine Arts in Buenos Aires, commented:

[1] Not included in the original catalogue. *--Ed.*

Arata creates with limited means an enormous variety of analogous and sequential images. He proposes that the spectator search for images that correspond to his sensitivity. . . . Lights and colors fuse in an harmonious ensemble of subtle combinations of values and tones.

Arata has had one-man shows in Buenos Aires (Art Gallery International, 1970; Camea, S.A., 1971) and Montevideo (Karku Gugelmeier Gallery, 1971), and this year participated in a group show at the Bertha Schaefer Gallery in New York City. He is represented in private collections in Argentina, Canada, and France.

This is his first exhibition in the Washington area. *--J.G-S.*

CATALOGUE

Sculptures

1. *Vibrating Expansion*, 60 x 46"
2. *Becoming*, 60 x 46"
3. *Dynamic Vision I*, 60 x 46"
4. *Dynamic Vision II*, 60 x 46"
5. *Harmonic Vibration I (A,B)*, 40 x 24"
6. *Harmonic Vibration II (A,B)*, 40 x 24"
7. *Harmonic Vibration III (A,B)*, 40 x 24"
8. *Unstable Equilibrium*, 20 x 24"

May 2 - 21, 1972

OSCAR CURTINO OF ARGENTINA

In his search for a light-hearted, simplified depiction of reality, Oscar Curtino abandoned his interest in abstract and figurative expressionism to create a personal style that has elements in common with the pre-Renaissance primitives, especially his use of flat color, rigid line, and emphasis on narrative content. At the same time, in what might be called pop-fashion, there is a relation to the baroque-inspired decorations--virgins, angels, and cherubs--that are often painted on mud-flaps and the side panels of trucks in some parts of Argentina and other Latin American countries, a tradition earlier popular in Spain and Italy.

Curtino was born in San Francisco, Córdoba, Argentina, in 1938 and studied there at the Municipal Academy and at the School of Fine Arts of the National University of Córdoba. In 1964 he attended classes at the workshop of internationally known Argentine painter Raquel Forner. He has had four one-man shows in Buenos Aires (Witcomb Gallery, 1964; Forum Gallery, 1964; Saber Vivir Gallery, 1964; Bonino Gallery, 1968) and two in Córdoba in 1962. His work has been included in numerous national exhibitions, including two shows at the now-defunct Zegrí Gallery in New York City (1969, 1970), and in 1968 he participated in the Salon of Young Painters at the Museum of Modern Art in Paris. He has been awarded more than ten prizes, among them fellowships to study in Buenos Aires and Paris.

Works by Curtino are in museum collections in Córdoba, Tucumán, Santa Fe, and Buenos Aires, Argentina, and in the Museum of Contemporary Art of Chile.

This is his first one-man show in the United States. *--J.G-S.*

CATALOGUE

Oils

1. *La consagración (The Consecration)*, 143 x 189 cm.
2. *La partida (The Departure)*, 66 x 141 cm.
3. *Aparición triunfal (Triumphal Apparition)*, 92 x 146 cm.
4. *Anunciación con gato (Annunciation with Cat)*, 90 x 121 cm.

5. *El viaje (The Journey),* 72 x 85 cm.
6. *Madona a caballo (Madonna on Horseback),* 72 x 85 cm.
7. *Aparición con ángeles y trompetas (Apparition with Angels and Trumpets),* 72 x 85 cm.
8. *Madona con el niño y querubines (Madonna with Child and Cherubs),* 72 x 85 cm.
9. *Ascensión de Venus con ángeles (Ascension of Venus with Angels),* 72 x 85 cm.
10. *Madona en el trono (Madonna on the Throne),* 72 x 85 cm.
11. *Mujer amacándose (Woman in a Hammock),* 72 x 85 cm.
12. *Presentación de la Madona a un ángel donante (Presentation of the Madonna to a Giving Angel),* 72 x 85 cm.
13. *El milagro de la niña ciega (The Miracle of the Blind Child),* 67 x 80 cm.
14. *Aparición con ángeles (Apparition with Angels),* 67 x 80 cm.
15. *Madona haciedo milagros (Madonna Making Miracles),* 67 x 80 cm.
16. *Planchadora con querubines (Ironer with Cherubs),* 67 x 80 cm.
17. *Adoración con ángeles (Adoration with Angels),* 67 x 80 cm.
18. *Angel con angelitos (Angel with Little Angels),* 67 x 80 cm.
19. *Aparición (Apparition),* 67 x 80 cm.
20. *Madona rodeada de querubines (Madonna Surrounded by Cherubs),* 67 x 80 cm.
21. *Anunciación (Annunciation),* 67 x 80 cm.
22. *Anunciación (Annunciation) I,* 67 x 80 cm.
23. *Angel con vaso azul (Angel with Blue Glass),* 67 x 80 cm.
24. *El profeta (The Prophet),* 67 x 80 cm.
25. *Mujer con alas azules (Woman with Blue Wings),* 67 x 80 cm.

May 25 - June 7, 1972

LANDSCAPES BY MARCIAL GODOY OPAZO OF CHILE [1]

Last year the paintings of Marcial Godoy were exhibited for the first time in this area at the Inter-American Development Bank. The current show, consisting of a series of paintings executed within recent months, is Godoy's second in Washington.

Chile is a country of extraordinary beauty, especially to the painter's eye. With its curious, elongated shape, the country is bordered on one side by the Pacific Ocean and on the other by the Andes Mountains, with deep valleys between. Godoy renders the characteristics of the landscape with a great sense for synthesis of the elements and a feeling for brilliant color.

Born in 1933 in Valparaíso, Godoy studied at the School of Fine Arts in Santiago and at the University of Chile, 1952-1957. Several years later he studied privately with the well-known Chilean painters Nemesio Antúnez and Pablo Burchard. Since 1952 he has had four one-man shows in Chile, including an exhibit at the Museum of Valparaíso in 1958, and three in Caracas where he currently resides. He has participated in group shows in Chile, Argentina, Peru, and Venezuela.

Works by the artist are in public collections in Chile and Washington, D.C., and in private collections in Santiago, Lima, Bogotá, and Caracas. *--J.G-S.*

June 21 - July 11, 1972

PHOTOGRAPHS BY JOAQUIN CORTES OF VENEZUELA

Joaquín Cortés began studying photography in 1961 in Caracas and last year attended a seminar at New York University while at the same time studying with the well-known photographer Philippe Halsman. He has published several photographic books, among them *Andinos,* 1968, and *Retazos de vida,* 1969, both printed in

[1] The list of works exhibited is unavailable. *--Ed.*

Caracas, and has had his work reproduced in numerous magazines in Caracas, Barcelona, and Amsterdam.

Cortés was born in Barcelona, Spain, in 1938, but has been a Venezuelan citizen for many years. He has had two one-man shows in Caracas and New York City and has participated in several group shows in this country and in Germany.

CATALOGUE

Photographs

1. *Parque del Este*
2. *Market*
3. *Curiepe*
4. *Timotes*
5. *Timotes*
6. *Yare*
7. *Caracas*
8. *Araya*
9. *Caracas*
10. *Bus Stop*, Caracas
11. *Bus Stop*, Caracas
12. *The Andes*
13. *Ejido*, the Andes
14. *The Andes*
15. *Diamond Mine*, Guayana
16. *Curiepe*
17. *Parque del Este*
18. *Mérida*, the Andes
19. *Ejido*, the Andes
20. *Caracas*

June 21 - July 11, 1972

CARMEN AND VICTOR MILLAN OF VENEZUELA

Rarely does one find native artists working together, and it is even more unusual to find a husband and wife team, but such is the case with Venezuelans Carmen and Víctor Millán. The entire Caribbean area abounds with good primitive artists, and Venezuela has some of the finest, among them Feliciano Carvallo, who is not only a neighbor of the Milláns but the person responsible for having introduced them to the world of painting.

Víctor Millán was born in Punta de Araya, Sucre, Venezuela, in 1919 and had his first exhibition in 1954 at the Taller Libre de Arte in Caracas. Prior to becoming a painter, he was a professional diver. Filmmaker Luis A. Roche produced a documentary on his life and work in 1967.

Carmen was born in Clarines, Anzoátegui, between 1915 and 1920 and under the tutelage of her husband began to paint seriously some twelve years ago. She has had several exhibitions, including shows at the Pinacoteca and Cruz del Sur galleries in Caracas, 1962 and 1963. Both Carmen and Víctor are mentioned in several books on primitive painting in Venezuela and have works in important private collections in the country.

The Milláns work together and share in common a great sense of creativity and imagination, but their paintings are quite different. Carmen shows a preference for neutral colors and massive figures interwoven in a tight composition while her husband uses vivid colors and generally defines his figures against an intricate background.

The current show is their first joint exhibition outside Venezuela. --*J.G-S.*

EXHIBITION LIST [1]

Oil on Canvas

Víctor Millán

1. *La procesión en Mare Abajo* (Procession in Mare Abajo), 142 x 107 cm.
2. *La selva* (The Forest), 142 x 110 cm.
3. *La selva I* (The Forest I), 120 x 88 cm.
4. *La selva II* (The Forest II), 120 x 88 cm.
5. *Corpus Cristi in Naiguatá* (Corpus Christi in Naiguatá), 117 x 84 cm.
6. *Fiesta de San Juan* (Feast of Saint John), 104 x 74 cm.
7. *Baile de los diablos* (Dance of the Devils), 104 x 74 cm.
8. *Burro entre los árboles* (Donkey under the Trees), 73 x 53 cm.
9. *Carrusel* (Carrousel), 73 x 54 cm.
10. *Ramo de flores* (Bouquet of Flowers), 69 x 51 cm.
11. *Flores y frutas* (Flowers and Fruits), 58 x 58 cm.

Carmen de Millán

1. *Niños* (Children), 89 x 121 cm.
2. *Mujeres* (Women), 83 x 117 cm.
3. *Mujeres en la barca* (Women on the Boat), 62 x 89 cm.
4. *El manto azul* (The Blue Cloak), 62 x 89 cm.
5. *Mujer y niños* (Woman and Children), 57 x 86 cm.
6. *Grupo* (Group), 75 x 33 cm.
7. *Familia* (Family), 51 x 71 cm.
8. *Bautizo* (Baptism), 51 x 71 cm.
9. *Tres figuras* (Three Figures), 54 x 71 cm.
10. *Reina y sus damas* (Queen and Her Ladies), 54 x 71 cm.
11. *Mujeres* (Women), 54 x 71 cm.
12. *Mujer con frutas* (Woman with Fruits), 54 x 71 cm.
13. *Tocador de tambores* (Drum Player), 47 x 65 cm.
14. *Mujeres con niños* (Women and Children), 47 x 65 cm.
15. *Maternidad* (Maternity), 41 x 61 cm.

July 12 - August 6, 1972

MARIA ESTHER BALLIVIAN OF BOLIVIA

María Esther Ballivián, like many of her fellow artists in Bolivia, has been concerned primarily with international trends rather than what might be called the indigenous tradition that was prevalent in Bolivian art until some years ago. Ms. Ballivián began her career as a still life painter with post-cubist tendencies but in recent years has rejected that phase of her work in favor of abstract expressionism. She uses a vivid palette and heavy, wide brushstrokes.

Both a painter and engraver, Ms. Ballivián began her art studies in 1956 with Nemesio Antúnez in Santiago, Chile. For the next two years she worked in Paris at Atelier 17, under the direction of William Hayter, and attended sessions at the Grande Chaumière Academy. In 1966 she enrolled in the graphic workshop at the Museum of Modern Art in Rio de Janeiro. Born in 1927 in La Paz, the artist has had six solo shows in that city and in Santiago and Caracas, and has participated in group shows in Bolivia, Chile, and recently in Russia. Works by Ms. Ballivián are in several public collections, including the Museum of Modern Art of Rio de Janeiro, the

[1] Not included in the original catalogue. --*Ed.*

Museum of Art of La Paz, the Philadelphia Print Club, and the University of Texas.

This is her first exhibition in the United States. *--J.G-S.*

CATALOGUE

1-30. Paintings[1]

August 9 - 30, 1972

MARIO VILLANUEVA OF THE DOMINICAN REPUBLIC

Although a citizen of the Dominican Republic, Mario Villanueva has never exhibited in Latin America. He made his first professional appearance in 1968, participating in the *Modern Graphics Exhibition* at the Seiko Gallery in Taipei, Taiwan, and later that same year presented his work in the Twelfth Ton Fan Painting Exhibition at the Tien Educational Center in the same city. He had three one-man shows in Hong Kong and Taipei during 1969 (Sally Jackson Gallery, Hong Kong; Provincial Museum, Taipei; Art Guild Studio and Gallery, Taipei).

Villanueva was born in Washington, D.C., where his father was a member of the diplomatic corps, in 1948. After many years of absence, he returned to this country in 1969 to study graphic arts at the University of Wisconsin. From 1965 to 1967 he was in Spain, where he studied architecture (University of Madrid), drawing (San Fernando Academy), painting, and decoration. Works by the artist are in private collections in Taipei and Moscow.

His most recent paintings, completed in California where the artist currently resides, are monochromatic, classical renderings of the draped human figure characterized by elongation and stability of form.

This is Villanueva's first exhibition in Washington area. *--J.G-S.*

CATALOGUE

1-18. Paintings[2]

September 6 - 26, 1972

MARGARITA LOZANO OF COLOMBIA

In art it is generally impossible to distinguish the work of a woman from that of a man, but the pastels of Margarita Lozano are distinctly feminine. With a remarkable power of synthesis, she uses vigorous strokes to create interior scenes--sometimes with children, gardens, and flower arrangements that never fail to charm the eye. Her handling of her medium is extraordinarily fresh and free.

Ms. Lozano was born in 1936 in Paris, where her father was a member of the diplomatic corps, but is a Colombian citizen. In 1954 and 1955 she studied art in Paris and Rome and the following year went to Bogotá where she worked under the guidance of Juan Antonio Roda. In 1958 she attended the National School of Fine Arts of Bogotá, studying under Fernando Botero and Eduardo Ramírez, both well-known figures in the United States, and abroad. Ms. Lozano has had five solo shows in Bogotá, three at El Callejón Gallery, and in 1970 exhibited at the Ateneo of Caracas, Venezuela. She has participated in numerous national shows and has been the recipient of several prizes. Works by the artist are in private collections in Colombia, Venezuela, Holland,

[1] Titles are unavailable. *--Ed.*

[2] Titles are unavailable. *--Ed.*

France, Germany, and the United States, as well as in public collections such as the Luis Angel Arango Library and Museum of Modern Art in Bogotá and the University of Texas.

This is her first solo show in the United States. --*J.G-S.*

CATALOGUE

Pastels

1. *El taller (The Studio)*
2. *Interior con retrato (Interior with Portrait)*
3. *Interior en azul (Interior in Blue)*
4. *Interior en rosado (Interior in Pink)*
5. *Interior con silla dorada (Interior with Golden Chair)*
6. *Tocador Imperio (Empire Chest)*
7. *La alcoba (The Bedroom)*
8. *Niña en el interior de una casa (Child in a House)*
9. *El sombrero (The Hat)*
10. *Interior con manzanas verdes (Interior with Green Apples)*
11. *Bodegón con manzanas rosadas (Still Life with Red Apples)*
12. *Interior con niños (Interior with Children)*
13. *Niña en un interior rojo (Child in a Red Interior)*
14. *Flores y arabescos (Flowers and Arabesques)*
15. *Flores en canasto (Flowers in a Basket)*
16. *Flores fondo lila (Flowers on Lilac Background)*
17. *Flores sobre una repisa (Flowers on a Shelf)*
18. *Flores fondo rojo (Flowers on Red Background)*
19. *El violín (The Violin)*
20. *Niña con piña (Child with Pineapple)*
21. *Pequeña vendedora de flores (Little Flower Vendor)*
22. *Niña dormida (Child Sleeping)*

September 27 - October 16, 1972

FLORA REY OF ARGENTINA

Like many present-day painters, Flora Rey is concerned with the figure or representation of nature, but in distorting her forms and using intense hues of color she continues to show an affinity for the expressionistic tendency.

Born in Buenos Aires in 1935, Ms. Rey is the wife of the well-known Argentine painter Stefan Strocen who exhibited at the OAS in 1963. She began her art studies in 1952 at the Association of Fine Arts in her native city and had her first solo shows in Europe some eight years later (Latin American Gallery, Brussels, Belgium; Círculo de Bellas Artes, Madrid, Spain; and in Paris). In 1966 she returned to Madrid to exhibit at the Nebli Gallery. Besides having had several individual shows in Argentina, she has participated in numerous national salons during the past fifteen years and this year was awarded an important prize given by the Steinberg Foundation.

This is the artist's first appearance in the United States.

EXHIBITION LIST [1]

Paintings

1. *Evasión en rojo (Evasion in Reds)*
2. *Marine Serenity*
3. *Formal Instinct*
4. *Duality*
5. *Expression*
6. *Serene Reality*
7. *Claridad completa (Complete Clarity)*
8. *Observar y decidir (To Observe and Decide)*
9. *On the Same Level*
10. *Eminent*
11. *Expression in Symbols*
12. *Destino total (Total Destiny)*
13. *En lo profundo (Profundity)*
14. *Estética y concepción (Aesthetics and Conception)*
15. *Actitud de lucha (Attitude of Struggle)*
16. *A un mismo nivel, quietud (At the Same Level, Calm)*, engraving, 2/15
17. *Forms*
18. *Elements*
19. *Introversion*
20. *Interpretation*
21. *The Opposite*
22. *What Is This?*
23. *Perception*
24. *Interrogation*
25. *The Silence*

October 17 - November 8, 1972

FUKUSHIMA OF BRAZIL

For a number of years the OAS has been presenting the work of Japanese-Brazilian painters and sculptors living in São Paulo. Among the most prominent representatives, numbering more than a dozen and all belonging to SEIBI (São Paulo Fine Arts Club), are Manabu Mabe, Tomie Ohtake, Kazuo Wakabayashi, Masumi Tsuchimoto, and Yutaka Toyota. All have had one-man shows at the OAS. The current exhibit, under the sponsorship of Ambassador George Alvares Maciel, Representative of Brazil to the OAS, features the work of Tikashi Fukushima, another accomplished member of the group. This is his first one-man exhibition in the United States.

The Japanese-Brazilian artists have sustained in their work an identity with the principles of oriental art while at the same time integrating themselves into the mainstream of contemporary art in Brazil. All have become well-known personalities in their country of adoption, and their success there is reflected in their popularity in Japan as well as in other parts of the world.

Like his colleagues, Fukushima is highly skilled in the techniques of his art and has a refined, delicate sense of conception. The spontaneity and energy of his brushwork recall gesture painting. There is no reliance whatsoever on accident but, rather, every element has its place within a definite, carefully meditated structure as evidenced in his handling of subtle, overlapping planes and delicate harmonization of a wide range of colors.

Born in Fukushima, Japan, in 1920, the artist moved to Brazil in 1940 and became a citizen of that country

[1] Not included in the original catalogue. --*Ed.*

several years later. He studied painting in Rio de Janeiro from 1946 to 1949 with the Japanese artist Tadashi Kaminagai. Fukushima has had eight one-man shows in Rio de Janeiro and São Paulo and has participated in important group shows in Brazil, Japan, Venezuela, and the United States. In 1965 he was represented in the OAS exhibition *Japanese Artists of Brazil* and later that same year participated in a group show at the Guggenheim Museum in New York City. He has been awarded numerous prizes, including the Gold Medal at the Salon of Modern Art in São Paulo, 1969; First Prize at the Salon of Minas Gerais, 1961; and Acquisition Prize at the Eighth São Paulo Biennial, 1965. The artist is represented in the collections of the Museum of Modern Art of Rio de Janeiro, Pôrto Alegre, Belo Horizonte, Brasília, and Curitiba, and in the Museum of Contemporary Art of the University of São Paulo. --*J.G-S.*

CATALOGUE

1-20. Paintings[1]

November 9 - 26, 1972

VICTOR CHAB OF ARGENTINA: MONOCOPIES

The current exhibition of monocopies by Argentine artist Víctor Chab represents the artist's second appearance at the OAS. Chab exhibited paintings here in 1964, his first one-man show in the United States. During the eight years that have elapsed, Chab has had one-man shows in all the major capitals of Latin America and has become recognized in his own country as a young master. His monocopies, an adaptation of the monotype, are closely linked with the rest of his work in terms of form and color, repeating the same sense of sensitivity and imagination.

Chab explains the essentials of creating his monocopies as follows:

> Printing ink is applied with a roller to a sheet of metal. Certain zones are cleared of ink to create the primary form, and the sheet is then put under the press. Excess ink is removed with absorbent papers to achieve a total transparency of color. The metal sheet is then cleaned completely and another color of ink is applied. Again, all excess ink is removed, complementing and enriching the first image. The process of creating forms is repeated four or five times, with one superimposed upon another on the same sheet of paper until the desired result is obtained. Finally strips of inked cardboard are used on the copy to correct or better details. In fact, each monocopy is put under the press as many as twenty times, four or five to create form and fifteen or more to remove excess ink.

Born in Buenos Aires in 1930, Chab has had thirty-five one-man exhibitions in Latin America and the United States and has been represented in more than seventy group shows in this country, Latin America, and Europe. Among the more than fifteen prizes he has received are First Prize, *Esso Salon of Young Artists*, Buenos Aires, 1964; Honorable Mention, First Salon of Tapestry, Buenos Aires, 1967; and First Prize, *Rubén Darío International Competition* , Managua, Nicaragua, 1967. Works by the artist are in museums and private collections throughout the Western Hemisphere. --*J.G-S.*

CATALOGUE

1-20. Monocopies[2]

[1] Titles are unavailable. --*Ed*.

[2] Titles are unavailable. --*Ed*.

November 9 - 26, 1972

LIBERTI OF ARGENTINA: PAINTINGS AND DRAWINGS

More than fifty years after its beginnings, the surrealist movement, which brought about one of the most radical changes in the panorama of twentieth century art, is still widely popular, and the principles that govern it are essentially the same as those that made up the original framework. Although variations have developed through the years--all related to Freud-inspired explorations of the realm of the subconscious and the autonomous, spontaneous expression of that world--the trademarks of the movement remain virtually unchanged: forms, no matter how incongruous, are clearly identifiable, somehow related to reality as we see it; technique is meticulous, with an attention to minute detail akin to that of the Flemish school of the Middle Ages. Those works that we characterize as naive, infantile, or insane, although sometimes related to the dream world of surrealism, spring from other sources. To synthesize, surrealism represents a world in which the impossible is made possible, or as the Count of Lautréamont so cleverly phrased it: "Beautiful as the chance encounter of a sewing machine and an umbrella on a dissecting table."

Surrealism has had its advocates in Argentina since its inception. Some artists have entered the movement for a short time and later abandoned it while others have remained loyal to its principles throughout their careers. Two of the most notable personalities are Batlle Planas, now deceased, and Roberto Aizenberg.

This exhibition features the paintings and drawings of self-taught artist Juan Carlos Liberti, one of the most outstanding figures to join the movement in recent years. Liberti is intensely faithful to the canons of surrealism. His forms, though recognizable, belong to the realm of the imagination, a metaphysical, poetical world conceived by the artist, and are rendered in detail with small, fine brushstrokes.

Born in Buenos Aires in 1930, Liberti did not begin to exhibit professionally until 1970. He has had three one-man shows at the Rubbers Gallery in Buenos Aires and Córdoba during the past two years, and has participated in numerous national salons. Among his awards are Special Mention at the Municipal Salon of Plastic Arts and Third Prize for Drawing at the Sixth National Salon of Prints and Drawings, both in Buenos Aires, 1970.

This is the first presentation of Liberti's work outside Argentina. --*J.G-S.*

CATALOGUE

Oils

1. *Evasión (Evasion)*, 80 x 80 cm.
2. *Espacios celestiales (Celestial Spaces)*, 70 x 60 cm.
3. *Paisaje sobre las rías (Landscape of the Estuaries)*, 60 x 50 cm.
4. *Personaje contradictorio (Contradictory Personage)*, 80 x 45 cm.
5. *Invierno (Winter)*, 80 x 45 cm.
6. *Lienzo en atmósfera ventosa (Canvas in Windy Atmosphere)*, 60 x 80 cm.
7. *Atmósfera densa (Dense Atmosphere)*, 60 x 50 cm.
8. *Atmósfera turbulenta (Turbulent Atmosphere)*, 60 x 50 cm.
9. *Paisaje (Landscape)*, 65 x 40 cm.
10. *Promontorios inanimados (Inanimate Bulks)*, 60 x 40 cm.
11. *Reflujo (Ebb-Tide)*, 55 x 30 cm.
12. *Ciudad gótica (Gothic City)*, 55 x 30 cm.
13. *Personaje en Nimega (Character in Nimega)*, 40 x 30 cm.
14. *La perla de Ceilán (Pearl of Ceylon)*, 50 x 30 cm.
15. *Personaje con un objeto ovoide (Personage with an Ovoid Object)*, 50 x 30 cm.
16. *Columnata (Small Column)*,[1] 50 x 30 cm.

[1] Literal translation of this title is "Colonnade." --*Ed.*

Drawings

Tempera and ink

17. *Floración (Flowering)*, 43 x 31 cm.
18. *El organillero (The Organ Grinder)*, 45 x 25 cm.
19. *Figura de estatismo sugestivo (Suggestive Static Figure)*, 45 x 21 cm.
20. *Extraña simbiosis (Strange Symbiosis)*, 42 x 25 cm.

Pencil

21. *Los conquistadores (The Conquerors)*, 99 x 68 cm.
22. *Ciudad impenetrable (Impenetrable City)*, 63 x 49 cm.
23. *La sala de los relojes (The Room of Clocks)*, 35 x 24 cm.
24. *El bastón (The Cane)*, 35 x 24 cm.
25. *Vendedor de bártulos (Vendor of Household Goods)*, 35 x 22 cm.

November 27 - December 12, 1972

GEORGE LUIZ OF BRAZIL

Among the most talented of the young Brazilian abstractionists is George Luiz, who is presenting his first one-man exhibition in the Washington area. The artist employs a language of his own in his paintings of aerial views of cities, handling color skillfully and using broken forms to create a sense of infinite, geometrical space.

Born in Rio de Janeiro in 1935, George Luiz Martins Paredes studied painting in Brazil with Catherina Baratelli. Although he began participating in group exhibitions in 1965, he did not have his first one-man show until 1967 when he exhibited a series of works at the Escada Gallery in his native city. Since that time he has had eight one-man exhibitions in Rio de Janeiro, São Paulo, Santiago, New York City, Lisbon, and Madrid. Works by the artist are included in private and public collections in Brazil, Denmark, England, Portugal, Israel, and the United States.

CATALOGUE

Oils

1. *Edifícios da cidade vermelha (Buildings in Red City)*, 16 x 19"
2. *Cidade (City) LXII*, 24 x 16 1/2
3. *Favela at Rocinha*, 25 x 27"
4. *Night City*, 22 x 26 1/2"
5. *Pequena cidade amarela (Small Yellow Town)*, 12 1/2 x 16 1/2"
6. *The Sun Over Manhattan*, 20 x 24 1/2"
7. *Deserted City*, 21 x 25"
8. *Cidade verde (Green City)*, 25 x 27"
9. *Pequena cidade enevoada (Small Foggy Town)*, 16 1/2 x 18 1/2"
10. *Edifícios da cidade azul (Buildings in Blue City)*, 21 x 25"
11. *Cidade (City) LXII*, 25 x 27"
12. *City by Sunset*, 24 x 16 1/2
13. *Blue-Red Periphery*, 21 x 25"
14. *Central Park*, 16 1/2 x 20 1/2"
15. *Blue Vertical City*, 24 x 16 1/2"
16. *Cidade sob o sol (Sunny City)*, 21 x 25"
17. *Cidade (City) LIX*, 25 x 27"
18. *Cidade (City) LXIV*, 20 x 24"
19. *City under the Wind*, 21 x 25"
20. *Early Morning*, 20 x 24"

December 14, 1972 - January 7, 1973

CONTEMPORARY ART FROM THE CARIBBEAN:
BARBADOS, JAMAICA, TRINIDAD AND TOBAGO

In the last five years the membership of the Organization of American States, which for more than half a century stood at twenty-one, has increased by three, with the admission of Trinidad and Tobago, Barbados, and Jamaica. All three nations are cooperating actively in OAS programs in support of member states' economic, social, educational, scientific, and cultural development.

The new partners in our inter-American community, all members of the Commonwealth as well, have brought us a rich and varied legacy: the parliamentary tradition, interracial harmony, and cultures that are a unique blend of British, African, Chinese, Hispanic, and--especially in the case of Trinidad--Hindustani.

It is only natural that interplay among such widely differing elements should result in a lively and at times strikingly original artistic expression, of which the present exhibit offers a few highlights.

This is the first of what I am sure will be many showings of artists from our new member states. I trust that it will contribute to greater hemisphere-wide appreciation of the creative achievement of the peoples of Barbados, Jamaica, and Trinidad and Tobago. --*Galo Plaza*, Secretary General, Organization of American States.

For the first time in the history of exhibits of arts and handicrafts at the Pan American Union Building, a presentation is being made of a group of paintings and sculptures by nationals of three Caribbean states that have but lately joined the inter-American system.

In addition to a remote Spanish heritage, dating from the early period of discovery, and a far more significant legacy from the British, whose dominion prevailed until a decade ago, these three small English-speaking island countries claim a variety of living forms of cultural expression deriving from far-off Africa and Asia. With the coming of independence, once distinct traditions have tended to fuse in a new national consciousness, expressed in a single, integrated culture, which grows in vitality from day to day, enriched by cross-fertilization among the elements from which it derives.

As part of a program carried out by the Department of Cultural Affairs, a few weeks ago my colleague Angel Hurtado and I toured the three countries--Barbados, Jamaica, and Trinidad and Tobago--to make a careful selection of the best they have to offer in the visual arts. Limitations of exhibit space prevent anything like full coverage; nevertheless, in the case of each country, the compositions presented give a good idea of the quality of the work that is being done there and the varying directions it is taking. While the selection ranges from the ingenuous world of the primitives to the highly intellectual sphere of the abstractionists, in every instance we have sought to include only what is truly significant and representative of the ethnic background from which it springs. With the presentation we feel that the art of the English-speaking Caribbean is making a most impressive debut at OAS headquarters.

This initial group show will be followed at intervals, as space becomes available in our heavy exhibit schedule, by one-man exhibitions featuring a number of the artists who figure in the present sampling. We bid all welcome and look forward to their return as representatives of new facets of plastic development in the Americas. --*J.G-S.*

CATALOGUE

Paintings, Prints, and Sculptures

BARBADOS

Mary Armstrong
 1. *To Each His Own*, oil

Arthur Atkinson
2. *Critical*, acrylic
3. *Good Enough Day for Kite Flying*, acrylic

Joyce Daniel
4. *Landscape*, monoprint

Courtney O. Devonish
5-6. *Female Form I, II*, sculpture

Hartley Marshall
7. *No Man's Land*, etching and lithography

Wilfred Rogers
8. *East Coast Road*, oil

Stella St. John
9-10. *Petroglyph of St. Vincent I, II*, batik
11. *Breadfruit Leaf*, batik

JAMAICA

Valerie Bloomfield
12. *Portrait of a Politician*, 1972, 37 1/2 x 38"

Hope Brooks
13. *Abstract*, 1971, 31 x 29"

Clinton Brown
14. *Holy Ground*, 1972, 51 x 35"

Everald Brown
15. *Milk and Honey*, 1972, 39 x 27"
16. *Colorful Jamaica*, 1972, 39 x 27"
17. *Untitled Carving*, 37" height

Austin Campbell
18. *A Complex Growth*, sculpture, 55" height

Ralph Campbell
19. *Jamaica Landscape*, 1972, 40 x 34"

Karl Craig
20. *Wild Banana*, 31 x 37"

Milton Harley
21. *Abstract Painting*, 40 1/2" x 32 1/2"

Kapo (Mallica Reynolds)
22. *Teacher Teach*, 1972, 55 1/2 x 37 1/2"
23. *Victory Branch*, 1972, sculpture, 31" height

Edna Manley
24. *Untitled Carving*, sculpture. Loaned by Mr. David Berger, Philadelphia, Pennsylvania

Sidney McLaren
25. *North, South, East, and West Parade*, 1972, 50 x 28"

Mervin Palmer
26. *Burn Paper*, 1972, 30 x 24 1/2"

Karl Parboosingh
27. *View from Orange Park*, 48 x 41"

Seya Parboosingh
28. *Growing in the Sun*, 51 x 41"

George Rodney
29. *Fathoms*, 1972, 41 x 37"

Daisy Rose
30. *Kingston Hotel*, 1971, 25 x 20"

Beat Schwab
31. *Mark II, Series IV*, 31 x 31"

TRINIDAD AND TOBAGO

M. P. Alladin
32. *Corn*, acrylic, 48 x 48"

Sybil Atteck
33. *Balloon Seller*, oil, 31 x 49"

Ralph Baney
34. *Caribbean Rhythm*, wood sculpture, 69" height

Vera Baney
35. *Sculptural Pot*, ceramic (stoneware), 14 1/2" height

Leo Basso
36. *Still Life with Hibiscus*, oil, 24 x 18"

Patrick Chu-Foon
37. *Theme No. 1*, acrylic, 28 1/2 x 33"
38. *Form No. 2*, concrete, 16" height

Sarah Crook
39. *Abstraction*

Hettie De Gannes
40. *Rancho*, watercolor, 28 3/4 x 23"

Holly Gayadeen
41. *Folklore Fantasies*, monoprint, 25 3/4 x 21 1/2"

Boscoe Holder
42. *Seascape*, oil, 20 1/4 x 26"
43. *Woodford Square*, oil, 25 x 35 1/4"

Marcelio Hovell
44. *Folk Dancers*, oil, 21 1/2 x 26"

Arthur Magin
45. *Tranquil Wilderness*, mixed media, 28 1/4 x 25"

Sonnylal Rambissoon
 46. *Harmony in Café au Lait*, etching, 28 x 23"

Noel Vaucrosson
 47. *Storm over Monos Island*, watercolor, 24 1/4 x 31"

ABOUT THE ARTISTS

ALLADIN, M. P. Painter born in Trinidad, 1919. One of leading artists in his country and internationally known in the field of art education. Also, a writer, poet, and broadcaster. Studied at Birmingham College of Arts and Crafts, England; Columbia University, New York; and in Trinidad. Has taught in Canada and the West Indies. One-man and group shows in England, Spain, Brazil, the United States, and Canada, as well as in the Caribbean area. Recipient of numerous prizes and commissions.

ARMSTRONG, Mary. Painter born in Barbados, 1925. Has had solo and group exhibitions in Barbados and represented her country in important shows abroad (Expo '67, Montreal, Canada; São Paulo Biennial, 1969, 1971; Olympic Games, Mexico City, 1968). Awarded more than five prizes, including Banks Brewery Silver Cup, 1969.

ATKINSON, Arthur. Painter and draftsman born in Barbados, 1945. Has exhibited in Barbados and is the recipient of several prizes. Represented in the private collections of the Premier of Grenada and the Prime Minister of Guyana.

ATTECK, Sybil. Painter born in Trinidad, 1911. Studied in Trinidad, the United States (Washington University, St. Louis, Missouri), and in Europe. Lecturer and art teacher in secondary schools. Founding member and past president of Trinidad Art Society. Has had solo and group shows in Brazil, Canada, the United States, and in the Caribbean area. Awarded several prizes and commissioned to execute murals in hotels and office buildings in Port-of-Spain.

BANEY, Ralph. Sculptor born in San Fernando, Trinidad, 1929. Studied at Alfred University in New York, Brighton College of Arts and Crafts in Sussex (England), and at Naparima Teachers College in Trinidad. Art officer, Ministry of Education and Culture, 1962-1971. Has had one-man and group exhibitions in Trinidad, England, and the United States. Commissioned works include relief sculpture for altar of the Holy Cross, St. Finbar's Catholic Church, Port-of-Spain (1966). Represented in numerous public collections, among them the University of the West Indies and the National Museum and Art Gallery, both in Trinidad.

BANEY, Vera. Ceramist born in Trinidad, 1930. Married to sculptor Ralph Baney. Studied at Alfred University, New York; Brighton College of Arts and Crafts, Sussex (England); University of the West Indies, Trinidad; and University of Maryland, United States. Has exhibited in one-man and group shows in Trinidad, the United States, and Canada (Expo '67). Important commissions include mosaic mural for chapel of Bishop Anstey High School, Port-of-Spain, work done jointly with her husband.

BASSO, Leo. Painter born in Trinidad, 1901. Self-taught. Founding member and first vice-president of Trinidad Art Society. Has had one-man and group shows in the West Indies, England, and the United States. Considered one of the most outstanding native artists in the country.

BLOOMFIELD, Valerie. Painter and draftsman born in Scotland, 1932. Received diploma for drawing and painting from Glasgow School of Art, 1951. Teacher's certificate from Jordanhill Training College, Glasgow, 1958. Married Jamaican Andrew Bloomfield and took Jamaican citizenship, 1959. Has taught art in Jamaica, 1960-72, at secondary schools and the Jamaica School of Art. Has exhibited regularly in Jamaica. Silver medalist in 1971 Jamaica Festival. She is also a member of the Jamaica Playhouse and has appeared in many local theatre productions. Lives in Jamaica.

BROOKS, Hope. Painter born in Kingston, Jamaica, 1944. Graduated from Edinburg College of Art, Scotland, 1967. Joined the staff of the Jamaica School of Art, January 1968. Presently is tutor in charge of the Foundation Course at this school. Participated in many group exhibitions in the Caribbean and the United States.

BROWN, Clinton. Painter and sculptor, son of Everald Brown. Born in April 1954 in the Parish of St. Andrew,

Jamaica. Began painting in 1967 under the guidance of his father. This is the first time his work has been exhibited overseas.

BROWN, Everald. Painter and sculptor born in the Parish of St. Ann, Jamaica, 1917. A self-taught artist. Primary school education; a carpenter by trade. He is priest in the Ethiopian Orthodox (Coptic) Church in Jamaica where he teaches painting to the members of his church. Won awards in Jamaica in 1970 and 1971. His works have been included in several overseas exhibitions during 1972 and are to be seen on display in Jamaican missions overseas.

CAMPBELL, Austin. Sculptor born in the Parish of St. Mary, Jamaica, 1935. He was a part-time student of the Jamaica School of Art in 1965. Presently lives in Spanish Town where he is a full-time professional artist.

CAMPBELL, Ralph. Painter born in Kingston, Jamaica, 1921. Studied art under Edna Manley at the Institute of Jamaica in the 1940s. Under a British Council Scholarship, he studied for two years at the Camberwell School of Art in London. He has taught at the Jamaica School of Art and now teaches in a junior secondary school. He has participated in exhibitions in Britain, Germany, Canada, Cuba, Puerto Rico, Guyana, and the United States.

CHU-FOON, Patrick. Painter and sculptor, art officer at Ministry of Education and Culture, born in Trinidad, 1931. Studied in Trinidad and Mexico (University of the Americas, San Carlos Academy). Recipient of several important fellowships awarded by Trinidad government. Has had one-man and group shows in the West Indies, Brazil, Mexico (Palace of Fine Arts), England, Canada, and the United States.

CRAIG, Karl. Painter and graphic artist born in Montego Bay, Jamaica, 1936. Diploma from St. Martin's School of Art, London. After a brief period of teaching at the Jamaica School of Art, in 1958 he returned to England where he spent twelve years first in commercial art and then in the field of art education. He returned to Jamaica in 1971 as principal of the Jamaica School of Art. His creative work has included illustrations for many books, murals and paintings exhibited in Denmark, England, and the United States as well as in Jamaica.

CROOK, Sarah. Painter, sculptress, illustrator, and teacher born in England, 1946. Studied in France and England. First solo show at Canadian Imperial Bank of Commerce, Port-of-Spain, 1971. Currently teaches art at St. Joseph's Convent, St. Joseph.

DANIEL, Joyce. Graphic artist born in Barbados, 1933. Studied at Alberta College of Art, 1967-1971; Sir George Williams University; and Ontario College of Art. Currently teaches art. Has exhibited in Canada and Barbados.

DEVONISH, Courtney O. Sculptor born in Barbados, 1944. Has exhibited in solo and group shows in Barbados and England. Director and owner of Gallery 71 in Bridgetown.

GANNES, Hettie De. Painter born in Trinidad, 1935. Studied at Manchester College of Art, England. Has exhibited in solo and group shows in Trinidad.

GAYADEEN, Holly. Art educator and artist, art officer at Ministry of Education and Culture, born in Trinidad, 1930. Studied at West of England College of Art, Bristol. One-man and group exhibitions in Trinidad and Brazil (São Paulo Biennial). Past president of Trinidad Art Society. Held his second one-man show recently at National Museum and Art Gallery, Port-of-Spain.

HARLEY, Milton. Painter born in Jamaica, 1936. Went to the United States at the age of ten. Attended Pratt Institute Evening School, Brooklyn, New York; studied sculpture under Irma Rothstein in New York. Returned to Jamaica in 1961 to teach in secondary schools. Joined staff of Jamaica School of Art in 1966. Studied at Instituto Allende, Universidad de Guanajuato, Mexico, 1970-71, where he attained MFA degree. Presently, head of the Painting Department, Jamaica School of Art. Has exhibited outside of Jamaica in Spain, Canada, and the United States.

HOLDER, Boscoe. Painter, choreographer, and pianist born in Trinidad. Founding member of Trinidad Art Society. Has had one-man exhibitions in Port-of-Spain, New York City, Helsinki, Stockholm, and London. Paintings in permanent collection of Leicester Galleries, England, as well as in private collections in numerous countries throughout the world.

HOVELL, Marcelio. Painter and illustrator born in Trinidad. Self-taught. Has exhibited in group shows in Trinidad and abroad.

KAPO (Mallica Reynolds). Painter and sculptor born in Bynloss, Parish of St. Catherine, Jamaica, 1911. He is a "Shepherd" of a revivalist cult. A self-taught sculptor, he started painting in 1967. He held several one-man shows in Jamaica and exhibited at the Juster Gallery, New York (1952), in Los Angeles (1964 and 1968) and at the art gallery of the Center for Inter-American Relations, New York (1969). Has participated in group shows in Europe, Britain, and the United States. In 1969 was awarded the Musgrave Silver Medal for Painting and Sculpture by the Institute of Jamaica. Received the award offered by the Ministry of Finance and Planning for the best painting in the Annual National Exhibition of Painting, 1970.

MCLAREN, Sidney. Self-taught artist from Morant Bay, Jamaica. He is now seventy-seven years old; he started painting seriously for a living a few years ago. He received an award for his work in 1971 and has exhibited in England, Guyana, and the United States, as well as in Jamaica. Some of his work has been sent to Jamaican missions overseas.

MAGIN, Arthur. Painter born in Trinidad, 1912. Self-taught. Part-time studies at Heatherley School of Art, England, 1963. Has exhibited with Trinidad Art Society since 1960 and participated in group exhibitions in Canada, England, and the United States. One-man exhibitions in 1968 and 1972.

MANLEY, Edna. Painter and sculptress born in Bournemouth, England, 1900. Mother of Michael Norman, Prime Minister of Jamaica. Educated at West Cornwall College and St. Martin's School of Art, England. Has had numerous one-man and group exhibitions in Jamaica and London (French Galleries). Awarded first Musgrave Gold Medal, 1942. Has lived in Jamaica since 1922.

MARSHALL, Hartley. Printmaker born in Barbados, 1946. Educated at Queen's College. Specializes in graphics. Awarded CIDA Scholarship in 1967 and continued studies in art at Sir George Williams University, the University of Waterloo, and the University of Guelph. Currently teaches at the Parkinson Comprehensive School.

PALMER, Mervin. Painter born in Kingston, Jamaica, 1955. Is currently a second-year student at the Jamaica School of Art, specializing in painting.

PARBOOSINGH, Karl. Painter born in Highgate, Parish of St. Mary, Jamaica, 1923. Educated at Art Students League of New York, Académie des Beaux-Arts of Paris, Instituto Politécnico de Bellas Artes in Mexico City. Studied with George Cross, Fernand Léger, and Yaseo Kuniyoshi. Was artist in United States Army for four years. Taught at Jamaica School of Art. Has exhibited extensively in Europe, Britain, the United States, Puerto Rico, Mexico, as well as in one-man and group shows in Jamaica. Co-founder of the Contemporary Jamaican Artists' Association.

PARBOOSHINGH, Seya. Painter, wife of Karl Parboosingh, born in Allentown, Pennsylvania, 1925. She has had no formal art education but has worked with her husband and other Jamaican artists. She qualified in creative writing at American University. Exhibited widely throughout Jamaica and abroad. Has lived in Jamaica since 1957.

RAMBISSOON, Sonnylal. Etcher, engraver, and painter born in Trinidad, 1926. Awarded Trinidad Government Scholarship in Fine Arts, 1959. Studied in England at Brighton College of Art, Sussex, and Goldsmith's College, London University, and at Stanley W. Hayter's workshop in Paris. His works have been exhibited in Trinidad, England, and Venezuela. First Trinidad-born printmaker to be elected to Royal Society of Painters and Etchers, England.

RODNEY, George. Professional painter born in St. Catherine, Jamaica, 1936. Employed as graphic artist at Jamaica Broadcasting Corporation. A graduate of Jamaica School of Art, has studied, painted, and exhibited in the United States as well as in Jamaica. Studied at Art Students League in New York for two years.

ROGERS, Wilfred. Painter and draftsman born in Barbados, 1949. Has been painting since age of twelve. Self-taught. One-man exhibitions in Barbados. Represented in the collection of the Barbados Museum.

ROSE, Daisy. Painter born in the Parish of Clarendon, Jamaica, 1904. Primary school education; milliner by trade. Has been painting since school days. This is the first exhibition of her work outside Jamaica.

ST. JOHN, Stella. Painter born in Barbados, 1933. Although formerly a painter, now works primarily with batik. Has had several solo shows and represented Barbados in important exhibitions abroad (São Paulo Biennial, 1969 and 1971; Olympic Games, Mexico City, 1968).

SCHWAB, Beat. Graphic artist born in Bern, Switzerland, 1952, is a Jamaican citizen. Is presently in his final year at the Jamaica School of Art, specializing in graphics. Has lived in Jamaica since 1954.

VAUCROSSON, Noel. Watercolorist born in Trinidad, 1932. Master' degree in architecture, McGill University, Canada, 1967. Has had one-man and group shows in Trinidad and Canada. Represented in the National Collection of Trinidad and Tobago as well as in private collections in the West Indies, Australia, England, Canada, and the United States.

YEAR 1973

January 9 - 28, 1973

RAFA FERNANDEZ OF COSTA RICA

Rafa Fernández, a young Costa Rican artist who has gained national prominence only within the past few years, is the first painter in the country to follow a direction akin to surrealism. His world is inhabited by half-real, half-fantasy beings involved in the tasks of everyday life. The daily life motives are given further interest by the artist's use of cryptic ornamentation that is somehow associated with pre-Hispanic and popular art.

Fernández himself describes the essence of his work:

> Day after day I confront new mysteries and at the same time create new myths to explain my own existence. That is why I spend part if not all my time creating, searching for the elements necessary to my expression in the magic world of our people.

Born in San José in 1935, Fernández studied art there from 1950 to 1955 and later attended the School of Fine Arts in Managua and the Círculo de Bellas Artes in Madrid. He has had eleven one-man shows in San José, Tegucigalpa, Managua, Guatemala City, Madrid, and the United States, having made his first appearance in this country at the Knoxcapbell Gallery in Tucson, Arizona, 1971. He has participated in numerous group shows in San José and has represented Costa Rica in important international exhibitions such as the São Paulo Biennial, 1969; the Coltejer Biennial in Medellín, Colombia, 1968, 1970; the First Biennial of Painting of Monte Catini in Terni, Italy, 1969; and at the World's Fair in Osaka (Japan), 1970. He has been the recipient of several scholarships and awards, including the National Prize of Costa Rica in 1972, and is represented in public and private collections in Costa Rica, Honduras, Spain, and the United States. --*J.G-S.*

CATALOGUE

1-24. Paintings[1]

January 30 - February 20, 1973

LEONARDO NIERMAN OF MEXICO: TAPESTRY AND SCULPTURE

The name of Leonardo Nierman is by no means new to artistic circles in the United States, particularly here in Washington, where his paintings have been seen on a number of occasions at the IFA Gallery which represents him in this city.

The novelty of his current exhibit at OAS headquarters resides in the fact that it presents two facets of the young Mexican master's work which had not previously been shown here: tapestries and sculpture. Both unquestionably bear the stamp of the personality which has caused his paintings to be among the best known in Latin America, marked as they are by the brio of his brush strokes, the power of his color masses, and the mystery of his themes.

At a tapestry workshop in Mexico, which employs the techniques and practices for which the Gobelins are known in France, Nierman's cartoons are interpreted with utmost fidelity. The sole difference lies in the mutation of the lustrous finish of his acrylic paintings on Masonite into the soft surface produced by wool. Yarn is spun to

[1] Titles are unavailable. --*Ed.*

order for each tapestry and the multicolored skeins are blended to produce a faithful, woven rendition of the intense tonalities of his paintings. The tapestry technique translates the living flow of color with an exactness that could not be attained by other weaving processes. Despite their ample size, one could wish that many of the hangings were larger still, on a scale proportionate to the vast stone walls of the medieval castles of Europe whose gloom and cold drafts tapestries were invented to combat.

In his sculpture Nierman imparts three-dimensional form to the signs, motions, and free-flowing shapes that make up fragments of many of his paintings, reducing them to their ultimate essentials, carving them in onyx or casting them in bronze. By the artist's alchemy the birds, spirals, and flames that glow in color on his canvases are transmuted into the shining metal and luminous rock of the Mexican earth.

Leonardo Nierman was born in Mexico City in 1932, of European parents. His studies led him to a bachelor's degree in physical and mathematical sciences, but previously he had taken up music, and as a precocious violinist had performed at concerts and music festivals in various parts of Mexico. A little over twenty years ago he began to paint, and in the last two decades, in addition to participating in group exhibitions, he has had more than thirty one-man shows in Paris, Rome, London, Tel Aviv, New York, Chicago, Philadelphia, Los Angeles, Washington, El Paso, and Toronto. His last exhibit was at the Museum of Contemporary Art in Bogotá, Colombia, late in 1972.

Leonardo Nierman is considered one of the outstanding personalities in contemporary Mexican art. The underlying characteristic of his work is research to define physical and even metaphysical reality in terms of abstract form. In addition to engaging in painting, drawing, sculpture, and tapestry design, he has executed murals and stained-glass windows. --*J.G-S.* English translation by Ralph E. Dimmick.

CATALOGUE

1-22. Bronze sculptures and tapestries[1]

February 22 - March 14, 1973

THE MANZUR WORKSHOP OF BOGOTA: WORKS BY ITS ASSOCIATES

After living for several years in the United States, where he attended graduate school and studied new artistic trends, first on an OAS fellowship and later with the help of the Guggenheim Foundation, Colombian painter David Manzur (born 1929) returned to Bogotá to follow his profession. Around 1965 he decided to admit three or four students to his studio, and shortly thereafter that number had grown to more than a dozen.

At present the Manzur Workshop has an enrollment limit of 120 students. These, divided into three groups, go to the workshop for four-hour sessions only twice weekly, for unlike other artists who devote themselves to teaching, Manzur spends the rest of his time producing his works and studying new materials and new forms. Each student continues his work in his own studio, each week bringing to class the works begun in the previous session--a system which may disappear in mid-1973 when construction is completed on the handsome new building that will house the workshop and expand its facilities. Those attending the workshop are also subjected to the inescapable task--and the rigorous discipline--of live drawing, an obligatory subject for students at all levels.

The Manzur Workshop is now training students from outside Colombia as well, and each year there is a waiting list of prospective entrants. Students remain an average of two years at the workshop, which offers neither diplomas nor certificates nor any other document of an academic nature. The duties of the director are limited, in his own words, to "the technical part, without compromises, without guarantees of anything," since "in the workshop there are no common ideas, and those who attend it do not have to think the way the director thinks."

[1] Titles are unavailable. --*Ed.*

Curiously, Manzur never shows his own works to the students, since he is not interested in creating proselytes or in founding what usually connotes a "school."

If, after finishing his training, an artist becomes interested in the work of his teacher, David Manzur invites his collaboration--as an equal in capability and rank--on team efforts to create murals or tapestries.

Two years ago, on one of my periodic visits to the workshop to teach short courses on art history and appreciation, I issued an invitation to its most outstanding students--some of them now professional artists in their own right--to participate in a group exhibit here. The idea was to let Washington see a synthesis of the output of a workshop that is constantly producing artists, orienting them toward searching for an individualistic creative concept without reverting to simplified solutions, and teaching them, above all, to maintain discipline and dominate the technique until it is finally refined.

The result is this exhibit, varied in trends, concepts, and means of expression, which Manzur and I very carefully selected in Bogotá a few months ago. It includes some associates still at the workshop and others who have left it to begin their own careers. The abundance of drawings--the most austere of the media--in the group reaffirms the solidity of the teaching and the rigor of the system that, as this selection shows, includes abstract, primitive, expressionist, and neo-figurative manifestations, among others.

If a comment can be made on the effectiveness of the system used by David Manzur--sole teacher and guide of the workshop--it is that every two years it produces several personalities who achieve immediate prominence within the new generations creating the art of Colombia, one of the most important centers of Latin American art today. --*J.G-S.*

CATALOGUE

Painting, Drawing, Print, Sculpture

Doris Angel
 1. *Obsesión (Obsession) No. 4*, 1973, mixed media, 80 x 100 cm.
 2. *Obsesión* (Obsession) *No. 2* [1]

Luz Clemencia Arenas
 3. *Mujer* (Woman), pencil drawing

Lydia Azout
 4. *Still Life* [2]

Maggy Becerra
 5. *Diseño (Design)*, tapestry

Teresa Bernal
 6. *Estructura geométrica* (Geometric Structure)

Olga Botero
 7. *Estructura en rojo (Structure in Red)*, 1972, mixed media, 60 x 82 cm.
 8. *Integración al espacio* (Spacial Integration),[3] 1972, mixed media, 82 x 60 cm.

[1] Not included in the original catalogue but also exhibited. --*Ed.*

[2] In the list sent by the David Manzur Workshop for this exhibition, no. 4 appeared as *Otoño* (Autumn), 1972, acrylic, 60 x 80 cm. --*Ed.*

[3] Not included in the original catalogue but also exhibited. --*Ed.*

María Eugenia Bravo
 9. *Dibujos (Drawings)*, 1972, 58 x 112 cm.

Magdalena Bravo
 10. *Drawings*

Gerardo Caballero
 11. *El médico (Physician)*, drawing

Julián Delgadillo
 12. *Dibujo (Drawing)*, ink, 1972

Beatriz Echeverri
 13. *Monumento a la carne (Anatomical Monument)*, 80 x 100 cm.

Fanny Finkelman
 14. *Estructuras parabólicas (Forms from the Parables)*[1]

María Antonia González [2]
 15. *Dibujo (Drawing)*, pencil

Clara Gutiérrez
 16. *Atracción (Attraction)*, 1973, mixed media, 80 x 80 cm.

Ligia Hoyos
 17. *Dos mitades (Two Halves)*, 1972, pencil drawing, 90 x 65 cm.

Gloria Jaramillo
 18. *Bodegón (Still Life) No. 2*, 1972, mixed media

Clara Kassin
 19. *Círculos superpuestos* (Superimposed Circles)

Ana Kerpel
 20. *Bodegón (Still Life)*, 1972, acrylic

Ada Leary
21-22. *Oleo (Oil)*

Suzanne Liska
 23. *The Last Warmth*, 1972, acrylic on canvas, 100 x 80 cm.

Sara Mekler
 24. *Collage No. 5*

Vivian Moreinis
 25. *Facetas (Facets)*, 1973, acrylic, 100 x 180 cm.

Oscar Naranjo
 26. *Túnel (Tunnel)*, mixed media

[1] Literal translation of this title is "Parabolic Structures." --*Ed*.

[2] In the original catalogue María Antonia González appeared as María Antonia Gutiérrez. --*Ed*.

Ximena Otero
 27. *Dos figuras (Two Figures)*, 100 x 80 cm.

Carlos Padilla
 28. *Dibujo (Drawing)*, mixed media

Clara Ramírez[1]
 29. *Figure*

Yolanda Rodríguez
 30. *Grabado (Engraving)*

Clemencia Salazar
 31. *Cristalización (Crystallization)*, mixed media

Ana Samper
 32. *El reposo (Rest)*, 1972, mixed media, 88 x 68 cm.

Pedro Sandino
33-34. *Relief in Canvas*
35-36. *Escultura (Sculpture)*, metal

Maruja Shaio[2]
37-38. *Composición (Composition) No. 1 and No. 2*, mixed media

Eugenia Simmonds[3]
 39. *Bodegón (Still Life)*, acrylic

Fanny Stern
40-41. *Drawing*

Patricia Tavera
 42. *Concreción humana (Human Consecration)*,[4] 1972

Libia Tenorio
 43. *Dualidad (Duality)*, 80 x 100 cm.

Marlene Troll
 44. *Dibujos (Schematic Drawings)*, 1973, gouache and pen

[1] In the list sent by the Manzur Workshop for this exhibition, Clara Ramírez is not included, instead Clara Cervantes is listed with an untitled work dated 1972. *--Ed.*

[2] In the original catalogue Maruja Shaio (Maruja Shaio de Possin) appeared twice, as Maruja Shaio and as Maruja Possin. *--Ed.*

[3] Although Eugenia Simmonds and Eugenia Valencia are listed in the original catalogue, both exhibiting a *Still Life*, the list sent by the Manzur Workshop for this exhibition only includes Eugenia Simmonds. *--Ed.*

[4] Literal translation of this title is "Human Concretion." *--Ed.*

Ana Uribe[1]
 45. *Collage*

Eugenia Valencia[2]
 46. *Bodegón (Still Life)*

Amparo Vélez
 47. *Bodegón (Still Life) No. 2*, acrylic

Irma Wronsky
 48. *Micromundo (Microworld)*, 1972, acrylic, 40 x 48 cm.

Pilar Zea
 49. *Bodegón (Still Life)*, 1972, acrylic, 80 x 100 cm.

BIOGRAPHICAL NOTES [3]

ANGEL, Doris. Painter, born in Colombia. Studies at the David Manzur Workshop. Has participated in group exhibits in Bogotá.

AZOUT, Lydia. Sculptress, born in Bogotá, Colombia, 1942. Studies at the David Manzur Workshop, Bogotá. This is the first exhibition of her work.

BRAVO, Magdalena. Painter, draftsman, born in Colombia. Studies at the David Manzur Workshop, Bogotá. Participated in national salons and group exhibitions of the Manzur Workshop in Bogotá.

BRAVO, María Eugenia. Draftsman, born in Colombia. Studies at the David Manzur Workshop and has participated in its group exhibits in Bogotá.

DELGADILLO, Julián. Draftsman, born in Colombia. Studies at the David Manzur Workshop, Bogotá. Participated in national salons.

FINKELMAN, Fanny. Sculptress, born in Medellín, Colombia, 1941. Studies at the David Manzur Workshop and has participated in its group exhibitions in Bogotá.

GONZALEZ, María Antonia. Painter, draftsman, born in Bogotá, Colombia, 1944. Studied ceramics at the National University with Beatriz Daza, 1964; porcelain painting under different artists, 1967; ceramics at the Prodeo School under Antonio Madero; painting and drawing at the David Manzur Workshop, 1971 to present. This is the first exhibition of her work.

JARAMILLO, Gloria. Painter, born in Colombia. Studies at the David Manzur Workshop and has participated in its group exhibitions in Bogotá.

KASSIN, Clara. Sculptress, born in Bogotá, Colombia, 1948. Studied at the Chapel Hill School, Waltham (Massachusetts); School of Fine Arts, University of Los Andes; and is presently studying at the David Manzur Workshop, Bogotá. Has participated in group exhibitions since 1965. Won the Place Award, University of Boston, 1965, among other prizes.

KERPEL, Ana. Painter, born in Bogotá, Colombia. Studies drawing and painting at the David Manzur Workshop, Bogotá. This is the first exhibition of her work.

[1] Not included in the original catalogue. --*Ed.*

[2] See footnote 3 on previous page. --*Ed.*

[3] Not included in the original catalogue. See Index of Artists for reference on those not listed here. --*Ed.*

MEKLER, Sara. Painter, born in Poland. Studies at the David Manzur Workshop, Bogotá. Held one individual exhibition and has participated in the Manzur Workshop group shows in Bogotá, where she lives.

NARANJO, Oscar. Painter, tapestry designer and weaver, born in Colombia. Studies at the David Manzur Workshop, Bogotá. Has participated in national salons and the Manzur Workshop group exhibitions in Bogotá.

OTERO, Ximena. Artist born in Colombia. Studies at the David Manzur Workshop and has participated in its group exhibitions in Bogotá.

RODRIGUEZ, Yolanda. Printmaker, born in Colombia. Studies at the David Manzur Workshop, Bogotá. Participated in national salons.

SHAIO, Maruja (Maruja Shaio de Possin). Painter, born in Colombia. Studies at the David Manzur Workshop and has participated in its group exhibitions in Bogotá.

TAVERA, Patricia. Painter, draftsman, born in Bogotá, Colombia, 1947. Has studied at the David Manzur Workshop since 1969. In 1971 studied engraving at the National University, Bogotá. Has participated in national exhibitions, including those held by the Manzur Workshop in Bogotá.

TENORIO, Libia. Draftsman, born in Colombia. Studies at the David Manzur Workshop and has participated in its group exhibitions and national salons.

TROLL, Marlene. Draftsman, born in Colombia. Studies at the David Manzur Workshop and has participated in its group exhibitions in Bogotá.

URIBE, Ana. Painter, born in Colombia. Studies at the David Manzur Workshop, Bogotá. Has participated in national salons.

VALENCIA, Eugenia. Painter, born in Cali, Colombia. Studies at the David Manzur Workshop in Bogotá and has exhibited in its group exhibitions.

WRONSKY, Irma. Painter, born in Berlin, Germany. Studies at the David Manzur Workshop, Bogotá. Held individual exhibitions in Bogotá, where she has also participated in group exhibits since 1968. Has lived in Colombia since 1946.

ZEA, Pilar. Painter, born in Colombia. Studies at the David Manzur Workshop in Bogotá and has participated in its group exhibitions.

March 15 - April 14, 1973

JOSEFINA PERAZZO OF ARGENTINA: OILS

Although Josefina Perazzo has been studying art for more than twenty years, it was not until 1965 that her first works were exhibited publicly in salons and galleries. From that very moment, her personality has intrigued art critics and lovers alike, above all because of the sureness in her use of color. Her sometimes unrecognizable forms, precisely drawn and strange in appearance, surrounded by sparkling backgrounds of smooth color, have earned her the reputation as one of the new creative forces in Argentine art, strong and sure in her concepts. A student of art history, of aesthetics, and, generally speaking, of philosophy, Ms. Perazzo makes use of several elements that tend to motivate her works: time, space, and machinery, man's conquest of space and time, and his interplanetary explorations. With these elements she conceives this luminous world, solid and safe, that is her present-day painting, rich in color and abundant in imaginative solutions.

Josefina Testa de Perazzo was born in 1922 in the Argentine capital, where she has always resided. She began her studies at the University of Buenos Aires in 1950, majoring in art history, but in 1956 she began studying painting techniques, first at the Association for the Promotion of Fine Arts, where she took drawing classes for two years. From 1958 to 1964 she attended the workshop of painter Horacio Butler, a pioneer of modern art in

Argentina, who taught her painting and drawing techniques. From 1965 to 1968 she studied at the Advanced School of Fine Arts in Buenos Aires, attending every course: painting, sculpture, engraving, murals, industrial design, and handicrafts. This variety of knowledge, together with the theoretical courses she had already completed, give to her work the sureness and maturity that characterize it.

Ms. Perazzo's works have been included in more than twenty group exhibitions, where she has won various prizes and mentions. To date, she has had only seven individual shows, ranging from the first in 1967 in Buenos Aires Lambert Gallery, to the one last year in the salon of the Municipal Bank of Buenos Aires. Outstanding among these are her solo presentation in 1969 at the Lirolay Gallery, and the simultaneous exhibitions held in 1971 at three cultural centers of the Olivetti Argentine Company, whose art collection includes several of her works. Other paintings by Ms. Perazzo are found in the collections of the museums of Mar del Plata and Mercedes in Argentina, at the University City in Paris, and in the Embassy of Argentina in Brussels.

This is the first presentation of works by Josefina Perazzo in the United States. --*J.G-S*. English translation by Arbon J. Lowe.

CATALOGUE

Paintings

1. *Cuatro... tres... dos... uno... cero (Four . . . Three . . . Two . . . One. . . Zero)*
2. *A Cry Within Me . . . A Cry Within Us All*
3. *Pequeño instante en un tiempo infinito (A Fleeting Instant in Infinite Time)*, acrylic, 150 x 150 cm.
4. *Tras la sombra insidiosa de un mundo petrificado (Beyond the Insidious Shadow of a Petrified World)*, acrylic, 150 x 150 cm.
5. *Aquella extraña visión nocturna (That Strange Nocturnal Vision)*, acrylic, 130 x 130 cm.
6. *Y es el presente y el futuro (And It Is Present . . . And It Is the Future)*
7. *Comenzando su fantástico galope (Beginning the Fantastic Gallop)*, triptych
8. *He visto al hombre surcar el cielo (I Have Seen Man Plow the Sky)*, oil, 120 x 120 cm.
9. *Rompecabezas de ruedas y manivelas (Riddles of Wheels and Cranks)*
10. *Monstruo devorador del tiempo y la distancia (Monster Devourer of Time and Distance)*, oil on canvas, 100 x 100 cm.
11. *Long Day's Journey of a Long History*
12. *Almagestum novum (Giovanni Battista Ricioli)*, diptych
13. *Ciento sesenta días en tres días (One Hundred Sixty Days in Three Days)*
14. *Y es para el hombre un modo nuevo de ser hombre (And It Is for Man a New Way of Being a Man)*
15. *Aquella extraña visión nocturna (That Strange Nocturnal Vision) II*
16. *Intellectual Exploration of Outer Space*
17. *Evolución de la mecánica celeste (Evolution of Celestial Machinery)*
18. *E l'uomo é nel suo spirito* (And Man Is in His Spirit)
19. *El grito más fuerte del hombre... su coraje, su orgullo, su fe (Man's Strongest Shout . . . His Courage, His Will, His Hope)*, acrylic, 80 x 80 cm.
20. *Ostinato rigore (Stubborn Rigor)*
21. *Ruedas, tubos, la máquina... la máquina... la máquina (Wheels, Tubes, the Machine . . . the Machine . . . the Machine)*, 1972, oil on canvas, 31 1/2 x 39 1/2"
22. *Secrets of the Cosmos*
23. *Fantastic Adventure*
24. *Epopeyas del universo (Epics of the Universe)*
25. *Somnium (Johannes Kepler)*

April 24 - May 16, 1973

NESSIM BASSAN OF PANAMA

When Nessim Bassan first appeared on the art scene in Panama three years ago, he was immediately acknowledged as a professional of mature and exceptional talent. By that time he had already abandoned an early

interest in abstract expressionism to develop his ideas in terms of simple, abstract forms on large, flat planes. Departing from painting in the traditional sense, Bassan works with plastic materials or heavy duck canvas and is concerned with creating points of tension on the surface, achieving his objective either by inserting objects from behind or overlapping or patching materials on the front of the canvas. All of the works on exhibition are white.

Born in Panama City in 1950, Bassan was only twenty years old when he was awarded Second Prize at the annual Xerox Art Festival held in Panama in 1970. In 1971 he won First Prize in the same festival and last year again was awarded Second Prize. Bassan began studying art in 1958 at the Isabel Almolda Academy of Art in Panama City, continued his studies at the Peddie School in New Jersey, 1964-1968 and, upon graduation, attended Colgate University for two years. In 1971, after leaving Colgate, he worked under the well-known Brazilian printmaker Roberto De Lamônica at the Art Students League in New York City. Last year he participated in the Coltejer Biennial in Medellín, Colombia, and had his first one-man show at the Panamanian Institute of Art. This is Bassan's first one-man exhibition outside Panama. --*J.G-S.*

CATALOGUE

1-17. Paintings[1]

May 17 - June 6, 1973

JAIME MUÑOZ OF COLOMBIA

Although he has worked in more than one medium, Jaime Muñoz has devoted most of his artistic career to watercolor, rendering the landscapes around Medellín and the city itself in a serene, realistic manner. Muñoz, who was born in Medellín in 1915, studied art during the decade of the 1930s at the Institute of Fine Arts in Medellín and at the National School of Fine Arts in Bogotá, working at different times under Pedro Nel Gómez, Ignacio Gómez Jaramillo, and Eladio Vélez. He had his first one-man exhibition at the National Theater in Panama City in 1942 and since that time has had six additional shows in Colombia. He has participated in numerous group exhibitions in his country and in 1967 was awarded Second Prize at the National Salon of Watercolorists in Cali.

EXHIBITION LIST [2]

Watercolors

1. *Santa Rosa No. 3*
2. *La Candelaria*
3. *Andes No. 2*
4. *Santuario (Sanctuary) No. 2*
5. *Santa Rosa No. 2*
6. *Andes No. 1*
7. *San Francisco*
8. *Iglesia de Rionegro (Church of Rionegro)*
9. *San Vicente No. 2*
10. *Santuario (Sanctuary) No. 1*
11. *San Cristóbal No. 2*
12. *San Vicente No. 1*
13. *San José*
14. *Santa Bárbara*
15. *San Luis*

[1] Titles are unavailable. --*Ed.*

[2] Not included in the original catalogue. --*Ed.*

16. *Santa Rosa No. 1*
17. *San Cristóbal No. 1*
18. *Granada*
19. *Santo Domingo*
20. *El Peñol*

May 17 - June 6, 1973

DORA RAMIREZ OF COLOMBIA

The art movement in Colombia is one of the most vigorous and progressive in South America today. Although Bogotá draws the greatest number of artists, there are several cities in the interior of the country that have nurtured personalities who have contributed significantly to the plastic arts. Dora Ramírez, who is exhibiting for the first time in the United States, was born in 1923 in Medellín, the second largest city in Colombia and the site of the Coltejer Biennial of Art. The Biennial, inaugurated in 1968, has attracted attention not only to Medellín but to the country as a whole and is acquiring ever increasing prominence internationally.

Ms. Ramírez had her formal training in painting and drawing at the School of Fine Arts, the Bolivarian Pontifical University in 1943-45, and at the Institute of Plastic Arts in 1960-64, all in Medellín. In recent years she has been teaching art to children at the Contemporary Gallery and at the Colombian-North American Center. She has had six individual shows in Medellín, Bogotá, and in San Juan (Puerto Rico) and has participated in numerous group exhibits, including the Twenty-first Salon of National Artists, Bogotá, 1970; *Contemporary Art of Colombia*, Ponce Museum, Puerto Rico, 1970; and the Coltejer Biennial, Medellín, 1972.

Her painting has a neat, luminous quality, and her monumental forms, which in earlier works were influenced by the well-known Medellín-born painter Fernando Botero, are now flat. Her approach to her subject, whether it be a portrait of a lady, an egg in a cup, or a bowl of fish, is poetic and joyous, full of optimism. Having exhibited professionally only since 1967, Ms. Ramírez is a relative newcomer to the Colombian art world, but she is certainly a personality worthy of note.

CATALOGUE

Serie Gulliver (Gulliver Series)

1. *Duraznos y cerezas para dos (Cherries and Peaches for Two)*
2. *Tres limones y un panecito (Three Lemons and a Piece of Bread)*
3. *La luna entra en la casa (The Moon Enters the House)*
4. *Como un cuchillo, como una flor, como absolutamente nada en el mundo (Like a Knife, Like a Flower, Like Absolutely Nothing Else in the World)*
5. *La pecera pública (The Public Aquarium)*
6. *La señora está servida (The Lady Is Served)*
7. *La olla atómica (The Atomic Pot)*

Serie Magia (Magic Series)

8. *Voy a hacerte una casa en el aire (I Am Going to Build You a House in the Air)*
9. *Presentación de una granadilla (Presentation of a Granadilla)*
10. *En la ventana abierta (In the Open Window)*
11. *De tejas arriba (Everything under the Sun)*
12. *La Atlántida, un continente perdido (Atlantis, a Lost Continent)*
13. *La Atlántida segunda (The Second Atlantis)*
14. *La Atlántida tercera (The Third Atlantis)*

Serie Figuras (Figures Series)

15. *Detrás, un cielo azul (Behind, a Blue Sky)*

16. *La tierra éramos nosotros (We Were the Earth), Manuel Mejía Vallejo*
17. *La niña y la tortuga (The Child and the Turtle)*
18. *La niña y la mariposa (The Child and the Butterfly)*
19. *Una de aquellas fotos... (One of Those Photos . . .)*
20. *Hasta que la muerte nos separe (Until Death Do Us Part)*

Serigraphs

21. *De tres a cinco minutos (From Three to Five Minutes)*
22. *Para subir al cielo se necesita una escalera grande y una chiquita (To Reach the Sky One Needs a Big Ladder and a Little One)*

June 8 - 27, 1973

SPANISH LANDSCAPES BY ORNELLAS OF PERU

As can be evidenced in the current exhibition featuring the work of Peruvian-born artist Ornellas, the Spanish tradition in painting has much to offer today's artists in terms of concept and technique as well as subject matter. Ornellas, who was born in Lima in 1916, has lived and worked in Madrid for more than twenty years, and from 1949 to 1952 studied under the well-known Spanish painter Daniel Vásquez Díaz. It was through his teacher that he was introduced to the feeling and techniques of the Spanish school.

Ornellas's early work, during the period following his studies with Vásquez Díaz, was characterized by a calm, penetrating realism that clearly reflected the influence of seventeenth century Spanish painting. Gradually, however, his painting began to tend toward abstraction. Like Nicolas de Staël, he began to reduce the elements of realism to neat, solid masses of color. At times there are elements in his work that recall the vigorous, spontaneous small scale sketches of Sorolla. The paintings on exhibition have large, flat surfaces with complex zones that describe views of the Spanish landscape.

Since 1938 Ornellas has had more than ten one-man exhibitions in Peru, Spain, France, and England and has participated in group shows in those countries as well as in Chile. He is represented in several museum collections in Peru and Spain as well as in the private collections of members of European nobility, among them the Counts and Countesses de Rose, de Guerre, de Peyster, and G. de Peña, all of Paris, Lord and Lady Vaughan of London, the Marquise de Narros of Madrid, and the Marquis and Marquise de Campo Real, also of Madrid.

This is the artist's first exhibition in the Untied States. --*J.G-S.*

CATALOGUE

Oils on Wood

1. *La costa (Coastline)*, 61 x 32 cm.
2. *Paisaje gris (Gray Landscape)*, 61 x 32 cm.
3. *Desierto (Desert)*, 61 x 32 cm.
4. *Campo amarillo (Yellow Field)*, 61 x 22 cm.
5. *Casas sobre el mar (Houses by the Sea)*, 61 x 22 cm.
6. *Monte negro (Black Mountain)*, 61 x 46 cm.
7. *Reflejos (Reflections)*, 61 x 38 cm.
8. *Paisaje ocre (Ocher Landscape)*, 61 x 41 cm.
9. *Cerca de Ciudad Real (Near Ciudad Real)*, 61 x 41 cm.
10. *Cerca de Jaén (Near Jaén)*, 61 x 22 cm.
11. *Paisaje rojo (Red Landscape)*, 61 x 46 cm.
12. *Paisaje castellano (Castilian Landscape)*, 80 x 22 cm.
13. *Campo dorado (Yellow Field)*, 80 x 22 cm.
14. *Paisaje extremeño (Landscape in Extremadura)*, 80 x 22 cm.

15. *Nevado cerca de Candanchú (Near Candanchú)*, 73 x 56 cm.
16. *Costa de Levante (Levant Coastline)*, 73 x 56 cm.
17. *Fábrica en Alicante (Factory in Alicante)*, 73 x 56 cm.
18. *Paisaje de Sevilla (Sevillian Landscape)*, 73 x 56 cm.
19. *Cerca de Granada (Near Granada)*, 73 x 56 cm.
20. *Paisaje de Extremadura (Extremadura Landscape)*, 75 x 61 cm.
21. *Paisaje de Castilla (Castilian Landscape)*, 80 x 47 cm.
22. *Carretera de Trujillo (Road to Trujillo)*, 81 x 61 cm.
23. *Castilla (Castile)*, 122 x 31 cm.
24. *Costa (Coastline)*, 115 x 47 cm.
25. *Costa cerca de Almería (Coastline near Almería)*, 100 x 61 cm.
26. *Alava*, 121 x 90 cm.
27. *Castilla (Castile)*, 100 x 81 cm.
28. *Cielo castellano (Castilian Sky)*, 100 x 82 cm.
29. *Ciudad Real*, 100 x 82 cm.
30. *Costa mallorquina (Mallorca Coastline)*, 90 x 76 cm.
31. *Paisaje pirenaico (Pyrenean Landscape)*, 100 x 82 cm.

June 28 - July 18, 1973

ACOSTA GARCIA OF URUGUAY

Unlike other Latin American nations, Uruguay has no rich pre-Columbian past, but the esoteric symbols and rhythmical patterns of line that characterize pre-Columbian art have found their way into the paintings and graphics of the young Uruguayan artist Luis Acosta García.

Born in 1943 in Montevideo, Acosta García studied architecture for two years, 1960-1962, and later entered the National School of Fine Arts to study painting and graphics. In 1968 he worked under the tutelage of the Uruguayan painter and engraver Raúl Cattelani. Acosta García had his first one-man show at the Municipal Gallery in Montevideo in 1971 and has participated in group exhibitions in Uruguay (National Salon of Plastic Arts, 1970, 1971 and 1972), Puerto Rico (Latin American Print Biennial, San Juan, 1972), Yugoslavia (International Exhibition of Graphic Arts, Ljubljana, 1971), as well as in Argentina, Spain, France, Switzerland, and in West Germany. He has been awarded three national prizes, including the Gold Medal presented at the Salto Spring Salon in 1971. His work is represented in museum collections in Uruguay and Argentina.

This is the artist's first exhibition in the United States.

CATALOGUE

1. *American Revolution*
2. *The Earth Is a Man*
3. *Young Machine*
4. *Mechanic Orange*
5. *American Moon*
6. *Candombe Dance*
7. *Beautiful Machine*
8. *Morning Bird*
9. *Atomic Angel*
10. *Happy Day*
11. *American Bird*
12. *Use the Bomb*
13. *One*
14. *The Big Man*
15. *Meeting*
16. *Black Bird*

July 19 - August 9, 1973

BATUZ OF ARGENTINA

Argentina is a melting pot of cultures, predominately of European origin. Hungarian-born Batuz, who immigrated to Argentina in 1949, began his career as an artist in his adopted country. As a professional artist, he has worked in more than one medium but has devoted most of his career to the graphic arts. Both his paintings and prints are characterized by a richness of color and intricate abstract forms.

Rafael Squirru, the well-known Argentine critic and founder of the Museum of Modern Art in Buenos Aires, has written:

> Among the European artists who have profited from the spatial opportunity offered by America, both in the geographical and the spiritual sense, Batuz deserves a place of high regard.

Batuz was born in Budapest in 1933 and became a citizen of Argentina in 1955. He began his career as an artist in 1950, a year after arriving in Buenos Aires. He has had twelve one-man shows, all in Buenos Aires, and has participated in numerous national salons. Works by Batuz are included in private collections in Argentina, Germany, France, and the United States.

The current exhibition, the artist's first in this country, consists of a series of serigraphs that compile a 1972 portfolio. --*J.G-S.*

CATALOGUE

Portfolio of Serigraphs

1. *Intuisión (Intuition) No. 7*
2. *Intuisión (Intuition) No. 12*
3. *Intuisión (Intuition) No. 13*
4. *Intuisión (Intuition) No. 18*
5. *Imagen (Image)*
6. *Prólogo (Prologue)*
7. *El mundo del artista (World of the Artist)*

July 19 - August 9, 1973

JACOBO NOWENS OF ARGENTINA

The paintings of Argentine abstractionist Jacobo Nowens might be seen as intuitive interpretations of outer space or, more simply, as a balancing of cryptic forms in any space. There is a dramatic element in his work that is further heightened by his use of deep colors and long, broad brushstrokes that tend to pull or flow in opposite directions, sometimes converging, to create a sense of tension.

Nowens, who is both a painter and art director of the monthly magazine *Dinamis*, was born in Buenos Aires in 1933. He began his art studies in 1948. Since 1966 he has had twelve one-man shows in his native city and has participated in numerous group shows in Argentina, including the Municipal Salon of Moreno and Merlo earlier this year. He has been the recipient of several prizes and is represented in the collections of the Museum of Jewish Art of Buenos Aires, the Museum of Art of Tucumán, and the Museum of Art of Berazategui.

This is the first presentation of Nowens's work in the United States. --*J.G-S.*

CATALOGUE

Oils on Canvas

1. *Los primeros tiempos (The Earliest Times)*, 30 x 40 cm.
2. *Los primeros tiempos (The Earliest Times)*, 40 x 40 cm.
3-7. *Los primeros tiempos (The Earliest Times)*, 40 x 50 cm.
8. *Los primeros tiempos (The Earliest Times)*, 50 x 60 cm.
9-19. *Paisaje de luz y color (Landscape of Light and Color)*, 100 x 80 cm.
20. *Paisaje de luz y color (Landscape of Light and Color)*, 60 x 80 cm.
21. *Paisaje de luz y color (Landscape of Light and Color)*, 72 x 92 cm.
22-23. *Paisaje de luz y color (Landscape of Light and Color)*, 120 x 80 cm.
24. *Paisaje metafísico (Metaphysical Landscape)*, 80 x 60 cm.
25-26. *Fue la luz que creó al hombre (Light Created Man)*, 150 x 80 cm.
27. *Hombre y luz, juntos (Man and Light Together)*, 100 x 80 cm.
28. *Desciende una nueva luz (A New Light Descends)*, 120 x 80 cm.
29. *Se incrusta una nueva luz (Encased in a New Light)*, 100 x 80 cm.
30. *Nueva luz para el hombre (New Light for Man)*, 150 x 80 cm.

August 16 - September 5, 1973

RECHANY OF PUERTO RICO

Jorge Rechany is a painter who for many years followed a traditional approach to art, with precise, realistic renderings of nature, but recently his work has become more expressionistic and rigid in linear concept.

Born in San Juan, Puerto Rico, in 1914, Rechany began his art studies in 1927 with the painter Ramón Frade and later attended the workshop of Alejandro Sánchez Felipe. From 1936 to 1940 he attended the National Academy of Design in New York City and in 1958 studied for a year at the School of Sculpture and Painting and at the Advanced Center of the Plastic Arts, both in Mexico City. He has had nine one-man shows in his native Puerto Rico since 1934 and in 1962 exhibited at the San Marco Gallery in Rome. Besides having been represented in numerous national exhibitions, he has participated at the Third Hispanic-American Biennial, Barcelona (Spain), 1955; the First Inter-American Biennial of Painting and Prints, Mexico City, 1958; and at the Biennial of Latin American Prints, San Juan (Puerto Rico), 1970 and 1972.

Rechany has executed several murals in Mexico City and San Juan, and his paintings are included in public and private collections in Mexico, Puerto Rico, Belgium, and Italy.

CATALOGUE

Oils

1. *Electra*
2. *Igora II*
3. *Igora III*
4. *Igora IV*
5. *Igora V*
6. *Ultima llamada (Last Call)*
7. *Ticirón*
8. *Isla (Island)*
9. *Palomas (Doves)*
10. *La Virgen del Camino (The Virgin of the Road)*
11. *Fauna marina (Sea Fauna)*
12. *Flores (Flowers)*
13. *La actriz, Helena Montalbán (The actress, Helena Montalbán)*
14. *Retrato de María (Portrait of María)*
15. *Retrato de Isabel Norniella (Portrait of Isabel Norniella)*

October 25 - November 11, 1973

TRIBUTE TO PICASSO

Organization of American States. Tribute to Pablo Picasso (1881-1973). Resolution adopted at the Twelfth Plenary Session held April 14, 1973.

WHEREAS:

Pablo Picasso, who symbolized what is now considered contemporary art, died on April 8;

The Organization of American States, in its duty to cooperate in the development of culture, seeks to extol art as an instrument of peace, liberty, and brotherhood among peoples;

Picasso's work of genius, full of Hispanic content, exerted enormous influence on the contemporary art of the Americas and of the entire world; and

His work places him in the category of the great masters of painting, as one of the most illustrious figures in the world of art,

THE GENERAL ASSEMBLY

RESOLVES:

1. To express the deep sorrow of the Americas at the death of this exceptional artist.

2. To provide that tribute be paid to the memory of Pablo Picasso, on October 25, 1973, the anniversary of his birth, through the organization of an exhibit of paintings of the Americas, to be held at the headquarters of the Organization, with the participation of painters from each of the member states.

TRIBUTE TO PICASSO

INTRODUCTION

Pablo Picasso died in France on April 8, 1973, as the Third Regular Session of the General Assembly of the Organization of American States was meeting in Washington, D.C. The representation in this supreme organ of the inter-American system unanimously agreed that tribute should be paid to the artist's memory.

This exhibition, composed of twenty-four works representing the twenty-four nations of the Organization of American States, was planned in order to render a truly inter-American homage to Picasso. It is the result of a rigorous selection made by our Unit of Visual Arts and Crafts, taking into account the principal currents in contemporary art which, for the most part, have resulted from innovations undertaken by Picasso, the boldest of all contemporary painters, in his long and fruitful career. All twentieth-century art to date testifies to the influence of the great Spanish pioneer who throughout three generations constantly renewed his ideas without ever abandoning his unique expression.

In the Americas, where many have followed in his footsteps, it was fitting that this tribute was organized to embrace the trends prevalent in the art world of today. All the trends form part, in one way or another, of the tradition that inspires contemporary creativity and includes the directions in which Picasso intervened, discovering, developing, or modifying. The trends also include the primitive school, a direction not followed by Picasso but one that he encouraged and strongly stimulated at the beginning of the twentieth century, which reminds us of the wisdom of reflecting now and then on the fresh, pure well-springs of art in order to cleanse it of excesses of intellectualism.

With this simple tribute, the Organization of American States honors the memory of an artist whose contribution to humanity lives on in the contemporary painting of Americas. --*Galo Plaza*, Secretary General, Organization of American States.

CATALOGUE

Domingo Gatto (Argentina)
 1. *Picasso, floración de hierro (Picasso, Flowering of Iron)*, 1973, oil, 78 x 59"

Stella St. John (Barbados)
 2. *Red Batik*, 1973, 96 x 35"

María Luisa Pacheco (Bolivia)
 3. *Colinas (Hills)*, 1973, mixed media, 50 x 66"

Antônio Henrique Amaral (Brazil)
 4. *Bananas e corda (Bananas and Rope)*, 1973, oil, 48 x 72"

Rodolfo Opazo (Chile)
 5. *La vigilancia única (The Unique Vigilance)*, 1972, oil, 26 x 33"

David Manzur (Colombia)
 6. *Formas para atrapar la luz (Forms to Catch the Light)*, 1973, mixed media

Lola Fernández (Costa Rica)
 7. *Oleo* (oil), 1973

Cundo Bermúdez (Cuba)
 8. *Viernes 9 de noviembre (Friday, November 9th)*, 1973, oil, 48 x 34"

Darío Suro (Dominican Republic)
 9. *Rosa y negro (Pink and Black)*, 1959, gouache and tempera, 34 x 23"

Aníbal Villacís (Ecuador)
10. *Precolombino (Pre-Columbian)*, 1973, mixed media, 48 x 48"

Mauricio Aguilar (El Salvador)
11. *Pera (Pear)*, 1973, oil, 48 x 36"

Elmar Rojas (Guatemala)
12. *Estampas de la realidad (Glimpses of Reality)*, 1972, oil, 48 x 60"

Joseph Jean-Gilles (Haiti)
13. *Paysage Haïtien (Haitian Landscape)*, 1973, oil, 30 x 48"

José Antonio Velásquez (Honduras)
14. *Paisaje de San Antonio (View of San Antonio)*, 1973, oil, 47 x 60"

Everald Brown (Jamaica)
15. *A-Key Ackee Time*, 1973, oil, 26 x 28"

José Luis Cuevas (Mexico)
16. *Las verdaderas Damas de Aviñón (The Real Ladies of Avignon)*, 1973, ink, 25 x 33"

Armando Morales (Nicaragua)
17. *Mujer a punto de regresar (Woman About to Return)*, 1973, oil, 50 x 40"

Guillermo Trujillo (Panama)
18. *Iconografía prehispánica (Pre-Hispanic Iconography)*, 1973, oil, 32 x 36"

Carlos Colombino (Paraguay)
19. *Variación I sobre módulo y reflejo (Variation I on Modulation and Reflection)*, 1973, mixed media,
 59 x 59"

Fernando de Szyszlo (Peru)
20. *Interior Armendáriz (Armendáriz Interior)*, 1973, oil, 59 x 47"

M. P. Alladin (Trinidad and Tobago)
21. *Palms*, 1973, oil, 48 x 48"

Jasper Johns (United States)
22. *Target*, 1958, oil, 36 x 36"

Carlos Páez Vilaró (Uruguay)
23. *¡Hola Picasso! (Hello, Picasso!)*, 1973, oil, 77 x 51"

Alejandro Otero (Venezuela)
24. *Coloritmo (Colorhythm)*, 1960, duco on board, 78 x 18"

BIOGRAPHIES OF ARTISTS

AGUILAR, Mauricio (San Salvador, El Salvador, 1919-). Painter. Studied in Paris at the workshop of Christian Bérard and later attended the Académie Julian. He has had one-man shows in San Salvador, Lima, New York City, and Washington, D.C. He has participated in group exhibitions in Paris, New York, and São Paulo (São Paulo Biennial, 1967). Lives in New York City.

ALLADIN, M. P. (Trinidad, 1919-). Painter, poet, and art educator. Studied at Birmingham College of Arts and Crafts in England, Columbia University in New York, and in Trinidad. He has had one-man and group exhibitions in Trinidad and Tobago, Barbados, Jamaica, British Guiana, Brazil, Spain, England, Canada, and the United States, and has received several awards. Lives in Port-of-Spain, where he is director of culture of the Ministry of Education and Culture.

AMARAL, Antônio Henrique (São Paulo, Brazil, 1935-). Painter and printmaker. Has been awarded prizes in Brazil, Chile, and Cuba. He has had one-man shows in São Paulo, Rio de Janeiro, Santiago, Buenos Aires, La Paz, Mexico City, Geneva, London, and Washington, D.C. Major group exhibitions: São Paulo Biennial, 1959, 1961, 1963, 1965, 1967; *Brazilian Art Today*, Museum of Modern Art, São Paulo, Royal College of Art, London, 1964; International Festival of Painting, Cagnes-sur-Mer, France, 1971; Coltejer Biennial, Medellín, Colombia, 1972. In 1971 he was awarded the Grand Prize at the Twentieth National Salon of Modern Art in Rio de Janeiro (grant to travel and paint). Currently lives in New York City and São Paulo.

BERMUDEZ, Cundo (Havana, Cuba, 1914-). Painter and draftsman. Studied art in Cuba and Mexico. He has had one-man shows in Havana, Lima, Santiago, Port-au-Prince, and Washington, D.C., and has executed murals in Havana and San Juan (Puerto Rico). Major group exhibitions: San Francisco Museum of Art; Museum of Fine Arts, Buenos Aires; the Houston Museum of Art; Biennial of Venice and of São Paulo. Among the public collections in which he is represented are the William Rochill Gallery, Kansas City; the Museum of Modern Art, New York; and the National Museum of Havana. Lives in San Juan, Puerto Rico.

BROWN, Everald (Parish of St. Ann, Jamaica, 1917-). Self-taught painter and sculptor who is a carpenter by trade and priest of the Ethiopian Orthodox (Coptic) Church in Jamaica. He has been the recipient of several national awards, and his works have been included in group exhibitions in Washington, D.C., as well as in Europe. Lives in Kingston.

COLOMBINO, Carlos (Concepción, Paraguay, 1937-). Painter, printmaker, and architect. He has been the recipient of several awards, including the Grand Prize at the First Biennial of Quito, 1968. Since 1956 he has had one-man exhibitions in Asunción, Panama City, Buenos Aires, La Paz, Santiago, Madrid, Paris, and Washington, D.C. Major group exhibitions: *South American Art Today*, Dallas Museum of Fine Arts, 1959; Fourth Paris Biennial, 1965; *Art of America and Spain*, Madrid and other European capitals, 1963-1964; Menton Biennial, France, 1970; *Great Young Artists of Today*, Paris, 1970; Coltejer Biennial, Medellín (Colombia), 1970. Lives in Asunción.

CUEVAS, José Luis (Mexico City, 1933-). Draftsman and printmaker. Has had more than seventy-five one-man

exhibitions in the United States, Latin America, and Europe. Awards include First International Prize for Drawing, Fifth São Paulo Biennial, 1959; Seventh International Black and White Exhibition, Lugano (Switzerland), 1962; First International Prize for Printmaking, First New Delhi Triennial, 1968. Series of lithographs: *The Worlds of Kafka and Cuevas, Crime by Cuevas, Homage to Quevedo, La Rue des Mauvais Garçons*, among others. Over 100 group exhibitions. Major public collections: Museum of Modern Art and Guggenheim Museum, New York; Philadelphia Museum of Art; Phillips Collection, Washingotn, D.C.; Museum of Fine Arts, Caracas; Museum of Modern Art, Bogotá. Lives in Mexico City.

FERNANDEZ, Lola (Costa Rica, b. Cartagena, Colombia, 1926-). Painter. Is a member of the faculty of the School of Fine Arts, University of Costa Rica, San José. She has had solo shows in San José, Bogotá, Panama City, Geneva, and Washington, D.C. She has participated in group exhibitions in Costa Rica, Mexico, the United States, and in Europe. Lives in San José (Costa Rica), and Geneva (Switzerland).

GATTO, Domingo (Buenos Aires, Argentina, 1935-). Painter and printmaker. Major one-man exhibitions in Buenos Aires, Córdoba, Washington, D.C., and San Juan (Puerto Rico). He has been awarded more than thirty national prizes, including grants to travel and work in Spain and Israel, 1965, and in Greece, 1969. He has participated in group exhibitions in Argentina, Colombia, Israel, and the United States. Lives in Buenos Aires.

JEAN-GILLES, Joseph (Hinche, Haiti, 1943-). Painter. Has had one-man exhibitions in Washington, D.C., New York City, and Port-au-Prince. His work has been included in group exhibitions in New York (Studio Museum, Harlem, 1965; Brooklyn Museum, 1969), Haiti, and Colombia (Coltejer Biennial, Medellín, 1972). Lives in Nyack, New York.

JOHNS, Jasper (Augusta, Georgia, 1930-). Painter and printmaker. Has had more than forty one-man exhibitions in the United States and Europe. Since 1957 has participated in more than 100 group exhibitions, including the Venice Biennial, 1958 and 1964. Major one-man exhibitions: Jewish Museum, New York City, 1964; Pasadena Art Museum, California, 1965; Ashmolean Museum, Oxford, England, 1965; National Collection of Fine Arts, Washington, D.C., 1966; Philadelphia Museum of Art, 1970; Museum of Modern Art, New York, 1970, 1971; circulating exhibitions sponsored by the Museum of Modern Art, 1968, 1970; Minneapolis Institute of Art, 1971; Houston Museum of Fine Arts, 1972. Has lived in New York City since 1952.

MANZUR, David (Neira, Colombia, 1929-). Painter, printmaker, and stage designer. Has had one-man shows in Bogotá, Cali, Toronto, Washington, D.C., and New York City. He was awarded the Guggenheim Foundation Fellowship in 1961 and 1962 and an OAS grant in 1964. He studied at the Art Students League and Pratt Graphic Arts Center, both in New York City, as well as at the Institute of Science in Chicago. Major group exhibitions: Venice Biennial, 1958; *Art of America and Spain*, Madrid, Barcelona, and other European cities, 1963-64; *Art of Colombia*, Madrid and Rome, 1963; São Paulo Biennial, 1963; Art Institute of Chicago, 1965; Coltejer Biennial, Medellín, 1970; *Colombian Artists Today*, Museum of Modern Art, Bogotá, 1973. Lives in Bogotá, where he directs the David Manzur Workshop.

MORALES, Armando (Granada, Nicaragua, 1927-). Painter, draftsman, and printmaker. Has received numerous awards, including the Ernest Wolf Prize for Best Latin American Artist at the São Paulo Biennial, 1959, and the J.L. Hudson Prize at the Pittsburgh International, 1964. He has had one-man shows in Lima, Panama City, Bogotá, Mexico City, Detroit, Kansas City, Washington, D.C., New York City, and Toronto. Among the public collections in which he is represented are the Museum of Modern Art, New York; the Institute of Contemporary Art, Boston; the Guggenheim Museum, New York City; the Institute of Art, Detroit; and the Museum of Fine Arts, Caracas. Lives in Princeton, New Jersey, and New York City.

OPAZO, Rodolfo (Santiago, Chile, 1935-). Painter, draftsman, and printmaker. Has had one-man shows in Santiago, Panama City, Buenos Aires, La Paz, Washington, D.C., and New York City. He has received numerous awards, including Honorable Mention at the Fifth São Paulo Biennial, 1959. He has participated in group exhibitions in São Paulo (São Paulo Biennial, 1959, 1961, 1965), Cali, Caracas, San Juan, Berlin, Madrid, Nottingham, Washington, D.C., and New York. Among the public collections in which he is represented are the Museum of Modern Art of New York and Buenos Aires. Lives in Santiago.

OTERO, Alejandro (El Manteco, Venezuela, 1921-). Painter and sculptor. He has had numerous one-man exhibitions in capital cities of Latin America as well as in London, Paris, and Washington, D.C. Recipient of the

National Painting Prize in 1958. Major group exhibitions: Pittsburgh International, 1956, 1958; Venice Biennial, 1956, 1962, 1966; São Paulo Biennial, 1957, 1959; Museum of Modern Art, New York, 1957; *Venezuelan Painting*, Museum of Fine Arts, Caracas, 1961; Le Havre Museum, France, 1963; Guggenheim International, 1964; *Art in Latin America since Independence*, 1966. In 1971-72 obtained a Guggenheim Memorial Fellowship for advanced research in the visual arts at Massachusetts Institute of Technology. Lives in Caracas.

PACHECO, María Luisa (La Paz, Bolivia, 1919-). Painter and draftsman. Has had solo shows in La Paz, Buenos Ares, Santiago, Lima, Caracas, Washington, D.C., and New York City. Major group exhibitions: São Paulo Biennial, 1953, 1955, 1959; *South American Art Today*, Dallas Museum of Fine Arts, 1959; *Magnet: New York*, New York, Pittsburgh, Mexico City, 1965; *The Emergent Decade*, Guggenheim Museum, 1966; *Art in Latin America since Independence*, Yale University, University of Texas, University of Arizona, San Francisco Museum of Art, 1966. Awarded Guggenheim Memorial Fellowship in 1958, 1959, and 1960. Lives in New York City.

PAEZ VILARO, Carlos (Montevideo, Uruguay, 1923-). Painter and sculptor. Has had one-man and group exhibitions in Montevideo, Rio de Janeiro, São Paulo, Madrid, Rome, Paris, London, Washington, D.C., and New York City, as well as in the capital cities of several African nations. Awarded a prize at the Eighth São Paulo Biennial. He has executed murals in public buildings in the United States, Latin America, Africa, Australia, and Tahiti, including the Pan American Union tunnel mural. He co-produced and directed with Gerard Levy-Clerc the films *Batouk* and *Pulsation*, both of which were selected for presentation at the Cannes Film Festival, 1967 and 1969. Lives in São Paulo.

ROJAS, Elmar (Guatemala City, 1937-). Painter and architect. Graduated from the National School of Fine Arts and University of San Carlos, Guatemala City. He has had one-man exhibitions in Guatemala City and Washington, D.C. Major group exhibitions: *Art of America and Spain*, Madrid, Barcelona, and other European cities, 1963-64; Paris Biennial, 1959, 1961, 1965; São Paulo Biennial, 1967, 1969; International Festival of Painting, Cagnes-sur-Mer, France, 1969; Palace of Fine Arts, Mexico City, 1970. Lives in Guatemala City.

ST. JOHN, Stella (Barbados, 1933-). Self-taught painter. Turned from painting to creating batiks some six years ago. She has had solo shows in Barbados and London and has participated in group exhibitions in Mexico City (International Olympic Festival, 1968), San Juan (Puerto Rico), São Paulo (São Paulo Biennial, 1967, 1971), Washington, D.C., and in Jamaica and Guyana. Lives in Christ Church, Barbados.

SURO, Darío (La Vega, Dominican Republic, 1917-). Painter, draftsman, printmaker. Has had one-man shows in Santo Domingo, Mexico City, Madrid, New York City, and Washington, D.C. Major group exhibitions: Riverside Museum, New York City, 1939; Palace of Fine Arts, Mexico City, 1946; Hispanic-American Biennial, Madrid, Barcelona, 1951; Pittsburgh International, 1952; Coltejer Biennial, Medellín, Colombia, 1970. Has frequently contributed articles on pre-Columbian and contemporary art to publications in the Dominican Republic, Spain, and the United States. Lives in Washington, D.C., where he is Minister of Cultural Affairs of the Embassy of the Dominican Republic.

SZYSZLO, Fernando de (Lima, Peru, 1925-). Painter, draftsman, and printmaker. Has had one-man shows in Lima, Rio de Janeiro, São Paulo, Santiago, Quito, Mexico City, Havana, Bogotá, San Juan (Puerto Rico), Paris, Washington, D.C., and New York City. Major group exhibitions: São Paulo Biennial, 1957, 1959; Venice Biennial, 1958; Pittsburgh International, 1958; Art Institute of Chicago, 1959; Institute of Contemporary Art, Boston, 1963; Guggenheim International, 1963; *Art of Latin America since Independence*, Yale University, University of Texas, University of Arizona, San Francisco Museum of Art, 1966; *The Emergent Decade*, the Guggenheim Museum, 1966; Coltejer Biennial, Medellín, Colombia, 1970. He was awarded the Guggenheim Foundation Fellowship in 1958, 1959, and 1969. Lives in Lima.

TRUJILLO, Guillermo (Horconcitos, Panama, 1927-). Painter and architect. He has had one-man exhibitions in Panama City, Lima, San Juan (Puerto Rico), Madrid, and Washington, D.C. In 1970 and 1973 he was awarded First Prize at the National Xerox Art Competition in Panama City. Major group exhibitions: Hispanic-American Biennial, Barcelona (Spain), 1957; São Paulo Biennial, 1959, 1967; *Art of Latin America since Independence*, Yale University, University of Texas, University of Arizona, San Francisco Museum of Art, 1966; Coltejer Biennial, Medellín, Colombia, 1970. Trujillo lives in Panama City and is professor of architecture at the National University.

VELASQUEZ, José Antonio (Caridad, Honduras, 1906-). Self-taught painter who practiced different trades until he began to paint in 1933. Until recent years, he still worked as a barber and was mayor of the town of San Antonio de Oriente (Honduras). He has had one-man exhibitions in Tegucigalpa and in several other capital cities of Latin America as well as in Washington, D.C. He has participated in numerous group shows, including the São Paulo Biennial, the exhibition *From Rousseau to Our Day* in Knokke-Le-Zoute (Belgium), in museums in Rotterdam and Baden-Baden, the Pittsburgh International, and the Coltejer Biennial, Medellín, Colombia. Lives in Tegucigalpa.

VILLACIS, Aníbal (Ambato, Ecuador, 1927-). Painter and draftsman. Studied at the San Fernando Academy and at the National School of Fine Arts in Madrid. He has had one-man exhibitions in Quito, Guayaquil, Caracas, Bogotá, Rio de Janeiro, Madrid, and Washington, D.C., and has participated in group exhibitions in capital cities of Latin America as well as in the United States. He has been the recipient of numerous national prizes. Lives in Quito.

November 13 - 28, 1973

ANA MARIA BLANCO OF ARGENTINA

Although Argentina covers an immense territory, there is a certain unity in the artistic climate of the country. Buenos Aires, Latin America's largest capital city, is necessarily the center of activity, but the art movement is by no means restricted to Buenos Aires alone. Even the smaller cities in the interior have a significant number of highly creative personalities who are well aware of contemporary art trends and help contribute to the art movement as a whole.

The current exhibition features the work of Ana María Blanco who was born in San Juan, Argentina, in 1917 and has lived there since childhood. The only exception was the period between 1945 and 1948 when she studied painting and drawing in Buenos Aires with Ernesto Scotti. Ms. Blanco has had five solo shows in Argentina since 1949 and has exhibited outside the country in Rio de Janeiro and Paris. She has participated in local and national group exhibitions, including the National Salon of Plastic Arts in Buenos Aires in 1963, and in 1971 she participated in the exhibition Great Young Artists of Today in Paris. Works by Ms. Blanco are in public collections in Mendoza and San Juan.

This is the first presentation of her paintings in the United States. --*J.G-S.*

EXHIBITION LIST [1]

Paintings

Del círculo (The Circle)

 1-2. *De la serie azul (From the Blue Series)*, oil
 3. *De la serie violeta (From the Violet Series)*, oil
 4. *De la serie jaune (From the Jaune Series)*, oil
 5. *De la serie blanca (From the White Series)*, oil
 6. *De la serie jaune (From the Jaune Series)*, oil
 7. *De la serie negra (From the Black Series)*, relief
 8-9. *De la serie argenta (From the Argenta Series)*, collage
 10. *De la serie verde (From the Green Series)*, oil
 11. *De la serie violeta (From the Violet Series)*, oil
 12. *De la serie negra (From the Black Series)*, oil
 13-14. *De la serie roja (From the Red Series)*, oil
 15. *De la serie jaune (From the Jaune Series)*, oil

[1] Not included in the original catalogue. --*Ed.*

16. *De la serie roja (From the Red Series)*, oil
17. *De la serie negra (From the Black Series)*, oil
18. *De la serie gris (From the Gray Series)*, oil
19. *De la serie jaune (From the Jaune Series)*, oil
20. *De la serie blanca (From the White Series)*, relief
21. *De la serie violeta (From the Violet Series)*, oil
22-24. *De la serie roja (From the Red Series)*, oil
25. *De la serie azul (From the Blue Series)*, oil
26. *De la serie verde (From the Green Series)*, oil
27-28. *De la serie gris (From the Gray Series)*, oil

November 13 - 28, 1973

MINIATURES BY RENE AGUERO SOSA OF ARGENTINA

Argentine born René Agüero Sosa is a self-taught artist who specializes in miniatures competently executed in watercolor. While he has dedicated much of his time to this field, he has also pursued his interest in other areas, such as political science which led to a career in the diplomatic field, medicine, and languages, and he has been a fiction writer, journalist, musician, lecturer in languages and geography, and an aviation technician. His works have been exhibited in Argentina as well as in several European countries.

CATALOGUE

Watercolors

1. *Despúes de la lluvia (After the Rain)*
2. *Quincho criollo (Creole Shack)*
3. *Salto Dos Hermanas, Cataratas del Iguazú (Dos Hermanas Falls, Iguazú Falls)*
4. *Lago Mascardi y Cerro Bonete (Lake Mascardi and Bonete Hill)*
5. *El viejo cacique (The Old Chief)*
6. *Hospital de clínicas*, Montevideo
7. *La carta (The Letter)*
8. *Ambiente (Environment)*
9. *La cantante (The Singer)*
10. *Mar y rocas (Sea and Rocks)*, Mar del Plata
11. *Pampa y nubes (Pampa and Clouds)*
12. *Camino al calvario (Road to Calvary)*
13. *El maestro (The Maestro)*
14. *Rio Jáchal (Jáchal River)*
15. *Verónica*
16. *Tafí del Valle*, Tucumán
17. *Bariloche, Rio Negro*
18. *Estancia (Ranch)*, Santiago del Estero
19. *Amanecer, Canal de Beagle (Sunrise, Beagle Canal)*, Tierra del Fuego
20. *Cataratas del Iguazú (Iguazú Falls)*
21. *Misiones*
22. *Rápidos del Río Cranberry (Cranberry River Rapids)*, United States
23. *Cataratas de Aguas Negras (Black River Falls)*, United States

December 3 - 16, 1973

PAINTINGS BY MARIO TORAL OF CHILE

Early this year Washington's Fendrick Gallery presented a comprehensive exhibition of watercolors by Chilean-born artist Mario Toral. The current exhibition, Toral's second in the Washington area, consists of paintings, a medium in which the artist has been working for only a short number of years.

Although the major part of his career has been devoted to watercolor and the graphic arts, Toral brings the same degree of professionalism to painting. His work is representative of a new trend that is taking form in contemporary Latin American expression, which might best be described as a new reality that goes beyond the oneiric and literary implications of surrealism to become a more absolute reality. Elements are taken from the real world, converted into plastic signs or symbols, and sustained within a geometric framework.

Toral was born in Santiago in 1934 and worked in the studio of Henri Adam in Paris. He later became professor of painting at the School of Art of Santiago's Catholic University and currently is an artist in residence at Fordham University in New York. He has had more than fifteen one-man shows in his native Chile, Argentina, Brazil, the United States, and France and has participated in numerous national and international exhibitions, among them, the Second International Triennial of Color Engraving, Grenchen, Switzerland, 1961; the Exhibition of Graphic Arts, Museum of Fine Arts, Belfort, France, 1961; the Fifth International Print Biennial, Ljubljana, Yugoslavia, 1963; *Chilean Painting*, Museum of Modern Art, Buenos Aires, 1967; First Biennial of Modern Art, Quito, 1968, and the Second and Third International Exhibition of Original Drawings, Rijeka, Yugoslavia, 1970 and 1972. He has been awarded eight prizes, including First Prize for Printmaking at the Salon of Fine Arts, Paris, 1961; First Prize for Printmaking at the Official National Salon, Santiago, 1962; the Critics' Prize for Best Exhibition of the Year, Santiago, 1963; and the Wolf Prize for Latin American Artists at the Ninth São Paulo Biennial, 1967.

Toral's work is represented in the collections of the Museum of Modern Art of New York, São Paulo, and Rio de Janeiro; the Brooklyn Museum of Art and the Metropolitan Museum of Art in New York City; and the Museum of Contemporary Art in Santiago. *--J.G-S.*

CATALOGUE

Oil and Acrylic on Canvas, 1973

 1-2. *Pintura (Painting) I and II*, 72 x 72"
 3. *Pintura (Painting) III*, 84 x 50"
 4-9. *Pintura (Painting) IV and IX*, 60 x 60"
10-11. *Pintura (Painting) X and XI*, 60 x 50"
12-14. *Pintura (Painting) XII and XIV*, 50 x 36"

December 17, 1973 - January 6, 1974

ANTONIO ALCANTARA OF VENEZUELA

Antonio Alcántara was born at the end of the last century and today is considered among the best-known artists in Venezuela. He was one of the young painters who around 1916 contributed to the post-impressionist style that characterizes the important group of landscapists later known as the School of Caracas.

Devoted to drawing and painting since an early age, Alcántara was introduced to impressionism by two artists--the Bohemian Rumanian Samys Mützner and Emilio Boggio, a brilliant Venezuelan who was an expatriate in Paris and a friend of both Pissarro and Renoir. Alcántara's personality and his talent allowed him to assimilate their teaching rapidly and to create his own style adapted to the light and violence of the tropical landscape.

Alcántara was soon discovered and appreciated by Venezuelan and foreign collectors alike. His landscapes awakened considerable interest when they were taken to Europe and the United States. Still, however, he had to face a long period of difficulties in a country where art had a very limited public. With strong determination, he was able to organize exhibitions and participate in numerous shows in Venezuela and abroad, subsequently receiving prizes and medals in Spain and Belgium. Aware of his own artistic merit and certain of the direction that he had chosen, he evolved imperceptibly toward an original interpretation of the Venezuela landscape. Rather than adhere to a fixed, orthodox impressionism, he began to analyze the tropical light until he arrived at a technique that has affinities with divisionism. Remembering the advice of the master Boggio, he began to observe the dawn, the clouds, and rainy days with greater care. He was no longer interested in the violence of color but rather in the decomposition of light on objects. Although Alcántara prefers to paint with oils, he always uses soft, pastel hues that give a poetic expression to his work. With the years came success and recognition of

his talent. Alcántara is now represented in museums and private collections in his own country and has exhibited in New York, Paris, and Madrid. He has traveled around the world adapting his vision to the European, American, and Japanese landscapes. Untiring, he is as active now as when he was a restless boy rising before dawn to walk miles to paint El Avila, the mountain that dominates the Caracas Valley, in the morning sun.

CATALOGUE

Oils

1. *El Avila under the Sun*, seen from the Country Club, Caracas
2. *El Avila Slopes with Huts*, Caracas
3. *Oromana Forest, Seville*, Spain
4. *Tree, San José del Avila*, Caracas
5. *Manglares, Isla de los Corales (Coral Islands)*, Falcón, Venezuela
6. *La Seine, Sunset*, Melun, France, 65 x 50 cm.
7. *Salto de La Llovizna (La Llovizna Falls)*, Caroní River, Venezuela
8. *El Bosque de Barbizon por la tarde (Afternoon in the Barbizon Forest)*, France, 55 x 46 cm.
9. *Ormana among Pines*, Seville, Spain
10. *Los pinos de San Marcos (The Pines of San Marcos)*, Loja, Spain, 65 x 50 cm.
11. *Barbizon Forest at Noon*, France
12. *El Avila desde el Country Club (El Avila Seen from the Country Club)*, Caracas, 1950
13. *Azabu Gardens, Prince Hotel*, Tokyo
14. *Gardens of the International Hotel*, Kyoto
15. *Gardens of the Sheraton Park Hotel*, Washington, D.C.
16. *Playa de Torremolinos (Torremolinos Beach)*, Málaga, Spain, 55 x 46 cm.
17. *El Avila desde el Country Club (El Avila at Noon Seen from the Country Club)*, Caracas, 1950
18. *Atardecer en Tokyo (Sunset in Tokyo)*
19. *Among the Palms*, Honolulu
20. *Gardens of the Lake Side Hotel*, Hikko, Japan

ABOUT THE ARTIST

ALCANTARA, Antonio. Born in Caracas, June 27, 1898. Studied at the School of Fine Arts of Caracas, 1917-1923, where his professors were Cruz Alvarez García and Almeida Crespo. Obtained prizes and diplomas.

1920 Meets the masters Emilio Boggio, Samys Mützner, and Ferdinandov, from whom he learned the technique of impressionism. First individual exhibition in the galleries of the School of Music and Speech, Caracas.
1922 Individual exhibition at the Venezuela Club. Landscapes and figures executed in Margarita.
1930 International exhibition in Liège, Belgium. Obtained Diploma and Silver Medal.
1949 Group exhibition at the Soviet-Venezuelan Center, Caracas. The Ambassador of the Soviet Union acquired the painting *El Avila as Seen from Florida*. Individual exhibition at the House of the Writer, Caracas.
1950 Group exhibition at the Ateneo de Valencia, Venezuela.
1951 Exhibited at the First Hispanic-American Biennial of Art, Madrid. Obtained a Diploma and one of his works was reproduced in the catalogue (painting in the collection of Don Eugenio Mendoza). Exhibited at the Museum of Fine Arts of Caracas, Gallery of Independent Artists. Annual Salon, Ateneo de Valencia, Venezuela. Awarded Antonio Edmundo Monsanto Prize.
1951-52 First trip to the United States, Portugal, Spain, and France.
1952 Exhibition at the Museum of Fine Arts of Caracas, Annual Salon. Obtained the Federico Brandt Prize. The Museum of Fine Arts acquired the work. Individual exhibition at the Museum of Fine Arts, Caracas.
1954 Participated in the group exhibition organized by the Secretary General of the Tenth Inter-American Conference of Caracas.
1965 Individual exhibition at the Mendoza Gallery, Caracas.
1966-67 Second trip to Spain, France, Italy, and Greece, visiting museums and art galleries.
1967 Individual exhibition at the Mendoza Gallery, Caracas.

1968	Exhibition organized by the Gallery of Modern Art and a group of admirers in tribute to the artist's seventieth birthday.
1969	Individual exhibition at the Emil Walter Gallery, New York City.
1969	Individual exhibition at the Gallery of Modern Art, Caracas.
1969-70	Third trip to France, Spain, and Italy.
1969	Participated in the exhibition of contemporary art in Monaco. Obtained Diploma of Honor.
1970	Individual exhibition at the Marcel Berhein Gallery, Paris. Group exhibition organized by the Association of Venezuelan Painters and Sculptors in tribute to Venezuelan Navy.
1971	Individual exhibition at the Gallery of Modern Art, Caracas. Group exhibition at the Caravaggio Gallery, Caracas.
1972	Exhibition of drawings and oils at the LI Gallery, Caracas.
1972	Group exhibition at the Marcos Castillo Gallery, Caracas. Traveled to Mexico, the United States, Japan, and Hawaii.
1973	*Exhibition of Masters* at the Acquavella Gallery, Caracas. Individual exhibition at the Mendoza Gallery, Caracas.

YEAR 1974

January 7 - 21, 1974

COLONIAL ARCHITECTURE OF MEXICO

In 1967 Judith Hancock de Sandoval was awarded an OAS grant to study colonial architecture in Mexico. During a period of two years she compiled a photographic archive of over 22,000 photos of colonial buildings at different locations throughout the country, most of which were acquired for the archives of Harvard's Fogg Art Museum, the National Gallery of Art, Washington, D.C., and the National Institute of Anthropology and History of Mexico. The current exhibition consists of a selection of those photos as well as more recent works.

Mrs. Sandoval, wife of Mexican film director Douglas Sandoval, was born in New York City and attended the universities of Arizona, New Mexico, and Ohio Wesleyan, as well as the Institute of Fine Arts and the Mexican-North American Cultural Institute, both in Mexico City. She has published her photos in books by Elisa Vargas Lugo de Bosch and the late Dr. Francisco de la Maza, and currently is planning to publish more than 230 photos in a major book on colonial monuments in the State of Michoacán. Her work in Zacatecas was completed with the assistance of former Governor José Rodríguez Elías, Governor Pedro Ruiz González, and Roberto Félix, Director of Public Works. --*J.G-S.*

CATALOGUE

Photographs

1. *Government Palace*, Zacatecas
2. *Fountain at Plaza of Santo Domingo*, Zacatecas
3. *Cloister of San Agustín*, Zacatecas
4. *Cathedral*, Zacatecas
5. *Cathedral*, Zacatecas (façade)
6. *Cathedral*, Zacatecas (right lateral door)
7. *La Bufa*, Zacatecas
8. *La Guadalupe*, Guadalupe (façade)
9. *Santo Domingo*, Sombrerete (façade)
10. *La Parroquia*, Mazapil (façade detail)
11. *La Parroquia*, Jerez (façade)
12. *Wooden Ceiling, La Guadalupe*, Chalchihuitos
13. *Choir Loft, Chapel del Tránsito*, Fresnillo
14. *Hacienda San Mateo of Valparaíso* (rear view)
15. *Hacienda San Mateo of Valparaíso* (chapel and main house)
16. *Hacienda El Mezquite* (chapel)
17. *Hacienda El Mezquite* (arches on plaza)
18. *Ovens for Mezcal Production, Hacienda Tolosa*
19. *Grinding Platform, Hacienda La Trinidad*
20. *Granaries, Hacienda Santa Mónica*
21. *Storage Barns, Hacienda La Encarnación*
22. *House, Hacienda Santa Ana*
23. *Chapel Door, Hacienda La Encarnación*
24. *Chapel Altarpiece, Hacienda El Salto*
25. *Roof of Chapel, Hacienda San Mateo of Valparaíso*
26. *House Façade, Nochixtlán* (with balcony)
27. *House Façade, Nochixtlán* (with column)
28. *House Façade*, Pinos

29. *House Balcony*, Villanueva
30. *House of the Countess, Zacatecas* (chapel door)

<div align="right">January 7 - 21, 1974</div>

LUIS QUINTANILLA OF MEXICO

Among the new personalities emerging in the Mexican art world is Luis Quintanilla. A self-taught artist, Quintanilla is both a painter and draftsman. As a painter, he works within the post-cubist tradition, using a brilliant palette and applying the paint neatly in flat compositions. His drawings, on the other hand, are generally realistic renderings of the human figure.

Although he is a Mexican citizen, Quintanilla was born in 1930 in Washington, D.C. He is the son of Luis Quintanilla, former Ambassador of Mexico to the Organization of American States. Following his student years, which were spent in the United States, Mexico, and the Soviet Union, he was involved professionally in both agriculture and mining. It was not until some ten years ago that he began to work in the field of the plastic arts. Since 1965 he has participated in several group shows in Mexico City and in 1971 presented his first one-man exhibition there at the Gallery of Mexican Art.

This is Quintanilla's first exhibition outside Mexico. --*J.G-S.*

EXHIBITION LIST [1]

Paintings and Drawings

1-14. *Sin título (Untitled)*, acrylic on canvas
1-10. *Mindscapes*, drawings from the series *Explosión 1973 (Explosion 1973)*

<div align="right">January 22 - February 13, 1974</div>

RAFAEL PENAGOS OF COLOMBIA: DRAWINGS

Among the new personalities emerging in the Colombian art world is Rafael Penagos, a highly competent and imaginative artist whose work combines an obvious appreciation for the draftsmanship of the old masters with the search for a language of his own time. Like many other artists in Colombia today, including the master Enrique Grau whose work can be considered as one of the points of departure for him, Penagos is concerned with drawing as an art in itself, not merely as a means to an end.

Characteristic of Penagos's work is the use of the undulating line to define the female face or nude figure. His drawing is always relaxed but sure and void of any element that might distract from the unity of the human form. In its solidity, purity of line, and unity of conception, it corresponds to the classical.

Born in Suesca, Colombia, in 1941, Penagos has devoted his career solely to drawing. In 1959 he studied at the School of Fine Arts of the National University in Bogotá, but he is essentially a self-taught artist. He has had twelve one-man shows in Colombia, among them exhibitions at the Rebeca Gallery, 1968, 1969, and 1970; the Luis Angel Arango Library, 1972; and the El Minuto de Dios Museum of Contemporary Art, 1972 and 1973. In 1973 he exhibited at the Institute of Hispanic Culture in Madrid. Penagos has participated in more than twenty group exhibitions, and his work is represented in the collections of the El Minuto de Dios Museum of Contemporary Art, the Museum of Art at the University City, the Museum of Modern Art, and the Bank of Colombia, all in Bogotá, as well as in the collection of Braniff International in Texas.

[1] Not included in the original catalogue. --*Ed.*

This is Penagos's first exhibition in the United States. --*J.G-S.*

CATALOGUE

1 - 28. Drawings[1]

January 22 - February 13, 1974

NELLY SARMIENTO OF COLOMBIA: CERAMIC SCULPTURES

In Colombia it is not unusual for craftsmen, especially weavers and potters, to carry their skills and concepts beyond craftmaking to create pure plastic forms. Nelly Sarmiento is among those who have most successfully crossed the line. Having studied ceramics in the studio of Tina Vallejo for three years, 1961-1964, she gained a thorough knowledge of the techniques of the craft and later went to Denmark, where she worked with the sculptress Hildegard Isenstein, 1969-1970. Her ceramic sculptures are fantasy-like, often complex forms in which there is a feeling of solidity and a perfect blending of texture, form, and color.

Born in 1926 in Zapatoca, Colombia, Ms. Sarmiento began exhibiting her work professionally in 1968 and since that time has had six solo shows in Colombia and Germany. She has been awarded three national prizes and has participated in numerous group exhibitions in her native country as well as in Canada (Ceramics International '73, Alberta), Venezuela (*Women in Contemporary Art*, Institute of Fine Arts, Caracas), and in Argentina.

This is the first presentation of her work in the United States. --*J.G-S.*

EXHIBITION LIST [2]

Sculpture

1. *Contorsión (Contortion) II*, ceramic, white and black, 40 x 30 cm.
2. *Unión (Union) II*, ceramic, brown, 40 x 25 cm.
3. *Fuerza (Strength)*, ceramic, green, 40 x 60 cm.
4. *Explosión (Explosion)*, ceramic and stone, white, 40 x 40 cm.
5. *Vida (Life)*, ceramic and stone, white, 60 x 25 cm.
6. *Hostia (Sacrifice)*,[3] corrugated ceramic, polychrome, 38 x 38 cm.
7. *Fecundidad (Fecundity) III*, ceramic, various enamels, 28 x 28 cm.
8. *Figura (Figure) II*, ceramic, metallic black, 55 x 30 cm.
9. *Formación (Formation)*, ceramic, green, 38 x 38 cm.
10. *Unión (Union) III*, ceramic, metallic black, 60 x 35 cm.

February 14 - March 12, 1974

RALPH BANEY OF TRINIDAD AND TOBAGO

Generally using the rich woods native to Trinidad, sculptor Ralph Baney creates imaginative, free forms that are dictated by the nature of the material with which he works. Simply by responding to the torsions of the tree trunk, natural swellings, and the rhythm of the fibers, the artist is led to find a diversity of plastic values.

[1] Titles are unavailable. --*Ed.*

[2] Not included in the original catalogue. --*Ed.*

[3] Literal translation of this title is "Host." --*Ed.*

One of the most representative artists in his country today, Ralph Baney was born in San Fernando, Trinidad, in 1929. He was educated at Brighton College of Art, Sussex, England, 1957-1962; Alfred University, New York, 1968; and the University of Maryland, MFA, 1973. He has had four one-man exhibitions, including shows at the University of Maryland Art Gallery in 1972 and the Sculpture House Gallery in New York City in 1973, and has participated in more than ten two-man and group shows in Trinidad and abroad. Major group exhibitions include the São Paulo Biennial in 1967 and 1969, and Expo '67 in Canada. Baney has received five national prizes, and his work is represented in the collections of the National Museum and Art Gallery and University of the West Indies, both in Trinidad, and the Institute of Education of the University of the West Indies in Jamaica, among others. In December 1972 he participated in the OAS exhibition *Contemporary Art from the Caribbean*. --*J.G-S.*

EXHIBITION LIST [1]

Sculpture

1. *Newborn*, 1973, Trinidad samaan wood, height 111"
2. *Caribbean Rhythm*, 1972, Trinidad samaan wood, height 69"
3. *Standing Figure*, 1973, black walnut wood, height 56"
4. *Marine Form*, Trinidad apermat wood, length 39"
5. *Sanctuary III*, walnut wood and stone, height 39 1/2"
6. *Union*, 1971, oak wood, height 56"
7. *Three Piece Form*, 1971, maple wood, height 24"
8. *Golconda Woman*, Trinidad cyp wood, height 41 1/2"
9. *Standing Figure*, 1972, Trinidad roble wood, height 39"
10. *Musical Form*, walnut wood, height 30"
11. *Pierced Form*, 1971, sycamore wood, height 24"

March 15 - April 7, 1974

ART OF THE AMERICAS IN WASHINGTON PRIVATE COLLECTIONS
TRIBUTE TO THE ARTS OF THE AMERICAS

Exhibition coordinator: Jane Harmon de Ayoroa

INTRODUCTION

The Organization of American States joins the Washington Performing Arts Society in saluting the arts of the Americas with this exhibition of works by hemisphere artists in private collections in the metropolitan area of Washington. It is the first of a series that will be repeated in 1975 and 1976.

It is only fair to mention that the Corcoran Gallery of Art organized a similar exhibition some years ago and, prior to that, almost twenty-five years ago, the OAS presented two shows of modern art from Cuba and Mexico, also with works from local private collections.

The situation has changed markedly in the last quarter century. Today there are many more works by Latin American artists in collections in the area, and many more nationalities are represented. The OAS has done its part in helping to bring about these changes by providing permanent space in its headquarters for exhibitions of Latin American art and handicrafts for the past twenty-eight years. Until recently, it was the only consistent outlet for Latin American art in this country.

It is important to note that the OAS has acted only as an intermediary between the artists and the collectors, without any financial gain whatsoever. To our satisfaction, many collectors who have acquired works from our exhibitions have later sought out the artists of their interest in commercial galleries elsewhere, even traveling to Latin America to do so. Thus, while many works are being seen here for the second time, others are having their first local showing.

Consistent with the complex panorama of art in the Americas today, there is no predominant style in the

exhibition. The language employed is for the most part international, in some cases with only accents or subtle forms of differentiation that give a clue to the geographical origin of the works, thus affirming once again that there is no longer a national art, at least in terms of concept or technique, although it may sometimes be seen in the theme or subject matter.

As the first in a series of exhibits that will bring together the great variety of tendencies in the Americas, this show includes the representation of at least one artist from each of the OAS member nations, with only one work per artist. The sole example from the United States, belonging to a Latin American-born collector now living in this area, was chosen in order that we might show that there is truly a cross-cultural exchange between the northern and southern parts of the hemisphere. Although Canada is not an OAS member nation, it seemed appropriate that it be represented with at least one example.

In many instances we had access to several important works by artists who now enjoy international fame, and we would like to have those artists more fully represented. We have, therefore, chosen to present those same artists again in the coming exhibitions.

In the Washington area alone, more than one hundred persons have been collecting the art of the Americas over the years. Not only have we had to limit the number of collections from which we have chosen works, but some collections have been so extensive that we have had to select paintings or sculptures of smaller size by artists who might have been represented with much larger works. In the future exhibits we shall try to avoid these limitations. In no case, however, will we include works that belong to commercial galleries or to their owners.

This exhibition and those to follow will be useful as a survey of the art of the Americas in the hands of local collectors. It is a tribute to the collectors because it represents their foresight to look beyond the immediate horizon to a region rich in cultural history where paths are being reopened by today's artists. --*J.G-S.*

ACKNOWLEDGEMENTS

The Organization of American States would like to express its sincere appreciation to the Washington Performing Arts Society, especially to Mrs. James D. Theberge, Chairman of the Tribute to the Arts of the Americas, and Mrs. MacKenzie Gordon, Visual Arts Chairman; to the American Security and Trust Company for its contribution for the publication of the catalogue; and to the following collectors for their kindness in lending works to this exhibition:

Mr. and Mrs. Roberto Alvarez, Dr. and Mrs. Narciso Anillo, Mr. and Mrs. B.G. Bechhoefer, Ambassador and Mrs. William Bowdler, Mr. and Mrs. J.A. Boyer, Ambassador and Mrs. Henry E. Catto, Dr. Renald Cote, Mr. and Mrs. Dixon Donnelley, Mr. and Mrs. Guillermo Espinosa, Mr. and Mrs. Henry J. Fox, Ambassador and Mrs. Gonzalo García-Bustillos, Mr. and Mrs. Mackenzie Gordon, Mr. E. David Harrison, Mr. and Mrs. John Hechinger, Mr. and Mrs. Fred Jestaedt, Mr. and Mrs. Basil Korin, Mr. and Mrs. David Lloyd Kreeger, Dr. and Mrs. Fernando Leyva, Mr. and Mrs. Antonio Lulli, Mr. H. Marc Moyens, Mr. and Mrs. Alfonso Perea, Mr. and Mrs. Ernesto Ruiz de la Mata, Mrs. Nina Auchincloss Steers, Mr. and Mrs. Darío Suro, Mr. and Mrs. Norman Tolkan, Mr. and Mrs. Peter Treadway, Mr. and Mrs. Luis Ugueto, Embassy of Canada, Embassy of Jamaica.

CATALOGUE

Painting, Drawing, Sculpture

Rodolfo Abularach (Guatemala, 1933-)
 1. *Untitled*, 1958, ink on paper, 22 x 35". Coll. Ambassador and Mrs. Gonzalo García-Bustillos

Mauricio Aguilar (El Salvador, 1919-)
 2. *Coffee Grinder*, 1966, oil on Masonite, 36 x 40 1/2". Coll. Ambassador and Mrs. Gonzalo García-Bustillos

Félix Aráuz (Ecuador, 1935-)
 3. *Untitled*, 1970, tempera on paper, 22 1/2 x 31". Coll. Mr. and Mrs. J. A. Boyer

Mary Armstrong (Barbados, 1925-)
4. *One More Handful*, 1970, oil on Masonite, 11 1/2 x 12 1/2". Coll. Mr. and Mrs. Peter Treadway

Alejandro Aróstegui (Nicaragua, 1935-)
5. *Untitled*, 1964, mixed media, 31 1/4 x 48". Coll. Ambassador and Mrs. William Bowdler

Rudy Ayoroa (Bolivia, 1927-)
6. *Diemos*, 1970, Plexiglass, light, motor, diameter 36". Coll. Mrs. Nina Auchincloss Steers

Ada Balcácer (Dominican Republic, 1930-)
7. *Untitled*, ink on paper, 33 1/2 x 22 1/2". Coll. Mr. and Mrs. Darío Suro

Ralph Baney (Trinidad, 1929-)
8. *Woman*, 1970, wood, height 36". Coll. Mr. and Mrs. Fred Jestaedt

Cundo Bermúdez (Cuba, 1914-)
9. *After the Act*, 1961, oil on canvas, 30 1/2 x 41". Coll. Ambassador and Mrs. William Bowdler

Fernando Botero (Colombia, 1932-)
10. *The First Lady*, 1967, oil on canvas, 72 x 65". Coll. Mr. and Mrs. Antonio Lulli

Ary Brizzi (Argentina, 1930-)
11. *Confluencias (Confluences) No. 3*, 1969, acrylic on canvas, 39 1/2 x 39 1/2". Coll. Mr. and Mrs. Alfonso Perea

Gerardo Caballero (Colombia, 1938-)
12. *Untitled*, 1970, pencil on paper, 23 x 17". Coll. Dr. and Mrs. Fernando Leyva

Emiliano Di Cavalcanti (Brazil, 1897-)
13. *Untitled*, 1941, oil on canvas, 12 1/2 x 16". Coll. Mr. and Mrs. Dixon Donnelley

Manuel Chong Neto (Panama City, 1927-)
14. *Pareja vestida de negro (Couple Dressed in Black)*, 1967, oil on canvas, 48 x 33". Coll. Dr. Renald Cote

Carlos Colombino (Paraguay, 1937-)
15. *Ita (Stone)*, 1965, wood, 63 x 63". Coll. Mr. and Mrs. Roberto Alvarez

Carlos Cruz-Diez (Venezuela, 1923-)
16. *Cromointerferencia (Chromointerference)*, 1970, Plexiglass and silkscreen, 23 x 23". Coll. Anonymous

José Luis Cuevas (Mexico, 1933-)
17. *De la serie de los funerales de un dictador (Funeral of a Dictator Series)*, 1957-58, ink on canvas, 75 x 50 1/2". Coll. Mr. H. Marc Moyens

Gene Davis (United States, 1920-)
18. *Untitled*, acrylic on canvas, 78 1/2 x 91". Coll. Dr. and Mrs. Narciso Anillo

Lola Fernández (Costa Rica, b. Colombia, 1926-)
19. *Untitled*, 1965, oil on canvas, 47 1/2 x 31 1/2". Coll. Mr. and Mrs. Guillermo Espinosa

Rafael Ferrer (Puerto Rico, 1933-)
20. *I Bring Truth*, 1963, iron. Coll. Mr. and Mrs. Ernesto Ruiz de la Mata

Raquel Forner (Argentina, 1902-)
21. *Astropeces (Astrofish)*, 1961, oil on canvas, 47" x 47". Coll. Mr. and Mrs. Guillermo Espinosa

Pedro Friedeberg (Mexico, b. Italy, 1937-)
22. *Ornithodelphia: The City of Bird Lovers*, 1963, ink on paper, 15 1/4 x 19 1/4". Coll. Mr. and Mrs. Norman Tolkan

Tikashi Fukushima (Brazil, b. Japan, 1920-)
23. *Untitled*, 1972, oil on canvas, 38 x 30". Coll. Ambassador and Mrs. Gonzalo García-Bustillos

Marcelo Grassmann (Brazil, 1925-)
24. *Untitled*, 1960, ink on paper, 19 x 25". Coll. Ambassador and Mrs. William Bowdler

Sarah Grilo (Argentina, 1920-)
25. *Untitled*, oil on canvas, 48 3/4 x 52 3/4". Coll. Mr. and Mrs. Norman Tolkan

Asilia Guillén (Nicaragua, 1887-1964)
26. *We Are of Today*, 1962, oil on canvas, 17 x 17". Coll. Mr. and Mrs. MacKenzie Gordon

Alfredo Halegua (Uruguay, 1930-)
27. *Untitled*, 1970, painted steel, 6 x 3 x 1'. Coll. Mr. and Mrs. John Hechinger

Roberto Huezo (El Salvador, 1947-)
28. *Landscape*, 1973, acrylic, 14 x 19". Coll. Ambassador and Mrs. Henry E. Catto

Angel Hurtado (Venezuela, 1927-)
29. *Triptych: Mars, Venus, Mercury*, 1971, collage, 39 1/2 x 60". Coll. Ambassador and Mrs. Gonzalo García-Bustillos

César Izquierdo (Guatemala, 1937-)
30. *Untitled*, 1966, oil on canvas, 17 x 22 3/4". Coll. Ambassador and Mrs. William Bowdler

Humberto Jaimes Sanchez (Venezuela, 1930-)
31. *Untitled*, 1963, acrylic on canvas, 47 x 44". Coll. Ambassador and Mrs. Gonzalo García-Bustillos

Jasmin Joseph (Haiti, 1923-)
32. *Lion*, oil on Masonite, 23 x 54". Coll. Mr. H. Marc Moyens

Wifredo Lam (Cuba, 1902-)
33. *Your Own Life*, 1942, gouache on paper, 41 1/2 x 34". Coll. Mr. and Mrs. David Lloyd Kreeger

Georges Liautaud (Haiti, 1899-)
34. *Crucifixion*, iron, 12 x 11". Coll. Mr. H. Marc Moyens

Eduardo Mac Entyre (Argentina, 1929-)
35. *Dentro de un círculo (Within a Circle)*, 1970, acrylic on canvas, 50 1/2 x 50 1/2". Coll. Ambassador and Mrs. Henry E. Catto

David Manzur (Colombia, 1929-)
36. *Spatial Equilibrium*, 1969, wood, nylon, acrylic on canvas, 59 x 67". Coll. Mr. and Mrs. Alfonso Perea

María Martins (Brazil, 1900-1973)
37. *Untitled*, 1971, bronze, 36 x 30". Coll. Mr. and Mrs. Dixon Donnelley

Roberto Matta (Chile, 1912-)
38. *Curved Night*, 1958, oil on canvas, 45 1/2 x 57 1/2". Coll. Mr. and Mrs. Guillermo Espinosa

Carlos Mérida (Guatemala, 1891-)
39. *Tiempo-espacio (Time and Space)*, 1965, oil on canvas, 28 x 36". Coll. Mr. and Mrs. B. G. Bechhoefer

Armando Morales (Nicaragua, 1927-)
40. *No. 2*, 1961, oil on canvas, 39 x 60". Coll. Mr. E. David Harrison

Leonardo Nierman (Mexico, 1932-)
41. *Feather*, 1960, oil on canvas, 20 x 24". Coll. Mr. and Mrs. David Lloyd Kreeger

Guillermo Núñez (Chile, 1930-)
42. *Untitled*, 1966, oil on canvas, 14 x 18". Coll. Mr. and Mrs. Basil Korin

Alejandro Obregón (Colombia, b. Spain, 1920-)
43. *Untitled*, 1961, oil on canvas, 17 x 22". Coll. Mr. and Mrs. MacKenzie Gordon

Rodolfo Opazo (Chile, 1935-)
44. *Untitled*, 1962, oil on canvas, 48 3/4 x 52 3/4". Coll. Mr. and Mrs. Norman Tolkan

Amelia Peláez (Cuba, 1887-1968)
45. *Mujeres en el balcón (Women on Balcony)*, 1944, gouache on paper, 21 1/2 x 29 1/2". Coll. Ambassador and Mrs. William Bowdler

Héctor Poleo (Venezuela, 1918-)
46. *Untitled*, 1945, pen and ink, 13 x 9". Coll. Mr. and Mrs. Luis Ugueto

Rogelio Polesello (Argentina, 1939-)
47. *No. 20*, 1963, oil on canvas, 77 x 51". Coll. Ambassador and Mrs. Gonzalo García-Bustillos

Cândido Portinari (Brazil, 1903-1962)
48. *Untitled*, 1941, gouache on paper, 11 x 8 1/2". Coll. Mr. and Mrs. Dixon Donnelley

René Portocarrero (Cuba, 1912-)
49. *Angeles (Angels)*, 1941, gouache on paper, 14 x 9". Coll. Ambassador and Mrs. William Bowdler

Omar Rayo (Colombia, 1928-)
50. *Words*, 1962, oil on canvas, 27 x 25". Coll. Mr. and Mrs. Basil Korin

Jean-Paul Riopelle (Canada, 1923-)
51. *Untitled*, 1954, oil on canvas, 29 x 36". Coll. Embassy of Canada

Diego Rivera (Mexico, 1886-1957)
52. *Woman with a Basket*, 1937, tempera on paper, 14 3/4 x 11". Coll. Mr. and Mrs. B.G. Bechhoefer

Joaquín Roca Rey (Peru, 1923-)
53. *Untitled*, bronze, 12 x 10". Coll. Mr. and Mrs. Antonio Lulli

St. Jean (Haiti)
54. *Noël Merci Noël*, 1972, oil on canvas, 19 1/2 x 27". Coll. Mr. H. Marc Moyens

Norberto Santana (Dominican Republic, 1943-)
55. *Head*, 1970, oil on canvas, 16 x 12". Coll. Mr. and Mrs. Darío Suro

Alfredo Da Silva (Bolivia, 1936-)
56. *Macrocosmos*, 1962, oil on canvas, 50 x 35 3/4". Coll. Mr. and Mrs. Basil Korin

Jesús Rafael Soto (Venezuela, 1923-)
57. *Vibración (Vibration)*, 1963, mixed media, 42 x 42". Coll. Mr. and Mrs. Luis Ugueto

Fernando de Szyszlo (Peru, 1925-)
58. *Wamani*, 1963, oil on canvas, 32 x 44". Coll. Mr. and Mrs. Antonio Lulli

Rufino Tamayo (Mexico, 1899-)
59. *Boy's Head*, 1972, oil on canvas, 15 x 10". Coll. Mr. and Mrs. B.G. Bechhoefer

Joaquín Torres-García (Uruguay, 1874-1949)
60. *Composición constructiva (Constructivist Composition)*, 1931, oil on canvas, 23 x 18". Coll. Mr. and Mrs. MacKenzie Gordon

Raúl Valdivieso (Chile, 1931-)
61. *Cabeza (Head) I*, 1964, bronze, 31 1/2" x 16". Coll. Mr. E. David Harrison

Adela Vargas (Nicaragua, 1911-)
62. *Leyenda de La Peña del Tigre (Legend of La Peña del Tigre)*, 1970, oil on canvas, 15 1/2 x 19". Coll. Ambassador and Mrs. Henry E. Catto

José Antonio Velásquez (Honduras, 1906-)
63. *San Antonio de Oriente*, 1971, oil on canvas, 52 x 66". Coll. Ambassador and Mrs. Gonzalo García-Bustillos

Kazuo Wakabayashi (Brazil, b. Japan, 1931-)
64. *Untitled*, 1969, mixed media, 30 x 30". Coll. Mr. and Mrs. Guillermo Espinosa

Barry Watson (Jamaica, 1931-)
65. *Shepherd in the Spirit*, 1964, oil on canvas, 35 1/2 x 47 1/2". Coll. Embassy of Jamaica

Francisco Zúniga (Mexico, b. Costa Rica, 1912-)
66. *Seated Woman*, 1966, bronze, 30 x 34 x 50". Coll. Mr. and Mrs. Henry J. Fox

BIOGRAPHICAL NOTES [1]

BALCACER, Ada. Painter, draftsman, printmaker, ceramist, textile designer, born in Santo Domingo, Dominican Republic, 1930. Graduated from the Escuela Nacional de Bellas Artes, Santo Domingo, 1956; for three years worked at the Taller Libre, Universidad de Río Piedras, Puerto Rico. Lived and worked in New York, where she studied artistic design, printmaking, and ceramics in private and public institutions, including the Art Students League. In 1962 she returned to Santo Domingo, where she was a founding member of the group *Proyecta*, 1968, and held several individual exhibitions. Participated in national and international group shows in France, England, Yugoslavia, and biennials in Santo Domingo (1949), Hispanic-American Art, Madrid (1951), and Puerto Rico (1972).

CAVALCANTI, Emiliano Di. Painter, draftsman, born in Rio de Janeiro, Brazil, 1897. In 1916 entered the Law School in Rio de Janeiro and later in São Paulo but never finished. Studied painting with George Fischer Elpons, São Paulo, 1918, and at the Académie Ranson, Paris, 1923. Lived in Paris, 1923-1925, and 1935-40. One of the forerunners of modern art in Brazil, started as a caricaturist exhibiting since 1916, Salão dos Humoristas, São Paulo. Conceived and participated in the Semana da Arte Moderna, São Paulo, 1922. Illustrated a Portuguese edition of the work of Oscar Wilde, and published the album *Fantoches*, São Paulo, 1921. Decorated the João Caetano Theater, Rio de Janeiro, 1929. Exhibited in Lisbon, Brussels, London, Berlin, Amsterdam, Montevideo, Buenos Aires, and New York. Participated in most of the modern art exhibitions in Brazil, including the São Paulo Biennial, where he was awarded one of his highest distinctions in 1953, the Prize to the Best National Painter, and was honored by a retrospective exhibition, 1963.

JOSEPH, Jasmin. Painter, terra-cotta sculptor, born in Grande Rivière du Nord, Haiti, 1923. Did not receive any formal education. In 1948 joined the Centre d'Art, Port-au-Prince. Soon after, executed sculptures for the Holy Cathedral, Port-au-Prince. In 1950 gave up sculpture and began painting.

LAM, Wifredo. Painter, draftsman, born in Sagua la Grande, Cuba, 1902. Studied at the Academia de San Alejandro, Havana, 1921-23; Academia Libre and studio of Fernando Alvarez de Sotomayor, Madrid, 1923-29,

[1] Not included in the original catalogue. See Index of Artists for reference on those not listed here.--*Ed.*

under a Cuban scholarship. Worked in Barcelona, 1936-37. Fought with the Republicans in the Spanish Civil War. Left Spain and settled in Paris, 1938. Associated with the surrealists, mainly André Breton and Max Ernst. During the German occupation settled in Cuba, 1941-46. Traveled and spent long periods in New York, Cuba, and Paris, where he settled, 1952. Illustrated books by André Breton and Aimé Césaire, among others. Since 1928 has held individual exhibitions in Madrid, Paris, New York, Port-au-Prince, Havana, London, Malmö Caracas, Maracaibo, Milan, Venice, Rome, Geneva, Turin, Basle, Hannover, Amsterdam, Stockholm, Brussels, Frankfurt, Zürich. Participated in important group shows in Europe, the United States, and Latin America, including *Exposition internationale du surréalisme*, Paris, 1947 and 1959; *50 ans d'art moderne*, Brussels, 1958; Pittsburgh International, and *Documenta*, Kassel, 1959; Grands et jeunes d'aujourd'hui, Paris, 1966; *Painting in France: 1900-1967*, touring the United States, 1968; Venice Biennial, 1972. Among his awards are First Prize, National Salon, Havana, 1951; Gold Medal for Foreign Painter, Premio Lissone, Rome, 1953; Guggenheim Award, New York, 1964; Premio Parzotto, Milan, 1965.

MARTINS, Maria. Painter, sculptress, draftsman, printmaker, born in Campanha, Minas Gerais, Brazil, 1900. Died in Rio de Janeiro, 1973. Studied music in Brazil and France to become a pianist. Later studied drawing and painting at the Academy of Fine Arts in Rio de Janeiro and Paris; finally devoted herself to sculpture, studying with Catherine Barjanski in Paris and Jespers in Brussels. As wife of a Brazilian ambassador, lived in Latin America, Europe, the Orient, and the United States, studying, working, and exhibiting. Since 1941 held individual exhibitions in Washington, D.C., New York, Paris, São Paulo, and Rio de Janeiro, including its Museum of Modern Art, 1956. Participated in national and international group shows at the Museum of Modern Art, New York, 1943; *Exposition internationale du surréalisme*, Paris, 1947; Biennial of São Paulo, 1951-55, 1965, and 1973; Venice Biennial, 1952; Salon de Mai, Paris, 1952, among others. Received several awards including the National Prize for Sculpture, São Paulo Biennial, 1955.

RIVERA, Diego. Painter, muralist, draftsman, illustrator, printmaker, born in Guanajuato, Mexico, 1886. Died in Mexico City, 1957. Studied at the Academia de San Carlos, Mexico City, 1898-1905; through a Mexican scholarship, in Madrid, 1907-08, and Paris, 1909-10. Lived and worked in Paris, 1909-20; Moscow, 1927-28, as delegate of the Mexican Communist Party, and where he was associated with the artists' group *Octobre*; in San Francisco, Detroit, New York, 1930-34. Although expelled several times from the Communist Party, occupied high positions in syndicates, and co-founded *El Machete*, 1922, periodical of the Revolutionary Syndicate of Technical Workers, Painters, and Sculptors, which eventually became the journal of the Party in Mexico City. Held high positions in Mexican art-related institutions. Signed, with André Breton, the *Manifesto for a Free Revolutionary Art*, actually written by Leon Trotsky, 1938. Illustrated, with David Alfaro Siqueiros, Pablo Neruda's *Canto General*, 1950, among other publications, and designed the scenography for José Revueltas's play *The Quarter of Solitude*, 1950. Founding member of the muralist movement with José Clemente Orozco and David Alfaro Siqueiros, and one of the forerunners of modern art in Latin America, executed numerous murals in Mexico City, Chapingo, Cuernavaca, Coyoacán, San Francisco, Fresno, Detroit, and New York City. Since 1910 his work has been shown in important individual and group exhibitions in Europe, the United States, and Latin America. Received important awards and honors, including Master of Monumental Painting, Moscow School of Fine Arts, 1927; Fine Arts Gold Medal, American Institute of Architects, 1929; National Award for the Plastic Arts, Mexico City, 1950.

SANTANA, Norberto. Painter, draftsman, born in Santo Domingo, Dominican Republic, 1943. Graduated from the Escuela Nacional de Bellas Artes, where he is a professor. Traveled in Europe and the United States, living in New York. Since 1966 has held individual exhibitions in Santo Domingo and Washington, D.C. Participated in national and international shows, including the *International Exhibition of Young Artists*, New York, 1970. Was awarded the Alpaca Prize, Twelfth Biennial of Plastic Arts, Santo Domingo, 1972.

WATSON, Barrington. Painter, draftsman, born in Lucea, Hanover, Jamaica, 1931. Studied at London School of Painting and Graphic Art, and the Royal College of Art, also in London, under a Jamaican government and British Council scholarship; Rijksakademie, Amsterdam, under a Dutch government grant; Académie de la Grande Chaumière, Paris, Academia de Belle Arti, Rome, and Academia de Bellas Artes, Madrid, through a German government scholarship and travel grant. Taught at colleges and schools in London and Jamaica; was director of the Jamaica School of Art, 1962-66. Since 1959 has held individual exhibitions in London, Panama City, New York, Toronto, Washington, D.C., Atlanta, Brasília, and Kingston. Participated in numerous national and international group shows, including the Royal Academy, London, 1958-60; *Face of Jamaica*, traveling in Germany and England, 1963-64; Third Exhibition of Original Drawings, Museum of Modern Art, Rijeka, 1972;

São Paulo Biennial, 1973. Received a Special Award, First Barcelona International Exhibition, 1967, and a Fulbright Professorship, 1971.

ZUÑIGA, Francisco. Sculptor, draftsman, lithographer, painter, born in San José, Costa Rica, 1912. From an early age worked with his father, a local sculptor of religious figures; at the age of fifteen entered the School of Fine Arts, San José; in Mexico City worked with Manuel Rodríguez Lozano and at the La Esmeralda Art School, 1936-37; later worked in the atelier of Guillermo Ruiz. Traveled in Europe, 1967; San Francisco, 1972, where he started his first series of lithographs. Professor at La Esmeralda Art School, 1938-70; co-founded an independent workshop where well-known sculptors were trained, 1943; member of the Plastic Integration Group, seeking to integrate architecture and sculpture. Executed many monuments and sculptures in public sites, mainly in Mexico. Since 1936 has held individual exhibitions in Central America, Mexico, and the United States, including the Museo Nacional de Costa Rica, San José, 1954; Museo de Arte Moderno, Mexico City, 1969; Phoenix Art Museum, 1972; Santa Barbara Museum of Art and Sculpture Garden, 1973. Participated in numerous Mexican salons and international exhibitions, including the Third Sculpture International, Philadelphia, 1949; International Exhibition, Brussels, 1958; *Mexican Art*, traveling in Europe, 1959-61. Won many awards, including First Prizes for Sculpture, Mexican Salons, 1957 and 1960; Diego Rivera Prize for Mexican Sculptor, Second Inter-American Biennial, Mexico City, 1960. Has lived in Mexico since 1936 and is a Mexican citizen.

April 9 - 28, 1974

BERNARDO CID OF BRAZIL

Bernardo Cid is one of the outstanding personalities in the Brazilian art world today and can be considered one of the most accomplished surrealist painters in the whole of Latin America. Although he has been exhibiting professionally since 1951, it was not until recent years that he began to attract wide attention.

A self-taught artist, Cid is inclined toward pure, oneiric subject matter. In his work objects and human figures are transformed into new images of uncertain definition. His source or point of departure is the pictorial world of Hieronymus Bosch, but if he shares Bosch's fascination for the macabre and grotesque, unlike Bosch, he never attempts to moralize, and his use of color is restricted to a monochrome interplay of light and shadow.

Bernardo Cid de Souza Pinto was born in São Paulo in 1925. He has had more than ten one-man shows in São Paulo and London and has participated in numerous national and international exhibitions including the Coltejer Biennial in Medellín, Colombia, 1969 and 1971, where he received high praise from the critics. He has been the recipient of several national prizes and is represented in museum collections in Brazil as well as in private collections in his own country and abroad.

This exhibition, Cid's first individual show in the United States, was made possible with the cooperation of the Brazilian Ministry of Foreign Affairs. --*J.G-S.*

CATALOGUE

Paintings

1. *Ovulo de pomba (Pigeon's Egg)*, 100 x 100 cm.
2. *Homem, oratório de pomba (Pigeon's Oratory)*, 100 x 100 cm.
3. *Sonhos da razão (Dreams of Reason)*, 100 x 100 cm.
4. *Sem título (Untitled)*, 100 x 100 cm.
5. *Sem título (Untitled)*, 50 x 100 cm.
6. *Sem título (Untitled)*, 93 x 73 cm.
7. *Sem título (Untitled)*, 93 x 73 cm.
8. *Sem título (Untitled)*, 93 x 73 cm.
9. *Pátio (Patio)*, 65 x 92 cm.
10. *Um pouco antes (A Little Before)*, 92 x 65 cm.
11. *A pomba (Pigeon)*, 80 x 80 cm.
12. *Sem título (Untitled)*, 80 x 80 cm.

13. *Olho (Eye)*, 80 x 60 cm.
14. *Subida (Rise)*, 80 x 60 cm.
15. *Espera (Wait)*, 73 x 60 cm.
16. *Algo, depois de morto, manter-me a cabeça erguida (After My Death, Hold My Heart Erect)*,[1] 50 x 70 cm.
17. *Ato de bravura (Act of Courage)*, 50 x 70 cm.
18. *Eis que surge (There It Rises)*, 70 x 50 cm.
19. *Beijo (Beautiful)*,[1] 73 x 54 cm.
20. *De dentro (From Inside)*, 65 x 54 cm.
21. *O início (The Beginning)*, 65 x 54 cm.
22. *O anjo (The Angel)*, 65 x 55 cm.
23. *O que restou (What Is Left)*, 70 x 50 cm.
24. *Visão (Vision)*, 60 x 50 cm.
25. *Touro (Bull)*, 74 x 69 cm.
26. *Outro anjo (Another Angel)*, 55 x 38 cm.

April 9 - 28, 1974

TAPESTRIES BY PARODI OF BRAZIL

Born in 1933 in Rio de Janeiro, Parodi is a well-known Brazilian tapestry maker whose work is being shown for the first time in the United States. Parodi began to study art in 1943 but abandoned his career as a painter in 1964 to devote full time to the design and making of tapestries. Within a period of ten years, he executed three hundred and sixty works and designed cartoons for some one hundred more.

Parodi has had four one-man exhibitions in Rio de Janeiro and in August will exhibit at the National Museum of Fine Arts there. He has participated in more than twelve group exhibitions, including the show *Brazil Export '73* in Brussels, Belgium. His tapestries hang in various public buildings in Rio de Janeiro and São Paulo, as well as in the Embassies of Brazil in Nairobi and Paris. *--J.G-S.*

EXHIBITION LIST [2]

Handmade Tapestry

1. *Tamilis*, 134 x 130 cm.
2. *Primavera (Spring)*, 124 x 113 cm.
3. *Guará (Pampas)*, 155 x 113 cm.
4. *Almora*, 138 x 111 cm.
5. *Farfalha (Boasting)*, 180 x 106 cm.
6. *Amazonas (Amazons)*, 155 x 115 cm.
7. *Narciso*, 182 x 104 cm.
8. *Fiori*, 165 x 133 cm.
9. *Nocturno (Nocturne)*, 167 x 130 cm.
10. *Um horizonte (Horizon)*, 134 x 124 cm.
11. *Calix*, 159 x 112 cm.
12. *Elamiur*, 156 x 130 cm.
13. *Anverso (Obverse)*, 143 x 115 cm.
14. *Adrim*, 137 x 121 cm.

[1] Literal translation of title no. 16 is "Something, After My Death, Will Hold My Head Up High;" of title no. 19 is "Kiss." *--Ed.*

[2] Not included in the original catalogue. *--Ed.*

May 7 - 29, 1974

MANUEL GONZALEZ OF GUATEMALA

Although born in El Salvador, Manuel de Jesús González has lived in the neighboring country of Guatemala since early childhood and became a Guatemalan citizen some years ago. During the short time that he has been exhibiting professionally, he has distinguished himself as an exceptionally fine draftsman. Reminiscent of the surrealists, his forms are executed with great neatness and clarity and give an impression of solidity within a transparent atmosphere.

Born in 1951 in Santa Ana, El Salvador, González studied fine arts and architecture at the University of San Carlos in Guatemala City from 1970 to 1972, and later worked in the studio of the well-known Guatemalan artist Roberto Cabrera. He has had five one-man shows since 1972 and has participated in group exhibitions in both El Salvador and Guatemala. Last year he was awarded Honorable Mention at the September Fifteenth Central American Competition held in Guatemala's National Library.

This exhibition is the artist's first in the United States. --*J.G-S*.

EXHIBITION LIST [1]

Drawings

1.a,b,c,d.	*Secuencia (Sequence) I*
2-17.	*Homenaje al personaje desaparecido (Homage to a Vanished Figure)*
18.a,b,c,d.	*Secuencia (Sequence) II*
19-24.	*Sin título (Untitled)*
25.a,b,c.	*Tríptico* (Triptych)
26-28.	*Fotografía (Photograph) I, II, III*
29-38.	*Sin título (Untitled)*

May 31 - June 20, 1974

ARMANDO SENDIN OF BRAZIL

Although he was born in Brazil and has spent most of his adult life there, Armando Sendin received his formal art training outside the country. He took his first course in art at the age of ten at the School of Fine Arts of Priego (Spain), some years later he studied art and aesthetics while living in Chile, and from 1950 to 1952 he attended classes at the University of Paris, worked with ceramics at the National Factory of Sèvres, and studied with Zuloaga in Segovia (Spain).

Sendin, born in Rio de Janeiro in 1925, had his first one-man show in São Paulo in 1949. Since then he has had more than twelve exhibitions in different cities in Brazil and has twice exhibited in New York (Zegrí Gallery, 1970, and Iramar Gallery, 1972). He has participated in numerous national and international exhibitions, including the São Paulo Biennial of 1967, 1969, and 1973, and is represented in private collections in Brazil and abroad, as well as in public collections such as São Paulo's Museum of Modern Art. The major part of Sendin's painting has been in the abstract, nonfigurative direction; however, in his most recent work he introduces elements of reality, usually in collage form, while still keeping the abstract organization of his composition. This development results in a new expression of a lyrical and fantastic nature.

Sendin has received more than fifteen prizes, including First Prize at the Second Biennial of Santos, 1973, and the Santos Dumont Prize awarded to a Brazilian artist at the last São Paulo Biennial, 1973.

[1] Not included in the original catalogue. --*Ed*.

The current exhibit is Sendin's first in the Washington area. *--J.G-S.*

CATALOGUE

Paintings

1. *Astral Silence*
2. *The Messenger*
3. *At Five in the Afternoon*
4. *Metaphor*
5. *Ghost*
6. *Abyss*
7. *Transfiguration*
8. *The First Day*
9. *Four Liturgical Songs*
10. *Ludia*
11. *Transinfinite*
12. *Over There*
13. *Seclusion*
14. *Toil*
15. *Lovers*
16. *Tentative*
17. *At a Good Hour*
18. *Tranquility*
19. *Meeting*
20. *Sunday*
21. *Traveler*
22. *Grand Prix*

June 24 - July 22, 1974

NICOLAS ESPOSITO OF ARGENTINA

Among the artists receiving increasing attention in the Argentine art world is Nicolás Espósito. Espósito's work belongs to the realm of fantasy, with the human figure taking the principal role in a constant interplay of impossible situations. There is something childlike in his approach to form, which is synthesized and schematic, but the concept is sophisticated and purely plastic. Although his treatment of certain themes might be interpreted as propaganda or illustration, content is always subordinate to form. Espósito's is essentially a lyrical expression, humorous at times, with a spirit of innocence that brings it close to poetry.

Born in Italy in 1927, Espósito moved to Argentina during early childhood and later became an Argentine citizen. He studied painting, drawing, sculpture, and ceramics in Argentine workshops. Since 1961, when he had his first exhibition as a professional painter at the Peuser Gallery in Buenos Aires, he has had eleven one-man shows in Argentina and Paraguay. He has participated in numerous national salons and has been the recipient of more than a dozen prizes.

This is the artist's first exhibition in the United States. *--J.G-S.*

CATALOGUE

Oils

1. *Yo, ella y los próceres (The Worthy, She, and I)*, 118 x 38 cm.
2. *Viaje imaginario (Imaginary Journey)*, 95 x 87 cm.
3. *La guerra y la paz (War and Peace)*, 84 x 90 cm.
4. *Mi lugar en el espacio (My Place in Space)*, 90 x 92 cm.

5. *Volando en el espacio (Flying in Space)*, 90 x 90 cm.
6. *Fábula de sueños (The Fiction of Dreams)*, 70 x 65 cm.
7. *Drama bajo el puente (Drama below the Bridge)*, 50 x 55 cm.
8. *Crónica de una señora (A Lady's Chronicle)*, 50 x 55 cm.
9. *Así en el cielo como en la tierra (In the Sky as on the Earth)*,[1] 55 x 60 cm.
10. *Tiempo maravilloso (Fabulous Times)*, 70 x 65 cm.
11. *Aquí se refleja un verano (A Summer Is Reflected Here)*, 60 x 65 cm.
12. *Sin auxilio de palabras (Without the Help of Words)*, 60 x 65 cm.
13. *Como un gran abrazo (Like a Great Embrace)*, 32 x 33 cm.
14. *El paraíso (Paradise)*, 18 x 24 cm.
15. *Hacia un lugar sin fin (Toward an Infinite End)*,[1] 36 x 32 cm.
16. *La casa nuestra (Our House)*, 23 x 24 cm.
17. *De nuestra vida (About Our Life)*, 23 x 24 cm.
18. *Inteligente y sensible (Intelligent and Sensible)*,[1] 23 x 24 cm.
19. *Crónica de una muñeca (A Doll's Chronicle)*, 65 x 64 cm.
20. *Autorretrato, 1933 (Self-Portrait, 1933)*, 24 x 30 cm.
21. *Un gran amor en el espacio (A Great Love in Space)*, 122 x 153 cm.
22. *Presencia del amor (The Presence of Love)*, 20 x 31 cm.

Temperas

23. *Volando en su pureza (Flying in Its Pureness)*, 30 x 35 cm.
24. *Mientras juegan o dormitan (While They Play or Nap)*, 30 x 35 cm.
25. *El beso (The Kiss)*, 30 x 35 cm.
26. *En realidad, un sueño (In Reality, a Dream)*, 30 x 35 cm.
27. *Concentrado como una estatua ciega (Concentration Like That of a Blind Statue)*, 30 x 35 cm.
28. *Crónica de una modelo (A Model's Chronicle)*, 30 x 35 cm.
29. *La equilibrista (The Balancer)*, 30 x 35 cm.
30. *Dos tiempos (Two Times)*, 30 x 35 cm.
31. *Anunciación (Annunciation)*, 30 x 43 cm.
32. *En el jardín de la vida (Garden of Life)*, 47 x 37 cm.

July 30 - August 30, 1974

GESNER ARMAND OF HAITI

It was some thirty years ago that primitive artists in Haiti began to receive serious recognition in their own country. Little time passed before they began to be promoted heavily by commercial galleries and the press abroad. In spite of the fact that there are a number of highly competent, professionally trained artists in the country, there is still a tendency to associate Haitian art solely with the primitives.

Gesner Armand, who is having his first one-man exhibition in the United States, is representative of the non-primitive Haitian art. The only characteristics one might find in his work that would relate him to the naives are his use of vivid, fresh colors and his interest in Haitian subject matter. Armand was born in Croix-des-Bouquets, Haiti, in 1936 and began his studies in Haiti at the Centre d'Art. In 1959 he spent a year in the workshop of the painter Juan Soriano in Mexico City where he studied ceramics. Two years later he was awarded a fellowship by the French government that enabled him to study at the School of Fine Arts of Paris.

Armand has had eight one-man shows in Haiti and Mexico and has participated in group exhibitions at the Brooklyn Museum in 1959 and the Museum of Modern Art of the City of Paris in 1962, among others. His work is represented in the Museum of Haitian Art in Port-au-Prince and in private collections in Germany, Mexico,

[1] Literal translations of these titles are: no. 9, "In Heaven as It Is on Earth;" no. 15, "Toward an Infinite Place;" and no. 18, "Intelligent and Sensitive." --Ed.

and the United States. *--J.G-S.*

EXHIBITION LIST [1]

Paintings

1. *Vieille chaise dans un jardin (Old Chair in a Garden)*
2. *Ouvre-toi, ferme-toi (Open Yourself Up, Close Yourself Up)*
3. *Pigeons en liberté (Doves in Freedom)*
4. *Pigeons fuyant (Doves Running Away)*
5. *Feuilles et couscous (Leaves and Couscous)*
6. *Sous-alimenté (Underfed)*
7. *Oeufs sur fond bleu (Eggs on a Blue Background)*
8. *Fleur et papillons (Flower and Butterflies)*
9. *Dans le paysage (In the Landscape)*
10. *Chien errant (Errant Dog)*
11. *O Soleil! (Oh, Sun!) I*
12. *Sous la tonnelle (Under the Barrel)*
13. *Trois cerfs-volants (Three Kites)*
14. *Deux cerfs-volants (Two Kites)*
15. *Détente (Relaxing)*
16. *O Soleil! (Oh, Sun!) II*
17. *Bicyclette en fête (Festive Bicycle)*
18. *Oiseau (Bird)*
19. *Bananier cassé (Broken Banana Tree)*
20. *La fleur, le fruit (The Flower, the Fruit)*
21-28. Drawings[2]

September 9 - October 2, 1974

FIVE ARTISTS FROM MEDELLIN: GRAPHICS IN BLACK AND WHITE

There is a marked consistency of quality in the art produced in Colombia due, largely, to the fact that the artists give equal importance to mastering the techniques of both painting and drawing. Seldom does one find there a painter who is not a good draftsman or a draftsman who is not competent with brushes and oil. The current exhibition brings together five artists who have spent the greater part of their adult years, first as students and then as professionals, in Medellín, the city of greatest importance in Colombia after Bogotá and the site of the Coltejer Biennial.

This exhibition was conceived when I was in Medellín more than a year ago. I was surprised to see so many of the younger generation working in black and white and even more struck by the diversity of directions and approaches to technique and subject matter. Among the new personalities emerging, I selected five, each with a different expression, all of whom I believe will eventually be recognized as young masters in their field.

Francisco Valderrama, the oldest of the group, is represented in the exhibition with prints. He uses smashed cans along with other elements to create abstract relief forms on paper.

Renán Arango is a refined craftsman whose work has overtones of surrealism. In his drawings, fragments of the female nude and war helmets are placed in paradoxical juxtaposition.

[1] Not included in the original catalogue. *--Ed.*

[2] Titles are unavailable. *--Ed.*

Londoño demonstrates a highly imaginative and personal approach to portraiture through line and contour. He is represented in the exhibition with both prints and drawings.

Félix Angel is a gifted draftsman whose drawings have a sense of the dynamic brought about largely by his use of long, nervous pencil strokes.

The drawings of Pascual Ruiz are characterized by a meticulous rendering of volumes within an eerie atmosphere. --*J.G-S.*

EXHIBITION LIST [1]

Prints

Francisco Valderrama
1-4. *De la serie Objetos para llevar a la Luna (From the Series Objects to Take Over to the Moon)*, intaglio
5-8. *De la seris Epilepsia (From the Series Epilepsy)*, print

Drawings

Renán Arango
9-18. *De la serie Imágenes (From the Series Images)*

Armando Londoño
19-21. *De la serie Testimonios (From the Series Testimonies)*
22-24. *De la serie Burócratas (From the Series Bureaucrats)*
25-26. *De la serie Enlaces (From the Series Links)*

Félix Angel
27-29. *De la serie El ídolo (From the Series The Idol)*
30-34. *De la serie Figuras (From the Series Figures))*

Pascual Ruiz
35-40. *Ciclismo colombiano (Colombian Cycling) I, II, III, IV, V, VI*
41-42. *Ruta ciclística politizada (Politicized Cycling Circuit) I, II*
43-44. *Persecución motorizada (Motorized Chase), I, II*

ABOUT THE ARTISTS

ANGEL, Félix. Painter and draftsman born in Medellín, 1949. Studied architecture at the National University of Colombia in Medellín, 1967-73. He has had nine one-man shows in Colombia and Ecuador and has been awarded three prizes in painting and drawing. His work is represented in the Zea Museum in Medellín and the Museum of Contemporary Art of Bogotá, as well as in other public and private collections in Colombia and abroad.

ARANGO ROJAS, Renán D. Painter and draftsman born in Barranquilla, 1944. Studied art at the University of Antioquia. In 1974 he studied printmaking in the workshop of Aníbal Gil. He has had three one-man shows in Medellín and Cali since 1971 and has participated in numerous group shows, including the Seventh August Salon at the Museum of Contemporary Art in Bogotá in 1973. His work is represented in the Antioquia University Museum and in private collections in Colombia and abroad.

LONDOÑO, Armando. Draftsman and printmaker born in Cali, 1947. Studied art for one year at Antioquia University and later studied privately with different local artists. Since 1970 Londoño has had three one-man shows and participated in numerous group exhibitions in Colombia as well as in Caracas and Barcelona. He has been awarded three prizes for printmaking and drawing during the past three years. He currently lives in Paris.

[1] Not included in the original catalogue. --*Ed.*

RUIZ, Pascual. Painter and draftsman born in Medellín, 1951. Studied art at the Institute of Plastic Arts of Antioquia University. He had his first one-man show in 1972 in Medellín. He has participated in group exhibitions in Colombia and Ecuador and is represented in private and public collections in those two countries.

VALDERRAMA, Francisco. Printmaker born in Medellín, 1930. He was educated at the Schools of Fine Arts of Medellín and Bogotá. He has had six one-man shows in Colombia and Ecuador and has participated in more than a dozen national group exhibitions. His work is represented in private collections in Colombia and abroad.

October 8 - 25, 1974

ANTONIO LOPEZ SAENZ OF MEXICO

The OAS art exhibition program, now in its twenty-eighth year, has introduced to the Washington public hundreds of Latin American artists, most of whom were exhibiting for the first time in the United States although often already well known in their own countries. The current exhibition of recent works by the Mexican artist Antonio López Sáenz represents a discovery for both the OAS and the public in that it is the artist's first professional show anywhere.

Although López Sáenz has never exhibited his work prior to now, he has been painting seriously for more than fifteen years. I was introduced to him by the painter Felipe Orlando when in Mexico City in 1972, and it was only after much insistence that he finally agreed to bring his works to our gallery.

López Sáenz began as a figurative painter and in time became increasingly concerned with abstraction. There is an overall flatness in his compositions and a subtle, delicate handling of color which is the most outstanding characteristic of his work. His forms resemble enlarged cells, but at the same time, perhaps as a result of his work and studies in archaeology, they share an affinity with the forms seen on Maya stelae and in some Toltec murals.

Born in Mazatlán, Sinaloa, Mexico, in 1936, López Sáenz moved to Mexico City at the age of seventeen and there studied painting and art history at the San Carlos Academy. Upon graduation in 1958 he worked for a number of years at the Institute of Anthropology and History, where he was involved principally in the restoration of the Teotihuacán murals and in drawing archaeological monuments. While at Teotihuacán, he underwent a religious experience that eventually led him to abandon his work to join the Benedictine Order of the Monastery of Santa María de la Resurrección under Father Gregorio Lemercier. Together with other monks, he initiated a widely publicized, controversial program involving experimentation with psychoanalysis that was considered in conflict with Church dogma. At the end of five years he left the Monastery to devote himself once more to his art, supporting himself by handcrafting jewelry and other objects as well as printmaking. Since 1970, apart from painting, he has been involved in filmmaking on an amateur basis, having acted in and directed films as well as having collaborated on several screenplays. --*J.G-S.*

EXHIBITION LIST [1]

1-20. Paintings
21-30. Drawings

[1] Not included in the original catalogue. The titles of the paintings and drawings exhibited are unavailable. --*Ed.*

November 19 - December 4, 1974

PAINTINGS AND CONSTRUCTIONS
BY LUIS MOLINARI FLORES OF ECUADOR [1]

Following rigorously the geometric trend, Luis Molinari Flores has been an advocate of the new trend in which painting in relief is being practiced in all its possibilities. A three-dimensional structure of wood covered with canvas is the basis for austere exercises of forms and shapes.

Born in Guayaquil, Ecuador, in 1929, Molinari Flores is a self-taught painter who studied architecture at the University of Buenos Aires, graduating in 1958. Under a French government grant, he studied engraving in Paris at the National School of Fine Arts, 1961-63, and for three years taught at the Alsacienne School. Co-founder and former president (1964-65) of the Association of Latin American Artists in Paris, he participated in its yearly exhibits of 1962 and 1965. Back in Quito in 1967, he was a founding member of the group *Van*.

Molinari Flores held individual exhibitions in Buenos Aires, 1959; Quito, 1967; Guayaquil, 1967; New York, 1970; and Bogotá, 1972 and 1974. His participation in major group exhibitions includes the Third Biennial of Paris, Museum of Modern Art, 1963; *Young Artists from Around the World*, Union Carbide Building, New York, 1969; Latin American Print Biennial, San Juan (Puerto Rico), 1970 and 1972; National Print Exhibition, Brooklyn Museum, New York, 1970; Third Coltejer Biennial, Medellín (Colombia), 1972; Fourth International Biennial of Graphic Arts, Florence (Italy), 1974.

Works by Molinari Flores are to be found in museum collections in Buenos Aires, Algiers, Havana, and in cities in Ecuador and the United States, as well as in private collections in Latin America and the United States.

This is the artist's first solo exhibition in the Washington area. --*J.G-S.*

EXHIBITION LIST

Paintings and Prints

 1. *Hexagonal Section, Proposition*, acrylic on canvas, 80 x 76"
 2. *Mexica*, acrylic on canvas, 55 x 72"
 3. *Duke's Indigo Mood*, acrylic on canvas, 47 x 47"
 4. *Multiple Vectorial Proposition*, acrylic on canvas, 47 x 47"
5-6. *Hexagonal Proposition I and II*, acrylic on canvas, 47 x 47"
 7. *Mayan II*, acrylic on canvas, 47 x 47"
8-9. *Untitled*, acrylic on canvas, 47 x 47"
 10. *Untitled*, acrylic on canvas, 19 x 28"
 11. *Construction 24*, wood and canvas, 48 x 71 x 21"
 12. *Construction 25*, wood on canvas, 36 x 72 x 26 1/2"
 13. *Derived from Construction 24*, acrylic on paper, 36 x 24"
 14. *Tension C*, acrylic on paper, 30 x 22"
 15. *Diptych*, acrylic on canvas, 58 1/2 x 94"
 16. *Open Vectorial Proposition*, wood relief, 33 x 33"
 17. *Cross Vectorial Proposition*, wood relief, 19 1/2 x 19 1/2"
 18. *Armónico (Harmonic) A*, silkscreen, 22 x 30"
 19. *Derived from Construction 24*, silkscreen, 40 x 30"
 20. *Untitled*, silkscreen, 30 x 40"

[1] This exhibition, first scheduled for November 19 - December 4, 1974 and re-scheduled for January 1975, was finally cancelled. The catalogue here reproduced was never distributed. --*Ed.*

YEAR 1975

February 18 - March 10, 1975

MARTHA CHAPA OF MEXICO

An active current of realism continues to characterize contemporary Mexican art, a realism that reflects a serene view of life and also an adherence to a rigid system of rules. We might add that, although this type of expression is a product of the academy, it does represent a significant contribution to the modern world, interested in a return to reality through the arts.

A clear indication of this interest lies in the work of the young Mexican painter Martha Chapa, whose painting first became known a few years ago with her one-man show in 1970 in the Galería Roma. Since that date she has had several individual exhibits in that gallery.

Between 1965 and 1968 Martha Chapa studied with the Spanish painter Juan Mingorance and between 1964 and 1970 she also took regular classes with the Mexican painter Luis Sahagún. In the last few years she has had six one-man showings in Mexico City, two in Monterrey, one in Ciudad Juárez, and one in Guadalajara.

Martha Chapa's work is characterized by landscapes (gardens and views of the outskirts of Mexico City) and still life paintings of native fruits of Mexico. In her use of dark ocher and her simple realism, her work is frankly Spanish in flavor. She currently favors smooth surfaces on her canvas, but has also shown great skill in the use of the palette knife to produce tougher textures.

At a recent exhibit, the Mexican intellectual José Iturriaga made the following observation to Martha Chapa in connection with her still life:

> You take great delight in painting still life, but, in so doing, you are tormented by the effort of purifying your profession.

Earlier, the recently deceased Mexican muralist David Alfaro Siqueiros addressed the painter in this enthusiastic vein:

> You have talent and ability; your schooling and your own temperament have given you an appreciation of volume, space, light, and texture; moreover, you have enormous discipline in your favor.

This is Martha Chapa's first one-man show abroad. It has been organized under the auspices of the Secretariat of Foreign Affairs of Mexico. --*J.G-S.*

CATALOGUE

Paintings

1. *Landscape*
2. *La cebolla (Onion)*
3. *La manzana (Apple)*
4. *Manzanas (Apples)*
5. *Sunset*
6. *Noon*
7. *La pera (Pear)*
8. *Garden*

 9. *Backyard*
10. *Membrillo (Quince)*
11. *La manzana (Apple)*
12. *La manzana (Apple)*
13. *Los árboles (Trees)*
14. *La cebolla (Onion)*
15. *Landscape*
16. *Late in the Afternoon*
17. *La manzana (Apple)*
18. *Bodegón (Still Life)*
19. *Morning*
20. *La manzana (Apple)*

March 18 - April 7, 1975

CRUXENT OF VENEZUELA

J.M. Cruxent has had a distinguished career as both archaeologist and painter. As an artist, he has been concerned with the romantic, natural disorder of informalism as well as with the classic, more rigid forms of kinetic art. As an archaeologist he has made significant discoveries about the pre-Columbian world, most of which have been published, and, as a by-product of his explorations, has come upon previously unknown Indian tribes inhabiting the Venezuelan jungle near the Orinoco and Amazon Rivers.

It is difficult to ascertain to what extent Cruxent's explorations have influenced his painting, but there can be no doubt that his understanding of the pre-Hispanic world and his contact with the aboriginals of the Venezuelan jungle have enriched his capacity for plastic expression.

This exhibition, Cruxent's first in the United States, consists of his works in the informalist trend. Objects that he has found during his expeditions--fishing nets, hammocks, vegetable fibers that once served as rooftops, pieces of wood--are pasted on the canvas in free form, then painted with a heavy impasto. While the materials help to create texture, they also serve to construct different planes and to articulate space. Whatever the direct relationship might be between art and archaeology, seldom has the scientific expedition been so useful to the creative artist.

Born in Barcelona, Spain, in 1911, José María Cruxent became a Venezuelan citizen more than thirty years ago. He was for many years director of the Museum of Natural Science in Caracas. He began to exhibit his paintings in 1960 and had his first one-man show at the Museum of Fine Arts in Caracas in 1962. He has had more than fifteen one-man exhibits in Caracas, Brussels, Paris, London, San Juan, and other major cities in Europe and South America and has participated in more than thirty national and international group shows in Venezuela and abroad. --*J.G-S.*

CATALOGUE

Paintings

 1. *Engin périmé (Obsolete Machine)*, Caracas, 1974, 62 x 44 cm.
 2. *Au-delà de l'instinct vital (Beyond Instinct)*, Caracas, 1974, 55 x 55 cm.
 3. *Contentement de Socrate (Socrates' Contentment)*, Caracas, 1972, 110 x 140 cm.
 4. *La femme: la seule cible (The Woman: The Only Target)*, Caracas, 1972, 100 x 150 cm.
 5. *El toro no cae en la maraña (Nets Cannot Catch Bull)*, Caracas, 1974, 115 x 88 cm.
 6. *Estratagema (Stratagem)*, Caracas, 1974, 116 x 88 cm.
 7. *Paroxysme (Paroxysm)*, Caracas, 1974, 80 x 82 cm.
 8. *Declenchement automatique (Automatic Start)*, Caracas, 1974, 88 x 115 cm.
 9. *Excitation-réaction (Excitation-Reaction)*, Caracas, 1974, 55 x 55 cm.

10. *Vers la liberté (Toward Freedom)*, Caracas, 1974, 115 x 88 cm.
11. *Premier animal qui parle (First Talking Animal)*, Caracas, 1972, 115 x 88 cm.
12. *Excitant sthénique (Agitation)*,[1] Caracas, 1974, 88 x 72 cm.
13. *Fonction de l'attention (Function of Attention)*, Caracas, 1974, 55 x 88 cm.
14. *Turpides*, Caracas, 1972, 92 x 132 cm.
15. *Fiction protectrice (Protecting Fiction)*, Caracas, 1974, 81 x 81 cm.
16. *Révolution physiologique (Physiological Revolution)*, Caracas, 1974, 88 x 72 cm.
17. *The Aisle*, Caracas, 1974, 89 x 73 cm.
18. *Dimension spécifique (Specific Dimension)*, Caracas, 1974, 89 x 73 cm.
19. *Bête de somme (Beast of Burden)*, Caracas, 1972, 120 x 120 cm.
20. *Noyau dur (Core)*, Caracas, 1973, 120 x 120 cm.
21. *Tribute to Emma Goldman*

WORLDS OF A PAINTER: J.M. CRUXENT,[2] 20 minutes, color film
A production of National Television of Venezuela, awarded a prize at the Twenty-fifth Venice Biennial.

Script:	Clara D. de Sujo
English translation:	Audrey R. Turner
Narration:	Margot Bushnell and Francis Gysin
Music selection:	Aureliano Alfonzo
Photography and editing:	Angel Hurtado
Additional scenes:	Maruja Rolando and the Natural Science Museum
Direction:	Angel Hurtado and Clara D. de Sujo

Special acknowledgment to the Venezuelan Institute of Scientific Research and the Natural Science Museum.

April 8 - 30, 1975

SCULPTURES BY BEATRIZ ECHEVERRI OF COLOMBIA

Beatriz Echeverri began her art studies in 1955 at Catholic University in Bogotá and later studied for eight years at the David Manzur Workshop in the same city. During a period of several years, she moved from painting toward three-dimensional form, using solid pieces of metal and leather as well as other materials to create relief-like images on canvas. Her current work falls fully within the realm of sculpture.

Her forms, primarily heads and torsos, begin with a papier-mâché base that has been hardened with a plastic substance. When the primary form has been completed, she covers it with irregular pieces of thick, rough leather that has passed through only the very early stages of tanning. The patching and stitching as well as the textural quality of the leather itself give the works a morbid appearance not unlike that of the *tsantsas* or shrunken heads of the Jívaro Indians of Ecuador.

Miss Echeverri, who was born in Salamina, Colombia, in 1938, can be considered one of the most promising new figures in Colombian art. Although she has been represented in four group exhibitions, including the exhibition of members of the David Manzur Workshop shown here at the Pan American Union in 1973, this is her first solo show. *--J.G-S.*

EXHIBITION LIST [3]

Sculptures

1. *Katty*

[1] Literal translation of this title is "Sthenic Stimulant." *--Ed.*

[2] This film was shown at the opening of this exhibition. *--Ed.*

[3] Not included in the original catalogue. *--Ed.*

2. *Transpiración (Perspiration)*
3. *Cardenal (Cardinal)*
4. *Retrospección (Retrospection)*
5. *Manus*
6. *Niñez (Childhood)*
7. *Infinito (Infinite)*
8. *Muerte en el tiempo (Death in Time)*
9. *Huida (Escape)*
10. *Sir*
11. *Signo (Sign)*
12. *Magia (Magic)*
13. *Deseo (Desire)*
14. *Antaño (Yesterday)*

April 8 - 30, 1975

CARLOS PADILLA OF COLOMBIA: DRAWINGS

Among the new figures emerging in the Colombian art world is Carlos Padilla. Padilla began exhibiting his work professionally in 1970 with a one-man show at the Marlene Hoffman Gallery in Bogotá. He has had four additional one-man exhibits, all in Bogotá, and has participated in eight group exhibitions, including that of the David Manzur Workshop members held here at the Pan American Union in 1973. Born in Bogotá in 1946, he studied art at the National University of Colombia and the David Manzur Workshop, 1967-1970, and later attended Delgado College in New Orleans, 1971-1972.

Padilla, who works exclusively in the medium of drawing, depicts nostalgic subjects that are reminiscent of those seen on postcards or in magazine illustrations of some fifty or sixty years ago. He avoids the sweetness of pure illustration by treating his subjects with a certain dryness and austerity. Characteristic of his work is a clean surface, with color limited to transparent hues that serve primarily as background, and a delicate but firm, almost static, line.

This is the artist's first one-man show outside Colombia. --*J.G-S*.

CATALOGUE

Drawings

1. *Who's Afraid of Virginia Woolf?*
2. *Señoritas Leticia, Florencia, and Caquetá Vichadas*
3. *Junio and Julia*
4. *The Whites*
5. *Interrogation*
6. *The Poor Little Old Lady*
7. *The Bridge*
8. *San Gregorio* (Saint Gregory)
9. *Tradition*
10. *Luis and Perla de Otún*
11. *First Communion*
12. *The Twenty*
13. *The Bourgeoisie*
14. *The Chinaman*
15. *María*
16. *The Daughter of Rana*

17. *Paradise*[1]
18. *Concord* [1]
19. *Absence*[1]
20. *Yolanda*[1]
21. *Myth*[1]

June 5 - 24, 1975

PRINTS AND DRAWINGS BY NELSON ROMAN OF ECUADOR

Since its beginnings the modern art movement in Ecuador has been based upon the expressionistic trend. While expressionism, dating back to Goya, has had its proponents throughout Latin America, two of the most significant figures are the Mexicans José Clemente Orozco and José Luis Cuevas. Nelson Román, a draftsman and printmaker, continues the tradition both in his dramatic approach to subject matter and in his fluid handling of line, and is emerging as one of the more outstanding young personalities in his country.

Born in Latacunga, Ecuador, in 1945, Román attended Quito's Central University School of Fine Arts from 1962 to 1968. He later studied in Quito in the workshops of the Spanish painter Manuel Viola and the Argentine Silvio Benedetto and with Ecuadorian painter Moisés Vilella. In 1973 he was awarded a fellowship to study printmaking at the School of Decorative Arts in Nice, France.

Román has had eleven one-man exhibitions in Quito and Guayaquil and in 1969 exhibited at the Museum of Modern Art in Bogotá. He has participated in group exhibitions in Quito, Guayaquil, and Havana, as well as in the Second Latin American Print Biennial in Santiago de Chile in 1968 and the Second Latin American Biennial of Graphic Arts in Cali, Colombia, in 1973. His work is represented in public collections in Quito and Bogotá and in private collections in Ecuador and abroad. He has been awarded two important prizes, including the fellowship to study in France, 1973-1974.

Currently, Román is traveling in the United States at the invitation of the U.S. Department of State. This is his first one-man exhibit in this country. --*J.G-S.*

EXHIBITION LIST [2]

Drawings

1. *Boletín y elegía de las mitas (Bulletin and Elegy of the Mitas)*[3]
2. *Donde hay pactos, brujerías, políticos (Where There Are Pacts, Witcheries, Politicians)*
3. *Guayrapamushca II*
4. *Guayrapamushca I*
5-7. *Personajes antropomorfos y paisaje (Anthropomorphic Figures and Landscape) I, II, III*
8. *El loco verde (Green Madman)*
9. *El resucitado (The Revived)*
10. *Lagla*

Prints

11. *San Antonio y la res (Saint Anthony and the Carcass)*, etching
12. *En penumbra (In Shadows)*, etching

[1] Also exhibited but not included in the original catalogue. --*Ed.*

[2] Not included in the original catalogue. --*Ed.*

[3] *Mita* was the enforced Indian labor in colonial times. --*Ed.*

13. *Alrededor de la mesa (Around the Table)*, etching and aquatint
14. *El regreso (The Return)*, aquatint
15. *Personajes antropomorfos (Anthropomorphic Figures)*, etching and aquatint
16. *Sonata en Re Menor para guitarra, violín y flauta (Sonata en E Minor for Guitar, Violin, and Flute)*, etching
17. *Alrededor de la mesa (Around the Table) I*, etching and aquatint
18. *Noche de brujería (Night of Witchery)*, etching and aquatint
19. *Corrida de toros (Bullfight)*, etching and drypoint
20. *Corriendo y casi volando (Running and Almost Flying)*, etching and aquatint
21. *Niños (Children)*, etching
22. *Personaje en la mesa (Figure at the Table)*, aquatint
23. *Alrededor de la mesa (Around the Table) II*, etching
24. *La charla (The Conversation)*, etching and aquatint
25. *Personajes antropomorfos (Anthropomorphic Figures) I*, etching and aquatint
26. *Niña sobre el muro (Girl on the Wall)*, black and white lithograph
27. *Niña sobre el muro (Girl on the Wall)*, color lithograph
28. *La carreta (The Cart)*, black and white lithograph
29. *La carreta (The Cart)*, color lithograph

June 25 - July 15, 1975

CONTEMPORARY CRAFTS OF THE AMERICAS: 1975 [1]

News Release E-49/75, Organization of American States, Washington, D.C., June 23, 1975.-- *Contemporary Crafts of the Americas: 1975*, an exhibition consisting of sixty objects, textiles, woodcarvings, ceramics, metals, and other materials made by young craftsmen from all the Americas, will open in the Art Gallery of the Organization of American States (OAS) on Wednesday, June 25, at 5:30 P.M.

The original exhibition was organized by Colorado State University with the aid of a grant from the National Endowment for the Arts and consisted of more than 300 objects.

The works to be shown here were selected by the Colorado State University and will be exhibited for two years throughout the United States under the auspices of the Smithsonian Traveling Exhibition Service, starting in September.

The exhibit at the OAS will remain open to the public through July 15.

CATALOGUE

Helen Adderley (Bahamas)
1. *Evening Belt*, simulated pearls, 4'6" long

Myriam Aguirre Lama (Chile)
2. *Little Feet*, pendant, silver, lapis lazuli, 1 x 5"

Angelino Alcántara García (Peru)
3. *La familia* (The Family), stone, 7 lb., 4 x 8"

[1] No catalogue was made by the OAS for this exhibition which was accompanied by the publication *Contemporary Crafts of the Americas: 1975*, by Nilda C. Fernández Getty and Robert J. Forsyth, copyright 1975 by Colorado State University, published by Henry Regnery Company, Chicago, Ill., with texts in English, Spanish, French, and Portuguese. --*Ed.*

Michael A. Arntz (United States)
 4. *Spring Creek, Series IV*, porcelain clay, 3 lb., 14 x 10 x 10"

Isabel Baixas Figueras (Chile)
 5. *Atacama*, wool, 28 lb., 19 x 21"

Marcioly Medeiros Bento and Maria Helena da Silva Bento (Brazil)
 6. *Banco* (Stool), wood, 2' x 1'6"

Cornelia Katharine Breitenback (United States)
 7. *Untitled No. 1*, cotton velvet, silkscreen, 3 lb., 4 1/2 x 7'

Carlos Bugueño Trujillo (Chile)
 8. *Moto Karlos I*, wood, 1 lb., 7 x 7"

Pat Byer (Jamaica)
 9. *Coconut Loving Cup*, sterling silver and coconut shell, 25 oz., 6 x 7"

Teresa Calderón (Venezuela)
 10. *Pectoral*, silver, 10 oz., 8 x 11"

Nuria Carulla (Colombia)
 11. *La dama del abanico* (Lady with Fan), Limoges enamel on copper, 1 lb., 9 x 8"

Raúl Célèry Zolezzi (Chile)
 12. *Tintinábulo*, forged brass and copper, iron nails, 2 lb., 20 x 6"

La Arena Cerámica (Panama)
 13. *Plato* (Plate), ceramic, 12" diam.

Cecilia Coca Passalacqua (Costa Rica)
 14. *Carmen*, wool, embroidered, 6 lb., 1'6" x 1'6"

Carlos Jorge Corral (Chile)
 15. *Gallo negro* (Black Rooster), terra-cotta, 2 lb., 8 x 10"

Linda Dalton (United States)
 16. *Seated Couple*, chair, stuffed cotton, acrylics, 15 lb., 34 x 20 x 24"

Palli Davene Davis (United States)
 17. *Chocolate Walnut Birthday Cake Puzzle*, wood and leather, 1' x 8"

Cristián Diez Sánchez (Chile)
 18. *Plato* (Plate), copper, 11 lb., 21" diam.

Inge Dusi (Costa Rica)
 19. *Cordillera andina* (The Andes), linen and velvet, 28 lb., 6' x 5'6"

Judith Poxon Fawkes (United States)
 20. *Home Sweet Home*, wool, 3 1/2'

Mary Fischer de Traver (Peru)
21-23. *Candlestick*, set of three, silver, 3 lb., 6" tallest

Humphrey T. Gilbert, Jr. (United States)
 24. *Teapot*, silver and walnut handle, 8 x 10 x 12"

Angela Girón C. (El Salvador)
 25. *Tres sombreros* (Three Hats), braided palm, 5 x 12"

Lukman Glasgow (United States)
 26. *Slipped Shadow*, ceramic, 6 lb., 11 x 9 x 10"

Luis Alberto González (Puerto Rico)
 27. *La Sagrada Familia - Nacimiento* (Holy Family - Nativity Scene), mahogany, 3 lb., 9 1/2 x 11"

Wayne Hammer (United States)
 28. *Bolt Action Worm Cutter*, brass and copper, 3 x 2 x 1"

Harold B. Helwig (United States)
 29. *Three Part Conversation*, enamel on copper, 12 x 8 x 12"

Pedro Harnández Gidansky (Chile)
 30. *Pájaro* (Bird), Limoges enamel on copper, 1 lb., 9 x 2"

Kudjuak (Canada)
 31. *Composition*, stroud, cotton, duffle, 32 x 47"

Pedro Leiva Soto (Chile)
 32. *Caballo marino* (Sea Horse), repoussé copper, 24 x 1/2"

Lilian Lipschitz (Uruguay)
 33. *Pulsera* (Bracelet), silver and pearls, 1 1/2 lb., 3 x 1/2"

Delfino Pedro López Chuc (Guatemala)
 34. *Calendario maya (Mayan Calendar)*, wool, 22 lb., 6'6"

Janet Luks (United States)
 35. *Savouries*, wool, cowhair, fibers, 40 lb., 4 x 4'

Alphonse Mattia (United States)
 36. *Bow Saw*, mixed media, 5 lb., 2 x 1 1/2'

Luis Mandiola Uribe (Chile)
 37. *Cabeza* (Head), white clay, 22 lb., 12 x 10"

Paul Marioni (United States)
 38. *Dalí*, stained glass, 15 lb., 27 1/2" x 26"

Mónica Martínez Palma (Chile)
 39. *Joyero* (Jewel Box), copper, 1/2 lb., 3 x 3"

Richard Mawdsley (United States)
 40. *The Pequot*, silver and onyx, 1.5 oz., 3 x 3 1/2"

Jesús Mendoza Hernández (Mexico)
 41. *Plato con conejo michoacano* (Plate with Michoacan Rabbit), copper, 13 oz., 9" diam.

Mineo Mizuno (United States)
 42. *Screw*, ceramic, 2 lb., 6 1/2 x 19 1/2"

Violeta Moriamez Rivas (Chile)
 43. *Collar* (Necklace), sterling silver and wool, .33 lb., 4 x 6"

June Utako Morioka (United States)
 44. *Whirlpool*, ceramic, 10 lb., 16 1/2 x 11 1/2"

Susan Marie Mueller (United States)
 45. *Dreams of Escape*, wool and cowhair, 13 lb., 5 1/2' x 2 1/4" x 8"

Stanley Joel Moskowitz (United States)
 46. *Icculrac II*, wood, mixed media, 1' x 1 1/2' x 5"

Murat Briére (Haiti)
 47. *Chien de mer* (Sea Dog), wrought iron, 9 lb., 28 x 37"

Gordon Orear (United States)
 48. *Ceramic Construction No. 2*, ceramic, 6 lb., 14 x 16"

Jerónimo de la Ossa and Mariela de la Ossa (Panama)
 49. *Molas de San Blas* (Molas of San Blas), cotton, 21 x 16"

Myrtha Pachike Lecourt de Colombo (Argentina)
 50. *Paisaje del Chaco* (Chaco Landscape), fiber, 6.5 lb., 32 x 40"

Rafael Paredes Rojas (Chile)
 51. *Hembra* (Female), whale tooth, 1 lb., 8 x 2 1/2"

Vernon Patrick (United States)
 52. *Peaches and Cream: The Presidential Bag*, ceramic, 10 lb., 12 x 26"

Patricio Quevedo Espinoza (Chile)
 53. *Conjunto orfebre* (Jewelry Set), copper, 1 lb.

Escolástico Quispe, Rosa Mamani, and Pailo Nilca (Peru)
 54. *Landscape*, wool, 4 x 5'

Nancy Rabbitt (United States)
 55. *Untitled*, mixed media, fibers, 12 oz., 6 1/2" w/base

Victoria Eugenia Robledo (Colombia)
 56. *Engendro de saíno* (Boar's Embryo), sterling silver, boar tooth, 1/2 lb., 2' x 1'6"

Isis Sanon Monte Serrat (Brazil)
 57. *Máscaras (Masks)*, ceramic, 4 lb.

Natalie R. Silverstein (Canada)
 58. *Untitled Framed Plate*, enamel on copper, 1 lb. 8 x 8"

David Moffett Snell (United States)
 59. *No Deposit, No Return*, fabricated silver, 9 1/2 oz.

Donald A. Stuart (Canada)
 60. *Cutlery Sets* (three), sterling silver, rosewood, ivory, stainless steel, 8" each

Susan Tantlinger (United States)
 61. *John Mitchell*, cotton, 10 lbs., 4 1/2 x 6'

Janet Roush Taylor (United States)
 62. *Teabag Series*, wool, linen, hemp, 35 lb., 9'

Luis Guillermo Trespalacios Meza (Colombia)
 63. *Zarcillos* (Earring), coin silver and stones, .28 oz., 2"

Elizabeth Tuttle (United States)
 64. *Ego Holder*, wool-rayon, sisal, 1 lb., 4 1/2 x 6 x 4"

Daisy Urquiola de Wende (Bolivia)
 65. *Aymara Composition,* appliqué on handwoven material and wool, 74 x 28"

Leoncio Veli Alfaro (Peru)
 66. *Mate burilado* (Chiseled Gourd), 3 lb., 15 x 30"

Lynda Watson (United States)
 67. *Aerial View Neckpiece*, sterling silver, 9 x 11"

Barbara Wilk (United States)
 68. *Nude in Bubble Bath*, wool, dacron cotton, 5 lb., 5' x 32"

Pilar Yanez Rivadeneira (Chile)
 69. *En el mar* (In the Sea), sackcloth, wool, 20 x 26"

BIOGRAPHICAL NOTES [1]

BRIERE, Murat. Sculptor born in Port-au-Prince, Haiti, 1938. Self-taught as a sculptor, studied painting and drawing under DeWitt Peters in Port-au-Prince, before devoting himself to sculpture. Works with old oil drums, transforming them into flat images. Exhibited in Haiti and abroad, including the United States (*The Naive Tradition, Haiti*, Milwaukee Art Center, Wisconsin, 1974, among others). His work is represented in private collections in Haiti and the United States, and in the collection of the Musée d'Art Haïtien and the Episcopalian Church in Haiti, and the Davenport Art Gallery in Iowa, among others.

CALDERON, Teresa. Jeweler born in Caracas, Venezuela, 1941. Studied at the Escuela de Artes Plásticas y Aplicadas Critóbal Rojas, Caracas. Traveled in Europe and the United States. Was a painter before deciding on designing and making jewelry, particularly what she calls *pectorales*, ornamented necklaces reminiscent of pre-Columbian ones.

July 15 - August 12, 1975

TAPESTRIES BY IVAN OSORIO OF NICARAGUA

Iván Osorio began designing and making tapestries some five or six years ago and since then has had several one-man shows in Managua, with an exhibit scheduled for Mexico City next year. This is his first one-man show outside Nicaragua. In creating his tapestries, he uses imported English wool and, although giving his own interpretation, generally bases his designs on pre-Columbian motifs.

Born in Managua in 1935, Osorio attended Notre Dame University in the United States, graduating with a degree in architecture. He has had a multi-faceted career as a city planner, director of his own advertising agency, and press secretary to the President of Nicaragua.

CATALOGUE

Tapestries

 1. *IOP*, 2'9" x 5'11"
 2. *Gavilán I* (Sparrow Hawk I), 4'5" x 5'2"

[1] Not included in the original catalogue. See Index of Artists for those not listed here --*Ed.*

3. *Gavilán II (Sparrow Hawk II)*, 4'8" x 7'4"
4. *Gavilán III (Sparrow Hawk III)*, 6'6" x 4'8"
5. *Gavilán IV (Sparrow Hawk IV)*, 6'6" x 4'8"
6. *Quetzalcoatl III*, 4'5" x 7'3"
7. *Sunrise*, 4'7" x 4'7"
8. *Sundown*, 4'9" x 3'6"
9. *Sueño (Dream)*, 3'11" x 3'4"
10. *Juventud (Youth)*, 4'7" x 3'7"
11. *Salamander I*, 9'8" x 3'6"
12. *Salamander II*, 9'8" x 3'6"
13. *Thirteen Out to Save the World*, 4'8" x 8'
14. *Paz (Peace)*, 5'1" x 3'6"
15. *Paz (Peace) II*, 5'4" x 3'7"
16. *Peace, Always*, 4'8" x 5'5"
17. *Dragon Lizard*, 7'6" x 3'6"
18. *Red Dragon Lizard*, 8'6" x 3'6"
19. *Lagarto (Lizard)*, 7'6" x 3'6"
20. *The Man and the Moon Forever*, 10' x 4'6"
21. *La llave (The Key)*, 6'7" x 4'9"
22. *Ancestral*, 5'1" x 4'7"
23. *Picnic*, 4'9" x 5'11"
24. *Odalisca (Odalisk)*, 3'11" x 8'10"
25. *Knot*, 4'8" x 7'3"
26. *Crucifijo (Crucifix)*, 7'3" x 3'5"
27. *Guerrero (Warrior)*, 3'5" x 4'
28. *Colt*, 5'11" x 4'6"
29. *We Leave Our Mark*, 5'8" x 4'8"
30. *Discriminating Mirror*, 5'11" x 4'6"
31. *Crocodile*, 4' x 7'

August 19 - September 12, 1975

BILL CARO OF PERU

During the past ten years painting in Peru seems to have grown to full maturity. The development of a solidly based art movement in the country is traceable to the non-figurative painters Fernando de Szyszlo, Arturo Kubotta, José Milner, Venancio Shinki, and others who established their reputations during the decades of the 1950s and 1960s. Now a new generation has emerged to take its place alongside the older, having broken with the pure abstractionists to explore a more figurative approach to plastic matter. It accomplishes its objective brilliantly, incorporating a new vision of Peru's pre-Columbian and colonial past with its potential for future progress.

Among the most outstanding of the artists who make up the group of figurative painters is Bill Caro, whose work was shown outside Peru for the first time at the Coltejer Biennial in Medellín, Colombia, in 1972. Caro's is a kind of *trompe l'oeil* painting that is resolved with extraordinary effectiveness. Using an austere, monochrome palette, he focuses on disintegrating building façades, junked automobiles, garbage piles--anything or anyplace that indicates destruction and the passing of time. Depth of volume and tactile effects are obtained with the use of a thick impasto.

The Peruvian critic Carlos Rodríguez has commented that Caro's painting is neither sentimental nor cruel, and that while his technique is impeccable, he somehow goes beyond photorealism to capture the life of "ex-things."

Born in Mollendo, Arequipa, Peru, in 1949, Caro studied architecture and drawing at the School of Engineering of the National University in Lima from 1966 to 1971. He considers himself a self-taught painter. He began exhibiting his work professionally in 1969 and since that time has had four one-man shows in Lima and another at the Luis Angel Arango Library in Bogotá, 1973. He has participated in numerous group shows in Peru as well

as in Colombia (Coltejer Biennial, 1972) and Cuba (Casa de las Américas, Havana, 1973), and has been awarded three important prizes in Peru, among them Honorable Mention at the 150th Anniversary of the Republic, 1971, and an Acquisition Prize at the Coltejer Biennial.

This is the artist's first exhibition in the United States. *--J.G-S.*

EXHIBITION LIST [1]

Oil and Acrylic

1. *Cilindros (Cylinders)*
2. *Pala mecánica (Mechanical Shovel)*
3. *Automóvil (Automobile)*
4. *Esquina limeña (Lima Corner) I*
5. *Cocina de convento (Convent's Kitchen)*
6. *Basura (Waste)*
7. *Cuadro No. 8, de la serie Barriadas (Painting No. 8, from the City Districts Series)*, 150 x 75 cm.
8. *Cementerio de automóviles (Automobile Cemetery)*
9. *Cuadro No. 1, de la serie Barriadas (Painting No. 1, from the City Districts Series)*, 80 x 78 cm.
10. *Cuadro No. 4, de la serie Barriadas (Painting No. 4, from the City Districts Series)*, 95 x 90 cm.
11. *Cuadro No. 6, de la serie Barriadas (Painting No. 6, from the City Districts Series)*, 154 x 50 cm.
12. *Casona abandonada (Abandoned House)*
13. *Interior*
14. *Costado de vieja casona (Side of an Old House)*
15. *Esquina limeña (Lima Corner) II*
16. *Posada del Oidor (The Judge's Lodgings)*

September 4 - 22, 1975

ENGRAVINGS BY CARLOS BARBOZA OF COSTA RICA

In 1961 a number of students from the National School of Fine Arts of Costa Rica joined to form the *Totem* group. Among the more promising figures in the group was Carlos Barboza who has become an outstanding young printmaker. He has been awarded several prizes for his prints in Spain as well as in Italy (Third International Biennial of Graphic Arts, Florence, 1972) and in Costa Rica (First Annual Salon of Plastic Arts, National Museum of Costa Rica, 1973).

Barboza's engravings are skillfully executed and conceived with imagination. There is a sense of mystery and foreboding in his compositions, with the realistic human form often appearing together with geometric elements.

Born in San José, Costa Rica, in 1943, Barboza was granted a fellowship by the Costa Rican government in 1968 to study at the San Fernando School of Fine Arts in Madrid. Several years later he received a second government grant that allowed him to stay in Madrid to study printmaking, mural painting, and restoration. He continued his studies of mural restoration in 1973 in Italy, having been awarded a UNESCO fellowship.

Since 1969 he has had five one-man exhibitions in Costa Rica as well as in Mexico and Spain and has participated in more than thirty group exhibitions in Costa Rica, Puerto Rico, and the United States.

This is the artist's first one-man exhibition in this country. *--J.G-S.*

[1] Not included in the original catalogue. *--Ed.*

EXHIBITION LIST [1]

Etchings

1. *Pelea (Fight)*
2. *Vencedor (Victorious)*
3. *Vencido (Conquered)*
4. *Turista (Tourist)*
5. *Fábula (Fable)*
6. *Desconocido (Unknown)*
7. *Death*
8. *Manifestación (Manifestation)*
9. *Tauromaquia (Bullfight)*
10. *Personaje (Personage)*, 1973
11. *M*, 1973
12. *M*
13. *Dolor (Sorrow)*
14. *REA*, 1972
15. *A*
16. *Horizonte (Horizon)*, 1973
17. *Recuerdo de Perugia (Remembrance of Perugia)*
18. *Recuerdo de Sermoneta (Remembrance of Sermoneta)*
19. *Recuerdo de Roma (Remembrance of Rome)*
20. *Recuerdo de Verona (Remembrance of Verona)*
21. *Consejo (Counsel)*, 1973
22. *Artesano (Artisan)*, 1974
23. *Recuerdo de Venecia (Remembrance of Venice)*
24. *Torso I*
25. *Torso II*
26. *Torso III*
27. *Torso IV*
28. *Torso V*

Drawings

29. *Muerto en Tilarán (Dead Boy in Tilarán)*
30. *Recuerdo de Florencia (Remembrance of Florence)*
31. *Despedida (Farewell)*
32. *Niño italiano (Italian Boy)*
33. *Lorenza*

September 16 - October 6, 1975

PAINTINGS BY JAIME BENDERSKY OF CHILE

The trend toward realism in painting today is international. Among the more outstanding of the South American realists is the Chilean Jaime Bendersky, who is exhibiting a recently completed series of paintings that use battered fuel drums as the subject.

Bendersky goes beyond what is usually captured by the photographic lens to analyze his subject fully and, repeating the principle of all great realistic painting of the past, bases composition on abstraction. He is concerned first with the organization of forms and counterpoints within the composition and, secondly, with

[1] Not included in the original catalogue. --*Ed.*

shape, texture, and color, thus converting his painting into what might best be described as ultra-realism. Everyday objects take on another dimension, losing nothing of their solidity, even though simulated on a flat surface, but given a new equilibrium.

Bendersky acknowledges the influence of the Chilean painter Camilo Mori under whom he once studied color and composition; however, it is undoubtedly his training and experience in the field of architecture that have played an important role in his ability to order forms in space and to achieve a three-dimensional effect.

Born in General Picó, Chile, in 1922, Bendersky attended the School of Architecture of the University of Chile, graduating in 1950. He has been professor of architectural composition and graphic expression at the University of Chile for more than fifteen years, while at the same time heading his private architectural firm. Although he has painted for many years, he did not begin exhibiting professionally until 1971. Since that time he has had four one-man shows in Santiago and Mexico City and has participated in group exhibitions in Chile. His paintings are in private collections in Chile and Mexico (Presidential Palace of Los Pinos). This is the artist's first exhibition in the United States. *--J.G-S.*

CATALOGUE

Paintings

1. *Chorus Girls*
2. *Nocturne*
3. *Moon Cargo*
4. *Fragments*
5. *Isometric Group*
6. *Old People*
7. *Variations on a Rusted Theme*
8. *Polychrome Cargo*
9. *Tar*
10. *Trio*
11. *The Widows*
12. *Old Pals*
13. *The Trumpets*
14. *Water Carriers*
15. *Blue Cadets*
16. *Rugged View*
17. *Close-Up I*
18. *Oil*
19. *On the Beach*
20. *The Sentinel*
21. *Close-Up II*
22-29. *Locks and Handles I, II, III, IV, V, VI, VII, VIII* [1]

October 7 - 30, 1975

MIGUEL ANGEL VIDAL OF ARGENTINA

Miguel Angel Vidal, Eduardo Mac Entyre, and Ary Brizzi form the outstanding trio of Argentine artists who in the early 1960s began to explore the possibilities of generative form. The generative or modular paintings of Vidal, who is having his first one-man exhibition in the United States, consist of multiple, straight lines drawn in the same direction to form a dynamic, harmonious structure that is sustained within a defined space. There is no indication whatsoever of air or any other element to indicate the distance between the picture and the

[1] Also exhibited but not included in the original catalogue. *--Ed.*

spectator. Line conveys both color and a suggestion of light while the overall effect created is kinetic, with the forms seeming to be in actual vibration.

It is highly possible that the concept of generative form in art has its roots in *Fraktur*, which was used as an artistic expression in Germany and in Spain as early as the seventeenth century and was later brought to the Americas. One of the best examples of *Fraktur*, originally a calligraphic exercise to elaborate upon a signature, is in the painting *Portrait of Conde Gálvez* by Fray Pablo de Jesús and Father San Gerónimo that hangs in Mexico's Museum of History.

Vidal was born in Buenos Aires in 1928 and studied there at the National Academy of Fine Arts. He has had ten one-man shows in Argentina since 1960 and has exhibited twice in Venezuela. He has participated in more than one hundred group exhibitions including *Eight Contructivist Painters*, National Museum of Fine Arts, Buenos Aires, 1964; *Modern Argentine Painting and Sculpture*, Institute of Contemporary Art, London, 1961; *Generative Art*, Museum of Modern Art, Rio de Janeiro, 1962; *New Art of Argentina*, Walker Art Center, Minneapolis, traveling in the United States, 1964-65; *Beyond Geometry*, Center for Inter-American Relations, New York, 1968; *Argentinische Kunst der Gegenwart*, Kunsthalle in Basel, and also shown in Lugano, Bonn, Munich, and Hamburg, 1971; *Six Argentine Painters*, Museum of Modern Art, City of Paris, 1973; and *In the Decade*, the Guggenheim Museum, New York, 1974. Among the collections in which his work is represented are the National Museum of Fine Arts, Buenos Aires; the Museum of Modern Art, New York; and the Albright-Knox Gallery, Buffalo, New York. *--J.G-S.*

EXHIBITION LIST [1]

Acrylics on Canvas

1. *Cosmovisión (Cosmic Vision)*, 140 x 140 cm.
2. *Conocimiento unificado (Unified Knowledge)*, 140 x 140 cm.
3. *Resonancia (Resonance)*, 120 x 120 cm.
4. *Estructura y poesía, serie Diálogos (Structure and Poetry, from the Dialogues Series)*, 100 x 100 cm.
5. *Sinfonía de luz y forma (Symphony of Light and Form)*, 100 x 100 cm.
6. *Equilibrio (Equilibrium)*, 100 x 100 cm.
7. *Tensión hacia los bordes (Tension Toward the Borders)*, 100 x 100 cm.
8. *Megaton I*, 100 x 100 cm.
9. *Transfiguración (Transfiguration) I*, 100 x 100 cm.
10. *Verde al infinito (Infinite Green)*, 100 x 100 cm.
11. *Permanencia topológica, morado (Topological Permanence, Purple)*, 100 x 100 cm.
12. *Formas hacia la luz (Forms Toward Light)*, 100 x 100 cm.
13. *Nueva luz, serie Diálogos (New Light, Dialogues Series)*, 100 x 100 cm.
14. *Translación al infinito (Moving Toward the Infinite)*, 110 x 72 cm.
15. *Confluencias topológicas azules y verdes (Topological Confluences of Blues and Greens)*, 120 x 100 cm.
16-19. *Módulos topológicos reversibles (Reversible Topological Modules)*, acrylic and aluminum, 35 x 35 cm.

November 3 - 21, 1975

PAINTINGS BY RAMON OVIEDO OF THE DOMINICAN REPUBLIC

Ramón Oviedo, winner of three national awards in his native Dominican Republic, has created the works for this exhibition as an answer to the title of the painting by Gauguin *Where Do We Come From? What Are We? Where Do We Go?*, which hangs in Boston's Museum of Fine Arts. Oviedo is interpreting a philosophical attitude of a master of the past faced with a remote world of color that resembles that of the Caribbean where Oviedo lives and works. But, whatever his intentions, in no way could his paintings be seen in terms of literature. His primary concern is with plastic values.

[1] Not included in the original catalogue. *--Ed.*

Oviedo's painting is less static and perhaps more three-dimensional than Gauguin's, but his forms are primitive and full of pathos. He generally uses a bluish-gray color for forms and, in shocking contrast, an intense red for the background.

Born in Barahona in 1927, Oviedo studied photoengraving and cartography in the Canal Zone. He first began exhibiting his paintings professionally in 1964, when he participated in a group show in Santo Domingo. He had his first one-man exhibit there at the Andrés Gallery in 1966. Since then he has participated in group exhibitions in Brazil, Mexico, Puerto Rico, and Spain. He received important national awards in 1966 and 1969 and last year was awarded the Grand Prize of Honor at the Thirteenth Biennial of Plastic Arts in Santo Domingo.

Oviedo, the leading figure in the new generation of Dominican painters, is having his first one-man exhibition abroad.

CATALOGUE

Paintings

From the Series ¿Quiénes Somos? (What Are We?)

1. *Blanco (White)*
2. *¿Hacia dónde vamos? (Where Do We Go?)*
3. *Eco estéril (Sterile Echo)*
4. *Duración de piedra (Duration of Stone)*
5. *Movimiento involuntario (Involuntary Movement)*
6. *Deseo de liberación (Liberation Desire)*
7. *Contemplando la gran obra (Contemplating the Big Work)*
8. *Auto-vigilancia (Self-Vigilance)*
9. *Hueco del origen (Hole in the Origin)*
10. *¿De dónde vinimos? (Where Do We Come From?)*

November 3 - 21, 1975

DRAWINGS BY MANUEL MONTILLA OF THE DOMINICAN REPUBLIC

Among the most promising of the young artists to have appeared in recent years in the Dominican Republic is Manuel Montilla. Montilla has been participating in group exhibitions in his native country since 1971 and was awarded several important prizes while still a student, but he first attracted wide public attention when he received First Prize for Drawing at Santo Domingo's Thirteenth Biennial of Plastic Arts last year.

Born in 1948 in La Romana, Montilla attended the National School of Fine Arts where he had intensive training in drawing. He has developed a highly personal technique and expression using soft, feathery strokes and subtle lines to depict biological forms such as internal body organs or polyps that have a jelly-like, almost transparent quality.

His work is represented in the collection of the National Palace of Fine Arts as well as in several private collections in the Dominican Republic.

This is his first one-man exhibition. --*J.G-S.*

CATALOGUE

Drawings
1. *Serenity*
2. *Lover*
3. *Figures That Come from Space*
4. *Latin Americans*
5. *Integration*

6. *Metamorphosis*
7. *Figures Seen through a Lens*
8. *Desperate Figures*
9. *Saddened Figure*
10. *Profile in Formation*
11. *Figure Seen through a Foot*
12. *Resting Figure No. 3*
13. *Resting Figure No. 1*
14. *Resting Figure No. 2*
15. *Compenetration*
16. *Figure in Space*
17. *Foreign Figure*
18. *Genesis*
19. *Fragment*
20. *What a Head Saw*
21. *The Equality Between Two Figures*
22. *Women in Transparencies*
23. *Homage to Pablo Neruda*
24. *Crouched Figure*
25. *One That Goes and Another That Comes*
26. *Toward Another Place*

November 25 - December 11, 1975

FELICIANO BEJAR OF MEXICO

There is a widespread tendency among artists working today to diversify, to explore all media. Yet, of course, this was the spirit that characterized the Renaissance, evident on a grand scale with artists such as Leonardo, Michelangelo, and Cellini who conveyed their statements not only through painting, but also through sculpture, architecture, decorative or mechanical objects and, in the case of Leonardo, even the design of elaborate pageants.

Feliciano Béjar typifies the modern-day artist who is constantly in search of a new medium for the expression of his ideas. Béjar began as a painter, following general tradition, and gradually began to work with wood, metals, glass, plastics, and other materials to create sculptures and other objects; he is also a printmaker and has designed and executed tapestries. This exhibition consists of sculptures, relief objects that the artist calls "magiscopes," and tapestries.

Béjar's approach to sculpture is somewhat like that of a jeweler working with a precious stone, but the delicate forms are given new, enlarged dimensions. The "magiscopes" have what can only be described as a jewel-like quality, revealing a constant interplay of color, light, and transparencies.

Béjar was born in Jiquilpan, Michoacán, Mexico, in 1920. At the age of eight he had polio and was paralyzed for four years. During that time he began to learn the techniques of different popular crafts. After only several years of formal education, he worked briefly with a family business and later traveled extensively, first through Mexico and Central America, then in the United States where he lived between 1945 and 1947, and finally in Europe. In 1950 he had the opportunity to learn glass-making techniques from the craftsmen in Murano. It was not until many years later, however, that he began to use glass to create sculptures.

Since he began exhibiting professionally in 1948, Béjar has had more than eighty one-man exhibitions in Mexico, El Salvador, England, France, Holland, Canada, and the United States. In New York he has exhibited at the Bertha Schaefer Gallery in 1967, 1968, 1971, and 1974, and at Tiffany and Company in 1967 and 1968. This year he had his second one-man exhibit at Mexico City's Museum of Modern Art. He has participated in more than forty group exhibitions in Latin America, Europe, and the United States and in 1973 was awarded the sculpture prizes at the Mexican Plastics Salon. He has fifteen works in the exhibition *Portrait of Mexico*, which is being circulated under the auspices of the Mexican government to museums in Europe, China, Australia, and New

Zealand, 1968-1975.

Among the public collections in which Béjar is represented are the Museum of Modern Art, Mexico City; the Milwaukee Art Center, Wisconsin; the Montreal Museum of Fine Arts, Canada; and the Castle Museum, Norwich, England.

This is his first one-man exhibition in the Washington area. --*J.G-S.*

CATALOGUE

Sculptures

 1. *Columna de colores (Column of Colors)*, 1971, plastic, 90 x 30 x 30 cm.
 2. *Tlahuiohtli Ib*, 1972, aluminum and crystal, 240 x 270 cm.
 3. *Columnas transparentes (Transparent Columns)*, 1973, plastic, 180 x 40 x 40, 120 x 40 x 40,
 90 x 40 x 40 cm.
 4. *Custodia (Shrine)*, 1973, steel and crystal, 120 x 80 x 15 cm.
 5. *Los nueve universos (The Nine Universes)*, 1974, nickel-plated bronze and plastic, 125 x 135 x 135 cm.
 6. *El antiguo universo (The Old Universe)*, 1974, plastic and glass, 15 x 100 x 100 cm.
 7. *Bosque de círculos (Forest of Circles)*, 1974, three plastic discs, 150 cm. (diameter)
 8. *Triángulos (Triangles)*, 1974, plastic, 70 x 222 x 52 cm.
 9-10. *Caja transparente (Transparent Box) I, II*, 1974, crystal and plastic, 71 x 71 x 71 cm.
 11. *Caja de colores (Color Box) I*, 1975, 60 x 60 x 60 cm.
 12. *Moléculas (Molecules)*, 1975, chromium-plated bronze, 210 x 60 x 40 cm.
 13. *Vuelo (Flight)*, 1975, plastic, 80 x 60 x 40 cm.
 14. *Integración (Integration)*, 1975, silver-plated bronze, 220 x 100 x 100 cm.

Reliefs

 15. *Caminos magiscópicos (Magiscopic Routes)*, 1974, plastic, 85 x 85 cm.
16-17. *Variación sobre un círculo (Variation on a Circle) C, D*, 1975, plastic, 85 x 85 cm.

Tapestries

18-20. *Variación sobre un círculo (Variation on a Circle) III, IV, V*, 1974, 185 x 185 cm.
21-25. *Variación sobre un círculo (Variation on a Circle) VII, IX, X, XI, XIII*, 1975, 185 x 185 cm.

December 15, 1975 - January 9, 1976

ENRIQUE CAREAGA OF PARAGUAY

While staying within the mainstream of geometric art, an ever-increasing number of artists of recent generations have manifested a concern with pure form defined and intensified through luminosity. Among the artists working in this direction is Enrique Careaga, possibly one of the most brilliant artists to have appeared in Paraguay during the last decade.

Careaga gradually moved from an imprecise, abstract expression to his present work which is characterized by clear, sharp-edged forms emerging from a dense, dark background. For a while he experimented with circular and other odd-shaped canvases which gave his work a three-dimensional, almost sculptural appearance. But these exercises were to lead him back to the traditional square canvas. In his most recent paintings, Careaga uses a restricted palette, generally with blue predominating, and obtains all gradations of light and shadow in a rhythmical sequence of elongated planes which form mysterious bodies that seem to float in the depth of an inter-spatial world.

Born in Asunción in 1944, Careaga studied there at the National University's School of Architecture, 1964, and at the Lucinda Moscarda School of Fine Arts, 1959-1963. In 1965 he helped found Asunción's Museum of

Modern Art. He began participating in group exhibitions in 1964, representing Paraguay at the Córdoba Biennial in Argentina and, the following year, was invited to exhibit at the São Paulo Biennial. In 1966 the government of France granted him a fellowship to study in Paris. Since then he has participated in group exhibitions in France (*Structures, Light, Movement*, Denise René Gallery, 1967; *Exposition-Position*, Denise René Gallery, 1969; Sixth Biennial of Paris, 1969; Great Young Artists of Today, Grand Palais, Paris, 1969, 1972, and 1973), Belgium, Switzerland, Italy, Argentina, Bolivia, Mexico, and Venezuela.

Careaga had his first one-man exhibition at the Tayi Gallery in Asunción in 1966 and after his exhibition at the OAS gallery will exhibit in Milan in early 1976. He received national awards in Paraguay in 1964 and 1966 in the fields of painting and printmaking and was awarded a Gold Medal at the Third Córdoba Biennial in Argentina, 1966. He is represented in important private collections in Latin America and Europe and in the public collections of the Museum of Modern Art of Asunción and the National Library of Paris.

This is his first one-man exhibition in the United States. --*J.G-S.*

CATALOGUE

Acrylics on Canvas, Paris, 1975

1. *Constellation elliptique (Elliptical Constellation) AS 7513*, 120 x 120 cm.
2. *Sphère spatio/temporelle (Spatio/Temporal Sphere) BS 7523*, 120 x 120 cm.
3. *Sphère spatio/temporelle (Spatio/Temporal Sphere) BS 7512*, 80 x 80 cm.
4. *Constellation elliptique (Elliptical Constellation) CS 7534*, 80 x 80 cm.
5. *Sphère spatio/temporelle (Spatio/Temporal Sphere) DSW 7541*, 80 x 80 cm.
6. *Constellation elliptique (Elliptical Constellation) ESW 7553*, 80 x 80 cm.
7. *Sphère spatio/temporelle (Spatio/Temporal Sphere) FSW 7561*, 80 x 80 cm.
8. *Constellation elliptique (Elliptical Constellation) GSW 7573*, 80 x 80 cm.
9. *Sphère spatio/temporelle (Spatio/Temporal Sphere) HSW 7581*, 80 x 80 cm.
10. *Sphère spatio/temporelle (Spatio/Temporal Sphere) NV 3375*, 75 x 75 cm.
11. *Sphère spatio/temporelle (Spatio/Temporal Sphere) KW 3475*, 75 x 75 cm.
12. *Constellation elliptique (Elliptical Constellation) IS 7593*, 60 x 73 cm.
13. *Sphère spatio/temporelle (Spatio/Temporal Sphere) JS 7510*, 60 x 73 cm.
14. *Sphère spatio/temporelle (Spatio/Temporal Sphere) JS 7511*, 60 x 73 cm.
15. *Constellation elliptique (Elliptical Constellation) IS 7592*, 60 x 73 cm.
16. *Sphère spatio/temporelle (Spatio/Temporal Sphere) HS 7582*, 60 x 73 cm.
17. *Constellation elliptique (Elliptical Constellation) GS 7574*, 60 x 73 cm.
18. *Sphère spatio/temporelle (Spatio/Temporal Sphere) FS 7562*, 60 x 73 cm.
19. *Constellation elliptique (Elliptical Constellation) ES 7554*, 60 x 73 cm.
20. *Sphère spatio/temporelle (Spatio/Temporal Sphere) DS 7542*, 60 x 73 cm.
21. *Constellation elliptique (Elliptical Constellation) CS 7532*, 60 x 73 cm.

YEAR 1976

February 11 - 20, 1976

CONTEMPORARY PRINTMAKERS OF THE AMERICAS

Contemporary Printmakers of the Americas is the first of a series of art exhibitions that will tour the United States and Latin America under the auspices of the General Secretariat of the Organization of American States. The objective of the exhibitions is to further cultural interchange among the American nations and, especially, to reach those regions where, without this kind of program, there would be little exposure to American art in its broadest geographical sense. The Bicentennial of the United States is an appropriate occasion to inaugurate the touring exhibition program.

In this first exhibition, each of the OAS member nations is represented by at least one artist, each artist by one work. The viewer will find affinities as well as differences, works identifiable with the culture of the nation from which the artist comes alongside works that are international in concept. The selection covers almost the entire range of printmaking techniques--woodcut, drypoint, etching, aquatint, lithography, and silkscreen. Without pretending to be exhaustive in scope, it includes artists of established international reputation as well as younger, lesser-known personalities. Nearly all have been awarded national or international prizes; many teach printmaking at university workshops. While priority was given to artists who have dedicated the greater part of their careers to printmaking, many of the exhibitors are, at the same time, painters or sculptors.

It is hoped that this exhibition and those yet to come will result in a greater understanding and appreciation among the American people of the richness and diversity of creative expression throughout the hemisphere. -- *Alejandro Orfila*, Secretary General, Organization of American States.

We wish to express our appreciation to the lenders to the exhibition--the individual artists, private collectors, and galleries--as well as to Janet Flint, Curator of Prints and Drawings, National Collection of Fine Arts, Washington, D.C.; Rafael Squirru, Buenos Aires; and La Tertulia Museum, sponsor and organizer of the American Biennial of Graphic Arts, Cali, Colombia.

The exhibition was organized by the Visual Arts Unit, Department of Cultural Affairs, General Secretariat, Organization of American States. Unit Chief: José Gómez-Sicre. Exhibition Coordinator: Jane Harmon de Ayaroa.

CATALOGUE

Prints

Sergio Camporeale (Argentina)
1. *Descripción de un área urbana reservada y condicional (Description of a Conditional and Reserved Urban Area)*, 1973, color silkscreen, 16 1/4 x 11 1/2". Lent by the Center of Art and Communication, Buenos Aires.

Aida Carballo (Argentina)
2. *Hacéte rulos, María (Curl Your Hair, Maria)*, 1968, etching, 25 1/2 x 16 1/4"

Delia Cugat (Argentina)
3. *Series of Relations*, 1973, lithograph, 30 3/4 x 23". Lent by the Center of Art and Communication, Buenos Aires.

Raquel Forner (Argentina)
4. *Mutantes alienados (Alienated Mutants)*, 1974, color lithograph, 3 1/2 x 19"

Alicia Orlandi (Argentina)
5. *Imagen borgiana o El Aleph (Borgian Image or The Aleph)*, etching/aquatint, 25 x 18 1/2"

María Cristina Santander (Argentina)
6. *La mala idea (Bad Idea)*, 1974, mixed media, 29 1/2 x 22"

Miguel Angel Vidal (Argentina)
7. *Sin título (Untitled)*, 1975, silkscreen, 25 1/2 x 30"

Hartley Marshall (Barbados)
8. *Honor Me Not in Marble*, 1971, etching, 22 x 16 1/2"

Rudy Ayoroa (Bolivia)
9. *Jane*, 1974, silkscreen, 23 x 29". OAS Permanent Collection of Art.

Gil Imaná (Bolivia)
10. *Mujer y muro (Woman and Wall)*, 1974, aquatint, 25 1/2 x 19"

Ruth Bess (Brazil)
11. *Strange Flower*, 1974, mixed media, 29 x 21 1/2"

Maria Bonomi (Brazil)
12. *O solo, grande aglutinador de recompensas (The Ground, Great Agglutinator of Rewards)*, 1974, lithograph, 35 x 23 1/2"

Odetto Guersoni (Brazil)
13. *Formas justapostas (Juxtaposed Forms)*, 1974, silkscreen, 34 3/4 x 23 1/2"

Angelo Hodick (Brazil)
14. *The Vise*, 1972, lithograph, 29 1/2 x 22". Lent by Mr. John Sirica, Washington, D.C.

Fayga Ostrower (Brazil)
15. *Untitled*, 1974, lithograph, 17 x 22 3/4"

Ernesto Fontecilla (Chile)
16. *Barcelona Suite No. 5*, 1975, etching/aquatint, 29 1/2 x 23"

Mario Toral (Chile)
17. *Stone Captives II*, 1975, lithograph, 22 1/2 x 34 1/2"

Leonel Góngora (Colombia)
18. *Transformation*, 1970, lithograph, 29 1/4 x 22 1/2"

Alfredo Guerrero (Colombia)
19. *People, Series III*, 1974, engraving, 30 1/2 x 22 1/2"

Omar Rayo (Colombia)
20. *PAX-XAP-XIV*, 1974, intaglio, 22 x 30". Lent by Associated American Artists, New York.

Carlos Barboza (Costa Rica)
21. *Story III*, 1972, etching, 13 1/2 x 19 1/4"

Cundo Bermúdez (Cuba)
22. *Caridad del Cobre (Virgin of Copper)*, 1970, silkscreen, 37 x 28 1/2"

Hugo Consuegra (Cuba)
23. *Hello, How Was Your Life*, 1974, lithograph, 27 1/4 x 19 3/4". Lent by Associated American Artists, New York.

Ada Balcácer (Dominican Republic)
24. *Untitled*, 1969, etching. Lent by Mr. Darío Suro, Washington, D.C.

Nelson Román (Ecuador)
25. *Bishops, Cardinals, and People*, 1974, etching/aquatint

Mario Bencastro (El Salvador)
26. *Untitled*, 1974, silkscreen, 18 x 24"

Rodolfo Abularach (Guatemala)
27. *Enigmatic Eye*, 1969, lithograph, 22 5/8 x 29 3/8". OAS Permanent Collection of Art.

Hervé Télémaque (Haiti)
28. *Untitled*, 1972, silkscreen, 30 1/2 x 22 1/2". Lent by H. Marc Moyens, Alexandria, Virginia.

Mario Castillo (Honduras)
29. *The Arrest*, 1975, monotype, 24 x 18"

Mike Auld (Jamaica)
30. *Nyabingi*, 1975, silkscreen, 26 x 20"

José Luis Cuevas (Mexico)
31. *El Dr. Rudolph van Crefeld y su paciente no. 1 (Dr. Rudolph van Crefeld and His Patient No. 1)*, 1973, lithograph, 22 x 29 3/4". OAS Permanent Collection of Art.

Olga Dondé (Mexico)
32. *Strawberry*, 1974, color lithograph, 30 x 23"

Francisco Toledo (Mexico)
33. *Ocho sapos (Eight Toads)*, 1974, etching/aquatint, 31 x 22 1/4". Lent by Martha Jackson Gallery, New York.

Dino Aranda (Nicaragua)
34. *Prisoners*, 1973, etching, 11 x 17 1/4". Lent by Mr. Tom Hart, Washington, D.C.

Julio Zachrisson (Panama)
35. *El comején (The Termite)*, 1974, drypoint, 15 x 19". OAS Permanent Collection of Art.

Enrique Careaga (Paraguay)
36. *Untitled*, 1972, silkscreen, 28 x 28"

Orlando Condeso (Peru)
37. *There Is No Life No Longer . . .* , 1973, etching/photo, silkscreen, 21 x 31". OAS Permanent Collection of Art.

Carlos Dávila (Peru)
38. *Constants of the Moon*, 1975, color intaglio, 21 1/2 x 29 3/4"

Sonnylal Rambissoon (Trinidad and Tobago)
39. *The Marvin Improvisations*, 1975, silkscreen, 18 1/2 x 23 1/2"

David Becker (United States)
40. *Union Grove Picnic*, 1975, etching, 22 x 30". Lent by Franz Bader Gallery, Washington, D.C.

Misch Kohn (United States)
41. *Homage to C.B.*, 1973, aquatint, 31 1/2 x 25 1/2". Lent by Jane Haslem Gallery, Washington, D.C.

Mauricio Lasansky (United States)
42. *Kaddish I*, 1975, color etching, 42 x 26"

Peter Milton (United States)
43. *Daylilies*, 1975, etching, 25 1/2 x 37 1/2". Lent by Franz Bader Gallery, Washington, D.C.

Gabor Peterdi (United States)
44. *Kalalau*, 1971, relief etching, embossing, soft ground etching. Lent by Jane Haslem Gallery, Washington, D.C.

Luis Acosta García (Uruguay)
45. *Plastic Man*, 1973, mixed media, 30 1/4 x 26"

Miguel Bresciano (Uruguay)
46. *La Señora Cosimo (Mrs. Cosimo)*, 1972, color woodcut, 26 1/2 x 35". Lent by Mr. John McKaughan, Dallas, Texas.

Antonio Frasconi (Uruguay)
47. *Malafrasca IV*, 1974, color woodcut, 24 1/2 x 35 1/4"

Luis Solari (Uruguay)
48. *Alegoría divertida (Charming Allegory)*, 1975, color etching/drypoint, 11 x 17"

Carlos Cruz-Diez (Venezuela)
49. *Untitled*, 1974, silkscreen, 29 1/2 x 29 1/2". Lent by A. Hurtado.

Luisa Palacios (Venezuela)
50. *Flor metálica (Metallic Flower)*, 1967, etching/aquatint, 25 1/4 x 19"

Marcos Yrizarry (Puerto Rico)
51. *Untitled*, 1973, intaglio, 31 1/2 x 25". Lent by Institute of Puerto Rican Culture, San Juan.

ABOUT THE ARTISTS

ABULARACH, Rodolfo. Born 1933, Guatemala City, Guatemala. Selected one-person exhibitions: OAS, Washington, D.C., 1959; Buchholz Gallery, Munich, 1969; Vértebra Gallery, Guatemala City, 1970; Graham Gallery, New York, 1970; Estudio Actual, Caracas, 1973; Museum of Modern Art, Bogotá, 1974; La Tertulia Museum, Cali, 1974. Has participated in more than one hundred group exhibitions in Latin America, the United States, and Europe. Awards include: Purchase Prize, Fifth São Paulo Biennial, 1961; First Prize for Drawing, *Art of America and Spain*, Madrid and other European cities, 1963-64; First Prize for Drawing, Art Festival, Cali, 1969; First Prize, Latin American Print Biennial, San Juan (Puerto Rico), 1972; Medal, Graphics Biennial, Ibiza, 1974. Museum collections include: Museum of History and Fine Arts, Guatemala City; Museum of Fine Arts, Caracas; Museum of Modern Art, São Paulo; Museum of Modern Art, Bogotá; Museum of Modern Art, New York; Metropolitan Museum of Art, New York; Brooklyn Museum, New York; Philadelphia Museum of Art; San Francisco Museum of Art; Museum of Art and History, Geneva.

ACOSTA GARCIA, Luis. Born 1943, Montevideo, Uruguay. Selected one-person exhibitions: Municipal Gallery, Montevideo, 1971; OAS, Washington, D.C., 1973; Pueblo Gallery, São Paulo, 1974. Selected group exhibitions: International Print Biennial, Ljubljana, 1971; Latin American Print Biennial, San Juan (Puerto Rico), 1972, 1974; International Miró Prize exhibition, Barcelona (Spain), 1970; National Salon of Plastic Arts, Montevideo, 1970, 1971, 1972. Has received three national prizes. Museum collections include: National Museum of Art, Montevideo; Juan M. Blanes Municipal Museum, Montevideo; Print Museum, Buenos Aires.

ARANDA, Dino. Born 1945, Managua, Nicaragua. Selected one-person exhibitions: Praxis Gallery, Managua, 1966; OAS, Washington, D.C., 1969; Vértebra Gallery, Guatemala City, 1969; Forma Gallery, San Salvador, 1971; Everson Museum of Art, Syracuse (New York), 1973. Selected group exhibitions: New York World's Fair, 1964; World's Fair of Berlin, 1964; Butler Institute of American Art, Youngstown (Ohio), 1966; Corcoran School of Art, 1966; University of Alabama Art Gallery, University, 1969; *Aranda, Aróstegui, Selva*, Praxis Gallery in Managua and National University in León (Nicaragua), 1971. Awards include: First Prize, National Award for Drawing, Managua, 1962.

AULD, Mike. Born 1943, Kingston, Jamaica. Has had one-person exhibitions in Kingston and Washington, D.C. Selected group exhibitions: *Twelve Afro-American Artists*, Catholic University, Washington, D.C., 1968; *Jamaican Art*, Smithsonian Institution, Washington, D.C., 1969; Martin Luther King Library, Washington, D.C., 1974. Awards include: First Prize for Sculpture, Martin Luther King Library, Washington, D.C., 1974.

AYOROA, Rudy. Born 1927, La Paz, Bolivia. Selected one-person exhibitions: OAS, Washington, D.C., 1968; Group Gallery, Jacksonville (Florida), 1969; University of Puerto Rico Museum of Art, San Juan, 1972; Franz Bader Gallery, Washington, D.C., 1974; Museum of Contemporary Art, Bogotá, 1976. Selected group exhibitions: *New Art Group*, Van Riel Gallery, Buenos Aires, 1955, 1956; *Ayoroa, Boto, Vardanega*, Buenos Aires, 1957; Coltejer Biennial, Medellín, 1970, 1972; *Twelve Artists from Latin America*, Ringling Museum of Art, Sarasota, Isaac Delgado Museum of Art, New Orleans, 1971; *Bolivian Art Today*, Museum of Modern Art, Paris, 1973; Great Young Artists of Today, Paris, 1973; Latin American Print Biennial, San Juan (Puerto Rico), 1974.

BALCACER, Ada. Born 1930, Dominican Republic. Has had one-person exhibitions in Latin America. Has participated in group exhibitions in Latin America and the United States.

BARBOZA, Carlos. Born 1943, San José, Costa Rica. Selected one-person exhibitions: Institute of Hispanic Culture, Madrid, 1972; Chapultepec Gallery, Mexico City, 1972; Disforma Gallery, San José, 1974; OAS, Washington, D.C. 1975. Selected group exhibitions: International Graphics Biennial, Florence, 1970, 1972, 1974; Latin American Print Biennial, San Juan (Puerto Rico), 1970; Graphics Biennial, Ibiza, 1970; São Paulo Biennial, 1971; Annual Plastics Salon, San José, 1973, 1974. Awards include: Gold Medal, International Graphics Biennial, Florence, 1972; Gold Medal, Annual Plastics Salon, National Museum of Costa Rica, San José, 1973. Collections

include: Arts and Letters, San José; Spanish Museum of Contemporary Art, Madrid; Institute of Hispanic Culture, Madrid.

BECKER, David. Born 1937, Milwaukee, Wisconsin. Has had one-person exhibitions and participated in group exhibitions in the United States. Purchase Awards include: Annual Print Exhibition, State University College, Potsdam (New York), 1970; National Print Exhibition, Georgia State University, Atlanta, 1970; National Print and Drawing Competition, Davidson (North Carolina), 1972; Potsdam Prints '72, Potsdam (New York); Annual Calgary Graphics Exhibition, Alberta College of Art, Alberta, 1972; National Print Exhibition, New York, 1973; National Exhibition of Prints, Library of Congress, Washington, D.C., 1973. Collections include: Art Institute of Chicago; Butler Institute of American Art, Youngstown (Ohio); Rose Art Museum, Brandeis University, Waltham; Alberta College of Art, Alberta; Ohio University, Athens; Library of Congress, Washington, D.C.

BENCASTRO, Mario. Born 1949, Ahuachapán, El Salvador. Has had one-person exhibitions in San Salvador and New York. Selected group exhibitions: Avanti Gallery, New York; Forest Hills Art Center, Queens (New York); Brooklyn Museum, Community Gallery, New York; Israel-Spanish-American Institute, New York; Springville Museum of Art, Utah.

BERMUDEZ, Cundo. Born 1914, Havana, Cuba. Selected one-person exhibitions: San Francisco Museum of Art, 1946; Centre d'Art, Port-au-Prince, 1947; OAS, Washington, D.C., 1948; Institute of Contemporary Art, Lima, 1959; Bacardi Gallery, Miami. Selected group exhibitions: San Francisco Museum of Art; Museum of Fine Arts, Houston; Museum of Modern Art, New York; Museum of Modern Art, Buenos Aires; Museum of Modern Art, Paris. Museum collections include: National Museum, Havana; Museum of Modern Art, New York; Museum of Fine Arts, Caracas; William Rochill Gallery, Kansas City.

BESS, Ruth. Born 1924, Hamburg, Germany, Brazilian citizen. Has had one-person exhibitions in Brazil, Venezuela, France, Germany, and the United States. Has participated in group exhibitions in Brazil, Chile, Colombia, Puerto Rico, England, Italy, Poland, Yugoslavia, Japan, and the United States. Awards include: Gold Medal, Second International Graphics Biennial, Florence; First Prize, Third Latin American Print Biennial, San Juan (Puerto Rico). Museum collections include: Museum of Modern Art, Rio de Janeiro; Print Museum, Buenos Aires; La Tertulia Museum, Cali; Museum of Modern Art, New York.

BONOMI, Maria. Born 1935, Meina, Italy, Brazilian citizen. Selected one-person exhibitions: OAS, Washington, D.C., 1959; Cosme Velho Gallery, São Paulo, 1966, 1971, 1972; Buchholz Gallery, Munich, 1970, 1971; Museum of Modern Art, Rio de Janeiro, 1971. Selected group exhibitions: São Paulo Biennial, 1955, 1959, 1963, 1965, 1967, 1973; *Twelve Brazilian Artists*, Museum of Bezalel (Jerusalem), 1960; Beith-Solokov Gallery, Tel Aviv, 1960; International Print Biennial, Ljubljana, 1961, 1963, 1965, 1967, 1969, 1971, 1973; *100 Prints of the Year*, Riverside Museum, New York, 1964; *Paintings and Prints from Brazil*, Museum of Modern Art, Mexico City, 1965; International Biennial of Prints, Fredrikstad (Norway), 1972. Awards include: Gold Medal, International Triennial of Contemporary Printmaking, Carpi (Italy), 1969; Best National Engraver, Museum of Modern Art, São Paulo, 1971. Museum collections include: Museum of Modern Art, São Paulo; Museum of Modern Art, Rio de Janeiro; Museum of Modern Art, New York; Museum of Contemporary Art, Skopje.

BRESCIANO, Miguel. Born 1937, Montevideo, Uruguay. Selected one-person exhibitions: Bruzzone Gallery, Montevideo; Lirolay Gallery, Buenos Aires, 1966; Gallery U, Montevideo; 1968; National Library, Prague, 1968; National Museum of Fine Arts, Santiago (Chile), 1970. Selected group exhibitions: International Print Biennial, Ljubljana, 1965, 1967, 1969; International Print Biennial, Krakow, 1968, 1970, 1972; American Biennial of Graphic Arts, Cali, 1971, 1973; Xilon V, Geneva, 1969; Latin American Print Biennial, San Juan (Puerto Rico), 1970, 1972; British International Print Biennial, Bradford, 1972. Awards include: Grand Prize, National Salon of Fine Arts, Montevideo, 1966; Gold Medal, Biennial of Graphic Arts, Florence, 1968; Grand Prize for Printmaking, Latin American Competition, Havana, 1970; First Prize for Printmaking, Pan American Exhibition of Graphic Arts, Cali, 1970; Anthony Parton Prize, British International Print Biennial, Bradford, 1972. Museum collections

include: National Museum of Fine Arts, Montevideo; Print Museum, Buenos Aires; Museum of Modern Art, São Paulo; Museum of Modern Art, New York; Chicago Institute of Art; Museum of Modern Art, Ljubljana.

CAMPOREALE, Sergio. Born 1937, Buenos Aires, Argentina. Has had one-person exhibitions in Argentina, Chile, the United States, and Israel. Has participated in group exhibitions in Argentina, Colombia, Puerto Rico, Austria, England, France, Germany, Poland, and Yugoslavia. Awards include: Silver Medal, American Biennial of Graphic Arts, Cali, 1971; Third Prize, Manuel Belgrano Municipal Salon, Buenos Aires, 1971; Grand Prize, Manuel Belgrano Salon, Buenos Aires, 1972.

CARBALLO, Aida. Born 1916, Buenos Aires, Argentina. Has had one-person exhibitions in Buenos Aires and Washington, D.C. Has participated in group exhibitions in Argentina and abroad. Museum collections include: Museum of Fine Arts, Buenos Aires; Museum of Modern Art, New York; Museum of Contemporary Art, Madrid; National Museum of Art, Warsaw.

CAREAGA, Enrique. Born 1944, Asunción, Paraguay. Selected one-person exhibitions: Tayi Gallery, Asunción, 1966; Sincron Gallery, Brescia, 1975; OAS, Washington, D.C., 1975. Selected group exhibitions: São Paulo Biennial, 1965, 1969; *Structures, Light, and Movement*, Denise René Gallery, Paris, 1967; Great Young Artists of Today, Paris, 1968, 1972, 1973, 1975; *Exposition-Position*, Denise René Gallery, Paris, 1969; Coltejer Biennial, Medellín, 1970. Awards include: Gold Medal, American Art Biennial, Córdoba (Argentina), 1966. Museum collections include: Museum of Modern Art, Asunción.

CASTILLO, Mario. Born 1932, San Pedro Sula, Honduras. Has had one-person exhibitions in Costa Rica, Guatemala, Honduras, Mexico, and the United States. Has participated in group exhibitions in Brazil, Colombia, Costa Rica, El Salvador, Guatemala, Honduras, Nicaragua, Germany, Italy, and the United States. Awards include: Grand Prize, Fourth Annual Salon of Painting, Tegucigalpa; San Vito Romano Medal, Italy.

CONDESO, Orlando. Born 1947, Lima, Peru. Selected one-person exhibitions: Billar-T Gallery, Lima, 1970; Carlos Rodríguez Gallery, Lima, 1972. Selected group exhibitions: Institute of Contemporary Art, Lima, 1966; Museum of Art, Lima, 1968; National Print Competition, Lima, 1969; Latin American Print Biennial, San Juan (Puerto Rico), 1970, 1972; Biennial of American Graphics, Santiago (Chile), 1970; *Three Peruvian Artists*, OAS, Washington D.C., 1971; Tennessee Fine Arts Center, Nashville, 1971; Contemporary Printmakers from Pratt Graphics Center, New York, 1972; International Print Exhibition, Museum of Modern Art, São Paulo, 1972; National Print Exhibition, Brooklyn Museum, New York, 1972; Colorado State University, Fort Collins, Colorado, 1972; *New York Contemporary Graphic Arts Exhibition*, Taiwan, 1973; Palace of the Legion of Honor, San Francisco, 1973; *Prints from Pratt Graphics Center*, São Paulo, 1973.

CONSUEGRA, Hugo. Born 1929, Havana, Cuba. Selected one-person exhibitions: OAS, Washington, D.C., 1956; Museum of Fine Arts, Caracas, 1958; Havana Gallery, Havana, 1964; Cisneros Gallery, New York, 1969, 1971. Selected group exhibitions: São Paulo Biennial, 1955, 1961, 1963; *Gulf Caribbean Art Exhibition*, Museum of Fine Arts, Houston, 1956; Pittsburgh International, 1958; *The United States Collects Pan American Art*, Art Institute of Chicago, 1959; Salon des Comparaisons, Museum of Modern Art, Paris, 1959; Third Paris Biennial, Museum of Modern Art, 1963; Coltejer Biennial, Medellín, 1972; Hawaii National Print Exhibition, Honolulu, 1975. Awards include: National Council of Culture Prize, Havana, 1959, 1962-1965; Honorable Mention, Second Biennial of Mexico, 1960. Museum collections include: National Museum, Havana; Casa de las Américas, Havana; Isaac Delgado Museum of Art, New Orleans; National Gallery, Sofia.

CRUZ-DIEZ, Carlos. Born 1923, Caracas, Venezuela. Selected one-person exhibitions: Museum of Fine Arts, Caracas, 1955, 1960; Buchholz Gallery, Madrid, 1956; Il Punto Gallery, Torino, 1965; Signals Gallery, London, 1965; M.E. Thelen Gallery, Essen, 1966; Conkright Gallery, Caracas, 1966, 1967, 1969; Denise René Gallery, Paris, 1969; Special Salon, Venice Biennial, 1970; Del Cortile Gallery, Rome, 1971. Selected group exhibitions: *Structures, Light, and Movement*, Denise René Gallery, Paris, 1967; *Light and Movement*, Museum of Modern Art, Paris, 1967; *Latin American Art, 1931-1966*, Museum of Modern Art, New York, 1967; São Paulo Biennial,

1967; *From Mondrian to Kinetic Art*, Denise René Gallery, Paris, 1967; *Optical Art*, Museum of Art, Oslo, 1968; *Spatial and Kinetic Art*, Le Havre Museum, France, 1968; May Salon, Paris, 1970, 1972; *Kinetic Art*, Oxford Museum, England, 1970. Represented in museum collections in Latin America, the United States, and Europe.

CUEVAS, José Luis. Born 1933, Mexico City, Mexico. Selected one-person exhibitions: OAS, Washington, D.C., 1954, 1963; Bonino Gallery, Buenos Aires, 1959; Philadelphia Museum of Art, Pennsylvania, 1960; Silvan Simone Gallery, Los Angeles, 1960, 1962; Antonio Souza Gallery, Mexico City, 1963; Profili Gallery, Milan, 1964; Misrachi Gallery, Mexico City, 1966, 1970; San Francisco Museum of Art, 1970; Michael Wyman Gallery, Chicago, 1972; Museum of Modern Art, Mexico City, 1972; Museum of Modern Art, Bogotá, 1973; Aele Gallery, Madrid, 1973; Palace of Fine Arts, Brussels, 1974; Museum of Modern Art, Paris, 1976. Has participated in more than one hundred group exhibitions in Latin America, the United States, and Europe, including the Venice Biennial, 1972. Awards include: First International Prize for Drawing, São Paulo Biennial, 1959; First International Prize, International Exhibition of Black and White, Lugano, 1962; Madeco Prize, Biennial of American Graphics, Santiago (Chile), 1965; First International Prize for Printmaking, Triennial of Graphic Arts, New Delhi, 1968. Museum collections include: Museum of Modern Art, Mexico City; Guggenheim Museum, New York; Metropolitan Museum of Art, New York; Philadelphia Museum of Art, Pennsylvania.

CUGAT, Delia. Born 1930, Buenos Aires, Argentina. Selected one-person exhibitions: Antígona Gallery, Buenos Aires, 1963; Bonino Gallery, Buenos Aires, 1968; El Triángulo Gallery, Buenos Aires, 1971. Has participated in group exhibitions in Buenos Aires, Havana, San Juan (Puerto Rico), London, Madrid, and Chicago. Has received several national awards.

DAVILA, Carlos. Born 1935, Lima, Peru. Selected one-person exhibitions: Institute of Contemporary Art, Lima, 1962, 1968; Art Center, Lima, 1963; Martha Faz Gallery, Santiago (Chile), 1964; Miami Museum of Modern Art, Florida, 1966; OAS, Washington, D.C., 1968. Selected group exhibitions: Paris Biennial, Museum of Modern Art, 1965; *3,000 Years of Peruvian Art*, Madrid, London, Paris, Rome, 1967; Pratt Graphics Center, New York, 1971; Associated American Artists, New York, 1971; University of Georgia, Athens, 1972; University of Florida, Gainesville, 1973; International Art Fair, Basel, 1973, 1974; British International Print Biennial, Bradford, 1974; International Art Fair, Düsseldorf, 1974. Museum collections include: Mint Museum, Charlotte (North Carolina); National Library, Paris.

DONDE, Olga. Born 1935, Mexico City. Selected one-person exhibitions: OAS, Washington, D.C., 1970; Arvil Gallery, Mexico City, 1971, 1973; Museum of Contemporary Art, Bogotá, 1974. Has participated in group exhibitions in Mexico.

FONTECILLA, Ernesto. Born, 1938, Santiago, Chile. Selected one-person exhibitions: Carmen Waugh Gallery, Santiago, 1967, 1969, 1971; Museum of Fine Arts, Santiago, 1967; University of Chile, Santiago, 1967; Pecaníns Gallery, Barcelona (Spain), 1973; Aele Gallery, Madrid, 1973; Trece Gallery, Barcelona (Spain), 1974. Selected group exhibitions: Latin American Print Biennial, San Juan (Puerto Rico), 1970; American Biennial of Graphic Arts, Cali, 1973; International Print Biennial, Tokyo, 1972; International Art Fair, Basel, 1974. Awards include: First Prize for Drawing and Printmaking, University of Chile, Santiago, 1967; Grand Prize, Casa de las Américas, Havana, 1967; Prize to Best Printmaker of the Year, Pratt Graphics Center, New York, 1967, 1968, 1969; Purchase Prize, Biennial of American Graphics, Santiago, 1968. Museum collections include: Museum of Fine Arts, Santiago; Museum of Modern Art, New York; Isaac Delgado Museum of Art, New Orleans.

FORNER, Raquel. Born 1902, Buenos Aires, Argentina. Selected one-person exhibitions: OAS, Washington, D.C., 1957; Museum of Modern Art, Rio de Janeiro, 1960; Bonino Gallery, Buenos Aires, 1952, 1953, 1954, 1955, 1957, 1958, 1960, 1965, 1967, 1970; National Museum of Fine Arts, Buenos Aires, 1962; Drian Galleries, London, 1967, 1970; Corcoran Gallery of Art, Washington, D.C. 1974; Aenne Abels Gallery, Cologne, 1968. Selected group exhibitions: Pittsburgh International, 1935, 1958, 1964, 1967; *Argentine Painting*, National Gallery of Art,

Washington, D.C., 1956; Venice Biennial, 1958; *South American Art Today*, Dallas Museum of Art, 1959; *International Painting*, Museum of Modern Art, New York, 1959; São Paulo Biennial, Guest of Honor, 1961; *Contemporary Argentine Art*, Museum of Modern Art, Paris, 1963. Awards include: Gold Medal, International Exhibition, Paris, 1937; Grand Prize of Honor, National Salon of Fine Arts, Buenos Aires, 1956; Press Prize, Inter-American Art Biennial, Mexico City, 1958; Grand Prize of Honor, American Art Biennial, Córdoba (Argentina), 1962. Museum collections include: Museum of Fine Arts, Buenos Aires; Museum of Modern Art, Buenos Aires; Museum of Modern Art, Mexico City; Dallas Museum of Fine Arts, Texas; Museum of Modern Art, New York.

FRASCONI, Antonio. Born 1919, Buenos Aires, Argentina. Uruguayan citizen. Selected one-person exhibitions: Santa Barbara Museum of Art, California, 1946; Brooklyn Museum, New York, 1946, 1964; Smithsonian Institution (traveling exhibition), 1953, 1964; Cleveland Museum of Art, Ohio, 1952; National Museum of Art, Montevideo, 1961; Baltimore Museum of Art, Maryland, 1963; Penelope Gallery, Rome, 1967. Has participated in more than one hundred national and international exhibitions, including the Venice Biennial, 1968. Awards include: Joseph Pennell Memorial Medal, Annual Exhibition, Pennsylvania Academy of Fine Arts, Philadelphia, 1953; W.H. Walker Prize, Print Club of Philadelphia, Pennsylvania, 1964; National Salon of Fine Arts, Montevideo, 1967; International Print Biennial, Tokyo, 1974. Represented in museum collections in Latin America and the United States.

GONGORA, Leonel. Born 1932, Cartago, Colombia. Selected one-person exhibitions: OAS, Washington, D.C., 1962; Museum of Modern Art, Bogotá, 1964; Ohio State University, Lima, 1968; Boris Mirski Gallery, Boston, 1969; Pecanins Gallery, Mexico City, 1971; Lerner-Heller Gallery, New York, 1971, 1973, 1974, 1975; El Callejón Gallery, Bogotá, 1974; Alexandra Monnet Gallery, Brussels, 1974. Selected group exhibitions: *Mexico: The New Generation*, Portland Art Museum (Oregon), Arkansas Arts Center in Little Rock, Museum of Contemporary Art in Houston, University of Texas at Austin, Fort Worth Art Center (Texas), Balboa Park Fine Arts Gallery in San Diego, 1967; *Selected Works from Latin America*, Stamford Museum, Connecticut, 1971; *Ten Years of Colombian Art*, La Tertulia Museum, Cali, 1971; Latin American Print Biennial, San Juan (Puerto Rico), 1972, 1974; American Biennial of Graphic Arts, Cali, 1971, 1973; *Thirty-two Colombian Artists Today*, Museum of Modern Art, Bogotá, 1973; International Exhibition of Original Drawings, Museum of Modern Art, Rijeka, 1974. Awards include: First Prize for Drawing, Sixteenth Salon of Colombian Artists, National Museum of Art, Bogotá; First Prize for Drawing, Museum of Contemporary Art, Bogotá; Honorable Mention, Sixth Biennial of American Graphics, Santiago (Chile); Lithography Prize, Tenth National Art Festival, La Tertulia Museum, Cali. Museum collections include: Museum of Modern Art, Bogotá; Museum of Modern Art, Mexico City; Museum of Modern Art, New York; Phoenix Art Museum; Minnesota Museum of Art, St. Paul; Des Moines Museum, Iowa.

GUERRERO, Alfredo. Born 1936, Cartagena, Colombia. Selected one-person exhibitions: Belarca Gallery, Bogotá, 1970, 1971, 1973. Selected group exhibitions: *Schemes 67*, Museum of Modern Art, Paris, 1967; Coltejer Biennial, Medellín, 1970, 1972; American Biennial of Graphic Arts, Cali, 1971, 1973; Latin American Print Biennial, San Juan (Puerto Rico), 1972, 1974; Graphics Biennial, Ibiza, 1972, 1974; International Exhibition of Original Drawings, Museum of Modern Art, Rijeka, 1974; International Print Biennial, Krakow, 1974. Awards include: Gold Medal for Printmaking, American Biennial of Graphic Arts, Cali, 1973. Museum collections include: Museum of Modern Art, Bogotá; Museum of Modern Art, Cartagena; Museum of Modern Art, Quito.

GUERSONI, Odetto. Born 1924, Jaboticabal, São Paulo, Brazil. Selected one-person exhibitions: Astréia Gallery, São Paulo, 1963; Museum of Modern Art, Rio de Janeiro, 1963; OAS, Washington, D.C., 1971; Fujibe Gallery, Osaka, 1973. Selected group exhibitions: British International Print Biennial, Bradford, 1970 and 1972; International Print Biennial, Ljubljana, 1971; Latin American Print Biennial, San Juan (Puerto Rico), 1972, 1974; International Print Biennial, Fredrikstad (Norway), 1972. Awards include: Purchase Prize, São Paulo Biennial, 1971; New World Prize, International Salon of Graphic Arts, Museum of Modern Art, São Paulo. Museum collections include: Museum of Modern Art, São Paulo; Museum of Modern Art, Rio de Janeiro; Museum of Modern Art, Skopje; Museum of Modern Art, Kyoto.

HODICK, Angelo. Born 1945, Rio de Janeiro, Brazil. Selected one-person exhibitions: Petite Gallery, Rio de Janeiro, 1968, 1969; Jefferson Place Gallery, Washington, D.C., 1972. Selected group exhibitions: National Exhibition of Modern Art, Museum of Modern Art, Rio de Janeiro, 1964, 1967; *Young National Printmakers*, Museum of Contemporary Art, São Paulo, 1966; *Three Aspects of Brazilian Drawing*, exhibition circulated through Latin America, 1968; *Pan American Exhibition of Graphic Art*, Museum of Modern Art, Bogotá, 1970.

IMANA, Gil. Born 1933, Sucre, Bolivia. Has had one-person exhibitions in Latin America, the United States, and Europe. Has participated in group exhibitions in Argentina, Bolivia, Brazil, Ecuador, Mexico, France, Spain, and Russia. Has received several national awards. Museum collections include: National Museum of Art, La Paz; Charcas Museum, Sucre; Museum of Modern Art, Tel Aviv; The Hermitage, Leningrad; National Gallery, Sofia.

KOHN, Misch. Born 1916, Kokomo, Indiana. Selected one-person exhibitions: Institute of Design, Chicago; Art Institute of Chicago; Kansas City Art Institute; Los Angeles County Museum; Cincinnati Art Museum; Museum of Art, University of New Mexico. Has participated in more than one hundred group exhibitions in the United States and abroad. Museum collections include: Akron Art Institute, Ohio; Art Institute of Chicago; Baltimore Museum of Art; Brooklyn Museum, New York; Museum of Modern Art, New York; Metropolitan Museum, New York; Los Angeles County Museum of Art; National Gallery of Art, Washington, D.C.; National Collection of Fine Arts, Washington, D.C.; Philadelphia Museum of Art; Seattle Art Museum; Fogg Art Museum, Harvard University.

LASANSKY, Mauricio. Born 1914, Buenos Aires, Argentina, United States citizen. Selected one-person exhibitions: Museum of Contemporary Art, Madrid, 1954; Los Angeles County Museum, 1961; Brooklyn Museum, New York, 1961; Seattle Art Museum, 1961; Palace of Fine Arts, Mexico City, 1969. Has participated in more than two hundred group exhibitions in the United States and abroad. Recent awards: First Prize, Latin American Print Biennial, San Juan (Puerto Rico), 1970; First Prize, International Biennial of Graphic Arts, Florence, 1970; First Prize, Color Prints of the Americas, New Jersey State Museum, Trenton; First International Prize, Print Exhibition, Honolulu, 1970. Museum collections include: Museum of Modern Art, New York; Art Institute of Chicago; Philadelphia Museum of Art; Seattle Museum; National Collection of Fine Arts, Washington, D.C.; Tulsa Museum; National Gallery of Victoria, Melbourne.

MARSHALL, Hartley. Born 1946, Bridgetown, Barbados. Selected one-person exhibitions: Pelican Gallery, Bridgetown, 1972; Hilton Art Gallery, Bridgetown, 1973, 1974. Selected group exhibitions: *Contemporary Art of the Caribbean*, OAS, Washington, D.C., 1972; *Women Artists*, Barbados, 1972; *Barbadian Art*, Kingston, Jamaica, 1973. Collections include: Ministry of Education, Ministry of External Affairs, Government of Barbados.

MILTON, Peter. Born 1930, Pennsylvania. Has had more than thirty one-person exhibitions in the United States and Latin America. Selected group exhibitions: *American Prints of the Sixties*, National Collection of Fine Arts, Washington, D.C.; *American Graphics Workshop*, Cleveland Museum of Art; *New American Prints, Forty Contemporary Artists*, traveling exhibition in Berlin, Brussels, Stockholm, Tel Aviv, and Yugoslavia; *Extraordinary Realities of American Art*, Whitney Museum, New York; International Graphics Biennial, Gamlegyen (Norway); Fourth International Exhibition of Original Drawings, Museum of Modern Art, Rijeka. Awards include: Grand Prize, International Print Biennial, Seoul, 1972; First Prize for Printmaking, American Biennial of Graphic Arts, Cali, 1973; Pennell Fund Purchase, Library of Congress, 1973. Museum collections include: Museum of Modern Art, New York; Metropolitan Museum, New York; Philadelphia Museum of Art; Museum of Fine Arts, Boston; Baltimore Museum of Art; Cincinnati Art Museum; Cleveland Museum of Art; Detroit Institute of Art; National Collection of Fine Arts, Washington, D.C.; Corcoran Gallery of Art, Washington, D.C.

ORLANDI, Alicia. Born 1937, Buenos Aires, Argentina. Selected one-person exhibitions: Lirolay Gallery, Buenos Aires; Witcomb Gallery, Buenos Aires; Dorival Gallery, Buenos Aires; Art Center, Lima. Selected group exhibitions: International Print Biennial, Tokyo, 1966, 1972; *Argentine Artists of Paris and Buenos Aires*, Torcuato Di Tella Institute, Buenos Aires, 1968; *Xilon V*, Geneva, 1969; Miró International Drawing Prize, Barcelona

(Spain), 1974; Paris Biennial, 1971; Latin American Print Biennial, San Juan (Puerto Rico), 1970, 1972, 1974; *Latin American Prints from The Museum of Modern Art, New York,* Center for Inter-American Relations, New York, 1974. Awards include: First Prize for Printmaking, National Salon of Plastic Arts, Buenos Aires; First Prize, Second Triennial of Printmaking, Buenos Aires; First Prize, Second Latin American Print Biennial, San Juan (Puerto Rico). Museum collections include: Museum of Modern Art, Buenos Aires; Eduardo Sívori Municipal Museum, Buenos Aires; Museum of Art, Lima; Museum of Modern Art, New York.

OSTROWER, Fayga. Born Lodz, Poland, 1920. Brazilian citizen. Selected one-person exhibitions: Museum of Modern Art, São Paulo, 1953, 1956; Museum of Modern Art, Rio de Janeiro, 1958, 1966, 1968; Stedelijk Museum, Amsterdam, 1959; Art Institute of Chicago, 1960; Institute of Contemporary Art, London, 1962; Astréia Gallery, São Paulo, 1965; San Francisco Museum of Art; Amos Andersons Konstmuseum, Helsinki, 1967. Group shows: in Argentina, Brazil, Mexico, Venezuela, Italy, Poland, Yugoslavia, and the United States. Awards include: National Prize, São Paulo Biennial, 1957; Grand International Prize, Venice Biennial, 1958; Critics' Prize, Rio de Janeiro, 1963, 1967, 1969, 1972; Engraving Prize, Second International Graphics Biennial, Florence, 1970. Museum collections include: National Museum of Fine Arts, Rio de Janeiro; Museum of Modern Art, Rio de Janeiro; Museum of Modern Art, São Paulo; Museum of Modern Art, New York; San Francisco Museum of Art; Library of Congress, Washington, D.C.; Victoria and Albert Museum, London; Institute of Contemporary Art, London; Museum of Art, Hamburg; Stedelijk Museum, Amsterdam; Museum of Modern Art, Tel Aviv.

PALACIOS, Luisa. Born 1923, Caracas, Venezuela. Selected one-person exhibitions: Mendoza Foundation Gallery, Caracas, 1966; Print Gallery, Caracas, 1971; Acquavella Gallery, Caracas, 1971, 1973. Has participated in group exhibitions in Venezuela and abroad, including the Venice Biennial, 1964. Awards include: First Prize, Planchart Salon, Caracas, 1958; National Prize for Drawing and Printmaking, Caracas, 1963; Prize to Best Latin American Exhibition of Drawing and Printmaking, Central University of Venezuela, 1967.

PETERDI, Gabor. Born 1915, Budapest, Hungary. United States citizen. Selected one-person exhibitions: Ernst Museum, Budapest, 1930, 1934; Yale University, 1954; Art Institute of Chicago, 1955; Brooks Memorial Art Gallery, Memphis, 1952, 1953, 1955, 1962; Minneapolis Institute of Arts, 1957; Brooklyn Museum, New York, 1959; University of California, Berkeley, 1960; Salt Lake Art Center, 1962; Oakland Art Museum, 1962; Cleveland Museum of Art, 1962. Has participated in more than one hundred group exhibitions in the United States and abroad. Museum collections include: Art Institute of Chicago; Museum of Modern Art, New York; Metropolitan Museum, New York; Whitney Museum of American Art, New York; Corcoran Gallery of Art, National Collection of Fine Arts, and National Gallery of Art, Washington, D.C.; Baltimore Museum of Art; Philadelphia Museum of Art; Kunstmuseum, Düsseldorf; Rijksmuseum, Amsterdam; Museum of Prague; National Gallery of Victoria, Melbourne; Museum of Modern Art, São Paulo.

RAMBISSOON, Sonnylal. Born 1926, Trinidad. Selected one-person exhibitions: Trinidad and Tobago National Museum, 1970, 1972. Selected group exhibitions: Royal Society of Painters and Etchers, London, 1963, 1964, 1968; Royal Academy of Art, London, 1970; Latin American Prints, Caracas, 1968; São Paulo Biennial, 1973. Awards include: Trinidad Government Silver Medal of Honor; Order of Humming Bird for Services to Art, 1972. Museum collections include: Trinidad National Museum, Port of Spain; Wellington Art Gallery, New Zealand.

RAYO, Omar. Born 1928, Roldanillo, Valle, Colombia. Selected one-person exhibitions: Museum of Modern Art, São Paulo, 1955, 1973; Van Riel Gallery, Buenos Aires, 1957; The Contemporaries, New York, 1961, 1962, 1965; OAS, Washington, D.C., 1961, 1964; Associated American Artists, New York, 1965, 1968; Rubbers Gallery, Buenos Aires, 1965; Museum of Fine Arts, Caracas, 1968; Museum of Modern Art, Bogotá, 1971; Museum of Modern Art, Rio de Janeiro, 1972; Museum of Modern Art, Mexico City, 1973. Has participated in more than one hundred group exhibitions in Latin America, the United States, and Europe. Awards include: Honor Prize, Latin American Print Biennial, San Juan (Puerto Rico), 1970; First Prize, Salon of Colombian Artists, Bogotá, 1970; International Prize, São Paulo Biennial, 1971; First Prize for Drawing, American Biennial of Graphic Arts, Cali, 1971; Medal, International Biennial of Frechen (Germany), 1972. Museum collections include: National

Museum of Bogotá; Museum of Modern Art, Rio de Janeiro; Museum of Fine Arts, Caracas; Museum of Modern Art, New York; Metropolitan Museum, New York; Philadelphia Museum of Art; Baltimore Museum of Art; Museum of Modern Art, Munich; Museum of Contemporary Art, Nagaoka (Japan).

ROMAN, Nelson. Born 1945, Latacunga, Ecuador. Selected one-person exhibitions: Museum of Modern Art, Bogotá, 1969; Siglo 20 Gallery, Quito, 1969, 1970; Altamira Gallery, Quito, 1970, 1971, 1972, 1975; Caspicara Gallery, Guayaquil, 1974; OAS, Washington, D.C., 1975. Selected group exhibitions: Casa de las Américas, Havana, 1967; Biennial of American Graphics, Santiago (Chile), 1968; American Biennial of Graphic Arts, Cali, 1973. Awards include: First Prize, Gold Medal, National Salon of Graphic Arts, Quito, 1972. Museum collections include: Museum of Latin American Art, Casa de la Cultura, Quito; Museum Of Modern Art, Bogotá.

SANTANDER, María Cristina. Born 1942, Buenos Aires, Argentina. Has had one-person exhibitions in Argentina, Bolivia, Paraguay, Spain, Poland, and the United States. Has participated in group exhibitions in Argentina, Brazil, Chile, Puerto Rico, Austria, Germany, Italy, Spain, and Poland. Has received several national awards as well as First Prize, Graphics Biennial, Ibiza, 1968. Museum collections include: Museum of Modern Art, Buenos Aires; Museum of Modern Art, Asunción; Museum of Contemporary Art, Madrid.

SOLARI, Luis. Born 1918, Fray Bentos, Uruguay. Selected one-person exhibitions: OAS, Washington, D.C., 1964; Museum of Contemporary Art of the University of São Paulo; and Museum of Art, Rio Grande do Sul (Brazil), 1966; Zegrí Gallery, New York, 1967, 1969; El Morro Gallery, San Juan (Puerto Rico), 1971; San Diego Gallery, Bogotá, 1975; Arte-Horizonte Gallery, Madrid, 1975. Selected group exhibitions: International Biennials of Florence, Vienna, Barcelona (Spain), Ljubljana, Venice (1972), Frechen (Germany), and Tokyo; *100 Years of Uruguayan Painting*, Corcoran Gallery of Art, Washington, D.C.; Color Prints of the Americas, New Jersey State Museum, Trenton; *Color Print USA*, Lubbock (Texas); National Exhibition of Prints, Library of Congress, Washington, D.C. Awards include: First Prize for Drawing, National Salon of Fine Arts, Montevideo, 1955, 1964; First Prize for Painting, National Salon of Fine Arts, Montevideo, 1965; Gold Medal for Printmaking, First Graphic Arts Biennial, Cali, 1971; Merit Award, Pratt Graphics Center, New York, 1968. Museum collections include: National Museum of Fine Arts, Montevideo; Juan Manuel Blanes Municipal Museum, Montevideo; Museum of Modern Art, São Paulo; Museum of Modern Art, Rio de Janeiro; Museum of the Americas, Madrid; Museum of Modern Art, New York; Brooklyn Museum, New York; Cincinnati Museum of Art.

TELEMAQUE, Hervé. Born 1937, Port-au-Prince, Haiti. Selected one-person exhibitions: Mathias Fels Gallery, Paris, 1964, 1967, 1971; Studio Marconi, Milan, 1967; Marc Gallery, Washington, D.C., 1972; Museum of Modern Art, Paris, 1976. Selected group exhibitions: Museum of Decorative Arts, Paris, 1967; Venice Biennial, 1968, 1972; Paris Biennial, 1969; *Artistic Creation in France, 1960-1972*, Grand Palace, Paris, 1972; Salon of Young Painters, Paris, 1964, 1967. Museum collections include: Museum of Haitian Art, Port-au-Prince; Museum of Modern Art, Paris; Museum of Modern Art, Stockholm; Museum of Fine Arts, Caracas; Museum of Fine Arts, Ostende (Belgium); Casa de las Américas, Havana.

TOLEDO, Francisco. Born 1940, Oaxaca, Mexico. Selected one-person exhibitions: Fort Worth Art Center, Texas, 1959; Antonio Souza Gallery, Mexico City, 1959, 1965; Hamilton Galleries, London, 1964; Daniel Gervis Gallery, Paris, 1965; Haaken Gallery, Oslo, 1966; Juan Martín Gallery, Mexico City, 1969, 1970, 1975; Martha Jackson Gallery, New York, 1974, 1975. Selected group exhibitions: May Salon, Museum of Modern Art, Paris, 1963, 1964; *Five Young Mexican Artists*, Center for Inter-American Relations, New York, 1970; International Print Biennial, Tokyo, 1972; Festival of Two Worlds, Spoleto, 1973; *Fifteen Mexican Artists*, Phoenix Art Museum, 1973; *Contemporary Painting in Mexico*, Museum of Modern Art, Tokyo, 1974. Museum collections include: Museum of Modern Art, Mexico City; Museum of Modern Art, New York; Philadelphia Museum of Art; Tate Gallery, London; Kunstnerns Hus, Oslo.

TORAL, Mario. Born 1934, Santiago, Chile. Selected one-person exhibitions: Museum of Modern Art, São Paulo, 1955; Museum of Modern Art, Rio de Janeiro, 1964; Central Gallery, Santiago, 1963, 1965, 1967, 1969,

1971, 1972; Fendrick Gallery, Washington, D.C., 1973; OAS, Washington, D.C., 1973; Museum of Modern Art, Rijeka, 1974; Aele Gallery, Madrid, 1975. Selected group exhibitions: Paris Biennial, 1961; *International Printmakers of Paris*, National Gallery of Canada, Ottawa, 1962; *Art of America and Spain*, Madrid and other European cities, 1963-64; São Paulo Biennial, Salon of Surrealist and Fantastic Art, 1965; *Latin American Art since Independence*, Yale University and University of Texas, 1966; International Exhibition of Original Drawings, Museum of Modern Art, Rijeka, 1970, 1972. Awards include: First Prize for Printmaking, Salon of Fine Arts, Paris, 1961; Honorable Mention, International Print Biennial, Ljubljana, 1963; Critics' Prize, Best Exhibition of the Year, Santiago, 1963; Vinkovic Prize, International Biennial, Rijeka, 1972. Museum collections include: Museum of Fine Arts and Museum of Contemporary Art, Santiago; Museum of Modern Art, Rio de Janeiro; Museum of Modern Art, New York; Metropolitan Museum of Art, New York; Brooklyn Museum, New York; Museum of Modern Art, Rijeka.

VIDAL, Miguel Angel. Born 1928, Buenos Aires, Argentina. Selected one-person exhibitions: Rubbers Gallery, Buenos Aires, 1960; Bonino Gallery, Buenos Aires, 1970, 1974; Estudio Actual, Caracas, 1974; OAS, Washington, D.C., 1975. Selected group exhibitions: *Modern Argentine Painting and Sculpture*, Institute of Contemporary Art, London, 1961; *Young Argentine Painters*, Museum of Modern Art, Mexico City, 1962; *Argentine Painting*, Museum of Contemporary Art, Santiago (Chile), 1963; *New Art of Argentina*, Walker Art Center, Minneapolis, touring the United States, 1964-65; São Paulo Biennial, 1965; *Beyond Geometry*, Center for Inter-American Relations, New York, 1968; *Made of Plastic*, Flint Institute of Arts, Michigan, 1968; *Argentinische Kunst der Gegenwart*, Kunsthalle in Basel, also shown in Lugano, Bonn, Munich, and Hamburg, 1971; *Six Argentine Painters*, Museum of Modern Art, Paris, 1973; *In the Decade*, Guggenheim Museum, New York, 1974. Awards include: Critics' Prize, National Salon of Plastic Arts, Buenos Aires, 1968; First Prize, Italo Salon, Museum of Modern Art, Buenos Aires, 1971. Museum collections include: National Museum of Fine Arts, Buenos Aires; Museum of Modern Art, Buenos Aires; Museum of Modern Art, Rio de Janeiro; Museum of Modern Art, New York; Guggenheim Museum, New York; University of Texas, Austin.

YRIZARRI, Marcos. Born 1936, Mayagüez, Puerto Rico. Has had one-person exhibitions in Puerto Rico, Italy, Spain, and the United States, and has participated in more than thirty group exhibitions. Awards include: First National Prize, Latin American Print Biennial, San Juan (Puerto Rico), 1970; Gold Medal, Fifteenth Printmaking Salon, Madrid, 1966; Javier Báez Prize, Casa de las Américas, Havana, 1969. Museum collections include: Ponce Museum, Puerto Rico; Museum of Modern Art, New York; Museum of Modern Art, Madrid; Skopje Museum, Yugoslavia.

ZACHRISSON, Julio. Born 1930, Isla de Mafafa, Panama. Selected one-person exhibitions: Institute of Hispanic Culture, Madrid, 1961; Institute of Panamanian Art, Panama City, 1963, 1965, 1972; OAS, Washington, D.C., 1964; Molesworth Gallery, Dublin, 1966; Seiquer Gallery, Madrid, 1967, 1969, 1971; Colibrí Gallery, San Juan (Puerto Rico), 1970. Has participated in group exhibitions in Panama City, Cali, Mexico City, Lima, Quito, Havana, Santiago (Chile), Madrid, Barcelona (Spain), Naples, Florence, Vienna, Copenhagen, Geneva, Krakow, Ljubljana, and New York. Museum collections include: Institute of Panamanian Art, Panama City; Museum of Contemporary Art, Madrid; Museum of Modern Art, New York; Cincinnati Art Museum; Philadelphia Museum of Art; National Collection of Fine Arts, Washington, D.C.; Museum of Contemporary Art, Skopje.

February 26 - March 22, 1976

AIDA CARBALLO OF ARGENTINA: ETCHINGS AND LITHOGRAPHS

Aida Carballo is one of those artists who has an extraordinary talent for expressing pathos, for transcending human reality to reach the depths of the subconscious. None of her subjects is allowed to escape her penetrating, somewhat eerie vision. While she is highly skilled in the techniques of printmaking, it is that powerful capacity for feeling, her sensitivity toward other human beings, that gives her work universality and makes her one of the truly outstanding graphic artists in Argentina today.

Born in Buenos Aires in 1916, Ms. Carballo studied art at the national schools Prilidiano Pueyrredón and Ernesto de la Cárcova. Although she studied mural painting as well as the graphic arts, she has devoted her career almost exclusively to printmaking. She began participating in group exhibitions in 1948 and was awarded several prizes, including a fellowship from the government of France to study for a year in Paris, 1958. Still, she remained a somewhat mysterious personality until recent years. She has had one-person exhibitions in Buenos Aires, including a major show at the National Museum of Fine Arts, and is represented in most of the important museum collections in Argentina as well as in the Museum of Modern Art in New York, the Museum of Contemporary Art of Madrid, and the National Museum of Art in Warsaw, Poland.

An etcher and lithographer, Ms. Carballo generally works directly on the metal or stone. Like most printmakers, she is also an accomplished draftsman, but her drawings have rarely been exhibited.

This is her first exhibition in the United States. --*J.G-S*.

CATALOGUE

Prints

1. *Autorretrato con autobiografía (Self-Portrait with Autobiography)*, 1973, etching, 8/15, 65 x 42 cm.
2. *Calvos herméticos (The Hermetic Balds)*, 1972, etching, 3/10, 64 x 48 cm.
3. *La sospecha (The Suspicion)*, from the Series *Los levitantes (Levitants)*, 1967, lithograph, special print, 47 x 32 cm.
4. *Manzanas de Río Negro (Apples from Río Negro)*, from the Series *Los Amantes (The Lovers)*, 1965, lithograph, 24/25, 48 x 33 cm.
5. *Hombrecitos bañándose (Little Men Bathing)*, 1961, etching, 7/10, 45 x 32 cm.
6. *Pasajero sumiso (Docile Passenger)*, 1967, etching, 6/7, 28 x 38 cm.
7. *Los amantes en la noche (Lovers of the Night)*, 1965, lithograph, 23/25, 54 x 40 cm.
8. *De los amantes (The Lovers)*, 1965, lithograph, 24/25, 53 x 40 cm.
9. *De los amantes en la ribera (Lovers on the Beach)*, 1965, 24/25, 54 x 41 cm.
10. *Squasso*, color etching, artist's proof, 65 x 40 cm.
11. *El conductor y las basuras (The Conductor and the Garbage)*, 1964, etching, 7/10, 63 x 40 cm.
12. *Hacéte rulos, María (Curl Your Hair, María)*, 1968, etching, artist's proof, 25 1/2 x 16 1/4"
13. *Pasajera con aro (Passenger with Earring)*, 1967, heliogravure, 3/5
14. *Beatrice*, 1965
15. *Pasajero en colectivo (Passenger on a Bus)*, 1967, etching, 5/10
16. *Xenobia*, 1971, woodcut, 4/15
17. *Autoridades en colectivo y una mosca (Authorities on a Bus and a Fly)*, 1965, etching, 9/10
18. *La cola (The Line)*, from the Series *Querido Buenos Aires (Dear Buenos Aires)*, lithograph, 49/55
19. *No hagan olas (Don't Make Waves)*, 1968, etching, 3/5
20. *Tierra, flor y dulce brisa (Earth, Flower, and Sweet Breeze)*, from the Series *Los Locos (Mad People)*, 1963, lithograph, 23/50
21. *Quieta meditación (Quiet Meditation)*, from the Series *Los Locos (Mad People)*, 1963, lithograph, 23/50
22. *El señor Señor entra en la casa de los locos (The Gentleman Gentleman in the Mad House)*,[1] 1963, 23/50
23. *Las extrañas voces de la morada de las locas (The Strange Voices from the House of the Crazy Women)*, 1963, 23/50
24. *La lombriz es una leve pariente de la locura (The Parasite Is a Distant Relative of Madness)*, 1963, 23/50
25. *La luz y la voz (The Light and the Voice)*, 1963, 23/50

[1] Literal translation of this title is "Mister Mister Enters the Mad House." --*Ed.*

February 26 - March 22, 1976

DOMINGO GATTO OF ARGENTINA: SILKSCREEN PRINTS

In 1970, when he was still a relatively new figure in the Argentine art world, Domingo Gatto had a one-man exhibition of paintings here at the OAS gallery. During the six years that have elapsed, his work has become increasingly more subtle and refined, and he has established a permanent place for himself in modern Argentine painting. There is a remarkable continuity in Gatto's work that leaves no doubt about the seriousness of his objective. He has shown little interest in pursuing new directions or finding new solutions; if there is any change it is in a further synthesis of form, omitting all that is superfluous. In his concept of reality, he consistently maintains a sense of the poetic.

In adherence to a long-established policy of presenting an artist twice only if he works in more than one medium, this second exhibition shows Gatto as a printmaker. While the characteristics that define his painting are applicable to his silkscreen prints, including an austerity of color, the spectator will find certain variations that result from the flat, mat finish of the prints.

Since having exhibited at the OAS in May 1970, Gatto has had one-man exhibitions in Argentina (Buenos Aires, Córdoba, Mar del Plata, Santa Fe) and in Caracas, San Juan in Puerto Rico, Miami, and New York and has been awarded two national prizes. In 1972 he participated in an exhibition circulated under the auspices of the Argentine government to museums in nine European countries. In 1973 he represented Argentina in the exhibition *Tribute to Picasso*, which was organized by the General Secretariat of the OAS and circulated in museums in Santo Domingo, Port-au-Prince, and Atlanta. --*J.G-S.*

EXHIBITION LIST [1]

Silkscreens

1. *La magia del equilibrista* (The Magic of the Ropedancer)
2. *El ángel equilibrista* (The Ropedancer Angel)
3. *El prestidigitador* (Juggler)
4. *Imagen transcendente* (Transcendental Image)
5. *El profeta delirante* (Delirious Prophet) *II*
6. *Concentración de elementos* (Concentration of Elements)
7. *La nueva morada* (New Dwelling)
8. *Paisaje etéreo* (Ethereal Landscape)
9. *Evasión* (Evasion)
10. *La hija del sueño* (Daughter of the Dream)
11. *Maternidad (Maternity)*
12. *Dispersión predilecta* (Favorite Dispersion)
13. *De la misma tierra* (From the Very Earth)
14. *De la tierra y el círculo rojo* (From the Earth and the Red Circle)
15. *Desde el paisaje* (From Landscape)
16. *El profeta delirante* (Delirious Prophet)
17. *Paisaje (Landscape)*
18. *La idea fija* (Fixed Idea)
19. *En el aire de aquí y allá* (In the Air, Here and There)

[1] Not included in the original catalogue. --*Ed.*

March 1 - 10, 1976

CORPUS OF MAYA HIEROGLYPHIC INSCRIPTIONS
Peabody Museum of Archaeology and Ethnology

HANDICRAFTS OF THE MAYA REGION
Courtesy of the Government of Mexico

No catalogue was found for this exhibition which was made possible through the collaboration of the Peabody Museum of Archaeology and Ethnology of Harvard University, the Mexican government, and the General Secretariat of the Organization of American States. A flyer issued then by the OAS stated:

> The First Ladies of Mexico and the United States, Mrs. María Ester Zuno de Echevarría and Mrs. Betty Ford, will co-sponsor this exhibition highlighting the results of decades of archaeological explorations in Mexico and Guatemala, looking toward the decipherment of a language that reflects the rise and fall of classic Maya civilization from A.D. 600 to A.D. 900. The Mexican government is sending authentic folk costumes and handicrafts from Maya communities. Two volumes of Maya hieroglyphic descriptions may be acquired at the exhibit. Proceeds will go to the Museum of Archaeology of Guatemala.

The exhibition also included photographs of Mayan sculptures. It was originally intended as a tribute to the publication *The Corpus of Maya Hieroglyphic Inscriptions*, by Ian Graham and Eric von Euw, Peabody Museum of Archaeology and Ethnology, Harvard University, Cambridge, Massachusetts, 1975. Later, it was redesignated as a benefit for the Museum of Archaeology of Guatemala, heavily damaged by the 1976 earthquake. --*Ed.*

March 23 - April 19, 1976

ANTONIO BARRERA OF COLOMBIA: LANDSCAPES

Antonio Barrera's landscapes do not correspond to traditional landscape painting but, rather, to a new vision, a new way of looking at nature in terms of large, open spaces. Barrera is concerned with the interplay of flat surfaces. Using subtle gradations of color, he divides his space horizontally in asymmetrical sections, eliminating all that is literary or incidental. Clouds, shadows, or figures are suggested only for the purpose of scale or, more specifically, to give a sense of vastness that characterizes the great plains of his native Colombia.

Born in Bogotá in 1948, Barrera studied at the School of Fine Arts of Colombia's National University, graduating in 1974. He had three consecutive one-person exhibitions in Bogotá and Medellín last year, and has participated in national salons and group exhibitions, including *Landscape 1900-1975*, which was presented at the Museum of Modern Art in Bogotá. He is represented in the collections of the Museum of Modern Art, the Museum of the National University, and the Cafetero Bank, all in Bogotá, as well as in private collections in Colombia and abroad.

This is Barrera's first one-person exhibition outside Colombia. --*J.G-S.*

EXHIBITION LIST [1]

Paintings

1. *Paisaje (Landscape) I*, 1975, pastel, 70 x 100 cm.
2. *Paisaje (Landscape) II*, pastel
3. *Paisaje (Landscape) III*, pastel
4. *Paisaje (Landscape) I*, acrylic
5. *Paisaje (Landscape) II*, acrylic
6. *Paisaje (Landscape) III*, acrylic
7. *Paisaje (Landscape) IV*, acrylic
8. *Paisaje (Landscape) V*, acrylic
9. *Paisaje (Landscape) IV*, pastel
10. *Paisaje (Landscape) V*, pastel
11. *Paisaje (Landscape) VI*, pastel
12. *Paisaje (Landscape) VII*, pastel

March 23 - April 19, 1976

SERGIO TRUJILLO OF COLOMBIA: PHOTOGRAPHS

Although creative photography gained wide acceptance in Colombia many years ago, there has been a recent trend away from realism toward a more abstract or universal concept of nature. Two years ago, Sergio Trujillo Dávila had several one-man exhibitions in the Washington area, one of which was held at the Pan American Health Organization. In that show he displayed a group of photographs that had as their subject torn, weather-beaten posters seen on the building walls in Bogotá. His keen eye enabled him to determine the interesting elements and in printing his negatives he achieved a synthesis of form that gave his final work an expression independent of that of the subject by itself. In the current exhibition Trujillo has focused his attention on the human foot. Using the same sharp sense of evaluation that characterized his earlier photographs, he gives his subject a new dimension that is further dramatized by a vibrant interplay of light and shadow.

Born in Bogotá in 1947, Trujillo, who is the son of a well-known Colombian painter, studied architecture at the National University of Bogotá and later became interested in photography and graphic design. In 1968 he attended the David Manzur Workshop for a semester. He has been exhibiting his photographs professionally since 1973, when he had his first one-person show at the Avenida 19 Gallery in Bogotá. Since then he has exhibited in the Washington area at PAHO and at the Oxon Hill and Rockville Libraries. He has participated in several national and international exhibitions, including Bifoto International in Berlin, 1974, and was awarded a prize at the Fourteenth Cinematography Festival in Cartagena. --*J.G-S.*

CATALOGUE

Photographs[2]

March 23 - April 19, 1976

URUETA OF COLOMBIA

The sculptures of Eduardo Urueta, which I first saw during a visit to the Museum of Contemporary Art in

[1] Not included in the original catalogue. --*Ed.*

[2] Titles are unavailable. --*Ed.*

Bogotá last year, are created with a feeling for plasticity and sense of elegance that are all the more surprising considering that they are made from the door panels of abandoned automobiles. Of course, the use of automobile parts to create sculpture is not uncommon, but there is a tendency for most artists to treat such materials in a romantic fashion, either hammering, smashing, or in some other way accentuating an existing damage. Urueta takes a different approach. His conception of form is basically classical, emphasizing simplicity, purity, and equilibrium. Rather than intensify the damage, he selects the significant part of the door panel, cuts off the unnecessary elements, and leaves only what has plastic relevance. The form is then placed in a direction that creates the necessary balance, and is painted a flat black or white. As a result, there is rarely any indication of the origin of the material, and each object takes on its own significance.

Urueta was born in Bogotá in 1940 and had no training in art until 1970. In that year he entered the National School of Fine Arts, where he studied for four years. As a child he had learned auto-body repair while working with his father and, later, was employed by the local repair shop where he still works. Although he studied both painting and sculpture, his natural inclination was toward the latter, and it was in sculpture that he could combine the skills he had acquired in working with metal with his vision as an artist. In 1974 he began participating in group exhibitions in Bogotá and the following year he had his first one-person exhibition at the Museum of Contemporary Art.

This is the artist's first exhibition outside Colombia. --*J.G-S.*

EXHIBITION LIST [1]

Metal Sculptures

1. *Composición (Composition), No. 10*, 155 x 110 x 52 cm.
2. *Composición (Composition), No. 11*, 90 x 90 x 69 cm.
3. *Composición (Composition), No. 12*, 107 x 85 x 45 cm.
4. *Viajera (Traveler), No. 1*, 98 x 68 x 38 cm.
5. *Viajera (Traveler), No. 2*, 85 x 85 x 50 cm.
6. *Composición (Composition), No. 13*, 116 x 85 x 52 cm.
7. *Composición (Composition), No. 14*, 90 x 75 x 25 cm.
8. *Viajera (Traveler), No. 3*, 95 x 70 x 35 cm.

This exhibition was made possible with the cooperation of Rodolfo Lerry and Company, where the artist is employed, and Avianca Airlines.

April 21 - May 19, 1976

PAINTINGS BY ENRIQUE ARNAL OF BOLIVIA

Although the paintings of Enrique Arnal have a national character, the artist makes a statement about reality that has universal meaning. The isolated figure of the miner or Bolivian *cholo*, whose origin and status are identifiable by his dress, becomes a symbol of the human condition. The artist never discloses the subject's personal identity, for the face, when shown, is blurred or abstracted in movement, or turned away from the viewer entirely. While Arnal's technique involves attention to minute detail, especially in the rendering of clothing, it is the representation of movement--whether of the face or the full figure in motion--that makes the paintings so powerful and evocative.

During the past years Arnal has also painted a series of works on the condor, the strange and powerful bird of prey that is unique to the Andes. In these works he has laid aside social content to focus on pure painting, but, again, it is his skillful rendering of movement that enables him to capture the dignity and grandeur of his subject.

Arnal was born in Catavi, Potosí, Bolivia, in 1932. He attended the workshop of the well-known Chilean painter Nemesio Antúnez in 1954 while living in Santiago. He has had more than fifteen one-man exhibitions in La Paz,

[1] Not included in the original catalogue. --*Ed.*

Buenos Aires, Asunción, and Santiago and has participated in numerous national and international group shows, including the exhibition *Art of Latin America since Independence*, which was organized by Yale University and the University of Texas, 1966; the São Paulo Biennial, 1955 and 1971; and the Coltejer Biennial, Medellín, 1972. He has been awarded seven municipal and national prizes, among them First Prize at the First INBO Biennial of Art held in La Paz last year. He was twice awarded a grant by the Patiño Foundation to study and work in Paris. Arnal is represented in the National Museum of Art of La Paz as well as in other public collections in Bolivia and in the Art Museum of the University of Texas at Austin.

This is his first one-man exhibition in the United States. --*J.G-S.*

CATALOGUE

1-14.Paintings[1]

May 19 - June 17, 1976

TOÑO SALAZAR OF EL SALVADOR: CARICATURES 1925 - 1975

In the Spanish-speaking countries the name Toño Salazar has become legend. Perhaps more than any other individual, it was he, through his widely published caricatures and illustrations, who was responsible in the early decades of the century for introducing the Latin American public to the young men and women of Europe who were on their way to becoming leading figures in the world of culture and politics. In effect, he represented a cultural link between the two continents.

Born in 1900 in Santa Tecla, El Salvador, Salazar began his career at the age of sixteen. In 1920 he went to Mexico where he studied at the National Academy of Fine Arts and worked at the Museum of Archaeology and Anthropology alongside Rufino Tamayo. The most important of his early work dates from 1925, when he drew caricatures of the young men who were to shape the Mexican cultural revolution, among them the painters José Clemente Orozco and Diego Rivera, the philosopher José Vasconcelos, and the humanist writer Alfonso Reyes. In 1930 he moved to Paris where he almost immediately found employment with *Matin*, directed by Henri de Jouvenel and Colette, and afterwards his work began to appear in other French newspapers and magazines such as *Le Figaro, L'Intransigeant*, and *Nouvelles Littéraires*. It was through his contact with the publishing world that he met Jean Cocteau, Pablo Picasso, Igor Stravinsky, James Joyce, Herman von Keyserling, Serge Diaghilev, Paul Claudel, and Ida Rubinstein, all of whom were to be subjects of his work. During the same period his caricatures were also published in the *New York Herald Tribune* and *Vanity Fair*.

At the beginning of World War II he moved to Argentina, where he was a regular contributor to *La Prensa, La Razón, Crítica, La France Nouvelle*, the organ of the French Resistance in Buenos Aires, and *La Nación*. His work still appears regularly in the latter. After a few years he returned to El Salvador and in 1949 was appointed consul general of El Salvador in Uruguay. Since then he has served in diplomatic posts in France, Italy, and Israel.

At the age of seventy-six, with a career that spans more than five decades, Salazar now lives in his native El Salvador and continues to draw as diligently as ever, having produced since 1970 a corpus of work that includes caricatures of Henri Matisse, Jorge Luis Borges, Julio Cortázar, and Pablo Casals, among others.

This exhibition, a retrospective of the period from 1925 to 1975, is intended as a tribute to a man who had a remarkable capacity to distinguish those who were to be the leaders of the future--artists, musicians, literary figures, philosophers, and politicians--and the ability to capture their personalities through the art of caricature.

About his work Salazar has said:

> My eyes believe only in exaggeration. . . . When working at the old Anthropology Museum in

[1] Titles are unavailable. --*Ed.*

Mexico, my eyes saw a new world, complementing my previous vision. It is from this Mexican source and from the pre-Columbian Salvador that my drawing derives--Paris gave it intelligent wings for its flight.

--J.G-S.

CATALOGUE

Caricatures 1925 - 1975

1916

1. *Francisco Gavidia*

1925, Mexico

2. *Alfonso Reyes*
3. *José Guadalupe Posada*
4. *Genaro Estrada*
5. *José Vasconcelos*
6. *Diego Rivera*
7. *José Clemente Orozco*
8. *Angel María Garivay*
9. *José Juan Tablada*
10. *Xavier Villarrutia*
11. *Adolfo Best Maugard*
12. *Rufino Tamayo*
13. *Ramón del Valle Inclán*

1930, Paris

14. *Jean Cocteau*
15. *La Comtesse de Noailles*
16. *Marie Laurencin*

1940, Caricature Essay in Color

17. *Pablo Picasso*
18. *Paul Valéry*
19. *Don Miguel de Unamuno*
20. *Ida Rubinstein*
21. *Mariscal von Hindenbourg*
22. *Ali-Baba and the Forty Thieves*
23. *Illustrations,* published in Buenos Aires
24. *Caricatures,* from *Antología apócrifa*
25. *Federico García Lorca*
26. *Manuel de Falla*
27. *G.K. Chesterton*
28. *Pablo Neruda*
29. *Rudyard Kipling*

1950

30. *Illustrations,* from *Treasure Island*
31. *Writers of Uruguay*
32. *Delmira Agustini*
33. *Horacio Quiroga*

1960

34. *Leyendas de Guatemala*, by Miguel Angel Asturias
35. *Miguel Angel Asturias*
36. *Dehumanization*
37. *Pablo Picasso*
38. *Alfonso Reyes*
39. *Count Herman von Keyserling*
40. *Greta Garbo*
41. *Igor Stravinsky*
42. *James Joyce*

1970, Paris and San Salvador

43. *Haile Selassie*
44. *Bishop Makarios*
45. *King Faisal*
46. *Emir Ahmed Zahi Yamani*
47. *Golda Meir*
48. *Gabriel García Márquez*
49. *Pablo Casals*
50. *Julio Cortázar*
51. *Pablo Picasso*
52. *Henri Matisse*
53. *Aaron Copland*
54. *Benny Goodman*
55. *André Breton*
56. *Jorge Luis Borges*

May 19 - June 17, 1976

PAINTINGS BY SAN AVILES OF EL SALVADOR

San Avilés, a young painter from El Salvador who presently lives and works in Paris, is among the artists of recent years who have rejected abstraction and experimentation in favor of a return to painting in which the predominant concern is with technique and an exact rendering of form. The realism, or what might best be described as ultra-realism of Avilés, has its roots in fifteenth century Flemish painting, which he studied in depth together with Italian primitive painting during his early years in Paris. His subjects, whether the human form or an object, are rendered with painstaking delicacy and precision and remain poised and immobile in an atmosphere of absolute calm.

Born in 1932 in Santa Ana, El Salvador, San (Ernesto) Avilés studied in his native country with the Spanish master Valero Lecha from 1950 to 1954. In 1956 he was awarded a fellowship by the government of El Salvador to study in Europe. He entered the Royal Academy of San Fernando in Madrid, 1956-1961. In 1971 he was given a grant to study printmaking at the Stamperia Dello Stratto in Rome.

Avilés has had seven one-person exhibitions in El Salvador, France, and Italy and has participated in group exhibitions in those countries as well as Spain and the United States. His work is represented in the private collections of Prince Philip of England as well as in collections in El Salvador and abroad.

This is the artist's first one-person exhibition in the United States. *--J.G-S.*

CATALOGUE

Paintings

 1. *Retrato de Gregorio (Portrait of Gregorio)*

2. *Cristo en la morgue (Christ in the Morgue) I*
3. *Cristo en la morgue (Christ in the Morgue) II*
4. *Plegaria (Prayer)*
5. *Casa de Adán y Eva (House of Adam and Eve)*
6. *Interior*
7. *Pera soltera (Lone Pear)*
8. *Autorretrato en casa de Herodes (Self-Portrait in the House of Herod)*
9. *Naturaleza sola (Nature Alone)*
10. *Retrato del Espíritu Santo (Portrait of the Holy Spirit)*
11. *Interior con mariposa (Interior with Butterfly)*
12. *Pera en baño turco (Pear in Turkish Bath)*
13. *Retrato de pera (Portrait of a Pear)*
14. *Endibia (Endive)*
15. *San Sebastián (Saint Sebastian)*

June 17 - July 19, 1976

ANTONIO DIAZ CORTES OF MEXICO: PAINTINGS AND WOODCUTS

While it is not unusual to find an occasional Oriental accent in pre-Hispanic art, painter and printmaker Antonio Díaz Cortés is one of the few contemporary artists in Latin America whose work is in any way related to that of the Orient. Certainly, this is in part the result of his having lived and studied in Tokyo for several years, where he was widely exposed to both ancient and modern Japanese expression.

Born in San Luis Potosí, Mexico, in 1935, Díaz Cortés studied at the local art school during 1955 and later attended La Esmeralda School of Painting and Sculpture in Mexico City, 1957-1961. Assisted by a fellowship awarded by the OAS, he enrolled at the University of Wisconsin in Madison, from which he received a Master of Arts degree in 1964. From 1969 to 1971 he was in Tokyo where he specialized in learning different printmaking techniques. He has had one-person exhibitions in Mexico City, New York City, Madison, Milwaukee, and Tokyo and has participated in more than fifteen group shows in Mexico and the United States. He is represented in the public collections of the National Institute of Fine Arts in Mexico City, the National University of Mexico, and the University of Wisconsin.

This is the artist's first one-person exhibition in the Washington area.

EXHIBITION LIST [1]

Paintings

1. *From Space*
2. *Astronaut*
3. *Deseo (Desire)*
4. *Gestación (Gestation)*
5. *Alumbramiento (Birth)*
6. *Invierno (Winter)*
7. *Frozen Heads*
8. *Eclipse*
9. *From the Column*
10. *Models*
11. *Heads*

[1] Not included in the original catalogue. --*Ed.*

Woodcuts and Linocuts

12. *Upon the Rectangle*
13. *Meeting of Moons*
14. *Daguerreotype of Moon*
15. *Afro-Am*
16. *Sirens*
17. *Link*
18. *Akari*
19. *Columns*
20. *Fruit of Eve*
21. *Column and Torso*
22. *Couple*
23. *Feminine Masculine*
24. *Apple and Eve*
25. *Sayonara*
26. *Two*

Tapestries

27. *Woven Link*
28. *Upon Rectangles*

June 17 - July 19, 1976

RAFAEL ZEPEDA OF MEXICO: LITHOGRAPHS AND ENGRAVINGS

This exhibition, consisting of lithographs and engravings created over a period of years by Mexican printmaker Rafael Zepeda, was made possible through the courtesy of Mexico's National Institute of Fine Arts. In the earliest works, Zepeda used recognizable elements of reality but, unlike the Mexican nationalist or realist artists, he arranges the forms in an abstract, asymmetrical composition. Although he retains the same composition in much of his later work, the forms themselves have become abstract rather than realistic.

Born in Mexico City in 1938, Zepeda studied there at the National School of Plastic Arts from 1958 to 1962. From 1968 to 1971 he attended the Academy of Fine Arts of Krakow, Poland, where he studied printmaking, graphic design, and film animation. He has had ten one-person exhibitions in Mexico, Nicaragua, Venezuela, the United States, and Poland and has participated in important print exhibitions in Mexico and abroad, among them the First International Triennial of Carpi, Modena, Italy, 1969; the International Biennial of Santiago, Chile, 1970; and *Young Painters of Mexico*, Paris, 1976. He has been awarded seven national and international prizes and is represented in the collections of the Museum of Modern Art, Mexico City; the Print Museum, Buenos Aires; the Museum Ugo Da Carpi, Modena; and the Museum of the National Academy of Fine Arts, Krakow.

This is Zepeda's first one-person exhibition in the Washington area. --*J.G-S.*

EXHIBITION LIST [1]

Prints

1. *Turbulencia citadina (Urban Turbulence)*, engraving, 2/10, 41 x 36 1/2 cm.
2. *Lunar Conquest, Realism*
3. *Composición de tres planos (Composition of Three Planes)*, 1967, etching, 3/10, 27 x 19 1/2"
4. *Forma (Form) I*, engraving, 4/10, 53 x 41 1/2 cm.

[1] Not included in the original catalogue. --*Ed.*

5. *Segunda composición en negros sobre un tema religioso (Second Composition in Blacks on a Religious Theme)*,
 1967, engraving, 2/10
6. *Good Try, Old Fellow!*
7. *No se pinte (Anuncio) (Advertising Prohibited)*, 1967, engraving, 2/10
8. *Realismo con "A" (Realism with "A")*
9. *Bocanada de agua de mar, por donde la tierra devuelve su vértigo (Whiff of Sea Water, Where the Earth Returns
 Its Vertigo)*, engraving, 2/10, 54 x 41 cm.
10. *Pronunciación gráfica (Graphic Pronunciation)*, 1967, engraving, 3/10
11. *Grabado con tema olímpico (Graphic with Olympic Theme)*, 1968, engraving, 1/10
12. *Ralicismo (Realism) No. 1*
13. *Un pensamiento bien negro (A Very Black Thought)*, engraving, 2/10, 41 x 52 cm.
14. *Juego gráfico (Graphic Game)*, engraving, 2/10, 40 x 64 cm.
15. *Comic No. 38*, 1967, 3/20
16. *Composición en negros sobre una forma conocida (Composition in Blacks on a Known Form)*
17. *Homenaje al grillo mayor (Homage to the Older Cricket)*, etching, 2/10, 27 x 19 1/2"
18. *Función del Pop Comic sobre la "A" (Function of Pop Comic on "A")*, 1967, 3/10
19. *Diálogo Camp (Camp Dialogue)*, 1967, etching, 3/10
20. *Contrapunto concreto (Concrete Counterpoint)*, 1967, etching, 2/10, 27 x 19 1/2"

July 21 - August 17, 1976

TWO ARTISTS FROM MARACAIBO: CARMELO NIÑO AND JULIO VENGOECHEA

In selecting the artists who participate in the OAS exhibition program, there has always been an attempt to give attention not only to those who live and work in the major capitals but also to show the work of those who live in the smaller, interior cities of the Latin American nations.

One of the most economically and culturally progressive cities in Venezuela, other than Caracas, is Maracaibo, which lies in the torrid, coastal area that is the center of the country's petroleum industry. Historically, the name of the country itself originated in this region since the Spaniards, upon first seeing the houses rising out of the lake, were reminded of Venice and decided to call the entire territory "Little Venice," or Venezuela.

Maracaibo's Fine Arts Center is the cultural heart of the region. Housed in a handsome, modern architectural complex, it has regular performances of theater, music, and dance as well as art exhibitions and lectures. The Center has done much to encourage young persons working in the field of the plastic arts particularly and, in terms of funding and promotion, has been the major force behind the Mali-Mai Tapestry Workshop in the Guajiro region. An exhibition of Guajiro tapestries was shown here at the OAS gallery in 1972, and, *subsequently, a similar exhibition toured the United States under the auspices of the Smithsonian's Traveling Exhibition Service, 1972-1974.

Some months ago, I was invited by the Center to select the work of two young artists from Maracaibo for presentation at the OAS gallery. Those chosen were Carmelo Niño and Julio Vengoechea, both of whom are exhibiting for the first time outside Venezuela. Each works in a different medium and has a distinct, personal expression.

The refined, satirical drawings of Carmelo Niño are filled with strange, fantasy-like figures that are surrounded by thick vegetation. Born in Maracaibo in 1951, Niño studied at the local Neptalí Rincón School of Fine Arts from 1967 to 1970 and that same year had his first one-person exhibition at Maracaibo's Fine Arts Center. Since then he has had two one-person shows in Maracaibo and has participated in some ten group exhibitions, including the Fourth National Salon of Young Artists, Caracas, 1975, where he won an Acquisition Prize.

Julio Vengoechea, trained as an industrial engineer, began to work with photography many years ago and during the past three years has been involved in creating what he calls "photographic recompositions." Searching for a purely plastic expression, avoiding the decorative, he uses fragments of color photographs that he himself has made to form intriguing patterns that have a kaleidoscopic effect. Born in Panama in 1940, Vengoechea has lived in Maracaibo for more than twenty years and is a Venezuelan citizen. He had his first one-person exhibition at the Fine Arts Center in Maracaibo in 1974 and has had two one-person shows in Caracas. He has participated

in five group exhibitions and in 1974 was awarded First Prize for Color Photography together with an Honorable Mention in the Professional Photographers Salon of the State of Zulia.

We wish to acknowledge the cooperation of VIASA, Venezuelan National Airlines, for having made this exhibition possible. *--J.G-S.*

EXHIBITION LIST [1]

Carmelo Niño

Paintings

1. *La familia (The Family)*, acrylic on canvas, 120 x 140 cm.
2. *Niña en el parque (Child in the Park)*, acrylic on canvas, 75 x 85 cm.
3. *Mujer con pájaro (Woman with Bird)*, acrylic and earth on canvas, 91 x 128 cm.

Drawings, India Ink on Canvas

4. *Sorpresa (Surprise)*, 1975, 67 x 86 cm.
5. *Velorio (Wake)*, 60 x 80 cm.
6. *Circo privado (Private Circus)*, 60 x 85 cm.
7. *Cabeza (Head)*, 60 x 85 cm.

Julio Vengoechea

Photographic Recompositions

1. *¿Iré hacia A, hacia B, o me regreso a X? (Shall I Go Toward A, Toward B, or Return to X?)*
2-3. *Polarización (Polarization) I, II*, 1975
4. *Relieves en azul metálico (Reliefs in Metallic Blue)*
5. *Reminiscencias (Reminiscences)*
6. *Si cierro los ojos... (If I Close my Eyes . . .)*, 1975, 19 x 19"
7. *Mansiones verdes (Green Mansions)*
8. *Ciérrame para siempre al exterior (Close Me Off from the Outside Forever)*
9. *Senderos asimétricos del azar (Asymmetrical Paths of Chance)*
10. *Detrás de fachadas moran duendes amables (Friendly Gnomes Live Behind the Façades)*
11. *... Destruído allí el espíritu de la libertad... (. . . Once the Spirit of Liberty Was There Destroyed . . .)*
12. *Una obscuridad de soles (A Darkness of Suns)*

August 18 - September 15, 1976

THREE ARTISTS FROM TRINIDAD AND TOBAGO: VERA BANEY, OTTWAY JONES, SONNYLAL RAMBISSOON

This exhibition brings together three artists from Trinidad and Tobago. Vera Baney is an accomplished ceramist who has been able to go beyond the conventional, rigid rules that tend to govern her medium to create hand-built forms that have a mysterious, almost magical quality, with the sense of mystery enhanced by unexpected openings and rough-textured surfaces. In some instances, her works bear a resemblance to sacred objects of the Far East.

Born in Trinidad in 1930, Baney studied at Brighton College of Art (1959-1962) in England, as well as in the Caribbean and at the University of Maryland. She has had several one-person exhibitions in Trinidad and at the

[1] Not included in the original catalogue. *--Ed.*

University of Maryland Art Gallery and has participated in group shows in this area, including the exhibition *Contemporary Art from the Caribbean*, OAS, December 1972, as well as in London at the Commonwealth Institute, 1974, and in Trinidad. In 1967 she represented Trinidad and Tobago at Expo '67 in Montreal and in 1975 was a participant in the São Paulo Biennial. She has completed numerous special commissions, among them a mosaic mural for the chapel of Bishop Anstey High School and a ceramic cross for the Norwegian Seamen's Mission, both in Trinidad.

Ottway Jones is a young painter and draftsman who is represented in the exhibition with a series of drawings in which different forms--both human and abstract--are densely interwoven. Jones was born in Trinidad in 1945 and attended Presentation College there. He is currently studying at Howard University. He has been awarded several fellowships and prizes and has had one-person exhibitions in Trinidad and Tobago and the Virgin Islands. In the Washington area his work has been included in exhibitions at the Martin Luther King Library, the Opus 2 Gallery, and at Howard University.

Sonnylal Rambissoon, the senior representative of the group, is a highly skilled printmaker whose technique involves the use of plywood, Masonite, and vinyl. His improvisational forms have an abstract appearance but, in some cases, can be associated with reality. Born in Trinidad in 1926, he studied at Brighton College of Art (1959-1964), Sussex, as well as in London, and attended summer workshops in France, England, Canada, and the United States. He has held numerous teaching positions in Trinidad and Tobago and is at present vice-principal of the Marabella Junior Secondary School. He has had two one-person exhibitions of his prints and watercolors at the National Museum and Gallery of Trinidad, 1971 and 1973, and has participated in important national and international exhibitions, including the São Paulo Biennial, 1969 and 1971. Rambissoon has received national awards for his contributions as both an artist and an educator and in 1968 was elected an associate member of England's Royal Society of Painters and Etchers. He was represented in the exhibition *Contemporary Art from the Caribbean*, which was presented at the OAS Gallery in December 1972, as well as *Contemporary Printmakers of the Americas*, an exhibition organized by the OAS that is currently touring museums and university galleries in the United States. --*J.G-S.*

EXHIBITION LIST [1]

Vera Baney

Ceramics

1. *Notations*
2. *Monarch*
3. *Lateral Notches*
4. *Flight*
5. *Family Fusion I*
6. *Debut*
7. *Lateral Notches II*
8. *Family Fusion II*
9. *Two Is One*
10. *Distant Echo*
11. *Caribbean Surf*
12. *Keeping Watch*
13. *Open Song*
14. *Bounty*
15. *Higher Levels of Order*
16. *Adjudicator*
17. *Natural Forces*
18. *Coscorols*
19. *Split Form*
20. *The Messengers*

[1] Not included in the original catalogue. --*Ed.*

21. *Unified Force Lines*
22. *Perception*
23. *First Day*
24. *Inner Variations*
25. *Place of Rarest Purity*

Ottway Jones

Drawings

1. *Forces and Formation*
2. *Forces and Formation*
3. *Forces and Formation*
4. *Forces and Formation*
5. *Forces and Formation*
6. *Reverse Metamorphosis*
7. *Thoughts on Soweto I*
8. *Drum Spirit of Shango*
9. *Reré, Profile of a Vision*
10. *Ritual for Soil*
11. *Justices of War*
12. *Elephon, Message*
13. *Thoughts on Soweto*
14. *La Lune Spirit*
15. *Emergence, Ancestral Dance Study*
16. *Dismissal of a Power*

Sonnylal Rambissoon

Prints

1. *Marvin Improvisations*, silk screen, 34 x 30 cm.
2-4. *Theme of The Rime of the Ancient Mariner*, wood, Masonite, vinyl, 46 x 39 cm.:
 a. *All in a Hot and Copper Sky*
 b. *The Sun Now Rose upon the Right*
 c. *Almost upon the Western Wave*
5. *Emerald-White*, wood, Masonite, vinyl, 52 x 31 1/2 cm.
6. *Secret Garden*, wood, 52 x 30 cm.
7-8. *Magenta I, II*, wood, plywood, vinyl, 44 x 27 cm.
9-11. *Genesis of the Flamingo I, II, III*, Masonite, vinyl, wood, 41 x 35 cm.
12. *Improvisations on an Orange Theme*, metal, wood, vinyl, 48 x 42 cm.
13-15. *Night and Day Series*, iron, metal, vinyl, 41 x 31 cm.:
 a. *Night*
 b. *Day*
 c. *Evening*
16. *Triptych I*, etching (zinc), 16 1/2 x 32 cm.
17. *Naparima Diptych*, etching (copper), 19 x 30 cm.
18. *Swinging*, etching, engraving, aquatint (copper), 54 x 40 cm.
19. *Theme of The Ancient Mariner: The Albatross*, etching and aquatint, 50 x 33 cm.

September 16 - October 13, 1976

CESAR VALVERDE OF COSTA RICA

César Valverde can be considered as one of the forerunners of modern art in Costa Rica. During a career that spans more than twenty years, he has had ten one-person exhibitions in Costa Rica, including an exhibit at the

National Museum in San José in 1968, and has participated in more than twenty group shows in his own country as well as in Colombia, Mexico, Venezuela, Spain, Italy, and the United States. He was represented in a group exhibition at the OAS gallery in 1964.

Born in San José in 1928, Valverde studied in Rome from 1953 to 1955, having been awarded a fellowship by the Italian government, and in 1957 came to Washington, D.C., where he attended the Corcoran School of Art. From 1958 to 1960 he studied at the Regional School of Art in Manchester, England. He only recently resigned after having served for many years as director of the School of Fine Arts of Costa Rica's National University. During the past year, he was coordinator of CREAGRAF, a regional center for specialized studies in the graphic arts that was established by the OAS and the government of Costa Rica for students from Central America.

In this exhibition, Valverde is represented by a series of new works on paper in which he has used silkscreen inks applied by a method similar to that used by engravers to create a monotype. His work has always been essentially expressionistic, but the angularity of form that characterized his paintings of an earlier period has been replaced by a more sculptural approach, with the forms more rounded and compact.

Works by Valverde are included in public collections in Costa Rica and Venezuela, among them the Museum of Modern Art of Mérida, Venezuela, and the Presidential Palace in San José, as well as in private collections in Costa Rica and abroad. His awards include Special Prize given by the Exposition Palace in Rome, 1954, and the National Prize for Painting in Costa Rica, 1975.

This is the artist's first one-person exhibition in the United States. --*J.G-S.*

CATALOGUE [1]

1. *Two Figures*
2. *Woman with Bird*
3. *Hope*
4. *Sitting Figure*
5. *Anxiety*
6. *Woman and Fish*
7. *Sitting Figure II*
8. *Memory*
9. *The Wait*
10. *Maternity*

EXHIBITION LIST

Silkscreen Inks

1. *Memory*
2. *Weaver of Destiny*
3. *Devil's Procession*
4. *Figures in Yellow*
5. *Despair*
6. *Minaya and Ximena*
7. *Figures in Blue*
8. *Indian Reminiscences*
9. *Agony*
10. *Figure*
11. *Figure*
12. *The Hammock*

[1] Although the first ten titles under Catalogue appeared in the original catalogue, the thirty-four titles reproduced under Exhibition List correspond to those of the works actually exhibited. --*Ed.*

13. *Celestine*
14. *In the Market*
15. *En lucha con la muerte (Fight with Death)*, 1975, monotype, 8 1/2 x 28 1/2"
16. *The Vulture*
17. *Waiting for the Fall*
18. *Anxiety*
19. *Blind Child*
20. *Store Dialogue*
21. *Blanche*
22. *Talking Women*
23. *Contest*
24. *Actress and Director*
25. *Unfinished Dream*
26. *Figure*
27. *St. Theresa's World*
28. *Ritual*
29. *Sisters*
30. *The Beginning*
31. *Woods*, oil
32. *Woods in Blue*, etching
33. *Head*
34. *Maternity*

October 7 - 20, 1976

EGAR: PHOTOGRAPHS OF COLOMBIA

Photography has been developing as an important movement in Colombian art for many years. Among the great creators with the lens in the country today is Egar (Efraín García Abadía). His training includes instruction under the famous Colombian photographers Juan Sass, Arthur Kramer, and Leo Matiz. Having worked as a photographer for various newspapers and magazines in his country, Egar has also occasionally contributed to *Time*, *Life*, and the *Christian Science Monitor*. He has served as an instructor for professional groups in the Colombian government and has received special recognition and awards in national exhibitions. Thus far, he has held one-man shows in Medellín and Bogotá.

Egar was born in 1931 in Tuluá, Colombia. Upon completion of high school, he began his work in the field of amateur photography. Due to his background as a news photographer, his style is somewhat documentary with an accent on action and movement. His subjects are generally peasants and workers of Colombia. Intense drama emerges from his work which is considered to be of major importance in contemporary Latin American photography.

This is Egar's first one-man exhibit in the United States and the first presentation of his work in the Washington area. --*J.G-S.*

EXHIBITION LIST [1]

Photographs

1. *Colombia, ayer, hoy* (Colombia, Yesterday, Today)
2. *Colombia campesina* (Rural Colombia)
3. *Tierra: 150 años, 2 siglos* (Earth: One Hundred and Fifty Years, Two Centuries)
4. *Los balcones de Cartagena* (Balconies in Cartagena)

[1] Not included in the original catalogue. --*Ed.*

5. *Fuerte de San Fernando* (San Fernando Fort), Cartagena
6. *Defensa contra las invasiones piratas* (Defense Against the Pirates' Invasions)
7. *Dos siglos de historia: San Pedro Claver* (Two Centuries of History: San Pedro Claver)
8. *Cartagena de Indias*, 1976
9. *Nuevo amanecer* (New Sunrise)
10. *Río Caquetá: autopista de la selva* (Caquetá River: Highway in the Forest)
11. *Bogotá, metrópoli de los Andes* (Bogotá, Andean Metropolis)
12. *La viajera* (The Traveller), San Agustín Archaeological Park
13. *Músico precolombino* (Pre-Columbian Musician), San Agustín Archaeological Park
14. *Dios precolombino de la muerte* (Pre-Columbian God of Death), San Agustín Archaeological Park
15. *Tumba precolombina* (Pre-Columbian Tomb, San Agustín Archaeological Park
16. *La tierra para el que trabaja* (The Land Is for the One Who Works It)
17. *Tribu epinayú: la alegría del agua* (Epinayú Tribe: The Joy of the Water), Guajiro Desert
18. *Tres razas: un país* (Three Races: One Country), Urabá Forest
19. *Madre indígena guambiana* (Guambian Mother), Southern Colombia
20. *El shock del futuro* (Shock of the Future)
21. *El Compa Sancho*
22. *El pescador de ilusiones* (Fisherman of Illusions)
23. *El pequeño Buda* (Little Buddha)
24. *Amanecer del pescador* (Dawn of the Fisherman)
25. *El pescador no tiene fortuna, sólo su atarraya* (A Fisherman Has No Fortune, Only His Casting Net)
26. *Cantando bajo la lluvia...* (Singing in the Rain . . .)
27. *La última etapa...* (The Last Stretch . . .), 1976, black and white photograph, 11 1/2 x 15 1/4"
28. *Ganarás el pan...* (You Will Earn Your Bread . . .)
29. *El arado que usó mi abuelo* (The Plow That My Grandfather Used), Department of Nariño, 1976
30. *Campesina* (Peasant Woman), Department of Boyacá, 1970
31. *La marcha del trabajo* (Workers' Parade)
32. *Mujer campesina* (Peasant Woman), 1964
33. *Camino al mercado* (Road to the Market), 1976, black and white photograph, 11 1/2 x 15 1/4"
34. *La larga espera* (Long Wait)
35. *Marcha al progreso, colonización en el Caquetá* (Towards Progress, Settlement in Caquetá)
36. *La niña-madre* (The Girl-Mother)
37. *El derecho al trabajo* (Right to Work)

October 14, 1976

OPENING OF THE MUSEUM OF MODERN ART OF LATIN AMERICA

It was in 1957--nineteen years ago--that the Council of the Organization of American States accepted a proposal by the Representative of Mexico, Ambassador Luis Quintanilla, for the initiation of a collection of works by Latin American artists, selected principally from the exhibitions which have been regularly presented in the headquarters building for some three decades. The collection has grown steadily, and has been enriched by donations from private individuals and business concerns interested in promoting worldwide knowledge and appreciation of contemporary art of the Americas.

The collection now comprises more than two hundred works, in all media. Painting predominates, but sculpture and drawing are well represented, and there are prints executed in a wide variety of techniques. The ensemble presents an overview of tendencies and currents that have made themselves felt in the hemisphere over the last forty years. Many works acquired in early years for modest sums have seen their value multiply several times over. The aesthetic qualities which determined their choice, and which still distinguish them, enhance their historical significance. Periodically, selections have been lent for short periods to museums both in our own hemisphere and on the other side of the Atlantic. At headquarters, however, only a few could be displayed in one small gallery, others being scattered throughout offices of the General Secretariat.

This year, the Representative of Venezuela to the Organization, Ambassador José María Machín, proposed to the Permanent Council that, in tribute to the two-hundredth anniversary of the independence of the host country,

a museum of modern art of Latin America be established in the city of Washington. The Permanent Council, agreeing, decided that the annex to the main headquarters building be used for this purpose and that the nucleus of the display be constituted by the existing permanent collection. Although limited in size, the museum would provide a unique center for the study of its specialty, and bear graphic witness in the capital of the United States to the artistic values cultivated by that country's neighbors to the south.

The Council generously furnished the funds required for adapting to museum purposes the building which had first served as the residence of the Secretaries General of the Organization and had later been used as office space. Today, in a public ceremony, the distinguished Bolivian man of letters, Ambassador Fernando Ortiz Sanz, formally opens the new museum in the name of the Permanent Council, of which he is currently chairman.

As Secretary General of the Organization of American States, I am deeply gratified that a long-standing aspiration, of great cultural significance, has been realized during my term of office. This museum will stand as a permanent monument in this world capital to the bonds of friendship uniting the peoples of the Americas, to their common dedication to the democratic ideals set forth in the Declaration of Independence whose bicentennial is commemorated this year, and to the high achievement of artists from the countries of Latin America. --*Alejandro Orfila*, Secretary General, Organization of American States.

ARTISTS REPRESENTED IN THE ART MUSEUM OF THE AMERICAS

ABULARACH, Rodolfo (Guatemala)
ACOSTA GARCIA, Luis (Uruguay)
AGUILAR, Mauricio (El Salvador)
ALBORNO, Pablo (Paraguay)
ALLADIN, M.P. (Trinidad and Tobago)
ALMEIDA, Gilberto (Ecuador)
AMARAL, Antônio (Brazil)
ANGEL, Félix (Colombia)
ARANDA, Dino (Nicaragua)
ARAUZ, Félix (Ecuador)
ARMAND, Gesner (Haiti)
AROSTEGUI, Alejandro (Nicaragua)
AYOROA, Rudy (Bolivia)
BARRADAS, Rafael (Uruguay)
BARRERA, Antonio (Colombia)
BELAUNZARAN, Carlos (Mexico)
BENDERSKY, Jaime (Chile)
BENEDIT, Luis F. (Argentina)
BERMUDEZ, Cundo (Cuba)
BERNI, Antonio (Argentina)
BESS, Ruth (Brazil)
BLANCO GOMEZ, Ana (Argentina)
BONOMI, María (Brazil)
BORDA, Osvaldo (Argentina)
BRICEÑO, Trixie (Panama)
BRIZZI, Ary (Argentina)
BROWN, Everald (Jamaica)
BURCHARD, Pablo (Chile)
BURLE MARX, Roberto (Brazil)
CABALLERO, Gerardo (Colombia)
CABRERA, Roberto (Guatemala)
CAMACHO, Jorge (Cuba)
CAÑAS, Benjamín (El Salvador)
CAÑAS, Carlos (Argentina)
CANTOR, Manuel (Colombia)
CAPRISTO, Oscar (Argentina)
CARBALLO, Aida (Argentina)

CAREAGA, Enrique (Paraguay)
CARNEIRO, Vicente (Brazil)
CARREÑO, Mario (Chile)
CASTILLO, Carlos (Peru)
CASTILLO, Sergio (Chile)
CASTRO-CID, Enrique (Chile)
CHAB, Víctor (Argentina)
CID, Bernardo (Brazil)
COLOMBINO, Carlos (Paraguay)
CONDESO, Orlando (Peru)
CONSUEGRA, Hugo (Cuba)
CORONEL, Rafael (Mexico)
CRUXENT, J.M. (Venezuela)
CUEVAS, José Luis (Mexico)
DAVILA, Carlos (Peru)
DEIRA, Ernesto (Argentina)
DIAGO, Roberto (Cuba)
DIOMEDE, Miguel (Argentina)
DONDE, Olga (Mexico)
DOWNEY, Juan (Chile)
DREYFUS, Bernard (Nicaragua)
DUTARY, Alberto (Panama)
ECHEVERRI, Beatriz (Colombia)
EGAR (Efraín García, Colombia)
ESPOSITO, Nicolás (Argentina)
ESTOPIÑAN, Roberto (Cuba)
FELGUEREZ, Manuel (Mexico)
FERNANDEZ MURO, José (Argentina)
FERNANDEZ, Lola (Costa Rica)
FERNANDEZ, Rafael (Costa Rica)
FERRARI, Adolfo De (Argentina)
FERRER, Rafael (Puerto Rico)
FIGARI, Pedro (Uruguay)
FORNER, Raquel (Argentina)
FORTE, Vicente (Argentina)
FREIRE, Nelly (Argentina)
FUKUSHIMA, Tikashi (Brazil)
GATTO, Domingo (Argentina)
GIRONELLA, Alberto (Mexico)
GONGORA, Leonel (Colombia)
GRACIA, Carmen (Argentina)
GRAMCKO, Elsa (Venezuela)
GRASSMANN, Marcelo (Brazil)
GRAU, Enrique (Colombia)
GRILO, Sarah (Argentina)
GUAYASAMIN, Osvaldo (Ecuador)
GUERSONI, Odetto (Brazil)
GUILLEN, Asilia (Nicaragua)
HALEGUA, Alfredo (Uruguay)
HERNANDEZ, Camila (Mexico)
HURTADO, Angel (Venezuela)
JAIMES SANCHEZ, Humberto (Venezuela)
JEAN-GILLES, Joseph (Haiti)
KUBOTTA, Arturo (Peru)
LAMONICA, Roberto De (Brazil)
LIAUTAUD, Georges (Haiti)
LIBERTI, Juan C. (Argentina)

LONDOÑO, Armando (Colombia)
LOPEZ SAENZ, Antonio (Mexico)
MABE, Manabu (Brazil)
MAC ENTYRE, Eduardo (Argentina)
MACHADO, Ricardo (Argentina)
MALDONADO, Estuardo (Ecuador)
MANZUR, David (Colombia)
MARTINO, Federico (Argentina)
MARTINS, Aldemir (Brazil)
MATTA, Roberto (Chile)
MERIDA, Carlos (Guatemala)
MILIAN, Raúl (Cuba)
MILLAN, Carmen (Venezuela)
MILLAN, Víctor (Venezuela)
MOHALYI, Yolanda (Brazil)
MONTILLA, Manuel (Dominican Republic)
MORALES, Armando (Nicaragua)
MORI, Camilo (Chile)
MUNTAÑOLA, Roser (Panama)
NAVARRO, Héctor (Mexico)
NEGRET, Edgar (Colombia)
NIERMAN, Leonardo (Mexico)
NIÑO, Carmelo (Venezuela)
NUÑEZ, Guillermo (Chile)
OBREGON, Alejandro (Colombia)
ODUBER, Ciro (Panama)
OPAZO, Rodolfo (Chile)
ORELLANA, Gastón (Chile)
ORTIZ MONASTERIO, Luis (Mexico)
OSSAYE, Roberto (Guatemala)
OTERO, Alejandro (Venezuela)
OVIEDO, Ramón (Dominican Republic)
PACHECO, María Luisa (Bolivia)
PADILLA, Carlos (Colombia)
PAEZ VILARO, Carlos (Uruguay)
PALACIOS, Ciro (Peru)
PANTOJA, Oscar (Bolivia)
PELAEZ, Amelia (Cuba)
PENAGOS, Rafael (Colombia)
PEÑALBA, Rodrigo (Nicaragua)
PERAZZO, Josefina (Argentina)
PEREIRA, Manuel (Peru)
PEREIRA, René (Peru)
POLEO, Héctor (Venezuela)
POLESELLO, Rogelio (Argentina)
PORTINARI, Cândido (Brazil)
PORTO, Raul (Brazil)
PORTOCARRERO, René (Cuba)
PRESAS, Leopoldo (Argentina)
PRETE, Danilo Di (Brazil)
PUCCIARELLI, Mario (Argentina)
QUIROA, Marco (Guatemala)
RAMIREZ, Dora (Colombia)
RAMIREZ, Eduardo (Colombia)
RAMOS MARTINEZ, Alfredo (Mexico)
RENART, Emilio (Argentina)
REY, Flora (Argentina)

ROCA REY, Joaquín (Peru)
RODRIGUEZ, Alirio (Venezuela)
RODRIGUEZ, Marta (Colombia)
ROJAS, Elmar (Guatemala)
ROSADO DEL VALLE, Julio (Puerto Rico)
RUIZ, Pascual (Colombia)
SABOGAL, José (Peru)
SAENZ, Leoncio (Nicaragua)
SANCHEZ, Thorvald (Cuba)
SANDINO, Pedro (Colombia)
SEGALL, Lasar (Brazil)
SENDIN, Armando (Brazil)
SHINKI, Venancio (Peru)
SICRE, Juan José (Cuba)
SILVA, Alfredo Da (Bolivia)
SIQUEIROS, David Alfaro (Mexico)
SOTO, Jesús (Venezuela)
SUPISICHE, Ricardo (Argentina)
SZALAY, Lajos (Argentina)
SZYSZLO, Fernando de (Peru)
TABARA, Enrique (Ecuador)
TAMAYO, Rufino (Mexico)
TEIXEIRA, Alberto (Brazil)
TORAL, Mario (Chile)
TORRES-GARCIA, Joaquín (Uruguay)
TOYOTA, Yutaka (Brazil)
TRUJILLO, Guillermo (Panama)
TRUJILLO, Sergio (Colombia)
URUETA, Eduardo (Colombia)
VALDERRAMA, Francisco (Colombia)
VALDIVIESO, Raúl (Chile)
VALENCIA, César (Ecuador)
VALVERDE, César (Costa Rica)
VASQUEZ, Carlos (Chile)
VEGA, Jorge de la (Argentina)
VELASQUEZ, José Antonio (Honduras)
VENGOECHEA, Julio (Venezuela)
VERGARA GREZ, Ramón (Chile)
VIDAL, Miguel Angel (Argentina)
VIGAS, Oswaldo (Venezuela)
VILLACIS, Aníbal (Ecuador)
VILLEGAS, Armando (Peru)
WAKABAYASHI, Kazuo (Brazil)
ZACHRISSON, Julio (Panama)
ZAPATA, Carol (Carol Miller de Zapata, Mexico)
ZEPEDA, Rafael (Mexico)

ACKNOWLEDGEMENTS

The Organization of American States acknowledges the generosity of the following persons and institutions who have contributed some works to the Permanent Collection, composed of current works of 198 artists of the Americas:

Mr. Joseph Cantor; Mr. Lewis M. Helm; Mr. Benjamin Martin; Mr. Francisco Matarazzo Sobrinho; Mrs. Roberto Ossaye; Mr. and Mrs. John A. Pope; Mr. T. Rieber; The Honorable Nelson Rockefeller; Banco de la República Oriental del Uruguay, Montevideo, Uruguay; International Business Machines Corporation, Armonk, New York; International Petroleum Corporation (INTERCOL), Bogotá, Colombia; Workshop of the Arts,

Washington, D.C.

BIOGRAPHICAL NOTES [1]

ALBORNO, Pablo. Painter, born in Asunción, Paraguay, 1878, where he died in 1958. Graduated from the Escuela de Artes y Oficios, Montevideo. Under a Paraguayan government scholarship also studied at the Royal Academy of Rome, 1903-06, and Venice Academy, 1906-08, obtaining in both places an Academic Distinction Award. Besides teaching drawing in official institutions, founded and directed the Escuela de Artes y Oficios, 1909, and the Academia Nacional de Artes Aplicadas para Obreros, both in Asunción, and was also the creator of the annual Salón de Primavera. Held individual exhibitions in Rome, 1904, 1905, and 1907, and in Asunción and Buenos Aires. In the 1930s published several books on colonial art in Paraguay. Participated in national and international group exhibitions, including the *First Baltimore Pan American Exhibition of Contemporary Paintings*, Baltimore Museum of Art, 1931. Was awarded, among other prizes, a Silver Medal, International Exposition, Buenos Aires, 1910.

MORI, Camilo. Painter, muralist, born in Valparaíso, Chile, 1896. Died in Santiago de Chile, 1973. Spent long periods in Europe, 1920-32 and 1957, living mainly in Paris. Under Chilean grants studied in Madrid, 1922-23, and Paris, 1929-32, while also traveling in Europe and studying in Germany and Italy. Lived in Buenos Aires, 1927, and New York, 1937-39, where he painted the mural at the Chilean Pavilion of the World's Fair, 1939. In Santiago de Chile he was a member of the *Montparnasse Group*, taught drawing at the School of Architecture, University of Chile, and directed for several years the Museum of Fine Arts. Held numerous individual exhibitions in Chile, including the important retrospective show celebrating the fiftieth anniversary of his artistic activities, Sala de la Universidad de Chile, 1962. Since 1912 has participated in national salons and international shows, including the Salon d'Automne, Paris, 1921, where he was not only admitted but selected as member of the Salon Society and was a member of its jury in 1932; Salón de Otoño, Madrid, 1922; Salon des Indépendants, Paris, 1927; Pittsburgh International, Pennsylvania, 1935; and *Latin American Exhibition of Fine and Applied Art*, Riverside Museum, New York, 1939. Since 1916 has been awarded prizes and distinctions in national salons in Santiago, Valparaíso, and Viña del Mar, including the National Prize, 1950, highest Chilean distinction for the arts.

RAMOS MARTINEZ, Alfredo. Painter draftsman, printmaker, born in Monterrey, Nuevo León, Mexico City, 1875. Died in the United States, 1946. Studied at the Academia de Bellas Artes de San Carlos, Mexico City, under Santiago Rebull, José María Velasco, and others. Under a grant from Mrs. Phoebe Apperson Hearst, studied in Europe. Traveled in France, England, Germany, and Italy, taking residence in Paris, 1900-10. In Mexico City was the director of the School of Fine Arts, 1911, and founded the first School of Outdoor Painting, Santa Anita, 1913. Painted murals in Mexico and California, including those at the Santa Barbara Chapel, 1934, Chapel of Mary Star of the Sea, La Jolla, 1937-38, and created the stained glass for Saint John's Catholic Church, Claremont, 1944. Held individual exhibitions in Mexico, London, New York, and California, where he also participated in group shows. Was awarded several prizes including a Gold Medal, Salon d'Automne, Paris, 1904. Lived in Los Angeles from 1929 until his death.

October 19 - November 15, 1976

AZAR OF DOMINICAN REPUBLIC

While Aquiles Azar has made an outstanding contribution to the development of drawing in his native Dominican Republic, art has been by no means his sole occupation. At the University of Santo Domingo, Azar studied both philosophy and letters and dentistry, and he went on to obtain a master's degree in odontology at the University of Buenos Aires. He has established and maintains an active practice and is well known in the dental field. It is perhaps not surprising, therefore, that his first one-man show (1960) took place at the headquarters of the Dominican Odontological Society.

[1] Not included in the original catalogue. See Index of Artists for reference on those not listed here. *--Ed.*

Azar took up art as an incidental pastime, studying first at the school run by George Hausdorf; later he transferred to the National School of Fine Arts, where he took courses for a period of four years. While he engages both in painting and in drawing, he makes more frequent use of the latter medium. His work is expressionistic in manner, subject matter being treated somewhat enigmatically. His most characteristic feature is a fluid line, swirling throughout the surface of the paper.

Since his debut, mentioned above, Azar has had no fewer than nineteen individual exhibits--one at the Inter-American Development Bank, here in Washington in 1971, the others in the Dominican Republic and Puerto Rico. He participates regularly in national salons and has obtained a number of awards. Examples of his work may be found in many private collections in his native country and abroad, and also in the National Gallery of Fine Arts in Santo Domingo and the Art Museum of Ponce, Puerto Rico. --*J.G-S.*

CATALOGUE

Ink on Canvas or Paper

1. *Lechuza (Owl) I*, 32 x 44"
2. *Muchacho (Boy) I*
3. *Cabeza de apóstol (Apostle)*
4. *Mariposa (Butterfly) I*, 32 x 44"
5. *Bodegón (Still Life) I*, 15 x 40"
6. *Apóstol Juan (Apostle John)*
7. *Mariposa (Butterfly) II*, 32 x 44"
8. *Cabeza (Head) I*, 32 x 44"
9. *Lechuza (Owl) II*, 32 x 44"
10. *Bodegón (Still Life) II*, 11 x 36"
11. *Muchacho (Boy)*
12. *Muchacha (Girl)*
13. *Bodegón (Still Life) III*,[1] 30 x 32"
14. *Bodegón (Glasses and Bottle)*[1]
15. *Lechuza (Owl) III*,[1] 14 x 25"
16. *Mariposa (Butterfly) III*,1 16 x 22"
17. *Lechuza (Owl) IV*,[1] 32 x 44"
18. *Niño (Child)*[1]
19. *Cabeza (Head) II*,[1] 32 x 44"
20. *Lechuza (Owl) V*,[1] 27 x 39"

October 19 - November 15, 1976

BIDO OF THE DOMINICAN REPUBLIC

Cándido Bidó is one of the outstanding young painters to be found in the Dominican Republic today. His prestige has mounted steadily over the past ten years, both at home and abroad. His subject matter is drawn from the daily life of his native island--street vendors, peasants, tropical fruits. Emphasis on intense color is characteristic of Dominican art, and in his use thereof Bidó follows the prevailing trend. His flat conceptions, composed of vast planes of color, particularly deep hues of blue, mark a new departure, however.

Bidó claims to be self-taught. He has been active as a painter for more than fifteen years. Between 1962 and 1975 he had thirteen one-man shows; all were held in his own country save for two in nearby Saint Thomas in 1969 and 1970. In addition, he has participated in group shows of Dominican art presented in New York, Puerto Rico, Colombia, Spain, France, Israel, and Brazil.

[1] Also exhibited but not included in the original catalogue. --*Ed.*

This is the first presentation of paintings by Bidó in the Washington area. --*J.G-S.*

CATALOGUE

Oils and Acrylics on Canvas

1. *La vendedora (Vendor)*, acrylic
2. *El viaje (The Trip)*, acrylic, 50 x 50"
3. *Fruit*[1]
4. *La madre (Mother)*, oil and acrylic
5. *La tajada (Slice)*, oil and acrylic, 50 x 50"
6. *Mujer en primer plano (Close-up of a Woman)*, oil and acrylic
7. *Cabeza (Head)*, oil and acrylic, 50 x 50"
8. *El dolor de muela (Toothache)*, acrylic
9. *Mujer, caña y batey (Woman with Sugar Cane)*, oil and acrylic, 50 x 50"
10. *Figure*
11. *Pueblito (Town)*, oil
12. *Women*[2]

November 18 - December 8, 1976

GABRIELA CHELLEW OF CHILE: PAINTINGS

The coolness that characterizes much abstract geometric painting is tempered in the work of Chilean artist Gabriela Chellew by her use of strikingly intense colors that produce a sensorial effect. The large, balanced compositions on view are the result of two years of work during which the artist has been involved in both painting and research.

Born in Santiago de Chile in 1934, Ms. Chellew received all her formal training there, having begun to study art more than fifteen years ago when she attended a watercolor course taught by Hardy Wistuba. Later she attended other private workshops and enrolled in the art schools of the National and Catholic Universities for brief periods. She is the author of four books on the theory of art, all of which were published in Chile, and is currently director of the Department of Art of Chile's National University School of Fine Arts.

The artist had her first one-person exhibition in Santiago in 1971, and has participated in more than ten group exhibitions there, including *Tribute to Mondrian*, which was presented at the Museum of Fine Arts in 1972.

This is her first exhibition in the United States. --*J.G-S.*

EXHIBITION LIST [3]

Paintings

Serie de los planos concéntricos (Concentric Planes Series)

1. *Tafu (Grotto)*, 1972, 80 x 100 cm.

[1] Although this title appeared in the original catalogue, the list used during the exhibition shows *Boats*, which may correspond to *La Regata* (Regatta) included in the list sent by the artist for this exhibit. --*Ed.*

[2] This work was listed as "Flowers" in the exhibition list used during the show. --*Ed.*

[3] Not included in the original catalogue. --*Ed.*

2. *Tramel-tramel (Horizon)*, 1974, 80 x 100 cm.
3. *Relmu (Rainbow)*, 1975, 65 x 80 cm.

Serie Tensiones (Tensions Series)

4. *Oposición (Opposition) I*, 1974, 100 x 100 cm.
5. *Oposición (Opposition) II*, 1974, 100 x 100 cm.
6. *Oposición (Opposition) III*, 1975, 80 x 80 cm.

Serie Color (Color Series)

7. *Peuma (Illusion)*, 1975, 80 x 80 cm.
8. *Light I*
9. *Light II*

Serie Oblicuas (Oblique Series)

10. *Rukapillan (Home of Lightning)*, 1975, 65 x 80 cm.
11. *Signo (Sign) I*, 1974, 80 x 100 cm.
12. *Signo (Sign) II*, 1975, 80 x 100 cm.
13. *Antu (The Sun)*, 1975, 80 x 80 cm.
14. *Elyapi (Oak Budding in Spring)*, 1975, 80 x 80 cm.

Serie Tramas (Plots Series)

15. *Trama (Plot) I*, 1975, 80 x 100 cm.
16. *Trama (Plot) II*, 1976, 80 x 100 cm.
17. *Trama III: invierno (Plot III: Winter)*, 1976, 80 x 100 cm.
18. *Trama IV: lemunantu (Plot IV: The Sun That Penetrates the Forest)*, 1976, 80 x 80 cm.
19. *Trama V: verano (Plot V: Summer)*, 1976, 80 x 80 cm.
20. *Poncho*
21. *Casino*

November 18 - December 8, 1976

WOODCARVINGS BY JAIME SOTOMAYOR OF CHILE

Born in Santiago de Chile in 1936, Jaime Sotomayor is professor of sculpture and woodcarving at the Patagonia Institute in Magallanes, Chile, and the Chilean Technical University in Tierra del Fuego, where he has also had three one-man exhibitions. He participated in Santiago's International Fair in 1964, 1965, and 1966. In 1975 he executed a bronze and granite monument to the Petroleum Pioneers in Tierra del Fuego.

EXHIBITION LIST [1]

1. *Don Quijote cabalgando (Don Quixote on Horseback)*
2. *Sancho cabalgando (Sancho on Horseback)*
3. *Caza a caballo (The Hunt on Horseback)*
4. *Sancho y el rucio (Sancho and the Donkey)*
5. *Indígena cazando (Indian Hunting)*
6. *India navegando (Indian Canoeing)*
7. *Materia y espíritu (Matter and Spirit)*
8. *Piedad (Piety)*

[1] Not included in the original catalogue. --*Ed*.

 9. *San Juan (Saint John)*
10. *Oración (Prayer)*
11. *Bondad (Generosity)*
12. *Cristo (Christ)*
13. *Don Quijote y los molinos de viento (Don Quixote and the Windmills)*
14. *Quijotización de Sancho (Quixotization of Sancho)*
15. *Desnudo (Nude)*
16. *Don Quijote soñando (Don Quixote Dreaming)*
17. *Desnudo (Nude)*
18. *Universalidad de Quijote (Universality of Quixote)*
19. *Trabajo (Work)*
20. *Fetiche (Amulet)*

December 17, 1976 - January 17, 1977

LUIS GUEVARA MORENO OF VENEZUELA

Luis Guevara Moreno is one of the most versatile and highly respected artists in Venezuela today. Not only is he a painter, draftsman, and printmaker but, at different periods during his career, he has designed stained glass windows for several churches as well as stage sets. Apart from the period from 1950 to 1954 when he was attracted to geometrical abstraction and the *Madí* group, his interest generally has been directed toward an expressionist treatment of the human form.

This exhibition consists of a selection of works that the artist calls "graphic transpositions." Each of the prints is unique, created through a technique that involves drawing, photoengraving, and lithography.

Born in Valencia, Venezuela, in 1926, Guevara Moreno attended the School of Plastic Arts in Caracas and later studied printmaking at the Ecole Supérieur des Beaux-Arts in Paris. He has had more than ten one-person exhibitions in Caracas and other cities in Venezuela and earlier this year exhibited his graphic work at Galería Venezuela, a gallery supported by the Venezuelan government in New York. He has participated in numerous national and international exhibitions, including the Salon des Réalités Nouvelles, Paris, 1951, 1952, and 1953; the Venice Biennial, 1956 and 1958; and the São Paulo Biennial, 1957. He has been awarded more than a dozen prizes.

This is the artist's first exhibition in the Washington area. --*J.G-S.*

CATALOGUE

Graphic Works

1-20. *Graphic Transposition,*[1] edition of one

[1] Titles are unavailable. --*Ed.*

YEAR 1977

January 18 - February 18, 1977

DRAWINGS BY JUAN RAMON VELAZQUEZ OF PUERTO RICO

Drawing is the purest form of plastic expression, but for almost two decades and until some five years ago, drawing was seriously neglected while artists turned their attention toward experiments with technology, earth works, happenings, and other forms of expression. While many Latin American artists participated in the process of experimentation that was taking place internationally, there were those who continued to draw and several, in fact, who became recognized masters of the medium. Today, there is a vital rebirth of interest in drawing, especially among the young artists of Latin America, and even the smallest of the Latin American nations can claim one or more draftsmen of outstanding merit.

Juan Ramón Velázquez is a young draftsman and printmaker from Puerto Rico who, after having enjoyed some success as a painter, discovered the satisfaction of working with line. Although he is essentially self-taught, he studied lithography for two months at Pratt Graphics Center in New York, having been awarded a grant by the Institute of Puerto Rican Culture, 1973. Velázquez has an extraordinary talent for a delicate and meticulous rendering of volume. While his forms have an abstract, fantasy-like appearance, they are actually composed of elements taken from reality.

Born in Río Piedras in 1950, Velázquez had his first one-person exhibition at the Museum of Art of the University of Puerto Rico in 1973. Since then he has had six exhibitions in San Juan and in 1975 exhibited his drawings at the Galería del Parque in Medellín, Colombia. He has been awarded three prizes in Puerto Rico and is represented in important public and private collections there. This is his first exhibition in the continental United States. --*J.G-S.*

CATALOGUE [1]

Drawings

1. *Muñones (Stumps)*
2. *Paños alrededor (Surrounding Cloth)*
3. *Escena de un interior (Interior Scene)*
4. *Escena infantil (Childlike Scene)*
5. *Escultura en la plaza (Sculpture in the Plaza)*
6. *Radiaciones y una masa (Radiations and a Mass)*
7. *Bodegón (Still Life)*
8. *Primer ventarrón (First Stiff Wind)*
9. *Segundo ventarrón (Second Stiff Wind)*
10. *Orígenes (Origins)*
11. *Flor (Flower)*
12. *Vórtice (Vortex)*
13. *La caverna (The Cavern)*
14. *Forma sombreándose (Form Shading Itself)*
15. *Forma tímida (Timid Form)*
16. *Nuestros paños (Our Cloth)*
17. *Abstracciones en tela (Abstractions on Cloth)*

[1] Although the seventeen titles given under Catalogue appeared in the original publication, the twenty titles actually exhibited are given under Exhibition List. --*Ed.*

EXHIBITION LIST

1. *La niñez* (Childhood)
2. *Flor* (Flower)
3. *Viento* (Wind)
4. *Sombras y nudos* (Shadows and Knots)
5. *La carga* (The Load)
6. *Hombre en ropaje* (Man Dressed)
7. *Mujer con sombrero* (Woman with Hat)
8. *¿?* [sic]
9. *Fin de una vida* (End of a Life)
10. *Escultura en el suelo* (Sculpture on the Floor)
11. *Sueños* (Dreams)
12. *Tábano* (Horsefly)
13. *Río de ilusiones* (River of Illusions)
14. *Espejismo* (Mirage)
15. *Lo que quedó* (That Which Remained), 1976, pencil on paper, 23 x 29"
16. *Bolsa de sorpresas* (Bag of Surprises)
17. *Filamentos* (Filaments), 1976, pencil on paper, 23 x 29"
18. *Bomo*
19. *Hombre comiendo pan* (Man Eating Bread)
20. *El gran oído* (The Great Ear)

February 23 - March 24, 1977

PAINTINGS BY RAINER BINECK OF PERU

Abstract painting was introduced in Peru during the mid-1950s by Fernando de Szyszlo, who emerged as one of the most outstanding figures in the modern art of Latin America. While artists belonging to the generations that followed have taken other directions, there are those who continue to express themselves through abstraction, as does Rainer Bineck, whose paintings are currently on exhibition. Bineck uses dark, somber colors and applies his paint with a palette knife to achieve a heavy textural effect.

Born in Lima in 1938, Bineck began to exhibit his work professionally in 1972. Since then he has had more than ten one-man exhibitions in Lima and last year exhibited at the Museum of Contemporary Art in Bogotá. He has participated in invitational salons at the Museum of Art in Lima as well as in other group exhibitions there and in Santiago de Chile. He has also executed several murals.

This is Bineck's first exhibition in the United States. --*J.G-S.*

EXHIBITION LIST [1]

Paintings

1-2. *Masas móviles meta-psíquicas musicales (Musical Metapsychical Mobile Masses)*, 120 x 120 cm.
 3. *Masas móviles meta-psíquicas musicales (Musical Metapsychical Mobile Masses)*, 100 x 80 cm.
4-8. *Masas móviles meta-psíquicas musicales (Musical Metapsychical Mobile Masses)*, 80 x 80 cm.
 9. *Masas móviles meta-psíquicas musicales (Musical Metapsychical Mobile Masses)*

[1] Not included in the original catalogue. --*Ed.*

April 1 - May 1, 1977

SILVERWORKS FROM RIO DE LA PLATA, ARGENTINA
(18TH AND 19TH CENTURIES)

From the collections of the Isaac Fernández Blanco Museum
and the José Hernández Museum, Buenos Aires, Argentina

Circulated by the Smithsonian Institution Traveling Exhibition Service,
with support from the American Revolution Bicentennial Administration.

FOREWORD

In 1776, the Spanish government established Buenos Aires as a free port and the capital of a viceroyalty (colonial territory) that included present-day Argentina, Uruguay, Paraguay, and Bolivia. From this area, Greater Argentina came to include all the Río de la Plata ("silver river") countries. This collection of silver objects, brought here from Argentina to celebrate the 200th anniversary of the independence of the United States, typifies the outstanding cultural and social aspects of Argentine life during the 18th and 19th centuries. It also represents the degree of achievement and sophistication acquired by Argentina 200 years ago.

This catalogue offers some historical background surrounding the manufacture of silver objects in Argentina and the uses of silver pieces, including *mates* and incense burners. A large part of the exhibition, from the Isaac Fernández Blanco Museum in Buenos Aires, consists of creatively designed *mates*, used for drinking special tea; *sahumadores* (incense burners) and other household items; and elaborate religious objects including Bible stands and chrismal containers. A selection from the José Hernández Museum, also of Buenos Aires, features silver pieces used as apparel for the *gaucho* (nomadic herdsman): spurs, bridle chains, belts, and daggers.

This catalogue has been freely adapted from a translation of the catalogue written by Adolfo Luis Ribera for the Instituto Italo-Latino Americano, Rome, 1974.

The Smithsonian Institution Traveling Exhibition Service proudly presents this special collection of silver. --*Eileen Harakal*, Exhibit Coordinator; *Antonio Diez*, Program Coordinator.

SILVERWORKS FROM RIO DE LA PLATA, ARGENTINA

The silver in this exhibition comes from the region known in the 18th century as Río de la Plata ("river of silver"). The area--present-day Argentina, Uruguay, Paraguay, and Bolivia--was a colonial territory of Spain from 1776 until 1816, when the four provinces broke from Spain. At first they remained united, but soon Paraguay, Bolivia, and then Uruguay seceded. The remaining area became the Argentine Republic in 1853.

Silver, extracted from the land since the 17th century by millions of native workers, was the prime contributor to the economy of the Spanish mainland as well as the Latin American territory. It was used as currency, merchandise, and raw material. The routes to and from the mines, source of the country's independence and wealth, are called *caminos de la plata* ("silver streets"), and Río de la Plata is the main gateway to commercial and tourist traffic. Even the name *Argentina* refers to this metal.

Silver appeared in the Río de la Plata as a raw material for artisans at the beginning of the 17th century. A regional style reflecting the influence of neighboring areas such as Portuguese Brazil and Chile is noticeable in works of the region at this time. These artifacts--*mate* (herbal tea and the container for the brew), horse apparel, knives, liturgical objects--show us what life was then like: how people worked, traveled, fought; what their environment and family life were like; and in what they believed.

From about 1780 to 1850, silver objects were in common use throughout the country, due to a stable government and economy.

Spanish, Portuguese, and, later, Creole master craftsmen greatly changed the forms and meaning of the silversmith's art. Although part of the same environment, they were guided by different needs and aims. The

Church commissioned pieces whose nature was largely determined by the dictates of liturgical or ecclesiastical ornamentation; while colonial families, on the other hand, commissioned various objects for even the most prosaic domestic uses.

With the increasing use of cattle, especially in the Pampas (treeless plains) and seaside regions, new symbols appear, among them the *gaucho* (nomadic herdsman). For him and his mount, the silversmith created beautifully refined and elegant tools. The *gaucho*'s equipment as well as certain parts of Argentine homes were embellished with *rastras* (sword belts rich in bosses and chains), daggers, whips, and spurs; the silver *mate* and *bombilla* (special straw used to sip *mate*) seem to have heightened the pleasure of *mate* devotees. The *gaucho*'s passion, pride, and ambition were all focused on his horse--which he covered with silver harnesses, from the elaborate saddle to the crownpiece, brow band, reins, stirrups, and even the bit--all exquisitely rendered. Museums and private collections display this past splendor, but many of these objects are still used in traditional festival observances throughout Argentina.

During the early period of conquest and colonization, Spanish artisans not only contributed their own work, but also collaborated with other artists. While producing enormous numbers of precious objects, they also taught European techniques to their apprentices, both native and foreign. About 2,500 people involved in various arts, professions, and occupations joined the expedition of Nicolás de Ovando (Spanish governor of the West Indies, 1460-1518) to the West Indies at the beginning of the 16th century. Río de la Plata had not yet been discovered by Europeans.

Although Buenos Aires was only a tiny community of huts, the number of gold- and silversmiths there increased throughout the 17th century. Many were Portuguese; their style had an enormous influence on everything produced along the seacoast. There was a fairly large market for their work--within the limits of a small population and normal economic development. In addition to those objects produced in Buenos Aires, others were imported from Europe and Upper Peru. Not all of the objects in Buenos Aires classified as Peruvian, however, were produced in that area.

The Peruvian master silversmiths and other artisans continued to use the techniques and styles learned in northern workshops after they had settled in Río de la Plata. In a 1748 list of forty-six gold- and silversmiths in Buenos Aires there are three Paraguayans, two Italians, and nineteen Argentinians. In the whole area from 1600 to 1815, only forty-four of 268 gold- and silversmiths are from Argentina.

No object--gold or silver--has been found with the mark of a Buenos Aires gold- or silversmith. Engraved signatures, however, have appeared since the late 19th century. This exhibition is rich in objects for religious, civil, and rural uses, such as chalices, candelabras, and crosses. Also shown are Upper Peruvian containers for chrism--holy oils used in certain sacraments. Unlike those used in Europe, these containers were quite large, with hinged lids; and inside were compartments or special sections to hold the small vials, spoons, and pincers. The containers are supported on curved legs, have locks, and are topped by a cluster of fruits similar to pomegranates --an ornamental motif having religious significance.

The exhibition includes diverse items of lay use, among them incense burners and *mates*, most from the 18th and 19th centuries, a few from the early 20th. The *mate*, and the *bombilla* used with it, is perhaps the most typical artisan product of Argentina. Dating the *mates* is not easy, and without documentary proof the criterion is style; this allows for a fair approximation. From analysis and comparison of the various examples, it seems that the oldest (17th century) are from Peru where baroque and rococo decoration prevailed. There is evidence, however, of *mates* in the Río de la Plata, Argentina, in the early 18th century. Some have saucers, but usually they are gourds, pear-shaped or spherical, partially or completely covered in silver, and supported by three double-curved legs. The lids have a round opening consisting of a pierced hole where the *bombillas* can be inserted. There are different types, with variations in shape, from different areas.

Some antique *mates* were made of tin with a tin *bombilla* and a little wooden spoon. Examples of wood, horn, ivory, and terra-cotta appear in the 19th century. At the beginning of the 20th century, pottery and porcelain versions were manufactured in Europe. Due to the extraordinary inventiveness of the early silversmiths, one cannot always give a name to the particular form that the *mate* took. Eighteenth-century examples, full of baroque and rococo elements, are more ornate, while neoclassic examples have more restrained decoration, purer lines. Both types exhibit high artistic quality, and both use the best silver alloy.

From about 1850 to 1875, while talented silversmiths remained, mechanization of the technique and economic factors contributed to the designs. When *bombillas* began to be made of metal, the filters used gold and silver wires where there had originally been horsehair and vegetable fibers. There is mention of a silver *bombilla* in Buenos Aires as early as 1714; the *mate*, however, was used still earlier. American gold- and silversmiths introduced two basic variations of the *bombilla*, slightly altering the shape. All antique *bombillas* are one piece; separate parts are fused into one by soldering. For hygienic reasons, though, modern industry separated the stem from the filter by a screw mechanism.

Water for the *mate* is heated in a container called a *pava*, which has a spout and a handle. This is thought to be an Argentine adaptation of the kettle. While it resembles a teapot or coffeepot, it is used only to heat the water, not to prepare or hold the brew. One of the more interesting *pavas* is the *pava-forenello*, an 18th-century Peruvian instrument, made of silver. Its striking quality is the inclusion of a vertical chamber in which rests a coal, kept hot by means of a horizontal conduit opened on the side. Its use in 18th-century Peru is documented in two engravings. While few examples have been preserved, those surviving are of the highest quality. Variations typical of baroque, rococo, and neoclassic styles are reflected in the shapes and decoration, but there are differences between those following European norms and those produced by native artisans.

A limited number of incense burners, so prevalent in Latin America, has been preserved--most from the 19th century, in the main attributable to Argentine silversmiths. The most common type is round, resting on a turned column in the middle of a round, flat base. A hinged lid provides ventilation and release of the smoke. Decoration usually reflects plant motifs, which in 18th-century burners are combined with rococo designs. Toward the end of that century neoclassic influence began to be felt, as the design of the containers assumed the shape of small boats. The Upper Peruvians continue the tradition of embellishing the lid with rounded masses of fruit or birds.

The shape of some incense burners is inspired by animals--turkeys, peacocks, llamas. The filigree examples nearly always come from Peru. In some cases the animals are in pairs and their bodies form two separate burners, about 20-30 cm. high. Besides this type of burner, there are also several examples of hand warmers and portable braziers, which in early times were used both as incense burners and cigar lighters. These coal containers were called *chofetas*.

Incense burners appear in Spain in the 18th century. Their forms vary with the styles of different periods; the examples featured here differ from the best known of their Spanish counterparts, even though both types have long wooden handles inserted in the sides to prevent heat loss. Coffeepots, chocolate pots, and teapots also have wooden handles; they are so sparsely decorated, however, that the beauty of the pieces rests on the skillful proportions of the simple geometric forms, and on the natural luster of the silver.

There are two different types of works achieved by Latin American gold- and silversmiths: in one, relief predominates to give rich ornamental effects; in the other, the hammered and forged metal itself is dominant.

TECHNICAL NOTES

Silver and gold are rare, precious metals; for this reason man has always associated them with power, prestige, and wealth. The interest stimulated by these metals depends as much upon their appearance and resistance to the ravages of time as upon their scarcity.

Silver is a malleable white metal with a melting point of about 960° C (about 1760° F); it can be polished. It is found in a native state and in a number of other minerals, including argentite (silver sulfide, Ag_2S), which is dark gray or black; and cerargyrite (silver chloride, $AgCl$), grayish-white. Its most important source is as an impurity in a dark gray mineral, galena (lead sulfide, PbS).

Silver and gold have been used in personal ornaments, decorative ritual objects, and elaborate tableware. Fragments of silver pieces have been found in the deepest excavations at Troy. In Crete, during the Minoan period, silver was used in dagger blades. Silver objects surviving from antiquity are rarer than those made of gold.

Gold and silver are almost indestructible, though silver is susceptible to tarnish. Silver items were often remelted and recast into different objects. The metal, then, was often more highly valued for itself than for its appearance;

this attitude has now been supplanted by an interest in preserving the object as well as its silver content.

Atmospheric pollution is the chief cause of tarnish on silver. Air is polluted by sulfur-containing vapors that cause silver to tarnish more or less rapidly, depending upon their concentrations in the air. Silver can likewise become tarnished by contact with the sulfur in vulcanized rubber, in certain paints, and in synthetic fabrics.

To preserve silver art objects, then, an environment free of tarnishing agents is necessary. It is also important to avoid constant polishing with substances that, while not seeming to be abrasive, will eventually obliterate delicate relief and distinguished marks by repeated removal of minute layers of tarnished metal. The problem of corrosion is even greater with silver objects buried in the ground. Disintegrative chemicals in the soil and in the groundwater combine with the silver to return it to its original state in nature--a mineral. This often prevents the restoration of long-buried objects.

DOCUMENTS

The following documents illustrate the restrictions imposed on the production of silver objects in the New World prior to the establishment of Buenos Aires as a free port.

No. 2 (Chapter of a Royal communiqué to the magistrates of the Royal Tribunal at Santo Domingo, reminding them of the ban on gold- and silversmiths, having their own bellows and smelting operations):

> To the magistrates of our Royal Abbey in Hispaniola: You already know how the Catholic King, my lord and ancestor, ordered and decreed that on that island there should be no bellows or other smelting tools except those in our foundries, and that any gold- and silversmith caught soldering would be severely punished. I have now learned that on that island there are gold- and silversmiths working in gold and silver, exercising the above-mentioned functions publicly, operating shops for his purpose, and having in their homes forges, bellows, and other smelting tools--and that you have allowed and continue to allow this. This could make a mockery of our law and lead to disrespect for our person. I am astounded that you have allowed it to happen and am therefore issuing the accompanying decree that this activity must cease immediately. You are to carry out this order faithfully and to prosecute any transgressors. --Dated Granada, 26 October 1526. I the King. Countersigned (on behalf of the Pope) by the Bishop of Osma, Canaria, Beltrán and Ciudad Rodrigo.

No. 4 (Royal Ordinance to the authorities of the Island of San Juan de Puerto Rico, wherein gold- and silversmiths are permitted to settle, but on the condition that their work be done in the royal foundries in the presence of inspectors, etc.):

> Don Carlos, etc., we ordered, through out communiqué dated Granada, 26 October 1526, that in our West Indian islands and territories there should be no gold- and silversmiths working in gold and silver, or exercise their trade in any way whatsoever, or own bellows or other smelting tools, all of which is more clearly outlined in the said communiqué. Now Baltasar De Castro, our governor of the island of San Juan, on behalf of the city of Portorico and Villa San Germán of the said island, informs us that by banning gold- and silversmiths, that land is at a great disadvantage. He has prevailed upon our good will to suspend our above-mentioned decree, which we have granted after consulting with the members of our Council of the Indies. Be it known therefore by this letter that despite the above-mentioned decree we hereby license those gold- and silversmiths now in San Juan, or who might settle there, to exercise their profession, provided that they do not have in their homes or shops bellows, ovens (furnaces), or crucibles, or other smelting tools. However, they may work with silver and gold in their shops if they do not melt, forge or refine it there. Any smelting or refinishing must be done in our foundry before our inspector and with our officials present; after that, they may work in their homes as outlined above. We command that these regulations be strictly observed under pain of death and loss of all worldly goods by our Chamber and Treasury for any violator of these laws. In order that these measures be known to all so that no one might claim ignorance of the law, we order that this ordinance of ours be posted in the squares, markets, and other public places of the cities, towns and localities of the Indies and maritime

possessions, by means of the town crier and before the public clerk. --Given in Madrid, 21 August in the year of our Lord 1528. I the King. Countersigned (for the Pope) by the Bishop of Osma, Canaria, Beltrán, Ciudad Rodrigo and Manuel.

HISTORICAL NOTES

The founder of the first settlement in Buenos Aires was Pedro de Mendoza (1487-1537), a wealthy Spaniard with influence on Emperor Charles V (King Charles I). A renowned conquistador, he was commissioned to settle the Río de Plata region in exchange for financing an expedition. He was also to found three forts and take possession of about 600 miles of Chilean coastline.

Mendoza assembled one of the best-equipped expeditions ever to leave Spain, with eleven ships, 100 horses, and 1,200 settlers. His fleet arrived at the Río de la Plata in 1536, where Mendoza founded Santa María del Buen Aire, a short distance from present-day Buenos Aires.

The Spaniards set about building a mud-hut fort and village--to their chagrin, without the help of Indians suitable for enslavement. The local Querandí tribe was nomadic; its members fiercely resisted Spanish attempts to force them into supplying food and labor. The Querandí besieged the starving community; after stout resistance, the syphilis-racked Mendoza lost heart. He abandoned the settlement, and died en route back to Spain. Meanwhile, other members of Mendoza's expedition had founded Asunción, the capital of Paraguay.

Potosí, Bolivia, was the largest silver-mining town in South America during the colonial period. Founded in 1545, its silver production increased rapidly; by the end of the 16th century it was the largest exporter of silver in the New World. The population approached 160,000 during this period, making Potosí the largest commercial center in the Viceroyalty of Peru.

The production of silver increased sharply after 1572. The introduction of mercury in the refining process allowed lower-quality ore, not suitable for smelting, to be profitably extracted. Massive Indian labor, combined with a relatively small capital investment, produced sustained growth of silver production until the mid-1600s. While production picked up again after 1740, Potosí never regained its former position. The mining industry declined during various wars for independence, and by 1825 Potosí's population had fallen to 8,000.

CATALOGUE

The number preceding each entry indicates SITES catalogue number. The number directly in front of the entry indicates the Argentina museum's inventory number.

From the José Hernández Museum, Buenos Aires, Argentina

1-14. Sword-belt with chiseled gold decoration, rosette with flowers, six rows of silver sheets, gold decorations, and six gold bosses of Spanish coins. *Porteño*,[1] Independence Period (1820 and after). Weight: 480 gr.

2-24. Drinking vessel (*mate*) with "little tail"; chiseling appears to be floating on water's surface, with fish-like supports.

3-30. Knife with steel blade; initials in gold. Entre Ríos, Independence Period.

4-62. Dagger, steel blade, chiseled silver handle and sheath with gold decoration. *Porteño*,[1] Independence Period.

5-67. Antique silver *Nazarena*[2] spurs, with broad arch and rosette (spur wheel) with 16 teeth. Entre Ríos, Colonial Period (before 1820).

6-103. Spur with broad band openwork and chiseled strap, iron rowel with twenty-two teeth, and silver wedge. Independence Period.

[1] *Porteño* means from Buenos Aires. --*Ed.*

[2] *Nazarena* ("from Nazareth") is a spur with a very large rowel. --*Ed.*

7-126. Antique *mate*, with chiseled goblet base. Colonial Period. Weight: 220 gr.

8-137. Chin-strap; browband with chain, relief, and chiseled boss; and large silver ring to pastern.

9-140. Chin-strap with rings, and two silver sheets, relief and chiseled. Browband with large relief and chiseled rings, with Argentine shield, center, and sphere with half-moon as pendant. Entre Ríos, Independence Period. Weight: 680 gr.

10-142. Chin-strap of thirty-nine small plates (links), with a flower chiseled in each center. Two sheets in relief, silver hemisphere surrounded by chiseled laurel branches. Pendant formed by chiseled ring. Entre Ríos, Independence Period.

11-156. Chin-strap with jointed silver sheets (hinges), with two rosettes and browband. Silversmith: C. López. *Porteño,*[1] Independence Period. Weight: 750 gr.

12-157. Crownpiece of hinged silver sheets, decorated with hinged rosettes. Silversmith: Merlo. *Porteño,*[1] Independence Period. Weight: 880 gr.

13-158. Crownpiece with hinged sheets, decorated with rosettes. Initials: S.A. Silversmith: P.B. *Porteño,*[1] Independence Period. Weight: 850 gr.

14-172. Dagger, octagonal handle, blade marked: H. Becquer y Cía. Arbolito; fluted and openwork back. Length: 50 cm. Silver-plated metal sheath, openwork and wrought-sheath handle. *Porteño,*[1] Independence Period.

15-174. Dagger, braided silver handle and sheath; sheath handle in openwork silver; S-shaped hilt. Marked: Becker y Cía. Solingen steel blade. Length: 63 cm. Entre Ríos, Independence Period.

16-175. Dagger, silver-plated metal handle and sheath; ornate, S-shaped hilt; steel blade, smooth back. Length, 58 cm. *Porteño,*[1] Independence Period.

17-177. Dagger, wrought-steel blade, marked: Frieder Herder Abr. Scha., Solingen; handle and sheath in chiseled silver, with gold decoration. Entre Ríos, Independence Period.

18-183. Dagger, wrought-steel blade. Brand: Anezin Hnos. y Cía. Metal handle and hilt. Leather sheath with handle, back, opening, and tip in chiseled and silver-plated metal. Entre Ríos, Independence Period. Length: 76 cm.

19-184. Reins of silver chains, with balls and links in smooth silver, *Porteño,*[1] Independence Period. Weight: 1,250 gr.

20-231. Spurs in classic Cuyan or Chilean style; band and long strap in iron with silver decoration, iron rowels with thirty teeth (16 cm. in diameter); and leather straps with tooled buckles. Chilean, with inscription: *Por la Razón o la Fuerza, año 1875.*

21-251. Metal spur called *Nazarena,*[2] Cuyan or Chilean style. Large openwork strap. Iron rowel with twenty-five teeth. Independence Period.

22-277. Spiral Straw.

23-278. Smooth drinking vessel with goblet base. *Porteño,*[1] Colonial Period.

24-343. Relief and chiseled drinking vessel; base and stem in silver. The foot has figures of three angels and the initials: B.P. Entre Ríos, Independence Period.

25-473. Silver straw.

26-524. Knife, Dufour steel blade, handle with gold rings; sheath inscribed: De Gaumois. *Porteño,*[1] Independence Period.

27-546. Dagger, Kirsachbaum Solingen steel blade, chiseled silver handle and hilt. Initials: N.R. Leather sheath with opening and tip in chiseled silver. Length: 60 cm. *Porteño,*[1] Independence Period.

28-554. Knife, Libertad steel blade, silver handle and sheath with chiseled tip; left-handed handle (unlike the sheath). Silversmith: P.A. *Porteño,*[1] Independence Period.

29-558. Knife, Libertad fluted steel blade, braided silver handle and sheath. Length: 25 cm. Entre Ríos, Independence Period.

30-584. Dagger, wrought-steel blade, chiseled silver handle and sheath. Length: 45 cm. Silversmith: Calasso. *Porteño,*[1] Independence Period.

31-601. Whip with stick of one piece of silver, in spiral, with chiseled tip; hand-braided rawhide lash.

[1] See footnote 1 on page 345. *--Ed.*

[2] See footnote 2 on page 345. *--Ed.*

Litoral,[1] Independence Period. Weight: 450 gr.

32-605. Dagger, cast-steel blade, hilt with S-shaped branches of wrought silver; leather sheath with chiseled and wrought-silver tip. Length: 69 cm. *Porteño*,[2] Independence Period.

33-609. *Caronero*[3] type dagger (originally carried under the saddle), wrought-steel blade, wrought-silver handle and hilt, leather sheath. Length: 69 cm. *Porteño*,[2] Independence Period.

34-621. Small knife. Solingen steel blade, chiseled silver handle and sheath. Length: 20 cm. *Porteño*,[2] Independence Period.

35-626. Sword-belt, star-shaped center in openwork silver, with a coin, six chains with links, and bosses of silver coins. Silversmith: Soler. Initials: J.E. *Porteño*,[2] Independence Period. Weight: 200 gr.

36-627. Sword-belt, circular-shaped center with openwork and chiseled daisy; metal decorations. Inscription at center: Teodoro Roman. Four-strand chain, two strands of which carry a small fake coin; bosses with silver Spanish coins; edge and center of gilded metal. *Porteño*,[2] Colonial Period.

37-676. Chiseled silver sword-belt, rosette with openwork, manufacturer's mark, crown and laurel branches; two-strand chain and silver bosses with the letters: P.A.J. Entre Ríos, Independence Period.

38-719. Chiseled silver dagger. Armería Nacional (National Armory) steel blade, with importer's name engraved: Broqua S. Scholberg, Montevideo. Silver scabbard chiseled in high relief, long handle and slots in the cover and scabbard-holder. Length: 60 cm. Uruguay. Independence Period.

39-797. Sword-belt with mark of the *hacienda* at center; six strands of silver chains with cuff-link-type buttons. Silversmith: C. Silva. *Porteño*,[2] Independence Period. Weight: 380 gr.

40-900. Leather sword-belt, called fish-scale, 60 cm. long, with silver Spanish coins (*patacones*); also Argentine, Chilean, Bolivian, and Uruguayan coins. Two square decorations with gilded ornaments, center, and three wrought-silver hearts.

41-917. Stirrups, pear-shaped arch covered with leather. Two gold bosses and two stars laminated in gold. Entre Ríos, Independence Period.

42-927. Stirrups, chiseled stirrup iron, and arch. Applied heart with initials M.E. *Porteño*,[2] Colonial Period. Weight: 1,180 gr.

43-934. Stirrups with wide arch, chiseled and openwork stirrup-bar. Initials: J.B. Silversmith: Galasso. *Porteño*,[2] Independence Period.

44-938. Stirrups, chiseled and openwork stirrup iron, arch, and crown, with gold decorations. Stirrup-bar of smooth sheet silver. *Brasero*[4] type. Entre Ríos, Independence Period. Weight: 1,080 gr.

45-944. Chiseled and openwork silver stirrups, inscribed: Baldomero Espínola. Stirrup-leathers with flat buckles. *Porteño*,[2] Independence Period. Weight: 1,100 gr.

46-959. Stirrups, chiseled stirrup iron, and half-arch; simplicity characteristic of the silversmith's work. Flat buckles on the stirrup-leathers; buckle with chiseled rosette, center. Silversmith: O. Puccio. Typical of Buenos Aires, Independence Period. Weight: 1,500 gr. (restored).

47-965. Stirrups, chiseled stirrup iron and arch, and openwork stirrup-bar. *Brasero*[4] type. Entre Ríos, Independence Period. Weight: 1,230 gr.

48-970. Whip with ring (short rod), cylindrical, in chiseled silver with gold decoration. Initials: M.J., and Uruguayan shield in gold. Lash and other parts in natural leather. Uruguay, Independence Period. Weight: 450 gr.

49-988. Flintlock in shape of head, with silver chain and ring of silver and iron; figure of lion.

50-991. Pear-shaped silver flintlock, with long chain and figure of a colt attached.

51-1029. Stirrups; stirrup iron, smooth arch and strap, with inscription: Fausto Farías. Silversmith: J.A.

[1] The area known as *Litoral* in Argentina is the coastal region of the Paraná River. --*Ed.*

[2] See footnote 1 on page 345. --*Ed.*

[3] *Caronero* is a term deriving from *carona*, the padding used under the saddle, next to the animal's back. --*Ed.*

[4] *Brasero* means "brazier". --*Ed.*

Villegas. Bell type. Crupper buckles of tubular metal, and of rawhide. *Porteño,*[1] Independence Period. Weight: 1,600 gr.

52-1095. Spurs, band with gold initials: R.G., rowel and strap tooled and chiseled, ten-tooth rosette called cock's comb. Bridge with instep and sole in leather, with part in silver chain. *Porteño,*[1] Independence Period. Weight 1,040 gr.

53-1112. Whip, chiseled silver rod, with decorations, braided leather lash and lasso. *Porteño,*[1] Independence Period. Weight: 350 gr.

54-1113. Whip with chiseled silver handle, with silver chain on handle, and rawhide lash. *Porteño,*[1] Independence Period.

55-1118. Whip with chain, short silver rod, smooth ring with name Luis Domínguez. Other parts in natural leather. Silversmith: Manuel Solar. *Porteño,*[1] Independence Period.

56-1155. Whip with black carob handle, covered in chiseled silver and braided leather lash, with initials: M.S. Entre Ríos and Corrientes, Independence Period.

57-1189. Iron bit, of chain with small tube, and silver cups, 7 cm. in diameter; movable silver bridge, chiseled, representing flowers and birds. Entre Ríos, Independence Period.

58-1190. Padlocked bit with curb chain, chiseled silver cups, 10 cm. in diameter; chiseled bridge. Entre Ríos, Independence Period.

59-1194. Iron bit with tube and ornate chiseled silver cups, 10 cm. in diameter; chiseled and openwork detached bridge, with initials: F. R. Entre Ríos, Independence Period.

60-1235. Silver reins, long round buckles (clasps), and long whip with braided cords and three silver buckles. *Porteño,*[1] Independence Period. Weight: 820 gr.

61-1240. Whip, silver stick with buckles (clasps) decorated with large rings of wrought solid gold; double lash of rawhide; leather handle, inscribed: Jacinto Solís. Silversmith: Bazardi. *Porteño,*[1] Independence Period. Weight: 950 gr.

From the Isaac Fernández Blanco Museum, Buenos Aires, Argentina

62-IFB 1. Drinking vessel (*mate*), cast and chiseled. Two dogs pictured as legs, the ends as claws grasping a sphere. Height: 17 cm. Chilean or Cuyan, 19th century.

63-IFB 3. Repoussé silver *mate*, with engraving of warrior at the base. Diameter: 22 cm.; base: 10 cm. 19th-20th century.

64-IFB 9. Repoussé *mate*, chiseled and cast, on the back of an ostrich figure. Diameter: 13 cm.; height: 23 cm. Buenos Aires, 1923.

65-IFB 15. Silver *mate*, repoussé and chiseled, with gold decoration. Diameter: 9 cm.; height: 18 cm. Argentina, 19th century.

66-IFB 18. *Mate*, chiseled, cast, and repoussé. Diameter: 9 cm.; height: 23 cm. Buenos Aires, 19th century.

67-IFB 21. Semispheric silver *mate*, cast, repoussé, and chiseled. Base diameter: 10 cm.; height: 21 cm. Buenos Aires, 19th century.

68-IFB 36. Chiseled, repoussé, and turned *mate*. Initials I. F. B., at base. Base diameter: 8 cm.; height: 20 cm. Buenos Aires, 19th century.

69-IFB 41. Repoussé and chiseled *mate*, oval. Initials: I. P. D., at base. Base diameter: 8 cm.; height: 18 cm. Buenos Aires, 19th century.

70-IFB 265. Repoussé, cast, and chiseled *mate*. Base diameters: 9 cm.; height: 22 cm. Buenos Aires, 19th century.

71-IFB 271. Engraved, cast, and chiseled *mate*, held by three legs with floral motifs. Height: 14 cm.

72-IFB 274. Carved *mate*, cast and chiseled. Oval vessel with three curved legs, each having a serpent. Diameter: 7 cm.; height: 13 cm. Argentina, 19th century.

73-IFB 235. Repoussé, cast, and chiseled *mate*. Base diameter: 10 cm.; height: 21 cm. Buenos Aires, mid-19th century.

74-IFB 295. Repoussé and chiseled *mate*; gold shield with initials: D. J. Base diameter: 11 cm.; height: 20 cm. Buenos Aires, 19th-20th century.

75-IFB 302. Cast and chiseled *mate*; neck reads: *Nicefora Molina Gunio 30 de 1897.* Base diameter: 8 cm.; height: 18 cm. Argentina, 1897.

76-IFB 305. Cast, repoussé, and chiseled *mate*. Diameter: 11 cm.; height: 18 cm. Argentina, 19th century.

[1] See footnote 1 on page 345. --*Ed.*

77-IFB 307. Cast, chiseled, and carved *mate*; Argentine shield at top. Base diameter: 9 cm.; height: 17 cm. Buenos Aires, 19th century.

78-IFB 304. Repoussé, cast, and chiseled *mate*, with gold incrustations.

79-IFB 310. Carved, cast, and chiseled *mate*. Base diameter: 9 cm.; height: 17 cm. Argentina, 19th century.

80-GG 234. Repoussé, chiseled, and cast *mate*. Width: 7 cm.; height: 11 cm. Peru, 18th-19th century.

81-GG 115. Carved and engraved *mate*. Height: 16 cm. Argentina, 19th century.

82-GG 117. Carved, cast, and chiseled *mate*. Base diameter: 9 cm.; height: 21 cm. Buenos Aires, 18th century.

83-GG 131. Chiseled and carved *mate*. Base diameter: 9 cm.; height: 20 cm. Buenos Aires, 18th century.

84-GG 132. Carved, cast, and chiseled *mate*. Diameter: 7 cm.; height: 18 cm. Buenos Aires, 19th century.

85-GG 134. Chiseled, engraved, cast, and carved *mate*. Diameter: 9 cm.; height: 19 cm. Buenos Aires, 19th century.

86-GG 146. Repoussé and chiseled *mate*. Base diameter: 8 cm.; height: 16 cm. Argentina, 19th century.

87-GG 158. Carved, chiseled, and engraved *mate*; belt reads: Carmen G. D. Gedron. Base diameter: 8 cm.; height: 16 cm. Argentina, 19th century.

88-GG 159. Chiseled and repoussé *mate*. Height: 16 cm. Argentina, 20th century.

89-GG 160. Chiseled *mate*. Base diameter: 7 cm.; height: 15 cm.

90-GG 162. Carved, cast, and chiseled *mate*. Diameter: 8 cm.; height: 16 cm. Argentina, 20th century.

91-GG 171. Cast and chiseled *mate*; initials: C.M., on one side, J.M.C. on the other. Width: 7 cm.; height: 13 cm. Argentina, 19th century.

92-GG 143. Chiseled, repoussé, and cast semispheric *mate*. Pyramidal shape; round base ornamented with five leaves. Base diameter: 9 cm.; height: 20 cm.

93-GG 127. Carved and chiseled *mate*, with short cylindrical neck. Initials: R. H., inscribed in lower part. Diameter: 9 cm.; height: 19 cm.

94-IFB 280. Repoussé and chiseled *mate*; oval vessel made by entirely covering a pumpkin with silver. Diameter: 7 cm.; height: 7 cm.

95-IFB 257. Chiseled, repoussé *mate*; spherical with gold adornments. Diameter: 9 cm.; height: 20 cm.

96-IFB 286. Repoussé, cast, and chiseled spherical *mate*. Diameter: 8 cm.; height: 19 cm.

97-IFB 58. *Sahumador* (incense burner), engraved, chiseled, filigree, and cast. Diameter: 19 cm.; height: 40 cm. 19th century.

98-IFB 60. Cast and chiseled *sahumador*. A wild bird (cockatoo) rests at the top. Width: 12 cm.; height: 38 cm. Peru, 19th century.

99-IFB 64. Hammered silver, repoussé, cast, and chiseled *sahumador*. A swan rests at top; initials: E.P. de C.

100-IFB 78. Hammered silver, cast, filigree, and chiseled *sahumador*, with a lion at the top.

101-IFB 134. Hammered silver, cast, filigree, and chiseled *sahumador*. Diameter: 22 cm.; height: 23 cm. Peru, 19th century.

102-IFB 162. Hammered silver, cast, and chiseled *sahumador*, having a perforated, irregularly shaped lid. A rooster rests at the top. Height: 26 cm. Buenos Aires, 19th century.

103-IFB 164. Repoussé, cast, and chiseled *sahumador*. Diameter: 10 cm.; height: 25 cm. Buenos Aires, mid-19th century.

104-IFB 169. Repoussé and chiseled *sahumador*. Lid with perforated scales, atop a chicken. Width: 10 cm. height: 26 cm. Buenos Aires, 19th century.

105-IFB 220. Repoussé, chiseled, and cast *sahumador*, with a swan at the top. Width: 10 cm.; height: 26 cm. Buenos Aires, mid-19th century.

106-GG 183. Repoussé, cast, and chiseled *sahumador*. Width: 18 cm.; height: 22 cm. Buenos Aires, late 18th century.

107-GG 184. Hammered, perforated, repoussé, and chiseled *sahumador*. Width: 18 cm.; height: 22 cm. Buenos Aires, late 18th century.

108-IFB 185. Hammered, repoussé, perforated, and polished *sahumador*, with gold ornaments. The knob depicts a flame. On the lid rests a warrior's statue. Width: 18 cm.; height: 33 cm. Peru, 18th century.

109-GG 204. Hammered, chiseled, and cast *sahumador*. Three vipers form the base. Diameter: 14 cm.; height: 29 cm. Buenos Aires, 19th century.

110-GG 207. Hammered, cast, perforated, and chiseled *sahumador*. Initials: M.A., on the lid. Width: 20 cm.; height: 25 cm. Buenos Aires, 19th century.

111-GG 209. Repoussé, cast, and chiseled *sahumador*. Marks: C. Silva and P. Nino. Height: 26 cm. Buenos

Aires, 19th century.

112-GG 47. Repoussé and chiseled *sahumador*. Height: 24 cm. Buenos Aires, 19th century.

113-GG 211. Hammered, cast, and chiseled *sahumador*. Width: 16 cm.; height: 17 cm. Buenos Aires, 18th century.

114-115-
GG 178. Pair of hammered, cast, chiseled, and perforated *sahumadors*. Width: 16 cm.; height: 17 cm. Peru, 18th century.

116-GG 214. Repoussé, cast, and chiseled *sahumador*. Height: 17 cm. Argentina, 19th century.

117-IFB 146. Silver repoussé candlestick, cast and chiseled, with cedar support. Diameter: 43 cm.; height: 50 cm. Buenos Aires, 18th century.

118-119-VAL
166 & 167. Pair of carved candlesticks. Width: 16 cm.; height: 24 cm. Argentina, 19th century.

120-IFB 182. Carved and cast candlestick. Diameter: 23 cm.; height: 18 cm. Argentina, 19th century.

121-NOEL 313. Oil lamp of cast and chiseled silver. Width: 14 cm.; height: 28 cm. Argentina, 19th century.

122-123-GG 70. Pair of carved and cast candlesticks. Height: 25 cm. Argentina, 19th century.

124-125-GG 72. Pair of cast and chiseled candlesticks. Width: 12 cm.; height: 18 cm. Argentina, 19th century.

126-GG 71. Candlestick. Width: 20 cm.; height: 18 cm. Argentina, 19th century.

127-IFB 50. *Pava* (kettle); vessel of hammered silver. Diameter: 25 cm.; height: 29 cm. Peru, 18th century.

128-129-
FB 80 & 83. Two similar repoussé, chiseled, and carved trays. Width: 23 cm.; length: 29 cm. Peru, 18th century.

130-IFB 154. Circular tray of "battered" silver. Initials: B.A.R. Diameter: 24 cm. Argentina, 19th century.

131-GG 40. Serving dish, inscribed: X.R. Mexia. Width: 25 cm.; length: 39 cm. Argentina, 19th century.

132-GG 44. Silver dish. Inscribed: María Luisa. Diameter: 27 cm. Argentina, 19th century.

133-GG 49. Silver dish. Initials: C.D.M. Diameter: 18 cm. Argentina, 19th century.

134-GG 50. Silver dish. Mouth width: 7 cm.; height: 7 cm. Argentina, 19th century.

135-136-
GG 97 & 107. Similar gourds with base, silver fringe, and handle. Diameter: 7 cm.; mouth width: 7 cm. Argentina, 19th century.

137-GG 277. Sugar bowl of hammered and chiseled silver. Width: 12 cm. Argentina, 19th century.

138-GG 287. Hammered and chiseled sugar bowl. Width: 11 cm.; height: 4 cm. Argentina, 19th century.

139-GG 37. Silver vessel, cast, chiseled, and repoussé. Diameter: 38 cm. Argentina, 19th century.

140-GG 301. Silver straw (for use with *mate*). Length: 22 cm. Argentina, 19th century.

141-IFB 7. Silver straw, cast and repoussé. Length: 23 cm. Argentina, 19th century.

142-IFB 2. Silver straw. Length: 20 cm. Argentina, 19th century.

143-VAL 1-94. Chocolate-maker of hammered and chiseled silver. Width: 27 cm.; height: 25 cm. Buenos Aires, 18th century.

144-IFB 252. Repoussé *crismera* (extreme unction vessel), with small recipients inside. Two lateral handles, grenadine, and leaves of gold. Width: 24 cm.; height 34 cm. Peru, 18th century.

145-IPB 118. Repoussé, perforated, cast, and chiseled *crismera*. Width: 24 cm.; height: 40 cm. Peru, 18th century.

146-IFB 4. Repoussé, cast, and chiseled monstrance (used to expose the host in religious ceremonies of adoration). Inscribed: *Dio esta obra el de/boto Dn Juan Paraco/el 24 de siembre de/1852.* Width: 61 cm.; height: 85 cm. Peru, 18th century.

147-IFB 340. Repoussé, cast, perforated, and chiseled alms box.

148-GG 234. Cast, perforated, and chiseled cross with colored stones. Necklace of 27 beads, with small hands in between. Cross width: 16 cm.; height: 20 cm. Peru, 19th century.

149-GG 129. Repoussé, cast, and chiseled thurible (censer for religious use). Width: 16 cm.; length: 107 cm. (with chains). 18th century.

150-VAL 98. Repoussé, perforated, and chiseled holy water pot. Width: 23 cm.; height 35 cm. Río de la Plata, 18th century.

151-VAL 152. Silver chalice, repoussé, chiseled, and filigree. Diameter: 11 cm.; height 21 cm. Bolivia (?), 19th century.

152-VAL 15. Repoussé and chiseled silver tabernacle (wooden box covered with silver). Width: 35 cm.; height: 43 cm.; thickness: 29 cm. Peru, 18th century.

153-VAL 56. Repoussé and chiseled halo. Diameter: 35 cm. Peru, 18th century.

154-VAL 383. Repoussé, perforated, cast, and chiseled crown. 37 cm. square. Buenos Aires, 18th century.

155-IFB 119.	Bible stand of repoussé and chiseled silver over wooden support. Width: 32 cm.; height: 55 cm.; depth: 34 cm. Argentina, 19th century.
156-NOEL 535.	Repoussé and chiseled Bible stand. Width: 35 cm.; height: 38 cm.; depth: 33 cm. Argentina, 19th century.
157-VAL 12.	Bible stand of chiseled and repoussé silver; wooden support covered with red velvet. Width: 37 cm.; height: 38 cm. Peru, 18th century.
158 & 159-NOEL 113 & 114.	Pair of hammered and chiseled bulls. Width: 16 cm.; height: 12 cm. Bolivia, 19th century.
160-IFB 70.	Repoussé and chiseled pin. Width: 5 cm.; length: 20 cm. Bolivia, 19th century.
161-IFB 71.	Repoussé and chiseled pin. Width: 8 cm.; length: 29 cm.
162-IFB 70.	Chiseled pin made by the Araucano Indian tribe. Width: 6 cm.; length: 15 cm. Argentina or Chile, 19th century.
163-GG 55.	Repoussé and chiseled silver pin. Width: 12 cm.; length: 34 cm. Bolivia, 19th century.
164-GG 59.	Perforated and chiseled pin. Width: 10 cm.; length: 33 cm. Bolivia, 19th century.
165-GG 60.	Repoussé, chiseled, and perforated pin. Width: 10 cm.; length: 35 cm. Bolivia, 19th century.
166-GG 68.	*Bomba* pin. Length (not counting cross): 23 cm.
167-GG 293.	Cast and chiseled pin. Width: 6 cm.; length: 13 cm. Bolivia, 19th century.
168-VAL 593.	*Curaca*[1] (ceremonial) club of repoussé and chiseled silver, wood, and iron. Inscribed: *Hecho de Apolinar, Hueca,* followed by: *Domingo Peyceao. Año de IPIES (1735).* Width: 10 cm.; height: 159 cm. Peru, 1735.
169-GG 197.	*Sahumador* of cast, chiseled, and filigree silver. Width: 23 cm.; height: 19 cm. Peru, 19th century.
170-INV 215.	Repoussé and chiseled silver pitcher.
171-INV 159.	Repoussé and chiseled silver pitcher, with gold incrustations. Marks at handle: D. and A. Width: 14 cm.; height: 12 cm.
172-INV 15.	Hammered, cast, and chiseled cup. Width: 16 cm.; height: 7 cm.
173-INV 16.	Hammered, cast, and chiseled cup. Inscribed: Virginia V. De Galindez. Width: 20 cm.; height: 10 cm.
174-INV 48.	Silver straw. Length: 21 cm.
175-INV 12.	Hammered and cast kettle. Width: 12 cm.; height: 8 cm. Bolivia, 19th century.
176-IFB.	*Sahumador,* engraved, chiseled, filigree, and cast. Peru, 19th century.
177-IFB.	*Mate,* 19th century.
178-IFB.	*Sahumador* in form of swan.

BIBLIOGRAPHY

Anderson, Lawrence. *The Art of Silverwork in Mexico, 1519-1936.* New York: Oxford University Press, 1941.

Boylan, Leona Davis. *Spanish Colonial Silver.* Santa Fe: Museum of New Mexico Press, 1974.

Brunner, Herbert. *Vecchi Argenti Europei.* Milan: Bramante Editrice, 1965.

_____. *Encyclopedia of Latin America.* New York: McGraw-Hill, 1974.

_____. *French Master Goldsmiths and Silversmiths from the Seventeenth to the Nineteenth Century.* New York: French and European Publishers, Inc., 1966.

Marshall-Johnson, Ada. *Hispanic Silverwork.* New York: Hispanic Society of America, 1944.

Muthmann, Friedrich. *L'Argenterie Hispano-Sud-Américaine à l'époque coloniale.* Geneva: Editions des Trois Collines, 1950.

Oman, Charles. *Golden Age of Hispanic Silver, 1400-1665.* London: Her Majesty's Stationer's Office, 1968.

_____. *Platería en el siglo XX.* Mexico: Carlos Pizano y Saucedo, 1961.

[1] *Curaca* is an Indian chief. --*Ed.*

Ribera, Adolfo Luis. *Catálogo de platería*. Buenos Aires: Museo Municipal de Arte Isaac Fernández Blanco, 1970.

_____. *La Platería en el Río de la Plata*. Buenos Aires, 1955.

Taullard, A. *Platería sudamericana*. Buenos Aires: Peuser Ltda., 1941.

_____. *Three Centuries of Peruvian Silver*. Exhibition sponsored by the government of Peru, 1967.

Wyler, Seymour. *The Book of Old Silver, English, American and Foreign*.
 New York: Crown Publishers, 1937.

ACKNOWLEDGEMENTS

The Smithsonian Institution Traveling Exhibition Service would like to express appreciation to the following for their assistance in making this exhibition a reality:

Prof. Federico B. Brook, Cultural Vice-Secretary of the Instituto Italo-Latino Americano, Rome.
Martha E. Goodway, Metallurgist, Conservation Analytical Laboratory, National Museum of History and Technology, Smithsonian Institution.
Sra. Haydée Paganini de García Mellid, former Director; Prof. Héctor H. Eschenone, Director of the Museo Isaac Fernández Blanco, Buenos Aires.
Sr. Juan Manuel Figueredo Antequeda, Director, Department of Cultural Affairs of the Chancery; and René Sanmartino de Vélez Fúnez, Assistant, Ministry of Foreign Relations and Culture, Buenos Aires.
Prof. Paolo Mora, Central Institute for Restoration, Rome, author of "Technical Notes" of this catalogue.
Mr. Arnaldo T. Musich, Ambassador, and Hernán Massini Ezcurra, Cultural Attaché, Embassy of Argentina, Washington, D.C.
Mr. Adolfo Luis Ribera, author of catalogue, *Argentería del Río de la Plata*, issued 1974.
Prof. Vincente Trípoli, Director, and María Margarita Gibezzi Pareja, Division Chief, Museo José Hernández, Buenos Aires.
Sr. Rafael M. Vázquez, former Ambassador, and Luis María Riccheri, former Cultural Attaché, Embassy of Argentina, Washington, D.C.
Mr. John Warner, Administrator, and William Blue, Assistant Administrator for International Activities, American Revolution Bicentennial Administration.

May 12 - July 15, 1977

SCULPTURES BY JOYCE OF GUATEMALA

In 1975 Guatemalan sculptress Joyce was awarded the São Paulo Biennial's Francisco Matarazzo Sobrinho Prize, the prize given to the best Latin American artist. This exhibition includes the series of seven sculptures exhibited at São Paulo, entitled *Variations on a Circle*, as well as new works, all of which lend themselves handsomely to the setting of the Pan American Union Building's Aztec Garden and the loggia of the Museum of Modern Art of Latin America.

Joyce's sculptures are executed in chromed metal and, although not large in size, have a quality that makes them appear massive. In a natural setting, the geometric, hard-edged forms contrast with the freedom and romantic feeling of vegetation, while there is a harmonizing effect produced by the surroundings reflected in the shiny surfaces of the works. Joyce claims that her sculptures are inspired by pre-Columbian Mayan stelae, finding affinities in the concept of working with space and simplified forms. It was through her collaboration with the Tikal Association and Guatemala's Museum of Ethnology and Archaeology that she first gave careful attention to the archaeological areas of her country and learned to fully appreciate her Mayan heritage.

Born in Mexico City in 1938, Joyce (Vourvoulias) moved to Guatemala City while still a child and is a Guatemalan citizen. She presently lives and works outside Philadelphia. She studied at the University of Mexico, 1958, the University of Wisconsin, 1959, and at Silpakorn University of Fine Arts in Bangkok, Thailand, 1960-62.

She had her first professional exhibition in Guatemala City upon her return in 1965. Since then she has had six one-person exhibitions in Guatemala and in 1975 exhibited at the Trend House Gallery in Tampa, Florida. Last year she was represented in the exhibition *Latin American Horizons: 1976,* which circulated to five museums in Florida.

This is the first time her sculptures have been exhibited in Washington, D.C. *--J.G-S.*

CATALOGUE

Sculptures

Serie Variaciones de un círculo (Series Variations on a Circle)

1. *Intimidad (Intimacy)*, chromium-plated iron
2. *Entrelazamiento (Interlacing)*, chromium-plated iron and industrial painting
3. *Nacimiento (Birth)*, 1975, chromium-plated iron, 102" (height)
4. *Procreación (Procreation)*, chromium-plated iron
5. *Mutilación (Mutilation)*, chromium-plated iron
6. *Fragmentación (Fragmentation)*, chromium-plated iron
7. *Cataclismo (Cataclysm)*, chromium-plated iron, 40 1/2 x 36 x 6 1/2"

Estelas (Stelae)

8. *Qo yvech ch'uxic (Yours Shall Be What Is Here)*, chromium-plated iron, 32" height
9. *Qui iaric (They Propagate, Giving Fruit to Many)*, chromium-plated iron, 40 1/2 x 56 1/2 x 18"
10. *Tocoquil (She Who Carries the Sun on Her Back)*, stainless steel
11. *Xavi e gabavil (These Were Also Gods)*, stainless steel
12. *Iqui balam (Jaguar of the Moon)*, stainless steel, 44" (height)
13. *U vinaquil huyub (The Little Man of the Forest)*, stainless steel, 5'4" (height) x 1/4" (thickness)
14. *Molay (Together)*, stainless steel, 6'4" (height)
15. *Icoquih (Star of the Aurora)*, stainless steel, 52 1/2" (height)

August 23 - September 18, 1977

SERGIO MONTECINO OF CHILE

Chilean painter Sergio Montecino has devoted the major part of his career to portraits and landscapes. He began exhibiting his work professionally in 1942 and since then has had twelve one-man exhibitions in Santiago de Chile, including an exhibit at the National Museum of Fine Arts in 1972, as well as in São Paulo and Rio de Janeiro. Among the group exhibitions in which he has participated outside Chile are the São Paulo Biennial, 1947, 1949; the First Biennial of Hispanic Art in Madrid, 1951; the First Biennial of Quito, 1960; and *Seashore Painting of the 19th and 20th Centuries*, which was presented at the Carnegie Institute Museum of Art, in Pittsburgh, 1965. His work is represented in museum collections in all the major cities in Chile and in private collections in Chile, Brazil, and Venezuela.

Born in Osorno, Chile, in 1916, Montecino has taught painting for many years at the School of Fine Arts of the University of Chile, where he also studied, 1938-1944. He has been awarded more than twenty prizes in Chile as well as fellowships that have allowed him to travel and study in Brazil, Italy, Poland, and Great Britain.

The paintings on exhibition were completed during the early 1970s, some years after Montecino returned from a trip to Easter Island. Using an expressionistic approach that has characterized his work for more than a decade, he has effectively captured the haunting and dramatic qualities of the monumental stone statues (*moai*) that have drawn so much attention to Easter Island as well as the coastline and landscape.

This is the artist's first one-man exhibition in the United States. *--J.G-S.*

EXHIBITION LIST [1]

Paintings

1. *Playa de Anakena (Anakena Beach)*
2. *Nubes (Clouds)*
3. *Aju de Vinapú*
4. *Mataveri*
5. *Hanga-Roa*
6. *Tupa*
7. *Terevaka*
8. *Caballos (Horses)*
9. *Moai*
10. *Moai*
11. *Rana Roraka*
12. *Moai*
13. *Aju de Akivi*
14. *Moai*
15. *Rana Rorako*
16. *Moai yacente (Yacent Moai)*[2]
17. *Desde el Rana Kao (From Rana Kao)*
18. *Tongariki*
19. *Orongo*

September 19 - October 14, 1977

SANDINO OF COLOMBIA: METAL SCULPTURE

Colombian sculptor Pedro Sandino, like many artists, has pursued two careers simultaneously and established his reputation as a professional artist only during the past ten years. Prior to that, he completed studies in orthodontics at the National University in Bogotá, taught oral pathology at the Catholic University there, and was responsible for designing a special apparatus for teleradiography that is used in dental clinics throughout Colombia. Upon his retirement from teaching, he enrolled briefly in the National University's School of Fine Arts and later attended the workshop of the well-known Colombian artist David Manzur, where he acquired the tools necessary to his development as a creative artist.

Sandino's work falls within the direction initiated by Edgar Negret and Eduardo Ramírez Villamizar, the precursors of modern sculpture in Colombia. Using steel or aluminum, he achieves an intriguing effect of rhythmical movement by using minimal forms, generally tending toward the geometric, in which all but the most essential elements have been eliminated.

Sandino has had four one-person exhibitions in Colombia since 1967, including shows at the Marta Traba and El Callejón galleries, and has participated in numerous national exhibitions. In 1973 he was represented in an exhibition at the OAS that featured selected students' work from the David Manzur Workshop. This is his first one-person exhibition in the United States. *--J.G-S.*

CATALOGUE

Sculpture

1. *Form I*

[1] Not included in the original catalogue. *--Ed.*

[2] Literal translation of this title is "Lying Moai." *--Ed.*

2. *Continuity*
3. *Module*
4. *Synthesis*
5. *Evolving Line*
6. *Form II*
7. *Form III*
8. *Module II*
9-15. Stained glass[1]

September 19 - October 14, 1977

SERGIO TRUJILLO OF COLOMBIA: PAINTINGS

Sergio Trujillo Magnenat is one of the forerunners of modern art in Colombia. During a long period of his career, his painting was essentially realistic although it had overtones of the imaginative and fantastic elements that characterize his painting today. In his most recent work, he demonstrates the same skillful technique seen in the earlier years, while his major concern is exploring the metaphorical realm of magic realism.

Born in Manzanares, Caldas, Colombia, in 1911, Trujillo Magnenat attended the School of Fine Arts in Bogotá from 1927 to 1932. Since then he has taught painting and executed numerous murals in Colombia, has had one-person exhibitions and participated in group shows in Colombia and abroad. He has been awarded prizes in Bogotá, Madrid, and Viña del Mar in Chile. In 1975 a retrospective exhibition of his work was presented at the museum of Colombia's National University. Works by Trujillo are included in the National Museum of Bogotá and in private collections in Colombia. Although this is his first one-person show in the United States, he was represented in an exhibit of Colombian painting held at the OAS in 1949. --*J.G-S.*

EXHIBITION LIST [2]

Paintings

1. *Biografía (Biography) IV*
2. *Biografía (Biography) III*
3. *Monumento (Monument) I*
4. *Tiempo (Time) II*
5. *Biografía (Biography) VI*
6. *Biografía (Biography) I*
7. *Biografía (Biography) IX*
8. *Biografía (Biography) X*
9. *Tiempo (Time) I*
10. *Biografía (Biography) V*
11. *Biografía (Biography) II*
12. *Biografía (Biography) VII*
13. *Monumento (Monument) II*
14. *Biografía (Biography) VIII*

[1] Also exhibited but not included in the original catalogue. The titles of the stained glass pieces are unavailable. --*Ed.*

[2] Not included in the original catalogue. --*Ed.*

October 17 - November 14, 1977

ROLANDO CASTELLON OF NICARAGUA

Nicaraguan painter Rolando Castellón is a self-taught painter who has traveled widely and exhibited his work in Europe, Central America, and on the West Coast of the United States. His acrylic compositions on paper are sophisticated and imaginative in concept, with transparent colors applied in multiple layers on cuts or folds of paper that are combined to create a relief-like, three-dimensional picture plane. In his search for different plastic solutions, he has also worked from an actual three-dimensional form or base to create what might be termed a modern-day *retablo*. In these works, painted planes are connected parallel to or above the central picture plane and may be opened or closed to create an entirely new composition.

Castellón was born in Managua in 1937, but has lived in San Francisco since the early 1970s. He has had more than ten one-person exhibitions, including shows at the Praxis Gallery, Managua, 1970; the Marquoit Gallery, San Francisco, 1973, 1974, and 1975; and the Heino Heiden Gallery, Lübeck, Germany, 1976. Group exhibitions in which he has participated include the First Biennial of Central American Painting, San José, Costa Rica, 1971, where he was awarded Nicaragua's National Prize; *Drawings, U.S.A.*, Minnesota Museum of Art, St. Paul, 1973; and *Today's Art of Latin America*, Madrid, 1977.

This is the artist's first exhibition in Washington, D.C. --*J.G-S.*

EXHIBITION LIST [1]

Acrylics on Paper

1. *Fold XVII*
2. *Fold XIII*
3. *Fold VIII*
4. *Fold VII*, 31 x 21 1/4"
5. *Fold D*
6. *Fold A*
7. *Fold IX*
8. *Fold XVI*
9. *Fold V*
10. *Fold XV*
11. *Fold XIV*
12. *Fold B*
13. *Fold XII*
14. *Fold C*
15. *Fold XI*
16. *Fold VI*
17. *Fold X*
18. *Fold XVIII*

November 21 - December 12, 1977

SCULPTURES BY JEAN CLAUDE RIGAUD OF HAITI

Although primitive and folk art have predominated in Haiti for more than thirty years, there have always been Haitian artists who have worked successfully with sophisticated, international trends. Sculptor Jean Claude Rigaud is adept in the handling of different materials, whether marble, wood, or metal. He creates a variety of abstract compositions in which he tends to simplify volume by eliminating all useless, descriptive detail, and

[1] Not included in the original catalogue. --*Ed.*

achieves continuity of form through integrated masses. While there are easily recognizable influences in his work, he is clearly attempting to make a personal and authentic statement within the field of modern sculpture.

Born in Haiti in 1945, Rigaud attended the National Autonomous University of Mexico from 1965 to 1968 and, during his student years, was awarded First Prize for Sculpture at a competition sponsored by the University, as well as Honorable Mention in an exhibition held at the National Institute of Fine Arts. From 1968 to 1976 he lived in New York, where he was employed by an architectural firm and attended Columbia University Teachers College. He now lives and works in Miami. Since his first professional exhibition in Mexico City in 1968, he has had one-man exhibitions in Port-au-Prince, New York City, and Santo Domingo. This is Rigaud's first exhibition in Washington, D.C. --*J.G-S.*

EXHIBITION LIST [1]

Sculpture

1. *Baile (Dance)*
2. *Equilibrium*
3. *Soldado (Soldier)*
4. *Desintegración (Disintegration)*
5. *Dinamismo (Dynamism)*
6. *Hombre histórico (Historic Man)*
7. *Construcción (Construction)*
8. *Metamorfosis (Metamorphosis)*
9. *Ritmo musical (Musical Rhythm)*
10. *Reactor*
11. *Prior*
12. *Mujer (Woman)*
13. *Balance*
14. *Prayer*
15. *Sleepy*

December 9, 1977 - January 14, 1978

RAQUEL ORZUJ OF URUGUAY: PAINTINGS

Charts, space rockets, and other forms associated with furthering communication appear in the series of paintings entitled *Peace Symbology* by Raquel Orzuj of Uruguay.

Born in Montevideo in 1939, Orzuj attended the National School of Fine Arts of Uruguay in 1952 and between 1956 and 1964 periodically attended courses at the Torres-García Workshop, where she studied with Horacio and Augusto Torres, José Gurvich, and Manuel Pailós. In 1968 she became director of La Ronda, a workshop specializing in the teaching of art to children. Both a painter and draftsman, Orzuj has participated in more than twenty group exhibitions in Uruguay and in 1977 was represented in the Joan Miró International Exhibition in Barcelona, Spain. She had her first professional one-person exhibition in Punta del Este, Uruguay, in 1972 and has had seven exhibits in Montevideo since then. Her work is included in the collections of the Juan Manuel Blanes Municipal Museum of Fine Arts and the National Museum of Plastic and Visual Arts in Montevideo; in the Municipal Museum of Fine Arts in Salto, Uruguay; the Museum of Modern Art of Mexico; and the Lugo Museum in Spain. She is represented in numerous private collections and has been awarded several national prizes. --*J.G-S.*

[1] Not included in the original catalogue. --*Ed.*

EXHIBITION LIST[1]

Paintings

Serie de la paz (Peace Series)

1. *Contraluz (Against the Light)*
2. *Paloma (Dove)*
3. *Banderas al sol (Flags to the Sun)*
4. *Carta a New York (Letter to New York)*, 1977, acrylic, 90 x 100 cm.
5. *Ceibo-paz (Ceibo-Peace)*
6. *Carta de amor (Love Letter)*
7. *Flor-paz (Flower-Peace)*
8. *Carta a la ciudad de Washington (Letter to the City of Washington)*, 1977, acrylic, 100 x 110 cm.
9. *Carta a New York (Letter to New York) II*
10. *Paloma (Dove) II*
11. *Contraluna (Against the Moon)*
12. *Abrazo-paz (Embrace-Peace)*
13. *Carta a todos (Letter to Everyone)*, 1977, acrylic, 110 x 100 cm.
14. *Carta a Washington (Letter to Washington)*
15. *Carta a mis hijos (Letter to my Children)*
16. *Desde el cielo (From Heaven)*
17. *De cara al sol (Facing the Sun)*
18. *Carta del Uruguay (Letter from Uruguay)*, 1977, acrylic 110 x 100 cm.
19. *Carta del Uruguay (Letter from Uruguay) III*
20. *Carta a todos (Letter to Everyone) II*

Serie Crónicas contra la guerra (Chronicles Against War Series)

21. *Mundo-paz (World-Peace)*, 1977, inks, 110 x 100 cm.
22. *Contra la guerra (Against War) II*
23. *Mundo-paz (World-Peace) II*
24. *Crónicas contra la guerra (Chronicles Against War) III*
25. *Crónicas contra la guerra (Chronicles Against War)*
26. *Crónicas contra la guerra (Chronicles Against War) IV*
27. *Carta del Uruguay (Letter from Uruguay) II*

[1] Not included in the original catalogue. *--Ed.*

YEAR 1978

January 18 - February 7, 1978

MUSEUM OF MODERN ART OF LATIN AMERICA: NEW ACQUISITIONS

A year has now gone by since the Museum of Modern Art of Latin America opened its doors. The collection housed in the Museum had its modest beginnings some twenty years ago, at the inspiration of the Representative of Mexico. The Museum itself came into existence in 1976, as a bicentennial gift to the United States, at the proposal of the Permanent Representative of Venezuela. Established by action of the Permanent Council, the Museum operates under the jurisdiction of that body, which, throughout the years, has given enthusiastic and continuing support to the idea of bringing together characteristic works of Latin American artists and presenting them in demonstration of the spirit of the region's culture.

Contemporary artists of Latin America are represented in many United States museums, but their works are too seldom featured and rarely shown in a group, as evidence of the existence of a solidly established, continent-wide movement. It can be said without fear of overstatement that the Museum of Modern Art of Latin America, with its specialized collection of high-quality works in varying media, has few equals in the Western Hemisphere. The thousands who have visited the Museum during the past year have had a unique opportunity to appreciate the power, imagination, and probity of the tradition that is being forged by the artists of the neighbor countries to the south. Almost without exception, the Museum has met with warm acceptance from the art-loving public.

The current exhibition consists in a selection of acquisitions dating from the past year, October 1976 to December 1977. Until Museum facilities are enlarged, shows of this nature--which in time will present the whole of the collection--will take place in the gallery of the Pan American Union Building. It is only a matter of time before the Museum becomes the dynamic center for the promotion, enjoyment, and study of contemporary Latin American art that its founders envisioned. --*J.G-S.*

CATALOGUE

Drawings

Dino Aranda (Nicaragua)
 1. *No. 3*, 1977, pencil on paper, 30 1/2 x 22 3/4"
 2. *No. 6*, 1977, pencil on paper, 30 1/2 x 22 3/4"

Cantatore (Argentina)
 3. *Untitled*, 1958, pen and ink on paper, 13 1/2 x 10". Anonymous gift.

Carmelo Niño (Venezuela)
 4. *Sorpresa (Surprise)*, 1975, pen and ink on canvas mounted on cork, 33 3/4 x 26 1/4"

Alberto Dutary (Panama)
 5. *Untitled*, pen and ink on paper, 11 x 17". Anonymous gift.

Joaquín Torres-García (Uruguay)
 6. *Untitled I*, 1943, pen and brown ink, 5 x 8"
 7. *Untitled II*, 1944, pen and brown ink, 5 x 8"
 8. *Untitled III*, 1944, pen and brown ink, 5 x 8"
 9. *Untitled IV*, 1944, pen and brown ink, 5 x 8"
 10. *Untitled V*, 1944, pen and brown ink, 5 x 8"
 11. *Untitled VI*, 1944, pen and brown ink, 8 x 5"

Juan Ramón Velázquez (Puerto Rico)
12. *Filamentos (Filaments)*, 1976, pencil on paper, 23 x 29"
13. *Lo que quedó (That Which Remained)*, 1976, pencil on paper, 23 x 29"

Paintings

Benjamín Cañas (El Salvador)
14. *Kafka: cartas a Milena (Kafka: Letters to Milena)*, 1976, oil on wood panel, 24 x 24"

Rolando Castellón (Nicaragua)
15. *Fold VII*, acrylic on paper, 31 x 21 1/4"

José Paulo Ifanger (Brazil)
16. *Untitled*, acrylic on canvas, 23 1/2 x 31 1/2"

Angel Hurtado (Venezuela)
17. *Signo en el espacio (Sign in Space)*, 1962, oil on canvas, 62 x 76"

Leonardo Nierman (Mexico)
18. *Génesis (Genesis)*, acrylic on Masonite, 36 x 48"

Tomie Ohtake (Brazil)
19. *No. 9*, 1975, acrylic on canvas, 39 x 39"

Felipe Orlando (Mexico)
20. *Mujer sentada (Seated Woman)*, 1976, oil on canvas, 44 x 57"

Photographs

Egar (Efraín García, Colombia)
21. *Faces*, 1976, black and white photograph, 15 1/4 x 11 1/2"
22. *La última etapa... (The Last Stretch . . .)*, 1976, black and white photograph, 11 1/2 x 15 1/4"
23. *Camino al mercado (Road to the Market)*, 1976, black and white photograph, 11 1/2 x 15 1/4"

Julio Vengoechea (Venezuela)
24. *Si cierro los ojos... (If I Close My Eyes . . .)*, 1975, photographic composition, 19 x 19"
25. *Polarización (Polarization)*, 1975, photographic composition, 18 1/2 x 29 1/2"

Prints

Carlos Barboza (Costa Rica)
26. *Horizonte (Horizon)*, 1973, etching 9/20, 12 x 10"
27. *REA*, 1972, etching 9/15, 12 x 10"

Roberto Berdecio (Bolivia)
28. *Sin título (Untitled)*, 1947, lithograph 8/32, 19 x 17"

Fernando Torm (Chile)
29. *Sunset Stage No. 2*, 1969, color serigraph, artist's proof, 35 x 28". Gift of Mr. Irving Jurow.
30. *Sunset Stage No. 4*, 1969, color serigraph artist's proof, 35 x 28". Gift of Mr. Irving Jurow.

Francisco Copello (Chile)
31. *Landscape in Development*, color serigraph, artist's proof, 19 x 23". Gift of Mr. Irving Jurow.

José Luis Cuevas (Mexico)
32. *Autorretrato con prostituta vieja (Self-Portrait with Old Prostitute)*, 1976, lithograph 11/20, 18 1/2 x 13"
33. *La Renaudière, la sala (La Renaudière, the Parlor)*, 1976, color etching, artist's proof, 15 1/2 x 19 1/2"

34. *La Renaudière, el cuarto de dibujo (La Renaudière, the Studio)*, 1976, color etching, artist's proof, 15 1/2 x 19 1/2"
35. *La Renaudière, la cocina (La Renaudière, the Kitchen)*, 1976, color etching, artist's proof, 15 1/2 x 19 1/2"
36. *La Renaudière*, 1976, color etching, artist's proof, 19 1/2 x 15 1/2"
37. *Autorretrato (Self-Portrait)*, 1958, woodcut, 12 x 18 1/2". Anonymous gift.

César Valverde (Costa Rica)
38. *En lucha con la muerte (Fight with Death)*, 1975, monotype, 18 1/2 x 28 1/2"

Rafael Zepeda (Mexico)
39. *Composición de tres planos (Composition of Three Planes)*, 1967, etching 3/10, 27 x 19 1/2"
40. *Contrapunto concreto (Concrete Counterpoint)*, 1967, etching, 2/10, 27 x 19 1/2"
41. *Homenaje al grillo mayor (Homage to the Older Cricket)*, 1967, etching, 2/10, 21 x 17"

Sculptures

Rudy Ayoroa (Bolivia)
42. *Prisms*, 1976, Plexiglass, light and motor, 24 1/2 x 28 x 28"
43. *Towers*, 1976, Plexiglass, light and motor, 40 x 16 x 16"

Joyce (Joyce Vourvoulias, Guatemala)
44. *Cataclismo (Cataclysm)*, 1975, chromed metal, 40 1/2 x 36 x 6 1/2"
45. *Qui iaric (To Multiply)*, 1975, chromed metal, 40 1/2 x 56 1/2 x 18"

BIOGRAPHICAL NOTES [1]

BERDECIO, Roberto. Painter, muralist, printmaker, born in Sucre, Bolivia, 1913. Self-taught as an artist, was granted a Guggenheim Fellowship, New York, 1940. Traveled in South America and studied Inca archaeology and colonial architecture. Went to Mexico where he participated in the muralist movement and worked with Siqueiros. Both went to New York as delegates to the First American Artist Congress Against War and Fascism, 1936, and created a workshop, 1936-38. Joined the Spanish Republican Army, 1938-39. Executed a mural in Fresno, California, 1941, and portable murals and decorations in Mexico City, 1941-42. Published a *Manifesto* which became the basis for the creation of the Unión de Artistas Plásticos de Bolivia (Union of Plastic Artist of Bolivia), 1943. Held individual exhibitions in La Paz, 1931; New York, 1938; San Francisco Museum of Art, 1941. Was awarded several prizes and honors. At present lives in the United States.

COPELLO, Francisco. Printmaker, born in Santiago, Chile, 1938. Studied in Santiago; Florence, through an Italian government fellowship, 1962-66; Pratt Graphic Center, New York, 1967. Founder, with Fernando Torm, of Studio F, Santiago, 1969. Held individual exhibitions in Florence and Santiago. Participated in group shows in Italy, Chile, the United States, and Uruguay. Was awarded a prize at the Brooklyn Museum, New York, 1968.

TORM, Fernando. Painter, draftsman, printmaker, born in Santiago, Chile, 1944. A well-recognized composer and pianist, he is a self-taught plastic artist. While studying music in Paris and New York, traveled in Europe and the United States. Founder, with Francisco Copello, of Studio F, Santiago, 1969. Held individual exhibitions in Santiago, New York City, Princeton, Trenton, and Mexico City. Participated in national and international shows, including the Print Biennial, Santiago, 1970; International Print Biennial, Ljubljana, 1975; International Biennial, Frechen, 1976. Was awarded a prize in painting, Santiago, 1966.

[1] Not included in the original catalogue. See Index of Artists for reference on those not listed here.--*Ed.*

February 7 - 28, 1978

ARMANDO FRAZÃO OF BRAZIL

Contemporary Brazilian painting is more or less evenly divided between realism and abstraction. Within the abstract direction, the tendency is toward expressionism or a kind of gesture painting characterized by free forms, open compositions, and a calligraphic element that was introduced into Brazilian painting by the Japanese-Brazilian artists who settled in São Paulo. Among the most successful of the abstract expressionists to appear recently is Armando Frazão, whose evolution in the immediate future will merit close attention.

In his compositions, Frazão uses a rich palette, with the calligraphic element in black, a delicate brushstroke, especially in the color zones, and free forms that are sometimes combined with rectilinear shapes. Although he has never had a one-person exhibition in Brazil, his work has been shown in group exhibitions in Rio de Janeiro, and he has had solo exhibits in France and Spain. He has also participated in group exhibitions in Switzerland and Italy.

Born in Rio de Janeiro in 1943, Frazão began studying art while still a child, taking courses in design at the Museum of Modern Art in New York, 1954-1956, and studying painting and lithography under the well-known Chilean artist Nemesio Antúnez at Taller 77 in Santiago, 1956-1957. In 1959, while living in Lisbon, he studied design with Dacosta. Works by Frazão are included in private collections in Europe and Latin America.

This is the first exhibition of his work in the United States. --*J.G-S.*

EXHIBITION LIST [1]

Paintings

1. *Alien*
2. *In Blue*
3. *Deep and Down*
4. *In Blue II*
5. *The Bird, Late Afternoon*
6. *The Conflict*
7. *Blue and Colors*
8. *Blue and Other Colors*
9. *Brasília I*
10. *Brasília II*
11. *The Forest*
12. *Lightning and the Forest*
13. *Moon and the Sixties*
14. *Figure and the Sixties*
15. *The Odd Implosion*
16. *Green and Colors*
17. *Blue Plus*
18. *A Touch of Red*
19. *Smash*
20. *For Oto, Merry Christmas*
21. *Below, the River*
22. *Crossroads*
23. *The Upper Window*
24. *The Amazon*
25. *Jung I*

[1] This list was not included in the original catalogue. Although the exhibition list used during this show indicates that only eighteen paintings were exhibited, the list sent by the artist for this exhibition is reproduced here in its entirety. There is no indication in the files of which were the works actually exhibited. --*Ed.*

March 1 - 27, 1978

FELIX ANGEL OF COLOMBIA

In Latin America, where the tradition of drawing has never been abandoned and where good draftsmen are abundant, Félix Angel is one of the most significant figures to emerge in recent years. In 1974 the drawings of this young Colombian artist were seen in this same gallery in the exhibition *Five Artists from Medellín*. That exhibit, in fact, established his reputation in his own country where, until then, his work was little known.

Although Angel works almost exclusively with pencil or black ink on paper, he is also a painter, and several works on canvas are included in the current exhibit. His subjects during the earlier period were prototypes of the athlete, the politician, and the military man, all drawn with dramatic characteristics tending toward the tragic and divorced from any form of human communication. In his recent work, his subjects are taken entirely from the world of competitive sports. While football and baseball players are the focus of much of his attention, he has introduced the horse--not the horse as traditionally seen in art, but, rather, in its role as a competitor. It may sometimes appear as the secondary figure in the composition, but more often it is the principal, having taken on a symbolic meaning, and the rider is reduced to an insignificant accessory. The expression in these works is as profound as before, but the long, nervous pencil strokes have become more vigorous to convey a sense of speed and force. The intensity with which this young artist approaches his subjects touches the best of the central core of expressionism.

In exploring different avenues of creative expression, Félix Angel has published several books, including a novel and a nonfiction work on his fellow artists in Medellín, both of which were sold out after their first printings, and he is a professional architect.

Born in Colombia's industrial city of Medellín in 1949, Angel studied there at the Institute of Fine Arts and at the National University of Colombia in Bogotá. He has had six one-person exhibits in Medellín and Cali and in 1974 exhibited in Guayaquil. He has participated in group exhibitions in Bogotá, Cali, Medellín, Caracas, and Havana and recently showed his work at the Noble-Polans Gallery in New York City and at the Forma Gallery in Miami. He has been awarded prizes during four successive years in the Salon of Young Art, sponsored by the Zea Museum in Medellín, and his work is included in our Museum of Modern Art of Latin America as well as in the Zea Museum, the Museum of Contemporary Art of Bogotá, the Museum of Modern Art of Cartagena, and the Museum of Bogotá's National University. *--J.G-S.*

EXHIBITION LIST [1]

 1-30. Pencil drawings
31-32. Acrylics

April 6 - May 2, 1978

MANUEL DE LA FUENTE OF VENEZUELA

In Venezuela, where abstract and kinetic art have dominated for almost two decades, there is a strong revival of interest in figurative expression. Masses of humanity, in which the individual has become a nameless, faceless entity, provide the subject matter for sculptor and draftsman Manuel de la Fuente.

As is common to most sculpture of high quality, there is a sense of monumentality in de la Fuente's works even though the actual dimensions are small. It is almost as if they were conceived as studies for large-scale sculptures intended for vast, open spaces. The artist skillfully creates a sense of vibration and tension in the sculptural mass, and the light breaking over the crowd of figures compressed into the bronze lends an impressionistic quality. Each figure within the group has its own plasticity but remains anonymous.

[1] Not included in the original catalogue. Titles are unavailable. *--Ed.*

Whether they are mobs of people crossing a bridge or waiting for a bus, the figures seem not to be directed by any conscious thought but by instinct, or as if moved by some unknown force, and we are made keenly aware of their impotence. In groups, they recall scenes from the films of Eisenstein. As individuals, they bring Kafka's protagonists to mind. Whatever the intention, the artist's primary concern is with pure sculptural plasticity, and the results are powerful.

The same spirit that characterizes de la Fuente's sculptures is found in his drawings. While it is not unusual for sculptors to draw or sketch their ideas before executing the model and producing the actual work of art, it is seldom that a sculptor's capacity for expression in line is equal to that shown in his three-dimensional work. In this case, the drawings can be considered as works of art in and by themselves. We find the same vibrancy produced by line, white space, and shadow that we find in the sculptures.

De la Fuente was born in Spain in 1932. He received his academic training in Spain and has been a member of the faculty of the University of the Andes since he emigrated to Venezuela in 1959. He has participated in numerous group exhibitions in Spain and Venezuela, but it was not until last year that he had his first one-person exhibition in Caracas (Gallery of National Art).

This is the artist's first exhibition in the United States. --*J.G-S.*

We wish to extend our gratitude to the Gallery of National Art in Caracas, a dependency of the National Council of Culture of Venezuela, for its cooperation in having made this exhibition possible.

EXHIBITION LIST [1]

Drawings

1. *La pared (The Wall)*, 1975, charcoal on paper, 66 x 83.1 cm.
2. *El autobús (The Bus)*, 1976, charcoal, ink, and gouache on paper, 33 x 47 cm.
3. *La ciudad (The City)*, 1976, charcoal on paper, 49.3 x 49.5 cm.
4. *El cubo (The Bucket)*, 1977, charcoal on paper, 32.8 x 46.9 cm.
5. *El mercado (The Market)*, 1977, charcoal on bristol paper, 66 x 96.4 cm.
6. *La bajada (The Descent)*, 1977, charcoal on paper, 32.8 x 47.8 cm.
7. *La pared (The Wall)*, 1977, charcoal on bristol paper, 51 x 66.2 cm.
8. *El ascensor (The Elevator)*, 1978, charcoal on paper, 65.8 x 95.3 cm.
9. *La escalera mecánica (The Escalator)*, 1978, charcoal on paper, 44 x 57.8 cm.
10. *La playa (The Beach)*, 1978, charcoal on bristol paper, 66 x 96.3 cm.
11. *La ducha (The Shower)*, 1977, 66 x 96.3 cm.
12. *La coca cola (The Coca-Cola)*, 46 x 69 cm.
13. *El autobús (The Bus)*, 66 x 96.3 cm.
14. *El columpio (The Swing)*, 66 x 96.3 cm.
15. *La puerta (The Door)*, 66 x 96.3 cm.
16. *Un árbol (A Tree)*
17. *La pala mecánica (Steam Shovel)*
18. *El autobús (The Bus)*

Sculptures

1. *El autobús (The Bus)*, 1976, bronze, 12 x 40 x 30 cm.
2. *La bajada (The Descent)*, 1976, bronze, 35 x 50 x 29 cm. Coll. Mr. José Peragine, Caracas.
3. *La ciudad (The City)*, 1976, bronze, 28 x 26 x 25 cm.
4. *La ducha (The Shower)*, 1976, bronze, 24 x 30 x 20.5 cm.
5. *La pala (The Shovel)*, 1976, bronze, 80 x 30 x 30 cm. Coll. Galería de Arte Nacional, Caracas.
6. *La pala mecánica (The Steam Shovel)*, 1976, bronze, 26 x 30 x 18 cm.
7. *La playa (The Beach)*, 1976, bronze, 4 x 41 x 37 cm. Coll. Galería de Arte Nacional, Caracas.

[1] Not included in the original catalogue. --*Ed.*

8. *La publicidad (Publicity)*, 1976, bronze, 14.5 x 51 x 26.5 cm.
9. *El grado (The Graduates)*, 1977, bronze, 6 x 70 x 30 cm.
10. *El polvo (The Dust)*, 1977, bronze, 15 x 30 x 30 cm. Coll. Galería de Arte Nacional, Caracas.
11. *El parque (The Park)*, 1977, bronze, 53 x 24 cm.

May 5 - June 1, 1978

LUIS HERNANDEZ CRUZ OF PUERTO RICO

Exuberant color, reflecting the luminous color of the tropics, and inventive forms are combined in the work of Luis Hernández Cruz to create a symbolic and evocative world that is rich in visual possibilities. The forms are ordered within a cohesive structure, but there is a constant transformation as a result of their arrangement and of the frequently overlapping planes. Hernández Cruz is accomplished as both a painter and printmaker, and the consistently mature quality of his work allows him to be ranked as one of the most outstanding artists Puerto Rico has ever had.

Henández Cruz has developed his expression gradually over a period of twenty years. Born in San Juan in 1936, he attended the University of Puerto Rico, where he is now director of the Department of Fine Arts, and later studied at the American University in Washington, D.C. Since 1958 he has had sixteen one-person exhibitions in Puerto Rico, and his work has been shown in this country in New York (Caravan House Gallery, 1971) and New Jersey (Newark Museum, 1971), as well as in Madrid (Institute of Spanish Culture, 1968; Spanish Museum of Contemporary Art, 1973). Group exhibitions in which he has participated include the *Esso Salon of Young Artists*, OAS, Washington, D.C., 1965; the Second Coltejer Biennial in Medellín, Colombia, 1970; the Second International Print Biennial of Tokyo, 1972; *Cultural Heritage of Puerto Rico*, Metropolitan Museum of Art, New York, 1973; the Print Biennial of Ljubljana, Yugoslavia, 1973, 1975; and the São Paulo Biennial, 1975. His awards include First Prize given by the Institute of Puerto Rican Culture, 1963; First Prize, *Esso Salon*, Puerto Rico, 1964; and the National Prize for Puerto Rico, Second Biennial of Latin American Prints, San Juan, 1972.

This is the artist's first exhibition in Washington, D.C. *--J.G-S.*

CATALOGUE

Acrylics

1. *Formas de rito (Ritual Forms)*
2. *Centro de conjuros (Center of Incantations) II*
3. *Construcción espacial con signos ancestrales (Spatial Construction with Ancestral Symbols)*
4. *Topografía espacial (Spatial Topography)*
5. *Elegía a G.H. (Elegy to G.H.)*
6. *Composición con formas orgánicas sobre gran forma blanca (Composition with Organic Forms on a Big White Form)*
7. *Composición totémica en gris y rojo (Totemic Composition in Gray and Red)*
8. *Composición en blanco y ocre (Composition in Black and Ocher)*
9. *Composición con gajos anaranjados (Composition with Orange Branches)*
10. *Composición con totem blanco (Composition with White Totem)*
11. *Composición sobre forma ocre (Composition upon an Ocher Form)*
12. *Sombra arqueológica (Archaeological Shade) III*
13. *Flechas y fuego (Arrows and Fire)*

Silkscreens

1. *Composición en blanco y marrón (Composition in White and Brown)*, 30 x 36"
2. *Momento de huellas (Moment of Tracks)*, 30 x 36"
3. *Sobre campo marrón broncinio (Upon a Bronze Brown Field)*, from the *Signos 1976 (Symbols 1976)* Series, 30 x 36"

4. *Sobre campo marrón profundo (Upon a Deep Brown Field)*, from the *Signos 1976 (Symbols 1976)* Series, 30 x 36"
5. *Sobre campo azul (Upon a Blue Field)*, from the *Signos 1976 (Symbols 1976)* Series, 30 x 36"
6. *Sobre campo verde (Upon a Green Field)*, from the *Signos 1976 (Symbols 1976)* Series, 30 x 36"
7. *Sobre campo amarillo (Upon a Yellow Field)*, from the *Signos 1976 (Symbols 1976)* Series, 30 x 36"
8. *Sobre campo marfil (Upon an Ivory Field)*, from the *Signos 1976 (Symbols 1976)* Series, 30 x 36"
9. *Movimientos ignorados (Obscure Movements)*, 30 x 36"
10. *Torso de sol (Sun Torso)*, 30 x 36"
11. *Signos en el rojo (Symbols in Red)*, 30 x 36"
12. *Piel y amarillo (Hide and Yellow)*
13. *Muro verde, piedra negra (Green Wall, Black Stone)*
14. *Pájaros de barro (Clay Birds)*, 30 x 36"
15. *Signos en pugna (Contrasting Symbols)*
16. *Paisaje con forma negra (Landscape with Black Form)*
17. *Signos arcaicos (Archaic Symbols)*, 30 x 36"
18. *Bacumbé*, 30 x 36"
19. *Perfiles de flechas, puntas de plumas (Arrow Wings, Feather Points)*
20. *Signos indígenas (Indigenous Symbols)*

June 1 - 30, 1978

VICTOR LEWIS OF PANAMA

Primitive art has become fashionable with the public in recent years largely because it represents a compromise for those who do not appreciate radical art forms but who, at the same time, do not want to appear outmoded by demonstrating an interest in academic or conventional expressions. But there is considerable confusion resulting from the fact that much art, especially painting, is interpreted or marketed as primitive when it is not. Sometimes painting is thought to be necessarily primitive if it has characteristics that are neither modern nor realistic. In other instances, painters who have been academically trained have deliberately adopted a pseudo-primitive expression, generally to mask their incompetence with more sophisticated forms of art.

Latin America is a vast region that has produced and continues to produce legitimate primitive or naive artists. An excess acclaim has led some to become assembly-line painters, but there are many who have persevered in their devotion to art, and the spontaneity and freshness of their approach is quite evident to those who have learned to look at painting. These artists have no professional training and follow no pre-established formulas but are able to convert what they see before them into plastic symbols of their own invention.

Víctor Lewis, who is exhibiting his work for the first time in the United States, is a genuine primitive painter. He creates his own world when he tries to depict the world around him and, fulfilling one of the conditions of good primitive painting, renders what he sees with absolute veracity. His forms are solid and well defined, and the interplay of luminous colors is based upon reality, but it is a reality heightened by the intensity of the burning light of the tropics.

Although there are exceptions, most primitive artists rely little on their imagination when choosing their subject or leit-motif. Their immediate environment is sufficient. All of Lewis's paintings focus on his native Colón, which lies at one extreme of the Panama Canal. And rarely does a primitive painter consider art his primary profession since he is normally active at another trade that provides him and his family daily wages. In Lewis's case, painting comes between assignments at the local movie house, where he does the lettering and design of the signs for the façade.

Born in Colón in 1918, Lewis is self-taught and had his first one-person exhibition in 1968. He has participated in national shows in Panama and Cuba and last year received First Prize at the annual Xerox Salon in Panama City. His paintings hang in numerous government buildings in Panama, including the Presidential Offices, and he is represented in private collections in Panama, Ecuador, and Costa Rica. --*J.G-S.*

CATOLOGUE

1. *Casa del pueblo (House in Town)*, 44 x 34"
2. *Caminante con su paraguas azul (Stroller with Blue Umbrella)*, 49 x 37"
3. *El cochero feliz (The Happy Coachman)*, 48 x 38"
4. *Logia Tres Hermanas (Three Sisters Lodge)*, 33 x 31"
5. *Niños jugando football (Children Playing Football)*, 44 x 36 1/2"
6. *El pescador (The Fisherman)*, 34 x 31 1/2"
7. *Barrio Coolie Town (Coolie Town)*, 42 x 31"
8. *Hombre corriendo (Man Running)*, 35 x 29 1/2"
9. *Mujer barriendo (Woman Sweeping)*, 32 x 25 1/2"
10. *Logia Star (Star Lodge)*, 31 x 25"
11. *Los novios (The Sweethearts)*, 38 1/2 x 29 1/2"
12. *Casa Miller (Miller House)*,[1] 31 x 25"
13. *El militar (The Soldier)*, 32 1/4 x 27 1/2"
14. *Naranjas por botellas (Oranges for Bottles)*, 43 x 33"
15. *El carretillero (Cart Pusher)*, 41 3/4 x 30 1/4"
16. *Protegiendo la niñez (Protecting Childhood)*, 41 x 30 3/4"
17. *Fumando en el balcón (Smoking on the Balcony)*, 40 x 40"
18. *Abarrotería Antón (Antón's Market)*,[1] 24 1/2 x 24 1/2"
19. *El limpia botas (The Boot Cleaner)*, 29 x 19"
20. *La lavandera (The Washer Woman)*, 38 1/4 x 28"
21. *Mujer vestida de verde con su paraguas rojo (Woman Dressed in Green with Her Red Umbrella)*, 24 1/2 x 24 1/2"
22. *Niña con su muñeca (Child with Doll)*, 19 x 19"
23. *Los turistas (Tourists)*, 19 x 19"
24. *Cargando agua (Carrying Water)*, 31 x 25"
25. *Saltando la soga (Jumping Rope)*, 18 x 24"
26. *Nocturno Calle 7 (Calle 7 at Night)*, 18 x 24"
27. *La familia (The Family)*, 38 x 30"
28. *Mr. Williamson*, 31 x 25"
29. *Domingo sin suerte (Unlucky Sunday)*, 30 x 25"
30. *Hombres trabajando (Men Working)*, 24 x 16 3/4"

June 5 - July 30, 1978

A BACKWARD GLANCE AT CUEVAS: DRAWINGS AND PRINTS, 1944-1977
A tribute to José Luis Cuevas on the twenty-fourth anniversary of his first exhibition
at the General Secretariat of the Organization American States

FOREWORD

I met José Luis Cuevas in Washington in 1954 at the inauguration of his first one-man exhibition outside Mexico. Although it was clear that this soft-spoken young man had an extraordinary talent, few could have realized that one day he would become a major figure in the history of Latin American art. Now, after having had more than seventy one-man exhibitions and having participated in countless group shows, he is recognized internationally as one of the most formidable draftsmen of our day. His work is represented in most of the major museums of the United States, Latin American, and Europe.

It is an honor to host this tribute in recognition of his achievements and contributions to the world of art. The Museum of Modern Art of Latin America, which was inaugurated in 1976, is presenting a *Backward Glance at Cuevas*--its first major temporary exhibition--consisting of a selection of works by Cuevas from Washington

[1] Translation of these titles is: no. 12, "Miller Store;" no. 18, "Antón Hardware." --*Ed.*

collections. Most of the works in the exhibit date from the 1950s and 1960s, when he spent a considerable amount of time here. To complement the exhibition, we are presenting to the public for the first time the OAS-produced documentary film entitled *Reality and Hallucination*, and exhibiting black and white photos by the Mexican photographer Daisy Ascher. Both provide fascinating insight into Cuevas's life and work. --*Alejandro Orfila*, Secretary General, Organization of American States.

A BACKWARD GLANCE AT CUEVAS

Cuevas is a phenomenon. I should not venture to use this word were it not that the development of José Luis Cuevas's artistic personality over the last two decades has constituted what is truly a case apart. In our day, so abundant in unexpected change, rarely does one come upon the figure of a young artist who has taken a powerful stand, who continues firm in a single given mode of expression, blind as it were to veering trends and the latest in aesthetic fashions. Recent movements--informalism, abstract impressionism, pop art, op art--have swept by like rivers, at times turbulent, at times majestic, only to blend themselves at last with other streams or to waste away in dry sands of oblivion. Unmoved by the shifting flow, Cuevas's work rises ever firmer, like a constantly broadening delta.

Abstract informalism reigned supreme when Cuevas appeared upon the art scene. Some of his contemporaries reproached him for his indifference in its regard. A few wondered aloud whether he would ever be capable of handling it--rather like college graduates skeptical of a freshman's ability to make it into his junior year. Finally, in 1957, to show that he had the ability--though not the need--to follow the current fashion, Cuevas produced five large paintings entitled *The Conquest of Mexico*, in which he showed complete mastery in the handling of masses from the viewpoint of abstract expressionism. "I refuse to mess around in sand and asphalt though," he said, adding that he was past the age for making sand castles on the beach. "The tide of snobbery will soon wash this fashion away," he declared, and went back to his usual practices, leaving those who were urging him to "progress" to hunt through art magazines for newer and more up-to-date trends to exploit.

Today, if a majority of the artists of the generation now approaching forty avidly pursues the latest novelty, there is also a considerable number who keep a careful eye on Cuevas's inflexible production. This number includes not only those on whom he can be said to exert a direct influence but also persons following a different direction from the one he has taken. His case in this regard is indeed phenomenal.

His other pronounced singularity consists in the fact that, while he is capable of working in a great variety of media--lithography; wood and metal engraving; painting in oil, fresco, acrylic, or black enamel on canvas, cardboard, or paper--his means of expression *par excellence* continues to be drawing. A significant anecdote in this regard concerns an artist who once asked Cuevas, in a somewhat disdainful tone, when he was going to take up painting--as if painting constituted a superior form of art which Cuevas had not yet attained. By way of answer, Cuevas reached into an old cupboard which he used for storing things in his studio, and from among dust-covered papers of all sorts he produced a roll of canvas, about three meters long, on which were clearly to be seen oil sketches for one of his most celebrated drawings, *The Funeral of a Dictator*. "As you can see," Cuevas explained, "I use oil for sketches, since it is a medium which lends itself more readily to corrections. When I do a drawing, if I make a mistake, all I can do is tear the paper up and start all over again."

One of the few cases of a youthful prodigy who has fulfilled his promise, Cuevas boldly holds his ground amid the din of controversy, attacks having served but to strengthen his personality. Triumphing over a semi-official canon which held Mexican art in seeming bondage, he has succeeded in imposing himself at home. Abroad, without yielding an inch of his immutable artistic principles, he has won admiration even from those of totally different bent.

When Cuevas appeared upon the scene, Mexico was dominated by a standard criterion--social realism--which left but a single path open to the artist, one which permitted no evolution. Those who did not conform languished in oblivion or were the constant butt of attack by the conformers. The latter often veiled their deficiencies under a cloak of super-nationalism or narrow political sectarianism. The big three--Rivera, Orozco, Siqueiros--were revered for their work, their authority, and the international renown they had won over the years. Siqueiros's preoccupation was always with politics; Orozco and Rivera were chiefly concerned with their own work and chances of continuing success. It was the lesser disciples--those of the least talent--who constituted the most ferocious and implacable defenders of the official line. They pronounced anathema upon all who departed

from it--upon all who failed to produce works with a "message," or who did not engage in realistic depiction of the environment, particularly in its Indian aspects. Not only that, the Indian element had to be treated according to the conventions of the movement. Any freedom of handling, any departure from the established line was greeted with scorn and mockery, as a surrender to "French" or "foreign" influence.

For many long years the names of Tamayo and Mérida were anathema in the pseudo-revolutionary circles of would-be painters who had set themselves up as the champions of national artistic integrity. If a critic was so unlucky as to write anything that could be interpreted as favorable to either of the two, he too came under attack. The castle was firmly guarded. No enemy was permitted to approach the moat. When Cuevas appeared on the scene, he was greeted first with indifference, then with mockery. He was an upstart, a mere child; all he did was draw. He was no rival in the field of painting, least of all a competitor in commissions for murals. Yet something told the lordly second-raters that the quiet, nearsighted, blond-haired lad might--just might--be the David who would turn into a giant-killer.

Cuevas was only fourteen years old when, in 1947, he rented an empty room on a side street in Mexico City for a few pesos and gave his first exhibit. He was a shy, timid adolescent, whose avoidance of others disguised a great self-assurance. This was his first professional act, his first attempt to communicate with the public through the medium of art. The exhibit contained drawings of great power, in which an alert eye could readily discern the marks of a new, emerging talent. But nothing happened. No one saw the show. Not one word appeared in the newspaper. The sole reminder of the debut is a sign of modest proportions, printed on the poorest of cardboard. No disturbance was caused by the appearance of this newcomer on the scene, where center stage was jealously held by the artistic establishment. The only public attention paid him at this time consisted in an invitation for him to give a talk on art at a seminar on values attended by students of philosophy and science. Cuevas chose to speak on cinematography, for which he has had a passion ever since earliest childhood, and which today constitutes an ideal escape for him in moments of fatigue or depression.

Inglorious but undiscouraged, José Luis went back to his home. He destroyed many of the drawings that had figured in the exhibit, none of which had been sold, and set once more to work. He used cheap paper, for at first the only material he had for indulging in his "mania" for drawing was scrap from his grandfather's paper factory. His family, middle-class and comfortably well-off, could have aided him to acquire better material; however, accustomed to seeing him drawing in the factory all day long from the age of two or three, using whatever came to hand, they gave no thought to the matter. Later, when the factory went out of business, at about the time of Cuevas's first show, he resorted to a variety of papers, bought for pennies, in limited quantity.

This point is not without significance, for it is only rather recently that Cuevas has been able to overcome his fear of working on real drawing paper. If one of his colleagues gave him a fine sheet, he hesitated to make a mark on it, overawed by its quality. He was used to the freedom afforded by cheap paper, which could be torn up for the slightest of mistakes. In addition, cheap paper offered varying resistance to his pen; in overcoming it he was led to refine his stroke and his wrist gained strength. Exercising itself on rough surfaces, his hand developed new resources. His line grew vigorous and acquired an expression of its own. It did not flow unconsciously: it presented a challenge to the draftsman. It would be hard to say to what degree Cuevas owes his linear refinement to his apprenticeship with material of poor quality.

The use of poor quality paper and Cuevas's habit of making excursions into dangerous neighborhoods led the artist to develop both a power for capturing images rapidly and a splendid technique. Using a solid mixture of India ink and Arabic gum (since liquid ink would have spilled in his pocket), he would take a short stand on a street corner, a peep through the back door of a bordello, or a quick glance at an inmate of the insane asylum, sketching rapidly, reducing what he saw to essentials.

José Luis Cuevas was born in Mexico City in 1933. An error in his birth certificate has made him appear a year younger, satisfying to a limited degree his horror of aging and dying; nevertheless, 1933 is the correct date. His first steps were taken in his grandfather's paper factory, located in an alley in a lower-class neighborhood. Cuevas has stated both verbally and in writing that his love of drawing goes back so far into his childhood that he cannot remember when first it manifested itself. The declaration is borne out by his mother, from whom he inherited his artistic bent, for she speaks of his drawing figures with charcoal or chalk on the flagstones of the patio as a child of two or three. Later José Luis restricted his efforts to paper, using a graphite pencil or colored crayon, and eventually he graduated to India ink. The earliest of his sketches which have survived date from about the

age of ten. They show no innocent candor or any other childish characteristic; the lines are astonishingly firm and sure.

Between the years of ten and eleven, José Luis came down with rheumatic fever, a serious illness which has lingered latent within him, affecting his health with a certain degree of frequency. This meant long months of rest in bed, and while he could sketch from time to time he was not able to do so with the zeal of better days. He found an escape from reality in reading, however. He devoured adventure stories and children's condensations of classics. Finally he came upon Dostoevski, whose work was perhaps decisive in Cuevas's discovery of himself through drawing. The Russian novelist opened up to him a world of passion and violence; he gave him a new perception of his own surroundings; he taught him to extract and analyze the basest aspects of human nature. Cuevas declares that the two truly profound influences he has undergone are literary: the works of Dostoevski and Kafka. Plastic influences (Orozco, Goya, Grünewald, Picasso) have provided him with no more than tools of his trade.

The work of the two great writers has had a deep effect on Cuevas's artistic sensitivity. With one, the encounter came at the beginning of his adolescence, with the other, at its end. Dostoevski gave Cuevas a deep feeling for human suffering at a time when he needed to draw from a model. Kafka awakened his imagination, leading him to transform reality into fantasy, into dreams, without, however, bringing about any change in the values he had acquired by reading the Russian master.

It is important to note that Cuevas's work, transcending illustration, never subordinates artistic purity to literary values. When his drawing has a story to relate, there is no recourse to allusion, to allegory, or to the graphic equivalent of rhetoric; the narrative power is intrinsic in the strokes of his pen. I would quote in this regard what I said in my prologue to his book *The Worlds of Kafka and Cuevas*:

> Kafka's work has doubtless found competent illustrators in the past; it will in all likelihood find other and inimitable interpreters in the future. I question, however, whether it will ever be possible again to produce a graphic version as deeply and intimately felt as this. It would mean finding for the Czech writer a plastic artist as similar in nature as the Mexican draftsman of this book.[1]

Be it said that, in dealing with Kafka's hallucinatory characters and situations, Cuevas did not aim to produce illustrations in the usual sense.

The passage of time has but made this more clear. No concessions were made to facilitating understanding either of the text or of the drawings. The fragments of Kafka's work remain as they are, in a dream-world interplay of reality and the absurd, while the ideas behind them are triumphantly interpreted in graphic compositions with a life of their own. They are spiritual offspring of the writer, but they are not subordinated to his literary intent, however fascinating and profound in meaning it may be.

Though guided by the two literary geniuses and aided by the plastic artists I have mentioned, the young draftsman nonetheless created a world of his own, which derives its strength from the Mexican environment, without any conscious effort on Cuevas's part at engaging in artistic nationalism. Comparison of his work with pre-Columbian art or with the compositions of Posada or Orozco may provide a sense of continuity, of a link with tradition; there is, however, no suggestion of imitation--merely evidence of a lesson thoroughly digested and assimilated.

José Luis had an uneventful adolescence. The onetime patient, the object of his mother's loving attention, under obligation to keep quiet, shunned the company of those of his own age. He attended school, but he detested physical exercise, in which he could not engage. This soon brought about a certain coldness between him and his father. The latter, a sports-loving type, urged his sons, especially the eldest, to develop their muscles and their bodily strength, a course which life had denied to José Luis, the youngest of the family.

[1] In this his first venture into the field of graphic reproduction, Cuevas had as his collaborator a Philadelphia printer who is also a great artist, Eugene Feldman, who executed and printed the photolithographs.

Movies were the main entertainment of the rather unsociable and constantly self-absorbed boy. His first contact with screen personalities came about when he was quite small, thanks to visits to the family by a friend of his grandfather. This friend was related to the French comic Max Linder, a star of silent films who in some respects was a forerunner of Chaplin. Proud of his relationship with the actor, who, though dead, was still famous, the friend was always talking about the movies, screen comedies, and humorous situations. Although he wasn't yet old enough to be taken to movie houses, José Luis drank in the conversation and developed an interest in the art of the screen. When he was a little bigger, he started going to Saturday-afternoon double features. They cost less than a peso. The movie houses had names like "Cinelandia" and "Avenida" and were located for the most part along the Calle San Juan de Letrán. There he developed a great liking for the comic genre of which he had heard Max Linder's relative speak when he was small. By then the comic heroes were Charlie Chase, Laurel and Hardy, the Three Stooges, Our Gang, and Leon Erroll. They involved the boy in a world of ridiculous, incredible situations and frenzied activity, which left him at one moment breathless with suspense and at the next bursting with laughter. Recollections of these experiences were to have a decided influence on his later work.

At the time Cuevas was in grade school, Mexico had just taken over the foreign oil companies and the country was undergoing a period of intense nationalism, manifested in numerous civic acts of a patriotic nature. As the only blond in his class, José Luis was assigned the role of Uncle Sam in pageants and, dressed as such, was forced to parade to the hoots of demonstrators for whom his costume was that of the Devil himself. The shy, timid lad seethed with rebellion at these carryings-on, whose meaning he was not able to perceive. Finding them insincere, he wanted no part of them. As time went by, he came to see the meanness of the motives that prompted them. Later he was to discover that art too could serve political purposes and be used by second-raters for irrational manifestations of nationalism.

This early experience with political indoctrination came as a distinct shock to the boy; it roused him against symbols, slogans, and ideological systems that claim to be immutable, that admit of no criticism, that attack every thought of opposition. It is in his grade-school years then that one finds the roots of his political independence, the origin of his rejection of every form of compulsion and totalitarian authority, and the beginning of his disgust with blind discipline and harsh, impenetrable dogma. It was this period of school life that saw the birth of that spirit of rebellion that has made of Cuevas the most hotly discussed and widely attacked Mexican artist of the last twenty years.

From Cuevas's preadolescent years of solitude date the drawings that most nearly approach literary illustration. What they illustrate, however, are but states of soul--anxieties, the ambition to win renown. Recollection of illness is a favorite theme and the one most forcefully portrayed at this time.

José Luis was only in the fifth grade, but art was already such an obsession with him as to make him try to convince his elders that it could constitute a profession and be treated with utmost seriousness. The National School of Fine Arts operated at the college level and was therefore too advanced and perhaps excessively academic for a grade-school student. There was, however, another official institution, the School of Painting and Sculpture maintained by the Secretariat of Public Education, and located in the Calle La Esmeralda. José Luis was ten, going on eleven, and the minimum age for enrollment was fourteen. So greatly did he pester his mother--who like his paternal grandmother had in her day indulged in painting and drawing--that she finally decided to take him there and ask that he be treated as an exception, in view of his skill. He was given a test, which he passed with flying colors. In view of his age, he was admitted to night classes only as a special student, but assigned to the most advanced section in drawing, which used a life model. The older students were amazed at the ease and penetration he exhibited in doing his assignments. This triumph in the presence of those older than himself did much for his self-assurance. His temperament, however, at once clashed with the routine nature of the subject matter imposed upon the student body. Superficial Indianism with sentimental touches was all that minor artists had derived from the triumphs of the Mexican muralist school, as represented by the work of its three leaders, Rivera, Orozco, and Siqueiros. The first-mentioned was the most widely imitated, owing to the sweetly flattering character of the product. The other two were copied only in part by the following generation, who borrowed no more than details and the means of achieving certain effects. Indian children *à la Rivera*, mothers with babies, flower vendors--these formed the preferred subject matter of so-called social realism. These derivative works of the artistic camp followers of the movement passed into the hands of United States collectors of more limited means than those able to afford originals by the big three.

José Luis could not remain untouched by the formal requirements of his surroundings and during the brief

period when he attended classes on the Calle La Esmeralda he leaned now toward Orozco and now toward Siqueiros, feeling more of an affinity for their artistic concepts than for those of Rivera. One can see traces of these leanings in some of his early works. Immature from the conceptual viewpoint, they nonetheless show the power and skill of the young hand that executed them.

The tragically inclined, mordant temperament of the young draftsman could find no nourishment, however, in a facile, shallow treatment of "national" themes. Cuevas therefore sought his first mode of expression in the dramatic tensions characterizing the works of Orozco, in the expressive lines with which that artist imparted life to details of a hand or a torso. From Siqueiros he learned to see forms as blocks of sculpture. This viewpoint is brilliantly characterized in the work of Siqueiros's greatest period, when he penetrated as no one ever had before the mystery of pre-Columbian sculpture, particularly that of the Aztecs. While this was the first formal influence upon Cuevas, he quickly escaped from it, turning his interest next to Picasso and finally to Goya. In the process he began to develop a style, a calligraphy of his own.

This formative process of assimilating guidance and moving ahead was suddenly cut short, when illness prevented Cuevas from continuing to attend classes at the School of Painting and Sculpture. At twelve he had met with the first serious obstacle to his career. It did not suffice, however, to turn him from his long-held determination to become an artist. Rendered physically inactive for a long period of months, during which he could use neither pen nor pencil, he did not cease to mature spiritually. Weakened by rheumatic fever, however, his heart was thereafter to pose him a constant menace.

The point to note about this young artist from the first is his interest in perfecting his chosen medium of expression: line. Everything else--message, theme, the very composition itself--is subordinated to purely linear values, to the rich vibration of pen strokes racing across paper, as in the ancient art of China and Japan. This is what gives his drawing its true character and a worth which caused him to be recognized from a very early date as a consummate professional. His drawings as a child, those dating from his adolescence, and those of his present maturity all show the same characteristics of assurance and seriousness. His attitude may change as regards theme, and his technique may vary in certain aspects, but the quality of his product never differs.

Very soon he began, timidly but firmly, to seek recognition. Eager to become a significant figure in the art of his country, then confined within a single attitude or formula, he was actively attentive to what could be offered him by other artists who had won or were seeking their freedom. He sought out galleries which displayed the works of other young non-conformists and he began to take part in group shows.

His first solo exhibit--the one which no one saw or heeded--was a thing of the past. He had to put his message across and would use any means to achieve his goal. A call to independence had stirred his restless spirit; he wanted to be held in regard without humbling himself to routine teaching methods he found outdated. He was not about to do what others of his generation did to win favor with their elders. His aesthetic approach was different from that of the sole artist whose example he might have followed, Rufino Tamayo. Cuevas was an analyst of form, in whose work line held sway. Tamayo, inspired by popular and archaic art, emphasized color, paying little heed to drawing as such. Like Gauguin he was a sumptuous colorist; his dry and inexpressive lines are overpowered by the richness of his palette. In addition, Tamayo and Cuevas failed to establish the contact which might have helped them in their struggle against pharisaism in art politics. For reasons which need not be gone into at this point, from the outset Tamayo avoided Cuevas, refusing to recognize the power the young man was coming to manifest.

The place Cuevas was making for himself in the art world aroused the jealousy of many of his contemporaries and even that of certain members of the preceding generation, some well known, some less so. The more he asserted his right to be taken into account, the greater the number of his competitors or enemies. His rising success was unpardonable--the increasing quality of his drawing, his continuous technical progress embittered his rivals, who gave vent to their frustration in one attack after another. As time went by, as Cuevas's work showed ever-greater signs of maturity, as his personality came to impose itself with the inexorability of fate, the combat became less fierce and, wearied of it, the vanquished simply turned their backs on the dreamer, whose aim since earliest youth had been to be appreciated.

I became acquainted with José Luis Cuevas through the painter Felipe Orlando, who was the first person to speak to me of "a young draftsman of talent, who shows great promise." He sent me a photograph of a drawing

which, though of a simple nature, possessed great power. Then, in late 1952 or early 1953, I made a short trip to Mexico and at last had a chance to see the rest of Cuevas's work. We arranged for an exhibit in the gallery at OAS headquarters in 1954. This was the beginning of Cuevas's reputation, for the report by the critic of the *Washington Post* that the entire exhibit was sold out on the opening day led to an article in *Time* magazine which made the young man known to the rest of the world.

The exhibit was originally planned for March, but José Luis did not dare ask his father for money to come to Washington and in order to pay for his plane ticket the artist had to sell the best of his production--some forty drawings--at about five dollars apiece to the Mexican collector Alvar Carrillo Gil, who had been the first to take an interest in his work. Having sold everything, Cuevas had to set to work again to have something to exhibit, and as a result the show had to be postponed until July--a month which turned out to be one of the hottest in decades.

At this time the artist was as yet in his first, formative phase, when he still needed stimulus from outside--a model or situation to be transmuted into lines. Armed with his mixture of India ink and Arabic gum and his cheap paper, he set off on the route he had long been taking, between the sections known as Tepito and Nonoalco, along the Callejón del Organo, seeking out prostitutes, fortune-tellers, peddlers, beggars, dwarfs, abnormal children, and the like. It was about this time that his brother, who was studying medicine, introduced him into the world of hospitals for the poor, where he captured a series of women in childbirth, victims of fights or accidents, and the dying. When the brother decided to specialize in psychiatry, he took José Luis along to the main hospital for the insane. There the artist's work, already marked by bitterness and tension, became charged with depressive anxiety, and reached limits of hallucination that can be compared only to that exhibited by the best of Goya's black period. The violently insane, imprisoned in strait jackets, take on a strange grandeur, a peculiar symbology; bodies limp from electric shock lie in the heavy abandonment of death.

As in the case of all Cuevas's work, the fierce power and the symbolic character which he imparts to these figures from the world of the insane have distant roots in the pre-Columbian Indian sculpture of his country. Cuevas has extracted from that art its most striking feature, its element of savage cruelty, without indulging in any sort of imitation of Indian motifs.

It is at this point in his career that, although still dependent upon a model, Cuevas's art enters upon maturity. By a labor of distillation and analysis, he suddenly succeeds in imparting to his work a maximum of grandeur. What could have been mere illustrations of delirium, studies of figures in pain by a relatively clever adolescent, or evidence of a morbid fascination with human decay appears instead as an exercise in line drawing marked by a degree of control rarely encountered in art today. It proclaims a creative genius who, even as a child, had had an intuitive appreciation of the value of pure drawing--an appreciation which has remained unshaken throughout his subsequent career. In the period of which we are speaking, Cuevas's drawing, considered from the graphic standpoint, is as significant as what comes from his pen today. The only difference lies in his method of creation. At that time he needed a model, the stimulus of ambient reality. Today all his thematic material has been stored away in his subconscious, and from it--like a magician pulling rabbits out of a hat--he draws his subject elements, altered by imagination and enhanced by creative fancy. These elements are converted into the personages of dubious individual existence but of undeniable symbolic value who populate his work. In an art world given over to the frivolity of sudden change and rapidly passing fashion they stand stoically firm against the indifference of the snob and the stupid imperception of the seeker after novelty. To ask Cuevas to change his attitude or technique would be as foolish as to expect an apostle to renounce his faith or change his teaching to please a civil authority. Herein lies the fount of the respect Cuevas has won from the truly creative artists of his day. Here too is the source of the envy, intrigue, and scorn he has provoked among the mediocre. You either take José Luis Cuevas's drawing or you leave it; you admire it or you spit upon it. The expectorators are generally those who have been denied the faculty of linear expression; the admirers are those who have succeeded in understanding the message of his drawing and the eloquent power of a line traced on paper.

The transition from the artist dependent upon a model to the creator of a completely personal humanity, to the master of a circus world of oddities, freaks, and monsters, has been a slow and painful one. As I said before, there has been no change in quality. There has been refinement, elimination of the nonessential, but Cuevas's line--his artistic means of communication--has remained the same from the beginning.

It was under the trying circumstances I have mentioned above that Cuevas had his first show abroad.

Postponement of the exhibit from March to the off-season month of July had raised the risk of failure. I must confess I worried about the consequences of tearing an already depressed young man away from his own country and bringing him to face what might be early defeat--a disaster of the kind that can make one abandon one's career. The very last cent of the money he made from the sale to Carrillo Gil went for the plane ticket. If Cuevas were to return to Mexico without having sold a single work, one could easily foresee the calamity it would represent, given his sensitive nature and his general tendency toward depression.

The somber overall mood of the works Cuevas brought with him gave me further cause for concern. I was afraid no one would have the courage to buy a single one of those foreboding figures. I could already see the shock it would be to that boy who was venturing for the first time to show his work to foreign eyes. I warned him not to worry if it did not sell, telling him he must push ahead whether or not it met with public favor, reminding him that the artist draws for himself and not for others--and so forth and so on.

To my surprise, while we were in the process of getting ready for the exhibit, a number of people--for the most part OAS staff members--curious about what was under way, evidenced first surprise and then admiration for what they saw. A few people began to inquire about prices. The opening was still two days off when someone took the plunge and bought a drawing. Fearing hesitation on the part of buyers, I had set prices at the lowest level imaginable--from fifteen to sixty dollars. A local collector bought two of the most expensive ones and told me, behind Cuevas's back, that he would never hang them on the wall, saying he planned to keep them in a portfolio that he could open whenever he felt the need for an emotional shock. Their effect was one that he could not sustain for any length of time. By the day of the opening, seventy-five percent of the works had been sold; two days later every single one had been purchased. Somewhat earlier I had written to Alfred H. Barr, one of the few persons I thought capable of a true appreciation of the form and content of Cuevas's work, informing him of the exceptional quality of the young man's drawings. On the opening day I received a card from Barr, sent from Maine, telling me to set aside a good example for presentation to the acquisitions committee of the New York Museum of Modern Art. Word of this spread like wildfire. I reserved two of the best items for Barr to show to his committee; later, when I took them personally to Barr at his office in the Museum, he told me both were far too good to let go. They have remained in the Museum, although they are almost never on view.

Cuevas's career since 1954 has unfolded at a pace which leaves one dizzy. Shortly after his international debut in Washington, he received a proposal for a show in Paris. Although according to the books every item in it was sold, he did not receive one penny from the agent. A number of art dealers offered him contracts, but the artist shied away. He refused to accept the existence of a world, outside Mexico, in which he had aroused great expectation. He was disconcerted by the presence, alongside genuine admirers, of scoundrels who wished to exploit him. The period of adjustment was a difficult one, and during it Cuevas moved with great caution. The envious, so numerous in the outer circles of the art world, refused to admit the success and universal acceptance of the young introvert who kept so silent in social gatherings.

He exhibited in one after another of the Latin American capitals, and his fame grew accordingly. In 1959 he won the International Prize for Drawing at the São Paulo Biennial, receiving the votes of an overwhelming majority of the twenty-two critics composing the jury. Envy now knew no bounds. Word of the award was hushed up in Mexico, and even in Brazil there were those who sought to keep it quiet. True connoisseurs, however, incapable of base intrigue, served to spread his fame.

In 1961 he married his sweetheart of adolescent days, Berta Riestra, by whom he has had three daughters. Marriage has provided a cushion for his ineptitude in dealing with the details of daily life and petty bureaucratic demands: his wife looks after these things for him. No longer is he beset by fear of solitude: he has bridged the communication gap that separated him from those around him. The presence of his daughters and his desire for a close relationship with them have played a decisive role in this change; they provide the response for which his silent meditations called.

Shortly after his marriage, he embarked on a year-long trip abroad, the excuse for which was furnished by an exhibit at the Galleria Obelisco in Rome. He had already seen a good part of the Americas; now he was making the acquaintance of the Old World. Travel in countries of similar cultural background had strengthened him in his habits and beliefs, and in his sense of self-assurance. He was fully prepared to face the flattering surprises and the worldly atmosphere with which Paris and Rome might seek to beguile him.

The rest--his return to Mexico, his struggle in the press against the nationalistic forces that held Mexican culture in bondage, his ultimate triumph over mediocrity--all this is well known. Today Cuevas's presence at a public gathering in Mexico City evokes the same curiosity as that of a well-known screen actor or sports star.

The publicity given to his activities at times is carried to excess, but, far from trying to avoid it, the artist revels in this attention. It represents his sole revenge on those who ignored or scorned him in his humble beginnings.

The Mexican muralists were the subject of publicity from the start, and until the day of his death Diego Rivera received exceptional treatment in his country's press. Orozco was not much given to self-advertisement and frequently avoided newsmen, but Siqueiros had a well-developed talent for making the papers. One wonders whether his passion for politics was not the result of his obsession with occupying the public eye. At certain moments, when they felt a need for publicity, both Rivera and Siqueiros feigned engagement in questionable acts that they knew would arouse comment. Tamayo, more retiring by nature, makes fewer appearances in print.

Cuevas, then, does no more than continue a well-established tradition. He can and does make news on any number of topics. He has been doing so actively ever since 1957 when, in an act unthinkable in others of his young generation, he proceeded to attack the establishment in a series of articles published in the literary supplement of the Mexico City daily *Novedades*. In scathing references to the "cactus curtain" that smothered artistic freedom, he exposed the weakness of the Mexican school of painting. This was but the first of his assaults on all forms of nationalism--the inspiration and constant butt of his ridicule.

Extremely generous in his aid to other artists, he has promoted their exhibits. He has made countless appearances on radio and television; he has been the subject of documentaries and has taken part in films. It was he who first called the tourist district the Zona Rosa, and it was there that he once invited the public to watch him do a wall painting which he himself thereupon destroyed, as a demonstration of the ephemeral value of the mural art he had so long attacked.

On a later occasion, he challenged those he considered enemies to a public debate. The resulting mass meeting would have turned any political agitator green with envy. He daringly provided posters bearing his own image so that, as he put it, the mob that hated him could give vent to its hatred by covering them with insults. There was even a dummy of Cuevas to be burned at the end of the event, like the figure of Judas at Mexican folk festivals. Foes and would-be troublemakers were vanquished by his courage and wit. And once again Cuevas achieved his objective of filling column after column in the newspapers.

The personality of José Luis Cuevas excites two violent--and violently opposed--public reactions. On the one hand, he enrages those who ignorantly believe him a talentless publicity seeker; he likewise infuriates the pseudo-avant-garde, stung by his attacks on leftists who use nationalism as a cloak for base and obscurantist maneuvering. On the other hand, he arouses the most extravagant admiration in groups of the young who, equally blind to the true value of his work and without any understanding of the road he has traveled, hail him as a champion of rebellion against the established order, without seeking to advance further in their appreciation.

An amusing test of his popularity came about when he allowed himself to be persuaded by a small group to present himself as a candidate for the Chamber of Deputies, representing the Zona Rosa, at the 1970 elections. The night the returns came in he telephoned me long-distance to tell me, laughing with satisfaction, that he had received only two votes--his own and his wife's.

The important thing about all this publicity as regards the Cuevas phenomenon is that it has no effect on the artist's work. Cuevas is a public figure at home and a well-known personally abroad, but he does not permit the hullabaloo surrounding him to detract in any way from the high quality of his drawing. Every two years there is a show of his latest work at the Grace Borgenicht Gallery in New York, and the serious, responsible public of that great world art capital greets it with unvarying enthusiasm. This continued success among connoisseurs is a sure sign that his drawing remains steadily at the same high level of achievement. If his penwork is ever more exquisitely suggestive, if the variations of his strokes show increasing polish and delicacy, it is thanks to his faculty of self-criticism. He is ever on the alert to ensure against a slip from the heights he has so laboriously attained.

Ever since his student days at the School of Painting and Sculpture on the Calle La Esmeralda, Cuevas has

shown an inclination to graphics. As an adolescent he made a few etchings, aquatints, and engravings, and he tried his hand at linoleum block, woodcut, and lithography. Beginning with the album *The Worlds of Kafka and Cuevas*, he has developed a profound interest in illustration. To be more precise, it is an interest in a purely graphic interpretation of literary ideas, without any subordination of line to word. In exploring this area, he has produced a series of albums which place him at the pinnacle of cultivators of the art of lithograph: *Recollections of Childhood* (1962); *Cuevas-Charenton* (1966); *Crime by Cuevas* (1968); and that masterpiece of technical and conceptual audacity entitled *Homage to Quevedo* (1969). In the last-mentioned he has recourse to a number of previously unused devices, and the quality of the work makes it a veritable jewel in its genre.

Cuevas's *Comedies* (1972) illustrates the facility with which the artist handles all graphic processes, though the basic one is lithography. Here Cuevas has made use of drypoint, linoleum block, etching, intaglio, and collage--all reproduced by lithography. Created with complete freedom, these compositions exhibit an obscure interplay of symbols, which the artist has deliberately treated as if he were a continuer of Matisse or Picasso, much like the musician who borrows a theme or device from another composer, improvising upon it in his own manner. Exercises of this type can be performed only by professionals who make no attempt at any sort of disguise. An artist fully assured of his ability to speak for himself may, moved by admiration or yielding to fatigue, borrow a subject or a stylistic trait, but he declares it openly, thereby manifesting his capacity for receiving, assimilating, and making his own what was in origin another's.

In the same year, 1972, the Olivetti office-machine company commissioned Cuevas to do a series of lithographs entitled *La Rue des Mauvais Garçons*. The name is simply the street address of the establishment at which they were printed. These six lithographs rank among the best of Cuevas's graphic production.

Each graphic undertaking, each series of compositions as a rule results from a mass of previous sketches and drawings. Of all this the artist uses but a small part, for, once he begins the transfer to plate or stone, his previous thoughts dissolve into new ideas. The artist's constant urge to create, to find new solutions, drives him almost always to use his preliminary sketches as no more than remote points of departure for the finished product.

In keeping with the age in which he lives, Cuevas has experimented with two theatrical productions in Mexico, and he has sketched costumes and scenery for a ballet in New York. He has written articles and critical introductions for exhibits by his colleagues. Gradually the shy lad who avoided parties and artists' get-togethers has become more sociable. He possesses a fascinating personality, highly expressive of his restless nature.

As for his place in Mexican art, one should note that at the same time that he was condemning the useless, inexpressive, irrelevant depictions of proletarian motherhood, the repetition of which was supposed to represent the maintenance of national tradition, Cuevas was seeking in the roots of the national aesthetic for other sources of creative inspiration; that while he was inveighing against the mechanical imitations turned out by the Popular Graphics Workshop, he was simultaneously turning to pre-Hispanic sculpture in search of forms and inner meaning. A tracing of the outlines of ancient idols would have been a task for a museum copyist. Extracting the essential expression of those idols and transferring it to a subject such as Landrú or the Marquis de Sade--that, on the other hand, was being a truly creative, genuinely Mexican artist. Probing into feeling without copying the ways in which other have depicted it--this is the manner in which Cuevas has won his place in the art world of today. To combine the spirit of Mantegna, of Goya, of Picasso, of Orozco, of Posada with reminiscences of the Aztec goddess of death, Coatlícue, as she appears in massive, floridly baroque carvings in basalt, bespeaks the marvelous.

Toys with which Mexican children play, drawings in pre-Columbian codices, American movies of the silent-film days, naive illustrations recalled from adventure stories read in childhood--all these have provided elements for his thematic repertory and inspiration to his power of constant invention. Few can be aware that the greatest influence on some of Cuevas's recent drawings and on two or three of his latest albums of lithographs is that strange film of the 1930s *Freaks*, which the artist came upon by chance in a film library in Los Angeles. In it he found the confirmation of many figures in his cast of characters.

Cuevas has said that his drawing represents the solitude of man of today, his inability to communicate. It is for this reason that he distorts figures to the point of uniqueness. In *Freaks* the characters appear in the solitude of their distortions; they live in isolation; they come together only to show themselves to the public and, at the end, to wreak vengeance on those who make fun of them; they rebel to transform the beautiful adulteress who figures in the plot into a "duck woman," slashing her over and over with a razor. The mocker has become one more solitary freak.

For every deformity, for every humped back, for every monstrously bloated body supported on pindling legs, there is a point of departure, a model. For the excessively hairy, there is Riemenschneider's *Magdalene* in Munich and Ribera's *Bearded Lady* in the Duke of Lerma's palace in Toledo. Cuevas's world is based in truth; each archetype corresponds to a living being. This is the source of Cuevas's strength, of the power of his work to impose itself upon the viewer over the years. This it is that makes his art truly Mexican, in the best of the national tradition.

The world of Cuevas is not one of invention, but of transformation. The transformation is wrought by a mind which, yielding to nothing, gathers, assimilates--and comes forth with a concept possessing a power and a life peculiarly its own.

Early in 1973 an event occurred that significantly affected both the themes and the aim of Cuevas's work. Owing perhaps to the agitation of a nonstop existence of exhibits, travels, interviews, and publicity stunts, the artist had a recurrence of the heart trouble from which he had suffered in his childhood. The diagnoses varied from doctor to doctor but left him with only two choices: an indefinitely long period of complete rest, or an operation that offered only minimum chances of success. Neither was to Cuevas's liking, but he opted for the more drastic alternative and set off for Houston, where specialists in this delicate branch of surgery are centered. There were painful tests and many anxious moments, and finally the decision, taken by a team that included his own personal physician, Dr. Teodoro Cesarman, of Mexico City: no operation. The seriousness of Cuevas's condition and the findings of the doctors were widely publicized in the Mexican press and reverberated throughout art circles on both sides of the Atlantic.

A certain number of art dealers, for whom a tragic outcome would result in increased prices for the Cuevas drawings they had in stock, circled like vultures about the bulletins from his bedside. During the period in which he hovered as it were between life and death, a man typical of those who think of art in terms of investment appeared at the Misrachi Gallery--which represents Cuevas in Mexico City--and selected a large number of the artist's compositions, asking that they be held for him until the following day. Returning on the morrow, he expressed pious regret at the passing of an artist "so young and of such great talent." When the staff informed him that Cuevas, far from having died, seemed to have started on the road to recovery, laying aside his false sorrow the would-be buyer declared that, such being the case, he was no longer interested in the works reserved for him. Obviously he had read the wrong paper.

The test was a severe one for Cuevas, but it opened up for him a new world of human experience. No sooner was he allowed to resume drawing than he began to sketch the hospital scene--slashed chests, gaping wounds, tendons and arteries bared to view. Then there were the cardiograms--hundreds of them--mute but eloquent witnesses to the fluctuations of the organ on whose beat his life depended. They seemed a bit like notes for a work by Jackson Pollock. Finding a cryptic message in these wavering lines, Cuevas took them as a point of departure for drawings recording the tragedy of certain but undated outcome that has left an indelible stamp upon his life.

A new phase is opening in his work--one that nevertheless has a distant link with the sketches painfully drawn by a twelve-year-old cardiac patient as he questioned the future with wondering eyes.

Cuevas does not weaken amid the agitation of frequent change by which tricksters seek to confuse the unwary, leading them to believe that art follows the frivolous trends of fashion. In the decades since his debut, any number of new movements and pseudo-geniuses have appeared and vanished, like comedy acts of fleeting popularity, the ultrarefined public to which they addressed themselves having quickly wearied of their routines. Still others, unable to advance, have boldly proclaimed that art is dead. Cuevas has persisted--and will continue to persist--in the esteem of people of understanding. His firmness has won, and holds for him, the respect of those who do not allow themselves to be taken by surprise. He was and remains a great draftsman, perhaps of more significance than we realize, ever concerned for quality, ever attached to the best in the tradition, both national and international, in which he was reared. This, then, is the Cuevas phenomenon. --*J.G-S*. English translation by Ralph E. Dimmick.

CATALOGUE

Drawings

1. *Autorretrato (Self-Portrait)*, 1943, charcoal, 12 1/2 x 12 1/2". Private collection.
2. *Self-Portrait with Mumps*, 1944, ink and watercolor, 20 x 17". Private collection.

3. *Autorretrato (Self-Portrait)*, 1944, ink, 12 1/2 x 9". Private collection.
4. *Houses*, 1946, wax crayon, 7 1/2 x 5". Private collection.
5. *Nude*, 1947, pencil, 12 x 8 1/2". Private collection.
6. *Sketch from Life, José Clemente Orozco*, 1948, pen, brush, and ink, 12 1/2 x 10". Private collection.
7. *Rosa*, 1948-49(?), brush and ink, 25 1/2 x 9 1/2". Private collection.
8. *Neighbor Woman*, 1948, ink and gouache, 12 1/2 x 9 1/2". Private collection.
9. *Mireya*, 1948, pencil, 21 1/2 x 12 1/2". Private collection.
10. *Portrait*, 1948, sanguine, 25 1/2 x 19". Private collection.
11. *Page of Sketches*, 1949, pen and ink, 11 x 17". Private collection.
12. *Woman*, 1949, blue ink, 7 1/2 x 5". Private collection.
13. *Boceto (Sketch)*, 1950, mixed media, 14 x 10 1/2". Private collection.
14. *Toilette*, 1950, ink, 15 1/2 x 10 1/2". Private collection.
15. *Autorretrato (Self-Portrait)*, 1950, blue pencil, 17 1/2 x 13". Private collection.
16. *Imaginary Portrait of Diego Rivera*, 1951, blue pencil, 17 1/2 x 12 1/2". Private collection.
17. *Two Figures*, 1951, blue pencil, 11 x 16 1/2". Private collection.
18. *Variety II*, 1953, gouache, 14 x 21 1/2". Private collection.
19. *Woman Giving Birth*, 1954, ink, 17 x 24 1/2". Private collection.
20. *Prostitute*, 1954, mixed media, 11 x 17". Coll. H. Marc Moyens.
21. *Prostitute*, 1954, mixed media, 20 x 26 1/2". Private collection.
22. *Message of the God*, 1956, wash ink, diam. 18 1/2". Private collection.
23. *Two Drawings Pasted on Green Paper*, 1956, ink and watercolor, diam. 10 1/2, 14 x 20 1/2". Private collection.
24. *Self-Portrait as a Baby*, brush and ink, 25 x 19". Private collection.
25. *Study on a Portrait of Ingres*, 1956, pencil and ink, 22 x 17". Private collection.
26. *The Widow*, 1957, pen and ink, 23 x 28 1/2". Private collection.
27. *Estudio del niño de Mantegna con un trozo de carne (Study on the Christ Child of Mantegna with Beef)*, 1957, brush and ink, 47 x 32". Private collection.
28. *Portrait of Jaimes Sánchez*, 1957, ink, 7 1/2 x 6". Coll. Teresa and Angel Hurtado.
29. *Study on the Arnolfinis*, 1957, ink and pencil, 22 1/2 x 16". Private collection.
30. *Self-Portrait After Completing Illustrations for Kafka*, 1957, ink and watercolor, 17 x 8". Private collection.
31. *Four Studies for Kafka Illustrations*, 1957, mixed media, 6 1/2 x 8 1/2, 9 1/2 x 12 1/2, 8 3/4 x 9 3/4, 3 x 4 1/4". Private collection.
32. *Childhood of Mae West*, 1957, ink, 22 x 28". Private collection.
33. *Self-Portrait Influenced by Kafka*, 1957, ink, 8 1/2 x 5 1/2". Private collection.
34. *Self-Portrait Influenced by Kafka*, 1957, ink, 8 1/2 x 5 1/2". Private collection.
35. *Self-Portrait Influenced by Kafka*, 1957, ink, 8 1/2 x 5 1/2". Private collection.
36. *Sketch for Double Portrait*, 1958, ink, 14 x 17". Private collection.
37. *Funerales de un dictador (Funeral of a Dictator)*, 1958, ink on canvas, 50 1/2 x 75". Coll. H. Marc Moyens.
38. *Conquest of Mexico*, 1959, oil on paper, 26 x 40". Private collection.
39. *Conquest of Mexico*, 1959, oil on paper, 40 x 26". Private collection.
40. *Conquest of Mexico*, 1959, oil on paper, 26 x 40". Private collection.
41. *Conquest of Mexico*, 1959, oil on paper, 26 x 40". Private collection.
42. *Self-Portrait after Goya*, 1960, ink, 72 x 36". Private collection.
43. *Self-Portrait with Rimbaud*, 1962(?), ink and watercolor, 12 1/2 x 8 1/2". Private collection.
44. *Self-Portrait with Bearded Woman of Ribera in Toledo*, 1963, ink, 11 x 15". Private collection.
45. *Marquis de Sade, Family Portrait*, 1963, ink, 22 x 27 1/2". Coll. Mr. and Mrs. MacKenzie Gordon.
46. *Las verdaderas damas de Aviñón (The Real Ladies of Avignon)*, 1973, three drawings, ink and watercolor, 13 x 16, 16 x 13, 29 1/2 x 35 1/2". Coll. Museum of Modern Art of Latin America.
47. *The Secret of Walter Raleigh, No. 25*, 1976, ink and watercolor, 25 1/2 x 38 1/4". Coll. Teresa and Angel Hurtado.

Prints

48. *After the War*, 1950, linoleum, 13 1/2 x 7 1/4". Private collection.
49. *Peace*, 1950, linoleum, 13 1/2 x 10". Private collection.
50. *Head*, 1962, lithograph, 22 x 30". Private collection.
51. *Cuevas/Charenton, Eating Beast*, 1965, color lithograph, 22 1/2 x 30". Private collection.

52. *Cuevas/Charenton, Worm Eaten Skull*, 1965, color lithograph, 22 1/2 x 30". Private collection.
53. *Music*, 1966, color lithograph, 22 x 26". Private collection.
54. *La Rue des Mauvais Garçon, The Lady Magician*, 1972, color lithograph, 22 x 30". Private collection.
55. *La Renaudière, la cocina (La Renaudière, the Kitchen)*, 1976, color etching, 15 1/2 x 19 1/2". Coll. Museum of Modern Art of Latin America.
56. *La Renaudière, la sala (La Renaudière, the Living Room)*, 1976, color etching, 15 1/2 x 19 1/2". Coll. The Museum of Modern Art of Latin America.

June 6 - July 30, 1978

CHASING CUEVAS WITH A CAMERA.
PHOTOGRAPHS BY DAISY ASCHER OF MEXICO [1]

Several years ago Mexican photographer Daisy Ascher undertook the project of documenting in black and white the everyday life of José Luis Cuevas. Although she had already proved herself competent in the field of experimental photography, where she is concerned with the interpretation of light and movement, she refrained from her usual approach to produce a straightforward but unique photographic diary that gives us a more complete vision of the real and fantastic world through which Cuevas moves and which, at the same time, provides the source material for all his work. We see him in real situations--standing in the midst of hanging carcasses at a meatpacking plant, sketching the residents of a home for the aged, and visiting the cardiologist for a check-up--and we see him in situations of his own invention in which he simulates his own death or lies in bed beside a figure with a rubber death mask. It is a fascinating pictorial journey and perhaps the only work of its kind dedicated to a major figure in contemporary art.

Miss Ascher was born in 1944 in Mexico City and began her study of photography eight years ago under the guidance of George Konduros. She has had fourteen one-person exhibitions in galleries in Mexico City, has lectured on photography and participated in conferences at Mexico's National University, and has collaborated on projects for several newspapers and magazines. She is also founder and director of the Daisy Ascher Photography School in Mexico. Many of the photographs in the current exhibition are included in Ms. Ashley's book entitled *José Luis Who?*, which was published only this year.

The photographic exhibition coincides with *A Backward Glance at Cuevas*, the first major exhibit presented at the Museum of Modern Art of Latin America. It forms part of the tribute being paid to Cuevas by the General Secretariat of the Organization of American States on the twenty-fourth anniversary of his first exhibition here at the OAS. *--J.G-S.*

July 12 - August 5, 1978

PAINTINGS BY BERNARD SEJOURNE OF HAITI

Haitian painter Bernard Séjourné was born in Port-au-Prince in 1947. After completing his studies at the Academy of Fine Arts there, he attended the Jamaican School of Fine Arts and Crafts in Kingston and the Art Students League and American Art School in New York City. He has had one-man exhibitions in those countries as well as in Senegal (Festival of Black Arts, Dakar, 1965), Canada (Expo '67, Montreal), and Mexico (Museum of Modern Art, Mexico City, 1976). In the United States, his work has been included in group exhibits of Haitian art at the Newark Museum, 1971; the Brooklyn Museum, 1972; and at the Washington County Museum in Hagerstown, Maryland, 1972. *--J.G-S.*

[1] No list of photographs exhibited is available. *--Ed.*

EXHIBITION LIST [1]

Paintings

1. *En mémoire de vous (In Memory of You)*
2. *Erzulie Freda*
3. *La vendeuse (The Vendor)*
4. *Le miroir (Mirror)*
5. *Maternité (Maternity)*
6. *Les amants (The Lovers)*
7. *Le soleil, la mer, le ciel, toi et moi (The Sun, the Sea, the Sky, You and I)*
8. *La première fois (The First Time)*
9. *La Vierge d'or (The Golden Madonna)*
10. *Erzulie Gé Rouge*
11. *Fille bleue (Love in Blue: Blue Girl)*
12. *Bogie d'Orca, plage (Bogie d'Orca, Beach)*
13. *A Frantz Fanon (To Frantz Fanon)*
14. *Paradis perdu (Lost Paradise)*
15. *Bouquet du matin (Misty Bouquet)*[2]
16. *Sonate: Au clair de lune (Sonata: Au Clair de Lune)*

August 7 - September 8, 1978

FOUR PRIMITIVE PAINTERS FROM JAMAICA:
EVERALD BROWN, CLINTON BROWN, SIDNEY McLAREN, KAPO

The art tradition in Jamaica dates from the second half of the eighteenth century when Europeans, especially the British, went to the island to sketch the landscape, public celebrations, and daily life. These sketches from nature often served as illustrations for books and other publications printed in the artists' homeland. The same general pattern was followed during the nineteenth century, but by the early twentieth century Jamaica had a considerable number of artists of professional rank--most of them Jamaican-born--whose works can be seen in the National Gallery of Jamaica as well as in museums in Europe.

Today Jamaica claims both artists who have been schooled in the academic and modern traditions as well as a number of highly talented self-taught artists whose work, for lack of a more appropriate definition, we call primitive. Although they are included in almost all group exhibits of Jamaican art and have been successful with the public, only a few have contact with the official art world, and many live far from Kingston.

Early this year, I went to Jamaica for the purpose of selecting the works in the current exhibit. All four artists represented--Everald and Clinton Brown, Sidney McLaren, and Kapo Reynolds--were participants in the exhibition *Contemporary Art from the Caribbean*, which was presented at the OAS gallery in 1972. In each instance, I found that they had been able to sustain the high quality and spontaneity of expression evident in their earlier work. Although the present exhibit is limited to paintings, all the artists, with the exception of McLaren, are sculptors as well as painters. Religion or mysticism plays a strong role in the lives of all, but only the two Browns, father and son, use it as a direct source of reference for their compositions.

Everald Brown, who is a carpenter by trade, lives in the mountains several hours outside Kingston and is a practicing Ras Tafarian priest. The Ras Tafarians follow the teaching of the Coptic Christian Church of Ethiopia and Haile Selassie, blended with a twist of native-bred mysticism. Brother Brown's son Clinton serves as his preaching assistant. Although elements from the natural surroundings appear in their paintings, both create

[1] Not included in the original catalogue. --*Ed.*

[2] Literal translation of this title is "Morning Bouquet." --*Ed.*

fantasy worlds that are filled with rich color and imaginative, enigmatic forms that derive from their religious beliefs. All members of the Brown family are talented, self-taught musicians, and Brother Brown himself invents, decorates, and executes a variety of exotic musical instruments reminiscent of those of medieval times.

McLaren was trained as a carriage-maker but was forced to abandon his trade with the introduction of the motor car on the island. He then began to farm a small plot of ground given him by his father, but found himself powerless against hurricanes that repeatedly destroyed his crops. Quite by accident, he discovered his talent for art and now, at eighty-three, "if it pleases the Lord, my desire is to go on drawing and painting until I can do no more." McLaren has painted a considerable number of self-portraits that have great charm, but more typical of his work are the realistic renderings of scenes from his native St. Thomas in which he meticulously depicts every detail, including the cables leading from the electric light poles. The predominance of white in his compositions gives them a luminous quality and wonderful sense of joy.

Mallica Reynolds (Kapo), the best known of the four, has been promoted by personalities such as the late Errol Flynn and, more recently, by jazz singer Roberta Flack. Only this year, one of his paintings was acquired for Amsterdam's Stedelijk Museum. In 1976 he was ordained as a bishop of a revivalist sect, and he mixes art and his official duties with ease and a certain delight. His painting, like McLaren's, is based on visible reality. Controlling his use of color, he focuses his attention on crowds of people at the seashore or in an urban setting, and repeats selected elements in a constant pattern. Kapo also excels in portraiture and is an accomplished woodcarver, gladly giving demonstrations of his techniques to interested tourists. In 1966 he received a gold medallion from Emperor Haile Selassie when he presented him with one of his works.

The opening of the exhibition coincides with the anniversary of Jamaica's sixteenth year of independence. Dr. David Boxer, Director of the National Gallery of Jamaica, served as coordinator in Jamaica and assisted me in the selection of the works. The Cultural Department of the Prime Minister's Office in Kingston, the Embassy of Jamaica in Washington, and Jamaica's Permanent Mission to the OAS worked in close collaboration with us to ensure the exhibition's success. --*J.G-S.*

CATALOGUE

Paintings

Everald Brown
 1. *Chanting*, 1978, oil on canvas board, 18 x 36"
 2. *Next Door Neighbor*, 1978, oil on canvas board, 18 x 36"
 3. *Duppy Family*, 1978, oil on canvas board, 18 x 36"
 4. *The Word Is Life*, 1978, oil on canvas board, 18 x 36"
 5. *Victory Dance*, 1976, oil on canvas board, 49 x 33"
 6. *Dramatic Landscape*, 1978, oil on canvas board, 18 x 36"
 7. *Roots*, 1977, oil on canvas, 23 1/2 x 29 1/2"
 8. *Sign*, ca. 1970, oil on canvas board

Clinton Brown
 9. *Next Door Neighbor*, 1978, oil on canvas board, 18 x 36"
 10. *Country Scene*, 1978, oil on canvas board, 18 x 36"
 11. *Heaven Declare*, 1978, oil on canvas board, 18 x 36"
 12. *Down in the Valley*, 1978, oil on canvas board, 18 x 36"
 13. *Landscape*, 1978, oil on canvas board, 18 x 36"
 14. *A Son Is Born*, 1978, oil on canvas board, 18 x 36"

Kapo (Bishop Mallica Reynolds)
 15. *Orange Paradise*, 1975, oil on cardboard, 75 x 50"
 16. *Solomon*, 1970, oil on cardboard, 24 x 24"
 17. *Over the River*, 1972, oil on cardboard, 30 x 24"
 18. *My Guardian Angel*, 1975, oil on cardboard, 51 x 45"
 19. *King Kubalee*, 1974, oil on cardboard, 40 x 26"

Sidney McLaren
20. *Self-Portrait*, 1968, mixed media on cardboard, 27 x 19"
21. *Creative Imagination*, 1977, mixed media on cardboard, 41 x 29"
22. *Montego Bay*, 1978, mixed media on cardboard, 22 x 17"
23. *Morant Bay*, 1978, mixed media on cardboard, 36 x 23"

ABOUT THE ARTISTS

BROWN, Clinton. Son of Everald Brown, born in 1954 in Kingston, Jamaica. Primary school education. An assistant to his father in the Ras Tafarian priesthood, he began painting in 1967 under the guidance of his father. He has exhibited in Jamaica (1969, 1972, 1977) and at the OAS, Washington, D.C. (1972).

BROWN, Everald. Born in 1917 in the Parish of St. Ann, Jamaica. Primary school education. A carpenter by trade, he is also a painter, sculptor, musician, and Ras Tafarian priest. He has exhibited in Jamaica (1969, 1972, 1977), at the OAS, Washington, D.C. (1972, 1973), and in El Salvador (1977). In Jamaica, he has been awarded bronze and silver medals, 1970 and 1974, and this year received a grant from the National Gallery of Jamaica. He is represented in the collection of the Museum of Modern Art of Latin America in Washington, D.C.

KAPO (Bishop Mallica Reynolds). Born in 1911 in Bynloss, Parish of St. Catherine, Jamaica. He is a painter and sculptor as well as an ordained bishop of a revivalist sect. In addition to numerous exhibits in Jamaica, he has exhibited in New York (1952, 1969), Los Angeles (1964, 1968), and at the OAS in Washington, D.C. (1972). He has won numerous prizes in Jamaica, including the Silver Musgrave Medal, 1969, and in 1977 was awarded by the Jamaican government the Order of Distinction in the field of art. He is represented in the collection of the Stedelijk Museum of Amsterdam.

McLAREN, Sidney. Born in 1895 in St. Thomas, Jamaica. Primary school education. He began to paint when he was almost sixty-five years old. He has exhibited in England, Guayana, at the OAS in Washington, D.C. (1972), as well as in Jamaica. He has been awarded numerous prizes for his work in Jamaica, 1960, 1964, 1973, and 1977, including the Silver Musgrave Medal in 1975.

August 17 - September 17, 1978

VICTOR DELFIN: SCULPTURES OF PERU

The Aztec Garden, which lies between the Museum and the OAS building, provides a handsome setting for sculpture and, although not a regular feature of our program, we periodically use the area for special exhibitions. This summer we are exhibiting a selection of works by Peruvian-born artist Víctor Delfín. Delfín welds pieces of iron and other metals to create monumental bird and animal forms. He is generally concerned with large planes and masses but always selects certain aspects of his subject such as muscles or feathers and claws to describe in detail. The result is a stylized, decorative work that is often quite awesome.

In the Western world, welding iron to create works of art is a tradition of Moorish-Spanish origin, dating from the early Middle Ages. In modern times, the tradition was revived in Spain by Pablo Gargallo, Julio González, and Pablo Picasso. Although Delfín did not begin to work with sculpture until 1967, welding techniques and the materials with which he works have been familiar to him since early childhood, when he often watched or assisted his father who was an ironsmith.

Delfín was born in Lobitos, Piura, Peru, in 1927. He studied painting and drawing at the School of Fine Arts in Lima and, upon graduation, directed the Regional Schools of Art of Puno and Ayacucho. He also taught briefly in Santiago de Chile. His sculptures have been exhibited in the United States, Colombia, Ecuador, Peru, Venezuela, Belgium, and Spain, with his most recent exhibit having been at the Bayard Gallery in New York City (March 1978). He has been commissioned to complete large-scale sculptures for public areas in Peru, the Dominican Republic, and the United States, and is represented by smaller works in private and public collections here and in Latin America. *--J.G-S.*

This exhibition was made possible through the generosity of the Sociedad de Industrias of Peru, whose members

include the following: Aceros Arequipa, Radio América y TV, Etermit, Fábrica Tejidos La Unión, Inresa Hidrostal, Pisopak, La Parcela, Textil Piura, and Compañía Industrial Perú-Pacífico. Transportation was provided by Aero Peru.

EXHIBITION LIST [1]

Iron Sculptures

1. *Pez (Fish)*
2. *Peacock*
3. *Bird of Ayacucho*
4. *Ave del paraíso (Bird of Paradise)*
5. *Relieve (Relief)*
6. *León (Lion)*
7. *Caballo (Horse)*
8. *Caballo (Horse)*
9-10. *Tapestries*[2]

September 11 - October 6, 1978

IRENE CARDENAS OF ECUADOR: PAINTINGS, ENGRAVINGS, MONOTYPES

In Ecuador one finds a significant number of women who are making important achievements in art, with most exploring the different directions of abstraction. Among the most accomplished and versatile is painter and printmaker Irene Cárdenas, who began exhibiting her work professionally in Quito in 1972. In her painting she sometimes creates superimposed planes that serve as a center from which the rest of the composition evolves, while in other instances structured forms are silhouetted against a dark background, or solid, free-form planes project from the canvas toward the spectator. In her engravings and monotypes, she demonstrates a particularly sensitive handling of color and thorough knowledge of technique.

Irene Cárdenas was born in Quito in 1920 and studied at the School of Fine Arts of Quito's Central University. She has had four one-person exhibitions in Quito and Guayaquil and in 1974 exhibited her work at the Palace of Fine Arts of Guadalajara, Mexico. She has participated in numerous national and international exhibitions, including the Biennial of Latin American Prints in San Juan, Puerto Rico, 1974 and 1976; the Third International Graphics Annual in New Hampshire, 1975; and the Print Biennial in Krakow, Poland, 1976. In 1973 she was awarded First Prize for Print at the National Competition sponsored by the Casa de la Cultura Ecuatoriana in Quito and in 1977 received Honorable Mention for Painting at the First National Plastic Arts Competition sponsored by the Central Bank of Ecuador. Her work is represented in museums in Quito as well as in the Columbus Museum of Arts and Crafts in Columbus, Georgia.

This is the artist's first one-person exhibition in the United States. --*J.G-S.*

EXHIBITION LIST [3]

Paintings

1-2. *Pintura (Painting)*, oil
 3. *Pintura (Painting) No. 3*, oil

[1] Not included in the original catalogue. --*Ed.*

[2] The titles are unavailable. --*Ed.*

[3] Not included in the original catalogue. --*Ed.*

4. *Pintura (Painting) No. 2*, oil
5. *Pintura (Painting) No. 11*, acrylic
6. *Pintura (Painting) No. 13*, acrylic
7. *Pintura (Painting) No. 20*, acrylic
8. *Pintura (Painting) No. 30*, acrylic
9. *Pintura (Painting) No. 65*, oil

Engravings

10. *Grabado (Engraving) No. 76*
11. *Grabado (Engraving) No. 77*
12. *Grabado (Engraving) No. 78*, 6/6
13. *Grabado (Engraving) No. 81*, 4/6
14. *Grabado (Engraving) No. 85*
15. *Grabado (Engraving) No. 87*, 3/8
16. *Grabado (Engraving) No. 89*, 1/8
17. *Grabado (Engraving) No. 91*
18. *Grabado (Engraving) No. 93*, 1/10
19. *Grabado (Engraving) No. 94*, 1/10

Monotypes

20. *Monotipo (Monotype) No. 111*
21. *Monotipo (Monotype) No. 400*
22. *Monotipo (Monotype) No. 403*
23. *Monotipo (Monotype) No. 406*
24. *Monotipo (Monotype) No. 414*

September 28 - October 30, 1978

MEXICO TODAY SYMPOSIUM:
DIFFERENT EXPRESSIONS OF MEXICAN CONTEMPORARY ART

Mexico Today, a national symposium of exhibitions, seminars, films, performing arts, and courses on contemporary Mexico, is made possible by grants from the National Endowment for the Humanities and the National Endowment for the Arts, and is sponsored and organized by Meridian House International, the Smithsonian Resident Associate Program,and the Center for Inter-American Relations. *Mexico Today* is organized in cooperation with the government of Mexico through the Ministry of Foreign Affairs.

The exhibitions of the symposium will take place at the following museums: the Museum of Modern Art of Latin America, Washington, D.C.; the Alternative Center for International Arts, New York; the High Museum of Art, Atlanta; and the Mexican Museum, San Francisco.

SPONSORS COMMITTEE

Santiago Roel, Secretary of Foreign Affairs; Fernando Solana, Secretary of Public Education; Emilia Téllez Benoit, Sub-Secretary "C" of Foreign Relations; Víctor Flores Olea, Sub-Secretary of Culture and Recreation,

[1] This exhibit consisted of a selection of works from a larger exhibition of the same name organized by the Museum of Modern Art in Mexico City and circulated in the United States in conjunction with the *Mexico Today Symposium, 1978-1979*. Its catalogue, issued in Mexico City by the Museum of Modern Art of Mexico City, includes all the artists mentioned in its "Prologue" (here reproduced). However, only those artists who have been selected to exhibit at the Museum of Modern Art of Latin America are listed under "Catalogue" and "About the Artists." --*Ed.*

Ministry of Public Education; Hugo B. Margáin, Ambassador of Mexico in Washington, D.C.; Juan José Bremer, General Director, National Institute of Fine Arts; Ambassador Luis de la Hidalga, Director of Cultural Affairs and Publications, Ministry of Foreign Relations; Luis del Valle, Director of International Relations, National Institute of Fine Arts; Ernesto Yáñez de la Barrera, General Director of Cultural Affairs, Ministry of Foreign Relations.

WORKING COMMITTEE

Fernando Gamboa, Exhibition Curator, Technical Sub-Director of the National Institute of Fine Arts and Director of the Museum of Modern Art; Patricia Ortiz Monasterio, Exhibition Coordinator.

PROLOGUE

The twentieth century has been a period of great artistic development in Mexico. The birth of muralism at the beginning of the twenties revolutionized Mexican art and thought. The death of three men, the muralists José Clemente Orozco, Diego Rivera, and David Alfaro Siqueiros, brought another change in art.

The muralism with its social criticism was finished, but simultaneously a pictorial movement of a different type was growing and maturing, represented by three great names: Rufino Tamayo, Carlos Mérida, and Gunther Gerzso. Then came an explosion of talent that until now has produced a great variety of currents. The bridge between the masters of muralism and the young painters of today is an artist of unique style named Juan Soriano, a figure of lyrical talent.

The artists who represent Mexico in the exhibition *Different Expressions of Mexican Contemporary Art* show the plurality of artistic credos and the freedom that characterizes the panorama of visual arts in Mexico. Realism and abstractionism in various forms serve to integrate this show that is divided into two exhibitions that will take place simultaneously in Washington, D.C., and Atlanta. The same artists will be represented in each city by different works.

Gilberto Aceves Navarro is a painter who contrasts expressive violence with the lyrical softness of his color. Rafael Coronel, an exponent of critical realism, is a great draftsman, possessor of a sharp sense of observation with which he captures the human psyche. Francisco Corzas seduces the eye with his baroque atmosphere; his figures, either richly robed or startlingly nude, evoke the painting of the past seen by the modern mind, his brushstrokes create works of timeless sensual beauty. Enrique Estrada is the critical realist who, in treating dramatic scenes from the history of Mexico, underscores the vices of the present. Manuel Felguérez, a geometric and constructivist artist in whose work "form opens the path to color," is preoccupied with the problem of space, always in search of new aesthetic solutions. Fernando García Ponce, another geometric artist, builds with the vigor of the architect and the imagination of the poet and creates spiritualized, sensual paintings in vibrant, dramatic color. Luis López Loza, an artist using a "flat" technique that avoids abstraction, creates profiles of beings and objects detached from reality. Agueda Lozano is an abstractionist, a "geometrician of the fantastic," whose painting is a game of superimposed planes, of rich textures that suddenly brings the surprise of a change of perspective in an ambience of delicacy and harmony. Teresa Morán recreates, in her own way, the basic elements and objects of everyday life in an atmosphere of mystery and unreality. Emilio Ortiz, an innovator in figuration, a painter who belongs to the "fantastic" trend in Mexican art, is in some ways related to surrealism: he creates introverted chimerical images in illusory depths, strange objects adrift in a restless universe. Antonio Peláez, a lyrical abstractionist, fills his large, pictorial surfaces with rich textures and graffiti achieving an atmosphere of singular harmony. Vicente Rojo, an abstractionist, gives with colors of strange beauty a human-romantic element to his severe works of powerful geometric vigor. Ignacio Salazar, another abstractionist and the youngest of the group, creates sober, powerful geometric compositions alive with brilliant color.

We hope that the presentation of these exhibitions in the *Mexico Today Symposium* will be welcome by the American people as symbol of the friendship of their neighbors south of the Rio Bravo. We express our deepest gratitude for the hospitality that two distinguished and active museums have given us: the Museum of Modern Art of Latin America in Washington, D.C., and the High Museum of Art in Atlanta. --*Fernando Gamboa*, Director of the Museum of Modern Art, Mexico City.

The Museum of Modern Art of Mexico City thanks the institutions, artists, and collectors for their permission

to use their paintings. Without their gracious assistance these exhibitions would not have been possible: Fundación Televisa, Mexico; Galería de Arte Mexicano, Mexico City; Galería Estela Shapiro, Mexico City; Galería Juan Martín, Mexico City; Galería Ponce, Mexico City; Mr. Gilberto Aceves Navarro, Mr. Rafael Coronel, Mr. Enrique Estrada, Mr. Antonio Peláez, Mrs. Teresa Morán, Mr. Ignacio Salazar, Mr. Juanito Aceves R., Dr. Víctor Chellet, Mr. Juan Ibáñez, Dr. David Levine, Dr. Harvey Mannes.

CATALOGUE

Gilberto Aceves Navarro
1. *Variaciones sobre una obra de Durero: La decapitación de San Juan Bautista (Variations on a Work by Dürer: The Decapitation of John the Baptist) No. 20*, 1977, oil on canvas, 80 x 100 cm. Coll. Dr. David Levine, Mexico.
2. *Variaciones sobre una obra de Durero: La decapitación de San Juan Bautista (Variations on a Work by Dürer: The Decapitation of John the Baptist) No. 33*, 1977, oil on canvas, 150 x 180 cm. Coll. of the artist.
3. *Variaciones sobre una obra de Durero: La decapitación de San Juan Bautista (Variations on a Work by Dürer: The Decapitation of John the Baptist) No. 80*, 1978, oil on canvas, 100 x 125 cm. Coll. Mr. Juanito Aceves R., Mexico.
4. *Variaciones sobre una obra de Durero: La decapitación de San Juan Bautista (Variations on a Work by Dürer: The Decapitation of John the Baptist) No. 24*, 1978, oil on canvas, 100 x 125 cm. Coll. of the artist.
5. *Variaciones sobre una obra de Durero: La decapitación de San Juan Bautista (Variations on a Work by Dürer: The Decapitation of John the Baptist) No. 20*, 1978, oil on canvas, 100 x 125 cm. Coll. Dr. David Levine, Mexico.

Rafael Coronel
6. *Mujer de Ticomán (Woman from Ticomán)*, 1978, oil on canvas, 125 x 100 cm. Coll. of the artist.
7. *Mujer de Sonora (Woman from Sonora)*, 1978, oil on canvas, 125 x 100 cm. Coll. of the artist.
8. *Old Man from Hamburg*, 1978, oil on canvas, 125 x 100 cm. Coll. of the artist.
9. *Housekeeper*, 1978, oil on canvas, 125 x 100 cm. Coll. of the artist.
10. *Profile of Old Woman*, 1978, oil on canvas, 100 x 125 cm. Coll. of the artist.

Enrique Estrada
11. *Revolucionario muerto (Dead Revolutionary), No. 2*, 1975, oil on canvas, 90 x 140 cm. Coll. of the artist.
12. *Personages of the Struggle of Factions*, 1976, oil on canvas, 192 x 244 cm. Coll. of the artist.

Manuel Felguérez
13. *Las dos soluciones (The Two Solutions)*, 1973, lacquer on canvas, 125 x 150 cm. Coll. Museo de Arte Moderno, Mexico City.
14. *La influencia de la oscuridad (The Influence of Darkness)*, 1973, lacquer on canvas, 125 x 190 cm. Coll. Museo de Arte Moderno, Mexico City.
15. *La energía del punto cero (The Energy of Point Zero)*, 1973, lacquer on canvas, 125 x 150 cm. Coll. Museo de Arte Moderno, Mexico City.
16. *Origen de la reducción (The Origin of Reduction)*, 1973, lacquer on canvas, 125 x 150 cm. Coll. Museo de Arte Moderno, Mexico City.
17. *El estímulo B (The Stimulus B)*, 1973, lacquer on canvas, 125 x 150 cm. Coll. Museo de Arte Moderno, Mexico City.

Antonio Peláez
18. *Pared pública (Public Wall)*, 1973, oil on canvas, 120 x 180 cm. Coll. of the artist.
19. *Interrupción (Interruption)*, 1973, oil on canvas, 130 x 170 cm. Coll. of the artist.
20. *Reflejo en el muro (Reflex on the Wall)*, 1978, oil on canvas, 100 x 150 cm. Coll. of the artist.
21. *Fantastic Wall*, 1978, oil on canvas, 120 x 140 cm. Coll. of the artist.
22. *Cables*, 1978, oil on canvas, 110 x 80 cm. Coll. of the artist.

Vicente Rojo
23. *Negación (Denial) No. 38*, 1974, acrylic on canvas, 110 x 110 cm. Coll. Galería Juan Martín, Mexico, D.F.
24. *Negación (Denial) No. 45*, 1974, acrylic on canvas, 110 x 110 cm. Coll. Galería Juan Martín, Mexico, D.F.
25. *Recuerdo (Remembrance) No. 102*, 1976, oil on canvas, 110 x 110 cm. Coll. Galería Juan Martín, Mexico, D.F.

ABOUT THE ARTISTS

ACEVES NAVARRO, Gilberto. Born in Mexico City on September 24, 1931. In 1950 he attended La Esmeralda School of Painting and Sculpture. In 1952 he worked under David Alfaro Siqueiros on the murals of the Rectory Building at the National University of Mexico. From 1955 to 1957 he was a teacher at the Instituto Regional de Bellas Artes in Acapulco, Mexico. From 1965 to 1968 he taught at the Mexican-North American Exchange Institute in Los Angeles (California); and from 1971 on, at the Escuela Nacional de Artes Plásticas, Mexico City. Individual exhibitions: many in private and institutional galleries in Mexico and the United States. Participated in sixty collective exhibitions in New York, Paris, Tokyo, San Diego (California), Mexico City, Portland (Oregon), Nebraska, Montreal, San Antonio (Texas), Osaka, Medellín, Lugano, Guadalajara, Brussels, Warsaw, Belgrade, Tehran, and Nancy. Between 1956 and 1957 he won the Nuevos Valores de la Plástica (New Values in Art) Prize in Mexico City, and in 1958, 1964, and 1971 the Salón de la Plástica Mexicana (Mexican Art Salon) Prize, Mexico City, for his paintings.

CORONEL, Rafael. Born in Zacatecas, Mexico, on October 24, 1932. In 1952 he moved to Mexico City and began his studies in architecture. In 1954 he abandoned architecture and dedicated himself entirely to studying art at La Esmeralda School of Painting and Sculpture. Individual exhibitions: Mexico City, Washington, D.C., Phoenix, Puerto Rico, and Beverly Hills. Collective exhibitions: Michigan, São Paulo, Tokyo, Puerto Rico, and Mexico. In São Paulo he won the Córdoba Prize for the Best Young Latin American Painter. In Tokyo he won the First Prize at the Biennial of Figurative Art.

ESTRADA, Enrique. Born on September 2, 1942 in Tapachula, Chiapas, Mexico. He began his studies at the Escuela Nacional de Artes Plásticas San Carlos, Mexico. In 1966 he collaborated with Siqueiros on the Polyforum murals in Mexico City. From 1970 to 1972 he taught at the Centro de Artes Plásticas A.C., Mexico City, In 1974 and 1975 he did three stage designs for the performing arts center, Casa del Lago, Mexico City. Individual exhibitions: in several private galleries and at the Museo de Arte Moderno de México in Mexico City. Collective exhibitions: Mexico City, Cuernavaca, and Havana.

FELGUEREZ, Manuel. Born in Zacatecas in 1928. He studied at the Escuela Nacional de Artes Plásticas, at the Académie de la Grande Chaumière, Paris, and La Esmeralda School of Painting and Sculpture. In 1954 he studied at the Académie Colarossi, Paris, on a scholarship granted by the French government. Individual exhibitions: Mexico City, Paris, New York, Washington, D.C., and Lima. Collective exhibitions: Paris, Boston, New York, St. Louis, Tucson, Tokyo, São Paulo, Montevideo, Madrid and Barcelona, Barranquilla, Havana, San Diego (California), Montreal, New Delhi, Brussels, Puebla, Zacatecas, Pátzcuaro, and other cities.

PELAEZ, Antonio. Born in Villa de Llanes, Spain, in 1921. He has lived in Mexico since 1936. He studied art at La Esmeralda School of Painting and Sculpture. Numerous individual exhibitions in Mexico City, Paris, Jalapa (Mexico), and Madrid. Collective exhibitions: Montreal, Austin, and San Antonio (Texas), São Paulo, and throughout Mexico.

ROJO, Vicente. Born in Barcelona, Spain, in 1932. He has lived in Mexico since 1949. He studied art at La Esmeralda School of Painting and Sculpture. Individual exhibitions: Mexico City, Miami, Barcelona (Spain), Madrid, Havana, Bogotá, San Antonio (Texas), and Jalapa and Guadalajara. Collective exhibitions: Paris, Mexico City, São Paulo, Tokyo, Phoenix (Arizona), San Diego (California), Montreal, New Delhi, San Antonio (Texas), New York, and Havana.

October 11 - November 3, 1978

JUAN SORIANO OF MEXICO

Juan Soriano is one of the best examples of the intermediate generation of modern Mexican art, that is, the generation that sprang up after the three great muralists--Rivera, Orozco, and Siqueiros--and their equally great contemporary Rufino Tamayo. In the course of a career notable for many-sided expressions, Soriano has attained a position of great prestige in his country's art circles today.

His first compositions were in the popular vein of the primitives, but into them he introduced elements of

folklore, dreams, and fantasy. He next evolved an elementary technique of portraiture, and thereafter took up abstract expressionism, the works produced during this period being distinguished by the richness of his palette. Currently he leans toward a simplified realism, with color as the dominant factor in his production.

Fernando Gamboa, the director of the Mexico City Museum of Modern Art, states:

> Soriano has never been influenced by any particular tendency. His strong personality needs freedom. Without a doubt, he is an artist to whom it is vital to allow his colors to flow in all kinds of forms and figures. It should also be noted that this artist is a forerunner, and that one of his principal merits is to have been the link between the great masters such as Tamayo, Mérida, and Gerzso and the new generations.

Soriano began to become known in the 1940s. His first one-man show took place in 1941 at the National University of Mexico. Many other such shows have taken place in his native country since, the latest having been held last year at the Juan Martín Gallery in Mexico City. In addition, Soriano has enjoyed individual presentations in Rome, 1956; San Francisco, 1958; and Brussels, 1963. This, however, is his first one-man exhibit in the eastern United States.

His works have appeared in numerous group shows in Mexico and abroad--in Chicago, Philadelphia, New York, Toronto, Vancouver, Ottawa, Montreal, Tokyo, London, and no fewer than seven different cities in France. It is in that country that he now resides and that he has worked for the past two years. He recently won an award at Cagnes-sur-Mer to add to the numerous ones he had received in Mexico.

Compositions by Soriano are to be found in three museums in Mexico, in the Philadelphia Museum of Art, the San Francisco Museum of Art, the Museum of Art of San Juan (Puerto Rico), and the Museum of Modern Art, New York.

The Museum of Modern Art of Latin America expresses its appreciation to the Televisa Cultural Foundation of Mexico, whose president, Emilio Azcárraga-Milmo, has generously lent the works that appear in this exhibition. Juan Soriano is currently working under a special grant from the Foundation. --*J.G-S*.

CATALOGUE

Paintings

1. *León con las mariposas (Lion with Butterflies)*, 1978, oil and tempera on canvas, 117 x 90 cm.
2. *Calavera roja (Red Skeleton)*
3. *Jonas*
4. *Snow*
5. *Forgotten Tomb*
6. *The Donkeys*
7. *The Boat and the Stones*
8. *El árbol amarillo (Yellow Tree)*, 86 x 71 cm.
9. *Swimming Ducks*
10. *Skull in Profile*
11. *Naturaleza muerta con rana (Still Life with Frog)*, 1978, oil and tempera on canvas, 61 x 46 cm.
12. *Yellow Pansies*
13. *The Cats*
14. *El jardín (The Garden)*, 61 x 50 cm.
15. *Flowers and Butterfly*
16. *Bird at the Window*
17. *El pajarito rojo (The Red Bird)*, oil and tempera on canvas, 46 x 27 cm.
18. *Bird in Sunlight*
19. *The Bird and Its Reflection*
20. *Nymphs*
21. *La madrugada (Dawn)*, 66 x 55 cm.
22. *The Frogs and the Branch*

November 7 - December 7, 1978

HISPANIC-AMERICAN ARTISTS OF THE UNITED STATES:
ARGENTINA, BOLIVIA, CHILE, CUBA, URUGUAY

Last month, the Lowe Art Museum of the University of Miami exhibited simultaneously a show of works by Hispanic-American artists living in the Southeastern United States and the Esso Collection of Latin American Art. The Esso Collection, which is now the property of the Lowe Museum, was formed in 1965. It includes representative works of the period by artists who were only beginning to attract attention, but who now enjoy wide recognition, both nationally and internationally.

Early this year I was invited by the Lowe Art Museum to choose the paintings and sculptures to be included in the Hispanic-American exhibit. All artists submitting works for consideration were either citizens or permanent residents of the United States. The majority were born in Cuba and were brought to this country during their childhood; nearly all have been here for more than twenty years.

The present exhibition consists of selected works from the Miami show and compositions by Hispanic-American artists from more northerly parts of the United States. They display a wide variety of expression and techniques and, most important, a high standard of quality. Indeed, quality is the sole common denominator since most of the artists tend to work in relative isolation from one another.

During coming years, the Museum of Modern Art of Latin America will present other exhibitions focusing on Hispanic-American artists of varying descent. Each of these ethnic groups has enriched in a distintive way the cultural life of a country which for a century and a half has been known as a melting pot of races and civilizations. -- *J.G-S.*

The Museum of Modern Art of Latin America expresses its appreciation to Dr. Ira Licht, Director of the Lowe Art Museum, and Mr. and Mrs. Francisco Mestre, Friends of Art, Lowe Art Museum, for their cooperation in making available the works presented on this occasion.

CATALOGUE

Painting

Alejandro Anreus
 1. *Seated Woman*, 1978, pen and ink on paper, 17 x 14"

Cundo Bermúdez
 2. *The Magician*, 1978, oil on canvas, 47 1/2 x 56"

Humberto Calzada
 3. *The House across the Street*, 1978, acrylic on canvas, 72 x 51"

Ramón Carulla
 4. *Interwoven Wall Series*, 1978, mixed media, 28 1/2 x 43"
 5. *Wall No. 1*, 1978, mixed media, 60 1/2 x 50 1/2"

Hugo Consuegra
 6. *Madame de Jamais*, 1978, acrylic on canvas, 66 x 48"

Belisario Contreras
 7. *Two Figures*, 1958, oil on canvas, 30 x 40"

Emilio Falero
 8. *Homage to Miró*, 1977, oil on canvas, 36 x 48"

Agustín Fernández
9. *Untitled*, 1977, oil on canvas, 52 x 51"

Juan González
10. *Untitled*, 1978, mixed media, 28 x 20 1/4"

Osvaldo Gutiérrez
11. *The Window*, 1978, acrylic on canvas, 50 x 60"

Miguel Jorge
12. *The Garden in Front of the Sea*, 1978, acrylic on canvas, 60 x 48"

McAllister Kelly
13. *Vision*, 1978, acrylic on canvas, 74 x 74"
14. *Omega*, 1978, acrylic on canvas, 74 x 74"

Raquel Lázaro
15. *Space Capsule RLS2-27-78*, mixed media, 40 x 30"
16. *Space Capsule RLS7-13-78*, mixed media, 60 x 80"

José María Mijares
17. *Self-Portrait from a Mirror*, 1977, oil on canvas, 66 x 50"
18. *Baroque Lament*, 1978, oil on canvas, 54 x 38"

Roberto Montes de Oca
19. *Door to the Past*, 1978, acrylic on canvas, 48 x 36"

Efraim Oliver
20. *Evening*, 1977, acrylic on canvas, 40 x 50"

María Luisa Pacheco
21. *Aruma*, 1962, oil on canvas, 40 x 46"

Dionisio Perkins
22. *Panel Composition*, 1978, acrylic on canvas, 40 x 50"

Víctor Piedra
23. *Untitled*, 1978, acrylic on canvas, 72 x 36"
24. *Untitled*, 1978, acrylic on canvas, 72 x 36"

Enrique Riverón
25. *Unpainted Triangle*, 1977, mixed media, 40 1/2 x 40 1/2"

Baruj Salinas
26. *Untitled*, 1978, acrylic on canvas, 34 1/2 x 37"

Thorvald Sánchez
27. *Still Life*, 1978, acrylic on canvas, 49 x 49"

Rafael Soriano
28. *Etruscan Torso*, 1978, oil on canvas, 30 x 40"
29. *Untitled*, 1978, oil on canvas, 30 x 40"
30. *Untitled*, 1978, oil on canvas, 30 x 40"

César Trasobares
31. *Portrait of a Chaperone*, 1978, mixed media, 22 x 29"
32. *As de Copas (Ace of Cups)*,[1] 1978, mixed media

Rafael Vadía
33. *Undercurrent*, 1978, acrylic on canvas, 69 1/4 x 45"
34. *Untitled*, 1978, acrylic on canvas, 69 1/4 x 45"

Sculpture

Roberto Estopiñán
35. *Double Torso*, 1978, bronze, 12 x 14 x 14"

Enzo Gallo
36. *Untitled*, 1977, pink marble

Gay García
37. *Head*, 1978, bronze

Eladio González[2]

Rolando Gutiérrez
38. *Chrysalis*, 1978, marble, 25 x 24 x 7"

Alfredo Halegua
39. *Chana*, 1969, aluminum, 48 x 36 x 36"

Tony López
40. *Forever*, 1978, bronze, 38 x 12 1/2 x 6"

Rolando López Dirube
41. *Untitled*, 1977, copper and wood

Alfredo Lozano
42. *Symphony*, 1975, bronze

Tomás Oliva
43. *Skeet*, 1978, iron, 65 x 14 x 13"

Manuel Rodulfo Tardo
44. *The Beginning*, 1978, alabaster

ABOUT THE ARTISTS

ANREUS, Alejandro. Born 1960, Havana, Cuba. Attended Art Students League, New York. Studied under Professor Mario Santi, Elizabeth, New Jersey. One-person exhibition: Press Association, La Paz, Bolivia. Included in various group shows in the United States. Received several awards.

BERMUDEZ, Cundo. Born 1914, Havana, Cuba. Studied in Cuba and Mexico. Executed murals in Cuba and Puerto Rico. Has exhibited in Cuba, Peru, Chile, Haiti, Venezuela, Argentina, New York, Florida, Puerto Rico, France, the Soviet Union; *Tribute to Picasso*, OAS, Washington, D.C., 1973; and at the Biennials of São Paulo

[1] In the Spanish playing cards, the cups are one of the four suits and correspond to the hearts. --*Ed.*

[2] Titles of the works exhibited by this artist are unavailable. --*Ed.*

and of Venice. Awards include: Honorable Mention, UNESCO Graphics Biennial, San Juan (Puerto Rico); Public collections include: Museum of Modern Art of Latin America, Washington, D.C.; Museum of Modern Art, New York; William Rockhill Nelson Art Gallery, Kansas City; Museum of Fine Arts, Caracas; National Museum, Havana.

CALZADA, Humberto. Born 1944, Havana, Cuba. Graduated University of Miami, 1968. Started painting in 1976. One-person exhibitions: Forma Gallery in Coral Gables and Eurart in Washington, D.C. Awards include: First Prize, South Miami Art Festival, 1977. Public collections include: Southeast Banking Group and Fidelity National Bank, Miami.

CARULLA, Ramón. Born 1938, Havana, Cuba. Self-taught artist. Has exhibited in Florida, Canada, Venezuela. Awards include: Cintas Fellowship. Public collections include: Barnetts Bank of Miami, Florida; Pace Collection, Miami; New School for Social Research, New York; CBS International, Miami.

CONSUEGRA, Hugo. Born 1929, Havana, Cuba. Attended San Alejandro School of Fine Arts, Havana, and University of Havana. One-person exhibitions: Cuba, Venezuela, New York, Miami, Washington, D.C. (OAS). Group exhibitions in Latin America, the United States, Europe, and the Caribbean. Participated in the Third, Sixth, and Seventh Biennials, São Paulo; Second Biennial, Mexico; Third Biennial, Paris; Second and Third Biennials of San Juan (Puerto Rico). Awards include: Honorable Mention, Second Biennial, Mexico, 1960. Public collections include: Isaac Delgado Museum, New Orleans; National Endowment for the Arts, New York; New York University art collection; Museum of Modern Art of Latin America, Washington, D.C.; National Gallery, Sofia, Bulgaria.

CONTRERAS, Belisario. Born 1916, Valparaíso, Chile. Studied at Corcoran School of Art and American University in Washington, D.C. One-person exhibitions: Washington, D.C., New York, Rhode Island, and Kentucky.

ESTOPIÑAN, Roberto. Born 1921, Havana, Cuba. Studied at San Alejandro School of Fine Arts, Havana. Has traveled extensively in Europe, Asia, and the Middle East. Has exhibited in New York (Museum of Modern Art), Philadelphia, Cuba, Argentina, Colombia, France, and Spain. Awards include: National Prize for Sculptors, Cuba; Third Prize, International Competition, Tate Gallery, London. Public collections include: Museum of Modern Art of Latin America, Washington, D.C.

FALERO, Emilio. Born 1947, Sagua la Grande, Cuba. Attended Miami-Dade Community College and Barry College, Miami. One-person exhibitions in Miami. Group exhibitions in Miami, Palm Beach, and Fort Lauderdale, all in Florida. Included in *Homage to Miró* exhibit, Mallorca, 1978. Awards include: Society of the Four Arts, Palm Beach, 1976; Cintas Fellowship, 1977.

FERNANDEZ, Agustín. Born 1928, Havana, Cuba. Graduated San Alejandro School of Fine Arts, Havana. Studied under George Grosz and Yasuo Kuniyoshi, Art Students League, New York. One-person exhibitions: Cuba, Madrid, Washington, D.C., New York, Caracas, Paris, Milan, Venice, London, and Puerto Rico. Numerous group exhibitions in Europe and the Americas. Awards include: Honorable Mention, Fourth Biennial, São Paulo; Cintas Fellowship.

GALLO, Enzo. Born 1927, Padua, Italy. Moved to Cuba when eighteen years old. Graduated San Alejandro School of Fine Arts, Havana, 1956. Traveled and worked in Italy and Mexico. Has exhibited in Milan (Museum of Modern Art), New Orleans (Museum of Art), and in Florida.

GAY GARCIA, Enrique. Born, 1928, Santiago de Cuba, Oriente, Cuba. Graduated San Alejandro School of Fine Arts, Havana. Worked with Siqueiros and José Gutiérrez at Instituto Politécnico, Mexico. Director, School of Fine Arts, Santiago de Cuba, Oriente. Included in the Biennial of São Paulo and of Venice. Has exhibited in New York, California, and Florida. Awards include: UNESCO Scholarship, 1960.

GONZALEZ, Eladio. Born 1937, Matanzas, Cuba. Studied at San Alejandro School of Fine Arts, Havana; Art Institute, Chicago; and in Madrid and Paris. Has exhibited in New York, Chicago, and Miami.

GONZALEZ, Juan. Born 1945, Cuba. Graduated University of Miami. At present teaches drawing at the School

of Visual Arts, New York. One-person exhibitions: New York and Miami. Group exhibitions: Florida, New York, California, Delaware, and Indiana in the United States, and Caracas and London. Public collections include: Vassar College, New York; Hirshhorn Museum, Washington, D.C.; Indianapolis Museum of Art.

GUTIERREZ, Osvaldo. Born 1917, Matanzas, Cuba. Has exhibited in Cuba, Chile, Venezuela, Argentina, Mexico, Uruguay, Colombia, El Salvador, Puerto Rico, Florida, and in the Museum of Modern Art of Paris and of New York. Awards include: National Prize, Ministry of Education, Havana, 1951; Third Prize, *Pan American Art Exhibition*, Miami, 1971; Cintas Fellowship. Public collections include: National Museum, Havana; National Museum, Montevideo.

GUTIERREZ, Rolando. Born 1919, Havana, Cuba. Graduated San Alejandro School of Fine Arts, Havana. Taught at School of Fine Arts, Santa Clara, Cuba, 1952-1962; University of Puerto Rico, Arecibo, 1967; Maricao Craft School, San Juan (Puerto Rico), 1969-1971. One-person exhibitions in Puerto Rico. Group exhibitions: Second and Third Biennials of Latin American Graphics, San Juan (Puerto Rico) and in New York and Miami. Public collections include: National Museum, Havana; Ponce Art Museum, Puerto Rico; British Museum, London; Museum of Modern Art, Barcelona (Spain); National Library, Paris.

HALEGUA, Alfredo. Born 1930, Montevideo, Uruguay. Graduated School of Plastic Arts, Montevideo. Lecturer, American University, Washington, D.C., 1964-65. Numerous one-person and group exhibitions in the United States and Europe, including: Rodin Museum, Paris; Kongresshalle, West Berlin; Baltimore Museum of Art; Ringling Museum of Art, Sarasota; Corcoran Gallery of Art and OAS, Washington, D.C.; national and municipal art museums, Montevideo. Has received various awards. Public collections include: National Gallery of Art, Washington, D.C.; Baltimore Museum of Art; Museum of Modern Art of Latin America, Washington, D.C.; Museum of Modern Art, Rio de Janeiro; National Collection of Fine Arts, Washington, D.C.; National Museum of Fine Arts and Juan Manuel Blanes Museum, Montevideo; Oklahoma Art Center.

JORGE, Miguel. Born 1928, Havana, Cuba. Studied at Harvard University; Harvard Graduate School of Design; Parsons School of Design, New York; School of Fine Arts, Madrid; and at Yale University under Joseph Albers. Executed murals in Cuba, Europe, and the United States. One-person exhibitions: Havana, Madrid, Málaga, and Miami.

LAZARO, Raquel. Born 1917, Havana, Cuba. Graduated University of Havana and Biscayne College, Miami. Taught drawing at San Alejandro School of Fine Arts, Havana, and University of Havana. Has exhibited in Havana, New York, and Miami. Has received several awards.

LOPEZ, Tony. Born 1918, Cuba. Studied and taught in Cuba. Numerous exhibitions in Cuba and Florida. Included in Biennial of Spanish American Art, Madrid. Has received various awards. Public collections include: National Museum, Havana.

LOPEZ DIRUBE, Rolando. Born 1928, Havana, Cuba. Studied at Brooklyn Museum, New York; Art Students League, New York; National Academy of Graphic Arts, Madrid. One-person exhibition: Museum of Contemporary Art, Caracas. Group exhibitions: São Paulo Biennial; Biennial of Spanish American Art, Madrid; Coltejer Biennial, Medellín. Has executed murals and monumental sculptures in Florida. Public collections include: National Museum, Havana; Museum of Contemporary Art, Madrid; Metropolitan Museum of Art, New York; Philadelphia Museum of Art; Free Library, Philadelphia; Museum of Contemporary Art, Caracas.

LOZANO, Alfredo. Born 1913, Havana, Cuba. Studied at San Alejandro School of Fine Arts, Havana; Free School of Sculpture, Mexico; Sculpture Center, New York. Has exhibited in Cuba, Venezuela, Puerto Rico (Ponce Art Museum), New York, Houston, and Florida. Included in Second Biennial of São Paulo. Awards include: National Prize for Sculpture, Havana, 1938, 1950, 1951.

McALLISTER KELLY, Rosana. Born 1931, Buenos Aires, Argentina. Lived in Cuba for many years. Has exhibited in Washington, D.C., Florida, and Guatemala. Awards include: Atwater Kent Award, Society of the Four Arts, Palm Beach, 1969; Honorable Mention, *Hortt Memorial Exhibition*, Fort Lauderdale, 1971; *Pan American Art Exhibition*, Miami, 1969.

MIJARES, José María. Born 1922, Havana, Cuba. Studied at San Alejandro School of Fine Arts, Havana.

Included in the Biennial of São Paulo, 1953, and of Venice, 1956. Group exhibitions: Paris (Museum of Modern Art), Venezuela, Japan, Puerto Rico, and in the United States. Awards include: First Prize, San Alejandro School, Havana, 1944, 1950; Cintas Fellowship, 1970.

MONTES DE OCA, Roberto. Born 1949, Cuba. Studied at Miami-Dade Community College. Graduated University of Miami, 1976. Numerous student exhibitions in Miami.

OLIVA, Tomás. Born 1930, Guanabacoa, Cuba. Graduated San Alejandro School of Fine Arts, Havana, 1952; Royal School of Ceramics, Madrid, 1953. Studied ceramics in Paris. Taught at School of Architecture and San Alejandro School of Fine Arts in Havana. Has exhibited in Havana, Madrid, Paris, and New York.

OLIVER, Efraim. Born 1930, Matanzas, Cuba. Studied at University of Havana. Has exhibited in Palm Beach (Society of the Four Arts), Naples, and Miami.

PACHECO, María Luisa. Born 1919, La Paz, Bolivia. Studied at School of Fine Arts, La Paz, and Academy of San Fernando, Madrid. One-person exhibitions: La Paz, Buenos Aires, Santiago, Lima, Caracas, Washington, D.C. (OAS), and New York. Group exhibitions: São Paulo Biennial, 1953, 1955, 1959; Dallas Museum of Art; Guggenheim Museum, New York; Yale University; University of Texas; University of Arizona; San Francisco Museum of Art. Awards include: First Prize Murillo, La Paz; Guggenheim Fellowship, 1958-1960. Public collections include: Museum of Modern Art of Latin America, Washington, D.C.; Museum of Modern Art, São Paulo; Museum of Modern Art, New York.

PERKINS, Dionisio. Born 1929, Havana, Cuba. Self-taught artist. Has exhibited in Havana, New York, Miami, Puerto Rico, and Venezuela. Awards include: Cintas Fellowship. Public collections include: National Museum, Havana.

PIEDRA, Víctor. Born 1922, Oriente Province, Cuba. Attended San Alejandro School of Fine Arts, Havana. Studied under Rolando López Dirube in Puerto Rico. Experience in diamond cutting, ceramics, and textile design. One-person exhibitions: Madrid, Barcelona (Spain), and in Puerto Rico. Group exhibitions in Europe, South America, and the United States.

RIVERON, Enrique. Born 1902, Cienfuegos, Cuba. Studied in Cuba, Spain, Italy, France, Belgium. Cartoonist and illustrator in Havana, New York (*New York Times, New Yorker, Cine Mundial*), and in South America. Staff artist for Walt Disney Studios, California. Started to paint in 1941. One-person exhibitions: Paris, Havana, New York, Wichita, Miami. Received various awards in juried exhibitions.

RODULFO TARDO, Manuel. Born 1913, Matanzas, Cuba. Studied at San Alejandro School of Fine Arts, Havana; in Mexico on a scholarship; Art Students League, New York. Director, School of Plastic Arts, Havana. One-person exhibitions: New York and Florida. Has exhibited at the Museum of Modern Art, Paris; Biennial of Spanish American Art, Madrid; Metropolitan Museum of Art, New York; Philadelphia Museum; Brooklyn Museum, New York. Awards include: Gold Medal, Tampa University, Florida.

SALINAS, Baruj. Born 1935, Havana, Cuba. Studied at Kent State University, Ohio. One-person exhibitions: in the United States (Florida, Massachusetts, Texas, Chicago, Washington, D.C.), France, Spain, Switzerland, Canada, Mexico, and Israel. Group exhibitions: Cuba, Mexico, Texas, Guatemala, and Venezuela. Included in the Seventh Graphic Arts Biennial, Ibiza. Awards include: Excellence Prize, Seventh International Grand Prix of Painting, Cannes; Cintas Fellowship; Best Watercolor, *Hortt Memorial Exhibition*, Fort Lauderdale, 1969.

SANCHEZ, Thorvald. Born 1933, Havana, Cuba. Self-taught artist. Included in 1977 Biennial, Mint Museum, Charlotte, North Carolina; Society of the Four Arts, Palm Beach; *Hortt Memorial Exhibition*, Fort Lauderdale. Awards include: Best of Show, Gulf Coast Ninth Juried Show, Florida. Public collections include: Museum of Modern Art of Latin America, Washington, D.C.

SORIANO, Rafael. Born 1920, Matanzas, Cuba. Studied at San Alejandro School of Fine Arts, Havana. Director, School of Fine Arts, Matanzas, 1952-1955. Professor, University of Miami, 1967-1979. Has exhibited in Cuba, El Salvador, Mexico, Madrid, Guatemala, and Florida (including the Ringling Museum, Sarasota). Has received various awards.

TRASOBARES, César. Born 1949, Holguín, Cuba. Graduated Florida State University, Tallahassee. At present, teaches history of art, Miami-Dade Community College. Numerous exhibitions in Miami and throughout Florida.

VADIA, Rafael. Born 1950, Havana, Cuba. Attended Miami-Dade Community College, and University of Miami. Graduated Florida International University, Miami. Studied at New York Studio School with session in Paris. Numerous exhibitions in the Miami area.

December 5, 1978 - January 7, 1979

HUMBERTO AQUINO OF PERU

Humberto Aquino's work might be classified as hyperrealist or surrealist, but because of his specific interest in obtaining a transcendental meaning out of familiar, everyday objects, it also falls well within the realm of magic realism. In each of his compositions imagination and fantasy are given free play. Sometimes the forms or objects are easily recognizable but there seems to be no relationship among them; in other instances, familiar objects appear together with strange, biomorphic forms. In all of his work, there is a touch of something eerie and absurd, of reality as we know it transformed into something new.

Whatever the literary intention, it is important to look at each of Aquino's paintings in terms of its pure, plastic value, for rarely does an artist demonstrate such an extraordinary capacity to handle all the elements of his medium with such success. Aquino's drawing is exquisite; the pictorial elements are selected and depicted with unusual care; and there is a delicate tonal unity in his color, which tends toward the neutral.

Aquino was born in Lima in 1947. From 1965 to 1970 he studied painting, drawing, and printmaking at the National School of Fine Arts there. From 1966 to 1967 he studied stage design at the National Institute of Dramatic Art, which is also in Lima. In 1972 he was awarded a grant by the British Council to study painting at Cardiff College of Art in Wales and, only recently, was awarded a Fulbright Grant which brought him to study at Pratt Institute in New York.

Aquino has had ten one-person exhibitions in Lima, Bogotá, and London since he began showing his work professionally in 1970 and has participated in more than a dozen group exhibits in Colombia, El Salvador, Peru, the United States, and Great Britain. He has received prizes for painting and drawing in Peru and Colombia.

This is Aquino's first one-person exhibition in the United States. --*J.G-S.*

CATALOGUE

Drawings and Paintings

1. *Teresa Giannina*, 1978, mixed media, black and color pencil, watercolor, ink, 35 x 35 cm.
2. *Muñeca (Doll)*, 1978, mixed media drawing, 10 x 10 cm.
3. *Sibelius*, 1978, pencil drawing, 102 x 76 cm.
4. *Naturaleza muerta (Still Life)*, 1978, mixed media, 35 x 55 cm.
5. *Cocina (Kitchen)*, 1978, mixed media, 28 x 31 cm.
6. *Somerset Maugham*, 1978, mixed media, 44 x 56 cm.
7. *Desde el interior (From Inside)*, 1978, mixed media, 12 x 30 cm.
8. *Retrato (Portrait)*, 1978, mixed media, 43 x 63 cm.
9. *Formas mutantes (Mutant Forms)*, 1978, mixed media, 11 1/2 x 16 cm.
10. *La gran constante (The Great Constant)*, 1978, oil, 51 x 63 cm.
11. *Mis botines (My Boots)*, 1978, oil, 50 1/2 x 45 cm.
12. *1,500-1,999*, 1978, oil, 31.7 x 31.7 cm.
13. *Espacios vitales (Vital Spaces)*, 1978, mixed media, 65 x 50 cm.
14. *Retrato (Portrait) II*, 1978, oil, 41 1/2 x 30 1/2 cm.
15. *Composición (Composition)*, 1978, mixed media, 20 x 25 cm.

December 5, 1978 - January 7, 1979

HUGUETTE FRANCO OF PERU: WORKS ON PAPER

During the past few years, there has been intense restlessness among creators working in the graphic arts, with considerable interest directed toward the exploration of new methods and techniques of production. The sophisticated mechanical devices now on the market have been experimented with primarily in Europe, the United States, and Canada, but South Americans have also been using them, with one of the most successful being Peruvian-born artist Huguette Franco.

In this exhibition, Franco's first one-person show, she is presenting two series of works on paper, each quite different from the other but both of exceptionally high quality and interest. In one series she has used a duplicator that was only recently developed by Xerox, which produces an impression of her original with incredible accuracy and precision. Her images of wrapped and tied bundles are printed or copied in such a way that she obtains not only the original color but the full illusion of three-dimensional form, with the latter being as precise as that of the Flemish primitives. In the other series we find an entirely different technique and image, with the artist working on paper in watercolor. These compositions have the appearance of ancient manuscripts veiled in delicate, transparent color.

Huguette Franco was born in Lima in 1944 and studied at the School of Plastic Arts of Lima's Catholic University. Among her professors were three of Peru's most progressive artists--Fernando de Szyszlo, Julia Navarrete, and Adolfo Winternitz. Upon completion of her studies in Lima, Franco was awarded a fellowship to study graphic design at the Cooper Union's School of Art and Architecture in New York (1971-1973). She has participated in four group exhibitions in Peru and the United States and was awarded four prizes in the field of graphic art while still a student. She is represented in the collection of the Museum of Modern Art in New York. --*J.G-S.*

EXHIBITION LIST [1]

Graphics and Drawings

1-18. *Xerox Prints*[2]
19-22. *Escritos (Writings)*,[2] watercolor

[1] Not included in the original catalogue. --*Ed.*

[2] Titles are unavailable. --*Ed.*

YEAR 1979

January 30 - February 26, 1979

ARMANDO LONDOÑO OF COLOMBIA: DRAWINGS AND PRINTS

From Medellín, Colombia's second largest cultural center, have come some of the country's most important artists. It is the birthplace of internationally known painter Fernando Botero, who had his first one-person exhibition outside Colombia at the Organization of American States in 1957, as well as that of Dora Ramírez, one of the leading women in Colombian art today. In 1974 we presented the exhibition *Five Artists from Medellín*. Two of the group--Félix Angel and Armando Londoño--have since begun to receive national attention, and both have been exhibiting their work successfully in the United States and Europe.

Although born in Cali in 1947, Armando Londoño's work developed during the years he studied and worked in Medellín. He has lived in Paris, Stockholm, and Tel Aviv for brief periods and is currently living and working in New York.

As a draftsman, Londoño demonstrates full command of his craft, obtaining subtle variations of chiaroscuro and endowing his subjects with a three-dimensional quality and sense of weight. He is equally competent as a printmaker, both in the handling of concept and technique. Hats, neckties, and other elements of men's attire appear throughout his work, sometimes with a human face occupying the background of the composition, suggesting that human personality has become overshadowed and subordinated to dress, sometimes in combination with incongruous elements that lend a surrealist accent to his work.

Londoño has had five one-person exhibitions in Medellín since 1970 and has participated in more than twenty group shows, including the exhibition at the OAS, the First Biennial of Graphic Arts in Caracas, 1977, and exhibits at the Noble Polans and Cayman Galleries in New York City. He was twice awarded First Prize for Printmaking at the Salon of Young Artists sponsored by the Museum of Art of Medellín, 1970 and 1972, and is represented in museum collections in Colombia as well as in the Museum of Modern Art of Latin America.

This is the artist's first one-person exhibition in the United States. --*J.G-S.*

EXHIBITION LIST [1]

1-12. Drawings
13-17. Prints

January 30 - February 26, 1979

LUCIANO JARAMILLO OF COLOMBIA: PAINTINGS

Luciano Jaramillo, who belongs to the generation immediately following that of Alejandro Obregón, Enrique Grau, and Eduardo Ramírez Villamizar--the forerunners of modern art in Colombia--is one of the most outstanding figures in Colombian art today. His early work was within the abstract expressionist tradition. Gradually he began to turn his interest toward figurative painting but continued to treat his subject expressionistically, defining form solely through the use of loose, fluid brushstrokes and bold color. During the

[1] Not included in original catalogue. The titles of the drawings and prints are unavailable. --*Ed.*

past several years he has created his paintings in series that correspond to different events and well-known historical figures. In this exhibition, we have examples from the series entitled *Boda en Tívoli (Wedding in Tivoli)*, *Niño de Gretel (Gretel's Child)*, *Vincent Van Gogh, Simón Bolívar*, and *Manuela Sáenz*, Bolívar's companion.[1] Each of the paintings is a powerful example of the artist's imagination and ability to express different moods and character traits of a single subject.

Jaramillo was born in Manizales, Colombia, in 1938 and studied at the Paul Colin School in Paris from 1956 to 1958. He has had one-person exhibitions in Bogotá and Cali, Colombia, as well as in Paris, and has been represented in group exhibitions in Colombia, Argentina, Brazil, Chile, Mexico, Panama, the United States, and Venezuela. In 1962 he participated in an extensive exhibition of Colombian art organized by the Organization of American States that circulated in Italy, Germany, Spain, and Sweden under the auspices of the OAS, the government of Colombia, and International Petroleum Company. He has received awards for his paintings in Colombia and Chile and is represented in numerous museum collections, including the Museum of Modern Art and the Museum of Contemporary Art in Bogotá, the Museum of Contemporary Art in Santiago, Chile, and the Museum of Modern Art of Latin America.

This is Jaramillo's first one-person exhibition in the United States. *--J.G-S.*

EXHIBITION LIST [2]

Oils, 90 x 90 cm.

1-10. *Simón Bolívar Series*[3]
11-18. *Manuelita Sáenz Series*[3]

March 5 - April 2, 1979

MIGUEL ANGEL BENGOCHEA OF ARGENTINA

The urban landscape is a recurring motif in the work of Argentine artist Miguel Angel Bengochea, who is having his first one-person exhibition in the United States. Bengochea's color is almost always transparent, and he works with acrylic on raw or untreated canvas. The different forms in his compositions are broken or overlapped, creating a sense of rhythm and movement reminiscent of that of the futurists.

Born in Buenos Aires in 1945, Bengochea attended the National Academy of Fine Arts there and studied under the Argentine master Juan Carlos Castagnino. From 1968 to 1970 he worked and traveled in Europe. He has had eight one-person exhibitions in Buenos Aires since 1967 (La Ruche, Arte Nuevo, H, and Scheinsohn Galleries) and last year exhibited at the San Diego Gallery in Bogotá. He has participated in numerous national and international exhibitions, including Great Young Artists of Today (Museum of Modern Art, Paris, 1969), *Contemporary Argentine Art* (Museum of Modern Art, Mexico City, 1975), *Modern Argentine Drawing* (Corcoran Gallery of Art, Washington, D.C.; Municipal Gallery, Boston; University of Texas Museum of Art, Austin; New Orleans Museum of Art; Cleveland Institute of Art, Ohio; and Museum of Modern Art, San Francisco, 1975-1976), and *Contemporary Art of Spanish America* (Madrid, 1977).

Bengochea has received several important national prizes and is represented in the collections of the Museum of Fine Arts, Museum of Modern Art, and Eduardo Sívori Museum in Buenos Aires; the Genaro Pérez Museum in Córdoba (Argentina); and, in this country, in the Cleveland Museum of Art. *--J.G-S.*

[1] According to the list used during the exhibition, only the two last series were actually exhibited. *--Ed.*

[2] Not included in the original catalogue. *--Ed.*

[3] Detailed titles of the works exhibited are unavailable. *--Ed.*

CATALOGUE

Acrylics

 1. *Tiempo final (The End of Time)*, 1976, 130 x 130 cm.
 2. *Los trífidos (The Trifids)*, 1976, 150 x 130 cm.
 3. *Destilerías (Distilleries) I*, 1978, 150 x 120 cm.
 4. *Destilerías (Distilleries) II*, 1978, 150 x 120 cm.
 5. *Serie de la ciudad (The City Series) III,*[1] 1977, 100 x 100 cm.
6-7. *Serie de la ciudad (The City Series) VI*, 1978, 100 x 100 cm.
 8. *Destilerías (Distilleries) III*, 1978, 120 x 100 cm.
 9. *Sin tregua (Without Respite)*, 1976, 130 x 130 cm.
 10. *Jugando a la ecología (Playing with Ecology)*, 1976, 130 x 100 cm.
 11. *Ritmo sostenido (Sustained Rhythm)*, 1976, 130 x 100 cm.
 12. *Paisaje urbano (Urban Landscape)*, 1976, 100 x 100 cm.
13-16. *Serie de la ciudad (The City Series) I, II, IV, V*, 1977, 90 x 80 cm.
17-18. *Destilerías (Distilleries) IV, V*, 1978, 200 x 140 cm.
19-20. *Paisaje urbano (Urban Landscape) II, III*, 1977, 200 x 140 cm.

Pencil Drawings[2]

21-22. *Testimonio (Testimony) I, II*, 100 x 70 cm.
23-24. *Polución (Pollution) I, II*

Watercolors[2]

25-26. *Destilerías (Distilleries) I, II*
27-28. *Serie de la ciudad (The City Series), I, II*

March 5 - April 2, 1979

CARLOS PACHECO OF ARGENTINA

Carlos Pacheco is an accomplished printmaker who has experimented with various techniques. In this exhibition, his first one-person show in the United States, he presents a series of recent works in which he explores the possibilities offered by combining planes of color and textural relief with imaginative abstract forms.

Pacheco was born in La Plata, Argentina, in 1932 and studied with the well-known painter Faustino Brughetti and at the School of Fine Arts of La Plata. In 1964 the government of France awarded him the Braque Prize which allowed him to study under Stanley W. Hayter at Atelier 17 in Paris. He later participated in a printmaking workshop at Croydon College in London. Since 1963 Pacheco has had more than twenty one-person exhibitions in Argentina and Italy, including two exhibits at the Museum of Modern Art in Buenos Aires, 1966 and 1972, and has participated in numerous national and international exhibitions, among them the International Print Graphic Arts Biennial in Florence, Italy, 1976. He has received prizes in both Argentina and Italy.

Works by Pacheco are included in the collections of the Museum of Modern Art and Museum of Fine Arts in Buenos Aries, as well as in other museums in Argentina. --*J.G-S.*

[1] Although this title appeared in the original catalogue, the work actually exhibited was *Medio ambiente (The Environment)*, acrylic, 120 x 150 cm. --*Ed.*

[2] Also exhibited but not included in the original catalogue. --*Ed.*

CATALOGUE

Prints

1. *Brera*, 1974, 3/15
2. *Prototipo (Prototype)*, 1972, 4/12
3. *Brac*, 5/15, 1974
4. *Casa Rosa* (Pink House), 1975, 2/15
5. *Lumamijuvisado*, 1976, 3/30
6. *Canicas (Marbles)*, 1972, 3/13
7. *Noche moscata (Moscata Night)*, 1972, 1/13
8. *Pola*, 1976, 3/15
9. *Osornisia*, 1973, 7/10
10. *A Pablo Neruda (To Pablo Neruda)*, 1974, 20/20
11. *A Pablo Casals (To Pablo Casals)*, 1976, 1/14
12. *Camaiore*, 1974, 12/12
13. *Trieste*, 1974, 12/14
14. *A Pablo Picasso (To Pablo Picasso)*, 1974, 21/30

April 3 - May 1, 1979

WASHINGTON BARCALA OF URUGUAY

Abstract art in Uruguay was born with Joaquín Torres-García and his work in the realm of constructivism. Although Washington Barcala was associated with the workshop of Torres-García only briefly in 1942, his most recent compositions inevitably bring to mind those of the late master. Like Torres-García, Barcala arranges his space in asymmetrical order and produces a feeling of warmth and emotion not usually identified with constructivist art. Using paint and color sparingly, he builds his compositions from pieces of burlap, string, wood, and other found materials that project slightly from flat surfaces. The works are exceptionally well conceived, with an interesting interplay of texture and tonal values, and, in spite of their small size, convey a sense of monumentality.

Born in Montevideo in 1920, Washington Barcala attended the Círculo de Bellas Artes there from 1938 to 1942. From 1974 to 1978 he lived in Madrid. There was a lapse of almost thirty years between his first and second one-person exhibitions--the first in Montevideo in 1947, the second in Madrid in 1975--although he participated in several group exhibitions of Uruguayan art during the 1960s (Museum of Modern Art, São Paulo; Museum of Modern Art, Buenos Aires) and in 1958 was awarded First Prize for Painting at the National Salon of Plastic Arts in Montevideo. During the 1970s, he participated in important international exhibits, including the International Festival of Painting in Cagnes-sur-Mer, *Contemporary Art of Spanish America* in Madrid, and Great Young Artists of Today in Paris.

Works by Barcala are in museum collections in Montevideo and in the Museum of Contemporary Art of Madrid, as well as in private collections in Uruguay, Spain, and France. This is the artist's first one-person exhibition in the United States. --*J.G-S.*

EXHIBITION LIST [1]

Mixed Media Compositions

1. *Historia X-2-A*
2. *Historia F-R-3*
3. *Historia B-A*

[1] Not included in the original catalogue. --*Ed.*

4. *Historia N-4*
5. *Historia T-Z-2-2*
6. *Historia D-J-1-1*
7. *Historia 2-C-5*
8. *Historia M-P-V-8*
9. *Historia 123-R*
10. *Historia 5-C-9*
11. *Historia R-4-P*
12. *Historia O-O-R*
13. *Historia 1-2*
14. *Historia T.M.*
15. *Historia V-9-B-3*
16. *Historia 4-4-4-4*
17. *Historia B-5*
18. *Historia C-C-T*
19. *Historia W-2-C-7*

May 31 - June 27, 1979

MIKE AULD OF JAMAICA

The work of Jamaican artist Mike Auld is rooted in the African folklore and tradition that have played such an important role in his own cultural heritage. Auld, who studied art at Howard University in Washington, D.C., where he now teaches, is a sculptor, painter, and printmaker. In this exhibition he is showing a selection of recent sculptures constructed with bicycle parts and a large composition on dried goat skin. All his forms, whether human or abstract, are symbolic references to African or Caribbean legends and impart a sense of magic.

Mike Auld was born in Kingston in 1943. Prior to teaching at Howard University, he was an art instructor at Sidwell Friends School, also in Washington, D.C. His work has been exhibited in Jamaica as well as locally (Smithsonian Institution, Catholic University, Howard University, District of Columbia Public Library). In 1976 Auld was represented in *Contemporary Printmakers of the Americas*, an exhibit sponsored by the OAS that circulated to college and university museums in the Southeastern United States. --*J.G-S.*

EXHIBITION LIST [1]

1. *Sacrifice*, 1979
2. a. *I and I No Free*, 1978-79
 b. *Negus*, 1978-79
3. *Tax-I No. 2*, 1978-79
4. *Ogun*, 1979
5. *Isis and Osiris*, 1978
6. *Bear Down and Bear Up*, 1976
7. *. . . Now, Fly*, 1976
8. *Trip Tek, Specimen No. 1, No. 2, No. 3*, 1978
9. *Bambara Woman*, 1977
10. *Ras Tafari, The Family of Jah*, 1978
11. *Dreams of Freedom*, 1973
12. *Sun-Son*, 1979
13. *Horus*, 1978
14. *Obeah-Man, Doctor Bird, Sen-Se Fowl*, 1976
15. *Olokun Returns*, 1976
16. *Life Cycle*, 1973
17. *We Came before Columbus*, 1978
18. *Ancestors*, 1979

[1] Not included in the original catalogue. --*Ed.*

May 31 - June 27, 1979

DAVID BOXER OF JAMAICA

Jamaica is steadily producing new personalities in the field of the plastic arts. Among the most outstanding of the younger generation is David Boxer who, besides being a professional painter, is also director of Jamaica's National Gallery of Art.

Although Boxer's early works were essentially abstract, his most recent paintings present variations of the human figure treated expressionistically. He is particularly adept at using transparencies or overlapping planes to create a mysterious atmosphere in his compositions.

David Boxer is a self-taught painter who had his first one-person exhibit in Kingston in 1970. Since then he has had eleven one-person exhibits in Kingston, New York, and Los Angeles, and his paintings have been included in group exhibits in Jamaica, Mexico, Venezuela, the United States, and Great Britain. He received a doctorate in art history from the Johns Hopkins University in Baltimore and, prior to being appointed to his present position, taught at the University of Maryland, at George Mason College in Virginia, and at the Cultural Training Center in Kingston. --*J.G-S.*

CATALOGUE

Paintings

1. *White Crucifixion*, 1974
2. *Dialogue*, 1975
3. *Fontainbleutych*, 1974
4. *Torn Head I*, 1974
5. *Torn Head II*, 1974
6. *Graffiti Head*, 1974
7. *Dream*, 1975
8. *Song of the Youths*, 1975-76
9. *Pietà*, 1976
10. *Nervfeld*, 1977
11. *Aurora*, 1977-78
12. *Notte*, 1977-78
13. *Titian Head*, 1978
14. *Ru Head*, 1978
15. *Sleep*, 1978
16. *Youth*, 1978
17. *B.J.R. as a Renaissance Youth*, 1978
18. *Damaged Gauze Head*, 1978
19. *Thirty Variations on a Renaissance Youth*, 1978
20. *Traume*, 1979

June 28 - July 25, 1979

ROBERTO HUEZO OF EL SALVADOR

During a relatively short period of time, Roberto Huezo has established his reputation as one of El Salvador's most outstanding young painters. He began to exhibit his work professionally in 1967, while studying architecture at the National University in San Salvador, and since then has had more than a dozen one-man exhibitions there as well as having participated in group exhibits in Cuba, Guatemala, and the United States.

Since he began painting, Huezo's work has been dictated by his interest in creating tactile or textural values, or a kind of sculptured painting in which certain forms or areas of the composition are made to protrude from the

flat surface, solving in part the problem of the third dimension. His earliest works were painted on wood, and he actually carved the surface; his most recent works are on canvas, with the relief forms produced by mixing modeling paste, gesso, and other elements. Undoubtedly, much of his interest in relief forms and his dexterity in the handling of his materials are the result of his belonging to a family of accomplished cabinet makers.

In this exhibition Huezo is presenting a series of recent paintings based on variations of a single subject--the egg. The asymmetry of his compositions and fascinating interplay of flat and textured surfaces give the works an austere plastic value. Whether one focuses on his ability to create the illusion of perspective or to appeal to the sense of touch, it is certain that this young artist is opening new avenues for modern art in his country.

Born in San Salvador in 1947, Huezo attended the National and Catholic Universities there. He has been awarded several grants to study abroad and is represented in private collections in both El Salvador and the United States. This is his first one-man exhibition outside El Salvador. --*J.G-S.*

EXHIBITION LIST [1]

Acrylic and Modeling Paste on Canvas

1. *Variación (Variation) XVI*
2. *Variación (Variation) XXII*
3. *Variación (Variation) VI*
4. *Variación (Variation) XIII*
5. *Variación (Variation) I*
6. *Variación (Variation) IX*
7. *Variación (Variation) VII*
8. *Variación (Variation) XVIII*
9. *Variación (Variation) VIII*
10. *Variación (Variation) XI*
11. *Variación (Variation) II*
12. *Variación (Variation) X*
13. *Variación (Variation) IV*
14. *Variación (Variation) XVII*
15. *Variación (Variation) XIV*
16. *Variación (Variation) V*
17. *Variación (Variation) XV*
18. *Variación (Variation) XXI*
19. *Variación (Variation) III*
20. *Variación (Variation) XII*
21. *Variación (Variation) XIX*
22. *Variación (Variation) XX*

July 26 - August 22, 1979

SEVEN ARTISTS FROM OAXACA: RUFINO TAMAYO WORKSHOP

The Rufino Tamayo Workshop in Oaxaca is the creation of Roberto Donis, a young painter who was born in the northern part of Mexico (San Luis de Potosí, 1934) and who took up residence in Oaxaca in 1969. It is

[1] Not included in the original catalogue. --*Ed.*

named in honor of the internationally known Mexican master who was born in Oaxaca and is supported by Mexico's National Institute of Fine Arts.

Prior to founding the workshop Donis served on the faculty of Benito Juárez University in Oaxaca and spent four years working and traveling in the United States and Europe. In 1974 he decided to bring together a group of gifted young people who manifested an intense interest in art but who had little or no knowledge of the skills needed to express themselves. The policy that governed when the workshop was established remains the same. The participants were expected to be highly disciplined but were allowed to develop with absolute freedom. Donis's role was to show them how to use their materials and to serve as advisor, helping to solve specific plastic problems. For most, creative expression did not come easily; each had to struggle with the particular medium with which he wished to work. But this had the advantage of forcing the discovery of a personal concept, and eliminated the tendency toward repeating what is fashionable or an excess of experimentation for the sake of experimentation alone.

Among the seven young artists represented here--all born in the State of Oaxaca and most of whom began to participate in the workshop in their late teens--the common denominator is a remarkable refinement in their work and a high degree of professional maturity. Each has taken a different direction, with some having chosen abstraction and others having taken a figurative approach. All have taken part in exhibitions in Mexico--the Museum of Modern Art in Mexico City exhibited them as a group in 1976--but they remain relatively unknown. Their accomplishments thus far indicate that they may one day emerge as major figures in Mexican art. --*J.G-S.*

EXHIBITION LIST [1]

Engravings

Atanasio García Tapia
 1. *Femenino* (Feminine) *No. 10*, mixed media, 34 x 49 cm.
 2. *Tranmutación* (Transmutation), mixed media, 34 x 49.05 cm.
 3. *Femenino* (Feminine) *No. 1*, mixed media, 34 x 49 cm.
 4. *Femenino* (Feminine) *No. 9*, mixed media, 34 x 49.05 cm.
 5. *Evolución (Evolution)*, mixed media, 39 x 49 1/2 cm.

Oils on Canvas

Ariel Mendoza Baños
 6. *Imagen petrificada* (Petrified Image), 105 x 150 cm.
 7. *Signos* (Signs), 105 x 120 cm.

Abelardo López Moreno
 8. *Alfalfar viejo* (Old Alfalfa Field), 110 x 145 cm.
 9. *Paisaje en día caluroso* (Landscape on a Hot Day), 105 x 120 cm.

Carlos Vázquez Kauffman
10. *Realización inconsciente* (Unconscious Realization), 105 x 150 cm.
11. *Tratando de ocultarlo* (Trying to Hide It), 105 x 150 cm.

[1] Not included in the original catalogue. --*Ed.*

Alejandro Herrera Cruz
12. *Reflejo de tí* (A Reflection of You), 105 x 120 cm.
13. *Proyección sobre planos* (Projection on Planes), 105 x 120 cm.

Cecilio Sánchez Franco
14. *Campiña cálida* (Hot Land), 95 x 110 cm.
15. *Concepción de un paisaje florido* (Image of a Flowered Landscape), 100 x 120 cm.

Felipe de Jesús Morales López
16. *Mujer con niño* (Woman with Child), 85 x 107 cm.
17. *Los panaderos* (Bread Vendors), 100 x 110 cm.

Filemón Santiago
18. *La gallina ciega* (Blind Man's Buff)
19. *Barriendo la ausencia* (Sweeping the Absence)

ABOUT THE ARTISTS

GARCIA TAPIA, ATANASIO.[1] Graphic artist, born in the District of Teposcolulo, Oaxaca, 1951. Since 1972 has participated in sixteen exhibitions in Mexico City, Oaxaca, Toluca, Aguascalientes, Juchitán, and in the Latin American Print Biennial, San Juan (Puerto Rico), 1978. Was awarded First Prize for Print, Cámara Junior Contest, Oaxaca, 1972; Second Prize for Print, Eighth National Competition of Plastic Arts, Aguascalientes, 1973.

HERRERA CRUZ, Alejandro. Painter, graphic artist, born in Oaxaca, 1955. Has participated in six exhibitions in Oaxaca, Mexico City, and Aguascalientes, 1973-79.

LOPEZ MORENO, Abelardo. Painter, draftsman, graphic artist, born in San Bartolo Coyotepec, Oaxaca, 1957. Since 1973 has participated in nine group exhibitions in Oaxaca, Mexico City, and Aguascalientes. Was awarded Third Prize for Paining, Thirteenth National Contest of Plastic Arts, Aguascalientes, 1978.

MENDOZA BAÑOS, Ariel. Painter, draftsman, graphic artist, born in Tamazulapan, Oaxaca, 1956. Held one individual exhibition in Puebla, 1976. Has participated in over twenty group exhibitions in Toluca, Mexico City, Juchitán, Tehuantepec, Oaxaca, Rotterdam, and Aguascalientes. Was awarded prizes at the National Competition of Plastic Arts, Aguascalientes, 1974 and 1978.

MORALES LOPEZ, Felipe de Jesús. Painter, draftsman, born in San Pedro Martín Ocotlán, Oaxaca, 1959. Has participated in four exhibitions in Mexico City and Monterrey.

SANCHEZ FRANCO, Cecilio. Painter, draftsman, graphic artist, born in San Jerónimo Yahuiche, Oaxaca, 1957. Has participated in eighteen group shows in Mexico City, Aguascalientes, Oaxaca, and Rotterdam.

SANTIAGO AVENDAÑO, Filemón. Painter, graphic artist, born in San José Sosola Etla, Oaxaca, 1958. Held one individual exhibition in Chicago (Illinois). Has participated in nineteen group shows in Juchitán, Tehuantepec, Mexico City, Aguascalientes, Rotterdam, Madrid, and Monterrey.

VAZQUEZ KAUFFMANN, Carlos. Painter, draftsman, graphic artist, born in Oaxaca, 1955. Has participated in nine group shows in Juchitán, Mexico City, and Aguascalientes.

[1] Not included in the original catalogue. --*Ed*.

August 23 - September 21, 1979

LIA BERMUDEZ: SCULPTURES OF VENEZUELA

The development of Lía Bermúdez's career as an artist is the result of both discipline and a fertile imagination. Bermúdez, who has lived and worked for many years in Maracaibo, alternated between painting and sculpture until the early 1970s, but ultimately chose to work with sculpture. In this exhibition she is represented by a series of small works that are characteristic of the larger body of her production. Constructing the sculptures from copper or iron, she creates a variation of angles with straight, vertical lines extending into space, used in juxtaposition with curved or rounded forms. It is the combination that gives her work special interest.

Born in 1930 in Caracas, Lía Bermúdez has lived in Maracaibo since 1948. She attended the School of Plastic Arts in Caracas and in Maracaibo, studying briefly under the now internationally known Venezuelan artist Jesús Rafael Soto. Bermúdez has had four one-person exhibitions in Venezuela, of which two were at the Center of Fine Arts in Maracaibo, 1956 and 1973, and has participated in more than thirty group exhibitions. In 1976 she was awarded Venezuela's National Prize for Sculpture. She has been commissioned to create both murals and sculptures for public buildings in Maracaibo, among the most important being the facade of the Banco Central de Venezuela, and is a member of the faculty of the University of Zulia's School of Architecture, where she teaches graphic composition and theory of form and design.

This is the first exhibition of Bermúdez's sculptures outside Venezuela. --*J.G-S.*

EXHIBITION LIST [1]

Sculptures

1. *Solaris*
2. *Miraca*
3. *Catatumbo*
4. *Los taques*
5. *Moruy*
6. *Caimare*
7. *Guarero*
8. *Arimpia*
9. *Adicora*
10. *Sinamaica*
11. *Conticinio*
12. *Tepuy*

August 23 - September 21, 1979

IMAGE, SILK, AND COLOR

Venezuela, one of the most heavily industrialized nations in Latin America, was among the first to encourage the participation of its creative artists in the industrial process. The exhibition *Image, Silk, and Color*, which is being circulated under the auspices of the Museum of Contemporary Art of Caracas, evolved from a proposal made by Alicia Briceño de Espinoza, Director of Cobalto, a newly established firm in Caracas that specializes

[1] Not included in the original catalogue. --*Ed.*

in printing textiles. In an attempt to demonstrate the possibilities of the application of fine art to textile design, and thus raise the standards of quality in the field, ten of Venezuela's most prominent artists were asked to submit designs to be printed on silk imported especially for the project from Japan. The designs were printed by skilled craftsmen at the Cobalto Workshop. The result is a series of remarkably fine prints on silk, executed in a limited edition, which have an intrinsic value and degree of quality rarely seen in work of this nature.

The presentation of the exhibition at the Museum of Modern Art of Latin America follows the exhibit's inaugural presentation at the Museum of Contemporary Art in Caracas. *--J.G-S.*

We wish to acknowledge the cooperation of Sofía Imber, Director of the Museum of Contemporary Art of Caracas, and Alicia Briceño de Espinoza, Director of Cobalto, for having made the presentation of the exhibition possible.

PARTICIPANTS

1. *Carlos Cruz-Diez*
2. *Manuel Espinoza*
3. *Gego*
4. *Angel Hurtado*
5. *Gerd Leufert*
6. *Alejandro Otero*
7. *Alirio Palacios*
8. *Luisa Palacios*
9. *Mercedes Pardo*
10. *Jesús Rafael Soto*

BIOGRAPHICAL NOTES[1]

ESPINOZA, Manuel. Painter, graphic artist, born in San José de Guaribe, Guárico, 1937. Studied in art schools in Valencia (Venezuela), 1953, and Caracas since 1954; Academy of Fine Arts, Rome, 1958; Print Workshop of Professor Bersier at the Ecole Nationale Supérieure des Beaux-Arts, Paris, 1959. Also took a course on history of art given by Pierre Francastel at the Ecole du Louvre in Paris in 1959, as well as other courses given by Professor Stabenau and Hans Trier at Hochschule für Bildende und Angewandte Kunst, Berlin, 1960. Co-directed with Jacobo Borges the *Círculo El Pez Dorado*, 1964. Co-founder of the Centro Experimental de Arte, Universidad de los Andes, Mérida, 1965, and of the Galería de Arte Nacional, 1976, of which he was the first director. Professor of graphic art in different institutions. Held individual exhibitions in Caracas, including the Museo de Bellas Artes in 1960 and the Museo de Arte Contemporáneo in 1976. Participated in national salons and other group shows in Venezuela and abroad, including *Latin American Art*, Paris, 1962; *Contemporary Venezuelan Painting*, New York, Tel Aviv, and Jerusalem, 1963; Second American Biennial of Graphic Arts, Cali, 1973. Since 1954 has been awarded important national prizes such as First Prize, Salón D'Empaire, Maracaibo, 1957; Roma Prize, Caracas, 1958; Henrique Otero Vizcarrondo Prize, 1958 and 1966; First Acquisition Prize, Museo de Bellas Artes, 1974.

GEGO (Gertrudis Goldschmidt). Painter, graphic artist, sculptor, born in Hamburg, Germany, 1912. Graduated as an architect, University of Stuttgart, 1938. Traveled to the United States and worked in sculpture and graphic arts, 1959-61. Was a Tamarind Fellow, Los Angeles (California), 1966. In 1962 started to integrate sculpture with architecture and since then has executed many of these environmental structures in Venezuela. Teaches art in higher education and art related institutions. Held individual exhibitions in Munich, Caracas, Bogotá, New York,

[1] Not included in the original catalogue. See Index of Artists for reference on those not listed here.*--Ed.*

and San Francisco, including the Museo de Bellas Artes, 1961, 1964, and 1968, and the Museo de Arte Comtemporáneo, 1977, both in Caracas. Participated in group exhibitions in Venezuela and abroad. Was awarded important national prizes including First National Prize for Drawings, Official Salon, 1967, and the National Prize for the Plastic Arts, 1979. Has lived in Venezuela since 1939 and is a Venezuelan citizen.

PALACIOS, Alirio. Painter, draftsman, graphic artist, born in Tecupita, Territorio Federal Delta Amacuro, 1938. Graduated from the Escuela de Artes Plásticas y Aplicadas, Caracas, 1959. Also studied painting, Academy of Fine Arts, Rome, 1961; engraving, University of Peking, under a Chinese government scholarship, 1962-65; etching, Workshop of Professor Ruzinski, University of Warsaw, 1968, and University of Krakow, 1974-75; Engraving Workshop, Academy of Art, Berlin, 1969; Contemporary Engraving Center, Geneva, 1973-74. Taught art and held high positions in art related institutions. Founding member of the Taller de Artistas Gráficos Asociados (TAGA), Caracas, 1976. Held individual exhibitions in Caracas and other cities in Venezuela, in Peking, Warsaw, Geneva and other cities in Switzerland. Participated in national and international group shows, including the Seventh International Youth Festival, Vienna, 1959, and the São Paulo Biennial, 1977. Since 1957 has won numerous awards including the Henrique Otero Vizcarrondo Prize, Caracas, and the Arturo Michelena Prize, Valencia (Venezuela), 1961; Roma Prize, Caracas, 1966; Gold Medal, Graphic Arts Biennial, Barranquilla, 1966; Gold Medal, First Graphic Arts Biennial, Cali, 1971; Gold Medal, Third International Biennial of Graphic Arts, Florence, 1972; National Prize for the Plastic Arts, Caracas, 1977.

PARDO, Mercedes. Painter, muralist, graphic artist, stage designer, born in Caracas, 1922. Studied at the Escuela de Artes Plásticas y Aplicadas, Caracas, 1941-44; Academia de Bellas Artes, Santiago (Chile), 1945-48; Ecole du Louvre and under Cassou, De La Fertie, and André Lhote, Paris, 1949. Lived in Paris, 1949-51 and 1960-69. Founder of the Art Education Department, Museo de Bellas Artes, 1959, and the Children's Art Expression Workshop, Fundación Mendoza, 1972, of which she was the director, 1977. Created several stage designs for the Teatro del Ateneo and other theatres in Caracas, 1957-60. Illustrated several books and published *Signos*, 1963, a series of twelve books of her graphic work reinterpreting the signs of the zodiac. Held individual exhibitions in Caracas and other Venezuelan cities, and in Santiago (Chile), Madrid, and Mexico City, including the Museo de Bellas Artes, Caracas, 1962 and 1969; Museo de Arte Moderno, Mexico City, 1978. Participated in national and international group shows, including the International Fair, Brussels, 1958; Biennial of São Paulo, 1959; Biennial of Venice, 1962; American Biennial of Córdoba (Argentina), 1964. Was awarded national prizes including the National Prize for Applied Arts, 1964, and the National Prize for the Plastic Arts, 1978, both in Caracas.

September 25 - October 22, 1979

INES CORDOVA OF BOLIVIA

Inés Córdova has found a highly imaginative way of using cloth and traditional patchwork techniques to create compositions that resemble collage. Since Bolivia produces some of the finest weavings in Latin America, Córdova has access to a rich variety of raw material with which to work. Her well-developed sense of abstract composition, delicate craftsmanship, and combination of fabrics of different textures and colors result in a serious expression that is uniquely rooted in her native environment.

Born in Potosí, Bolivia, in 1927, Inés Córdova studied at the National School of Fine Arts in La Paz, 1944-1949, and later attended workshops in Montevideo, Madrid, Barcelona (Spain), and Ayacucho (Peru). In addition to creating the patchwork compositions, she is an accomplished ceramist. Her work has been exhibited in individual and group shows in Bolivia, Brazil, Colombia, Venezuela, France, Germany, Spain, Switzerland, and the United States. In 1977 she was awarded First Prize at the Second INBO Biennial in La Paz and in 1979 she represented Bolivia in the São Paulo Biennial in Brazil. She has executed numerous ceramic murals in public buildings in La Paz, and is represented in public and private collections in Bolivia, Colombia, and Venezuela.

The artist's first exhibition in Washington, D.C., took place in 1977, when her work was shown together with that of her husband, Bolivian painter Gil Imaná. *--J.G-S.*

CATALOGUE

Patchwork

1. *Cosmos andino (Andean Cosmos)*, 97 x 162 cm.
2. *Altiplano (Highland)*, 60 x 81 cm.
3. *Lago (Lake)*, 73 x 100 cm.
4. *La cumbre (Summit)*, 97 x 130 cm.
5. *Tiahuanacu*, 73 x 100 cm.
6. *Quebrada (Broken Terrain)*, 54 x 75 cm.
7. *Ruinas (Ruins)*, 60 x 73 cm.
8. *Luz altiplánica (Light of the Highland)*, 38 x 46 cm.
9. *Copacabana*, 60 x 81 cm.
10. *Salar de Uyuni (Salt Deposits of Uyuni)*, 60 x 70 cm.
11. *Orillas del lago (Shoreline)*, 60 x 81 cm.
12. *Dolor andino (Andean Grief)*, 60 x 70 cm.
13. *Nieve andina (Andean Snow)*, 73 x 100 cm.
14. *Invierno (Winter)*, 50 x 60 cm.
15. *Milluní*, 50 x 60 cm.
16. *Después de la partida (After the Departure)*, 60 x 73 cm.
17. *Estrecho de Tiquina (Tiquina)*, 73 x 100 cm.
18. *Sombras (Shadows)*, 50 x 60 cm.

October 24 - November 14, 1979

GILBERTO REBAZA OF PERU

Peruvian born painter Gilberto Rebaza, one of the finest colorists in Latin America, is presenting his work in the United States for the first time. Rebaza is a highly inventive artist who began his professional career as an abstractionist and later turned toward a figurative expression, focusing on the human form and other identifiable objects from reality. In his most recent paintings, there is a link to the work of Rufino Tamayo, the father of modern painting in Latin America, as well as to the well-known Nicaraguan artist Armando Morales, especially in the massive, motionless forms, all of which are heavily outlined to heighten the sculptural effect. Rebaza simplifies his compositions to include only the most essential elements, with color playing the dominant role. His work provokes a profound sense of loneliness and isolation, and demonstrates the capacity of a mature personality who soon will be recognized as one of the most outstanding artists in Latin America.

Born in Trujillo, Peru, in 1939, Gilberto Rebaza studied at the National School of Fine Arts in Lima from 1958 to 1962. He has had only three one-person exhibitions in Lima, the last in 1977 at Gallery 9, but has participated in numerous group exhibitions. In 1965 he represented Peru at the São Paulo Biennial. Rebaza's work is included in private collections in Lima. *--J.G-S.*

CATALOGUE

Oils on Canvas

1. *Gente de mar (Sea People)*, 150 x 170 cm.

2. *Playa Dulce*, 150 x 170 cm.
3. *La cosecha (The Harvest)*, 150 x 150 cm.
4. *Maternidad con frutas y sonaja (Maternity with Fruits and Tambourine)*,[1] 150 x 150 cm.
5. *Pescadores (Fishermen)*, 1978, 150 x 122 cm.
6. *Floristas (Flower Vase)*,[2] 1979, 150 x 122 cm.
7. *Varadero (Sweeper)*, 114 x 98 cm.
8. *Ruta hacia el pueblo (Route to Town)*, 114 x 98 cm.
9. *Lustrabotas con pomo azul (Shoeshine Boy with Blue Polish)*, 114 x 98 cm.
10. *Niño con frutero (Child with Fruit Basket)*, 101 x 93 cm.
11. *Maternidad con botijas al fondo (Maternity)*,[1] 100 x 85 cm.
12. *Florista (Florist)*, 100 x 85 cm.
13. *Niño con sandía (Child with Watermelon)*, 98 x 82 cm.
14. *Niña con jaula de pájaros (Child with Birdcage)*, 1979, 76 x 69 cm.
15. *Figura dormida (Sleeping Figure)*, 76 x 69 cm.
16. *Cacerola con frutas (Bowl with Fruit)*, 69 x 76 cm.
17. *Figura con frutero y embudo (Figure with Fruit)*,[1] 70 x 63 cm.
18. *Caja con frutas (Box with Fruit)*, 66 x 66 cm.

December 10, 1979 - January 6, 1980

MARIA MARTORELL OF ARGENTINA: PAINTINGS

Geometric abstraction remains a vital current in Argentine art and one of its most successful exponents is María Martorell. Martorell turned from figurative painting to begin a serious investigation of geometric forms and space during the early 1960s. Later, she expanded her explorations to color, movement, and vibration. Characteristic of her work over the past five years are compositions with undulating bands of color that recall the rhythmical movement of sea waves or of banners agitated by the wind. In this exhibition we can observe the proficiency with which she handles all the elements that are essential to her expression. While the paintings need no interpretation, it is curious to note that both the imagery and the color are closely related to those found in the textiles of the artist's native province of Salta, Argentina.

María Martorell began her art studies in Salta in 1942 and later traveled and studied briefly in Europe. She has had more than a dozen one-person exhibitions in Buenos Aires, the first in 1957, and also has exhibited her work in Barcelona (Spain), Madrid, Paris, Caracas, Bogotá, and New York. She has participated in more than thirty national and international exhibitions in Argentina and abroad. Among the collections in which her work is represented are those of the Museum of Modern Art in Buenos Aires, the Museum of Modern Art in Mexico City, and the Chase Manhattan Bank in New York.

This is the artist's first one-person exhibition in Washington. --*J.G-S.*

CATALOGUE

Oils

1. *Circumpolar*, 1975, 100 x 100 cm.
2-4. *Variaciones (Variations) No. 2, No. 3, No. 4*, 1977, 100 x 100 cm.

[1] Literal translation of this title is "Maternity with Fruits and Rattle." --*Ed*.

[2] Literal translation of title no. 6 is "Florists;" of no. 11, "Maternity with Jars in the Background;" of no. 17, "Figure with Fruit and Funnel." --*Ed*.

5. *Isondi*, 1974, 100 x 100 cm.
6. *Espectros (Spectrum)*, 1974, 105 x 105 cm.
7. *Rojo-azul (Blue-Red)*, 1976, 80 x 90 cm.
8. *Cneis No. 1*, 1976, 90 x 90 cm.
9-10. *Círculo (Circle) No. 1, No. 2*, 1976, 80 x 80 cm.
11. *Sigua A*, 1976, 80 x 80 cm.
12. *Zig-Zag*, 1977, 80 x 80 cm.
13. *Zig-Zag No. 2*, 1976, 70 x 70 cm.
14-16. *Aproximación top (Top Approximation)*, 1979, 60 x 60 cm.
17. *Sigua*, 1979, 50 x 50 cm.

Prints[1]

18. *Serigrafía (Silkscreen)*
19-20. *Aproximación top (Top Approximation)*
21. *Lázaro (Lazarus)*
22. *Cneis*
23. *Isométrico (Isometric)*
24-25. *Sigua*

[1] Not included in the original catalogue but also exhibited. --*Ed.*

YEAR 1980

January 11 - 21, 1980

PAL KEPENYES OF MEXICO

Hungarian born sculptor Pal Kepenyes has been living in Mexico for more than twenty years now and is a resident of that country. In addition to his work in sculpture, he is also engaged in the design of jewelry and decorative objects.

Kepenyes studied at the School of Fine Arts in Budapest and in Paris. Since 1946 he has exhibited in Budapest, Paris, London, Berlin, New York, Los Angeles, and Miami, as well as in different cities in Mexico.

EXHIBITION LIST [1]

Sculpture

1. *Lobo* (Wolf)
2. *Angel sin cabeza* (Angel without Head)
3. *Buho* (Eagle-Owl)
4. *Caballo* (Horse)
5. *Iguana*
6. *Vivo* (Alive) *IV*
7. *Angel remendado* (Mended Angel)
8. *Mujer del pozo* (Woman of the Well)
9. *Yin Yan*
10. *San Blas* (Saint Blas)
11. *Túnel* (Tunnel)
12. *Brazo mecánico* (Mechanic Arm)
13. *Vivo* (Alive) *II*
14. *Vivo* (Alive) *III*
15. *Túnel* (Tunnel) *II*
16. *Ifigenia*
17. *Vivo* (Alive) *I*
18. *Cabeza de un antepasado* (Ancestor's Head)
19. *Fábrica (Factory)*
20. *Herido de bala (Wounded by Bullet)*
21. *Caja grande (Large Box)*
22. *Conciencia del secreto (Conscience of Secret)*
23. *Generación (Generation)*
24. *Madre e hijo (Mother and Son)*
25. *Pozo del deseo (Open Wishing Well)*
26. *El puente (Bridge)*

[1] Not included in the original catalogue. --*Ed.*

January 22 - February 19, 1980

ROBERTO GONZALEZ GOYRI OF GUATEMALA: PAINTINGS

This is the second exhibition of works by the Guatemalan artist Roberto González Goyri at the headquarters of the Organization of American States. In his first show, presented in 1951, the artist was represented by a series of sculptures. Although he has not abandoned the medium of sculpture, the present exhibit, consisting entirely of paintings, represents a new direction taken by the artist and an important contribution to modern art in Central America. In general, the paintings deal with national themes and are characterized by the dexterity and imagination with which the artist handles his subject matter, as well as his feeling for rich and vibrant color.

Born in 1924 in Guatemala City, Roberto González Goyri attended the National Academy of Fine Arts there and soon after completing his studies assisted the Guatemalan painter Julio Urruela in executing stained glass windows for the National Palace in the capital. Prior to his exhibit at the OAS in 1951, González Goyri was awarded a scholarship by the Guatemalan government for study in New York at the Art Students League and at the Sculpture Center. Since 1948 he has had seven one-man shows in his native country and abroad and has participated in more than forty group exhibitions, including the Twenty-third Venice Biennial. In 1952 he received an important prize in the international sculpture competition *The Unknown Political Prisoner*, held in London. In Guatemala City he has executed mosaic murals for the Piccioto Building (1958), concrete reliefs for the Social Security Institute (1959) and the Bank of Guatemala (1964), an acrylic mural for the Conquistador Hotel (1972), and concrete murals for the Guatemalan-American Cultural Institute (1973). Among public collections in which his work is represented are those of the Museum of Modern Art, New York; the Joslyn Museum, Omaha, Nebraska; the Lowe Art Museum at the University of Miami; and museums in Guatemala and El Salvador.

This is González Goyri's first exhibition of painting outside Guatemala. --*J.G-S.*

Grateful acknowledgement is made of cooperation received from the Guatemalan Institute of Tourism and the National Department of Fine Arts of Guatemala which has made presentation of this exhibition possible.

CATALOGUE

Acrylics, 135 x 105 cm.

1. *Angeles custodios (Guardian Angels)*
2. *Día de Primera Comunión en el pueblo (First Communion Day in the Village)*
3. *Pescadores (Fishermen)*
4. *Concierto de flautistas (Flute Concert)*
5. *Piedad (Piety)*
6. *Reminiscencias folklóricas (Memories of Folklore)*
7. *Libertad contra oscurantismo (Freedom versus Obscurantism)*
8. *Alegría de vivir (The Joy of Living)*
9. *Bañistas y peces (Bathers and Fishermen)*
10. *Niña y Barrilete (Girl with Kite)*

February 27 - March 17, 1980

RICARDO PEREZ ALCALA OF BOLIVIA: WATERCOLORS

One of the prevalent trends in today's art is a return to a depiction of reality seen in much of pre-Renaissance art, especially that of the Low Countries. It requires from the artist not only full command of his medium but, also, a refined perception that will allow him to properly select and organize the different elements within the composition. In this reality, each object is described with minute detail, and the entire composition is bathed with a sheer transparency that lends it an airless quality. Bolivian artist Ricardo Pérez Alcalá is an exceptionally gifted watercolorist who accomplishes his task exceedingly well. Keeping firm control of the plastic values, he depicts objects with patient accuracy, excelling in the rendering of surface textures of disintegrating walls and doors, and presents a penetrating view of reality that almost transcends matter.

Pérez Alcalá was born in Potosí, Bolivia, in 1939 and attended the School of Fine Arts there (1952-1958). He later studied architecture at San Andrés University in La Paz and at San Simón University in Cochabamba. He has had eleven one-person exhibitions in Bolivia, Ecuador, and Mexico and has participated in important group shows in La Paz, Quito, Mexico City, Moscow, Paris, and Barcelona (Spain). He represented Bolivia twice at the São Paulo Biennial, first in 1969 and again in 1973.

The artist has been the recipient of more than a dozen prizes, including three awards in the field of architecture and in 1975 was awarded the Grand Prize at the First INBO Biennial held in La Paz. He is represented in public collections in Bolivia and Ecuador, including the National Museums in La Paz and Quito, and in private collections in Bolivia, Ecuador, Mexico, and the United States.

This is Pérez Alcalá's first one-person exhibition in the United States. --*J.G-S.*

CATALOGUE [1]

Watercolors

1. *Patio y escalera (Patio and Stairway)*, Cuzco
2. *Pencas (Peasant Women)* [2]
3. *Puente Procesión (Procession on the Bridge)* [2]
4. *Puerta y muros (Door and Walls)*
5. *La gotera (Gutter)* [2]
6. *Balcón y lágrimas (Balcony and Tears)*
7. *Puerta y movimiento (Door and Movement)*
8. *Exodo (Exodus)*
9. *El muro blanco (White Wall)*
10. *Puertas tapiadas (Adobe Doors)* [2]
11. *Puerta y muro azul (Door and Blue Wall)*
12. *Ventana y gas (Window and Gas)*
13. *Zaguán Zapatería (Shoemaker's Doorway)* [2]
14. *Lavadero (Washroom)*
15. *La puerta y el gallo (Door and Rooster)*
16. *Tambo (Roadside Inn)* [2]
17. *La tarde (Afternoon)*
18. *El galpón (Garage)* [2]
19. *Pueblo en sombra (Town in Shade)*
20. *La hora del pan (Bread Time)*
21. *Piedras formando un muro (Stones Forming a Window)*
22. *Puerta blanca (White Door)*
23. *Puerta de chapa (Metal Door)*
24. *Hojarasca (Rubbish)* [2]
25. *Las jaulas (The Cages)*
26. *Albañil (Bricklayer)*
27. *Albañil (Bricklayer)*
28. *Muro azul (Blue Wall)*
29. *Muro rosa (Pink Wall)*
30. *La hora del desayuno (Breakfast Time)*

[1] The list of works reproduced under Catalogue is the one that appeared in the original catalogue. Nevertheless, the titles of the works actually exhibited are given under Exhibition List. --*Ed.*

[2] Literal translations of these titles are: no. 2, "Agave Leaves;" no. 3, "Procession Bridge;" no. 5, "The Leak;" no. 10, "Walled-Up Doors;" no. 13, "Shoe Store in an Entry Hall;" no. 16, "Open Market;" no. 18, "Shed;" no. 24, "Dead Leaves." --*Ed.*

EXHIBITION LIST [1]

1. *Pueblo en sombra (Town in Shade)*
2. *Tambo* (Open Market)
3. *Puerta blanca (White Door)*
4. *La hora del pan (Bread Time)*
5. *Calle del Cuzco* (Street in Cuzco)
6. *Puerta de chapa* (Sheet Metal Door)
7. *Las jaulas (Cages)*
8. *El muro blanco (White Wall)*
9. *La puerta y el gallo (Door and Rooster)*
10. *Bodegón* (Still Life)
11. *Muro azul (Blue Wall)*
12. *El galpón* (Shed)
13. *Piedras formando un muro* (Stones Forming a Wall)
14. *Zaguán zapatería* (Shoe Store in an Entry Hall)
15. *Ventana y gas (Window and Gas)*
16. *Patio y escalera (Patio and Stairway)*
17. *Tapias (Mud Walls)*
18. *Puerta y movimiento (Door and Movement)*
19. *La tarde (Afternoon)*
20. *Pencas* (Agave Leaves)
21. *Puerta y muros (Door and Walls)*
22. *La ventana (Window)*
23. *Puente Procesión* (Procession Bridge)
24. *El páramo* (Paramo)
25. *El páramo* (Paramo)
26. *Cómplices en la mañana* (Accomplices in the Morning)
27. *El Cristo del Alma* (Christ of the Soul)
28. *El changador* (Carrier)
29. *El páramo* (Paramo)
30. *La cocina* (Kitchen)
31. *Balcón y lágrimas (Balcony and Tears)*
32. *El changador* (Carrier)

March 18 - April 11, 1980

TEN ARGENTINE ARTISTS

The exhibition *Ten Argentine Artists* consists of a selection of paintings originally presented in a competition that took place in Buenos Aires in 1979 under the sponsorship of the Piñero Pacheco Foundation. Formed in 1975, the Piñero Pacheco Foundation is concerned with furthering research in various fields to promote greater communication in both the national and international communities. Last year Dr. Rafael Squirru, a founder of the Museum of Modern Art in Buenos Aires and former Director of the Department of Cultural Affairs of the Organization of American States, was asked to serve as advisor to the Foundation and, specifically, to organize a competition that would bring together the work of a group of Argentine painters who merited wider attention both in their own country and abroad. It was determined that participation would be limited to artists between the ages of thirty-five and fifty-five who were living and working in Argentina. Although their work might have been awarded national prizes, none had received a prize in competitions outside Argentina.

Participants in the Piñero Pacheco Foundation's competition were selected by a panel of professional colleagues, with a separate jury or panel given the responsibility of giving the prizes. As Director of the Museum of Modern

[1] Not included in the original catalogue. *--Ed.*

Art of Latin America, I was invited to participate on the Jury of Awards, and the Museum itself was designated to be the recipient of the painting awarded first prize--*Homage to Frank Lloyd Wright* by Juan Carlos Liberti. Second and third prizes were given to Ricardo Laham and Jesús Marcos, whose paintings are to become a part of the collections of the Museum of Modern Art in Buenos Aires and the Piñero Pacheco Foundation, respectively.

The works in the exhibition cover the range of trends seen in present-day Argentine painting. Award winning artists Laham and Marcos together with Héctor Giuffré, Eduardo Giusiano, Carlos Gorriarena, Gabriel Messil, and Pablo Suárez are exhibiting in our gallery for the first time. Three of the artists--first prize winner Juan Carlos Liberti, Federico Martino, and Carlos Alberto Salatino--have had one-man exhibitions here in the past.

On behalf of the General Secretariat of the OAS, of which the Museum is a part, we wish to acknowledge the generous support of the Piñero Pacheco Foundation and its President, Wenceslao Bunge, and Argentina's Ministry of Foreign Affairs for having made this presentation possible. --*J.G-S.*

EXHIBITION LIST [1]

Paintings

Carlos Gorriarena
 1. *The Official Resting next to His Dog*
 2. *Hazy Memories*

Eduardo Giusiano
 3. *Portrait with Red Hat*
 4. *The Model and the Assistant of the Photographer*

Pablo Suárez
 5. *Untitled*
 6. *Untitled*

Héctor Giufré
 7. *Still Life*
 8. *Lateral Light*

Jesús Marcos
 9. *Unexpected Presence*
10. *The Wait*

Federico Martino
11. *Projection of Fire*
12. *Projection of Fire*

Juan Carlos Liberti
13. *To Frank Lloyd Wright*, 1979, oil on canvas, 39 x 39"
14. *Internal Fire*

Ricardo Laham
15. *White Relationships*
16. *White Relationships II*

Carlos Salatino
17. *Derivative Forms in a Golden Light*
18. *Spatial Successions*

 [1] Not included in the original catalogue. --*Ed.*

Gabriel Messil
19. *Untitled*
20. *Inverted Spaces*

BIOGRAPHICAL NOTES[1]

GIUFRE, Héctor. Painter, born in Buenos Aires, 1944. Studied with Mateo Mollo and at the School of Fine Arts Ernesto de la Cárcova, Buenos Aires. Is the author of three manifestos on realism, 1968, 1973, and 1975. Since 1968 has held individual exhibitions in Buenos Aires. Since 1964 has participated in national and international exhibitions, including *Today's Art of Latin America*, Madrid, 1977, and the Biennial of Paris, 1977, as well as others held at the Museo de Arte Moderno, 1972-76, and the Museo Nacional de Bellas Artes, 1973-76, Buenos Aires; Museu de São Paulo Assis de Chateaubriand, 1974; Museo de Arte Moderno, Mexico City, 1975; and Museo de Arte Contemporáneo, Madrid, 1975.

GORRIARENA, Carlos. Painter, draftsman, born in Argentina. Co-founder of the *Grupo del Plata*, Buenos Aires, 1960-65, has participated in its exhibitions. Lived in France invited by the Michael Karoly Memorial directed by Bertrand Russell, 1962. Since 1960 has held individual exhibitions in Buenos Aires and Caracas. Participated in group exhibitions in Argentina and abroad, including the Biennial of Cali, 1975.

LAHAM, Ricardo. Painter, born in Buenos Aires, 1940. Held individual exhibitions in Buenos Aires and Caracas. Participated in national salons and group exhibitions in Buenos Aires and the First Biennial of Mexico, 1978. Was awarded the Georges Braque Prize for Painting, Museo Nacional de Arte Moderno, 1969, and the Marcelo de Ridder Prize, Museo Nacional de Bellas Artes, 1973, both in Buenos Aires.

MARCOS, Jesús. Painter, draftsman, printmaker, born in Spain, 1938. Lived in Mexico, New York, and Paris, 1965-71. Held individual exhibitions in Argentina, including the Museo de Arte Moderno, Buenos Aires, 1976, and in Guatemala City, Mexico City, Rio de Janeiro, and La Paz. Participated in Argentine and international group shows including *Latin American Prints*, Mexico, 1966; *Latin American Painting*, Musée d'Art Moderne, Paris, 1968; Print Biennial, Havana, 1969; *Modern Prints*, Bibliothèque National, Paris, 1970, and 1974; *100 Years of Painting and Sculpture in Argentina (1878-1978)*, Salas Nacionales de Exposiciones, Buenos Aires, 1978. Was awarded First Prize for Drawing, Bahía Blanca (Argentina), 1960, and Honorable Mention, Buenos Aires, 1972, and 1974, among others. Has lived in Argentina since 1953 and is an Argentine citizen.

MESSIL, Gabriel. Painter, draftsman, printmaker, sculptor, born in Buenos Aires, 1934. Graduated from the Arts Manuel Belgrano and Prilidiano Pueyrredón National Schools of Fine Arts, Buenos Aires, 1963. Under a French scholarship, 1967, lived and worked in Paris for some years. Since 1961 has held individual exhibitions in Argentina, Brazil, Colombia, Peru. Participated in numerous group exhibitions in Argentina and abroad, including *Opinião 66*, Museu de Arte Moderna, Rio de Janeiro, 1966; *Beyond Geometry*, Instituto Torcuato Di Tella, Buenos Aires and New York, 1968; and at group shows held at the Musée d'Art Moderne, Paris, such as Grands et Jeunes d'Aujourd'hui, 1968-69; Latin American Artists in Paris, 1968, Salon des Comparaisons, 1969; and Paris Biennial, 1971. Won several prizes in Buenos Aires, including the Ver y Estimar Prize, 1966; Braque Prize, 1967; and the Grand Mention of Honor, Acrílico Paolini, 1974.

SUAREZ, Pablo. Painter, sculptor, born in Buenos Aires, 1937. Studied with Raquel Forner, Buenos Aires. Under a United States scholarship, 1965, lived and worked in the United States. Has held individual exhibitions in Argentina since 1961. Since 1960 has participated in national salons and Argentine group exhibitions held at the Museum of Modern Art and the National Museum of Fine Arts, Buenos Aires, among others. Also participated in international shows in Bulgaria; the United States, including *The Emergent Decade*, Cornell University and the Solomon R. Guggenheim Museum, New York, 1965-66; and in Venezuela and Italy. Won the Cámara Argentina de la Industria Plástica Prize, Plástica con Plásticos Salon, Buenos Aires, 1966.

[1] Not included in the original catalogue. See Index of Artists for reference on those not listed here. *--Ed.*

April 8 - May 8, 1980

PHOTOGRAPHS BY ALVARADO-JUAREZ OF HONDURAS

Honduran photographer Francisco Alvarado-Juárez is presenting a selection of color photographs taken in Guatemala, Honduras, Ecuador, and Peru.

Born in Tela, Honduras, in 1950, Alvarado-Juárez moved with his family to New York while still in his teens. He studied at the State University of New York at Stony Brook from 1969 to 1974 and later attended classes at the International Center of Photography. He first exhibited his work professionally in 1976 and, since moving to Washington, D.C., where he now lives, has participated in group exhibitions shown at the General Services Administration and the District Building. His photographic essay on San Antonio Palopó in Guatemala was published recently in a book of verses written by Chilean poet Enrique Lihn. Alvarado-Juárez is also a painter and in 1978 participated in the exhibition *36 Hours*, which was shown here in Washington, D.C. Earlier this year he had a one-person exhibition at the Cayman Gallery in New York City. He is represented in the private collection of Mr. and Mrs. Joseph Hirshhorn. *--J.G-S.*

EXHIBITION LIST [1]

Photographs

 1-9. *San Antonio Palopó*, Guatemala, 1978
10-15. *Otavalo*, Ecuador, 1977
 16. *Golfo de Fonseca*, Honduras, 1978
 17. *Sacsaihuamán*, Cuzco, Peru, 1977
 18. *Huaraz*, Peru, 1977
 19. *La Esperanza*, Ecuador, 1977
 20. *Tegucigalpa*, Honduras, 1978
 21. *San Lucas Tolimán*, Guatemala, 1978
 22. *Lago Titicaca*, Bolivia, 1977
 23. *Cuenca*, Ecuador, 1977
 24. *San Pedro de la Laguna*, Guatemala, 1978
 25. *Santa Rosa de Copán*, Honduras, 1978
 26. *Tela Atlántica*, Honduras, 1978
 27. *Antigua*, Guatemala, 1978
 28. *San Lorenzo*, Honduras, 1978
 29. *Panajachel*, Guatemala, 1978
 30. *San Pedro de la Laguna*, Guatemala, 1978
31-32. *La Esperanza*, Ecuador, 1977
 33. *Zipaquirá*, Colombia, 1977
 34. *Santa Rosa de Copán*, Honduras, 1978
 35. *Sololá*, Guatemala, 1978
 36. *Ayacucho*, Peru, 1977
 37. *Golfo de Fonseca*, Honduras, 1978

April 14 - May 17, 1980

EDMUNDO AQUINO OF MEXICO

For more than twenty-five years, Edmundo Aquino has dedicated himself to the plastic arts, both as a creator and teacher. Born in Oaxaca, Mexico, in 1939, he began to attend classes at the National University of Mexico in Mexico City when only fourteen years of age. Having completed his formal training in art and art education,

[1] Not included in the original catalogue. *--Ed.*

he taught at the National University's School of Plastic Arts in 1963, then returned to Oaxaca where he was appointed chief of the plastic arts section of the School of Fine Arts there, 1964-1967. The next three years were spent in Paris where, having been awarded scholarships by the French and British governments, he studied printmaking at the National School of Fine Arts of Paris and the Slade School of Fine Arts in England. Since 1973 he has been living in Mexico City where he has produced the most important part of his work.

Aquino is a highly versatile artist who excels in various media--drawing with both pencil and pastel, painting, and printmaking. He has also created designs for tapestries that are among the best seen in Mexico today. Although interested in Mexican subject matter, he rejects the picturesque, easy descriptions of Indian life in favor of an imaginative, expressionistic language that is rich in both line and color.

Edmundo Aquino has had twenty-five one-man exhibitions in Mexico, the United States, France, and Spain, including a one-man exhibit at the Museum of Modern Art in Mexico City, 1978-79, and has received awards for his work in Mexico and France. He has participated in more than thirty-five national and international exhibitions, among them the Paris Biennial, 1969; *Fifteen Mexican Painters*, which was circulated by the Mexican government to museums in Arizona, New Mexico, Texas, and Pennsylvania, 1973-74; the Fourth International Biennial of Graphic Arts in Florence, Italy, 1974; the International Festival of Painting in Cagnes-sur-Mer, France, where he was awarded the National Prize, 1974; and the São Paulo Biennial, 1979. He is represented in the collections of the Museum of Modern Art in Mexico City, the Mexican Museum in San Francisco, the University of Massachusetts, the California College of Arts and Crafts in Oakland, and the Slade School of Fine Arts of London's University College.

This is Aquino's first one-man exhibition in Washington, D.C. --*J.G-S.*

EXHIBITION LIST [1]

Pastel and Pencil Drawings, 1979, 56 x 76 cm.

1. *Pajarada* (Birds)
2. *Preámbulo* (Preface)
3. *Esperando al azar* (Waiting for Luck)
4. *El grillo* (Cricket)
5. *Horizontes solos* (Lonely Horizons)
6. *Los cuervos* (Ravens)
7. *Conjurando la lluvia* (Conjuring for Rain)
8. *Conjuro de tazas* (Conjuration of Cups)

Drawings

9. *Flirteo de colibrí* (Hummingbird Flirt)
10. *La Ronda* (The Round)
11. *Invocando la mañana* (Invoking the Morning)
12. *Atardecer de las mariposas* (Sunset of the Butterflies)
13. *Flores de carne* (Flowers of Meat)
14. *Los rumberos* (Rumba Dancers)
15. *La noche de los heliotropos* (The Night of the Heliotropes)
16. *Cara No. 1* (Face No. 1)
17. *Cara No. 2* (Face No. 2)
18. *Mitad de un recuerdo* (Half of a Remembrance)
19. *Secreto antiguo* (Old Secret)
20. *El espejo* (Mirror)

[1] Not included in the original catalogue. --*Ed.*

Acrylics on Canvas

 21. *Tiempo suspendido* (Suspended Time)
 22. *La otra imagen* (The Other Image)
 23. *La nube y la vaca* (Cloud and Cow)

Tapestry

24-26. *Homenaje a Georgia O'Keeffe* (Homage to Georgia O'Keeffe)
 27. *A través de una sombra* (Through a Shadow)

May 20 - June 7, 1980

RAMIRO JACOME OF ECUADOR

Ramiro Jácome of Ecuador has suddenly emerged into the world of modern Latin American art as a new personality. Previously he was well known through numerous exhibitions in his native country. His presence is characterized by the sure expression of a highly personal plastic language. In his attempt to order chaos, he cultivates a harsh, almost bitter expressionism dominated by dramatic, often aggressive, overtones. His intent, however, is neither literary nor illustrative; each composition represents a new investigation of a purely plastic idea. Although one senses certain new cosmopolitan influences in his work--stemming perhaps from international art trends rather than from his predecessors in Ecuadorian art--Jácome's painting remains uniquely his own. Harmonizing an inner reality, he maintains a personal calligraphy as well as a highly individual feeling for color. His work demonstrates a mature artistic conception which merits close attention in the future.

Born in 1948 in Quito, Ramiro Jácome is a self-taught artist. He has held one-man shows in Ecuador and Peru and has participated in group exhibitions in Colombia, France, Italy, Washington, D.C., and Brazil, including the São Paulo Biennial in 1977.

The present exhibition is the artist's first one-man show in the United States.-- *J.G-S.*

EXHIBITION LIST [1]

Paintings, Drawings, and Prints

 1. *Bandera (Flag)*, 1980, oil, 52 x 70 cm.
 2. *Cabeza de joven pintor (Head of Young Painter)*, 1980, acrylic, 40 x 40 cm.
 3. *Lección de anatomía (A Class in Anatomy)*, 1980, oil, 40 x 50 cm.
 4. *Historieta amorosa (A Lovely Vignette)*, 1980, ink, 50 x 70 cm.
 5. *Amor que nace, crece y se desgasta (Love Which Is Born, Grows, and Is Used Up)*, 1979, acrylic,
 150 x 105 cm.
 6. *La conquista de la virtud (The Conquest of Virtue)*, 1979, tempera, 50 x 70 cm.
 7. *Capricho barroco (Baroque Whimsy)*, 1979, etching, 50 x 35 cm.
 8. *Amor del alba (Love of Dawn)*, 1980, oil, 70 x 50 cms.
 9. *Pequeña ronda nocturna (Small Nocturnal Serenade)*, 1980, acrylic, 108 x 75 cm.
 10. *Vasos comunicantes (Communicating Jars)*, 1980, oil, 75 x 108 cm.
 11. *Eurípides (Euripides)*, 1979, acrylic, 150 x 105 cm.
 12. *Reyes Católicos (The Catholic Kings)*, 1978, ink, 50 x 50 cm.
 13. *El brindis de Baco (The Toast of Bacchus)*, 1979, acrylic, 105 x 75 cm.
 14. *Personajes del parque (Characters in the Park)*, 1975, mixed media, 50 x 70 cm.
 15. *Poeta español (Spanish Poet)*, 1980, ink, 50 x 70 cm.
 16. *Las visitas a Picasso (Visits to Picasso)*, 1979, tempera, 70 x 50 cm.

[1] Not included in the original catalogue. --*Ed.*

17. *El nacimiento de Venus (Birth of Venus)*, 1978, ink, 50 x 70 cm.
18. *Deidades (Deities)*, 1977, mixed media, 50 x 70 cm.
19. *Instancia eterna (Eternal Instance)*, 1977, tempera, 70 x 50 cm.
20. *Paraíso íntimo (Intimate Paradise)*, 1979, tempera, 70 x 50 cm.
21. *Estudio (Study)*, 1980, acrylic, 43 x 60 cm.
22. *Vecindario (Neighborhood)*, 1980, oil, 52 x 70 cm.
23. *Electrodomesticado (Electrodomesticated)*, 1980, oil, 52 x 70 cm.

June 17, 1980

INAUGURATION OF *CAJA MAGICA* (MAGIC BOX), A TAPESTRY BY LEONARDO NIERMAN OF MEXICO

Press Release E-83-80, Washington, D.C., June 18, 1980 (OAS). A whimsically colorful tapestry from Mexico now adorns the lobby of the new office building of the Organization of American States here.

The tapestry, a creation that is reminiscent of the colors and tones of the forests and plains of America, was woven by one of Mexico's most outstanding artists, Leonardo Nierman.

The work was donated to the hemispheric Organization by the Mexican government. Rafael de la Colina, Mexican Ambassador to the OAS, presented the gift "in a gesture of friendship towards all of the countries of America, and as a tribute to the efforts of the OAS."

Nierman's tapestry, made especially for the lower level entry-way of the modern building, is the first piece of artwork donated to the Organization for its new offices by a member country.

. . . Nierman described his work: "It can be seen as the side of a wooden box with a series of colors and symbols that represent the OAS. . . ."

. . . José Gómez-Sicre, Director of the Museum of Modern Art of Latin America, spoke of his profound satisfaction with Nierman's weaving. He pointed out that "the primordial character of the weaving is found in its search for a definition of physical reality, and even the metaphysical, through abstract form."

Leonardo Nierman was born in Mexico City in 1932. A graduate in both physics and mathematics, he chose to become a violinist, performing in concerts and festivals throughout Mexico and abroad. Now he is an artist of multiple capacity and world fame, concentrating mainly on painting, drawing, sculpture, and the weaving of tapestry. Currently, in addition to the OAS, the Kennedy Center for the Performing Arts displays three of the artist's masterpieces.

June 26 - July 25, 1980

ART OF TODAY IN PARAGUAY

The last twenty years have been decisive for the history of modern art in Paraguay: the prestige of contemporary trends is now firmly established in that country. The first exhibitions in Washington of Paraguayan artists exemplifying those trends took place at the headquarters of the Organization of American States in 1966. A highly successful one-man show of compositions by the pioneering figure, Carlos Colombino, a versatile exploiter of many media, best known for his self-invented "xilo-painting" on wood, was quickly followed by a group exhibition of works by thirteen of his compatriots.

Carlos Colombino has now organized a new show for exhibition at the OAS, featuring the production of ten Paraguayan painters and engravers; to this have been added three compositions by the Paraguayan sculptor Hermann Guggiari.

These artists do not constitute a "school," nor is present-day Paraguayan art characterized by any prevailing trend. Activity is lively, fresh, and varied; the product evidences both energy and strength.

The General Secretariat expresses its appreciation to Carlos Colombino for his care and effort in assembling this exhibit, and to the Paraguayan Ministry of Foreign Affairs for its support of the initiative and assistance with shipment of the exhibition to Washington. --*J.G-S.*

EXHIBITION LIST [1]

Luis Alberto Boh
 1. Ink drawing

Carlos Colombino
 2-3. Woodcuts
 4-5. Ink drawings

Pedro Florentín Demestri
 6-7. Pencil drawings

Miguel Heyn
 8-9. Ink drawings

Edith Jiménez
10-11. Silkscreens

Bernardo Krasniansky
12-14. Drawings

Selmo Martínez
15-16. Ink drawings

Ricardo Migliorisi
17-19. Colored drawings

Jenaro Pindú
20-21. Ink drawings

Susana Romero
22-23. Pencil drawings

Hermann Guggiari
24-26. Sculptures

ABOUT THE ARTISTS

BOH, Luis Alberto. Born in Asunción in 1952. Illustrator for the Asunción newspaper *ABC*. Began to exhibit in 1970; first one-man show in 1972, last two in Asunción in 1975 and 1979.

FLORENTIN DEMESTRI, Pedro. Born in Asunción in 1958. Currently studying architecture. First one-man shows held in Argentina, 1977 and 1978. Represented in the Museum of American Art in Maldonado (Uruguay), and a number of private collections.

HEYN, Miguel. Born in Asunción in 1950. Studied graphics, painting, and other techniques with Lívio Abramo and Olga Blinder. Compositions included in group exhibitions in Asunción and Madrid and in the São Paulo Biennial.

[1] Not included in original catalogue. The titles of the works exhibited are unavailable. --*Ed.*

JIMENEZ, Edith. Born in Asunción in 1925. Studied under Jaime Bestard. First received training in engraving in Asunción from the Brazilian printmaker Lívio Abramo. Later received instruction in graphics from him in São Paulo. Has participated in the São Paulo Biennial and in group shows in Asunción, Buenos Aires, Caracas, Montevideo, and São Paulo. First solo exhibition in 1952.

KRASNIANSKY, Bernardo. Born in Asunción in 1951. One-man shows in Asunción, Buenos Aires, and São Paulo, beginning in 1966. Winner of awards at international competitions in Paraguay and Uruguay. Represented in the Museum of Modern Art and Paraguayan Museum of Contemporary Art, Asunción; Museum of Contemporary Art, Skopje (Yugoslavia); Center for Arts and Communications, Buenos Aires; and Museum of Modern Art, São Paulo.

MARTINEZ, Selmo. Born in Asunción in 1948. Winner of First Prize in contest held in Asunción in 1970. Has exhibited at the São Paulo Biennial and in Asunción, Montevideo, and a number of cities in Spain.

MIGLIORISI, Ricardo. Born in Asunción in 1948. Has traveled extensively in the Western Hemisphere. Worked as an illustrator and founded the Salgar Workshop in Barranquilla (Colombia). Has resided in Bogotá since 1966 and is currently studying architecture.

PINDU, Jenaro. Born in Asunción in 1946. First one-man show in Montevideo in 1977. Has participated in the 1967 São Paulo Biennial and in 1979 received the Grand Prize at the Maldonado Biennial in Uruguay.

ROMERO, Susana. Born in Argentina in 1938. Has resided in Asunción since 1968. Worked in various media. First solo show in 1963 in Savona (Italy). Has participated in the Maldonado Biennial in Uruguay and several other important group exhibitions.

July 29 - August 26, 1980

JULIO OLIVERA OF URUGUAY

In that portion of South America known as the Southern Cone, descendants of the African immigration that took place in colonial times have gradually moved northward, leaving only a few vestiges of their ancestral customs and culture. Uruguay, and more particularly its capital, Montevideo, constituted the sole area in which a comparatively abundant Black population persisted.

In our own century, numbers have dropped off, and only a few families and neighborhoods there still actively preserve the traditions of the past. Small though this minority may be, its presence is nonetheless noticeable: its poems, music, and dances lend a special accent to the culture of the River Plate area.

The folk dances and traditional ceremonies of the Blacks have provided fruitful inspiration to painters, photographers, filmmakers, anthropologists, and other scholars. The results are particularly interesting when the interpreter is not only Uruguayan but also of African extraction.

Such is the case with Julio Olivera, a painter born in Montevideo in 1939. A self-taught artist, he first exhibited at an open salon in 1966. All his efforts have been devoted to depicting the life of Blacks in Uruguay. His compositions are bright with color and are characterized by flowing, rhythmic lines. He may be viewed as continuing the tradition initiated by the Uruguayan master Pedro Figari (1861-1938), who immortalized the popular Negro dance known as the *candombe*.

In addition to painting, Olivera is actively engaged in promoting manifestations of Black aspects of Uruguayan folklore. He has organized a group of dancers and musicians whose performances generally take place at Carnival time. Olivera has exhibited in Brazil and Paraguay as well as in his native Uruguay. Last year his works were seen at the Inter-American Development Bank in Washington, D.C. --*J.G-S.*

EXHIBITION LIST [1]

Watercolors

1. *Los sueños de Andrea* (Andrea's Dreams)
2. *Doña Juana*
3. *Lubolo* (Carnival Masquerade)
4. *Tío Lili* (Uncle Lili)
5. *Don Pascual*
6. *El escobero* (Grand Marshal of the Carnival Parade)
7. *Carnaval* (Carnival)
8. *La mama vieja* (Old Mother)
9. *La ilusión* (Illusion)
10. *Meta lonja* (Beating the Drums)
11. *Barrio Reus al Sur* (District Reus to the South)
12. *Pal candombe* (For the Candombe)
13. *Noche en Ansina* (Night at Ansina)
14. *Amanecer en Ansina* (Sunrise at Ansina)
15. *Cabeza de lubolo* (Masquerade Head)
16. *Isla de Flores y Minas* (Island of Flores and Minas)
17. *Luna de los candombes* (Moon of the Candombes)
18. *El pequeño Alex* (Little Alex)
19. *Madonna*
20. *... Y callaron los tambores* (. . . And the Drums Became Silent)
21. *Carmela, la reina* (Carmela, the Queen)
22. *El gramillero*
23. *Marabunta*
24. *San Salvador y Minas (San Salvador and Minas)*
25. *Dama de la filigrana* (Filigree Lady)
26. *Casas del sur montevideano* (Houses in South Montevideo)
27. *Perfil* (Profile)
28. *Doña Esther*
29. *Oxala*
30. *La fe* (Faith)

August 27 - September 22, 1980

HELENA DUNSHEE DE ABRANCHES TOWNSEND

A new presence has recently made itself felt on the art scene in Brazil--that of the sculptor Helena Dunshee de Abranches Townsend.

Born in Rio de Janeiro, she initiated formal study in 1969 at the art school maintained by the Museum of Modern Art in that city. She also took special courses in drawing, composition, and art evaluation.

Simplification of forms and masses is perhaps the most characteristic feature of her style. She utilizes a variety of materials for her sculptures and shows a preference for carving as a means of execution.

Helena Dunshee de Abranches Townsend's first individual exhibition took place at her own studio in 1977. Since that time the artist has participated in a number of group shows in Brazil. This is the first exhibit of her work to be presented outside that country. --*J.G-S.*

[1] Not included in the original catalogue. --*Ed.*

EXHIBITION LIST [1]

Sculpture

1. *Corfu*
2. *Négresse* (Black Woman)
3. *Amon I*
4. *Amon II*
5. *Amon III*
6. *Falo I* (Phallus I)
7. *Falo II* (Phallus II)
8. *Falo II* (Phallus II), wood
9. *Falo III* (Phallus III)
10. *Isis*
11. *Amazona* (Amazon)
12. *Persona* (Person)
13. *Persona* (Person), wood
14. *Homo*
15. *Fruto* (Fruit)
16. *Semente* (Seed)
17. *Fruto/Semente* (Fruit/Seed), wood
18. *Kuoros*
19. *Horos*
20. *Seuil* (Threshold)
21. *Cisne* (Swan)
22. *Equus*
23. *Kuoros*

September 23 - October 15, 1980

MAYA KLIPPER FROM ARGENTINA

Although Maya Klipper is a Romanian by birth, she has lived in Argentina for several years. She studied painting there under the guidance of Horacio Blas Mazza and Roberto González and in 1973 attended the Alfredo De Vincenzo Graphic Workshop. Since then Ms. Klipper has participated in numerous group shows and exhibited in local salons in Argentina. Her first one-person show was held last year in Buenos Aires. The present OAS exhibit is the second solo exhibit of her career.

Maya Klipper works in diverse media, invariably marked by curvilinear elements, the inherent expression of her artistic vision. --*J.G-S*.

EXHIBITION LIST [2]

Prints

1. *Historias en blanco* (From Stories in White Series), etching
2. *El hombre encadenado* (Chained Man), intaglio
3. *El retorno a la unidad* (Coming Back to Unity), etching
4. *El comienzo* (From the Beginning Series), etching
5. *Historias en blanco* (From Stories in White Series), etching

[1] Not included in the original catalogue. --*Ed*.

[2] Not included in the original catalogue. --*Ed*.

6. *Historias en blanco* (From Stories in White Series), monotype
7. *Las cosas interiores* (Interior Things), etching
8. *El comienzo*(From the Beginning Series), etching
9. *Historias en Blanco* (From Stories in White Series), monotype
10. *El comienzo* (From the Beginning Series), etching
11. *Historias en blanco* (From Stories in White Series), monotype
12. *Historias en blanco* (From Stories in White Series), etching
13. *El comienzo* (From the Beginning Series), etching
14. *El comienzo* (From the Beginning Series), etching
15. *El comienzo* (From the Beginning Series), etching
16. *Historias en blanco* (From Stories in White Series), monotype

September 23 - October 15, 1980

VECHY LOGIOIO FROM ARGENTINA

Vechy Logioio was born in Santa Rosa, Province of La Pampa, Argentina, in 1933. As a young woman, wanderlust and a vocation for art took her to Europe. For seven years she lived in Geneva, where she first studied music. She then switched to painting under the tutelage of the Swiss artist Maurice Wenger.

Upon return to her native land, Logioio continued her studies under Andreína Baj, later entering the workshop of Emilio Pettoruti, the forerunner of cubism in Latin America. She also was a pupil of Horacio Butler and Santiago Cogorno, both highly regarded Argentine artists.

Having absorbed this varied technical background, Ligioio's further development depended entirely upon the depth and extent of her natural talent. Curiously, perhaps, Logioio never thought of her art as a "career." The compulsion to paint and to draw sprang solely from a profound desire to reveal the special world that existed within her and clamored for release. That world--her world--is remote, dreamlike, a visual reality that one cannot, must not, touch. Yet, veiled though they are, the subjects--be they nudes, flowers, or portraits--are vibrant, alive. Airy as they seem, they have volume and substance. The palette is low-keyed, persistently monochromatic: muted terra-cottas, grays, and yellows. The same delicate handling of media is evident in her drawings, in which weightlessness and transparency prevail.

A wife and mother of two, Vechy Logioio divides her time between her studios in Colonia (Uruguay), and Buenos Aires. Over the past decade she has exhibited singly and in group shows in Buenos Aires, and in Venezuela, Italy, Spain, and now in the United States, under the auspices of the government of Argentina and the Organization of American States. --*J.G-S.*

The Museum of Modern Art of Latin America wishes to acknowledge the invaluable assistance of the Ministry of Foreign Affairs of Argentina in making this exhibition possible and the generous help of the Rubbers Gallery of Buenos Aires in the preparation of the show.

EXHIBITION LIST [1]

Oils

1. *Composición* (Composition), 100 x 75 cm.
2. *Composición* (Composition), 100 x 75 cm.
3. *Retrato* (Portrait), 130 x 97 cm.
4. *El alquimista* (Alchemist), 100 x 75 cm.
5. *Figura* (Figure), 120 x 80 cm.
6. *Figura* (Figure), 130 x 97 cm.

[1] Not included in the original catalogue. --*Ed.*

7. *Torso*, 100 x 75 cm.
8. *Torso*, 100 x 75 cm.
9. *Torso*, 100 x 75 cm.
10. *Barranca* (Gorge), 100 x 75 cm.
11. *Barranca* (Gorge), 60 x 80 cm.
12. *En el atelier* (In the Workshop), 130 x 97 cm.
13. *Médanos* (Dunes), 130 x 97 cm.

Drawings

14. *Torso*, 100 x 72 cm.
15. *Torso*, 100 x 72 cm.
16. *Composición* (Composition), 100 x 72 cm.
17. *Figura reclinada* (Reclining Figure), 140 x 72 cm.

October 7 - November 26, 1980

COLONIAL ART OF PERU
A selection of works from the collection of Marshall B. Coyne of Washington, D.C.

FOREWORD

It is both a novel experience and a special privilege for the Organization of American States to present this exhibition featuring the eighteenth-century school of Cuzco at its Museum of Modern Art of Latin America.

The paintings and sculptures on view constitute but part of a large collection acquired over many years by Mr. Marshall B. Coyne, in places often remote from the works' origins in Peru. Quite aside from their intrinsic aesthetic value, they offer vivid proof of the early existence in the Americas of a tradition of free and spontaneous art. When one takes into account also the evidence of frequent use of unorthodox techniques, one cannot but be led to interesting comparisons with contemporary art movements in our hemisphere. It was the thought that a backward glance at our cultural roots could bring about a better appreciation of current endeavor that induced the Museum to make an exception to its announced policy of featuring the artists and trends of our own day.

As Secretary General of the Organization of American States, I take particular pleasure in thanking Mr. Coyne for his generous loan and cooperation, without which the present exhibition would not have been possible. -- *Alejandro Orfila*, Secretary General, Organization of American States

COLONIAL ART OF PERU: SCHOOL OF CUZCO PAINTING

It may well seem strange that a museum of modern art, dedicated to the presentation of new forms of aesthetic expression, should be the site of an exhibit of works executed more than two centuries ago. There is a reason for this apparent anomaly, however. In addition to exemplifying a style imported from Europe and refashioned by native hands into a blend of Old- and New-World cultures, this collection demonstrates the important role tradition has played in Spanish-American art.

The colonial phase of art in America was preceded by a long native period, its origins lost in time, which has left monuments of amazing complexity and refinement. Previous exhibitions at the headquarters of the Organization of American States have shown the persistence of the indigenous tradition, a tradition whose existence some deny, either from ignorance or because of manifest prejudice, seeking to depreciate art produced in our countries today. Disregarding such detractors, whose ranks are fortunately ever fewer, we propose to present a complete view of artistic expression in Latin America--the product of numerous currents, some harmonious, some in conflict with one another, many representing long-established cultural patterns. Thus, in venturing to display in a museum whose concern is the present a group of compositions two hundred years old, we seek to show, by a vision of what has gone before, that contemporary painting and sculpture in America are not the work of chance, but spring, rather, from a fertile past.

Cuzco was the capital of the Inca Empire, the last native civilization to flourish in South America, over much of which it held sway. It was only natural that the conquistadors and early colonists should have felt it necessary to rear there a quantity of monuments to the Christian faith. Sometimes their churches and convents--at times even their houses--were erected on massive foundations laid by the Incas, visibly crushing beneath their weight the last vestiges of what the monks of that day considered pagan abomination. The same took place in Mexico City, though not in quite the same way as in Cuzco.

A number of origins have been suggested for the so-called Cuzco school of painting. The most generally accepted attributes its beginnings to a first wave of religious painters sent from Europe to decorate the churches erected wherever the Spaniards established their domain in native territory. Some of the first monks to arrive were endowed with artistic gifts, and painters and carvers in stone and wood were among the craftsmen of all types who sailed in the king's galleons from southern Spain to the New World. Some had knowledge of the Sevillian manner of painting--a style which came to be called a school in the seventeenth century, once the more notable practitioners, following the example of José de Ribera, "Lo Spagnoletto," adopted Caravaggio's use of chiaroscuro. The prestige won by these second-rank artists had its influence on the more humble among their followers, who catered to the less-demanding public at home and overseas, particularly the latter, where distance rendered comparisons of quality impossible. Payment, moreover, was adjusted to the fact that the objective pursued was not artistic perfection but the rapid indoctrination of subject peoples in the Catholic faith.

With all due allowance for qualitative differences, we are able to distinguish two enduring--and contradictory--characteristics of Spanish American colonial painting, at least as regards the school of Cuzco. On the one hand we find a number of conventional simplifications, sometimes awkward or even crude in effect. Against these are set numerous refinements--in the painting of flowers and in the reproduction of embroidery, lace, and the textures of cloth. This constant contrast provides the school of Cuzco with its greatest charm. Though incongruous and naive in effect to us today, its product evidences an attempt to incorporate the sophisticated tendencies of Renaissance Spain. We find a belated cultivation of classical forms and at times catch glimpses of high baroque. Chiaroscuro hints at Ribera; emphasis on a protuberant modeling of forms is a clear echo of Italy. Soft draperies recall Flemish painters; calm, clear blue skies bring Patinir to mind. A predominance of bold, sharply defined, two dimensional forms owes much to Byzantine art. While certain artistic solutions, certain conventions, reveal a more or less conscious influence of the native past--one which should not be undervalued--the visible effect is overwhelmingly European or mestizo.

The intention is at times realistic, at times classical. The net effect is a synthesis whose inconsistencies have great charm for present-day eyes attracted by the naive. Thus, the quilting of certain garments is reproduced with the technical probity of the great craftsmen of the period, yet it is often coupled with a face of hieratic cast or two-dimensional renderings of anatomy. These contrasting effects suggest the works produced by certain medieval guilds, in which a variety of craftsmen had a hand. The Cuzco painters, bound to religious themes but free in their mode of expression, may be classed among the true primitives in Latin American art, by virtue both of their situation in time and their manner of execution.

The use of gold leaf and embossing became abundant about the middle of the eighteenth century, but it is best to date a picture on the basis of the age of the original canvas. And one should not forget that painting was also done on other materials. At the very beginning parchment was used, after that wood, and then canvas. The canvas first used was cotton; later, painters were able to obtain canvas woven of flax, from Spain or the Low Countries. From time to time throughout the period in which the school of Cuzco was active, painting was also done on metal plates, either of copper or of tin.

Over the years, thousands of Cuzco school paintings have found their way out of Peru, and they continue to turn up throughout South America. Let those concerned for the integrity of Peru's artistic heritage take no alarm, however: no masterwork of Peruvian colonial painting has left the country. The truly great compositions--those for which there could be no substitute--remain at home, in private or public collections. The works that have made their way abroad for the most part exemplify the mass product of seventeenth--and eighteenth--century Cuzco workshops. They are interesting and attractive, but they are in no respect rare.

The turn of historical events toward the end of the eighteenth century led to new orientations in painting. Under the humanistic influence of the Enlightenment, separatist ideas were introduced into the colonies, which eventually proclaimed their independence, cutting political ties with Spain. A spirit of iconoclasm filled the air, and religious themes disappeared from art. Painting was taken over by those with a talent for portraits of civil

and ecclesiastical dignitaries. These professionals, in addition to official likenesses of revolutionary heroes, produced battle scenes and depictions of other historical events. In the high Andes there remained only a scattering of rustic artisans who eked out a living with chisel or brush, turning out crude votive offerings to be hung in the sacristies and side chapels of humble village churches, in communities in which Faith held out firmly against all the attacks of Reason. Thus came to an end the school of Cuzco, which for two centuries had provided imagery for a Catholic church triumphant over Indian idolatry.

The works here presented are taken from a vast collection assembled by Mr. Marshall B. Coyne from a number of American countries. Since space will not permit exhibition of more than half of the collection, we have selected compositions notable for the air of freshness they impart and the intensity of feeling which they convey, as well as for their excellent state of conservation. Contributing to the last-mentioned is the work performed in recent months by a pair of Washington restoration experts, Roberto and Josefa Arce.

The Museum of Modern Art of Latin American expresses its thanks to Mr. Coyne for his generous loan and for his cooperation in organizing an exhibit which, owing to the wealth and variety of its content, permits the viewer not only to appreciate the splendors of the school of Cuzco but also to arrive at an understanding of a most significant epoch in the history of art in America. --*J.G-S*. English translation by Ralph E. Dimmick.

CATALOGUE

Painting

Unless otherwise noted all paintings are oil on canvas attributed to the eighteenth century. Measurements appear in inches. Height precedes width.

1. *Coronation of the Virgin*, 60 x 48
2. *Saint Barbara*, 30 x 24
3. *Saint Christopher*, 32 x 22
4. *The Holy Trinity*, 40 x 32
5. *Archangel*, 36 x 24
6. *Saint Rose of Lima*, 48 x 34
7. *Archangel*, 35 x 26
8. *Virgin Child*, 41 x 28
9. *Adam and Eve*, 30 x 36
10. *Virgin with Child*, 40 x 28
11. *Saint Roque*, 19th century, 30 x 25
12. *Virgin of the Rosary*, 21 x 17
13. *The Holy Family*, 27 x 21
14. *Archangel*, 32 x 26
15. *Our Lord of the Earthquakes*, 66 1/2 x 40
16. *Saint Ignatius of Loyola*, 41 1/2 x 28 1/2
17. *Pentecost*, 21 x 16
18. *Enthroned Virgin*, 42 x 32
19. *Archangel*, 40 x 27
20. *Nursing Virgin*, 39 x 31
21. *Saint Martin*, oil on tin, 13 x 10
22. *Virgin and Child*, 24 x 23
23. *Christ with Crown of Thorns*, 40 x 31

Sculpture

All sculptures are wood carvings attributed to the eighteenth century. Measurements appear in inches. Height precedes width and depth.

24. *Virgin*, 46 x 15 x 12
25. *Saint Christopher*, 40 x 12 x 10
26. *Christ*, 40 x 15 x 12

27. *Archangel*, 37 x 14 x 14

October 16 - November 10, 1980

JUAN EGENAU OF CHILE

The first time I was aware of the work of Juan Egenau was in 1964, when I served on a panel to judge the works of the *Esso Salon of Young Artists*. The *Esso Salon* traveled to several different countries of Latin America to select the winners of national art shows, who eventually would be represented in a group exhibition at the Organization of American States in Washington, D.C.

Juan Egenau was among those entering the contest in Chile, and I was startled and impressed by the refined professionalism of this new personality that had been formed entirely in Chile in the two principal universities: Catholic University and National University, both in Santiago. He received First Prize in the Chilean show, and from then on I followed his progress step by step. Fulfilling his promise, Egenau began to emerge as one of the most creative sculptors in Latin America.

After his initial success in the Esso competition, Egenau's career took off. He received numerous awards in various salons, contests, and biennials, culminating with the Grand Prize in the 1979 Valparaíso Biennial in Chile. He has been a professor of art at his alma mater, the National University of Santiago. He also participated in many group shows in Chile, and in São Paulo, New York, and Providence (Rhode Island). His work has been installed in many places in Chile, including the national capital.

Egenau expresses his sculptural concepts in a variety of materials, but raw aluminum is the key ingredient. His technique gives the idea of compactness, of form compressed into solid mass. The aluminum is worked in a fashion that evokes a machine-like surface of an airplane. He openly uses bolts and screws, defining their function without disguise. His voluptuous and sinuous curves combine nature and technology to produce a surprisingly sensual effect. Here is an artist endowed with a high sense of invention.

The show now on view is the first solo exhibit of Egenau's works in the United States, and, at this point, I wish to express our appreciation to the Permanent Delegation of Chile to the OAS and to the Chilean Ministry of Foreign Affairs for their assistance in helping to assemble and transport these examples of Egenau's art. *--J.G-S.*

CATALOGUE

Sculpture

1. *The Strategist*
2. *My Love Series, No. 5*
3. *My Love Series, No. 4*
4. *Armor for a Torso*
5. *Belligerent Head No. 1*
6. *Ancestor*
7. *Japanese Ancestor*
8. *Belligerent Head No. 2*
9. *Armor for My Ego*
10. *Medieval Torso*
11. *Reclined Torso*[1]
12. *Witness for Violence*[1]

[1] Also exhibited but not included in the original catalogue. *--Ed.*

November 13 - 29, 1980

HUMBERTO PEREZ OF COLOMBIA

The trend of figurative expressionism emanating from the art of British painter Francis Bacon has been adopted as a point of departure by many important Latin American artists, in particular Colombian engravers.

The main characteristic in the works of Humberto Pérez now being exhibited is the intertwining human forms--grotesque and defiant--sometimes a compact mass of rich color. Above all, his work shows a pervasive and subtle sense of humor with very effective results.

The quality of Pérez's painting corresponds to the black and white conception of art. His drawing demonstrates a definite contemporary drafting capability--emphasizing masses instead of lines.

Humberto Pérez was born in Medellín, Colombia, in 1931. He studied drawing and design at the Pasadena and Claremont Colleges in California, 1955-1960. Later, he studied painting and illustration at the Art Center of Los Angeles, 1960-1964. Devoting most of his time to painting and illustration, Pérez started creating and accumulating his works, with limited interest in showing them. He has been for years working somewhat segregated from the prevalent art work in Colombia.

Since 1965 Pérez has occasionally displayed his work in group shows and has held three solo exhibits--two in Medellín, 1965 and 1968, and one in Cali, 1979. This is his first show in the United States. --*J.G-S.*

EXHIBITION LIST [1]

 1-11. Oils
12-20. Drawings

December 5, 1980 - January 4, 1981

ART OF TODAY IN BARBADOS

Eight years ago this December, the Organization of American States celebrated the incorporation into its ranks of the newly independent nations of Barbados, Jamaica, and Trinidad and Tobago with an exhibition of works by artists from those countries that gave clear evidence of the cultural enrichment they bring to the hemispheric community.

Warmly received by the public, this panoramic view of contemporary art in the English-speaking Caribbean was followed from 1972 to 1980 by a number of other exhibits of artists from that area, largely in the form of individual presentations.

Sculpture, painting, and graphics flourish in the Antilles, and a good idea of recent developments can be gained from the present exhibition of talents at work in Barbados. The abundance of media of which they make use is paralleled by the variety of their modes of expression, which range from the severely academic to all-out abstraction.

Deep appreciation is here expressed to the Ministry of External Affairs and the Ministry of Education and Culture of Barbados, for the generous support which has made this exhibit possible, and to Mr. Grantley Prescod whose able assistance has done much to ensure the success of the presentation. --*J.G-S.*

[1] Not included in the original catalogue. Titles of works exhibited are unavailable. --*Ed.*

CATALOGUE

Painting, Drawing, Sculpture

Akyem
 1. *"i" Self-Portrait*, pencil
 2. *Niah-Binghi*, pen and ink

Arthur Atkinson
 3-6. *Drawing for a Paw Paw Tree*, charcoal
 7. *Great White Visitor from the North*, mixed media
 8. *Dancer*, mixed media

William (Bela) Bertalan
9-11. *Three Figures*, brass
 12. *Ghost Ship*, brass

Hubert Brathwaite
 13. *Independence Celebrations*, oil
 14. *Coney Island*, Barbados, oil

Karl R. Broodhagen
 15. *Drawing No. 1 (Millie in Profile)*, felt pen
 16. *Drawing No. 2 (Three-quarters)*, felt pen

Virgil L. Broodhagen
 17. *Out of Darkness*, oil

Patricia Burton
 18. *Theme 80*, acrylic
 19. *Out of Chaos, Order, Peace, Hope*, acrylic

Allison Chapman-Andrews
 20. *Blackman's Gully No. 2*, 1979, acrylic on canvas
 21. *9th Avenue*, 1978, acrylic on canvas

Judi Christensen
 22. *Youth*, 1980, solid Barbados mahogany
 23. *Eclipse*, 1979, Barbados mahogany

Joyce Daniel
 24. *The Conductor*, etching
 25. *Casting the Net*, etching
 26. *Peasant Homes*, color etching
 27. *Promenade*, color woodcut
 28. *Portrait of a Worker*, color woodcut

Courtney O. Devonish
 29. *Group Forms*, wood
 30. *The Split*, mahogany

Maurice C. Drakes
 31. *Sweet Potato Vendor*, oil

Verton Hoyte
 32. *Abandoned and Alone*, pencil
 33. *Togetherness*, pencil

Omowale
 34. *Slumber*, charcoal
 35. *My Brother's Keeper*, charcoal

Barbara Preston
 36. *Mother and Child*, oil
 37. *Paint*, oil

Stella St. John
 38. *Batik No. 1*
 39. *Batik No. 2*
 40. *Batik No. 3*

Sundiata
 41. *New Boy*
 42. *Man Reading*, pencil

Villet
 43. *Assemblage with Three Bottles, White and Brown*
 44. *Assemblage with Perfume Bottle "Odoris Japanois"*
 45. *Collage Composition Number 3*
 46. *Collage Composition Number 4*
 47. *Collage Composition Number 5*
 48. *Collage of Barbados Handmade Papers*

BIOGRAPHICAL NOTES [1]

AKYEM (Ras Akyem Akin-Yemi Ramsay). Painter, muralist, draftsman, ceramist, born in Barbados, 1953. Studied at the Jamaica School of Art, 1979, but considers himself mainly a self-taught artist. Joined the Yoruba Foundation, 1973. Founding member of the group De Peoples' Art Movement (DePAM), 1977, with Omowale and Sundiata. Executed murals in Barbados. Since 1973 has participated in group exhibitions in Barbados. Won several prizes for painting and drawing in Barbados, including First Prize for Drawing, 1978, and Most Outstanding Artist, 1979, both awarded by the June Academy of Arts; National Award for Outstanding Work in Fine Arts, Barbados Industrial Development Corporation, 1979. This same year he also won the award from the Christian Action for Development in the Eastern Caribbean to study for a diploma in fine arts at the Jamaica School of Art.

ATKINSON, Arthur. Painter, draftsman, born in Barbados, 1945. Self-taught as an artist. Has worked as set designer for the Barbados Dance Theatre Company and other performing groups. Since 1969 has held individual exhibitions in Barbados. Participated in national and international shows, including the São Paulo Biennial, 1971; and Carifesta held in Guyana, 1972, Jamaica, 1976, and in Cuba, 1979. Won several awards at the annual National Independence Festival of Creative Arts and other national shows.

BERTALAN, William (Bela). Self-taught sculptor born in Hungary, 1910. Worked in the United States as sculptor of architectural ornament, poster designer, and advertising photographer. In Barbados produced pottery and ceramics, 1948-60; terra-cotta sculpture and wood carving, 1960-65; since then, he has worked in cast sculpture in bronze, aluminum, and brass. Participated in group exhibitions in Barbados and the United States. Has lived in Barbados since the 1940s.

BRATHWAITE, Hubert. Painter, commercial artist, born in Barbados, 1930. Mainly self-taught, received some training from Hector Whisler and Briggs Clarke. Member of the Barbados Arts Council. Since 1955 has participated in national and international shows, including Carifesta held in Guyana, 1972, Jamaica, 1976, and Cuba, 1979. Won several awards in Barbados, including Silver Medal, Annual Industrial Exhibition, 1967, 1968,

[1] Not included in the original catalogue. See Index of Artists for reference on those not listed here. --*Ed.*

and 1970; First Prize, Barclays International and British Airways, 1978; Award of Honor, National Festival of Creative Arts, 1979.

BROODHAGEN, Karl R. Sculptor, painter, draftsman, born in British Guyana, 1909. Self-taught, except for a British Council Scholarship to Goldsmiths' College, London, 1952-54. Has exhibited in London, Guyana, Trinidad, Jamaica, Mexico, and Barbados. Has lived in Barbados since the age of fifteen.

BROODHAGEN, Virgil L. Painter, born in Barbados, 1943. Studied painting and sculpture with his father, Karl R. Broodhagen, and is presently studying art, University of Manitoba, Canada, where he also works as design draftsman for restoration and recording of old and historical buildings. Since 1976 has held individual exhibitions in Toronto and Florida. Since 1971 has had several joint exhibitions with his father and participated in group shows in Canada and the United States.

BURTON, Patricia. Painter, born in England, 1936. Studied at the Epsom School of Art, Surrey, and Bournemouth Municipal College of Art, Hampshire, both in England. Participated in group exhibitions in Barbados and Jamaica, and in the São Paulo Biennial, 1967. Moved to Barbados, 1966, to teach art and crafts at the St. Michael's School.

CHAPMAN-ANDREWS, Alison. Painter, born in England, 1942. Studied at the Walthamstow School of Art, 1959-63, and the Royal School of Art, London, 1963-66. Member of the Barbados Arts Council. Held individual exhibitions in Barbados. Since 1965 has shown in group exhibitions in London and Barbados and has participated in Carifesta held in Jamaica, 1976, and Cuba, 1979. Has lived in Barbados since 1971, is a Barbadian citizen, and teaches at the St. Michael's School.

CHRISTENSEN, Judi Graburn. Sculptress, born in Calgary, Alberta, Canada, 1940. B.A. in English literature with minor in art, 1964-68; also studied at the Department of Art--toward a B.F.A. degree--University of Calgary, 1968-71. Worked in welded sculpture and plastic and cast stone reliefs with Katie Ohe and Roy Leadbetter, Alberta; in graphics at S.W. Hayter's Atelier, Paris, 1965. Self-taught as a wood carver, started working with Barbados mahogany in 1977. Since that year has held individual exhibitions in Barbados. Participated in group shows in Canada and Barbados, including the *Canada West Show*, touring Western Canadian museums, 1971-72. Has lived in Barbados since 1972.

DANIEL, Joyce. Paintmaker born in Barbados, 1933. Studied applied arts in Canada at the Alberta College of Art, 1967-71, under a Canadian International Development Agency grant, 1967; received an M.A. in Art Education, University of Iowa, where she also studied printmaking under Mauricio Lasansky and Keith Achepohl, 1978-80, under a Latin American Scholarship Program of American Universities and the OAS. Also attended summer courses at Sir George William University, 1969, and Ontario College of Art, 1969-70, both in Canada. Since 1972 has held individual exhibitions in Barbados. Since 1967 has participated in group exhibitions in the Caribbean area, Canada, and the United States, including Expo '67, Montreal, 1967; and Carifesta held in Guyana, 1972, and Jamaica, 1976. Won in Barbados the National Award, 1977; Her Majesty the Queen's Jubilee Award, 1977; and several times the Award of Excellence at the National Independence Festival of Creative Arts.

DEVONISH, Courtney O. Sculptor, ceramist, born in Chalky Mount, St. Andrew, Barbados, 1944. Lived in England, 1962-70, and studied at the Coventry College of Education, majoring in arts and crafts, specializing in sculpture, and graduating with a Teacher's Certificate, 1969. Received the Diploma in Ceramic Art, Instituto Statale d'Arte, Castelli (Italy), 1979. Founder of the C.O.D. (Courtney O. Devonish) Pottery and Ceramics Workshop, 1974, exhibited in individual and group shows in England, Barbados, the United States, Canada, and Italy, participating also in Carifesta held in Guyana, Jamaica, and Cuba. In Barbados was awarded First Prize in 1975, 1976 (Most Outstanding Exhibit), and 1977 and recently was granted a six-month OAS fellowship to study ceramics abroad.

DRAKES, Maurice C. Painter born in Barbados, 1934. Did not receive any formal art education. Since 1954 has exhibited in individual and group shows in Barbados, England, and Jamaica. Won First Prize, 1956, and other awards at the Barbados Agricultural and Industrial Exhibition, 1955-60. Ceased entering competition shows in 1960.

HOYTE, Verton. Draftsman, born in Trinidad, 1960. Self-taught as an artist, lives in Barbados.

OMOWALE (Alan Omowale Stewart). Painter, draftsman, muralist, commercial designer, illustrator, set and costume designer, born in Barbados, 1950. B.S. (with honors), Sociology and Political Sciences, University of the West Indies, Cave Hill, St. Augustine. Member of the Yoruba Foundation since 1973 and founding member of the group De Peoples' Art Movement (DePAM), 1977, with his twin brother, Sundiata, and Akyem. Executed murals in Barbados. Has exhibited in individual and group shows in Barbados and Jamaica since 1973. Was awarded several prizes at the annual National Independence Festivals of Creative Arts, 1976-78, and also won the Bussa Award, Yoruba Foundation, 1976.

SUNDIATA (Ian Sundiata Stewart). Painter, draftsman, muralist, illustrator, set and costume designer, born in Barbados, 1950. B.S. (with honors) in Economics, University of West Indies, Cave Hill, St. Augustine. Mainly self-taught as an artist. Founding member of the group De Peoples' Art Movement (DePAM), 1977, with his twin brother, Omowale, and Akyem. Executed murals in Barbados. Since 1973 has exhibited in individual and group shows in Barbados. Was awarded several prizes at the annual National Independence Festival of Creative Art; the Bussa Award for Outstanding Work, Yoruba Foundation, 1976; First Prize for Most Outstanding Artist, June Academy of Art, 1976; and Award for Outstanding Work in the Area of Fine Art, Barbados Industrial Development Corporation, 1978. At present lives in Trinidad and Tobago.

VILLET, Cynthia (Cynthia Villet Gardner). Painter, graphic artist, born in Beaufort West, Union of South Africa, 1934. Studied at Sir John Cass School of Art, London, 1955; Vancouver School of Fine Art, under Canadian painter Jack Shadbolt, 1960; and Bezalel Academy, Jerusalem, 1973. Held individual exhibitions in Johannesburg and Cape Town (South Africa), Jerusalem, and Barbados. Since 1960 has participated in group exhibitions in Vancouver, Jerusalem, and Barbados. Never entered into contest exhibitions. Was chosen Artist of the Month, Artists' House, Bezalel (Jerusalem), 1973. A Canadian citizen, has lived in Barbados since 1962.

December 11, 1980 - January 24, 1981

MANABU MABE
A tribute to Manabu Mabe on the nineteenth anniversary of his first presentation
at the General Secretariat of the Organization of American States

Lowe Art Museum, University of Miami, Coral Gables, Florida
October 8 - November 30, 1980

Museum of Modern Art of Latin America, Organization of American States, Washington, D.C.
December 11, 1980 - January 24, 1981

FOREWORD

In its endeavors to further mutual understanding among the nations composing the Organization of American States and increase appreciation of their individual achievements, the General Secretariat has met with singular success in programs for the promotion of the arts. Presentations at the Organization's headquarters have in some instances marked the first step towards fame by young creative or performing artists who have since gone on to world renown. More frequently they have served to introduce an artist of reputation in his own country to the international public.

It is source of much gratification to be able from time to time to bring back some of these now celebrated artists, and to provide a perspective of the changes that have come about since first they bowed under OAS auspices--the evolution that has occurred in their style, the increased mastery they have gained of their craft.

The General Secretariat is particularly pleased to reintroduce, after a lapse of almost two decades, the pioneer figure in the fusion of the age-old art of Japan with that of contemporary Brazil, Manabu Mabe. The receptiveness of Brazil to contributions from the many peoples that have thronged to its hospitable shores has resulted in a cultural flowering of unique characteristics, admired both at home and abroad. If the name of Manabu Mabe had relatively little echo at the time of his exhibit at OAS headquarters in 1962, today it is one to conjure with, not only in Brazil, but throughout Latin America, the United States, Japan, and Europe.

The General Secretariat is deeply grateful to the Brazilian government, to the Biscayne Bank of Miami, and to the artist himself whose generous assistance has made this exhibition possible. I am confident that the art-going public will be equally thankful for this new view of the achievement of a figure of singular significance in the Latin American painting of our day. --*Alejandro Orfila*, Secretary General, Organization of American States.

MANABU MABE: THE DEVELOPMENT OF HIS ART

Of Japanese birth, Manabu Mabe is one of those first-rate artists to have emerged from the arts program of the Organization of American States. It was in the OAS galleries that he held his first exhibit outside Brazil, his adopted country. Thus far we have mounted only one other special show of this kind, and that was in the case of the Mexican artist José Luis Cuevas. However, the Secretary General decided that it was our duty and our pleasure to pay tribute to Mabe's ever-ascending career, a career that has made a magnificent contribution to the art of Latin America.

In 1979 Mabe was the subject of a similar honor in his native Japan. But even as we were contemplating the pleasure of holding a retrospective of his fruitful career, the airplane returning his works from Japan was lost in the Pacific. Latin America and the world are thus deprived of fifty choice paintings by this prodigious artist. Since then Mabe has executed a series of paintings to be presented at the Lowe Art Museum of the University of Miami and then here at the Organization of American States in Washington, D.C.

When the Mabe family arrived in Brazil in 1934, Manabu was only ten years old. The trip from Kumamoto in the south of the Japanese archipelago to the port of Santos involved many long, tiring days, but the emigrants looked forward to a promised land of work for the whole family and to a new economic stability. Manabu was already old enough to understand that a complete change in his life was approaching. What he could not suspect was the transformation that his presence was soon to bring about in the emerging art of Brazil. His adjustment was relatively easy and he quickly began to learn Portuguese. Though the Mabes settled in a land of coffee plantations, he remembered the things he had learned in Japan, above all, calligraphy. Thus began a process of transculturation, a mixing of customs, the absorption of the old art of Japan into the context of a new art of varied origins--mostly European--that prevailed in the art of Brazil at the time.

A few years after they had set themselves up in the coffee backlands, Manabu's father died, and Manabu, as the oldest of seven children, assumed leadership of the family. He bought land and started farming. He and his brothers planted rice and vegetables and continued to work the coffee crop. It was during this period of hardship that his bent for art began to assert itself in his first experiments in decoration and the ornamentation of utilitarian objects. Eventually his talent drew him to São Paulo, a city with a Japanese population second only to Tokyo. There, with the help of one of his brothers, he began a family industry of hand-painted neckties, doilies, scarves, and kerchiefs. Although he himself had to sell these items on the streets of the city, in free moments he worked on small and medium-sized paintings.

In 1951 he married his wife Yoshino, and in the same year an oil painting of his was admitted to the National Salon in Rio. This event determined the course of his career and definitely established his vocation as a painter.

This early period was marked by an attachment to reality, a dependence on nature, particularly landscape. Mabe sketched his family--several of them also artists--and his work began to appear in group shows in Brazil, particularly São Paulo. In time, that penchant for realism began to yield to the freedom of abstraction. Within this infinite world, which he still inhabits, his personality matured. The spirit, influenced as it is by great Japanese art, eschews the figurative and is clearly abstract from the time it came into being. It was during this period I first met Manabu Mabe in São Paulo in 1959. While I was organizing a South American exhibition for the Dallas Museum of Art, I was at the same time looking over the Brazilian contributions, seeking new personalities. My attention was attracted by three works of abstract expressionism that had that "something more," something that was not just the simple surface effect that could be anticipated, because at that time the textural phase of abstract expressionism predominated in the competition. The three paintings, apart from an absolute mastery of color and its possibilities, offered a depth, a hidden message, something that distinguished the artist from the followers of the current trend. After including him in my selection, I learned that the artist was Japanese by birth and underlying culture. This strengthened my opinion of the artist. Here was no fraud or simple copying of effects. His work was legitimately produced within a tradition, without tricks or guile. It was the first step of a style, or rather, of a sensitivity--in this case Japanese--that was claiming a small place within the new Brazilian art. From

this fresh approach would emerge Japanese, Brazilian, and Japanese-Brazilian followers in the ateliers of Brazil.

At that Fifth São Paulo Biennial, I served on the panel of judges, and I was far from alone in nominating Mabe for First Prize in the national sector. He won by an overwhelming majority, and the Dallas Museum of Art purchased his work.

The year 1959 launched what was to be a dizzying career for the young immigrant who was already on the way to becoming a naturalized citizen of Brazil. In Paris, at the Young Artists' Biennial, he won a prize in the form of a fellowship. In 1960 he won another outstanding award at the Venice Biennial. His work was now sustained by an ever-widening and constant demand. Beginning with his solo exhibit at the galleries of the Organization of American States headquarters in Washington, D.C., his one-man shows multiplied and extended to prestigious galleries in Paris, Rome, Venice, Trieste, New York, and London. His work appeared in La Paz, Bolivia; Oakland, California; Washington State; and Minneapolis, Minnesota, among other places abroad. All of the important cities of Brazil were host to his exhibits. In 1965 his paintings were shown for the first time in Tokyo. This marked two milestones: the homecoming of the bearer of the seeds of Japanese art to a country of the New World, and the confirmation of Brazil as a land of promise that welcomed the contributions of diverse races and cultures.

As the proof of the latter proposition, a group of Japanese artists residing in Brazil banded together under the acronym of SEIBI and soon drew favorable reviews in Sao Paulo. It was Manabu Mabe that captained this invasion into the modern art of Brazil. Each spring annual salons were held, and at Mabe's suggestion I made contact with these new personalities. Mabe also recommended artists for whom I might stage exhibitions in the OAS galleries in the United States. Thus, one by one, they have presented their works and received enthusiastic acclaim. Later, upon returning to Brazil, they have established their standing in the art world and have been invited to exhibit not only in the Western Hemisphere, but in the Japan of their origin.

At the beginning of his career, when he followed the figurative mode, Mabe seemed to be tending in the direction of the Ukiyo-e school of eighteenth century Japan. This same school had also exerted quite an influence on nineteenth century French painting in its use of asymmetry of space. Later, however, Mabe deliberately sought simplicity, austerity, the occult essence, in fact, of Zen Buddhism, that he intuitively incorporated into his art. Few human creations are more subtle and ineffable than the gardens of Zen wherein asymmetrical and textural elements play dominant roles.

In this search for the essential, Mabe creates an art of harmonies of form, of insinuations, of expressions, of attitudes that are realized in large cryptic forms. They are nebulous, phantasmal images of a reality akin to those executed by his ancestors in old Japan with foliage and clouds and glimmerings of water--more suggestive than descriptive. Of ancient Chinese lineage, Zen thinking has helped Westerners to penetrate oriental aesthetics. In Japan Zen was the mental exercise of the samurai, and for the West Zen has meant the manifestation of a new pantheism in search of occult values, reachable only by intuition. Mabe, a São Paulo samurai, still practices the tea ceremony, which goes beyond the religious to permeate the aesthetic domain. The rite for taking tea has been celebrated from the fifteenth century until now by those who have incorporated Zen thinking into their everyday activities.

In the past few years Mabe has given various inflections to his painting, but without ever disturbing the basic principles that were intrinsic to his maturation. His technique did not alter, but there was a growing tendency to incorporate figures into some of his large compositions. The transparent, gaseous masses that infused his paintings in the past began to assume solidity. Larvae, caterpillars, twisted and rolled up tree leaves seemed to want to show themselves--not with full definition, but rather as ectoplasms. The human form also insinuated itself, but still behind a veil of imprecision. Chinks of light and luminous color took the edge off these forms, blurring their definition. All the while their transparencies of color or their chromatic planes have become ever richer and more suggestive. Mabe's is a personality that is constantly seeking, growing. Thus it has come to be that today he is considered one of the solid masters of pictorial art in Latin America.

Mabe travels the world, paints, receives his friends, and likes to cook for them when they meet at his vast estate outside of São Paulo. Manabu alternates the sukiyaki of Japan with Brazilian feijoada at table, and again contrives that cultural intermixture that in art has made possible the wedding of age-old Japan and youthful Brazil.

These fusions exemplify the creation of a new world of additions and identifications that is emerging in South America. One sees, moreover, no incongruity in the fact that this humble immigrant who came to Brazil to gather the ripe coffee beans and to drink their essence still also remains faithful to the spirituality of the tea ceremony. In the hands of Manabu Mabe, Japanese and European brushes alternate. He drinks his meditative tea in decorated transparent porcelain to a background of samisen music, yet never would he reject his little cup of strong coffee taken to the beat of Brazilian music. *--J.G-S.*

CATALOGUE

Unless otherwise noted all paintings are acrylic and oil on canvas dated 1980. Measurements appear in inches.

1. *Simplicity*, 71 x 79"
2. *After the Sea*, 71 x 79"
3. *Sundown*, 71 x 79"
4. *Singing*, 71 x 79"
5. *Meeting Place*, 71 x 79"
6. *Spring Rain*, 71 x 79"
7. *Free*, 71 x 79"
8. *Times Goes On*, 1979, 71 x 79"
9. *A Happy Day*, 60 x 72"
10. *Nocturne*, 60 x 72"
11. *A Serene Afternoon*, 60 x 72"
12. *Vibrant Brazil*, 60 x 72"
13. *A Smiling Future*, 60 x 72"
14. *Dreaming*, 60 x 72"
15. *After the Rain*, 60 x 72"
16. *Vitória Régia*, 60 x 72"
17. *Solemn Pact*, 59 x 79"
18. *Autumn Leaf*, 59 x 79"
19. *Flowers of Good*, 59 x 79"
20. *Circle of Light*, 59 x 79"
21. *Old Song*, 59 x 79"
22. *Reminiscences*, 59 x 79"
23. *Miami*, 59 x 79"
24. *Happy Journey*, 59 x 79"
25. *Mission*, 50 x 50"
26. *Work*, 40 x 50"
27. *Sentimental Song*, 40 x 50"
28. *A Flight*, 40 x 40"
29. *Luminous Points*, 40 x 40"
30. *Happy End*, 40 x 40"
31. *White*, 1963, oil on canvas, 39 x 44". Coll. Museum of Modern Art of Latin America
32. *Agony*, 1963, oil on canvas, 75 x 75". Coll. Museum of Modern Art of Latin America
33. *Grey*, undated, oil on canvas, 58 x 67". Coll. Museum of Modern Art of Latin America

YEAR 1981

MUSEUM OF MODERN ART OF LATIN AMERICA RECENT ACQUISITIONS
(January 1978 - December 1980)

The last presentation of recent acquisitions by the Museum of Modern Art of Latin America took place in January 1978. The number of pieces that have been added to the collection since that time has far exceeded all expectations. Ninety artists from eighteen countries are represented by 127 new works in varying media, dating from different periods of their creators' development.

Mexico figures prominently in the additions. The Museum is privileged to present on extended loan compositions by the internationally renowned José Clemente Orozco and Rufino Tamayo. Also represented is the workshop in Oaxaca named for the latter, where a group of young artists, as yet but little known in their own country, is turning out work of great vigor and promise.

Cuba is another country whose representation has been significantly increased. A young generation of expatriates that has taken up residence in the United States is active in a number of fields; the high quality of their achievement is readily apparent.

The section of the Museum devoted to naive art has been enhanced by works of great charm from Brazil and Jamaica, and a broader view of the accomplishment of a number of artists of established reputation is provided by additional examples of their production.

The Museum makes grateful note of the fact that much of its recent enrichment is to be attributed to private collectors, who are generously sharing with the public their accumulations of many years.

The only drawback offered by the Museum's growth is lack of adequate space to display the holdings in their entirety. If the galleries are currently occupied solely by recent acquisitions, it is in order to provide the opportunity for a first view of the enlargement, since 1978, of the world's only collection devoted exclusively to contemporary art of Latin America and the Caribbean. --*J.G-S.*

CATALOGUE

Rodolfo Abularach
 1. *Enigmatic Eye*, 1969, lithograph, 29 1/4 x 29"

Ismael Añez
 2. *Untitled*, 1977, color engraving, 19 1/2 x 12 1/2"
 3. *Untitled*, 1977, color engraving, 12 1/2 x 12 1/2"

Félix Angel
 4. *Untitled*, 1978, pencil and Crayola on paper, 18 x 24"
 5. *Untitled*, 1977, pencil and Crayola on paper, 24 x 18"
 6. *Untitled*, 1978, pencil and Crayola on paper, 30 x 40"
 7. *Untitled*, 1978, pencil and Crayola on paper, 30 x 40"

Edmundo Aquino
 8. *El grillo (The Cricket)*, 1979, pencil and pastel on paper, 30 x 22"

Humberto Aquino
9. *Sibelius*, 1978, pencil on cardboard, 40 x 30"

Enrique Arnal
10. *Untitled*, 1979, acrylic on canvas, 50 x 48"

Daisy Ascher
11. *Untitled*, 1978, black and white photograph, 10 x 7"
12. *Untitled*, 1978, black and white photograph, 7 1/2 x 5 1/2"
13. *Untitled*, 1978, black and white photograph, 5 x 8"

Washington Barcala
14. *Historia (History) M-P-V-8*, 1979, construction: cloth, thread, and pencil on paper, 20 x 27 1/2"

Nessim Bassan
15. *Untitled*, n.d., watercolor on paper, 22 1/2 x 28 1/2"

Mario Bencomo
16. *Civil*, 1980, acrylic on canvas, 50 x 40"

Miguel Angel Bengochea
17. *The City Series*, 1977, acrylic on canvas, 31 1/4 x 35 1/2"

Alfredo Bigatti
18. *Raquel*, ca. 1925-27, bronze, 15 x 9 1/2 x 9 1/2". Gift of Mrs. Raquel Forner.

Ricardo Borrero
19. *Farm Scene*, n.d., oil on wood panel, 8 1/2 x 10 1/2". Gift of Mrs. Jefferson Patterson.

David Boxer
20. *Aurora*, 1978, mixed media on canvas, 40 x 50"

Clinton Brown
21. *A Son Is Born*, 1978, oil on canvas board, 36 x 18"

Everald Brown
22. *Victory Dance*, 1976, oil on canvas mounted on wood panel, 33 x 49"

Constancia Calderón
23. *Homenaje a la "A" (Tribute to the "A") No. 2*, 1976, acrylic on canvas, 40 x 40"

Humberto Calzada
24. *La casa de enfrente (The House Across the Street)*, 1978, acrylic on canvas, 72 x 51"

Sergio Camporeale
25. *Descripción de un área urbana reservada y condicional (Description of a Reserved and Conditional Urban Area)*, 1973, color silkscreen, 16 1/4 x 11 1/2"

Aida Carballo
26. *Hacéte rulos, María (Curl Your Hair, María)*, 1968, color etching, 25 1/2 x 16 1/2"

Mario Carreño
27. *Cuban Landscape*, 1945, gouache on paper, 27 x 21". Anonymous gift.

Ramón Carulla
28. *4-String Series I*, 1979, oil on paper, 30 x 43"

Raúl Cattelani
29. *Gris en una forma (Gray Form)*, 1970, color woodcut, 19 1/2 x 8"
30. *Espíritu del pasado (Spirituality of the Past)*, 1970, 22 x 10"
31. *Gran forma con gris (Large Form with Gray)*, 1970, color woodcut, 25 x 12"
32. *Estructura de una forma (Structure of a Form)*, 1968, color woodcut, 21 1/2 x 12"
33. *Amarillo dinámico (Dynamic Yellow)*, 1968, color woodcut, 26 1/2 x 14". Anonymous gift.

E. Cevallos
34. *Children Fishing*, 1970, tempera on paper, 31 x 37". Gift in memory of Janet Elizabeth Ruben.

Inés Córdova
35. *Lake*, n.d., patchwork, 29 x 39 1/2"
36. *Lakeshore*, 1973, patchwork, 24 x 20"

Pedro Coronel
37. *Masks*, 1952, oil on canvas, 20 x 27". Gift of Mrs. Mark S. Massel.

Carlos Cruz-Diez
38. *Physichromie (Physiochrome) No. 965*, 1977, aluminum and acrylic, 40 x 60"

José Luis Cuevas
39-47. *Autorretrato (Self-Portrait)*, 1978, etchings, 10 x 8"
 48. *Baño de vapor (Steambath)*, 1978, etching, 15 1/2 x 21 1/2"
 49. *Retrato con Saskia (Self-Portrait with Saskia)*, 1978, etching, 20 x 15 1/2"
 50. *Autorretrato con modelos (Self-Portrait with Models)*, 1978, etching, 15 x 21 1/2"
 51. *The Giant Series*, 1971, five-part lithograph printed in color, 22 x 30"
 52. *La Torre de Babel (Tower of Babel)*, 1972, color lithograph, 18 x 22"

José Cúneo
 53. *Paisaje de escena campestre (Camp Scene Landscape)*, n.d., oil on wood panel, 20 x 26". Gift of Mrs. Jefferson Patterson.

Francisco da Silva
 54. *Untitled*, 1972, gouache on canvas, 20 x 26". Gift of Mr. Sidney A. Jaffe, in memory of Luba Jaffe.

José Antônio da Silva
 55. *Mulheres trabalhando (Women at Work)*, 1954, oil on canvas, 22 x 29 3/4". Gift of Mrs. Jefferson Patterson.

Manuel de la Fuente
 56. *The Bus*, n.d., bronze, 5 x 11 x 16"
 57. *The Bus*, 1976, charcoal on paper, 26 x 37 1/2"
 58. *The Swing*, 1976, charcoal on paper, 26 x 37 1/2"
 59. *Coca-Cola*, 1978, charcoal on paper, 18 1/2 x 27 1/2"

Omar d'León
 60. *Untitled*, 1978, pen and ink on paper, 18 x 24"
 61. *Frutas mutantes (Mutant Fruit)*, 1978, oil on canvas, 28 x 37"

Olga Dondé
 62. *Desintegración de la pareja por mecanismos de espejos multicolores (Disintegration of the Couple by Mechanisms of Multicolored Mirrors)*, 1977, oil on canvas, 43 1/2 x 43 1/2"
 63. *Of the Mutants*, 1977, lithograph, 19 1/2 x 24"

Bernard Dreyfus
 64. *Totem*, 1978, acrylic and synthetic varnish on wood cubes, 80 x 20 x 20"

Roberto Estopiñán
 65. *Torso doble (Double Torso)*, 1978, bronze, 12 x 14 x 14"

Gay García
 66. *Cabeza (Head)*, 1978, bronze, 15 x 7 x 15"

Domingo Gatto
 67. *Doorway*, 1975, silkscreen, 8 1/2 x 11". Gift of Mrs. Jefferson Patterson.

Rubens Gerchman
 68. *Moradias coletivas (Tenement Houses)*, 1964, mixed media on paper, 20 x 27 1/4"

Marcelo Grassmann
 69. *Untitled*, n.d., etching, 12 1/4 x 19"
 70. *Untitled*, n.d., etching, 17 3/4 x 23". Gift of Mr. Sidney A. Jaffe, in memory of Luba Jaffe.

Enrique Grau
 71. *Edad de oro (The Golden Age)*, 1979, pastel on paper, 39 1/2 x 27 1/2". Gift of the Museum of Modern Art, Cartagena, Colombia.

K. Guma
 72. *Untitled*, n.d., oil on Masonite, 32 x 35". Gift in memory of Janet Elizabeth Ruben.

Sérvulo Gutiérrez
 73. *Landscape*, 1943, oil on paper, 10 1/2 x 14". Gift of Mrs. Jefferson Patterson.

Luis Hernández Cruz
 74. *Construcción espacial con signos ancestrales (Spatial Construction with Ancestral Signs)*, 1976, acrylic on canvas, 60 x 72"

Alejandro Herrera
 75. *Desdoblamiento (The Double)*, 1978, oil on canvas, 37 1/2 x 43"

Angelo Hodick
 76. *The Vise*, 1972, lithograph, 30 x 22". Gift of Mr. John Sirica.

Roberto Huezo
 77. *Variación (Variations) XI*, 1979, acrylic and modeling paste on canvas, 48 x 31 1/2"

Ramiro Jácome
 78. *The Conquest of Virtue*, 1980, tempera on paper, 27 x 19"

Luciano Jaramillo
 79. *Simón Bolívar*, 1976, oil on canvas, 71 x 59"

Kapo (Bishop Mallica Reynolds)
 80. *Solomon*, 1970, oil on canvas board, 24 x 24"

Eduardo Kingman
 81. *La cena miserable (The Poor Supper)*, 1945, gouache on paper, 15 x 20"
 82. *Sorrow*, 1945, gouache on paper, 15 x 20"

Mauricio Lasansky
 83. *Kaddish I*, 1975, color etching, 42 x 26"

Raquel Lázaro
 84. *Spaceship in Yellow*, n.d., acrylic on canvas, 30 x 40"

Víctor Lewis
85. *Caminando con su paraguas azul (Walking with Her Blue Umbrella)*, 1976, oil on canvas, 36 x 48"

Juan Carlos Liberti
86. *To Frank Lloyd Wright*, 1979, oil on canvas, 39 x 39". Gift of Piñero Pacheco Foundation, Buenos Aires.
87. *Vislumbrando la alborada (Catching a Glimpse of Dawn)*, 1971, 21 x 15"
88. *El constructor (The Builder)*, n.d., 18 1/2 x 12". Anonymous gift.

Vechy Logioio
89. *Torso*, n.d., oil on canvas, 39 x 30"

Armando Londoño
90. *Untitled*, 1978, pencil on paper, 29 1/2 x 22"

Abelardo López
91. *Día canicular (Canicular Day)*, 1978, oil on canvas, 57 1/2 x 47 1/2"

Arturo López Rodezno
92. *Untitled*, 1962, enamel on ceramic tile, 12 x 17". Gift of Mrs. Mark S. Massel.

Manabu Mabe
93. *Grey*, ca. 1962, oil on canvas, 58 x 67". Gift of Mr. Yutaka Sanematsu.
94. *Pacto solene (Solemn Pact)*, 1980, oil and acrylic on canvas, 59 x 79"

Vicente Martín
95. *Un mate para Juan Manuel (A Mate Tea for Juan Manuel)*, 1976, enamel on canvas, 39 1/2 x 39 1/2"

Federico Martino
96. *Untitled*, 1970, silkscreen, 15 1/2 x 12". Anonymous gift.

María Martorell
97. *Variaciones (Variations) No. 4*, 1978, oil on canvas, 39 1/2 x 39 1/2"

Sidney McLaren
98. *Creative Imagination*, 1977, mixed media on cardboard, 25 1/2 x 33 1/2"

Ariel Mendoza
99. *Presiento tu imagen (I Sense Your Image)*, 1978, oil on canvas, 47 1/2 x 37 1/2"

Felipe Morales
100. *Night of Work in Winter*, 1977, oil on canvas, 43 1/2 x 39 1/2"

Teodoro Núñez Ureta
101. *Landscape*, n.d., watercolor on paper, 14 x 19". Gift of Mrs. Jefferson Patterson.

Miguel Ocampo
102. *Sin título (Untitled) 77/9*, 1977, acrylic and airbrush on canvas, 56 x 50". Gift of the Government of Argentina to the OAS.

José Clemente Orozco
103. *Dance in the Bordello*, ca. 1920, oil on canvas, 30 x 39". Extended loan.

Fayga Ostrower
104. *Untitled*, 1973, color woodcut, 25 1/4 x 19". Gift of Mr. Sidney A. Jaffe, in memory of Luba Jaffe.

Guillermo Ovalle
105. *Untitled*, 1980, charcoal and pastel on paper, 20 x 25 1/2"

106. *Untitled*, 1979, charcoal and pastel on paper, 20 x 25 1/2"

Humberto Pérez
107. *Untitled*, n.d., pencil on cardboard, 30 x 23"

Fidelio Ponce de León
108. *Amigos (Friends)*, 1937, oil on canvas, 20 1/8 x 26"

Lincoln Presno
109. *Textured Circle*, n.d., acrylic on canvas, 46 x 32"

Gilberto Rebaza
110. *Niño con frutero (Child with Fruit Basket)*, 1978, oil on canvas, 40 x 37"

Gonzalo Ribero
111. *Sentinels*, 1978, oil on canvas, 29 x 23 1/2". Gift of A. Da Silva.

Richard Rodríguez
112. *Door, Oldtown*, 1977, black and white photograph, 9 x 10"
113. *Fort de Cornvailles*, 1977, black and white photograph, 11 x 9 1/2"

Cecilio Sánchez
114. *Furia de un crepúsculo (Fury of Sunset)*, 1978, oil on canvas, 43 1/2 x 57 1/2"

Filemón Santiago
115. *Venganza del conejo (Revenge of the Rabbit)*, n.d., oil on canvas, 59 x 39 1/2"

N. Seoane
116. *O Irapuri*, n.d., oil on canvas, 36 x 50". Gift of Mr. Sidney A. Jaffe, in memory of Luba Jaffe.

Daniel Serra-Badué
117. *Rojo (Red)*, 1956, oil on canvas, 26 x 31"

Alfredo Sinclair
118. *Paisaje lunar (Lunar Landscape)*, 1980, silkscreen, 20 x 15 1/2"

Luis A. Solari
119. *Alegoría divertida (Charming Allegory)*, 1975, color drypoint etching, 18 x 24"

Rafael Soriano
120. *Nave flotante (Floating Ship)*, n.d., oil on canvas, 50 x 60"
121. *El cabalgar de la noche (The Night Is Riding)*, n.d., oil on canvas, 34 x 50"

Rufino Tamayo
122. *Trembling Woman*, 1949, oil on canvas, 39 x 32". Extended loan.

Mario Toral
123. *Stone Captives II*, 1975, color lithograph, 22 1/2 x 34 1/2

Guillermo Trujillo
124. *El bodegón (Still Life)*, 1975, oil on canvas, 20 x 24"

Rafael Vadía
125. *I Turn Three Shades of Red and Gold with No Words at My Command*, 1979, acrylic on canvas, 69 x 51"

Carlos Vázquez
126. *Profundidad del vacío (Depth of Emptiness)*, 1978, oil on canvas, 57 x 47 1/2"

Juan Ramón Velázquez
127. *Restaurant*, 1979, lithograph, 22 x 30"

ABOUT THE ARTISTS

ABULARACH, Rodolfo. Born 1933, Guatemala City, Guatemala. Studied architecture and painting, National University, Guatemala; School of Art, Pasadena City College, California; and Art Students League, New York. Professor of painting and drawing, National School of Fine Arts, Guatemala. Selected individual exhibitions: University Museum, Rio Piedras (Puerto Rico); Museum of Archaeology, Guatemala City; Museum of Modern Art in Bogotá and in Cali; and galleries in Mexico, Panama, Nicaragua, El Salvador, Costa Rica, Venezuela, Ecuador, Germany, New York, and Washington, D.C. (OAS, 1959). Awards include: Guggenheim Fellowship, 1962, 1964; Purchase Prize, Fifth São Paulo Biennial, 1959; First Prize for Drawing, International Exhibition, Madrid, 1963; and Art Festival, Cali, 1969; First Prize, Latin American Print Biennial, San Juan (Puerto Rico), 1972; Medal, Graphics Biennial, Ibiza, 1974. Public collections include: Museum of Modern Art, Metropolitan Museum, and Brooklyn Museum, New York; Philadelphia Museum of Art; University of Texas Art Museum, Austin; San Francisco Museum of Art; High Museum of Art, Atlanta; Milwaukee Art Center; University Museum Puerto Rico, Rio Piedras; Museum of History and Fine Arts, Guatemala City; National Museum, La Paz; Museum of Modern Art in Bogotá, Cali, and São Paulo; Museum of Art and History, Geneva; Institute of Hispanic Culture, Madrid. Lives in New York.

AÑEZ, Ismael. Born Venezuela. Studied Cristóbal Rojas Art School, Caracas; La Esmeralda Academy, Mexico City; School of Fine Arts, Rome; and Alfredo de Vicenzo Studio, Buenos Aires. Individual exhibitions: galleries in Bogotá, Mexico City, Los Angeles, New York, Madrid, Caracas, and Buenos Aires. Selected group exhibitions: Second Mexican Biennial, 1960; Museum of Fine Arts, 1975, and Museum of Contemporary Art, 1976, Caracas; Palace of Fine Arts, Mexico City, 1975; and in Buenos Aires. Represented in private collections in Venezuela.

ANGEL, Félix. Born 1949, Medellín, Colombia. Studied Institute of Fine Arts and architecture at National University, Medellín. Professor, Institute of Fine Arts and other institutions in Medellín. Author of *Te quiero mucho, poquito, nada* and *Nosotros*. Individual exhibitions: Panamanian Art Institute in Panama City and galleries in Medellín, Cali, Bogotá, San Juan (Puerto Rico), New York, Philadelphia, Miami, and Washington D.C. (OAS, 1978). Selected group exhibitions: National Salon, Bogotá, 1972, 1973; Museum of Modern Art, Cali, 1972; Zea Museum, Medellín, 1973; Museum of Modern Art and National University Museum, Bogotá, 1974; OAS, Washington, D.C., 1974; Museum of Fine Arts, Caracas, 1977; Casa de las Américas, Havana, 1977; and galleries in Miami, New York, and Denver. Awards include: Honorable Mention, Second Spanish-American Biennial, Mexico City, 1980. Public collections include: Zea Museum, Medellín; Museum of Contemporary Art, Bogotá; Museum of Modern Art, Cartagena; National University Museum, Bogotá; Panamanian Art Institute, Panama City. Lives in Washington, D.C.

AQUINO, Edmundo. Born 1939, Oaxaca, Mexico. Studied National University, Mexico City; National School of Fine Arts, Paris; and Slade School of Fine Arts, London. Individual exhibitions: galleries in Spain, France, Mexico (including Museum of Modern Art, Mexico City), and the United States (including OAS, Washington, D.C., 1980). Selected group exhibitions: Paris Biennial, 1969; Latin American Print Biennial, San Juan (Puerto Rico), 1972, 1974; Biennial of Black and White, Lugano, 1972; museums in Arizona, New Mexico, Texas and Pennsylvania, 1973-74; International Biennial of Graphic Arts, Florence, 1974; International Biennial of Graphic Arts, Ljubljana (Yugoslavia), 1975. Awards include: National Prize, International Festival of Painting, Cagnes-sur-Mer, 1974; Third Prize, Spanish-American Biennial of Painting, Mexico City, 1978. Public collections include: National Library, Paris; University of Massachusetts, Amherst; Slade School of Fine Arts, London; Museum of Modern Art, Mexico City; Mexican Museum, San Francisco. Lives in Mexico.

AQUINO, Humberto. Born 1947, Lima, Peru. Studied painting, drawing and printmaking, National School of Fine Arts, Lima; stage design and theatrical costume, National Institute of Dramatic Art, Lima; Cardiff College of Art, Wales; and Pratt Institute, New York, on Fulbright Fellowship. Individual exhibitions: galleries in Lima, Bogotá, London, and Washington D.C. (OAS, 1978). Selected group exhibitions: International Exhibition, Santiago (Chile), 1972; Coltejer Biennial, Medellín, 1972; National Museum of Wales, Great Britain, 1973; Museum of Modern Art, Cali, 1976; and galleries in El Salvador, Peru, the United States, and Great Britain. Awards include: Gold Medal, Goodyear Competition, Lima, 1972. Public collections include: Art Institute of Chicago and University of Texas Art Museum, Austin. Lives in New York.

ARNAL, Enrique. Born 1932, Catavi, Potosí, Bolivia. Attended workshop of Chilean painter Nemesio Antúnez. Individual exhibitions: galleries in La Paz, Buenos Aires, Asunción, Santiago (Chile), Lima, New York, Caracas (Museum of Fine Arts), and Washington, D.C. (OAS, 1976). Selected group exhibitions: Yale University and University of Texas, 1966; São Paulo Biennial, 1971; Coltejer Biennial, Medellín, 1972; Dallas Museum of Art. Awards include: Second Prize, National Salon of Plastic Arts, La Paz, 1961; First Prize, INBO Biennial, La Paz, 1975; Patiño Foundation grant. Public collections include: National Museum of Art, La Paz; University of Texas Art Museum, Austin; Phillips Collection, Washington D.C.

ASCHER, Daisy. Born 1944, Mexico City, Mexico. Studied under George Konduros. Founder and director of Daisy Ascher Photography School, Mexico City. Author of *José Luis Who?*, a photographic documentary on the life of Mexican artist José Luis Cuevas. Individual exhibitions: galleries in Mexico City and Washington D.C. (OAS, 1978).

BARCALA, Washington. Born 1920, Montevideo, Uruguay. Studied Fine Arts Circle, Montevideo, under José Cúneo. Individual exhibitions: galleries in Montevideo, Madrid, Bogotá, and Washington D.C. (OAS, 1979). Selected group exhibitions: International Festival of Painting, Cagnes-sur-Mer, France; Museum of Modern Art in São Paulo, Rio de Janeiro, Buenos Aires, and Paris; and galleries in Madrid and Barcelona (Spain). Awards include: First Prize for Painting, National Salon of Plastic Arts, Montevideo, 1958. Public collections include National and Municipal Museums of Art, Montevideo; Museum of Contemporary Art, Madrid. Lives in Madrid and Montevideo.

BASSAN, Nessim. Born 1950, Panama City, Panama. Studied at Isabel Almolda Academy of Art, Panama City; Peddie School, New Jersey; Colgate University and Art Students League, New York, under Brazilian printmaker Roberto De Lamônica. Individual exhibitions: galleries in Panama City (including Panamanian Art Institute) and Washington D.C. (OAS, 1973). Participated in Coltejer Biennial, Medellín, 1972. Awards include: Second Prize, Xerox Art Festival, Panama, 1970, 1972; First Prize, Xerox Art Festival, 1971. Represented in private and public collections in Panama, including Panamanian Art Institute.

BENCOMO, Mario (Mario Díaz Bencomo). Born 1953, Pinar del Río, Cuba. Studied Miami-Dade Community College. Individual and group exhibitions in the Miami area (including the Museum of Science). Awarded local prizes. Represented in private and public collections in Brazil, New York, and Miami, including the Miami Public Library. Lives in Miami.

BENGOCHEA, Miguel Angel. Born 1945, Buenos Aires, Argentina. Studied National Academy of Fine Arts and under Argentine master Juan Carlos Castagnino, both in Buenos Aires. Individual exhibitions: galleries in Buenos Aires, Bogotá, and Washington D.C. (OAS, 1979). Selected group exhibitions: Museum of Modern Art in Paris, Mexico City, and San Francisco; Corcoran Gallery of Art, Washington D.C.; University of Texas Art Museum, Austin; New Orleans Museum of Art; Cleveland Institute of Art; and in Madrid. Public collections include: Museum of Fine Arts, Museum of Modern Art, and Eduardo Sívori Museum, Buenos Aires; Genaro Pérez Museum, Córdoba (Argentina); and Cleveland Museum of Art. Lives in Argentina.

BIGATTI, Alfredo. Born 1898, Buenos Aires, Argentina. Died 1964, Buenos Aires. Studied National Academy of Fine Arts, Buenos Aires, and in Paris under sculptor Antoine Bourdelle. Professor of sculpture, School of Fine Arts, Buenos Aires. Numerous exhibitions in Latin America, Europe, and the United States, including OAS, Washington, D.C., 1957, and Museum of Modern Art, Paris, 1963. Awards include: National Prize for Sculpture, Buenos Aires, 1935; Grand Prize for Sculpture, International Exhibition, Paris, 1937; Gold Medal for Printmaking, International Exhibition, Brussels, 1958. Represented in private and public collections in the United States, Latin America, and Europe.

BORRERO, Ricardo. Born 1874, Gigante, Huila, Colombia. Died 1931, Bogotá. Landscape artist. Studied School of Fine Arts, Bogotá; in Seville; and Colarossi Academy, Paris. Professor and director, School of Fine Arts, Bogotá. Awards include: Gold Medal, Spanish-American Exhibition, Seville, 1930. Retrospective exhibition, Colombian-American Center, Bogotá, 1979. Represented in private and public collections in Colombia.

BOXER, David. Born 1946, St. Andrew, Jamaica. Doctorate, Art History, Johns Hopkins University, Baltimore. Director, National Gallery of Art, Kingston, Jamaica. Individual exhibitions: galleries in Kingston, New York, Los Angeles and Washington, D.C. (OAS, 1979). Group exhibitions: galleries in Jamaica, Mexico, the United

States, Venezuela, and Great Britain. Represented in private collections in Jamaica, Mexico, the United States, Venezuela, Canada, and Cuba. Lives in Jamaica.

BROWN, Clinton. Born in 1954, Kingston, Jamaica. Son of artist Everald Brown. Self-taught artist under guidance of his father. Preaching assistant, Ras Tafarian sect. Has exhibited in Jamaica and Washington, D.C. (OAS, 1972, 1978). Public collections include: National Gallery of Art, Kingston. Lives in Jamaica.

BROWN, Everald. Born in 1917, Parish of St. Ann, Jamaica. Primary school education. Carpenter by trade. Self-taught artist (painter, sculptor, musician). Ras Tafarian priest. Has exhibited in Jamaica, El Salvador, and Washington, D.C. (OAS, 1972, 1973, 1978). Awards include: Silver Medal, National Competition, Kingston; National Gallery of Art grant, Kingston, 1978. Public collections include: National Gallery of Art, Kingston. Lives in Jamaica.

CALDERON, Constancia. Born 1937, Panama City, Panama. Studied Rosemont College, Pennsylvania; Académie de la Grande Chaumière and Académie Julian, Paris. Individual exhibitions: galleries in Munich, Paris, Panama City (Panamanian Art Institute), and Washington, D.C. (OAS, 1964). Public collections include: Panamanian Art Institute, Panama City; Esso Standard Oil Collection, Florida.

CALZADA, Humberto. Born 1944, Havana, Cuba. Studied University of Miami. Individual exhibitions: galleries in Miami, San Juan (Puerto Rico), New York, and Washington, D.C. Selected group exhibitions: Lowe Art Museum, Miami; and OAS, Washington, D.C., 1978. Awards include: Cintas Fellowship, 1979-80; Fellowship, Florida Fine Arts Council, 1980. Public collections include: Fidelity National Bank, Miami; National Reserve Bank, Atlanta. Lives in Miami.

CAMPOREALE, Sergio. Born 1937, Buenos Aires, Argentina. Studied National Schools of Fine Arts Manuel Belgrano and Prilidiano Pueyrredón, Buenos Aires. Member of the art group *Grabas*. Solo exhibitions of this group: Museum of Modern Art, Miami; Museum of Modern Art, Bogotá; and galleries in Buenos Aires, Caracas, Mexico City, Medellín, Madrid, Warsaw, and Bonn. Individual exhibitions: Argentina, Chile, the United States, and Israel. Awards include: Silver Medal, Biennial of Graphic Arts, Cali, 1971. Public collections include: Museum of Fine Arts and Museum of Modern Art in Buenos Aires, and Museum of Modern Art in Cali and Bogotá. Lives in Buenos Aires.

CARBALLO, Aida. Born 1916, Buenos Aires, Argentina. Studied National Schools of Fine Arts Prilidiano Pueyrredón and Ernesto de la Cárcova. Selected individual exhibitions: National Museum of Fine Arts, Buenos Aires, and OAS Washington, D.C., 1976. Awards include: fellowship from the government of France for study in Paris, 1958-59; Critics Prize, National Salon of Plastic Arts, Buenos Aires, 1963; Grand Prize, National Salon of Plastic Arts, Buenos Aires, 1964. Public collections include: National Museum of Fine Arts, Buenos Aires; Museum of Modern Art, New York; Museum of Contemporary Art, Madrid; National Museum of Art, Warsaw. Lives in Argentina.

CARREÑO, Mario. Born 1913, Havana, Cuba. Citizen of Chile since 1957. Professor of Latin American Art, Catholic University, Santiago (Chile). Selected individual exhibitions: National Museum of Fine Arts, Havana, 1957; Institute of Modern Art, Boston, 1943; Museum of Modern Art, San Francisco, 1944; Museum of Fine Arts, Caracas, 1957, 1978; and galleries in Paris, Miami, Santiago (Chile), and Buenos Aires. Selected group exhibitions: Museum of Modern Art, Paris, 1941; Museum of Modern Art, New York, 1943; São Paulo Biennial, 1951, 1953, 1957; Venice Biennial, 1952; Pittsburgh International, 1951, 1953, 1957; Museum of Art, Houston, 1956; Yale University, 1966; Lowe Art Museum, Miami; and OAS Washington, D.C., 1946, 1947, 1952, 1959, 1962. Awards include: Guggenheim International Prize, 1965. Public collections include: Museum of Modern Art, New York; Museum of Modern Art, San Francisco; Museum of Fine Arts, Caracas; Carroll Reece Museum, Johnson City; Museum of Fine Arts, Havana; Museum of Fine Arts, Santiago (Chile); Metropolitan Museum and Art Center, Coral Gables. Lives in Chile.

CARULLA, Ramón. Born 1938, Havana, Cuba. Self-taught artist. Has exhibited in Florida (including the Lowe Art Museum), Canada, Venezuela, Colombia, Mexico, and Washington, D.C. (OAS, 1978). Awards include: Cintas Fellowship, 1973-74 and 1979-80. Public collections include: New School for Social Research, New York; Art in Public Places Program (Dade County), Public Library System, CBS International, G.B. Searle, and Pace Collections, Miami; and banks in Miami and Chicago. Lives in Miami.

CATTELANI, Raúl. Born 1927, Montevideo, Uruguay. Studied National School of Fine Arts, Montevideo. Individual exhibitions: galleries in Montevideo and La Plata. Selected group exhibitions: Second Biennial of Printmaking, Mexico City, 1960; Pratt Institute, New York, 1963; International Biennial of Graphic Arts, Ljubljana, 1963, 1965, 1967, 1969; International Biennial of Graphic Arts, Krakow; International Exhibition of Woodcuts, Museum of Art and History, Geneva, 1969. Awards include: Gold Medal, National Salon, Montevideo, 1965; OAS scholarship to study in Mexico City, 1970. Public collections include: National Museum of Fine Arts and Municipal Museum, Montevideo; Museum of Modern Art, Buenos Aires; Museum of Modern Art, Mexico City.

CORDOVA, Inés. Born 1927, Potosí, Bolivia. Studied National School of Fine Arts, La Paz, and attended workshops in Montevideo, Madrid, Barcelona (Spain), and Ayacucho (Peru). Has exhibited in Bolivia, Brazil, Colombia, Venezuela, France, Germany, Spain, Switzerland, and Washington, D.C. (OAS, 1979). Represented Bolivia in São Paulo Biennial, 1979. Awards include: First Prize, Second INBO Biennial, La Paz. Represented in private and public collections in Bolivia, Colombia, Venezuela, and the United States. Lives in Bolivia.

CORONEL, Pedro. Born 1923, Zacatecas, Mexico. Studied La Esmeralda Academy, Mexico City, and in Paris under painter Brauner and sculptor Brancusi. Has exhibited in Mexico, France, Italy, Japan, and the United States. Participated in the Sixth São Paulo Biennial, 1961, and exhibitions at the Solomon R. Guggenheim Museum and Cornell University Museum, New York, 1965. Awards include: First Prize for Painting, Palace of Fine Arts, Mexico City, 1959; José Clemente Orozco Prize, Second Inter-American Biennial of Mexico, 1960; Prize for Painting, Salon of Mexican Painting, Mexico City, 1966. Public collections include: Museum of Modern Art, Mexico City.

CRUZ-DIEZ, Carlos. Born 1923, Caracas, Venezuela. Studied School of Fine Arts, Caracas. Assistant director, School of Fine Arts, Caracas. Individual exhibitions: Museum of Fine Arts, Caracas; Museum of Modern Art, Bogotá; and galleries in Madrid, Torino, London, Paris, Venice, Rome, Brussels, Munich, Barcelona (Spain), and New York. Selected group exhibitions: Stedelijk Museum, Amsterdam, 1961; Pittsburgh International, 1961; Venice Biennial, 1962, 1970; Museum of Modern Art in Paris and New York, 1967; São Paulo Biennial, 1953, 1957, 1963, 1967, 1979; Museum of Art, Oslo, 1968; May Salon, Paris, 1970, 1972; Oxford Museum, England, 1970. Awards include: International Painting Prize, Ninth São Paulo Biennial, 1967; Second Prize, International Painting Festival, Cagnes-sur-Mer, France, 1969; National Plastic Arts Prize, Caracas, 1971. Public collections include: Victoria and Albert Museum, London; Museum of Modern Art in New York, Paris, and Bogotá; Museum of Contemporary Art, Montreal; Museum of Fine Arts, Caracas; Museum of Contemporary Art, Chicago; and other museums in Grenoble, Munich, Vienna, and Cologne. Lives in Paris.

CUEVAS, José Luis. Born 1933, Mexico City. Studied engraving under Lola Cueto, Mexico City College. Selected individual exhibitions: art museums in Philadelphia, Santa Barbara, and Phoenix; Munson-Williams-Proctor Institute, Utica; Museum of Modern Art in Mexico City, Bogotá, and Paris; Museum of Contemporary Art, Caracas; Palace of Fine Arts, Brussels; and galleries in Puerto Rico, Canada, El Salvador, Peru, Brazil, Switzerland, Italy, and Washington, D.C. (OAS, 1954, 1963, 1978). Participated in Venice Biennial, 1972, among other group exhibitions. Awards include: First International Prize for Drawing, São Paulo Biennial, 1959; First Prize, International Exhibition of Black and White, Lugano, 1962; Madeco Prize, Biennial of American Graphic Arts, Santiago (Chile), 1965; First International Prize for Printmaking, Triennial of Graphic Arts, New Delhi, 1968. Public collections include: Museum of Modern Art, Solomon R. Guggenheim Museum, and Brooklyn Museum, New York; art museums in Philadelphia, Worcester, Santa Barbara, Dallas, and Phoenix; museums of the universities of Michigan (Ann Arbor), California (Los Angeles), and Texas (Austin); Munson-Williams-Proctor Institute, Utica; Museum of Fine Arts, Caracas; Museum of Modern Art in Bogotá and São Paulo; National Gallery of Painting, La Paz; Museum of Fine Arts in Lyon and Marseille; Museum of Art, Tel Aviv. Lives in Paris and Mexico City.

CUNEO, José. Born 1887, Montevideo, Uruguay. Died 1977. Studied Fine Arts Circle, Montevideo; Vity Academy, Paris, under Van Dongen; and Académie de la Grande Chaumière, Paris. Individual exhibitions: galleries in Montevideo, Paris, Buenos Aires, Milan, Bogotá, and Baltimore. Selected group exhibitions: Spanish-American Exhibition, Seville, 1939; Venice Biennial, 1954; Spanish-American Exhibition, Barcelona (Spain), 1955. Awards include: Gold Medal, National Salon, Montevideo, 1941, 1942, 1949; Bronze Medal, International Art Exhibition, Paris, 1937. Public collections include: Jeu de Paume, Paris; and museums in Uruguay and Argentina.

DONDE, Olga. Born 1935, Mexico City, Mexico. Self-taught painter. Individual exhibitions: National Museum, Querétaro; Museum of Contemporary Art, Bogotá; and galleries in Mexico City. Selected group exhibitions: Palace of Fine Arts, Mexico City, 1968, and Carroll Reece Museum, Johnson City, 1969. Represented in private and public collections in Mexico, Colombia, and the United States. Lives in Mexico.

DREYFUS, Bernard. Born 1940, Managua, Nicaragua. Studied Charpentier Academy, Colin Studio, and Bournet Studio, Paris; and Art Center College of Science, Los Angeles. Individual exhibitions: galleries in New York, Managua, Nice, and Washington, D.C. (OAS, 1972). Selected group exhibitions: Autumn Salon, Paris, 1961; and galleries in the United States, Nicaragua, Costa Rica, France, and Belgium. Awards include: First Prize, Central American Painting, Costa Rica Biennial, San José, 1971. Public collections include: University of Texas Art Museum, Austin; Institute of Contemporary Art, Boston; Museum of Modern Art, São Paulo. Lives in Paris.

ESTOPIÑAN, Roberto. Born 1921, Havana, Cuba. Studied San Alejandro School of Fine Arts, Havana. Has traveled extensively in Europe, Asia, and the Middle East. Has exhibited in New York (Museum of Modern Art), Philadelphia, Cuba, Argentina, Colombia, France, Spain, and Washington, D.C. (OAS, 1964, 1976, 1978). Awards include: National Prize for Sculpture, Cuba; Third Prize, International Competition, Tate Gallery, London. Represented in public and private collections in the United States and Latin America. Lives in New York.

FUENTE, Manuel de la. Born 1932, Spain. Emigrated to Venezuela 1959. Studied School of Fine Arts in Seville and International School of Art in Florence. Professor, University of the Andes, Venezuela. Selected individual exhibitions: National Gallery of Art in Caracas, and OAS, Washington, D.C., 1978. Group exhibitions in Spain and Venezuela. Represented in public and private collections in Spain, Venezuela, and the United States. Lives in Venezuela.

GATTO, Domingo. Born 1935, Buenos Aires, Argentina. Studied National School of Fine Arts, Buenos Aires. Individual exhibitions: galleries in Buenos Aires, New York, Rome, Jerusalem, Caracas, and Miami. Selected group exhibitions; Museum of Modern Art, Buenos Aires; Carroll Reece Museum, Johnson City; and Latin American Print Biennial, San Juan (Puerto Rico), 1972. Awards include: Honorable Mention, National Salon of Plastic Arts, Buenos Aires. Public collections include: Museum of Modern Art and Eduardo Sívori Museum, Buenos Aires; Museum of Modern Art, Miami. Lives in Argentina.

GAY GARCIA, Enrique. Born 1928, Santiago de Cuba, Oriente, Cuba. Studied San Alejandro School of Fine Arts, Havana, and Instituto Politécnico, Mexico, under José Gutiérrez and David Alfaro Siqueiros. Director, School of Fine Arts, Santiago de Cuba. Participated in Biennial of São Paulo and of Venice. Has exhibited in New York, California, Florida, and Washington, D.C. (OAS, 1978). Awards include: UNESCO scholarship, 1960. Represented in private and public collections in the United States and Latin America. Lives in Miami.

GERCHMAN, Rubens. Born 1942, Rio de Janeiro, Brazil. Studied National School of Fine Arts, Rio de Janeiro. Directed and made scenography for 35 mm color film, *Triunfo hermético*, 1972. Individual exhibitions: Brazil (including Museum of Modern Art in Rio de Janeiro and São Paulo), and New York. Group exhibitions: galleries in Paris, Buenos Aires, Rio de Janeiro, São Paulo, and Washington, D.C. Awards include: Honorable Mention, Eighth São Paulo Biennial; Travel Prize to New York, National Salon of Modern Art, Rio de Janeiro, 1972. Public collections include: Indiana University, Bloomington; Museum of Contemporary Art, São Paulo; Museum of Modern Art in New York and Cali.

GRASSMANN, Marcelo. Born 1925, São Simão, São Paulo, Brazil. Self-taught artist. Individual exhibitions: galleries in Brazil, Italy, France, Washington, D.C. (OAS, 1960). Group exhibitions: Argentina, Chile, the United States, Italy, Austria, Peru, Mexico, and England. Awards include: Travel Prize, First National Salon of Modern Art, 1952; First Prize for Drawing, São Paulo Biennial, 1959; Prize for Sacred Art, Venice Biennial, 1958. Public collections include: Museum of Modern Art in Rio de Janeiro, São Paulo, and Buenos Aires; Dallas Museum of Fine Arts.

GRAU, Enrique. Born 1920, Cartagena, Colombia. Studied National School of Fine Arts, Bogotá, and Art Students League, New York, under Harry Sternberg, Morris Kantor, and George Grosz. Professor, National School of Fine Arts, Bogotá. Individual exhibitions: Colombia, Rome, New York, and Washington, D.C. (OAS, 1958, 1964). Selected group exhibitions: Venice Biennial, 1950; International Exhibition, Valencia (Venezuela), 1955; *Gulf Caribbean Art Exhibition*, Houston Museum of Art, 1956; São Paulo Biennial, 1957, 1959, 1961, 1963;

Milwaukee Art Center, 1957; Solomon R. Guggenheim Museum, New York, 1958 and 1960; Carroll Reece Museum, Johnson City, 1969; and galleries in Colombia and Spain. Awards include: First Prize, Tenth National Salon of Art, Bogotá; Prize for Painting, Ministry of Education, Bogotá, 1962. Represented in private and public collections in Latin America, the United States, and Europe. Lives in Colombia.

GUTIERREZ, Sérvulo. Born 1914, Ica, Peru. Died 1961, Lima. Studied under Emilio Pettoruti in Argentina. Also known as professional boxer. Exhibited in Latin America and Europe. Participated in group exhibit at OAS, Washington, D.C., 1957. Represented in public and private collections in Latin America.

HERNANDEZ CRUZ, Luis. Born 1936, San Juan, Puerto Rico. Studied University of Puerto Rico and American University, Washington, D.C. Director, Department of Fine Arts, University of Puerto Rico. Individual exhibitions: Puerto Rico (including University Museum, San Juan), New York, Miami, and Washington, D.C. (OAS, 1978). Selected group exhibitions: Institute of Hispanic Culture, Madrid, 1968; Second Coltejer Biennial, Medellín, 1970; Newark Museum, New Jersey, 1971; International Print Biennial, Tokyo, 1972; Museum of Contemporary Art, Madrid, 1973; Metropolitan Museum of Art, New York, 1973; Print Biennial of Ljubljana, 1973, 1975; São Paulo Biennial, 1975. Awards include: First Prize, *Esso Salon*, San Juan (Puerto Rico), 1964; National Prize, Second Latin American Print Biennial, San Juan (Puerto Rico), 1972. Represented in private and public collections in Latin America and the United States.

HERRERA, Alejandro. Born 1955, Oaxaca, Mexico. Studied Rufino Tamayo Workshop, under Roberto Donis. Group exhibitions: in Mexico--Oaxaca, Aguascalientes, Mexico City (Museum of Modern Art, 1976)--and in Washington, D.C. (OAS, 1979). Lives in Mexico.

HODICK, Angelo. Born 1945, Rio de Janeiro, Brazil. Individual exhibitions: galleries in Rio de Janeiro and Washington, D.C. Selected group exhibitions: Museum of Modern Art, Rio de Janeiro, 1964, 1967; Museum of Contemporary Art, São Paulo, 1966; Museum of Modern Art, Bogotá, 1970. Represented in private collections in Brazil, Colombia, and Washington, D.C.

HUEZO, Roberto. Born 1947, San Salvador, El Salvador. Studied National University and Catholic University, El Salvador. Individual exhibitions: galleries in San Salvador, Miami, and Washington, D.C. (OAS, 1979). Group exhibitions: Guatemala, El Salvador, Cuba (Casa de las Américas, 1979), and the United States. Represented in private and public collections in El Salvador and the United States.

JACOME, Ramiro. Born 1948, Quito, Ecuador. Self-taught artist. Individual exhibitions: galleries in Ecuador, Peru, and Washington, D.C. (OAS, 1980). Group exhibitions: Second Coltejer Biennial, Medellín, 1970; Museum of Modern Art, Bogotá, 1976; Italo-American Biennial of Printmaking, Rome, 1978; and galleries in Colombia, France, Italy, and Brazil. Awards include: First Prize, National Salon, 1979. Represented in private and public collections in Ecuador and the United States. Lives in Quito.

JARAMILLO, Luciano. Born 1938, Manizales, Colombia. Studied Colin Studio, Paris. Has executed murals for public buildings in Colombia. Individual exhibitions: galleries in Colombia, Paris, and Washington, D.C. (OAS, 1979). Selected group exhibitions: São Paulo Biennial, 1961, 1963; Paris Biennial, 1961; University of Texas Art Museum, Austin; and galleries in Colombia, Argentina, Brazil, Chile, Mexico, Panama, the United States, and Venezuela. Public collections include: Museum of Modern Art and Museum of Contemporary Art, Bogotá; Museum of Contemporary Art, Santiago (Chile). Lives in Colombia.

KAPO (Bishop Mallica Reynolds). Born 1911, Bynloss, Parish of St. Catherine, Jamaica. Self-taught painter and sculptor. Ordained bishop of a revivalist sect. Has exhibited in Jamaica, New York, Los Angeles, and Washington, D.C. (OAS, 1978). Awards include: Silver Musgrave Medal, Jamaica, 1969. Represented in private and public collections in Jamaica and the United States, as well as the Stedelijk Museum, Amsterdam. Lives in Jamaica.

KINGMAN, Eduardo. Born 1913, Loja, Ecuador. Studied National School of Fine Arts in Quito and School of Fine Arts in San Francisco. Forerunner of Indigenist expressionism in Ecuador. Executed murals for Ecuadorian Pavilion, New York World's Fair, 1939, and Ministry of Agriculture, Quito. Has exhibited in Ecuador and Colombia. Represented in private and public collections in Latin America.

LASANSKY, Mauricio. Born 1914, Buenos Aires, Argentina. United States citizen. Studied School of Fine Arts, Buenos Aires, and Atelier 17, New York. Professor of Art, University of Iowa. Selected individual exhibitions: Museum of Contemporary Art, Madrid, 1954; Los Angeles County Museum of Art, 1961; Brooklyn Museum, New York, 1961; Seattle Art Museum, 1961; San Francisco Museum of Art, 1945, 1950; Art Institute of Chicago, 1947; Palace of Fine Arts, Mexico City, 1969. Major international group exhibitions in Latin America, Europe, and the United States. Awards include: Guggenheim Fellowship, 1943, 1953; First Prize, Latin American Print Biennial, San Juan (Puerto Rico), 1970; First Prize, International Biennial of Graphic Arts, Florence, 1970; First Prize, Color Prints of the Americas, New Jersey State Museum, Trenton, 1970; First International Prize, Print Exhibition, Honolulu, 1970. Public collections include: Museum of Modern Art and Brooklyn Museum, New York; Art Institute of Chicago; Philadelphia Museum of Art; Seattle Art Museum; National Museum of American Art, Washington, D.C.; National Gallery of Victoria, Melbourne. Lives in Iowa.

LAZARO, Raquel. Born 1917, Havana, Cuba. Studied University of Havana and Biscayne College, Miami. Professor of Art, San Alejandro School of Fine Arts, Havana, and University of Havana. Has exhibited in Havana, New York, Miami (including Lowe Art Museum), and Washington, D.C. (OAS, 1978). Lives in Miami.

LEON, Omar d'. Born 1929, Managua, Nicaragua. Studied School of Fine Arts, Managua and in San Francisco. Selected group exhibitions: First Biennial of Hispanic Art, Madrid, 1951; Second São Paulo Biennial, 1953; *Gulf-Caribbean Art Exhibition*, Houston Museum of Fine Arts, 1956. Represented in private collections in Latin America and the United States. Lives in California.

LEWIS, Víctor. Born 1918, Colón, Panama. Self-taught artist. Has exhibited in Panama, Cuba, and Washington, D.C. (OAS, 1978). Awards include: First Prize, Annual Xerox Salon, Panama City, 1977. Represented in private and public collections in Panama, Costa Rica, and the United States. Lives in Panama.

LIBERTI, Juan Carlos. Born 1930, Buenos Aires, Argentina. Self-taught artist. Individual exhibitions: galleries in Argentina, Puerto Rico (University Museum), Venezuela, and Washington, D.C. (OAS, 1972). Selected group exhibitions: Museum of Modern Art, National Museum of Fine Arts, and Eduardo Sivori Museum, Buenos Aires; Museum of Modern Art, Mexico City, 1975; Corcoran Gallery of Art, 1975, and OAS, 1980, Washington, D.C.; Museum of Contemporary Art, Madrid, 1976; Art Institute of Chicago, 1976. Awards include: Third Prize for Drawing, Sixth National Salon of Prints and Drawings, Buenos Aires, 1970; First Prize, Piñero Pacheco Foundation Competition, Buenos Aires, 1979. Represented in private and public collections in Latin America and the United States. Lives in Buenos Aires.

LOGIOIO, Vechy. Born 1933, Santa Rosa, Province of La Pampa, Argentina. Studied in Switzerland under Maurice Wenger and in Argentina at the workshops of Emilio Pettoruti and Horacio Butler, and under Andreína Baj and Santiago Cogorno. Has exhibited in Argentina, Venezuela, Italy, Spain, and Washington, D.C. (OAS, 1980). Represented in private collections in Latin America, Europe, and the United States. Lives in Argentina.

LONDOÑO, Armando. Born 1947, Cali, Colombia. Studied Antioquia University, Medellín. Individual exhibitions: in Colombia, and New York and Washington, D.C. (OAS, 1979). Selected group exhibitions: First Biennial of Graphic Arts, Caracas; Miró Competition, Barcelona (Spain); Graphics Biennial, Ibiza; Washington, D.C. (OAS, 1974); and galleries in New York and Miami. Awards include: First Prize for Printmaking, Salon of Young Artists, Medellín, 1970, 1972. Represented in private and public collections in Colombia and the United States. Lives in New York.

LOPEZ, Abelardo. Born 1957, Oaxaca, Mexico. Studied Rufino Tamayo Workshop, Oaxaca, under Roberto Donis. Group exhibitions: in Mexico (Oaxaca, Aguascalientes, and Museum of Modern Art in Mexico City, 1976) and Washington, D.C. (OAS, 1979). Awards include: Prize, National Competition of Plastic Arts, Aguascalientes, 1978. Lives in Mexico.

LOPEZ RODEZNO, Arturo. Born 1906, Copán, Honduras. Died 1975. Studied architecture at University of Havana and painting at Julian Academy in Paris. Director, National School of Fine Arts, Tegucigalpa. Executed numerous fresco murals for public buildings in Honduras. Has exhibited in Honduras, Costa Rica, El Salvador, Guatemala, Colombia, the United States, France, and Italy. Awards include: First Prize, National Salon, Honduras. Represented in private and public collections in Latin America, the United States, and Europe.

MABE, Manabu. Born 1924, Kumamoto, Japan. Emigrated to Brazil in 1934. Selected individual exhibitions: Museum of Modern Art, Rio de Janeiro, 1960; National Museum of Fine Arts, Montevideo, 1960; Institute of Contemporary Art, Lima, 1963; Museum of Fine Arts, Houston, 1970; Lowe Art Museum, Miami, 1980; and galleries in Rio de Janeiro, São Paulo, New York, Buenos Aires, Paris, Rome, Trieste, Venice, Mexico City, Lisbon, Tokyo, and Washington, D.C. (OAS, 1962, 1980). Selected group exhibitions: São Paulo Biennial, 1953, 1955, 1959, 1965, 1971, 1973; Dallas Museum of Art, 1959; Venice Biennial, 1960; OAS, Washington, D.C., 1961, 1962, 1965, 1966, 1976; Institute of Contemporary Art, Boston, 1961; Royal College of Art, London, 1965; Museum of Contemporary Art, São Paulo, 1966; Coltejer Biennial, Medellín, 1972; Museum of Modern Art, Tokyo, 1973. Awards include: First Prize, Fifth São Paulo Biennial, 1959; Braun Award, First Paris Biennial, 1959. Represented in museum collections in Latin America, Europe, Japan, and the United States. Lives in São Paulo.

McLAREN, Sidney. Born 1895, St. Thomas, Jamaica. Died 1979. Primary school education. Self-taught artist. Began to paint at the age of sixty-five. Has exhibited in Jamaica, England, Guyana, and Washington, D.C. (OAS, 1978). Awards include: Silver Musgrave Medal, Jamaica, 1975. Represented in private and public collections in Jamaica and the United States.

MARTIN, Vicente. Born 1911, Montevideo, Uruguay. Studied Fine Arts Circle and Torres-García Workshop, Montevideo; and Académie de la Grande Chaumière, Paris. Professor of drawing and painting, National School of Fine Arts, Montevideo. Selected group exhibitions: First and Third São Paulo Biennials, 1951, 1955; Venice Biennial, 1960; Inter-American Biennial, Mexico City, 1958, 1960. Awards include: Gold Medal, National Salon, 1959. Public collections include: National Museum and Municipal Museum, Montevideo; Museum of Fine Arts, Santiago (Chile); Museum of Modern Art in Rio de Janeiro, São Paulo, and Buenos Aires; Museum of Hispanic Art, Madrid; Portland Art Museum, Oregon. Lives in Montevideo.

MARTINO, Federico. Born 1930, Buenos Aires, Argentina. Studied National School of Fine Arts in Buenos Aires and Corcoran School of Art in Washington, D.C. Individual exhibitions: Buenos Aires, Miami (including Miami Museum of Modern Art) and Washington, D.C. (OAS, 1963). Group exhibitions: galleries in England, Mexico, Argentina, and Uruguay. Participated in biennials in Mexico City, São Paulo, and Venice. Awards include: OAS fellowship. Represented in private and public collections in Latin America and the United States. Lives in Argentina.

MARTORELL, María. Born 1919, Salta, Argentina Studied in Argentina and Europe. Individual exhibitions: galleries in Buenos Aires, Bogotá, Caracas, Madrid, Paris, and Washington, D.C. (OAS, 1979). Selected group exhibitions: Palace of Fine Arts, Havana, 1957; Museum of Modern Art, Buenos Aires, 1960; Museum of Contemporary Art, Santiago (Chile), 1962; National Museum of Fine Arts, Buenos Aires, 1963, 1970; Museum of Modern Art, Mexico City, 1975; International Festival of Painting, Cagnes-sur-Mer, 1972. Awards include: Honorable Mention, National Salon, Buenos Aires, 1971. Public collections include: Museum of Modern Art, Buenos Aires; Museum of Modern Art, Mexico City; Chase Manhattan Bank, New York. Lives in Argentina.

MENDOZA, Ariel. Born 1956, Oaxaca, Mexico. Studied Rufino Tamayo Workshop, Oaxaca, under Roberto Donis. Individual exhibition: Puebla (Mexico). Group exhibitions: in Mexico (Oaxaca, Aguascalientes, and Museum of Modern Art in Mexico, 1976) and Washington, D.C. (OAS, 1979). Awards include: Prize, National Competition of Plastic Arts, Aguascalientes, 1974, 1978.

MORALES, Felipe. Born 1959, Oaxaca, Mexico. Studied Rufino Tamayo Workshop, Oaxaca, under Roberto Donis. Group exhibitions: Museum of Modern Art, Mexico City, 1976; OAS, Washington, D.C., 1979. Lives in Mexico.

NUÑEZ URETA, Teodoro. Born 1912, Arequipa, Peru. Professor of Art History, University of Arequipa. Painter and watercolorist. Has executed murals for public buildings in Lima, including Ministry of Housing and Ministry of Education. Has exhibited in Peru, Chile, Canada, the United States, and Central America. Awards include: Guggenheim Fellowship, 1943; National Prize, 1954. Decorated by Peruvian government, 1980. Represented in private and public collections in Latin America and the United States.

OCAMPO, Miguel. Born 1922, Buenos Aires, Argentina. Studied architecture, National University, Buenos Aires. Individual exhibitions: galleries in Rio de Janeiro (including Museum of Modern Art, 1959), New York, Miami,

Ottawa (National Art Center, 1974), Buenos Aires, Montevideo, Panama City, Caracas, Paris, Rome, Madrid, and Washington, D.C. (OAS, 1969). Selected group exhibitions: National Gallery of Art, Washington, D.C., 1955; Dallas Museum of Art, 1959; Art Institute of Chicago, 1959; Walker Art Center, Minneapolis, 1964; Akron Art Institute, Ohio, 1964; University of Texas Art Museum, Austin, 1965. Participated in Venice Biennial, 1956; São Paulo Biennial, 1953; Festival of Two Worlds, Spoleto, 1963. Public collections include: Museum of Modern Art, New York; Albright-Knox Art Gallery, Buffalo; University of Texas Art Museum, Austin; National Museum of Fine Arts and Museum of Modern Art, Buenos Aires; Museum of Modern Art, Rio de Janeiro; National Museum of Fine Arts, Montevideo; State Collection, Paris.

OROZCO, José Clemente. Born 1883, Ciudad Guzmán, Jalisco, Mexico. Died 1949, Mexico City. Founding member of the Mexican muralist movement with Diego Rivera and David Alfaro Siqueiros. One of the forerunners of modern art in Latin America. Exerted influence on United States artists, such as Jackson Pollock. Important murals in Latin America and the United States. Represented in major museum collections throughout the world.

OSTROWER, Fayga. Born 1920, Lodz, Poland. Brazilian citizen since 1940. Studied Getulio Vargas Foundation, Rio de Janeiro; Atelier 17, Paris; and Brooklyn Museum Art School, New York. Selected individual exhibitions: Museum of Modern Art, São Paulo; Ministry of Education and Museum of Modern Art, Rio de Janeiro; Museum of Modern Art, San Francisco; Art Institute of Chicago; Institute of Contemporary Art, London; Stedelijk Museum, Amsterdam; Amos Andersson Museum, Helsinki; OAS, Washington, D.C., 1955. Group exhibitions in Latin America, Asia, Europe, and the United States. Awards include: Fulbright Fellowship, 1954; National Prize, São Paulo Biennial, 1957; Grand International Prize, Venice Biennial, 1958; Critics Prize, Rio de Janeiro, 1963, 1967, 1969, 1972; Engraving Prize, Second International Graphics Biennial, Florence, 1970. Public collections include: National Museum of Fine Arts, Rio de Janeiro, Museum of Modern Art in São Paulo and Rio de Janeiro; San Francisco Museum of Art; Museum of Modern Art, New York; Library of Congress, Washington, D.C.; Victoria and Albert Museum and Institute of Contemporary Art, London; Museum of Art, Hamburg; Stedelijk Museum, Amsterdam; Museum of Modern Art, Tel Aviv.

OVALLE, Guillermo. Born 1957, Bogotá, Colombia. Studied David Manzur Workshop, Bogotá, and at present Art Students League, New York. Has exhibited in Bogotá and Miami. Lives in New York.

PEREZ, Humberto. Born 1931, Medellín, Colombia. Studied drawing and design, Pasadena College and Claremont College, California; and painting, Art Center, Los Angeles. Individual exhibitions in Colombia and Washington, D.C. (OAS, 1980). Participated in group exhibitions at Museum of Modern Art in Bogotá and Medellín, and is represented in their collections. Lives in Colombia.

PONCE DE LEON, Fidelio (Alfredo Fuentes Pons). Born 1895, Camagüey, Cuba. Died 1949. One of the forerunners of modern art in Cuba. Studied San Alejandro School of Fine Arts, Havana. Individual exhibitions in Havana, Boston, and New York. Participated in *Cuban Painting Today*, Museum of Modern Art, New York, 1944, among other group exhibitions. Awarded national prizes, 1935, 1938. Retrospective of his work, National Museum, Havana, 1957. Represented in the Museum of Modern Art, New York, as well as private and public collections in the Americas.

PRESNO, Lincoln. Born 1917, Montevideo, Uruguay. Studied Fine Arts Circle and Torres-García Workshop, Montevideo. Has executed numerous murals for public buildings in Uruguay. Has exhibited in Uruguay, Argentina, Brazil, Ecuador, Mexico, Czechoslovakia, the Netherlands, Spain, Egypt, Syria, and the United States (including OAS, 1964). Participated in the First, Second, and Third São Paulo Biennials, 1951, 1953, 1955. Awards include: Gold Medal, National Salon, 1952, 1955. Public collections include: National Museum and Municipal Museum, Montevideo; University of Texas Art Museum, Austin. Lives in Montevideo.

REBAZA, Gilberto. Born 1939, Trujillo, Peru. Studied National School of Fine Arts, Lima. Individual exhibitions: galleries in Lima and Washington, D.C. (OAS, 1979). Group exhibitions: São Paulo Biennial, 1965; Museum of Modern Art, Lima; and galleries in Cuba, Chile, and Peru. Represented in private collections in Peru and the United States.

RIBERO, Gonzalo. Born 1942, Cochabamba, Bolivia. Studied Academy of Fine Arts, Cochabamba; School of Architecture, Mackenzie University, São Paulo; Paulist Association of Fine Arts, São Paulo; and under Brazilian artist Yutaka Toyota. Has exhibited in São Paulo, La Paz, Cochabamba, and Washington, D.C. (OAS, 1970).

Participated in Eighth São Paulo Biennial, 1965, and Coltejer Biennial, Medellín, 1968. Represented in private collections in Bolivia and Brazil. Lives in Bolivia.

RODRIGUEZ, Richard. Born 1950, Havana, Cuba. Studied master's program in photography, George Washington University, Washington, D.C. Instructor of photography, Northern Virginia Community College. Has exhibited in Washington, D.C. (including Washington Project for the Arts), San Francisco, New York, Charlottesville, and Richmond (Virginia Museum of Fine Arts). Awards include: Best in Show, *Photography Exhibition*, the Athenaeum, Virginia Museum of Fine Arts, Alexandria, 1980; Prize, National Artists' Alliance, Photography Competition, New York, 1980. Public collections include: Corcoran Gallery of Art, Washington, D.C.; Northern Virginia Community College. Lives in Washington, D.C.

SANCHEZ, Cecilio. Born 1957, Oaxaca, Mexico. Studied Rufino Tamayo Workshop, Oaxaca, under Roberto Donis. Group exhibitions: in Mexico (Oaxaca, Aguascalientes, and Museum of Modern Art in Mexico City, 1976) and Washington, D.C. (OAS, 1979). Lives in Mexico.

SANTIAGO, Filemón. Born 1958, Oaxaca, Mexico. Studied Rufino Tamayo Workshop, Oaxaca, under Roberto Donis. Individual exhibition: Chicago. Group exhibitions: in Mexico (Oaxaca, Aguascalientes, and Museum of Modern Art in Mexico City, 1976), the Netherlands, and Washington, D.C. (OAS, 1979). Lives in Chicago.

SEOANE, N. Born 1930, Santos, State of São Paulo, Brazil. Numerous individual exhibitions in Latin America and Europe. Selected group exhibitions: Sixth, Seventh, and Ninth São Paulo Biennials, 1961, 1963, 1967; Second Art Biennial, Santiago (Chile); Museum of Modern Art in Rio de Janeiro and São Paulo; and galleries in New York, Uruguay, Chile, England, and Portugal. Executed mural, Department of Agriculture, São Paulo. Awards include: Gold Medal, Museum of Modern Art, São Paulo, 1965. Public collections include: Museum of Modern Art in New York, Rio de Janeiro, São Paulo, and Tel Aviv.

SERRA-BADUE, Daniel. Born 1914, Santiago, Cuba. Studied School of Fine Arts in Santiago, Havana, and Barcelona (Spain); Art Students League and Pratt Institute, New York. Instructor of drawing and painting, Brooklyn Museum Art School; professor of art, St. Peter's College, New Jersey. Individual exhibitions: galleries in Havana, New York, Washington, D.C., Philadelphia, Barcelona (Spain), Miami, and Puerto Rico. Selected group exhibitions: Art Institute of Chicago, 1938; Whitney Museum of American Art, New York, 1940; Pennsylvania Academy of Fine Arts, 1941; Carnegie Institute, Pittsburgh, 1941; First Spanish-American Biennial, Madrid, 1951; Fifth São Paulo Biennial, 1959; Graphics Biennial, Ibiza, 1974 and 1980; Ringling Museum of Art, Sarasota, 1980; and numerous national salons in Havana. Awards include: Guggenheim Fellowship, 1938, 1939; Lippincott Prize, Pennsylvania Academy of Fine Arts, 1941; Purchase Prize, Seventh National Salon and Second Hispanic-American Art Biennial, Havana, 1954; Cintas Fellowship, 1963, 1964; First Prize for Painting, Fifty-sixth Annual Exhibition, American Society of Contemporary Arts, New York, 1974. Public collections include: National Museum, Havana; Metropolitan Museum, New York; Public Library, New York and Miami; Butler Institute of American Art, Youngstown (Ohio). Lives in New York.

SILVA, Francisco da. Born 1910, Alto Tejo, Acre, Brazil. Self-taught artist. Has exhibited in São Paulo, Geneva, Lausanne, Lisbon, and Paris. Included in exhibition of Brazilian primitive artists circulated in Europe including Moscow, 1966. Awards include: Honorable Mention, Venice Biennial, 1966. Represented in private collections in Brazil and Europe.

SILVA, José Antônio da. Born 1909, Sales de Oliveira, São Paulo, Brazil. Worked as agricultural laborer. Self-taught artist. Individual exhibitions in São Paulo. Selected group exhibitions: São Paulo Biennial, 1951-1961; Venice Biennial, 1952, 1966; Pittsburgh International, 1955; Museum of Modern Art, São Paulo, 1956. Awards include: Honorable Mention, São Paulo Biennial, 1951; Jury's Prize, São Paulo Biennial, 1961. Public collections include: Museum of Modern Art in São Paulo, Rio de Janeiro, and New York.

SINCLAIR, Alfredo. Born 1915, Panama City, Panama. Studied workshop of Panamanian artist Humberto Ivaldi and Ernesto de la Cárcova School of Fine Arts, Buenos Aires. Individual exhibitions: galleries in Buenos Aires, Panama City (including National Museum, 1959, and Panamanian Art Institute, 1963), and Washington, D.C. (OAS, 1963). Selected group exhibitions: OAS, Washington, D.C., 1953; São Paulo Biennial, 1957; Biennial of Mexico, 1958; and galleries in Venezuela, Costa Rica, Guatemala, Argentina, Spain, Germany, France, Mexico, El Salvador, Colombia, and the United States. Awards include: Grand Prize, Xerox Competition, Panama, 1969.

Public collections include: University of Texas Art Museum, Austin; Museum of Contemporary Art, Bogotá; Panamanian Art Institute, Panama City.

SOLARI, Luis A. Born 1918, Fray Bentos, Uruguay. Studied Fine Arts Circle, Montevideo; Académie de la Grande Chaumière, Paris; and in New York. Individual exhibitions: Montevideo, Buenos Aires, São Paulo, Santiago, Bogotá, New York, Dallas, San Juan (Puerto Rico), Paris, Madrid, Tel Aviv, and Washington, D.C. (OAS, 1964). Selected group exhibitions: International Biennial of Florence, Venice, Barcelona (Spain), Ljubljana, and Tokyo; Corcoran Gallery of Art, Washington, D.C.; New Jersey State Museum, Trenton; Library of Congress, Washington, D.C. Awards include: First Prize for Drawing, National Salon of Fine Arts, Montevideo, 1965; Gold Medal for Printmaking, Art Festival, Cali, 1970; Merit Award, Pratt Graphics Center, New York, 1968. Public collections include: National Museum of Fine Arts and Municipal Museum, Montevideo; Museum of Modern Art in São Paulo, Rio de Janeiro, New York; Museum of the Americas, Madrid; Metropolitan Museum and Brooklyn Museum, New York; Cincinnati Art Museum, Ohio; Library of Congress, Washington, D.C.; San Francisco Museum of Art; New Jersey State Museum, Trenton; University of Texas Art Museum, Austin. Lives in Port Washington, New York.

SORIANO, Rafael. Born 1920, Matanzas, Cuba. Studied San Alejandro School of Fine Arts, Havana. Director, School of Fine Arts in Matanzas and professor of design, University of Miami. Individual exhibitions in Havana (including Palace of Fine Arts, 1955). Group exhibitions in Cuba, El Salvador, Mexico, Madrid, Florida (including Lowe Art Museum in Coral Gables and Ringling Museum of Art in Sarasota), Georgia (High Museum of Art, Atlanta), and Washington, D.C. (OAS, 1978). Awarded prizes in national and international art festivals in Miami. Represented in private collections in Latin America and the United States. Lives in Miami.

TAMAYO, Rufino. Born 1899, Oaxaca, Mexico. Most influential forerunner of modern art in Latin America, especially on generation of the 1940s and 1950s. Recent retrospectives, Phillips Collection, Washington, D.C., and Solomon R. Guggenheim Museum, New York, 1979. Important murals in Latin America and the United States. Represented in major museum collections throughout the world. Lives in Mexico.

TORAL, Mario. Born 1934, Santiago, Chile. Studied School of Fine Arts, Paris, under Henri Adam. Professor, Catholic University, Santiago, and artist-in-residence, Fordham University, New York. Selected individual exhibitions: Museum of Modern Art in São Paulo and Rio de Janeiro, 1964; OAS, Washington, D.C., 1973; Museum of Modern Art, Rijeka, 1974; and galleries in Spain, New York, France, Argentina, and Brazil. Selected group exhibitions: Paris Biennial, 1961; National Gallery of Canada, Ottawa, 1962; São Paulo Biennial, 1965; Yale University and University of Texas, 1966. Awards include: First Prize for Printmaking, Salon of Fine Arts, Paris, 1961; Honorable Mention, International Print Exhibition, Ljubljana, 1963; Critics' Prize, Best Exhibition of the Year, Santiago (Chile), 1963; Vinkovic Prize, International Print Biennial, Rijeka; Gold Medal, Eighth São Paulo Biennial, 1965; Wolf Prize, Ninth São Paulo Biennial, 1967; Guggenheim Fellowship, 1974-75. Public collections include: Metropolitan Museum of Art, Museum of Modern Art, and Brooklyn Museum, New York; Museum of Contemporary Art, Santiago (Chile); Museum of Modern Art, Rio de Janeiro and Rijeka. Lives in New York.

TRUJILLO, Guillermo. Born 1927, Horconcitos, Panama. Studied architecture, University of Panama; landscape design and ceramics, Institute of Hispanic Culture, Madrid; and painting, San Fernando School of Fine Arts, Madrid. Has executed murals for public buildings in Panama. Individual exhibitions: galleries in Panama City (including National Museum and Panamanian Art Institute), Lima, Caracas, Madrid, Miami, and Washington, D.C. (OAS, 1961). Selected group exhibitions: Spanish-American Biennial, Barcelona (Spain), 1957; Second Coltejer Biennial, Medellín, 1970. Awards include: Honorable Mention, Fifth São Paulo Biennial, 1959; Second Prize, *Esso Salon of Panama*, 1964. Represented in private and public collections in Latin America and the United States.

VADIA, Rafael. Born 1950, Havana, Cuba. Studied Miami-Dade Community College; New York Studio School with summer session in Paris; School of Fine Arts, Paris; and Florida International University. Individual exhibitions: Paris, Miami, and Washington, D.C. Numerous group exhibitions in the Miami area, including Lowe Art Museum, Museum of Science, and Metropolitan Museum and Art Center. Awards include: Verna Lammi Prize, Norton Museum, Palm Beach, 1980. Represented in private and public collections in Florida, including Miami-Dade Public Library System.

VAZQUEZ, Carlos. Born 1955, Oaxaca, Mexico. Studied Rufino Tamayo Workshop, Oaxaca, under Roberto

Donis. Group exhibitions: in Mexico (Oaxaca, Aguascalientes, and Museum of Modern Art in Mexico City, 1976) and Washington, D.C. (OAS, 1979). Lives in Mexico.

VELAZQUEZ, Juan Ramón. Born 1950, Río Piedras, Puerto Rico. Studied lithography, Pratt Graphics Center, New York. Individual exhibitions: Puerto Rico (including University Museum, Rio Piedras), Colombia, and Washington, D.C. (OAS, 1977). Group exhibitions in Puerto Rico and El Salvador. Public collections include: University Museum in Río Piedras and Museum of Fine Arts in San Juan, both in Puerto Rico where he lives.

January 27 - February 26, 1981

ART OF VENEZUELA TODAY

It will soon be five years since the Museum of Modern Art of Latin America opened its doors to the public. Since it was the Permanent Representative of Venezuela to the Organization of American States--at that time Ambassador José María Machín--who was instrumental in the establishment of the Museum, it seems appropriate to present in this anniversary year a panorama of contemporary art in that country.

The exhibit was first shown in Boston, as part of the celebration of the 350th anniversary of the city's founding. During the latter part of 1980, it was on view in New York City.

The works composing the collection provide an overall view of creative endeavor in a country that for more than two decades has occupied a vanguard position in developments in the arts. In a flowering of activity in all lines, trends range from abstract expressionism to kinetism, from post-impressionism to hyper-realism.

The Museum takes this opportunity to express deep appreciation to the Ministry of Foreign Affairs of Venezuela and to the country's Embassy in the United States and Permanent Mission to the OAS for generous support in making this presentation possible. --*J.G-S.*

CATALOGUE

Painting, Drawing, and Sculpture

Antonia (Ana Antonia Azuaje)
 1. *La papeleta de la muerta (Death Ballot)*, oil on canvas, 51 x 61 cm. (20 x 24")

Aryssasi (Alcides Rubén Yssasi)
 2. *Orinoco*, oil on canvas, 70 x 59 cm. (27 1/2 x 23")

Pablo Benavides
 3. *Cerro San Antonio, el valle (Saint Anthony's Hill, the Valley)*, oil on canvas, 46 x 70 cm. (18 x 27")

Francisco Bellorín
 4. *Mujer vegetal (Vegetal Woman)*, pastel on paper, 100 x 65 cm. (39 x 25"), framed

Henry Bermúdez
 5. *Presencia mágica (Magical Presence)*, acrylic and ink on canvas, 110 x 140 cm. (43 x 55")

Lía de Bermúdez
 6. *Sin título (Untitled)*, iron and steel sculpture, height 45 cm. (18")

Corina Briceño
 7. *Sin título (Untitled)*, pastel and pencil on paper, 60 x 85 cm. (23 x 33"), framed

Omar Carreño
 8. *Composición (Composition) No. 5*, acrylic on canvas, 100 x 100 cm. (39 x 39")

Feliciano Carvallo
9. *Selva azul (Blue Jungle)*, oil on canvas, 40 x 50 cm. (16 x 20")

Ender Cepeda
10. *Figuras con perro (Figures with Dog)*, oil on canvas, 100 x 78 cm. (43 x 31")

Jorge Chacón
11. *Oriel*, oil on canvas, 60 x 73 cm. (23 x 29")

Luis Chacón
12. *Satélite (Satellite) No. 38*, polished aluminum sculpture on a polyethylene base, height 78 cm. (30")

Carlos Cruz-Diez
13. *Inducción cromática: azul + negro + blanco = amarillo (Chromatic Induction: Blue + Black + White = Yellow)*, acrylic on wood, 100 x 100 cm. (39 x 39")

Iván Estrada
14. *Fotografía agraciada (Graceful Photograph)*, pencil and crayon on paper, 64 x 50 cm. (25 x 20")

Luis Guevara Moreno
15. *Arturo Art Pur*, collage, 50 x 40 (19 x 15")

Francisco Hung
16. *Materias flotantes (Floating Matters)*, acrylic on canvas, 80 x 100 cm. (31 x 39")

Humberto Jaimes Sánchez
17. *Muro cromático (Chromatic Wall)*, oil on canvas, 67 x 82 cm. (26 x 32")

Ernesto León
18. *Hay algo al revés (Something Is Turned Around)*, pencil and charcoal on paper, 97 x 67 cm. (38 x 26")

Emerio Darío Lunar
19. *Viajero (Traveler)*, oil on canvas, 60 x 69 cm. (23 x 27")

Mateo Manaure
20. *Columna policromada (Polychrome Column)*, mixed media, 143 x 56 cm. (56 x 22")

Ana María Mazzei
21. *Intangible Wood Structures*, oil on cedar wood, 110 x 110 cm. (43 x 43")

Juan Mendoza
22. *Sin título (Untitled)*, acrylic on canvas, 130 x 75 cm. (51 x 29")

Elsa Morales
23. *Cuando anochece allá en el cerro (When Night Falls There in the Mountain)*, oil on canvas, 90 x 80 cm. (35 x 31")

Manuel Vicente Mujica
24. *Interior con figura en verde (Interior with Figure in Green)*, oil on canvas, 92 x 70 cm. (36 x 27")

Carmelo Niño
25. *Sin título (Untitled)*, oil on canvas, 90 x 80 cm. (25 x 31")

Luisa Palacios
26. *Punta azul (Blue Point)*, oil on canvas, 70 x 90 cm. (27 x 35")

Anita Pantin
27. *La muerte de J. María España (The Death of J. María España)*, acrylic on canvas, 76 x 84 cm. (30 x 33")

Pedro Piña
28. *Intersección policromada (Polychromed Intersection)*, acrylic on Formica, 90 x 120 cm. (35 x 47")

Héctor Poleo
29. *Laberinto (Labyrinth)*, acrylic on canvas, 70 x 70 cm. (27 x 27")

Carlos Prada
30. *Sin título (Untitled)*, bronze sculpture, height: 19 cm. (7 1/2")

Francisco Quilici
31. *El espacio se cierra sobre el tradicional espacio (Space Closes on Traditional Space)*, acrylic, pastel, crayon and ink on canvas, 120 x 120 cm. (47 x 47")

José Antonio Quintero
32. *Arboles, helechos y montaña (Trees, Ferns, and Mountain)*, oil on canvas, 130 x 90 cm. (51 x 35")

Nerio Quintero
33. *Y querían volar (And They Wanted to Fly)*, acrylic and crayon on canvas, 86 x 75 cm. (34 x 29")

Alirio Rodríguez
34. *Vestigios (Vestiges) V,* 1972, acrylic on canvas, 55 x 46 cm. (21 x 18")

Margot Romer
35. *Pentimento I*, oil on canvas, 87 x 124 cm. (34 x 49")

Edison Rosales
36. *Of the Sea and the Andes*, wool on wood, 100 x 60 cm. (39 x 23 cm.)

Eduardo Rosales
37. *Persistencia de la irrealidad (Persistence of Irreality)*, acrylic on canvas, 76 x 61 cm. (30 x 24")

Octavio Russo
38. *Estación germinal (Germinal Season) II*, pencil on paper, 50 x 71 cm. (20 x 28")

Norman Salas
39. *Barcos de pesca (Fishing Boats)*, oil on canvas, 80 x 60 cm. (31 x 23")

Braulio Salazar
40. *Paisaje (Landscape)*, oil on canvas, 95 x 76 cm. (37 x 30")

Edgar Sánchez
41. *Rostro (Face) I*, 1978, watercolor and pencil on canvas, 100 x 95 cm. (39 x 37")

Jesús Soto
42. *Azul-más-azul (Blue and More Blue)*, mixed media, 85 x 85 cm. (33 x 33")

William Stone
43. *Va a nacer (About to Be Born)*, oil on canvas, 100 x 100 cm. (39 x 39")

Oswaldo Subero
44. *Pintura bidimensional (Bidimensional Painting) No. 79*, acrylic on canvas, 80 x 70 cm. (31 x 27")

Víctor Valera
45. *Relieve-tacos-azules (Relief-Blue-Plugs)*, mixed media, 60 x 60 cm. (23 x 23")

Oswaldo Vigas
46. *Lúdicas (Playful)*, 1966, oil on canvas, 100 x 80 cm. (39 x 31")

Esther Wallis
47. *Pinos (Pine Trees)*, pastel on canvas, 50 x 65 cm. (20 x 25")

Cornelis Zitman
48. *Carajitas (Girls)*, bronze, height 112 cm. (44")

BIOGRAPHICAL NOTES [1]

ANTONIA (Ana Antonia Azuaje). Painter, born in Venezuela. Self-taught artist.

ARYSSASI (Alcides Rubén Yssasi). Painter, born in Venezuela. Self-taught artist.

BELLORIN, Francisco. Painter, graphic artist, born in Caripito, Monagas, Venezuela, 1941. Studied Escuela de Artes Plásticas y Aplicadas, Caracas, and printmaking with Atilio Giuliani, Rome. Lived and worked in Europe, 1961-64. In 1972-74 specialized in printmaking in Warsaw, Geneva, and Mexico City, under a scholarship from the Instituto Nacional de Cultura y Bellas Artes and the University of Zulia. Since 1978 has been a member of the group *Nuevo espacio*. Held individual exhibitions in Morocco, Brussels, Bogotá, Venezuela, New York. Participated in group shows in Venezuela and Europe. Was awarded several prizes, including First Prize with Great Distinction, Royal Academy of Fine Arts, Brussels, 1965; Antonio Edmundo Monsanto Prize, 1970, and Andrés Pérez Mujica Prize, 1971, both at the Arturo Michelena Salon, Ateneo de Valencia (Venezuela).

BENAVIDES, Pablo. Painter, born in Caracas, Venezuela, 1918. Studied Escuela de Artes Plásticas, Caracas, 1940-45. Has exhibited mainly in Caracas and was awarded the Arístides Rojas Prize for Landscape, Official Salon, Caracas, 1963.

BERMUDEZ, Henry. Painter, draftsman, graphic artist, born in Maracaibo, Zulia, Venezuela, 1951. Studied Escuela de Artes Plásticas, Maracaibo, 1965-1970. Lived in Mexico City and studied graphics at the National School for Painting and Sculpture. Held individual exhibitions in Maracaibo, Caracas, and Mexico City. Participated in numerous group exhibitions in Latin America, the United States, and Europe, including the Third Biennial of Drawing, Cleveland (England), 1976, Tenth Biennial of Paris, 1977. Was awarded several prizes in Venezuela. Lives in New York.

BRICEÑO, Corina. Painter, draftsman, born in Caracas, Venezuela, 1943. Studied with Pedro Centeno Vallenilla at Escuela de Artes Plásticas y Aplicadas and graduated from Centro de Enseñanza Gráfica. Also studied art at the Universidad Central de Venezuela, and Universidad Simón Bolívar, both in Caracas. Held one individual exhibition in Caracas. Participated in national salons and group shows in Colombia, the United States, France, and Argentina. Was awarded the Emilio Boggio Prize, Arturo Michelena Salon, Ateneo de Valencia (Venezuela), 1978.

CARREÑO, Omar. Painter, draftsman, printmaker, born in Porlamar, Nueva Esparta, Venezuela, 1927. Studied Escuela de Artes Plásticas y Aplicadas, Caracas; Académie de la Grande Chaumière, Ecole Nationale Supérieure des Beaux-Arts, Collège de France, and Ecole du Louvre, Paris; International Center of Studies for the Conservation and Restoration of Cultural Heritage, Rome. Lived in Paris, 1952-62. Member of the group *Los disidentes*, 1950. Since 1950 has held individual exhibitions in Venezuela (including the Museo de Bellas Artes, Caracas, 1965, 1974), Paris, Lausanne, Florence, Rome, Venice. Participated in the Salon de Mai, 1954, and Salon des Comparaisons, 1955, Paris; Biennial of Venice, 1958, 1962; and many other group exhibitions. Since 1950 has been awarded numerous prizes and distinctions in Venezuela, including the National Prize for Plastic Arts, Caracas, 1972; Arturo Michelena Prize, Ateneo de Valencia (Venezuela), 1973; and the Order of Andrés Bello, Third Degree, Caracas, 1978.

CARVALLO, Feliciano. Painter, born in Naiguatá, Vargas, Venezuela, 1920. Attended elementary school for the first time at the age of ten. Except for some direction received from Armando Reverón, is a self-taught artist. Since 1948 has held several individual shows in Venezuela, including Galería de Arte Moderno, Caracas, institution that organized his first one-man show in Paris, 1966. Participated in group exhibitions in his country

[1] Not included in the original catalogue. See Index of Artists for reference on those not listed here. --*Ed.*

and abroad, including Washington and New York. "The Primitive of Naiguatá," as he was first known, was awarded, among others, the National Prize for Painting, and the Armando Reverón Prize, Official Salons, 1966.

CEPEDA, Ender. Painter, born in Maracaibo, Zulia, Venezuela, 1945. Studied Experimental Center of Art, Mérida, 1966, and School Neptalí Rincón, Maracaibo, 1970, both in Venezuela. Exhibited individually in Maracaibo and Caracas and participated in national salons and other group exhibits in Venezuela and Colombia. Was awarded a Scholarship Prize at the First Salon of Drawing and Painting, Maracaibo, 1975.

CHACON, Jorge. Painter, born in San Cristóbal, Táchira, Venezuela, 1933. Since 1968 has held individual exhibitions in Caracas.

ESTRADA, Iván. Draftsman born in Valencia, Carabobo, Venezuela, 1950. Studied technical and mechanical drawing while working as graphic designer in Valencia. Member of the group *Nueva visión*, Valencia, 1974-76. Participated in national group exhibitions, including *El dibujo nuevo en Venezuela*, 1978, and the traveling exhibition *Manos de siempre, signos de hoy*, 1979.

LEON, Ernesto. Draftsman, born in Caracas, Venezuela, 1956. Studied Academia Superior de Bellas Artes de San Fernando, Madrid; Centro de Estudios Gráficos, Caracas; and graduated from the Instituto Nacional de Conservación y Restauración, Mexico. Participated in national group exhibitions. Was awarded the Fundarte Prize, Second Drawing Salon, Caracas, 1980.

LUNAR, Emerio Darío. Painter, draftsman, born in Cabimas, Zulia, Venezuela, 1940. After finishing elementary school, studied accordion and took a correspondence course in humorous drawing. Did advertising design while working in the family winery and playing in local bands. At the age of twenty-six started painting on his own, copying illustrations and postcards. In 1969 was awarded the José Ortín Rodríguez Prize, Salon D'Empaire, Maracaibo, and held his first individual exhibition in Caracas, which was followed by others in Venezuela. Participated in national group shows, winning several other prizes.

MAZZEI, Ana María. Painter, graphic artist, born in Caracas, Venezuela, 1941. Studied School of Fine Arts, Torino, 1956-58; in Caracas at Escuela de Artes Plásticas y Aplicadas, 1969-73, Centro de Artes Gráficas, 1972-75, and Workshop of Luisa Palacios, 1977-81; and in Geneva at the Center for Contemporary Prints, 1975. Held individual exhibitions in Venezuela and abroad, including the Museum of Latin American Engravings, San Juan (Puerto Rico). Participated in national and international shows in Latin America and Europe, including the São Paulo Biennial, 1973, and the Salon d'Automne, Paris, 1978. Among other prizes, won the Honorable Mention, Plastic Arts Salon, Caracas, 1976.

MENDOZA, Juan. Painter, born in Maracaibo, Zulia, Venezuela, 1946. After graduating from the Neptalí Rincón School of Plastic Arts in Maracaibo, lived in London and New York, 1968-1975. Exhibited in Maracaibo and Caracas.

MORALES, Elsa. Painter, born in Santa Teresa del Tuy, Miranda, Venezuela, 1941. Self-taught as an artist, held her first individual exhibition in Caracas, 1969, followed by others in Venezuela and in New York. Participated in national salons and other group exhibitions in Latin America and the United States. Was awarded several distinctions, among others, Honorary Mention, Miami, 1974, and the Bárbaro Rivas Prize, Arturo Michelena Salon, Valencia (Venezuela), 1979.

MUJICA, Manuel Vicente. Painter, born in Duaca, Lara, Venezuela, 1924. In 1942 entered the Escuela de Artes Plásticas y Aplicadas, Caracas. Under a scholarship from the Instituto Nacional de Cultura y Bellas Artes, traveled to Spain, 1967, and visited other European countries. Held individual exhibitions in Caracas and other Venezuelan cities, and in Madrid and Barcelona (Spain) where he also participated in group exhibitions. Won the Critics' Award, Barcelona (Spain), 1967, among other prizes.

NIÑO, Carmelo. Painter, draftsman, born in Maracaibo, Zulia, Venezuela, 1951, where he studied at the Escuela de Artes Plásticas, 1967-70. Held individual exhibitions in Venezuela, including the Galería de Arte Nacional, Caracas, 1977. Participated in group exhibitions in Venezuela, Cuba, the United States, and Europe, including the International Triennial of Drawing, Wroclaw (Poland), and the Salon d'Automne, Paris, 1978. In Venezuela was awarded a Scholarship Prize, Maracay, 1971; First Prize, National Salon of Young Artists, Caracas, 1975,

among other distinctions.

PANTIN, Anita. Painter, draftsman, born in Caracas, Venezuela, 1949. Studied Workshop Episcopo, Rome; Instituto de Diseño Neumann-Ince and Luisa Palacios Workshop, Caracas; Center of Contemporary Prints, Geneva. In 1977 held her first individual exhibition, followed by others in Caracas. Participated in national exhibitions in Caracas.

PIÑA, Pedro. Painter, born in Zulia, Venezuela, 1953. Studied Escuela de Artes Plásticas, Maracaibo, where he lives, works, and exhibits.

PRADA, Carlos. Sculptor, jewelry designer, born in Cumaná, Sucre, Venezuela, 1944. Studied Escuela de Artes Plásticas y Aplicadas, 1958-62, and completed the graduate course Light, Color, and Vision, Instituto Pedagógico, Caracas, 1973. Was selected as one of the eight Venezuelan sculptors to work under the English sculptor Kenneth Armitage, Caracas, 1964. Under a scholarship from the Instituto Nacional de Cultura de Bellas Artes, 1965-66, traveled in Europe and the United States where he returned in 1970 and 1979. Held high positions in art schools and institutions. Executed sculptures for public buildings in Caracas. Designed the medals for the Rómulo Gallegos Latin American Literary Prize and the National Prize for Music and Literature, 1972. His first individual exhibition took place at the Museo de Bellas Artes, 1965, followed by others in Caracas and other Venezuelan cities. Participated in national and international shows, including the Fourth Biennial of Young Artists, Paris, 1965, and the Third Coltejer Biennial, Medellín, 1972. As a jewelry designer has also participated in international shows in Venezuela, Ireland, and West Germany. Among his most important awards are the National Prize for Sculpture, 1966, and the International First Prize for Sculpture, Madurodam (Netherlands), 1967.

QUILICI, Francisco. Painter, draftsman, printmaker, born in Caracas, Venezuela, 1954. Studied Instituto de Diseño Neumann-Ince and Centro de Enseñanza Gráfica, Caracas. Held one individual exhibition in Caracas, 1980. Participated in group shows in Venezuela, the United States, Colombia, and France, including Grands et Jeunes d'Aujourd'hui, Paris, 1980. Among his most important awards are the Bernardo Rubinstein Prize, 1978, and the Eduardo Alemán Prize, 1980, both for printing, Arturo Michelena Salon, Valencia (Venezuela).

QUINTERO, José Antonio. Painter, draftsman, printmaker, born in Caracas, Venezuela, 1946. Studied in Caracas at Escuela de Artes Plásticas y Aplicadas, 1960-64; Instituto de Diseño Neumann-Ince, 1964-68; Print Workshop of Luisa Palacios; Print Workshop of Luis Chacón; and Graphic Center of the Instituto Nacional de Cultura y Bellas Artes. Since 1963 has held individual exhibitions in Caracas. Has participated in national and international group shows, including the International Biennial of Print, Pistoia, 1968, and First International Biennial of Print, Catania, 1969, both in Italy; Second International Exhibition of Original Drawings, Rijeka, 1970; Biennial of Cali, 1977; First Latin American Biennial of Graphic Art, Rome, 1980. Won several distinctions for printmaking and in 1973 the Prize for Landscape and the First Prize Avellán, Caracas.

ROMER, Margot. Painter, draftsman, printmaker, born in Caracas, 1938. Studied with Armando Lira, 1952; Workshop of Lucio Rivas, 1963-64; Taller Libre de Arte, 1965-68; Escuela de Artes Plásticas y Aplicadas and Centro Gráfico, 1969-71; Print Workshop of Luisa Palacios, 1973-74. Formed, with Ana María Mazzei and others, a group of young artists who searched for new expressions based on pop art, 1972-74, and organized exhibitions such as *Contributing to the General Confusion*, 1972, and *Skin to Skin*, 1973. Founding member of the Taller de Artistas Gráficos Asociados (TAGA), 1976, taught art, and held high positions in art-related institutions. Since 1972 has held individual exhibitions in Caracas and Bogotá. Participated in group shows in Latin America, the Caribbean, and Europe, including the Biennial of São Paulo, 1973; Graphic Arts Biennial, Segovia (Spain), 1974; Graphic Arts Biennial, Cali, 1977; Salon d'Automne, Paris, 1978. Among other awards, won the Arturo Michelena Prize, Valencia (Venezuela), 1977.

RUSSO, Octavio. Draftsman, born in Monagas, Venezuela, 1948. Studied Escuela de Artes Plásticas y Aplicadas, 1966-68; Centro Gráfico, 1966-70; Centro de Enseñanza Gráfica, 1980, all in Caracas. Founder and director of Museo de Arte Contemporáneo, Porlamar, Nueva Esparta. Held individual exhibitions in Porlamar. Participated in national group exhibitions. Won the Armando Reverón Prize for Drawing, Arturo Michelena Salon, Valencia (Venezuela), 1973.

SALAZAR, Braulio. Painter, draftsman, born in Valencia, Carabobo, Venezuela, 1917. Studied with Emma

Silveira, Valencia, 1928-32. Traveled periodically to Caracas to visit the Museum of Fine Art and receive instruction from Antonio Monsanto, Rafael Monasterios, and Rafael González. Under a scholarship from the Carabobo state government, traveled to Mexico; attended the San Carlos School of Art as well as the studio of Diego Rivera, Guerrero Galván, and other painters, learning fresco techniques, 1947. Visited the United States and Europe, residing mainly in France and Italy, 1948-49. Founder of the First Workshop of Drawing and Painting, Valencia, 1945, which became in 1948 the Escuela de Artes Plásticas y Aplicadas, and where he was director and professor until 1970. Founding member of the Ateneo and the group *Studio* also in Valencia. Executed a stained-glass mural, University Campus, Caracas, 1953, and mosaic, fresco, and ceramic murals in Valencia. Since 1935 has held individual exhibitions in Valencia, Caracas, and Maracay. Since 1942 participated in national salons and group exhibitions in Venezuela, the Caribbean countries, Mexico, and Colombia. Among many other awards and distinctions won the Arturo Michelena Prize, Valencia, 1948 and 1963, and in Caracas was awarded the Order of Andrés Bello in 1973, the National Prize for Plastic Arts in 1976, and Order of Miguel José Sanz, First Degree, in 1979.

SANCHEZ, Edgar. Painter, draftsman, printmaker, born in Aguada Grande, Lara, Venezuela, 1940. Studied Escuela de Artes Plásticas, Barquisimeto, 1954-59; Architecture School, Central University of Venezuela, Caracas, 1960-66; Printmaking Workshop, New York, 1970-72. Founding member and director of the Lithography Workshop, Centro de Enseñanza Gráfica, Caracas, where he continues to teach. Since 1968 has held individual exhibitions in Barquisimeto; Caracas (including the Museo de Bellas Artes, 1968) and New York. Participated in national and international shows in the United States, Mexico, and Spain, as well as biennials in Paris, 1967; Cali, 1977; Cleveland (England), 1977; Krakow, 1978. Won numerous national awards, including first prizes at Salon of Young Artists, 1963, National Salon of Drawing and Print, 1966, and National Salon of New Drawing, 1979, all in Caracas.

SOTO, Jesús Rafael. Painter, sculptor, born in Ciudad Bolívar, Bolívar, Venezuela, 1923. Studied, under a scholarship, at the Escuela de Artes Plásticas y Aplicadas, Caracas, 1942-47, and was named director of the Escuela de Bellas Artes, Maracaibo, 1947-49. In 1950 went to Paris, met Agam, Tinguely, and Pol Bury, and started investigating the field of kinetic art. Executed murals, sculpture pieces, and kinetic structures for public buildings in Venezuela, France (including the new UNESCO building in 1969 and the Centre Pompidou in 1979, both in Paris), Germany, Switzerland (including the Bureau International du Travail, Geneva, 1974), Canada, and other countries. In 1973 the Jesús Rafael Soto Foundation headed by him created the Museo de Arte Moderno Jesús Rafael Soto in Ciudad Bolívar with his private art collection. Among his many individual exhibitions are those held at different museums in Venezuela, Colombia, the United States, Belgium, Germany, France, Switzerland, Denmark. Has participated in national and international shows, including Parisian salons and many avant-garde exhibitions in Europe; biennials in São Paulo and Venice; museums in South and North America, Europe, Japan, and Israel. Among his most important awards are the National Prize for Painting, Caracas, 1960; Wolf Prize, São Paulo Biennial, 1963; David Bright Prize, Venice Biennial, 1964; Intergraphik Prize, East Berlin, 1980. His decorations and distinctions include Chevalier de l'Ordre des Arts et des Lettres, Paris; Gold Medal, International Biennial of Graphics, Oslo; Gold Medal, Convegno Internazionale Artisti Critici e Studiosi d'Arte, Rimini (Italy), 1967; Conseiller d'Honneur, Association Internationale des Arts Plastiques, UNESCO, Paris; Order of Andrés Bello, First Degree, Caracas. Lives in Paris and Caracas.

STONE, William. Painter, printmaker, sculptor, born in Caracas, Venezuela, 1945. Studied Taller Libre de Arte, Escuela de Artes Plásticas y Aplicadas, Instituto de Diseño Neumann-Ince, Print Workshop of Luisa Palacios, all in Caracas. Formed, with Margot Romer and others, a group of young artists who searched for new expressions based on pop art, 1972-74, organizing exhibitions such as *Contributing to the General Confusion*, 1972, and *Skin to Skin*, 1973. Held individual exhibitions in Caracas, Madrid, and the United States. Participated in national and international group shows, including the São Paulo Biennial, 1973. Won several awards in Caracas, including the Pegaso Prize, Ateneo de Caracas, 1965; José Loreto Arismendi Prize, Official Salon, 1969; Fundación Mendoza Prize, 1973; as well as the Juan Lovera Prize, Arturo Michelena Salon, Valencia (Venezuela), 1978.

SUBERO, Oswaldo. Painter, born in Caracas, Venezuela, 1934. Studied at the Escuela de Artes Plásticas y Aplicadas, Caracas, 1954-58; Accademia delle Belle Arti, Rome, 1961-65; with Frank Popper, University of Vincennes, Paris, 1970-72; and attended the graduate course Light, Color, and Vision, Instituto Pedagógico, Caracas, 1973. Held high positions and is a professor in art-related institutions. Since 1960 has held individual exhibitions in Madrid, Rome, Caracas and other Venezuelan cities, including the Museo de Arte Moderno Jesús

Rafael Soto, Ciudad Bolívar, 1977. Participated in national and international group shows in Italy, France (including Grands et Jeunes d'Aujourd'hui, Paris, 1972), Colombia, and Peru. Was awarded Gold Medal, First Mostra Internazionale di Pittura, Rome, 1965; Vicson Prize (1974), and Morales Lara Prize (1975), Salon Arturo Michelena, Valencia (Venezuela); Order of Andrés Bello, Third Degree, Caracas, 1979.

ZITMAN, Cornelis. Sculptor, draftsman, industrial designer, born in Leyden, Zuid, Netherlands, 1926. Studied at the Academy of Fine Arts, Leyden, 1943; Royal Academy of Fine Arts, The Hague, 1945-47. In Venezuela, worked as a technical designer in a construction company, as a furniture designer, and as professor of drawing. Held individual exhibitions in Caracas (including the Museo de Bellas Artes, 1962, and the Museo de Arte Contemporáneo, 1976), Paris, Amsterdam, Oslo, Bogotá, New York, and Tokyo. Participated in group exhibitions in Venezuela and Europe. Won the National Prize for Sculpture, Official Salon, Caracas, 1951; First Prize, Biennial of Small Sculpture, Budapest, 1971; Prize for Sculpture, National Salon, Caracas, 1976. Has lived in Venezuela since 1947.

February 5 - 27, 1981

HUGO ROJAS OF BOLIVIA

Born in La Paz, Bolivia, in 1936, Hugo Rojas initiated his formal studies in art at the National School of Fine Arts in La Paz in 1954. During 1957-1960, he studied at the Integrated Normal School and later he attended special courses in serigraphy in Lima, Peru.

Hugo Rojas's first individual exhibition took place at the Municipal Salon in La Paz in 1956. Since that time he has held eleven one-man shows and has participated in a number of group exhibitions in Argentina, Brazil, Colombia, Puerto Rico, and Spain.

The art of Hugo Rojas is a good example of the abstract tradition in Bolivia today. With special emphasis on landscaping, he treats his native country as a dramatic rendering of its orography in which an infinite wealth of minerals makes surprising changes in the color of the earth. In the geometrical angularity of shapes in his work, abundant in modern Bolivian art, Hugo Rojas can definitely be called a real Bolivian painter. --*J.G-S.*

EXHIBITION LIST [1]

Oils

1. *Andino* (Andean)
2. *Altiplano* (High Plateau) I
3. *Ruinas* (Ruins) I
4. *Milenio* (Millenary)

Silkscreens

5. *De los mitos* (About Myths)
6. *Telúrico* (Telluric)
7. *Altiplano* (High Plateau) II
8. *La cumbre* (Summit)
9. *De la tierra* (From the Earth)
10. *Ruinas* (Ruins) *II*
11. *Puna*
12. *La carretera* (Road)
14. *La ventana* (Window)
15. *Ancestro* (Ancestor)

[1] Not included in the original catalogue. --*Ed.*

March 3 - 27, 1981

ROBERTO GALICIA OF EL SALVADOR

The work of Roberto Galicia stands out in contemporary Salvadoran painting by reason of its meticulous craftsmanship. Compositions are consciously and carefully structured, and the refinement of their execution results in surfaces that are extraordinarily clean and neat. The constant opposition between rationalistic abstraction--exemplified by straight lines and rigid squares--and subjective emotion--suggested by the overlaps of irregular paper edges--may be taken as symbolic of the age-old conflict between reason and sentiment.

A figure highly representative of the spirit of artistic inquiry that characterizes the rising generation in El Salvador, Roberto Galicia was born in the town of Ahuachapán in 1945, and it was there that he received elementary instruction in drawing. In 1977 he moved to the capital, San Salvador, and entered the university as a student of architecture. At the same time he began to frequent the workshop of the well-known Salvadoran artist Carlos Cañas and under his direction took up painting in a systematic manner. Only a year later he was able to hold his first one-man show at the National University. This marked the start of his professional career in a country which, though small, has a lively art scene.

In addition to painting, Galicia has engaged in stage design and book illustration. In cooperation with his fellow painter Roberto Huezo, he executed an important mural in San Salvador's Teatro Presidente. The artist's work has figured in group shows in Brazil, Central America, France, Germany, and the United States and has won him awards and recognition at a number of salons and biennial expositions.

The cooperation of the Patronato Pro-Cultura of El Salvador in making this exhibit possible is deeply appreciated. --*J.G-S.*

EXHIBITION LIST [1]

Oils on Illustration Board

1-15. *Estudio (Study) I-XV*

March 3 - 27, 1981

JOSE NERY OF EL SALVADOR

Central America is fortunate in possessing, in addition to well-established art centers and schools that provide excellent professional training in painting and sculpture, an abundance of self-taught artists, of the type generally identified as "primitives." Their attention tends to focus on nature and the environment, which they analyze, idealize, and depict with an attention to minute detail that is taught in none of the academies. At one time or another, each of the Central American republics has had at least one of these intuitive landscape painters, some of whom have achieved a renown extending well beyond national borders. One such example is provided by the Nicaraguan embroiderer and painter Asilia Guillén. Another is furnished by the Honduran José Antonio Velásquez, arguably the best primitive ever to appear in Latin America.

It is not surprising that the land of El Salvador, with its picturesque villages and its spectacular volcanoes, mountain valleys, and lakes, should prove a fertile source of inspiration to native practitioners of art naif. A place of distinction in their ranks is held by José Nery, notable for his fastidious technique, his clarity, and his rigorous attention to detail.

Nery was born in 1951 in the town of Jiquilisco. While still a child he moved to the colorful village of San Marcos, not far from his country's capital, San Salvador. Entirely self-taught, he has been active for the last nine

[1] Not included in the original catalogue. --*Ed.*

years. He has participated constantly in group shows in his native land, winning a number of awards. In 1975 he was proclaimed the most promising artist of that year.

Deep appreciation is here expressed to the Patronato Pro-Cultura of El Salvador for its generous assistance in rendering this exhibit possible. --*J.G-S.*

EXHIBITION LIST [1]

Paintings

1-7. *San Marcos*

March 31 - April 24, 1981

ANTONIO PELAEZ OF MEXICO

When, some seven years ago, the Mexican painter Antonio Peláez abandoned the representational style that he had long favored, abstractionism--which has not enjoyed great popularity in the land south of the Rio Grande--gained an adherent who quickly took rank as one of the foremost exponents of the mode in all Latin America.

Peláez's compositions display a masterly handling of all the essential elements of painting. They combine the intellectual attraction of carefully calculated geometric forms with the sensual appeal of a delicate palette, and the richness and variety of the textures are a constant invitation to touch. The subdued range of pale color and the stability suggested by the prevalence of straight lines give rise to a sensation of poise and placidity. Contemplating one of Peláez's paintings, the viewer has the feeling of gazing across space at a calm horizon.

Antonio Peláez was born in 1921 in the Spanish province of Asturias. He was still but a child when his family moved to Mexico, and there he has lived ever since. He is a Mexican citizen.

In 1937 he enrolled at the school of painting and sculpture known as La Esmeralda, where he studied under such well-known figures as Jesús Guerrero Galván and José Moreno Villa. Later he served as an assistant to the celebrated Diego Rivera and his wife Frida Kahlo.

From 1952 to 1980 Peláez gave a total of fifteen one-man shows: nine in Mexico, four in Paris, one in Madrid, and one in San Juan, Puerto Rico. He has traveled extensively in Latin America, the United States, and Europe and has frequently participated in foreign group exhibitions--in Sydney, Brussels, Tokyo, Austin (Texas), and a number of French cities. He figured in a group show devoted to Mexican abstract art that was presented at OAS headquarters in 1978. This is his first individual exhibit in the United States.

Appreciation is here expressed to the Mexico City Museum of Modern Art and to the Mexican Secretariat of Foreign Affairs for assistance in making this exhibition possible. --*J.G-S.*

EXHIBITION LIST [2]

Oils on Canvas

1. *Interrupción* (Interruption), 1973, 130 x 170 cm.
2. *Fuente* (Fountain), 1978, 50 x 60 cm.
3. *La compuerta* (Floodgate), 1979, 120 x 180 cm.

[1] Not included in the original catalogue. --*Ed.*

[2] Not included in the original catalogue. --*Ed.*

4. *Función doble* (Double Show), 1979, 100 x 180 cm.
5. *El cemento y las flores* (Cement and Flowers), 1979, 120 x 140 cm.
6. *Suspensión* (Suspension), 1979, 90 x 120 cm.
7. *Pirámide lunar* (Lunar Pyramid), 1979, 100 x 80 cm.
8. *Zona prohibida* (Prohibited Zone), 90 x 120 cm.
9. *Umbral arcaico* (Archaic Threshold) *I*, 1979, 60 x 85 cm.
10. *Pared pública* (Public Wall), 1979, 60 x 85 cm.
11. *Mecanismo elemental* (Elemental Mechanism), 1979, 50 x 70 cm.
12. *Ejes* (Axis), 1979, 50 x 70 cm.
13. *Puerta secreta* (Secret Door), 1980, 120 x 140 cm.
14. *Conducto secreto* (Secret Path), 1980, 90 x 120 cm.
15. *Trabe mágica* (Magic Beam), 1980, 120 x 100 cm.
16. *Aire verde* (Green Air)
17. *Día de fiesta y día después* (Celebration Day and the Day After)
18. *Correspondencia del jazz* (Jazz Correspondence)
19. *De fuego y piedra* (Fire and Stone)
20. *Rayo* (Thunder)

April 28 - May 22, 1981

DENNIS KAN OF VENEZUELA: PHOTOGRAPHS

The Venezuelan photographer Dennis Kan was born in his country's capital, Caracas, in 1953.

While he is currently embarked upon a program leading to the Master of Fine Arts degree at the George Washington University, he is also actively engaged in the practice of his profession, as is attested by his frequent participation in group exhibitions in Venezuela and the United States and five one-man shows--four in Washington, D.C., and one in Memphis, Tennessee.

His prints are remarkable, not only for their technical quality but also for the imagination they reveal, as Kan exploits with dazzling success the often surprising effects to be obtained from close-range photography--the aesthetic possibilities inherent in vegetable textures, for example. The viewer is thereby introduced to a whole new order of forms, perceived only through the vision of an artist. --*J.G-S.*

EXHIBITION LIST [1]

Photographs

1. *Vecino (Neighbor)*
2. *Tercer cinturón (Third Belt)*
3. *Bugs*
4. *Mall*
5. *Marea alta (High Tide)*
6. *Two-Dimensional Visitors*
7. *Sin título (Untitled)*
8. *Tradición (Tradition)*
9. *Andes*
10. *Sin título (Untitled)*
11. *Sin título (Untitled)*
12. *The Night J.L. Died*
13-14. *La Guaira*
15. *Exchange*

[1] Not included in the original catalogue. --*Ed.*

16. *Geométrico (Geometric)*
17. *Luz (Light)*
18. *Independencia 1821 (Independence 1821)*

April 28 - May 22, 1981

CONSUELO MENDEZ OF VENEZUELA

Venezuela today is a veritable beehive of artistic activity, production being as remarkable for variety as for quality. All contemporary currents have their followers; all media find cultivators. A healthy spirit of adventure pervades oil painting, printmaking, collage, and sculpture.

In graphics, trends range from the highly traditional to the boldly experimental, dramatic expressionism being represented by a newly emergent artist of rank, Consuelo Méndez. Skilled in every aspect of her craft, she creates prints of striking sobriety and austerity.

Consuelo Méndez was born in Caracas in 1952. She first undertook the study of art in 1970 in Houston, Texas, where she attended the school attached to the Museum of Art and took courses in communications, drawing, and painting at Rice University. Later she enrolled at the San Francisco Art Institute, from which she graduated in printmaking in 1973. In 1976 she obtained a certificate in the same field from the San Francisco branch of the University of California and that year she returned to Venezuela, where she attended the First Workshop for Young Illustrators, a joint undertaking of the Ministry of Education and the National Council for Culture (CONAC). During 1979 and 1980 she took courses in graphic arts offered by CONAC.

Consuelo Méndez has executed murals in public buildings in California, Texas, and Venezuela, and her prints are to be found in public and private collections both in the United States and her own country, notably in the Permanent Graphic Archives of the National Gallery in Caracas.

The present show, representative of the artist's professional maturity, is her first individual exhibition in the United States. --*J.G-S.*

EXHIBITION LIST [1]

Graphic Work and Drawings

1.a. *Cara* (Face)
 b. *Cayendo* (Falling)
 c. *Esperando* (Waiting)
2.a. *Pajarito en blanco* (Bird in White)
 b. *Garza negra* (Black Heron)
 c. *Alas de mariposa* (Butterfly Wings)
3.a. *Garza entre hojas* (Heron among Leaves)
 b. *Garza entre verdes* (Heron among Greens)
 c. *Pájaro en relieve* (Relief of Bird)
4. *...En tres etapas* (. . . In Three Steps)
5. *Esta cantidad de vuelo por la piel* (How Many Wings on the Skin!)
6. *Muñecas de trapo de todos los colores se ríen de mí* (Rag Dolls of Different Colors Laugh at Me)
7. *Pascua imaginaria* (Chimerical Easter)
8. *Autorretrato* (Self-Portrait)
9. *Perfil en negros* (Profile in Blacks)
10. *Cara* (Face)
11. *Desnudo* (Nude)

[1] Not included in the original catalogue. --*Ed.*

12. *Más allá de un desnudo* (Beyond a Nude)
13. *Esta cantidad de vuelo por la piel* (How Many Wings on the Skin!)
14. *Desde adentro* (From Inside)
15. *Retrato de César Rengifo* (Portrait of César Rengifo)
16. *Ser de nuevo por las calles* (Being Once Again in the Streets)
17. *Arrastro cosas* (I Drag Things Along)
18. *Rastros* (Traces)
19. *Apenas queda un rastro* (Hardly a Trace Remains)
20. *Autorretrato* (Self-Portrait)
21. *Desintegración* (Disintegration)
22. *Vengo de lejos de este cansancio* (I Come from Far Away with This Weariness)
23. *Estos son mis dedos recortados* (These Are the Cut-outs of My Fingers)

May 26 - June 19, 1981

SHEILA LICHACZ OF PANAMA

Sheila Lichacz was born in Monagrillo, Panama, in 1942. She undertook the study of art at the Inter-American University in Puerto Rico, and in recent years has enjoyed very considerable success. Since 1977 she has had ten individual exhibits and participated in numerous group shows.

Most of the artist's career has been devoted to the depiction of the fruits and household utensils to be found in the tropics. The representation is so simplified as to border on abstraction. The intricate designs of her compositions exude great power, however, and the towering masses, with their feeling for volume, convey a sense of solidity suggestive of sculpture.

This is Sheila Lichacz's first individual presentation in the United States. *--J.G-S.*

EXHIBITION LIST [1]

Pastels

1. *Retazos de mi cielo (Remnants of My Sky)*
2. *Tinajas (Jars)*
3. *Flor de banana* (Banana Flower)
4. *Supervivencia* (Surviving)
5. *Patria sagrada* (Sacred Homeland)
6. *Guanábanas* (Sour-Sop)
7. *La hora de los mameyes* (The Hour of the Mameyes)
8. *Sábado de carnaval* (Saturday of Carnival)
9. *Por los Bajos de Herrera* (In the Bajos de Herrera)
10. *Optimismo y pesimismo* (Optimism and Pessimism)
11. *Aguacates* (Avocados)
12. *Caimitos*
13. *Sí, tinajas, siempre tinajas* (Yes, Jars, Always Jars)
14. *Melones* (Melons)
15. *Mandarinas* (Tangerines)
16. *El beso* (The Kiss)

[1] Not included in the original catalogue. *--Ed.*

May 26 - June 19, 1981

ROGELIO PRETTO OF PANAMA

Though still a relative newcomer on the art scene, Rogelio Pretto has already had no fewer than five one-man shows, in addition to being included in important group exhibitions both in his native Panama and in Mexico.

His last individual exhibit took place in 1980 at the Gallery Meeting Point in Miami, Florida. Both the subject matter of the pictures there displayed and the technique employed by the artist led to a readily understandable first impression that the work was that of a researcher in the field of entomology: fastidiously executed depictions of insects constituted the bulk of the show. A more careful examination of the compositions, however, revealed the purely plastic values which were the true object of Pretto's concern.

The current exhibit does not concentrate on insects but draws rather on a variety of human elements, each of which is analyzed in a highly effective manner. Sensitivity to color values and skill in rendering minute detail are characteristic features of the paintings here on view, part of whose charm derives precisely from their minimal format.

Rogelio Pretto was born in Colón, Panama, in 1944 and began to exhibit in 1976. He considers himself to be self-taught. --*J.G-S.*

EXHIBITION LIST [1]

Temperas

1. *John Lennon: resumen* (John Lennon: Summary), 1980
2. *La herencia* (The Heritage), 1980
3. *Opciones* (Options), 1981
4. *La galería y el pueblo* (The Gallery and the People), 1981
5. *Toquecitos de rojo* (Fine Strokes of Red), 1981
6. *Los que sí y los que no* (Those Who Are and Those Who Are Not), 1981
7. *Averías* (Damages), 1981
8. *Cuatro hermanas plásticas* (Four Plastic Sisters), 1981
9. *Encuentro de dos tiempos* (Encounter of Two Times), 1981
10. *Destino* (Destiny), 1981
11. *Aluminio* (Aluminum), 1981
12. *Mística del amanecer* (Mystic of Sunrise), 1980
13. *Conquistador*, 1980
14. *Niños del mañana* (Children of Tomorrow), 1981
15. *Viajeros de fantasía* (Fantasy Travelers), 1980
16. *Arroyo tropical* (Tropical Creek), 1980
17. *Transición* (Transition), 1981
18. *El flip, flop de Peter* (The Flip, Flop of Peter), 1981
19. *Ajedrez de la pareja* (The Couple's Chess), 1980
20. *Pobre soñador* (Poor Dreamer), 1981
21. *Fuente de descanso* (The Fountain of Rest), 1981
22. *Pedal del ahora* (Pedals of the Present), 1981
23. *Sillas del ayer* (Chairs of Yesterday), 1980. Coll. Mr. and Mrs. de la Guardia.
24. *Amistad* (Friendship), 1980. Coll. Mr. and Mrs. Marcelo Narbona.
25. *Semáforo de los ñames* (Trafic Light of the Yams), 1980. Coll. Mr. Fernando Eleta Casanovas.
26. *Mr. Reed*, 1981. Coll. Mr. and Mrs. Bruce Motta.
27. *Don Gregorio y el hijo* (Don Gregorio and Son), 1981. Coll. Mr. and Mrs. Michael Baitel.
28. *Refrescos* (Refreshments), 1981. Coll. Mr. and Mrs. Michael Baitel.

[1] Not included in the original catalogue. --*Ed.*

29. *Centinela* (Sentry), 1981. Coll. Mr. and Mrs. Bruce Motta.
30. *Guardián* (Guardian), 1981. Coll. Mr. Michael Baitel.

June 23 - July 17, 1981

TARO KANEKO OF BRAZIL

For the past two decades, the only place outside of Brazil and Japan where the art of Brazilians of Japanese origin has been systematically exhibited and promoted has been the headquarters of the Organization of American States. Almost all the important figures of this ethnic sector have been presented individually or in groups. Starting with the pioneer Manabu Mabe, they include Tomie Ohtake, Tikashi Fukushima, Kazuo Wakabayashi, Yutaka Toyota, Masumi Tsuchimoto. All, though born in Japan, have long been residents in Brazil. The acceptance they have met in their new homeland is striking evidence of that vast country's power to appreciate the contributions of other civilizations and to incorporate foreign elements into an ever-richer but ever-distinctive Brazilian culture.

With the appearance of Taro Kaneko, the first Brazilian-born painter of Japanese descent, an important step has been taken toward the establishment of a Nippo-Brazilian tradition in Latin American art. Kaneko first saw the light of day in Gália, in the state of São Paulo, in 1953. While still very young, he began the study of painting with the master Manabu Mabe. Later he enrolled at São Paulo University's School of Architecture and City Planning, from which he graduated in 1978, having taken as his special field research into the application of color in cities.

While maintaining a professional career as an architect, Kaneko actively pursues his avocation as a painter of landscape and has won numerous awards since 1970. Increasingly appreciated by the public, his works are to be found in many private collections in São Paulo. A refined colorist, he makes use of bold brushwork, sometimes splashy in effect. Always, however, there is an accent suggestive of the art of Japan, especially in the open spaces that give breath and repose to his compositions.

While Kaneko has participated in a goodly number of group exhibitions during the last twelve years, both in Brazil and in Japan, he has had only three one-man shows: two exhibits of building projects and urban designs presented in São Paulo and an exhibit of paintings in Asunción, Paraguay.

This is the first presentation of the work of Taro Kaneko in the United States. --*J.G-S.*

EXHIBITION LIST [1]

Oil on Canvas

1. *Colina (Hill)*, 50 x 60 cm.
2. *Mar (Sea)*, 70 x 80 cm.
3. *Montanha (Mountain)*, 70 x 80 cm.
4. *Verde (Green)*, 70 x 80 cm.
5. *Primavera (Springtime)*
6. *Reflexo (Reflex)*, 50 x 60 cm.
7. *Matagal (Brushwood)*, 80 x 70 cm.
8. *Infinito (Infinite)*, 50 x 60 cm.
9. *Movimento (Movement)*, 70 x 80 cm.
10. *Manhã (Morning)*, 70 x 80 cm.
11. *Brisa (Breeze)*
12. *Terra (Earth)*
13. *Verão (Summer)*, 70 x 80 cm.

[1] Not included in the original catalogue. --*Ed.*

14. *Melancolia (Melancholy)*, 50 x 60 cm.
15. *Alegría (Joy)*
16. *Morro (Knoll)*, 70 x 80 cm.
17. *Brilho (Brightness)*, 50 x 60 cm.
18. *Inverno (Winter)*, 70 x 80 cm.
19. *Intuição (Intuition)*, 70 x 80 cm.
20. *Natureza (Nature)*, 70 x 80 cm.
21. *Sereno (Serene)*, 70 x 80 cm.
22. *Notre Dame*, 70 x 80 cm.
23. *Guarujá*, 70 x 80 cm.

June 23 - July 17, 1981

CARLOS CLEMEN OF BRAZIL

In the ever-expanding panorama of Latin American graphic art, Carlos Clémen emerges as a masterly draftsman and an expressionist of great power. His firm line and his striking contrasts between pure black and white convey with burning intensity the most varied of moods.

Clémen's personal style has evolved from his long training as an illustrator and layout designer. Taking the *photoromance* (soap opera in comic-book format) as his point of departure--"a springboard" in the words of the Brazilian critic Telmo Martino--he has raised commercial illustration to the rank of art. The vigor of his strokes and his use of sequential drawing, with its implied sense of action, brings his subjects vividly to life.

Carlos Clémen was born in Buenos Aires, Argentina, in 1942, but he has lived in São Paulo, Brazil, for more than ten years and now has a Brazilian family. His art studies were done at institutions in the two cities mentioned.

He has been a frequent participant in group exhibitions in Brazil and his one-man shows now number nine. These have taken place in Argentina, Brazil, and Paraguay, and compositions by him are to be found in public and private collections in all three countries.

This is Clémen's first presentation in the United States. *--J.G-S*.

EXHIBITION LIST [1]

Drawings

1-16. *Sin título (Untitled)*

July 21 - August 14, 1981

ROSLYN K. CAMBRIDGE OF TRINIDAD AND TOBAGO

Roslyn K. Cambridge was born in Trinidad in 1946. She studied at the Washington School of Art in Port Washington, New York; at the Phoenix School of Design in New York City; and she obtained the degree of Bachelor of Fine Arts, cum laude, from Howard University in 1978.

In her career as a professional, she has lectured on different aspects of the arts in several parts of the country and has given demonstrations in a variety of media. She has participated in a score of group exhibitions in the

[1] Not included in the original catalogue. *--Ed*.

Washington area and had her first individual show here in October 1980.

Cambridge follows the path of abstract expressionism, her works being characterized by mystical symbolism with philosophic and religious overtones. The present series, *Cyclic Infinity*, is her accomplishment in the Master of Fine Arts degree at Howard University, 1981. --*J.G-S.*

EXHIBITION LIST [1]

Paintings (Mixed Media)

1- 7. *Alpha and Towards Omega*, B.F.A. Series
8-14. *Cyclic Infinity*, M.F.A. Series
 15. *The Presence*
 16. *Homage to Majorie*
 17. *Extrospectives*
 18. *Connections*
 19. *Visions*
 20. *Untitled*
 21. *Images*
 22. *Improvisations*
 23. *Untitled*

July 21 - August 14, 1981

KATHERINE WILLIAMS OF TRINIDAD AND TOBAGO

With the coming of the recent wave of immigrants from Latin America and the Caribbean to metropolitan areas of the United States and Canada, a new type of urban festival--carnival--now enlivens the streets of cities all along the eastern seaboard. Katherine Williams, a new immigrant of many talents, has several times served as judge at *Jump Up*, the celebrated carnival held in Trinidad and Tobago, where she was born in 1941. Since coming to the United States she has been responsible for the enormously successful Caribbean section of the Smithsonian Institution's 1979 and 1980 Festivals of American Folk Life, the only occasions on which carnival, in its full-fledged street version, has been seen in Washington, D.C. Williams also serves as editor and publisher of *Festivals*, a magazine devoted to the colorful folk celebrations of Caribbean and Latin American newcomers to the United States.

The breadth and depth of Katherine Williams's experience in the realm of the folk festival and her intimate feeling for the spirit of carnival are clearly brought out by this exhibition of photographs. Taken at the carnivals staged by West Indians in Boston and New York City and at the Creole Mardi Gras in New Orleans, the pictures bring to life in vivid detail a type of celebration characteristic of peoples from widely separated areas of the Americas.

The essence of Williams's photographs is controlled candor: while her intent is to surprise the subject, to capture movement and action, she never loses sight of the need to produce a balanced composition. Ethnologically, the pictures illustrate how African traditions of dance, music, and color have blended with European and indigenous elements into a new and truly American cross-cultural manifestation; spiritually, they constitute a visual ode to human joy. --*J.G-S.*

[1] Not included in the original catalogue. --*Ed.*

EXHIBITION LIST [1]

Photographs

Music

Music is an integral part of the carnival celebration. The sounds come together to provide a rich backdrop that inspires the masqueraders and spectators to dance through the street without thought of distance or time.

1. *Carnival in Boston*
2. *Mas in Brooklyn*
3. *Carnival in Boston*
4. *Carnival in Boston*
5. *Mas in Brooklyn*
6. *Mardi Gras*, New Orleans
7. *Mas in Brooklyn*
8. *Mardi Gras*, New Orleans
9. *Mardi Gras*, New Orleans

Fancy Costumes

Carnival costumes are designed to strike the spectator with their richness, dignity, exotic quality, or erotic appeal. For the wearer it is an escape into make-believe.

10. *Mas in Brooklyn*
11. *Mas in Brooklyn*
12. *Mas in Brooklyn*
13. *Mardi Gras*, New Orleans
14. *Mas in Brooklyn*
15. *Mas in Brooklyn*
16. *Mardi Gras*, New Orleans
17. *Mas in Brooklyn*
18. *Mas in Brooklyn*
19. *Mas in Brooklyn*
20. *Mas in Brooklyn*
21. *Mardi Gras*, New Orleans
22. *Carnival in Boston*
23. *Kiddies, Carnival in Brooklyn*
24. *Carnival in Boston*
25. *Mas in Brooklyn*
26. *Mardi Gras*, New Orleans
27. *Carnival in Boston*
28. *Mas in Brooklyn*
29. *Mas in Brooklyn*

Ole Mas

Much of Ole Mas is traditional and seen every year. Individuality is the key ingredient. Each Mas player creates his/her own costume.

30. *Mardi Gras*, New Orleans
31. *Mas in Brooklyn*
32. *Mas in Brooklyn*
33. *Mas in Brooklyn*

[1] Not included in the original catalogue. --*Ed.*

34. *Mas in Brooklyn*
35. *Mardi Gras*, New Orleans
36. *Mas in Brooklyn*
37. *Mas in Brooklyn*
38. *Mas in Brooklyn*
39. *Mardi Gras*, New Orleans

Spirit of Carnival

The urban Caribbean carnival is a rich blend of cultures representing the diverse countries from which Caribbean immigrants come. National identities are sublimated for the occasion. As a celebration, it reinforces the Caribbean identity, ensures the continuation of Caribbean culture in the United States, and adds a new dimension to the American cultural scene.

40. *Mardi Gras*, New Orleans
41. *Mas in Brooklyn*
42. *Mardi Gras*, New Orleans
43. *Mardi Gras*, New Orleans
44. *Mas in Brooklyn*
45. *Carnival in Boston*
46. *Mardi Gras*, New Orleans
47. *Mardi Gras*, New Orleans
48. *Mardi Gras*, New Orleans
49. *Mas in Brooklyn*
50. *Mardi Gras*, New Orleans
51. *Mardi Gras*, New Orleans
52. *Carnival in Boston*

July 30 - September 15, 1981

SALVADOR MANZANO OF MEXICO

Stretching between the headquarters building of the Organization of American States and the Museum of Modern Art of Latin America, the Aztec Garden provides, not for the first time, an appropriately formal outdoor setting for an exhibition of sculpture; free forms take on a monumental dignity when viewed against a background of luxuriant but disciplined nature.

The present show features the art of Salvador Manzano, an outstanding figure in the generation of abstractionists that has sprung up in Mexico during the past decade. In his compositions he captures ever-flowing form, whose sensuous undulations appeal as strongly to the sense of touch as to the eye--a characteristic, be it said, of all good sculpture.

Manzano was born in Mexico City in 1952. Though he soon evidenced a precocious talent, he did little to cultivate it methodically until 1975, when he enrolled at the National University's School of Plastic Arts where, among other subjects, he took up city planning. While pursuing his studies, he actively engaged in producing and exhibiting.

In addition to participating in several group exhibitions in Mexico, the United States, and the Netherlands, Manzano has had four one-man shows--three in Mexico and one, last year, at the Mexican Museum in San Francisco. Work by him may be found in that institution's permanent collection and in the collections of the National School of Plastic Arts and the National Museum of Fine Arts of the University of Mexico. This is Manzano's first presentation in the eastern United States. --*J.G-S.*

EXHIBITION LIST [1]

Steel Sculpture

1. *Espacio infinito* (Infinite Space)
2. *Encuentro* (Encounter)
3. *Continuidad espacial* (Space Continuity)
4. *Continuidad espacial* (Space Continuity)
5. *Dualidad* (Duality)
6. *Estrella brillante* (Bright Star)
7. *Nebulosa* (Nebulous)

August 20 - September 14, 1981

CESAR IZQUIERDO OF GUATEMALA

Though Guatemalan by birth, César Izquierdo has long been identified with the avant-garde of Nicaragua, of which country he was a resident throughout the third quarter of this century. Only recently has he returned to his native land.

Izquierdo's paintings and drawings are highly dramatic. Generally abstract in nature, they are strongly infused with the spirit of pre-Columbian art. One detects in particular the influence of the carvings on the monuments of Tikal and the great Maya cities of Yucatán. The drawings, which breathe fierceness and defiance, could be taken for highly elaborate studies for sculpture; the paintings, similarly marked by minuteness of detail, are so suggestive of work in relief as to constitute an invitation to touch. If color is of incidental importance, by his skillful handling of thick textures and bold lines Izquierdo achieves effects similar to those of art brut.

Izquierdo was born in Santa Cruz del Quiché, Guatemala, in 1937. Entering the National School of Plastic Arts in Guatemala City in 1954, he studied there until 1956, when he obtained a scholarship to the School of Fine Arts in Managua, Nicaragua. There he became a pupil of Rodrigo Peñalba, the guiding force in modern Nicaraguan art, and was promptly accepted by the country's artists as one of their own.

Izquierdo's work has frequently figured in shows devoted to contemporary Nicaraguan art and has been included in dozens of other group exhibitions presented in various cities of the United States, France, Germany, Puerto Rico, and other parts of Latin America. He has had over a score of one-man shows in the Central American capitals, Mexico City, and Madrid. The present exhibit provides a comprehensive view of the creative powers of an outstanding figure in contemporary Central American art. *--J.G-S.*

EXHIBITION LIST [2]

Oils

1. *Sentimiento de vuelo* (Flight Feeling)
2. *Paisaje de lo incierto* (Landscape of the Uncertain)
3. *Ventana del recuerdo* (Window of the Recollection)
4. *Sonata en gris sostenido* (Sonata in Gray Sharp)
5. *Itinerario de una gran ilusión* (Route of a Great Illusion)
6. *Nocturnal*
7. *Noche de amor* (Night of Love)
8. *Dinamismo controlado* (Controlled Dynamism)
9. *Lágrimas por una pasión* (Tears for a Passion)

[1] Not included in the original catalogue. *--Ed.*

[2] Not included in the original catalogue. *--Ed.*

10. *Mansión del Espíritu Santo* (Holy Spirit Mansion)

Drawings

11. *¿Cuándo me van a bajar de aquí?* (When Are They Going to Take Me Down?)
12. *Alma desolada* (Desolated Soul)
13. *Nostalgia*
14. *Consternación y miedo* (Consternation and Fear)
15. *Soledad pasional* (Passional Solitude)
16. *Ambición al acecho* (Lurking Ambition)
17. *Abnegada comprensión* (Dedicated Understanding)
18. *Conformidad por impotencia* (Conformity by Impotence)
19. *Temor indefenso* (Defenseless Fear)
20. *Dignidad ofendida* (Offended Fear)
21. *Estigmas del sacrificio* (Stigmas of Sacrifice)
22. *La esperanza* (Hope)
23. *Orgullo satisfecho* (Satisfied Pride)
24. *El mensaje* (The Message)
25. *La bestia* (Beast)

September 17 - October 9, 1981

EDUARDO GIUSIANO FROM ARGENTINA

Present-day Argentine art is characterized by two main streams, equal in importance, each having a new concept of reality and seeking for new modes of expression. One of these streams is that of abstraction; within it a wide variety of subcurrents can be distinguished. The other stream is figurative in nature. Among the more interesting personalities evolving within the latter is that of the expressionist Eduardo Giusiano.

Giusiano's work conveys an eerie feeling. The entire composition seems to be pervaded by a vibration that renders volumes and planes mobile; the overall effect is one of extreme plasticity. Brushstrokes are short, nervous, and sensitive; applied as a rule in only one direction they result in a smooth, airy texture suggestive of animal hide. The color range is a harmony of lightly tinted grays. Delicate, sensuous, and intimate, Giusiano's compositions reveal a highly refined artistic personality.

Giusiano was born in Córdoba, Argentina, in 1931. After graduation from the School of Fine Arts in Córdoba, the provincial capital, he moved to Buenos Aires, where he has since pursued his career. He has had fourteen one-man shows, all in Argentina, and has participated in numerous group exhibitions, some in his native country and others abroad--in Barcelona (Spain), Bonn, and Santiago de Chile. His work was included in the important group show organized last year by the Piñero Pacheco Foundation and presented first in Buenos Aires and later at the Organization of American States' gallery in Washington, D.C.

Giusiano received five significant awards at salons held in Argentina from 1968 to 1978. Compositions by his hand hang in seven Argentine museums, in the Museum of Modern Art of Santiago de Chile, and in well-known private collections throughout South America. This is his first one-man show in the United States. --*J.G-S.*

EXHIBITION LIST [1]

Paintings

1. *Espantapájaros I* (Scarecrow I)
2. *Espantapájaros II* (Scarecrow II)

[1] Not included in the original catalogue. --*Ed*.

3. *El pájaro y la dama* (The Bird and the Lady)
4. *Interior uno* (Interior One)
5. *El viaje del mago* (The Magician's Trip)
6. *La caja del mago I* (The Magician's Box I)
7. *La caja del mago II* (The Magician's Box II)
8. *La modelo con sombrero blanco* (The Model with the White Hat)
9. *La modelo I* (The Model I)
10. *La modelo II* (The Model II)
11. *Interior II*
12. *Interior III*
13. *El pájaro del mago* (The Magician's Bird)
14. *Retrato* (Portrait)
15. *La tarde del gato* (The Afternoon of the Cat)
16. *El patio del mago* (The Magician's Yard)
17. *La silla del mago* (The Magician's Chair)

September 17 - October 9, 1981

TATY RYBAK FROM ARGENTINA

Though Taty Rybak terms her work sculpture, my personal inclination is to classify it as a type of drawing. Save for some of the creations of Alexander Calder, nothing has been done along this line since the initial experiments made by Jean Cocteau during the Dada years.

Call Rybak's compositions openwork sculpture, background-bonded drawing, or what you will, they are fascinating exercises in metalcraft and show in all cases the hand of a master draftsman. Structures are efficiently plotted to endow "ventilated" form with firmness and stability. Fluidness of line and extreme simplification of figures create distinctly poetic effects. Some of the works on view have an African flavor: their rhythm represents a Western artist's approach to a distant and exotic culture.

Rybak was born in Buenos Aires in 1943. She received training in painting from Horacio Butler and in sculpture from Leo Vinci. During the years from 1972 to 1975, she made a number of trips to Africa, to study traditional techniques and concepts of sculpture as practiced in Zimbabwe, Tanzania, Mali, and Kenya. In 1976 she attended art courses in Mahabalipuram, India. She has traveled in other parts of Asia and in Europe.

While Rybak has participated in group shows in a number of Argentine cities, she has thus far had only one solo exhibit which took place in Buenos Aires in 1978. This is the artist's first individual presentation in the United States.--*J.G-S.*

EXHIBITION LIST [1]

Sculpture

1. *Pas de Trois*
2. *El grito* (Scream)
3. *Trajeado* (Dressed with a Suit)
4. *Nuestras cúpulas* (Our Domes)
5. *Prisionera* (Prisoner)
6. *Madre latinoamericana* (Latin American Mother)
7. *Nosotros, la ciudad* (We, the City)
8. *Geometrizados* (Geometricized)
9. *Una pareja* (The Couple)

[1] Not included in the original catalogue. --*Ed.*

10. *Para la reproducción* (For Reproduction)
11. *Progresión* (Progression)
12. *Madre* (Mother)
13. *Oceanidad* (Oceanity)
14. *Aquellos cuatro* (Those Four)

October 13 - November 6, 1981

JORGE ROCHA OF COLOMBIA

Jorge Rocha is a self-taught artist of growing reputation in his native Colombia. Born in Bogotá in 1949, he manifested a talent for drawing while still in his childhood. His rise to prominence began about ten years ago, as a result of his participation in municipal and national salons. His first individual presentation took place in 1975 at the Luis A. Arango Library and it met with such success that it has been followed by no fewer than thirteen additional one-man shows. Rocha has received a number of significant awards in Colombia and has exhibited abroad in Barcelona (Spain), and in the capital of Panama.

A composition by Rocha is a sum of diverse parts, so well coordinated as to achieve independent existence as an entity in itself. The artist himself has declared that in understanding a painting or drawing he proceeds upon the assumption that he is engaged in an act of architectural construction, owing to the need to articulate the several structural elements into a unified whole. His strokes--be they made by pencil, crayon, or brush--are uniformly meticulous in execution, producing remarkably clean surfaces. Owing to the nature of the component parts, the forms that gradually emerge upon his drawing board or canvas are frequently reminiscent of the work of the Italian mannerist Arcimboldo (1527-1593), with their profusion of vegetables and fruits.

This is the first individual presentation of Rocha's work in the United States. *--J.G-S.*

EXHIBITION LIST [1]

Drawings

1. *Máscara y paisaje (Mask and Landscape)*
2. *Paisaje andino (Andean Landscape)*
3. *Dama (Lady)*
4. *Peculiar Still Life*
5. *Doralina*
6. *Retrato (Portrait)*
7. *Composition with Grasshopper*
8. *Adolescent*
9. *Flirt*
10. *Modelo (Model)*
11. *Venus*
12. *Still Life*
13. *Insinuación (Insinuation)*
14. *For a Girl Friend*
15. *Enigmatic Portrait*
16. *Personage with Mask*
17. *For a Draftsman*
18. *Fruit Tree*
19. *Scenario*
20. *Romantic Landscape*

[1] Not included in the original catalogue. *--Ed.*

October 13 - November 6, 1981

PASCUALA OF COLOMBIA

While art flourishes throughout Latin America today, in few countries is the creative spirit so clearly manifest as in Colombia, a veritable hotbed of budding talent. Noteworthy in the generation that is now coming into prominence is the figure of Pascuala, the artistic signature of Luz Marina de Villamizar.

Pascuala is a follower of the growing neorealist trend. Though often handled metaphorically, the subject is the dominant factor in her compositions; color, in a range of pale hues, is an entirely subordinate element.

Pascuala was born in Bogotá in 1949 and received a degree in art from the Jorge Tadeo Lozano University located in that city. She has participated widely in salons and group exhibits both in the capital and in other cities of Colombia. Her first individual show took place only last year at El Callejón, a leading Bogotá gallery. The current exhibition marks her first presentation in the United States. *--J.G-S.*

EXHIBITION LIST [1]

Paintings

1. *Desierto I* (Desert I)
2. *Desierto II* (Desert II)
3. *Desierto III* (Desert III)
4. *Cubo* (Pail)
5. *Laguna* (Pond)
6. *Borrasca* (Storm)
7. *Reflejo* (Reflex)
8. *Arcos frontispicios* (Frontispiece Arches)
9. *Ruinas* (Ruins)
10. *Castillo* (Castle)
11. *Meseta de piedra* (Stone Plateau)
12. *Ventana* (Window)
13. *Laberinto* (Labyrinth)
14. *Cascada* (Cascade)
15. *Estructuras* (Structures)
16. *Atardecer* (Sunset)

November 10 - December 4, 1981

RICARDO DAVILA OF ECUADOR

The career of the Ecuadorian painter Ricardo Dávila is of extremely recent date; it was only in 1978 that he made his debut in a show held at the Office of the General Secretariat of the Organization of American States in Quito. Known in his country's art circles by his first name alone, he considers himself self-taught, though in reality he received a certain amount of art instruction while studying in Brazil to be an architect.

Restless in spirit, he has experimented with a number of realistic trends, taking as a rule the human figure as his subject. The present exhibit represents to some degree a synthesis of the various tendencies, fused in an expressionistic manner.

In the year of his debut, Dávila took part in an international salon in Paris, and thereafter in a number of group exhibitions both at home and abroad, Lima, Caracas, and Pomaire (Chile) being among the Latin American cities

[1] Not included in the original catalogue. *--Ed.*

in which his works have been seen. This year the Architects Association of Quito gave him a one-man show in the Ecuadorian capital. Compositions by his hand are to be found in a number of public institutions in Ecuador and in the Museum of Modern Art of Caracas.

This is Dávila's first presentation in the United States. --*J.G-S.*

EXHIBITION LIST [1]

Paintings

1. *El pintor* (The Painter)
2. *Acto de amor* (Act of Love)
3. *El niño* (The Boy)
4. *Mensajera del viento* (Messenger of the Wind)
5. *Vuelo* (Flight)
6. *Retrato de Rossana* (Portrait of Rossana)
7. *Cabeza* (Head)
8. *El niño de las frutas* (The Boy of the Fruits)
9. *El soplo* (The Blowing)
10. *Angustia* (Anguish)
11. *Mathos*
12. *La mañana* (Morning)
13. *Tejedora de ilusiones* (Weaver of Illusions)
14. *Mujer con pendiente* (Woman with Earrings)
15. *Vestal*
16. *Triste espera* (Sad Waiting)
17. *La ascensión* (Ascension)
18. *Despertar del amor* (Awakening of Love)
19. *Reposo* (Rest)
20. *Bañistas* (Bathers)
21. *Oteador* (Sly Observer)
22. *Acto teatral* (Theatrical Act)
23. *Máscara viva* (Living Mask)
24. *El pintor y la modelo* (Painter and Model)
25. *Rostro elemental* (Elemental Face)

December 14, 1981 - January 17, 1982

RETABLOS FROM PERU [2]

The art of the *retablo*--a portable cupboard, containing carved figures depicting a dramatic scene, usually religious in nature--had its inception in eleventh-century Spain. It was almost certainly introduced into America by the clergy who accompanied the Spanish conquistadors on their expeditions of exploration and conquest. As a form of folk art it flourished in colonial Peru, attaining particular brilliance in the Andean highlands around Ayacucho, where the carvings executed were larger in scale.

Originally intended as an instrument for propagation of the Catholic faith, the *retablo* emphasized episodes from Biblical history and the lives of the saints. The nativity scene, with the figures of the Magi and the shepherds, was particularly popular, especially at the Christmas season. Later, the *retablo* came to be viewed as more of an ornamental object, and secular scenes were depicted--dances such as the one known as *la marinera*, and civic

[1] Not included in the original catalogue. --*Ed.*

[2] No list of works exhibited is available. --*Ed.*

celebration. There were even *retablos* purely commercial in character, intended for window display, such as the one full of hats which is shown for the first time in this exhibition.

Carvings were originally done in wood, which was then polychromed and gilded. In Peru the *piedra de Huamanga*--a sort of soft, whitish soapstone--was much used. Later, figures were made of other materials, such as plaster and papier-mâché. While the most usual type of *retablo* is an upright box with doors that swing open, some *retablos* took the form of small, highly decorated chests. In such cases the inside of the lid tended to echo the principal scene depicted within.

Retablos were sold in small-town markets to members of the middle and lower classes, who were thus enabled to worship at home before a symbolic altarpiece of reduced size. By the latter years of the nineteenth century the popularity of the *retablo* had faded, but in the first two decades of the twentieth it underwent a revival, thanks in large part to the inspired work of the master craftsman Joaquín López Antay, whose creations are jewels of the genre. The present exhibition is fortunate in presenting several examples of his talent as well as *retablos* by the similarly skilled artists Julio and Jesús Urbano.

The Museum of Modern Art of Latin America is pleased to offer the first large-scale exhibit of the art of the *retablo* in the Washington area. It is deeply grateful to the Museum of Peruvian Culture and to Miss Elvira Luza, both of Peru, for lending important pieces for display, and it expresses sincere appreciation to the Industrial Bank of Peru and Braniff International Airlines, for assistance which has made the exhibition possible. --English version by Ralph Dimmick.

YEAR 1982

January 14 - February 6, 1982

CESAR MENENDEZ OF EL SALVADOR

There is an increasing preference for the use of chiaroscuro in Latin American art today. In El Salvador, which now leads Central America in creative activity, nowhere is the tendency more evident than in the work of César Menéndez.

In his case, the contrast between bright and dark is handled in a decidedly formal manner: highlights and shadows constitute essential elements of structure. Straight lines and precise curves predominate in Menéndez's compositions, in which the overlapping planes, so clearly defined in the foreground, dissolve into a background of mist. The transition is effected in a highly disciplined, systematic, and at the same time sensitive manner. Menéndez is obviously a figure to be reckoned with in the growing Latin American movement toward romanticism.

The artist was born in San Salvador in 1954. He studied at his country's National Academy of Art and in 1976 began to participate in group shows, not only at home and in other parts of Central America, but also in Argentina. He has had five one-man shows in San Salvador and one in Guatemala City, and now devotes a certain amount of time to art instruction.

Awarded First Prize in a contest for art students organized by the Salvadoran Ministry of Education, Menéndez later achieved a similar success at the Third Salon of Central American Art.

This is Menéndez's first presentation in the United States. --*J.G-S.*

EXHIBITION LIST [1]

1-10. *Theme of the New Series*,[2] oil and acrylic on canvas

January 14 - February 6, 1982

ELENA CASTRO-MORAN OF EL SALVADOR

Although basically realistic in nature, the painting of Elena Castro-Morán exhibits romantic and literary overtones and exudes an atmosphere of nostalgia and sentimentalism. From the viewpoint of technique, there is definite exclusion of all superfluous elements. Synthesis and simplification--at times carried to an extreme--predominate in the artist's treatment of subject matter, which is also characterized by clarity of definition and a preference for brilliant color.

Elena Castro-Morán was born in San Salvador and studied painting there with Oscar Martínez. Later she traveled to Miami, where she took courses in art history and design at a local junior college. After graduation she continued her artistic education in Italy, at the Academy of Fine Arts of Perugia.

[1] Not included in the original catalogue. --*Ed.*

[2] Titles are unavailable --*Ed.*

The artist has participated in numerous group exhibitions and has had five individual shows to date: two in Perugia, one in Athens, one in Paros (Greece), and one in San Salvador. This is her first presentation in the Washington area. --*J.G-S.*

EXHIBITION LIST[1]

Oils on Canvas

1. *The Memory of the Sea*
2. *Encuentro fortuito (Fortuitous Meeting)*
3. *Watching the Sea*
4. *El paseo de Ana (Ana's Promenade)*, 20 x 25"
5. *The Fisherman's Dream*
6. *Parting*
7. *Melancholy*
8. *At the Beach*
9. *Sunday Afternoon*
10. *La orden (The Command)*, 16 x 20"
11. *The Angel That No One Sees*
12. *Window with Boats*
13. *Guilt*
14. *Shell*
15. *Dialogue*
16. *Children's Play*
17. *Shell Eye*
18. *Paper Boats*
19. *Woman*
20. *The Forgotten Letter*

February 9 - March 7, 1982

NEW PAINTING OF COSTA RICA

Until recently, painters and sculptors of Costa Rica have been rather timid in their artistic expression. Painting has tended toward the merely descriptive, focusing on landscape and rural life, watercolor being the preferred medium. Experimentation with form never ventured beyond the bounds of simplified realism; color was invariably used in a conventional manner.

During a recent trip to Costa Rica, I was delighted to discover in a large group exhibition a number of works that I felt merited presentation abroad, and I invited the artists to participate in a sample showing of what might be called the "new painting" of Costa Rica. Several other figures of similar significance came to my attention after the present exhibition had already taken shape. I hope that they may be presented later, in a sequel to this show.

I would express appreciation first of all to the President of Costa Rica, His Excellency Rodrigo Carazo Odio, who took great personal interest in this endeavor. I wish likewise to recognize the assistance lent by Tabacalera Costarricense, S.A., through its Manager/Public Relations Coordinator, Héctor Cornejo Valverde; to the following airline companies, LACSA, TACA International, SAHSA, and Air Florida; to Coordinated Caribbean Transport, Inc.; Cervecería Costa Rica, S.A.; Xerox of Costa Rica; Organización Aduanera; and to the Costa Rican Institute of Tourism, without which this exhibition would not have been possible. --*J.G-S.*

[1] Not included in the original catalogue. --*Ed.*

EXHIBITION LIST [1]

Paintings

Rodolfo Stanley
 1. *Nivel bajo* (Low Level)
 2. *Máscara* (Mask)

Gonzalo Morales
 3. *Interior con violetas* (Interior with Violets), oil on canvas, 39 1/2 x 31 1/2"
 4. *Interior*

Alberto Ycaza
 5-9. *Cronómetro I, II, III, IV, V* (Chronometer I, II, III, IV, V)

Martalicia Almeida
 10. *Páramo I*, oil on canvas, 47 1/2 x 35 1/2"
 11. *Páramo II*

Xenia Gordienko
12-14. *Noche tropical I, II, III* (Tropical Night I, II, III)

Ricardo Ulloa Barrenechea
 15. *Paisaje* (Landscape), oil on canvas, 39 1/2 x 31 1/2"

Cathy Giusti
 16. *Desde mi ventana* (From My Window), oil on canvas, 26 x 19"
 17. *El pájaro del dulce encanto* (Bird of the Sweet Charm)
 18. *Pájaro bajo la niebla* (Bird under the Fog)

Oscar Méndez
 19. *Tlilaztlán*, oil on canvas, 40 x 40"
 20. *Huapilli*
 21. *Guayabo I* (Guava Tree I)
 22. *Huaytilli*

Luis Chacón
 23. *El grupo* (Group)
 24. *Nidos del bosque* (Nests of the Forest), acrylic on canvas, 41 1/2 x 31 1/2"
 25. *Notre-Dame*
 26. *Flora*

Lola Fernández
 27. *Serie de las máquinas I* (The Machines Series I), 1972, oil
 28. *Serie de las máquinas II* (The Machines Series II), oil

Amparo Rivera
 29. *Hogar I* (Home I), oil on canvas, 14 x 10"
 30. *Hogar II* (Home II)

Carlos Bates
 31. *Composición 42* (Composition 42), oil on canvas, 44 1/2 x 34 1/2"
 32. *Composición 54* (Composition 54)

[1] Not included in the original catalogue. --*Ed*.

Rafa Fernández
 33. *Personaje mágico* (Magic Character)

BIOGRAPHICAL NOTES

ALMEIDA, Martalicia. Born in Monterrey, Mexico, in 1937, is now a citizen of Costa Rica. In addition to participating in many group shows in that country, has had three individual presentations at the National Museum in San José.

BATES, Carlos. Born in New Jersey, United States, in 1949, holds a B.A. in Fine Arts from Yale University. Has had one-man shows both in Costa Rica and the United States. Has lived in Costa Rica since 1968.

CHACON, Luis. Born in San José, Costa Rica, in 1953. Has exhibited in individual and group shows in Costa Rica, Chile, Japan, France, and Spain.

FERNANDEZ, Lola. Born in Cartagena, Colombia, in 1926. Studied fine arts at the University of Costa Rica, the National University of Bogotá, and the Academy of Fine Arts in Florence. Has traveled extensively in Central and South America, Europe, and Japan. Has exhibited in individual and group shows both at home and abroad. Lives in Costa Rica and is a Costa Rican citizen.

FERNANDEZ, Rafa. Born in San José, Costa Rica, in 1935. Studied art in Costa Rica, Nicaragua, and Spain. Has exhibited frequently, both in individual and group shows, in Costa Rica, Nicaragua, Honduras, Guatemala, Mexico, Brazil, the United States, Spain, Italy, and Japan.

GIUSTI, Cathy. Born in Santiago, Chile, in 1935. Studied at the Esempi Art School in San José, Costa Rica. In addition to participating in group shows in Costa Rica, has enjoyed one individual presentation in New York. Lives in Costa Rica.

GORDIENKO, Xenia. Born in San Ramón, Costa Rica, in 1933. Participated in group shows in that country and has had two individual presentations, one at home and one in Spain.

MENDEZ, Oscar. Born in Tres Ríos, Costa Rica, in 1943. In addition to enjoying a one-man show in his own country, has participated in group exhibitions there and in Colombia and the United States.

MORALES, Gonzalo. Born in San José, Costa Rica, in 1945. Has participated in group exhibitions in Cuba, Nicaragua, Spain, and Costa Rica, in addition to holding a one-man show in the last-mentioned country.

RIVERA, Amparo. Born in Turrialba, Costa Rica, in 1919. Exhibited in a group show held in San José in 1981.

STANLEY, Rodolfo. Born in San José, Costa Rica, in 1934. Has exhibited his work in several group exhibitions in his native country. Winner of the International Contest organized by Xerox in 1979.

ULLOA BARRENECHEA, Ricardo. Born in San José, Costa Rica, in 1928. Has participated in group exhibitions in Costa Rica and Spain and has had one individual presentation in each of these countries.

YCAZA, Alberto. Born in León, Nicaragua, in 1945, now a citizen of Costa Rica. Has exhibited frequently, both individually and in group shows, in Costa Rica, Colombia, Nicaragua, El Salvador, Spain, and the United States.

March 18 - April 12, 1982

ROBERTO LAUREANO OF PUERTO RICO

An interesting new development on the Puerto Rican cultural scene has been the emergence of the painter Roberto Laureano. The young artist's growing reputation now extends to the Washington area, where he has been exhibiting at local galleries while pursuing graduate study at the American University.

Laureano's work is remarkable for its subtlety, its transparency, and the delicacy of its brushwork. It exhibits total command of color, which is gradually reduced in intensity, to the point that it fades into the whiteness of the canvas. Subdued in effect, it is painting of "gesture," in which the artist says he is seeking to establish the relationship between the square as a form and abstract landscape.

Laureano was born in Puerto Rico in 1952. He received a B.A. in Fine Arts from the University of Puerto Rico and the degree of Master of Fine Arts in painting from the American University in Washington, D.C. Since 1970 his work has been presented in group exhibits and one-man shows in Puerto Rico and the Washington area. His awards include First Honorable Mention at the Contemporary Mural Contest, San Juan, 1972; First Honorable Mention in Watercolor at the First Contest of Plastic Arts, University of Puerto Rico, 1972; First Prize in Printmaking and First Prize in Painting at the Second Contest of Plastic Arts, University of Puerto Rico, 1973; a fellowship from the Plastic Arts Scholarship Fund, San Juan; and the Special Opportunity Scholarship of the American University. He has been a resident of the Washington area since 1974.

Appreciation is expressed to the Resident Commissioner of Puerto Rico, the Honorable Baltasar Corrada, and to the Puerto Rico Federal Affairs Administration for assistance in making this exhibition possible. --*J.G-S.*

EXHIBITION LIST [1]

Paintings

1. *Creación* (Creation), acrylic on canvas
2. *Paisaje vertical* (Vertical Landscape), acrylic on paper, 18 x 24"
3. *La fuga* (Escape), acrylic on canvas
4. *Cristalino* (Transparent), acrylic on paper, 18 x 24"
5. *En otra perspectiva* (In Another Perspective), acrylic on paper, 18 x 24"
6. *Frontal*, acrylic on paper, 18 x 24"
7. *La fina presencia del cielo* (The Tenuous Presence of the Sky), acrylic on canvas
8. *Fase nebulosa* (Nebulous Phase), acrylic on canvas
9. *Tenue* (Tenuous), acrylic on canvas
10. *Image III*, watercolor on paper
11. *Image II*, watercolor on paper
12. *Flotando en la brisa* (Floating in the Breeze), acrylic on canvas
13. *Image IV*, watercolor on paper
14. *Image I*, Watercolor on paper
15. *Verde (Green)*, acrylic on canvas

March 18 - April 12, 1982

HECTOR MENDEZ-CARATINI OF PUERTO RICO

A few photographs by Héctor Méndez-Caratini were included in a large group show at Organization of American States headquarters in September 1981. They attracted much attention, and, in response to the public interest expressed, a broader selection of his work has now been put on exhibit.

The subjects of these photographs are drawn largely from daily life in Puerto Rico, with an emphasis on folk arts and traditions. Méndez-Caratini's interest in this area and in archaeological studies renders his work a valuable tool for social and anthropological research carried out on the island, illustrating as it does the inhabitants' capacity for cultural expression in a variety of artistic media.

Méndez-Caratini was born in Puerto Rico in 1949. After study at Boston University, he graduated from the University of Puerto Rico in 1971 and also holds a certificate from the Germain School of Photography. He has

[1] Not included in the original catalogue. --*Ed.*

studied at the University of Arizona's Center for Creative Photography and he took part in photographic workshops held in Mexico City in 1978 and 1981. He is currently working toward a master's degree at the Center for Advanced Puerto Rican and Caribbean Studies.

In addition to participating in group shows, Méndez-Caratini has had one-man exhibits in San Juan, New York, and Mexico City. Examples of his work are to be found in the collections of the Metropolitan Museum of Art and the Museo del Barrio in New York City, the Library of Congress in Washington, the Institute for Puerto Rican Culture in San Juan, the Art Museum of Ponce (Puerto Rico), the Center for Creative Photography in Arizona, and the Mexican Council for Photography in Mexico City.

Thanks are expressed to the Resident Commissioner of Puerto Rico, the Honorable Baltasar Corrada, and to the Puerto Rico Federal Affairs Administration for assistance in making his exhibition possible. --*J.G-S.*

EXHIBITION LIST [1]

Photographs

 1-6. *Vejigante*, 11 x 14"
 7-14. *Petroglifo* (Petroglyph), 16 x 20"
 15. *Don Lolo*, 16 x 20"
 16. *Virgen de La Monserrate* (Virgin of Monserrate), 16 x 20"
 17. *Jíbaro (Countryman)*, 16 x 20"
 18. *Castro Ayala*, 16 x 20"
 19. *Cafetal (Coffee Trees)*, 16 x 20"
 20. *Niño y pared (Child and Wall)*, 16 x 20"
 21-25. *Fiesta de Santiago Apóstol (Festivity of James the Apostle)*, 11 x 14"

Photographic Portfolio (limited edition of twenty portfolios, each containing twenty photographs)

 1-20. *Petroglifo* (Petroglyph)

April 2 - 17, 1982

NEW WORK OF JOSE LUIS CUEVAS [2]

During the months of March and April 1982 several art centers in Europe and Latin America are exhibiting works by José Luis Cuevas, as an homage to the artist who in 1981 was awarded the Premio Nacional de Bellas Artes of Mexico. This is an important award that is granted to nationally prominent artists and that has been bestowed in the past on Diego Rivera, Rufino Tamayo, and David Alfaro Siqueiros.

The Museum of Modern Art of Latin America, adhering to this extensive recognition of the artist, has the honor of presenting Cuevas, once more, with etchings belonging to the last phase of his graphic production, a medium through which the creative genius of this artist reaches plenitude. Cuevas's first public appearance occurred at the OAS, almost thirty years ago. --*J.G-S.*

PROGRAM, April 2, 1982

Panel Discussion: José Luis Cuevas
 Prof. Marta Traba, Art Critic and Historian
 José Gómez-Sicre, Director, Museum of Modern Art of Latin America

[1] Not included in the original catalogue. --*Ed.*

[2] No catalogue was made for this exhibition. Reproduced here is the invitation to the panel discussion and opening of the artist's exhibition. --*Ed.*

The Museum of Modern Art of Latin America will exhibit a selection of fourteen etchings, the *Barcelona Series*, 1981, printed by Ediciones Polígrafa of Barcelona, Spain.

OTHER EXHIBITIONS OF JOSE LUIS CUEVAS DURING MARCH AND APRIL 1982

Barcelona, Spain:	Galería Joan Prats
	Galería Eude
United States:	Schweyer-Galdo Galleries, Birmingham, Michigan
	Meeting Point Art Center, Coral Gables, Florida
	Tasende Gallery, La Jolla, California
Paris, France:	Galerie Michel de Lorme
Mexico City:	Galería Secretaría de Hacienda
	Galería Kin
	Galería Pecanins
	Universidad Metropolitana
	Galería de Arte Mexicano
	Galería Juan Martín
	Oficina de Cartón y Papel de México
	Galería Peralvillo
	Galería Sloane Racota
	Galería Librería Porrúa
Lima, Peru:	Galería Ivonne Briseño

April 6 - 23, 1982

ALTHEA BASTIEN OF TRINIDAD AND TOBAGO

The technique of batik was developed long ago in the islands of Indonesia and the South Seas and has since met with worldwide favor. The textiles on which designs are printed allow for great flexibility in combining and spreading colors, an advantage of which Althea Bastien makes full use.

The artist was born in Port of Spain, Trinidad, 1933. From 1952 to 1965 she studied art at Froebel Teachers' College in England. In addition to participating in group shows in that country, at home, and in Switzerland, Sweden, the United States, and Brazil, she has held five individual exhibitions: one in England and four in Trinidad and Tobago. This is her first solo presentation in the United States.

EXHIBITION LIST [1]

Batiks

1. *Eye of the Swamp*
2. *Tidal Pink*
3. *The Family*
4. *Lamentation*
5. *African Mask I*
6. *The Helisphere*

[1] Not included in the original catalogue. --*Ed*.

 7. *Stellar Galactica*
 8. *Innards*
 9. *African Mask II*
10. *Foetal Agony*
11. *Flowers of Stone*
12. *The Serpents*
13. *African Mask III*
14. *Carnival in Hades*
15. *Buccoo Reef*
16. *Pan Vibes*
17. *Off Cuts*
18. *Maskerade*
19. *Reefscape*
20. *Papa Bois*
21. *Meditation*
22. *In a Green Night*
23. *The Posturing*
24. *African Mask IV*
25. *Kyaws and Kodens*
26. *Dance of the Spirits*
27. *The Blues*
28. *Favella*
29. *Reflections*
30. *J'Ouvert Morning*
31. *High on a Hill*
32. *Wild Stallion*
33. *Signatures in Sand*
34. *African Mask V*
35. *Five O'Clock Mass*
36. *Through a Glass Greenly*
37. *People Ranch*
38. *Snake Pit*
39. *Blanchisseuse*
40. *Sea Glass*
41. *Red Clouds*
42. *Macho Man*
43. *Wooing Wood*
44. *Crotons*
45. *Indian Chief*
46. *Chanticleer*
47. *Think Pink*
48. *Caribbean Sunset*

April 13 - May 10, 1982

GUILLERMO OVALLE OF COLOMBIA

A predilection for the effects of chiaroscuro--the subtle interplay of light and shadow, the contrast between brightness and dark so dear to the hearts of many romantic artists--is the outstanding characteristic of Guillermo Ovalle's artistic expression.

Further distinguishing his production is the poetic veil that envelops many of his compositions, a veil deriving from the preference he shows for suggesting, rather than defining. This is particularly noticeable in his drawings and pastels. His refined use of color and the dexterity with which he achieves effects of pathos belie his youth: as a rule such skill is the product of long years of professional experience.

Ovalle was born in Bogotá, Colombia, in 1957. His original ambition, strongly favored by his family, was to become a concert pianist. The plastic arts soon came to exert an irresistible pull upon him, however, and he gave up music to study at the workshop of the distinguished Colombian painter David Manzur. Upon the termination of his training there, he was appointed to a teaching position and later he assumed the functions of assistant director.

Ovalle's position as the generally recognized outstanding new personality in Colombian art has been confirmed by the following individual exhibitions of his work: Galería El Callejón, Bogotá, 1979; Central National Bank, Miami, Florida, 1980; and Forma Gallery, Miami, Florida, 1981. He has participated, also, in a number of group shows in Colombia, Mexico, and the United States. He is represented in the permanent collection of this Museum. --*J.G-S.*

Catalogue courtesy of the Art Workshop of David Manzur, Bogotá, Colombia.

EXHIBITION LIST [1]

1. *Panorama: View from the Terrace*
2. *Figure and . . .*
3. *Dream on a Pleasant Summer Afternoon*
4. *Dialogue at Noon*
5. *In the Morning*
6. *Awake*
7. *Dawn*
8. *In the Island of Death*
9. *City People in a Valley*
10. *Gaze at a Friend*
11. *Walking Woman*
12. *Dream*
13. *View from the Terrace at 4 P.M.*

ABOUT THE ARTIST

Born in Bogotá, Colombia, in 1957. Studied High School degree at Colegio Torrez-Preciado in Bogotá, 1975; David Manzur's Art Workshop, Bogotá, 1974-1978; Art Students League, New York City, 1979-1981.

Group Exhibitions

1975 *Selected Artists from David Manzur's Art Workshop*, Salon XX, Banco de Colombia, Bogotá
1976 *Selected Artists from David Manzur's Art Workshop*, Galería El Puente, Bogotá
1979 *Six Artists from David Manzur's Art Workshop*, Salon XX, Banco de Colombia, Bogotá
1979 *Fine Art Auction Exhibition* (selected by a jury), Channel 2 PBS, Miami
1980 Salon de Agosto (selected by a jury), Museo de Arte Contemporáneo, Bogotá
1980 Second Biennial of Spanish-American Drawing (invited), Mexico City
1980 *Contemporary Colombian Art*, Art and Culture Center, Hollywood, Florida
1981 *Fine Art Auction Exhibition* (selected by a jury), Channel 2 PBS, Miami
1981 *Recent Acquisitions*, Museum of Modern Art of Latin America, Washington, D.C.
1981 *Five Young Artists*, Galería El Callejón, Bogotá

Individual Exhibitions

1979 Galería El Callejón, Bogotá
1980 Central National Bank, Miami
1981 Forma Gallery, Coral Gables

[1] Not included in original catalogue. --*Ed.*

Bibliography

Panorama Artístico Colombiano 1981. Bogotá: Librería Central, 1981.
Rivero, Mario. "Guillermo Ovalle," *Diner's Club Magazine*, January 1982, Bogotá.

May 13 - June 4, 1982

OLGA SINCLAIR OF PANAMA

The name Sinclair, long illustrious in contemporary Panamanian culture, now makes a second generation appearance as Olga Sinclair takes a place beside her father Alfredo among the leading artists of her country.

Alfredo has been active as a painter for more than thirty years and qualitatively ranks as one of Panama's best. As a teacher, he has contributed to the education of a number of younger artists, effectively transmitting ideas without imposing his personal style. Such is the case with his daughter Olga, who is in no sense to be considered a mere imitator or follower of her father. She is to be viewed rather as an artist in her own right--a professional of principle and discipline, seriously dedicated to her work.

Her compositions are subtle, evocative, subjective, and lyrical in the extreme, but have no literary or illustrative implications. Miss Sinclair concentrates upon the human figure but provides a schematic vision of reality, omitting details and suggesting volumes by simplified contours. Her delicate brushwork is almost eerie in its effect.

Olga Sinclair was born in Panama City in 1957. She began the study of art with her father about 1970. After obtaining a diploma in pedagogy in 1974, she went to Madrid where she was enrolled for two years at the School of Applied Arts. Currently she is a student at the University of Santa María la Antigua in Panama.

In addition to participating in numerous group exhibitions in Panama, Colombia, Mexico, and Spain, she has had over half a dozen shows of her own, the most important of which were two that took place last year--one at Gallery 80 in Panama City and a joint exhibition with her father at the gallery known as El Callejón in Bogotá, Colombia.

This is Olga Sinclair's first presentation in the United States. *--J.G-S.*

EXHIBITION LIST [1]

Drawings

1-7 and 18-23. *Sin título (Untitled)*

Oils

 8. *La espera* (The Waiting)
 9. *En la habitación* (In the Room)
10. *Sueño de Osiris* (Osiris's Dream)
11. *La zurcidora* (Mender)
12. *La diseñadora* (Designer)
13. *Sueño de vida* (Life Dream)
14. *Levitación*
15. *Reposo* (Rest)
16. *En la butaca* (On the Orchestra-Chair)
17. *Dama del cinto rojo* (Lady with Red Belt)

[1] Not included in original catalogue. *--Ed.*

June 8 - 25, 1982

HOMAGE TO WOMEN ARTIST OF THE AMERICAS
A selection of works from the permanent collection of the Museum of Modern Art of Latin America

To open a new door in this hemisphere to a more positive future we must look to our common cultural foundations: the matrix of ideals, values, habits, traits, traditions, and customs that not only make each society distinctive and unique but also provide a certain common frame of reference to all of us as Americans.

Despite their diversity, the American nations do possess elements of a common angle of cultural vision. Today as yesterday our overall objective as citizens of the Americas remains to accept and live with our differences as societies, while coming to terms with the common elements of our regional culture, converting them into rich assets which serve to help us understand each other better.

The uniqueness of this current exhibit is that it demonstrates, in a vivid and positive way, the extraordinary contributions to our common inheritance made over many decades by outstanding women artists. Their vision has become ours, and we are truly grateful for the aesthetic brilliance and sensitivity which enable them to provide a flaming sense of beauty in which we see reflected our finest hopes and aspirations.

The Museum of Modern Art of Latin America is a trail-blazing institution for promoting greater cultural interpenetration among the diverse strains and tendencies of hemispheric art. Through this current exhibition, it not only honors women artists but also the singular contribution made by the Inter-American Commission of Women to the well-being of our entire hemisphere.

The OAS Museum is performing an outstanding public service by making available this rich treasury of art pulsating in the minds and hearts of the women of Latin America and the Caribbean today. --*Alejandro Orfila*, Secretary General, Organization of American States.

Painting has been one of the few activities to which women have had access over the years; but little significance has been given to their artistic work. It was considered as an adornment to their education.

Except in rare cases, it is only in this, the twentieth century, that women have come into their own in the pictorial field with a sense of professionalism; and they can, without restrictions, give free rein to their creative capabilities.

The Inter-American Commission of Women, which during its fifty-four years of intensive labor has been promoting the participation of women in all spheres of life, proposed holding an exhibition of the works of women artists from all the countries of the region. Thanks to the kind and generous collaboration of the Museum of Modern Art of Latin America, it has been possible to set up this exhibition which consists of works that are in the permanent collection of the Museum.

Nevertheless, in spite of its limitations, we feel that it fulfills the objectives that the IACW seeks: to disseminate American women's pictorial works, stimulating and supporting their artistic ability. At the same time, we hope that this will motivate future exhibitions which will include the works of women artists from those states that are not yet represented in the permanent collections of the Museum. --*Julieta Jardi de Morales Macedo*, President, Inter-American Commission of Women, Washington, D.C.

The Inter-American Commission of Women, founded in 1928, works for the extension of civil, political, economic, social, and cultural rights of women in the Americas. Since its inception women have gained full political rights in every country. The IACW encourages women of the Americas to exercise their rights, accept their civic responsibilities, and to take a more active role in their country's development.

Following the great upheaval at the end of the eighteenth century, France was long a hotbed of revolutionary activity. Institutions--political, cultural, and social--were under constant attack, led more often than not by artists and men of letters. Not unsurprisingly, it was against this background that the modern movement for women's rights came into being. Curiously, however, it was sparked, not by a Frenchwoman or other European, but by an arrival from the New World, the Peruvian Flora Tristán, who, by an odd but not inappropriate turn of fate,

was to become the grandmother of that most antiestablishment of postimpressionist painters, Paul Gauguin.

In this hemisphere, the women's movement obtained official backing with the creation at the Sixth International Conference of American States (Havana, 1928) of the Inter-American Commission of Women. At that time, only in the United States did women have the right to vote. In the half century that has since elapsed, however, the franchise has everywhere been won, thanks in large part to the efforts of the IACW, which has also sought to ensure women's progress in all fields of endeavor, and complete equality of opportunity for self-realization of every kind, without respect to sex.

The Museum of Modern Art of Latin America pays tribute to the Commission's achievement with an exhibition of works by women artists of the Americas. Drawn from the Museum's permanent collection, the selection on view represents only a fraction of the more than 380 women of the hemisphere who have exhibited at OAS headquarters, individually or collectively, over the past thirty-five years.

While completeness of coverage is obviously impossible (one notes the absence of the late Mexican surrealist Frida Kahlo, for example), the exhibition attempts to reflect the variety of the contribution women have made to the development of art in the Americas--the directions they have taken, the media they have employed, and the techniques they have devised or adapted for personal use--as well as the high quality of their attainment.

In order that the hemispheric panorama may be complete, the National Museum of American Art has graciously lent works by three outstanding women artists of the United States for inclusion in this display--Romaine Brooks, Louise Nevelson, and Helen Frankenthaler.

Thanks are hereby extended to that institution; to the Inter-American Commission of Women and its President, Dr. Julieta Jardi de Morales Macedo; and to the missions and delegations of the OAS member states for the cooperation they have so effectively extended to the organizers of this presentation. --*J.G-S.*

The Museum of Modern Art of Latin America was established in 1976 by Resolution of the Permanent Council of the Organization of American States in celebration of the two-hundredth anniversary of the independence of the United States. An independent unit within the General Secretariat, it functions under the direct jurisdiction of the Secretary of the Permanent Council (Assistant Secretary General of the OAS).

WOMEN ARTISTS WHO HAVE EXHIBITED AT THE OAS INDIVIDUALLY OR COLLECTIVELY [1]

1946 Hemilce Saforcada, Argentina
 Katharine Birdseye Lang, United States
 Amelia Peláez, Cuba

1947 Djanira Gomes Pereira, Brazil
 María Izquierdo, Mexico
 Mary St. Albans, United States
 Carolyn G. Bradley, United States

1948 Luce Carpi Turnier, Haiti
 Mane Bernardo, Argentina
 Norah Borges, Argentina
 Lucía Capdepont, Argentina
 Raquel Forner, Argentina
 Juana Lumerman, Argentina
 Crete Coppola, Argentina

[1] The countries next to the artist's name do not necessarily indicate place of birth, but the country where the artist was living and working in the year when this exhibit was held. Although many of these artists have exhibited more than once at the OAS, their names appear only under the year when their work was shown for the first time in individual or group exhibitions. The list does not include exhibitions prior to 1945. --*Ed.*

Sarah Baker, United States
Olga Mary, Brazil

1949 Lola Alvarez Bravo, Mexico
 Marianne, Mexico
 Marguerite Burgess, United States
 Alida Conover, United States
 Alice Decker, United States
 Laura Glenn Douglas, United States
 Julia Eckel, United States
 Lucile Evans, United States
 Frances Ferry, United States
 Aline Fruhauf, United States
 Margaret Casey Gates, United States
 Lois Mailou Jones, United States
 Norma Mazo, United States
 Helen Rennie, United States
 Sarah Silberman, United States
 Celine Tabary, United States
 Mary Bradley Waltkins, United States
 Andrea Pietro Zerega, United States
 Elena Hosmann, Argentina
 Estela Escobar, Colombia
 Mercedes Salas, Colombia
 Piedad Salas, Colombia

1950 Doris Stone, Honduras
 Elsa Andrada, Uruguay
 María L. Vasconcellos, Uruguay
 Helena Aramburú, Peru
 María Olga Piria, Uruguay
 Lily Salvo, Uruguay

1951 Eugenie Gershoy, United States
 Edith Hoyt, United States
 Theodora Kane, United States
 Miriam McKinnie, United States
 Ruth Starr Rose, United States

1952 Carmen Antúnez, Mexico
 Susana Guevara, Chile
 Laguardia (Carmen Fernández de Herrera), Paraguay

1953 Anita Moore, United States
 Peggy Kelbaugh, Canada
 Noemí Mella, Dominican Republic
 Bibí Zogbé, Argentina
 Roser Muntañola, Panama
 Mary Ruth Snow, United States
 Hazel van Natter, United States
 Mary Hovnanian, United States
 Joyce Field, United States
 Jane Love, United States
 Lila Asher, United States
 Inez Leinbach, United States
 Mimi Bolton, United States
 Elaine Hartley, United States

1955 Fayga Ostrower, Brazil
 Marina Núnez del Prado, Bolivia
 Irma Díaz, Mexico
 Cynthia Green, United States
 Jane Blatter, United States
 Dorothy Hood, United States
 Anne Truitt, United States
 Babette Kornblith, United States
 Thea Ramsey, United States

1956 Geles Cabrera, Mexico
 Graciela Aranís, Chile
 Ana Cortés, Chile
 Ximena Cristi, Chile
 Olga Morel, Chile
 Matilde Pérez, Chile
 Maruja Pinedo, Chile
 Aída Poblete, Chile
 Laura Rodig, Chile
 Graciela Fuenzalida, Chile
 Lily Garafulic, Chile
 Sylvia Daoust, Canada
 Louise Gadbois, Canada
 Kathleen Deery Phelps, Venezuela
 Amanda de León, Venezuela
 Carmen Silva, Chile
 Isi Cori, Chile
 Ruth Safford, United States
 Gabriela Garfias, Chile
 Juana Lecaros, Chile
 Magdalena Lozano, Chile
 Mónica Soler Vincens, Chile

1957 Sarah Grilo, Argentina
 Alma Taharally, British Guiana
 Florence Cavigioli, British Guiana
 Vivian Antrobus, British Guiana
 Liliana García Cambier, Dominican Republic
 Virginia Simón, Dominican Republic
 Jeanne Labautière, Martinique
 Claudine Marie-Claire, Martinique
 Ginette Mangallon, Martinique
 Solange Pettrelluzz-Questel, Martinique
 Rhoda Jackson, Jamaica
 Gloria Escoffery, Jamaica
 Ana Hendricks, Jamaica
 Eva Wilkin, Nevis
 Lucila Engels, Curaçao
 Sybil Richardson, Trinidad
 Jeanette Pollard, Trinidad
 Nina G. Lamming, Trinidad
 Aline M. Kean, St. Thomas
 Marie Moore, St. Thomas
 Ruth M. Gregory, St. Croix
 Sasha Manson, St. Croix
 Lily A. Auguste, St. Lucia
 Rosemary Charles, Grenada

Olga Albizu, Puerto Rico
Solange Arana, Puerto Rico
Asilia Guillén, Nicaragua
María Luisa Pacheco, Bolivia

1958 Alicia Tafur, Colombia
 Helou Motta, Brazil

1959 Maria Bonomi, Brazil
 Elsa Gramcko, Venezuela
 María Moreno Kierman, Argentina

1960 Lilia Carrillo, Mexico
 Edith Behring, Brazil
 Vera Bocayuva Mindlin, Brazil
 Anna Letycia, Brazil
 Lygia Pape, Brazil
 Isabel Ponz, Brazil
 Judith Márquez, Colombia
 Cecilia Porras, Colombia
 Lucy Tejada, Colombia
 Martha Peluffo, Argentina
 Francisca Ramos de los Reyes, Argentina
 Virginia de Vera, Chile
 Noemí Gerstein, Argentina

1961 Marysole Worner, Mexico
 Maria Helena Andrés, Brazil
 Gina Prado, Brazil
 Maruja Rolando, Venezuela
 Hilda López, Uruguay
 Ana María Moncalvo, Argentina
 Tilsa Tsuchiya, Peru

1962 Gloria Finn, United States
 Zoravia Bettiol, Brazil
 Ediria Carneiro, Brazil
 Carolina Muchnik, Argentina
 Yolanda Mohalyi, Brazil

1963 Lygia Clark, Brazil
 Cristina Merchán, Venezuela
 Luisa Palacios, Venezuela
 Seka, Venezuela
 Tecla Tofano, Venezuela
 María Luisa de Tovar, Venezuela
 Thekla Zielke, Venezuela
 Freda, Brazil
 Maria Thereza Negreiros, Colombia
 Elena Eleska, Bolivia

1964 Lola Fernández, Costa Rica
 Nirma Zárate, Colombia
 Gracia Cutuli, Argentina
 Sara Gómez Díaz, Argentina
 Mary Meyer, United States
 Elisa Elvira Zuloaga, Venezuela

Constancia Calderón, Panama
Concha Barreto, Cuba
Gisela (Gisela Hernández), Cuba
Lourdes Gómez Franca, Cuba
Sita Gómez de Kanelba, Cuba
Ileana Govantes, Cuba
Rosana McAllister, Cuba

1965 Tomie Ohtake, Brazil
Rachel Strosberg, Brazil
Lotte Schulz, Paraguay
Delia Sara Cancela, Argentina
Delia Puzzovio, Argentina
Marta Minujín, Argentina
Alicia Penalba, Argentina
Marie José Gardère, Haiti
Feliza Bursztyn, Colombia
Gracia Barrios, Chile
Teresa Casanova, Venezuela
Lilian Gómez Molina, Argentina

1966 Rosina Becker do Valle, Brazil
Bertha Rappaport, Argentina
Thelma Cortés, Mexico
Esthela Gutiérrez, Mexico
Lourdes Luna, Mexico
María Freire, Uruguay
Mercedes Pardo, Venezuela
Luisa Richter, Venezuela
Leonor Cecotto, Paraguay
Ida Talavera, Paraguay
Edith Jiménez, Paraguay
Laura Márquez, Paraguay
Giti Neuman, Ecuador

1967 Carmen Gracia, Argentina
Berta Guido, Argentina
Myra Landau, Brazil
Wega Nery, Brazil
Dália Antonina, Brazil
Camila Hernández, Mexico
María Rodríguez Señeriz, Puerto Rico
Delia del Carril, Chile
Celina Gálvez, Chile
Patricia Israel, Chile
Rebeca León, Chile
Consuelo Orb, Chile
Dolores Walker, Chile
Rosa Vicuña, Chile
Roser Bru, Chile
María Luisa Señóret, Chile

1968 Evaline Sellors, United States
Doris Leeper, United States
Margaret Collazo, Argentina
Alicia Cajiao, Colombia
Marlene Hoffman, Colombia

María Elisa de la Fuente, Argentina
Josefina Robirosa, Argentina
Alicia Silman, Argentina
Nelia Licenziato, Argentina
Sonia Ebling, Brazil

1969 Beatrix Briceño, Panama
 Oderay Obaldía, Panama
 Fanny Sanín, Colombia

1970 Olga Dondé, Mexico
 Antonieta Figueroa, Mexico
 Rosita Alarcón, Chile
 Ana Rita Alvarez, Chile
 Edith Bravo, Chile
 Yolanda Bravo, Chile
 Etelvina Gaete, Chile
 Rosa Hualquimir, Chile
 Amelia Muñoz, Chile
 Juana Romero, Chile
 Nancy Hemenway Barton, United States

1971 Adela Vargas, Nicaragua
 Aída Burela, Peru
 Pilar Castañeda, Mexico
 Olga Lebedeff, Brazil
 Nelly Freire, Argentina

1972 María Elena Delgado, Mexico
 Ruth Bess, Brazil
 Carmen de Millán, Venezuela
 María Esther Ballivián, Bolivia
 Margarita Lozano, Colombia
 Flora Rey, Argentina
 Mary Armstrong, Barbados
 Joyce Daniel, Barbados
 Stella St. John, Barbados
 Hartley Marshall, Barbados
 Hope Brooks, Jamaica
 Valerie Bloomfield, Jamaica
 Edna Manley, Jamaica
 Seya Parboosingh, Jamaica
 Daisy Rose, Jamaica
 Sybil Atteck, Trinidad and Tobago
 Vera Baney, Trinidad and Tobago
 Sarah Crook, Trinidad and Tobago
 Hettie Mejias De Gannes, Trinidad and Tobago

1973 Doris Angel, Colombia
 Luz Clemencia Arenas, Colombia
 Lydia Azout, Colombia
 Maggy Becerra, Colombia
 Teresa Bernal, Colombia
 Olga de Botero, Colombia
 María Eugenia Bravo, Colombia
 Magdalena Bravo, Colombia
 Beatriz Echeverri, Colombia

Fanny Finkelman, Colombia
Clara Gutiérrez, Colombia
María Antonia González, Colombia
Ligia Hoyos, Colombia
Gloria Jaramillo, Colombia
Clara Kassin, Colombia
Ana Kerpel, Colombia
Ada Leary, Colombia
Suzanne Liska, Colombia
Sara Mekler, Colombia
Vivian Moreinis, Colombia
Ximena Otero, Colombia
Maruja Shaio de Possin, Colombia
Clara Ramírez,[1] Colombia
Yolanda Rodríguez, Colombia
Clemencia Salazar, Colombia
Ana Samper, Colombia
Eugenia Simmonds,[1] Colombia
Fanny Stern, Colombia
Patricia Tavera, Colombia
Libia Tenorio, Colombia
Marlene Troll, Colombia
Ana Uribe, Colombia
Eugenia Valencia,[1] Colombia
Amparo Velez, Colombia
Irma Wronsky, Colombia
Pilar Zea, Colombia
Josefina Perazzo, Argentina
Dora Ramírez, Colombia
Ana María Blanco, Argentina

1974 Judith Hancock de Sandoval, Mexico
Nelly Sarmiento, Colombia
Ada Balcácer, Dominican Republic
Maria Martins, Brazil

1975 Martha Chapa, Mexico
Helen Adderly, Bahamas
Myriam Aguirre Lama, Chile
Maria Helena da Silva Bento, Brazil
Cornelia Katharine Breitenback, United States
Pat Byer, Jamaica
Teresa Calderón, Venezuela
Nuria Carulla, Colombia
Cecilia Coca Passalacqua, Costa Rica
Myrta Pachike de Colombo, Argentina
Linda Dalton, United States
Inge Dusi, Costa Rica
Judith Poxon Fawkes, United States
Mary Fischer de Traver, Peru
Angela Girón, El Salvador
Lilian Lipschitz, Uruguay
Janet Luks, United States
Rosa Mamani, Peru

[1] See exhibition *The Manzur Worshop of Bogotá*, February 22, 1973. --*Ed.*

Mónica Martínez Palma, Chile
Violeta Mariamez Rivas, Chile
Susan Marie Mueller, United States
Mariela de la Ossa, Panama
Nancy Rabbitt, United States
Victoria Robledo, Colombia
Isis Sanon Monte Serrat, Brazil
Natalie R. Silverstein, Canada
Susan Tantlinger, United States
Janet Roush Taylor, United States
Elizabeth Tuttle, United States
Daisy Urquiola de Wende, Bolivia
Lynda Watson, United States
Barbara Wilk, United States
Pilar Yanez Rivadeneira, Chile

1976 Aida Carballo, Argentina
 Delia Cugat, Argentina
 Alicia Orlandi, Argentina
 María Cristina Santander, Argentina
 Gabriela Chellew, Chile
 Carol Miller, Mexico

1977 Joyce, Guatemala
 Raquel Orzuj, Uruguay

1978 Daisy Ascher, Mexico
 Irene Cárdenas, Ecuador
 Huguette Franco, Peru
 Raquel Lázaro, Cuba

1979 Lía Bermúdez, Venezuela
 Gego, Venezuela
 Inés Córdova, Bolivia
 María Martorell, Argentina

1980 Helena Townsend, Brazil
 Maya Klipper, Argentina
 Patricia Burton, Barbados
 Judi Christensen, Barbados
 Cynthia Villet, Barbados
 Allison Chapman-Andrews, Barbados
 Barbara Preston, Barbados
 Susana Romero, Paraguay
 Vechy Logioio, Argentina

1981 Consuelo Méndez, Venezuela
 Antonia (Ana Antonia Azuaje), Venezuela
 Corina Briceño, Venezuela
 Ana María Mazzei, Venezuela
 Elsa Morales, Venezuela
 Anita Pantin, Venezuela
 Margot Romer, Venezuela
 Ester Wallis, Venezuela
 Katherine Williams, Trinidad and Tobago
 Roslyn Cambridge, Trinidad and Tobago
 Taty Rybak, Argentina

Pascuala (Luz Marina Ramírez de Villamizar), Colombia
Sheila Lichacz, Panama

1982 Elena Castro-Morán, El Salvador
Althea Bastien, Trinidad and Tobago
Martalicia Almeida, Costa Rica
Cathy Giusti, Costa Rica
Xenia Gordiano, Costa Rica
Amparo Rivera, Costa Rica
Olga Sinclair, Panama

WOMEN ARTISTS REPRESENTED IN THE PERMANENT COLLECTION OF THE MUSEUM OF MODERN ART OF LATIN AMERICA

Daisy Asher, Mexico
Myrna Báez, Puerto Rico
Ruth Bess, Brazil
Ana María Blanco Gómez, Argentina
Maria Bonomi, Brazil
Beatrix Briceño, Panama
Constancia Calderón, Panama
Aida Carballo, Argentina
Julia Codesido, Peru
Inés Córdova, Bolivia
Olga Dondé, Mexico
Beatriz Echeverri, Colombia
Lola Fernández, Costa Rica
Raquel Forner, Argentina
Nelly Freire, Argentina
Consuelo Gotay, Puerto Rico
Carmen Gracia, Argentina
Elsa Gramcko, Venezuela
Sarah Grilo, Argentina
Vilma Gronning, Peru
Asilia Guillén, Nicaragua
Camila Hernández, Mexico
Joyce, Guatemala
Raquel Lázaro, Cuba
Vechy Logioio, Argentina
María Martorell, Argentina
Cecilia Mattos, Uruguay
Gladys Meneses, Venezuela
Carmen Millán, Venezuela
Carol Miller, Mexico
Yolanda Mohalyi, Brazil
Margarita Monsalve, Colombia
Roser Muntañola, Panama
Julia Navarrete, Peru
Tomie Ohtake, Brazil
Fayga Ostrower, Brazil
María Luisa Pacheco, Bolivia
Luisa Palacios, Venezuela
Amelia Peláez, Cuba
Gina Pellón, Cuba
Josefina Perazzo, Argentina
Dora Ramírez, Colombia
Marta Restuccia, Uruguay

Flora Rey, Argentina
Marta Rodríguez, Colombia
Taty Rybak, Argentina
Nina Squires, Trinidad and Tobago
Tanya, Ecuador
Cynthia Villet Gardner, Barbados
Celeste Woss y Gil, Dominican Republic

EXHIBITION LIST [1]

Daisy Ascher (Mexico)
1. *Untitled*, 1978, black and white photograph

Myrna Báez (Puerto Rico)
2. *Nubarrones en Barazas (Storm Clouds in Barazas)*, 1977, silkscreen, 30 x 22" (sheet). Gift of Cartón y Papel.

Ruth Bess (Brazil)
3. *Tapir hereditariedade (Tapir Inheritance)*, 1968, etching with embossing, 23 x 16 1/2"

Constancia Calderón (Panama)
4. *Homenaje a la A (Tribute to the A) No. 2*, 1976, acrylic on canvas, 40 x 40"

Aida Carballo (Argentina)
5. *Autorretrato autobiográfico (Autobiographical Self-Portrait)*, 1973, etching, 16 x 25" (image)

Inés Córdova (Bolivia)
6. *Orillas del lago (Lakeshore)*, 1973, patchwork, 24 x 20"

Julia Díaz (El Salvador)
7. *Mother and Child*. Coll. of the artist.

Olga Dondé (Mexico)
8. *Mandarina (Tangerine)*, 1969, oil on Masonite, 8 x 10"

Beatriz Echeverri (Colombia)
9. *Woman*, 1974, leather sculpture, 44 x 19 x 19"

Lola Fernández (Costa Rica)
10. *Return of the Ancestor*, 1967, oil on Masonite, 67 x 48"

Raquel Forner (Argentina)
11. *Astroseres negros (Black Astrobeings)*, 1961, oil on canvas, 47 x 47"

Nelly Freire (Argentina)
12. *Women*, 1968, pen and ink on paper, 13 x 18 1/2"

Elsa Gramcko (Venezuela)
13. *Composición (Composition) No. 2*, 1958, oil on canvas, 37 x 50"

Sarah Grilo (Argentina)
14. *Tema en azules (Motif in Blues) No. 5*, 1955, oil on canvas, 25 x 31 1/2"

[1] Not included in the original catalogue. All the works exhibited belong to the permanent collection of the Museum of Modern Art of Latin America, OAS, except nos. 7, 33, and 34. --*Ed.*

Asilia Guillén (Nicaragua)
15. *Héroes y artistas vienen a la Unión Panamericana para ser consagrados (Heroes and Artists Come to the Pan American Union to Be Consecrated)*, 1962, oil on canvas-covered board, 20 x 24"

Camila Hernández (Mexico)
16. *Maternidad (Maternity)*, n.d., inlaid amate bark fibers on amate bark paper, 17 x 19 1/2"

Joyce (Guatemala)
17. *Cataclismo (Cataclysm)*, 1975, chromium-plated iron, 40 1/2 x 36 x 6 1/2"

Vichy Logioio (Argentina)
18. *Torso*, 1980, oil on canvas, 39 x 30"

Carmen de Millán (Venezuela)
19. *Mujeres (Women) No. 2*, 1971, oil on canvas, 45 x 32"

Carol Miller (Mexico)
20. *Balam Cat*, 1965, bronze sculpture

Julia Navarrete (Peru)
21. *Untitled*, 1978, charcoal on paper, 40 x 30"

Tomie Ohtake (Brazil)
22. *No. 9*, 1975, acrylic on canvas, 39 x 39"

Fayga Ostrower (Brazil)
23. *Untitled*, 1973, color woodcut, 25 1/4 x 19". Gift of Mr. Sidney A. Jaffe.

María Luisa Pacheco (Bolivia)
24. *Composición (Composition)*, 1960, oil on canvas, 48 x 60"

Amelia Peláez (Cuba)
25. *Mar Pacífico (Hibiscus)*, 1943, oil on canvas, 45 1/2 x 35". Gift of IBM.

Josefina Perazzo (Argentina)
26. *Ruedas, tubos, la máquina... la máquina... la máquina... (Wheels, Tubes, the Machine . . . the Machine . . . the Machine . . .)*, 1972, oil on canvas, 31 1/2 x 39 1/2"

Dora Ramírez (Colombia)
27. *Autorretrato en una ventana abierta (Self-Portrait at an Open Window)*, 1977, acrylic on canvas, 48 x 47"

Marta Rodríguez (Colombia)
28. *Desnudo (Nude)*, 1972, pencil on paper, 19 1/2 x 13 1/4" (image)

Taty Rybak (Argentina)
29. *Prisionera (Prisoner)*, 1980, metal sculpture, 23 x 46 x 10"

Nina Squires (Trinidad and Tobago)
30. *Fish Forms*, 1977, mixed-media print, 30 x 22 1/8" (sheet). Gift of Cartón y Papel.

Tanya (Ecuador)
31. *Liberation*, 1978, silkscreen, 30 x 22" (sheet). Gift of Cartón y Papel.

Cynthia Villet (Barbados)
32. *Composition No. 5*, 1980, collage with handmade paper, 9 x 12"

Helen Frankenthaler (United States)
33. *Summer Scene, Provincetown*, acrylic on canvas mounted on paperboard, 20 x 24". Coll. National Museum

of American Art, Smithsonian Institution, gift of the Woodward Foundation.

Romaine Brooke (United States)
34. *Dame en deuil (Widow in Profile)*, oil on canvas, 36 1/2 x 28". Coll. National Museum of American Art, Smithsonian Institution, gift of the artist.

BIOGRAPHICAL NOTES [1]

BAEZ, Myrna. Painter, printmaker, born in Puerto Rico, 1931. Studied University of Puerto Rico and Plastic Arts Workshop, Institute of Puerto Rican Culture, San Juan; Academia de Bellas Artes de San Fernando, Madrid; Pratt Institute, New York. Lived in Madrid, 1951-57, and traveled in Europe. Held individual exhibitions in Puerto Rico and the United States, including *Ten Years of Graphics and Painting, 1971-1981*, traveling in the United States and Puerto Rico. Participated in numerous group shows in Puerto Rico, the Americas, and Europe, including several biennials in Puerto Rico and abroad. Was awarded numerous prizes in Puerto Rico, including First Prize, Ateneo Puertorriqueño, 1963, 1967, 1970; First Prize, First Salon of Painting, Friends of UNESCO, Puerto Rico, 1974; First Prize for Painting, Revista Sin Nombre, 1975. This year she was awarded a Fellowship for Achievements in the Arts, National Endowment for the Arts.

CODESIDO, Julia. Painter, printmaker, born in Lima, Peru, 1892. Died in Lima, 1979. Studied Escuela de Bellas Artes, Lima, with José Sabogal. Traveled to Mexico to study the muralist movement, 1935. Member and one of the leaders of the *Grupo indigenista*. Since 1929 has held individual exhibitions in Lima, Mexico City (Palacio de Bellas Artes, 1935), New York (1936); San Francisco (Museum of Modern Art, 1937), Paris (Galerie Barreiro, 1939, and Petit Palais, 1953), Buenos Aires (1958), Barcelona (Spain, 1963). Participated in group exhibitions in Peru and abroad. Won, among other awards, the Premio Nacional de Cultura.

GOTAY, Consuelo. Graphic artist, born in Mayamón, Puerto Rico, 1949. Studied Department of Fine Arts of University of Puerto Rico and Department of Art and Education, Columbia University, New York. Also studied printing techniques, Graphic Arts Workshop, School of Architecture, San Juan. Participated in various international shows, including the Latin American Print Biennial, San Juan, 1974; *Encuentro de Artistas Plásticos Latinoamericanos*, Casa de las Américas, Havana, 1976; and in Puerto Rican group exhibitions in Dominican Republic and Switzerland. In 1973 was awarded Honorable Mention, Christmas Festival of the Puerto Rican Athenaeum.

GRONNING, Vilma. Painter, draftsman, born in Lima, Peru, 1941. Studied Corcoran Art School, Washington, D.C., 1966; Northern Virginia Community College, 1976; B.A., American University, Washington, D.C., 1979; M.F.A., American University, Washington, D.C., 1981. Held individual exhibitions in Washington, D.C., and Virginia. Participated in group exhibitions in the United States. Won First Prize for Drawing and Second Prize for Painting, Northern Virginia Community College, 1976. Lives in the United States and is a U.S. citizen.

MENESES, Gladys. Draftsman, printmaker, born in Tucupita, Territorio Federal Delta Amacuro, Venezuela, 1938. Studied Escuela de Artes Plásticas y Aplicadas, Caracas, 1958; Accademia di Belle Arti and the Workshop of Attilio Giuliani, Rome, 1962-63; University of Tokyo, 1970-73. Founding member of the *Círculo El Pez Dorado*, Caracas, 1960; *Grupo Ariosto*, Barcelona (Venezuela), 1964; Taller Tapia, Lechería (Venezuela), 1973. Author and illustrator of the poetry book *El sol la volvió color*. Also illustrated the book *Poemas* by Gustavo Pereira, 1978. Since 1961 has held individual exhibitions in Venezuela (including the Museo de Bellas Artes, Caracas, 1967) and in Japan. Since 1958 has participated in national and international group shows, including print biennials in Santiago (Chile, 1965) and Puerto Rico (1970-72). Won, among other Venezuelan awards, the José Loreto Arismendi Prize and the Roma Prize, Official Salons, Caracas, 1962; and the National Prize for Drawing and Printmaking, National Salon, Maracay, 1972.

MILLER, Carol. Sculptress, photographer, journalist, born in the United States, 1933. Considers herself self-taught as an artist. Held individual exhibitions in Mexico City (including the Poliforum Cultural Siqueiros, 1973) and other Mexican cities, and in Chicago, San Francisco, and Dallas. Participated in Mexican and North

[1] Included here are the curricula vitae of those artists who have never exhibited at the Museum, but whose work is represented in its permanent collection. These biographical notes did not appear in the original catalogue. --*Ed.*

American group shows, including *Contemporary Mexican Art*, Museo de Arte Moderno, Mexico City, 1966; *Women in Mexican Art*, Mexico City, traveling in the United States, 1972-73. Has lived in Mexico City since the 1950s.

MONSALVE, Margarita. Printmaker, born in Bogotá, Colombia, 1948. Studied Escuela de Bellas Artes, Universidad de los Andes. Worked as assistant to Juan Antonio Roda in his workshop. Held individual exhibitions in Bogotá. Participated in national salons.

NAVARRETE, Julia. Painter, draftsman, born in Lima, Peru, 1938. Studied Escuela de Artes Plástica, Catholic University in Lima, 1958-63, with Adolfo Winternitz and Fernando de Szyszlo; Ecole des Beaux-Arts in Paris, 1964-66, with Professor Eugene Clairin, through a French scholarship. Since 1974 has held individual exhibitions in Lima. Participated in national and international shows, including the Graphics Biennial of Ibiza, 1968; São Paulo Biennial, 1975; *Arte Actual Iberoamericano*, Madrid, 1977. Won the Incentive Prize, Fourth Painting Contest, Peruvian-North American Cultural Center, Lima, 1964.

PELLON, Gina. Painter, draftsman, printmaker, born in Cuba, 1926. Studied Escuela de Bellas Artes in Havana, as well as in Paris, 1969. Held individual exhibitions in Switzerland, Belgium, Denmark, Venezuela, Netherlands, Norway. Since 1965 has participated in almost all the annual Parisian salons and has been included in international group shows, such as surrealist exhibitions held in São Paulo and Bratislava (1967), Brussels (1968), Cologne (1971), and Paris (1972); Biennial of Cali, 1973; and numerous others all over Europe. Was awarded Prize for Painting, Biennial of Menton, 1970. Has lived in Paris since 1959.

RESTUCCIA, Marta. Painter, draftsman, graphic artist, born in Montevideo, Uruguay, 1937. In that city studied drawing with Raquel Penino Ruiz, 1945-47; Escuela Nacional de Bellas Artes, 1955-56; drawing and painting with Jorge Damiani, Instituto Uruguayo de Artes Plásticas, 1964-65; printmaking with Luis A. Solari, Círculo de Bellas Artes, 1968; art history, Club de Grabado, 1975. Illustrated many books, magazines, and newspapers. Since 1969 has held individual exhibitions in Montevideo. Since 1964 has participated in national and international group shows, including biennials in Maldonado (1977), Rijeka (1976-78), Mexico City (1980); Joan Miró International Drawing Prize, Barcelona (Spain), 1974-77; and others in Uruguay, Argentina, Brazil, Spain, Portugal. Was awarded many Uruguayan prizes and distinctions, including Acquisition Prize, National Salon, 1968; First Prize for Drawing, Club de Grabado, 1974 and 1975; Bronza Slide Prize, Cine Club of Uruguay, Montevideo, 1976.

RODRIGUEZ, Marta. Draftsman, printmaker, born in Bogotá, Colombia, 1947. Obtained a B.A., Fine Arts School, Universidad de los Andes, 1971. Also studied printmaking with Luis Camnitzer, Universidad Jorge Tadeo Lozano, Bogotá, 1979. Held individual exhibitions in Colombia, Ecuador, and Panama. Participated in national salons and other Colombian group shows in Colombia, Venezuela, and the United States. Was awarded Second Recognition for Drawing (Medal), August Salon, Bogotá, 1974.

SQUIRES, Nina. Painter, printmaker, born in Trinidad, 1929. Started painting in England, 1953. For some time studied at the Hammersmith and the Central Schools of Art, London. Has widely exhibited in the West Indies and in the United States, Canada, England, Spain, and other European countries, as well as at the São Paulo Biennial, 1963, 1973, and 1975. Was awarded the Alcoa Distinction, 1953.

WOSS Y GIL, Celeste. Painter, draftsman, born in Santo Domingo, 1881. Studied at the Academia de Bellas Artes, Santiago (Cuba), under the direction of José Joaquín Tejeda; National Academy of Design; and Art Students League, New York, under the painters George Luks and Frank Vincent Du Mond. Lived in Cuba, traveled in Europe and the United States. Founder and director for ten years of the very influential Academia de Pintura y Dibujo that preceded the National School of Fine Arts. Since 1924 has held individual exhibitions in Santo Domingo. Since 1911 has participated in national and international group shows in Cuba, the United States (including the New York World's Fair, 1939), Argentina, Brazil, Peru, and Uruguay.

July 1 - 30, 1982

CECILIA MATTOS OF URUGUAY [1]

Cecilia Mattos holds two interests in common with many artists of the younger generation today: a preference for drawing as a medium and for the analytical interpretation of reality as subject matter.

Executed in minute detail, and as a rule in pencil, Mattos's compositions reveal the hand of a most meticulous draftsman. As such, the artist has won great prestige both at home, in her native Uruguay, and abroad.

For the most part, she avoids distortion in her treatment of the human figure. She takes rather an approach which is perhaps best characterized as poetic transformation, seeking to imbue her subjects with special significance. At one time she was greatly preoccupied with motherhood and with all the biological mysteries of fecundation and the gestation process.

Mattos was born on July 13, 1958, in the Uruguayan capital, Montevideo. After study there with the painter E. Ribeiro, she came to the United States to pursue her artistic development at Merced College in California. She has participated in group shows and salons in Uruguay and Mexico, and several of her compositions have been included in an exhibit of Latin American drawings which the OAS Museum has organized for circulation outside the Western Hemisphere.

This is the first presentation of the work of Cecilia Mattos in the United States. *--J.G-S.*

July 1 - 30, 1982

LINCOLN PRESNO OF URUGUAY [1]

With the current exhibit, the Uruguayan master Lincoln Presno makes his second appearance at OAS headquarters. Some two decades ago he was first presented to the Washington public with an unusual show featuring tapestries made of dyed cowhides.

While Presno is regularly classified as a painter, his creative activity is by no means confined to work with canvas and brush. He has, for example, developed a specialty in murals that makes no use of pigment, but are constituted instead of natural objects such as pebbles picked up on the beach, rocks, sand, and marble. He has also worked with electrolyzed aluminum to produce highly asymmetric compositions of architectonic effect. In his actual painting, he limits himself to a restricted palette in which the neutrals--black, white, and gray--predominate. In all his creative endeavor he displays a preference for geometric design.

Presno was born in Montevideo in 1917. He first took up painting at the Fine Arts Circle in 1943, and two years later he joined the workshop of Joaquín Torres-García, a leading forerunner of present-day Latin American art. In 1952 Presno began to participate actively in salons and competitions, at which he has received a number of awards, both at home and abroad. His works have been included in group exhibits in Argentina, Brazil, Czechoslovakia, Ecuador, Egypt, Mexico, the Netherlands, Japan, Syria, the United States, and Uruguay. The list of his one-man shows is so extensive as to preclude mention at this time. *--J.G-S.*

July 7 - October 8, 1982

PRESENCE ON THE PATH: BEATRIZ BLANCO FROM VENEZUELA

Amid the band of innovators who so greatly enliven the contemporary art scene in Venezuela, Beatriz Blanco

[1] The list of works exhibited is unavailable. *--Ed.*

holds a place apart by virtue of her experimentation in giving a new dimension to sculpture.

The form of her work is purely structural--flat, as if cut off from the material of which it is made, the material usually being wood. Blanco's essential interest, however, is in movement, which counterbalances the structural rigidity of the compositions.

Her basic subject is the human figure. Her strolling personages bring to mind the creations of the sculptor Alberto Giacometti and the painter Giorgio De Chirico, the first individuals in the history of modern art to discover the mystery and charm that envelop a solitary figure walking in a deserted square or a lonely park. Such settings evoke vividly the void in which modern man moves, and the quiet agony surrounding the endless soul-searching by which his spirit is obsessed. Blanco's figures are not designed to convey any sense of individual identity; they stand as symbols of human beings in solitude.

Blanco has worked in almost all the plastic media, and has even engaged in photography. Sculpture, however, is her primary means of artistic expression. The present exhibit represents her first individual presentation in the United States. --*J.G-S.*

BEATRIZ BLANCO: DEFINING THE FIGURE AND SPACE

In the initial work of the Venezuelan artist Beatriz Blanco, who started in 1968 in Caracas, and in the sculptural group presently exhibited in the gardens of the Museum of Modern Art of Latin America in Washington, D.C., there is a line of continuity which gives particular value to her compositions.

In the first place, her work--one of the most interesting in modern art of Venezuela--has always been devoted to the human figure. This figure, throughout its evolution in the past fourteen years, has gone through various stages representing solitude and encounter, but it has not substantially changed, since it deals with the image of a man or a woman, silhouetted or entirely described, cut out in sculptures, or reflected in illusory spaces determined by the paint. The terms painting or sculpture to describe the artist's work are quite inappropriate. They fail to give an exact idea of the expressive system of Beatriz Blanco because she uses both media, mixing them with silkscreen and photography, as forms of communication. Not only are these creations a search for beauty but they also inform, with metaphorical richness, about how man and woman create their own space on earth and how they interact within it.

The second important aspect which the artist has systematically developed--and one of the most attractive in her work--is precisely the concept of space. She succeeds in creating, most of the times simultaneously, a real and an illusory space. Illusory planes, reflections, transpositions, and visual deceptions are achieved with a rare refinement and invariable ingenuity, and all are used to determine the pictorial space. The outline of the cut metal which follows the shadows and lights of the silhouettes is utilized fully to establish, in three dimensions, the interplay between real and illusory space. Within this Beatriz is able to integrate harmoniously the figure and the space: both carry equal weight and are interpreted inseparably.

This exhibition at the Museum brings together five large pieces, about seven feet high, done in Corten steel left in its natural state, as opposed to other small works where the silhouettes are painted. The encounter of the groups is very lively and not at all accidental, due to the spontaneity with which the figures seem to move, with grace and freedom. Special attention is given to rhythm, to a faithful pursuit of beautiful contours and vigorous effects. At the same time, these walking people, almost colliding with each other in the circle where they are gathered, lack any form of rhetoric. The artist's intention to communicate does not go beyond the vitality of the forms and their festive presence in the space they themselves have conquered. The impetus of life gives each figure in the group an evident agility and frees them from the rigidity so frequent in figures made from cuttings.

The insistence of Beatriz Blanco on interrelating form, space, and light, with the intention of transmitting the harmony of the human body in movement transforms the gathering of the five sculptures into a type of "happening" ruled by its own laws, and it reaches an evident degree of autonomy from to the conventional space where they have been placed. The first purpose of these "happenings" to create an illusory and fictitious space (but as alive as real) within the real space is achieved without any difficulty. The aperture of each silhouette, thanks to the cuttings of the shadows, and the aperture of the illusory space, which they form with their grouping, double the participatory feeling of this open work.

All these notions, discoveries, and sensations are not new; they come from the seventies, but they will continue as long as they are recycled with new formal contributions and new semantic propositions, as is the case with Beatriz Blanco. Her richest contribution in this aspect is ambiguity. By means of this ambiguity the viewer is forced to distrust the visual effects, but only to be able to add to them the spiritual and illuminating factors which alter them. Appearance is nothing without the essence, the path is always purifying, for solitude and/or encounter sublimate the human being. All of the above concepts stubbornly fight to find their place in the work of Beatriz Blanco, which I have known since its beginning. Now they are defined with greater professionalism and clearer mind, less dispersed and experimental than before. Beatriz Blanco has created good work, with personality and with a solid intention to contribute. --*Marta Traba*, Art Critic.

CATALOGUE

". . . form, space, light, and movement are no longer an illusion of suspended time; they are interrelated, they are a presence and a manifestation of its many realities."

Sculptures

1-5. *Presence on the Path*, 1982, Corten steel

ABOUT THE ARTIST

Born in Caracas, Venezuela, in 1944. She studied at the Cristóbal Rojas School of Plastic Arts in Caracas and at the Center for Experimental Arts of the University of the Andes in Merida, Venezuela. She worked in sculpture, drawing, graphic arts, and photography. She also engaged in cinema as part of her visual research. In 1978-79 she worked as an instructor of child creativity in Fundarte, INCE, and the Rondalera Institute, Caracas.

Individual Exhibits

1969 *Presence*, La Gárgola de Tancredo, Maracaibo
1973 *Presence or the Encounter of the Image with Itself*, Ateneo de Caracas, Caracas
1977 *Simultaneous Realities*, Fototeca, Caracas
1981 *Presence on the Path*, Center for the Living Force, New York
1982 *Presence on the Path*, Museum of Modern Art of Latin America, Washington, D.C.

Awards

1969 Only Prize of the Experimental Biennial, Valencia (Venezuela)
1970 Second Arturo Michelena Prize
1972 First Acquisition Prize, Salon of Young Artists, Maracay
1973 Pérez Mujica Prize, Arturo Michelena Salon, Valencia (Venezuela)
1980 Fundarte Grant

Public Collections

Museum of Modern Art, Mérida
Casa del Orinoco, Ciudad Bolívar
Ateneo de Valencia (Venezuela)
Rómulo Gallegos Center for Latin American Studies, Caracas
Simón Bolívar University, Caracas
Fundarte, Caracas
National Art Gallery, Caracas

Bibliography

Dictionary of Plastic Arts of Venezuela, Caracas, 1973
The Works in the Arturo Michelena Salon, Venezuela, 1977
Guevara, Roberto. *Art for a New Scale*. Caracas: Ediciones Maraven, 1979

September 2 - 30, 1982

YOLANDA AGUIRRE OF BOLIVIA

Yolanda Aguirre is a new figure in Bolivian art. A painter of great refinement who works in minute detail, she pursues realism not as an end in itself but for its suggestive value--for its capacity to convey the inner essence of the subject depicted. While her compositions encompass no more than a fragment of a larger whole, they nonetheless impart to the viewer, in a manner at once naturalistic and expressive, a strong sense of totality. Her sheet-covered figures, captured as it were during gynecological examination, constitute a striking tribute to motherhood. In her handling of drapery she finds herself in the great line of the still-life masters of the sixteenth and seventeenth centuries; however, her cloth is not just cloth but rather the symbol of maternity.

Aguirre was born in La Paz, Bolivia, in 1923. She enrolled at the Academy of Fine Arts there in 1951, and two years later undertook study with the late María Luisa Pacheco. Among her other teachers are Armando Pacheco, Agnes de Frank, and Enrique Arnal. In addition, she has been a student at the School of Architecture of the University of San Andrés in the Bolivian capital. In that city examples of her work can be found at both the Municipal Salon of Modern Art and the National Museum of Art. Aguirre has participated in several group shows in her native country and has also had individual exhibits there. This is her first presentation in the United States. *--J.G-S.*

EXHIBITION LIST [1]

Oils on canvas

1. *Genesis I*, 1982, 29 x 24 5/8"
2. *Genesis II*, 1981, 31.5 x 13 5/8"
3. *Genesis III*, 1980, 32 x 25 5/8"
4. *Genesis IV*, 1980, 29 x 23 5/8"
5. *Genesis V*, 1981, 36 x 29"
6. *Genesis VI*, 1980, 36 x 25 5/8"
7. *Genesis VII*, 1982, 36 x 25 5/8"
8. *Genesis VIII*, 1980, 32 x 25 5/8"
9. *Genesis IX*, 1980, 39 5/8 x 25"
10. *Genesis X*, 1980, 32 x 25 5/8"
11. *Genesis XI*, 1981, 39 5/8 x 25"
12. *Genesis XII*, 1982, 32 x 25 5/8"
13. *Genesis XIII*, 1981, 29 5/8 x 25 5/8"
14. *Genesis XIV*, 1982, 36 x 29"
15. *Genesis XV*, 1980, 31 5/8 x 25 5/8"
16. *Genesis XVI*, 1980, 31 5/8 x 25 5/8"

September 2 - 30, 1982

BENJAMIN PORTER OF BOLIVIA

Photography, with its capacity to capture human types both in action and in repose, is of immense documentary value in the anthropological and sociological areas. It can be of particular significance in the case of a country such as Bolivia, where age-old cultures flower amid one of the world's most dramatic and splendorous landscapes.

The changing colors of the soil, the glistening snows of the towering Andes, and the luminous skies of Bolivia provide a never-ending temptation and challenge to photographers. Less frequently, however, does the human

[1] Not included in the original catalogue. *--Ed.*

scene draw their attention. We are fortunate to be able at this time to present an exhibit centering on the people of Bolivia, as a complement to a show of the work of a highly sophisticated contemporary Bolivian painter.

These photographs were taken as simple documents, without aesthetic intention. They should be viewed as a direct, naturalistic statement of life as it is lived in a remote and fascinating land.

Benjamín Porter is a professional photographer, now based in New York, who undertook serious study of his art at the University of North Carolina in 1968, after an initial period as a free lance. While he has traveled extensively throughout the world, he has a special interest in Latin America. His work on Bolivia provides a good measure of the keenness of his perceptions, his feeling for his subject, and the mastery of his craft. --*J.G-S.*

EXHIBITION LIST [1]

Photographs

1. *Potosí*, 1980
2. *Potosí*, 1980
3. *La Paz*, 1978
4. *Potosí*, 1980
5. *Culpina*, 1978
6. *Huallas*, 1979
7. *Huallas*, 1978
8. *Manquiri*, 1979
9. *Potosí*, 1978
10. *Potosí*, 1978
11. *Potosí*, 1979
12. *Potosí*, 1978
13. *Potosí*, 1979
14. *Pazña*, 1980
15. *Potosí*, 1980
16. *Potosí*, 1980
17. *Potosí*, 1982
18. *Potosí*, 1982
19. *Tarija*, 1978
20. *Tinguipaya*, 1978
21. *Sucre*, 1982
22. *Tarija*, 1978
23. *Tarija*, 1978
24. *Tinguipaya*, 1978
25. *Potosí*, 1980
26. *Oruro*, 1975
27. *Potosí*, 1978
28. *Potosí*, 1978
29. *Potosí*, 1978
30. *Potosí*, 1975
31. *Potosí*, 1982
32. *Tarabuco*, 1980
33. *La Paz*, 1982
34. *Potosí*, 1979
35. *Potosí*, 1980
36. *Santa Cruz*, 1979
37. *Entre Ríos*, 1980

[1] Not included in the original catalogue. --*Ed.*

October 5 - 29, 1982

RICARDO CINALLI OF ARGENTINA [1]

Highly unusual both in concept and in medium, the work of Ricardo Cinalli shows him to be a remarkably imaginative and sensitive artist. His focus is that of the close-up, in which overall vision is abandoned in favor of concentration upon detail, enlarged in this case to monumental proportions. The works constituting this exhibit seem to be studies for murals, ready for transposition to walls. By virtue of their scale, they provide the viewer with an overwhelming experience of form. Says the artist: "I have isolated each part of the body to create an individual awareness of its components."

As regards medium, Cinalli makes use of layers of tissue paper, pasted together, color being provided by pastel pigments. In combination with the approach he has taken to his subject matter, this technique renders his compositions altogether unique.

Cinalli was born in Froylán Palacios, in the Argentine province of Santa Fe, in 1948. From 1958 to 1970, he studied at the Fornell Academy of Drawing and Painting in Rosario. Later he took up music at the conservatory and psychology at the university located in the same city. In 1975 he went to England to attend the Hornsey College of Art.

To date Cinalli has had three one-man shows: in Rosario, Montreal, and Orebro (Sweden). He has participated in a number of group exhibitions, and examples of his works are to be found in many private and public collections. This is his first presentation in the United States. --*J.G-S.*

October 5 - 29, 1982

CRISTINA SANTANDER OF ARGENTINA

The printmaker and painter Cristina Santander was born in Buenos Aires, Argentina, and engaged in professional study there, at the National School of Fine Arts.

Santander takes a romantic approach to reality. Abundantly rich in color, her work reveals a decorative vision that has links with art déco.

Santander's graphics have been presented in individual exhibitions on forty-four occasions, in her native Argentina and abroad, in Bolivia, Germany, Italy, Japan, Spain, Uruguay, and Venezuela. The artist has participated in numerous group shows, including one held at OAS headquarters in 1976, and has received awards for her work in Argentina and Spain. --*J.G-S.*

EXHIBITION LIST [2]

Prints

1. *Violetas* (Violets)
2. *Azalea azul* (Blue Azalea)
3. *Azalea blanca* (White Azalea)
4. *Violetas* (Violets)
5. *Kimono*
6. *La rosa rosa* (Pink Rose)
7. *Begonia*

[1] The list of works exhibited is unavailable. --*Ed.*

[2] Not included in the original catalogue. --*Ed.*

8. *Muguets* (Lilies of the Valley)
9. *El mantón* (Mantle)
10. *La sombrilla* (Parasol)
11. *Adan* (Adam)
12. *Eva* (Eve)
13. *Jardín de rosas* (Rose Garden)
14. *Desde el balcón* (From the Balcony)
15. *El cuadro* (Picture)
16. *El círculo* (Circle)
17. *La noche* (Night)
18. *La fiesta* (Party)
19. *El gato* (Cat)
20. *Las amapolas* (Poppies)
21. *Renacimiento* (Rebirth)
22. *El bosque* (Forest)

November 4 - 30, 1982

CELIA CHERTER OF MEXICO

Celia Cherter was born in Pachuca, the capital of the State of Hidalgo, Mexico, in 1929. While she received her artistic initiation at the Esmeralda and San Carlos Academies in Mexico City, she can be considered self-taught in that she soon gave free rein to her creative instincts.

After long years of hard, dedicated labor, Cherter has become expert in handling the metal plates, acids, and burins essential to the exercise of the engraver's craft. She has specialized in color compositions, consisting for the most part of a joyous interplay of flowers, birds, and landscape.

Cherter's compositions figure in numerous public and private collections and have been exhibited on no fewer than forty-six occasions in cities of both Mexico and the United States, twenty of these instances being constituted by individual shows. This is, however, the first presentation of Cherter's work in Washington, D.C.--*J.G-S.*

EXHIBITION LIST[1]

Etchings and Collages

1. *Mi pueblo* (My Hometown)
2. *Ondulación* (Undulation)
3. *Nocturno de aves* (Nocturne of Birds)
4. *Aves y encajes* (Birds and Laces)
5. *Vuelo de colores* (Flight of Colors)
6. *Manzanar* (Apple Orchard)
7. *Posando* (Posing)
8. *Flores y aves* (Flowers and Birds)
9. *Libando* (Gathering Nectar)
10. *Holgorio* (Boisterous Spree)
11. *Búsqueda* (Searching)
12. *Secreto* (Secret)
13. *Aves y frutas* (Birds and Fruits)
14. *Macetas* (Flower Pots)
15. *Recuerdos* (Remembrances)
16. *Globero* (Balloon Vendor)

[1] Not included in the original catalogue. --*Ed.*

17. *Laguna* (Lagoon)
18. *En el trópico* (In the Tropic)
19. *Anhelo* (Longing)
20. *Nocturnal*
21. *Ave de fuego* (Firebird)
22. *Alos* (Cockatoo)
23. *Vuelo de cigüeñas* (Storks in Flight)
24. *Atardecer* (Sunset)

November 4 - 30, 1982

ALEJANDRO COLUNGA OF MEXICO

While the thirty-three-year-old Mexican painter Alejandro Colunga has enjoyed numerous one-man shows in his own country, in other parts of Latin America, in Europe, and in several cities of the United States, he has never previously exhibited in Washington, D.C.

Colunga was born in 1949 in Guadalajara, a city that still preserves many vestiges of its colonial past. The baroque churches of the old neighborhood in which he grew up were to find their way into the paintings of his later years.

In 1968 Colunga started to study architecture, but after three years he renounced it for music--more precisely rock music--combining this interest with courses in anthropology and languages at the local university. These studies in turn were abandoned, and he fell into a vagabond existence, eking out a living with odd jobs in traveling circuses. At one point he became a member of a gypsy caravan.

Fernando Gamboa, a distinguished critic and former director of the Mexican Museum of Modern Art, has written of Colunga:

> Colunga's powerfully expressionistic figurative art derives in part from Hispanic-Mexican religious spectacles, with their profusion of lights. In the whirlwind of his fantastic imagery there also appear, however, figures reminiscent of his dealings with sorcerers and magicians, with the clowns and trapeze artists of traveling circuses, with puppet shows, with street walkers and their frightful hangers-on. One finds animals too--the "dogs of the Evil One," and other beasts more imaginary than real--not to speak of devils, ghosts, and figures out of old wives' tales told at night by candlelight in the cottages of country villages.

One might also find in Colunga's highly imaginative art reflections of the pottery of his native Jalisco, whose fanciful designs and colorful decorations have made the names of Tlaquepaque and Tonalá known far and wide. --*J.G-S.*

EXHIBITION LIST [1]

Paintings

1. *Madona malabarista* (Juggling Madonna)
2. *Elefante en la feria* (Elephant in the Fair)
3. *Niños navegando sobre pez* (Children Riding a Fish)
4. *Niños jugando canicas* (Children Playing Marbles)
5. *Niño loco jugando con su cochecito* (Crazy Child Playing with His Toy Car)
6. *Niño de pijama rojo en sueño con aves* (Boy with Red Pajamas Dreaming about Birds)
7. *El aprendizaje* (Learning)

[1] Not included in the original catalogue. --*Ed.*

8. *Proyecto para escultura sobre madera X* (Plan for a Sculpture on Wood X)
9. *Proyecto para escultura sobre madera VIII* (Plan for a Sculpture on Wood VIII)
10. *Mago de tres cabezas* (Three-Headed Magician)
11. *Avioncito FIV de Pepe Alvarez* (Pepe Alvarez's FIV Plane)
12. *Mago cantando* (Singing Magician)
13. *Borracho sobre barra roja con perros* (Drunkard on a Red Bar with Dogs)
14. *Mago con iguanas de Puerto Vallarta* (Magician with Iguanas from Puerto Vallarta)
15. *Payaso con rosa* (Clown with Rose)
16. *Vendedor de banderitas* (Vendor of Little Flags)
17. *Madona del santuario* (Madonna of the Sanctuary)
18. *Madona con máscara en carnaval* (Masked Madonna in Carnival)
19. *Pepito y su banda de música* (Pepito and His Band)
20. *Perro malabarista* (Juggling Dog)
21. *Mago con orejas* (Magician with Ears)
22. *Niño mago jugando en la playa* (Magician Boy Playing on the Beach)

November 9 - December (?), 1982 [1]

PERUVIAN HANDICRAFTS

Press Release E-126/82, OAS, Washington, D.C., November 5, 1982. The Museum of Modern Art of Latin America will feature an exhibition of various forms of handicrafts from Peru. . . . The Ambassador and Permanent Representative of Peru to the Organization of American States (OAS) Luis Marchand Stens and Mrs. Marchand, the Ambassador of Peru to the United States Fernando Schwalb and Mrs. Schwalb, and the Secretary General of the OAS Alejandro Orfila and Mrs. Orfila will sponsor the exhibit.

The crafts to be displayed feature traditional Peruvian gourd carvings, ceramics, weaving, and painting. The exhibit, collected by the government of Peru, is part of the observance marking 1982 as the Inter-American Year of Handicrafts. . . .

Among the selection of ceramics, the famous Bull of Pucará is to be found. Traditionally, the decorated bull was a religious object, used to bring good health and fertility to the herd. Today it is used mainly as a vessel for *chicha*, a liquor used in religious festivities and other important events. The old ceramic work, without wheel or glaze, cannot be compared to that of today. Present techniques are enhanced by these two elements of European origin, but even so, they do not reach the perfection of skill and design of their more primitive predecessors.

In weaving, the ancient Peruvians mastered all phases of craftsmanship, including sophisticated techniques using gauze and negative dyes.

Ancient Peruvian painting was equally advanced. It included image-making, and paintings on cloth, enamel, and wood. Image-making, spurred by the intense religious life of the Spanish viceroyalty, reached a brilliant apex and then declined. Today, due to the demand of collectors, image-making is commercial rather than religious. . . .

THE PERUVIAN GOURD

Orlando Velorio's free interpretations of traditional Peruvian gourd carvings provide an introduction to an art that has flourished in the Andean republic for some four thousand years. Indeed, the earliest surviving decorated gourds date back to the pre-ceramic Huaca Prieta era.

Gourds were originally employed as bowls, cups, spoons, or water jugs--a utilitarian function which still persists

[1] The catalogue for this exhibition is unavailable. The OAS Press Release is partially reproduced here, as well as the entire text of *The Peruvian Gourd*, by Mr. José Gómez-Sicre, which appeared in the invitation sent out for this exhibition. --*Ed.*

in the arid coastal region of Peru. To facilitate such use they were often bound with cord while still on the vine, to ensure their growth into the desired shapes. After the coming of the Spaniards, gourds came to serve as an instrument of communication between villages; carvings depicting important events constituted a sort of illustrated newspaper.

Gourd carving today is carried out principally in the village of Cochas, located high in the Andes, at an altitude of 10,500 feet. Children are introduced to the art at the age of four or five, taught at home by a parent or an older brother or sister. Thus the tradition of their pre-Columbian Indian ancestors lives on into the twentieth century.

After carving, gourds are generally scorched with a glowing eucalyptus stick, to produce a surface of varying shades of brown. However, gourds may also be coated with cooking oil, after which burnt straw is rubbed into the etchings to produce black outlines. Less commonly, prior to carving, gourds may be treated with dye, as a rule purple; etching results in white-outlined designs. *--J.G-S.*

November 11, 1982

DOMINICAN ARTIST PRESENTS A MURAL TO THE OAS

Press Release C-190/82, OAS, Washington, D.C., November 11, 1982. Dominican artist Raman Oviedo presented today a mural to the Secretary General of the Organization of American States. At the presentation ceremony the artist said: "The mural has no title, but I would call it *Mama América*, since it represents a group of figures that struggle for the welfare of the American nations."

The work was presented by the Dominican Republic Ambassador to the Organization of American States, Mr. Eladio Knipping Victoria, to the OAS Secretary General, Mr. Alejandro Orfila. Both agreed with the Director of the Museum of Modern Art of Latin America, Mr. José Gómez-Sicre, in recognizing Oviedo as "the most prominent artist of the Caribbean and of Latin America. . . . The Dominican Ambassador stated that "even though Oviedo belongs to the Dominican expressionistic tendency, there are renaissance overtones in his work. . . . This mural proves, once again, my country's interest in contributing to the spiritual unity of Latin America."

. . . This art work was installed in the eighth floor of the new building of the OAS General Secretariat.

November 12, 1982

ORIGIN OF A NEW DIMENSION: A MURAL BY RAQUEL FORNER

Press Release E-125/85, OAS, Washington, D.C., November 5, 1982. Raquel Forner, a renowned forerunner of the Latin American modern art movement, will present to the Organization of American States (OAS), on November 12, her most recent work. The painting, destined to grace the new OAS Secretariat Building, is an abstract expressionist piece entitled *Origin of a New Dimension*. The painting is being donated by the government of Argentina as well as Mrs. Forner.

. . . The dynamic 82-year-old artist . . . spent seven months toiling on the wall-size mural, although she indicated that "it was not a great effort, it flowed naturally, and I am very pleased to present it to the OAS."

The mural is typical of her visionary nature. . . . The artist interprets her work to mean "the contact of modern man with the cosmos, resulting in an improved future race which will comprehend that we are all brothers in a world without divisions."

RAQUEL FORNER

For many months the dean of Argentine women artists, Raquel Forner, has been at work on a mural for the entrance hall of the new Secretariat Building of the Organization of American States in Washington, D.C., toiling away in the house in a picturesque quarter of Buenos Aires that for forty years has served her as both residence

and studio.

Finished at last, the painting now joins murals by the Brazilian Manabu Mabe, the Peruvian Fernando de Szyszlo, and a tapestry by the Mexican Leonardo Nierman to transform the building lobby's cavernous reaches into a dazzling vision of the creative talent so abundantly active in Latin America today.

It is astonishing that an artist who has been exhibiting for over half a century should still produce work so forward-looking and youthful in spirit. At an age at which no one would be surprised to find her engulfed in the past, Raquel Forner lives in the future, seeking by intuition to depict races as yet unborn, worlds whose existence is still unknown to man. Her exploration of the mystery of interplanetary space predates the voyages of the astronauts. The prescience of her imagination is a matter for judgment by the para-humanity of eons to come.

Typical of her visionary nature is the mural she has painted for Washington, characteristically entitled *Origin of a New Dimension*. Its strongly contrasting colors, fluid lines, and amoebic shapes suggest the evolution of form from the amorphous, of structure from chaos. Arms stretch out, not in threat or in grasping acquisitiveness, but in gestures of friendship, prefiguring a harmonious world order to come.

Forner was born in Buenos Aires and received her initial training there at the National Academy of Fine Arts. She absorbed the basics that were imparted, but rebelled against the formal style that then reigned in Argentine art. It is not surprising that the first work she submitted to the official salon, following her graduation, was rejected for her "distorted" handling of the human figure. More receptive was the atmosphere in Paris, where she went for further study with the Franco-German artist Emile Othon Friesz. Othon Friesz imposed no formulas or doctrines upon her, encouraging her rather in the path of self-expression.

After two years abroad, Forner returned home, to join with other young artists--Alfredo Guttero, Pedro Domínguez Neira, and the sculptor Alfredo Bigatti whom she was later to marry--in the establishment in 1932 of the Free Courses of Plastic Art, which opened new doors of opportunity to would-be artists in the Argentine capital. One should note that to this day Forner retains a special interest in the rising generation and always has a good word to say to or about the young who show talent and discipline. Her own career, for over fifty years, has been one of constant activity, continuing evolution, and ever-growing reputation. Exhibitions in great cities of both the Old World and the New have been the occasion of frequent travel abroad. Finding idleness unbearable, she fills these absences from her studio with work in graphics, creating lithographs of striking intensity, distinguished in recent years by brilliant color.

Forner's dedication to her art is matched by the honesty with which she views both her own accomplishments and those of others. Her frankness may at times approach the point of rudeness. She has no patience with dilettanti, with those whose work is geared only to the fashions of the moment. Quick to recognize genuine talent, however, she is generous in its praise.

While she has been an expressionist since early in her career, she has never been content to remain at a given level of achievement but has ever sought new ways to give vent to human feeling through color and form. At the time of the Spanish Civil War, the use of symbols gave a vaguely surrealistic air to her large-scale compositions, generally neutral in tone. Worn rocks, severed hands, and other manifestations of anguish and pain loomed large in later pictures. The grays and ocher of her beginnings have gradually given way to more brilliant hues, applied in flat effects suggestive of mosaics of stained-glass windows. Most recently one finds in her work reflections of the interplanetary age into which the world has entered.

Origin of a New Dimension is symbolic both of Forner's evolution and of the spirit which informs it. The grays of the lateral figures aspire toward the bright colors of the central composition; humanity in bondage is dazzled by a vision of a freer, more abundant life to come--a universe of music and joy. The generous gift of the government and people of Argentina to the Organization of American States is more than a work of art: it bears a message of peace, fraternity, and happiness for all. --*J.G-S.*

December 9 - 31, 1982

MARIA MARTINEZ-CAÑAS

Periodically the Museum of Modern Art of Latin America focuses its attention on the figure of what might be termed the "complete photographer"--the artist responsible for the entire photographic process, from the snap of the shutter to the drying of the finished print. Such is the case with María Martínez-Cañas.

Miss Martínez-Cañas was born in Havana, Cuba, in 1960, but today is a citizen of the United States. A graduate of the Philadelphia College of Art, where she studied from 1978 to 1982, she currently holds a fellowship at the Chicago Art Institute which permits further development of her photographic instinct.

As a girl she grew up surrounded by works of art, her father, Dr. José Martínez-Cañas, being one of the early collectors of modern Latin American painting and sculpture. From early days she felt an impulse to create compositions of her own, an impulse which the camera enabled her to satisfy, thanks to the opportunity it affords for a structured reordering of observed reality.

Despite the relatively short length of time she has been working in the photographic field, Miss Martínez-Cañas is readily classifiable as a full-fledged professional. She has participated in group shows in Philadelphia, San Juan (Puerto Rico), and Miami. This year the Barbara Gillman Gallery, located in the last-mentioned city, displayed an extensive collection of her prints. Figuring prominently among them were her *Linears*--laboratory products of geometric nature--and multiple compositions consisting in a harmonious collage of elements of reality.

Concerning her recent work, this highly original artist of the lens says:

> The *Fragment Pieces* are the conclusion of earlier work. In this process I relate abstract patterns, shapes, and forms, combining them with conventional images that are torn apart. By doing this I am exposed to a polarity: tradition-abstraction. The *Fragment Pieces* are light drawings done by hand gestures; they represent a fragment of human energy.

This is the first presentation of Miss Martínez-Cañas's work in the Washington, D.C., area. --*J.G-S.*

EXHIBITION LIST [1]

Photographs

1-7. *Map Series*
8-20. *Fragment Pieces*

December 9 - 31, 1982

SILVIA MALAGRINO

The Argentine writer-photographer Silvia Malagrino was born in 1950 in Buenos Aires, where she undertook studies in French and Spanish literature. Upon their conclusion she gave classes in those subjects and engaged both in translation of French poetry and in original composition, her work being published not only in the Americas but also in Europe.

It was only after she came to the United States, some four years ago, that she took up photography, which now

[1] Not included in the original catalogue. --*Ed.*

constitutes her major interest. She received her first instruction in the art at the Visual Studies Workshop in Rochester, New York, complementing it with later study at the Philadelphia College of Art. She soon exhibited such skill and artistic instinct that she was engaged to teach photography at the Cheltenham Art Center and at Temple University's Center for Contemporary Studies, both located in Pennsylvania. She also works as a free lance.

Concerning her slides and prints, in which she conjures up a dream world--a blending of elements remembered from the past--Silvia Malagrino has made the following statement:

> For the past year I have been working with the content of my dreams and my memory. In the process of rearranging the chaotic elements coming from both experiences, I learned that Time was my concern. In *A Bomb Desert*, my recent piece, I explore among other things the anxiety of living at the edge of Time, as a personal and cultural dimension. The piece is a sequential work consisting of thirty-one photo-collages. To make the collages I combine my own shots with media images and I incur into the personal and collective memory of destruction.

Silvia Malagrino's photographic creations have appeared in group shows in Cheltenham, Norfolk, and Philadelphia. This is her first individual exhibit. --*J.G-S.*

EXHIBITION LIST [1]

Photographs

1. *Page 1*
2. *Page 3*
3. *Page 7*
4. *Page 11*
5. *Page 12*
6. *Page 16*
7. *Page 18*
8. *Page 19*
9. *Page 21*
10. *Page 22*
11. *Page 23*
12. *Page 25*
13. *Page 26*
14. *Page 27*
15. *Page 28*
16. *Page 30*

YEAR 1983

January 10 - February 14, 1983

ALEJANDRO OBREGON: RECENT PAINTINGS

INTRODUCTION

It is a long time ago, well over twenty years, that I met for the first time with Alexander Obregón who then lived in Barranquilla, and it is with pleasure therefore that I react to the news of his current show in Miami and Washington.

The particularly thorny issue that preoccupied those of us who at that time took an interest in art developments outside the United States was defined by the relationship of such foreign contributions, their freedom from or their dependence upon the strong presence that the so-called New York School exerted in the late 1950s.

Obregón, like many other painters who have reached positions of prominence in Latin American countries, is a case in point, and a particularly felicitous one in my view. For his paintings at the time were neither unrelated to nor, in a subservient sense, derived from North American sources. Instead, Obregón managed to remain aware of world currents as much as he continued to administer to the creative environment of his native Colombia. Such double identity is of course a Latin American fate, but only artists are burdened with a need to exteriorize it.

A painting by Obregón, completed in 1965, and subsequently purchased by the Guggenheim Museum, reminds us of this tension between world view and national stance, and like many other such works from Obregón's hand, testifies to his ability to force a reconciliation between such seeming opposites. The artist had then already mastered the secret of spontaneity--a gestural freedom embraced by his North American colleagues, and by the French surrealists before. But, Obregón's forms, and even more his colors, breathe an air far removed from urban sophistication, and his subjects, exotic perhaps to North Americans, reflect authentic predilections with images and realities of his Caribbean world.

It will be good to feel a whiff of it in Obregón's newest selection, and thereby trace the changing context to his art. --*Thomas M. Messer*, Director, The Solomon R. Guggenheim Museum.

OBREGON: A WILD VOCATION

Many years ago, a friend asked Alejandro Obregón to help him look for the body of the skipper of his boat, who had drowned at dusk while they were fishing in the Ciénaga Grande (Great Swamp) for twenty-pound shad. Both spent the whole night going back and forth across that immense paradise of withered waters, exploring the most unthought of turns with searchlights, following the drift of floating objects that tend to lead to the pools where drowned men stop to sleep. Suddenly Obregón saw him: he was submerged up to his crown, almost sitting in the water, and the only thing floating on the surface were the errant strands of his hair. "He looked like a Medusa," Obregón told me. He grasped the bundle of hair with two hands and with the colossal strength of a painter of bulls and storms, he drew the whole drowned man up, eyes open, huge, dripping the mud of sea anemones and manta rays, and flung him like a dead shad into the bottom of the boat.

That episode, which Obregón tells me once more because I ask him to every time we get dead drunk--and it also gave me the idea for a story about drowned men--is perhaps the only instant in his life that most resembles his art. That's the way he paints, really, as if he were fishing up drowned men out of the darkness. His painting, with horizons of thunderclaps, comes out dripping with fighting minotaurs, patriotic condors, lusty goats, bellowing barracudas. In the midst of this stormy fauna of his personal mythology walks a woman crowned with Florentine garlands, the same, as always and as never, who goes meandering through his paintings with clues changed

because she is really the impossible creature for whom this reinforced-concrete romantic wants to die. Because that's what he is, the way all of us romantics are, the way it has to be: shameless.

The first time I saw that woman was the very same day I met Obregón thirty-two years ago in his studio on the Calle de San Blas in Barranquilla. It had two large, ungainly rooms and through their straddling windows the Babylonian din of the city rose up. In another corner, between the last Picassian still lifes and the first eagles of his heart, there she was, with her hanging lotuses, green and sad, holding her soul in her hand. Obregón, who had just returned from Paris, was going about as if he had been bitten by the smell of guava. He was already just like that self-portrait of him that looks down on me from the wall as I write, the same portrait that he tried to murder one mad night with five shots from a high-caliber pistol. Still, what most impressed me when I met him was not that pair of clear corsair eyes that made marketplace faggots sigh, but his big, coarse hands, the ones we saw him use to deck a half dozen Swedish sailors in a whorehouse brawl. They are the hands of an Old Castilian, tender and savage at the same time, like those of Don Rodrigo Díaz de Vivar, the Cid, who fed his hunting falcons on his beloved one's doves.

Those hands are the perfect instruments for a wild vocation that has not given him an instant of peace. Obregón paints before he makes any use of reason, at all hours, no matter where, with what he has at hand. One night, during the time of the drowned man, we had gone to drink rotgut rum in a half-finished sailor's bar. The tables were piled in the corners, between bags of cement and piles of limestone, and carpenter's benches served as doors. Obregón seemed to be flying high for a long time, carried away by the smell of turpentine, until he climbed up onto a table with a can of paint, and with a few swift big-brush strokes the master painted a green unicorn on the empty wall. It wasn't easy to convince the proprietor that that single brushstroke was worth more than the whole building itself, but we managed. The nameless bar went on to be called *The Unicorn* from that night on, and it became an attraction for gringo tourists and Bogotá boobs until the inexorable winds that carry off time carried it off to hell.

On another occasion Obregón had fractured both his legs in an automobile accident and for two weeks in the hospital he sculpted his totemic animals in the plaster of the cast with a scalpel loaned him by a nurse. The master stroke was not his however, but what the surgeon had to do in order to take the cast off the two sculptured legs, which now reposes in a private collection in the United States. A reporter who visited him at home asked him, with a touch of annoyance, what was wrong with his little spaniel, because she wouldn't stay quiet for a moment, and Obregón answered him: "It's just that she's nervous because she knows I'm going to paint her." He painted her, of course, as he paints everything that crosses his path, because he thinks that everything that exists in the world was made to be painted. In his viceregal house in Cartagena de Indias, where the whole Caribbean Sea comes in through a single window, you can find his own daily life and another life painted everywhere: on lampshades, on the toilet seat, on mirrors, on the cardboard crate the refrigerator came in. All kinds of things that to other artists are a defect are legitimate virtues to him, like sentimentality, like symbols, like lyrical outbursts, like patriotic fervor. Even some of his failures stay alive, like that woman's head that was scorched in the kiln but which Obregón still keeps in the best place in his house, with half of a side eaten away and a queen's diadem on its forehead. It is impossible to think that the failure there was not sought after and calculated when in that face without eyes the inconsolable sadness of the woman who never arrived is revealed.

Sometimes, when there are friends in the house, Obregón will station himself in the kitchen. It is a pleasure to see him setting out the broad blue knives,[1] the pig's snout with a carnation in the nose, the ribs of veal with the heart still there, green plantains from Arjona, cassava from San Jacinto, yams from Turbaco. It's a pleasure to see how he prepares everything, how he cuts and distributes it according to form and color, how he sets it all to boiling with the touch of the same angel with which he paints. "It's like throwing the whole landscape into the pot," he says. Then, while it boils, he goes about tasting the stew with a wooden spoon and emptying bottle after bottle of "Tres Esquinas" rum into it so that it will end up replacing the water that is evaporating in the pot. In the end you understand why you have to wait so long for a ceremony like that, worthy of the Pontifex Maximus, and what it is all about is that the Stone-Age stew that Obregón serves on *bijao* leaves is less a matter of cooking than it is a painting to be eaten.

[1] The term used in the Spanish text is *mojarra*, which is a kind of dagger but also a sea fish. --*Ed.*

He does all things like that, the way he paints, because he doesn't know how to do things any other way. It's not that he only lives to paint. No. It's that he lives only when he paints. Always barefoot, in a cotton undershirt that at some time past must have been used to clean his brushes, and pants he has cut off himself with a butcher's knife, and with a bricklayer's rigor that God would have liked in his priests. --*Gabriel García Márquez*. Translated from the Spanish by Gregory Rabassa.

ALEJANDRO OBREGON

When Alejandro Obregón burst upon the art world in Colombia, with the technical skills he had acquired abroad, a new era opened up for painting in this country. Up to then, Colombian painting had moved slowly, timidly, and unadventurously, even though there were well-trained artists and some who were capable of achieving a certain greatness as regards space and dimension. Ultimately, however, it suffered from the acceptance of conventional precepts of a quiescent immobility, to survive in the same way as waxwork figures, in a bloodless repose, through representations which, though possibly perfect, were lifeless and sterile, without allowing for any negligence, for any inconformity or for any agony of the spirit. That is in fact what is called academic art, however competent and faultless it may be. Obregón, having no feeling for wax figures, began to eat away, to dismember that pictorial world, to perforate it like a termite. It was thus that an iconoclast appeared on the scene, to demolish those lifeless images. He also came to inject a new spirit into Colombian art, to give it a new brilliance, to bring blood and fire into a fossilized world. Without doubt, Obregón saved Colombian painting from a long, drawn-out crisis.

I got to know the artist by corresponding with him on more or less official business when he was director of the Bogotá Art School. We then lost touch for some time, to finally meet again in Paris, on two occasions: in 1949 and in 1954. As is only natural, his powers of persuasion and his spontaneous gaiety overcame my inhibitions and he dragged me to various places of entertainment where we saw the then "daring" shows which today would be merely the equivalent of those given at the end of term in a conservative school. From Pigalle to the Boulevard Saint Michel, from "Les Naturistes" to the "Café Dupont," we started to discuss a possible exhibition in Washington, in the tired old OAS gallery. At that time Alejandro was still searching for ways to express his ideas. There was a bit of several personalities in his work, but he showed no embarrassment in painting out the impact that some of the leading artists of that time had on his work. Picasso first, then Clavé, and to a lesser degree Tamayo. This approach, these starting points, were merely circumstantial, as if he simply said hello to these artists and then turned and went on his way. It may have been Clavé, with his baroque shadows, his rupture in image and volume, his sfumatos, who had the greatest effect on his creative power. In fact, what might be considered influence was merely a jumping board towards a new course which was to be his very own. That was around 1954.

For twenty years I have watched Alejandro Obregón's career, step by step. I have seen the birth and maturing of his personality, one of the most vigorous to appear in the new art, the soundest art to be produced so far in Latin America. At the time I speak of Alejandro was living in Alba, in the center of the south of France. He lived in a cabin he built himself in the shade of some Roman walls. Like a patient conqueror of Gaul, he worked there with that enthusiasm and discipline that come naturally at the age of thirty-four. If the modern painters I have mentioned had an effect upon his technique or his way of painting, he likewise sought in the Old Masters, in his visits to the Louvre, the basis of the truth of Western plastic tradition. I remember an oil of his, of an extraordinary purity, a still life now in a Buenos Aires collection, which breathed the pale, precise atmosphere of a Piero della Francesca. The Venetian mosaics and the great painters of Ducal Venice constituted another well-assimilated lesson. And out of all that, as from a crucible, emerged the Alejandro Obregón we know today.

Obregón's 1955 Washington show was in the nature of a landmark, even though the artist himself refused to exclude a single work which showed his initial influences. Crowds invaded the hall from the early afternoon, with most of them wishing to purchase his works. I barely managed to save an oil which I was commissioned by Alfred Barr to reserve for the collection of the Museum of Modern Art in New York. Barr had also been asked by Nelson Rockefeller to choose another. Not to be left behind, the Phillips Collection, one of the best depositaries of new painting, purchased another canvas. The exhibition was completely sold out. And that is when a new Obregón was born.

Years later, the painter said to me: "There are two precise phases in my career--before and after my exhibition at the OAS." After this show, the painter returned to Europe and a short time later came back to Colombia,

where he found what he needed: the sea, the sky, the sea birds of the coast, the mangroves, the hieroglyphics of the jaguars. He also made brief incursions into the valleys of the Andean highlands and painted condors and parts of mountains, gorges, and the very drama of nature itself. While his palette for the coast was brilliant and luminous, for the highlands, for the cold regions, it was cold. Very few paintings within the scene of current Latin American art have the same emotion as a large canvas by Obregón, owned years ago by the National Museum of Bogotá, which represented the cordillera and the condor. Black and violet were the instrument of color. He carried the same theme to a mural in a bank building on Carrera Séptima in Bogotá, in a most successful fresco painted with the greatness and dignity of a seasoned maestro. By this time he was the Alejandro Obregón admired and sought after by everyone. The name became internationally known; he won prizes and was mentioned by foreign critics as a definitive reality. He did not need the label of the Paris School.

Although Obregón had studied in France, he also did so in England and in the United States and in Spain. Thus he came to be the product of dissimilar cultures which would provide a new message for America. That has been the case: today he is a leading figure among the great artists of the Continent.

Time has not separated us altogether. We meet frequently in Colombia. I have followed him from time to time to Cartagena and Barranquilla and I have seen him paint iguanas surrounded by a large family of tame iguanas in his Barranquilla studio. Together we have visited the remains of jungle animals on the coast, where he finds scales and feathers which are superimposed and show through just like they do in his happiest pictorial fragments, in those glazes which have been his distinctive mark over a long part of his career. Together we have enjoyed the belligerent light of the tropics, and I even obliged him, as master that he is in that field, to paint a fresco and have it filmed, so that the youth of America who continue to follow the old techniques might learn from it.

In his moments of greatest meditation on painting, his rich pictorial fragments are grouped together like a Roman mosaic, producing a fascinating whole. It is not a jigsaw puzzle but great organic units, conceived through the union of small zones of true chromatic lyricism. There have been very few painters in our nations who can express themselves with such a technique and who, if they do manage to do so, rather than merely showing us their skill, leave us with a feeling of lyricism. By now, Obregón has switched to acrylics, which makes it necessary to use a different technique. He and I have argued this point. Nevertheless, his works structurally do not lose any of their freshness even though his brushstrokes may appear flatter. The force of a great creator, with an absolute command of his own plastic language, is always predominant. A baroque colorist deeply emotional, Alejandro Obregón has saved his country's painting from a dangerous crisis and has given Latin American art a new slant. --*J.G-S*. Translated from the Spanish by Hanka de Rhodes.

ALEJANDRO OBREGON, PAINTER

"To paint is to produce air from earth, light from matter." --Alejandro Obregón, interview with J.G.C.B.[1]

Productive Anarchy and Conservative Revolution

The sea has ninety-two different kinds of winds and Alejandro Obregón knows them all. Quite likely he has painted most of them over the forty-year period in which he has been Colombia's most important painter. And even if he has not actually painted them, in his works one can breathe their uncontrollable fury and sense the sultry atmosphere of the Caribbean. An atmosphere which becomes heavy at *siesta* time but is equally capable of leaving one inert and defenseless when confronted by the sight of a hurricane--always named after a woman--which blows away roofs of buildings and maddens huge revolving trees flying whistling overhead. The same can be said about Obregón's painting, one moment calm and passive and the next breaking loose and impressing us with a complete transformation.

Due to his sensitivity to tropical nature, his work is the product of an organic development thanks to which Obregón, by learning to see and to transform, has made various generations of Colombians see not only the

[1] All quotes by Alejandro Obregón were taken from the interview granted to J.C. Cobo Borda in 1981, which appeared in *Cromos* magazine, Bogotá, 1981.

aesthetic adventure of modern art but, also, the physical and spiritual elements implicit in their own landscape: the invisible horizon of a country called Colombia. A landscape which, thanks to Obregón, maintains its qualities in the face of time and all the avant-garde movements that come and go.

Thus we must start out from the fact that Alejandro Obregón (born in 1920) is a painter--nothing more, nothing less. In this elementary fact lies the complexity of any approximation to his work and to the enchantment which arises from it. As suggested by Hofmannsthal in a speech to students in Germany (Munich, 1927), the chaotic nature of the time could only be overcome by the euphemistic paradox of "productive anarchy" and "conservative revolution," which are valid terms to describe Obregón himself. No one has ever described this unique figure better than Gabriel García Márquez, as evidenced in the pages he has written in this catalogue. Those of us who have the good fortune to know Obregón (and this term is by no means an exaggeration), realize that his painting is indivisible from the man himself. A knight whose castle is the city of Cartagena; a mad and untameable creator who has never lost his good manners. The ultimate paradox, however, is that any valid work must transcend its author and speak for itself.

From an Ideal World to Market Fluctuations

Jakob Burckhardt's writing devoted to Rubens, which was considered to be "the final confession of his life," allows us to trace by way of contrast the soil which nurtured Western art. This soil was not that of "the big modern cities, whose variable wealth made them unstable. A public opinion, nourished on constant changes, did not exist; nor did a press which could act as its spokesman, with sufficient influence to make art in certain areas and even the independent thinking of the artists dependent on it. In those days, no sudden 'pathos' emerged and extended over the culture of the various social groups in large towns, merely to give way to another in a short time. In brief, there was no public on which everything, including painting, relies today. Contests and exhibitions did not exist, either."

Burckhardt goes on to say: "As topic for his art, Rubens expressed the unity of the ideal world as well as the real life of the Latin peoples." A world at the same time legendary and biblical, mythological and allegorical, pastoral and visionary, historical and current, which is animated and kept at a precise pitch by its powerful naturalism whose inspiration can be found in its own capacity for life. "His enormous inventiveness was directed mainly towards the constant perception and representation of that reality."[1]

Three centuries after Rubens, around 1944, we meet Alejandro Obregón, descendant of a family of Spanish landowners on the northern coast of Colombia. Though he did not find that ideal world, he, too, had in mind to become a great painter. With views to enduring, in the milieu of a Latin American country where plastic arts were limited to narrating earthy anecdotes, he directed his efforts at fighting for personal freedom in painting and at mastering its specific language.

Obregón had received the European modern art lesson--painting as a pictorial place, accomplished with pictorial media, to produce pictorial compositions. Consequently, amid the bitter nationalism of those decades, through his work he asked that "painting should be simply painting," rather than a literary transposition--a language suitable for transmitting certain particular messages through an image.

Yesterday he was a pioneer; today, although he has conquered the territory, he continues using his explorer's vision towards the inside of his world. And despite the fact that in Colombia--a country called the Tibet of South America--art has never been widely exposed to the outside world, Obregón, more than anyone else, has preserved his deep roots in Colombian culture. This culture in the process of being formed is made of Spanish, Black, and Indian contributions; of Caribbean and Andean polarities; of rhetoric and somnolence; of lucidity and brilliance; all of which have found their truest expression in the canvasses of Obregón and the novels of Gabriel García Márquez.

Obregón knows how to narrate the physical atmosphere of Colombia just as García Márquez knows how to paint the nostalgic, captious vision of a world parched by failure and solitude. A solitude which, as he himself says, is the opposite to solidarity. A solitude which Obregón himself has described for posterity in a painting called

[1] Jakob Burckhardt, *Rubens*, Buenos Aries, 1950, p. 53.

Violencia (1962), one of his most beautiful works. Both, painter and writer, with their climatic descriptions--the hurricane-like blasts of light crossing all of Obregón's canvasses, the everlasting heat prevailing in García Márquez's Macondo--exist in an orbit of their own, far from the ups and downs of the marketplace, to depict from that consciously assumed anachronism the most accurate picture of this vast sorrowful fatherland, with all its colors and its lights. Or is it not an anachronism to decipher manuscripts, to arduously draw strange calligraphy on a blank canvas? Through a maniacal repetition of their favorite motifs, they have also told us that only with work with its own obsessions and with the world that gave it life can one produce forms common to everyone, open up a dialogue.

"What Matters Is to Create a State of Mind"

In consequence, Obregón started by painting emotions, and one of the most vivid and compact of such emotions, perceived throughout his work with repeated passion, is that of freedom. Freedom to create, freedom to combine, freedom to make mistakes.

"To be always right is very boring, it paralyzes one," he says frequently. And those states of mind--from triumph to defeat; from inertia to surprise, which in his painting may well lead from a vital spark to the unmodifiable solidity of death; from lush flowers to a perennial overall gray--confirm the existence of a supreme, mysterious imperfection, even more beautiful than the finished product, which is nothing but a "tremor of time," that fleeting beauty which his painting captures with devilish speed, time that comes and goes and changes, like the sea; which clears the perspective or clouds the view; ephemeral time which endures in a sensitive recording in but a few lines.

Brave and daring, Obregón aimed at something more than merely to capture those sensations. He attempted the outrageous task of fitting all of Colombia into the frame of his pictures--and he succeeded in doing so. He succeeded in creating a conventional, pedestrian image of what we are like, in giving us a recognizable but more intensely vital face. In this way he has painted the sea and the mountains, the bull and the iguana, the barracuda and the condor. He succeeded in bringing forth, from the beaches of the Caribbean to the snows of the Andes, our true people--not photographically but in their real form, not abstract but solid, not specifically detailed but seen through images in which they are embodied. In effect, not symbolic but real images. People, as Obregón himself has said, who in fact are a mixture of "gentleness and violence."

Air-Sea-Landscape-Dialogues

Thus one might claim that one of the few decisive territories of Colombian art is that staked out by Alejandro Obregón; however, the actual presence offered by his canvasses is not so much that of the earth and its millenary rearrangements but the more subtle presence of air and its endless metamorphosis: the space-landscape.

Marta Traba, his best interpreter,[1] has said that Obregón has ontological dimensions: a womb which produces his own creatures, thanks to which all such creatures are interrelated in a constant search for primary sources: life/death, light/shadow, proximity/distance. There, inside that womb, the revelations and apparitions are knotted together in a chain of meanings which invariably ends by leading back to his own painting. This is to say, to the eye of the spectator who has become accustomed to recognizing it as his own; to accepting that the unforeseen emerges from the habitual, the fantastic from the commonplace, and that a discovery comes out from a series of unsuccessful attempts. Painting, as we know, has to do mainly with morals and boldness, not changes of subject matter, but a change in the vision.

That, ultimately, is Obregón's great paradox. As Hernando Valencia Goelkel has said: "His imagery has been penetrating actively into the mind of the public who at times does and at others does not recognize itself in the steady output of work that cannot, strictly speaking, be reduced to an iconic function. (Iconic in the sense proposed by Harold Rosemberg: 'As in times past, our public secrets are embodied in icons. This does not mean that their meaning has been understood, merely that the image is accepted as a given thing and that no further questions are raised as to its presence.') Obregón does not provide the key or keys to his painting in the final, polished work; he always bears in mind (and sometimes exercises) the right to return, to be supported by the

[1] Marta Traba, "Obregón," Bogotá, unpublished manuscript on the painter's work up to 1974, written in 1978.

past in order to establish a new curve to the upward spiral. Of this intimate pondering the spectator has but the clues provided by the works themselves; no one suspects the meditation, the applied intelligence, whose path remains unknown. The process is undecipherable and its outcome, the painting itself, retains all the enigmas in the deceitful schemata of the image."[1]

But Obregón's images, despite their laconic nature and the silent eloquence which is characteristic of them, do offer some clues. In 1974, when the Museum of Modern Art of Bogotá held his first retrospective, this exhibition, at Obregón's request, was titled simply *Aire Mar Paisaje Diálogos (Air-Sea-Landscape-Dialogues)*. Four words which spell out his contribution and demonstrate how the titanic, baroque accumulation of his canvasses merely shows up, in reverse, the few elementary figures which make up his world. "What one can paint is very limited. The sea, air, earth, people, and animals, and an eternal combination of them all. Two-legged creatures, four-legged creatures, and politicians (who should not be painted at all). Four or five subjects, and three colors: red, blue, and yellow. Only it is much easier to paint a defeated man than a triumphant man. The victor has no scars. He has nothing."

"One cannot paint air because it does not exist. If one wants to paint air, one paints the wing of a bird."

A romantic expressionist, lacking the aggressive attitude of his European and North American counterparts, Obregón, both figurative and abstract, has managed to maintain a realistic as well as poetic interpretation (unforeseeable and recognized) of nature in perpetual movement. A nature which, while concentrating on its central figures--from woman to chameleon, from beast to angel, from flower to a tiger's skull--did not cease to remain open to the possibilities of further metamorphosis.

While his paintings have those stormy skies, that zig-zag lightning, those heavy black clouds, they also have sun, as a fixed eye, which makes the painting full of eclipses by being so near the light and allows the carnivorous density of its animal vegetation to coexist with the lunar halo of its veiled female silhouettes. These paintings seem to have the liquid-like nature of a dream and to constantly change their myths (the whole exists in each part), nevertheless they remain heedful of reality, of a flight of reality in the plastic space, and at the same time they express another category of poetry: immobility.

Roland Barthes has said: "The image of movement can only be represented when movement is detained; to represent it, movement must become immobilized at the end of its run; it is that inaudible, unsustainable repose which Baudelaire has called the emphatic truth of a gesture and which is found again in demonstrative painting, that of Gros for example; that suspended, oversignificant gesture could be called divine inspiration, since it is the motion of a god silently creating the destiny of man--in other words, perception."[2]

His light or dark figures, contrasting upon the extensive magical background in which Obregón is a virtuoso, expand on the basis of glazes and transparencies and become dissociated, thus recovering their dynamism, pricked by a rain of luminous arrows until they finally explode in a fulminating visual blast: explosions of color. Never with naturalistic detail but impregnated with a pantheistic élan--delicacy and violence, furor and freshness--they manage to suggest those curiously emaciated, almost archetypal forms which spring up and are destroyed in turn, renewing the original chaos of any creation: night/day, sun/moon, plenitude/corpse.

But these forms do not come to the foreground, they remain in the back, ruling over the whole. All that we get is that luminous, prolific flora which like a leafy arbor contains a semi-naked woman, hidden by a veil of modesty, or else masked queens with a winged serpent crawling over them. At their feet, like an offering--"how difficult it is to love but how pleasant to be courteous"--are those stranded remains which people Obregón's

[1] Hernando Valencia Goelkel, "Caballero solo," in the collective volume *Alejandro Obregón*, Bogotá, 1979, p. 46, which also includes writings by Alvaro Cepeda, J.G. Cobo Borda, Juan García Ponce, José Gómez-Sicre, Bernardo Restrepo Maya, Daniel Samper, Marta Traba, et al. Also see J.G. Cobo Borda, "Obregón el Maestro," in *La alegría de leer*, Bogotá, 1976, pp. 207-216, which constituted originally one of the texts of the *Air-Sea-Landscape-Dialogues* catalogue, Bogotá, June 1974.

[2] Roland Barthes, "Las láminas de la enciclopedia," in *Nuevos ensayos críticos*, Buenos Aires, 1973, p. 143.

scenic composition, that seem to have been washed up by the surf and whose traces he has always preserved: the head of an alligator, an eagle's wings, the ferocious teeth of a fish, the skeleton of a bird, an iguana creeping out from hell, a goat's leg, an ecstatic owl, the outlines of walls in the distance, the fiery red of a volcano, the giddy immobility of something in flight, of something that passes, trembling and shaking. Is it an angel, a pelican?

Speaking of Cézanne, Rilke wrote: "With each picture one sees how necessary it was to go even further than love; it is, of course, natural to love each thing when one is making it; but if the creator displays such love, he lessens the quality of the thing, he judges it instead of saying it."

To say things . . . Obregón does not name them in order to evoke them, he names them for the sake of naming them. Possibly for this reason he destroys them and only accepts them again when they return to life, when they are strong once more, just like the intense visions which his imagination cannot help painting. There we have those alligator men, those bird women, all that mythology so much his own, reminding us of the truth which gives them their *raison d'être*, and which Obregón has described as follows: "A picture should not represent, it should exist on the basis of its own energy." These figures do not represent anything but the painting itself; in the space created, they are merely a cobalt blue, a zinc white, a Veronese green and a crimson red. The hand and the eye of a painter.

The Unceasing Fury

A painter, fortunately, is never satisfied with himself. Restless, discontent, he never ceases to attempt to mold that stubborn material, to extract from it its secrets, without ever achieving, happily for us, the pure repose of perfection. He goes on working, investigating, fully conscious that his objects are merely a pretext and not a conclusion, not an end: "If I paint a landscape, it turns into a nude. If I paint a nude, it turns into a landscape. The object is something to focus on, to see where it takes one. A barracuda does not represent the sea or a fish but symbolizes speed. Birds are air-flight."

It is this eager and alert intimacy with the world that Obregón has been acquiring which makes each of his brushstrokes a break from the established cliché and confirms his primary conviction: to paint with fury. Says Dore Ashton, in his book *A Fable of Modern Art*: "A painter, or any artist, has the duty not to be conscious of his perceptions. Cubism, as Picasso said, was not the intellectual and conceptual activity that so many wanted to make of it, but a natural, organic process which was born directly from the very act of painting."[1]

In Obregón's case, his painting acts as a live membrane which allows us to escape from our routine and open the way to new sensations. It clears our eyes to perceive both the terrible and exhilarating reality of Colombia which at the same time crawls and flies, enchants and sinks, is surface and is depth; moves us beyond words, or simply remains there, in stupid silence. Thus the blunt, hard-wearing fabric of the world crumbles every time he touches it, without breaking the conventions of painting--the brush and the acrylics, the canvas stretched on the frame--but extracting from it new meanings to be shared with us. Our response, usually stiff and cold, becomes full of warmth and brightness. The reality of appearances is there, but at the same time--and there is nothing we can do about it--the true falsehood which is art.

A knowing mixture of delicacy and wantonness, of dumbness and vehemence, Obregón combines creative rapture with keeping his feet anchored on the ground: his ground, his soil, which he has never left for long and to which he always returns.

"To work without worrying about anyone and to become strong," is what Cézanne asked for. Maybe for the same reason Alejandro Obregón's painting, with its own life and authority, has never become numb and is a basic part of the little good that has happened to us Colombians. In his painting, the economy of methods which is characteristic of it, with the tireless working-over and refinement of such methods, has become a lavish squandering of a few elements. The decisive point, however, is that this scene-landscape is driven by the invisible force of the wind. A *galerna* or a *tramontana* (stormy winds from the northwest and the north), the mistral, which

[1] Dore Ashton, "Rilke," chapter of *A Fable of Modern Art*, translated into Spanish in *Scandalar*, New York, No. 2, April-June 1978, p. 18.

blows every other day and on the ninth day drives sailors berserk; those winds which open up great holes of silence in the midst of their tense calm and then spring up again, making the sea rough, spewing up foam, making the fish fly in the air and people tremble before the mystery of something that, like painting, has a life of its own.

In the same way as Turner, Obregón has asked to be tied to the mast of the ship in the middle of a storm, to face the lashing waves, the dying lights, and the fury of the sea. The fury of looking hungrily at the world and making it his own. --*J.G. Cobo Borda*. Translated from the Spanish by Hanka de Rhodes.

CATALOGUE

Paintings

1. *Angela de la media noche (Midnight Angel)*, 1982, acrylic on canvas, 69" x 67"
2. *Después de la lluvia (After the Rain)*, 1982, acrylic on canvas, 70" x 71"
3. *El último cóndor (The Last Condor)*, 1982, acrylic on canvas, 69" x 67"
4. *Vuelo (Flight)*, 1982, acrylic on canvas, 69" x 67"
5. *Un litoral (Coastline)*, 1982, acrylic on canvas, 69" x 67"
6. *Paisaje con buho (Landscape with Owl)*, 1982, acrylic on canvas, 69" x 67"
7. *Nube (Cloud)*, 1982, acrylic on canvas, 59" x 59"
8. *De la luna (Of the Moon)*, 1979, acrylic on canvas, 63" x 55"
9. *Aguila azul (Blue Eagle)*, 1982, acrylic on canvas, 69" x 67"
10. *Arcángel (Archangel)*, 1982, acrylic on canvas, 69" x 67"
11. *Nepentes (Nepenthes)*, 1982, acrylic on canvas, 69" x 67"
12. *Arcángel para Feliza (Archangel for Feliza)*, 1982, acrylic on canvas, 69 x 67"
13. *Angela y arpía (Angel and Harpy)*, 1982, acrylic on canvas, 59" x 59"
14. *Elegía a Blas (Elegy to Blas)*, 1979, acrylic on canvas, 82" x 68"
15. *Ave caída (Fallen Bird)*, 1981, acrylic on canvas, 15" x 13"
16. *Angela y cabra (Angel and Goat)*, 1981, acrylic on wood, 18" x 14"
17. *Hombre caimán (Alligator Man)*, 1981, acrylic on wood, 18" x 14"
18. *Aparición (Apparition)*, 1982, acrylic on wood, 15" x 13"
19. *Leyenda de Guatavita (Guatavita Legend)*, 1981, acrylic on wood, 15" x 13"
20. *Paisaje (Landscape)*, 1982, acrylic on wood, 15" x 15"
21. *Marina (Seascape)*, 1982, acrylic on wood, 12" x 12"
22. *Tres elementos (Three Elements)*, 1982, acrylic on wood, 15" x 13"
23. *Bahía de Cartagena (Cartagena Bay)*, 1981, acrylic on wood, 15" x 13"
24. *Guatavita*, 1981, acrylic on wood, 15" x 13"
25. *Guatavita*, 1981, acrylic on wood, 15" x 13"
26. *Cóndor y cabra (Condor and Goat)*, 1981, acrylic on wood, 15" x 13"
27. *Angela y bestia (Angel and Beast)*, 1981, acrylic on wood, 25" x 23"
28. *Angela de cartulina (Cardboard Angel)*, 1981, acrylic on wood, 14" x 12"
29. *De la luna (Of the Moon)*, 1980, acrylic on canvas, 82" x 68"
30. *Retrato de un antepasado loco (Portrait of a Mad Ancestor)*, 1979, acrylic on canvas, 54" x 51"
31. *Guatavita*, 1981, acrylic on wood, 33" x 29"
32. *Laguna (Lagoon)*, 1981, acrylic on wood, 15" x 13"
33. *Flor naranja (Orange Flower)*, 1982, acrylic on canvas, 69" x 67"
34. *Mangle (Mangrove)*, 1982, acrylic on canvas, 69" x 67"
35. *Ladera (Hillside)*, 1982, acrylic on canvas, 60" x 67"
36. *Toro cóndor (Bull Condor)*, 1982, acrylic on canvas, 69" x 67"
37. *Rayo de sol y trueno seco (Sunbeam and Thunderbolt)*, 1982, acrylic on canvas, 69" x 67"

January 19 - February 18, 1983

MAMY TOJA OF PARAGUAY

The panorama of the plastic arts in Paraguay has been continually broadened in recent years, as new trends have penetrated the country, new schools have developed, new groups have formed, and an increasing number of young artists have made their presence felt on the cultural scene.

Mamy Toja exemplifies the inquiring spirit that is always open to new ideas and ready to experiment. A figure in constant evolution, she has taken a number of different approaches to painting, following in turn the examples of the constructivists, the Franco-Russian abstractionist Vasili Kandinski, and the American pop artists. She has sought constantly, however, to place her personal stamp on the work created under these influences. In general, it may be said that the flatness of her surfaces and the careful articulation of her compositions constitute a form of synthetic cubism.

Mamy Toja was born in Asunción in 1937. In addition to participating in group shows in her native Paraguay, she has had several individual exhibits there.

This is the first presentation of her work in the United States. --*J.G-S.*

EXHIBITION LIST [1]

Oils on Canvas

1. *Chaleco* (Vest), 1980, 30 x 20 cm.
2. *Pantalón* (Pants), 90 x 45 cm.
3. *Capelina* (Lady's Hat)
4. *Jumpsuits*
5. *Sombrilla en la playa* (Umbrella on the Beach)
6. *Pantalón con sandalias y pipa* (Jeans with Sandals and a Pipe), 1981, 45 x 35 cm.
7. *Composición de corte y confección* (Sewing Composition), 80 x 80 cm.
8. *Corbata y monedero* (Tie and Purse), 1981, 48 x 23 cm.
9. *Pollera* (Skirt), 1981, 80 x 40 cm.
10. *Conjunto de vestir* (Clothing Ensemble), 1981, 60 x 80 cm.
11. *Short y bolsa* (Shorts and Bag), 1981, 40 x 25 cm.
12. *Conjunto de snickers* (Sneakers Ensemble), 1982, 60 x 80 cm.
13. *Campera y boina* (Jacket and Beret)
14. *Arpa y guarania* (Harp and Guarania), 1981, 50 x 80 cm.
15. *Teatro lírico* (Lyrical Theatre)
16. *El burrito mecánico* (Mechanical Donkey), 1980, 29 x 33 cm.
17. *El Vaquero* (Cowboy), 1980, 26 x 28 cm.
18. *Fiesta de carnaval* (Carnival Party)
19. *Fábrica* (Factory)
20. *Viaje a la luna* (Trip to the Moon)
21. *Mujer sofisticada con cirugía estética* (Sophisticated Woman with Plastic Surgery), 1980, 40 x 30 cm.
22. *Rosas y mariposas* (Roses and Butterflies)
23. *Restaurant*
24. *Gaviotas* (Sea Gulls)
25. *Itá Enramada*
26. *El ciprés* (Cypress Tree)
27. *Lapacho lila* (Lilac Lapacho)
28. *Tom Jones*
29. *Autorretrato* (Self-Portrait)
30. *Jarrón azul* (Blue Jar)
31. *Mariposa* (Butterfly)

[1] Not included in the original catalogue. --*Ed.*

February 24 - March 5, 1983

TANYA OF ECUADOR

Though born in Prague, Czechoslovakia, in 1935, Tanya grew up in Quito, Ecuador. She is a citizen of Ecuador. There, at an early age she began the study of painting with her father, an architect, painter, and pedagogue who had practiced in Europe before moving to South America. Her instruction in art was continued at the Windsor Mt. School in Lenox, Massachusetts, under the direction of Si Silliman, a disciple of Josef Albers. Still later she studied at Reed College in Portland, Oregon; at the Los Angeles County Art Institute in California; in Geneva, Switzerland, where she worked with the sculptor Henri Paquet; and at the Académie de la Grande Chaumière in Paris.

In 1960 Tanya went to Mexico to exhibit at the invitation of the Organization for the International Promotion of Culture (OPIC), an agency of the Secretariat of Foreign Affairs. She has remained in that country ever since, both practicing and teaching painting. She is married to the Mexican sculptor Luis Barreiro.

Tanya's work conveys something of the spirit of the German romantics of the late nineteenth century, in whose paintings human figures dissolve into landscapes. Her compositions capture earth and sky in a process of constant transformation, melting into one another in dramatic outbursts of color.

Tanya's work has been presented individually and in group shows in Brazil, Costa Rica, Ecuador, Honduras, Israel, Mexico, and Venezuela. This is her first exhibit in the United States. --*J.G-S.*

EXHIBITION LIST [1]

Mixed Media on Canvas

1. *Liberación (Liberation)*, 80 x 140 cm.
2. *Paisaje onírico (Oneiric Landscape)*, 80 x 140 cm.
3. *Paisaje onírico (Oneiric Landscape)*, 60 x 50 cm.
4. *Paisaje onírico (Oneiric Landscape)*, 80 x 100 cm.
5. *Canto del viento (Song of the Wind)*, 200 x 120 cm.
6. *Amanecer (Dawn)*, 100 x 120 cm.
7. *Paisaje onírico, serie Homejane a J.S. Bach (Oneiric Landscape, Homage to J.S. Bach Series)*, 80 x 140 cm.
8. *Paisaje onírico, serie Homenaje a J.S. Bach (Oneiric Landscape, Homage to J.S. Bach Series)*, 100 x 120 cm.
9. *Paisaje onírico, serie Homenaje a J.S. Bach (Oneiric Landscape, Homage to J.S. Bach Series)*, 180 x 120 cm.
10. *Paisaje onírico, serie Homenaje a J.S. Bach (Oneiric Landscape, Homage to J.S. Bach Series)*, 122 x 61 cm.
11. *Paisaje onírico (Oneiric Landscape)*, 100 x 160 cm.
12. *Personaje astral (Cosmic Figure)*, 160 x 100 cm.
13. *Paisaje onírico (Oneiric Landscape)*, 160 x 100 cm.
14. *Paisaje onírico (Oneiric Landscape)*, 60 x 40 cm.
15. *Paisaje onírico, serie Homenaje a J.S. Bach (Oneiric Landscape, Homage to J.S. Bach Series)*, 100 x 120 cm.
16. *Paisaje onírico (Oneiric Landscape)*, 100 x 160 cm.
17. *Paisaje onírico, serie Homenaje a J.S. Bach (Oneiric Landscape, Homage to J.S. Bach Series)*, 160 x 100 cm.
18-19. *Paisaje onírico (Oneiric Landscape)*, 60 x 40 cm.
20. *Paisaje onírico, serie Homenaje a J.S. Bach (Oneiric Landscape, Homage to J.S. Bach Series)*, 91 x 61 cm.
21. *Paisaje onírico (Oneiric Landscape)*, 100 x 120 cm.
22. *Espíritu de danza (Spirit of Dance)*, 180 x 120 cm.
23. *Paisaje onírico (Oneiric Landscape)*, 20 x 50 cm.

[1] Not included in the original catalogue. --*Ed.*

24. *Figura de explosión (Exploding Figure)*, 60 x 40 cm.
25. *Personaje astral (Cosmic Figure)*, 60 x 40 cm.
26. *Paisaje onírico (Oneiric Landscape)*, 20 x 50 cm.
27. *Espíritu de danza (Spirit of Dance)*, 60 x 40 cm.

April 14 - 29, 1983

TRIBUTE TO JOSE ANTONIO VELASQUEZ (1906-1983)

PROGRAM

1. Opening remarks by Ambassador Alejandro Orfila, Secretary General of the Organization of American States

2. Remarks by His Excellency Víctor Cáceres Lara, Minister of Culture and Tourism of Honduras

3. Remarks by His Excellency Ambassador Roberto Martínez Ordóñez, Permanent Representative of Honduras to the Organization of American States

4. Presentation of the film *The World of a Primitive Painter*, the award-winning OAS tribute to José Antonio Velásquez

José Antonio Velásquez, to whose memory the present exhibition constitutes a posthumous tribute, was several times honored in life by the Organization of American States. The Organization indeed takes much pride in the knowledge that his worldwide renown is in part attributable to the efforts it has made over the past four decades to promote a greater appreciation abroad of the talents and achievements of contemporary Latin American artists.

If the charm of Velásquez's compositions is readily apparent careful study reveals the exceptional quality of his workmanship. This, joined with the purity of his artistic intent and his abiding attachment to motifs furnished by his native Honduras, soon gained Velásquez a reputation as the most important naive painter of his day. At present his oeuvre is universally recognized as constituting one of the most significant of Latin American contributions to the art of our times.

Since Velásquez's disappearance from the art scene, demand for his compositions has but increased. They are among the most treasured possessions of private and public collections on both sides of the Atlantic, and nowhere have they been the object of greater admiration than in this House of the Americas. *--J.G-S.*

CATALOGUE

Oils on Canvas

1. *Village Scene*, 1982. Coll. The White House.
2. *Vista de San Antonio de Oriente (View of San Antonio de Oriente)*, 1949, 19 3/4 x 29 3/4".
 Coll. Embassy of Honduras.
3. *Vista de San Antonio de Oriente (View of San Antonio de Oriente)*, 1966, 20 1/2 x 28".
 Coll. Ambassador and Mrs. Joseph John Jova.
4. *Vista de San Antonio de Oriente (View of San Antonio de Oriente)*, 1969, 36 x 46".
 Coll. Ambassador and Mrs. Joseph John Jova.
5. *Vista de San Antonio de Oriente (View of San Antonio de Oriente)*, 1966, 20 1/2 x 27 1/2".
 Coll. Ambassador and Mrs. Joseph John Jova.
6. *Vista de San Antonio de Oriente (View of San Antonio de Oriente)*, 1957, 26 x 37".
 Coll. Museum of Modern Art of Latin America.
7. *Vista de San Antonio de Oriente (View of San Antonio de Oriente)*, 1972, 47 1/4 x 60 1/2".
 Coll. Museum of Modern Art of Latin America.
8. *Gran vista de San Antonio (Church of San Antonio de Oriente)*, 1966, 44 1/2 x 56".
 Coll. Mr. José Gómez-Sicre.

9. *Plaza Morazán en Tegucigalpa (Morazán Plaza in Tegucigalpa)*, 1969, 42 1/2 x 48".
 Coll. Mr. José Gómez-Sicre.
10. *Vista de Tegucigalpa (View of Tegucigalpa)*, 1971, 36 1/2 x 48". Coll. Mr. José Gómez-Sicre.
11. *El ojo (The Eye of God)*, 1980. Coll. Mr. José Gómez-Sicre.
12. *Un 15 de setiembre, aniversario de la Independencia de Centroamérica (September 15: Anniversary of the Independence of Central America)*, 1970, 17 3/4 x 21 3/4". Coll. Mr. and Mrs. Jacobo Goldstein.
13. *Vista de San Antonio de Oriente (View of San Antonio de Oriente)*, 1962, 8 1/2 x 11 1/2".
 Coll. Mr. and Mrs. Jacobo Goldstein.
14. *Vista de San Antonio de Oriente (Details of San Antonio de Oriente)*, 1954, 28 1/2 x 20 1/2".
 Coll. Mr. and Mrs. Guillermo Espinosa.
15. *Vista de San Antonio de Oriente (View of San Antonio de Oriente)*, 1972, 23 1/2 x 35 1/2".
 Coll. Mr. and Mrs. Angel Hurtado.
16. *Domingo de Ramos (Palm Sunday)*, 1980, 37 1/4 x 47 1/4". Coll. Mrs. Raquel Liebes.
17. *Vista de San Antonio de Oriente (View of San Antonio de Oriente)*, 1980, 24 x 20". Coll. Mrs. Raquel Liebes.
18. *Vista de San Antonio de Oriente (View of San Antonio de Oriente)*, 1983, 20 x 23".
 Coll. Ms. Mireya Lima and Ms. Edith Lima.

Posters

19. *Parque Central de Tegucigalpa (Central Park of Tegucigalpa)*. Coll. Embassy of Honduras.
20. *Vista de San Antonio de Oriente (View of San Antonio de Oriente)*.
 Coll. Permanent Mission of Honduras to the OAS.
21. *Escena nocturna de San Antonio de Oriente (Night View of San Antonio de Oriente)*.
 Coll. Mr. and Mrs. Jacobo Goldstein.

Photographs by Francisco Alvarado-Juárez

22-37. Latest photographs of *Antonio Velásquez and San Antonio de Oriente*

May 6 - June 3, 1983

DIANDERAS

Nieves Dianderas was originally classified as a figurative painter of postimpressionist tendencies. However, as a result of her trips to Europe and journeys in the coastal and mountain regions of her native Peru, she has developed a pictorial language all her own, and is now firmly embarked upon the path of abstractionism.

In *Cadences in Time*, she imposes on the viewer an entirely personal view of the universe. Figurative elements are not totally lacking; Dianderas's open spaces are traversed by ghostly, bird-like markings that hang weightless in space, like the notes of a song. Energy of mysterious origin is expressed in rhythmic movements, suggestive of nebulae in formation; waves of light flow diagonally across the canvas. Quietude is but ephemeral; the overall effect is one of perpetual motion--though full realization of the concept doubtless occurs solely in the artist's mind. Transparent, free of graphic reference points, Dianderas's works reflect that fleeting moment in which macrocosm and microcosm are fused in the primal act of creation. They are as it were poetic allusions achieved with elements of color and light in painting of absolute purity.

This is the artist's first individual exhibit in the Washington area. --*Oscar R. Méndez*

EXHIBITION LIST [1]

Acrylic on Canvas

1-20. *Serie Cadencias del tiempo (Cadences of Time Series)*

[1] Not included in the original catalogue. --*Ed.*

ABOUT THE ARTIST

Nieves Dianderas was born in Lima, Peru, on July 30, 1929. She began her studies of drawing and painting at the studio of Germán Suárez Vértiz and later went on to the studios of Alejandro González Trujillo and Juan Manuel Urgarte Eléspuru. Eventually, she enrolled at the National School of Fine Arts, from which she graduated with a teaching certificate. In 1958, 1964, and 1969 she undertook independent studies of art in Amsterdam, Paris, Madrid, New York, São Paulo, and Rio de Janeiro; 1970 and 1971 she devoted to classes in Peruvian archaeology, ethnomusicology, and folklore at Lima's University of San Marcos.

Dianderas has participated in more than a score of significant group shows in Peru, Ecuador, and Colombia. Her first individual exhibit took place in Lima in 1974; it has been followed by a number of others both at home and abroad--in Colombia, Ecuador, and the United States.

Works by Dianderas are to be found in public collections such as those of the Museum of Contemporary Art in Bogotá, Braniff International Airways in Dallas, the Museum of Art and History in Lima, Jans Gallery in the Hague, Porras Omana Gallery in Caracas, and the Banco Cafetalero of Bogotá, as well as private collections in Peru, Ecuador, Colombia, Venezuela, the United States, France, the Netherlands, and Sweden.

June 14 - July 8, 1983

IVAN PETROVSZKY
An exhibition organized by the Museo de Bellas Artes of Caracas

The Museo de Bellas Artes of Caracas takes great pleasure in presenting this exhibit by the distinguished Venezuelan painter and designer Iván Petrovszky, in its permanent effort to broaden the diffusion of the country's art abroad.

Born in Hungary in 1913, Petrovszky has been living in Venezuela since 1945 and has been highly active as an artist, in addition to teaching and writing on the subject. He has shown his work at a number of exhibitions, has been awarded major prizes, and generally speaking, has made an important contribution to the nation's cultural life.

This exhibition includes a selection of twenty-four of Petrovszky's works, showing a striking synthesis of the thematic elements--particularly human forms--and the treatment of colors, as a result of a consistent creative effort. We are certain that this exhibit will be very well received by the American public.

We wish to take this opportunity to thank the Museum of Modern Art of Latin America of the Organization of American States and, very specially, its director, José Gómez-Sicre, for their enthusiastic support of this significant event. --*Carlos Silva*, Director, Museo de Bellas Artes, Caracas.

AN INTERVIEW WITH IVAN PETROVSZKY BY MEMBERS OF THE RESEARCH DEPARTMENT, MUSEO DE BELLAS ARTES OF CARACAS

On the occasion of the exhibition of Iván Petrovszky in Washington, D.C., the Museo de Bellas Artes has asked the artist to put forward some of his ideas on art as well as comments on his own creative process.

This, of course, is not the first time Petrovszky speaks of theory. As a matter of fact, he recalls that he was a forerunner of art sections in the Venezuelan press with full-page articles on various European painters as far back as in 1947, when this was a novelty in this country.

Petrovszky professes to be an heir to Cézanne, from whose work he thinks all modern art has originated. He also acknowledges, however, other influences such a Matisse's, or Velázquez's and Brueghel's, among the classics. In his opinion, painting should be an expression of pure pictorial qualities, stemming from a slow, profound inner process of ripening which in turn should materialize in eliminating what is accessory while grasping the essential through a parallel work of analysis and synthesis of forms.

Considering the peaceful climate suggested by Petrovszky's work through its thematic as well as formal elements, we sought to find a certain world outlook in it. There is an obvious interest in the human figure and, secondly, in the urban ambiance. Horizontality also seems to be prevalent. This is seen in the treatment of the subject through the attitude of the figures (often seen resting, reading or sleeping, sitting or lying down) and also in the formal treatment of a number of his paintings, resolved on the basis of horizontal lines. Composition, the selection of the range of colors, the type of material used, all of these correspond to the particular theme Petrovszky wishes to paint.

The artist admits that, in the long run, he becomes identified with his models, but he insists that the initial contact is an accidental one; to him, the theme is merely a starting point. He stresses:

> If a painter is to comply with the requirements of the so-called plastic values, if he is to say something through the elements of expression, the fact of representing people will be a *plus* rather than a *minus*, provided that the figuration is not detrimental to the representation or to the solution of those plastic values.

Q. What kind of painting were you doing when you arrived in Venezuela in the 1940s?

I.P. It was figurative painting which I later tried gradually to simplify or synthesize. This, to be sure, is one of the characteristics of my work. I went on simplifying forms and figures as much as I could, until I wound up with works that were mostly, though never totally, abstract.

Q. Was your work in Venezuela substantially different from what you had been doing in Europe?

I.P. When I came to this country I began to use a new technique called "Armenian bole," which consisted in painting over a red background in the style of the classical Venetian artists. Since I didn't master the technique my paintings darkened. Later on I spent some time in Spain and when I returned to Venezuela in 1956 or 1957, there was a definite change in my painting as the tones became visibly clearer.

Q. Did the intense light of the tropics, the Venezuelan scenery, have anything to do with that change?

I.P. I don't think so. Actually I believe more in what you might call the inner ambience--the human, artistic ambience--than in the physical surroundings. My sojourn in Europe was extremely important to me, as it was to many of the young Venezuelan artists who were there. Contact with the museums changes one's viewpoint a lot; so it is not so much the geographic environment which influences you. I don't even think it's very important where you do your work of art. Art is universal.

Q. Your work shows an obvious consistency. Yet, would you feel that there have been any significant changes, moments, or stages in your painting?

I.P. Certainly there have been changes, but rather for technical reasons. There were times when I painted mainly with watercolors and tempera, where water is used to dissolve the material and the drawing comes into form through transparency; whereas in oil painting there is none of the freshness or spontaneity found in the aqueous medium. The two techniques have run parallel; when I find something new in one I try to mold it into the other so as to accomplish a sort of fusion that will enrich both.

Apart from this, there were periods when I was more polychromatic, and others when--if I may coin a new word--I was "oligochromatic," that is to say, I used a more limited scale of colors. This depends on a certain process through which I am seeking increased simplification so as to finally paint with very little color, on the basis of nuances, i.e., subtle transitions within a gamut of whites. Of course this slow process of synthesis cannot be catalogued into strictly limited periods.

Q. I understand you have said on several occasions that for the artist, "representation--the subject--is but an excuse to be able to speak of plastic problems."

I.P. True, but when you are speaking of plastic problems you can either disregard people or you can integrate

them into your work. Actually, representing people is a more difficult, more complicated affair than showing a landscape, for instance. Any distortion in the latter would be of small importance; not so in the human figure. Therefore it is not at all easy to be figurative. In abstract painting you will find substantial freedom of representation, whereas when you are using human forms you must be more faithful, more attached to the nature of forms, without neglecting the basic requirements of painting.

Q. Writings on your work often speak of a "humanistic vision" as an essential trait of your painting. What do you think they mean by that?

I.P. That's a very interesting question I have been asked frequently. It is not so much a humanistic vision but a fundamental interest in the human element. I do a lot of drawing on the street, on squares, or in parks as I have a sort of an aversion to pose; to me, the best model is the one who is sleeping or reading a newspaper, or simply resting. Some people think that there is a social attitude in this. True, those stooping figures convey the idea of sadness, loneliness, and poverty; however, this is a coincidence as I do not intend to make any direct political protest. I merely accept my models the way they are--simple, poor people, the kind of people you would usually meet in public parks.

Q. The themes as well as the colors of your work suggest a rather peaceful, quiet state of mind. Is that deliberate?

I.P. No, they are not expressing a state of mind; that can only be done through a sketch. Painting is a more conscientious type of work; more elaborate, less spontaneous, excepting tempera, which is the combination of a drawing, often done with vehemence, and of painting built upon that drawing. In oil painting you must discard and summarize insistently.

Q. The subjects of some of the canvases seem to issue from earlier ones. Would you say there is actually a sequence?

I.P. Yes, there is, because unlike classic painters, we modern painters are not represented in a few dozen but in hundreds of works. Yet the idea of the modern artist is not to pound on the canvas or to torture the canvas, but to pound on himself. The work of art results from an inner ripening; it settles down little by little.

Q. On most of your works the human figure's line and color blend with the background, forming a continuous plane. Does this reflect an idea concerning man's relation with his world?

I.P. No, not directly. But since we are talking of this, it might be interesting to note that one's subconscious has a much sounder, more sincere, and more decided logic than one's consciousness. . . . However, the artist shouldn't analyze his work too much; one often works quite unconsciously.

In my opinion, the important thing for the artist is to believe in himself, in his own capacity, and to face the canvas with an idea in mind. If by chance he realizes that it doesn't work, he should then try to tackle with the idea in another work of his. --*Caracas, March 1983.*

CATALOGUE

Paintings

1. *Still Life with Watermelon,* oil on canvas, 58.2 x 38.9 cm.
2. *Sleeping Man,* mixed technique on cardboard, 49 x 37 cm.
3. *La vieja (Old Woman),* oil on canvas, 81 x 56 cm.
4. *Two Women Sitting,* mixed technique on cardboard, 48 x 44 cm.
5. *Still Life,* oil on canvas, 42 x 52.5 cm.
6. *La ciudad blanca, Ibiza (The White City, Ibiza),* oil on canvas, 130 x 81 cm.
7. *Confrontation,* mixed technique on cardboard, 50 x 40 cm.
8. *En la playa (On the Beach),* oil on canvas, 73.1 x 60.7 cm.
9. *Rojo y azul (Red and Blue),* tempera on cardboard, 34 x 24 cm.
10. *Still Life with White Background,* oil on canvas, 53 x 59 cm.

11. *Sleeping Man*, tempera on cardboard, 41 x 28 cm.
12. *La familia (Family)*, mixed technique on cardboard, 46 x 52 cm.
13. *Meditating*, oil on canvas, 70 x 32 cm.
14. *Still Life with Bottle and Watermelon*, oil on canvas, 40 x 60 cm.
15. *Chess Players*, oil on canvas, 45 x 71 cm.
16. *Nueva York en azules y grises (New York in Blues and Grays)*, mixed technique on cardboard, 56 x 40 cm.
17. *La botella azul (The Blue Bottle)*, oil on canvas, 53.7 x 39.5 cm.
18. *Diagonal*, mixed technique on cardboard, 47 x 62 cm.
19. *Upwards*, mixed technique on cardboard, 31.5 x 43.5 cm.
20. *Group in Blue and Red*, mixed technique on cardboard, 33 x 41 cm.
21. *Still Life with Vertical Tendencies*, oil on canvas, 65 x 46 cm.
22. *Sleeping Fat Man*, mixed technique, 31 x 48 cm.
23. *La lectura (The Reading)*, acrylic and tempera, 39 x 27 cm.
24. *La conversación (Conversation)*, mixed technique, 28 x 38 cm.

ABOUT THE ARTIST

Iván Petrovszky completed his secondary and university education in Budapest. He studied painting at the private academy of István Szönyi. As soon as he finished his studies, he devoted himself to painting, participating in several collective exhibitions.

In the spring of 1941 he won the Rome Prize in competition. In autumn of that year he traveled to Italy on a scholarship, remaining in Rome until mid-1943. Subsequently he lived in Spain as a displaced person for two years.

In 1945 he arrived in Venezuela and four years later he took up the country's citizenship.

In 1949 and 1950 he organized several exhibitions, lectured widely, published articles on art, and accepted a teaching position in a local school.

Between 1950 and 1956 he dedicated himself entirely to his art and spent some time in the Balearic Islands as well as in Paris. In October of 1958 he took up a teaching job at the Escuela de Artes Plásticas of Caracas.

After his return to Caracas in 1956, he held the following individual exhibitions: Círculo de Bellas Artes, Maracaibo, 1957; Galería de Arte Contemporáneo, Caracas, 1958; Museo de Bellas Artes, Caracas, 1959; Sala de Exposiciones de la Fundación Eugenio Mendoza, Caracas, 1962; Ateneo de Valencia (Venezuela), 1962.

In 1967 he left Caracas for New York where he lived until 1970. An exhibit of his work was held at the Inter-American Development Bank in Washington, D.C., in 1969. On his return to Venezuela he presented a one-man exhibition at the Sala de Exposiciones de la Fundación Mendoza in 1972 and in 1976 held another one-man show at the Museo de Bellas Artes.

He participated in several collective exhibits winning the following awards in Venezuela: Federico Brandt Prize, Arturo Michelena Prize, and D'Empaire Prize in 1958; National Prize for Drawing and Printmaking, 1959; Drawing Prize, Arturo Michelena Salon, 1960; A.E. Monsanto Prize, 1961; Painting Prize awarded by the Municipal Council of Valencia, 1962; John Boulton Prize, 1963; Drawing Prize, CONAC, 1980.

The Venezuelan government acquired one of Petrovszky's works for the permanent collection at La Casona (the President's official residence). The Budapest Museum of Fine Arts has acquired two of Petrovszky's works for their permanent collection.

July 12 - October 7, 1983

FOUR LATIN AMERICAN SCULPTORS

BEATRIZ BLANCO (Venezuela)

One-person exhibitions

1969 La Gárgola de Tancredo, Maracaibo
1973 Ateneo, Caracas
1977 Fototeca, Caracas
1981 Center for the Living Force, New York
1982 Museum of Modern Art of Latin America, Washington, D.C.

Group exhibitions

Museum of Fine Arts, Caracas
Estudio Actual, Caracas
Ateneo, Maracay
Mendoza Salon, Caracas
Arturo Michelena Salon, Valencia (Venezuela)
University of Venezuela, Caracas
National Gallery of Art, Caracas
Zenith Gallery, Washington, D.C.

Awards and grants

1967 Grant from the Department of Culture of the Embassy of the United States and the National Institute
 of Culture, Caracas
1969 First Prize, Experimental Biennial, Valencia (Venezuela)
1970 Second Arturo Michelena Prize, Valencia (Venezuela)
1972 First Acquisition Prize, Maracay
1973 Pérez Mujica Prize, Arturo Michelena Salon, Valencia (Venezuela)
1980 Fundarte Scholarship for Research in the United States

Collections

Museum of Modern Art, Mérida (Venezuela)
Casa del Orinoco, Ciudad Bolívar
Ateneo, Valencia (Venezuela)
Rómulo Gallegos Center for Latin American Studies, Caracas
Fundarte, Caracas
National Gallery of Art, Caracas
Museum of Modern Art of Latin America, Washington, D.C.

VALERIE BRATHWAITE (Trinidad, has lived in Venezuela since 1969)

One-person exhibitions

1965 Town Hall, San Fernando (Trinidad)
1966 Balisier House, Port of Spain
1967 Studio One, San Fernando (Trinidad)
1971 BANAP Gallery, Caracas, 1971
1072 Art Gallery of INCIBA, Caracas
1976 Museum of Fine Arts, Caracas
1977 Institute of Design, Caracas
 House of the Artists, Stockholm

Museum of Contemporary Art, Caracas
1978 Sala Mendoza, Caracas
1982 Sala Mendoza, Caracas

Group exhibitions: in England, Venezuela, Canada, and Sweden

Awards

1973 University of Carabobo (Venezuela)
1975 First Prize, National Sculpture Salon, Valencia (Venezuela)

Collections: examples of her work are to be found in many private and public collections in Holland, England, Jamaica, Sweden, Trinidad, Venezuela, the United States, and Norway

Commissions

1966 Mural for Oil Workers Union, San Fernando (Trinidad)
1982 Sculpture Garden Museum, Valencia (Venezuela)
 Sculpture, Metro Operations Building, Caracas

JOYCE OF GUATEMALA (Guatemala)

One-person exhibitions

1968 *Light Paintings* (Neon), Vittorio Gallery, Guatemala City, 1968
1970 *Studies in Irony, Kinetic Sculptures*, National Fine Arts School, Guatemala City
1973 *Stalae Sculptures*, Macondo Gallery, Guatemala City
1975 Guatemalan Pavilion, Thirteenth International Biennial of São Paulo
1976 *Seven Variations on a Circle*, Homage to Joyce by the Fine Arts Department of Guatemala for having won the Francisco Matarazzo Sobrinho Grand Prize for Latin America at the Thirteenth International Biennial of São Paulo, Guatemala City
1977 *Sculptures by Joyce of Guatemala*, Museum of Modern Art of Latin America, Organization of American States, Washington, D.C.
1979 *Joyce of Guatemala: Sculpture*, Marian Locks Gallery, Philadelphia (Pennsylvania)
1982 *Joyce of Guatemala: Sculpture*, Barbara Gillman Gallery, Miami
1983 *Tribute to the Moon: The Temple and the Guardians*, Lehigh University, Bethlehem (Pennsylvania)

Awards

1972 First Prize, Juannio National Art Exhibition, Guatemala City
1975 Honorable Mention, Certamen Permanente Centro Americano "15 de Septiembre" (Central American
Art Competition and Permanent Exhibition), Guatemala City
1975 Francisco Matarazzo Sobrinho Grand Prize for Latin America, Thirteenth International Biennial of São Paulo

CHARLES J. SEPLOWIN (Puerto Rico)

One-person exhibitions

1974 Warren Benedek Gallery, New York City
1978 Paco Gallery, New York City
1980 Elizabeth Weiner Gallery, New York City

Group exhibitions

1970 Museum of Art, Rhode Island School of Design, Providence
1972 Art Gallery of the American Academy of Arts and Letters, New York City

1973	Brooklyn Museum, New York City
1975	The Aldrich Museum of Contemporary Art, Ridgefield (Connecticut)
	State University of New York, Potsdam
1976	Grand Rapids Art Museum, Grand Rapids (Michigan)
1977	Xerox Corporation, New York City
1978	Center for Inter-American Relations, New York City
	O.K. Harris Gallery, New York City
1979	Drawing Center, New York City
1982	Drawing Center, New York
	Sculpture Center, New York

Collections

Titan Steel Corporation, New York City
University of New Hampshire, Durham
Montclair State College, Upper Montclair (New Jersey)
Municipal Fire House Center, New York City

EXHIBITION LIST [1]

Beatriz Blanco (Venezuela)
 1-2. *Presencia (Presence) I and II*, 1983, Corten steel
 3. *Presence on the Path*, 1982, Corten steel, 77 3/4 x 48 x 27 1/2"

Valerie Brathwaite (Trinidad and Tobago)
 4-5. *Couple with Stripes*, 1982, cement

Joyce of Guatemala (Guatemala)
 6. *Fallen Guardian*, 1982, stainless steel

Charles J. Seplowin (Puerto Rico)
 7-8. *Blades I and II*, 1982, steel, 20 x 12 x 6"

August 4 - 26, 1983

GRACIELA GOMEZ OF COLOMBIA

Born in Bogotá, Colombia. Teacher of fine arts at the Tanagra Academy, the Institute of Artistic Research, Abraham Lincoln College, and other institutions, all in Bogotá. Lectured on art, children's education, and other art-related subjects. Taught a short course on "The Pedagogy of Color." Served as jury member for several art contests.

Selected group shows (since 1956)

1956	Salon of Fine Arts, Bucaramanga (Colombia)
1967	*Colombian Painters*, Popular Bank, Bogotá
1975	Twenty-fifth Salon of Fine Arts and Salon of Visual Arts, Bogotá
1977	Buchholz Gallery, Bogotá
1979	Fourth International Biennial, Valparaíso
1980	Center for Inter-American Relations, New York
	Fjorten Gallery, Copenhagen

[1] Not included in the original catalogue. --*Ed.*

Selected individual shows (since 1954)

1954 National Library, Bogotá
1960 Dilfin Gallery, Birmingham (Alabama)
1965 Institute of Artistic Research, Bogotá
1977 Luis Angel Arango Library, Bogotá
 Bacardi Gallery, Miami
1978 Maravén Cultural Association, Caracas
 Charpentier Gallery, Quito
 Art 4 Gallery, New York City
1979 Quenaton Gallery, La Paz
 Municipal Museum of Guayaquil
 OAS Gallery, Quito
1980 Nicolaj Church, Copenhagen
 Funarte, Rio de Janeiro
1981 UNESCO Headquarters, Paris
 Institute for Inter-American Cooperation, Madrid
1982 General Society, Paris
 Institute of Hispanic Culture, Bogotá
 Museum of Fine Arts, San Juan (Puerto Rico)

EXHIBITION LIST [1]

Acrylics on Canvas

1. *¡América! ¡América!*, triptych, 100 x 180 cm.
2. *Pensamientos* (Thoughts), triptych, 100 x 176 cm.
3. *Plegaria* (Prayer), triptych, 100 x 162 cm.
4. *Composición I* (Composition I), 85 x 112 cm.
5. *Composición II* (Composition II), 85 x 112 cm.
6. *Latinidad, ¡Presente!* (Latin Americans, Present!)
7. *Mensaje* (Message), 85 x 112 cm.
8. *Cavilación* (Meditation), 56 x 85 cm.
9. *Atmósfera* (Atmosphere), 56 x 85 cm.
10. *Rostros* (Faces), 56 x 85 cm.
11. *Ofrenda* (Offering), 56 x 85 cm.
12. *Esperanza* (Hope), 56 x 85 cm.
13. *Reflejos* (Reflections), 45 x 85 cm.
14. *Madonna*, 40 x 55 cm.
15. *Melancolía* (Melancholia), 42 x 51 cm.
16. *Carácter* (Character), 42 x 51 cm.
17. *Ancestro* (Ancestor), 42 x 51 cm.
18. *Figura* (Figure), 42 x 51 cm.
19. *Inocencia* (Innocence), 42 x 51 cm.
20. *Proyecto de mural* (Project for a Mural), 30 x 65 cm.

September 14 - September 30, 1983

GRACIELA RODO BOULANGER RETROSPECTIVE EXHIBITION

FOREWORD

In its efforts to increase mutual understanding among member states of the Organization of American States

[1] Not included in the original catalogue. --*Ed.*

and add to the benefits of individual achievements, the General Secretariat has had notable success through its programs in the promotion of the arts. For some artists, presentation at the headquarters of the Organization has been the first stepping stone to international recognition. More often, the Organization has exhibited the works of artists already well known in their country.

On this occasion, however, the Organization and its Museum of Modern Art of Latin America takes special pride in presenting the work of Graciela Rodo Boulanger of Bolivia. Her characteristic style has been known in Europe and North America and enjoys a wide appeal with audiences of all ages.

We are especially grateful to the Permanent Mission of Bolivia to the Organization of American States, Lublin Graphics, Inc., and the artist for their generous collaboration in making this event possible. I am sure that everyone who has the opportunity to see these works will be enriched by Madame Boulanger's singular talent. --*Alejandro Orfila*, Secretary General, Organization of American States.

GRACIELA RODO BOULANGER

Graciela Rodo Boulanger's one-woman show at the gallery of the Organization of American States, under the auspices of the Museum of Modern Art of Latin America, is one of her major exhibitions in Washington, D.C. The show, which runs from September 14 through September 30, reveals an artist with a unique international perspective which can be traced back to her South American roots.

As one of the most widely known artists to come from South America today, this unusually gifted woman is internationally recognized particularly for her unique treatment of the continuous theme of children colored by the cultural elements of her native Bolivia.

Rodo Boulanger is an excellent technician and a supreme colorist. It is easy to see the South American penchant for repetitive bands of color much like the decorative costumes worn by the Indians who dwell in her homeland. It is Rodo Boulanger's spirit and interpretation of her Latin heritage that stamp her art as strictly Rodo Boulanger.

One of the most interesting aspects of Rodo Boulanger's portfolio is its diversity. She works with equal facility in oils, watercolors, pastels, lithography, and etching. Graciela Rodo Boulanger explains:

> For me, the subject usually dictates the medium. I suppose you can do one subject in a variety
> of mediums, but you cannot do them the same way. Some subjects are better suited to oils,
> some to watercolors--it is what you want to express as an end result.

Recently, she has added sculpture and tapestry to the mediums in which she works. A 1979 tapestry, *Les belles années* done in wood, silk, and linen, will be on display in this exhibition.

The result that one sees when viewing Rodo Boulanger's work is the universal spirit of children portrayed in an illusion of child-like innocence. Providing commentary for a book on Rodo Boulanger's life and work published by Lublin Graphics, John Ciardi addressed the "essential duplicity" of the adult artist who can see as a child while retaining the critical detachment of a mature artist:

> Picasso once said that he spent his whole life in learning how to draw like a child, and many
> other artists have shared his sentiments. Graciela Rodo Boulanger seems always to have known
> how to draw like a child, while knowing that, in reaching for the illusion of childlike innocence,
> one cannot be childish about it.

Former Pan-American Museum Director José Gómez-Sicre, a leading expert on South American art, says of Rodo Boulanger's work:

> It is highly personal, a joyful approach to daily scenes, pervaded by candor and innocence.

ABOUT THE ARTIST

Born in La Paz, Bolivia, February 16, 1935, Graciela Rodo Boulanger exhibited at an early age innate talents as both a musician and a visual artist. It was logical that as the daughter of a concert pianist, Rodo Boulanger began playing the piano at age seven and achieved such virtuosity, she gave her first recital eight years later. Although she had always demonstrated a natural proclivity for drawing, it was not until she was eleven that her businessman father recognized that her artistic abilities warranted formal training. She studied both disciplines at the School of Fine Arts, first in her hometown and then in Santiago, Chile. Her dual studies continued in Vienna at the Conservatory and at the Kunstakademie, where at sixteen she staged her first one-woman show. Her reputation preceded her to similar exclusive showings in Salzburg and Zürich. All the while, she was giving concert recitals.

At twenty-two Rodo Boulanger returned to South America where for the next four years she continued playing the piano and painting. She gave several recitals and performed with the Chamber Orchestra of Radio Argentina; she had personal exhibitions, including two major exhibits at Galería H and Galería Antígona in Buenos Aires.

The point of divergence from these parallel professional courses occurred in 1961 in Paris. Her artistic path crossed with Johnny Friedlaender, the renowned engraver. Rodo Boulanger spent the next seven years studying and working with Friedlaender. Exposed to the full range of artistic mediums, Rodo Boulanger realized she no longer could juggle two exacting professions. Art became her vocation, the piano her recreation.

Rodo Boulanger's assiduous application to the visual arts has been richly rewarded. She has earned an international reputation with nearly 100 personal exhibitions on three continents to her credit. The United Nations elected her as an official 1979 UNICEF "Year of the Child" poster artist. In the United States Rodo Boulanger shows have been held in New York City, Chicago, Los Angeles, San Francisco, Houston, Scottsdale, New Orleans, and Washington, D.C.

Rodo Boulanger's work is easily recognizable for, like most great artists, she has developed a distinctive style. She is an artist of exceptional scope and versatility who has earned artistic freedom by perfecting her craft. She has always understood that inspiration is inextricably bound with the skillful manipulation of her mediums--etching, lithography, watercolor, pastel, and oil.

EXHIBITION LIST [1]

Oils

1. *L'enfant aux papillons* (Child with Butterflies), 1966, 24 x 29"
2. *Madone au bélier* (Madonna with Ram), 1976, 24 x 29"
3. *Le soliste* (The Soloist), 1982, 32 x 32"
4. *Madone l'Oiseau* (Madonna Bird), 1976, 24 x 29"
5. *Trois violons* (Three Violins), 1972, 24 x 29"
6. *Madone au mouton* (Madonna with Sheep), 1976, 24 x 29"
7. *Madone du lac* (Madonna of the Lake), 1976, 24 x 29"
8. *Le violoniste solitaire* (The Lonely Violinist), 1972, 31 x 38"
9. *La fuite en Egypte* (Flight to Egypt), 1976, 30 x 30"
10. *Untitled A-7*, 30 x 30"
11. *Madone* (Madonna), 1976, 31 x 38"
12. *Le vendeuse d'oiseaux* (Bird Vendor), 1977, 40 x 40"
13. *Madone de l'espérance* (Madonna of Hope), 1976, 18 x 22"
14. *Jeudi matin* (Thursday Morning), 1974, 31 x 38"
15-18. *Les adieux I, II, III, IV* (Farewell I, II, III, IV), 1974, 31 x 31"
19. *Le chat de la mariée* (The Bride's Cat), 1980, 25 3/4 x 32"

[1] Not included in the original catalogue. --*Ed.*

Tapestry

20. *Les belles années* (The Beautiful Years), 1979, wool, silk, and linen

October 6 - 28, 1983

RENE MORON OF ARGENTINA

René Morón--graphic artist, painter, creator of murals--was born in the Argentine province of Río Negro in 1929. He began the study of art in 1948 at the Zier Academy in Buenos Aires, but in 1949 he transferred to the Manuel Belgrano School of Fine Arts where he was enrolled for a number of years. Until 1960 he worked and exhibited as an independent artist, but in that year he joined the so-called *Grupo Sur*, presenting his compositions in the company of such distinguished figures as Ezequiel Linares, Aníbal Carreño, Mario Loza, Leo Vinci, and Carlos Cañás.

Morón has had numerous one-man shows and has participated in group exhibits in Argentina, Brazil, Chile, Mexico, Peru, and Venezuela, as well as England, Germany, and Japan. In 1965 a selection of his paintings was presented at the headquarters of the Organization of American States in Washington, D.C.

Morón has received numerous awards: Grand Prize for Painting at the Buenos Aires Municipal Salon in 1959; Prize for Painting offered by the Argentine Ministry of Social Welfare and Public Health at the National Salon in 1959; Second Prize at the National Salon of Plastic Arts, Buenos Aires, 1962; First Acquisition Prize at the National Salon in Mar del Plata.

Among the most important of the artist's murals is one at the office of the Commander in Chief of the Argentine Air Force, in the Condor Building in Buenos Aires (1964). Three stories, it is composed of ceramic tile of the artist's own design and execution. Another outstanding mural composition is the tribute to the Argentine aviator Jorge Newbery, done in 1977 at the university that bears his name.

Examples of Morón's work are to be found in numerous public and private collections. A number of books and pamphlets have been devoted to the artist.

Writing of him, the well-known Argentine critic Rafael Squirru stated:

> In his most inspired moments, Morón attacks vast canvases with driving energy, applying color in thick impasto to create visions imbued with intense love for the reality of an America of pampa and cordillera which he captures with eagle eye.

CATALOGUE

Paintings

1. *Flores y pájaros de América del Sur (Flowers and Birds of South America)*, mixed media
2. *Metamorfosis de pájaros (Metamorphosis of Birds)*, original of serigraph
3. *Metamosfosis de pájaros y mariposas (Metamorphosis of Birds and Butterflies)*, mixed media
4. *Gaviota de América del Sur (South American Sea Gull)*, 1983, original of serigraph
5. *Metamorfosis de gallo (Metamorphosis of a Rooster)*, mixed media
6. *Flores de America del Sur (Flowers of South America)*, mixed media
7. *Flores de América del Sur (Flowers of South America)*, mixed media
8. *Garzas blancas (White Herons)*, tempera
9. *Besos de palomas (Kissing Doves)*, tempera and inks
10. *Girasoles del sur (Sunflowers of the South)*, watercolor
11. *Aves del cielo (Birds in the Sky)*, watercolor
12. *Canto de gallos (Cockcrow)*, watercolor
13. *Riña de gallos (Cockfight)*, watercolor and ink
14. *Enojos de aves (Ruffled Birds)*, tempera and inks

15. *Pájaro y alimento en flores (Bird Seeking Food in Flowers)*, tempera
16. *Mariposas en flores (Butterflies in Flowers)*, watercolor
17. *Colobrí en flor (Blooming Hummingbird)*, watercolor
18. *Otoño en Bariloche (Autumn in Bariloche)*, watercolor
19. *Río Negro*, tempera
20. *Nacimiento en primavera (Birth in Spring)*, tempera and watercolor
21. *Espantapájaros (Scarecrow)*, tempera and inks
22. *Cañaverales del sur (Cane Fields of the South)*, tempera and watercolor
23. *Pichones en peligro (Fledglings in Danger)*, tempera
24. *Médanos y cactus del sur (Dunes and Cacti of the South)*, tempera

November 1 - 25, 1983

TABO TORAL OF PANAMA

Panamanian painters have made conspicuous contributions to the development of art in our hemisphere. The freshness of their approach, their creative exuberance, and their bold use of color make them one of the most attractive groups in Middle America. Names such as those of Guillermo Trujillo, Alberto Dutary, Chong Neto, the two Sinclairs, Adán Vásquez, Antonio Alvarado, Constancia Calderón, and Víctor Lewis have already won wide renown, and their number grows with each new generation.

A recent arrival on the Panamanian scene is Tabo Toral. Despite his years--he only recently turned thirty--and the fact that he has made but fleeting acquaintance with formal instruction, having briefly attended art schools in Baltimore and Canada, he shows a well-developed style and thorough mastery of his craft, both the products of his own individual effort.

Toral's work bubbles with conflicting concepts, resulting from the age-old struggle between mind and the senses. Rigorous intellectual discipline is manifested in straight though vibrant lines which cut across the picture horizontally, dividing it into strips that create an illusion of perspective. The austerity of this effect is offset by the aforementioned vibrations, by the warmth of Toral's color, and by a strange atmosphere suggestive of a message conveyed in an unknown language. Toral's plastic expression calls for analysis in depth.

I was unaware of this representative of the youngest generation of Panamanian artists until a short time ago, when I was named to serve on the jury for a competition held in his country. I joined enthusiastically in the vote which awarded him first prize.

Toral's work is well ordered, clear, and direct, void of pictorial trickery. Not content with superficial effects, he seeks to infuse his compositions with underlying meaning. His colors are clear and unmarked by stridency: to the harshness of a deep purple or a bright red he prefers shades of lilac and rose. Earth tones--gray and ocher--play a harmonizing role in his compositions, which are restful to the spectator's eye. Recently, in canvases of vast dimensions, he has tended toward geometric abstraction, with kaleidoscopic or mosaic-like results. Eliminating the ephemeral, he aims at the permanent and definitive.

I find myself strongly drawn to Tabo Toral's painting and shall follow his development with keen interest, sure that I have encountered an artist with a brilliant future. His youthful maturity speaks well both for himself and for the art of his country. *--J.G-S.*[1]

TABO TORAL AND THE NEED FOR FORMS

When in 1926 Kandinsky published the first German edition of *Point and Line to Plane (Punkt und Linie zu Fläche)*, he took pains to point out in the preface of that short work the organic ties of the thoughts set forth

[1] Former Museum director and renowned art critic José Gómez-Sicre has graciously accepted our invitation to comment on this exhibition, which he originated before his retirement early this year.

therein. This refers to his previous approach in *Concerning the Spiritual in Art (Ueber das Geistige in der Kunst)*.

The physical effect the work of art causes and the corresponding spiritual vibrations with their subsequent deep meanings are all thoughts gathered in both works. This is the development of one and the same form to such an extent that it will be defined, in the narrow sense, as nothing but the separating line between surfaces of color. But it has also an inner meaning, of varying intensity, and, properly speaking, form is the outward expression of this inner meaning or of one's inner need.

Thus in painting there will be one effect at the purely visual level and one dividing line between points, lines, segments, planes, and colors. Another effect, and this is what is useful to stress here, will be the strength, the fullness with which those boundaries, essentially intellectual, are successfully expressed.

An obvious feature of Toral is the lengthy and persevering inquiry precisely related to the inappreciable nature of the existential development of a specific form, the square.

The theme, if we can call it that, of his latest exhibition entitled *The Diamond* is the square. Let us say, however, that it is a square that is put together and filled "like an invasion of surrounding areas." I emphasize the fullness Toral displays in establishing the deep spiritual feeling of the square, just as it appears to him in an initial "boundary line," separating so many things--actually one in particular. It "is the square that prevails" and that resists each and every other geometric form. Thus, as he himself indicates, the proportions are highly important to his work. This is not only because they determine its structural framework, but also because the dimensions provide the basis for the entire subsequent development. For example, $32 \times 45 = (3 + 2 = 5; 4 + 5 = 9 \ldots)$. The proportions grow out of themselves until exhausting the boundary line between the plane, focal points, and color. Thus, where the numbers do not reach directly, it will be clear that it is the color, and the color only, that has determined the surface. This is disturbing reading, a thick batter that is hard to digest.

Once again, Toral faces the pureness of formality in art. His desire to see the inconceivable, to hear the inner meaning of the outward expression, to feel "the inner palpitation" of a diamond-square, quiet, and modest being, is found here in expanded form. *--Dr. Edilia Camargo*, UNESCO, New York, 1983

EXHIBITION LIST [1]

Oils on Canvas

 1. *29-8-82*, 50 x 50"
 2. *15-11-82*, 25 x 25"
 3. *11-9-82*, 24 x 24"
 4. *1-10-83*, 50 x 50"
 5. *25-10-82*, 24 x 24"
 6. *14-9-82*, 24 x 24"
 7. *23-8-83*, 30 x 30"
 8. *29-7-83*, 25 x 25"
 9. *1-8-83*, 20 x 20"
 10. *15-5-80*, 60 x 64"
 11. *24-9-83*, 50 x 50"
 12. *10-12-82*, 23 x 23"
 13. *29-11-82*, 18 x 18"
 14. *28-11-82*, 20 x 20"
 15. *3-12-82*, 30 x 30"
 16. *4-10-83*, 50 x 50"
 17. *21-9-83*, 40 x 40"
 18. *28-8-83*, 18 x 18"
 19. *9-8-83*, 25 x 25"
 20. *15-8-83*, 26 x 26"

[1] Not included in the original catalogue. *--Ed.*

21. *9-10-83*, 12 x 12"
22. *24-8-83*, 12 x 12"
23. *25-8-83*, 19 x 19"
24. *11-8-83*, 19 x 19"
25. *24-8-83*, 13 x 13"
26. *10-8-83*, 19 x 19"
27. *3-2-83*, 15 x 15"
28. *9-12-82*, 17 x 17"
29. *4-3-83*, 28 x 28"

ABOUT THE ARTIST

Tabo Toral was born in Panama in 1950. Received his academic training in the Maryland Institute College of Art and continued in the Nova Scotia College of Art, Canada. In 1976 he received a scholarship from the OAS to study at the Regional Center for Graphic Arts in Costa Rica. In 1981 he obtained the Panarte 81 First Prize from the Museum of Contemporary Art in Panama. Oil on canvas, silkscreen, and etching are Tabo's preferred media. His illustrations have been commissioned by the *Washington Post* and also exhibited at the Pavillon de L'Humour in Montreal. In 1983 he was selected to design the posters for the First Latin American Book Fair held in Georgetown. At present, Tabo Toral is residing in the Washington, D.C., area.

Selected solo exhibitions (since 1976)

1976 Estructura Gallery, Panama City
1979 Sótano Gallery, Panarte, Panama City
1980 Garcés-Velásquez Gallery, Bogotá
1981 ArteConsult Gallery, Panama City
1983 Forum International Gallery of Fine Art, Atlanta (Georgia)
 Arteconsult Gallery, Panama City

Selected group exhibitions

1977 Biennial of Graphic Arts, Cali
1978 First Show of Graphic Arts, La Paz
1980 *Four Avant-Garde artists*, Gallery ETC, Panama City
 Biennial of San Juan (Puerto Rico)
1981 Biennial of São Paulo
 Graphics of America, Signs Gallery, New York City
 Contemporary Art of Panama, Signs Gallery, New York City
 Contemporary Art of Panama, Forma Gallery, Miami
1982 *Contemporary Art of Panama*, Museum of Contemporary Art, Panama City
 Biennial of San Juan (Puerto Rico)
1983 Second Latin American Art Biennial, Cayman Gallery, New York City
 Mural, Museum Vial-Bogarín, El Tigre (Venezuela)
 Second International Exhibition of Prints and Drawings, Macon (Georgia)
 International Art Fair, Madrid
 Vodra Gallery, Jersey City State College, New Jersey
 Second Wesleyan Exhibition held at University of South Carolina (Beaufort), University of Mississippi
 (Jackson), Alabama School of Fine Arts (Birmingham), Chatahoochee Valley Art Association (La Grange,
 Georgia)
 ARTEXPO, New York, New York City
 Henri Gallery, Washington, D.C.

Selected Permanent Collections

Museum of Contemporary Art of Panama
Rayo Museum of Latin American Prints and Drawings, Roldanillo (Colombia)
World Bank, Washington, D.C.
Museum of Modern Art of Latin America, Washington, D.C.

November 29 - December 30, 1983

PRIMITIVE ARTISTS OF NICARAGUA

THE PRIMITIVE ART SCHOOL OF NICARAGUA

Rousseau once said to Pablo Picasso that they both were the best painters of their era. Parodying that witty remark, it could well be said that the primitive painting of Nicaragua and the various art tendencies that coexist today constitute the excellence of Nicaraguan painting, which arose from the will and expression of national modernity, beginning in the 1950s.

It was not in vain that Rodrigo Peñalba, the artist who introduced contemporary painting in Nicaragua and the teacher--as well as director of the School of Fine Arts--of the then young artists, was the person to encourage Doña Asilia Guillén, a very old embroiderer, to take up the artist's brushes. She then became a naive painter who conceived and presented the world as an archipelago populated by multiple details, reflecting perhaps the little islands of the Great Lake of Granada, her native city. José Gómez-Sicre later sponsored a successful show of Doña Asilia, Nicaragua's first primitive painter, in the gallery of the OAS.

But primitive painting as a movement arose in Nicaragua on an island of the Archipelago of Solentiname, in the same Great Lake, to the south. Eduardo Arana, a farmer, was the first painter of this group. He received elementary guidance from the painter Roger Pérez de la Rocha who is now one of Nicaragua's major painters. With the example of Eduardo--who signs his work simply thus--the other painters of Solentiname began to emerge, promoted by the poet and priest Ernesto Cardenal, now Minister of Culture of Nicaragua: Carlos García, Olivia Guevara, Alejandro Guevara, Rodolfo Altamirano, Milagros Chavarría. Alejandro Guevara has said:

> Painting in Solentiname is considered a job. A painter plants a banana or a corn plant in his picture as he does it in the field. . . . I have always considered that the details of a picture are very significant. Why? Because, for example, a sailboat that a painter paints is always going somewhere, the painter knows this. When the painter paints small farms, he does it with the same care and the same technique as if he were going to live on them.

Painters of the Indian neighborhoods of Monimbó and Subtiava, of Somoto and Boaco, of the Atlantic Coast and of León and Masaya have already exhibited in various countries of Latin America and Europe, acquiring what could be called world fame. In 1982 a show was presented in West Berlin, and German critics called it the best exhibition seen there in the last ten years. The well-known Yugoslavian art critic Bihalju Merin has said that Nicaraguan primitive painting can only be compared to Haitian and Yugoslavian primitive painting. --*Julio Valle*[1]

CATALOGUE

Oils

Faustino Altamirano
 1. *El Chato Medrano*, 1983, 54 x 38 cm.
 2. *Educación de adultos (Adult Education)*, 1983, 56 x 38 cm.

Fernando Altamirano
 3. *Portuaria de San Carlos (Port of San Carlos)*, 1983, 60 x 45 cm.
 4. *Islote (Little Island)*, 1983, 56 x 38 cm.
 5. *Platanal (Banana Plantation)*, 1983, 39 x 53 1/2 cm.

Luis Alvarado
 6. *Comunidad El Pochote (El Pochote Community)*, 41 1/2 x 31 1/2 cm.

[1] Julio Valle is a well-known Nicaraguan poet.

Eduardo Arana
7. *Río Papaturro (Papaturro River)*, 1982, 56 x 38 cm.

Rodolfo Arellano
8. *Parque de Solentiname (Solentiname Park)*, 1983, 56 x 38 cm.
9. *Adán y Eva (Adam and Eve)*, 80 1/2 x 55 cm.

Alejandro Cabrera
10. *Finca con corral (Farm with Corral)*, 1983, 63 x 44 cm.

Julia Chavarría
11. *La cosecha de café (Picking Coffee)*, 1983, 55 x 80 cm.

Milagros Chavarría
12. *La cosecha de cacao (Picking Cacao)*, 81 x 56 cm.

Carlos García
13. *Loma de la Isla Chichicaste (Hill on Chichicaste Island)*, 1983, 62 x 81 cm.
14. *Cazador de venado (Deer Hunter)*, 1983, 63 x 59 cm.

Mercedes Graham
15. *La noche del cadejo (The Night of the Cadejo)*,[1] 29 x 35 cm.

Miriam Guevara
16. *Río al atardecer (River at Dusk)*, 1983, 44 x 56 cm.

Olivia Guevara
17. *Lago de Nicaragua (Lake Nicaragua)*, 1983, 30 x 56 cm.

Olga Madariaga
18. *Las Peñitas (Small Rocks)*, 1983, 46 x 34 cm.
19. *La habitación (The Room)*, 1983, 31 x 41 cm.

Carlos Marenco
20. *Fiesta popular (People's Festival)*, 1983, 38 x 25 1/2 cm.

Pablo Mayorga
21. *Puerto de San Carlos (Port of San Carlos)*, 1980, 38 1/2 x 35 1/2 cm.
22. *La pesca (Fishing)*, 1983, 80 x 53 1/2 cm.
23. *Pedimos la paz (We Ask for Peace)*, 1983, 51 x 71 cm.
24. *El pescador (Fisherman)*, 1983, 46 x 33 cm.

Rosa Pineda
25. *Casitas de Solentiname (Little Houses of Solentiname)*, 56 x 40 cm.
26. *La caza de zahínos (Hunting Zahinos)*,[2] 1983, 80 x 55 cm.

Rafael
27. *La palmera (Palm Tree)*, 1980, 38 x 30 1/2 cm.

Mariana Samson
28. *La hija del cacique (The Chief's Daughter)*, 70 x 50 cm.

[1] *Cadejo* is a fantastic animal that is believed to wander in the streets at night. --*Ed.*

[2] In Nicaragua *zahíno* is a wild pig. --*Ed.*

Yelba Ubau
29. *La escuela (The School)*, 1983, 30 1/2 x 38 cm.

BIOGRAPHICAL NOTES [1]

ARANA, Eduardo. Painter born in Solentiname about forty years ago. Has always been a farmer. Received some basic orientation in art from the Nicaraguan painter Roger Pérez de la Rocha. Exhibited in Nicaragua, Costa Rica, Venezuela, the United States, and Germany.

ARELLANO, Rodolfo. Painter born in Solentiname, 1943. Participated in the main exhibitions of primitive art in Nicaragua. Also exhibited in Peru, Costa Rica, Venezuela, the United States, Germany, and Austria.

CHAVARRIA, Julia. Painter born in Solentiname, where she still lives, about thirty years ago. Works on a corn plantation. Exhibited in Nicaragua and Venezuela.

CHAVARRIA SEQUEIRA, Milagros. Painter born in Solentiname, 1958. Started painting in 1969. Has participated in group exhibitions in Nicaragua and abroad.

GARCIA, Carlos. Painter born in Solentiname, 1955, where he still lives. Exhibited in Nicaragua, Germany, and Austria.

GRAHAM, Mercedes. Painter born in Nicaragua, 1941. Started painting stones giving them animal forms. Presently paints themes about the Spanish Conquest in Panama. Exhibited in Nicaragua, Panama, Germany, and Austria. Has lived in Panama since 1961.

GUEVARA, Miriam. Painter born in Solentiname, 1957. Lived in Costa Rica, 1977-1979, as a political refugee. Started painting at the age of thirteen. Exhibited in Nicaragua, Costa Rica, Cuba, Peru, and the United States.

GUEVARA, Olivia. Painter born in Solentiname, 1926, where she lived until 1977. Resided in Costa Rica as a political refugee, 1977-1979. Started painting in her fifties. Exhibited in Nicaragua, Peru, Costa Rica, Cuba, Germany, Austria, and the United States.

MARENCO, Carlos. Painter born in Monimbó, Masaya, 1958, where he still lives. Started painting at the age of twelve. Has exhibited in Nicaragua and Costa Rica since 1977.

MAYORGA, Pablo. Painter and draftsman, born in Solentiname, 1955. Started drawing at an early age. His animal stylizations decorate the walls of the church of Solentiname. Presently alternates his work as a farmer with his creative production in painting and polychromed wood. Exhibited in Nicaragua, Costa Rica, the United States, and Germany.

UBAU, Yelba. Painter born about twenty-five years ago, near the frontier with Costa Rica, where she had been an elementary teacher until 1977. Started painting under the influence of the Solentiname painters. Exhibited in Nicaragua, Costa Rica, the United States, and Germany.

[1] Not included in the original catalogue. --*Ed.*

YEAR 1984

CONTEMPORARY INDIAN AND INUIT ART OF CANADA

This exhibition, prepared by Indian and Northern Affairs Canada (INAC) and circulated with the assistance of the Department of External Affairs, Canada, opened at the United Nations General Assembly Building, New York, on November 1, 1983, under the sponsorship of the United Nations Educational Scientific and Cultural Organization (UNESCO).

INTRODUCTION

The Government of Canada, through Indian and Northern Affairs Canada, is pleased to present this exhibition in honor of the accomplishments of Canada's native people. From the late 1940s and continuing to this day, Indian and Inuit artists have combined traditional skills, legends, and world views with new methods of expression. This has resulted in artistic achievements that have been appreciated and recognized by the nation as a whole.

Over 100 paintings, sculptures, prints, and wall hangings are included in this exhibit which provides insight into the history and diversity of these contemporary arts. Through them, the artists express a concern for the continuation and reinterpretation of these rich cultural heritages and a desire to bridge past and present worlds.

INDIAN ART

The contemporary art of Canada's Indians reveals a rich variety of imagery and styles. While drawing on their own traditions as well as the experience of modernism in art, native artists eloquently bridge past and present and strive to achieve a balance between these two worlds.

From cities and reserve communities across Canada, native artists express their unique messages in all media. Out of the diversity emerge common themes which link artists of different generations and varied cultural backgrounds. These areas of concern have evolved into four modes of art according to which the exhibition has been organized: 1) the expression of paradox (two worlds); 2) realism (people and places); 3) the exploration of the oral tradition; and 4) formalism.

Contemporary Canadian Indian art manifests many states of being.

Two Worlds

The challenge of the present is the concern of a group of artists who have adopted a modernist approach designed to provoke questions about the place of traditional Indian beliefs in the modern world. Making use of images from surrealism, expressionism, assemblage, or other contemporary styles, they present us with visual paradoxes. Thus we are forced to confront the often tragic recent history of the Indian, as well as modern society's discomfort in the face of technology and urbanism and the need to reconcile the two realities.

People and Places

The search for identity has led many artists back to memories of childhood, to familiar scenes of everyday life and to the faces which people the communities they live in. The quality of realism unites these works, however diverse the styles in which they are expressed. Always the images picture particular seasonal activities and specific individuals--often the artists themselves. While some are intimate and anecdotal, others record a way of life kept alive only in the memories of the elders.

The Oral Tradition

In the past three decades there has been a major revival of interest in traditional mythology and religion among Canadian Indians. The awareness that the knowledge of these beliefs was being lost spurred members of the native community to record the traditions before they vanished. Artists have been in the vanguard of this effort, and it is through the visual record they are creating that much of this knowledge is being preserved. Painters such as Norval Morrisseau believe that traditional cosmology contains insights into the inherent order of the natural world which can help restore the balance lost.

Formalism

An emerging group of contemporary native artists who have focused on another aspect of the Indian heritage have drawn their inspiration from the aesthetic qualities of traditional native art. The formal ideas and designs are derived from the quillwork, beadwork, basketwork, painting, and carving of earlier art forms. Out of these are created striking new works which are totally modern.

The many facets of contemporary Canadian Indian art included in this exhibition reflect diverse regional traditions, styles, and themes. Although anchored in the heritage of the past, few of these works could have been created by the ancestors of the artists.

Canada invites everyone to celebrate the artistic achievements of its native people.

INUIT ART

Historical Background

Contemporary Canadian Inuit art is rooted in the imagery, traditions, and skills of an old and rich Arctic culture.

In the past, the ancestors of today's Inuit fashioned the hunting implements, domestic utensils, and clothing they needed for survival out of the available natural materials--stone, ivory, bones, and skins. Often great care was taken to enhance these necessities with decorative patterns or to incorporate human and animal representations into the overall form. Despite the difficulties that came with living in a harsh environment, life also had its pleasures and rituals. Toys and games were made for the children, as were special amulets and charmed figures. The latter might be carried by hunters to assist them in their quest for a good catch or used by shamans, individuals endowed with extraordinary powers, in magical and religious ceremonies.

Beginning about the seventeenth century, when whalers, explorers, and traders started travelling in the North, Inuit turned these same carving and decorative skills in another direction, to make objects for trade. Among these were incised tusks, ornamental cribbage boards, and finely worked figurines and miniatures.

Today's Inuit art evolved from this history of making utilitarian implements, amulets, and objects for trade. Beginning in the late 1940s, a time when much of the Arctic was suffering economic hardship, projects were organized to encourage the Inuit to further develop and expand their creative talents as a means of support. In communities across the Arctic, stone carving became the vehicle for an outpouring of beautiful and imaginative work which has not only provided the Inuit with an additional source of income but has also since developed into a major Canadian art form.

Inuit Art and the North Today

For the Inuit of Canada, contemporary art has matured in a period of cultural transition.

Over the past forty years, modern technology and a shift from camp life to permanent settlements have altered and redefined the northern lifestyle. Houses have replaced igloos and tents. Airplanes, skidoos, and motorboats, rather than sleds pulled by dog teams and kayaks, are now the main means of transportation. Wage employment in the community, store-bought goods, schools, and other centralized services now supplement subsistence living on the land.

Yet, even with all these changes, or perhaps because of them, artists young and old have consistently turned to memories of camp life, to their knowledge of the animal world and to the stories and legends of their grandparents for their subject matter. Collectively, the artworks have become a strong and vital record of the traditional Inuit ways.

Sculpture

The first contemporary sculptures, created by men and women who lived most of their lives in the old camp style, reveal their intimate and interdependent relationship with the land and its animals. In these works, the classic themes of Inuit art are given form--symbolic mother-and-child groups, commanding spiritual and mythological representations, powerfully executed animal studies, imaginative bird figures, and descriptive scenes of daily life.

As an art form, Inuit sculpture has encompassed a variety of approaches including narrative compositions, folk pieces, abstractions, feats of technical virtuosity, and studies in realism.

Printmaking

When experimentation with printmaking began in the late 1950s, the past once again became linked with a new mode of artistic expression. As with the sculpture, contemporary graphic images have antecedents in the carving of prehistoric times, the incised ivory work of the trading era, and even the inlay and appliqué design women used to decorate clothing. The stone-block printing method, devised in the northern workshops, has become a uniquely Inuit contribution to the history of Canadian art. This technique and its companion, the stencil, have defined the essential character of the Inuit print.

Printmaking workshops, now established in several communities across the Arctic, have become identified with individual styles and themes. Each workshop has also developed its own distinctive technical vocabulary. While stone-block printing continues to be the main mode of graphic expression, other media, particularly engraving, serigraphy, and lithography, have been introduced to extend the image maker's possibilities.

Wall Hangings

In a number of communities, textile arts have emerged from the traditional sewing skills. Using appliqué and embroidery, Inuit women create wall hangings that combine color, shape, and texture in powerful two-dimensional images. A variation of this medium has been developed in one community where woven tapestries are made.

The Artists

For the Inuit artists of the 1950s, hunters and women who lived most of their lives on the land, carving and drawing were unselfconscious activities, putting in stone and on paper what they knew intuitively of the world around them. For their sons and daughters, born on the land, but living most of their lives in the settlements, art has become a chosen profession and a means of capturing and remembering the past.

A third generation of young artists is now further exploring the art forms. Their work is guided by a keen awareness of the history and conventions of the art and, within this framework, a desire to search for new possibilities in individual expression. Whereas the subject itself was once the main focus, it is now a vehicle for further innovation.

ACKNOWLEDGEMENTS

Exhibit design: George Nitefor, National Film Board of Canada
Brochure design: Acart Graphic Services, Inc., Ottawa
Guest Curator, Indian Art: Dr. Ruth Phillips, Carleton University, Ottawa
Research Consultant, Indian Art: Deirdre Tedds, Ottawa
Photography: François Proulx, Les frères Proulx Brothers Inc., Ottawa

The Inuit art works have been reproduced by permission of the Canadian Eskimo Arts Council on behalf of the

artists and their co-operatives.

The Indian art works have been reproduced by permission of the artists.

CATALOGUE

Paintings, Sculptures, and Prints

Indian Art

Carl Beam (Ojibwa, 1943)
 1. *States of Being '82*, 1982, mixed media, handmade paper, 77 x 103 cm.

In this painting, as in his other works, Carl Beam confronts the inescapable reality of technology for both Indians and whites in the modern world. By juxtaposing the images of Sitting Bull and Albert Einstein, he strives to balance the spiritual insights of Indian tradition with those of Western science.

Simon Brascoupé (Mohawk, Algonquin, 1948)
 2. *The Stolen Gift*, 1982, stencil ink on paper, 63.5 x 48.5 cm.

Simon Brascoupé's *The Stolen Gift* refers to the theft of culture from Peruvian Indians at the time of the Spanish Conquest. A great predatory bird dominates this composition, rich in cosmic symbolism which echoes both native and Christian beliefs.

Allen Sapp (Plains Cree, 1929)
 3. *Esquoio Getting Snow for Water*, 1981, acrylic on canvas, 51 x 60 cm.

Allen Sapp is one of Canada's most esteemed artists. He paints well-remembered images of the daily and seasonal activities of friends and relatives from his childhood memories of the Red Pheasant Reserve in Saskatchewan.

Freda Diesing (Haida, 1925)
 4. *Old Woman Portrait Mask, 1975*, alderwood, cedar bark trim, 26 x 19 x 15 cm.

Realism was always a part of traditional Northwest Coast art, for portrait masks were used during traditional winter ceremonials and potlatch celebrations. Freda Diesing's mask is true to its classic prototype. The old woman is shown with a labret in her lower lip, a sign of prestige worn by women of high-ranking families.

Norval Morrisseau (Ojibwa, 1931)
 5. *101 -- The Mermaid and the Fish Spirit, 1967*, oil on paper, 57 x 77 cm.

Morrisseau's innovative forms, based on his study of traditional Ojibwa birchbark scrolls and rock painting, have deeply influenced the styles of many younger artists. Considered the father of contemporary Woodlands Indian art and the founder of the Woodlands school of "legend painting," he has achieved international recognition. His art records the traditional and mythological beliefs of the Ojibwa people in which shamanic human/animal transformation is the central concept.

Michael Robinson (Cree, 1948)
 6. *Spirit Lodge*, 1982, etching, aquatint on paper, 75.5 x 57.5 cm.

Michael Robinson's mystical and visionary art combines highly personal beliefs with allusions to traditional Ojibwa religion. *Spirit Lodge* depicts the sacred bear and turtle of the Midé society, suspended in the space and time of the dream world.

Robert Davidson (Haida, 1946)
 7. *T-Silii-AA-Lis Raven Finned Killer Whale*, 1983, serigraph 5/99, 750 x 1050 cm.

A blend of traditional and contemporary life experience has given Robert Davidson the confidence to explore and create from within the formal conventions of Northwest Coast art. In a recent print he combines traditional designs in a novel way, pushing to their logical limits the rules governing traditional Northwest Coast design.

Phillip Young (Micmac, 1938)
 8. *Heritage No. 5*, 1981, serigraph 8/15, 76 x 56 cm.

While his work *Heritage No. 5* appears abstract, the color and etched design of a traditional Micmac bark container inspired this recent print by Philip Young. The five triangles (trees) across the bottom represent the five generations that have lived since the box was made.

Inuit Art

Ipeelee Osuitok (Cape Dorset, 1923)
 9. *Owl*, 1967, green stone, 29 x 16 x 19 cm.

Owl is carved in the beautiful green stone which has become a hallmark of Cape Dorset sculpture. Known for his fine work in ivory in the 1940s and for his involvement in the beginnings of printmaking in the 1950s, Osuitok has since worked primarily in stone and is one of the community's foremost sculptors.

John Tiktak (Rankin Inlet, 1916-1981)
10. *Mother and Child*, circa 1962, gray stone, 36.5 x 12.5 x 18 cm.

Mother and Child illustrates a well-known artist's approach to this classic subject in Inuit art. Tiktak has simplified the forms of the woman and the child who actually would be carried on the mother's back inside her parka. The figures are fused in the roughly hewn stone to form an icon of motherhood.

Kenojuak Ashevak (Cape Dorset, 1927)
11. *Birds Feeding among Spring Flowers*, 1983, stonecut and stencil, 62.5 x 85.7 cm.
 Printed by Sagiatuk Sagiatuk (Cape Dorset, 1932).

Birds Feeding among Spring Flowers illustrates Kenojuak's genius for decorative graphic images. Working with her favorite bird subject, she uses the motif to compose intricate and, in this case, lyrical patterns of shape, line, and color. As she has said, "I'm just trying to make something beautiful, that's all."

Josie Papialuk (Povungnituk, 1918)
12. *Fixing an Igloo during a Wind Storm*, 1980, serigraph and stencil, 50.5 x 65 cm.
 Printed by Josie Sivurapik (Povungnituk, 1954)

In *Fixing an Igloo During a Wind Storm*, Josie Papialuk uses vibrant bands of color to represent visually the strong wind blowing over the men patching holes in an igloo. According to the artist, "all the winds are different. During the fall, for instance, they are red." In this print, serigraph and stencil techniques were combined by the printmaker to translate and complement Papialuk's original drawing.

Janet Kigusiuq (Baker Lake, 1926)
13. *Untitled*, wall hanging, 1979, duffle, felt, embroidery floss, 114 x 149.5 cm.

Two scales of imagery have been juxtaposed in this appliquéd wall hanging. The foreground bird provides a focal point around which the hunting and travelling vignettes unfold. Kigusiuq comments that she has heard stories of huge birds strong enough to capture people.

Lipa Pitsiulak (Pangnirtung, 1943)
14. *Sea Bird Spirit, 1980*, green stone, 18 x 27 x 12.5 cm.

Sea Bird Spirit is an example of a familiar image within Inuit art--the fantastic creature composed of parts of different animals and humans. While often purely imaginary, such beings are also inspired by traditional legends and beliefs. The sea, as Lipa explains, "has its own particular creatures, even dogs and birds, which are seen only occasionally and usually by shaman people."

March 1 - 30, 1984

CONTEMPORARY ART OF HONDURAS

CATALOGUE

Paintings

Gustavo Armijo
 1. *Los que acusan (The Accusers)*, drawing, Chinese ink on paper, 56 x 86 1/2 cm.

Mario Castillo
 2. *Dama con violín (Woman with Violin)*, oil on canvas, 77 x 102 cm.

Aníbal Cruz
 3. *Nosotros los pobres (We the Poor)*, oil on canvas, 72 1/2 x 105 1/2 cm.

Dino Fanconi
 4. *Pescadores (Fishermen)*, oil on canvas, 56 1/2 x 87 cm.

Elio Flores
 5. *Figuras (Figures)*, oil on canvas, 38 x 51 cm.

Teresita Fortín
 6. *Sueños (Dreams)*, oil on canvas, 76 x 89 cm.

Gelasio Giménez
 7. *Livitación del muerto de risa (Levitation of the Smiling Corpse)*, oil on canvas, 35 1/2 x 45 1/4"

Benigno Gómez
 8. *Jardín (Garden)*, oil on canvas, 59 x 84 1/2 cm.

Virgilio Guardiola
 9. *Miss Universo Inc. (Miss Universe Inc.)*, oil on canvas, 30 x 40 1/2"

Juan Ramón Laínez
10. *El pez (The Fish)*, oil on canvas, 100 x 120 cm.

Raúl Laínez
11. *Arreglo floral (Flower Arrangement)*, oil on canvas, 48 x 65 cm.

Dante Lazzaroni
12. *La calumnia (The Calumny)*, oil on canvas

Víctor López
13. *La corbata partidista (The Party Necktie)*, oil on canvas, 89 x 127 1/2 cm.

Mario Mejía
14. *La noche de las cucarachas (The Night of the Cockroaches)*, oil on canvas, 76 x 102 1/2 cm.

Oscar Mendoza
15. *Venus ante el espejo (Venus Before the Mirror)*, pastel on cardboard, 55 x 61 1/2 cm.

Lutgardo Molina
16. *Reflejos (Reflections)*, oil on canvas, 81 1/2 x 99 cm.

Ezequiel Padilla
17. *Pastel rojo (Red Pastry)*, oil on canvas, 77 1/2 x 102 cm.

Luis H. Padilla
18. *Pintura (Painting) No. I*, oil on canvas

César Rendón
19. *Popol Vuh*, mixed media on cardboard, 113 1/2 x 73 cm.

Alán Roldán Caicedo
20. *Acuario (Aquarium)*, watercolor, 45 1/2 x 56 cm.

Miguel Angel Ruiz
21. *Maniquíes (Mannequins)*, oil on canvas, 73 1/2 x 95 cm.

María Talavera
22. *Girasoles (Sunflowers)*, oil on canvas, 61 x 71 cm.

José Antonio Velásquez
23. *San Antonio de Oriente*, oil on canvas, 66 x 94 cm. Coll. Museum of Modern Art of Latin America, OAS, Washington, D.C.

Pablo Zelaya Sierra
24. *La dama (The Lady)*, oil on canvas, 69 1/2 x 94 cm.

Roque Zelaya
25. *San Antonio de Flores*, oil on canvas, 46 x 56 cm.

BIOGRAPHICAL NOTES[1]

ARMIJO VARGAS, Gustavo. Painter, draftsman, born in Comayagüela, Honduras, 1945. Studied plastic arts at Escuela Nacional de Bellas Artes in Tegucigalpa, and painting at Universidad Nacional Autónoma in Mexico City. Is a member of the Council for Plastic Arts, Ministry of Culture and Tourism, and professor of painting at Escuela Nacional de Bellas Artes, Tegucigalpa. Held individual exhibitions in Honduras. Participated in group shows in Honduras, Costa Rica, El Salvador, and the United States.

CASTILLO, Mario. Painter, born in San Pedro Sula, Cortés, Honduras, 1932. Studied five years in Italy under a fellowship of the government of Honduras. Has held individual exhibitions since 1951 in Guatemala, Costa Rica, and Honduras. Participated in the International Exhibition of Contemporary Art, Rome, 1955, and Milan, 1956; Second Inter-American Biennial, Mexico City, 1958; *Central American Exhibition*, Kansas and New Orleans, 1963; *Art of America and Spain*, Madrid and other European cities, 1963-1964, among others. In addition to winning first prizes at national salons, he was awarded the San Vito Romano Medal in Rome.

CRUZ, Aníbal. Painter, born in San Juancito, Honduras, 1943. Studied in the workshop of Gelasio Giménez and the Escuela Nacional de Bellas Artes, Tegucigalpa, where he is now a professor. Traveled in America and Europe. Exhibited in individual and group shows in Honduras and abroad, including the São Paulo Biennial, 1967. Was awarded several national prizes and distinctions.

FANCONI, Dino. Painter, born in Tegucigalpa, 1950. Graduated from the Escuela Nacional de Bellas Artes, Tegucigalpa, and studied printmaking at the Universidad Gonzalo Facio, San José (Costa Rica), 1978. Held individual exhibitions in Honduras and participated in group shows in Nicaragua, Mexico, Costa Rica, Brazil, and the United States. Was awarded several prizes in national salons.

FLORES, Elio. Painter, born in Honduras. Studied at the Escuela Nacional de Bellas Artes, Tegucigalpa.

[1] Not included in the original catalogue. See Index of Artists for reference on those not listed here.--*Ed.*

Exhibited in national group shows and participated in the exhibition *Paintings from Honduras*, Washington, D.C., 1980. Won awards in national shows.

FORTIN, Teresa. Painter, born in Tegucigalpa, 1899. Started painting in 1928. Acquired knowledge and practice under the guidance of Max Euceda, Pablo Zelaya, Carlos Zúñiga, and the North American artist Cecil Underwood. Worked on stained glass for the Cathedral of Tegucigalpa and executed those of the Iglesia de la Medalla Milagrosa. Held individual exhibitions in Tegucigalpa, 1931, 1960, and 1967. In 1979 received the Pablo Zelaya Sierra National Prize for the Arts.

GOMEZ, Benigno. Painter born in Naranjito, Santa Bárbara, Honduras, 1934. Graduated from the Escuela Nacional de Bellas Artes, Tegucigalpa, 1959. Under a five-year scholarship from the Honduran government, continued studying in Rome. Exhibited in Honduras and abroad. Won prizes in Honduras and abroad, such as honor awards at the International Exhibition of Contemporary Painting in Gubbio, and the First European Quatriennial of Small Painting and Sculpture Sketch, both in Italy.

GUARDIOLA, Virgilio. Painter, draftsman, born in Tegucigalpa, 1947. Studied in Honduras, England, and Spain. Traveled in Central America, Mexico, the United States, France, Spain, Morocco. At present is the chief of the Department of Plastic Arts of the Escuela Superior del Profesorado, and professor, Escuela Nacional de Bellas Artes, Tegucigalpa. Held individual exhibitions in Tegucigalpa, San Pedro Sula, Paris, Ibiza. Participated in national and international group shows. Was twice awarded the Gran Premio Nacional de Pintura, among other national prizes.

LAINEZ, Juan Ramón. Painter, draftsman, born in Tegucigalpa, 1939. Studied at the Escuela Nacional de Bellas Artes, Tegucigalpa; Academia de Bellas Artes de San Fernando, Madrid, under a scholarship of the Honduran Institute of Hispanic Culture, 1965. Traveled in Europe. Since 1973 has been a professor at the Escuela de Bellas Artes. Held individual exhibitions in Honduras. Participated in national and international group shows, including the First Biennial *Mitos y Magia* (Myths and Magic), São Paulo, 1978. Was awarded prizes at annual art salons of the Instituto Hondureño de Cultura Interamericana, 1964 and 1972, and also won the the Amaya Amador National Prize, Council of the Central District, Tegucigalpa.

LAINEZ, Raúl. Painter, born in San Pedro Sula, Cortés, Honduras, 1923. Self-taught as an artist. Participated in group exhibitions in San Pedro Sula and Tegucigalpa. Held his first individual exhibition in 1980.

LAZZARONI, Dante. Painter, draftsman, graphic artist, born in Río Lindo, Cortés, Honduras, 1929. Studied at the Escuela Nacional de Bellas Artes, Tegucigalpa; Escuela Nacional de Artes Plásticas, Mexico City, 1949-53. Worked at the Escuela Nacional de Bellas Artes, 1954-71. Illustrated the *Antología de la poesía negra* by Claudio Barrera. Held individual exhibitions in Tegucigalpa. Participated in group exhibitions in Honduras and abroad, including New Orleans and Boston, 1963; *Art of America and Spain*, Madrid and other European cities, 1963-64; First Pan-American Salon of Painting, Cali, 1965. In 1983, when the Workshop of Painting was created in Tegucigalpa, the Ministry of Culture and Tourism named it Talleres de Pintura Dante Lazzaroni, in recognition to his contributions in the art field.

LOPEZ, Víctor. Painter, born in Tegucigalpa, 1946. Graduated from the Escuela Nacional de Bellas Artes. Participated in national exhibitions and the Biennials of Mexico and São Paulo.

MEJIA, Mario. Painter, born in Comayagüela, Honduras, 1946. Graduated from the Escuela Nacional de Bellas Artes, Tegucigalpa, 1964, of which he was the director, 1975-82. Organizer of the First Symposium of Artists and Intellectuals of Honduras, 1979. Has held individual exhibitions in Honduras since 1967. Participated in national and international group shows in the United States, El Salvador, Nicaragua, Mexico, Brazil, Cuba, Italy, and Spain. Was awarded the Pablo Zelaya Sierra National Prize for the Arts, Tegucigalpa, 1981.

MENDOZA, Oscar. Painter, born in Tegucigalpa. Graduated from the Escuela Nacional de Bellas Artes; studied printmaking at the University of Costa Rica under an OAS scholarship. At present works at the Escuela Nacional de Bellas Artes and studies architecture at the University of Honduras. Has exhibited in Honduras and abroad.

MOLINA, Lutgardo. Painter, born in Tegucigalpa, 1948. Graduated from the Escuela Nacional de Bellas Artes, where he was later a professor. Held individual exhibitions in Honduras. Participated in group shows in

Honduras and other Latin American countries. Was awarded several prizes in Honduras, including Second Prize, First Central American Biennial, San Pedro Sula, 1981.

PADILLA, Ezequiel. Painter, born in Tegucigalpa, 1945. Graduated from the Escuela Nacional de Bellas Artes and is at present studying engineering at the University of Honduras. Held individual exhibitions in Honduras. Participated in group exhibitions in Honduras and other American countries including the United States. Since 1965 has been awarded several prizes in his country.

PADILLA, Luis H. Painter, born in Honduras, 1947. Graduated from the Escuela Nacional de Bellas Artes, Tegucigalpa, 1967. Held individual exhibitions in Honduras and the United States. Participated in group exhibitions in Honduras, Central and South America; biennials in San José (Costa Rica), Valparaíso (Chile), and São Paulo; Xerox Contest, El Salvador and Nicaragua; Latin American Festival, Lima. Won several first prizes in national salons and the López Redezno Festival Prize.

RENDON, César. Painter, born in Ciudad de Gracias, Lempira, Honduras, 1941. Studied at the Escuela Nacional de Bellas Artes, Tegucigalpa; museum sciences in Mexico City, 1973-74; restoration of historical monuments and sites, Florence, 1980. Invited by the Department of States, visited the United States, 1978, and since then has been the director of the Plastic Arts Department, Ministry of Culture and Tourism in Tegucigalpa. Was awarded several first prizes in Honduras and Gold Medal, National Salon of Painting, Tegucigalpa, 1982.

ROLDAN CIACEDO, Alán. Painter, born in San Pedro Sula, Cortés, Honduras, 1952. Lived in New York, where he graduated from high school and was granted a scholarship to study at the Pratt Institute for one year. Participated in national group exhibitions. Won the First Prize for Painting in a National Interscholastic Contest in the United States, 1972.

RUIZ MATUTE, Miguel Angel. Painter, born in San Juancito, Honduras, 1928. Graduated from the Escuela Nacional de Bellas Artes, Tegucigalpa. Under a scholarship studied printmaking and mural painting at the Academia de San Carlos, Mexico City, 1948-53. Worked with Diego Rivera on the mural of the Teatro Insurgentes, and with O'Gorman on the mural at the University Library, Mexico City. Since 1953 has exhibited in Honduras and abroad. Was awarded the Bilbao Prize at the Second Havana Biennial in 1954 and the Pablo Zelaya Sierra National Prize for the Arts, Tegucigalpa, 1954. Developed his artistic career mainly abroad and at present lives in Spain.

TALAVERA, María. Painter, born in Amapala, Valle, Honduras. Attended college in the United States and resided for some years in San Francisco. For a short period studied drawing at the Escuela Nacional de Bellas Artes in Tegucigalpa and started painting under the direction of Gelasio Giménez, 1967. Participated in national salons and Honduran group shows in Nicaragua and the United states. Was awarded First Prize for Non-Professional Artists, National Salon, Tegucigalpa, 1967.

ZELAYA SIERRA, Pablo. Painter, born in Honduras, 1896, where he died in 1933. Lived most of his life abroad, leaving Honduras in 1916 and returning two months before his death. Studied under the Spanish artist Tomás Pavedano in Costa Rica; Academia de Bellas Artes de San Fernando, Madrid, under Benedito and Daniel Vásquez Díaz. Lived and worked as an elementary school teacher in Costa Rica, 1916-20, then resided in Madrid for twelve years, where he held individual exhibitions in 1930 and 1932. Participated in Spanish group shows in Spain and abroad, including the Salon des Indépendents, Paris. The Honduran National Prize for the Arts was named after him.

ZELAYA, Roque. Painter, born in Comayagüela, Honduras, 1958. Self-taught as an artist. Since 1978 has held individual exhibitions in Tegucigalpa; Costa Rica, Panama, and Caracas, 1982; Mexico, the United States, Central and South America, 1983. Since 1977 has participated in national salons; Honduran group shows, including the First Biennial of Central American Painting, San Pedro Sula, 1981; and international exhibitions in the States Unites and other countries, such as the Xerox Contest in Nicaragua and Panama and the Rome Biennial, both held in 1978. Won a gold medal in Honduras, among other prizes.

March 29, 1984

INAUGURATION OF MURAL BY CUNDO BERMUDEZ [1]

March 30 - May 6, 1984

FRANCISCO OLLER: A REALIST IMPRESSIONIST [2]
An exhibition organized by the Ponce Art Museum to commemorate the 150th anniversary of the birth of the Puerto Rican painter Francisco Oller (1833-1917).

Museo de Arte de Ponce
June 17 - December 31, 1983

El Museo del Barrio, New York
January 20 - March 18, 1984

Museum of Modern Art of Latin America, Washington, D.C.
March 30 - May 6, 1984

Museum of Fine Arts, Springfield, Massachusetts
May 27 - July 6, 1984

Museo de la Universidad de Puerto Rico, Río Piedras
August 3 - October 5, 1984

OLLER AND NINETEENTH CENTURY PAINTING

This exhibition aims at having the work of Francisco Oller better known and hopes to establish the basis for the evaluation of his significance. Oller's participation in the early development of impressionism and his close friendship with Pissarro and Cézanne are relatively well known. Yet, in spite of the high quality of Oller's work, he has been included all too infrequently in the general surveys of the art of the nineteenth century. This neglect is due in part to the scant diffusion his paintings have had outside of Puerto Rico.

Oller also played an important role in nineteenth century Spanish art. He lived in Madrid for five years (1878-83) and organized an important exhibition that brought the Spanish public in contact with his varied artistic production and with the impressionist movement which Oller had assimilated in France.

For Puerto Rico and its art the image of our reality that Oller has bequeathed us is of capital importance. His lyric interpretation of our landscape, his incisive characterization of our illustrious men, and his wonderful still lifes of the fruits of the tropics established a new way of looking at ourselves.

Even though many of Oller's paintings depict the reality of Puerto Rico, its illustrious men, its varied landscape, and its fruits, this is not the only frame of reference in the evaluation of his work. His participation in the

[1] No press release or invitation was issued for this event that coincided with the unveiling of a plaque in memory of former United States Vice-President Nelson Rockefeller. This 960 square foot ceramic tile mural, executed by the Cuban-born Cundo Bermúdez, is located in the then recently completed garden of the General Secretariat Building of the Organization of American States, F St. between 18th and 19th Sts. --*Ed*.

[2] The Museum of Modern Art of Latin America did not issue a catalogue for this exhibition which was accompanied by a comprehensive catalogue published by the Museo de Arte de Ponce, Puerto Rico, 1983. The list of works exhibited was taken from that catalogue, while the texts here reproduced constituted a leaflet handed out during the exhibition. --*Ed*.

ebullient artistic milieu of mid-nineteenth century Paris together with his friends Pissarro and Cézanne places him in the mainstream of the principal shaping forces of modern art. He was one of the actors in the saga of artistic renovation of the last century that changed the course of Western art. The importance of this movement was prophetically expressed by Antoine Guillemet in his letter to Oller of September 12, 1866, when he said: "We will eventually impose our way of seeing."

Oller and Realism

On several occasions Oller called himself a disciple of the French painter Gustave Courbet, the "Father of Realism." Courbet, the great renovator of painting in his time, was one of the key figures in the struggle against the reactionary ideas and practices of the Academy of Fine Arts in France. From Courbet, Oller assimilated the anti-academic stance and the preference for contemporary subject matter which he was to maintain throughout his work. Oller also developed his artistic philosophy following the realist school when he stated: "The artist, like the writer, has the obligation to be of use; his painting must be a book that teaches; it must serve to better the human condition; it must castigate evil and exalt virtue."

Oller and Impressionism

In the first trip to France (1858-65) Oller became involved with the principal avant-garde artists. An admirer of Manet, he studied with Renoir, Monet, and Bazille; his close friends were Cézanne, Guillemet, and Pissarro.

Oller's contacts with the French avant-garde were determinant in the development of his style, choosing like them to represent nature in a straightforward manner. Each trip to France brought him in contact with the more advanced artistic movements, which he incorporated in his repertoire. In *Banks of the Seine* we see Oller attempting to capture his impression of the passing moment, of the play of light and atmosphere in a direct and spontaneous manner. In this work he shows his adhesion to and understanding of pure impressionism, his control of technique and of the handling of color.

Oller and Puerto Rico

During his years in Puerto Rico Oller adopted a fundamentally realist style with some elements of impressionism. His intense study of nature and the varied greens of the tropics enriched his palette. In his landscapes Oller captures the intense light and the atmosphere of the tropics. He represented several aspects of sugar plantations. His still lifes deal with the form and colors of the fruits of Puerto Rico, depicted with an air of quiet dignity.

Oller did not practice any genre of painting exclusively. He was able to create significant genre scenes, beautiful landscapes, and extraordinary still lifes. Among his better works are impressive portraits in which he shows interest in conveying the physical appearance of his subjects and is also able to give us an image of their character.

Oller remained in his country due to his profound involvement with Puerto Rico. Oller conceived art to be "the representation of nature for the good of humanity." He committed his painting to his country and had to adjust his art to this circumstance.

The evident variation in the style of Oller, where we can find diverse elements of the realist and impressionist schools, conveys the artist's search for a more adequate means of capturing his impression of reality. He assimilates elements of diverse schools without copying any single artist. The original combination of different tendencies in his work has led us to call him a "realist impressionist."

Oller was the only Latin American painter to have participated in the creation of impressionism. He felt concern for educating his people, as much in the need for appreciating the arts as in that of pointing a finger at its defects and proclaiming its virtues. The reverses which he suffered in the course of his life failed to extinguish in him the creative fire. His determination not to yield in the face of adversity and, above all, the outstanding quality of his art, are what many years later continue to give relevance to the figure of Francisco Oller.

This exhibition has been organized thanks, in part, to grants from the National Endowment for the Arts, the Economic Development Administration, the Legislature of Puerto Rico, and the Ponce Municipal Government.

We also wish to thank the International Institute of the Americas of World University for their cooperation.

EXHIBITION LIST

Oils and Drawings

1. *Dr. Francisco Oller*, 1847, oil on canvas, 43 1/2 x 34". Coll. Ateneo Puertorriqueño.
2. *Capeadora a caballo (Lady Bullfighter on a Horse)*, ca. 1851-52, oil on canvas, 11 x 8 1/4".
 Coll. Instituto de Cultura Puertorriqueña.
3. *El pleito de la herencia (The Inheritance Lawsuit)*, ca. 1854-56, oil canvas, 17 1/4 x 24 1/2". Private collection.
4. *Fray Iñigo Abbad y Lasierra*, ca. 1854-56, oil on canvas, 45 x 36 7/8". Coll. Ateneo Puertorriqueño.
5. *Manuel Sicardó y Osuna*, ca. 1866-68, oil on canvas, 43 x 35 1/2". Coll. Ateneo Puertorriqueño.
6. *Bodegón con jarra, mangóes y mamey (Still Life with Jug, Mangoes, and Mammees)*, oil on canvas, 18 x 22".
 Coll. Instituto de Cultura Puertorriqueña.
7. *Bodegón con guineos, jarra y pajuiles (Still Life with Bananas, Jug and Cashews)*, ca. 1869-70, oil on canvas,
 18 1/2 x 22". Coll. Instituto de Cultura Puertorriqueña.
8. *Bodegón con vino, piña y mangóes (Still Life with Wine, Pineapple, and Mangoes)*, ca. 1869-70, oil on canvas,
 18 x 22". Coll. Instituto de Cultura Puertorriqueña.
9. *General Baldrich*, 1870-71, oil on canvas, 41 7/16 x 54 3/16". Coll. Municipio de Ponce.
10. *El estudiante (L'étudiant) (The Student)*, ca. 1874, oil on canvas, 25 1/2 x 21 1/4". Coll. Musée d'Orsay
 (Galerie du Jeu de Paume), Paris.
11. *Orillas del Sena (Banks of the Seine)*, 1875, oil on cardboard, 10 x 13 3/4. Coll. Musée d'Orsay (Galerie du
 Jeu de Paume), Paris.
12. *Molino (Moulin) (The Windmill)*, 1875, oil on canvas, 18 1/4 x 24". Coll. Francisco Cordero.
13. *Basílica de Lourdes (The Basilica of Lourdes)*, ca. 1876-77, oil on canvas, 9 1/2 x 12".
 Coll. Museo de la Universidad de Puerto Rico.
14. *Gruta de Lourdes (The Grotto of Lourdes)*, ca. 1876-77, oil on canvas, 9 1/2 x 13 1/4".
 Coll. Josefina Marxuach.
15. *La carga de Treviño (The Charge of Treviño)*, 1878, oil on canvas, 36 5/8 x 25 5/8".
 Coll. Palacio Real, Madrid, Spain.
16. *Paisaje español/estudio de jinete y caballo (Spanish Landscape/Study of Horse and Rider)*, 1879, oil on wood,
 9 1/2 x 12 3/4". Coll. Jacobo Ortiz Muria.
17. *Coronel Francisco Enrique Contreras*, 1880, oil on canvas, 59 x 41". Coll. Enrique Contreras.
18. *Autorretrato (Self-Portrait)*, 1880, oil on canvas, 23 1/2 x 19 5/8". Coll. Paniagua Charbonnier Family.
19. *El mendigo (The Beggar)*, 1881, oil on canvas, 27 5/8 x 22 1/8". Coll. Dr. Rafael Cestero.
20. *El cesante (Unemployed Man)*, ca. 1882, oil on canvas, 31 3/4 x 26". Private collection.
21. *Palacio de Alcañices (Palace of Alcañices)*, ca. 1883, oil on canvas, 25 1/2 x 21". Private collection.
22. *Carmen Alonso*, ca. 1884, oil on canvas, 24 x 18 1/2". Private collection.
23. *José Gautier Benitez*, ca. 1885-86, oil on canvas, 38 7/8 x 28 1/4". Coll. Ateneo Puertorriqueño.
24. *La ceiba de Ponce (The Ponce Silk-Cotton Tree)*, ca. 1887-88, oil on canvas, 19 x 27 1/4".
 Coll. Museo de Arte de Ponce.
25. *Conuco (Plot of Land)*, ca. 1888-90, oil on canvas, 12 x 18 1/4". Private collection.
26. *Trapiche meladero (The Sugar Mill)*, ca. 1890, oil on canvas, 10 1/2 x 13 3/4". Coll. Architect Miguel Ferrer.
27. *Hacienda Carmelita, Luquillo*, ca. 1888-1890, oil on wood, 10 1/2 x 13 3/4".
 Coll. Museo de la Universidad de Puerto Rico.
28. *Hacienda Aurora, vista del río (Hacienda Aurora, View of the River)*, ca. 1888-90, oil on canvas,
 12 1/2 x 13 3/4". Coll. Museo de la Universidad de Puerto Rico.
29. *Bodegón con aguacates y utensilios (Still Life with Avocados and Kitchen Utensils)*, ca. 1890-91, oil on canvas,
 21 x 32 1/2". Coll. Museo Histórico de Puerto Rico.
30. *Bodegón (Still Life)*, ca. 1890-91, oil on canvas, 17 3/8 x 25 1/8".
 Coll. Museo de la Universidad de Puerto Rico.
31. *Autorretrato (Self-Portrait)*, ca. 1889-92, oil on wood, 23 5/8 x 17 1/2".
 Coll. Museo de la Universidad de Puerto Rico.
32. *La escuela del maestro Rafael (The School of Rafael Cordero)*, ca. 1890-92, oil on canvas, 39 1/2 x 63".
 Coll. Ateneo Puertorriqueño.
33. *Casa-finca del Guaraguao (Guaraguao Farmhouse)*, ca. 1890-92, oil on wood, 22 1/2 x 11 5/8".
 Private collection.

34. *Hacienda Santa Bárbara*, ca. 1891-92, oil on wood, 20 1/8 x 30". Coll. Luisa María Elzaburu.
35. *Plátanos amarillos (Ripe Plantains)*, ca. 1892-93, oil on wood, 32 5/8 x 20 1/4".
 Coll. Hanny Stubbe de López.
36. *Plátanos verdes (Green Plantains)*, ca. 1892-93, oil on wood, 28 3/4 x 32 3/4".
 Coll. Victoria Stubbe de Besosa.
37. *Boceto para "El velorio" (Sketch for "The Wake")*, ca. 1892-93, oil on wood, 12 3/4 x 17".
 Coll. Museo de Arte e Historia de San Juan.
38. *Gatos, estudio para "El velorio" (Cats, Study for "The Wake")*, ca. 1892-93, oil on wood, 10 1/8 x 21 1/2".
 Coll. Museo de Arte de Ponce.
39. *Perro, estudio para "El velorio" (Dog, Study for "The Wake")*, oil on canvas, 11 5/8 x 15 7/8".
 Coll. Josefina Marxuach.
40. *Niño negro con güiro, estudio para "El velorio" (Black Boy with Güiro, Study for "The Wake")*, ca. 1892-93,
 oil on canvas, 17 3/4 x 13 1/6". Coll. Manuel A. Font.
41. *Mujeres, estudio para "El velorio" (Women, Study for "The Wake")*, ca. 1892-93, oil on canvas, 25 x 30".
 Coll. Museo de la Universidad de Puerto Rico.
42. *Hombres, estudio para "El velorio" (Men, Study for "The Wake")*, ca. 1892-93, oil on canvas, 27 x 48".
 Coll. Instituto de Cultura Puertorriqueña.
43. *El velorio (The Wake)*, 1893, oil on canvas, 96 x 156 1/2". Coll. Museo de la Universidad de Puerto Rico.
44. *Marina (Seashore)*, ca. 1893-94, oil on canvas, 14 1/8 x 22 1/4". Coll. Annette de Jesús Menéndez.
45. *Marina con bohío (Seashore with Thatched Hut)*, ca. 1893-94, oil on canvas, 14 1/8 x 22 1/2".
 Coll. Annette de Jesús Menéndez.
46. *Estudio de paisaje con bohío (Study for Landscape with Thatched Hut)*, ca. 1893-94, oil on canvas,
 15 5/8 x 6 1/4". Coll. Biblioteca Madre María Teresa Guevara, Universidad del Sagrado Corazón.
47. *Paisaje francés I (French Landscape I)*, ca. 1895-96, oil on canvas, 36 1/2 x 28 1/2".
 Coll. Instituto de Cultura Puertorriqueña.
48. *Paisaje francés II (French Landscape II)*, ca. 1895-96, oil on canvas, 25 3/4 x 36 1/4".
 Coll. Instituto de Cultura Puertorriqueña.
49. *Paisaje con lavandera (Landscape with Washerwoman)*, ca. 1895-96, oil on canvas, 25 3/4 x 21 1/2".
 Coll. Instituto de Cultura Puertorriqueña.
50. *Jardín (Garden)*, ca. 1895-96, oil on wood, 9 1/2 x 13 1/8". Private collection.
51. *Paisaje palma real (Landscape with Royal Palm Trees)*, oil on wood, 18 1/2 x 13 3/4".
 Coll. Ateneo Puertorriqueño.
52. *Paisaje del Guaraguao (Guaraguao Landscape)*, ca. 1897, oil on cardboard, 13 3/4 x 11 1/4".
 Coll. Paniagua Charbonnier Family.
53. *Hacienda Aurora*, ca. 1898-99, oil on wood, 12 1/2 x 22". Coll. Museo de Arte de Ponce.
54. *Paisaje con bohío (Landscape with Thatched Hut)*, ca. 1898-99, oil on wood, 8 7/8 x 12 3/4".
 Coll. Museo de la Universidad de Puerto Rico.
55. *Hatillo*, 1900, oil on wood, 10 5/8 x 13 3/4". Coll. Paniagua Charbonnier Family.
56. *George W. Davis*, 1900, oil on canvas, 54 x 35 1/4". Coll. La Fortaleza.
57. *William H. Hunt*, 1901, oil on canvas, 53 5/8 x 33 1/4". Coll. La Fortaleza.
58. *Guayabas (Guavas)*, ca. 1901-03, oil on wood, 15 1/2 x 26 7/8". Coll. Paniagua Charbonnier Family.
59. *Mameyes (Mammees)*, ca. 1901-03, oil on wood, 17 1/4 x 31 5/8". Private collection.
60. *Mangóes (Mangoes)*, oil on wood, 20 1/2 x 32 1/2". Coll. Eddie and Gladys Irizarry.
61. *Marina con palmera (Seashore with Palm Tree)*, 1903, oil on cardboard, 3 1/4 x 5 3/8".
 Coll. Elsa Tió Fernández de Coleman.
62. *Paisaje entre montañas (Mountainous Landscape)*, oil on wood, 6 7/8 x 5".
 Coll. Paniagua Charbonnier Family.
63. *Paisaje con tres figuras (Landscape with Three Figures)*, 1904, oil on wood, 7 1/4 x 5".
 Coll. Paniagua Charbonnier Family.
64. *Beekman Winthrop*, 1905, oil on canvas, 32 3/4 x 27 1/2". Coll. Museo de Arte de Ponce.
65. *Paisaje con palma real (Landscape with Royal Palm Tree)*, ca. 1908-10, oil on wood, 11 1/2 x 20 1/8".
 Coll. Rodríguez Molina Family.
66. *Paisaje nocturno (Nocturnal Landscape)*, oil on wood, 11 1/2 x 25 1/2". Coll. Carolina Zeno de Aponte.
67. *Encarnación Molina de Rodríguez Serra*, ca. 1910-12, oil on canvas, 23 1/4 x 19 1/4".
 Coll. Rodríguez Molina Family.
68. *Paisaje de Puerto Rico (Puerto Rican Landscape)*, ca. 1910-12, oil on wood, 22 3/4 x 13 5/8".
 Coll. Instituto de Cultura Puertorriqueña.

69. *Paisaje del Guaraguao, vista del río (Guaraguao Landscape, View of the River)*, oil on wood, 11 x 14 1/8". Coll. Gustavo Díaz Atiles.
70. *Piñas (Pineapples)*, ca. 1912-14, oil on wood, 21 1/4 x 34 1/4". Coll. Instituto de Cultura Puertorriqueña.
71. *Higüeras (Gourds)*, ca. 1912-14, oil on wood, 16 1/2 x 42". Coll. Paniagua Charbonnier Family.
72. *Palmillo (Palm Tree Fruit)*, ca. 1912-14, oil on wood, 16 3/4 x 38". Coll. Paniagua Charbonnier Family.
73. *La lavandera (The Washerwoman)*, ca. 1887-88, pencil drawing, 4 1/4 x 5 5/8". Coll. Dr. Francisco Olazábal.

April 17 - May 11, 1984

H. LLOYD WESTON OF JAMAICA

If something positive has been accomplished by the OAS, it has been to couple the art of the nations of Latin origin with the art of those countries of British origin in the Caribbean Basin, establishing the first foundation for an art of diverse roots into a hemispheric unity.

Within this context, what was recently known as the British West Indies, Jamaica, Barbados, and Trinidad and Tobago emerged as the principal focus of plastic creation. On several occasions the art gallery of the OAS has given shelter to outstanding artists from the region, sometimes collectively and at other times individually.

In spite of being absent from the direction of the Museum for more than a year, from time to time I intervene as a counselor; in this case to welcome in the program of OAS shows of art the distinguished Jamaican personality of H. Lloyd Weston, who with this exhibition of his works continues the purpose of bringing together the artists and their works throughout the whole continent.

Mr. Weston is a new personality renowned in the artistic and social circles of his native Jamaica and other cities, e.g., New York where he has an enthusiastic following. His main characteristics are the brilliancy of his palette, the subtlety of his brushstrokes and a special leaning towards landscapes, seascapes, and nature in general, including skillfully arranged flower pieces. --*J.G-S.*[1]

EXHIBITION LIST [2]

Paintings

1. *Port Maria by the Sea*, 1981, oil, 46 x 25"
2. *A Quiet Pond*, 1983, pastel, 14 x 17"
3. *Flowers by a Window*, 1981, oil, 24 x 30"
4. *Field and Flowers*, 1982, pastel, 19 x 25"
5. *The Sweeping Sky*, 1982, oil, 32 x 46"
6. *Flowers with Lavender Clouds*, 1981, oil, 30 x 36"
7. *Trees at Stonecliff*, 1982, oil, 36 x 24"
8. *A Private Walk*, 1982, pastel, 18 x 24"
9. *Burst of Feathers*, 1983, pastel, 19 x 25"
10. *Sunrise in the Mist*, 1983, oil, 34 x 46"
11. *Storm Watch*, 1983, pastel, 16 x 26"
12. *The Pink Sky*, 1982, pastel, 19 x 27"
13. *The Pink Orchid*, 1982, pastel, 15 x 22"
14. *The Blue Orchid*, 1982, pastel, 15 x 22"
15. *The Yellow Orchid*, 1982, pastel, 15 x 22"
16. *The Golden Orchid*, 1982, pastel, 15 x 22"

[1] Former Museum director and renowned art critic, Mr. José Gómez-Sicre, has graciously accepted our invitation to comment on this exhibition.

[2] Not included in the original catalogue. --*Ed.*

17. *Gardens of Sign Great House*, 1981, pastel, 22 x 24"
18. *Relationship*, 1980, pastel, 13 x 16"
19. *Summer Sensation*, 1980, oil, 30 x 40"
20. *A Wave of Flowers*, 1983, oil and pastel, 29 x 39"
21. *Out of Many Colors One Man*, 1982, oil, 16 x 30"
22. *Sunset at Negril*, 1982, pastel, 17 x 23"
23. *After the Storm*, 1982, pastel, 19 x 24"
24. *Spring in New York*, 1980, oil, 36 x 36"
25. *The Yellow Wall*, 1982, pastel, 18 x 24"
26. *Round Hill*, 1982, oil, 32 x 46"
27. *Moonlight at Stonecliff*, 1982, pastel, 19 x 23"
28. *Garden with Trees*, 1976, pastel, 13 x 16"
29. *Gardens of Versailles*, 1977, pastel, 12 x 17"
30. *Bamboo Grove*, 1983, pastel, 11 x 27"
31. *Shadow of the Mango Tree*, 1983, pastel, 21 x 29"
32. *Tree at Devon House*, 1983, pastel, 15 x 20"
33. *Flowers and Vines*, 1982, pastel, 22 x 29"
34. *View of Bogue Island*, 1982, pastel 15 x 22"
35. *Dream Meadow*, 1981, pastel, 15 x 20"
36. *A Gift of Tulips*, 1983, pastel, 21 x 27"

ABOUT THE ARTIST

Born in Kingston, Jamaica, Mr. H. Lloyd Weston was educated in Jamaica and the United States of America. His first formal encounter with art occurred at the College of Arts, Science, and Technology, in Kingston, Jamaica. Mr. Weston then attended Fairleigh Dickinson University, where he majored in English literature and creative writing and broadened his life-long interest in art.

After graduation he embarked upon independent study tours of London and Paris where he was attracted to the impressionist school of art. In addition to his studies in Europe, he studied abstract expressionism for two years with Vaclav Vitlacil and Joseph Stapleton at the Art Students League, New York City. Instructor Stapleton admired his work, took a serious interest, and became his personal mentor.

Mr. Weston draws upon his Jamaican background as a source of influence and inspiration for his art. His love and respect for nature is the dominant theme of his works which are characterized by an imaginative use of lush colors and a sound understanding of movement and form.

International acclaim occurred shortly after his New York premiere showing at the Center for Inter-American Relations in 1981. He has been on numerous radio and television talk shows throughout the New York metropolitan area. One highlight of his career was the favorable review he received from noted art critic, Renée Phillips, of the well-known New York gallery review, *Artspeaks*. More recently, in 1983, H. Lloyd Weston was officially placed on the United Nations list of "International Artists" with the exclusive privilege of participating in the United Nations Stamp Design Competitions.

Selected solo exhibitions

1981 Connecticut National Bank
 Center for Inter-American Relations, New York
1982 Ta Nisia Galleries, New York
 Round Hill Resort, Montego Bay, Jamaica
1983 Leroy Building, New York

Selected group exhibitions

1979 Art Students League, New York
1980 Saybrook Exhibition, Connecticut
1982 Keane Mason Gallery, New York
 Saratoga Exhibition, New York

Some private collections

H.E. Ambassador and Mrs. Enriquillo del Rosario, New York
Mr. and Mrs. Jacques Moore, Virginia
Mr. and Mrs. William Marquard, New York
M. Pierre Caruiti, Paris
Dr. Zelma Ann Henriques, New York
Mrs. Pauline Scarborough, North Carolina
Mr. and Mrs. Howard Lyons, Jamaica
Mr. and Mrs. Joseph Zednick, Illinois
Mr. and Mrs. Shelly Charone, Illinois
The Mutual Life Gallery, Jamaica
Dubnoff and Co., New Jersey

June 12 - July 17, 1984

NEW DIRECTIONS: MEXICAN WOMEN ARTISTS

Organization of American States, Washington, D.C.
June 12 - July 17, 1984

Cayman Gallery, New York
September 6 - October 13, 1984

It is most gratifying for Avon Mexico to give its support to this interesting effort, aiming to present before different audiences through the United States of America, this collection of pictorial art, representative of the present artistic expression of the contemporary woman of Mexico.

The advancement of woman and her positive participation in the arts, family, and community in Mexico is of special interest to Avon and is also the reason for our continued support through different programs.

New Directions: Mexican Women Artists is a good example of the national values that we want to share with all our visitors and friends.

We take the opportunity to thank the Foreign Relations Ministry, through the Direction of Cultural Affairs, as well as the National Institute of Fine Arts, through the Direction for International Relations, for their support which has allowed for the putting together this art collection now presented for your enjoyment.

With our best wishes.

Cordially,

Fernando Lezama Robles, President and General Director, Avon Cosmetics, S.A. de C.V., Mexico.

INTRODUCTION

New Directions: Mexican Women Artists was originally conceived in response to Avon Products, Inc., interest and commitment to highlight the artistic excellence achieved by women artists in Mexico.

The persons who have watched the exciting growth of Mexico's art movement during the past thirty years have seen the diversion from what was considered traditional art in Mexico into a richer and expanded interpretation of visual expressions.

The artists and art works included in this exhibition are representative of three generations of women artists reflecting an amazingly consistent stylistic element and a re-definition of contemporary vocabulary that speaks of Mexico's unspoken social, cultural, and political factors--among them the attitudes about women who happen

to be artists--and how it affects Mexican art today.

The purpose of this exhibition and accompanying catalogue is to establish the development of artistic expression from its earlier manifestations to its most recent contemporary experience. The exhibition is not comprehensive nor is it intended to be. It is just a starting point to further the opportunities for artists with close geographical boundaries with the United States, which at the same time will afford the public in the United States the opportunity to know the artistic accomplishments of the women artists from Mexico.

From the first generation of artists, we present the art work of Alice Rahon, Fanny Rabel, and Lilia Carrillo who emerged when the muralist movement was in its peak in Mexico and went on to produce highly individualized works of art.

Alice Rahon has a personality and temperament strikingly vibrant and impressive. A French woman who moved to Mexico in 1939 where she now lives, Miss Rahon is a living portrait of the layman's conception of a bohemian artist. Known as a surrealist, in her recent works she shows an inclination toward impressionism--by the exclusion of details, the audacity of her compositions, her understanding of the play with colors, the manner in which she portrays her surroundings, and the amazing ability to make eternal a passing movement.

In an interview, Alice Rahon spoke eloquently of the most basic premise in modern art: "My paintings before they became paintings were a flat surface which I covered with forms and colors; therefore all my paintings came from the force of the canvas. My painting came out of the flat surface." The paintings in this exhibition were done in the very last years of Alice Rahon's artistic production and they eloquently speak of her theories about creation.

In Fanny Rabel's *Panaroma citadino (Cityscape)* the viewer can contemplate characters and objects looking at each other in a promiscuous accumulation of images that make up a picture of a compulsive and chaotic world. This is, indeed, the main subject in Rabel's artistic production. Her work is charged with personal and poignant statements about human conditions, specially those dealing with traditions, values, social mores, economic realities, and political actions affecting the life-styles of the people in Mexico.

The second group of artists here included are Olga Dondé, Leticia Ocharán, Susana Campos, Teresa Cito, and Herlinda Sánchez Laurel, all well-known artists who have achieved a level of prominence in the contemporary art scene in Mexico.

Olga Dondé has a tendency to adapt, modify, and otherwise change about the concerns and methods she has encountered in her artistic endeavors. The diptych *Conjetural (Conjectural)* conveys its message through a pictorial language that is a combination of lithographs Dondé produced in the earlier part of the 1970s; later she worked with paper collage and crayon drawings. The artist has assembled an environment where rich textures play and co-exist with shapes that are evocative of tropical fruits and mythical imagery. These forms grow and intersect each other, creating illusions foreign but often familiar at the same time; they are variations of a single theme placed at the service of her personal artistic quest.

Leticia Ocharán's smooth, controlled geometric shapes boldly announce an artist who has found in abstract art the ideal field to make a monumental statement according to the dictates of her individual vision and conscience. Ocharán's colors and abstract forms are sophisticated in their subtlety. In her works the artist has managed to skillfully combine sound linear relationships, symbolic images, and textural variations into a unique revelation of reality about the human condition which is not normally evident in nonfigurative art.

The key to the creativity in Susana Campos's works is repetition, a constant replaying of color, forms, and linear surfaces. What emanates from the process involved in her work is the motivation to re-create surfaces, color, and forms that are the means to bring about a sense of wholeness in the woman she is, in the works she has created, in the mature artist she has become.

Teresa Cito discovered her need to create visual images early in life. As she very well puts it: "I knew I was going to be a painter when I was in my mother's womb." Her latest works have reached maturity with a more somber palette and more attention to structure. *Casas (Houses)*, included in this exhibition, is an exceptionally fine example of this mature period: well-defined shapes, fresh harmonies of colors, and a nostalgic feeling for her

native country.

Herlinda Sánchez Laurel, born near the Mexican border, is concerned with the social and political realities of the Mexicans in that area. Her work is a mirrored image of her philosophical concerns. Her work speaks of struggles, of causes, and of her love for her ancestors and her people, with the colorful freshness and spontaneity of a primitive painter. But, unlike the primitives, strong content and messages emanate from her production.

Irma Palacios's inspiration has not come from contemporary society. Her imagery places emphasis on the geography of her subjects, characterized by rich textures, freedom from any pretense, and adjustment of the forms skillfully placed in a setting of black and grayish tonalities and colors. An accomplished artist in full command of the medium, she is able to communicate tension, meditation, and serenity. Her special talent is the ability to observe reality while transforming it into her own personal visual statement.

Susana Sierra's works on canvas are done in a delicate yet forceful manner, enhanced and assisted by the medium utilized. In the works in this exhibit, the emphasis is placed on unlimited space where unusual objects float around spatial elements. The atmospheric effect of light and color is interpreted in their strong luminosity and reflected in her black or grayish tonalities. The vibrant intensity of the color and the transcendental comprehension of qualities and texture are pervasive in these works.

Elena Villaseñor searches intensely and incessantly for solutions to the problems of our times such as poverty, hunger, and wars. Her work represents a rich accumulation of both personal and indirect experiences which are clearly visible in her most recent production. In *Parodias de guerra I (War Parodies I)* included in this exhibition, frightening visions of death and isolation are vividly depicted in the midst of a state of structured chaos. It is Villaseñor's intimate concern along with her mastery of technique that allows her to create such fine compositions in a well-organized and coherent form. Her work belongs to an expressionist tradition, perhaps on the border of the best of the newest international movements in expressionism.

Nunik Sauret is a masterful painter who displays a great sensitivity for playing with color and for harmony in ornamental precision. The works in this exhibition are of an astonishing and vigorous force executed in a beautiful manner, thus, in a sense, making her a lyrical artist. Her works on paper as well as her canvasses speak of an exterior duality of strength and fragility--fragility and femininity--yet displaying a strong and dramatic refinement accomplished with the ability of an artist who knows the full extent of her craft. This exhibition presents her to the public in her full maturity and with remarkable promise for the future.

Ofelia Márquez Huitzil, a well-known member of the contemporary art scene in Mexico, is presently on a fellowship in Paris. Upon viewing her work in a studio visit, it became apparent that Márquez has undergone many transitions and stylistic changes. The pieces selected for this exhibition are among her latest before her departure a year ago. She has developed her own, unique painting expression, identified by the use of a variety of individual colors which has become characteristic of her recent style. Her inclination to apply colors separately rather than blending them results in massive caricatured figures, surrounded with slashes of color. A highly distinctive and expressive style is thereby created.

Anamario Pinto is an artist highly concerned with the visual components and the harmonious unity of forms and tones. In her work Pinto depicts landscapes in a basically realist manner with impressionist brushstrokes. Her subject matter, although simple and earthly, is thoughtfully considered and painted with care and attention to the detail; most notably is the artist's concern with the subtleties of coloration.

Manuela Generali's artistic career has fully blossomed in Mexico, her adopted home. Her work informs in a very personal manner of her knowledge of politics and prejudice, economics and values, life and death. In *Perdonen la tristeza (Forgive the Sadness)* the images of sadness and desolation are drawn in colors somewhat translucent, displaying the artist's consummate skill at conveying her story in a unique, stylistic way. She obtained her mastery of technique and medium through systematic experimentation; the resultant paintings display an optical quality quite different from other realist works. Aside from her visual narrative, Ms. Generali's main interest is the manifestation of ideas and images that make up her artistic and human concerns.

Gilda Castillo's work manifests a vocabulary which many artists feel has deep meaning within contemporary expressions: the mix of forms and colors to create an environment full of imageries that can relate to modern

as well as ancient times. Castillo's pastel landscapes make reference to an environment where the color delineates the boundaries. The genre is viable for her since it reflects her traditional values of permanency with real and enduring motifs.

Dulce María Núñez has an intense desire to create art reflecting her personal insights about life in Mexico, a form of expression that can, at the same time, be authenticated as "Mexican art." She has stated: "I want to create works that immediately make the viewer say: This was made by a Mexican artist."

What makes this statement unique is that she has taken a different path from what might usually be considered traditional Mexican art--she continuously investigates abstract expressionism in her creative process. In her paintings narrative figures are enhanced by the application of strong yet subtle colors, resulting in highly emotionally charged works that are extremely individualistic.

Mónica Mayer has chosen to create works characterized by their strong statements about the woman's accomplishments, life-styles, and struggles. She is the founder of a feminist group named *Polvo de gallina negra* (Black Hen Powder), dedicated to working with ethnic, political, and social structures of the feminist movement in Mexico City. Mayer's work is a mirror for her concerns: she uses the collage and mixed media to make her statement; she selects photographs, cuts Xerox photocopies, superimposes and juxtaposes them to be of service to an idea. Thus, her work acquires its true meaning, a message that goes beyond representation and transforms it into criticism--like a social manifest or an unveiling of an internal state. This gives direction to the serious progression of her themes, which allows us to understand her concerns both as an artist and as a human being.

Maris Bustamante's creativity finds expression in many and varied forms. The use of different media has enriched and complemented her works, creating new relationships among them. Known best as a performance artist, Bustamante is exhibiting here a drawing/collage in which she sets out to make a permanent visual statement about her environment. This piece reveals characteristics central to her creative process: the continuous experimentation with the medium and the struggle to create a valid visual representation of her flow of ideas.

The graphic works of Consuelo González Salazar are distinguished by the harmonious use of form and color in a simplified realist manner. She creates personal visual statements about the natural environment which result in a serious expression of her concerns with composition and delicate craftsmanship. Her depiction of the time-honored subject of still life is refreshing and light, due to well considered choices of color and shape.

Isabel Vázquez is an artist who in a relatively short length of time is establishing her presence in Mexico's contemporary art scene. By winning the First Prize in last year's Institute of Fine Arts Biennial in the Graphic Division, Vázquez's name has emerged as a highly original artist. Her finely crafted works take their power from a recognizable image and a basic clarity of thought and purpose. Feminine forms are important to her art, and she simplifies this subject matter and portrays it in archetypal imagery.

Paloma Díaz Abreu is the youngest artist in this exhibition. In her short but rich career, Paloma Díaz has established a name for herself among Mexico's younger generation of artists. Her paintings are characterized by the use of vivid primary colors which are utilized imaginatively and with dexterity to outline and flatly fill in the figures and shapes she has drawn.

I was indeed honored to have had the opportunity to curate this exhibition and it is with great pleasure that I present it to the viewing public. --*Nilda Peraza*, Curator.

ACKNOWLEDGEMENTS

An exhibition of this scale and magnitude has only been accomplished through the tireless efforts of a tireless group of individuals. First and foremost, sincere thanks to Avon Cosmetics, S.A. de C.V., of Mexico, Fernando Lezama Robles, President and General Director, and Enrique Villela, Director of New Business and Public Relations; Miguel Osuna, Public Relations Manager and his support staff, Dulce Juárez for coordinating all the details and Ana Elena Patiño for the poster and catalogue design. I am thankful to Eric Schwartz for producing the excellent photographic documentation for the catalogue.

I am grateful to Mónica Mayer for facilitating my work in Mexico. Many thanks to Magdalena Antuñano and

Vivian Kochen, from the Institute of Fine Arts (INBA), and Marina Gálvez from the Secretariat of Foreign Relations in Mexico.

I am particularly indebted to Marie Spiller for her invaluable assistance in researching and compiling the artists' biographical material for the catalogue and to Avon Products, Inc., for making this exhibition possible.

Finally, I specially thank the participating artists for lending the time, talent, and insights that make *New Directions: Mexican Women Artists*. --*Nilda Peraza*, Curator.

CATALOGUE

Maris Bustamante
1. *Aguila I (Eagle I)*, 1984, mixed media on paper, 95.5 x 70 cm.

Susana Campos
2. *Atrapados (Caught)*, 1983, acrylic on canvas, 120 x 105 cm.

Lilia Carrillo
3. *Contaminación primaveral (Spring Pollution)*, 1968, oil on canvas, 100 x 130 cm.

Gilda Castillo
4. *Naturaleza muerta (Still Life)*, 1984, pastel on paper, 53 x 73 cm.

Teresa Cito
5. *Casas (Houses)*, 1984, oil and sand on canvas, 120 x 150 cm.

Paloma Díaz Abreu
6. *Puñal en mano y de muerte herida (Dagger on Hand and of Death Wounded)*, 1983, acrylic on paper, 85 x 55 cm.

Olga Dondé
7. *Conjetural (Conjectural)*, 1975-1983, mixed media lithograph, 1975-1983, 77 x 114 cm.

Manuela Generali
8. *Perdonen la tristeza (Forgive the Sadness)*, 1981, oil on canvas, 180 x 140 cm.

Consuelo González Salazar
9. *Atrapados sin salida (Caught Without Escape) I*, 1983, monotype ink and pencil on paper, 47.5 x 34 cm.

Ofelia Márquez Huitzil
10. *La cabeza (The Head)*, 1981, oil on canvas, 90 x 120 cm.

Mónica Mayer
11. *La gloria (The Glory)*, 1984, collage on paper, 84 x 64 cm.

Dulce María Núñez
12. *Nepantla*, 1983, acrylic on canvas, 65 x 93 cm.

Leticia Ocharán
13. *La versión azul de mi conciencia (The Blue Version of My Conscience)*, 1983, acrylic on canvas, 118 x 143 cm.

Irma Palacios Flores
14. *Juego de sombras (Play of Shades)*, 1983, acrylic on canvas, 150 x 80 cm.

Anamario Pinto
15. *Reflejo (Reflection)*, oil on linen

Fanny Rabel
16. *Panorama citadino (Cityscape)*, triptych, 1982, acrylic on canvas, 130 x 240 cm.

Alice Rahon
17. *El arquero (The Archer)*, 1968, acrylic on canvas, 100 x 80 cm.

Herlinda Sánchez Laurel
18. *Familia campesina con padre ausente (Peasant Family with Absent Father)*, 1982, acrylic on canvas, 100 x 125 cm.

Nunik Sauret
19. *Sin título (Untitled)*, 1984, oil on canvas, 105 x 105 cm.

Susana Sierra
20. *Moradas (Dwellings)*, 1983, acrylic on paper, 190 x 150 cm.

Isabel Vázquez
21. *Danza profana (Profane Dance)*, 1983, aquatint on paper, 43 x 34 cm.

Elena Villaseñor
22. *Parodias de guerra (Parodies of War) I*, 1983, oil on canvas, 124 x 124 cm.

ABOUT THE ARTISTS

BUSTAMANTE, Maris. Born in Mexico. Graduated from La Esmeralda National School of Painting and Sculpture where she studied visual arts. In 1968 she began to exhibit in group and solo shows in Mexico and abroad. Since June 1983 she has been working with the feminist group *Polvo de gallina negra* (Black Hen Powder)--the first of its kind in Mexico--along with Mónica Mayer and Herminia Dorsal. With *No-grupo*, a performance art group, she has presented *La muerte del performance* (The Death of Performance) in 1980, which was viewed by 3,000 spectators at the Museum of Modern Art in Mexico City. In 1983 she participated in *Libros de artistas* (Artists' Books) at the Franklin Furnace in New York City. Her individual performances include *Ves, oyes, hueles y te vas* (See, Hear, Smell, and Leave) in 1982, at Los Talleres Gallery in Mexico City, and in 1983 *Ni tú eres tú ni yo soy yo* (Neither You Are You Nor I Am I) at the Metropolitana Gallery of the National University in Mexico City. She has also performed and exhibited in Frankfurt, Düsseldorf, Belgium, Brazil, Netherlands, New York, and Mexico.

CAMPOS, Susana. Born in Mexico City. Studied at the National School of Fine Arts of the National University in Mexico City. In 1966 she was accepted as a member of the National Salon of Fine Arts at INBA (National Institute of Fine Arts), Mexico City. In 1968-69 she received a fellowship from the French government to study printmaking in Paris under S.W. Hayter. Her group exhibitions in Mexico include: Annual Salon of Fine Arts, Painting Section, 1980; Inter-American Biennial, Carrillo Gil Museum, INBA, Mexico City, 1982; *Tribute to José Clemente Orozco*, Palace of Fine Arts, Mexico City, 1983; and *Artistas mujeres/Mujeres artistas* (Women Artists/Artists Women) at the Fine Arts Museum, Toluca, 1984. Her exhibitions outside Mexico include a 1978 traveling exhibition of Mexican painting that toured various museums in the United States. In 1981 she has had a one-person exhibition (a retrospective show of her work from 1967 to 1981) at the Carrillo Gil Museum, INBA, Mexico City. Her awards include: First Prize for Graphic Art, Annual Salon of Mexican Fine Arts, 1968; Honorable Mention, Annual Painting Salon, 1980. Her work is represented in the collection of the Museum of Modern Art of Latin America, OAS, Washington, D.C.

CARRILLO, Lilia. Born in Mexico City on November 2, 1929. She studied painting at La Esmeralda National School of Painting and Sculpture, Mexico City, from 1947 to 1951. Among her principal individual exhibitions are: Maison du Mexique, Paris, 1955; Antonio Souza Gallery, Mexico City, 1957 and 1961; Pan American Union, Washington, D.C., 1960; and at several occasions since 1963 at Galería Juan Martín, Mexico City. Her group exhibitions include: Institute of Contemporary Art in Lima, 1961; Tokyo Biennial, 1962; Competitive Exhibition of Young Mexican Painters, Museum of Modern Art, Mexico City, 1965.

CASTILLO, Gilda. Born in Mexico City in 1955. Graduated with a M.A. in Spanish-American literature from

the Philosophy School of the National University. Studied painting at La Esmeralda National School of Painting and Sculpture and at the Institute for Research and Experimentation in the Visual Arts, both branches of the National Institute of Fine Arts in Mexico City. Has participated in many group exhibitions which include: Carrillo Gil Museum, Solaris Gallery, Mer-Kup Gallery, Contemporary Art Forum, and the Museum of the Palace of Fine Arts, all Mexico City. She has also participated in the exhibition *México-Berlín. La creación femenina* (Mexico-Berlin. Women's Creation) at the Goethe Institute, Mexico City, and *Primera muestra de arte no-objetual* (First Exhibition of Non-Object Art), Medellín (Colombia).

CITO, Teresa. Born in Bengasi, Libya. From 1951 to 1956 she studied at the Instituto Statale d'Arte in Florence (Italy), and from 1973 to 1974 continued her studies at the San Carlos Academy and the National School of Fine Arts in Mexico City. Her individual exhibitions include: Metropolitana Gallery of the National University, 1981, and Kin Gallery, 1983, both in Mexico City. Her group exhibitions include: National Salon of Fine Arts, Palace of Fine Arts, 1981; *35 mujeres artistas* (Thirty-five Mexican Women Artists), a traveling exhibition in Europe, 1981, and also shown at the Carrillo Gil Museum, 1983; *Artistas contemporáneas* (Contemporary Women Artists), Metropolitana Gallery, 1984, all in Mexico City.

DIAZ ABREU, Paloma. Born in 1958. Studied at the San Carlos Academy, at the National School of Fine Arts of the National University, and at the Talleres Libres (Free Art Workshops), in Mexico City. Since 1982 she has been a student at the Hispanic-American University, majoring in art history. In her short but intense artistic career she has participated in over thirty group exhibitions in Mexico, Rome, and Paris. These include: Young Artists Biennial, Musée d'Art Moderne de la Ville de Paris; *Images, Messages d'Amerique Latine* (Images, Messages from Latin America), Villeparisis Cultural Center in Paris; Prenestini Gallery in Rome; Graphic Arts Biennial of the National Salon of Fine Arts, National Institute of Fine Arts, Mexico City, all of them in 1983; *Los de abajo y los de arriba* (Those Below and Those Above), Chopo Museum of the National University, Mexico City, 1984. Her illustrations appeared in the magazines *Crítica política* (1980), *Cartapacios* (1981), and were published in 1982 in *Plaquette Saurios*, with preface by Oscar Oliva.

DONDE, Olga. Born May 23, 1935 in the City of Campeche, in the southeast of Mexico. She has shown her work in over eighty group and individual exhibitions--in Mexico, Europe, Central and South America, and in the United States--since she began her career in 1968. Her art achievements have been published in *Who's Who in American Art* (1982), *Who's Who in the World* (1982-83), *Women of Mexico* (1980-81), and in a book devoted to her work entitled *El espectador re-crea la obra de arte: la obra artística de Olga Dondé* (The Spectator Re-Creates the Work of Art: The Artistic Work of Olga Dondé), published by Editorial SEP, Mexico. Among others, she has exhibited in the following locations: Houston Museum of Fine Arts, San Antonio Museum of Art, Fort Worth Art Museum, all in Texas; Contemporary Art Museum, Bogotá; Serra Gallery, Caracas; and the Panamanian Institute of Art, Panama City. Her exhibitions in Mexico include: Museum of Fine Arts, Toluca; FONAPAS, Oaxaca; and the Pinacoteca (Painting Gallery), University of Puebla. She is presently represented by Gabriela Orozco Gallery in Mexico City.

GENERALI, Manuela. Born in Lugano, Switzerland. Studied at St. John Cass College and the Wimbledon School of Art in London. Graduated with a B.F.A. from the National School of Fine Arts, National University, Mexico City. Her artistic development has taken place in Mexico where she has resided since 1978. Among her accomplishments is the 1983 Acquisition Prize for Painting, National Salon of Fine Arts held at the Palace of Fine Arts, and the mural *El turno del ofendido* (The Offended's Turn), created with Gustavo Aceves in the School of Sciences and Humanities, Naucalpan, Mexico. She has participated in numerous exhibitions held, among other places, at the Museum of Modern Art, Carrillo Gil Museum, Contemporary Art Forum, Chopo Museum of the National University, all in Mexico City.

GONZALEZ SALAZAR, Consuelo. Born in Torreón, Mexico, 1943. She studied art at the National Fine Arts School in Torreón and the Center for Research and Experimentation in the Visual Arts, Mexico City. She is a founding member of *El caracol* Workshop. Has participated in numerous group shows in her native Mexico and in the United States, including the exhibition *Artistas mujeres/Mujeres artistas* (Women Artists/Artists Women) at the Museum of Fine Arts, Toluca, 1984. She has had individual shows at the Banobras Gallery and Reforma Galery in Mexico City.

MARQUEZ HUITZIL, Ofelia. Born in Mexico City, 1959. Studied at La Esmeralda National School of Painting and Sculpture and graduated with a M.A. from the National Fine Arts School of the National University in

Mexico City. She has participated in various group shows, including *Artistas mujeres/Mujeres artistas* (Women Artists/Artists Women), Museum of Fine Arts, Toluca, 1984. In 1982 she received a fellowship from the French government to study in France and in 1983 won Honorable Mention at the Exhibition of Foreign Artists in Paris.

MAYER, Mónica. Born May 16, 1954 in Mexico. She studied visual arts at the National School of Fine Arts and obtained a M.A. from Goddard College, Los Angeles, California. She attended for two years the Feminist Studio Workshop of the Woman's Building, Los Angeles. She is a founding member of the feminist group *Polvo de gallina negra* (Black Hen Powder) in Mexico City. She has exhibited in group shows since 1973, including *Nuevas tendencias* (New Trends) at the Museum of Modern Art, Mexico City; *35 mujeres artistas* (Thirty-five Women Artists), a traveling exhibition in Europe, 1981, and also shown at the Carrillo Gil Museum in Mexico City in 1983; and *Artistas mujeres/Mujeres artistas* (Woman Artists/Artists Women), Museum of Fine Arts, Toluca, 1984. In 1980 she had a solo exhibition at the Anglo-Mexican Cultural Institute, Mexico City. She won Third Prize at the *Concurso Nacional de Artes Plásticas* (National Fine Arts Competition), and Honorable Mention at the Annual National Young Art Encounter. Her work is represented at the Museum of Modern Art in Mexico City.

NUÑEZ, Dulce María. Born 1950 in Mexico City. In 1975-78 she studied at La Esmeralda National School of Painting and Sculpture, INBA (National Insitute of Fine Arts), Mexico City. She also studied serigraphy with the painter Jan Hendrix at the Center for Research and Experimentation in the Visual Arts, Mexico City. Her graphic works, paintings, and drawings have been shown in one-person exhibitions since 1975 in Sala Wagner and José Clemente Orozco Gallery, INBA, Mexico City. Among her recent group exhibitions are: Graphic Arts Biennial of the National Salon of Fine Arts, INBA, Mexico City, 1981; and *Artistas mujeres/Mujeres artistas* (Women Artists/Artists Women), Museum of Fine Arts, Toluca, 1984.

OCHARAN, Leticia. Born May 28, 1942 in Villahermosa, Tabasco, Mexico. She began her artistic studies in 1965 under Salvador Bribiesca and at Escuela de Iniciación Artística No. 1 (School of Art Initiation No. 1) of INBA (National Institute of Fine Arts), Mexico City. She studied wood and metal engraving in 1968. Her individual exhibitions include: Lyf Gallery of the Light and Power Company, Mexico City, 1977; Arc Gallery, Mexico City, 1980; Viva México Gallery, Caracas, 1981. Among her group exhibitions are: National Salon of Fine Arts, Palace of Fine Arts, Mexico City, 1980; DINA Painting Salon, Gallery of the National Auditorium, Mexico City, 1981. Her prizes include: Fellowship Prize at the Seventeenth Exhibition of INBA Teachers of Art Education, Mexico City, 1978. Publications: in 1981 she illustrated the literary magazine *Sin embargo*.

PALACIOS FLORES, Irma. Born in 1943 in Iguala, Mexico. In 1973-79 she studied art in Mexico City at La Esmeralda National School of Painting and Sculpture, specializing in lithography, 1976-79. In 1980 she studied poster design under Félix Beltrón. She exhibited paintings in 1977 at the National School of Fine Arts, Mexico City. In 1979 a selection of her paintings, drawings, and graphic works was included in the Fourteenth National Competition for Students of Fine Arts held at the Palace of Fine Arts in Mexico City. She also exhibited paintings in the 1980 exhibition *Otra generación* (Another Generation) at the Contemporary Art Forum, and graphics at Casa de Cultura, both in Mexico City. In Spain, her drawings have been exhibited at the Joan Miró International Prize of Drawing in Barcelona, and at Sala de Cultura of the Navarra Burloda Savings Bank in Navarra.

PINTO, Anamario. Born in 1950 in Mexico. Has participated in several group exhibitions, including Casa del Lago, National University, 1969; *Five Mexican Artists*, Orr's Gallery, San Diego (California), 1977; *Exposición de artistas mexicanas* (Exhibition of Mexican Women Artists), Alvar and Carmen T. de Carrillo Gil Museum of Art, Mexico City, 1977; Taranman Gallery, London, 1982; and Capricorn Galleries, Washington, D.C., 1983. Individual exhibitions have been presented at Casa del Lago, National University, 1974; and at Lourdes Chumacero Contemporary Art Gallery, Mexico City, 1976, 1977, and 1980.

RABEL, Fanny. Born in 1922 in Poland, she is now a Mexican citizen. Painter, muralist, printmaker, and set designer, studied at La Esmeralda National School of Painting and Sculpture from 1940 to 1945. She initiated her career as part of David A. Sigueiros's muralist group and later was assistant to Diego Rivera. She held individual exhibitions in Israel and at the Museum of Art in Ein Harod, 1959-60; National Museum of Fine Arts, Havana, 1966; Museum of Alhóndiga, Guanajuato, 1980. She has participated in over one hundred group shows in Mexico, Peru, Argentina, Japan, Cuba, the Soviet Union, Poland, Paris, Berlin, Peking, Tel Aviv, Los Angeles, and New York, and print biennials in Yugoslavia, Chile, and Brazil. In 1984 she completed a mural at the Registro Público de Propiedades (Real Estate Registration Office), and in 1982 she executed another mural at

the Children's Hospital, both in Mexico City. She has been involved in theater set design, writing, and illustrations for books and magazines. Her works are included in the permanent collections of the Museum of Modern Art in Mexico City and New York and the Museum of the Holocaust in Israel, among others.

RAHON, Alice. Born in 1910 in Brittany, France. Arrived in Mexico in 1939, where she has resided since then. In 1953 she became a Mexican citizen. With her first individual exhibition in Mexico, under Carlos Merida's sponsorship, at the Arte Mexicano Gallery, she became part of the Mexican art movement. She has had more than thirty solo exhibitions in Mexico, the United States, France, and Italy. Her exhibitions include those held at the San Francisco Museum of Art (California), the Stendahl Art Gallery and Nierendorf Gallery in the United States, Cour d'Ingres in Paris, and in Mexico at the Museum of Fine Arts Museum in Toluca, as well as the Tamayo Museum, the Museum of Modern Art, and El Eco and Souza Galleries in Mexico City. Her work is represented in numerous important private and public collections.

SANCHEZ LAUREL, Herlinda. Born 1941 in Ensenada, Baja California, Mexico. In 1965-69 she began her studies at La Esmeralda School of Painting and Sculpture in Mexico City, at which time she held the position of president and technical advisor of the Alumni Association. In 1967, under the auspices of the Autonomous University of Baja California, she held a one-person exhibition in Ensenada. She studied in Europe in 1968-1969, then returned to Mexico where she painted in 1970 *Alegoría a la lucha* (Allegory of the Fight), a twenty-four square meter mural at the National Syndicate of Workers--an allegory of the 1968 student uprisings. Her works were exhibited in 1980 and 1982 in the annual painting salons at the National Institute of Fine Arts, Mexico City.

SAURET, Nunik. Born 1951 in Mexico. Has participated in exhibitions at the Zea Museum in Medellín (Colombia) and the Mexican Museum in San Francisco (California), 1979; *Gráfica y escultura* (Graphic Art and Sculpture) at Siqueiros Polyforum in Mexico City and *La mujer en las artes visuales* (Women in the Visual Arts), Museum of Modern Art, Cali (Colombia), 1980. She also participated in 1981 in *35 Kunstlerinnen aus Mexico* (Thirty-five Mexican Women Artists), Studio I, Kunstlerhaus Bethanien, Berlin, and other European cities.

SIERRA, Susana. Born in 1942 in Mexico City. Studied art at the National School of Fine Arts and with Roger von Gunten, Mexico City. Her individual exhibitions include Juan Martín Gallery in 1980 and 1983, and Museum of Modern Art, 1981, both in Mexico City; El Agora Gallery, Xalapa (Veracruz), 1982. Among her group exhibitions are: Goethe Institute, Mexico City, 1980; *35 Kunstlerinnen aus Mexico* (Thirty-five Mexican Women Artists), Berlin and other European cities, 1981; *Tres décadas de arte mexicano* (Three Decades of Mexican Art), Carrillo Gil Museum, Mexico City, 1982; and *Tres décadas de pintura mexicana* (Three Decades of Mexican Painting), Havana, 1983. Her awards include: Acquisition Prize, Annual Painting Salon of the Palace of Fine Arts, Mexico City, 1980 and 1983. She is presently represented by Juan Martín Gallery, Mexico City.

VAZQUEZ, Isabel. Born in 1947 in Mexico City. Studied at Atelier 17 with S.W. Hayter in Paris. Presently is a member of *El caracol* Workshop. In 1983 she won First Acquisition Prize at the Graphic Arts Biennial, National Institute of Fine Arts, Mexico City. She has participated in national and international art biennials as well as in group exhibitions throughout Mexico. She was included in the exhibition *Artistas mujeres/Mujeres artistas* (Women Artists/Artists Women) at the Museum of Fine Arts, Toluca, 1984.

VILLASEÑOR, Elena. Born in 1944 in Sahuayo, Michoacán, Mexico. She studied at La Esmeralda National School of Painting and Sculpture, Mexico City. During 1967-68 she was tutored by maestro Luis Sahagún. In 1980 she took courses in graphic arts at the Art Students League, New York. Her individual exhibitions include: Molino Santo Domingo, Mexico City, 1977; Chapultepec Gallery of the National Institute of Fine Arts, Mexico City, 1978; San Angel Gallery, Mexico City, 1980; and Krasking Gallery, Atlanta (Georgia), 1981. In 1978 she exhibited in Bulgaria where four of her works are now in the permanent collection of Mexican art of one of its museums. In 1979 and 1981 she was awarded First Prize for Graphic Arts at the National Graphic Art Competition *El árbol* (The Tree), Palace of Fine Arts, Mexico City; in 1980 she received Second Prize for Painting at the painting competition *La ciudad* (The City), National Auditorium of the National Institute of Fine Arts. She has participated in more than thirty group exhibitions in Mexico and abroad.

July 10 - 27, 1984

EVANDRO SALLES OF BRAZIL

The great adventure of drawing began in the earliest days of civilization. When primitive man felt the need for self-expression, he turned to carving on stone, using another, harder stone as a chisel. The marvelous petroglyphs thus produced and cave paintings such as those at Altamira attest the aesthetic feeling and plastic talent of our prehistoric ancestors. Much--and at the same time little--has changed since their days. Advanced methods have replaced primitive techniques, but the urge to graphic expression is a constant in all cultures.

No better example of its continuing power could be found than that afforded by the artist here presented, Evandro Salles of Brazil. His nervous lines, his tortured forms, his esoteric images, charged with emotion, reveal an artist of subtlety and keen sensitivity. With each composition he seemingly challenges himself to advance beyond surface form to convey the meaning that lies hidden behind outward appearance. Particularly in the pen-and-ink drawings which are his specialty, there is a manifest desire to extract a maximum of expressive power from the medium employed. Different types of pen and thicknesses of line are used to vary the monotony of black and white with a gamut of intermediate grays. Sometimes Salles creates "overlapping" drawings; in these, in which line alone predominates, one has the impression that the original sketch appeared to him lacking in strength and that he therefore superimposed a second, more thick and powerful one, which does not so much efface the original as infuse it with unexpected force.

Salles's drawings--in which figures connect and disconnect like parts of a jigsaw puzzle floating in the air--are rich in connotations and must be studied in detail for their meaning to become clear.

The work of this Brazilian artist displays a unique combination of talent, sensitivity, and youth, which anticipates a fruitful and exciting career. The Museum of Modern Art of Latin America takes pride in sponsoring his first exhibition in the United States. --*Angel Hurtado*, Audio Visual Specialist, Museum of Modern Art of Latin America.

EXHIBITION LIST [1]

1.	*Sem título (Untitled)*, 1981, 48 x 34.5 cm.
2-6.	*Sem título (Untitled)*, 1981, 51 x 36.5 cm.
7-10.	*Sem título (Untitled)*, 1981, 73.5 x 51 cm.
11-13.	*Sem título (Untitled)*, 1983, 101 x 73 cm.
14.	*Pensando em Klee (Thinking of Klee)*, 1984, 101 x 73 cm. Private collection, Brazil.
15-21.	*Sem título (Untitled)*, 1984, 101 x 73 cm.

ABOUT THE ARTIST

Evandro Vilela Teixeira de Salles was born in Belo Horizonte, Brazil, in 1955. Studied engraving at the University of Brasília in 1974 and design, engraving, painting, and graphic arts at the Rio de Janeiro School of Visual Arts from 1976 to 1978. Between 1979 and 1982 held three one-man shows in Brazil.

Selected group exhibitions

1970	Primeira mostra dos artistas plásticos de Brasília (First Exhibition of Plastic Artists of Brasília), Brasília
1977	*Mão de obra* (Manpower), Alliance Française, Copacabana
1978	*Poucos e raros* (Few and Rare), Museum of Art, São Paulo
1980	*Mostra configuração* (Configuration), traveling exhibition in Brazil, including the Museum of Contemporary Art, São Paulo
1981	*Are You Experienced?*, Vrije Universiteit, Brussels
	Viva arte brasileira, Brazilian House, Madrid

[1] Not included in the original catalogue. --*Ed.*

Visuelle erotik, Theaterclub, Dresden
World Art Atlas, Warande Cultural Center, Belgium
1982 *Llibres d'artista*, Metrònom, Barcelona, Spain
1983 Art Biennial, Pontevedra

Awards

1982 Bank of Brazil Prize, Exhibition of Brazilian Drawing
 Acquisition Prize, Fourteenth National Art Salon, Belo Horizonte
1983 State Cultural Council Prize, Eleventh Soccer Salon, Belo Horizonte

Public Collections

Art Museum, Clóvis Salgado Foundation, Belo Horizonte
Palace of the Arts, Belo Horizonte
Cândido Mendes Gallery, Rio de Janeiro
Cultural Center of Turnhout, Belgium

August 2 - 30, 1984

MIGUEL ANGEL MORALES OF PANAMA

Miguel Angel Morales was born in 1945 in Chiriquí Province, where he attended elementary school and business courses. He moved to Panama City and there completed his secondary education at the Institute Justo Arosemena, where he earned his diploma in science. He attended the School of Public Administration and Business of the National University of Panama.

Morales began his career in painting as a self-taught artist. He then decided to study with painter Yolanda Bech at the Centro de Arte y Cultura, under the direction of Carlos Arboleda, where he became the most promising student of his group.

As an amateur, he participated in several art competitions sponsored by the Office of the National Comptroller and was awarded several first prizes and honorable mentions. As a professional, he has entered a number of national competitions and his work has won him prizes and honorable mentions.

Yolanda Bech has said that in his compositions Morales achieves unity through rhythm of forms and a chromatic balance in which colors at once contrast and blend. The artist paints with remarkable and admirable tenacity, in a constant effort to excel in his work.

Dr. Víctor Fernández says that one salient feature of this artist's work is that he seeks out his subject matter and selects it from nature in the Panamanian tropics. From this magical and incredibly varied world, he captures the elements of form that give quality to his work. The colors in his paintings--the greens, yellows, blues, the pure and the more subtle reds--always blend together for a brilliant and flamboyant tonality reflecting in their way the fullness of life.

Agustín del Rosario observes that the recent floral paintings by Morales are more exuberant, not only in terms of form but also in terms of colors, which are more intricate and less unidimensional. In his most recent paintings, the artist devotes more detail to the hands, faces, and hips, and in the larger pictures they seem to leap from the canvas.

EXHIBITION LIST [1]

Oils

1. *Benita*, 22 x 18"

[1] Not included in the original catalogue. --*Ed*.

2. *Panchita*, 22 x 18"
3. *Florista con traje rojo* (Flower Vendor with Red Dress), 24 x 29"
4. *Floristas con flores naranjas* (Flower Vendors with Orange Flowers), 32 x 40"
5. *Florista con turbante rojo* (Flower Vendor with Red Turban), 32 x 40"
6. *Florista con turbante amarillo* (Flower Vendor with Yellow Turban), 32 x 22"
7. *La larga espera* (The Long Wait), 24 x 24"
8. *Florista con traje blanco* (Flower Vendor with White Dress), 26 x 31"
9. *La perezosa*, 1984, 22 x 22"
10. *Tres floristas* (Three Flower Vendors), 1984, 52 x 42"
11. *La reunión* (The Meeting), 1984, 49 x 49"
12. *Florista caderona* (Flower Vendor with Big Hips), 36 x 24"
13. *La hierbera y la florista* (The Herb Vendor and the Flower Vendor), 1984, 38 x 52"
14. *La coquetona* (Coquettish), 1984, 35 x 32"
15. *Dos floristas* (Two Flower Vendors), 38 x 53"
16. *Floristas con flores amarillas* (Flower Vendors with Yellow Flowers), 1984, 35 x 24"
17. *El agotamiento de la florista* (The Exhaustion of the Flower Vendor), 33 x 30"
18. *Floristas con paraguas* (Flower Vendors with Umbrella), 40 x 33"
19. *Dos floristas* (Two Flower Vendors), 38 x 53"
20. *La florista del escote* (Flower Vendor with Low-Neck Dress), 1984, 30 x 28"

September 6 - 28, 1984

DELIA SOLARI OF ARGENTINA

Delia Solari earned a degree in economic sciences and worked as a certified public account and a licensed administrator before devoting herself to the world of art. When she married, Solari gave up her career to become a full-time painter and mother to their two children. She studied with the artists Mary Lagsner, Julio Giustozzi, Marta Lozano, and Juan Carlos Casco Ross. She has remarked that working in the studio of Casco Ross was a very important experience in the development of her painting. Solari's background and training in mathematics also has exerted a strong influence on her compositions. Her work has been seen in numerous group shows in her native Argentina, as well as in Paraguay and Uruguay. She has also had individual exhibitions in Argentina, Uruguay, New York, and Paris.

In 1975, 1977, and 1982 Solari received First Prize in Painting at the Fernán Félix de Amador Salon of Fine Arts. She was also awarded first prizes in painting from the Fine Arts Salon of the Museum of Fine Arts in Luján and from the Municipal Salon in Lanús in 1981; the following year she received the same distinction at the Salon in San Fernando, all of them in Argentina.

In his essay entitled *Pintura, poesía y cántico* (Painting, Poetry, and Song), César Magrini writes:

> The painting of Delia Solari appears to me as calm, gentle, murmuring. There is in her work the tranquility of wisdom, a slow and sure development, and a mature technique difficult to discover at first, not because of artifice or pretense but because, as in life, the riches we possess become steadily more refined and part of our inner selves. The outward part is only an appearance, a reflection or a glimmer of real life, quietly beating and evolving within.

> The artist prepares her paintings serenely. Forms are composed, then taken apart gradually, then recomposed in a manner so subtle as to be scarcely noticeable, except under close and prolonged scrutiny.

> Stylistically, Solari's work bears a similarity to constructivism, but at the very moment it approaches it, the similarity ends, because Solari's paintings are poetic: the subject matter is secondary, but the treatment she gives them is original, unexplored. There is a subtle geometric delicacy in her landscapes that is reminiscent of Cézanne's experiments with his *Mont Sainte-Victoire*; light is cast in thin branches, loosened, and converted into an arpeggio of sensations. The artist's enduring sensitivity is her staunchest and most natural ally. It is

customary to say that silence makes itself heard most clearly. There is a sonorous silence to this artist's work that is profoundly impressive.

The Museum of Modern Art of Latin America is pleased to present Delia Solari to the public of the nation's capital.

CATALOGUE

Oils

1. *Lineal*
2. *Composición abstracta (Abstract Composition)*
3. *Terrenal (Earthly) No. 2*
4. *Composición lineal (Lineal Composition)*
5. *Hacia el más allá (Toward the Beyond) I*
6. *En el más allá (Hereafter)*
7. *Terrenal (Earthly) No. 1*
8. *Luminoso (Luminous)*
9. *Triangular I*
10. *Composición (Composition)*
11. *Abstracción (Abstraction) I*
12. *Una sinfonía abstracta (An Abstract Symphony)*
13. *Composición de planos y curvas (Composition of Planes and Curves)*
14. *Abstracción (Abstraction) II*
15. *Intimidad de mi taller (My Workshop's Intimacy)*
16. *Naturaleza (Nature)*
17. *Octogonal (Octagonal)*
18. *Ritmo y fuga (Rhythm and Fugue)*
19. *Triangular II*
20. *Articulación en azul (Articulation in Blue)*
21. *Sinfonía en verdes y amarillos (Symphony in Greens and Yellows)*
22. *Construcción trapezoidal (Trapezoid Construction)*
23. *Sobre líneas rectas y curvas (On Straight and Curved Lines)*
24. *Relación de triángulos (Relation of Triangles)*
25. *Elíptico (Elliptic)*
26. *Desarrollo en amarillo (Development in Yellow)*
27. *Hacia el más allá (Toward the Beyond) II*
28. *Abstracto terrenal (Earthly Abstraction)*
29. *Composición en planos (Composition in Planes)*
30. *Sinfonía en planos (Symphony in Planes)*

October 2 - 26, 1984

MATILDE PEREZ OF CHILE

Within the context of Chilean painting, the work of Matilde Pérez is truly exceptional. Explorations in optics and kinetics by Chilean artists have always been scarce. This artist is a true pioneer in this aesthetic direction.

Her interest in venturing into the sciences of light and motion parted from geometric abstraction, to which she devoted herself during the 1950s, as a member of the *Rectángulo* (Rectangle) group that introduced this trend in Chile. This experience allowed her to cultivate a compositional rigor, a rational command of color, respect for two-dimensionality, and a familiarity with plane geometry. She was just a pace away from delving into kinetics. A trip to France in the early 1960s made her take the decisive step. In Paris, she met Vasarely who gave her the basic directions. Later, the noted Argentine artist Julio Le Parc contributed to her assuredness in the new direction she had chosen and to which she has adhered ever since.

This exhibition summarizes this artistic journey. In approaching the optical effects by subject, the artist creates a gamut of visual situations through an active integration of time and motion.

The visual range encompasses two modalities. In one of them--virtual kineticism--the optical effects are produced by the apparent motion of static stimuli, not departing wholly from the traditional elements--canvas, oil, latex, and collages. The paintings are executed by using optical effects of black and white, or chromatic impressions created by a synthetic arrangement of color. The other modality introduces real motion through a luminous source that follows a strict programming of a temporal nature. In these kinetic pieces, in the strictest sense, the artist departs from the traditional materials.

The two modalities have coexisted throughout Matilde Pérez's artistic work, thus distinguishing her from other artists who considered the first of them just as a stepping stone to attain the second. By contrast, our artist works in virtual kineticism as well as in real kinetic luminance. Her first programmed luminary work was exhibited in Santiago de Chile in 1964.

These statements, by transforming the surrounding environment and creating a perspective aura that engages the viewer, offer interesting functional possibilities applicable to the design of urban environment. An example of this is a vast mural executed in 1982 at the important Santiago shopping center of Apumanque.

An overall appreciation of her output might state that this artist's work constitutes an opening towards the animation of time and space involved in planes and volumes, through a continuous stimulation of changing visual impressions, the instability of which submerges the sole theme. For this reason, her work may be perceived in a variety of ways, thus avoiding the single perception. --*Milan Ivelić*, Professor of Art History, Catholic University of Chile.

EXHIBITION LIST [1]

Paintings and Constructions

1. *No. 2*, 1962, wood construction, 150 x 200 cm.
2. *No. 3*, 1964, latex and oil on canvas, 110 x 155 cm.
3. *No. 9*, 1965, latex on wood, 100 x 100 cm.
4. *Alturas* (Heights), 1972, duco on wood, and cardboard, 160 x 220 cm.
5. *Inestabilidad* (Instability), wood construction, 85 x 100 cm.
6. *Composición dinámica* (Dynamic Construction), 1974, latex on canvas, 95 x 100 cm.
7. *Vertical*, 1975, 80 x 133 cm.
8. *No. 13*, 1977, wood construction, 100 x 100 cm.
9. *No. 11*, 1978, wood construction, 100 x 100 cm.
10. *No. 12*, 1979, wood construction, 100 x 100 cm.
11. *No. 15*, 1979, wood construction, 100 x 100 cm.
12. *No. 20*, 1982, wood construction, 100 x 120 cm.
13. *No. 21*, 1983, wood construction, 100 x 100 cm.
14. *Cajas del tiempo* (Time Boxes), 1984, triptych

Electronic Mobiles

15. *Ecos visuales* (Visual Echoes), 1971, 100 x 100 cm.
16. *Cruz del Sur* (Southern Cross), 1975, 150 x 150 cm.
17. *Noche, escultura azul* (Night, Blue Sculpture), 1977, 36 x 70 cm.
18. *Día, escultura blanca* (Day, White Sculpture), 1984, 36 x 70 cm.

19-26. Prints[2]

[1] Not included in the original catalogue. --*Ed.*

[2] Titles are unavailable. --*Ed.*

November 1 - 30, 1984

ART OF NEW MEXICO

The present exhibition of fifty artists who live and work in New Mexico was organized by the Arts/New Mexico Committee and presented at the Santuario de Guadalupe in Santa Fe last month.

The many different cultures and traditions celebrated with these objects attest to the strength and diversity of art made in New Mexico. In the words of the Honorary Chairman of the exhibition, Congressman Bill Richardson:

> New Mexico has long been recognized as an international art center. The exhibition reflects the vitality of the Native American, Anglo, and Hispanic artist who co-exist in an extraordinary nourishing environment.

On several occasions, the Museum of Modern Art of Latin America has presented exhibitions focusing on Hispanic-American artists of varying descent. Each of these ethnic groups has enriched in a distinctive way the cultural life of the United States. On this occasion, the Museum is pleased to present an exhibition of the current artistic activity of a region of the United States which shares a common cultural heritage with latin America. --*Rogelio Novey*, Acting Director, Museum of Modern Art of Latin America.

Honorary Chairman of the Exhibition: Congressman Bill Richardson
Curator of the Exhibition: Ellen Bradbury
Cultural Liaison: Maya Pool Jeffre

SPONSORS

Anheuser-Busch, Atlantic Richfield Foundation, Coca-Cola, Conoco, Gulf Oil Corporation, Homestake Mining, Phillips Petroleum Foundation, SOHIO, Sun Oil, Tenneco Inc.

CATALOGUE

Paintings, Drawings, Prints, Photographs, Sculptures

Gero Antresian
 1. *Ramagir*, impression No. 5/8, serigraph, embossed on paper

Felipe Archuleta
 2. *Carreta*, acrylic on gesso and cottonwood

Gilbert Atencio
 3. *San Ildefonso Pueblo, Basket Dance*, tempera on paper

Helen Beck
 4. *Perplexus*, color pencil and graphite on paper

Larry Bell
 5. *EL BKIN 32*, vapor on paper

David Bradley
 6. *Indian Zen X*, mixed-media monotype

Paul Caponigro
 7. *May Snowstorm*, 1984, Santa Fe, New Mexico

William Clift
 8. *Rainbow*, photograph

Helen Cordero
9. *Story Hour*, clay. Lent by Dr. and Mrs. Zigmind W. Kosicki.

Gloria Lopez Cordova
10. *Saint Francis*, wood

Blue Corn
11. *Pot*, clay

Doris Cross
12. *7IG*, mixed media

Dennis Culver
13. *Astrolithchart (008-12) with Keplerian and Eccentrics El-E3 Corridor*, gouache and pencil on paper

Rick Dillingham
14. *Untitled*, clay, glaze and gold leaf

John Fincher
15. *Flying Chaps over Black Mesa*, oil on canvas

Harry Fonseca
16. *Coyote Dressed as Rudolph Valentino*, acrylic on canvas

Ruben Gonzales
17. *Forgotten Heritage*, mixed media

R.C. Gorman
18. *Laughing Sisters*, 1984, bronze

Woody Gwyn
19. *Triptych*, pencil on paper. Lent by Mr. and Mrs. William W. Decker.

Betty Hahn
20. *Belladonna*, Polaroid photograph

Bob Haozous
21. *New Mexico Landscape, Pennsylvania State No. 3*

Helen Hardin
22. *Listening Woman*, etching

Alan Houser
23. *New Gossip*, bronze. Lent by Gallery Wall.

Luis Jimenez
24. *Old Woman with Cat*, epoxy with fiberglass. Lent by Cynthia Jimenez.

Gail Bird, Yazzie Johnson
25. *Belt*, gold, silver, agate, jasper, turquoise, garnets, lapis

Douglas Johnson
26. *Triptych*, casein on paper. Lent by Mr. James DeVries.

Lucy Lewis
27. *Olla, Parrot*, clay

Joseph Lonewolf
28. *Bowl, Flute Player*, clay. Lent by the Museum of New Mexico.

Bruce Lowney
29. *The Birth of Venus*, oil on canvas

Bruce Nauman
30. *Malice*, lithograph

Eugene Newman
31. *Bouquet II*, oil on canvas

Dick Mason
32. *Sangre de Cristo Mountains*, acrylic on canvas

Bernard Plossu
33. *Road in Taos*, photograph

Eliot Porter
34. *Pojoaque Valley, New Mexico*, 1950, photograph. Lent by the artist.

Eliseo Rodriguez
35. *New Mexico Crucifix*, straw on wood

Johnny and Marlene Rosetta
36. *Necklace*, lapis and gold

Meridel Rubenstein
37. *The Call of the Wild*, photograph

Ford Ruthling
38. *Two Chairs (Mother and Child)*, oil on canvas

Ken Saville
39. *Shrine of Our Lady of the Good to the Very Last*, wood and paint

Fritz Scholder
40. *Dream, No. 12*, oil on canvas. Lent by Ramona Scholder.

Elmer Schooley
41. *Winter Aspen Thicket*, oil on linen. Lent by Roswell Museum and Art Center.

Jaune Quick-to-See Smith
42. *Owhyee Desert*, 1984, oil on canvas

Margaret Tafoya
43. *Pot*, clay

Luis Tapia
44. *Star*, Russian olivewood, metal. Lent by Mr. Mack Hickman.

Horacio Valdez
45. *Queen of Heaven*, aspenwood and acrylic paint, silver crown

Ed Vega
46. *Red Facets*, Corten steel

Pablita Velarde
47. *Dressing Young Girl for Her First Dance*, tempera on paper

Frederico Vigil
48. *Cada uno tiene su cruz*, acrylic on Masonite

Randy Lee White
49. *Tongues of Fire*, mixed media

Maria Vergara-Wilson
50. *IKAT I*, wool. Lent by the Museum of New Mexico and the Spanish Colonial Arts Society.

December 5 - 28, 1984

MICHAEL PLYLER: PHOTOGRAPHS
Four Guatemalan Portfolios

Michael L. Plyler was born of American parents in Japan in 1955. He has travelled and lived in Japan, the Philippines, Taiwan, and Hong Kong. In 1968, he returned to the United States. After living in Ohio, Florida, and Illinois, he settled in Las Vegas, Nevada, where he has made his home for the past twelve years.

Plyler graduated with honors from the University of Nevada in December 1977, with a degree in American Indian Studies. In 1976 he bought an Olympus OM-1 and began capturing photographic images. Besides a basic black and white photographic laboratory course, his expertise has been self-acquired including teaching himself Ansel Adams's zone system. The artist works in both color and black and white, utilizing 35mm and 120 formats. The bulk of his black and white photographs are shot with a Mamiya 645 incorporating the basic tenets of Ansel Adams's zone system.

For years of observing the serene natural scenery in Far Eastern countries, the initial focus of Plyler's landscapes of the America West exemplified the suave pastels of the desertic Southwest. However, in 1980, he made his first visit to Guatemala. This visit changed his photographic orientation to candid portraiture. Plyler became obsessed with capturing the faces of the Mayan Indians there. Next he went a step further and began seeing the country and its people as a Guatemalan would.

Since that first visit in January of 1980, he has returned to Guatemala four times to record this ancient, enduring culture. During the 1983 visit, Plyler received a commission from the Instituto Guatemalteco de Turismo (INGUAT, Guatemalan Institute of Tourism) to photograph the country as he chose. On June 27, 1983, a thirty-two piece exhibit entitled: *Gracias Guatemala* opened in the INGUAT building in Guatemala City marking the first international showing of Plyler's work.

Plyler's photography has won numerous awards. Among the most recent distinctions are the selection of one of his images for publication in *The Best of Photography Annual: 1982*. His photographs have appeared in numerous publications: *Las Vegas Review Journal, Nevada Magazine, Albuquerque Journal*, and *Los Angeles Times*. His work is on file with *Sierra* magazine. Michael Plyler conducts nature photography workshops through the University of Nevada's Division of Continuing Education. He also teaches introductory photography at the Winchester Community Center in Las Vegas.

His latest exhibit was in the Museum of Man in San Diego, in 1984. Mr. Matt Damsker, art critic with the *Los Angeles Times*, praised Plyler's exhibit. Michael Plyler's future aspirations include publishing a book on Guatemala.

The Museum of Modern Art of Latin America is pleased to present Michael Plyler to the public of the nation's capital.

CATALOGUE

Photographs

Portfolio I: Color

1. *El pescadorito (The Little Fisherman)*, Lake Petén Itzá
2. *El suelo de la selva (Jungle Ground)*, El Petén
3. *La silueta de los pescadores (Fisherman's Silhouette)*, Lake Petén Itzá
4. *La puesta del sol (Sunset)*, Lake Petén Itzá
5. *Guacamayo (Macaw)*, El Petén
6. *El templo de las máscaras (The Temple of the Masks)*, Tikal
7. *Cinco centavos por una docena (Five Cents for a Dozen)*, Sololá
8. *Las vendedoras de flores (Flower Sellers)*, Chichicastenango
9. *La inocencia de Nebaj (Nebaj's Innocence)*
10. *Un ojo malo (An Evil Eye)*, Nahualá
11. *La mujer de Chajul (Woman from Chajul)*
12. *Dos hermanas de Chajul (Two Sisters from Chajul)*
13. *Madre e hijo (Mother and Son)*, San Juan Cotzal
14. *Bebé y trenzas (Baby and Braids)*, San Juan Cotzal
15. *Estela sin restauración (Stela with No Restoration)*, Tikal

Portfolio II: Black and White Portraits

16. *Cuatro hermanos de Santa María de Jesús (Four Brothers from Santa María de Jesús)*
17. *El vendedor de Pom (Pom Salesman) II*, Chichicastenango
18. *Juana Marcos*, Nebaj
19. *Doña Rafaela*, San Antonio de Aguascalientes
20. *El vendedor de los estropajos (Luffa Salesman)*, Nahualá

Portfolio III: Cuatro Iglesias de Antigua (Four Churches of Antigua)

21. *Dos pilares (Two Pillars)*, La Merced
22. *Detalle del techo (Roof Detail)*, La Merced
23. *Detalle de la fachada (Façade Detail)*, San Francisco
24. *El arco subterráneo (Underground Arch)*, San Francisco

Portfolio IV: The Natural Form

25. *Despojo del mar (Driftwood)*, Livingston
26. *Barcos, luz y nubes (Boats, Light, and Clouds)*, Livingston

ABOUT THE ARTIST

Individuals exhibitions

1983 *Gracias Guatemala*, Instituto Guatemalteco de Turismo (INGUAT), Guatemala City
 Michael Plyler, An Eclectic Vision, Santa Fe Center for Photography, New Mexico
1984 *Guatemalan Portfolio*, Museo Ixchel del Traje Indígena (Ixchel Museum of Indian Dress), Guatemala City

 Mayan Images, San Diego Museum of Man, California, 1984

Group exhibitions

1982 *Mayan Images*, University of Nevada Museum of Natural History, Las Vegas
1983 *Mayan Images*, Las Vegas Art Museum, Nevada

Awards

1983 First Place for Color Photography and First Place for Black and White Photography, International
 Photographic Competition, Museo Ixchel, Guatemala City

Publications

"Photo Essay" (on Guatemala). *The City Magazine*, Las Vegas. July 1984.

December 5 - 28, 1984

PRIMITIVE ARTISTS OF COMALAPA

The indigenous pictorial movement that emerged in San Juan Comalapa as well as in other native localities from
the need for an aesthetic expression reflecting the authentic traditions and values of their ancestors has a
prominent place in the contemporary art scene of Guatemala.

The self-taught artists, known as primitive or naive, create their pieces spontaneously, ignoring the formalities
of style, perspective, and proportion. These naive artists do not paint for the demands of audiences with
sophisticated and preconceived notions. Their work is characterized by the direct, exceptional coloring that
permeates all the branches of Guatemalan art, lending them a particular charm and beauty. The pieces are
inspired by ancestral traditions, colonial architecture, landscapes, important aspects of cultural life, and everyday
scenes of places where customs of bygone days are still very much alive.

This trend in Guatemalan art has caught the attention and the praise of the public in many cities throughout
Latin America, the United States, and Europe, where these artistic pieces have been exhibited in recent years.
Last September, the Metropolitan Museum of Guatemala presented this exhibition as part of its festivities in
honor of its new premises.

The Museum of Modern Art of Latin America is pleased to welcome artists Feliciano Bal Calí, Salvador Simón
Cumez, Vicente Curuchich, Alberto Iván Gabriel Samol, and Julián Gabriel Samol, all natives of San Juan
Comalapa and representatives of the second and third generation of Comalapan painters, and to give the public
of this city an opportunity to appreciate their individual and collective values and styles.

CATALOGUE

Paintings

Feliciano Bal Calí
 1. *Fiesta en el Cerro de Guadalupe (Fiesta in Guadalupe Hill)*, 135 x 90 cm.
 2. *Fiesta de Cofradía (Brotherhood "Fiesta")*, 135 x 90 cm.
 3. *La juguetería (Toy Store)*, 110 x 90 cm.
 4. *Procesión de Mashimón (Mashimón Procession)*, 110 x 120 cm.
 5. *Fiesta del Patrón San Juan (Patron Saint John's Day)*, 118 x 90 cm.
 6. *Plaza Antigua (Antigua Square)*, 105 x 75 cm.

Salvador Simón Cumez
 7. *Vista panorámica y desfile (Panoramic View and Parade)*, 90 x 105 cm.
 8. *Fiesta del 24 de junio (Celebration of June 24th)*, 123 x 97 cm.
 9. *Mercado 20 de Mayo (May 20th Market)*, 106 x 97 cm.
10. *Mercado antiguo (Old Market)*, 107 x 77 cm.
11. *Mercado frente a la iglesia (Market in Front of Church)*, 94 x 71 cm.
12. *Panorama y feria (Panorama and Fair)*, 100 x 70 cm.

Vicente Curuchich
13. *Baile de la Conquista (Dance of the Conquest)*, 88 x 67 cm.

14. *Despedida de los bailes (Farewell to Dancing)*, 88 x 67 cm.
15. *Baile del toro petate (Toro Petate Dance)*, 88 x 67 cm.
16. *Aparición de la Virgen (Appearance of the Virgin)*, 71 x 65 cm.
17. *Palo volador (Flying Stick Game)*, 60 x 47 cm.
18. *La fiesta (The Fiesta)*, 85 x 66 cm.

Alberto Iván Gabriel Samol
19. *El casamiento (The Wedding)*, 130 x 95 cm.
20. *Mercado (Market)*, 107 x 87 cm.
21. *La cocina (Kitchen)*, 104 x 87 cm.
22. *La pedida (The Request)*, 80 x 64 cm.
23. *Día de mercado (Market Day)*, 80 x 64 cm.
24. *La tejedora (The Weaver)*, 80 x 64 cm.

Julián Gabriel Samol
25. *Ficción presagiosa (Foreboding Fiction)*, 128 x 102 cm.
26. *Fiesta de San Juan (San Juan Fiesta)*, 128 x 102 cm.
27. *Corrida de toros (Bullfight)*, 82 x 64 cm.
28. *Casamiento (Wedding)*, 82 x 64 cm.
29. *Acarreando agua (Carrying Water)*, 58 x 42 cm.
30. *El barbero (The Barber)*, 58 x 42 cm.

ABOUT THE ARTISTS

BAL CALI, Feliciano. Born in San Juan Comalapa, June 9, 1943. Has participated in group exhibitions since 1968 in Guatemala City, El Salvador, Spain, the United States (Texas, Alabama), Italy, Germany, and Argentina. Awards: Third Prize, Tikal Association, Guatemala, 1979, and Second Prize, Second Paiz Biennial, Guatemala, 1980.

CURUCHICH, Vicente. Born in San Juan Comalapa, April 5, 1925. Has participated in group exhibitions since 1952 in Guatemala, Venezuela, Spain, Nicaragua, and the United States (Alabama).

GABRIEL SAMOL, Alberto Iván. Born in San Juan Comalapa, April 8, 1954. Has participated in group exhibitions since 1969 in Guatemala, Italy, Germany, the United States (Texas), Ecuador, Spain, and Argentina.

GABRIEL SAMOL, Julián. Born in San Juan Comalapa, June 23, 1958. Has participated in group exhibitions since 1977 in Guatemala, Germany, the United States (Texas), Italy, Spain, and Argentina. Awards: First Prize (Glifo de Oro), Second Paiz Biennial, Guatemala, 1980; and Honorable Mention, Third Paiz Biennial, Guatemala, 1982.

SIMON CUMEZ, Salvador. Born in San Juan Comalapa, August 27, 1968. Has participated in group exhibitions since 1974 in Guatemala, El Salvador, Italy, and the United States (Alabama). Awards: Xerox National Prize, El Salvador, 1979; First Prize, Tikal Association, Guatemala, 1979; and First Prize, Second Paiz Biennial, Guatemala, 1980.

YEAR 1985

February 7 - 28, 1985

FOTOGRUPO OF THE DOMINICAN REPUBLIC

One of the main objectives of *Fotogrupo*, since its founding as an organized group in 1977, has been to exhibit photographic art to the many enthusiastic members of the viewing public who crowd all its presentations.

The artists individually express themselves in different ways, e.g., through production of audiovisual materials, individual exhibits, lectures, and courses in photography. Their work in these fields is well known and has been highly praised by everyone interested in the subject; it has also meant that more and more people have come to appreciate photography. In addition, the column that *Fotogrupo* runs in the supplement of *Listin Diario* and the slide shows it presents throughout the country are the best evidence that the group, transcending the boundaries of a simple "art for art," has become a training ground--with great sensitivity and understanding of human life--for artists in photography.

The work of *Fotogrupo* already holds a distinguished and well-deserved place in the history of Dominican art--something it has achieved in only seven years of group work. Naturally, many of its members have spent much more time individually as photographers. But the bonds of friendship that have cemented in *Fotogrupo*, the enthusiasm it has instilled, and the assistance that the members provide one another have given each of them, from the oldest to the most recent, a sense of unity and equality in this form of artistic expression.

Photographs by the group may be viewed in such places as the Museum in Santo Domingo. Since 1978 *Fotogrupo* has presented fifteen shows in the Dominican Republic and has also held exhibits in Colombia, Nicaragua, Mexico, and Panama.

This exhibition is dedicated to lovers of photography and of culture in general and is born of the use of cameras, lenses, and film as tools of expression. The Museum of Modern Art of Latin America is proud to present *Fotogrupo* to the public of the nation's capital.

CATALOGUE

Photographs

José Ramón Andújar
 1. *Sacristy at San Pedro de Macorís*
 2. *Higuamo River*
 3. *Fisherman in La Caleta*

Osvaldo Carbuccia
 4. *Fishing Boats*
 5. *Lobster Man*

Wie Chiang
 6. *Window to the Village*
 7. *Bottles in the Sun*

Antonio García
 8. *Dominican Pots*
 9. *Typical Dining Room*

Wifredo García
10. *Resident of Sánchez*
11. *Pilgrim in Higüey*
12. *Waterbread Man*

Juan Guzmán
13. *Saturday, 9:00 A.M.*
14. *Small Merchant*
15. *House in the Country*

Lázaro Guzmán
16. *Colonial Santo Domingo*

Alejandro Lajara
17. *Libertad Street*
18. *Political Rally*

Manuel Pujols
19. *Worker of Salinas*
20. *Bell Tower in Manzanillo*

Carlos Roedán
21. *Corn*
22. *Constanza*
23. *Botanical Garden*

Rafael Sánchez
24. *Central Cordillera*
25. *Balcony in Macorís*

Vicente Tolentino
26. *Fence*
27. *Musician of Ocoa*
28. *Golden Sea*

José Alfredo Victoria
29. *Port of Haina I*
30. *Port of Haina II*
31. *Lighthouse of Sánchez*

Camilo Yaryura
32. *Cathedral of Santo Domingo*
33. *Fiesta in Cabral*
34. *Sabana Buey*

ABOUT THE ARTISTS

ANDUJAR, José Ramón. Studied commercial art and design at the School of Visual Arts in New York. Professional photographer specialized in advertising. Founding member of *Fotogrupo*. Has been awarded prizes in photographic shows held in the Dominican Republic and sponsored by Casa de Teatro, Scotia Bank, and the *San Pedro de Macorís Centennial Exhibition*, 1982.

CARBUCCIA, Osvaldo. Graduated as a civil engineer, Universidad Central del Este. Works as an engineer at the Porvenir Sugar Cane Mill. Exhibits regularly with *Fotogrupo*.

CHIANG, Wie. Born in Canton, China. Graduated as an architect, Universidad Autónoma of Santo Domingo. Joined *Fotogrupo* in 1962. Has participated in exhibitions in Panama, Mexico, Peru, and the Dominican Republic.

Has lived in Santo Domingo since 1962.

GARCIA, Antonio. Graduated as an architect, Universidad Autónoma of Santo Domingo. Joined *Fotogrupo* in 1982. Awards include: Office of Cultural Heritage Show and the *San Pedro de Macorís Centennial Exhibition*, 1982.

GARCIA, Wifredo. Founder of *Jueves 68* (1967) and *Fotogrupo* (1972). Has participated in numerous exhibitions in Europe and the Americas. His work is represented in the Museum of Man of Paris, the Gallery of Modern Art in Santo Domingo, the Museum of the Dominican Man, and the Museum of Oriental Culture in Moscow. He is the author of the books *Algo de mí* (Something From Me), 1974; *La catedral del bosque* (The Forest Cathedral), 1981; and *Fotografía: un arte para nuestro siglo* (Photography: An Art for Our Century), 1982. Awards include: the Grand Special Prize of the Jury, Cartagena (Spain), 1981; and First Prize for Color Photography, *Américas* Magazine International Competition, Washington, D.C., 1982.

GUZMAN, Juan. Architect. Has participated in numerous *Fotogrupo* exhibitions in Mexico, Nicaragua, Colombia, and his native country, including the Dominican Republic Art Biennial.

GUZMAN, Lázaro. Agricultural engineer. Has exhibited since 1974 with *Fotogrupo* in the Dominican Republic, Colombia, and Nicaragua.

LAJARA, Alejandro. Joined *Fotogrupo* in 1980 and has participated in group exhibitions in the Dominican Republic, Colombia, and Panama. His photographs have been used twice in the front cover of *Américas* magazine, OAS, Washington, D.C.

PUJOLS, Manuel. Architect. Joined *Fotogrupo* in 1980 after studying photography at the Universidad Autónoma of Santo Domingo and the Instituto Dominicano de Cine y Televisión. Has exhibited in the Dominican Republic, Colombia, Mexico, Nicaragua, and Panama.

ROEDAN, Carlos. Professional photographer, has worked in advertising since 1974. Founding member of *Fotogrupo* Has participated in various audiovisual presentations and competitions. Awards include: Eighth National Photography Competition, Office of Cultural Heritage Competition, and FAO Competition, 1984.

SANCHEZ, Rafael. Graduated as an architect from the Universidad Nacional Pedro Henríquez Ureña. Interested in photography since 1978, is a member of *Fotogrupo* since 1981. Has participated in exhibitions in Colombia, Panama, and his native country.

TOLENTINO, Vicente. Graduated as an architect, Universidad Autónoma of Santo Domingo. Interested in photography since 1954, his photographs are frequently reproduced in national publications. Has participated in numerous exhibitions, including the Art Biennial of Santo Domingo, and received awards at competitions organized by *Fotogrupo*.

VICTORIA, José Alfredo. Has participated in group exhibitions in Mexico, Colombia, Nicaragua, Panama, Peru, and his native country. Awards include: First Prize, *City of Mao Centennial Competition*, 1982; First Prize for Color Photography, *Food in the Dominican Republic Competition*, 1983; and First Prize, Sixteenth National Biennial of Plastic Arts, Santo Domingo, 1984.

YARYURA, Camilo. Has exhibited in Brazil, Spain, the United States (Washington, D.C.), Mexico, Panama, Colombia, and his native country. He has also held two individual presentations. He is represented in the permanent collection of the Gallery of Modern Art and the Museum of the Dominican Man, both in Santo Domingo. Awards include: First Prize, Ecologic Photography, Brazil, 1981; First Prize, *San Pedro de Macorís Centennial Exhibition*, 1982; Second Prize, *Américas* Magazine International Competition, Washington, D.C., 1982; and Second Prize, *City of Mao Centennial Competition*, 1982.

March 11 - 29, 1985

FERNANDO DE SZYSZLO: FIRST RETROSPECTIVE EXHIBITION
IN THE UNITED STATES

Since its beginnings, the Organization of American States has been fully aware of the importance the visual arts have in the integral development of societies and cultures and has, therefore, taken an active interest in promoting the arts in Latin America and the Caribbean. It has done so through its various programs for identifying and encouraging the human potential and the artistic talent to be found in its member states. As can be seen from the permanent collection of the Organization's Museum of Modern Art of Latin America, a great variety of techniques and media of modern artistic expression are part of a Latin American tradition that dates from pre-Hispanic times, and perhaps one of the best examples of this is the work of Fernando de Szyszlo.

The Organization of American States and its Museum of Modern Art of Latin America are proud to present the first retrospective of this renowned artist to be held in the United States. Although Szyszlo's painting is very much a part of the present in its vigor and contemporary flavor, it is already a part of the history of visual art in our hemisphere--contrasting the images of our past in juxtaposition with the complexities of modern society. He has achieved the goal of identifying one country--Peru--by aesthetics based on its exclusive characteristics, its special philosophy, and its individual social patterns.

I am sure that those who have the opportunity to enjoy the work of Fernando de Szyszlo will not only experience a great visual pleasure but also feel the authentic roots from which it is drawn. *--João Clemente Baena Soares*, Secretary General.

There is, perhaps, no more gratifying occasion for one who represents his country abroad than to further appreciation of his nation by displaying some aspect of its cultural values.

And cultural values they are, indeed, all those artistic expressions which dwell upon the various archetypes that make up the national heritage from which they spring. The process, as always, is to some extent one of reproduction, but it is also one of enhancement through that mysterious alchemy by which art enriches the spiritual character of a given people. The tension arising from the artist's dissatisfaction with his milieu alternates with an equally tense urge for its refinement, and thus the creative process brings about that seemingly miraculous change of some isolated work of art into a truly representative achievement of any given civilization. There lies, I have come to believe, the difference--subtle but perceptible--between artists who *represent* their countries and those who do no more than *present* them in one or another of their aspects. Let there be no doubt that through his oeuvre, Fernando de Szyszlo has become one cultural epitome of Peru in the past quarter century!

I care not much if some professional critic, carried away by his own high-flown rhetoric, will dismiss my "outsider's view" of Szyszlo's compositions, but I will not refrain from stating that I see in this pioneer and co-founder of Peruvian abstractionism the most lucid of delvers into the geometric intricacies of pre-Columbian designs. Brushing aside all the remaining imported "isms," Szyszlo stubbornly persists in practicing a type of non-figurative art that must be perceived as a genuine metaphor of an otherwise yet-unfathomed Peruvian reality.

As the public lingers on the works gathered for this first retrospective of Szyszlo's creative accomplishment to be held in the United States, I truly believe it will easily identify the colors and forms on his canvases with those very same features which, since time immemorial, have come to represent one main aspect of Peru's heritage. The timelessness of Szyszlo's compositions is in itself typical of a nation without spiritual bounds, of a country which partakes freely of world civilization but grasps it in a fashion that is inherent to Peru alone. *--Harry Belevan-McBride*, Acting Representative of Peru to the Organization of American States.

Fernando de Szyszlo was invited to hold his first one-man show in the United States at OAS headquarters over thirty years ago in 1953. Later from 1957 to 1960 he served as advisor to the Visual Arts Division of the OAS General Secretariat and in 1980 he was commissioned by the OAS to execute a mural for the new General Secretariat Building. It is, therefore, a special pleasure for the Museum of Modern Art of Latin America to host the present exhibition honoring the work of this distinguished artist in its newly renovated galleries.

Szyszlo's work has had a profound impact on the development of contemporary art trends in his native country of Peru. His influence has been felt by a generation of Latin American artists working in the late 1950s and 1960s, and he continues to play an important role in the cultural activities of his country. Szyszlo's constant allusion to the pre-Columbian tradition of the Peruvian coastal region lends a remarkable unity and cohesion to his production, and I am sure that the visitors to this exhibition will go away with a better understanding and a deeper appreciation of the cultural heritage of our Latin American societies.

For their many kindnesses the Museum of Modern Art of Latin America is grateful to the artist as well as to the Mission of Peru to the OAS and other lenders who generously made possible the realization of this special exhibition. --*Rogelio Novey*, Acting Director, Museum of Modern Art of Latin America.

The mural reproduced on the cover of this catalogue is a detail of a large work of Szyszlo. Painted in acrylic on stretcher-backed canvas, it is twenty-four feet in length, its expanse being interrupted by two doorways.

The painter calls the composition *Landscape at Paracas*, explaining that in it he sought to convey the mystery surrounding that barren peninsula south of Lima, with its ruins of pre-Incaic origin. The emptiness of the background contrasts with sweeping apparitions of cryptic intent; the neutral effect of the predominating earth tones is subtly accented by radiant, luminous flashes of color.

This mural, like compositions by other leading Latin American artists, was created to grace the building completed in 1979 to house the General Secretariat of the Organization of American States. The Organization's principal collection is to be found, however, in the Museum of Modern Art of Latin America, in which Szyszlo is also represented.

Szyszlo exemplifies the artist with a deep concern for culture, but free of the bonds that tendentiousness would seek to impose upon his work. In his painting, this bold pioneer of artistic renewal in Peru has sought to fuse the trends of the present-day vanguard with the rich and vigorous tradition of his country's pre-colonial past. --*J.G-S.*

FERNANDO DE SZYSZLO

Born in Lima, 1925, son of a Polish geographer and a Peruvian mother of Spanish-Indian descent.

A lithe, muscular man with a distinctive face and nose, gay and moody, a *bon vivant* who loves to drive his white sports car and who is much concerned with the destinies of his two sons, Vicente and Lorenzo, named after Szyszlo's first and constant idols--Vincent Van Gogh and D.H. Lawrence.

Szyszlo belonged to that small group of artists who first did abstract art on the South American continent after World War II, and he was the first abstract painter in Peru at a time when abstract painting was not well regarded on this side of the world.

> Very often we were attacked in the newspapers and magazines, not only by the art critics but more often by other painters--who, by the way, became abstract a few years later, when it was not as risky. The more common adjectives applied to my work then were "decadent," "un-Peruvian," "immoral," and the like.

Szyszlo feels that Peru, with its incredible mountains, deserts, and colors, and its fabulously rich cultural heritage, has been a basic stimulus to his painting.

> To think that we were here trying to do abstract art with the help of the discoveries of the European artists, when some centuries ago Peruvian artists were producing a highly developed, obviously autonomous, powerful art--that thought was a very explosive one. So I became involved, first spiritually, with pre-Columbian art; afterward I started to study it.

> I have never thought of taking anything directly out of that art. To be in contact with it is an important artistic experience, but you need to forget it and let it become part of your blood.

In his absorption with the pre-Columbian, he sometimes takes his boys to the reconstructed Inca palace, Puruchuco, near Lima:

> The thing I love most there is the solid, perennial, earthy quality it has. The adobe has this strange quality. It seems that people, our people, are made of it. It is tender, fragile, and yet time--and death--defeating.

> I've been in Machu Picchu twice, first in 1953; then in 1964 I spent a week there. Neruda's poem describes my reactions very well. It is really a work of art; the visible meeting point of the sacred with physical matter.

Szyszlo's small, secret studio faces the sky and the sea. He paints undisturbed, to the music of Bach and Vivaldi and of moderns like Mahler, Schönberg, and Berg. It takes him three weeks or more to complete a painting because he is working with transparent colors over opaque ones and must wait for the latter to dry. He works on several canvases at the same time.

Life for Szyszlo in Lima is varied and pleasant. The beach is only minutes away from his studio. He and his beautiful poetess-wife, Blanca, spend much time with their boys and meet with their friends, who include architects, writers, and politicians but no painters. He also teaches art at the Catholic University in Lima. He says:

> Mostly Peruvians buy my paintings, but I would guess that a third of them are bought by Latin American collectors. To my way of thinking, this is very important, since I feel that to be able to live here, I must be able to sell my paintings here.

> I don't feel isolated though I am not unaware that living in these countries we lack the stimulation that can be provided by new shows, new trends, good museums, and so forth. But by living here, I feel that I am fighting in a total way, not only artistically but politically, in every concern, to fulfill the destiny of a group. I think that we artists are needed to provide the myths for these new societies. It is a very challenging situation because at the bottom it is a fight to find an identity that, when found, will be individual but at the same time collective.

--Reprinted from *The Emergent Decade: Latin American Painting in the 1960's*. Text by Thomas M. Messer. Artists' profiles in text and pictures by Cornell Capa. Ithaca, N.Y.: Cornell University Press, 1966.

Caracas, January 3, 1965

Mr. Carlos Rodríguez Saavedra
Lima, Peru

Dear Carlos Rodríguez:

My stay in Peru was not very long, but I doubt that my impression would have changed a great deal even if I could have stayed a fortnight. You have, it seems to me, an ensemble of painters counting among their numbers some skillful performers but only one soloist of exceptional capacity.

I am referring to Fernando de Szyszlo, a painter of true stature, who, together with a handful of equally gifted practitioners in other Latin American republics, carries your continental standard. Szyszlo is one of the few painters with whom a Latin American quality is an attribute of form rather than a pictorial reference. He is inevitably Peruvian as Braque is inevitably French in his work, although he is bound to share the universal concerns and awareness that all artists today have in common.

What seem most important to me in Szyszlo's work is the intensive presence of content with definable visual, literary, and formal components. The visual element comes to the fore in Szyszlo's landscape allusions, which at times are traceable to a particular reminiscence of the

Peruvian landscape. The literary component, always present in cultivated minds, tends, in Szyszlo's case, to focus upon indigenous themes, which then strengthen the native timbre already contained in the visual allusion. Finally the formal component, evolving from cubism and deriving its initial momentum from Tamayo, furnishes the channel through which visual and literary allusions can be brought to the surface.

As with Tamayo, or for that matter with Obregón of Colombia and Irarrázaval of Chile, the distinction between figurative and non-figurative art, which concerns the public so much, is without meaning, for neither category is strictly applicable. Szyszlo's is not an art that can be separated from the palpable reality of the observed world, nor does it imitate such reality. Rather, it would seem, are we viewing formal analogies, parables if you wish, whose ideated transformations read like distant memories of the observed. From this act of mutation comes the evocative power of Szyszlo's forms, which contain a reality substance far exceeding in meaningfulness the observed fact or the literary plot from which they ultimately derive.

To some degree this process is, of course, inherent in artistic creation in general and therefore not a particular feature of Szyszlo's painting. It is rare, however, to see the uniquely personal and the generally valid, the indigenous motivation and the international common denominator, so intensively interlocked; nor among your contemporary painters are imagery and form as readily identifiable and yet fused into a coherent statement as is the case with Szyszlo.

With kind regards,

Sincerely,

Thomas M. Messer, Director, The Solomon R. Guggenheim Museum.

--Reprinted from *The Emergent Decade: Latin American Painting in the 1960's*. Ithaca, N.Y.: Cornell University Press, 1966.

Lima, April 20, 1965

Dear Tom Messer:

Following a common practice, you have made a kind of survey of contemporary Peruvian painting. I am not sure that this method really shows anything, though like any statistics it produces an undeniable impact.

I think that before the Peruvian situation can be fully understood, an exploration in depth is needed. My country has begun the process of winning back its true personality. The task is extremely hard, but I agree with Rilke that the artist should love difficulty. It is the price one pays for quality. Some artists--I return to the case of Szyszlo--have demonstrated remarkable insight into the essential values of Peru. Their insight has stimulated our painters to follow suit, to search out and decipher the true nature of our country.

The best of Peruvian painters are probing the soul of Peru. Adhering to an international standard, therefore, is not their true goal. I am sure that this adherence will develop in some instances, but only incidentally, when the essence of the Peruvian soul has become part of the artists' work.

I agree with you that the work of Szyszlo is of a very high order. In my judgment, he is the most important of today's Peruvian painters. When he first appeared, around 1945, the panorama of Peruvian painting was rather amorphous. The "indigenous" school had lost its dominance, and the eyes of the young painters were turned toward the "isms" of the Paris school. Owing to the time lag in Peru, however, these artists ended up importing concepts that were already discarded in Europe.

When Szyszlo returned from his first stay in France, he brought with him the language of non-figurativism, his initial contribution to the liberation of Peruvian painting. His second contribution came in 1963, after he had been living a long time in contact with his native land. A show of his paintings in Lima in December of that year signaled the emergence of Peru as the central theme of his painting. Through affinity with his country, Szyszlo has refined his technique, turning it into an unobtrusive instrument of his own spiritual richness, full of the memories, landscapes, themes, and colors of Peru.

The dramatic and sumptuous qualities that are the hallmark of Szyszlo's painting belong to his own personality. It is interesting to note that as the presence of Peru has become increasingly more visible in his work, there has been less and less evidence of the dull tension which darkened his canvases, of the neurotic way he had of composing his elements. What emerges is a composition no less intense but clearer and more luminous, no less fraught with suffering but more forceful.

Sincerely,

Carlos Rodríguez Saavedra, Peruvian Art Critic.

-- Reprinted from *The Emergent Decade: Latin American Painting in the 1960's*. Ithaca, N.Y.: Cornell University Press, 1966.

SZYSZLO

If life is best defined as movement, the highest praise which can be paid an artist is to say that life is a continuous act of creation, his art a continuous process of change. Movement and change have ever characterized Szyszlo's artistic endeavors, and of late they have come to constitute the subjects for his compositions.

While in his most recent painting they appear as figurative motifs, they were present by implication in his earlier abstractions, and at one time they found explicit expression in canvases crossed by bands of birds in flight. Szyszlo's aim was to surprise the secret and capture for eternity, by strokes and shades of his brush, the grace and charm of the matchless spectacle of a bird on the wing. It is an everyday sight, common to everyone's experience. Yet when a trained, intelligent hand isolates it within the confines of a blank rectangle, the infinitesimal fragment of reality becomes a marvel of unfathomable mystery.

Obviously there are many types of movement and endless possibilities of change. In Szyszlo's case, movement occurs without displacement, and change is inner-directed. I mean by this that movement does not tear him away from the roots on which he depends for nourishment and which permit his work to grow ever upward. That change means an ever-deeper delving into the innermost recesses of that bit of reality which provides the basis for his art and from which he derives his motifs, his symbols, his frenzy, and his strength. Like a tree or a man, his painting grows, ripens, and takes on movement. Constantly varying, it yet remains ever one and the same.

One of the most celebrated characteristics of Szyszlo as an artist is his ability to link the old with the new and to bridge the gap between European abstraction and pre-Hispanic folk art, nostalgic traces of which can be detected in his compositions. Some critics claim that Szyszlo's greatest accomplishment is to have imparted a Peruvian flavor to a type of art that is apparently rootless, which strives not to depict historical reality but to escape from it. Striking though this achievement may be, it is not of fundamental importance for Szyszlo's work, nor does it constitute the sources of its richness. Who indeed is the artist of note who does not in some measure combine the traditional with the avant-garde, whose work does not bear the stamp of his origin? Szyszlo has undoubtedly sought to impart a Peruvian character to his work, witness the titles he gives to his compositions. He makes a point of living and working in Lima; he draws inspiration from Peruvian personalities and events. This is a mere incidental detail, of no more than curiosity value; it relates only tangentially to what is really important. It is well to make the point at this time, when cultural nationalism--nationalism in its most virulent form--is undergoing revival. From the artistic viewpoint, national character--difficult to define other than in arbitrary terms--is without aesthetic value and constitutes no guarantee of success. It is for this reason then that I prefer to deal first with other characteristics of Szyszlo's work, ones which I feel make for its power of persuasion and its seductive effect on the viewer.

The first of these characteristics is elegance. This I would define as a sense of propriety and a gift for

maintaining a certain reserve in relation to the artist himself, to things, and to other people. With the exception of Tàpies, I can think of no other living painter who so consistently manages to keep the spectator at a distance from the world of his creation, obliging him to view what he is shown from a respectful remove. Szyszlo's work is not easily or quickly assimilated. It nearly always leaves the spectator with the feeling that something essential has escaped him, that what he sees and admires is only the tip of the iceberg. It does not put the viewer off; it merely eludes him.

Visiting Szyszlo's studio, I have had the opportunity of witnessing the various stages of a painting's creation. It is a fascinating process of increasing concealment. Subject and color are gradually suppressed; statement gives way to allusion; the explicit is replaced by the merely implied. The first stage consists in a firmly outlined drawing of a spectral figure--a stele, disks, a tomb, or something of like nature. This skeleton is gradually fleshed out with coats of paint, bright and aggressive in hue. At this stage the painting constitutes an exhibitionistic display of form and color, in which the images depicted withhold no secrets from the viewer. Next comes a stage in which the work is subjected to a process of dissimulation, and it is at this point that it acquires its elegance and its reserve. Additional coats of paint dim what had been glaringly bright; colors blend into one another, outlines lose precision, assurance becomes doubt, movement is reduced to a tremor. Everything is qualified and subdued and takes on an air of elusiveness. This is what produces the gap that the viewer cannot bridge. He cannot see what the artist has deliberately submerged beneath the surface, and of which only a presentiment persists. Expressive violence has not been banished: though disguised by subtle veils of color it struggles to escape from the depths of the canvas to the surface, which it scorches with its heat.

Szyszlo's censorship of context is responsible for another constant in his art--the mystery which excites our interest and arouses our imagination.

There is no such thing as pure abstraction. The mind of the viewer always ends by associating icily impersonal lines, tumultuous dots of color, geometric arrangements of dots, or flashily disposed highlights with some element of concrete reality. Thus Dubuffet's ridges suggest the shifting sands of a beach, and Mondrian's rectangles evoke the nightmares of bureaucratic compartmentalization and the horrors of regimented living. I am speaking for myself of course. There may be those who can appreciate a picture merely as a harmonious color arrangement, isolated from all ambient reality. This, however, is an impoverished form of vision. A work of art--and here I speak of music and literature as well as painting and sculpture--is enhanced in the degree that it evokes associations with the sum of human experience.

Though the viewer may be inevitably fated to establish a connection between what he sees and something in his personal life, Szyszlo's art, unlike that of other non-figurative painters, does not leave him freedom of choice in the matter. Szyszlo's painting has specific roots in external reality and, though they are purposely concealed, they nonetheless make themselves felt.

A study of Szyszlo's allusions to figurative reality--deliberate, unconscious, or merely chance--could be highly instructive, for it is precisely this elegant habit of insinuating without asserting, of suggesting rather than disposing, which creates the air of mystery that surrounds his works and gives them their enigmatic quality. Javier Sologuren, noting that certain recurring motifs in Szyszlo's canvases have an emblematic value, points out a few rational correspondences: "Little circles (seeds, drops of blood, sperm), bunched together or strung out in strands, seem to me to be connected with fecundity, procreation, and the transmission of life. Rods and crevices doubtless have the sexual significance typically associated with symbols of this nature." The reference is to a period in which Szyszlo's canvases frequently featured semispherical forms suspended in space, from cracks in which (wounds, mouths, vaginas) globules fell in cascades. Inevitably such images are associated with positive concepts of germination, birth, and the perpetuation of existence; however, they also show traces of such negative concepts as suffering and death.

In another period, Szyszlo's preference ran to dark blotches suggestive of nature in its primal state, before plants and fish had come into being--the world of rocks, of inert matter. Then over this lifeless mass there grew a covering soft and silky, and from it sprang feathery sheaves implying a higher form of existence. Life and movement are thereby imparted to the composition. On another plane, however, these same images of stone and feathers can suggest more recondite concepts--altars, axes, sacrifices and their victims, primitive rites, magic.

In still another phase, smooth-surfaced canvases featured disks, nearly always dark in color, occasionally cut into

sections, nearly always coupled or even in number. I associated them with darkened suns, moons in eclipse, nocturnal eyes, astral bodies, meteorites arrested in mid course. At the same time that they suggested to me the universe of planets and stars in space (and by extension the human reality of occult rites and their astrological symbols), they also brought to my mind--I know not why--the idea of death.

Those pictures were nearly always two-dimensional: the subject and its surrounding were at an equal distance from the spectator. Suddenly, however, perspective appeared in Szyszlo's work: the background became a deep, symmetrically ordered room with a flagstone floor, and in the foreground there arose a monumental, prism-shaped totem, a hybrid from whose trunk there sprouted claws, talons, eyes, teeth, feathers. In the years Szyszlo spent in Paris (1949-1955) he had a strong spiritual bond with Breton; however, it is in this later phase of his career, when his pictures featured this monster in a Renaissance setting, that the artist made his closest approach to surrealism. The visionary, as exemplified by Max Ernst, Magritte, or Delvaux, transports us into a hitherto unknown dimension, where beings seem drawn from the most secret recesses of the human soul--from instinct, from the subconscious, from dreams. In the case of those artists as in that of Szyszlo, the pictures permit of varying and at times contradictory interpretations, one of them rational and realistic.

Magic shrines are also stage settings in which we are presented with a spectacle. It is not plastic representation--the dialogue of light and shadow, the murmur of tonalities, the rhythmic relationship of volumes--that imparts to a picture its power of suggestion: it is the unfolding of an allegorical drama which, however strange it may seem, possesses real value for the present day. It is not just the atmosphere of luxury, the color, and the missing elements (side walls are lacking; the foreground is painted with precision but the background fades away to a mere suggestion) that turn Szyszlo's rooms into stage settings; it is above all the positioning of the actor. This personage, be it an idol or a marionette, unmistakably represents an elementary, alogical world; it stands in complete contradiction to the refinement and mental harmony of the surroundings. The function of these paintings is to reveal to the viewer how the encounter--harsh, disturbing, unlikely but nonetheless possible--between two worlds, two histories, two cultures, two periods, two attitudes toward life can produce a union fruitful in results for art. The compositions are as it were soliloquies in which the artist reflects on his work and on the sources on which it draws, particularly the cultural and historical identity of a world such as that of Latin America, in which two extremes--the primitive and the civilized, the rational and the magical, the refined and the barbaric--meet in a clash of alternatives. However greatly Szyszlo may appear to scorn the descriptive, his plastic endeavor is never limited to an appeal to the spectator's senses; it speaks of the artist's intelligence and of his culture.

A point on which I should like to dwell is the importance of the cultural factor in Szyszlo's work. It appears most obviously in references to the historical and literary sources in which his works find inspiration. While Marcel Duchamp, one of the most lucid artists of our time, complained toward the end of his life: "I am fed up with the idea that the painter is an ignoramus," the truth of the matter is that not a few present-day artists paint solely with their hands, reading but seldom and thinking not at all. Nothing could be more depressing than one of those round-table discussions at which a group of plastic artists theorize about what they are doing. Szyszlo belongs to the creative minority in which the humanistic tradition lives on. For its members painting is the expression of sensitivity and intelligence which draw nourishment from cultural sources ranging from philosophy to science. Refusing to consider art a "field of specialization," they endeavor to endow it with broader human meaning. The same good taste and high standards which Szyszlo shows in his experiments with forms and light are reflected in the authors, works, or events which he evokes or to which he pays tribute in his compositions--Rimbaud, Breton, Vallejo, Arguedas, the execution of Túpac Amaru. They are also reflected in the artist's writings. While specialists are wont to disdain external information of this type, it is of real importance, for it provides a guide to the understanding of a canvas and enriches the perception of the viewer who seeks intellectual as well as sensory enjoyment.

It is not merely in this external manner that the cultural presence makes itself felt however. It is inherent in the composition, in the nature of the images. Can one speak of an intellectual, learned element in painting that tells no story? Yes, and not merely by reason of Szyszlo's ambiguous system of occasionally subliminal references to figurative reality, in which to be sure the element does manifest itself. If the references to which I have previously called attention--those to the life cycle of reproduction and death, astral reality, the orders of existence, primitive practices of sacrifice and magic, theatrical allegory--if these are not "learned," then what is? The learned, the intellectual element is also encountered in technical aspects, in the inspiration and support Szyszlo has found in art of both past and present--in Picasso and the pre-Columbian paintings of Chancay, in Klee and the burial

objects of Chavín, in Hartung, Soulages, and Tamayo. All painters have undergone influences from other artists, but some are capable of discriminating among them and using them with intelligence, whereas others, lacking such insight, follow them blindly. The former are what we might call "learned" painters.

Still another presence has made itself felt in Szyszlo's work in recent years. Previously it has figured as a sort of unconsciousmemory, an underground stream that only occasionally surfaced in the paintings. I refer to the presence of the coastal landscape. I would not go so far as to say the coast is that of Peru, for such a statement would be lacking in truth. The geography of the Peruvian shore, with its majestic, fantastic dunes, its calm sea from which tiny islands rise up like stone gods, its splendid starry skies, and the pelicans and gulls that ride upon its winds is identified in the painter's experience with the areas near Lima or Ica, a fact clearly brought out by the general title of his last series of paintings, *On the Way to Mendieta*. The character of the region, however, does not differ greatly from that of other desert beaches of the Americas, such as those of Mexico, the Caribbean, and northern Brazil. Why is it that this presence, once dissimulated, is now flagrantly evident? That the answer has many parts is a further indication of the complex process and the contradictory elements from which true art comes into being.

Constant, yet ever changing, the coastal landscape has a mysterious beauty similar to that of the stars. It has given Szyszlo suggestions for coloring, organizing space, combining movements, and creating forms. It has also provided him with symbols and objects for meditation. Most important of all, it has furnished a bond with tradition--a loose bond, that implies no slavery.

The most direct impression conveyed by the landscape I have mentioned is one of nature in its purest state, that of paradise prior to the advent of man and history. It is nature untamed and untried. Since its sole obligation is to exist, it gives a promise of happiness, perfection, and fulfillment. In a certain way it exemplifies also the impossible ideal of so-called abstract art: a world of forms, colors, and ideas, but void of people. Save for the inevitable ravages of time, it is a world free of the miseries of existence, safe from the depredations attendant upon the arrival of man, who, unlike other members of the animal kingdom, is never content to coexist with nature but insists on dominating it, domination in the long run meaning destruction. For an artist to capture such a landscape calls for a degree of empathy that borders on magic. It means imbuing the colors and forms of his canvas with the same untouched, eternal character of their inspiration. Is it not the secret aspiration of every true artist to overcome death, to escape from the perishable human condition by the creation of enduring beauty? Yearning for the absolute explains in part abstract art's rejection of figuration. A similar striving for the ideal, represented to some degree by the coastal landscape, has led Szyszlo away from abstraction in his most recent compositions (the series entitled *On the Way to Mendieta*, perhaps the loveliest of all his creations), in which, despite endless transformations, figurative reality appears in the form of sprawling, iridescent dunes over which myriads of stars sparkle like a burst of fireworks.

Still more remains to be said. A non-geographical aspect of the coastal region is specifically Peruvian: the area is impregnated with history. It is full of burial grounds, in which whole societies of squatting mummies are surrounded by textiles, ceramics, and metalwork which the dry climate has preserved all but intact throughout centuries. The surface may be a desert, but below it lie buried civilizations which had achieved artistic means of expressing their experiences and their dreams, their aspirations and their fears, long before the Spanish conquest imposed the cultural values of Europe and Peru. Compared to the civilization of the Andean highlands, which achieved notable social development and spread throughout a vast empire, coastal civilizations such as those of Nazca and Paracas are limited, weak, and all but insignificant. From the viewpoint of creative imagination, however, they were bolder and left works imbued with remarkable vitality.

While Szyszlo has often manifested his opposition to cultural nationalism, he has never concealed his attraction to the art of those who in the remote reaches of the Peruvian coast, isolated from their fellows in other parts of the globe, solved for themselves the problems of artistic creation, showing a degree of invention equal to that of European artists of the same time. From their textiles, pottery, and utensils one can recreate forms of life perfectly intelligible to modern man, who falls beneath their spell and is enriched by them. Peruvian art has its beginnings on the coast, whose colors, birds, fish, and hills undergo unbelievably audacious metamorphoses in the work of men's hands. No Peruvian artist can ignore the closeness of the relationship. Perhaps this is the decisive reason for the presence of the coastal region in Szyszlo's work.

In the course of the past and present centuries, Peruvian artists have often attempted to resume the tradition broken by the Spanish conquest. They have rarely met with success. Perhaps deliberate intention was fatal to the

spontaneity which is as essential to true art as is reflection. In other cases, mere imitation of pre-Incaic motifs transformed artists into folklorist, into passive epigones of a bygone tradition. Up to now it has been almost impossible to drink at the fount of tradition without sacrificing freedom of invention, without stumbling into the superficiality and ephemerality of the merely picturesque.

While Szyszlo long strove for art of a cosmopolitan type, without specific cultural roots, in a strangely unintentional way he has ended by drawing ever closer to the pre-Columbian Peruvian tradition, without being harmed thereby. Perhaps he owes this success to the fact that he has made a lateral rather than a direct approach to that tradition, turning to the same landscape in which it had found inspiration, recreating its achievements on his own. Thus without meaning to do so, and though jealously maintaining his creative independence and his claim to the universal qualities to which every true artist aspires, Szyszlo has established a dialogue with the fecund cultures that lie buried beneath the sands of the landscape which provides the subject and the vehicle of the give-and-take.

Finally there is an element in Szyszlo's art which should be mentioned after all the others because in a certain way it sums them all up and is the result of their union. This is the element of the erotic. Szyszlo's painting must not only be seen, it must be read, divined, and imagined. In a high degree it also demands to be touched. The urge is a powerful one. It comes less from the color of the picture than from its texture. "Texture" is to be taken in the most literal sense, for the canvas gives the appearance of a tightly woven fabric, an erogenous intertwining of silky and rough threads, of soft and hard fibers, which asks to be touched, to be tactually sensed. Yet this painting which presents its surface as an object of desire is the same composition which seeks to conceal its content, and which must be viewed from a distance in order to be enjoyed. It both entices and repels. This mingling of attraction and rejection, of proximity and distance, of possession and loss--what is this but the dance of love, which awakens desire, keeps passion alive, and brings a pleasure that is ever new?

In Szyszlo's painting, alongside "believable" figures of classic cut we find their exact opposites--radical disfigurations of reality, hybrid creations in which objects and beings taken from life are decomposed and intermingled at the bidding of the imagination. Or rather at the bidding of desire, for these are works in which the erotic element is visible. All of Szyszlo's paintings are variations on a single phenomenon--metamorphosis. And invariably the composition has as its point of departure Szyszlo's motif of long standing, the stone form (a totem, an idol, a tomb, or a stele) around which his pictures have been organized for years. At times, like the statue in Rubén Dario's poem, the figure grows goats' hooves and women's breasts. Suggestions of femininity impart heat and sensuality to the stone, making of it an erogenous object, an instrument of pleasure. Simultaneously, in the same pictures there reappears, mingling with these elements, another creature belonging to the painter's private mythology--the bird. Here it is not the bird that figures in art, in history, in dreams, and in folklore, with details such as feathers, claws, spurs, and beaks that suggest the birds in pre-Hispanic textiles and pottery. It is the bird that represents life and watchfulness which we see dying, falling apart, melding into the stone, which thus becomes the altar on which this bloody sacrificial offering is presented.

Certain of Szyszlo's works may be taken as an allegory of the dreary theory advanced by De Sade and Bataille that the erotic is inseparable from death. According to that theory, amorous desire, though a manifestation of life, also implies its negation, since desire, carried to its ultimate consequences, degenerates into a violence that demands the death and destruction of the object of its pursuit. Szyszlo's ancestral totems join but do not fuse desire, represented by the tumescences of women's breasts, and death, symbolized by the still-warm bodies of recently sacrificed birds.

In almost all painting--formal or informal, traditional or avant-garde--there is an element of theater, of merry or sorrowful dialogue between beings imprisoned within the confines of the picture by an act of independent, outside will for purposes of communicating something. This is particularly true in the case of Szyszlo. In his instance the mute dialogue has as its topic matters central to the human experience--the appetite for enjoyment, an awareness of inevitable extinction, the urgency of desire, the presentiment of death.

By the appeal it makes to the full range of the senses and the opportunities it provides for both carnal enjoyment and intellectual analysis, Szyszlo's art shows itself human in the fullest meaning of the word.

Latin American painting has always been threatened by two opposing but equally frustrating fates: provincialism and cosmopolitanism. In the first case, the artist is enslaved by his immediate surroundings. He has flown too

low; he has taken the tree for the forest; he has mistaken handicrafts for works of art; his product has a merely picturesque value. In the second case, the artist languishes in bondage to all that is universal, as opposed to local. He suffers from an excess of imitation and a lack of invention, resulting from his attempt to be impersonal and to keep up with the whirlwind of changing tastes which the great cultural centers seek to impose as fashion. Few are the painters, who have managed to escape both dangers; few are those whose work shows disdain for both attitudes, whose originality springs from proudly acknowledged inner necessity and the ability to make intelligent use of everything, no matter what its source or lasting value, for the high purposes of art. Szyszlo is one of those few. --*Mario Vargas Llosa*. Translation by Ralph Dimmick.

ACKNOWLEDGEMENTS

The Museum of Modern Art of Latin American and the Permanent Mission of Peru to the OAS wish to express deep appreciation to the following institutions and individuals whose generous cooperation and support have made this exhibition possible:

H.E. Ambassador of Peru to the United States and Mrs. Marchand
Mr. José Gómez-Sicre
Mrs. Mirtha Virginia de Perea
Minister Counselor of the Permanent Mission of Costa Rica to the OAS
The Solomon R. Guggenheim Museum, New York, New York
The Archer M. Huntington Gallery of the University of Texas, Austin, Texas
The Dallas Museum of Fine Arts, Dallas, Texas
The White Art Museum, Cornell University, Ithaca, New York
Forma Gallery, Miami, Florida
Art Consult Gallery, Boston, Massachusetts
The International Bank of Boston of South Miami
The Biscayne Bank of Florida
The Banco Nacional S.A. of Brazil
Private collection of Mr. and Mrs. Raúl Valdez Fauli, Miami, Florida
The Praxis Gallery, Buenos Aires, Argentina
Private collection of Fernando de Szyszlo, Lima, Peru
International Manufacturers Hanover Trust, New York, New York
Southern Peru Copper Corporation, New York, New York
First Boston Corporation, New York, New York
Inca Travel, Washington, D.C.
The Chase Manhattan Bank, New York, New York
Belco Petroleum Corporation, New York, New York
Bell Helicopter Textron, Forth Worth, Texas
St. Joe Minerals Corporation, New York, New York
Eastern Airlines, Washington, D.C.
Grace Foundation, Inc., New York, New York
Manuel Velarde Aspillaga

EXHIBITION LIST [1]

Paintings

1. *Estudio en gris (Study in Gray)*, 1952, gouache, 10 3/4 x 8 1/2". Coll. Mr. José Gómez-Sicre, Washington, D.C.
2. *Sin título (Untitled)*, 1959, oil on canvas, 16 x 18". Coll. Mr. José Gómez-Sicre, Washington, D.C.
3. *Sin título (Untitled)*, 1962, oil on canvas, 52 x 36". Coll. Herbert F. Johnson Museum of Art, Cornell University, Ithaca, New York
4. *Illa*, 1962, oil on canvas, 50 x 50". Coll. Mr. and Mrs. Alfonso Perea, Washington, D.C.

[1] Not included in the original catalogue. --*Ed*.

5. *Huanacauri II*, 1964, oil on canvas, 62 x 51". Coll. The Solomon R. Guggenheim Museum, New York City
6. *Inkarri*, 1968, acrylic on wood, 59 x 59". Coll. Archer M. Huntington Art Gallery, University of Texas, Austin
7. *Casa de Venus (The House of Venus)*, 1978, acrylic on canvas, 58 1/2 x 46 1/4". Coll. Mr. and Mrs. Raúl Valdez-Fauli, Miami, Florida
8. *Camera magna*, 1980, acrylic on canvas, 47 x 47". Coll. Biscayne Bank, Miami, Florida
9. *Camera magna*, 1980, acrylic on canvas, 47 x 46 3/4". Coll. Bank of Boston International South of Miami, Miami, Florida
10. *El innombrable (He Who Cannot Be Named) XIII*, 1980, acrylic on canvas, 59 1/2 x 47". Coll. Artconsult International, Inc., Boston, Massachusetts
11. *Viento de otoño (Autumn Wind) VII*, 1980, acrylic on canvas, 78 x 70"
12. *El innombrable (He Who Cannot Be Named) XLV*, 1980, acrylic on canvas, 46 x 46"
13. *Camera magna*, 1980, oil on canvas, 39 x 31". Coll. H.E. Ambassador of Peru to the United States and Mrs. Marchand
14. *Cuarto de paso (Transient Room) XLI*, 1981, acrylic on canvas, 38 x 38"
15. *Cuarto de paso (Transient Room) XXXIV*, 1981, acrylic on canvas, 38 x 38"
16. *El innombrable (He Who Cannot Be Named)*, 1981, acrylic on canvas, 70 x 78"
17. *Viento de otoño (Autumn Wind) IX*, 1982, acrylic on canvas, 71 x 79". Coll. Banco Nacional (of Brazil), Miami, Florida
18. *Cuarto de paso (Transient Room) III*, 1982, gouache, 22 x 30"
19. *Anabase (Anabasis)*. "La tierra amplia a mi deseo y ¿quién le pondrá límites esta noche?" ("The earth heightens my desire, and who will set limits upon it tonight?"), 1982, acrylic on canvas, 58 x 58"
20. *Punchao*, 1982, acrylic on canvas, 70 x 78"
21. *Anabase (Anabasis) VIII*. "Por la puerta de cal viva se ven las cosas de la planicie: cosas vivas, ¡oh! cosas excelentes..." --Grisaille) ("Through the quick-lime door one sees the things of the plains: living things, oh! fine things . . ." --Grisaille), 1982, acrylic on canvas, 58 x 58"
22. *Anabase (Anabasis)*. "La violencia en el corazón del sabio y ¿quién le pondrá límites esta noche?" ("Violence is in the heart of the wiseman, and who will set limits upon it tonight?"), 1982, acrylic on canvas, 58 x 58"
23. *Viento de otoño (Autumn Wind) XVII*, 1982, acrylic on canvas, 46 x 46"
24. *Anabase (Anabasis)*. "Los que conocen las fuentes están con nosotros en este exilio" ("Those who know the sources are with us in this exile"), 1982, acrylic on canvas, 58 x 58"
25. *Cuarto de paso (Transient Room) I*, 1982, gouache, 30 x 22"
26. *Cuarto de paso (Transient Room) II*, 1982, gouache, 30 x 22"
27. *Anabase, estudio (Anabasis, Study)*, 1982, acrylic on canvas, 38 x 38"
28. *El innombrable (He Who Cannot Be Named) LI*, 1982, acrylic on canvas, 48 x 58"
29. *Paisaje: viento de otoño (Landscape: Autumn Wind)*, 1982, acrylic on canvas, 58 x 58"
30. *El canto de la tierra (The Song of the Earth) II*, 1983, acrylic on canvas, 70 x 78"
31. *El canto de la tierra (The Song of the Earth)*, 1984, acrylic on canvas, 46 x 46"
32. *Mesa ritual diez (Ritual Table Ten)*, 1984, acrylic on canvas, 58 x 58"
33. *Mesa ritual nueve (Ritual Table Nine)*, 1984, acrylic on canvas, 46 x 58"
34. *El canto de la noche (The Song of the Night)*, triptych, 1984, acrylic on canvas, 74 x 54", 74 x 74", 74 x 54"
35. *Mesa ritual doce (Ritual Table Twelve)*, 1984, acrylic on canvas, 46 x 58"

ABOUT THE ARTIST

One-Man Shows

1947 Instituto Cultural Peruano-Norteamericano, Lima
1948 Galería de Lima
1949 Galería de Lima
1950 Galerie Mai, Paris
1951 Sociedad de Arquitectos, Lima
1952 Galería de Lima
1953 Pan American Union, Washington, D.C.
1955 Galleria Numero, Florence
1956 Museu de Arte Moderna, Rio de Janeiro
 Galería Sudamericana, New York

Instituto de Arte Contemporáneo, Lima
1957 Museu de Arte Moderna, São Paulo
1959 Galería Antonio Souza, Mexico, D.F.
1960 Instituto de Arte Contemporáneo, Lima
1961 Galería Bonino, Buenos Aires
1962 Instituto de Arte Contemporáneo, Lima
Galeria Bonino, Rio de Janeiro
1963 Andrew Dickson White Museum of Art, Cornell University, Ithaca, New York
Galería Marta Faz, Santiago, Chile
1964 Museo de Arte Moderno, Bogotá
Museo de Bellas Artes, Caracas
1965 Instituto de Arte Contemporáneo, Lima
1966 Galería Artes, Quito
1967 Galería Moncloa, Lima
Galería de Carlos Rodríguez, Lima
1968 Casa de las Américas, Havana
Museo de Arte Moderno, Buenos Aires
Instituto de Arte Contemporáneo, Lima
1969 Galería Juan Martín, Mexico, D.F.
Galería de Carlos Rodríguez, Lima
Galería Carmen Waugh, Buenos Aires
Instituto Nacional de Cultura, Lima
1971 Galería Juan Martín, México, D.F.
1971 Galería El Morro, San Juan, Puerto Rico
Galería Arequipa, Arequipa
Museo de Arte de la Universidad de Puerto Rico
1972 Galería San Diego, Bogotá
Center for Inter-American Relations, New York (Retrospective)
1973 Museo de Arte Moderno, Bogotá
Museo de Arte Moderno, Mexico, D.F.
Galería de la Bienal de Coltejer, Medellín
Galería 9, Lima
1974 Forsythe Gallery, Ann Arbor, Michigan
Galería Juan Martín, Mexico, D.F.
Galería Forma, El Salvador
Galería Portobello, Caracas
Galería 9, Lima
1975 Galería San Diego, Bogotá
Galería El Túnel, Guatemala
Special Room, Twelfth Biennial of São Paulo
Galería 9, Lima
1976 Galería Aele, Madrid
Galería Juan Martín, Mexico, D.F.
Galería Adler/Castillo, Caracas
Galería 9, Lima
1977 Galería San Diego, Bogotá
Galería 9, Lima
Special Room, *Arte actual de Iberoamérica*, Madrid
1978 Galería Juan Martín, Mexico, D.F.
Instituto Panameño de Arte, Panama
Forma Gallery, Miami
Galería 9, Lima
1979 Galería San Diego, Bogotá
Galería Adler/Castillo, Caracas
Galería 9, Lima

Group Exhibits

1951 Salon de Mai, Paris
1957 Fourth Biennial of São Paulo
1958 Twenty-ninth Biennial of Venice
 Carnegie International, Pittsburgh
1959 *The U.S. Collects Pan American Art*, Art Institute of Chicago
1961 *Latin America: New Departures*, Institute of Contemporary Art, Boston
1963 Guggenheim International, New York
1965 *The Emergent Decade*, Guggenheim Museum, New York City
1966 *Art of Latin America since Independence*, Yale University, New Haven
1975 *Twelve Latin American Artists*, University Art Museum, Austin, Texas

Represented at:

Museo de Arte Moderno, Bogotá
Museo de Arte, Lima
Biblioteca Luis Angel Arango, Bogotá
Museo Interamericano de Pintura, Cartagena
Museo de Bellas Artes, Caracas
Instituto de Arte Contempráneo, Lima
Museo de Arte Contempóraneo, Santiago de Chile
Museu de Arte Moderna, São Paulo
Casa de la Cultura, Quito
Dallas Museum of Fine Arts, Texas
University Art Museum, Austin, Texas
The Solomon R. Guggenheim Museum, New York
Andrew Dickson White Museum of Art, Cornell University, Ithaca, New York
Instituto Panameño de Arte, Panama City
Museum of Modern Art of Latin America, OAS, Washington, D.C.
Casa de las Américas, Havana
Bienal Coltejer, Medellín
Museo de Arte de Ponce, Puerto Rico
Museo de Arte de Maldonado, Uruguay

April 2 - 30, 1985

FIVE COLOMBIAN MASTERS

Under the patronage of the Permanent Mission of Colombia to the OAS and the Colombian Ministry of Foreign Affairs, the Organization of American States and its Museum of Modern Art of Latin America pay tribute to five outstanding Colombian artists: Fernando Botero, Enrique Grau, Edgar Negret, Alejandro Obregón, and Eduardo Ramírez Villamizar.

FOREWORD

In its efforts to increase mutual understanding among the countries of the Inter-American system, the Organization of American States has consistently put special emphasis on the arts.

For more than thirty-five years the Organization has accentuated the visual arts by recognizing and exhibiting the work of the most original artists in Latin America and the Caribbean. For many of the artists who are today acknowledged as pre-eminent figures in the world of art, it was their exhibition at the headquarters of the OAS that was the first step on their path to international renown and acclaim.

With the establishment of the Museum of Modern Art of Latin America, in 1976, the OAS continued the tradition of widening its commitment to bring before the public the works of major Western Hemisphere artists who have made their mark on the world of modern art, many of whom are represented in the Museum's permanent collection.

On this occasion, the General Secretariat of the OAS and its Museum of Modern Art take pride in paying tribute to five Colombian masters: Fernando Botero, Enrique Grau, Edgar Negret, Alejandro Obregón, and Eduardo Ramírez Villamizar. Their remarkable originality and their exemplary energy and efforts in advancing modern art have more than justified the foresight and faith with which the OAS first presented their works, some thirty years ago, when they were on the threshold of their careers.

This retrospective of their work, although small, is presented in the hope that it will encourage young artists, as yet unknown, to continue the enrichment and broadening of the artistic profile of the Americas. --*João Clemente Baena Soares*, Secretary General.

INTRODUCTION

For more than three decades, the names of five masters--Fernando Botero, Enrique Grau, Edgar Negret, Alejandro Obregón, and Eduardo Ramírez Villamizar--have been synonymous with the development of art in Colombia. A reading of the catalogues of their shows, the newspaper articles they have inspired, and the criticism they have provoked could lead one to wonder whether they engaged in a purposeful community effort to identify with the spirit of their times and the character of contemporary Colombian society, or whether it was the irresistible urge to create that drove them, by separate paths and against all odds, to achieve the realization of their talents that has so enriched their nation's heritage. The truth lies somewhere in between. Each has attained a mode of expression that is entirely his own, yet one that at the same time reflects a Colombian mentality and a consciousness of a common destiny to be fulfilled.

The artistic integrity of these five contemporaries, the assurance of their manner, the freshness and clarity of their vision, take us as much by surprise today as they did those who witnessed their first appearance on the local and world stages. We have, moreover, the perspective required to realize that success and recognition have not tempted them to deviate from the high professional standards that have made them the teachers of two succeeding generations of artists in their country. By their effort they have placed Colombia in the front rank of aesthetic expression today.

The Museum of Modern Art of Latin America recalls with gratification that exhibitions presented under the auspices of the OAS General Secretariat advanced in some degree the early careers of all these artists. It now takes particular pleasure in paying tribute to their achievement on an occasion honored by the presence of His Excellency Belisario Betancur, President of the Republic of Colombia.

Each of the five masters is represented by three works, selected by the artist himself as symbolic of his accomplishment of the past three decades. The essay by Félix Angel, a Colombian artist on the staff of the Museum, and the other informative material that accompanies the exhibition should serve to place the compositions properly in the context of the artists' development.

This exhibition continues a new phase in the development of the Museum, which began in mid-1983 with the reorganization of the permanent collection financed by a generous grant from the U.S. National Endowment for the Humanities. Conscious of its responsibilities as the sole institution in the United States dedicated exclusively to the art of Latin America and the Caribbean, the Museum seeks to promote a greater appreciation of the artistic values and achievements of the peoples of those regions not only in the Washington area but throughout the Hemisphere.

I should like to take this opportunity to express the Museum's gratitude to the Permanent Representative of Colombia to the Organization of American States, Ambassador Francisco Posada de la Peña; to the Alternate Representative, Minister Consuelo Lleras; and to Mrs. Isadora Norden and Miss Nidia Restrepo of the Cultural Division of the Colombian Ministry of Foreign Affairs for the enthusiastic support they have lent to this project and their assistance in obtaining on loan works sent from Bogotá.

Similarly, I wish to thank other institutions which have kindly made works available for presentation at this time, and the artists themselves--Fernando Botero, Enrique Grau, Edgar Negret, Alejandro Obregón, and Eduardo Ramírez Villamizar--for the generosity with which they have responded to our initiative. --*Rogelio Novey*, Acting Director, Museum of Modern Art of Latin America.

FIVE COLOMBIAN MASTERS

It is an ambitious undertaking to seek to present five Colombian master artists from the several viewpoints of their place on the Colombian art scene, their relation to contemporary art in general, the differences that exist among them, and the qualities that render them significant. Such an undertaking presupposes, moreover, that the reader has some acquaintance not only with the evolution of modern art in the Americas but also with the fractured structure of Colombian society and the economic, political, and social circumstances that have determined the course of Latin American history in this century. It is hoped, however, that the present essay will provide the reader with a general context for viewing the art on display and serve as an introduction to the worlds of Fernando Botero, Enrique Grau, Edgar Negret, Alejandro Obregón, and Eduardo Ramírez Villamizar.

Latin American Art and the International Manner

Unlike in other parts of the world, in Latin America political, economic, social, and cultural development has not necessarily proceeded abreast. The Mexican Revolution was perhaps the last upheaval of the Old-World type, in which a radical change in the economic and social structure gave rise to a well-defined movement of artistic renewal with forms of expression that in some cases were particularly its own. Compare, for example, the work of the three great muralists--Diego Rivera, David Alfaro Siqueiros, and José Clemente Orozco--with what their contemporaries were then doing in Europe, where the struggle to maintain that continent's artistic leadership had reached critical limits.

The Mexican muralists showed that it was possible to change the direction of art in Latin America, adapting it to internal reforms and the aspirations felt by new nations. In consideration of the aesthetic dogmas proclaimed by the leading muralists and the political positions they took, many historians and critics have refused to term their endeavor a movement, calling it merely a *style*. It is a mistake, however, to analyze it from the standpoint of developments in European art during the early part of the century, since the cultural attitude it expresses is completely divorced from the evolutionary trend evidenced in European aesthetics in the period preceding the First World War.

Taking the reverse tack, one could well term postimpressionist developments in European art *styles* rather than *movements*, since despite the revolutionary character of their visual and formal concepts they remained within the general aesthetic guidelines laid down in the Renaissance.

Except for dadaism and surrealism, which were real intellectual movements inspired in attitudes rather than aesthetic dogma, the concept of "schools" or "isms" is without validity in the twentieth century. The most radical changes of direction in art--and the work of the Mexican muralists represents one of them--were brought about by the positions taken by individual artists. The rapid rate of change in the conventional, stratified order of Western society has made the relation between man and his environment increasingly tenuous. Cultural manifestations have been doomed from the start to short, fleeting existence.

If art is understood as the concrete expression in plastic terms of a spiritual disquietude--of a creative urge to identify society with its aspirations and goals--then the concept of an "international manner" in art is a contradiction in terms; it is not the reality people seem to think it is. For an international manner to exist, Western and non-Western societies would have had to grow so much alike that they could find expression in the same visual terms.

If the term "international manner" is identified with art in the European tradition (including, since 1945, art produced in the United States) which is the art on which the gallery directors, collectors, and critics of technologically advanced societies concentrate, this is but a trick of hucksters in the art market, who are less concerned with intrinsic values than with selling a product.

If, on the other hand, the term "art in the international manner" is expanded to mean art of worldwide acceptance, limited by no concepts of tendency, school, or movement but including all creative work of sufficient originality to find favor with the international public, then Latin American artists can take their place along with all who contribute to the evolution of art in the world today, even as such figures as Joaquín Torres-García, Amelia Peláez, Armando Reverón, and Andrés de Santamaría did in the past.

The Latin American artist is distinguished by his individuality and undogmatic view of life--one might say also by his unpragmatic nature and his disinclination to conformity. In some extreme cases, such as that of the Venezuelan Reverón, the artist has gone into voluntary isolation, to produce in the fashion he thinks most consistent with life and ambient society. Such an attitude is not so much a rejection of society as a demonstration of independence. Taken as a philosophy of life, the position reflects a romantic, decadent spirit.[1]

The nonexistence in Latin America of an aggressively active art market, swept by endless gusts of publicity has permitted the artist of that region to preserve a certain elemental integrity. He can hope for a return from his work that will allow him to live with dignity; he can expect recognition of his talent without need to pursue the more frivolous aspects of fame. Conversely, the scantiness of serious criticism which would both publicize the artist's effort and stimulate his development makes it more difficult for the Latin American to win a place on the international scene and impedes or delays appreciation of his work by many sectors of contemporary society.

The Beginnings of Contemporary Art in Colombia

The weakness of the country's economy in the 1940s and the drop in the price of coffee on the international market were some of the factors that led to radical changes in Colombia during the following decade.

The development of the artists who are the object of this study paralleled that of the country, as they experienced, reacted to, and reflected on the crises the nation was undergoing and the reforms and advances registered by its democratic system.

It should be noted in this regard that Colombian artists and intellectuals in general have rarely identified their work with partisan ideology.[2] The artist seeks rather to convey by his work his perception of reality. He is free to reflect it in all faithfulness, to reject it *in toto*, or to criticize it ferociously, as in the case of Fernando Botero, Enrique Grau, and Alejandro Obregón. He is also free to design an order in which life is elevated to a level of greater equability and harmony, better suited to the needs of mankind. The work of Edgar Negret and Eduardo Ramírez Villamizar provides the perfect example in this regard.

This attitude has permitted the artist to play a role in crises without betrayal of personal principle or subservience to the dictates of circumstance. The system's incapacity for coercion permits him to create work which is expressive of much more than the fervor of a given moment. Artists have been able to advance farther than other ranks of society, thanks to the support they have received from the intelligentsia, which, even in the worst of circumstances, has always managed to stir up a measure of controversy sufficient to maintain public interest in artistic activities. Like the other mass media, the press fortunately lacks the power to manipulate public opinion, and the degree of decorum it has always maintained has permitted cultivated persons to give expression in its pages to ideas and opinions on all aspects of national life, literature, and the visual arts.

The dominance exerted on Colombian life by the capital, Bogotá, was not confined to the political sphere, but also extended to the area of culture, this until about 1965, when other large cities began to develop cultural lives of their own. This is not to say that they had previously been lacking in cultural initiatives. They were less open to cosmopolitan influences, however; their undertakings were of a more provincial character--and for that very reason better suited to the mentality of the inhabitants.

By the end of the 1940s Enrique Grau (b. Cartagena, 1920), Edgar Negret (b. Popayán, 1920), Alejandro Obregón (b. Barcelona, Spain, 1920), and Eduardo Ramírez Villamizar (b. Pamplona, 1923) were completely caught up in the Bogotá art scene, having become to all intents and purposes residents of the capital. Fernando Botero was then still living in Medellín, where he had been born in 1932. Though he was a decade younger than

[1] For the sense in which "decadent" is employed here, see Stanton Catlin's introduction to the catalogue of the Botero exhibit at the Center for Inter-American Relations (New York, 1969).

[2] With a few exceptions, among others, Pedro Alcántara (1942-) and Clemencia Lucena (1945-1983).

the others, it did not take him long to join them in the ranks of the metropolitan avant-garde.[1] It was in 1948 that the first commercial art gallery, the Galería de Arte S.A., opened in the basement of a building on the Avenida Jiménez, in the heart of Bogotá. The galleries of the National Museum and the Gregorio Vásquez Hall of the National Library had already been the scene of exhibitions for some time; the latter was the site of the *Exhibition of Young Colombian Artists* which took place in 1947. Some of the artists were indeed young, others were not, but all formed part of the avant-garde and were united in rejecting tradition as represented by the figurative art of nationalistic tendency which then dominated the scene. Edgar Negret's *Ascension* (gesso, 1946), which appeared in the exhibition, was completely abstract in character.

Enrique Grau and Alejandro Obregón had had the opportunity to travel abroad, the former on a government scholarship, the latter as the result of family circumstances. Obregón had in fact been born in Spain, his father being Colombian, his mother Spanish. At the age of six the family moved to Barranquilla, Colombia, but later he was sent to school in Liverpool, England. When he returned to Barranquilla he took a job in a textile factory. Naturally inclined to adventure, he worked as a chauffeur and translator in the oil fields of Catatumbo, in southern Colombia, then went to Boston to study at the Museum of Fine Arts. He served for a while as Colombian vice-consul in Barcelona, but left to take a teaching position in Bogotá at the School of Fine Arts, of which he served as director in 1948 and 1949. In the latter year he moved to Alba, a small place near Avignon in southern France, where he remained until 1955.

During Obregón's short term as director of the School of Fine Arts, he sowed the seeds of artistic renewal in Colombia,[2] setting himself in opposition to traditionalists such as Pedro Nel Gómez, Carlos Correa, Luis Alberto Acuña, Alipio Jaramillo, and Ignacio Gómez Jaramillo, whose depictions of local scenes and customs enjoyed public favor and received official support.

Before moving to Bogotá, Grau, Negret, Ramírez Villamizar, and Botero had all received some instruction in art. They were not academics, however, since official academies had never been established in Colombia. With a clear consciousness of the meaning of their action, each of these artists sought to define his Latin American personality, rejecting worn-out concepts of artistic nationalism such as those advanced by the Mexican mural painters (who by that time were in decline, though their followers at home and abroad were much in evidence). Their aim was not to depict scenes of Colombian life with no more imagination than that required to justify selection of the subject, but to reinterpret for their fellow countrymen, in visual terms, the real world of Colombia, broadening the public's faculties of perception, enriching the accepted repertory of artistic imagery, and opening up new fields of aesthetic expression.

By the end of the 1940s abstract art had gained some ground in Colombia, although the public in general had no very clear idea of just what it was: people tended to apply the name to anything that departed from the figurative tradition.

> It took a good thirty years, dating from the time of Kandinsky's and Mondrian's first attempts in the line, for a real abstract art movement to develop. Contemporary abstract art originated in Europe, and only after World War II did it become generalized in the Western Hemisphere. Thus for artists of both North and South America it was an import from abroad. But--and this is the interesting point--it did not arrive as a fully developed and hardened model to be copied, as had been the case with the academic and impressionist manners. It provided, rather, broad guidelines, which permitted of new and unforeseen developments, not only in the world's great art centers but also in places less open to influences from abroad.

> In the case of Colombia, the appearance of abstract art took an intermediate form. It was

[1] It should be noted that these five artists never constituted a group sharing the same artistic philosophy. Completely independent of one another, they attained a similar measure of success thanks to the power of their individual oeuvre.

[2] See "Itinerario de Alejandro Obregón" in Eugenio Barney Cabrera's *Geografía del arte en Colombia* (Bogotá, Ministry of Education, 1963).

neither a tardy reflection of an established fashion nor a direct copy of an avant-garde model. At least initially the aim was real identification with the artistic trends current in mid-century. I do not think it an exaggeration to say that this was the first truly contemporary period in Colombia.[1]

The 1950s: Change and Controversy

On June 13, 1953, Colombia's democratic development was interrupted by a military coup d'état. At that time three of the five leading Colombian artists were in Europe (Grau and Ramírez Villamizar were not, but they had already made their first visits to New York and Paris). Their purpose in going there had not been to join the European vanguard but to observe it and to draw for themselves upon the sources from which it derived. Their experience of the Old World led them to understand that while, as Latin Americans, they had every right to develop a contemporary language of their own, they first needed to understand the past, so that they would not find themselves repeating it. The young artists explored the worlds of Goya, Velázquez, Giotto, Mantegna, and Piero della Francesca and examined very carefully the work of Gaudí, Picasso, Julio González, Anthony Caro, Graham Sutherland, Piet Mondrian, and Victor Vasarely, taking from them such elements as each found useful.

About 1955, at the height of the military dictatorship, the artists began to organize their careers in the same independent, individual fashion that has always characterized their activity. They divided their time among Colombia, the United States, and Europe. While they became as it were citizens of all three regions, they never lost their Colombian roots, a fact that is clearly evident from their work. Eventually Grau, Negret, and Ramírez Villamizar settled in Bogotá, Obregón in Cartagena, and Botero in New York and Paris.

Abstract art met with increasing favor in Bogotá where progressive circles were dominant. It also found a certain number of adherents--not very many it must be admitted--in other leading cities of the country. Botero, Grau, and Obregón were non-conventional in their figurative styles, whereas Negret and Ramírez Villamizar were radically abstract, but the general public lumped them all together under the classification of "modern." Contributing to the favorable reception in intellectual circles was the support lent by critics such as Marta Traba, a new arrival from Argentina. Her voice quickly became the most influential in the country in art matters. Despite all this, officialdom maintained a prudent distance from novelty, showing an indolent preference for traditionalists expressed in such public commissions as were conferred.

Thanks to high prices for coffee on world markets, Colombia shared in the general prosperity of the moment and seemed well on the way to modernization. Limited government support for cultural activities, however, threatened a depression in matters of art. The National Salon was eliminated in 1953. It had always provided a pretext for polemics, but whatever the feelings about it might be it was a necessity from the viewpoint of practicing artists. Programs devoted to art criticism--among them those of Marta Traba--were banished from national television. Two leading newspapers, El Tiempo and El Espectador, were first censored and then closed. Gradually, however, the cultural milieu developed its own defenses. Commercial galleries slowly but surely increased in number and exhibits were staged at social clubs and on other private premises. Alejandro Obregón's first one-man show in Medellín took place at the Professionals' Club. Even furniture stores began to hold art shows.

In 1955 a group of artists headed by the painter Judith Márquez began publication in Bogotá of the art magazine Plástica, which until 1960 played a prominent role in the formation of public taste. Writers such as León de Greiff, Eduardo Cote Lamus, Jorge Gaitán Durán, Rafael Maya, Alvaro Cepeda Samudio, and Gabriel García Márquez kept up a high level of literary production.

May 1957 saw the end of the military dictatorship and a strengthening of Colombian democracy. That same year Colombia was represented in the Fourth São Paulo Biennial by a selection organized by the University of America in Bogotá. It included paintings by Grau, Obregón, and Ramírez Villamizar, and engravings by

[1] María Elvira Iriarte, "Primeras etapas de la abstracción en Colombia," published in the Bogotá magazine Arte en Colombia (no. 23), p. 30.

Guillermo Silva Santamaría. Sculpture by Negret was included in a selection organized by the Visual Arts Section of the OAS General Secretariat for presentation on the same occasion. The São Paulo Biennials were coming to be considered one of the most significant of world art events, attracting entries from countries as far away as Vietnam and China.

The frequency with which the five artists covered by this essay appeared together at international art shows caused them to be considered the Big Five in Colombian art. A figure to be ranked with them was Guillermo Wiedemann. Born in Germany in 1905, he settled in Colombia and played an important role in the development of abstract art there until his death in 1969.

In her introduction to the Colombian section of the 1957 São Paulo Biennial catalogue, Marta Traba wrote:

> The artists participating in the Biennial represent only a sampling of the thirty or more highly qualified figures currently active in Colombia. They seek to arouse interest in what is being done in their field in Colombia. They are a reminder that Colombia, like other countries, has a role to play in contemporary art and makes a similar endeavor to discover and reveal genuine talent.[1]

During those same years the Visual Arts Unit of the OAS General Secretariat, headed by José Gómez-Sicre, was doing much to promote rising Latin American artists abroad. The temporary exhibition gallery at OAS headquarters had been the scene of a one-man show of paintings by Obregón in 1955. In 1956 it was the site of exhibits of sculpture by Negret and paintings by Ramírez Villamizar, and 1957 saw solo shows by Grau and Botero.

Marta Traba was charged with organizing the selection of artists to represent Colombia at the Fifth São Paulo Biennial in 1959. She included works by all of the Big Five except Edgar Negret, whose then-current obligations in New York did not permit him to participate. By that time the individual personalities, styles, and modes of expression of all five had become clearly defined. They continued to grow and evolve, however, and their work showed increasing refinement as time went by.

Of the five, Obregón enjoyed the widest recognition. He had been a prize-winner at the Third Hispanic American Biennial of Barcelona (1955) and had taken first place at the *Gulf Caribbean Art Exhibition* held in Houston in 1956. In the latter year he received the Guggenheim Foundation's Award for the best Colombian artist and in 1959 he won Honorable Mention at the São Paulo Biennial.

Obregón's prize-winning work in Houston was *Cattle Drowning in the Magdalena River*, now the property of the Museum of Fine Arts of Houston; as for the Guggenheim Prize he owed that to a composition known alternatively as *The Wake* and *The Dead Student*, now in the collection of the OAS Museum of Modern Art of Latin America. While both subjects are taken from Colombian history, it is history with a small "h"; the episodes recorded are altogether everyday happenings. As a rule, the small tragedies of daily life are recalled only by the individuals immediately affected; it is Obregón's gift to make of them something memorable. His work projects a Colombia whose magnitude is unknown to many of the country's own inhabitants; the cordillera whose peaks are swept by the clouds and storms of the tropics, the coasts that fade into the endless waters of the Caribbean and the Pacific, the jungle whose silence is broken only by the cries of savages and wild beasts. It projects also the mysteries of love and death.

The devices Obregón uses are simple; the effects he achieves derive from the skill with which he handles them. A composition is almost always divided into horizontal zones; the forms which spread across them are linked with them by color, thereby establishing similitude between object and subject, form and background. No attempt is made to "tell a story," despite the obvious implications of the artist's chosen subjects or themes. There is no contradiction between reality and the symbols used to express it in pictorial terms. The viewer experiences both the emotional charge conveyed by reality and--even in the case of the most tragic of topics--a previously unknown

[1] Marta Traba, presentation of the Colombian selection, catalogue of the Fourth São Paulo Biennial (1957), p. 164.

visual pleasure.

The other four artists, for all their differences, enjoyed a more or less equal measure of public esteem. Grau had won several prizes in Colombia: Honorable Mention at the First Salon of National Artists held in Bogotá in 1940, when Grau was barely twenty; First Prize for Painting at the Tenth Salon (1957); First Prize for Drawing at the Eleventh Salon (1958). He first practiced figurative painting of a geometric character, which the Colombian critic Germán Rubiano Caballero called "poetic neoclassicism."[1] It was slightly reminiscent of Picasso and Matisse, evidencing "the same exquisite care taken by the Spanish and French masters in works postdating their respective excesses in the cubist and fauvist lines."[2] Grau gradually slipped into a period of eclecticism. On the one hand his taste ran toward figuration of a distinctly classical type, resulting perhaps from his 1955-1956 stay in Florence and, on the other hand, toward the integration of figurative with abstract elements. In his bold use of resources he showed an inborn talent for resolving the problems of the pictorial surface.

Until the end of 1957, Ramírez Villamizar's activity was confined to painting. Then, slowly but surely, he began to venture into work in three dimensions, starting with reliefs which constitute the perfect introduction to the masterly sculptures he was to produce thereafter. In 1958 he received the Guggenheim Foundation Award for Colombia and in 1959 won the First Prize for Painting at the Twelfth Salon of National Artists. That same year he began work on a decoration for the headquarters of the Bank of Bogotá. Known as the *Golden Relief*, it is one of the most beautiful creations in the history of Colombian art. It combines geometric elements of the artist's invention with features inspired by the gilded altars of Bogotá's colonial churches. The relief was executed in wood and covered with gold leaf. It has the solemn, reverence-inspiring grandeur of baroque ecclesiastical art, but at the same time, thanks to Ramirez's bold innovations, it strikes a distinctly contemporary note.

Botero, the youngest of the Big Five, had won the Second Prize for Painting at both the Ninth and Tenth Salon of National Artists (1952, 1957), and in 1958, at the Eleventh Salon, his *Bridal Chamber: Homage to Mantegna* took the First Prize. Executed that same year, the work was inspired in Mantegna's 1474 frescoes for the Ducal Palace in Mantua. Botero later did a second version, which is now the property of the Hirshhorn Museum in Washington, D.C. The figures in this composition have suffered a form of distortion which was to become Botero's trademark: the heads and trunks are of exaggerated proportions, in strong contrast with the drastic reduction of the limbs. On this occasion the disproportion was not, however, carried to the lengths it was to attain later. Other characteristics of Botero's art are a monolithic monumentality, which recalls the pre-Columbian sculptures to be found in the archaeological zone of San Agustín in southern Colombia, and meticulously structured composition.

In 1959, at the Twelfth Salon, Botero's entry, *Apotheosis of Ramón Hoyos*,[3] was declared *hors concours*, and at the end of the decade he received the Guggenheim Foundation Award for Colombia and moved to New York.

Negret, prevented from participating in the 1959 São Paulo Biennial because of obligations in New York, had by that time established close relations with U.S. avant-garde sculptors such as Louise Nevelson, Robert Indiana, and Ellsworth Kelly. The limited role he played on the Colombian art scene is readily explainable by the hectic pace of his activities in Europe and the United States. Solo exhibitions and group shows followed one another in rapid succession in New York, Paris, London, and Washington. Among the more important were *Negret and Youngerman* (Gres Gallery, Washington, D.C., 1957), the New York Museum of Modern Art's exhibit of recent acquisitions in 1955, and the Venice Biennial of 1956. From this period date Negret's *Magic Gadgets*, whose

[1] Germán Rubiano Caballero, *Enrique Grau*, catalogue of the retrospective exhibition organized by the Centro Colombo-Americano of Bogotá (1983), p. 53.

[2] Ibid.

[3] Ramón Hoyos was a famous Colombian cyclist. Like Botero a native of the province of Antioquia, he won the Tour of Colombia competition on five occasions.

"shapes and colors have the poetic charm which is to be found in certain objects of daily use." [1]

Although Colombian art was dominated at that time by the presence and achievement of the Big Five, this did not prevent other, still-younger artists from making names for themselves and taking places beside their elders in public and privately sponsored exhibits. While the stylistic influence of their immediate predecessors is apparent in their work, they were nonetheless able to assert themselves as individuals. They were to some degree overshadowed by the Big Five and had to share in the hostile reception accorded the latter's work in conservative circles, but they paved the way for a new generation which was to take definite shape around 1966. All concerned joined in efforts to overcome the resistance of officialdom, the public's intransigent attitude toward novelty, and the influence of the art schools in which painting of a conventional stripe was firmly entrenched.

The public did not fully accept the directions taken by Colombian art, nor did it understand the confused succession of events on the international art scene, of which it had only second-hand knowledge. So rapidly did those events occur that the everyday gallery-goer could not hope to keep abreast of the constantly changing choices with which the art-consuming public was confronted. The beginning of the decade had seen the appearance of U.S. action painting and other less-publicized abstract trends, such as Brazilian lyric abstraction and Spanish informalism. Next came pop and op art, happenings, performances, and a variety of other attempts to stimulate a public whose natural and artificial appetites had been satisfied to the point of boredom. For social and economic reasons such attempts could have no counterpart in Latin America, except in a few cities such as Buenos Aires.

The Colombian avant-garde, headed by the Big Five, did not allow itself to be led astray by iconoclasm in Europe and the United States. It asserted its right to define in its own way the relationship between the artist and his work, and between art and the public. As a result, that part of the public which had been so bold as to admit that the time had come for a change in its aesthetic thinking did not feel itself betrayed, and the artistic evolution of the country took place without the trauma that attended its political development. Provincial cities began to make their voices heard in the cultural development of the nation; Colombian artists held their own under fire abroad; and, thanks to Fernando Botero, Enrique Grau, Edgar Negret, Alejandro Obregón, and Eduardo Ramírez Villamizar, art maintained its honor as the expression of all that was best in Colombian aesthetic perception.

Recognition

The decade of the 1960s began with a heated debate over the choice of artists to represent Colombia at the Second Mexico City Biennial. The National Fine Arts Administration had charged Marta Traba, "whose word had become law in Colombian plastic arts," [2] with making the selection and serving as Colombian commissioner at the event; however, at the instigation of the traditionalist painter Ignacio Gómez Jaramillo (1910-1970), it then proceeded to disqualify her choice of Botero, Obregón, Ramírez Villamizar, and Guillermo Wiedemann. Her choices were replaced with a new selection, in which the place of honor was held by the aforementioned Gómez Jaramillo, the leader of the opposition to Marta Traba. In a symbolic gesture, the artists originally selected excluded themselves from participation in the Biennial and staged a show of their own in the exhibit hall of the Luis Angel Arango Library. The show met with unprecedented public success and articles in the press fanned still further the fires of controversy. The discussion made clear that the generation of the Big Five had clearly established itself on the national scene and that it was setting the course for the development of Colombian art.

The opposition raised by traditionalist artists is readily understandable. It stemmed from their natural resistance to accepting new ideas and to seeing themselves supplanted by a younger generation. Another type of opposition came from those members of the public who were incapable of identifying with the new aesthetic. Their idea of what was "Colombian" was based on the type of art that had prevailed in the country several decades earlier.

[1] José Gómez-Sicre, presentation of the artists selected by the Visual Arts Unit of the OAS General Secretariat for participation in the Fourth São Paulo Biennial. Catalogue of the Biennial (1957), p. 381.

[2] This is the expression used by the painter Gonzalo Ariza (1912-) in his article "¿Dónde va nuestro arte?" published in *El Espectador* (May 28, 1958), p. 5.

It should be said in passing that throughout the 1950s the Big Five had shown a disposition to blend their artistic concepts with elements of Colombian reality. One may cite for example Enrique Grau's *Burnt Streetcar*, inspired by the 1948 riots in Bogotá. Mention has already been made of Alejandro Obregón's *Wake* and *Cattle Drowning in the Magdalena River*, works which were followed by the series entitled *Mojarras*, *Barracudas*, and *Condors*, which won him Honorable Mention at the 1959 São Paulo Biennial. Similarly, though Botero had taken up residence in New York, in his paintings one finds reflections of situations, personages, and ways of life that are typically Colombian, extending from his remarkable 1959 *Apotheosis of Ramón Hoyos* through the semiurban scenes done in the 1980s. The same holds for Botero's sculptures. Botero's continuing attraction to places and events of his youth is expressed in symbolic allusions to local geography and a picturesque gallery of social types ranging from prostitutes to military leaders, politicians, and middle-class pretenders to aristocracy.

Despite their pursuit of abstract values in sculpture, Negret and Ramírez Villamizar could not resist the natural impulse to relate to the land which, for better or for worse, had conditioned their cultural reflexes. The fact that Negret named one of the works of his European period (1950-1956) *Column Commemorating a Massacre* is indicative of his desire to establish a relationship between form and content, expressive of his clear understanding of the deeds committed by the public to which he addressed himself. The same inner desire is evidenced in his 1980 series entitled *The Andes*. As for Ramírez Villamizar, the most formally inclined of the five artists, works such as the *Golden Relief* and others he did thereafter provide an intellectual link with the colonial and pre-Columbian past. They bring the future into the present and show that the present is already past history.

By the 1960s the position of the Big Five was so firmly established that they had come to be called the masters of contemporary Colombian art. The term was less an expression of enthusiasm than a recognition of fact. The interest that the United States developed in Latin America at that time, fleeting though it was, helped expand the field of action not only for the five masters but for all leading members of what was by that time a well-established, multifaceted regional avant-garde. United States good will towards Latin America was expressed in a number of exhibitions, among them the 1964 *Esso Salons of Young Artists*, sponsored by what is now the Exxon Corporation, an initiative that reached its culmination in 1965 with a show in Washington, D.C., cosponsored by the OAS Visual Arts Unit. There were also the shows entitled *The Emergent Decade*, organized by Thomas Messer for the Solomon R. Guggenheim Museum in New York (1965), and *Art of Latin America since Independence*, organized by Stanton Catlin in 1966 for presentation at Yale University in New Haven, Connecticut, and the University of Texas at Austin. European institutions too were increasingly less chary of according recognition to the achievement of Latin American artists.

Latin America was conscious of the fact that if, in Marta Traba's words, it wanted "to play a role in modern art by persistence in the discovery of genuine aesthetic values," it could not submit to the dictatorship of prevailing artistic trends abroad. That would have implied an imitative role inconsistent with the times. On the other hand, the preoccupations of artists in other parts of the world could not be completely ignored. Latin American artists took their place in the international arena as equals, motivated by situations in their own countries. Their work did not conform to the general trend, but provided an alternative to it.

If one compares Obregón with U.S. abstract expressionists whose work is strictly contemporary with his--with figures who show the clearest affinity to the gestural period represent by *Cotopaxi*--one notes that Philip Guston and Clyfford Still, or even Frankenthaler and Yunkers, abandoning subject matter, freed the forces of painting, giving it a giddy independence which Obregón's work never achieved. Their action was in this respect characteristic of the whole postwar movement in the United States. A similar difference can be perceived in comparing Obregón's break with space with Rauschenberg's and Dine's incorporation, into a lyric space achieved by freely executed brushstrokes, of ordinary objects that "place" the painting, bringing it down to the level of everyday reality, thereby impeding flights of emotion. In this regard, with his usual clear vision of artistic phenomena, Juan García Ponce has made this acute observation: "Obregón is undoubtedly a modern painter, but his modernity stems from the eternal character of what he creates in the process of self-realization as a painter. From his viewpoint, stylistic variations merge into the immutable essence of painting, which justifies itself not by these variations but by the fact that they make its continued existence possible. Despite the obvious wealth of form they exhibit, Obregón's works have remained immune to the mania

for change that is characteristic of much of contemporary art.[1]

Obregón's horizontally structured oeuvre exudes a passionate romanticism. It speaks of sea and plains, of rivers and skies--a vast and inaccessible tropical setting for a life-and-death struggle between body and soul, the poetic and the pathetic. A composition of his may be likened to a musical score in which the horizontal stands for the staff and his self-invented symbols figure as notes in counterpoint. Even the boldest of chordal combinations contributes to the overall harmony. Color advances or retreats; it broadens into stridency or softens into the most sophisticated of pastel shades. Indeed it is color which sustains Obregon's magically ordered forms and holds the composition together. The emotional element, represented by small flashes of brilliant hue scattered hither and yon, cannot be repressed; however, it is transfigured as in the gallantly turned erotic verse of a medieval troubadour. *Violence* (collection of Hernando Santos, Bogotá) won for Obregón the Prize for Painting at the Fourteenth Salon of National Artists in 1962. It is one of the key works in Colombian painting of that period. The subject was not a new one for Obregón; indeed of the five masters it is he who has resorted to it most often. It appears as early as his 1948 *Massacre of April Tenth* and as late as his 1982 diptych *Death to the Human Beast and Victory of Peace.*[2]

In *Violence* the figure of a slain pregnant woman constitutes a classically Obregonian horizontal. It stands out in chiaroscuro against the symbolic skyline of the cordillera. Space is divided into two zones of differing pictorial value but similar visual tension. The balance obtained by counterposing the two zones and the risky use of the figure as a catalytic element reminds the viewer that, while the picture tells a story, the intention is to free reality of melodrama and transform it into an obvious symbol of irremediable tragedy.

The frightful drama of this theme would have reduced many a true artist to silence, yet Obregón has been able to celebrate an extraordinary funeral of grays and blacks for the lifeless, armless figure of a pregnant woman, stretched out against the horizon. Always before Obregón had tended to introduce the "saving note" of a brief flash of brilliant color, offsetting the all-pervading gloom of his grays. Here he has ventured nothing of the sort. The picture is the absolute in gray, in quiet, in silence. For the first time tragedy has found an interpreter capable of taking its measure.[3]

New honors came to Obregón in the sixties. In 1966 he won the First Prize for Painting at the Eighteenth National Salon of National Artists. In 1967 he represented Colombia in the Ninth Sao Paulo Biennial, at which he was honored with a room of his own and won the Francisco Matarazzo Prize. Recently the National Museum in Bogotá created a Hall of Masters in which Obregón is permanently represented.

After *Violence*--for which the series of *Variations on Violence* may be considered preliminary drafts--came the *Barracudas* of 1963, the 1965 *Cold River*, the *Icarus* paintings of 1967, the 1968 *Landscapes for Angels*, and the *Magic Spells* of 1969. During the 1970s Obregón worked on several series, among them *Homage to Saint-Exupéry* and *Annunciations*. He continues to treat themes he has made his own and which have become characteristics of his work. An exhibit of recent paintings was presented at the Metropolitan Museum of Miami in 1982 and early the following year at the Museum of Modern Art of Latin America in Washington, D.C.

> The years from 1959 to 1961 were of decisive importance for Grau's development. Compositions executed in 1959 are characterized by geometric forms, but a few months later the artist was once again working along figurative lines. After twenty years of experimentation, during which he had passed though a number of stages, Grau was finally to decide on the style which has now become his familiar characteristic. To be sure, it is not uniform, for it varies somewhat from period to period. Nonetheless, the fact is that since 1960 the artist has followed

[1] Marta Traba, published in the magazine *Eco* (Bogotá), 1978.

[2] In regard to the theme and the artists who employed it, see Germán Rubiano Caballero's article "El arte de la violencia," in *Arte en Colombia*, no. 25 (Bogotá, 1984).

[3] Marta Traba, *Mirar en Bogotá* (Bogotá, Colcultura, 1976).

a rather straightforward path of development.[1]

Up to 1959 Grau had practiced figuration which, without being fully geometric, nonetheless showed geometric characteristics. The change to which Rubiano alludes was not merely one of form, however, but also involved content. While Grau continued to employ many of the same thematic elements, he took a new approach to them, allowing them to project their true identity. Painting for him is still a plastic problem, to be stated and resolved along purely formal guidelines, and he shows an ever-greater mastery of technique--a mastery reminiscent of Dutch painters such as Frans Hals, of Goya, and of the Italian mannerists. The works, however, begin to "tell us something," though in a purposely ambiguous fashion. They provide the viewer with a novel perception of the world and of life, intriguing and even amusing, devoid of Botero's sarcasm and far removed from the epic sweep of Obregón's canvases. Grau's world is one of smiles, of hyperbolic innocence, which seems to us entirely possible once we become aware of the unrealness of reality. In an apparently simple composition such as *Children in the Shadow*, 1960 (collection of the National Museum in Bogotá), the plastic atmosphere created to justify the "shadow" and to produce the luminous effect of the lighted candle held by one of the children is merely the means whereby the artist conveys the guile which is the true subject of the work. As Grau becomes increasingly master of his vocabulary, his compositions escape simplistic analysis, and viewers are confronted with the incongruities to which the artist resorts to prevent them from discerning the possible significance of apparently arbitrary associations between objects and persons. Absurdity is one of the qualities of Grau's work, and in the impossibility of questioning it reside its virtues.

Costume jewelry, feathered hats, sashes, hairnets, shawls, combs, fans, bullfighter's costumes, gloves, dusters, handbags, Victrolas, corsets--all sorts of cast-off odds and ends--form a setting for the human figure, which takes its meaning from the heterogeneous surroundings of which it seems but one more element. If Obregón is a magician, Grau is a sleight-of-hand artist, whose skill permits him to achieve the most surprising of effects. At times he beguiles us with the nostalgia evoked by all sorts of commonplaces, by a premeditated disarrangement of orderly reality, by frivolity, by hedonism; at other times he challenges us to free our spirit from the bondage of poverty-stricken convention.

> Never before have we felt the carnal vitality of Grau's models to the extent we do in visiting the present exhibition. Never before have we been so boldly challenged by the indubitable vulgarity of the objects characterizing these figures and the surroundings in which they find themselves; ornaments, cheap costume jewelry, plastic flowers, moth-eaten feather boas which had long lain abandoned in attics. These all take on the nature they had before they fell into disuse and remind us of the decay to which such common objects are inexorably condemned. Commonness is for Grau the definitive characteristic of the world in which we live and it is this quality which he seeks to bring out in his works. This attitude on his part is responsible for the slight but excited palpitation of the hands, the lively brilliance of the eyes, the ambiguous sensuality of the smiles, and the aura of perversity which the figures exude over their surroundings.[2]

While Grau's inventive spirit has found full realization in his painting, it is not limited to that. His restless urge to create has led him to experiment with cinematography, sculpture, and other three-dimensional objects, stage design, and--naturally--drawing and engraving, in which he has obtained brilliantly ingenious results. He has enjoyed at least four retrospectives in Colombia, the largest and most seriously organized of which was the one held at the Colombian-American Center in Bogotá in 1982. With an exhibit held that same year in New York he once again confirmed his keenness of vision, technical skill, and mastery of his craft.

In 1962 Botero established himself in New York. Barely thirty, he could rely on youth, talent, and already gained professional recognition in advancing his reputation from that of the child prodigy of Colombian art to that of

[1] Germán Rubiano Caballero, *Enrique Grau*, catalogue of the retrospective exhibition organized by the Centro Colombo-Americano of Bogotá (1983), p. 79.

[2] Galaor Carbonell, "El realismo en la obra de Enrique Grau," in the catalogue of the exhibition held at the Galería San Diego (Bogotá, 1977), p. 3.

a painter of worldwide renown.[1]

Before the move to New York, in the years following the triumph of his *Bridal Chamber* at the Eleventh Salon of National Artists (1958), Botero produced several interesting series of works, chief among them his *Boys from Vallecas* and his *Mona Lisa*s, inspired respectively by celebrated compositions by Velázquez and Leonardo da Vinci. Up to *Bridal Chamber* effects of volume had derived in part from a carefully premeditated arrangement of elements in the composition, which justified either an effect of mobility or a hieratic pose: see, for example the *Apotheosis of Ramón Hoyos* or the 1958 *Miracle of St. Hilarius*. Thereafter, however, the canvas is almost always filled by a single figure, whose humanity seems to exceed the limits of the surface, to which paint is applied in broad, nervous strokes. The resulting monsters have an air of complete satisfaction with, and ignorance of, their grotesque proportions.

During this period the head dominates the picture by its size, while the limbs are drastically curtailed. Clothing explodes like fireworks, enveloping the figure in a gestural interplay of splashes of color, which Botero explained as his flirtation with the school of New York.[2] An excellent example of his work in this period is provided by the *Mona Lisa, Age Twelve* painted in 1959 and acquired by the Museum of Modern Art in New York in 1961. The second version of *Bridal Chamber*, which is now in the collection of the Hirshhorn Museum, dates from 1961, as do other works based on early-Renaissance predellas with which the artist had previously occupied himself. *Tribulations of Sister Angélica* represents a good example of them. If in these compositions Botero seemed to be repeating himself, the same could not be said of the "monsters" produced in the years from 1958 to 1962. The general concept is the same, but the problems posed are solved in different ways, one solution leading to another.

> The paintings and drawings of Fernando Botero are highly personal works, by no means to be confused with the types of figuration that have prevailed on the international scene in recent years. In some respects his art is archaic and provincial in character. It derives more from folk art, from the native tradition, and from the colonial imagery of Colombia than from the neofiguration of the 1950s or any other figurative "ism" of the early part of the century. Botero asserted in 1967: "I represent a protest against modern painting, yet I utilize what lies hidden behind it, treating with irony matters of common knowledge. I paint in a figurative and realistic manner, though not in the humdrum sense of faithfulness to reality. There is not one of my brushstrokes that does not delineate something real--a mouth, a hill, a pitcher, a tree. But what I paint is a reality of my own discovery. You might put it this way: I describe realistically an unreal reality.[3]

Around 1964 Botero began to take a more restful approach to his work. The violent colors employed in the *Boys from Vallecas* disappear; forms are modeled tranquilly in pastel or semineutral shades, reduced by the use of white. Previously the artist had stated:

> Color, however effective it may be, never has the lasting qualities of form. Distortion for me is an assertion of the total sensuality of form, completely void of all humanistic implications.[4]

Dating from this period are the *Still Life* with which the artist won First Prize at the *Intercol Salon of Young*

[1] As a matter of curiosity, it may be noted that at the auction of Latin American art held by Sotheby Park Bernet in November 1983 Botero's *The Musicians* went for $242,000.

[2] Cynthia Jaffee McCabe, *Fernando Botero*, catalogue of the Botero retrospective held at the Hirshhorn Museum in Washington, D.C. (1979), p. 54.

[3] *Historia del arte colombiano* (Barcelona, Salvat Editores, 1975, vol. 7), p. 1539.

[4] Ibid., p. 1544.

Artists[1] organized by the Bogotá Museum of Modern Art for artists under thirty-five, and the version of the El Greco portrait of *Cardinal Niño de Guevara* for which he won an award at the Second Biennial of Córdoba, Argentina.

In keeping with his ideas regarding the importance of form, around 1964 Botero initiated another phase which was to last for approximately ten years. During it he carried to the extreme his concept of the manipulation of form for aesthetic effect. He took a renewed interest in background, elements of which took on the same swollen proportions that had previously been attributes of the human figure alone. In the 1964 composition entitled *The Arnolfinis* (based on the celebrated wedding portrait of Jan van Eyck), brushstrokes have been shortened and color, no longer so exuberantly applied as in the *Mona Lisa*s, yields to the dictates of form. At the same time, elements in the setting--the window, the fruit on the floor whose sole purpose is to provide balance in the composition--undergo expansion, just like the pair of newlyweds. During this same period, Botero did a series of monochrome drawings, subordinating color--in which he had temporarily lost interest--to form.

By the end of the 1970s, Botero's fame was worldwide. In 1966 alone he had one-man shows in West Germany at the Staatliche Kunsthalle in Baden-Baden and the Brusberg Gallery in Hanover, and in the United States at the Milwaukee Art Center. In 1969 he exhibited at the Center for Inter-American Relations in New York, and in 1971 he entered into an exclusive contract with the Marlborough Gallery in that same city. In 1973 he moved to Paris. His career was firmly established, and his painting had achieved the height of its refinement. The bright colors which formerly dominated his canvases had given way to delicate shadings and chiaroscuro suggestive of the baroque masters. An excellent example of this stage of his development is provided by *Alof de Vignacourt, after Caravaggio* (1974), in which Botero imitates the pictorial virtuosity of the great Italian. The artist has said it constitutes his "diploma in manual dexterity." Shortly afterwards, however, Botero began to turn to sculpture, although without completely giving up painting. His three-dimensional compositions confirm the innate interest in form which he had declared early in the 1960s.

During Negret's European years (1950-1955) iron was the material he preferred in creating his sculptures, some of which were included in the Foreign Artists in Paris exhibition held at the Petit Palais shortly before his departure for New York. It was in Manhattan that he "discovered" aluminum, the metal in which he has since worked. Compositions are assemblages of individual parts, screwed and bolted together and painted in black, white, or primary colors, preferably red or blue. Of late he has made more use of yellow.

The most important works Negret did during his first New York years belonged to the series he called *Magic Gadgets*. It alternated with series known as *Watchmen* and *Eclipses*. In executing the last-mentioned, Negret made use of plexiglas, a material he ultimately found unsatisfactory. The *Magic Gadgets* were exhibited at the Fourth São Paulo Biennial in 1957, and the following year they had an individual showing at the National Library in Bogotá, where they met with an enthusiastic critical reception.

> At last we gave a show in Bogotá by a sculptor of world rank--a Colombian sculptor, Edgar Negret. Undoubtedly, much of his recent work requires slow and patient assimilation. The assurance with which he works, however, is evident at first glance. Here we have real works of art, the product of discipline and a clearly defined will. Eminently constructive, they are a valid expression of an epoch--our epoch--as well as of an artist.[2]

Indeed, the *Magic Gadgets* mark the beginning of Negret's artistic maturity.

Negret's European experience--his encounter with the architecture of Gaudí in Barcelona, with the primitive masks in the Museum of Man in Paris, and with the port life of Mallorca--unquestionably had a lasting influence on his artistic perception and sensitivity. The clear references to technology embodied in the *Magic Gadgets* could lead one to view him as a country boy fascinated with New York's mechanical appliances but while, like others of his generation, he felt the pull of assembly-line culture, he was too intelligent to give in to it completely. His

[1] Regional *Esso Salon of Young Artists*, 1964.

[2] Walter Engel, "Edgar Negret," published in the magazine *Plástica*, no. 10 (Bogotá, 1958).

originality consists in the fact that he is not only a man of the Third World who observes and analyzes the changes taking place about him but also an artist for whom the course of aesthetic development cannot be arrested. For Negret self-expression is transmuted into a way of life; the act of creation becomes a declaration of identity with his epoch.

> Early in the 1960s, one notes a new element in Negret's constructions: inner space, created by placing one sheet of folded aluminum against another, either similarly folded or flat. The hollow of which Negret had made use in creating his *Head of the Baptist* [1] recurs with increasing significance in the first pieces belonging to his *Navigators* [2] series and thereafter is never lacking in his compositions. Inner space gives body to the construction and enriches the composition by the contrast between the metallic forms and the transparent ones suggested by the folded aluminum. In the *Navigators* one also notes the presence of repeated elements--modules as it were--which had appeared earlier, though not in such pronounced degree, in the gessos Negret did in 1952 and in the early works he executed in Mallorca. Thanks to these modular forms, the new sculptures take on movement. Such are the elements of the vocabulary which the artist employs coherently and systematically to this day. [3]

Since the 1960s Negret has been asked to participate in the most exclusive of international shows. He was the only Latin American to take part in the *Sculpture from Twenty Nations* exhibition held at the Guggenheim in 1967. There he found himself in the company of the American Alexander Calder, the Englishman Henry Moore, and the Italian Alberto Giacometti. In 1968 he was invited to the Fourth Documenta show in Kassel, West Germany, and represented Colombia at the Thirty-fourth Venice Biennial where he won the David E. Bright Award for Sculpture. In addition he has had one-man shows in leading cities of Europe, North and South America, and the Far East.

Following the *Navigators* series came others entitled *Gemini, Cape Kennedy, Couplings, Bridges, Building Piles, Temple, Columns, Edifices, Towers, Watchtowers,* and *Ladders*. The most recent of his series bear the names *Metamorphoses, The Andes, Labyrinths,* and *Trees*.

> These are emphatically works of art, sculptural creations which follow their own laws in translating the material worlds into forms which, though entirely of the artist's invention, nonetheless relate to contemporary life. [4]

If Negret's sculpture has been characterized as "organic geometry," a description which accords well with its general spirit, then the term "rational geometry," though redundant, might be applied to the work of Ramírez Villamizar.

In many of Ramírez Villamizar's compositions, particularly those executed during the 1970s, the artist has made a rhythmically progressive use of repeated elements; this may be associated with the idea of growth. Negret, once he had fixed on a basic module, developed and refined it in many ways, or permitted it to expand around the axis which controls the "movement" of the piece. In Ramírez Villamizar's case, there is nothing emotional about the development process. It is worked out along rigidly mathematical lines, in arithmetic or geometric progressions, within clearly established limits indicative of the artist's controlling will. The composition has rationally defined proportions which cannot be modified, since any change of scale would be equivalent to a change of concept. Whereas Negret's compositions, thanks to their "organic" character, might freely grow or

[1] *Head of the Baptist* is a 1948 work of Negret done in gesso. It still retains figurative elements, albeit simplified, which conform to the concepts of empty and occupied space traditional in sculpture.

[2] *Navigators* is a series of aluminum sculptures done by Negret in the early 1960s.

[3] Germán Rubiano Caballero, *Escultura colombiana del siglo XX* (Bogotá, Fondo Cultural Cafetero, 1984), pp. 81-82.

[4] Ibid., p. 83.

shrink, Ramírez Villamizar's are perfect from the moment of conception and any weakness would be clearly reflected in a lack of balance.

As has previously been noted, it was in 1958 that Ramírez Villamizar turned from painting to sculpture. The reason for the shift is apparent in the last of his paintings, whose color planes reveal that the artist was obviously thinking along spatial lines leading to three-dimensional expression. Planes conceived as projecting in two-dimensional compositions need to move out, and eventually, in 1958, they separated from the background, the result being the *Golden Relief* done for the Bank of Bogotá. This represented not a transitional but an intermediate stage in the artist's development, the works belonging to the period are clearly conceived and fully realized. The *Golden Relief* was followed by others--the bronze done for the Cúcuta branch of the Bank of the Republic (1963), a work in concrete entitled *Pre-Columbian Serpent* which the artist executed for the Lux soft-drink plant in Cali in 1964, and the *Horizontal Mural* he did in white for the Luis Angel Arango Library in Bogotá between 1962 and 1965.

Along with these wall pieces Ramírez executed a freestanding work, consisting essentially of back-to-back reliefs, entitled *Tribute to the Poet Jorge Gaifán Durán* (1963). This represented the artist's escape from the wall into the realm of three-dimensional space. The plane which forms the backing of the two reliefs projects beyond them at the sides like a frame; one must make a complete circle of the work in order to have a full appreciation of it. It is interesting to compare this composition, in which movement is outer-directed, with ones done at the end of the decade, where movement begins at the horizontal, vertical, or oblique planes that form the outside of the structure and culminates in the inner space which they define. The interrelation of planes, the contrast between solid shapes and empty space, produces in this case an effect of fluidity and dynamism. A good example is furnished by the 1968 composition in plexiglas entitled *Suspended Construction*.

From 1967 to 1974 Ramírez Villamizar resided almost entirely in New York, where he undertook some of his most ambitious projects. At the Tenth São Paulo Biennial (1969) he won one of the prizes in the international category, other prizes being given to the German Erich Hause, the Canadian David Murray, and the Englishman Anthony Caro. Ramirez's monumentally conceived sculptures are generally executed on a large scale. A splendid example is afforded by his *Four Towers* (concrete, 1971) executed in connection with a sculpture symposium sponsored by the University of Vermont. The only Latin American to participate, he had as colleagues Clement Meadmore, Isaac Witkin, and Katsuji Kishida. The module he used in constructing *Four Towers* reappears in *Columnata*, done for Fort Tryon Park in upper Manhattan in 1972, and again in *Sixteen Towers*, erected in 1974 on the eastern heights of Bogotá as the sculptor's gift to that city, where he is now resident.

In 1973 Ramírez Villamizar did *Hexagon* for the Beach Channel High School in New York, and *From Colombia to John F. Kennedy*, a commission executed for the grounds of the Kennedy Center for the Performing Arts in Washington, D.C. These compositions anticipate the group with which he represented Colombia at the Thirty-seventh Venice Biennial in 1976.

In works done since 1976, Ramírez Villamizar places new emphasis on oblique elements. The titles he gives his compositions--*Polychromed Insects, Snail-Bird, Snail-Flower, Crab-Construction*--reflect the organic world. Organic though they may be in conception, they are fully rational in execution.

> Aspiring to situate sculpture in the human milieu, Ramírez Villamizar has simplified his work to an ever greater degree. In his most recent works, inner space has generative power: it creates forms and is itself form. Relations between parts are increasingly close and economical. By virtue of the space they enclose, the constructions have a great inner dynamism; however, they remain purposely calm and static.[1]

Final Observation

In evaluations of twentieth-century art, Latin America tends to be neglected. It is conveniently forgotten that,

[1] Marta Traba, *Eduardo Ramírez Villamizar*, catalogue of the exhibit held at the Galería Témpora (Bogotá, 1981).

for better or for worse, it plays a role in world history and therefore its accomplishments merit the same consideration as those of other parts of the globe. Only with the passage of time will it become apparent whether the political, economic, and social ups and downs suffered by Latin America have left it in a situation of inferiority with respect to areas more favored by fortune. Many will perhaps be surprised to discover that, despite the unfavorable surroundings from which they have sprung, Latin American artists have attained a place of honor alongside their colleagues from the industrialized nations, their achievement being all the more laudable in consequence.

The present development of Colombian art could not be understood had not Botero, Grau, Negret, Obregón, and Ramírez Villamizar appeared in the 1950s. Similarly, their accomplishment cannot be comprehended except in relation to the special circumstances of Colombian life and the history of their times. Their work is more than material for retrospectives and the gush of praise that accompanies them. These five artists have been the teachers of two younger generations, whose members admire their achievements and analyze carefully the reasons for their occasional failures.

The 1950s were the last period in which societies were confronted by group trends with which they were slow to identify. Today the artist is free to create models entirely of his own invention. Art should, however, satisfy a spiritual necessity, reflect a way of life, and enrich the viewer's visual perception. From this standpoint there is no need to explain why the work of the five Colombian masters is or is not contemporary. It should merely be accepted as the contribution of a Third World nation to twentieth-century visual art.

If we free ourselves of false expectations and customary prejudices with respect to Latin America, we shall arrive at a true understanding of the work of these and many other creative spirits of that region. Receiving it with civilized intelligence, we may even come to enjoy it. --*Félix Angel*, Exhibition Curator. Translated from Spanish by Ralph Dimmick.

EXHIBITION LIST

Fernando Botero

Oils on Canvas

1. *El arzobispo dormido (The Sleeping Archbishop)*, 1957, 24.1 x 88.9 cm.
 Coll. Mr. and Mrs. MacKenzie Gordon, Washington, D.C.
2. *Los Arnolfini 3 (The Arnolfini 3)*, 1964, 96.5 x 99.1 cm.
 Coll. Mr. and Mrs. MacKenzie Gordon, Washington, D.C.
3. *Tribulaciones de Sor Angélica (Tribulations of Sister Angélica)*, 1961, 52.7 x 274.3 cm.
 Coll. Mrs. Mimina Carrero, Bethesda, Maryland
4. *Camera degli sposi: homenaje a Mantegna (Bridal Chamber: Homage to Mantegna) II*, 1961,
 231.5 x 260.3 cm. Coll. Hirshhorn Museum and Sculpture Garden, Smithsonian Institution, Washington, D.C.

Enrique Grau

Oils on Canvas

5. *Homenaje a Mary Reyes (Tribute to Mary Reyes)*, 1962, 147 x 165 cm. Coll. Banco del Estado, Bogotá
6. *Rita 10:30 A.M.*, 1971, 130 x 200 cm. Private collection
7. *Rita 5:30 P.M.*, 1981, 170 x 140 cm. Aberbach Fine Arts, New York

Edgar Negret

Sculptures

8. *Fetish*, 1959, painted aluminum and wood, 76.2 x 42.5 x 11.5. Coll. of the artist, Bogotá
9. *Torre (Tower)*, 1975, painted aluminum, 88 x 65 x 35 cm. Coll. of the artist, Bogotá
10. *Laberinto (Labyrinth)*, 1984, painted aluminum, 65 x 89 x 65 cm. Coll. of the artist, Bogotá

Alejandro Obregón

Oils

11. *El velorio: el estudiante muerto (The Wake: The Dead Student)*, 1956, oil on canvas, 140 x 175 cm.
 Coll. Museum of Modern Art of Latin America (OAS), Washington, D.C.
12. *4 de mayo (May 4th)*, 1955, oil on wood, 25.4 x 110 cm. Coll. of Ms. Marcela Lleras, Washington, D.C.
13. *Memorias de Grecia (Memories of Greece)*, 1974, oil on wood, 134.5 x 142.5 cm.
 Coll. Banco de Colombia, Bogotá

Eduardo Ramírez Villamizar

Sculptures

14. *Homenaje a Vivaldi (Tribute to Vivaldi)*, 1963, wood relief, 120 x 100 cm. Coll. of the artist, Bogotá
15. *Pequeño pectoral precolombiano (Small Pre-Columbian Pectoral)*, 1970, wood, 68 x 68 x 82 cm.
 Coll. of the artist, Bogotá
16. *Construcción blanca (White Construction)*, 1975, welded iron, 110 x 178 x 130 cm. Coll. of the artist, Bogotá

LENDERS TO THE EXHIBITION

Joachim Jean Aberbach, New York
Mr. and Mrs. Miguel Aranguren, Arlington, Virginia
Mrs. Mimina Carrero, Consul of Venezuela in Baltimore, Bethesda, Maryland
Mr. and Mrs. MacKenzie Gordon, Washington, D.C.
Ms. Marcela Lleras, Washington, D.C.
Mr. Edgar Negret
Mr. Eduardo Ramírez Villamizar
One anonymous lender
Banco de Colombia, Bogotá
Banco del Estado, Bogotá
Hirshhorn Museum and Sculpture Garden, Smithsonian Institution, Washington, D.C.
Museum of Modern Art of Latin America, Organization of American States, Washington, D.C.

ABOUT THE ARTISTS

FERNANDO BOTERO

Botero was born in Medellín, the capital of the Department of Antioquia, in 1932. After a brief period of study at the Institute of Fine Arts in that city, he moved in 1951 to Bogotá, where he became active in art circles and soon won recognition for his avant-garde painting. From 1952 to 1955 he studied in Madrid and Florence. After a short sojourn in Mexico in 1956, he returned to Bogotá and taught at the School of Fine Arts of the National University from 1958 to 1960. He moved to New York in 1961, residing there until 1973. That year he transferred his studio to Paris, his present home. It was in Paris that he initiated his career as a sculptor in 1976.

Botero presents the unusual case of an artist who at a very early age developed a style of his own which established him firmly both on the local art scene and abroad. In 1952, at the age of twenty, he won Second Prize for Painting at the Ninth National Salon in Bogotá. He had a one-man show at the headquarters of the Organization of American States in Washington, D.C., in 1957. A year later he won the First Prize for Painting at the Eleventh National Salon in Bogotá, and when he was twenty-nine the Museum of Modern Art in New York acquired his *Mona Lisa, Age Twelve*, one of the more important of his compositions dating from the years 1958-1962. He won the Guggenheim International Award for Colombia in 1960, he took First Prize at the *Intercol Salon of Young Artists* in Bogotá in 1964, and he received the Second Prize for the Western Hemisphere at the *Esso Salon of Young Artists* in Washington, D.C., in 1965.

Among Colombian collections in which works by Botero can be found are those of the Museum of Antioquia in Medellín, the National Museum and the Museum of Modern Art in Bogotá, and the Tertulia Museum of

Modern Art in Cali. Institutions in the United States which own works of his are the Museum of Modern Art and the Solomon R. Guggenheim Museum in New York, the Hirshhorn Museum and Sculpture Garden and the Museum of Modern Art of Latin America in Washington, D.C., the Rhode Island School of Design in Providence, the Lowe Art Museum of the University of Miami in Coral Gables, and the Baltimore Museum of Art. --*F.A.*

ENRIQUE GRAU

Grau was born in Cartagena, the capital of the Department of Bolívar, in 1920. At the age of twenty he received First Honorable Mention for Painting at the First National Salon in Bogotá (1940). He studied from 1940 to 1943 at the Art Students League in New York and in 1955 and 1956 at the Academy of San Marco in Florence. He taught at the School of Fine Arts of the National University of Bogotá from 1951 to 1952 and again from 1957 to 1961, and at the School of Fine Arts of the University of the Andes from 1961 to 1963. He was the head of the Set Design Department of Colombian National Television from 1954 to 1958, years in which he also served as artistic adviser to the International Petroleum Company (Intercol).

Enrique Grau has engaged actively in painting, sculpture, drawing, engraving, stage design, and cinematography and has won distinction in nearly all of those fields. In 1957 he had a one-man show at the headquarters of the Organization of American States and won First Prize for Painting at the Tenth National Salon in Bogotá. The following year he took First Prize for Drawing at the Eleventh Salon. His setting for Sophocles' *Oedipus Rex* won First Prize at the Third Theater Festival in Cali, and at the Fifth Festival he took Second Prize with his setting for Jean Giraudoux's *Madwoman of Chaillot*. He has painted eight murals and produced five films. His portraits, in which the personality of the subject is captured in a style peculiarly his own, constitute a picturesque gallery of some of the most singular figures in the life of Bogotá.

Among Colombian institutions in which he is represented are the Museum of Antioquia in Medellín, the National Museum and the Museum of Modern Art in Bogotá, and the Tertulia Museum of Modern Art in Cali. He is also represented in the collection of the Museum of Modern Art of Latin America in Washington, D.C.

Enrique Grau currently lives in New York, where he is working in sculpture. --*F.A.*

EDGAR NEGRET

Negret was born in Popayán, capital of the Department of Cauca, in 1920. He studied at the School of Fine Arts in Cali from 1938 to 1943, but it was back home in Popayán that he established contact with the Spanish sculptor Jorge de Oteiza, who introduced him to the work of Henry Moore and other contemporary sculptors. In 1949 Negret visited the United States for the first time, after which he went to Europe, residing for varying periods in Barcelona, Paris, and Palma de Mallorca. He returned to New York in 1955 and set up a studio there. At that time he established relations with Ellsworth Kelly, Louise Nevelson, and Robert Indiana. In 1958 he received a UNESCO fellowship and taught at the New School for Social Research in New York. He returned to Colombia in 1963 but did not take up permanent residence in Bogotá till 1973. His ceaseless artistic activity has taken him to almost all quarters of the globe.

Negret is considered the introducer of modern sculpture in Colombia, just as Obregón is held to be the inaugurator of modern painting there. His first abstract compositions date back to the mid 1940s. Among the honors he had received are the Silver Medal of the Eighth São Paulo Biennial (1965), the Grand Prize of the Nineteenth National Salon in Bogotá (1967), and the David E. Bright Award for Sculpture at the Thirty-fourth Venice Biennial.

Works by Negret to be found in public locations are *Watchmen* (gardens of the Presidential Palace) and *Dynamism* in Bogotá, *Bridge* (gift of Colombia to Venezuela) in Caracas, and *Tower* (Cerro Nutibara Sculpture Park) in Medellín.

Colombian institutions in whose collections Negret is represented are those of the Museum of Antioquia in Medellín, the National Museum and the Museum of Modern Art in Bogotá, and the Tertulia Museum of Modern Art in Cali. His works are also to be found in the Museum of Modern Art in New York and the Museum of Modern Art of Latin America in Washington, D.C. --*F.A.*

ALEJANDRO OBREGON

Obregón was born in Barcelona, Spain, in 1920, to a Colombian father and a Spanish mother. When he was six the family moved to Barranquilla. In 1939 he studied at the school of the Museum of Fine Arts in Boston. Starting in 1944 he began to exhibit periodically at shows and in galleries in Bogotá. He taught at the School of Fine Arts in Bogotá and served as director of that institution in 1948 and 1949. He lived in France from 1949 to 1955, when he returned to Colombia. He first established residence in Bogotá, then moved to Barranquilla, where he served briefly as director of the local school of fine arts. He now lives in Cartagena.

In the view of many critics and historians of Latin American art, Obregón is the key figure in the development of modern Colombian painting, which revolves around his personality and work. He has received many distinctions, among them a prize at the Third Hispanic American Biennial of Barcelona (1955); First Prize at the *Gulf Caribbean Art Exhibition* in Houston, Texas (1956); the Guggenheim International Award for Colombia, New York (1956); Honorable Mention at the Fifth São Paulo Biennial (1959), First Prize at the Inter-American Salon in Barranquilla (1960), First Prize for Painting at the Fourteenth National Salon, Bogotá (1962), First Prize for Painting at the Eighteenth National Salon, Bogotá (1966), First Prize at the Second American Biennial of Córdoba, Argentina (1964), and the Francisco Matarazzo Grand Prize for Latin America at the Ninth São Paulo Biennial (1967).

Examples of Obregón's work can be found in such Colombian institutions as the Museum of Antioquia in Medellín, the National Museum and the Museum of Modern Art in Bogotá, and the Tertulia Museum of Modern Art in Cali. In the United States he is represented in the collections of the Museum of Modern Art and the Solomon R. Guggenheim Museum in New York, the Dallas Museum of Art, the Museum of Fine Arts in Houston, and the Museum of Modern Art of Latin America in Washington, D.C. He is also represented in the collection of the Institute of Hispanic Culture in Madrid, Spain. *--F.A.*

EDUARDO RAMIREZ VILLAMIZAR

Ramírez was born in Pamplona, in the Department of Norte de Santander, in 1923. In 1940 he began the study of architecture, but gave it up in 1943 for decorative arts. From 1950 to 1952 he traveled in the United States and Europe. After working in Colombia from 1952 to 1954, he returned to Europe, where he remained until 1956. He taught at the School of Fine Arts of the National University in Bogotá from 1957 to 1959 and from 1964 to 1965. In 1960 he taught painting in the Department of Art Education at New York University. In 1971 he was the sole Latin American invited to participate in the International Symposium on Sculpture held at the University of Vermont. He has lived in Bogotá since 1974.

Ramírez Villamizar started out as a painter, but in 1958 he began work in relief and in 1964 he turned entirely to sculpture. Among honors he has won are the Guggenheim International Award for Colombia, New York (1958), First Prize for Painting at the Twelfth National Salon, Bogotá (1959), Second International Prize at the Tenth São Paulo Biennial (1969), and First Prize for Sculpture at the Eighteenth National Salon, Bogotá (1966).

Works of Ramírez Villamizar to be found in public locations are the *Golden Relief* in the Bank of Bogotá; the *Horizontal Mural* in the Luis Angel Arango Library in Bogotá; a free-standing sculpture and three reliefs in the American Bank and Trust Company in New York; a reinforced concrete sculpture in Fort Tryon Park in Manhattan; the metal sculpture entitled *Hexagon* at the Beach Channel High School in New York; and *From Colombia to John F. Kennedy* at the John F. Kennedy Center for the Performing Arts in Washington, D.C.

Works by Ramírez Villamizar can also be found in the collections of the following institutions: the Museum of Antioquia in Medellín, the National Museum and the Museum of Modern Art in Bogotá, the Tertulia Museum of Modern Art in Cali (all in Colombia); the Museum of Modern Art in New York and the Museum of Modern Art of Latin America in Washington, D.C. (in the United States); and the Museum of Contemporary Art in São Paulo, Brazil. *--F.A.*

CHRONOLOGY

1920 Enrique Grau is born in Cartagena, Colombia.
 Edgar Negret is born in Popayán, Colombia.

 Alejandro Obregón is born in Barcelona, Spain, to a Colombian father and a Spanish mother.

1923 Eduardo Ramírez Villamizar is born in Pamplona, Colombia.

1926 The Obregón family moves to Barranquilla, Colombia.

1930 Obregón studies at Stony Hurst School, Liverpool, England, remaining until 1932.

1932 Fernando Botero is born in Medellín, Colombia.

1938 Negret studies at the School of Fine Arts in Cali, Colombia.

1939 Obregón studies at the Museum of Fine Arts School, Boston, Massachusetts.

1940 Grau wins Honorable Mention at the First Salon of National Artists. He travels to the United States on a government scholarship and studies at the Art Students League in New York until 1943.

 Obregón moves to Spain and serves as Colombian vice-consul in Barcelona until 1944.

 Ramírez Villamizar begins the study of architecture at the National University of Colombia, in Bogotá.

1944 Negret makes contact in Popayán with the Spanish sculptor Jorge de Oteiza.

1945 Grau, Negret, Obregón, and Ramírez Villamizar are all active in Bogotá art circles, exhibiting at salons and in commercial galleries.

1947 The First Salon of Young Colombian Artists permits appreciation of the advances made up to that time by new trends in Colombian art.

1948 Botero participates in his first group show, the *Exhibit of Antioquian Painters* held in Medellín.

 Obregón is named director of the School of Fine Arts in Bogotá, remaining in the post until 1949.

 Grau, Negret, Obregón, and Ramírez Villamizar have one-man shows under the auspices of the Colombian Society of Architects.

1949 Obregón moves to Alba, near Avignon, France.

1950 Grau, Negret, and Ramírez Villamizar exhibit together at the New School for Social Research in New York, in a show entitled *Sculpture and Painting of Colombia*.

 Grau begins to teach at the School of Fine Arts of the National University in Bogotá and continues to do so until 1952.

 After a visit to New York, Edgar Negret goes to Europe. He remains there until 1955, residing in Barcelona, Mallorca, and Paris, where he participates in the Salon des Réalités Nouvelles.

 Ramírez Villamizar visits France and remains until 1952.

1951 Botero moves to Bogotá and has his first one-man show at the studio-gallery of the photographer Leo Matiz.

1952 Botero receives Second Prize for Painting at the Ninth Salon of National Artists in Bogotá. He leaves for Europe and, after a visit to Barcelona, studies at the Academy of San Fernando in Madrid.

1953 Botero moves to Italy, where he studies painting and the technique of fresco at the Academy of San Marco in Florence.

1954 Grau becomes director of the Set-Design Department of Colombian National Television, a post he retains until 1958.

 Ramírez Villamizar travels again to New York, Paris, Madrid, and Rome.

1955 Botero returns to Bogotá and exhibits some of the works he had done in Europe.

 Grau visits Florence, where he studies engraving and the technique of fresco at the Academy of San Marco until 1956.

 Negret, who since 1950 has frequently exhibited together with Ramírez Villamizar in the United States and Europe, takes part in the group show Foreign Artists in Paris, held at the Petit Palais. He then goes to New York, where his work figures in the *New Acquisitions of the Museum of Modern Art* exhibit.

 Having returned to Colombia from Europe, Obregón has a one-man show in January at the General Secretariat of the Organization of American States.

1956 Botero visits Mexico.

 Grau exhibits at the Asterisco Gallery in Rome and executes a mural for the main building of the Intercol Refinery at Mamonal, Colombia.

 Negret has a one-man show of sculpture in January at the General Secretariat of the Organization of American States. He participates in the Venice Biennial.

 Obregón moves to Barranquilla and executes two murals, one of them, *Symbols of Barranquilla*, for the Banco Popular. He receives the prize for Colombia at the Guggenheim International in New York and wins First Prize in the *Gulf Caribbean Art Exhibition* at the Houston Museum of Fine Arts. Other participants in the latter exhibition are Botero, Grau, Negret, and Ramírez Villamizar.

 In September Ramírez Villamizar has a one-man show of paintings at the General Secretariat of the Organization of American States in Washington, D.C., followed by another in New York. One of his works is acquired by the New York Museum of Modern Art. He executes a mural for the Bavaria

Building in Bogotá.

An exhibition entitled *From Latin America*, organized by the Institute of Contemporary Art in Washington, D.C., is presented in Gallery 41 of the Corcoran Gallery of Art. Included in the show are works by Negret, Obregón, and Ramírez Villamizar.

An exhibition entitled *Five Avant-Garde Painters* opens in Bogotá. The five are Botero, Grau, Obregón, Ramírez Villamizar, and Guillermo Wiedemann.

1957 Botero has a one-man show at the General Secretariat of the Organization of American States. In October he wins Second Prize for Painting at the Tenth Salon of National Artists in Bogotá.

Enrique Grau begins to teach at the School of Fine Arts of the National University in Bogotá, an activity he continues until 1963. He has a one-man show at the General Secretariat of the Organization of American States and wins First Prize for Painting at the Tenth Salon of National Artists in Bogotá.

Works by Grau, Obregón, and Ramírez Villamizar are included in the Colombian representation at the Fourth São Paulo Biennial, a composition by Negret forms part of a selection organized for presentation at the same event by the General Secretariat of the Organization of American States.

The exhibition *Negret and Youngerman* takes place at the Gres Gallery in Washington, D.C.

Ramírez Villamizar begins to teach classes at the School of Fine Arts in Bogotá, continuing this activity until 1959.

1958 Works by Grau, Obregón, and Ramírez Villamizar are presented at the Pittsburgh International, sponsored by the Carnegie Institute in that city.

Fernando Botero wins First Prize for Painting at the Eleventh Salon of National Artists in Bogotá. He has a one-man show at the Gres Gallery in Washington, D.C. He begins to teach at the School of Fine Arts of the National University in Bogotá and continues to do so until 1960.

Grau participates in the First Inter-American Biennial in Mexico City, and the Venice Biennial. He executes a fresco for the Agricultural Loan Bank in Cartagena, Colombia. He wins First Prize for Drawing at the Eleventh Salon of National Artists in Bogotá.

Negret has an exhibit at the National Library in Bogotá covering his first fifteen years of activity and including his most recent compositions *Magic Gadgets*.

Ramírez Villamizar wins the Guggenheim International Award for Colombia. He begins work on his *Golden Relief* for the headquarters of the Bank of Bogotá.

1959 Botero's composition *Apotheosis of Ramón Hoyos*, classified as *hors concours*, is exhibited at the Twelfth Salon of National Artists.

Negret has a one-man show at the David Herbert Gallery in New York.

Obregón returns to Bogotá, where he executes a mural for the Luis Angel Arango Library.

Ramírez Villamizar wins First Prize for Painting at the Twelfth Salon of National Artists in Bogotá.

Colombia is represented at the Fifth São Paulo Biennial by Botero, Obregón, Ramírez Villamizar, and Guillermo Wiedemann. Obregón wins an Honorable Mention.

The exhibition *South American Art Today* at the Dallas Museum of Fine Arts includes works by Botero, Grau, Negret, Obregón, and Ramírez Villamizar.

1960 Botero executes a mural for the Central Mortgage Bank in Medellín, Colombia. He has his second one-man show at the Gres Gallery, in Washington, D.C. He takes up residence in New York and wins the Guggenheim International Award for Colombia.

The show *3500 Years of Colombian Art* opens in Miami, Florida. It travels afterward to Europe, where it is presented in Madrid, Rome, and Stockholm, among other cities. Included in the show are works by Botero, Grau, Negret, Obregón, and Ramírez Villamizar.

At the Inter-American Salon in Barranquilla, Colombia, Obregón wins First Prize and Grau takes second place.

1961 Botero has a one-man show at the Callejón Gallery in Bogotá. The Museum of Modern Art in New York acquires his *Mona Lisa, Age Twelve*.

Enrique Grau participates in the Sixth São Paulo Biennial.

Edgar Negret participates in the Second International Exposition of Contemporary Sculpture at the Rodin Museum, in Paris.

Alejandro Obregón participates in the *Latin America: New Departures* show organized by the Institute of Contemporary Art in Boston, Massachusetts. He has one-man show in Bogotá, Cali, and Barranquilla, all in Colombia, and in São Paulo, Brazil.

Marta Traba founds the Museum of Modern Art in Bogotá.

1962 Grau obtains the Ministry of Education Prize at the Fourteenth Salon of National Artists in Bogotá. On the same occasion Ramírez Villamizar receives the sole Prize for Sculpture and Obregón wins First Prize

for Painting with *Violence*.

Negret has a one-man show at the Luis Angel Arango Library in Bogotá.

Obregón is named director of the School of Fine Arts of Barranquilla, a post he retains until 1963.

1963 Grau, Obregón, Ramírez Villamizar, and a group of other young artists represent Colombia at the Seventh São Paulo Biennial.

Grau has one-man shows in Cali and Medellín in Colombia and in Panama City.

Negret wins the Sculpture Prize at the Fifteenth Salon of National Artists in Bogotá.

Obregón has a one-man show in Milan, Italy, and travels in Europe for several months.

1964 Botero wins First Prize at the *Intercol Salon of Young Artists* in Bogotá, the regional event in the *Esso Salon of Young Artists*, a competition sponsored by what is now the Exxon Corporation. The final stage of the competition takes place the following year in Washington, D.C., with the co-sponsorship of the General Secretariat of the Organization of American States. On that occasion Botero wins the Second Prize for the Western Hemisphere.

Obregón paints a mural for the Bogotá branch of the Commercial Bank of Antioquia. He wins First Prize at the Second American Biennial in Córdoba, Argentina.

The General Secretariat of the Organization of American States produces the film *Alejandro Obregón Paints a Mural*.

Ramírez Villamizar has a one-man show at the Graham Gallery in New York. He receives the Prize for Sculpture at the Sixteenth Salon of National Artists in Bogotá and is included in the *Sculpture for the Wall* exhibition at the Solomon R. Guggenheim Museum in New York.

1965 Works by Fernando Botero and Obregón are included in the show entitled *The Emergent Decade*, held at the Solomon R. Guggenheim Museum in New York.

Negret is the sole representative of Colombia at the Eighth São Paulo Biennial, where he wins the Silver Medal.

Negret and Ramírez Villamizar have a joint exhibition at the Graham Gallery in New York.

Obregón executes a mural for the branch of the National City Bank in Barranquilla, Colombia.

1966 Botero has one-man shows in West Germany at the Staatliche Kunsthalle in Baden-Baden, at the Buchholz Gallery in Munich, and at the Brusberg Gallery in Hanover, and in the United States at the Milwaukee Art Center.

Works by Botero, Grau, Obregón, and Ramírez Villamizar are included in the *Art of Latin America since Independence* exhibition organized for presentation at Yale University, New Haven, Connecticut.

Obregón receives First Prize for Painting at the Eighteenth Salon of National Artists in Bogotá and First Prize at the Cali Art Festival, Cali, Colombia.

Ramírez Villamizar wins First Prize for Sculpture at the Eighteenth Salon of National Artists. He has a one-man show at the Graham Gallery in New York.

1967 Works by Grau are included in group shows held in Manchester, New Hampshire, and at Brandeis University, Massachusetts.

Negret is invited to participate in the *Sculpture of Twenty Countries* exhibit at the Solomon R. Guggenheim Museum, in New York. At the National Salon in Bogotá, which had done away with awards for individual genres, he wins the Grand Prize with his *Cape Kennedy*. He has one-man show in Edinburgh and London in the United Kingdom, and is represented in the group show *Painting and Sculpture from the Nelson Rockefeller Collection* presented at the Baltimore Art Museum.

Obregón represents Colombia at the Ninth São Paulo Biennial. He is honored with a room of his own and wins the Francisco Matarazzo Grand Prize for Latin America. He executes a mural for the Agricultural Loan Bank in Bogotá and has a one-man show at the Luis Angel Arango Library in the same city.

Ramírez Villamizar takes part in group shows at the Museum of Modern Art and the Museum of Contemporary Crafts in New York. He executes a sculpture and three reliefs for the American Bank and Trust Company in the same city.

1968 Grau does a mural for the Government Palace in Montería, Colombia.

Negret represents Colombia at the Thirty-fourth Venice Biennial and is awarded the David E. Bright Prize for Sculpture by unanimous decision of the judges. He is invited to participate in the Fourth Documenta exhibition in Kassel, West Germany, and takes part in group shows held at the Art Gallery of Ontario, the National Gallery of Canada in Ottawa, and the Montreal Museum of Fine Arts.

Obregón takes up residence in Cartagena.

The Center for Inter-American Relations of New York, sponsors a one-man show of works by Ramírez Villamizar.

1969 The Center for Inter-American Relations of New York presents a one-man show of works by Botero, who exhibits that same year at the Claude Bernard Gallery in Paris.

Works by Grau are included in exhibits of Latin American art held at the Carrol Reece Museum in Johnson City, Tennessee, and at the Museum of Art of the University of Oklahoma.

Negret exhibits at the Bonino Gallery in New York.

Ramírez Villamizar represents Colombia at the Tenth São Paulo Biennial, where he is honored with a room of his own and wins the Second International Prize. He exhibits at the Buchholz Gallery in Munich.

1970 Botero has a retrospective at the Staatliche Kunsthalle in Baden-Baden, and the exhibit is circulated to four other German museums.

Work by Grau is presented in the Colombian Pavilion at the World's Fair in Osaka, Japan.

Edgar Negret has a one-man show at the Stedelijk Museum in Amsterdam.

The Center for Inter-American Relations of New York sponsors a one-man show of works by Obregón.

1971 Negret exhibits at the Buchholz Gallery in Munich and the Städtische Kunsthalle in Düsseldorf, West Germany. The Bogotá Museum of Modern Art organizes a retrospective of his work from 1956 to date.

Ramírez Villamizar is the sole Latin American invited to participate in the Second International Symposium on Sculpture sponsored by the University of Vermont. While there he executes a large-scale concrete sculpture, *Four Towers*, located on a freeway.

1972 Botero has a one-man show at the Marlborough Gallery in New York and opens a studio in Paris.

The Bogotá Museum of Modern Art presents a retrospective of the work of Ramírez Villamizar.

1973 The Bogotá Museum of Modern Art presents a retrospective of the work of Grau.

The Museum of Fine Arts of Caracas, Venezuela, presents a retrospective of the work of Negret.

Ramírez Villamizar does a large-scale sculpture in concrete for Fort Tryon Park in New York City and executes a composition in metal, *From Colombia to John F. Kennedy*, which constitutes the Colombian government's gift to the John F. Kennedy Center for the Performing Arts in Washington, D.C. He executes *Hexagon*, a sculpture in metal, for the Beach Channel High School in New York.

1974 Botero is honored with a small retrospective organized by UNESCO's Pilot Public Library for Latin America in Medellín, Colombia.

Negret has one-man shows in Puerto Rico, at the Bonino Gallery in New York, and at the Corcoran Gallery of Art in Washington, D.C.

The Museum of Modern Art of Bogotá presents a retrospective of the work of Obregón.

1975 Obregón is honored with a small retrospective at the UNESCO's Pilot Public Library for Latin America in Medellín, Colombia.

1976 The Museum of Modern Art of Latin America opens in Washington, D.C., as a tribute of the Organization of American States to the United States of America upon the occasion of the bicentennial of its independence. Included in the Museum collection are works by Grau, Negret, Obregón, and Ramírez Villamizar.

The Museum of Fine Arts of Caracas, Venezuela, presents a retrospective of the work of Botero.

The Center for Inter-American Relations of New York presents a retrospective of the work of Negret.

Ramírez Villamizar represents Colombia at the Thirty-seventh Venice Biennial.

1977 Botero presents the Museum of Antioquia in Medellín, Colombia, with sixteen works from his personal collection, covering the years 1958-1977. The Museum names the room in which they hang for the artist's son, Pedro Botero, who had died in an accident in 1974.

Grau exhibits his most recent work at the San Diego Gallery in Bogotá.

Negret is honored with a small retrospective at UNESCO's Pilot Public Library for Latin America in Medellín, Colombia.

1978 Ramírez Villamizar has a one-man show at the Museum of Fine Arts in Caracas, Venezuela.

1979 The Hirshhorn Museum and Sculpture Garden in Washington, D.C., presents a retrospective of the work of Botero.

The Bogotá Museum of Modern Art presents the exhibition *Twenty-five Years Afterwards*, which includes works by Negret, Robert Indiana, Jack Youngerman, Louise Nevelson, and Ellsworth Kelly.

1982 Grau has a one-man show at the Aberbach Fine Arts Gallery in New York.

1983 The Museum of Modern Art of Latin America in Washington, D.C., presents an exhibit of recent works by Obregón. He does a mural on the flora and fauna of Colombia for United Nations Headquarters in New York.

1984 Botero presents the Museum of Antioquia in Medellín, Colombia, with fifteen sculptures in different techniques, taken from his personal collection. They are exhibited in a special room which bears his name.

The National Museum in Bogotá inaugurates the first phase of its Hall of Masters, featuring the most

representative figures in Colombian Art. Among them are Botero and Obregón.

1985 The Museum of Modern Art of Latin America in Washington, D.C., organizes an exhibition of works of Botero, Grau, Negret, Obregón, and Ramírez Villamizar as a tribute to their accomplishment. The show is presented under the auspices of the government of Colombia and the General Secretariat of the Organization of American States.

SELECTED BIBLIOGRAPHIES

Monographs and Books

Arciniegas, Germán. *Fernando Botero*. Translated from Spanish by Gabriela Arciniegas. New York: Abrams, 1977.

Barr, Alfred, Jr. *Painting and Sculpture in The Museum of Modern Art, 1929-1967*. New York, 1977.

Bode, Ursula. *Fernando Botero: Das Plastisch Werk*. Catalogue. Hanover: Galerie Brusberg, 1978.

Carbonell, Galaor. *Negret, las etapas creativas*. Medellín: Fondo Cultural Cafetero, Editorial Colina, 1976.

Catlin, Stanton L., and Grieder, Terence. *Art of Latin America Since Independence*. Catalogue of exhibition sponsored by Yale University and University of Texas at Austin. New Haven: Yale University Press, 1966.

Compañía Central de Seguros. *Arte y artistas de Colombia*. Bogotá, 1977.

Fundación Banco Exterior. *Pintado en Colombia*. Catalogue. Madrid, 1984.

Gallwitz, Klaus. *Botero*. Catalogue. Munich: Galerie Buchholz, 1970.

Litografía Arco. *Alejandro Obregon*. Bogotá, 1982.

McCabe, Cynthia Jaffee. *Fernando Botero*. Catalogue of exhibition held at the Hirshhorn Museum and Sculpture Garden, Smithsonian Institution, Washington, D.C.: Smithsonian Institution Press, 1979.

Messer, Thomas M. *The Emergent Decade: Latin American Painters and Painting in the 1960's*. Artists' profiles in text and pictures by Cornell Capa. Catalogue of exhibition prepared under the auspices of the Cornell University and The Solomon R. Guggenheim Museum. Ithaca: Cornell University Press, 1966.

Ortega Ricaurte, Carmen. *Diccionario de artists en Colombia*, 2nd ed. Bogotá: Ediciones Plaza & Janés Ltda., 1979.

Panesso, Fausto. *Los intocables*. Bogotá: Ediciones Alcaraván, 1975.

Rivero, Mario. *Botero*. Barcelona: Ediciones Plaza & Janés Ltda., 1973.

_____. *Los de ayer y los de hoy*. Bogotá: Stamato Editores, 1982.

Rubiano Caballero, Germán. *Enrique Grau*. Catalogue. Bogotá: Centro Colombo-Americano, Fondo Cultural Cafetero and Arte en Colombia, 1983.

_____. *Escultura colombiana del siglo XX*. Bogotá: Ediciones Fondo Cultural Cafetero, No. 17, 1983.

Salvat Editores. *Historia del arte colombiano*. 7 vols. Barcelona, 1975.

Seguros Bolívar. *Alejandro Obregón*. Bogotá: Litografía Arco, 1979.

Traba, Marta. *Dos décadas vulnerables en las artes plásticas latinoamericanas, 1950-1970*. Mexico City: Siglo Veintiuno Editores, 1973.

_____. *Art in Latin America Today: Colombia*. Washington, D.C.: Pan American Union, 1959.

_____. *Seis artistas contemporáneos colombianos*. Bogotá: Editorial Alberto Barco, 1963.

_____. *Historia abierta del arte colombiano*. Cali: Ediciones Museo La Tertulia, 1974.

_____. *Mirar en Bogotá*. Bogotá: Biblioteca Básica Colombiana, Colcultura (Instituto Colombiano de Cultura), 1976.

Exhibition Catalogues and Periodicals

Ahlander, Leslie Judd. "Beautiful Group Exhibition at Gres." *Washington Post and Times Herald* (Washington, D.C.), June 7, 1959, sec. E, p. 7.

Barnitz, Jacqueline. "Botero: Sensuality, Volume, Colour." *Art and Artists* 5 (December 1970).

Canaday, John. "Fernando Botero." *New York Times*, March 29, 1969, sec. 1, p. 31.

Carbonell, Galaor. "El realismo en la obra reciente Enrique Grau." *Grau, obra reciente*. Catalogue. Bogotá: Galería San Diego, 1977.

Carli, Enzo. Text to the invitation for the opening of the exhibition *Enrique Grau*. Rome: Galleria L'Asterisco, 1956.

Catlin, Stanton L. *Ramírez*. Catalogue. New York: Center for Inter-American Relations, 1968.

Dietrich, Mahlow. *Kolumbianische Kunst der Gegenwart*. Catalogue. Baden-Baden, 1962.

Gerrit, Henry. "Reviews and Previews: Fernando Botero." *Art News* 71 (March 1972): 12.

Gómez-Sicre, José. "El Primer Salón Intercol." *Lámpara* (Bogotá) 10 (November 1964): 2-3.

_____. "A survey of South American Art." *Texas Quarterly* 8 (Autumn 1965): 10.

Hocke, Gustav René. "Fernando Botero: A Continent under the Magnifying Glass." *Art International* 18 (December 1974): 19-21, 34.

Honma, Masayoshi. "The Mechanistic Poetry of Edgar Negret." *Edgar Negret*. Catalogue. Tokyo: Contemporary Sculpture Center, 1982.

Judd, Donald. "New York Exhibitions: In the Galleries." *Art Magazine* 37 (January 1963): 55.

Kroll, Jack. "Reviews and Previews, New Names This Month." *Art News* 61 (December 1962): 20.

Messer, Thomas M. "Latin America: Esso Salon of Young Artists." *Art in America* 53 (October-November 1965): 120-121.

Montaña, Antonio. "Eduardo Ramírez Villamizar: arquitectura, escultura y vida." *Arte en Colombia* (Bogotá), no. 10 (1979).

Montealegre, Samuel. "XXXVII Bienal de Venecia, Eduardo Ramírez Villamizar." *Arte en Colombia* (Bogotá), no. 2 (1976).

Portner, Leslie Judd. "Art in Washington." *Washington Post and Time Herald* (Washington, D.C.), April 18, 1957, sec. F, p. 7.

Rubiano Caballero, Germán. "Enrique Grau." *Pluma* (Bogotá), December 1975.

Traba, Marta. "Acompañando una vez más a Ramírez Villamizar." *Ramírez Villamizar*. Catalogue. Bogotá: Galería Garcés Velásquez, 1979.

_____. "Conocimiento de Enrique Grau." *Arquitectura y arte* (Bogotá), 1 (1955), no. 3.

_____. "Negret." Catalogue accompanying the artist's exhibition at the Eighth São Paulo Biennial. Bogotá, 1965.

Trier, Eduard; Mellow, James; Traba, Marta; and Canaday, John. *Negret*. Catalogue. Caracas: Museo de Bellas Artes de Caracas, 1973.

April 2 - 30, 1985

COLOMBIA, CHURCH OF SANTA CLARA: COLONIAL ART [1]

This exhibition has been organized by the Colombian government with the help of the following entities:

The Presidency of the Republic
The Ministry of Foreign Affairs
The Colombian Embassy in Washington, D.C.
The Colombian Delegation to the Organization of American States
The Colombian Institute of Culture

REMARKS FOR AN EXHIBITION

Like all of Latin America, Colombia is caught up in a creative process of reinterpreting, evaluating and rescuing its cultural past. This calls upon a variety of disciplines: from theoretical aesthetic contributions to budgetary support, from scholarly research to establishing priorities regarding the feasibility of objectives.

One simple example--the restoration and preservation of our colonial heritage--prompts us to reflect on other forms that were once disdained. Faced with the unique architecture of this era, we come to realize that other architectural forms are equally important, that is, other life-styles, other cultural adaptations expressed in popular modes of architecture, in styles testifying to the contradictions and mobility of history.

This process links phenomena that were once considered isolated and conclusive; as if dividing the past into periods--while academically convenient--truly reflects reality; as if Colombians were reborn with each new era or new ideological or cultural criterion.

This exhibit illustrates the paintings and decoration of a temple, a church embellished like a mosque, that was begun in 1632 and successively transformed over the centuries, but was unable to escape abandonment and partial destruction. This was the convent of the Poor Clares, a religious community that has given us--aside from convents and churches either now extinct or fortunately restored such as the one in Bogotá containing the works presented here--one of the most important literary figures of the colonial period: Mother Francisca Josefa del Castillo who lived and wrote in Tunja, another city of the Andean highlands where the followers of St. Francis of Assisi and St. Clare established their first convent in New Granada.

It was Mother del Castillo, along with others such as the poet Hernando Domínguez Camargo and the chronicler or novelist Rodríguez Freile, who was responsible for some of the most valuable intellectual work to emerge from over two and a half centuries of colonial rule. Mystic, ascetic, yet vigorous and graceful in relating her own life, the work of this nun is essential in understanding the kind of religiousness prompting the decoration of the church represented in this exhibit.

[1] Although no illustration is reproduced in this publication, the captions of the original catalogue are shown here as footnotes in the places indicated in the text of the original catalogue. --*Ed.*

The Church of Santa Clara was rebuilt with a tremendous sense of responsibility and respect for the decorative styles found within. It is now a museum and is also used for concerts. Colombia has many examples of this syncretic art that defines an era, a syncretism that is especially noticeable in the architecture and decoration of churches and monasteries. Military architecture lives on in the heroic walled city of Cartagena de Indias. A portion of our civil architecture--while not particularly monumental--has disappeared. In Bogotá there are, along with Santa Clara, a number of religious architectural treasures. These and others found in cities and small towns throughout Colombia must be jealously preserved.

With this in mind, I must mention the tremendous blow to our cultural heritage dealt by the earthquake in Popayán two years ago. The city of Popayán must be rebuilt, just as our past must be reconstructed; for there lies a fundamental part of our essence as a nation and our projection towards the future. --*Belisario Betancur*, Bogotá, April 1985.

THE CHURCH OF SANTA CLARA

The Church of Santa Clara is now the only living testimony of what was once the convent of the Poor Clares in Bogotá; and its past can he understood solely in terms of the religious community that inspired and dignified it for over two hundred years.

The history of this order goes back to the thirteenth century when, in 1212, Clare of Assisi, a rich woman of noble birth, left her family to join other young women in founding a religious order based on the vows of poverty, prayer, abstinence, and penance advocated by St. Francis. At that time, *il Poverello* was preaching in the Italian region of Umbria, and these values would come to characterize his lifelong dedication to restoring ecclesiastic discipline and regenerating Western European civilization.

This order of cloistered nuns expanded throughout Europe and by the sixteenth century had established several convents in the New World. These were supported and encouraged by the Spanish who had acquired tremendous wealth in the lands of gold and silver comprising the viceroyalties of New Spain, New Granada, and Peru.

The first of these convents in New Granada (now Colombia and Panama) were established during the second half of the sixteenth century: one at Tunja in 1573 and the other at Pamplona in 1584. Early in the seventeenth century another convent was built in Cartagena (1621), and some time later, around 1630 or 1631, a convent was founded in Bogotá. The convents at Tunja, Pamplona, and Cartagena were established as a result of sizable bequests left by rich widows at the time of death. However, the convent in Bogotá was founded through the interest, perseverance, and financial assistance of Archbishop Fernando Arias de Ugarte who died in Lima in 1638, having never seen this work completed. He had left Bogotá for Peru in 1625.

The founding of convents in the New World had to have royal and papal approval. A royal license for the Convent of Santa Clara in Bogotá was signed on March 8, 1619 by Philip III, and papal authorization was granted in a brief signed by Urban VIII on December 1, 1628. By that time, work on the convent and the first church was already well underway. In fact, both of these structures were inaugurated only two years later. Twelve nuns originally took possession of the convent. Three of these were Carmelites who left their cloister accompanied by monks, civil authorities, and townspeople and marched in a magnificent procession to the new convent, there to seclude themselves for the remainder of their days, consecrated to the worship of God.

However, this first church must have been inadequate due to the fact that it was small, narrow, and poorly constructed. It was not in keeping with the richness and splendor with which the Poor Clares customarily adorned their churches, and in their opinion lacked the magnificence and grandeur befitting a place of worship. Therefore, shortly after taking possession, the first abbess, Damiana de San Francisco, began the enormous task of erecting a new church. The first stones for this structure must have been laid around the year 1632. This new project had the support and patronage of María Arias de Ugarte, sister of the founding archbishop. It was she, along with her niece, Abbess Damiana, and those to succeed her in this position, who supervised and oriented construction which had been entrusted to master bricklayer Mathias de Santiago, an experienced builder of the early seventeenth century.

The structure was completed fifteen or sixteen years later and dedicated on March 18, 1647, thereby becoming the third convent church of a feminine religious order constructed prior to the middle of the century in the cold,

isolated capital of New Granada. At that time, the city's most important buildings were religious ones.

The Church of Santa Clara is located at the southwest corner of Ninth Street and Eighth Avenue on a block approximately one hundred meters to the south of Bogotá's main square. The temple and convent occupied almost half the land with the remainder of the block being used to cultivate crops and as a cemetery for the religious order.[1]

The church is designed like most convent churches belonging to cloistered feminine orders. Two long high walls constructed in rough stone are joined by two end walls enclosing a space containing the presbytery, nave, and choirs. The presbytery and nave are separated by a pronounced semicircular torus arch resting on two pillars projecting from the face of the walls. The arch serves as a huge frame for the high altar set at the back of the presbytery, all of which constitutes an impressive visual conclusion to the enclosure. The floor level provides for another division of space as the presbytery is higher than the nave. This spatial separation is accentuated by two polychrome wooden ceiling vaults that seem to float above the interior like the heavens themselves. A clear distinction is therefore established between space reserved for the divine service and that destined to be occupied by the faithful. The nave is bordered at the back by two choir levels and a bell tower. These were separated from the nave by a polychrome wooden screen rising from the floor to the vault. The sacristy is located in a space apart, at the back of the presbytery, with a door between the two.

The roof of the church is constructed in two sections of different height and dimensions. The portion above the presbytery is higher than that over the nave and choir gallery, thus reemphasizing from the outside the spatial differences within. Both sections are built of wood and terra-cotta tile in the form of an incomplete hip roof with the smaller triangular slopes resting on the end walls of the building. The long sloping section above the nave and choir gallery is adorned on one corner with a graceful slanted belfry-wall that appears to be supported by the roof itself.[2]

Traditionally, the door of a cloister church is located on one of the side walls. The other is usually backed by the convent. Santa Clara has two doors on the same side. The main entrance is a semicircular arch graced by a beautiful stone and brick doorway topped with a broken pediment housing another smaller arcade with a niche that still holds a statue of St. Clare of Assisi.[3] The second door is also constructed in the form of an arch. The doorway is smaller and has been finished with a raised entablature. Each entrance has double doors decorated with wrought iron spikes to conceal the nails used in the wood.

These doors define the main facade of the church. Four windows, larger than the seven corresponding to the choir gallery and bell tower and designed to illuminate the nave and presbytery, plus the belfry-wall with three openings and sections separated by figurative brick cornices complete the facade. The minor facade has three rows of barred windows to illuminate the choir gallery and bell tower. However, both facades show the same ocher texture of the materials used to construct the walls and roof: stone (rough and cut) and terra-cotta (brick

[1] [Illustration No. 1] Map of Bogotá, 1852. The circle denotes the zone where the church, convent, and gardens were located. As provided for by royal mandates, these installations occupied the entire block. After the nuns were expelled from the convent in 1862, several Republican-style buildings were constructed on this spacious lot. The convent was demolished at the beginning of the twentieth century.

[2] [Illustration No. 2] The Main Facade. The imposing and textured volume of the church still dominates this old section of Bogotá located near the city's main square. The main facade is crowned on one corner by a graceful belfry-wall constructed at the end of the eighteenth century to replace that destroyed by an earthquake in 1785.

[3] [Illustration No. 3] Main Door of the Church. This beautiful stone and brick entryway, crowned by a niche bearing a statue of St. Clare of Assisi, was plastered over along with the rest of the facade until the mid-nineteenth century. At that time, there was an explosion in a house located across the street in front of the main facade that destroyed the plaster. The nuns did not have time to repair the damage, as they were expelled from the convent only a few years later.

and tile).

Yet, when the new church was opened to the faithful at the middle of the seventeenth century, the interior was very different from what we see today. The structure rose majestically in simple elegance by virtue of its sheer architectural volume, but it lacked the elaborate decoration now adorning the interior. The tremendous, long-term financial effort involved in construction, plus the necessity of first building the convent, did not allow for major decorative displays at the time of its dedication. However, we do know that it had another type of decoration: murals.

The heavy, textured masonry walls were covered with plaster on both sides; and the new whitewashed interior, like the wooden vaults and choir ceilings, was destined to hold an infinite array of decorative polychrome motifs featuring plants and animals. The vaults and ceilings were covered entirely with decoration while other areas, such as the walls, were only partially adorned thereby allowing for an invasion of new devotional decor in the form of paintings and retables.

The presbytery could well have been the most richly decorated part of the church being the area where the mass is celebrated. Murals ran along the socles on each side to the torus arch and up the three sides of the pillars to the cornices. The arch itself was adorned with new designs in the form of gilt flowers and a brilliant custodia at the keystone. The altar must have been a splendid enclosure.[1] If, in addition to this array of color and decoration, we add the polychrome lattice work situated to one side, the framed oil paintings hung on plaster walls above the socle, and the polychrome and gilt interior surface of the vault, the view upon entering the church through the nave must have been truly magnificent, just as it is today even after three hundred years of decorative changes to the interior.[2]

Despite the overwhelming presence of the vault, it is unlikely that in 1647 the nave could have been afforded the same decorative resources as the presbytery. Restoration has confirmed this fact, showing that the decoration in this part of the church was less elaborate. There is a retable set below the wooden organ loft and a fine polychrome socle running from the torus arch to what must have been the polychrome work adorning the latticed screen of the lower choir. This grille was removed over a hundred years ago along with a major portion of that covering the choir gallery. The white walls were destined to play an important role in the decoration of the church. They served as the backdrop for retables and paintings donated over the years by members of the congregation, prominent persons and families whose daughters, either out of imposition or vocation, had dedicated themselves to a life of seclusion behind the latticed parlors, choirs, and galleries of this convent.

In contrast, the choirs, especially the upper gallery, were to compete with the presbytery in terms of mural decoration. The beamed ceiling of the lower choir--an area where the nuns received holy communion through

[1] [Illustration No. 4] Torus Arch. The torus arch with its polychrome work now restored allows us to partially recreate the special atmosphere of the interior as it must have existed when the church was inaugurated during the seventeenth century. In the following century, this decoration was covered by wood carvings and paintings representative of other tastes. These would give the church its ultimate artistic expression as still exists today.

[2] [Illustration No. 5] View towards the High Altar. This is an interior view of the presbytery as it exists today. Decorative tendencies slowly evolving over the centuries now intermingle. The walls, partially covered with retables, paintings and murals in the seventeenth century and totally decorated in the eighteenth century, are now completely hidden behind red and gold wood panels that surround the paintings and retables, creating an interior atmosphere--set beneath the immense red, blue and gold star-studded heavens of the vaults--that is entirely removed from all exterior reality.

[Illustration No. 6] Interior View towards the Presbytery. This drawing depicts the interior of the church shortly after its dedication in 1647. The high altar, already built by this time, constitutes a splendid visual finale to the vaulted space where white walls blend with brightly colored murals, a few furnishings, and several paintings. The decorative process, begun during this period, would ultimately take over a hundred years to achieve what--with few exceptions--we see today.

a small window--was painted with designs of plants. The walls between the beams were painted with amphorae and flowers; and a niche in the end wall was adorned with angels.[1] The walls, niches, and ceiling of the upper choir, which must have held seating for nuns who accompanied the mass with music and hymns, bear a profusion of polychrome designs applied at various stages. The flat ceiling, built of planks covering wooden beams, was decorated with plant and animal motifs painted around an array of wooden gilt pentacles that seem to be a continuation of the star-studded heavens represented in the ceiling vaults of the presbytery and nave.[2] Window jambs and niches were painted with a variety of designs including representations of St. Francis and St. Clare adorning the jambs of the window with the Dominican and Franciscan symbols decorating the arch. There are two other windows in the end wall at the upper choir level. One bears the initials of Jesus Christ and the other of the Virgin Mary.

This early decoration, especially in the nave and presbytery, probably lasted only for a short while. The generosity of the faithful together with the religious fervor of the colonial era and the nun's constant preoccupation with further embellishing their new church, an attitude supported by pious, rich benefactors, inspired a gradual change in the appearance of the interior. The original murals were gradually covered by oil paintings or hidden behind gilt and polychrome retables fixed to the walls thus allowing for new devotions in gold furnishings.

The decoration process, beginning when the architecture was completed in 1647 and terminating with what we see today, could have lasted over one hundred and fifty years, almost up to the time of the struggle for independence in the early nineteenth century. It did not, however, coincide with the Republican era that to a great extent contributed to a weakening and, in many cases, the total destruction of these manifestations of Spanish colonial architecture.

During the second half of the seventeenth century and--except for a few disastrous years--throughout the eighteenth century, the interior decoration of the church steadily acquired a new appearance. In part, this was a direct contrast to the initial aesthetic response, although both were already imbued with a new sense of values as well as aesthetic and even ideological views which in many instances made them related and mutually dependent.

The constant presence of experienced architects, painters, carpenters, wood-carvers, silversmiths, goldsmiths, and masons made Bogotá a bustling center not only for architectural activity but moreover, in terms of decorating churches with altars, carvings, and paintings. In the seventeenth and eighteenth centuries, Bogotá's largest and most beautiful churches were clothed in wood and gilt; and, of course, due to the narrow, confined environment of the city in this particular era, the decorative achievements of one were bound to have repercussions for all. While artists and craftsmen still essentially retained an attachment to manneristic tastes and criteria, their work does begin to show an increased desire for greater freedom in design and the use of architectural-decorative elements. This was partially due to the tremendous sixteenth century campaign mounted by the Church to strengthen the Catholic faith: a type of counteroffensive designed to combat and offset the effects of the Protestant Reformation in Europe. Art played an important role in this process and all of the imagery involved

[1] [Illustration No. 7] Detail of the Choir Murals. The two choir areas are unique. Being secluded behind wooden screens, there were not decorated with gilded panels although they undoubtedly contained paintings and small retables or altars for the nuns to pray. The retables no longer exist. What has survived, hidden under heavy coats of lime, are the murals originally adorning the choirs, especially the niches and openings for the windows. Restoration work has uncovered this decoration so carefully applied at different stages over a period of many years. A wealth of chromatic information found in the plant motifs painted on this side of a niche in the choir gallery is particularly outstanding.

[2] [Illustration No. 8] The Choir Gallery. This space, reserved solely for nuns accompanying the mass with music and hymns, was noticeably enriched over the years. Niches in the walls were invaded by mural paintings and the flat ceiling was covered with gilt flowers and buds spread amid a multitude of animal and plant motifs, all polychromed. The vaulted ceiling of the presbytery and nave extends into this one and is embellished with a number of drawings of animals characteristic of different climates. Perhaps, these were done by the nuns themselves in memory of times past.

had one sole object: to encourage the devout sentiments of the clergy and the faithful.[1]

Although located in a far-off province, the Church of Santa Clara reflected the schemes and techniques of European art. A horror of bare space manifest itself and materials used to construct architecture revolved around a taste for gilt wood paneling, paintings, sculpture, and retables done in gold leaf.

Yet, this process is relatively slow. When the church was opened the decoration was much less than what we see today. This included the retable-frame of *St. Martin Sharing His Cloak with a Poor Man* located below the organ loft. The painting was done in 1647 by the noted Bogotá artist Gaspar de Figueroa and is a copy of a poor engraving of Van Dyck's painting found in the Church of Saventhem in Belgium. The presbytery held the impressive three-story altarpiece with five vertical bays and a base adorned with three sculptured gilt frontals. This work was commissioned by the church's benefactress María Arias de Ugarte.

This retable, done in gilded wood, was the first addition to the new church and probably was finished by March 18, 1647, when the building was dedicated.[2] The columns of the lower and center sections are almost identical to those found on the main altarpiece of the Church of San Francisco, which was built around 1630 and constitutes one of the most beautiful artistic works of the colonial era. Being Franciscans, it was natural for the Poor Clares to adopt the design of its most significant components: the columns.

The five bays of the first two stories house figures of different saints. The upper level, containing just three bays in order to accommodate the polychrome ceiling vault, holds a crucifix flanked by figures of Mary Magdalene and St. John the Evangelist.

Ultimately this retable represents a good portion of the evolutionary process taking place in the church after its completion in 1647. This process was to provide for a relationship in some cases, and a union in others, of the different forms of artistic expression which would eventually adorn a controlled and more or less uniform space, but one strongly characterized by a decorative desire, until an intense and vital interior atmosphere had been created.

The other retables must have been constructed and installed prior to the end of the seventeenth century. These include the *St. Francis* retable (1652), also located below the organ loft but somewhat more discrete than the *St. Martin* retable, and that of *The Institution of the Indulgence of St. Gregory.* All three are retable-frames with large paintings, and occupy the west wall of the nave facing the main entrance. Located as such, they would have been the first thing to attract the eye of the observer upon entering the newly constructed church.[3] Other altars were carved and assembled sometime later. These were built more along the lines of true retables with stories and bays defined by columns and entablatures. The *St. Martin* and *St. Gregory* retables also have these features and are beautifully worked, especially the latter. It was designed along the lines of another famous retable of the period built by Brother Diego de Loessing for the church of the Jesuits in Bogotá.

[1] [Illustration No. 9] A Wall Panel and Paintings. A horror of empty space is manifest on the walls of the interior. Surfaces between the paintings are covered by red wood panels appliquéd with carved gilt foliage. This creates a colored, textured layer that gives the church a new intense and forceful dimension totally opposed to its restrained exterior.

[2] [Illustration No. 10] The High Altar. The high altar was constructed around 1647 and donated to the church by María Arias de Ugarte, benefactress of the convent of the Poor Clares in Santa Fe de Bogotá. The three stories and five bays of this retable rise imposingly against the end wall of the presbytery and house a series of niches containing sculptures from the seventeenth, eighteenth, nineteenth, and twentieth centuries. These figures are a fine example of the variety of techniques used at different periods: wood, gummed fabric, and plaster, all gilded and polychromed.

[3] [Illustration No. 11] *St. Martin, St. Gregory,* and *St. Francis Retables.* This group of three retables located in front of the main entrance to the church constitutes the earliest decorative addition to the interior. These are characterized by large retable-frames designed to house a single pictorial work of generous proportions.

These retables were installed in the presbytery and nave; and undoubtedly took the place of paintings from the original convent church which had very likely been remodelled to accommodate the needs of a growing cloister.

A gilt and polychrome retable entitled *Lord of Humility* occupies a section of the wall between the two entrances to the nave. This is a pictorial-sculptural work comprised of two stories and three bays. They stand above a predella set on an altar table which is supported by projecting medallions ornamented with a curved leaf design, and separating three decorated gilt frontals. The central bay of the first level contains a vaulted niche for housing a figure representing the *Lord of Humility*, while the upper section holds a beautiful painting of *The Virgin of the Rosary* encased in a large elaborate frame. The painting is flanked by two others placed slightly higher.[1]

The nave also contains two retables located near the torus arch: *Santa Margarita María de Alcoque* on the west wall and *San Antonio* on the east wall. These are essentially pictorial-sculptural retables, however the latter is predominately sculptural. It is a beautiful polychrome and gilt fixture. The columns are adorned with twining vines and clusters of grapes on the upper two-thirds of each shaft and the lower third is decorated with a large round flower. A painting of St. Francis constitutes the central motif and is surrounded on all sides by small niches designed to house a series of sculptures. These occupy the side bays and upper story of the retable.[2]

There are two pictorial-sculptural retables inside the presbytery; one on each side between the torus arch and the stairs leading up to the high altar. These are *The Holy Family* and *The Pulpit Retable*. The latter was named for its close proximity to the pulpit, although originally the pulpit was set in the nave and not attached to the torus arch as we see it today. Both architectural fixtures are of excellent quality. Despite the fact that it contains three stories and three bays, the second of these retables is the smallest in the church and gives the impression of being a scaled-down version of a larger one. Yet, it does have a sense of harmony and its components do not clash. This altar was probably installed before 1658, year of the death of Gaspar de Figueroa who apparently did all seven paintings adorning the predella at the base of the retable.[3]

[1] [Illustration No. 12] *Lord of Humility Retable*. This retable known as *The Lord of Humility* or *The Lord of Good Hope* is located between the two doors of the church. It is set above an exquisite altar table and predella containing panels for paintings which were never done. The three bays of the retable are bordered by columns similar to those on the second level of the high altar. These, in turn, are a copy of those found on the famous altarpiece of the Church of San Francisco. *The Lord of Humility* has only one niche. This houses a sculpture of the devotion (seventeenth century). There is a polychrome entablature separating the niche from a fine painting of *The Virgin of the Rosary*. This work is enclosed in a elaborate frame indicative of the wealth and devotion of its donor.

[2] [Illustration No.13] The *St. Anthony Retable*. This fine pictorial-sculptural retable must have been installed towards the end of the seventeenth century. Its rich columns adorned with polychrome vines and grapes, along with the general arrangement and other decorative motifs, suggest a construction more in keeping with the baroque taste prevalent at the end of the seventeenth century and beginning of the eighteenth, as opposed to the manneristic style of the murals on the torus arch.

[3] [Illustration No. 14] *The Holy Family Retable*. This gilt and polychrome retable known as *The Holy Family*--name derived from an exceptional painting on canvas probably done by Baltazar de Vargas Figueroa that is set in the central bay of the second story--now contains only paintings. However, at one time there must have been a sculpture in the central niche at the ground which was later replaced by this image of *The Sacred Heart* (nineteenth century) mounted in an exquisite baroque frame. This is a beautiful architectural fixture that seems to lose its silhouette in order to reach out and blend with the gilt vaulted ceiling and the paintings of the presbytery where it is located.

[Illustration No. 15] *The Pulpit Retable*. This small retable located near the pulpit and composed of three stories and three bays to house paintings and sculptures probably was installed around 1658 or before due to the fact that the seven small paintings on wood adorning the base or predella are attributed to Gaspar de Figueroa.

The Holy Family is noted for a beautiful painting occupying the central bay of the second story. It is the work of the noted Bogotá artist, Baltazar de Vargas Figueroa, who together with his father Gaspar de Figueroa painted a number of works found in the church today.

María Arias de Ugarte, distinguished benefactress of the church and sister of the founding archbishop, died in 1664 and was buried in a crypt she had ordered constructed years earlier beneath the main altar. The nuns of the eighteenth century undoubtedly commemorated the hundredth anniversary of her death with considerable pomp in which the decoration of an area she helped to build and adorn played an important part. The Poor Clares were now a wealthy and powerful order; firmly established and economically secure due to large holdings amassed over a period of nearly one hundred and fifty years. A good part of these resources, along with donations and collections, were used to completely alter the appearance of the temple despite the fact that it already contained a wealth of paintings, sculptures, and retables gradually acquired over the years and in evidence today.

In 1764 this initial space--sober and restrained with its flat surfaces only partially relieved by multicolored murals--acquires a new interior dynamic, a new character particularly with respect to the vertical surfaces. This would lead to irreversible visual and textural sensations without entirely forsaking the original spatial concept.[1] Paintings once adorning bare white walls are now enclosed and surrounded by red and gilt carved wooden panels occupying the entire surface and even overlapping in some cases. The main altarpiece was also modified or "reinaugurated" with new figures and components, perhaps to make it more in keeping with the lavish decoration of the period. A magnificent tabernacle was added to the front of the retable. Its cylindrical center is carved with birds and flowers and is flanked by four beautifully worked columns. The piece is crowned with an elaborate niche containing a figure of St. Clare. The multitude of cherubs adorning the entablatures, the garlands, masks, fleurs-de-lis, emblems, corbels, stone chips and shells on the spandrels of niches, entablatures, and the predella also date from this period.

By revitalizing the interior and achieving a new formal expression totally removed from earlier efforts, the church and convent reach the height of their architectural-decorative expression during the second half of the eighteenth century. However, a number of events also begin to occur at this time which would threaten the work so patiently and persistently constructed over the years and eventually lead to the disappearance of the convent at the beginning of the twentieth century.

An earthquake in 1785 caused extensive damage to the convent and lesser damage to the church. Bogotá had suffered a similar tremor forty-two years earlier but the consequences were not so serious. The bell tower was lost as a result of the 1785 quake and the decoration, especially the sculptures, was probably affected as well. The convent was badly damaged, so much in fact that it was never fully restored. The situation was further aggravated by two later earthquakes in 1826 and 1827.

There were other events also contributing to the decline of the convent. These were tied to problems arising between the Church and the new Republican state during the first half of the nineteenth century following independence from Spain. Confrontations involving the two grew progressively worse and in 1861 the government, lead by General Tomás Cipriano de Mosquera, enacted legislation divesting the Church and the different religious orders in the country of considerable property which had been designated as mortmain under the law. The nuns were expelled from the convent in 1863 and the building was occupied by a battalion of soldiers. it then served as a school for several years and eventually became the headquarters of the Government Printing Office until it was finally demolished in 1912 to make way for a new structure more attuned to the eclectic architecture so favored in Bogotá at the time. This new architectural style was imposed at the expense of the "modest and

[1] [Illustration 16] Interior and the Vaults. The two polychrome vaults enclosing the interior space from above and separated from one another by a polychrome torus arch are actually ceiling vaults done in wood. These are interrupted at the windows of the nave and presbytery to form lunettes that are also vaulted. This seemingly heavenly body, with its red and blue colors accompanied by gilt stars each formed by a bud and five leaves, deeply dramatizes the area comprised of a single nave and, together with the decoration on the walls, provides a clear example of the grandeur and beauty with which the Poor Clares adorned their convent churches.

provincial" architecture preceding it.[1]

Having lost the religious community responsible for its care and support, the church gradually fell into a state of neglect until it was finally taken over by the Brotherhood of the Sacred Heart of Jesus. This congregation was composed of a number of people who were interested in repairing the damage caused by man and nature. However, this process of renovation included several unfortunate alterations to the interior.

A brief look at events beginning in 1855 is important in order to understand, in part, the "restoration" work of the Brotherhood. That year there was a violent explosion in one of the houses across the street in front of the main facade. The blast wave was tremendous but was partially absorbed by the heavy stone wall although the plaster was damaged. However, the blast penetrated the structure through the windows and doors, undoubtedly causing severe damage to the decoration along with that produced by material falling from the roof. This damage was never completely repaired by the nuns. As we know, they were forced to leave the convent seven years later. The pictorial works became scratched and torn, retables began to deteriorate and the sculptures and vaults lost some of their original appearance. When the Brotherhood took over, they assumed the task of reestablishing order in the church and restoring the appearance of the paintings, sculptures, retables, and vaults. In addition to this restoration process, some interior elements were reorganized as in the case of one of the retables. A new coat of paint was applied to the ceiling vaults covering old layers that had not yet come loose, and several of the paintings and statues were removed to make way for other figures and subjects more in keeping with the religious emphasis of the new group.[2]

However, the most fundamental alteration came when the Brotherhood decided to eliminate the lower choir by completely removing the wooden screen separating this section from the nave.

This was done in order to install two doors in the end wall. The entrances on the side were closed off. The wooden screen of the choir gallery was partially removed leaving only a section at the bottom resembling a balustrade. The organ loft was left intact.

The privacy of the choirs was destroyed and only imagination can recreate these spaces and the church as they once were. This portrayal of the Church of Santa Clara, while only an idea, is possibly very close to the original plan as it existed prior to 1882 when these sections were modified.[3]

[1] [Illustration 17] Eighth Avenue with the Church in the Background. The architectural volume of the temple and the belfry-wall are distinguishing features of this narrow street. Architectural elements of the Republican period blend with old colonial walls and bring new sensations, textures, and color to the urban structure of the city.

[2] [Illustration No. 18] The *Pietà* in the Lower Choir. The *Pietà* once occupied the lower choir. This new presentation affords a look at three different stages in the decorative process taking place in the church during the latter half of the seventeenth century. Murals painted in the niche were covered by this excellent oil from the Figueroa workshop that was also subsequently modified. It was repainted, and the two wealthy and worldly figures appearing in the painting were dressed as saints. No doubt, these were the same individuals who commissioned the work and donated it to the church.

[3] [Illustration No. 19] View towards the Back of the Church (choirs). This is the choir area as it exist today. In 1882 the large polychrome wooden screen shown in the drawing was modified. The portion covering the choir gallery was partially removed and that in front of the lower choir was eliminated completely. These alterations can be traced to the fact that the church was abandoned in 1863, after the nuns were expelled from the convent, and was later occupied by a congregation that had no use for these isolated spaces.

[Illustration No. 20] View towards the Back of the Nave. Several years after the church was dedicated in 1647, the choirs were probably enclosed behind a wooden polychrome grille or screen rising from the floor to the vault and completely separating these from the nave as seen here. The three large paintings in retable-frames

In 1970, the church and its enormous artistic heritage became the responsibility of the Fundación Museo de Santa Clara. Later, in 1975, the Colombian government, through the Instituto Colombiano de Cultura, purchased the church from the Poor Clares for a sum previously agreed upon between the religious order and the foundation. The tremendous task of restoring Santa Clara was then begun with the aim of eventually turning it over to the city as a museum of exceptional historical and artistic value.

Restoration work done between 1977 and 1983 involved the entire monument; for the true value of this structure lies in the close relationship between its architecture and the elements within, all forming part of a specific environment.

The roof is being restored to insure stability jeopardized over the years by the effects of time and nature. Work is being done on the foundation, the walls, floors, and windows in order to guarantee a more controlled environment for this immense artistic heritage. The vaults, ceilings, and walls are also being renovated in order to prevent further deterioration and bring to light early pictorial works concealed by man. The murals that have been restored blend harmoniously with the panels, retables, and paintings. They also provide for a better historic-aesthetic understanding of this convent church that is now over 350 years old. It is the spirit of this church, created during to many years, that is now being kept alive for all to enjoy. --*Germán Franco*. Translated from Spanish by Sharon de Navarro.

PICTORIAL WORKS

The pictorial works of the Church of Santa Clara are eloquent testimony to the surge of artistic creativity that occurred in Santa Fe de Bogotá, particularly throughout the seventeenth century. Despite the city's sedentary existence and geographic isolation, this century was to witness the emergence of a great many painter and workshops responsible for a wealth of activity in the plastic arts, especially that directed towards adorning the homes of prominent or lesser dwellings, convents, churches, and official buildings. Subjects and motifs were almost entirely religious. These were usually copies of prints or engravings from abroad, some of which were enriched or transformed by the more investigative artists of greater ability.

The most noted of these were the Acero de la Cruz brothers--Antonio in particular, who painted up to the time of his death in 1669--the Figueroas, especially Gaspar and his son Baltazar de Vargas Figueroa with their famous workshop; the towering figure of Gregorio Vásquez de Arce y Ceballos, who continued to work through the first decade of the eighteenth century; and the Fernández de Heredia brothers--Alonso and Tomás--who maintained their workshop until the end of the century. To these, one must add an infinite number of "nameless" painters who, either at the insistence of their masters or by their own hand, proceeded to satisfy and fulfill the demands and desires of colonial society in Bogotá and the surrounding areas.

An analysis of the formal elements present in these works shows tremendous aesthetic unity. Generally speaking, they have all the characteristics of seventeenth century painting in Bogotá and are representative of what is known as the Santa Fe school. This work, governed by Spanish norms and canons of the era "derived from a variety of aesthetics," forms a part of the art of the Counter-Reformation, sufficiently coded in Church councils, which was aimed entirely at encouraging the devout sentiments of members of the religious community and the faithful for the expressed purpose of achieving salvation of the soul.

Accordingly, the composition of these works features images placed in the foreground, either at the axis or situated at equal distances on each side thereby dividing the pictorial space into identical parts. Secondary figures are distributed symmetrically according to what can be considered as archaic or medieval schemes. There is nothing bold or audacious about these compositions. The radiant light or aureole is missing. Areas are demarcated to denote that pertaining to the earth and that corresponding to the heavens. There are statue-like saints and praying Virgins draped in heavy garments and shown in conic poses. Backgrounds are characterized by draperies framing the scene, angels distributed symmetrically, bays used to increase perspectives, balustrades,

are set below the organ loft and off to one side. These were among the first additions to the interior and were very likely installed between 1647 and 1652, thereby initiating a decorative process that would eventually lead to total surface decoration of the interior.

and idealized landscapes in all but a very few works.

Many of these paintings are reproduction of European prints as is the case of *The Flight into Egypt*. There are two of these works that are almost identical. One is attributed to Baltazar de Vargas Figueroa.

Groups of figures or images are juxtaposed and arranged in a conventional manner, often at the side of the main figure or at angles as seen in *The Immaculate Conception and the Four Fathers of the Church*. Color is generally subdued and contours vanish. Cooler tones predominate with only a few of these works being truly *tenebroso* in the baroque manner. These include some of the earliest paintings such as *The Annunciation* dated 1631, *The Adoration of the Shepherds, the Pietà*, and *The Holy Family*.

A series of seven archangels located in the presbytery merit special attention. These are characterized by foreshortening, movement, and flowing drapes; elements of a baroque nature that set these apart from their neighbors.

The distribution of images, paintings, and sculptures in the church does not follow any specific iconographic plan. Pictorial works were hung arbitrarily and with a criterion that was fundamentally decorative. Above all, paintings were arranged according to their format and in terms of the preferences and requests of donors and the faithful. Given these circumstances, we can understand how, for example, the legendary third century saint, Catherine of Alexandria, is represented by seven different paintings. The faithful must have been extremely devoted to this saint-guardian of maidens and defender of students, philosophers, lawyers, mailmen, notaries, professors, etc., for the church has more works portraying St. Catherine than any other figure. Other saints like Gertrude of Helfa, a thirteenth century German Benedictine nun proclaimed Patron Saint of the West Indies, is the subject of three works. There are also three paintings of St. Tomás de Villanueva, a Spanish Augustinian bishop canonized in 1658; four paintings of St. Anthony of Padua; four of Santa Rosa de Lima; two of St. Roque; and two of St. Ignatius of Loyola. Themes from the New Testament are also repeated (there are none from the Old Testament), such as the paintings of *The Annunciation*, two of *The Flight into Egypt*, two of the *Pietà* and others.

A number of events or anecdotes from the lives of saints or important individuals in the Church are also represented in Santa Clara. These include *The Institution of the Indulgence of St. Gregory, St. Martin of Tours Sharing His Cloak with a Poor Man* (1647), *St. Thomas Appearing to the Bishop Faustino*, and *The Virgin Blessing Bachelor Cotrina* (1668). This last work was donated by the father of one of the nuns of Santa Clara.

The group of portraits includes one of the Archbishop Fernando Arias de Ugarte. This work is set in a place of honor inside the presbytery as befitting the founder and benefactor of the convent. This is a life-sized portrayal depicting the archbishop, in full hieratic splendor, standing in front of a draped table with his coat of arms as was customary for the period. The tablet or plaque at his feet tells of his life, his work, and the consecration of the church in 1647.

Another two portraits were recently discovered during restoration work on the *Pietà*. Two figures clothed in garments typical of the seventeenth century were revealed behind those of Mary Magdalene and St. John Evangelist.

Themes relating to ecstasy and rapture--favored topics of baroque painters and the subject of much literature in the sixteenth and seventeenth centuries--also have their place in the church. *The Stigmatization of St. Francis of Assisi, The Transfixion of St. Theresa of Jesus* painted by Agustín García Zorro de Useche in 1698, and *The Vision of St. Ignatius of Loyola* by Gregorio Vásquez y Ceballos are prime examples.

The artistic works of Santa Clara are composed of a wealth of paintings and sculpture. What is shown here is but a limited example. However, it does give us an idea of the tremendous creative activity taking place in the small city that was Santa Fe de Bogotá during the seventeenth century. --*Jaime Gutiérrez*. Translated from Spanish by Sharon de Navarro.

CATALOGUE (dimensions of paintings include the frames)

Oils on Canvas

1. *El Angel Guardián (The Guardian Angel)*, 158 x 123 cm.
2. *San Gabriel Arcángel (St. Gabriel Archangel)*, 167 x 127 cm.
3. *San Jehudiel (St. Jehudiel)*, 152 x 124 cm.
4. *San Miguel Arcángel (St. Michael Archangel)*, 161 x 121 cm.
5. *San Uriel Arcángel (St. Uriel Archangel)*, 161 x 121 cm.
6. *San Sealtiel Arcángel (St. Sealtiel Archangel)*, 161 x 121 cm.
7. *San Rafael Arcángel (St. Raphael Archangel)*, 161 x 121 cm.
8. *Santa Clara (St. Clare)*, 159 x 123 cm.
9. *Retrato de Fernando Arias de Ugarte (Portrait of Fernando Arias de Ugarte)*, 224 x 153 cm.
10. *La adoración de los pastores (The Adoration of the Shepherds)*, 224 x 153 cm.
11. *San Guillermo (St. William)*, 203 x 132 cm.
12. *La Inmaculada Concepción y los cuatro Padres de la Iglesia (The Immaculate Conception and the Four Fathers of the Church)*, 202 x 159 cm.
13. *La transverberación de Santa Teresa (The Transfixion of St. Theresa)*, 170 x 170 cm.
14. *La estigmatización de San Francisco de Asís (The Stigmatization of St. Francis of Assisi)*, 178 x 170 cm.
15. *La visión de San Ignacio (The Vision of St. Ignatius)*, 121 x 188 cm.
16. *La Anunciación (The Annunciation)*, 174 x 189 cm.
17. *Santa Catalina de Alexandría (St. Catherine of Alexandria)*, 187 x 140 cm.
18. *La Virgen bendice al bachiller Contrina Talero (The Virgin Blessing Bachelor Contrina Talero)*, 95 x 72 cm.
19. *La Piedad (The Pietà)*, 260 x 180 cm.
20. *La Sagrada Familia (The Holy Family)*, 126 x 112 cm.

Sculptures

21. *San Vicente Ferrer (St. Vincent Ferrer)*, 63 x 34 cm.
22. *San Ignacio de Loyola (St. Ignatius of Loyola)*, 80 x 45 x 25 cm.
23. *San Buenaventura (St. Buenaventura)*, 101 x 50 x 47 cm.
24. *Retablo del Rosario (The Rosary Retable)*, 175 x 123 x 24 cm. Coll. Museum of Colonial Art, Bogotá.

April 9 - 26, 1985

LINDA KOHEN OF URUGUAY

Some painters take up art as a matter of instinct, with no thought of a career or worldly fame. Intuition guides them in the use of colors and brushes, suggesting themes, means of communication, and types of expression within their power of realization.

In our day, also, inflated prices for art have engendered a throng of fortune hunters who with mechanical ease grind out superficial compositions utterly void of inner meaning.

Here, however, we have a genuine artist, Linda Kohen, for whom painting constitutes her life goal. Fond of the figurative, she makes no attempt to surprise the viewer and shuns the algebraic effects of computerized abstraction, currently so much in vogue.

The worth of fashions, after all, resides in the talents of those who launch them, not in the skill exhibited by imitators, however clever they may be.

Guided by a clear perception of her vision of art, Linda Kohen paints solely for the sake of painting. Simple in concept, her works constitute an open invitation to the viewer to share that vision and the artist's enthusiasm for her craft.

Born in Italy in 1924, Kohen has been a citizen of Uruguay since 1940. She studied drawing and painting with

Pierre Fossey and Eduardo Vernazza in Montevideo, and painting with Horacio Butler in Buenos Aires. Since 1971 Kohen has had more than ten individual shows in Argentina, Brazil, Uruguay, and the United States (Miami). She has also participated in numerous national and international group exhibitions. She resides in São Paulo, Brazil. The Museum of Modern Art of Latin America takes pride in sponsoring her first exhibition in the nation's capital. --Adapted from a text by Art Critic P.M. Bardi.

EXHIBITION LIST [1]

Oils on Canvas

1. *El iluminado* (The Enlightened One)
2. *En el ascensor* (In the Elevator). Coll. of the artist.
3. *El ascensor* (The Elevator)
4. *Abriendo el ascensor* (Opening the Elevator)
5. *Grupo conversando* (Group Conversation)
6. *La mujer en el teléfono* (Woman on the Telephone)
7. *La mesa del orador* (Speaker's Table)
8. *El tribunal* (Court of Justice)
9. *El orador* (The Orator)
10. *Señor que lee el diario* (Man Reading the Newspaper)
11. *Multitud* (The Crowd)
12. *Platea, I* (Orchestra Seats, I)
13. *Platea, II* (Orchestra Seats, II)
14. *Los que deliberan, I* (Those Who Debate, I)
15. *Los que deliberan, II* (Those Who Debate, II)
16. *Los guantes de goma* (Rubber Gloves)
17. *Fuga uno: los lentes* (Fugue One: The Lenses)
18. *Fuga dos: las llaves* (Fugue Two: The Keys)
19. *Fuga tres: sobretodo* (Fugue Three: The Overcoat)
20. *Cajas, I* (Boxes, I)
21. *Cajas, II* (Boxes, II)
22. *Caja* (Box)
23. *Hombre y edificios* (Man and Buildings)
24. *Hombre y oficina* (Man and Office)
25. *Hombre en la escalera mecánica* (Man in the Escalator)
26. *Hombre en el tráfico* (Man Caught in Traffic)
27. *Hombre en el ascensor* (Man in the Elevator)
28. *Kiddush*
29. *Teléfono* (Telephone)
30. *La bolsa de papel* (Paper Bag). Coll. of the artist.

April 9 - 26, 1985

JULIO TESTONI OF URUGUAY

The name Testoni is one to conjure with in the realm of photography. The work of Alfredo Testoni, long synonymous with all that is best in the art in Uruguay, was exhibited at OAS headquarters in 1961. Now, twenty-four years later, the same locale is the site of another exhibit, this time devoted to the work of Alfredo's son, Julio Testoni.

While the two resemble one another in their keen aesthetic sensitivity and the high level of technical perfection they have attained, father and son differ in their choice of subjects and in the approach they take to their art.

[1] Not included in the original catalogue. --*Ed.*

The photographs by Julio Testoni which constitute the present exhibition are part of a series he has entitled *Ecological Expansion*. The photographer describes his attitude in taking them as that of "an artist of our times who seeks to permit natural elements to expand to the fullest extent of their splendor, drawing attention of nature's laws of ecological balance through manifestations in art."

In Julio Testoni's photographs, nature ceases to be "natural," being transformed by the artist's eye and the lens of his camera into a new form of reality. A simple element such as a flower is multiplied and distorted into a torrent of color and movement. The motif which gave rise to the photograph disappears; only the color and essence of the flower remain. A pine-covered landscape changes into a rushing river; a tree trunk becomes an aquatic monster; a drop of water expands into a sea. The artist's sensitivity, supported by prodigious technique, brings about a metamorphosis of external reality into an inner reality that is charged with a still greater burden of truth.

Owing to the mechanical nature of its processes, there has been much debate whether photography is to be classed as one of the fine arts. In the case of the two Testonis, there can be no doubt that it should. When photography does no more than register an event, it produces a document. When the scene or subject is handled in a creative manner aimed at emotional effect, the result is art.

Julio Testoni was born in Montevideo, Uruguay, in 1948. At the age of twelve he took to the camera and began his professional career taking pictures for two local newspapers, *La Mañana* and *El Diario*. At twenty-two he traveled to Rome on a fellowship from the Italian government and the Italian Broadcasting System. There he took a course in cinematography, followed by a course in color photography given in Milan. Since that time he has received more than fifteen prizes in contests held in Argentina, Brazil, and Uruguay. On five occasions he has been a finalist in the prestigious Clio Awards competition in the United States. His most recent distinction dates from last year, when he won First Prize at the Salon of Photographic Art sponsored by the Uruguayan-American Cultural Alliance. That prize has provided him with the opportunity to travel and exhibit in the United States. The Museum of Modern Art of Latin America is pleased to be the first institution to present Julio Testoni to the American public. *--Angel Hurtado*.

EXHIBITION LIST [1]

Photographs

1-23. *Expansión ecológica (Ecologic Expansion) I-XXIII*

May 7 - 31, 1985

CONTEMPORARY PAINTING OF EL SALVADOR

This is not the country of never more.
Here sorcery has loins and throats.
Fertility seems to be the whimsy of the gods,
but it has a scent, appetite, and eyes of glass.

Perhaps we are the country of ever more,
Where the people have the stoicism of rocks,
The complete stoicism of the wild twining plant!

--From "Penitential Sonnets" by David Escobar Galindo, Salvadoran poet

And the fields flower despite the weeping!
No! El Salvador has not drowned.

[1] Not included in the original catalogue. *--Ed.*

In the constant obscurantism of oblivion,
Its vibrant work remains.

These eight young Salvadoran painters show us an extensive variety of line, form, and intense color consistent with the tradition of modern Salvadoran painting.

They all show evidence of an intense searching, a questioning to find that conclusive suggestion of synthesis, of a message. Such is the case with the rural scenes by Edmundo Otoniel, Mauricio Mejía, and Gilberto Cardoza, which are handled with detailed discipline and meticulous treatment of design. Taken individually, these three artists have established personalities independent from each other. Nevertheless, dealing with the same theme of rural landscapes or people, they present us with an overall kaleidoscope of endless pictorial relations.

In Rodolfo Molina's atemporal proposal, sidereal space, and surrealistic abstractionism, the diaphanous nature of the forms reveals an authentic and restless personality, an imagination rich in vitality.

The presence of works by María Khan, Licry Bicard, Negra Alvarez, and Tití (María Teresa Escalante) in the exhibit proves the women's determination to participate in Salvadoran society's cultural development.

The work of María Khan is an inexhaustible flow of sensuality. With her women, fanciful, aerial figures hanging by the invisible thread of her guiding genius and imagination, she creates, in short, fantastic art.

Negra Alvarez relates clearly to human tragedy, to the day-to-day reality of the Salvadoran people, to their inborn nature, either through the figurative expressionism of her earlier work depicting dejected children and other beings, or through abstract rendition of mouths and jaws. This work has a strong visual impact, clear lines, and indisputable outreach.

Licry Bicard presents cultural patterns, traditions, or social criticism in her surrealistic work. With a dark, shadowy glaze she gives her characters of the past or the present an imprint of mystery swinging in time and space.

María Teresa Escalante's manifested quest to interpret her surrounding is present in her whimsical and magnified organic forms. Through them she achieves a subtle transparency as if they were microscopic organic tissues, flowers full of light. --*Alfredo Milián*, Minister Counselor, Permanent Mission of El Salvador to the OAS.

CATALOGUE

Negra Alvarez
 1. *Mordida senil (The Bite)*, 1985, oil on canvas, 100 x 132 cm.
 2. *Paisaje (Landscape)*, 1985, oil on canvas, 82 x 100 cm.
 3. *Y de una costilla... (And from a Rib . . .)*, 1984, oil on canvas, 48 x 58 cm.

Licry Bicard
 4. *Las locas (Crazy Ladies)*, 1984, oil on canvas, 37 x 50".
 5. *La Zona Rosa (The Pink District)*, 1984, oil on canvas, 32 x 39"

Gil (Gilberto Cardoza)
 6. *Paisaje (Landscape) I*
 7. *Paisaje (Landscape) II*

Tití (María T. Escalante)
 8. *Vegetation I*
 9. *Vegetation II*
10. *White Flag*

María Kahn
11. *Maternidad (Maternity)*, 1985, oil on canvas, 65 x 81 cm.
12. *Desnudo con rosa (Nude with Rose)*, 1985, oil on canvas, 65 x 81 cm.
13. *La pregunta (The Question)*, 1983-84, oil on canvas, 65 x 81 cm.

Mauricio Mejía
14. *De espaldas a la vida (Turning One's Back on Life)*
15. *Mercado tropical (Tropical Market)*
16. *Sueños celestes (Blue Dreams) II*

Rodolfo Molina
17. *Burbujas anti-crisis (Anti-Crisis Bubble)*
18. *Autoanálisis (Self-Analysis)*

Edmundo Otoniel
19. *Contadores de café (Coffee Workers) I*
20. *Contadores de café (Coffee Workers) II*
21. *Contadores de café (Coffee Workers) III*
22. *Contadores de café (Coffee Workers) IV*

BIOGRAPHICAL NOTES [1]

ALVAREZ, Negra (Margarita Alvarez de Martínez). Painter, born in Santa Ana, El Salvador. Studied at the Academy of Fine Arts, Louvain, 1967-69, and Institute Saint-Luc, Brussels, 1969-70. In San Salvador took courses in painting, ceramics, and metal work, 1971-77; studied drawing of the human figure with sculptor Benjamín Saúl and painting with Carlos Cañas, 1980. Traveled in Europe, 1967-70. Has taught art in different national institutions since 1972, and at present she is vice-director of the Escuela de Artes Aplicadas, Universidad Dr. José Matías Delgado, San Salvador, where she also teaches. Since 1981 has held individual exhibitions in San Salvador. Since 1980 has participated in national and international exhibitions, including the First Central American Biennial, San Pedro Sula (Honduras), 1981; *Premio Cristóbal Colón de Pintura*, Madrid, 1983; *Contemporary Art of El Salvador*, Bishop's University, Lennoxville (Canada), 1984.

BICARD, Licry (Lillian Cristina Andreu de Bicard). Painter, draftsman, born in San Salvador, 1944. Studied in San Salvador with painter Pedro Acosta García, 1969; Centro Nacional de Arte, 1971-72; Taller Estudio Arte Libre, 1976; drawing of the human figure with sculptor Benjamín Saúl, 1978-79; printmaking with architect José Roberto Suárez, Universidad Dr. José Matías Delgado, 1982. Since 1980 has held individual exhibitions in San Salvador and San José (Costa Rica). Since 1977 has participated in national and international exhibitions, including the Tenth Biennial of Plastic Arts, Guatemala City, 1977; Biennial of the Arts, Santa Ana (El Salvador), 1979; International Biennial of the Arts, Valparaíso (Chile), 1981, 1983; Inter-American Art Biennial, Mexico City, 1984, *Contemporary Art of El Salvador*, Bishop's University, Lennoxville (Canada), 1984.

GIL (Francisco Gilberto Cardoza Torres). Painter, born in Chalatenango, El Salvador, 1963. Considers himself a self-taught artist. Since 1980 has painted under the supervision of painter Víctor Barrière. In 1984 held his first individual exhibition in San Salvador. Participated in group exhibitions in San Salvador and Miami.

KAHN, María (María S. de Kahn). Painter, born in San Salvador, 1941. Studied in San Salvador, painting with Víctor Rodríguez Preza, 1975-76, and Carlos Cañas, 1980; drawing with sculptor Benjamín Saúl, 1978-79. Was invited to the Creative Workshop, Jerusalem, March 1985. Participated in group exhibitions in Honduras and abroad, including Juannio 82, Guatemala, 1982; International Fair of El Salvador, 1982, 1984; Spanish American Biennial of Art, Mexico City, 1984.

MEJIA, Mauricio. Painter, draftsman, born in San Salvador, 1956. Studied drawing and painting with Valero Lecha, Centro Nacional de Artes, 1973-75. Graduated as graphic designer, Escuela de Artes Aplicadas, Universidad Dr. José Matías Delgado, San Salvador, 1980. Under a scholarship of the Instituto de Cooperación Iberoamericana in Madrid, visited Spain and France, 1983. Since 1980 has held individual exhibitions in San Salvador and San José (Costa Rica). Participated in Salvadoran and Central American group shows in El Salvador, the United States (Louisiana, Georgia, Florida), Guatemala, Honduras, Costa Rica.

MOLINA, Rodolfo. Painter, born in San Salvador, 1959. Studied painting in San Salvador at Academia Mina

[1] Not included in the original catalogue. --*Ed.*

Heiman, 1970-76, and with César Menéndez, 1981. Graduated as an architect, Universidad Albert Einstein, San Salvador, 1984. Has held individual exhibitions in San Salvador since 1981. Participated in Salvadoran group shows in Honduras, Guatemala, El Salvador, and was included in the *Premio Cristóbal Colón de Pintura*, Madrid, 1983.

OTONIEL, Edmundo. Painter, illustrator, born in Ojo de Agua, Juizúcar, La Libertad, El Salvador, 1950. Studied architectural design, El Salvador; graphic design and children literature illustration in Venezuela (1979) and Costa Rica (1981). Considers himself a self-taught painter. Works as text-book illustrator, Ministry of Education. One of his works was reproduced in the UNICEF cards, 1985. Published the children's book *Era un mundo pequeñito* with text and illustrations of his own, Inter-American Project for Children's Literature (Pili), Venezuela, 1985. Since 1983 has held individual exhibitions in San Salvador. Participated in national group shows and represented his country in an exhibition of Latin American children's illustrations and books, traveling in Europe and Latin America, 1984-85.

TITI (María Teresa Escalante). Painter, born in San Salvador, 1953. Studied graphic design, Académie des Arts Modernes, Paris, 1972-73; Academia de Pintura Valero Lecha, San Salvador, 1975-76; interior design, La Salle Extension University, Chicago (Illinois), 1976; modern dance, Louis/Nikolais Dance Theater Lab, American Institute for the Alexander Technique, New York City; and awareness through movement with Dr. Moshe Feldenkrais, the New School, New York City. Has participated in group exhibitions in San Salvador since 1983, where she also held one individual exhibition in 1984.

May 16 - June 15, 1985

POLEO: A RETROSPECTIVE VIEW

PROGRAM

1. Film presentation: *Poleo and Poetic Figuration* (28 min.)

A documentary produced by the Museum of Modern Art of Latin America and CONAC of Venezuela on the life and work of Héctor Poleo. Filmed on location at the artist's atelier in Paris, the Tapestry Workshop in Aubusson (France), and in Caracas. Directed by Angel Hurtado and narrated by Roger Wilkison.

2. Presentation of Plaque

Secretary General João Baena Soares will present maestro Héctor Poleo with a commemorative plaque in recognition of his outstanding contribution to the art of the Americas.

3. Remarks by Ambassador Edilberto Moreno

4. Exhibition Opening: *Poleo: A Retrospective View*

5. Reception at the Aztec Garden

THE SURVIVING HUMANISM

All along the decade of the forties, three Latin American artists--Rivera, Siqueiros, and Orozco--executed mural paintings in several North American cities. The best known commission was Diego Rivera's at the Rockefeller Center in New York. By that time, the Venezuelan painter Héctor Poleo had already been living in New York for one year. His social concerns have been associated with those of the Mexican muralists, who had attained great renown in the international art world. But, strictly speaking, one could hardly notice thematic coincidences which could link Poleo's work to a trend of such marked characteristics as the Mexican muralism. If we consider that the art work is the most eloquent analysis, Poleo's paintings, executed in New York some time later, reveal a distinct personality of great autonomy in both the technical resources employed as well as in the original and strong themes without parallel throughout the continent: the tragedy of man facing dissolution and chaos, right at the same moment the horrors of war were taking place.

From his early work of the late thirties, where familiar themes such as portraits and suburban landscapes abound, Poleo has clearly shown that the greatest lesson he could learn from the French masters, especially Cézanne, was none other than the ability to measure the subtle power of the transparencies and a new sense of the pictorial density, conditions which he preserved all along his different stages. This is the basic difference distinguishing his work from that of most Latin American artists who were overcome by new expressionist visions of textural and chromatic emphasis.

Therefore, Héctor Poleo's artistic foundations are totally different. His is a most universal and open conception capable of receiving the influence of the classic world throughout the heritage of the Flemish and the Italian Renaissance. It is a basic and permanent legacy of plastic and human values, sensitive and ductile, to be nourished by American themes appearing at the beginning of the forties. From their start, these themes constituted a simple chronicle of rural man, his environment, and the daily burdens imposed upon him and his hard existence. This is counteracted by the dignity of the characters who, like a fortress, seem indestructible and serene. In spite of the drama in works such as *Los ciegos (The Blinds)*, Caracas, 1943, and in many others where the themes speak about the sufferings and struggles of the Venezuelan peasants, Héctor Poleo's paintings retain their previous very light pigmentation which highlights, with a sort of respect and delicacy, the human figures, the villages, and the natural environment. When the artist traveled to New York for a second stay, the excellence of both his painting and drawing continued as a commitment to fidelity and discretion, as he entered a heart-breaking stage on the testimony of war (*Memory of the Future*, drawing, New York, 1946). From that moment on, Héctor Poleo's painting becomes denser without losing that halo, brilliant and luminous, which defines everything without depleting it. He wants to be ruthless but not expressionist, bitter but not lacking hope, strong but not compelling. The purity of the light enhances, in fact, the landscapes of desolation, where the land appears like a global ruin. Sometimes, super-realistic entities evolve as in *Victoria*, New York, 1947, and *Angustia de la espera (Anguish of Waiting)*, New York, 1948. Over all the calcinated land stands the irony in the face of *El héroe (The Hero)*, New York, 1948, himself depicting a cruel landscape.

His move to Paris established a transition. Still in *Acecho (Lurking)*, Paris, ca. 1940, hope is hardly kept. However, formal changes are insinuated. Around the characters, always neatly defined, the lines become simpler and straighter. The atomic horror motivates new canvases, gouaches, and drawings where Hiroshima and Nagasaki's memories are represented with spots and scars.

The background designs begin to gain importance by the fifties. They offer, in crispy tonalities, a luminous contrast for the serene visages which seem to outlive all ages, to escape historic temporality. New alternatives are added to the former solutions in the guise of a counterpoint combination. The pictorial language turns into a bold synthesis of abstract resolutions and lines and detailed figuration, exceptionally executed. The irreconcilable turns into an alliance.

After the sixties the young master chooses that rare and difficult privilege of the poetic liberty. From then on, his painting changes and again becomes light, with that indefinition of the oneiric atmosphere, so vast in insinuations. The painting recovers with the caseins the light effect of the early years, but goes further in the vagueness of ghostly figures. It is the consequence of a craft deeply lived, without truces, without concessions. Similar to phantoms and reveries which arise before the conscience, Poleo's works stay sensitive to both old and new themes, from the tragic to the remote sensuality of memory. But they no longer constitute images of immediate presence. They are fused eras and remote memories, where the work incorporates the resonances.

Master of rebellion and courage, Héctor Poleo has also been a master of the immense dignity of man. His work is a moving homage to man because, even facing fratricidal holocaust and hopelessness, the human effigy is the inalterable witness through whom the history of an era, of a human group, of so many existences, is narrated.
--*Roberto Guevara*, National Director of Museums, National Council of Culture (CONAC), Caracas, Venezuela. Translation by Rosario Pérez-Mena.

CATALOGUE

Paintings

1. *Autorretrato (Self-Portrait)*, New York, 1947, oil on canvas, 50 x 90 cm.

2. *La batalla* (The Battle), Paris, 1962, casein, acrylic on canvas, 70 x 80 cm.
3. *De la terre à la terre (From Earth to Earth)*, Paris, 73 x 92 cm. Coll. of the artist.
4. *Le chapeau rose (The Pink Hat)*, Paris, 1963, 64 m 130 x 130 cm. Private collection.
5. *Hommage à Saint-Exupéry (Homage to Saint-Exupéry)*, Paris, 1968, acrylic on canvas, 130 x 130 cm. Coll. of the artist.
6. *Et tout reprend et reprendra* (And Everything Restarts and Will Restart Again), Paris, 1969, acrylic on canvas, 130 x 130 cm. Coll. of the artist.
7. *Un silence d'étoiles* (A Silence of Stars), acrylic on canvas, 130 x 130 cm.
8. *Ma blonde argile* (My Blond Clay), Paris, 1972, acrylic on canvas, 130 x 130 cm.
9. *La muraille* (The Wall), Paris, 1973, acrylic on canvas, 100 x 100 cm.
10. *La Mentonnaise*, Paris, 1974, acrylic on canvas, 130 x 162 cm. Coll. of the artist.
11. *Le nuage II* (The Cloud II), acrylic on canvas, 130 x 60 cm. Coll. of the artist.
12. *J'aime la voix de ton regard* (I Like the Voice of Your Look), acrylic on canvas, 130 x 162 cm.
13. *Le chapeau bleu (The Blue Hat)*, Paris, 1965, acrylic on canvas, 65 x 65 cm. Coll. of the artist.
14. *Spanish People*, New York, 1950, oil on canvas, 60.5 x 76 cm. Private collection.
15. *Le conquérant* (The Conqueror), Paris, 1965, acrylic on canvas, 60 x 73 cm. Private collection.
16. *L'oiseau blessé (The Wounded Bird)*, Paris, 1965, acrylic on canvas, 81 x 65 cm.
17. *El relojero* (The Watchmaker), Paris, 1958
18. *Désespoir* (Despair), Paris, 1982, acrylic on canvas, 81 x 100 cm.
19. *Le ciel se vide* (The Sky Empties Itself), Paris, 1969, acrylic on canvas, 100 x 100 cm. Private collection.
20. *Fleur de lune (Moon Flower)*, Paris, 1972, acrylic on canvas, 100 x 100 cm.
21. *Paisaje andino (Andean Landscape)*, Caracas, 1959, oil on canvas, 89 x 116 cm. Coll. of the artist.
22. *Le fil de cette destinée* (The Thread of this Destiny), Paris, 1968, acrylic on canvas, 130 x 130 cm.
23. *Eloigné du monde et du bruit* (Far Away from the World and the Noise), Paris, 1972-80, acrylic on canvas, 130 x 130 cm. Coll. of the artist.
24. *Paisaje de Antímano* (Antímano Landscape), Caracas, 1936, 52 x 67.5 cm.
25. *Atrás queda la angustia con espejos celestes* (Anguish Remains Behind with Blue Mirrors), Paris, 1980, acrylic on canvas, 130 x 130 cm.
26. *Venimos de la noche y hacia la noche vamos* (We Come from the Night and to the Night We Go), Paris, 1978, acrylic on canvas, 130 x 130 cm. Private collection.
27. *Julieta*, Caracas, oil on canvas, 67 x 38 cm.
28. *Patsy*, Mexico, 1940, oil on canvas, 50 x 48 cm.
29. *Solitude*, Paris, 1965, casein on canvas, 81 x 65 cm. Coll. of the artist.
30. *Esperando la lluvia (Waiting for the Rain)*, Paris, 1985, oil on canvas, 60 x 60 cm.
31. *Hacia la libertad* (Towards Freedom), tapestry
32. *L'inexorable dureté de l'espoir* (The Inexorable Harshness of Hope), Paris, 1972, acrylic on canvas, 46 x 48 cm. Coll. of Mr. and Mrs. Guillermo Pimentel, Washington, D.C.
33. *La muñeca rota* (The Broken Doll), New York, 1946, oil on canvas, 27 x 42 cm. Coll. of the Venezuelan Embassy, Washington, D.C.
34. *Familia andina (Andean Family)*, 1944, oil on canvas, 70 x 58.5 cm. Coll. of the Museum of Modern Art of Latin America, Washington, D.C.
35. *Grito frente al mar (Scream by the Sea)*, New York, 1948, oil on canvas, 20 x 24". Coll. Museum of Modern Art of Latin America, Washington, D.C.

Sculptures

1. *Espejo roto* (Broken Mirror), 1984
2. *Perfil (Profile) I*, 1984, steel
3. *Cabeza* (Head), 1984
4. *Perfil II con cola de caballo* (Profile II with Pony Tail), 1948, steel
5. *Perfil grande* (Large Profile), 1984

ABOUT THE ARTIST

Venezuelan painter, born in Caracas, Venezuela, in July 1918. Studied in Venezuela and Mexico. Lived in New York from 1945 to 1948. At present lives and works in Paris, France.

Selected exhibitions

1945 Arnold Seligmann Gallery, New York
 Pan American Union, Washington, D.C.
1948 San Francisco Museum of Art, San Francisco (California)
 Library of Congress, Washington, D.C.
 Arnold Seligmann Gallery, New York
1964 Galerie Drouant, Paris
1967 Acquavella Gallery, New York
1969 Galerie Villand et Galanis, Paris
1974 Museo de Bellas Artes, Caracas (retrospective)
 Museo de Arte Moderno, Mexico City (retrospective)
1974 Center for Inter-American Relations, New York (retrospective)
1978 Galerie Isnard, Paris
 Grand Palais, Paris
1983 Anvers and Liège (Belgium)
 Salon de Mai, Paris
1984 Exhibition of tapestries in Dallas (Texas) and Cologne (Germany), representing "Tapisseries d'Aubusson"

Selected Awards

1947 Guggenheim Foundation Fellowship, New York
1956 Acquisition Prize, Twenty-eighth Venice Biennial (Italy)

<div align="right">May 20, 1985</div>

INAUGURATION OF THE MURAL *TELURICA AMERICANA* BY INES CORDOVA FROM BOLIVIA [1]

INES CORDOVA AT THE ORGANIZATION OF AMERICAN STATES

For the International Institute of Integration under the Andrés Bello Agreement centered in La Paz, Bolivia, it is a true honor to co-sponsor the gift of the mural *Telúrica Americana* by the Bolivian artist Inés Córdova. This initiative responds to the interest of our organization to promote the art and culture of the member countries of the Institute. At the same time, it is a concrete answer to the necessity of identifying and projecting within a universal context the creative capability that emanates from the artistic tradition and the local environment of each one of the countries.

The work of Inés Córdova is representative of both elements in her country, Bolivia. However, it also reflects in its elements and composition a common factor of the Andean countries. Therefore, it transcends the borders and projects part of the Latin American soul, this time with her work *Telúrica Americana* from the walls of the new building of the Organization of American States, next to the work of the most important contemporary American artists.

It is fundamental that the hemispheric integration and fraternity base itself also on the mutual understanding of the artistic expression of the countries. The Institute, in expressing its admiration for the work of Inés Córdova, allows itself to congratulate the Organization of American States for the brilliant initiative in sponsoring the gift of this mural and to reaffirm its commitment to the art and culture in the member countries of this organization. --*Dr. Ramiro V. Paz*, Executive Director, International Institute of Integration.

Inés Córdova has found a highly imaginative way to utilize fabrics with traditional patch techniques in order to create compositions that resemble collage. Her well-developed sense of the abstract composition and her delicate

[1] This catalogue was published in Spanish by the International Institute of Integration, Andrés Bello Agreement. It was translated by Travis Kranz. --*Ed*.

craftsmanship make her to combine fabrics of different textures and colors to create a serious and unique language that is deeply rooted in her native environment. --*José Gómez-Sicre*, Museum of Modern Art of Latin America, Washington D.C., 1979.

Within the scope of Bolivian painting, Inés's art is an opening towards new mediums of expression which are able to invigorate the process. Her art gives shape to ideals rooted in the land through the use of materials related much more to the earth itself than the highly industrialized pigments. --*Teresa Gisbert*, Bolivian art critic.

Here is an artist that opens new perspectives, experiments with them, and carries them out. Inés Córdova does not only replace traditional elements but goes much farther, referring back to that earlier tradition where the textile was a very common medium of expression. The colors are also remembrance: earth colors and colors reminding of pre-Columbian civilizations that combine with geometric forms of a contemporary tradition in fine contrast. This is not the European mystique conflicting with the first tradition, but rather the subtle meeting of both civilizations. --*Rosario Zumarán Sanjinés*, Bolivian art critic.

The works of Inés Córdova immediately attracted my attention because of their originality, freshness, Bolivian characteristics, and their excellent execution. Inés Córdova works with scissors, fabric, glue, and thread. She calls her work collages, but much more is found than this. She allows color and the texture of the materials to participate in the final result together with knots, pieces of thread, careful stitches, careful gluing, and above all, a careful design. Inés Córdova creates landscapes of the imagination, totally abstract and nevertheless completely Bolivian, a constant remembrance of her environment. --*Marc Berkowitz*, Brazilian art critic.

The broad empty horizons--with only sky, steppe, and mountain--which were recreated into simple geometric forms executed in different types of fabrics, have become now a human geography. These thousands of forms of human presence, at times so subtle, give significance to that landscape. The earth becomes furrowed, the plain is broken by the parcel, and in the heart of that parcel rises the peasant house. The fundamental epic of man--so wonderfully described by Knut Hansum in his *Blessing of the Land*--has been exceptionally interpreted in these works.--*Hernán Rodríguez Castelo*, Ecuadorean art critic.

Inés Córdova de Imaná, creator of an original pictorial language without parallel in her country, has developed a technique with an unforeseeable future but nevertheless of important significance. --*Armando Soriano Badani*, Bolivian art critic.

ABOUT THE ARTIST

Inés Córdova was born in Potosí, Bolivia, 1927. She was head professor of the Ceramic Studio at the Escuela Nacional de Bellas Artes, La Paz; worked in Paris and traveled in Europe, 1969-73; professor of ceramics in the School of Architecture at the Universidad Mayor de San Andrés, La Paz; member of the Ceramic Section at the Consejo Nacional de Arte, and delegate from Bolivia to the Congress of Artists in Amsterdam (1969) and Belgrade (1970); visiting professor at the Universidad de los Andes de Mérida, Venezuela.

Represented Bolivia in painting exhibitions in Bonn, Hamburg, Frankfurt, and Stuttgart (Germany). In 1982 participated in the International Festival of Painting of Cagnes-sur-Mer in France.

Distinctions

Won commission for three murals, University of La Paz, 1964; Diploma of Honor, International Exposition of Ceramics, Geneva, 1965; Diploma of Honor, Twenty-fifth International Competition of Artistic Ceramics, Faenza, 1967; Second Prize for Painting, Murillo National Salon, La Paz, 1973; Diploma of Honor, Fourth International Ceramic Art Biennial, Vallauris (France), 1974; First Prize, *El Diario* National Competition of Ceramics, La Paz, 1977; Grand Prize, Second Art Biennial, National Institute of Fine Arts, La Paz, 1977; Second Prize, C. Guzmán de Rojas National Salon, Potosí, 1978. Prize for execution of a ceramic mural at "La Primavera," La Paz, 1980-81.

Individual Exhibitions and Murals

1949 Showroom, Ministry of Foreign Relations, La Paz
1950 Universidad Técnica, Oruro

Universidad de San Francisco Xavier, Sucre
Universidad de San Simón de Cochabamba
1951 Municipal Gallery, La Paz
School of Fine Arts, Rio de Janeiro
1955 Andrioletti Gallery, Montevideo
1956 Municipal Gallery, La Paz
1960 Showroom, Massana Conservatory, Barcelona (Spain)
1961 Gallery of the Syndicates, Madrid
1962 Municipal Gallery, La Paz
1963 Antígona Gallery, Buenos Aires
Municipal Gallery, La Paz
1964-65 Execution of three murals, University of La Paz
1965 Tertulia Gallery, Cali
1966 Municipal Gallery, La Paz, Sucre, and Cochabamba
1967 Execution of a ceramic panel, First National City Bank, La Paz and Callao
Bolivian-German Cultural Institute, La Paz
1968 Execution of five ceramic panels, Grace Lines, La Paz
Municipal Gallery, La Paz
National Museum of Art, La Paz
1969 The Artists' Showroom, San Diego (California)
Municipal Gallery, La Paz
1973 Track Gallery, Caracas
1974 National Museum of Art, La Paz
The Artists' Showroom, San Diego (California)
1975 Emusa Gallery, La Paz
1976 Trapecio Gallery, Lima
1977 Inter-American Development Bank, Washington, D.C.
1979 National Museum of Art, La Paz
OAS Gallery, Washington, D.C.
1980 Latin American Gallery, Lancaster (Pennsylvania)
Huber Art Center, Shippensburg (Pennsylvania)
1980-81 Execution of ceramic mural at "La Primavera," La Paz
1982 América Art Gallery, La Paz
1983 Bet-Haomanim, Jerusalem
1985 Execution of a mural, Organization of American States, Washington, D.C.

July 10 - 31, 1985

FERNANDO CARBALLO OF COSTA RICA

The immediate reaction of the viewer to the work of Fernando Carballo is a sense of shock. His drawings do not have a tranquilizing effect; they burn with an inner fire of strong emotional intensity which leaves the spectator ill at ease.

The expressionistic vision which provides the content of Carballo's drawings takes precedence over matters of form. Although the artist's technique is highly refined, graphic elements are merely the means whereby Carballo gives voice to the anguish he feels within. Francisco Amighetti has said of Carballo:

> He leads us into the domain of the subjective, to the expression of inner feeling. He is not ruled by the graphic value of line, but by the pictorial concept the drawing is to convey. Restless sculptural blocks gradually emerge from the strokes of his pencil or burin, but the human body, etched or sketched, remains a shapeless mass driven by a soul in torment. His is a world of fantasy, suggestive of the hallucinatory visions of Kafka or the lubricious imaginings of the Marquis de Sade.

EXHIBITION LIST [1]

1-14. Drawings

ABOUT THE ARTIST

Fernando Carballo was born in Cartago, Costa Rica, in 1941. He studied painting with Marco A. Aguilar in the San Luis Gonzaga College. He resides in San José.

Selected Individual Exhibitions

1973 Arts and Letters Institute, San José
1976 Rotary Club, Cartago
1977 Sokari Gallery, San José
1978 School of Fine Arts, University of Costa Rica, San José
1980 Tiempo Theater, San José
1981 National Theater Company, San José
1982 National Theater, San José
1985 National Theater, San José

Selected Group Exhibitions

1976 National Museum of Costa Rica, San José
1977 *Today's Art of Latin America*, Instituto de Cultura Hispánica, Madrid
1977 Antigua Gallery, San José
1978 Casa de las Américas, Havana
1978 Vienna (Austria)
1979 De Armas Gallery, Miami
1981 Circle of Readers, San José
1985 Museum Juan Santamaría, San José

Awards

1978 Aquileo J. Echeverría National Award (drawing), San José
1980 Stamp Edition *Art in Costa Rica*, San José
1982 Aquileo J. Echeverría National Award (painting), San José
1984 Award for Poetry Illustration, Embassy of Argentina, San José

July 10 - 31, 1985

ROBERTO SANDOVAL OF COSTA RICA

These massive sculptures by Roberto Sandoval--primitive, strong, laboring--stand rooted in the earth. They express the essence of the working, life-bearing woman in all her strength throughout the history of womankind.

Sandoval's women have the strength commonly attributed to men, but they incorporate the strength of both sexes. Physically strong from labor, these figures have an almost animal quality. The legs and feet are gnarled and knotted like the trunks of trees; their faces are sometimes like animals at bay, defending their young. In the figure *Working*, the sheaves that the woman carries in her hand is almost of the same material as her arms and legs--she is directly a part of nature, an expression of nature itself, as is the child sleeping on her back. The long,

[1] Not included in the original catalogue. The titles of the works exhibited are unavailable. --*Ed.*

stylized arms are characteristic of Sandoval's work.

These are not superwomen, despite their stature and strength: they are simply the woman at her fullest expression. In their vitality they almost breathe and move. Sandoval has captured the essence of a vital energy and life so that the bronze itself comes alive.

Roberto Sandoval was born in Alejuela, Costa Rica, in 1940. His father and stepfather were both sculptors, and his mother worked in the field of decorative arts. He studied with his stepfather, internationally known sculptor Manuel Zúñiga Rodríguez, and with master stone carver Dr. Milo Lazarevic. From 1975 to 1977 he studied at the Department of Fine Arts of Columbia University. He has exhibited individually and in group shows since 1971 in New York, California, and Italy. This is his first presentation in the nation's capital.

CATALOGUE

Bronze Sculptures

1. *Security*, 1982, 23" ht.
2. *Working and Carrying Her Whelp*, 1982, 15" ht.
3. *Woman*, 1982, 25" ht.
4. *Giving Birth near the River*, 10" ht.
5. *Satisfaction*, 1982, 22" ht.
6. *Love and Pregnancy*, 23" ht.
7. *Protecting*, 1982, 10" ht.
8. *Nursing the Child*, 15" ht.
9. *At Sunset*, 80" ht.
10. *Labor and Giving Birth*, 1985, 20" ht.
11. *Woman with Fish*, 1985, 23" ht.
12. *Building*, 1985, 22" ht.
13. *Mother Nature I*, 1985, 23" ht.
14. *Survival*, 1985, 21" ht.
15. *Loving*, 1985, 17" ht.
16. *Woman Beating Wheat*, 1985, 22" ht.
17. *Good Harvest*, 1985, 27" ht.
18. *Indignation*, 1985, 21" ht.
19. *Fertility*, 1985, 29" ht.
20. *Mother Nature II*, 83" ht.

August 13 - 31, 1985

IMAGES OF SURINAME

The arts have depicted the various attitudes, changes, and transformations that man's behavior has undergone since the very start of his social, economic, and political evolution. Among the visual arts, painting has perhaps been the medium most often used to describe situations, lifestyles, and aesthetic values, which vary from one society to another. It has often been said that the artist is a visionary who uses his creative talents to reveal elements of culture that represent the characteristic of the group to which he belongs.

The Museum of Modern Art of Latin America of the Organization of American States is pleased to exhibit for the first time, in its gallery in the headquarters building, a collection of images from Suriname as seen and depicted by its artists. These pieces belong to the State Collection. Unlike the procedure used on other occasions and under other circumstances, the Museum thought it best not to specify a given set of guidelines or approaches, since the interest that a sampling of this nature has is precisely the diversity and variation in expressive levels that it can offer to accurately reflect the arts in that country.

A first glance, for example, reveals that the woman is a dominant theme. However, at the same time we see differences in the way this theme is conceived and executed. No one stylistic pattern emerges and the diversity

is as rich and varied as the ethnic composition of the people of Suriname. Other themes such as landscapes and daily labors also capture some of the painters' interest, along with the more conventional themes such as portraits, purely graphic painting, and artistic speculation.

The Museum of Modern Art of Latin America hopes that this first sampling of Surinamese art here in the capital of the United States will help to bring the public closer to this young nation, not necessarily because of what it has in common with others, but rather to create an appreciation of the idiosyncracies and emotions, as expressed through the sensitivity of the artists.

EXHIBITION LIST [1]

Paintings and Drawings

J. A. Chin A Foeng
1. *Vlinder (Butterfly)*, oil, 100 x 100 cm.
2. *Abstrakt in Rood (Abstract in Red)*, oil, 83 x 93 cm.

A. Favery
3. *Surinaamse Vrouw (Surinamese Woman)*, oil, 73 x 93 cm.
4. *Fort Zeelandia (Fort Zeelandia)*, oil, 68 x 88 cm.

R. Flu
5. *Krantenjongen (Newspaper Boy)*, oil, 83.5 x 92.8 cm.
6. *De Twijfelaar (The Skeptic)*, oil, 72.8 x 124.5 cm.

G. Fung Loi
7. *Zakken Cement (Cement Bags)*, oil, 86 x 133 cm.
8. *Meloen (Pumpkin)*, oil, 69.5 x 91.5 cm.

R. Fung Loi
9. *Surinaamse Vrouwen (Surinamese Women)*, oil, 99.5 x 124 cm.

K. Flijders
10. *Boerderij in Landschap (Landscape with Farm)*, oil, 48.5 x 53 cm.

R. Getrouw
11. *Zittend Naakt (Sitting Nude)*, oil, 84.5 x 105 cm.
12. *Portret van een Vrouw (Portrait of a Woman)*, oil, 65 x 100 cm.

W. Grimmer
13. *Apinti Dron (Apinti Drum)*, oil, 52.5 x 72.8 cm.

N. Hatterman
14. *Oerwoud (Jungle)*, oil, 75.5 x 110.5 cm.
15. *Simón Bolívar*, oil, 76 x 116 cm.

S. Irodikromo
16. *Ritueel Slachten (Ritual Scene)*, oil, 107 x 107 cm.
17. *Twee Vrouwen (Two Women)*, batik, 79 x 87.5 cm.

R. Karsters
18. *Portret van Wijlen Chin (Portrait of the Late Chin)*, crayon, 100 x 70 cm.
19. *Portret van een Meisje (Portrait of a Girl)*, crayon, 40 x 48 cm.

[1] Not included in the original catalogue. --*Ed.*

L. K. D. Lieveld
20. *Kwi-Kwi*, acrylic, 46 x 64 cm.
21. *Savannabos (Savanna)*, acrylic, 45.5 x 64.5 cm.
22. *Stilleven met Vruchten (Still Life)*, acrylic, 56.5 x 79.5 cm.
23. *Coronie*, acrylic, 66.5 x 98.5 cm.

A. Mosis
24. *Toilet (Grooming)*, oil, 70.5 x 102 cm.

G. Ramdjiawansingh
25. *Bedelaar aan de Waterkant (Beggar on the Waterfront)*, watercolor, 24 x 27.5 cm.

C. San A Jong
26. *Baletdanseres (Ballet Dancer)*, oil, 84.5 x 103.5 cm.
27. *Dame met Blauwe Komono (Lady in Blue Kimono)*, oil, 108.5 x 119.7 cm.
28. *Arbeiders (Workmen)*, oil, 62.5 x 77.5 cm.

K. Siebert
29. *Twee Indiaanse Meisjes (Two Indian Girls)*, oil, 54 x 63.8 cm.

M. Stuart
30. *Sterfgeval (Death Scene)*, oil, 75.5 x 84.5 cm.

R. Tosari
31. *Landbouw (Agriculture)*, aquatint, 51 x 66 cm.
32. *Industrie (Industry)*, aquatint, 51 x 66 cm.
33. *Kunst (Art)*, aquatint, 51 x 66 cm.

A. Veninga
34. *Nene met Pijp (Nene with Pipe)*, oil, 78 x 68.3 cm.
35. *Bosland Dorp (Maroon Village)*, oil, 74.7 x 98 cm.

BIOGRAPHICAL NOTES [1]

CHIN A FOENG, Jules A. Painter, born Suriname, 1944, where he died in 1983. Since 1961 has held individual exhibition in Suriname, the Netherlands, French Guyana, and the United States (New York University, 1976). Participated in group exhibitions in Suriname, Netherlands (Oranje-Nassau Museum, Delft, 1963), Guyana (Carifesta, 1969), Yugoslavia (Museum Slovens Gradec, 1975), Brazil (São Paulo Biennial, 1977; Teatro Amazonas, Manaus, 1978), and Venezuela (Galería Durbán, Caracas, 1983).

FLU, Ron. Painter, born Singapore, China, 1934. Studied building engineering and architecture, Amsterdam. Considers himself a self-taught painter. Since 1965 has participated in group shows in Suriname (national salons, 1965-67 and 1974-78; Third Diaspora exhibition, 1982; and *Identity*, Surinaams Museum, 1084, all of them in Paramaribo) and abroad, including Netherlands (Amsterdam, Scheveningen, and other cities, 1968), Brazil (Manaus, 1978), Jamaica (Carifesta, 1977), and in Cuba (Carifesta, 1979, and *Art in Suriname*, Havana 1983). His work is represented in private collections in Suriname, Venezuela, the United States, and the Netherlands. Lives in Suriname.

FUNG LOI, Glenn. Painter, graphic artist, born in Suriname, 1945. Participated in group exhibitions in Suriname (National Arts Fair, Paramaribo, 1969, among others), Guyana (Carifesta, 1972), Netherlands (Rotterdam, 1974), and Cuba (Carifesta, 1979). Won Third Prize, Graphic Art Contest, Paramaribo, 1968.

FUNG LOI, Rocky. Painter, born in Suriname, 1954, where he held one individual exhibition in 1978.

[1] Not included in original catalogue. --*Ed*.

GETROUW, Rudi. Painter, graphic artist, born in Paramaribo, 1928. Graduated from the Royal Academy, the Hague, 1956. In 1957-59, studied lithography and etching in Amsterdam. At present is director of the Arts Department, Institute for Advanced Teacher Training, Paramaribo. Held one individual exhibition in Paramaribo, 1957. Participated in group shows in Suriname (National Arts Fair, 1969 and 1974; *Identity*, Surinaams Museum, 1984, both in Paramaribo), Netherlands (Delft, 1957; *Present Day Art in Suriname*, Amsterdam, Groningen, Scheveningen, and other cities, 1967), the United States, Aruba, Curaçao, Barbados (Carifesta, 1981). His work is represented in collections in Suriname, the Netherlands, the United States, Aruba, and Curaçao.

HATTERMAN, Nola. Painter, born in Amsterdam, Netherlands, 1899. Died in Suriname in 1984. Worked in Amsterdam and London, 1950. Held individual exhibitions in Suriname and between 1963 and 1980 participated in group shows in Paramaribo (including *Identity*, 1984), Amsterdam, Groningen, and other cities in Netherlands.

IRODIKROMO, Soeki. Painter, born in Suriname, 1945. Studied in academies in Rotterdam and Jakarta. Held individual exhibitions in Paramaribo (1965, 1973, 1978, 1980, and 1981), Amsterdam (1972 and 1983), and Gent (Belgium, 1982). Participated in national salons (1967, 1973-76), National Arts Fair (1967), and *Identity*, Surinaams Museum, 1984, as well as other group exhibitions in Rotterdam (1971), Paramaribo (1979, 1980, 1983), Luxembourg (Grand Concours International de Peinture, 1971), Jamaica (Carifesta, 1977), Cuba (Carifesta, 1979), Jakarta (Institute of Fine Arts, 1980), Barbados (Carifesta, 1981), Manaus (Brazil, 1981).

KARSTERS, Ruben Johan. Graphic artist, draftsman, photographer, musician, born Paramaribo, 1941. Studied in Netherlands, Italy, Belgium, and French Guyana. Held individual exhibitions in Paramaribo. Participated in group exhibitions in Suriname (National Arts Fair, 1969 and 1981, Third Diaspora exhibition, 1982, and *Identity*, Surinaams Museum, 1984, both in Paramaribo, among others), Nigeria (Festac '77, Lagos, 1977), Brazil (Teatro Amazonas, Manaus, 1978), Cuba (Carifesta, 1979, and *Arte de Suriname*, 1983, both in Havana), Barbados (Carifesta, 1981).

LIEVELD, Egbert K.D. Painter, born Suriname, 1919, where he has held individual exhibitions since 1952.

RAMDJIAWANSINGH, George. Painter, draftsman, born Suriname, 1954. Exhibited in Suriname (National Arts Fair, Paramaribo, 1975, among others), and Barbados (Carifesta, 1981).

SAN A JONG, Cliff. Painter, born Paramaribo, 1948. Studied at the Suriname Academy for Visual Arts in Paramaribo, 1968; Rÿks Academy, Amsterdam, 1970; Vrÿe Academy, the Hague, 1971. Held one-man shows in Amsterdam (1973), Paramaribo (1974-75), and Willemstad (Curaçao Museum, 1976). Participated in group exhibitions in Suriname (Red Cross Building, 1970; *Identity*, Surinaams Museum, 1984, both in Paramaribo), Netherlands (*Present Day Art in Suriname*, Amsterdam, Scheveningen, Utrecht, and other cities, 1967), Nigeria (Festac '77, Lagos, 1977), Brazil (São Paulo Biennial, 1977), Jamaica (Carifesta, 1977), Cuba and Barbados (Carifesta, 1979 and 1981). His work is represented in private collections in Suriname, the Netherlands, the United States, and Curaçao.

STUART, Manuel. Painter, born in Suriname, 1956. Held one individual exhibition in Paramaribo, 1983.

TOSARI, René. Graphic artist, born in Suriname, 1948. Held one-man shows and participated in group exhibitions in Amsterdam, 1973, 1979, and 1980; Eindhoven, 1974; Rotterdam (Foundation for the Arts), 1974; Diemen, 1980; Doorn, 1981;and other cities in Netherlands, as well as in Paramaribo, including Art Manifestation of Suriname, Artist Association, 1978, 1981, and 1982.

September 10 - 30, 1985

ANA KOZEL OF ARGENTINA

LIGHT AND SPACE IN THE PAINTING OF ANA KOZEL

Ana Kozel has been exhibiting individually since 1973, but for five years before that she had participated in group shows. Displaying firm assurance from the start, she soon developed a clearly defined plastic manner of conveying her vision of reality. Impelled by increasingly keen insight into basic essentials, she proceeded to organize forms

in her own way, as she has discerned them. This quality gives her work spontaneity and coherence.

From 1977 to 1980 her chief interest was to capture light on canvas, to represent it as a flowing stream through an unresisting mass, accompanied by a wake of mingled transparent and opaque matter. Her present work is characterized by a similar forcefulness, revealed in her dynamic treatment of planes and her zeal in opening up new spaces. Her effort in this line is based on scientific considerations: she sees space--organized in forms or structures that are not generally known but that coincide with scientific models--as synonymous with energy. She herself has said:

> In my last series, entitled *Spaces*, I have focused on conveying a form of spatial reality in which elements move at such speed that they leave behind only a fleeting, evasive halo, a condensation of simultaneous bursts of energy. An infinitely brief instant, which merely suggests the immensely powerful, dynamic force to be found in space.

The idea that space is not a vacuum stirs Kozel to inquire into its vital structures, to search for a dimension in which mass, movement, and energy produce bodies in constant formation and transformation.

In addition to her fascination with the suggestions to which scientific discoveries give rise, Kozel has a consciousness of the presence in the universe of the ineffable. She found a reflection of this some time ago in a poem by Paul Klee, a few lines of which may serve by way of example:

> Shining in the background there is a sort of calm
> And suddenly
> Something appears there
> Which is not of this world,
> Which comes, not from me,
> But from God.
> From God. It may be only an echo,
> Only a divine space,
> But at least it means God is near.
> Drops from the depths,
> Light itself.

Kozel quoted the poem in connection with the series she called *Light*, but it applies equally well to the highly original approach she has taken--bold and yet grave--in *Spaces*, the series now presented to the American public under the auspices of the Museum of Modern Art of Latin America, in whose permanent collection the artist is represented. --*Guillermo Whitelow*, National Director of Visual Arts of the Argentine Republic

Once again the Museum of Modern Art of Latin America takes pleasure in presenting an Argentine artist on the rise, increasingly recognized for the highly professional quality of her work. When in 1982 Ana Kozel approached the Museum in regard to a show in its temporary exhibition gallery, the quality of the compositions she submitted for evaluation was such that the Acquisitions Committee at once recommended a purchase for the permanent collection. This action was taken pursuant to the Museum's long-established policy of furthering, by exposure at the international level, the careers of artists from Latin America and the Caribbean who already have achieved a measure of recognition at home.

For the present exhibition a selection has been made from Ana Kozel's *Light* series, to which the Museum acquisition belongs, and from the more recent series which she has entitled *Spaces*. This permits an appreciation of the development which her work has undergone during the last five years.

Quite aside from the philosophic ideas they may embody, or the subjective interpretations to which they may give rise, the compositions stand on their own as visual concepts, distinguished for their neat brushwork, their harmony of design, and their chromatic balance. Their clarity and euphony is suggestive of the perfection to which man everywhere aspires. --*Rogelio Novey*, Acting Director, Museum of Modern Art of Latin America

ACKNOWLEDGEMENTS

This exhibition has been made possible by the generous cooperation and support of the following institutions in Buenos Aires: Ministry of Foreign Affairs and Worship of the Republic of Argentina, Museum of Modern Art, Bank of America, and Praxis Art Gallery.

CATALOGUE

Acrylics

1. *Descenso de la luz (Descending Light) I*, 1977, 114 x 114 cm.
2. *Descenso de la luz (Descending Light) II*, 1977, 114 x 114 cm.
3. *Ruptura de las ondas de luz (Breakage of Light Waves)*, 1978, 170 cm. ht. (rhomboidal shape of 120 x 120 cm.)
4. *Fuga, serie de la luz (Fugue, Light Series)*, 1985, 170 cm. ht. (rhomboidal shape of 120 x 120 cm.)
5. *Vibración (Vibration)*, 1980, 100 x 100 cm.
6. *Ascenso de la luz (Ascending Light)*, 1977, 100 x 141 cm.
7-8. *Serie de la luz (Light Series) IV, VII*, 1979, 100 x 100 cm.
9. *Serie de la luz: Movimiento (Light Series: Movement) XI*, 1980, 100 x 100 cm.
10. *Serie de la luz (Light Series) IX*, 1983, 100 x 100 cm.
11. *Serie de la luz (Light Series) III*, 1979, 100 x 100 cm.
12. *Serie de la luz (Light Series) X*, 1982, 100 x 100 cm.
13. *Desplazamiento espacial (Spacial Displacement)*, 1985, 150 x 110 cm.
14. *Agujero negro, danza cósmica (Black Hole, Cosmic Dance)*, 1985, 155 x 123 cm.

Serigraphs

15. *Serie de la luz (Light Series)*, 1979, 62 x 51 cm.
16. *Serie de la luz (Light Series) I*, 1984, 41 x 41 cm.
17. *Serie de la luz (Light Series) II*, 1984, 65 x 50 cm.
18. *Serie de la luz (Light Series) III*, 1985, 50 x 65 cm.
19. *Serie de la luz (Light Series) IV*, 1983, 50 x 65 cm.
20. *Ruptura de las ondas de luz (Breakage of Light Waves)*, 1984, 50 x 65 cm.
21. *Danza cósmica (Cosmic Dance)*, 43 x 37 cm.
22. *Espacios (Spaces)*, 1985, 50 x 70 cm.

October 30 - November 30, 1985

DALITA NAVARRO OF VENEZUELA[1]

HUMAN CLAY

In recent decades, the identification of man with nature has taken on increasing significance for those concerned with the possibilities of rational development in art. The exhaustive experimentation of previous years and the complexities of current aesthetic manifestations would seem to have prepared the way for new conceptual associations in which instinct is destined to play a more leading role.

Ceramic constitutes a privileged field, in that it brings the artist into direct physical contact with the material in which he works. To thrust one's hand into clay provides both a sensuous and a spiritual experience. The ceramist is as it were trapped: he has no choice other than to invent. In this dramatic encounter between brute matter and human creativity, the artist must draw strength from within. The evidence of the past, the history of civilization, tradition--the choices with which the artist is confronted in every society and time--are all external

[1] The list of works exhibited (23 ceramic pieces) is unavailable. --*Ed.*

to the creative act in which the ceramist strikes a balance between inner and outer force.

In modeling clay Dalita Navarro seeks to give shape to the inchoate. She delves for roots, she discovers fresh qualities in the kaolin, and possessed by the demiurge inherent in all human nature she transmutes the elements with which she works, establishing connections which gradually assume the form of a work of nature, perchance of art.

In a first phase her compositions presented a dramatic fusion of heads with the earth from which they seem to spring. One finds a certain degree of consistency among them: there is always an ovoid form in which a face seems to blend into the clay of which it is molded, and which continues malleable and friable like the earth from which fruits bud forth. These open compositions, obviously sculptural in intent, are imbued with the pathos of the human condition--a halfway stage between physical erosion and spiritual transfiguration.

From this initial stage Dalita Navarro moved on to another, which thus far seems definitive. Here the shapes of nature assume anthropomorphic qualities: fruits develop lips and eyelids. Voluptuously swelling forms suggest flesh and the temptations to which it gives rise--strange hybrids, endowed by the creator with a human presence.

Workers in fired clay have an age-old tradition of vacillation between fine and applied art. The ceramist may incline toward the production of useful or decorative objects, or he may view himself as a creator of sculpture, albeit limited in scale. Then there are cases such as that of Dalita Navarro, who seeks to develop qualities inherent in the nature of clay, to give new meaning to ceramic art. For Navarro, the work of clay should be able to stand on its own, representing no more than the artist's effort to create. Herein lies the bond between man and nature. In Navarro's fruits we recognize ourselves. Quite aside from similarities of form--lips, eyes, or other anthropomorphic traces--there is the concept of transferral, the clear aim of imbuing the ambient world with human characteristics, in a mysterious echo of our earthly condition.

These fruits possess a dual nature; they partake of both reality and fable. Quite aside from their formal beauty they have the power of revelation that is inherent to the work of art. The echoes they arouse--personal or otherwise--are as real to us as our dreams.

Arcimboldo took perverse delight in composing human faces of forms taken from all the realms of nature, from the daintiest to the utterly monstrous. Hieronymus Bosch practiced surrealism centuries before the term was invented. In all cultures and all continents, the correspondences between the human and the bestial are clearly evidenced. Navarro is heir to a tradition of vast proportions, a tradition that fills a contemporary need: that for recognition of the power of instinct. --*Roberto Guevara*, Director of Museums, National Council of Culture of Venezuela.

ABOUT THE ARTIST

Dalita Navarro, was born in Venezuela in 1945. Received her academic training with Esther Alzaibar and at the Cristóbal Rojas Visual Arts School in Caracas. From 1979 to 1983 she was the art director of the Galería Terracota of Caracas. She resides in Caracas. This is her first presentation in the United States.

Selected Individual Exhibitions

1981	Viva México Gallery, Caracas
1982	Fine Arts Center, Maracaibo
1983	G Gallery, Caracas
1984	700 Gallery, Maracaibo

Selected Group Exhibitions

1981	*Eight Viewpoints in Venezuelan Ceramic*, Meeting Point Art Center, Miami
1982	*Venezuelan Ceramic*, Carrillo Gil Museum, Mexico City
	Fortieth International Competition of Artistic Ceramic, Faenza (Italy)
1984	*Four Ceramists*, Venezuelan Embassy, Paris
	First World Triennial Exhibition of Small Ceramics, Zagreb (Yugoslavia)

Contemporary Venezuelan Ceramics, Venezuelan Consulate, New York
1985 British Crafts Center, London
 Invited to exhibit at the Ponce Museum, Puerto Rico, in the International Award Winners Exhibition
 of Latin America
 Numerous exhibitions in different cities of Venezuela

Awards

1980 Praxiles Valera Prize, awarded by sculptor Víctor Valera, Eighth National Firing Arts Exhibition,
 Valencia (Venezuela)
1984 Honorary Degree, Zagreb

Collections

Correo del Orinoco Museum, Ciudad Bolívar (Venezuela)
International Ceramic Museum, Faenza (Italy)
Simón Bolívar University, Caracas
Venezuelan Embassy, Paris
Museum of Pan American Friendship, Bolivar, New York
Banco Consolidado Foundation, Caracas

November 25 - December 30, 1985

TRADITIONAL TEXTILES OF COMALAPA [1]

Press Release E-110/85. Organization of American States, Washington, D.C., November 19, 1985. An exhibition
of traditional Guatemalan textiles, vivid in color and dazzlingly rich in both abstract and biomorphic designs, will
open at the Art Gallery of the Organization of American States (OAS). . . .

Representing five communities of a linguistic group in Guatemala called Cakchiquel-Mayan, the exhibit will
display eighty-nine textiles, all clothing or items of fabric made for use by the members of the Indian
communities in which they were produced, and many made by an ancient weaving method used by the Mayans
before the arrival of the Spaniards almost 500 years ago.

Also included in the exhibit will be twenty paintings by the Guatemalan primitive painter Andrés Curuchich.

This exhibit is being sponsored by Eduardo Mayora Dawe, Guatemalan Ambassador to the Organization of
American States, and Mrs. Dawe, and Secretary General João Clemente Baena Soares and Mrs. Baena Soares,
in cooperation with the Museum of Modern Art of Latin America and the Ixchel Museum in Guatemala City,
with contributions from the Philip Morris Companies, Inc.

On November 21st at 5:00 p.m., a lecture/film presentation entitled *The Language of Native Costume in a
Guatemalan Community* will be presented by Mrs. Linda Asturias de Barrios, curator of the Ixchel Museum of
Indian Dress, at the Museum of Modern Art of Latin America. . . .

EXHIBITION LIST

Textiles and Artifacts

> 1. White muslin
> 2. Paper airplanes (for hanging)

[1] Although no catalogue was issued for this exhibition, the following book was available for purchase:
Comalapa: Native Dress and Its Significance, by Linda Asturias de Barrios, translated from Spanish by Claudia
Feldmar (Guatemala City: The Ixchel Museum of Indian Dress of Guatemala, 1985). --*Ed.*

3. Big bread basket
4-5. Medium basket
6-11. Flat baskets
12-17. Skirt fabrics
18. Earthenware jug
19. Earthenware plate
20-21. Small straw mats
22-24. Bunches of paper flowers
25-26. Vases
27-30. Large incense burners
31. Small incense burner
32. Urn with a saint
33. White table cloth
34-36. White candles
37-44. Small candles
45. Spindle and two cotton balls
46. Spindle and one cotton ball
47-49. Bowls
50-55. Wooden beating sticks
56-57. Nets
58. Deerskin
59-63. Kerchiefs
64. Natural brown cotton ball
65. Small basket with muslin scraps
66. Pink ribbon
67-69. Small baskets
70-81. Plastic tubes
82-106. Mannequins
107. Brown loom
108. Blue loom
109. Black loom
110. Map of Guatemala
111-112. Indian blouses
113-132. Wigs

LIST OF WORKS BY ANDRES CURUCHICH

Paintings

1. *Recibió cargo de Capitana su fiesta* (She was granted the rank of captain in her feast)
2. *La Fiesta de San Juan Patrón, el 24 de Junio* (Celebration of Patron Saint John, June 24th)
3. *La mujer compra chamaro a los chichicastenangos y la mujer de Chichicasteca haciendo café* (The woman buys *chamaro* from the vendors of Chichicastenango, and the woman from Chichicasteca makes coffee)
4. *Ordeñando la vaca* (Milking the Cow)
5. *Marranero Comalapa* (Pig Butcher of Comalapa)
6. *El Seño San Antonio de Padua* (Saint Anthony of Padua)
7. *Posada el Señor San José y María* (Señor San José y María Inn)
8. *Esta componiente horchate para mandar una tinaja con el cofrade presente y con la capitana y con sus mayordomas una jicara cada una* (Making orgeat to be carried out in a jar by a member of the brotherhood, the captain and her assistants each carrying a gourdful)
9. *Un muerte esta descansando en todas las esquinas hasta llegar el cemeterio* (Death parade halting at each corner on the way to the cemetery)
10. *Santo Entierro* (Holy Burial)
11. *El hombre bajando carga de maiz a la mula* (Man with mule unloading corn)
12. *Nacimiento el niño Jesus todos los instrumentos estan tocando* (Musicians playing at a nativity scene)
13. *El hombre cortando leña en un aldea Paraxaj* (Man Splitting Firewood in a Paraxaj village)
14. *Las mujeres labando en el Río de Siguan Cabac* (Women washing in the Siguan Cabac River)

15. *Patio y la Iglesia de Comalapa* (Square and the Church in Comalapa)
16. *Baila torito en la casa de un cofradia* (Torito dance at a Brother's House)
17. *Fiesta de Comalapa. Los juegos el triángulo seguado y el palo alto tiene cebo tambien para no poder subir agarrar el premio la Iglesia* (Festivity in Comalapa. The games consist of a greased triangle and a pole which has also been greased to make it difficult to climb and win the prize given by the Church)
18. *Vendición de una casanuevo el madrino y padrino con sus candelas en las manos* (Benediction of a new house with witnesses holding candles)
19. *Bautismo* (Christening)
20. *Fueron hacer plaza en Tecpan* (Marketing in Tecpan)

BIOGRAPHICAL NOTE [1]

CURUCHICH, Andrés. Painter, born in San Juan Comalapa, Chimaltenango, 1891, where he died in 1969. A self-taught Cakchiquel-Mayan Indian, he never left his village except for a few visits to Guatemala City. Like all highland Indians, cultivated corn, worked as a mason, house painter, and occasionally as a butcher. Spent his last years devoted mainly to painting. Held individual exhibitions in Guatemala City; San Francisco (California), 1956; Dallas (Texas), 1958; Springfield (Illinois), 1958; Detroit (Michigan), 1959. The Guatemalan government bestowed him the Order of the Quetzal in the rank of Gran Cruz.

December 16, 1985 - January 17, 1986

COLONIAL ART OF ECUADOR
Selections from the Collection of the Stapleton Foundation of Latin American Colonial Art, Inc.

STAPLETON FOUNDATION EXHIBIT

In recent years, the Museum of Modern Art of Latin America has expanded its scope of activity, supplementing exhibits which fall clearly within the purview defined by its name with ones suggestive of the roots from which Latin American and Caribbean art of today has sprung.

Such is the case with this Christmas show of selected pieces from the collection of the Stapleton Foundation, the creations of anonymous Ecuadorian artists and artisans of the eighteenth and nineteenth centuries. It does not pretend to cover, even in summary form, artistic developments in the Andean nation during the two hundred years in question--a period in which Spanish colonial baroque reached its apogee in the religious establishments of that land, particularly in the city of Quito. It does reveal, however, the fashion in which often humble craftsmen sought to give aesthetic expression to the soul of the people in works reminiscent of their Iberian and Indian origins.

The collection from which the pieces on view are drawn was initiated about a century ago by Daniel Casey Stapleton, during the course of a long residence in Ecuador. The exhibit was made possible through the efforts of Mr. Stapleton's granddaughters, Stella-Mae Renchard Seamans and Roberta Renchard Freer, and facilitated by the cooperation of George Ronald Renchard, Randolph William Renchard, and Fred Korth, members of the board of trustees of the Stapleton Foundation of Latin American Colonial Art. To them the Museum of Modern Art of Latin America is most grateful for the opportunity to put on display for the first time in the city of Washington objects which it trusts will serve to increase public appreciation of the artistic achievement of dwellers in countries to the south of the Rio Grande.

The Museum would also express its thanks to the Representative of Ecuador to the Organization of American States, Ambassador Rafael García Velasco, for his enthusiastic support of this undertaking and his patronage of the presentation.

It is the Museum's hope that interest aroused by the exhibit will substantially help the Stapleton Foundation in

[1] Not included in the original catalogue. --*Ed.*

its effort to obtain the public and institutional backing that will permit it to achieve its goal of "establishing and maintaining a museum devoted to the care and display of Latin American colonial art," in which the pieces gathered by Daniel Casey Stapleton--more than one thousand in all--may be permanently on display for the enjoyment and edification of visitors from all parts of the world. --*Rogelio Novey*, Acting Director, Museum of Modern Art of Latin America.

DANIEL CASEY STAPLETON (1858-1920)

When standing he was tall, over six feet in height, but at the moment he was kneeling in a tiny hut on the bank of a tributary of the Amazon River. Dan Stapleton had heard there was a Roman Catholic priest there and had ridden many miles to attend mass. He was the only non-Indian for miles around and was surprised on entering the hut to find a woman whom he recognized as a fellow American already kneeling on the hard-packed floor. The two spoke briefly after mass, Dan identifying himself as a Nebraskan who had spent most of his adult life in that remote areas as resident manager for the British-owned Ecuadorian Land Company. It turned out that the woman too came from Nebraska. Engaged at the moment in a trip up the Amazon, she had had her boatmen make a lengthy detour in order that she might attend the service. Her name was Stella Hamilton, and her ultimate destination was the Orient. The two discovered in the course of their conversation that, in addition to their common origin, they had a number of similar interests. When time came to part Dan asked Stella where she would be a year from that time. Though Stella said she had no idea, Dan declared: "When I find you a year from today, I'll marry you." While Stella may have had her doubts at the time, a year later Dan did find her in Vancouver, Canada, and a few weeks later, on July 25, 1914, they were quietly married in Omaha.

The son of an immigrant noble from Wales, Daniel Casey Stapleton was born in 1858 in Joliet, Illinois. After trying his hand at homesteading in Nebraska in the mid 1880s, around 1890 he entered the employ of a London bank which sent him to manage property it owned in South America, and there he remained for the better part of thirty years. The Ecuadorian Land Company's holdings stretched over a vast area in a region of ill-defined boundaries between Colombia, Ecuador, and Brazil. Dan lived in a simple house on wood pilings amid the Indians who worked the company's coffee and copra plantations and mined for platinum and emeralds.

It was during these years of residence in South America that Dan acquired the thousand and more items comprising the Stapleton Foundation collection. They range from pre-Incaic stone carvings and hammered gold nose rings of the fifteenth century to seventeenth-century books printed on vellum and church ornaments of the eighteen hundreds. How did they come into his possession? Not having sifted through the mass of his correspondence and other papers, we do not know the full answer as yet. Most of the items date from his years of residence in Ecuador, and presumably he bought them. Considering the elaborate nature of the furniture and silverware, one wonders whether they ever graced his modest home in the back country. Some items of an ecclesiastical nature may have been given him in appreciation of services rendered the church; others may have been sold to him in times of economic distress.

The few letters we have read concerning Stapleton picture him as a fervent Roman Catholic, a Christian in deed as well as in word. He viewed all men as brothers, and to those in need he gave freely of his own.

P.J. Navarro, later president of the Quito Railway Company, writing in 1905, described the departure he and Stapleton made from the Ecuadorian capital on the eve of the battle of Latacunga, between the forces of President García and those of the insurgent General Alfaro. "The road to Luisa was crowded with runaways, wounded and sick soldiers. Every person we met was a person in distress. The occasion was propitious to reveal Mr. Stapleton's great heart: he had a soothing word and a helpful coin for everybody in that road of hardship."

The superior of a convent in Quito wrote: "Oh! How kind and thoughtful he was, without being troublesome. During an epoch of many revolutions . . . his first care was for us. . . . He made it his business to come every day . . . to see if we were in need, offering to do any commission that we might need. . . . He often left us money, . . . he even offered to do our marketing. . . . He was also much loved by the Clergy, his men too looked on him as a father. I mean his employees . . . they loved and respected him."

In 1912 Stapleton was knighted by Pope Pius X, who bestowed on him the Order of St. Sylvester, given for great charitable contributions and services to religion.

By the time of his marriage, Dan had built four churches--three in South America and one in Nebraska. The last mentioned is in a small town named Stapleton in his honor, in recognition of his idealism and abiding faith in the future of the state he called home.

In July 1916 Daniel and Stella had a daughter, Stellita, born in Omaha. Daniel died at the family home, then in Washington, D.C., in May 1920.

EXHIBITION LIST [1]

Wood carvings, gessoed and polychromed, eighteenth century to late nineteenth century

Figures Related to the Nativity Scene

1. *Melchior, Gaspar, and Balthasar (Wisemen)*
2. *Shepherd*
3. *Peasant Woman*
4. *The Flight to Egypt*
5. *King Gaspar*
6. *Ox and Ass*

Other Themes, Mostly Religious

7. *Angels*
8. *Angel, Equestrian (St. James?)*
9. *Angel, Equestrian (St. Michael the Archangel)*
10. *St. John the Baptist*
11. *St. John*
12. *General*
13. *Two Angels and the Child Jesus*
14. *Boy at Prayer*
15. *Retable with Immaculate Conception*

Paintings

16. *Santa Rosa de Lima (Saint Rosa of Lima)*, oil on canvas, late eighteenth century
17. *Our Lady of the Rosary*, Chiquinquira, oil on paper mounted on wood panel, late seventeenth century
18. *Holy Family with St. John the Baptist*, oil on canvas, late seventeenth century
19. *Immaculate Conception with St. Ignatius and St. Francis*, oil on copper, seventeenth century
20. *Death of St. Theresa*, oil on wood, seventeenth century
21. *Virgin Mary*, oil on wood, seventeenth century
22. *St. Ysidro*, oil on paper, probably on an European print, mounted on wood, seventeenth century.
23. *St. Francis of Assisi*, oil on canvas, seventeenth century, Cuzco or Bolivian school
24. *St. Domingo*, oil on wood, seventeenth century
25. *Our Lady of the Rosary with St. Domingo*, oil on paper, eighteenth century
26. *St. Clare of Assisi*, oil on canvas, eighteenth century
27. *St. Francis Xavier*, oil on copper, seventeenth century
28. *St. Rose and Two Other Saints*, oil on wood, mid-nineteenth century
29. *Apparition of St. Thomas*, oil on wood, eighteenth century. Frame nineteenth century

Furniture

30. Chest, Peruvian, decorated, seventeenth century
31. Medicine Chest or Gentleman's Chest
32. Chair, early eighteenth century

[1] Not included in the original catalogue. --*Ed.*

33. Chair, eighteenth century
34. Two Corner Cabinets, inlaid decorations, nineteenth century
35. Four Arm Chairs, wood and leather with hand decoration and embossing, seventeenth century
36. Desk, wood, seventeenth century
37. Two Church Pedestals for Flower Arrangement, gilded wood, seventeenth century

Silver

38. Holy Water Font, silver, eighteenth century
39. Pitcher and Basin, silver, early nineteenth century
39. Candlesticks (two of a set of six), silver, wood and iron, mid-nineteenth century
40. Tray, silver, mid-nineteenth century
41. Tray, silver, mid-nineteenth century
42. Tray, silver, mid-nineteenth century
43. Table Frame for Altar Use, silver and lead, late eighteenth to early nineteenth century
44. Bible Cover, Carmelite Order, silver and velvet, early nineteenth century
45. Bible Cover, Clarissian Order, silver and velvet, early nineteenth century
46. Candlesticks, Carmelite Order, silver, iron and wood, late eighteenth, early nineteenth century
47. Bible Stand, Clarissian Order, silver and wood
48. Candlesticks (two of a set of six), silver and iron, late nineteenth century
49. Crown of the Virgin, silver and brass, early nineteenth century
50. Candlesticks (two of a set of four), silver and iron, late eighteenth century
51. Bible Stand, bearing the symbols of the Virgin of the Rosary, silver and wood, nineteenth century
52. Container with Cap Crowned with a Monkey, silver, nineteenth century
53. Tray, silver, early nineteenth century
54. Three Different Crowns of Statues of the Virgin, silver and brass, nineteenth century
55. Stemmed Vessel with Chain, silver, mid nineteenth century
56. Case, in the shape of a Mass book, silver, mid-nineteenth century
57. Three Footed Drinking Vessels, silver, mid-nineteenth century
58. Double-handled Drinking Vessel, silver, mid-nineteenth century
59. Single-handled Footed Drinking Vessel, silver, mid-nineteenth century
60. Pyx, silver, late nineteenth century
61. Small Water Pitcher for Preparing the Sacrament of Communion, silver, early nineteenth century
62. Chalice, silver and gold, early nineteenth century
63. Small Wine and Water Pitcher for Preparing the Sacrament Communion, and tray, silver, early nineteenth century
64. Cup, silver, mid-nineteenth century
65. Three Mugs, silver, mid-nineteenth century
66. Cup, silver, mid-nineteenth century

APPENDIX

As mentioned in the Preface, this publication was intended to begin its coverage in 1945. Due to the resulting size, it was necessary to publish it in two volumes. In this section, information is provided about those artists whose curricula vitae will appear in the forthcoming volume.

BURCHARD, Pablo A. Painter, architect, born Chile, 1919. Studied painting at the University of Chile, graduating in 1945; attended drawing classes, Columbia University, New York, 1941; workshop of Abraham Rattner, New School for Social Research, New York, 1950, on a scholarship from the Henry and Grace Doherty Foundation. Since 1942 has held individual exhibitions in Chile and Washington, D.C. (OAS, 1950), and since 1939 has participated in group exhibition in his country and in the United States.

BURLE MARX, Roberto. Painter, draftsman, jewelry designer, architect, landscape designer, born São Paulo, 1909. Studied music and art in Germany, 1928, frequenting also the Dahlem Botanical Garden; painting in Rio de Janeiro, National Fine Arts School, 1930-37, winning the Gold Medal of that institution, 1937, and with Cândido Portinari. Started working as a landscape designer at the request of architect Lucio Costa, 1933. Individual exhibitions of his paintings, landscape, tile and fabric designs include Museum of Modern Art, São Paulo, 1952; Institute of Contemporary Art, London; Stedelijk Museum, Amsterdam, 1953; OAS, Washington, D.C., 1954, exhibition circulated by the Smithsonian Institution throughout the United States. Was awarded First Prize for Landscape Design, Biennial of São Paulo, 1953; Fine Arts Medal, American Institute of Architects, 1965; Honorary Doctorate, Royal College of Art, London, and Royal Academy of Arts, the Hague, 1982.

CABRERA, Roberto. Painter, draftsman, printmaker, born Guatemala City, 1939. Studied National School of Plastic Arts, Guatemala City. Held individual exhibitions in Guatemala; OAS, Washington, D.C., 1962. Since 1960 has participated in national salons and group exhibitions in Guatemala and Mexico. Was awarded several prizes.

CAMACHO, Jorge. Painter, draftsman, printmaker, illustrator, photographer, born Havana, 1934. Has lived in France since 1959. Considers himself a self-taught artist. Held individual exhibitions in Havana; OAS, Washington, D.C., 1958; and Paris. Participated in the biennials of São Paulo and Paris; Pittsburgh International; and other group exhibitions in Cuba, the United States, France, and Spain. Was awarded several prizes in Cuba.

CAPRISTO, Oscar. Painter, muralist, printmaker, illustrator, and stage designer, born Buenos Aires, 1921, where he studied at the People's University of La Boca; the Manual Belgrano National Preparatory School of Fine Arts; with engraver Fernando López Anaya and with painter Emilio Pettoruti. Since 1947 has held numerous individual exhibitions in Argentina; OAS, Washington, D.C., 1963. Participated in national salons and group exhibitions in Argentina and abroad. Was awarded several national prizes.

CASTILLO, Carlos Aitor. Painter, draftsman, stage designer, art critic, born Lima, 1913. Lived several years in Argentina, where he studied under Spilimbergo, among other masters. Held individual exhibitions in Lima, Quito, La Paz, various cities in Argentina, and the OAS, Washington, D.C., 1964. Participated in official salons in Argentina; biennials of São Paulo, Mexico City, and Havana; and other group shows abroad. Among other awards, won several first prizes for drawing and painting in Argentina; First Prize and Gold Medal, Lima, 1954; National Prize for Stage Design, Lima, 1961.

DIAGO, Roberto. Painter, draftsman, printmaker, illustrator, born Havana, 1920. Died Spain, 1955. Studied National School of Fine Arts, Havana, graduating 1941. Since 1943, illustrated books and short stories in Cuba and the United. Held individual exhibitions in Cuba; Haiti; OAS, Washington, D.C.,1953. Participated in group exhibitions in Mexico City, Stockholm, Guatemala City, Moscow, Paris, Buenos Aires, and several cities in the United States.

DIAZ, Julia. Painter, born Cojutepeque, El Salvador, 1917. Studied El Salvador; Europe, on a scholarship from

the government of El Salvador; attended several free academies in Paris; Madrid, on a scholarship from the Institute of Hispanic Culture. Held individual exhibition in El Salvador. Participated in group shows in France; the United States, including the OAS, Washington, D.C., 1951, 1957; Spain and various cities of Latin America. Was awarded several prizes.

DIOMEDE, Miguel. Self-taught painter, born Buenos Aires, 1902, where he died, 1974. Was a member of the Academia Nacional de Bellas Artes, Buenos Aires. Held individual exhibitions in Buenos Aires, including the Museo Nacional de Bellas Artes, 1958. Participated in the Biennial of São Paulo, and other group exhibits in Buenos Aires, Washington, D.C., Rio de Janeiro, and was a guest of honor at the International Exhibition of Punta del Este, Uruguay, 1959. His awards include Gold Medal, Buenos Aires, 1936; Bronze Medal, International Exhibition, Brussels, 1958.

DUTARY, Alberto. Painter, draftsman, born Panama City, 1932. Founder of the Instituto Panameño de Arte, Panama City, 1962. Studied Escuela de Bellas Artes, Panama City; Academia de San Fernando, and Escuela Nacional de Artes Gráficas, Madrid. Held individual exhibitions in Madrid; Panama City, including the Museo Nacional, 1960; OAS, Washington, D.C., 1961; Lima; New York; Bogotá; Maracaibo, Venezuela. Participated in the biennials of Barcelona (Spain), Medellín (Colombia); San Juan (Puerto Rico); and in other group exhibits in the United States, Spain, Colombia, El Salvador, and Panama. Won First Prize, Central American Painting Competition, El Salvador, 1962, among other prizes.

FIGARI, Pedro. Painter, lawyer, philosopher, journalist, writer, born Montevideo, Uruguay, 1861, where he died, 1938. Founded newspaper *El Diario*; published articles on poetry, education, law, and aesthetics, and several books, including *Arte Estética, Ideal*, 1912; directed School of Fine Arts and Crafts, 1915-17; traveled in Europe, often as diplomatic representative of his country. Took up painting as a profession, 1918. Lived in Buenos Aires, 1918-25, where he founded the *Sociedad de Amigos del Arte*, and in Paris, 1925-34. Although mainly self-taught, studied drawing and painting in his youth under Geofredo Sommavila in Montevideo, and frequented the workshop of Ripari, Venice, Italy, 1886. Held individual exhibitions in Buenos Aires; Montevideo, Paris, Barcelona (Spain). Posthumous one-man shows were held in New York; OAS, Washington, D.C., 1946; Montevideo and other Latin American countries. His work was also included posthumously in Latin American and international group exhibitions at the Museum of Modern Art, New York; Musée d'Art Moderne, Paris; OAS, Washington, D.C.; Museo de Bellas Artes, Caracas; Biennial of São Paulo, where his work was given a special room in 1961. Received, among other awards, Grand Prize, *Centennial of Uruguayan Independence Exhibition*, Montevideo, 1930; Gold Medal, Ibero-American Exhibition, Seville, Spain, 1930.

FORTE, Vicente. Painter, printmaker, born Lanús, Argentina, 1915. Founding member of the surrealist group *Orión*, Buenos Aires, 1939. Traveled in Europe, the United States, and Latin America. Executed murals in Buenos Aires, and at the Laurel Race Track, Maryland. Studied in Buenos Aires at the Mutualidad Estudiantes de Bellas Artes, Academia Nacional de Bellas Artes, and under Lino Spilimbergo and Emilio Pettoruti. Held individual exhibitions in Buenos Aires; Museu de Arte Moderna, São Paulo, 1961; OAS, Washington, D.C., 1962; Miami Museum of Modern Art, 1963. Participated in the biennials of São Paulo, Havana, Venice, and Córdoba (Argentina); and in other group exhibitions in Buenos Aires, Rio de Janeiro, and several cities in the United States. Was awarded first prizes for painting and drawing, and won the Grand Prize at the 1959 National Salon, Buenos Aires.

FRIEDEBERG, Pedro. Painter, draftsman, graphic artist, sculptor, architect, born Florence, Italy, 1937. Moved to Mexico, 1940, and is a Mexican citizen. Took courses in architecture, Ibero-American University, Mexico City, and later studied under painter and sculptor Mathias Goeritz. Founded *Los Hartos* group with José Luis Cuevas and Mathias Goeritz. Held individual exhibitions in Mexico City, New York, Washington, D.C. (OAS, 1963), Houston, Paris, Lisbon, and Munich. Participated in group exhibitions in Mexico and the United States.

GIRONELLA, Alberto. Painter, draftsman, printmaker, illustrator, born Mexico City, 1929. Considers himself a self-taught artist. Visited Madrid and Paris, where he associated with the group *Phases*. Illustrated, among other publications, *Terra Nostra*, by Carlos Fuentes. Held individual exhibitions in Mexico City, including the Palacio de Bellas Artes, 1972; OAS, Washington, D.C., 1959. Participated in the biennials of Mexico City and São Paulo; Salon de Mai, Paris; and other group exhibitions, including those held at the Palacio de Bellas Artes, Mexico City; Museo de Bellas Artes, Caracas; Musée d'Art Moderne, Paris; OAS, Washington, D.C.; Museum of Modern Art, Kamakura, Tokyo, and Kyoto; Museo de Arte Moderno, Buenos Aires; Solomon R. Guggenheim

Museum, New York, and other museums and universities in the United States. Among other awards, won a prize at the Biennial of Paris, 1959.

GRAMCKO, Elsa. Painter, sculptress, born Puerto Caballo, Venezuela, 1925. Studied art for a short period at the School of Fine Arts and philosophy at the National University in Caracas. Held individual exhibitions in Caracas, including the Museo de Bellas Artes; Washington (OAS, 1959), and New York. Participated in national salons in Caracas and group exhibitions in the United States and Europe. Was awarded several prizes in Venezuela, including John Boulton Prize, 1964; Armando Reverón Prize, 1965; National Prize for Sculpture, 1968, all in Caracas.

GUAYASAMIN, Oswaldo. Painter, muralist, draftsman, printmaker, sculptor, born Quito, 1919. Studied Escuela de Bellas Artes, Quito. Visited the United States at the invitation of the Department of States, 1943; Mexico, to study mural painting, 1943; other Latin American countries. Painted murals in Ecuador, Venezuela, and Spain. Held individual exhibitions in Latin America and Europe, including those presented in Quito at the Casa de la Cultura, 1942, and Museo de Arte Colonial, 1952; Museo de Bellas Artes, Caracas, 1953, and Mexico City, 1968; OAS, Washington, D.C., 1955; Palacio de Bellas Artes, Mexico City, 1968; Museo Español de Arte Contemporáneo, Madrid, 1972; Musée d'Art Moderne, Paris, 1973. Participated in the biennials of Barcelona (Spain), São Paulo (special room, 1957), Mexico City (special room, 1960); Pittsburgh International, 1955; and other group exhibits in Quito; New York, including its Museum of Modern Art, 1943; International Exhibition of Modern Art, Musée d'Art Moderne, Paris, 1946; Museo de Arte, Lima, 1958; Dallas Museum of Fine Arts, 1959. Was awarded several first prizes in Ecuador and Grand Prize, Biennial of Barcelona, 1956, among others.

GUILLEN, Asilia. Self-taught painter born Granada, Nicaragua, 1887. Died in Managua, 1964. Held an individual exhibition at the OAS, Washington, D.C., 1962. Participated in the Biennial of Mexico, 1980; and group shows in Nicaragua, the United States, including several exhibits at the OAS, Washington, D.C.; museums in Germany, Belgium, and Paris.

HURTADO, Angel. Painter, printmaker, documentary film maker, born El Tocuyo, Venezuela, 1927. Studied Escuela de Artes Plásticas, Caracas, and in Paris, on a scholarship from the Venezuelan government, where he also lived and worked, 1954-59 and 1964-70. Moved to Washington, D.C., 1970, and is the Director of the the the Audio Visual Program, Organization of American States. Held individual exhibitions in Paris, Washington, D.C. (OAS, 1959), and Caracas, including the Museo de Bellas Artes, 1967. Participated in the biennials of Venice, São Paulo, Medellín, Caracas, and Paris; and other group exhibitions in Venezuela, the United States, and Colombia. Was awarded several prizes, including John Boulton Prize, 1959; Armando Reverón Prize, 1960; National Prize for Painting, 1961, all in Caracas; also received Special Prize for Film, Venice Biennial, 1964, and the Golden Eagle Award for his documentary film on Jesús Soto, United States, 1973.

LAMONICA, Roberto De. Printmaker, born State of Mato Grosso, 1933. Studied graphic arts School of Fine Arts, São Paulo; in Rio de Janeiro attended the workshop of the Museum of Modern Art, and took special courses under French engraver Friedlaender. Visited Italy, Switzerland, the Soviet Union, and many Latin American countries. Held individual exhibitions in museums and galleries in Brazil, and at the Instituto de Arte Contemporáneo, Lima. Participated in biennials and other international group shows in Switzerland, Italy, Israel, Venezuela, Cincinnati, Lisbon, Mexico City, and Amsterdam. Was awarded a special prize, consisting of a trip to China, Salon Para Todos, Rio de Janeiro, 1957, among the numerous awards he won in contests and group shows in Brazil.

LIAUTAUD, Georges. Self-taught sculptor born Croix-des-Bouquets, Haiti, 1899. The OAS presented in 1960 his first individual exhibition abroad, and in 1968 exhibited in New York with Joseph Jean-Gilles. Participated in a number of group shows in Haiti; São Paulo Biennial, 1959; the United States, including Pittsburgh International, 1958, and those held at the Museum of Fine Arts, Houston, 1956; Art Institute of Chicago, 1959; several exhibits at the OAS, Washington, D.C.; as well as other museums in Germany, Belgium, and Paris.

MANAURE, Mateo. Painter, muralist, draftsman, printmaker, sculptor, ceramist, born Uracao, Venezuela, 1926. Studied School of Plastic Arts, Caracas. Lived Paris, 1947-48, 1950-52, where he associated with *Los Disidentes* group. In Caracas, co-founded the Taller Libre de Arte, 1948; executed murals at the Ciudad Universitaria; wrote articles in *El Nacional*; illustrated several books, and published a book of drawings. Held individual exhibitions in Venezuela, including the Museo de Bellas Artes; and Paris. Participated in group exhibitions in Venezuela,

France, Germany, and several countries of Latin America. Was awarded the National Prize for Plastic Arts, 1947, and John Boulton Prize, 1950 and 1965.

MARTINS, Aldemir. Draftsman, painter, printmaker, illustrator, born Ingazeiras, Brazil, 1922. Began to practice design at an early age. Taught drawing, designed aerial maps, and founded a group of artists in Ceará, 1942-45. Held individual exhibitions in São Paulo; Montevideo; Buenos Aires; OAS, Washington, D.C., 1958, among others. Participated in group shows in Rio de Janeiro; São Paulo; OAS, Washington, D.C., 1959, 1976, and other cities in the United States; Bolivia, Chile, Czechoslovakia, Japan, Mexico, Peru, Switzerland, Italy. His awards include First Prize for Drawing, Biennial of São Paulo, 1955; International First Prize for Drawing, Venice Biennial, 1956.

MERIDA, Carlos. Painter, muralist, draftsman, printmaker and stage designer born Guatemala City, 1891. Moved to Mexico, 1919. Traveled and lived in Europe, the United States and other Latin American countries for long periods of time. In Mexico City, was a member of the muralist group, participated in the execution of several murals, and founded the School of Ballet, 1931. Studied in Paris under well-known artists, such as Modigliani and Mondrian. Held individual exhibitions at the OAS, Washington, D.C., from 1945 on; Mexico City, including the Museum of Modern Art, 1961, 1970; Guatemala City, including the National Academy of Fine Arts, 1947; Museum of Fine Arts, Caracas, 1955; and in galleries in Paris, New York, Chicago, and other cities in the United States. Was awarded a prize at the *Gulf Caribbean Art Exhibition*, Houston, Texas, 1956, and at the São Paulo Biennial, 1957, among others.

MILIAN, Raúl. Draftsman, born in Havana, Cuba, 1914. Held individual exhibitions in Havana, the United States, and Canada. Participated in the Biennial of São Paulo; other group exhibits in the United States, including the OAS, Washington, D.C., 1956, 1976.

MOHALYI, Yolanda. Painter, draftsman, born Hungary, 1909. Moved to São Paulo, 1931. Studied Royal Academy of Fine Arts, Budapest. Held individual exhibitions in São Paulo, including its Museu de Arte, 1950, and Museu de Arte Moderna, 1955, and Museu de Arte Moderna, Rio de Janeiro, 1965. Participated in national salons; biennials of São Paulo (special room, 1965 and 1971), Tokyo, and Córdoba (Argentina); and in other group exhibitions in Rio de Janeiro; OAS, Washington, D.C., 1962; Bonn (Germany); London; San José (Costa Rica). Among her numerous awards, won Gold Medal, Salon of Fine Arts, São Paulo, 1937; First National Prize (Best Painter), São Paulo Biennial, 1963.

MUNTAÑOLA, Roser. Painter, born Barcelona, Spain, 1928. Moved to Panama City and is a Panamanian citizen. Studied in national fine arts schools in Buenos Aires, and San Jorge School of Fine Arts, Barcelona. Received scholarships from the Argentine and Spanish governments. Held individual exhibitions in Panama City, including its National Museum; Barcelona; OAS, Washington, D.C., 1960, with Ciro Oduber. Participated in group exhibitions in Panama, Europe, and the United States, including the OAS, Washington, D.C., 1960.

ODUBER, Ciro S. Painter, draftsman, born Panama, 1921. Studied with painters Roberto Lewis and Humberto Ivaldy, Panama; National School for Advanced Study in Art, Buenos Aires; San Jorge School, Barcelona, Spain. Held individual shows in Buenos Aires and other Argentine cities; Panama City, including its National Museum, 1959; OAS, Washington, D.C., 1960, with Roser Muntañola. Participated in group exhibitions in Panama, Europe, and the United States, including the OAS, Washington, D.C., 1953, 1959, 1976. Awards include Purchase Prize, Inter-American Exhibition, Cartagena, Colombia, 1959.

ORLANDO, Felipe. Painter, printmaker, illustrator, born Quemado de Güines, 1911. Has lived in Mexico City since 1951. Considers himself a self-taught artist. Held individual exhibitions in Havana, New York, Mexico City, and Los Angeles. Participated in the International Watercolor Exhibition, Brooklyn Museum, New York, 1943, 1949; biennials of Venice and Mexico City; and other Latin American and international group exhibits in Havana; New York, including the Museum of Modern Art, New York,1943, 1944; Washington, D.C. (OAS, 1946, 1947, 1952), and other cities in the United States; La Plata (Argentina), Caracas, and Paris.

OSSAYE, Roberto. Painter, born Guatemala City, 1927, where he died, 1954. Studied National Academy of Fine Arts, Guatemala City. Also lived and studied in the United States, 1948-51, on a Guatemalan government scholarship. Held individual exhibitions in Guatemala and New York City. Participated in group shows in Guatemala and the United States, including the OAS, Washington, D.C., 1951, 1976.

PELAEZ, Amelia. Painter, muralist, draftsman, illustrator, and ceramist, born Yaguajay, Cuba, 1887. Died in Havana, 1968. Studied Academia de San Alejandro, and with painter Leopoldo Romanach, Havana; Arts Students League, New York; Académie de la Grande Chaumière, Paris, on a Cuban government scholarship; other institutions in Paris and Havana. Traveled in Europe and to Mexico. Executed mural for National Accounting Office and Esso Building, Havana; illustrated books, including *Sept Poèmes*, by Léon-Paul Fargue. Held individual exhibitions in Havana and Paris; retrospective posthumous shows were held at Museo Nacional, Havana, 1968; Metropolitan Museum and Art Centers, Coral Gable, Florida, 1977; Museo de Arte Moderno, Bogotá, 1980. Participated in group shows and salons in Havana, Mexico City, and other Latin American countries; Paris, Stockholm and other European cities; New York, San Francisco, Boston, Chicago, Washington, D.C. (OAS, 1946, 1947, 1952, 1959), and other cities in the United States. Was awarded several prizes in national salons in Havana (1938, 1956, 1969), including First Prize, 1935; and at the *Gulf Caribbean Art Exhibition*, Museum of Fine Arts, Houston, Texas, 1956, among others.

PEÑALBA, Rodrigo. Painter, caricaturist, born León, Nicaragua, 1908. Died Managua, 1979. Studied Academy of Fine Arts, Chicago, 1926-30; Academia de San Fernando, Madrid, 1934, on a scholarship from the Nicaraguan government; Academia de Bellas Artes, Mexico City, 1936; Regia Scolla di Belle Arti, Rome, 1938-41. Appointed Director of the Escuela Nacional de Bellas Artes, Managua, 1948, was of the utmost importance in the cultural development of his country. Held individual exhibitions in Rome; OAS, Washington, D.C., 1947; New York, and Managua. Participated in group exhibitions in Managua, Caracas, and OAS, Washington, D.C., 1953, 1957, among others.

PORTINARI, Cândido. Painter, muralist, draftsman, printmaker, illustrator, poet, born Brodósqui, São Paulo, Brazil, 1903. Died in Rio de Janeiro, 1962. Studied at the School of Fine Arts, Rio de Janeiro, and in Paris and other European cities through a scholarship from the Brazilian government (1928-30). Executed murals in public buildings in Brazil, mainly Rio de Janeiro; Hispanic Room, Library of Congress, Washington, D.C., 1942; United Nations, New York, 1953. Illustrated books for publishing house Gallimard, Paris. Held individual exhibitions in Rio de Janeiro, including its Museu Nacional de Belas Artes, 1939, 1943, and Museu de Arte Moderna, 1953; Detroit Institute of Art and Museum of Modern Art, New York, 1940; OAS, Washington, D.C., 1947; São Paulo, including several shows at the Museu de Arte; Museum of Art, Munich; and in Paris. Since 1922, participated in numerous group exhibitions in museums and other institutions in Latin America and Europe, including Venice Biennial, 1950. Was awarded many prizes and distinctions, among them, Honorable Mention, Pittsburgh International, 1935; the French *Légion d'Honneur*, after an exhibition in Paris at the Galerie Charpentier, 1946; the U.S. International Fine Arts Council Gold Medal, as best painter of the year, 1955; Guggenheim National Award, New York, 1957.

PORTOCARRERO, René. Painter, muralist, draftsman, ceramist, illustrator, stage and costume designer, born Havana, Cuba, 1912, where he died, 1985. Although mainly self-taught, attended classes at the Academia de San Alejandro, Havana. Held individual exhibitions in Havana, including the Museo Nacional, 1967; New York; OAS, Washington, D.C., 1956; Museo de Arte Moderno, Mexico City, 1965. Participated in the biennials of São Paulo and Venice, where his work was exhibited in a special room, 1966; and in other group exhibitions in Cuba; the United States, including OAS, Washington, D.C., 1947, 1952; Venezuela; Sweden; Mexico. Received, among other awards, the Sambra Prize, São Paulo Biennial, 1963.

PRETE, Danilo Di. Painter, draftsman, printmaker, born Pisa, Italy, 1911, where he was an active member of the art community before moving to Brazil, 1946. Considers himself a self-taught artist. Held first individual exhibition in Lucca (Italy), followed by other in many European cities, and in São Paulo. Participated in the Quadrennial of Rome and biennials of Venice, São Paulo (special room, 1961, 1967), Córdoba (Argentina), Medellín (Colombia); other group exhibits in Europe, including the Royal College of Art, London, 1965; the United States, including the Dallas Museum of Fine Arts, 1959, and the OAS, Washington, D.C., 1962, 1966; and Latin America. Was awarded First Prize, Florence, 1939, where he also won the International Prize, *Il Fiorino*, 1966; First National Prize for Painting, Biennial of São Paulo, 1951, 1965).

QUIROA, Marco Augusto. Painter, born in Chicacao, Guatemala, 1937. Studied National School of Plastic Arts, 1953-1960. Traveled to Mexico on a national scholarship. Since 1958 has held individual exhibitions in Guatemala and Mexico City. Participated in the Paris Biennial; other group shows in Guatemala and Mexico; OAS, Washington, D.C., 1962, 1976. Was awarded First Prize, Central American Contest, San Salvador, 1961; and several other prizes, Carlos Valenti National Contest.

ROCA REY, Joaquín. Sculptor, draftsman, printmaker, born Lima, Peru, 1923. Studied Escuela Nacional de Bellas Artes, Lima, 1944-48, and in Bilbao, Spain, under Jorge de Orteiza, 1949-50. Traveled in Europe and also studied in Italy, through a scholarship from the Italian government, and in the United States, through an invitation of the Department of States, 1950. Held individual exhibitions in Lima, including the Art Museum, 1970; OAS, Washington, D.C., 1959; Museum of Fine Arts, Caracas, 1970; Museum of Modern Art in Rio de Janeiro and São Paulo, with Fernando de Szyszlo, 1956 and 1957. Participated in the biennials of Madrid, São Paulo, Mexico City, Venice (special room in 1972), Carrara (Italy), and Cali (Colombia); and other group shows held at the Tate Gallery, London, 1953; Petit Palais, Paris, 1958; and Dallas Museum of Fine Arts, 1959, among others.

SABOGAL, José. Painter, printmaker, illustrator, born Cajabamba, Peru, 1888. Died Lima, 1956. Studied Escuela de Bellas Artes, Buenos Aires, 1912-18. Traveled in Europe and North Africa, 1909-11; Mexico, 1922-25, where he associated with the Mexican muralists; the United States, invited by the Department of States, 1942-43. Taught at the Escuela de Bellas Artes, Lima, and was appointed its director, 1933-43. Held individual exhibitions in Peru, including its Museo de Arte, 1947, and in Mexico. Participated in group exhibitions in Buenos Aires; Puerto Rico; Golden Gate International Exposition, San Francisco, 1940; OAS, Washington, D.C., 1947; New York, and other cities in the United States. Was awarded Gold Medal, International Exhibition, Seville, Spain, 1928.

SEGALL, Lasar. Painter, draftsman, printmaker, sculptor, born Vilna, Lithuania, 1890. Moved São Paulo, 1923, became a Brazilian citizen, and died, 1957. Studied Akademie der Bildenden Künste, Berlin, 1906-09. Lived in Dresden and joined the German Expressionist movement, 1910-23, co-founding the *Dresden-Secession Group*. Founder of SPAM (Sociedade Pro-Arte Moderna), São Paulo. Held individual exhibitions in Germany, including the Folkwang Museum, Hagen, 1920, and Leipzig Museum, 1923; Paris, New York; OAS, Washington, D.C., 1948; Rio de Janeiro; Museu de Arte, São Paulo; posthumous exhibitions were held in Europe, sponsored by the Brazilian Ministry of Foreign Affairs. Participated in group shows in Germany; OAS, Washington, D.C., 1948, 1976; Biennial of São Paulo (special room, 1951-53), where a major exhibition of 200 pieces of his work was held in 1957. Was awarded prizes in Germany.

SICRE, Juan José. Sculptor, born in Carlos Rojas, Cuba. Died Cleveland, Ohio, 1974. Studied Academia de San Alejandro, Havana; Academia de San Fernando, Madrid; Académie de la Grande Chaumière, and workshop of José de Creeft, Paris. Executed large sculpture pieces for public buildings and parks in Cuba, Dominican Republic, Haiti, Venezuela, Puerto Rico, Mexico, Panama, Chile, Argentina, and the United States. Held individual exhibitions in Paris and Havana. Participated in group exhibitions in Paris, including the Salon d'Automne, 1928; Havana, and New York. Won, among other awards, First Prize, Association of Florentine Sculptors. Italy, 1924; Grand Prize, Ibero-American Exhibition, Seville, Spain, 1929.

SILVA, Alfredo Da. Painter, draftsman, printmaker, sculptor, born Potosí, Bolivia, 1936. Studied Escuela de Bellas Artes, Potosí; Escuela Nacional de Bellas Artes, Buenos Aires; and Pratt Institute of New York. Held individual exhibitions in Bolivia; Museum of Modern Art, Buenos Aires, 1960; OAS, Washington, D.C., 1961, 1964; Instituto de Arte Contemporáneo, Lima, 1967; Museu de Arte Moderna, Rio de Janeiro, 1977. Participated in the biennials of São Paulo, Córdoba (Argentina), La Paz, and Mexico City; other group exhibits in Bolivia; Argentina, including the Museo de Arte Moderno, Buenos Aires, 1960; Museu de Arte Moderna, São Paulo, 1962, 1969; Kongresshalle, Berlin, 1964; Washington, D.C., including OAS, 1966, 1974, and the Corcoran Gallery of Art, 1966; Musée d'Art Moderne, Paris, 1973; and other cities in Latin America, the United States, Spain, Germany, Finland, France. Was awarded prizes in Argentina, 1959 and 1964, and the Grand Prize, Second INBO Biennial, La Paz, 1977.

SIQUEIROS, David Alfaro. Painter, muralist, draftsman, printmaker, born Chihuahua, 1896. Died Mexico City, 1974. Studied at Academia de Bellas Artes, Mexico City, 1911-13; Escuela de Pintura al Aire Libre, Santa Anita, 1913. In 1911 engaged in politics and art-related activities, and since 1924 has devoted much time in working for the Communist Party. Arrested in 1930, was confined to the city of Taxco in 1931, and was expatriated for some years. Fought in the Mexican Revolutionary Army, 1914-1918, and in the Spanish Republican Army, 1938-39; organized syndicates and founded several magazines and newspapers; attended syndicalist congresses in Moscow, South America, and the United States. Founding member of the muralist movement in Mexico, was the author of its Manifesto, 1922. That same year started his first mural at the Escuela Nacional Preparatoria. Thereafter executed many others in Mexico, the United States, Argentina, Chile, and Cuba. Founded experimental workshop in New York, 1936-38, where new techniques were explored. Published an autobiography, *Me llamaban el*

Coronelazo, 1977, and other art-related writings. Held individual exhibitions in Mexico, including Palace of Fine Arts, Mexico City, 1947; Montevideo; Buenos Aires; Los Angeles and New York. Participated in international exhibitions, including Pittsburgh International, 1935; Riverside Museum, New York, 1939; Golden Gate International Exposition, San Francisco, 1940; Art Institute of Chicago, 1944; San Francisco Museum of Art in 1945. Was awarded several prizes, including the Prize for Foreign Artists, Venice Biennial, 1950; National Prize for Fine Arts, 1966; Lenin Peace Prize from the Soviet Union, 1967.

SZALAY, Lajos. Draftsman, illustrator, born Budapest, Hungary, 1909. Moved to Argentina at the end of the 1940s, and is an Argentine citizen. Studied School for Advanced Study of the Fine Arts, Budapest, 1927-35. Lived, worked, and studied in France. Illustrated several books in Budapest and Argentina. Exhibited in Europe, Latin America, and the United States, including the OAS, Washington, D.C., 1958, 1976.

TABARA, Enrique. Painter, draftsman, graphic artist, born Guayaquil, Ecuador, 1930. Studied at the School of Fine Arts, Guayaquil, and at the Escuela de Bellas Artes in Barcelona, Spain, 1955, through a scholarship from the Ecuadorian government. Held individual exhibitions at the Casa de la Cultura, Guayaquil, and in Quito; Museo de Arte Moderno, Barcelona, 1961, and galleries in Madrid; Museo de Arte Moderno, Bogotá, 1965; galleries in Lausanne and Basel, Switzerland; Munich and Bremen, Germany; Milan; Italy; OAS, Washington, D.C., 1964. Since 1951 has participated in national salons in Quito and other group shows held at the Museo de Arte, Lima, 1958; Palais des Beaux-Arts, Brussels, 1961; Musée d'Art Moderne, Paris, 1965; OAS, Washington, D.C., 1966; and in other institutions in Germany, Italy, Spain, Switzerland, the United States, Formosa and Japan. Was awarded several prizes, including Prize for Painting, Lausanne, 1960, and Gold Medal, Quito, 1970.

TORRES-GARCIA, Joaquín. Painter, draftsman, art teacher and lecturer, born Montevideo, Uruguay, 1874, where he died, 1949. Moved to Barcelona, 1892-20. Traveled in Europe; resided in New York, 1920-22; Italy, 1922-23; Paris, 1924-32; Montevideo, 1934-49. Worked with Antonio Gaudí on the church of the Sagrada Familia and on stained-glass windows for the cathedral of Palma de Mallorca, 1903-07. Painted murals in Spain, Belgium, and Uruguay. Founded the group and magazine *Cercle et Carré* with Michel Seuphor and others, Paris, 1930; the Taller Torres-García, Montevideo, 1944, and the Asociación de Arte Constructivo, Montevideo, 1935. Taught, lectured and published books on his art theories, such as *Universalismo constructivo*, Buenos Aires, 1944. Studied at the Academia de Bellas Artes and Academia Baixas, Barcelona. Held his first one-man show at the Salón de "La Vanguardia," Barcelona, 1900; thereafter exhibited individually in galleries in Barcelona, Bilbao, Madrid, including its Museo de Arte Moderno, 1933; Paris, New York, and Montevideo. Numerous posthumous exhibitions of his work were held in museums in Madrid, Montevideo, Buenos Aires, Paris, Washington, D.C. (OAS, 1961), Amsterdam, Baden-Baden, New York, Ottawa, Caracas, Rio de Janeiro. Since 1906, participated in official salons in Spain, France, and Uruguay; *First International Exhibition of Abstract Art*, Paris, 1930; Museum of Fine Arts, Lodz, Poland, 1931; OAS, Washington, D.C., 1950; galleries in New York, Barcelona, and Paris. After his death, his work continued to be included in numerous exhibitions in Europe, the United States, and Latin America, including the Biennial of São Paulo (special room, 1959); Institute of Chicago, 1959; Museo Nacional de Bellas Artes, Montevideo, 1966; Solomon R. Guggenheim Museum, New York, 1965; Museo Nacional de Bellas Artes, Buenos Aires, 1970. His awards include the National Prize for Painting, Montevideo, 1944.

VALENCIA, César. Painter, art critic, born Quito, Ecuador, 1918, where he studied at the Academy of Fine Arts. Served his country as cultural attaché in several Latin American countries. Exhibited his work in individual and Ecuadorian group shows in Latin America, including the Museum of Modern Art in Buenos Aires; OAS, Washington, D.C., 1963. Was awarded the Mariano Aguilera Award, 1944, the highest distinction given to an artist in Ecuador.

VERGARA GREZ, Ramón. Painter, born in Chile, 1920. Studied School of Fine Arts, University of Chicago, graduating 1945; with Emilio Pettoruti, Buenos Aires; in Brazil and Italy, on a scholarship from the Brazilian government, 1948, and the Italian government, 1954. Co-founded the *Grupo de los Cinco* (Group of the Five), 1943, and *Rectángulo* (Rectangle), 1956, which became *Forma y Espacio* (Form and Space), Santiago, 1965. Exhibited with these groups and participated in numerous national salons since 1943. Has also exhibited in group shows abroad, among other cities, in Bogotá, Buenos Aires, Lima, Madrid, Montevideo, Rio de Janeiro, and Washington, D.C. Was awarded First Prize, Santiago, 1951.

VIGAS, Oswaldo. Painter, draftsman, printmaker, physician, born Valencia, Venezuela, 1926. Studied School of

Fine Arts, Valencia, and at La Sorbonne, Paris. Held individual exhibitions in Venezuela, including the Museo de Bellas Artes, Caracas, 1952; Museo Español de Arte Contemporáneo, Madrid, 1957; Museo de Arte Contemporáneo, Bogotá, 1973; Museo de Arte Italiano, Lima, 1977; and galleries and other institutions in Paris and other European and Latin American countries, as well as in the United States. Participated in group shows in Paris; biennials in São Paulo and Venice; Pittsburgh International; OAS, Washington, D.C., from 1954; Musée des Beaux-Arts, Paris, 1956; Art Institute of Chicago, 1959; Museo de Bellas Artes, Caracas, 1961, 1962; Musée du Havre, France, 1963; and other galleries and institutions in Europe, the United States and Latin America. Among other prizes won a special award, *Gulf Caribbean Art Exhibition,* Museum of Fine Arts, Houston, 1956, and First Prize, Salon de Artes Plásticas, Caracas, 1957.

VILLEGAS, Armando. Painter, printmaker, born Pomabamba, Peru, 1928. Moved to Bogotá, 1952. Studied Escuela Nacional de Bellas Artes, Lima, 1945-51, and Bogotá, 1952-53. Held individual exhibitions in Bogotá; Museo de Bellas Artes, Caracas, 1957; OAS, Washington, D.C., 1958; other galleries and institutions in Lima and Madrid. Participated in the biennials of São Paulo, Mexico City, Córdoba (Argentina), Quito; Medellín (Colombia), San Juan (Puerto Rico); Guggenheim International, New York; Petit Palais, Paris, 1958; Art Institution of Chicago, 1959; Dallas Museum of Fine Arts, 1959; OAS, Washington, D.C., 1958, 1960, 1961; and other galleries and institutions in Latin America and the United States. Received, among other awards, First Prize, Writers and Artists Salon, Bogotá, 1955; Second Prize, Coltejer Mural Contest, Medellín, 1957.

YRARRAZAVAL, Ricardo. Painter, ceramist, born Santiago, Chile, 1931. Studied in Canada and traveled extensively in Europe. Studied in New York under André Racz; School of Fine Arts, Rome; Académie Julian, Paris. Started working in ceramics, 1954. Exhibited paintings and ceramics in Santiago de Chile. Participated in group shows in Chile and the United States, including the OAS, Washington, D.C., 1956 and 1958.

ZAÑARTU, Enrique. Chilean painter, draftsman, printmaker, illustrator, born Paris, 1921, of Chilean parents. Went to Chile as a child and studied engraving at the S.W. Hayter's Atelier 17, New York, 1944. Returned to Paris, 1949. Illustrated several books, including *Mythologie du Vent* by Jacques Charpier. Held individual exhibitions in Paris, Berlin, Frankfurt, and Washington, D.C. (OAS, 1956). Participated in numerous group shows in Europe, the United States and Latin America.

INDEX OF ARTISTS

Due to the chronological format of this publication, it was decided to list the date(s) of the exhibition(s) instead of page number(s) under each artist's entry. This approach increases the usefulness of this index, because it will allow the researcher to find exhibition dates without searching in the catalogue. Dates in *italics* indicate that information about the artist is included in that exhibition. When the date(s) is followed by (A), the information about the artist is listed in the Appendix. Due to peculiarities of Spanish last names, alphabetizing of the entries was done by the first last name, followed by the first name; therefore, ALCANTARA GARCIA, Angelino appears before ALCANTARA, Antonio.

ABULARACH, Rodolfo (Guatemala, 1933-). Painter, draftsman, printmaker, architect.
Apr.21/65; Mar.15/74; *Feb.11/76;* Oct.14/76; *Jan.15/81.*

ACEVES NAVARRO, Gilberto (Mexico, 1931-). Painter, draftsman.
Sep.28/78.

ACOSTA GARCIA, Luis (Uruguay, 1943-). Painter, graphic artist.
Jun.28/73; *Feb.11/76;* Oct.14/76.

ADDERLEY, Helen (Bahamas, 19?-). Artisan.
Jun.25/75.

AGÜERO SOSA, René (Argentina, 19?-). Painter, singer, composer, writer, journalist.
Nov.13/73.

AGUILAR, Mauricio (El Salvador, 1919-1978). Painter, printmaker.
Jan.18/66; *Sep.16/66;* *Oct.25/73;* Mar.15/74; Oct.14/76.

AGUIRRE LAMA, Myriam (Chile, 19?-). Artisan (jewelry).
Jun.25/75.

AGUIRRE, Yolanda (Bolivia, 1923-). Painter, draftsman.
Sep.2/82.

AKIN-YEMI RAMSAY, Akyem. See AKYEM.

AKYEM (Ras Akyem Akin-Yemi Ramsay, Barbados, 1953-). Painter, muralist, draftsman, ceramist.
Dec.5/80.

ALARCON, Rosita (Chile, ?). Artisan (pottery).
Apr.12/70.

ALBA, Salvador de (Mexico, ?). Architect.
Apr.11/66.

ALBIZU, Olga (Puerto Rico, 1924-). Painter.
Apr.21/65; Jun.13/66.

ALBORA CORREA, Alfonso D' (Chile, 1927-). Ceramist.
Dec.10/71.

ALBORNO, Pablo (Paraguay, 1878-1958). Painter.
Oct.14/76.

ALCANTARA GARCIA, Angelino (Peru, 19?-). Artisan (stone).
Jun.25/75.

ALCANTARA, Antonio L. (Venezuela, 1898-19?). Painter, draftsman.
Dec.17/73.

ALDAMA, Felipe (Argentina, b. Paraguay, 1932-). Sculptor.
Apr.21/65.

ALDO (Aldo Franceschini, Argentina, 1945-). Painter, draftsman.
May 23/66.

ALEGRIA, Santiago (Chile, 19?-). Painter.
Dec.10/71.

ALFARO SIQUEIROS, David. See SIQUEIROS, David Alfaro.

ALLADIN, M.P. (Trinidad and Tobago, 1919-). Painter, writer.
Dec.14/72; Oct.25/73; Oct.14/76.

ALMEIDA, Gilberto (Ecuador, 1928-). Draftsman.
Jun.18/69; Oct.14/76.

ALMEIDA, Martalicia (Costa Rica, b. Mexico, 1937-). Painter.
Feb.9/82.

ALTAMIRANO, Faustino (Nicaragua, 19?-). Painter.
Nov.29/83.

ALTAMIRANO, Fernando (Nicaragua, 19?-). Painter.
Nov.29/83.

ALVARADO, Antonio (Panama, b. France, 1938-). Painter, printmaker.
Apr.21/65.

ALVARADO-JUAREZ, Francisco (Honduras, 1950-). Photographer, painter.
Apr.8/80; Apr.14/83.

ALVARADO, Luis (Nicaragua, 19?-). Painter.
Nov.29/83.

ALVAREZ, Ana Rita (Chile, ?). Artisan (basketry).
>Apr.12/70.

ALVAREZ, Augusto H. (Mexico, ?). Architect.
>Apr.11/66.

ALVAREZ ORDOÑEZ, Joaquín (Mexico, ?). Architect.
>Apr.11/66.

ALVAREZ, Negra (Margarita Alvarez de Martínez, El Salvador, 1948). Painter.
>*May 7/85.*

AMARAL, Antônio Henrique (Brazil, 1935-). Painter, draftsman, printmaker.
>*Sep.23/71; Oct.25/73; Oct.14/76.*

ANDREU DE BICARD, Lilian Cristina. See BICARD, Licry.

ANDUJAR, José Ramón (Dominican Republic, 19?-). Photographer.
>*Feb.7/85.*

AÑEZ, Ismael (Venezuela, ?). Printmaker.
>*Jan.15/81.*

ANGEL, Doris (Colombia, ?). Painter.
>*Feb.22/73.*

ANGEL, Félix (Colombia, 1949-). Painter, draftsman, printmaker, architect.
>*Sep.9/74; Oct.14/76; Mar.1/78; Jan.15/81.*

ANREUS, Alejandro (Cuba, 1960-). Painter, draftsman.
>*Nov.7/78.*

ANTONIA (Ana Antonia Azuaje, Venezuela, 19?-). Painter.
>*Jan.27/81.*

ANTONINA, Dália (Brazil, 1918-). Painter.
>*May 23/67.*

ANTONIO HENRIQUE. See AMARAL, Antônio Henrique.

ANTRESIAN, Gero (United States, 1922-). Printmaker.
>Nov.1/84.

ANTUNEZ, Nemesio (Chile, 1918-). Painter, draftsman, printmaker, illustrator, architect.
>Sep.18/67; Sep.18/68.

AQUINO, Edmundo (Mexico, 1939-). Draftsman, painter, printmaker.
>*Apr.14/80; Jan.15/81.*

AQUINO, Humberto (Peru, 1947-). Painter, draftsman.
>*Dec.5/78; Jan.15/81.*

ARANA, Eduardo (Nicaragua, ca.1943-). Painter, farmer.
>*Nov.29/83.*

ARANDA, Dino (Nicaragua, 1945-). Painter, draftsman, printmaker.
>*Sep.3/69; Feb.11/76; Oct.14/76; Jan.18/78.*

ARANGO ROJAS, Renán D. (Colombia, 1944-). Draftsman, painter.
>*Sep.9/74.*

ARATA, Luis (Argentina, 1925-). Sculptor, civil engineer.
>*May 2/72.*

ARAUZ, Félix (Ecuador, 1935-). Painter, draftsman.
>*Jun.18/70; Mar.15/74; Oct.14/76.*

ARCHULETA, Felipe (United States). Woodcarver.
>Nov.1/84.

ARELLANO, Rodolfo (Nicaragua, 1943-). Painter.
>*Nov.29/83.*

ARENAS, Luz Clemencia (Colombia, 19?-). Draftsman.
>Feb.22/73.

ARMAND, Gesner (Haiti, 1936-). Painter, draftsman, printmaker, ceramist.
>*Jul.30/74; Oct.14/76.*

ARMIJO VARGAS, Gustavo (Honduras, 1945-). Painter, draftsman.
>*Mar.1/84.*

ARMSTRONG, Mary (Barbados, 1925-). Painter.
>*Dec.14/72; Mar.15/74.*

ARNAL, Enrique (Bolivia, 1932-). Painter, draftsman.
>*Apr.21/76; Jan.15/81.*

ARNTZ, Michael A. (United States, 19?-). Ceramist.
>Jun.25/75.

AROSTEGUI, Alejandro (Nicaragua, 1935-). Painter, printmaker.
>*Feb.15/66; Mar.15/74; Oct.14/76.*

ARTIGAS, Francisco (Mexico, ?). Architect.
>Apr.11/66.

ARYSSASI (Alcides Rubén Yssasi, Venezuela, 19?-). Painter.
>*Jan.27/81.*

ASCHER, Daisy (Mexico, 1944-). Photographer.
>*Jun.6/78; Jan.15/81; Jun.8/82.*

ASHEVAK, Kenojuak (Canada, 1927-). Graphic artist.
>*Jan.12/84.*

ASSLER, Federico (Chile, 1929-). Painter, muralist, draftsman, set and costume designer, architect.
>*Sep.18/67.*

ATENCIO, Gilbert (United States). Painter.
>Nov.1/84.

ATKINSON, Arthur (Barbados, 1945-). Painter, draftsman.
>*Dec.14/72; Dec.5/80.*

ATTECK, Sybil (Trinidad and Tobago, 1911-). Painter, muralist.
>*Dec.14/72.*

AUGRAIN DE CALDERON, Constance. See CALDERON, Constancia.

AULD, Mike (Jamaica, 1943-). Sculptor, painter, printmaker.
>*Feb.11/76; May 31/79.*

AVILES, San (Ernesto Avilés, El Salvador, 1932-). Painter.
May 19/76.

AYOROA, Rudy (Bolivia, 1927-). Painter, draftsman, printmaker, sculptor.
Sep.13/68; Mar.15/74; *Feb.11/76*; Oct.14/76; Jan.18/78.

AZAR, Aquiles (Dominican Republic, 1932-). Painter, draftsman, dentist.
Oct.19/76.

AZOUT, Lydia (Colombia, 1942-). Sculptress.
Feb.22/73.

AZUAJE, Ana Antonia. See ANTONIA.

BADII, Libero (Argentina, b. Italy, 1916-). Sculptor.
May 18/65.

BAEZ, Myrna (Puerto Rico, 1931-). Painter, draftsman, printmaker.
Jun.8/82.

BAIXAS FIGUERAS, Isabel (Chile, 19?-). Tapestry designer and weaver.
Jun.25/75.

BAL CALI, Feliciano (Guatemala, 1943-). Painter.
Dec.5/84.

BALCACER, Ada (Dominican Republic, 1930-). Painter, draftsman, printmaker, ceramist, textile designer.
Mar.15/74; Feb.11/76.

BALLIVIAN, María Esther (María Esther Ballivián de Perrin, Bolivia, 1927-1977). Painter, printmaker.
Jul.12/72.

BALMES, José (Chile, b. Spain, 1927-). Painter, illustrator.
Sep.18/67.

BANEY, Ralph (Trinidad and Tobago, 1929-). Sculptor, art officer.
Dec.14/72; Feb.14/74; Mar.15/74.

BANEY, Vera (Trinidad and Tobago, 1930-). Ceramist.
Dec.14/72; Aug.18/76.

BARBOZA, Carlos (Costa Rica, 1943-). Printmaker, draftsman.
Sep.4/75; Feb.11/76; Jan.18/78.

BARCALA, Washington (Uruguay, 1920-). Painter.
Apr.3/79; Jan.15/81.

BARRADAS, Rafael (Rafael Pérez Barradas, Uruguay, 1890-1929). Painter, draftsman, illustrator, set and costume designer.
Jan.18/66; Oct.14/76.

BARREDA, Ernesto (Chile, b. France, 1927-). Painter, architect.
Oct.3/66; Sep.18/67.

BARREIRO, Tanya Kohn de. See TANYA.

BARRERA, Antonio (Colombia, 1948-). Painter, draftsman, printmaker.
Mar.23/76; Oct.14/76.

BARRIOS, Gracia (Chile, 1927-). Painter.
Apr.21/65; Sep.18/67.

BARTON, Nancy Hemenway. See HEMENWAY BARTON, Nancy.

BASSAN, Nessim (Panama, 1950-). Painter.
Apr.24/73; Jan.15/81.

BASSO, Leo (Trinidad and Tobago, 1901-). Painter.
Dec.14/72.

BASTIEN, Althea (Trinidad and Tobago, 1933-). Batik artist.
Apr.6/82.

BATES, Carlos (Costa Rica, b. United States, 1949-). Painter.
Feb.9/82.

BATISTA, Tomás (Puerto Rico, 1935-). Sculptor.
Apr.21/65.

BATUZ (Argentina, b. Hungary, 1933-). Sculptor, printmaker, draftsman, graphic artist, architect.
Jul.19/73.

BEAM, Carl (Canada, 1943-). Painter.
Jan.12/84.

BECERRA, Maggy (Colombia, 19?-). Draftsman, tapestry designer.
Feb.22/73.

BECK, Helen (United States). Draftsman.
Nov.1/84.

BECKER, David (United States, 1937-). Printmaker, draftsman.
Feb.11/76.

BECKER DO VALLE, Rosina. See VALLE, Rosina Becker do.

BEJAR, Feliciano (Mexico, 1920-). Painter, sculptor, printmaker, set designer, tapestry designer and weaver.
Nov.25/75.

BELAUNZARAN, Carlos (Mexico, 1940-). Painter.
Aug.2/68; Oct.14/76.

BELL, Larry (United States). Sculptor.
Nov.1/84.

BELLORIN, Francisco (José Francisco Bellorín, Venezuela, 1941-). Painter, draftsman, graphic artist.
Jan.27/81.

BENAVIDES, Pablo (Venezuela, 1918-). Painter.
Jan.27/81.

BENCASTRO, Mario (El Salvador, 1949-). Printmaker, draftsman.
Feb.11/76.

BENCOMO, Mario (Mario Díaz Bencomo, Cuba, 1953-). Painter.
Jan.15/81.

BENDERSKY, Jaime (Chile, 1922-). Painter, architect.
Sep.16/75; Oct.14/76.

BENEDIT, Luis Fernando (Argentina, 1937-). Painter, draftsman, architect.
Oct.15/69; Oct.14/76.

BENGOCHEA, Miguel Angel (Argentina, 1945-).
Painter.
Mar.5/79; Jan.15/81.
BENTO, Marcioly Medeiros (Brazil, 19?-). Artisan
(wood).
Jun.25/75.
BENTO, Maria Helena da Silva (Brazil, 19?-).
Artisan (wood).
Jun.25/75
BERDECIO, Roberto (Bolivia, 1913-). Painter,
muralist, draftsman, printmaker.
Jan.18/78.
BERMUDEZ, Cundo (Cuba, 1914-). Painter,
draftsman, printmaker.
Oct.25/73; Mar.15/74; *Feb.11/76;* Oct.14/76;
Nov.7/78; Mar.29/84.
BERMUDEZ, Henry (Venezuela, 1951-). Painter,
draftsman, graphic artist.
Jan.27/81.
BERMUDEZ, Lía de (Venezuela, 1930-). Painter,
muralist, sculptress.
Aug.23/79; Jan.27/81.
BERNAL, Teresa (Colombia, 19?-).
Feb.22/73.
BERNI, Antonio (Argentina, 1905-1981). Painter,
draftsman, printmaker, illustrator, scenographer.
May 18/65; Oct.14/76.
BERTALAN, William (Bela). (Barbados, b.
Hungary, 1910-). Sculptor.
Dec.5/80.
BESS, Ruth (Ruth Bessaudo Couvaisier, Brazil, b.
Germany, 1924-). Printmaker, illustrator.
Jan.24/72; Feb.11/76; Oct.14/76; Jun.8/82.
BESSAUDO COUVAISIER, Ruth. See BESS,
Ruth.
BICARD, Licry (Lilian Cristina Andreu de Bicard,
El Salvador, 1944-). Painter, draftsman.
May 7/85.
BIDO, Cándido (Dominican Republic, 1936-).
Painter.
Apr.21/65; Oct.19/76.
BIGATTI, Alfredo (Argentina, 1898-1964). Sculptor,
draftsman, printmaker.
Jan.15/81.
BIGLIONE, Aldo (Argentina, 1929-). Printmaker.
May 1/67.
BINECK, Rainer (Peru, 1938-). Painter, muralist.
Feb.23/77.
BIRD, Gail (United States). Artisan.
Nov.1/84.
BLANCO GOMEZ, Ana María (Argentina,
1917-). Painter.
Nov.13/73; Oct.14/76.
BLANCO, Beatriz (Venezuela, 1944-). Sculptress,
draftsman, printmaker.
Jul.7/82; Jul.12/83.

BLOOMFIELD, Valerie (Jamaica, b. Scotland,
1932-). Painter, draftsman.
Dec.14/72.
BOH, Luis Alberto (Paraguay, 1952-). Draftsman,
illustrator.
Jun.26/80.
BONATI, Eduardo (Chile, 1930-). Painter.
Jun.15/65.
BONOMI, Maria (Brazil, b. Italy, 1935-).
Printmaker, painter, set designer.
Feb.11/76; Oct.14/76.
BORDA, Osvaldo (Argentina, 1929-). Painter,
printmaker.
May 18/65; Feb.13/69; Oct.14/76.
BORGES, Jacobo (Venezuela, 1931-). Painter,
draftsman, printmaker, stage designer.
Jun.15/65; Oct.25/66.
BORLA, Héctor (Argentina, 1947-). Draftsman.
Jan.26/68.
BOROWICZ, Bob (Chile, b. Poland, 1922-).
Printmaker, photographer.
Sep.18/67.
BORRERO, Ricardo (Colombia, 1874-1931).
Painter.
Jan.15/81.
BOTERO, Fernando (Colombia, 1932-). Painter,
draftsman, sculptor.
Apr.21/65; Mar.15/74; *Apr.2/85.*
BOTERO, Olga (Olga Echeverry de Botero,
Colombia, 19?-).
Feb.22/73.
BOXER, David (Jamaica, 1946-). Painter, art
historian.
May 31/79; Jan.15/81.
BRADLEY, David (United States). Printmaker.
Nov.1/84.
BRASCOUPE, Simon (Canada, 1948-). Draftsman.
Jan.12/84.
BRATHWAITE, Hubert (Barbados, 1930-). Painter,
graphic artist.
Dec.5/80.
BRATHWAITE, Valerie (Venezuela, b. Trinidad
and Tobago, 1940-). Sculptress, painter.
Jul.12/83.
BRAUN, Herman (Peru, 1933-). Painter, draftsman,
interior designer.
Nov.5/71.
BRAVO, Edita (Chile, 19?-). Artisan (pottery).
Apr.12/70.
BRAVO, Magdalena (Colombia, 19?-). Painter,
draftsman.
Feb.22/73.
BRAVO, María Eugenia (Colombia, 19?-).
draftsman.
Feb.22/73.
BRAVO, Yolanda (Chile, 19?-). Artisan (textile).
Apr.12/70.

BREITENBACK, Cornelia Katharine (United States, 19?-). Artisan (textile).
Jun.25/75.

BRESCIANO, Miguel (Uruguay, 1937-). Printmaker.
Feb.11/76.

BRICEÑO, Beatrix (Trixie Briceño, Panama, b. England, 1911-1985). Painter.
Mar.6/69; Oct.14/76.

BRICEÑO, Corina (Venezuela, 1943-). Painter, draftsman, photographer.
Jan.27/81.

BRICEÑO, Trixie. See BRICEÑO, Beatrix.

BRIERE, Murat (Haiti, 1938-). Sculptor.
Jun.25/75.

BRIZZI, Ary (Argentina, 1930-). Painter, draftsman, printmaker, sculptor.
Apr.21/65; *Jan.29/70*; Mar.15/74; Oct.14/76.

BROODHAGEN, Karl R. (Barbados, b. British Guiana, 1909-). Sculptor, painter, draftsman.
Dec.5/80.

BROODHAGEN, Virgil L. (Barbados, 1943-). Painter.
Dec.5/80.

BROOKE, Romaine (United States, 19?-). Painter,
Jun.8/82.

BROOKS, Hope (Jamaica, 1944-). Painter, muralist.
Dec.14/72.

BROWN, Clinton (Jamaica, 1954-). Painter, sculptor.
Dec.14/72; *Aug.7/78*; *Jan.15/81.*

BROWN, Everald (Jamaica, 1917-). Painter, sculptor, musician, carpenter, Ras Tafarian priest.
Dec.14/72; *Oct.25/73*; Oct.14/76; *Aug.7/78*; *Jan.15/81.*

BRU, Roser (Chile, b. Spain, 1923-). Painter, draftsman, printmaker.
Sep.18/67.

BUGUEÑO TRUJILLO, Carlos (Chile, 19?-). Artisan (wood).
Jun.25/75.

BURCHARD G., Pablo A. (Chile, 1919-). Painter, muralist, architect.
Oct.14/76(A).

BURELA, Aida (Aida Burela Tando de Sterling, Peru, 1934-). Painter.
Jun.2/71.

BURLE MARX, Roberto (Brazil, 1909-). Painter, draftsman, architect, landscape designer.
Oct.14/76 (A).

BURSZTYN, Feliza (Colombia, 1934-1982). Sculptress.
Apr.21/65.

BURT, Michael (Paraguay, 1931-). Painter.
Nov.22/66.

BURTON, Patricia (Barbados, b. England, 1936-). Painter.
Dec.5/80.

BUSTAMANTE, Maris (Mexico, 19?-). Painter, draftsman.
Jun.12/84.

BYER, Pat (Jamaica, 19?-). Artisan.
Jun.25/75.

CABALLERO, Gerardo (Colombia, 1938-). Draftsman, accountant.
Mar.24/70; Feb.22/73; Mar.15/74; Oct.14/76.

CABRERA, Alejandro (Nicaragua, 19?-). Painter.
Nov.29/83.

CABRERA, Roberto (Guatemala, 1939-). Painter, draftsman, printmaker.
Oct.14/76(A).

CACHO, Raúl (Mexico, ?). Architect.
Apr.11/66.

CAJAHUARINGA, Milner. See MILNER CAJAHUARINGA, José.

CAJIAO, Alicia (Colombia, 19?-). Painter.
Apr.16/68.

CALDERON, Constancia (Constance Calderón de Augrain, Panama, 1937-). Painter.
Jan.15/81; Jun.8/82.

CALDERON, Teresa (Venezuela, 1941-). Jewelry designer, jeweler.
Jun.25/75.

CALZADA, Humberto (Cuba, 1944-). Painter.
Nov.7/78; *Jan.15/81.*

CAMACHO, Jorge (Cuba, 1934-). Painter, draftsman, printmaker, illustrator, photographer.
Oct.14/76(A).

CAMBRIDGE, Roslyn K. (Trinidad and Tobago, 1946-). Painter.
Jul.21/81.

CAMPBELL, Austin (Jamaica, 1935-). Sculptor.
Dec.14/72.

CAMPBELL, Ralph (Jamaica, 1921-). Painter.
Dec.14/72.

CAMPOREALE, Sergio (Argentina, 1937-). Printmaker, draftsman.
Feb.11/76; *Jan.15/81.*

CAMPOS, Susana (Mexico, 19?-). Painter.
Jun.12/84.

CAÑAS HERRERA, Benjamín (El Salvador, 1933-1987). Painter, draftsman.
Jan.12/70; Oct.14/76; Jan.18/78.

CAÑAS, Carlos (Carlos Augusto Cañas, Carlos Gonzalo Cañas, or Carlos Gonzalo Rodríguez Cañas, El Salvador, 1924-). Painter, set designer.
Apr.21/65; *Aug.10/65.*

CAÑAS, Carlos (Argentina, 1928-). Painter.
Oct.13/65; *May 24/68*; Oct.14/76.

CANCELA, Delia Sara (Argentina, 1940-). Painter.
May 18/65.

CANDELA, Félix (Mexico, b. Spain, 1910-).
Architect, engineer.
 Apr.11/66.
CANTATORE (Argentina, ?). Draftsman.
 Jan.18/78.
CANTOR, Manuel (Colombia, 1939-). Painter,
draftsman.
 Jul.14/69; Oct.14/76.
CAPONIGRO, Paul (United States). Photographer.
 Nov.1/84.
CAPRISTO, Oscar (Argentina, 1921-). Painter,
muralist, printmaker, illustrator, stage designer.
 Jan.18/66; *Oct.14/76(A)*.
CARBALLO, Aida (Argentina, 1916-). Printmaker,
draftsman, illustrator, ceramist.
 Feb.11/76; *Feb.26/76*; Oct.14/76; *Jan.15/81*;
 Jun.8/82.
CARBALLO, Fernando (Costa Rica, 1941-).
Painter, draftsman.
 Jul.10/85.
CARBUCCIA, Osvaldo (Dominican Republic,
19?-). Photographer, civil engineer.
 Feb.7/85.
CARDENAS, Irene (Ecuador, 1920-). Painter,
printmaker.
 Sep.11/78.
CARDONA, Francisco (Colombia, 1937-). Sculptor.
 Apr.21/65.
CARDOZA TORRES, Francisco Gilberto. See
 GIL.
CAREAGA, Enrique (Paraguay, 1944-). Painter,
printmaker.
 Dec.15/75; *Feb.11/76*; Oct.14/76.
CARNEIRO, Vicente (Brazil, 1927-). Painter.
 Sep.17/70; Oct.14/76.
CARO, Bill (Peru, 1949-). Painter, draftsman,
architect.
 Aug.19/75.
CARO, Praxedes (Chile, ?). Artisan (pottery).
 Apr.12/70.
CARRAL, Enrique (Mexico, ?). Architect.
 Apr.11/66.
CARRASCO, Jorge (Bolivia, 1919-). Painter,
muralist.
 Oct.10/68.
CARRASCO, Matilde Pérez Cerda de. See
 PEREZ, Matilde.
CARREÑO, Aníbal (Argentina, 1930-). Painter,
tapestry designer.
 May 24/68.
CARREÑO, Mario (Chile, b. Cuba, 1913-). Painter,
draftsman, muralist, illustrator.
 Oct.14/76; *Jan.15/81*.
CARREÑO, Omar (Venezuela, 1927-). Painter,
draftsman, printmaker.
 Jan.27/81.

CARRIL, Delia del (Chile, b. Argentina, 1886-19?).
Painter, draftsman, printmaker.
 Sep.18/67.
CARRILLO, Lilia (Mexico, 1929-1974). Painter,
draftsman, printmaker.
 Apr.21/65; *Jun.12/84*.
CARULLA, Nuria (Colombia, 19?-). Artisan.
 Jun.25/75.
CARULLA, Ramón (Cuba, 1938-). Painter,
printmaker.
 Nov.7/78; *Jan.15/81*.
CARVALLO, Feliciano (Venezuela, 1920-). Painter.
 Jan.27/81.
CASALS, José (Peru, b. Chile, 1931-).
Photographer.
 Apr.13/67; *Feb.20/68*.
CASANOVA, Teresa (Venezuela, 1928-). Painter,
printmaker.
 Sep.2/65.
CASO, Alejandro (Mexico, ?). Architect.
 Apr.11/66.
CASTAÑEDA TAMBORREL, Enrique
(Mexico, ?). Architect.
 Apr.11/66.
CASTAÑEDA, Pilar (Mexico, 1941-). Painter.
 Sep.1/71.
CASTAÑO, Guillermo (Mexico, 1938-). Sculptor.
 Apr.21/65.
CASTELLON, Rolando (Nicaragua, 1937-). Painter,
draftsman.
 Oct.17/77; Jan.18/78.
CASTILLO, Carlos Aitor (Peru, 1913-). Painter,
draftsman, stage designer, art critic.
 Oct.14/76.
CASTILLO, Felipe (Chile, 1931-). Sculptor.
 Sep.18/67.
CASTILLO, Gilda (Mexico, 1955-). Painter.
 Jun.12/84.
CASTILLO, Mario (Honduras, 1932-). Painter,
draftsman, printmaker.
 Feb.11/76; *Mar.1/84*.
CASTILLO, Sergio (Chile, 1925-). Sculptor.
 Apr.21/65; *Jun.21/67*; *Sep.18/67*; *Sep.18/68*;
 Oct.14/76.
CASTRO-MORAN, Elena (El Salvador, 19?-).
Painter.
 Jan.14/82.
CASTRO-CID, Enrique (Chile, 1937-). Painter,
draftsman.
 Sep.18/67; *Sep.18/68*; Oct.14/76.
CATTELANI, Raúl (Uruguay, 1927-). Printmaker.
 Jan.15/81.
CAVALCANTI, Emiliano Di (Brazil, 1897-1976).
Painter, draftsman, caricaturist, illustrator.
 Mar.15/74.

CECOTTO, Leonor (Leonor González Cecotto, Paraguay, b. Argentina, 1920-1981). Painter, printmaker.
Nov.22/66.
CELERY ZOLEZZI, Raúl (Chile, 19 ?-). Artisan (metal).
Jun.25/75.
CEPEDA, Ender (Venezuela, 1945-). Painter.
Jan.27/81.
CERVANTES, Clara (Colombia, 19?-).
Feb.22/73.
CEVALLOS, E. (?). Painter.
Jan.15/81.
CHAB, Víctor (Argentina, 1930-). Painter, printmaker.
Apr.21/65; *May 18/65*; Jan.18/66; *Nov.9/72*; Oct.14/76.
CHACON, Jorge (Venezuela, 1933-). Painter.
Jan.27/81.
CHACON, Luis (Costa Rica, 1953-). Painter.
Feb.9/82.
CHACON, Luis A. (Venezuela, 1927-). Printmaker, painter, sculptor, navy officer.
Aug.21/67; Jan.27/81.
CHAPA, Marta (Mexico, 1946-). Painter.
Feb.18/75.
CHAPARRO DE GUTIERREZ, Clara. See GUTIERREZ, Clara.
CHAPARRO, Tala. See GUTIERREZ, Clara.
CHAPMAN-ANDREWS, Allison (Barbados, b. England, 1942-). Painter.
Dec.5/80.
CHAVARRIA, Julia (Nicaragua, ca.1953-). Painter, farmer.
Nov.29/83.
CHAVARRIA SEQUEIRA, Milagros (Nicaragua, 1958-). Painter.
Nov.29/83.
CHAVEZ, Santos (Chile, 1934-). Printmaker.
Sep.18/67; *Sep.18/68.*
CHELLEW, Gabriela (Chile, 1934-). Painter, draftsman.
Nov.18/76.
CHERTER, Celia (Celia Shkoorman de Chertarivsky, Mexico, 1929-). Painter, draftsman, printmaker.
Nov.4/82.
CHIANG, Wie (Dominican Republic, b. China, 19?-). Photographer, architect.
Feb.7/85.
CHIN A FOENG, Jules A. (Suriname, 1944-1983). Painter.
Aug.13/85.
CHONG NETO, Manuel (Panama, 1927-). Painter, draftsman.
Oct.10/67, Mar.15/74.

CHRISTENSEN, Judi Graburn (Barbados, b. Canada, 1940-). Sculptress.
Dec.5/80.
CHU-FOON, Patrick (Trinidad and Tobago, 1931-). Painter, sculptor, art officer.
Dec.14/72.
CHURBA, Alberto (Argentina, 1933-). Ceramist, muralist, and textile, tapestry, and industrial designer.
May 24/68.
CID, Bernardo (Bernardo Cid de Souza Pinto, Brazil, 1925-). Painter.
Apr.9/74; Oct.14/76.
CINALLI, Ricardo (Argentina, 1948-). Painter, draftsman.
Oct.5/82.
CITO, Teresa (Mexico, b. Libya, 19?-). Painter.
Jun.12/84.
CLEMEN, Carlos (Brazil, b. Argentina, 1942-). Draftsman, painter, printmaker, illustrator, photographer.
Jun.23/81.
CLIFT, William (United States). Photographer.
Nov.1/84.
COCA PASSALACQUA, Cecilia (Costa Rica, 192?-). Artisan (textile).
Jun.25/75.
CODESIDO, Julia (Peru, 1892-1979). Painter, printmaker.
Jun.8/82.
COEN, Arnaldo (Mexico, 1940-). Painter, graphic artist.
Jun.15/67.
COLINA, Manuel de la (Mexico, ?). Architect.
Apr.11/66.
COLLAZO, Margaret (Argentina, b. United States, 1931-). Draftsman.
Mar.19/68.
COLLIE, Alberto (Venezuela, 1939-). Sculptor.
Mar.23/66.
COLOMBINO, Carlos (Paraguay, 1937-). Painter, draftsman, printmaker, illustrator, architect.
Apr.21/65; Jan.18/66; *Jul.20/66*; *Oct.25/73*; Mar.15/74; Oct.14/76; Jun.26/80.
COLOMBO, Myrtha Pachike Lecourt de. See PACHIKE LECOURT DE COLOMBO, Myrtha Pachike.
COLUNGA, Alejandro (Mexico, 1949-). Painter.
Nov.4/82.
CONDESO, Orlando (Peru, 1947-). Printmaker, draftsman.
Jun.2/71; *Feb.11/75*; Oct.14/76.
CONSUEGRA, Hugo (Cuba, 1929-). Painter, draftsman, printmaker, architect.
Feb.11/76; Oct.14/76; *Nov.7/78.*
CONTRERAS, Belisario (Chile, 1916-). Painter.
Nov.7/78.

COPELLO, Francisco (Chile, 1938-). Printmaker.
Jan.18/78.

CORDERO, Helen (United States). Artisan (pottery).
Nov.1/84.

CORDOVA, Gloria Lopez (United States). Woodcarver.
Nov.1/84.

CORDOVA, Inés (Bolivia, 1927-). Painter, ceramist.
Sep.25/79; Jan.15/81; Jun.8/82; May 20/85.

CORN, Blue (United States). Artisan (pottery).
Nov.1/84.

CORONEL, Pedro (Mexico, 1923-1985). Painter, sculptor, printmaker.
Jan.15/81.

CORONEL, Rafael (Mexico, 1932-). Painter, draftsman, printmaker.
Nov.4/65; Jan.18/66; Oct.14/76; Sep.28/78.

CORRAL, Carlos Jorge (Chile, 19?-). Ceramist.
Jun.25/75.

CORTES, Joaquín (Venezuela, b. Spain, 1938-). Photographer.
Jun.21/72.

CORTES, Thelma (Mexico, 19?-). Printmaker.
Aug.23/66.

COSTIGLIOLO, José Pedro (Uruguay, 1902-). Painter.
Oct.3/66.

COUFAL, Eric (Mexico, ?). Architect.
Apr.11/66.

COUVAISIER, Ruth Bessaudo. See BESS, Ruth.

COVINGTON, Harrison W. (United States, 1924-). Painter.
Mar.21/68.

COX, Ernest Lee (United States, 1937-). Sculptor.
Mar.21/68.

CRAIG, Karl (Jamaica, 1936-). Painter, muralist, printmaker.
Dec.14/72.

CRESPO, Luis (Ecuador, 1911-). Painter.
Nov.6/69.

CRISTIANI, Ernesto (Uruguay, 1928-). Painter.
Apr.21/65.

CROOK, Sarah (Trinidad and Tobago, b. England, 1946-). Painter, sculptress, illustrator, teacher.
Dec.14/72.

CROSS, Doris (United States). Painter.
Nov.1/84.

CRUXENT, José María (Venezuela, b. Spain, 1911-). Painter, archaeologist.
Mar.18/75; Oct.14/76.

CRUZ, Aníbal (Honduras, 1943-). Painter.
Mar.1/84.

CRUZ-DIEZ, Carlos (Venezuela, 1923-). Painter, printmaker.
Jun.15/65; Oct.25/66; Mar.15/74; Feb.11/76; Aug.23/79; Jan.15/81; Jan.27/81.

CRUZ, Jaime (Chile, 1934-). Painter, printmaker.
Sep.18/67.

CUEVAS, José Luis (Mexico, 1933-). Draftsman, printmaker.
Oct.25/73; Mar.15/74; Feb.11/76; Oct.14/76; Jan.18/78; Jun.5-6/78; Jan.15/81; Apr.2/82.

CUGAT, Delia (Argentina, 1930-). Printmaker, draftsman.
Feb.11/76.

CULVER, Dennis (United States). Painter, draftsman.
Nov.1/84.

CUNEO, José (Uruguay, 1887-1977). Painter.
Jan.15/81.

CURUCHICH, Andrés (Guatemala, 1891-1969). Painter.
Nov.25/85.

CURUCHICH, Vicente (Guatemala, 1925-). Painter.
Dec.5/84.

CURTINO, Oscar (Argentina, 1938-). Painter.
May 2/72.

DALTON, Linda (United States, 19?-). Artisan.
Jun.25/75.

DANIEL, Joyce (Barbados, 1933-). Printmaker.
Dec.14/72; Dec.5/80.

DANNY (Daniel Vega de la Torre, Bolivia, 1932-). Tapestry weaver and designer.
Jul.8/71.

DAVIDSON, Robert (Canada, 1946-). Printmaker.
Jan.12/84.

DAVILA, Carlos (Peru, 1935-). Painter, draftsman, printmaker.
Sep.25/68; Feb.11/76; Oct.14/76.

DAVILA, Ricardo (Ecuador, 1955-). Painter, architect.
Nov.10/81.

DAVIS, Gene (United States, 1920-). Painter.
Mar.15/74.

DAVIS, Palli Davene (United States, 19?-). Artisan.
Jun.25/75.

DEIRA, Ernesto (Argentina, 1928-1986). Painter, draftsman, lawyer.
Apr.21/65; May 18/65; Jun.15/65; Oct.14/76.

DELFIN, Víctor (Peru, 1927-). Sculptor.
Aug.17/78.

DELGADILLO, Julián (Colombia, 19?-). Draftsman.
Feb.22/73.

DELGADO, María Elena (Mexico, 1921-). Sculptress.
Jan.5/72.

DEMARCO, Hugo R. (Argentina, 1932-). Painter.
May 18/65.

DERENONCOURT, Lionel (Haiti, 1945-). Painter.
Apr.21/65.

DESHAIES, Arthur (United States, 1920-). Printmaker.
Mar.21/68.

DEVONISH, Courtney O. (Barbados, 1944-). Sculptor, ceramist.
Dec.14/72; Dec.5/80.

DIAGO, Roberto (Cuba, 1920-1955). Painter, draftsman, printmaker, illustrator.
Oct.14/76(A).

DIANDERAS, Nieves (Peru, 1929-). Painter, draftsman, graphic artist.
May 6/83.

DIAZ CORTES, Antonio (Mexico, 1935-). Painter, printmaker.
Jun.17/76.

DIAZ, Julia (El Salvador, 1917-). Painter.
Jun.8/82(A).

DIAZ BENCOMO, Mario. See BENCOMO, Mario.

DIAZ ABREU, Paloma (Mexico, 1958-). Painter.
Jun.12/84.

DIESING, Freda (Canada, 1925-). Sculptress.
Jan.12/84.

DIEZ SANCHEZ, Cristián (Chile, 19?-). Silversmith.
Jun.25/75.

DILLINGHAM, Rick (United States). Ceramist.
Nov.1/84.

DIOMEDE, Miguel (Argentina, 1902-1974). Painter.
Oct.14/76(A).

DIRUBE, Rolando. See LOPEZ DIRUBE, Rolando.

DONDE, Olga (Mexico, 1935-). Painter, draftsman, printmaker.
Feb.24/70; Feb.11/76; Oct.14/76; *Jan.15/81;* Jun.8/82; *Jun.12/84.*

DOUCHEZ, Jacques (Brazil, b. France, 1921-). Painter, tapestry designer and weaver.
May 5/71.

DOWNEY, Juan (Chile, 1940-). Painter, draftsman, printmaker, sculptor, poet, architect.
Sep.23/65; Sep.18/67; *Sep.18/68;* Oct.14/76.

DOZIER, Otis (United States, 1904-). Painter, printmaker.
Jan.14/68.

DRAKES, Maurice C. (Barbados, 1934-). Painter.
Dec.5/80.

DREYFUS, Bernard (Nicaragua, 1940-). Painter, draftsman, printmaker.
Mar.10/72; Oct.14/76; *Jan.15/81.*

DUNSHEE DE ABRANCHES TOWNSEND, Helena. See TOWNSEND, Helena.

DUSI, Inge (Costa Rica, 19?-). Artisan (textile).
Jun.25/75.

DUTARY, Alberto (Panama, 1932-). Painter, draftsman.
Oct.14/76; *Jan.18/78(A).*

EBLING, Sonia (Brazil, 1926-). Sculptress.
Nov.21/68.

ECHEVERRI, Beatriz (Colombia, 1938-). Painter, sculptress.
Feb.22/73; *Apr.8/75;* Oct.14/76; Jun.8/82.

EGAR (Efraín García Abadía, Colombia, 1931-). Photographer.
Oct.7/76; Oct.14/76; Jan.18/78.

EGENAU MOORE, Juan (Chile, 1927-). Sculptor, architect.
Apr.21/65; Sep.18/67; *Oct.16/80.*

ELLIOTT, Jorge (Chile, 1916-). Painter, writer, theater director.
Sep.18/67.

ESCALANTE, María Teresa. See TITI.

ESPINOLA, Jenaro. See PINDU, Jenaro.

ESPINOZA, Manuel (Venezuela, 1937-). Painter, draftsman, printmaker.
Aug.23/79.

ESPOSITO, Nicolás (Argentina, b. Italy, 1927-). Painter.
Jun.24/74; Oct.14/76.

ESTOPIÑAN, Roberto (Cuba, 1921-). Sculptor.
Oct.14/76; *Nov.7/78; Jan.15/81.*

ESTRADA, Enrique (Mexico, 1942-). Painter.
Sep.28/78.

ESTRADA, Iván José (Venezuela, 1950-). Draftsman.
Jan.27/81.

ESTRADA DE GRAHAM, Mercedes. See GRAHAM, Mercedes

ETCHEVERRY, José Ricardo (Chile, 1947-). Graphic artist.
Nov.6/69.

FALERO, Emilio (Cuba, 1947-). Painter.
Nov.7/78.

FANCONI, Dino (Honduras, 1950-). Painter.
Mar.1/84.

FAVERY, A. (Suriname, 1905-19?). Painter.
Feb.6/57; Aug.13/85.

FAWKES, Judith Poxon (United States, 19?-). Artisan (textile).
Jun.25/75.

FELGUEREZ, Manuel (Mexico, 1928-). Painter.
Oct.14/76; *Sep.28/78.*

FERNANDEZ MEDEROS, Agustín (Cuba, 1928-). Painter, printmaker.
Nov.7/78.

FERNANDEZ MURO, José Antonio (Argentina, b. Spain, 1920-). Painter.
May 18/65; Oct.14/76.

FERNANDEZ, Lola (Costa Rica, b. Colombia, 1926-). Painter.
>*Apr.21/65*; *Oct.30/68*; *Oct.25/73*; Mar.15/74; Oct.14/76; *Feb.9/82*; Jun.8/82.

FERNANDEZ, Rafael (Costa Rica, 1935-). Painter.
>*Jan.9/73*; Oct.14/76; *Feb.9/82*.

FERRARI, Adolfo De (Argentina, 1898-1978). Painter.
>*Feb.17/72*; Oct.14/76.

FERRER, Rafael (Puerto Rico, 1933-). Painter, draftsman, sculptor.
>*Apr.21/65*; *Jun.13/66*; Mar.15/74; Oct.14/76.

FIGARI, Pedro (Uruguay, 1861-1938). Painter, lawyer.
>Jan.18/66; *Oct.14/76(A)*.

FIGUEROA, Antonieta (María Antonieta Flores de Figueroa, Mexico, 1931-). Painter, draftsman, batik artist.
>*May 27/70*.

FILCER, Luis (Mexico, b. Ukraine, 1927-). Painter.
>*Aug.2/68*.

FINCHER, John (United States). Painter.
>Nov.1/84.

FINKELMAN, Fanny (Colombia, 1941-). Sculptress.
>*Feb.22/73*.

FISCHER DE TRAVER, Mary (Peru, 19?-). Artisan.
>Jun.25/75.

FLIJDERS, Kenneth (Suriname, 1956-). Painter.
>Aug.13/85.

FLORENTIN DEMESTRI, Pedro (Paraguay, 1958-). Draftsman, architect.
>*Jun.26/80*.

FLORES, Elio (Honduras, 19?-). Painter.
>*Mar.1/84*.

FLORES DE FIGUEROA, María Antonieta. See FIGUEROA, Antonieta.

FLU, Ron (Suriname, b. China, 1934-). Painter.
>*Aug.13/85*.

FONSECA, Harry (United States). Painter.
>Nov.1/84.

FONTECILLA, Ernesto (Chile, 1938-). Printmaker, draftsman.
>*Sep.18/68*; *Feb.11/76*.

FORNER, Raquel (Argentina, 1902-1988). Painter, draftsman, printmaker.
>Jan.18/66; Mar.15/74; *Feb.11/76*; Oct.14/76; Jun.8/82; *Nov.12/82*.

FORTE, Vicente (Argentina, 1912-1980). Painter, printmaker.
>*Oct.14/76(A)*.

FORTIN, Teresa (Honduras, 1899-19?-). Painter.
>*Mar.1/84*.

FRACCHIA, Ida Talavera de. See TALAVERA DE FRACCHIA, Ida.

FRANCO, Huguette (Peru, 1944-). Draftsman, graphic artist.
>*Dec.5/78*.

FRANKENTHALER, Helen (United States, 1928-). Painter.
>Jun.8/82.

FRASCONI, Antonio (Uruguay, b. Argentina, 1919-). Painter, printmaker.
>*Feb.11/76*.

FRAZÃO, Armando (Brazil, 1943-). Painter, draftsman.
>*Feb.7/78*.

FREIRE, María (Uruguay, 1919-). Painter.
>*Oct.3/66*.

FREIRE, Nelly (Argentina, 1933-). Draftsman.
>*Oct.14/71*; Oct.14/76; Jun.8/82.

FREITAS, Ivan (Brazil, 1932-). Painter.
>*Nov.25/69*.

FRIAS AYERZA, Raúl (Argentina, 1911-). Painter.
>*Jan.7/71*.

FRIEDEBERG, Pedro (Mexico, b. Italy, 1937-). Painter, draftsman, graphic artist, sculptor, architect.
>*Mar.15/74(A)*.

FUENTE, Manuel de la (Venezuela, b. Spain, 1932-). Sculptor, draftsman.
>*Apr.6/78*; *Jan.15/81*.

FUENTE, María Elisa de la (Argentina, 19?-). Graphic and tapestry designer.
>*May 24/68*.

FUENTES PONS, Alfredo. See PONCE DE LEON, Fidelio.

FUKUSHIMA, Tikashi (Brazil, b. Japan, 1920-). Painter.
>*Apr.1/65*; *Oct.17/72*; Mar.15/74; Oct.14/76.

FUNG LOI, Glenn (Suriname, 1945-). Painter, graphic artist.
>*Aug.13/85*.

FUNG LOI, Rocky (Suriname, 1954-). Painter.
>*Aug.13/85*.

GABRIEL SAMOL, Alberto Iván (Guatemala, 1954-). Painter.
>*Dec.5/84*.

GABRIEL SAMOL, Julián (Guatemala, 1958-). Painter.
>*Dec.5/84*.

GADBOIS, Loise (Canada,1896-?). Painter.
>Mar.21/56.

GAETE, Etelvina (Chile, 19?-). Artisan (pottery).
>Apr.12/70.

GALICIA, Roberto (El Salvador, 1945-). Painter, printmaker, illustrator, stage designer.
>*Mar.3/81*.

GALLARDO, Jesús (Mexico, 1931-). Painter, draftsman, printmaker.
>*Aug.23/66*.

GALLO, Enzo (Cuba, b. Italy, 1927-). Sculptor.
>*Nov.7/78*.

GALVEZ, Celina (Chile, 1936-). Painter, draftsman.
Sep.18/67.

GAMARRA, José (Uruguay, 1934-). Painter, printmaker.
Jun.15/65.

GANNES, Hittie Mejias De (Trinidad and Tobago, 1935-). Painter.
Dec.14/72.

GARAFULIC, Lily (Chile, 1914-). Sculptress, printmaker.
Sep.18/67.

GARCIA (Chile, ?). Artisan (pottery).
Apr.12/70.

GARCIA, Antonio (Dominican Republic, 19?-). Photographer, architect.
Feb.7/85.

GARCIA TAPIA, Atanasio (Mexico, 1951-). Printmaker, draftsman.
Jul.26/79.

GARCIA, Carlos (Nicaragua, 1955-). Painter.
Nov.29/83.

GARCIA ABADIA, Efraín. See EGAR.

GARCIA PONCE, Fernando (Mexico, 1933-). Painter, graphic artist, architect.
Apr.21/65.

GARCIA, Gay. See GAY GARCIA, Enrique.

GARCIA, Héctor (Mexico, 1923-). Photographer.
Jan.5/72.

GARCIA, Wifredo (Dominican Republic, 19?-). Photographer.
Feb.7/85.

GARDERE, Marie-José (Haiti, 1931-). Painter.
Apr.21/65.

GARDNER, Cynthia Villet. See VILLET, Cynthia.

GATES, Robert F. (United States, 1906-). Painter, draftsman.
Jan.18/66.

GATTO, Domingo (Argentina, 1935-). Painter, printmaker.
May 5/70; Oct.25/73; *Feb.26/76*; Oct.14/76; *Jan.15/81.*

GAY GARCIA, Enrique (Cuba, 1928-). Sculptor, draftsman.
Nov.7/78; *Jan.15/81.*

GAYADEEN, Holly (Trinidad and Tobago, 1930-). Painter, printmaker, art educator.
Dec.14/72.

GEGO (Gertrudis Goldschmidt, Venezuela, b. Germany, 1912-). Painter, printmaker, sculptor, architect.
Aug.23/79.

GENERALI, Manuela (Mexico, b. Switzerland, 19?-). Painter.
Jun.12/84.

GEORGE LUIZ (George Luiz Martins Paredes, Brazil, 1935-). Painter.
Nov.27/72.

GERCHMAN, Rubens (Brazil, 1942-). Painter, printmaker, film director and scenographer.
Jan.15/81.

GERO, Julio (Argentina, b. Hungary, 1910-). Sculptor.
Feb.13/69.

GERSTEIN, Noemí (Argentina, 1910-). Sculptress.
May 18/65.

GETROUW, Rudi (Suriname, 1928-). Painter, graphic artist.
Aug.13/85.

GIL (Francisco Gilberto Cardoza Torres, El Salvador, 1963-). Painter.
May 7/85.

GILBERT, Humphrey T., Jr. (United States, 19?-). Artisan.
Jun.25/75.

GIMENEZ, Gelasio (Honduras, b. Cuba, 1926-). Painter, sculptor.
Apr.21/65; Mar.1/84.

GIRON, Angela (El Salvador, 19?-). Artisan.
Jun.25/75.

GIRONELLA, Alberto (Mexico, 1929-). Painter, draftsman, printmaker, illustrator.
Oct.14/76(A).

GIUFRE, Héctor (Argentina, 1944-). Painter.
Mar.18/80.

GIUSIANO, Eduardo (Argentina, 1931-). Painter, draftsman.
Mar.18/80; *Sep.17/81.*

GIUSTI, Cathy (Costa Rica, b. Chile, 1935-). Painter.
Feb.9/82.

GLASGOW, Lukman (United States, 1935-). Sculptor.
Jun.25/75.

GODOY OPAZO, Marcial (Chile, 1933-). Painter.
May 25/72.

GOLDSCHMIDT, Gertrudis. See GEGO.

GOMEZ, Benigno (Honduras, 1934-). Painter.
Mar.1/84.

GOMEZ, Graciela (Colombia, 19?-). Painter.
Aug.4/83.

GOMEZ MOLINA, Lilian (Argentina, 1926-). Printmaker.
Oct.13/65.

GONGORA, Leonel (Colombia, 1932-). Painter, draftsman, printmaker.
Feb.11/76; Oct.14/76.

GONZALES, Ruben (United States). Painter, sculptor.
Nov.1/84.

GONZALEZ SALAZAR, Consuelo (Mexico, 1943-). Painter, draftsman, printmaker.
Jun.12/84.

GONZALEZ, Eladio (Cuba, 1937-). Sculptor.
Nov.7/78.

GONZALEZ FRUTOS, Hugo (Paraguay, 1940-). Painter, filmmaker.
Nov.22/66.

GONZALEZ, Jaime (Chile, 1934-). Painter, architect.
Sep.18/67.

GONZALEZ, Juan (Cuba, 1945-). Painter, architect.
Nov.7/78.

GONZALEZ CECOTTO, Leonor. See CECOTTO, Leonor.

GONZALEZ, Luis Alberto (Puerto Rico, 19?-). Woodcarver.
Jun.25/75.

GONZALEZ, Manuel de Jesús (Guatemala, b. El Salvador, 1951-). Painter, draftsman.
May 7/74.

GONZALEZ, María Antonia (Colombia, 1944-). Painter, draftsman.
Feb.22/73.

GONZALEZ, Roberto (Mexico, 19?-). Printmaker.
Aug.23/66.

GONZALEZ GOYRI, Roberto (Guatemala, 1924-). Painter, muralist, draftsman, sculptor.
Apr.21/65; Jan.22/80.

GORDIENKO, Xenia (Xenia Gordienko de Sasso, Costa Rica, 1933-). Painter.
Feb.9/82.

GORMAN, R.C. (United States). Sculptor.
Nov.1/84.

GORRIARENA, Carlos (Argentina, 19?-). Painter, draftsman.
Mar.18/80.

GOTAY, Consuelo (Puerto Rico, 1949-). Printmaker.
Jun.8/82.

GRACIA, Carmen (Argentina, 1935-). Printmaker.
Jan.4/67; Oct.14/76.

GRAHAM, Mercedes (Mercedes Estrada de Graham, Nicaragua, 1941-). Painter.
Nov.29/83.

GRAMCKO, Elsa (Venezuela, 1925-). Painter, sculptress.
Oct.25/66; Oct.14/76; *Jun.8/82(A).*

GRASSMANN, Marcelo (Brazil, 1925-). Draftsman, printmaker.
Mar.15/74; Oct.14/76; *Jan.15/81.*

GRAU, Enrique (Colombia, 1920-). Painter, draftsman, printmaker, illustrator, stage designer.
Oct.14/76; *Jan.15/81; Apr.2/85.*

GRILO, Sarah (Argentina, 1920-). Painter, draftsman.
May 18/65; Mar.15/74; Oct.14/76; Jun.8/82.

GRIMMER, W. (Suriname, 19?-). Painter.
Aug.13/85.

GRONNING, Vilma (Peru, 1941-). Painter, draftsman.
Jun.8/82.

GUARDIOLA, Virgilio (Honduras, 1947-). Painter, draftsman.
Mar.1/84.

GUAYASAMIN, Oswaldo (Ecuador, 1919-). Painter, muralist, draftsman, printmaker, sculptor.
Oct.14/76(A).

GUERRERO, Alfredo (Colombia, 1936-). Draftsman, printmaker.
Feb.11/76.

GUERSONI, Odetto (Brazil, 1924-). Printmaker.
May 5/71; Feb.11/76; Oct.14/76.

GUEVARA MORENO, Luis (Venezuela, 1926-). Painter, draftsman, printmaker.
Oct.25/66; *Dec.17/76;* Jan.27/81.

GUEVARA, Miriam (Nicaragua, 1957-). Painter.
Nov.29/83.

GUEVARA, Olivia (Nicaragua, 1926-). Painter.
Nov.29/83.

GUGGIARI, Hermann (Paraguay, 1924-). Sculptor.
Apr.21/65; Nov.22/66; Jun.26/80.

GUIDO, Berta (Argentina, 1930-). Painter.
Jan.4/67.

GUILLEN, Asilia (Nicaragua, 1887-1964). Painter.
Jan.18/66; Mar.15/74; Oct.14/76; *Jun.8/82(A).*

GUINAND, Edgard (Venezuela, 1943-). Sculptor.
Apr.21/65.

GUMA, K. (?). Painter.
Jan.15/81.

GUTIERREZ, Alberto (Colombia, 1935-). Painter.
Jun.15/65.

GUTIERREZ, Clara (Clara Chaparro de Gutiérrez or Tala Chaparro, Colombia, 19?-).
Feb.22/73.

GUTIERREZ, Esthela (Mexico, 19?-). Printmaker.
Aug.23/66.

GUTIERREZ, Osvaldo (Cuba, 1917-). Painter.
Nov.7/78.

GUTIERREZ, Rolando (Cuba, 1919-). Sculptor, graphic artist.
Nov.7/78.

GUTIERREZ, Sérvulo (Peru, 1914-1961). Painter, sculptor, boxer.
Jan.15/81.

GUZMAN, Alberto (Peru, 1927-). Sculptor.
Apr.21/65.

GUZMAN, Juan (Dominican Republic, 19?-). Photographer, architect.
Feb.7/85.

GUZMAN, Lázaro (Dominican Republic, 19?-). Photographer, agricultural engineer.
Feb.7/85.

GWYN, Woody (United States). Draftsman.
Nov.1/84.

HAHN, Betty (United States). Photographer.
Nov.1/84.

HALEGUA, Alfredo (Uruguay, 1930-). Sculptor.
Mar.15/74; Oct.14/76; *Nov.7/78.*

HAMMER, Wayne (United States, 19?-). Artisan (metal).
Jun.25/75.

HANCOCK, Judith. See SANDOVAL, Judith Hancock de.

HANDA, Tomoo (Brazil, b. Japan, 1906-). Painter.
Apr.1/65.

HAOZOUS, Bob (United States). Sculptor.
Nov.1/84.

HARDIN, Helen (United States). Painter, printmaker.
Nov.1/84.

HARLEY, Milton (Jamaica, 1936-). Painter.
Dec.14/72.

HATTERMAN, Nola (Suriname, b. Netherlands, 1899-1984). Painter.
Aug.13/85.

HELWIG, Harold B. (United States, 19?-). Artisan.
Jun.25/75.

HEMENWAY BARTON, Nancy (Mrs. Robert D. Barton, United States, 1920-). Painter, designer.
Dec.11/70.

HENRIQUE ANTONIO. See AMARAL, Antônio Henrique.

HERNANDEZ, Agustín (Mexico, ?). Architect.
Apr.11/66.

HERNANDEZ, Camila (Mexico, 19?-). Amate tree bark artist.
Jun.15/67; Oct.14/76; Jun.8/82.

HERNANDEZ ORTEGA, Gilberto (Dominican Republic, 1924-). Painter.
Apr.21/65.

HERNANDEZ CRUZ, Luis (Puerto Rico, 1936-). Painter, draftsman, printmaker, sculptor.
Apr.21/65; Jul.11/68; May 5/78; Jan.15/81.

HERNANDEZ GIDANSKY, Pedro (Chile, 19?-). Artisan.
Jun.25/75.

HERRAN, Alvaro (Colombia, 1937-). Sculptor, muralist.
Apr.21/65.

HERRERA CRUZ, Alejandro (Mexico, 1955-). Painter, printmaker.
Jul.26/79; Jan.15/81.

HERRERA GUEVARA, Luis (Chile, 1891-1945). Painter.
Mar.26/69.

HEYN, Miguel (Paraguay, 1950-). Draftsman, printmaker.
Jun.26/80.

HODICK, Angelo (Brazil, 1945-). Printmaker, draftsman.
Feb.11/76; Jan.15/81.

HOFFMAN, Marlene (Colombia, 1934-). Weaver, textile artist.
Apr.16/68.

HOLDER, Boscoe (Trinidad and Tobago, 19?-). Painter, choreographer, pianist.
Dec.14/72.

HOUSER, Alan (United States). Sculptor.
Nov.1/84.

HOVELL, Marcelio (Trinidad and Tobago, 19?-). Painter, illustrator.
Dec.14/72.

HOYOS, Ligia (Ligia Hoyos de Rojas, Colombia, 19?-).
Feb.22/73.

HOYTE, Verton (Barbados, b. Trinidad and Tobago, 1960-). Draftsman.
Dec.5/80.

HUALQUIMIR, Rosa (Chile, 19?-). Artisan (textile).
Apr.12/70.

HUEZO, Roberto (El Salvador, 1947-). Painter, draftsman.
Mar.15/74; *Jun.28/79; Jan.15/81.*

HUNG, Francisco (Venezuela, b. China, 1937-). Painter.
Apr.21/65; Oct.25/66; Jan.27/81.

HURTADO, Angel (Venezuela, 1927-). Painter, printmaker, documentary film maker.
Mar.15/74; Oct.14/76; Jan.18/78; *Aug.23/79(A).*

ICAZA, Alberto. See YCAZA, Alberto.

ICAZA, Adela Vargas de. See VARGAS, Adela.

IFANGER, José Paulo (Brazil, ?). Painter.
Jan.18/78.

IMANA, Gil (Bolivia, 1933-). Painter, draftsman, printmaker.
Feb.11/76.

IOMMI, Ennio (Argentina, 1926-). Sculptor.
May 18/65.

IRARRAZAVAL, Ricardo. See YRARRAZAVAL, Ricardo.

IRIZARRY, Marcos. See YRIZARRY, Marcos.

IRODRIKOMO, Soeki (Suriname, 1945-). Painter.
Aug.13/85.

ISRAEL, Patricia (Chile, 1939-). Painter, printmaker.
Sep.18/67.

ISSASI, Alcides Rubén. See ARYSSASI.

IZQUIERDO, César (Guatemala, 1937-). Painter, draftsman.
Mar.4/66; Mar.15/74; *Aug.20/81.*

JACOME, Ramiro (Ecuador, 1948-). Painter, draftsman, printmaker.
May 20/80; Jan.15/81.

JAIMES SANCHEZ, (Angel) Humberto (Venezuela, 1930-). Painter, printmaker, stage designer.
> Apr.21/65; Oct.25/66; Mar.15/74; Oct.14/76; Jan.27/81.

JARAMILLO, Gloria (Colombia, 19?-). Painter.
> Feb.22/73.

JARAMILLO, Luciano (Colombia, 1938-1984). Painter.
> Jan.30/79; Jan.15/81.

JEAN-GILLES, Joseph (Haiti, 1943-). Painter.
> Jan.22/71; Oct.25/73; Oct.14/76.

JIMENEZ, Edith (Paraguay, 1925-). Painter, draftsman, printmaker.
> Nov.22/66; Jun.26/80.

JIMENEZ, Luis (United States). Sculptor.
> Nov.1/84.

JOHNS, Jasper (United States, 1930-). Painter, printmaker.
> Oct.25/73.

JOHNSON, Douglas (United States). Painter.
> Nov.1/84.

JOHNSON, Yazzie (United States). Artisan.
> Nov.1/84.

JONES, Ottway (Trinidad and Tobago, 1945-). Painter, draftsman.
> Aug.18/76.

JORGE, Miguel (Cuba, 1928-). Painter, muralist.
> Nov.7/78.

JOSEPH, Jasmin (Haiti, 1923-). Painter, sculptor.
> Mar.15/74.

JOYCE (Joyce Vourvoulias, Guatemala, b. Mexico 1938-). Sculptress.
> May 12/77; Jan.18/78; Jun.8/82; Jul.12/83.

KAHN, María (El Salvador, 1941-). Painter.
> May 7/85.

KAN, Dennis (Venezuela, 1953-). Photographer.
> Apr.28/81.

KANEKO, Taro (Brazil, 1953-). Painter, architect.
> Jun.23/81.

KAPO (Bishop Mallica Reynolds, Jamaica, 1911-). Painter, sculptor, Revivalist bishop.
> Dec.14/72; Aug.7/78; Jan.15/81.

KARSTERS, Ruben Johan (Suriname, 1941-). Draftsman, graphic artist, photographer, musician.
> Aug.13/85.

KASSIN, Clara (Colombia, 1948-). Sculptress.
> Feb.22/73.

KELLY, McAllister. See McALLISTER KELLY, Rosana.

KEPENYES, Pal (Mexico, b. Hungary, 19?-). Sculptor, jewelry designer.
> Jan.11/80.

KERPEL, Ana (Colombia, 19?-). Painter.
> Feb.22/73.

KETTERER, Guillermo (Paraguay, 1910-1977). Painter.
> Nov.22/66.

KIGUSIUQ, Janet (Canada, 1926-). Textile artist.
> Jan.12/84.

KINGMAN, Eduardo (Ecuador, 1913-). Painter, muralist, draftsman, printmaker.
> Jan.15/81.

KLIPPER, Maya (Argentina, b. Romania, 19?-). Printmaker.
> Sep.23/80.

KOHEN, Linda (Uruguay, b. Italy, 1924-). Painter.
> Apr.9/85.

KOHN, Misch (United States, 1916-). Printmaker.
> Feb.11/76.

KOHN DE BARREIRO, Tanya. See TANYA.

KOSICE, Gyula (Argentina, b. Czechoslovakia, 1924-). Sculptor.
> May 18/65.

KOZEL, Ana (Argentina, 1937-). Painter, printmaker.
> Sep.10/85.

KRASNIANSKY, Bernardo (Paraguay, 1951-). Draftsman, printmaker.
> Jun.26/80.

KUBOTTA, Arturo (Peru, 1932-). Painter, printmaker.
> Jun.15/65; Jan.18/66; Oct.14/76.

KUDJUAK (Canada, 19?-). Artisan (textile).
> Jun.25/75.

LAHAM, Ricardo (Argentina, 1940-). Painter.
> Mar.18/80.

LAINEZ, Juan Ramón (Honduras, 1939-). Painter, draftsman.
> Mar.1/84.

LAINEZ, Raúl (Honduras, 1923-). Painter.
> Mar.1/84.

LAJARA, Alejandro (Dominican Republic, 19?-). Photographer.
> Feb.7/85.

LAM, Wifredo (Cuba, 1902-1982). Painter, draftsman, printmaker, illustrator.
> Mar.15/74.

LAMONICA, Roberto De (Brazil, 1933-). Printmaker.
> Oct.14/76(A).

LANDA, Enrique (Mexico, ?). Architect.
> Apr.11/66.

LANDAU, Myra (Brazil, b. Romania, 1926-). Painter, draftsman, printmaker.
> Jan.24/67.

LA ROSA, Manuel (Mexico, ?). Architect.
> Apr.11/66.

LASANSKY, Mauricio (United States, b. Argentina, 1914-). Printmaker.
> Feb.11/76; Jan.15/81.

LUIZ, George. See GEORGE LUIZ.

LUKS, Janet (United States, 19?-). Artisan (textile).
 Jun.25/75.

LUNA, Arturo (Honduras, 1926-). Painter.
 Apr.21/65.

LUNA, Lourdes (Mexico, 19?-). Printmaker.
 Aug.23/66.

LUNAR, Emerio Darío (Venezuela, 1940-). Painter, draftsman.
 Jan.27/81.

MABE, Manabu (Brazil, b. Japan, 1924-). Painter.
 Apr.1/65; Jan.18/66; Oct.14/76; *Dec.11/80*; *Jan.15/81.*

McALLISTER KELLY, Rosana (Cuba, b. Argentina, 1931-). Painter.
 Nov.7/78.

MACCIO, Rómulo (Argentina, 1931-). Painter, draftsman, illustrator.
 May 18/65; Jun.15/65.

Mac ENTYRE, Eduardo (Argentina, 1929-). Painter, printmaker.
 May 18/65; Jun.15/65; Mar.15/67; Mar.15/74; Oct.14/76.

MACHADO, Ricardo (Argentina, 1923-). Painter, actor.
 Feb.16/65; Oct.14/76.

McLAREN, Sidney (Jamaica, 1895-1979). Painter, draftsman, farmer.
 Dec.14/72; Aug.7/78; Jan.15/81.

MADARIAGA, Olga (Nicaragua, 19?-). Painter.
 Nov.29/83.

MAGARIÑOS D., Víctor (Argentina, 1924-). Painter, draftsman.
 May 18/65.

MAGIN, Arthur (Trinidad and Tobago, 1912-). Painter.
 Dec.14/72.

MALAGRINO, Silvia (Argentina, 1950-). Photographer, writer.
 Dec.9/82.

MALDONADO, Estuardo (Ecuador, 1928-). Painter, draftsman.
 May 1/67; Oct.14/76.

MALLOL, Sergio (Chile, 1922-). Sculptor.
 Sep.18/67.

MAMANI, Rosa (Peru, 19?-). Artisan (textile).
 Jun.25/75.

MANAURE, Mateo (Venezuela, 1926-). Painter, muralist, printmaker.
 Jan.27/81(A).

MANDIOLA URIBE, Luis (Chile, 1934-). Painter, draftsman, printmaker, sculptor, ceramist.
 Sep.18/67; Jun.25/75.

MANLEY, Bryn J. (United States, b. England, 1900-). Painter, printmaker.
 Mar.21/68.

MANLEY, Edna (Jamaica, b. England, 1900-). Painter, sculptress.
 Dec.14/72.

MANZANITO (Chile, 19?-). Artisan (wicker).
 Apr.12/70.

MANZANO, Salvador (Mexico, 1952-). Sculptor, painter.
 Jul.30/81.

MANZUR, David (Colombia, 1929-). Painter, muralist, printmaker, stage designer, actor.
 Feb.22/73; *Oct.25/73*; *Mar.15/74*; Oct.14/76.

MARCOS, Jesús (Argentina, b. Spain, 1938-). Painter, draftsman, printmaker.
 Mar.18/80.

MARENCO, Carlos (Nicaragua, 1958-). Painter.
 Nov.29/83.

MARGARET. See COLLAZO, Margaret.

MARIA LUISA. See PACHECO, María Luisa.

MARIONI, Paul (United States, 19?-). Sculptor, glass blower.
 Jun.25/75.

MARQUEZ, Laura (Paraguay, 1929-). Painter, sculptress.
 Nov.22/66.

MARQUEZ HUITZIL, Ofelia (Mexico, 1959-). Painter, printmaker.
 Jun.12/84.

MARROQUIN, Raúl (Colombia, 1948-). Painter, draftsman, sculptor.
 Aug.5/71.

MARSHALL, Hartley (Barbados, 1946-). Draftsman, printmaker.
 Dec.14/72; Feb.11/76.

MARTIN, Vicente (Uruguay, 1911-). Painter.
 Jan.15/81.

MARTINEZ BONATI, Eduardo. See BONATI, Eduardo.

MARTINEZ, Margarita Alvarez de. See ALVAREZ, Negra.

MARTINEZ-CAÑAS, María (United States, b. Cuba, 1960-). Photographer.
 Dec.9/82.

MARTINEZ PALMA, Mónica (Chile, 19?-). Artisan.
 Jun.25/75.

MARTINEZ OSTOS, René (Mexico, ?). Architect.
 Apr.11/66.

MARTINEZ, Selmo (Paraguay, 1948-). Draftsman.
 Jun.26/80.

MARTINO, Federico (Argentina, 1930-). Painter, printmaker.
 Oct.14/76; Mar.18/80; *Jan.15/81.*

MARTINS, Aldemir (Brazil, 1922-). Draftsman, painter, printmaker, illustrator.
 Oct.14/76(A).

MARTINS PAREDES, George Luiz. See GEORGE LUIZ.

MARTINS, Maria (Maria de Lourdes Aceves Martins Pereira de Souza, Brazil, 1900-1973). Painter, sculptress, draftsman, printmaker.
Mar.15/74.

MARTORELL, María (María Vidal de Martorell, Argentina, 1919-). Painter.
Dec.10/79; Jan.15/81.

MASON, Dick (United States). Painter.
Nov.1/84.

MASSIN, Eugene Max (United States, 1920-). Painter, educator.
Mar.21/68.

MATTA, Roberto (Chile, 1912-). Painter, draftsman, printmaker, architect.
Jan.18/66; Sep.18/67; *Sep.18/68;* Mar.15/74; Oct.14/76.

MATTIA, Alphonse (United States, 19?-). Artisan.
Jun.25/75.

MATTOS, Cecilia (Uruguay, 1958-). Draftsman.
Jul.1/82.

MAWDSLEY, Richard (United States, 19?-). Artisan.
Jun.25/75.

MAYER, Mónica (Mexico, 1954-). Painter.
Jun.12/84.

MAYORGA, Pablo (Nicaragua, 1955-). Painter, draftsman, farmer.
Nov.29/83.

MAZZEI, Ana María (Venezuela, 1941-). Painter, graphic artist.
Jan.27/81.

MEDEIROS BENTO, Marcioly. See BENTO, Marcioly Medeiros.

MEJIA, Mario (Honduras, 1946-). Painter.
Mar.1/84.

MEJIA, Mauricio (El Salvador, 1956-). Painter, draftsman.
May 7/85.

MEKLER, Sara W. de (Colombia, b. Poland, 19?-). Painter.
Feb.22/73.

MENDEZ, Consuelo (Venezuela, 1952-). Draftsman, printmaker, illustrator, photographer.
Apr.28/81.

MENDEZ-CARATINI, Héctor (Puerto Rico, 1949-). Photographer.
Mar.18/82.

MENDEZ, Oscar (Costa Rica, 1943-). Painter.
Feb.9/82.

MENDOZA BAÑOS, Ariel (Mexico, 1956-). Painter, draftsman, printmaker.
Jul.26/79; Jan.15/81.

MENDOZA HERNANDEZ, Jesús (Mexico, 19?-). Artisan.
Jun.25/75.

MENDOZA, Juan (Venezuela, 1946-). Painter.
Jan.27/81.

MENDOZA NUÑEZ, Oscar (Honduras, 19?-). Painter.
Mar.1/84.

MENENDEZ, César (El Salvador, 1954-). Painter.
Jan.14/82.

MENESES, Gladys (Venezuela, 1938-). Painter, printmaker.
Jun.8/82.

MERALDI, Oscar (Uruguay, 1932-). Painter.
Dec.5/67.

MERIDA, Carlos (Guatemala, 1891-1984). Painter, muralist, printmaker, stage designer.
Jan.18/66; Mar.15/74; *Oct.14/76(A).*

MERISIER, Mortès (Haiti, 1925-). Painter, carpenter, electrician.
Apr.21/65.

MESA, Ricardo, (Chile, 1931-). Sculptor.
Sep.18/67.

MESSIL, Gabriel (Argentina, 1934-1986). Painter, draftsman, printmaker, sculptor.
Mar.18/80.

MESTRE, Héctor (Mexico, ?). Architect.
Apr.11/66.

MIGLIORISI, Ricardo (Paraguay, 1948-). Draftsman, printmaker, illustrator.
Jun.26/80.

MIJARES, José María (Cuba, 1922-). Painter.
Nov.7/78.

MIJARES, Rafael (Mexico, 1924-). Architect.
Apr.11/66.

MILIAN, Raúl (Cuba, 1914-). Draftsman.
Oct.14/76(A).

MILLAN, Carmen de (María del Carmen Aranguren de Millán, Venezuela, ca. 1915 and 1920-). Painter.
Jun.21/72; Oct.14/76; Jun.8/82.

MILLAN, Víctor (Venezuela, 1919-). Painter.
Jun.21/72; Oct.14/76.

MILLER, Carol (Mexico, b. United States, 1933-). Sculptress, photographer, journalist.
Oct.14/76; *Jun.8/82.*

MILNER CAJAHUARINGA, José (Peru, 1932-). Painter.
Jan.27/66.

MILTON, Peter (United States, 1930-). Printmaker, draftsman.
Feb.11/76.

MILTOS, Alberto (Paraguay, 1941-). Painter, draftsman, printmaker.
Nov.22/66.

MINUJIN, Marta (Argentina, 1941-). Painter, draftsman.
May 18/65.

MIRANDA, Silvio (Nicaragua, 1948-). Painter.
Apr.21/65.

MIZUNO, Mineo (United States, 19?-). Ceramist.
Jun.25/75.

MOHALYI, Yolanda (Brazil, b. Hungary, 1909-1979). Painter.
Oct.14/76(A).

MOLINA, Lutgardo (Honduras, 1948-). Painter.
Mar.1/84.

MOLINA, Rodolfo (El Salvador, 1959-). Painter.
May 7/85.

MOLINARI FLORES, Luis (Ecuador, 1929-). Painter, draftsman, printmaker.
Nov.19/74.

MOLL, Eduardo (Peru, b. Germany, 1929-). Painter, graphic artist.
Nov.13/70.

MONSALVE, Margarita (Colombia, 1948-). Painter, draftsman, printmaker.
Jun.8/82.

MONTE SERRAT, Isis Sanon. See SERRAT, Isis Sanon Monte.

MONTEALEGRE, Marcelo (Chile, 1936-). Photographer.
Aug.7/69.

MONTECINO, Sergio (Chile, 1916-). Painter.
Sep.18/67; *Aug.23/77*.

MONTES, Fernando (Bolivia, 1930-). Painter.
Dec.5/67.

MONTES DE OCA, Roberto (Cuba, 1949-). Painter.
Nov.7/78.

MONTIEL, Luis (Venezuela, 1914-). Tapestry designer and weaver.
Apr.3/72.

MONTILLA, Manuel (Dominican Republic, 1948-). Draftsman.
Nov.3/75; Oct.14/76.

MORA Y PALOMAR, Enrique de la (Mexico, 1907-). Architect.
Apr.11/66.

MORAIMEZ RIVAS, Violeta (Chile, 19?-). Artisan.
Jun.25/75.

MORAL, Enrique del (Mexico, 1906-). Architect.
Apr.11/66.

MORALES, Armando (Nicaragua, 1927-). Painter, draftsman, printmaker.
Jan.18/66; *Oct.25/73*; Mar.15/74; Oct.14/76.

MORALES, Elsa (Venezuela, 1941-). Painter.
Jan.27/81.

MORALES LOPEZ, Felipe de Jesús (Mexico, 1959-). Painter, draftsman.
Jul.26/79; *Jan.15/81*.

MORALES, Gonzalo (Costa Rica, 1945-). Painter.
Feb.9/82.

MORALES, Miguel Angel (Panama, 1945-). Painter.
Aug.2/84.

MORALES, Ricardo (Costa Rica, 1935-). Painter.
Jun.13/68.

MORASSI, Roberto (Uruguay, 1918-). Painter, photographer, sculptor.
Nov.22/71.

MOREINIS, Vivian (Colombia, 19?-). Painter.
Feb.22/73.

MORI, Camilo (Chile, 1896-1973). Painter.
Oct.14/76.

MORIAMEZ RIVAS, Violeta (Chile, 19?-). Artisan.
Jun.25/75.

MORIOKA, June Utako (United States, 19?-). Ceramist.
Jun.25/75.

MORON, René (Argentina, 1929-). Painter, draftsman, printmaker.
Jan.7/65; *Oct.6/83*.

MORRISSEAU, Norval (Canada, 1931-). Painter, draftsman.
Jan.12/84.

MOSIS, A. (Suriname, 19?-). Painter,
Aug.13/85.

MOSKOWITZ, Stanley Joel (United States, 19?-). Artisan.
Jun.15/75.

MOYA BARAHONA, Carlos (Costa Rica, 1925-). Painter, muralist, sculptor, graphic artist.
Apr.21/65.

MOZLEY, Loren (United States, 19?-). Painter.
Jan.14/68.

MUELLER, Susan Marie (United States, 19?-). Artisan (textile).
Jun.25/75.

MUJICA, Manuel Vicente (Venezuela, 1924-). Painter.
Jan.27/81.

MUÑOZ, Amelia (Chile, ?). Artisan (pottery).
Apr.12/70.

MUÑOZ, Jaime (Colombia, 1915-). Painter.
May 17/73.

MUNTAÑOLA, Roser (Panama, b. Spain, 1928-). Painter.
Oct.14/76(A).

NARANJO, Oscar (Colombia, 19?-). Painter, tapestry designer and weaver.
Feb.22/73.

NAUMAN, Bruce (United States, 19?-). Printmaker, sculptor.
Nov.1/84.

NAVARRETE, Julia (Peru, 1938-). Painter, draftsman.
Jun.8/82.

NAVARRO, Dalita (Venezuela, 1945-). Ceramist.
Oct.30/85.

NAVARRO, Héctor (Mexico, 1937-). Painter, draftsman, printmaker, stage and industrial designer, architect.
Aug.23/66; Oct.14/76.

NAYLOR, John Geoffrey (United States, b. England, 1928-). Painter, educator.
Mar.21/68.

NEGRET, Edgar (Colombia, 1920-). Sculptor.
Jan.18/66; Oct.14/76; *Apr.2/85*.

NERY, José (El Salvador, 1951-). Painter.
Mar.3/81.

NERY, Wega (Brazil, 1913-). Painter.
Jan.24/67.

NEUMAN, Giti (Ecuador, b. Czechoslovakia, 1941-). Painter.
Jun.29/66.

NEWMAN, Eugene (United States). Painter.
Nov.1/84.

NICOLA, Norberto (Brazil, 1930-). Painter, tapestry weaver and designer.
May 5/71.

NIERMAN, Leonardo (Mexico, 1932-). Painter, muralist, draftsman, printmaker, sculptor, violinist, physicist, mathematician.
Jan.30/73; Mar.15/74; Oct.14/76; Jan.18/78; *Jun.17/80*.

NILCA, Pailo (Peru, 19?-). Artisan (textile).
Jun.25/75.

NIÑO, Carmelo (Venezuela, 1951-). Painter, draftsman.
Jul.21/76; Oct.14/76; Jan.18/78; *Jan.27/81*.

NOE, Luis Felipe (Argentina, 1933-). Painter, draftsman, illustrator, art critic.
May 18/65.

NOUGUES, Isaías (Argentina, 1930-). Draftsman, architect.
Jan.29/70.

NOWENS, Jacobo (Argentina, 1933-). Painter.
Jul.19/73.

NUÑEZ, Dulce María (Mexico, 1950-). Painter.
Jun.12/84.

NUÑEZ, Guillermo (Chile, 1930-). Painter, draftsman, stage designer.
Jan.29/65; *Apr.21/65*; *Jun.15/65*; Jan.18/66; Sep.18/67; Mar.15/74; Oct.14/76.

NUÑEZ URETA, Teodoro (Peru, 1912-). Painter, muralist, art historian.
Jan.15/81.

OBALDIA, Oderay (Panama, 19?-). Tapestry weaver.
Apr.13/69.

OBREGON, Alejandro (Colombia, b. Spain, 1920-). Painter.
Mar.15/74; Oct.14/76; *Jan.10/83*; *Apr.2/85*.

OCAMPO, Miguel (Argentina, 1922-). Painter, draftsman, architect.
May 18/65; *Dec.9/69*; *Jan.15/81*.

OCHARAN, Leticia (Mexico, 1942-). Painter.
Jun.12/84.

ODUBER, Ciro S. (Panama, 1921-). Painter, draftsman.
Oct.14/76(A).

OHTAKE, Tomie (Brazil, b. Japan, 1913-). Painter, printmaker.
Apr.1/65; *Apr.29/68*; Jan.18/78; Jun.8/82.

OLIVA, Tomás (Cuba, 1930-). Sculptor.
Nov.7/78.

OLIVER, Efraim (Cuba, 1930-). Painter.
Nov.7/78.

OLIVERA, Julio (Uruguay, 1939-). Painter.
Jul.29/80.

OLLER, Francisco (Francisco Manuel Oller y Cestero, Puerto Rico, 1833-1917). Painter, draftsman.
Mar.30/84.

OMOWALE (Alan Omowale Stewart, Barbados, 1950-). Painter, draftsman, muralist, commercial designer, illustrator, set and costume designer.
Dec.5/80.

OPAZO, Rodolfo (Chile, 1935-). Painter, draftsman, printmaker.
Sep.18/67; *Oct.25/73*; Mar.15/74; Oct.14/76.

ORB, Consuelo (Chile, 1942-). Painter.
Sep.18/67.

OREAR, Gordon (United States, 19?-). Ceramist.
Jun.25/75.

ORELLANA, Gastón (Chile, 1933-). Painter.
Jan.6/66; Oct.14/76.

ORLANDI, Alicia (Argentina, 1937-). Draftsman, printmaker.
Feb.11/76.

ORLANDO, Felipe (Mexico, b. Cuba, 1911-). Painter, printmaker, illustrator.
Jan.18/78(A).

ORNELLAS, Francisco d' (Peru, 1916-). Painter, draftsman.
Jun.8/73.

OROZCO, José Clemente (Mexico, 1883-1949). Painter, draftsman, muralist, printmaker.
Jan.18/66; *Jan.15/81*.

ORTIZ MONASTERIO, Luis (Mexico, 1906-). Sculptor.
Feb.24/70; Oct.14/76.

ORTUZAR, Carlos (Chile, 1935-). Painter, sculptor, illustrator.
Sep.18/67.

ORZUJ, Raquel (Raquel Orzuj de Grostein, Uruguay, 1939-). Painter, draftsman.
Dec.9/77.

OSORIO, Iván (Nicaragua, 1935-). Tapestry designer and weaver.
Jul.15/75.

OSSA, Jerónimo de la (Panama, 19?-). Artisan (textile).
Jun.25/75.

OSSA, Mariela de la (Panama, 19?-). Artisan (textile).
Jun.25/75.

OSSAYE, Roberto (Guatemala, 1927-1954). Painter.
Oct.14/76(A).

OSTROWER, Fayga (Brazil, b. Poland, 1920-). Printmaker, illustrator, textile and jewelry designer.
Feb.11/76; Jan.15/81; Jun.8/82.

OSUITOK, Ipeelee (Canada, 1923-). Sculptor.
Jan.12/84.

OSUNA, Ramón. (Cuba, 1937-). Photographer.
Nov.26/68.

OSVALDO. See GUTIERREZ, Osvaldo.

OTERO, Alejandro (Venezuela, 1921-). Painter, printmaker, sculptor.
Jan.18/66; Oct.25/66; Oct.25/73; Oct.14/76; Aug.23/79.

OTERO, Ximena (Colombia, 19?-).
Feb.22/73.

OTONIEL, Edmundo (El Salvador, 1950-). Painter, illustrator.
May 7/85.

OVALLE, Guillermo (Colombia, 1957-). Painter, draftsman.
Jan.15/81; Apr.13/82.

OVIEDO, Ramón (Dominican Republic, 1927-). Painter, draftsman.
Nov.3/75; Oct.14/76; Nov.11/82.

PACHECO, Carlos (Argentina, 1932-). Printmaker.
Mar.5/79.

PACHECO, María Luisa (Bolivia, 1919-1982). Painter, draftsman, illustrator, textile designer.
Oct.25/73; Oct.14/76; Nov.7/78; Jun.8/82.

PACHIKE LECOURT DE COLOMBO, Myrtha (Argentina, 19?-). Artisan (textile).
Jun.25/75.

PACHNER, William (United States, b. Czechoslovakia, 19?-). Painter, illustrator.
Mar.21/68.

PADILLA, Carlos (Colombia, 1946-). Draftsman.
Feb.22/73; Apr.8/75; Oct.14/76.

PADILLA, Ezequiel (Honduras, 1945-). Painter.
Mar.1/84.

PADILLA, Luis H. (Honduras, 1947-). Painter.
Mar.1/84.

PAEZ VILARO, Carlos (Uruguay, 1923-). Painter, muralist, draftsman, illustrator, sculptor, ceramist, writer, popular music composer.
Oct.25/73; Oct.14/76.

PALACIOS, Alirio (Venezuela, 1938-). Painter, draftsman, printmaker.
Aug.23/79.

PALACIOS, Ciro (Peru, 1943-). Painter.
Nov.13/70; Oct.14/76.

PALACIOS FLORES, Irma (Mexico, 1943). Painter.
Jun.12/84.

PALACIOS, Luisa (Venezuela, 1923-). Painter, printmaker, ceramist.
Feb.11/76; Aug.23/79; Jan.27/81.

PALATNIK, Abraham (Brazil, 1928-). Painter, sculptor.
Jul.12/65.

PALMER, Mervin (Jamaica, 1955-). Painter.
Dec.14/72.

PANI, Mario (Mexico, 1911-). Architect.
Apr.11/66.

PANTIN, Anita (Venezuela, 1949-). Painter, draftsman.
Jan.27/81.

PANTOJA, Oscar (Bolivia, 1925-). Painter, draftsman.
Jul.20/65; Oct.14/76.

PAPIALUK, Josie (Canada, 1918-). Graphic artist.
Jan.12/84.

PARADA, Domingo (Bolivia, 1941-). Painter.
Jan.7/69.

PARBOOSINGH, Karl (Jamaica, 1923-1975). Painter.
Dec.14/72.

PARBOOSINGH, Seya (Jamaica, b. United States, 1925-). Painter.
Dec.14/72.

PARDO, Mercedes (Venezuela, 1922-). Painter, muralist, printmaker, stage designer.
Oct.25/66; Aug.23/79.

PAREDES, George Luiz Martins. See GEORGE LUIZ.

PAREDES SOTOMAYOR, Jaime. See SOTOMAYOR, Jaime.

PAREDES ROJAS, Rafael (Chile, 19?-). Artisan.
Jun.25/75.

PARODI (Brazil, 1933-). Painter, tapestry designer and weaver.
Apr.9/74.

PARRA, Manuel (Mexico, ?). Architect.
Apr.11/66.

PASCUALA (Luz Marina Ramírez de Villamizar, Colombia, 1949-). Painter.
Oct.13/81.

PATLAN, Francisco (Mexico, 19?-). Printmaker.
Aug.23/66.

PATRICK, Vernon (United States, 19?-). Ceramist.
Jun.25/75.

PELAEZ, Amelia (Cuba, 1887-1968). Painter, muralist, draftsman, illustrator, ceramist.
Jan.18/66; Mar.15/74; Oct.14/76; Jun.8/82(A).

PELAEZ, Antonio (Mexico, b. Spain, 1921-). Painter, graphic artist.
Sep.28/78; *Mar.31/81*.

PELLON, Gina (Cuba, 1926-). Painter, draftsman, printmaker.
Jun.8/82.

PELUFFO, Martha (Argentina, 1931-). Painter.
May 18/65.

PENAGOS, Rafael (Colombia, 1941-). Draftsman.
Jan.22/74; *Oct.14/76*.

PENALBA, Alicia (Argentina, 1918-). Sculptress.
May 18/65.

PEÑALBA, Rodrigo (Nicaragua, 1908-1979). Painter, caricaturist.
Oct.14/76(A).

PERAZZO, Josefina (Josefina Testa de Perazzo, Argentina, 1922-). Painter.
Mar.15/73; *Oct.14/76*; *Jun.8/82*.

PEREIRA, Manuel (Peru, 1935-). Sculptor, painter.
Apr.21/65; *Sep.16/66*; *Oct.14/76*.

PEREIRA, René (Peru, 1937-). Sculptor, painter.
Sep.16/66; *Oct.14/76*.

PEREZ CELIS (Argentina, 1939-). Painter, printmaker.
Oct.30/67.

PEREZ, Eduardo (Chile, 1937-). Painter, draftsman, printmaker.
Sep.18/67.

PEREZ, Humberto (Colombia, 1931-). Painter, draftsman, illustrator.
Nov.13/80; *Jan.15/81*.

PEREZ, Matilde (Matilde Pérez Cerda de Carrasco, Chile, 1924-). Painter.
Oct.2/84.

PEREZ BARRADAS, Rafael. See BARRADAS, Rafael.

PEREZ RAYON, Reynaldo (Mexico, ?). Architect.
Apr.11/66.

PEREZ ALCALA, Ricardo (Bolivia, 1939-). Painter, architect.
Feb.27/80.

PERKINS, Dionisio (Cuba, 1929-). Painter.
Nov.7/78.

PERLMUTTER, Jack (United States, 1920-). Painter, printmaker.
Jan.18/66.

PARRA, Manuel (Mexico, ?). Architect.
Apr.11/66.

PERRIN, María Esther Ballivián de. See BALLIVIAN, María Esther.

PETERDI, Gabor (United States, b. Hungary, 1915-). Printmaker.
Feb.11/76.

PETROVSKY, Ivan (Venezuela, b. Hungary, 1913-). Painter, printmaker.
Jun.14/83.

PIEDRA, Víctor (Cuba, 1922-). Painter, ceramist, textile designer.
Nov.7/78.

PIÑA, Pedro (Venezuela, 1953-). Painter.
Jan.27/81.

PINDU, Jenaro (Jenaro Espínola, Paraguay, 1946-). Draftsman, architect.
Jun.26/80.

PINEDA, Rosa (Nicaragua, 19?-). Painter.
Nov.29/83.

PIÑEROSS, Jorge (Colombia, 1929-). Painter.
Nov.16/67.

PINTO, Anamario (Mexico, 1950-). Painter.
Jun.12/84.

PITSIULAK, Lipa (Canada, 1943-). Sculptor.
Jan.12/84.

PIZARRO, Raúl (Chile, ?). Horncarver.
Apr.12/70.

PLOSSU, Bernard (United States). Photographer.
Nov.1/84.

PLYLER, Michael (United States, b. Japan, 1955-). Photographer.
Dec.5/84.

POLEO, Héctor (Venezuela, 1918-). Painter, draftsman, printmaker, tapestry designer.
Oct.25/66; *Mar.15/74*; *Oct.14/76*; *Jan.27/81*; *May 16/85*.

POLESELLO, Rogelio (Argentina, 1939-). Painter, printmaker.
Apr.21/65; *May 18/65*; *Jun.15/65*; *May 24/68*; *Mar.15/74*; *Oct.14/76*.

PONCE, Bernal (Chile, 1938-). Painter, printmaker.
Sep.18/67.

PONCE DE LEON, Fidelio (Alfredo Fuentes Pons, Cuba, 1895-1949). Painter, draftsman.
Jan.15/81.

PORTER, Benjamín (Bolivia, 1950-). Photographer.
Sep.2/82.

PORTER, Eliot (United States). Photographer.
Nov.1/84.

PORTINARI, Cândido (Brazil, 1903-1962). Painter, muralist, draftsman, printmaker, illustrator, poet.
Jan.18/66; *Mar.15/74*; *Oct.14/76(A)*.

PORTO, Raul (Brazil, 1936-). Painter, draftsman.
May 23/67; *Oct.14/76*.

PORTOCARRERO, René (Cuba, 1912-1985). Painter, muralist, draftsman, ceramist, illustrator, stage and costume designer.
Mar.15/74; *Oct.14/76(A)*.

POSSIN, Maruja. See SHAIO, Maruja.

POVEDA, Carlos (Costa Rica, 1940-). Painter, draftsman, graphic artist.
Mar.29/65; *Jan.18/66*.

PRADA, Carlos (Venezuela, 1944-). Sculptor, jewelry designer.
Jan.27/81.

PRESAS, Leopoldo (Argentina, 1915-). Painter, draftsman, illustrator.
Jan.26/68; Oct.14/76.

PRESNO, Lincoln (Uruguay, 1917-). Painter, draftsman, graphic artist, industrial designer, tapestry designer, sculptor.
Jan.15/81; *Jul.1/82*.

PRESTON, Barbara (Barbados, 19?-). Painter.
Dec.5/80.

PRETE, Danilo Di (Brazil, b. Italy 1911-). Painter, draftsman, printmaker.
Jan.18/66; *Oct.14/76(A)*.

PRETTO, Rogelio (Panama, 1944-). Painter.
May 26/81.

PRIETO, Alejandro (Mexico, ?). Architect.
Apr.11/66.

PROAÑO MORENO, Guillermo (Ecuador, 1915-). Photographer.
Jun.18/69.

PUCCIARELLI, Mario (Argentina, 1928-). Painter.
May 18/65; Oct.14/76.

PUCHE, Carlos Eduardo (Venezuela, 1923-). Photographer.
Mar.23/66.

PUJOLS, Manuel (Dominican Republic, 19?-). Photographer, architect.
Feb.7/85.

PUZZOVIO, Delia (Argentina, 1942-). Painter.
May 18/65.

QUEVEDO ESPINOZA, Patricio (Chile, 19?-). Artisan.
Jun.25/75.

QUILICI, Francisco (Venezuela, 1954-). Painter, draftsman, printmaker.
Jan.27/81.

QUINTANILLA, Luis (Mexico, b. United States, 1930-). Painter, draftsman.
Jan.7/74.

QUINTERO, José Antonio (Venezuela, 1946-). Painter, draftsman, printmaker.
Jan.27/81.

QUINTERO, Nerio (Venezuela, 1954-). Painter, draftsman.
Jan.27/81.

QUIROA, Marco Augusto (Guatemala, 1937-). Painter.
Oct.14/76(A).

QUISPE, Escolástico (Peru, 19?-). Artisan (textile).
Jun.25/75.

RABBITT, Nancy (United States, 19?-). Artisan (textile).
Jun.25/75.

RABEL, Fanny (Mexico, b. Poland, 1922-). Painter, draftsman, printmaker, stage designer.
Jun.12/84.

RAFAEL (Nicaragua, 19?-). Painter.
Nov.29/83.

RAHON PAALEN, Alice (Mexico, b. France, 1910-1987). Painter.
Jun.12/84.

RAMBISSOON, Sonnylal (Trinidad and Tobago, 1926-). Painter, draftsman, printmaker.
Dec.14/72; *Feb.11/76*; *Aug.18/76*.

RAMDJIAWANSINGH, George (Suriname, 1954). Painter, draftsman.
Aug.13/85.

RAMIREZ, Clara (Colombia, 19?-).
Feb.22/73.

RAMIREZ, Dora (Colombia, 1923-). Painter, draftsman, printmaker.
May 17/73; Oct.14/76; Jun.8/82.

RAMIREZ, Eduardo (Peru, 1945-). Painter, draftsman.
Jun.2/71.

RAMIREZ VILLAMIZAR, Eduardo (Colombia, 1923-). Painter, draftsman, sculptor.
Oct.14/76; *Apr.2/85*.

RAMIREZ DE VILLAMIZAR, Luz Marina. See PASCUALA.

RAMIREZ VAZQUEZ, Pedro (Mexico, 1919-). Architect.
Apr.11/66.

RAMOS MARTINEZ, Alfredo (Mexico, 1875-1946). Painter, draftsman, printmaker.
Oct.14/76.

RAMPOLLA, Frank (United States, 19?-). Painter.
Mar.21/68.

RAMSAY, Ras Akyem Akin-Yemi Ramsay. See AKYEM.

RAPPAPORT, Bertha (Argentina, 1919-). Painter, draftsman.
May 24/66.

RAYO, Omar (Colombia, 1928-). Painter, draftsman, printmaker.
Mar.15/74; *Feb.11/76*.

REBAZA, Gilberto (Peru, 1939-). Painter.
Oct.24/79; *Jan.15/81*.

RECHANY, Jorge (Puerto Rico, 1914-). Painter, muralist.
Aug.16/73.

RECINOS, Efraín (Guatemala, 1932-). Painter, muralist, sculptor, illustrator, stage designer, architect, engineer.
Mar.9/65; *Apr.21/65*.

RENART, Emilio J. (Argentina, 1925-). Painter, draftsman, sculptor.
Nov.24/65; Oct.14/76.

RENDON, César (Honduras,1941-). Painter, draftsman.
Mar.1/84.

RESENDIZ, Rubén (Mexico, 19?-). Printmaker.
Aug.23/66.

RESTUCCIA, Marta (Marta Restuccia de Arce, Uruguay, 1937-). Painter, draftsman, printmaker.
Jun.8/82.

REY, Flora (Argentina, 1935-). Painter, printmaker.
Sep.27/72; Oct.14/76.

REYNOLDS, Mallica. see KAPO.

RIBERO, Gonzalo (Bolivia, 1942-). Painter, architect.
Oct.14/70; *Jan.15/81.*

RICHTER, Luisa (Venezuela, b. Germany, 1928-). Painter, draftsman, printmaker.
Oct.25/66.

RIGAUD, Jean Claude (Haiti, 1945-). Sculptor.
Nov.21/77.

RIOPELLE, Jean-Paul (Canada, 1923-). Painter.
Mar.15/74.

RIQUELME, William (Paraguay, 1944-). Painter, draftsman.
Nov.22/66.

RIVADENEIRA ALMEIDA, Jorge (Ecuador, 1935-). Woodcarver.
Aug.20/70.

RIVERA, Amparo (Costa Rica, 1919-). Painter.
Feb.9/82.

RIVERA, Diego (Mexico, 1886-1957). Painter, draftsman, muralist, printmaker.
Mar.15/74.

RIVERON, Enrique (Cuba, 1902-). Painter, draftsman, cartoonist, illustrator.
Nov.7/78.

ROA, Israel (Chile, 1909-). Painter, muralist.
Sep.18/67.

ROBINSON, Michael (Canada, 1948-). Printmaker.
Jan.12/84.

ROBIROSA, Josefina (Argentina, 1932-). Painter, muralist, tapestry designer.
May 24/68.

ROBLEDO, Victoria Eugenia (Colombia, 19?-). Artisan.
Jun.25/75.

ROCA REY, Joaquín (Peru, 1923-). Sculptor, draftsman, printmaker.
Jan.18/66; Mar.15/74; *Oct.14/76(A).*

ROCHA, Jorge (Colombia, 1949-). Painter, draftsman.
Oct.13/81.

RODNEY, George (Jamaica, 1936-). Painter, graphic artist.
Dec.14/72.

RODO BOULANGER, Graciela (Bolivia, 1935-). Painter, printmaker.
Sep.14/83.

RODRIGUEZ, Alirio (Venezuela, 1934-). Painter, draftsman.
Jan.23/69; Oct.14/76; Jan.27/81.

RODRIGUEZ CAÑAS, Carlos Gonzalo. See CAÑAS, Carlos.

RODRIGUEZ, Eliseo (United States). Artisan.
Nov.1/84.

RODRIGUEZ SEÑERIZ, María. See SEÑERIZ, María.

RODRIGUEZ, Marta. (Colombia, 1947-). Draftsman, printmaker.
Oct.14/76; *Jun.8/82.*

RODRIGUEZ, Richard (Cuba, 1950-). Photographer.
Jan.15/81.

RODRIGUEZ PREZA, Víctor Manuel (El Salvador, 1936-). Painter.
Apr.21/65.

RODRIGUEZ, Yolanda (Colombia, 19?-). Printmaker.
Feb.22/73.

RODULFO TARDO, Manuel (Cuba, 1913-). Sculptor, painter, draftsman.
Nov.7/78.

ROEDAN, Carlos (Dominican Republic, 19?-). Photographer.
Feb.7/85.

ROGERS, Wilfred (Barbados, 1949-). Painter, draftsman.
Dec.14/72.

ROJAS, Elmar (Guatemala, 1937-). Painter, architect.
Feb.16/71; *Oct.25/73*; Oct.14/76.

ROJAS, Hugo (Bolivia, 1936-). Painter, printmaker.
Feb.5/81.

ROJO, Vicente (Mexico, b. Spain, 1932-). Painter, printmaker.
Sep.28/78.

ROLDAN CAICEDO, Alán (Honduras, 1952-). Painter, draftsman.
Mar.1/84.

ROMAN, Nelson (Ecuador, 1945-). Painter, draftsman, printmaker.
Jun.5/75; *Feb.11/76.*

ROMER, Margot (Venezuela, 1938-). Painter, draftsman, printmaker.
Jan.27/81.

ROMERO, Juana (Chile, 19?-). Artisan (Pottery).
Apr.12/70.

ROMERO, Susana (Argentina, 1938-). Painter, draftsman.
Jun.26/80.

ROSADO DEL VALLE, Julio (Puerto Rico, 1922-). Painter, muralist, draftsman, graphic artist.
May 21/65; Oct.14/76.

ROSALES, Edison (Venezuela, 1951-). Painter.
Jan.27/81.

ROSALES, Eduardo (Venezuela, 1949-). Painter.
Jan.27/81.

ROSE, Daisy (Jamaica, 1904-). Painter, milliner.
Dec.14/72.
ROSETTA, Johnny (United States, 19?-). Artisan.
Nov.1/84.
ROSETTA, Marlene (United States). Artisan.
Nov.1/84.
ROSSEL DE LA LAMA, Guillermo (Mexico, ?).
Architect.
Apr.11/66.
RUBADOUX, Craig (United States, 19?-). Painter.
Mar.21/68.
RUBENSTEIN, Meridel (United States).
Photographer.
Nov.1/84.
RUIZ MATUTE, Miguel Angel (Honduras,
1928-). Painter.
Jul.22/70; Mar.1/84.
RUIZ, Pascual (Colombia, 1951-). Draftsman,
painter.
Sep.9/74; Oct.14/76.
RUSSO, Octavio (Venezuela, 1948-). Draftsman.
Jan.27/81.
RUTHLING, Ford (United States). Painter.
Nov.1/84.
RYBAK, Taty (Argentina, 1943-). Sculptress.
Sep.17/81; Jun.8/82.
SABAT, Hermenegildo (Uruguay, 1933-). Painter,
draftsman.
Apr.21/65; Jun.15/65.
SABOGAL, José (Peru, 1888-1956). Painter,
printmaker, illustrator.
Oct.14/76(A).
SAENZ, Leoncio (Nicaragua, 1935-). Draftsman.
Feb.15/66; Oct.14/76.
SAFF, Donald Jay (United States, 1937-).
Draftsman, printmaker.
Mar.21/68.
SAGIATUK, Sagiatuk (Canada, 1932-). Printer.
Jan.12/84.
ST. JEAN (Haiti, ?). Painter.
Mar.15/74.
ST. JOHN, Stella (Barbados, 1933-). Painter, batik
artist.
Dec.14/72; Oct.25/73; Dec.5/80.
SAKAI, Kasuya (Argentina, 1927-). Painter,
draftsman, printmaker.
May 18/65.
SALAS, Norman (Venezuela, 1926-). Painter.
Jan.27/81.
SALATINO, Carlos Alberto (Argentina, 1939-).
Painter.
May 1/69; Mar.18/80.
SALAZAR, Braulio (Venezuela, 1917-). Painter,
draftsman.
Jan.27/81.
SALAZAR, Clemencia (Colombia, 19?-). Painter.
Feb.22/73.

SALAZAR, Toño (El Salvador, 1900-). Caricaturist,
draftsman, illustrator.
May 19/76.
SALGUEIRO, Mauricio (Brazil, 1930-). Sculptor.
Apr.21/65.
SALINAS, Baruj (Cuba, 1935-). Painter,
printmaker.
Nov.7/78.
SALLES, Evandro (Evandro Vilela Teixeira de
Salles, Brazil, 1955). Draftsman.
Jul.10/84.
SAMPER, Ana (Ana María Samper de Osorio,
Colombia, 19?-). Painter.
Feb.22/73.
SAMSON, Mariana (Nicaragua, 19?-). Painter.
Nov.29/83.
SAN A JONG, Cliff (Suriname, 1948-). Painter.
Aug.13/85.
SAN AVILES. See AVILES, San.
SANCHEZ FRANCO, Cecilio (Mexico, 1957-).
Painter, draftsman, printmaker.
Jul.26/79; Jan.15/81.
SANCHEZ, Edgar (Venezuela, 1940-). Painter,
draftsman, printmaker, architect.
Jan.27/81.
SANCHEZ LAUREL, Herlinda (Mexico, 1941-).
Painter, muralist.
Jun.12/84.
SANCHEZ HIDALGO, Joaquín (Mexico, ?).
Architect.
Apr.11/66.
SANCHEZ, Rafael (Dominican Republic, 19?-).
Photographer, architect.
Feb.7/85.
SANCHEZ, Thorvald (Cuba, 1933-). Painter.
Oct.14/76; *Nov.7/78.*
SANDINO, Pedro (Colombia, 1919-). Sculptor,
painter, dentist.
Feb.22/73; Oct.14/76; *Sep.19/77.*
SANDOVAL, Judith Hancock de (United
States, ?). Photographer.
Jan.7/74.
SANDOVAL, Roberto (Costa Rica, 1940-).
Sculptor.
Jul.10/85.
SANIN, Fanny (Colombia, 1935-). Painter.
Jul.14/69.
SANTANA, Norberto (Dominican Republic, 1943-).
Painter, draftsman.
Mar.15/74.
SANTANDER, (María) Cristina (Argentina, 1942-).
Painter, printmaker.
Feb.11/76; Oct.5/82.
SANTANDER, María Cristina. See SANTANDER,
Cristina.

SANTANTONIN, Rubén (Argentina, 1919-). Painter.
May 18/65.

SANTIAGO AVENDAÑO, Filemón (Mexico, 1958-). Painter, printmaker.
Jul.26/79; Jan.15/81.

SAPP, Allen (Canada, 1929-). Painter.
Jan.12/84.

SARMIENTO, Nelly (Colombia, 1926-). Sculptress.
Jan.22/74.

SASSO, Xenia Gordienko de. See GORDIENKO, Xenia.

SAURET, Nunik (Mexico, 1951-). Painter, printmaker, sculptress.
Jun.12/84.

SAVILLE, Ken (United States). Sculptor.
Nov.1/84.

SCANNAPIECO, Carlos (Argentina, 1940-). Printmaker.
May 24/68.

SCHOLDER, Fritz (United States). Painter.
Nov.1/84.

SCHOOLEY, Elmer (United States). Painter.
Nov.1/84.

SCHULZ, Lotte (Paraguay, 1925-). Painter.
Apr.21/65.

SCHWAB, Beat (Jamaica, b. Switzerland, 1952-). Printmaker.
Dec.14/72.

SEGALL, Lasar (Brazil, b. Lithuania, 1890-1957). Painter, draftsman, printmaker, sculptor.
Oct.14/76(A).

SEGUI, Antonio (Argentina, 1934-). Painter, draftsman, printmaker.
May 18/65; Jun.15/65.

SEGUIN, Oliver (Mexico, b. France, 1927-). Sculptor.
Apr.21/65.

SEJOURNE, Bernard (Haiti, 1947-). Painter.
Jul.12/78.

SELLORS, Evaline (United States, 19?-). Sculptress.
Jan.14/68.

SENDIN, Armando (Brazil, 1925-). Painter, draftsman.
May 31/74; Oct.14/76.

SEÑERIZ, María (María Rodríguez Señeriz, Puerto Rico, 1929-). Painter, draftsman, sculptress.
Jul.11/67.

SEÑORET, María Luisa (Chile, 1920-). Painter, printmaker, illustrator.
Sep.18/67.

SEOANE, Nelson (Brazil, 1930-). Painter.
Jan.15/81.

SEPLOWIN, Charles J. (Puerto Rico, 19?-). Sculptor.
Jul.12/83.

SERRA-BADUE, Daniel (Cuba, 1914-). Painter.
Jan.15/81.

SERRAT, Isis Sanon Monte (Brazil, 19?-). Ceramist.
Jun.25/75.

SHAIO, Maruja (Maruja Shaio de Possin, Colombia, 19?-). Painter.
Feb.22/73.

SHINKI, Venancio (Peru, 1932-). Painter.
Feb.20/68; Oct.14/76.

SHIRO, Flavio (Brazil, b. Japan, 1928-). Painter.
Apr.1/65.

SICRE, Juan José (Cuba, 1898-1974). Sculptor.
Oct.14/76(A).

SIEBERT, Klaus. (Suriname, 1952-). Painter.
Aug.13/85.

SIERRA, Susana (Mexico, 1942-). Painter.
Jun.12/84.

SILMAN, Alicia (Argentina, 1930-). Sculptress, tapestry designer.
May 24/68.

SILVA, Alfredo Da (Bolivia, 1936-). Painter, draftsman, printmaker, sculptor.
Jan.18/66; Mar.15/74; Oct.14/76(A).

SILVA, Carlos (Argentina, 1930-). Painter.
May 18/65.

SILVA, Francisco Domingos da (Brazil, 1910-). Painter.
Jan.15/81.

SILVA, José Antônio (Brazil, 1909-). Painter, agriculture laborer.
Jan.15/81.

SILVA BENTO, Maria Helena da. See BENTO, Maria Helena da Silva.

SILVERSTEIN, Natalie R. (Canada, 19?-). Artisan.
Jun.25/75.

SIMMONDS, Eugenia (See footnote #3, page 242) (Colombia, 19?-). Painter.
Feb.22/73.

SIMON CUMEZ, Salvador (Guatemala, 1968-). Painter.
Dec.5/84.

SINCLAIR BALLESTEROS, Alfredo (Panama, 1915-). Painter, printmaker.
Jan.15/81.

SINCLAIR, Olga (Panama, 1957-). Painter, draftsman.
May 13/82.

SIQUEIROS, David Alfaro (Mexico, 1896-1974). Painter, muralist, draftsman, printmaker.
Oct.14/76(A).

SIVURAPIK, Josie (Canada, 1954-). Printer.
Jan.12/84.

SMITH, Jaune Quick-to-See (United States). Painter.
Nov.1/84.

SNELL, David Moffett (United States, 19?-). Artisan (metal).
Jun.25/75.
SOBALVARRO, Orlando (Nicaragua, 1943-). Painter, sculptor.
Apr.21/65.
SOLA FRANCO, Eduardo (Ecuador, 1915-). Painter.
Dec.10/68.
SOLARI, Delia (Argentina, 19?-). Painter, accountant.
Sep.6/84.
SOLARI, Luis A. (Uruguay, 1918-). Painter, draftsman, printmaker.
Feb.11/76; Jan.15/81.
SOLOMON, Syd (United States, 1917-). Painter.
Mar.21/68.
SORDO MADALENO, Juan (Mexico, ?). Architect.
Apr.11/66.
SORIANO, Juan (Mexico, 1920-). Painter, printmaker, sculptor.
Oct.11/78.
SORIANO, Rafael (Cuba, 1920-). Painter.
Nov.7/78; Jan.15/81.
SOTO, Jesús Rafael (Venezuela, 1923-). Painter, sculptor, printmaker.
Jun.15/65; Oct.25/66; Mar.15/74; Oct.14/76; Aug.23/79; Jan.27/81.
SOTOMAYOR, Jaime (Chile, 1936-). Sculptor, printmaker.
Nov.18/76.
SPRUCE, Everett Franklin. (United States, 1908-). Painter.
Jan.14/68.
SQUIRES, Nina (Trinidad, 1929-). Painter, printmaker.
Jun.8/82.
SQUIRRU, Carlos (Argentina, 1934-). Painter.
May 18/65.
STANLEY, Rodolfo (Costa Rica, 1934-). Painter.
Feb.9/82.
STEKELMAN, Juan Carlos (Argentina, 1936-). Draftsman, printmaker.
Oct.30/67.
STERN, Fanny (Colombia, 19?-). Draftsman.
Feb.22/73.
STEWART, Alan Omowale. See OMOWALE.
STODDART, J. Godfrey (Venezuela, b. England, 1929-). Architect, landscapist.
Jul.8/68.
STONE, William (Venezuela, 1945-). Painter, printmaker, sculptor.
Jan.27/81.
STROSBERG, Rachel (Brazil, 1927). Printmaker.
Apr.1/65
STUART, Donald A. (Canada, 19?-). Artisan (metal).
Jun.25/75.

STUART, Manuel (Suriname, 1956-). Painter.
Aug.13/85.
SUAREZ, Pablo (Argentina, 1937-). Painter, sculptor.
Mar.18/80.
SUAREZ, Ruisdael (Uruguay, 1929-). Painter.
Apr.21/65.
SUBERO, Oswaldo (Venezuela, 1934-). Painter, printmaker.
Jan.27/81.
SUMMERFORD, Ben (United States, 1925-). Painter.
Jan.18/66.
SUNDIATA (Ian Sundiata Stewart, Barbados, 1950-). Painter, draftsman, muralist, illustrator, set and costume designer.
Dec.5/80.
SUPISICHE, Ricardo (Argentina, 1912-). Painter.
Jan.26/68; Oct.14/76.
SURO, Darío (Dominican Republic, 1917-). Painter, diplomat.
Jan.18/66; Oct.25/73.
SZALAY, Lajos (Argentina, b. Hungary, 1909-). Draftsman, illustrator.
Oct.14/76(A).
SZYSZLO, Fernando de (Peru, 1925-). Painter, draftsman, printmaker.
Apr.21/65; Jun.15/65; Oct.25/73; Mar.15/74; Oct.14/76; Mar.11/85.
TABARA, Enrique (Ecuador, 1930-). Painter, draftsman, graphic artist.
Jan.18/66; Oct.14/76(A).
TABORA, Fernando (Venezuela, b. Chile, 1927-). Architect.
Jul.8/68.
TAFOYA, Margaret (United States). Ceramist.
Nov.1/84.
TAFUR, Edgar (Colombia, 1929-). Sculptor.
Nov.16/67.
TAKAOKA, Yoshiya (Brazil, b. Japan, 1910-). Painter.
Apr.1/65.
TALAVERA DE FRACCHIA, Ida (Paraguay, 19?-). Painter, poetess.
Nov.22/66.
TALAVERA, María (María Williams de Talavera, Honduras, 19?-). Painter.
Mar.1/84.
TAMAKI, Yuji (Brazil, b. Japan, 1916-). Painter,
Apr.1/65.
TAMAYO, Rufino (Mexico, 1899-1991). Painter, draftsman, muralist, printmaker, sculptor.
Jan.18/66; Mar.15/74; Oct.14/76; Jan.15/81.
TANAKA, Shigeto (Brazil, b. Japan, 1910-). Painter.
Apr.1/65.
TANTLINGER, Susan (United States, 19?-). Artisan.
Jun.25/75.

TANYA (Tanya Kohn de Barreiro, Ecuador, b. Czechoslovakia, 1935-). Painter, draftsman, printmaker.
Jun.8/82; *Feb.24/83.*

TAPIA, Luis (United States). Sculptor.
Nov.1/84.

TAVERA, Patricia (Colombia, 1947-). Painter, draftsman.
Feb.22/73.

TAYLOR, Janet Roush (United States, 19?-). Artisan (textile).
Jan.25/75.

TEANA, Marino Di (Argentina, b. Italy, 1920-). Sculptor.
May 18/65.

TEIXEIRA, Alberto (Alberto Dias d'Almeida Teixeira, Brazil, b. Portugal, 1925-). Painter.
Apr.21/65; Sep.25/69; Oct.14/76.

TELEMAQUE, Hervé (Haiti, 1937-). Painter, draftsman, printmaker.
Feb.11/76.

TELLEZ, Eugenio (Chile, 1939-). Painter, draftsman, printmaker.
Jun.15/65.

TENORIO, Libia (Colombia, 19?-). Draftsman.
Feb.22/73.

TESTA, Clorindo (Argentina, b. Italy, 1923-). Painter, muralist, draftsman, architect.
May 18/65; Jun.15/65.

TESTA DE PERAZZO, Josefine. See PERAZZO, Josefina.

TESTONI, Julio (Uruguay, 1948-). Photographer.
Apr.9/85.

TIKTAK, John (Canada, 1916-1981). Sculptor.
Jan.12/84.

TITI (María Teresa Escalante, El Salvador, 1953-). Painter.
May 7/85.

TOJA, Mamy (María Eugenia Toja, Paraguay, n1937-). Painter.
Jan.19/83.

TOJA, María Eugenia. See TOJA, Mamy.

TOLEDO, Francisco (Mexico, 1940-). Painter, draftsman, printmaker.
Feb.11/76.

TOLENTINO, Vicente (Dominican Republic, 19?-). Photographer, architect.
Feb.7/85.

TOMASELLO, Luis (Argentina, 1915-). Painter.
May 18/65.

TORAL, Mario (Chile, 1934-). Painter, draftsman, printmaker.
Sep.18/67; *Dec.3/73; Feb.11/76;* Oct.14/76; *Jan.15/81.*

TORAL, Tabo (Panama, 1950-). Painter, graphic artist.
Nov.1/83.

TORM, Fernando (Chile, 1944-). Painter, draftsman, printmaker, composer, pianist.
Jan.18/78.

TORRES-GARCIA, Joaquín (Uruguay, 1874-1949). Painter, draftsman.
Mar.15/74; Oct.14/76; *Jan.18/78(A).*

TOSARI, Rene Darimin (Suriname, 1948-). Graphic artist.
Aug.13/85.

TOWNSEND, Helena (Helena Dunshee de Abranches Townsend, Brazil, 1926-). Sculptress.
Aug.27/80.

TOYOTA, Yutaka (Brazil, b. Japan, 1931-). Painter, draftsman, printmaker.
Apr.21/65; Jan.24/72; Oct.14/76.

TRASOBARES, César (Cuba, 1949-). Painter.
Nov.7/78.

TRAVER, Mary Fischer de. See FISCHER DE TRAVER, Mary.

TRESPALACIOS MEZA, Luis Guillermo (Colombia, 19?-). Artisan.
Jun.25/75.

TROLL, Marlene (Marlene Lloreda de Troll, Colombia, 19?-). Draftsman.
Feb.22/73.

TRUJILLO, Guillermo (Panama, 1927-). Painter, muralist, draftsman, graphic artist, tapestry designer, architect, landscape designer.
Apr.21/65; Jan.18/66; *Apr.13/69;* Oct.25/73; Oct.14/76; *Jan.15/81.*

TRUJILLO MAGNENAT, Sergio (Colombia, 1911-). Painter, muralist, draftsman.
Sep.19/77.

TRUJILLO DAVILA, Sergio (Colombia, 1947-). Photographer, architect.
Mar.23/76; Oct.14/76.

TSUCHIMOTO, Masumi (Brazil, b. Japan, 1934-). Sculptor, ceramist.
Apr.1/65; May 27/69.

TUTTLE, Elizabeth (United States, 19?-). Artisan (textile).
Jun.25/75.

UBAU, Yelba (Nicaragua, ca.1958-). Painter, teacher.
Nov.29/83.

ULLOA BARRENECHEA, Ricardo (Costa Rica, 1928-). Painter.
Feb.9/82.

UMLAUF, Charles (Karl A. Umlauf, United States, 1939-). Sculptor, painter.
Jan.14/68.

URBANO, Jesús (Peru, 19?-). Woodcarver.
Dec.14/81.

URBANO, Julio (Peru, 19?-). Woodcarver.
Dec.14/81.

URIBE, Ana (Colombia, 19?-). Painter.
Feb.22/73.

URQUIOLA DE WENDE, Daisy (Bolivia, 19?-). Artisan (textile).
Jun.25/75.

URUETA, Eduardo (Colombia, 1940-). Sculptor.
Mar.23/76; Oct.14/76.

VADIA, Rafael (Cuba, 1950-). Painter.
Nov.7/78; *Jan.15/81*.
VALDERRAMA, Francisco (Colombia, 1930-).
Printmaker.
Sep.9/74; Oct.14/76.
VALDEZ, Horacio (United States). Woodcarver.
Nov.1/84.
VALDIVIESO, Raúl (Chile, 1931-). Sculptor,
painter, draftsman.
Jan.18/66; Sep.18/67; *Sep.18/68*; Oct.14/76.
VALENCIA, César (Ecuador, 1918-). Painter.
Jan.18/66; *Oct.14/76(A)*.
VALENCIA, Eugenia (Colombia, 19?-). Painter.
Feb.22/73.
VALENZUELA, Leoncia (Chile, 19?-). Artisan
(textile).
Apr.12/70.
VALERA, Víctor (Venezuela, 1927-). Sculptor,
graphic artist.
Apr.21/65; Jan.27/81.
VALLE, Rosina Becker do (Brazil, 1914-). Painter.
May 10/66.
VALVERDE, César (Costa Rica, 1928-). Painter,
muralist, printmaker.
Sep.16/76; Oct.14/76; Jan.18/78.
VARGAS, Adela (Adela Vargas de Ycaza,
Nicaragua, 1911-). Painter.
Mar.25/71; Mar.15/74.
VASQUEZ, Carlos (Chile, 1931-). Painter,
printmaker.
Aug.7/69; Oct.14/76.
VAUCROSSON, Noel (Trinidad, 1932-). Painter,
architect.
Dec.14/72.
VAZQUEZ KAUFFMANN, Carlos (Mexico,
1955-). Painter, draftsman, printmaker.
Jul.26/79; Jan.15/81.
VAZQUEZ, Isabel (Mexico, 1947-). Printmaker.
Jun.12/84.
VEGA DE LA TORRE, Daniel. See DANNY.
VEGA, Ed (United States). Sculptor.
Nov.1/84.
VEGA, Jorge de la (Argentina, 1930-1971). Painter,
draftsman.
May 18/65; *Jun.15/65*; Oct.14/76.
VELARDE, Pablita (United States). Painter.
Nov.1/84.
VELASQUEZ, José Antonio (Honduras, 1906-
1983). Painter.
Jan.18/66; *Oct.25/73*; Mar.15/74; Oct.14/76;
Apr.14/83; Mar.1/84.
VELAZQUEZ, Juan Ramón (Puerto Rico, 1950-).
Painter, draftsman, printmaker.
Jan.18/77; Jan.18/78; *Jan.15/81*.
VELEZ, Amparo (Colombia, 19?-). Painter.
Feb.22/73.
VELI ALFARO, Leoncio (Peru, 19?-). Artisan.
Jun.25/75.

VENGOECHEA, Julio (Venezuela, b. Panama,
1940-). Graphic artist, photographer.
Jul.21/76; Oct.14/76; Jan.18/78.
VENIER, Bruno (Argentina, b. Italy, 1914-).
Painter, printmaker, stage designer.
Mar.5/71.
VENINGA, A. (Suriname, ?). Painter.
Aug.13/85.
VERGARA-WILSON, María (United States).
Weaver.
Nov.1/84.
VERGARA GREZ, Ramón (Chile,1920-). Painter.
Sep.18/67; *Oct.14/76(A)*.
VIAL, Matías (Chile, 1931-). Sculptor, printmaker.
Sep.18/67.
VICTORIA, José Alfredo (Dominican Republic,
19?-). Photographer.
Feb.7/85.
VICUÑA, Rosa (Chile, 1925-). Sculptress.
Sep.18/67.
VIDAL, Miguel Angel (Argentina, 1928-). Painter,
draftsman, printmaker.
May 18/65; *Oct.7/75*; *Feb.11/76*; Oct.14/76.
VIGAS, Oswaldo (Venezuela, 1926-). Painter,
draftsman, printmaker, physician.
Oct.25/66; Oct.14/76; *Jan.27/81(A)*.
VIGIL, Frederico (United States). Painter.
Nov.1/84.
VILAIRE, Patrick (Haiti, 1942-). Painter,
draftsman.
Dec.9/69.
VILCHES, Eduardo (Chile, 1932-). Printmaker.
Sep.18/67.
VILLACIS, Aníbal (Ecuador, 1927-). Painter,
draftsman.
Oct.25/73; Oct.14/76.
VILLAGRAN GARCIA, José (Mexico, 1901-).
Architect.
Apr.11/66.
VILLAMIL, Rafael (Puerto Rico, 1934-). Painter,
architect.
Jul.11/68.
VILLAMIZAR, Luz Marina Ramírez de. See
PASCUALA.
VILLANUEVA, Mario (Dominican Republic, b.
United States, 1948-). Painter, draftsman.
Aug.9/72.
VILLASEÑOR, Elena (Mexico, 1944-). Painter,
printmaker.
Jun.12/84.
VILLEGAS, Armando (Colombia, b. Peru, 1926-).
Painter, printmaker.
Oct.14/76(A).
VILLET GARDNER, Cynthia (Barbados, b. South
Africa, 1934-). Painter, graphic artist.
Dec.5/80; Jun.8/82.
VLAVIANOS, Nicolas (Brazil, b. Greece, 1929-).
Sculptor.
Apr.21/65.

VOELZ, Vernon (United States, 19?-). Sculptor.
Mar.21/68.

VOICHYSONK, Bernard F. (United States, 19?-).
Painter.
Mar.21/68

VOURVOULIAS, Joyce. See JOYCE.

WAKABAYASHI, Kazuo (Brazil, b. Japan, 1931-).
Painter.
Apr.1/65; *May 27/69*; Mar.15/74; Oct.14/76.

WALKER, Dolores (Chile, 1931-). Painter,
draftsman, printmaker.
Sep.18/67.

WALLIS, Esther (Venezuela, 1928-). Painter.
Jan.27/81.

WATSON, Barry (Barrington Watson, Jamaica,
1931-). Painter, draftsman.
Mar.15/74.

WATSON, Lynda (United States, 19?-). Artisan.
Jun.25/75.

WENDE, Daisy Urquiola de. See URQUIOLA DE
WENDE, Daisy.

WESTON, H. Lloyd (Jamaica, 1947-). Painter.
Apr.17/84.

WHITE, Randy Lee (United States). Painter.
Nov.1/84.

WILK, Barbara (United States, 19?-). Tapestry
weaver and designer.
Jun.25/75.

WILLIAMS, Hiram D. (United States, 1917-).
Painter, illustrator.
Mar.21/68.

WILLIAMS, Katherine (Trinidad and Tobago,
1941-). Photographer.
Jul.21/81.

WILLIAMS DE TALAVERA, Marís. See
TALAVERA, María.

WOSS Y GIL, Celeste (Dominican Republic, 1881-
19?-). Painter, draftsman.
Jun.8/82.

WRONSKY, Irma (Colombia, b. Germany, 19?-).
Painter.
Feb.22/73.

YANEZ RIVADENEIRA, Pilar (Chile, 19?-).
Artisan (textile).
Jun.25/75.

YAÑEZ DE LA FUENTE, Enrique (Mexico,
1908-). Architect.
Apr.11/66.

YARYURA, Camilo (Dominican Republic, 19?-).
Photographer.
Feb.7/85.

YAYA, Daniel (Peru, 1935-). Painter.
Apr.21/65.

YCASA, Adela Vargas de. See VARGAS, Adela.

YCAZA, Alberto (Costa Rica, b. Nicaragua, 1945-).
Painter, playwright, stage director.
Mar.25/71; *Feb.9/82.*

YEGROS, Angel (Paraguay, 1943-). Painter,
draftsman, printmaker.
Nov.22/66.

YOUNG, Phillip (Canada, 1938-). Printmaker.
Jan.12/84.

YRARRAZAVAL, Ricardo (Chile, 1931-). Painter,
draftsman, ceramist.
Sep.18/67(A).

YRIZARRY, Marcos (Puerto Rico, 1936-).
Printmaker.
Feb.11/76.

YSSASI, Alcides Rubén. See ARYSSASI.

YUSTMAN, Ricardo (Paraguay, b. Argentina,
1942-). Painter, draftsman.
Nov.22/66.

ZACHRISSON, Julio (Panama, 1930-). Painter,
draftsman, printmaker.
Feb.11/76; Oct.14/76.

ZAÑARTU, Enrique (Chile, b. France, 1921-).
Painter, draftsman, printmaker, illustrator.
Sep.18/67(A).

ZAPATA, Carol Miller de. See MILLER, Carol.

ZARATE, Nirma (Colombia, 1936-). Painter.
Apr.21/65; *Jun.15/65.*

ZEA, Pilar (Colombia, 19?-). Painter.
Feb.22/73.

ZELAYA SIERRA, Pablo (Honduras, 1896-1933).
Painter.
Mar.1/84.

ZELAYA, Roque (Honduras, 1958-). Painter.
Mar.1/84.

ZEPEDA, Rafael (Mexico, 1938-). Printmaker.
Jun.17/76; Oct.14/76; Jan.18/78.

ZERBE, Karl L. (United States, b. Germany,
1903-). Painter, printmaker.
Mar.21/68.

ZITMAN, Cornelis (Venezuela, b. Netherlands,
1926-). Sculptor, draftsman, industrial designer.
Jan.27/81.

ZOHN, Alejandro (Mexico, ?). Architect.
Apr.11/66.

ZUNIGA, Francisco (Costa Rica, 1912-). Sculptor,
draftsman, printmaker.
Mar.15/74.

INDEX OF EXHIBITIONS
BY COUNTRY

In this index the countries are listed in alphabetical order and the exhibitions under each country are in chronological order. Also, under each group exhibition, the names of the artists who participated are listed between parentheses. In exhibitions where more than one country (or artist[s] of more than one country) is represented, the exhibition name appears under each country with the corresponding artist(s).

ARGENTINA

Museum of Modern Art of Latin America Recent Acquisitions
 (January 1978 - December 1980) Jan.15/81
 (Miguel Angel Bengochea, Alfredo Bigatti, Sergio Camporeale, Aida Carballo,
 Domingo Gatto, Mauricio Lasansky, Juan Carlos Liberti, Vechy Logioio, Federico
 Martino, María Martorell, Miguerl Ocampo)
Eduardo Giusiano from Argentina Sep.17/81
Taty Rybak from Argentina Sep.17/81
Homage to Women Artists of the Americas Jun.8/82
 (Aida Carballo, Raquel Forner, Nelly Freire, Sarah Grilo, Vichy Logioio,
 Josefina Perazzo, Taty Rybak)
Ricardo Cinalli of Argentina Oct.5/82
Cristina Santander of Argentina Oct.5/82
Origin of a New Dimension. A Mural by Raquel Forner Nov.12/82
Silvia Malagrino Dec.9/82
René Morón of Argentina Oct.6/83
Delia Solari of Argentina Sep.6/84
Ana Kozel of Argentina Sep.10/85

BAHAMAS

Contemporary Crafts of the Americas: 1975 Jun.25/75
 (Helen Adderley)

BARBADOS

Contemporary Art from the Caribbean Dec.14/72
 (Mary Armstrong, Arthur Atkinson, Joyce Daniel, Courtney O. Devonish,
 Hartley Marshall, Wilfred Rogers, Stella St. John)
Tribute to Picasso Oct.25/73
 (Stella St. John)
Art of the Americas in Washington Private Collections Mar.15/74
 (Mary Armstrong)
Contemporary Printmakers of the Americas Feb.11/76
 (Hartley Marshall)
Art of Today in Barbados Dec.5/80
 (Akyem, Arthur Atkinson, William Bertalan, Hubert Brathwaite, Karl R.
 Broodhagen, Virgil L. Broodhagen. Patricia Burton, Allison Chapman-Andrews,
 Judi Christensen, Joyce Daniel, Courtney O. Devonish, Maurice C. Drakes, Verton
 Hoyte, Omowale, Barbara Preston, Stella St. John, Sundiata, Villet)
Homage to Women Artists of the Americas Jun.8/82
 (Cynthia Villet)

BOLIVIA

Oscar Pantoja of Bolivia Jul.20/65
Art of the Americas Jan.18/66
 (Alfredo Da Silva)
Fernando Montes of Bolivia Dec.5/67
Rudy Ayoroa of Bolivia Sep.13/68
Carrasco of Bolivia Oct.10/68
Parada of Bolivia Jan.7/69
Gonzalo Ribero of Bolivia Oct.14/70
Creative Stitchery on Handwoven Textiles from Bolivia by Nancy Hemenway Dec.11/70
Tapestries from Bolivia by Daniel Vega de la Torre Jul.8/71
María Esther Ballivián of Bolivia Jul.12/72
Tribute to Picasso Oct.25/73
 (María Luisa Pacheco)

George Luiz of Brazil Nov.27/72
Tribute to Picasso Oct.25/73
 (Antônio Henrique Amaral)
Art of the Americas in Washington Private Collections Mar.15/74
 (Emiliano Di Cavalcanti, Tikashi Fukushima, Marcelo Grassmann, Maria Martins,
 Cândido Portinari, Kazuo Wakabayashi)
Bernardo Cid of Brazil Apr.9/74
Tapestries by Parodi of Brazil Apr.9/74
Armando Sendin of Brazil May 31/74
Contemporary Crafts of the Americas: 1975 Jun.25/75
 (Marcioly Medeiros Bento, Maria Helena da Silva Bento, Isis Sanon Monte Serrat)
Contemporary Printmakers of the Americas Feb.11/76
 (Ruth Bess, Maria Bonomi, Odetto Guersoni, Angelo Hodick, Fayga Ostrower)
Opening of the Museum of Modern Art of Latin America Oct.14/76
 (Antônio Henrique Amaral, Ruth Bess, Maria Bonomi, Roberto Burle Marx, Vicente
 Carneiro, Bernardo Cid, Tikashi Fukushima, Marcelo Grassmann, Odetto Guersoni,
 Roberto De Lamônica, Manabu Mabe, Aldemir Martins, Yolanda Mohalyi, Cândido
 Portinari, Raul Porto, Danilo Di Prete, Lasar Segall, Armando Sendin, Alberto
 Teixeira, Yutaka Toyota, Kazuo Wakabayashi)
Museum of Modern Art of Latin America: New Acquisitions Jan.18/78
 (José Paulo Ifanger, Tomie Ohtake)
Armando Frazão of Brazil Feb.7/78
Helena Dunshee de Abranches Townsend Aug.27/80
Manabu Mabe Dec.11/80
Museum of Modern Art of Latin America Recent Acquisitions Jan.15/81
 (January 1978 - December 1980)
 (Francisco da Silva, José Antônio da Silva, Rubens Gerchman, Marcelo Grassmann,
 Angelo Hodick, Manabu Mabe, Fayga Ostrower, N. Seoane)
Taro Kaneko of Brazil Jun.23/81
Carlos Clémen of Brazil Jun.23/81
Homage to Women Artists of the Americas Jun.8/82
 (Ruth Bess, Tomie Ohtake, Fayga Ostrower)
Evandro Salles of Brazil Jul.10/84

CANADA

Art of the Americas in Washington Private Collections Mar.15/74
 (Jean Paul Riopelle)
Contemporary Crafts of the Americas: 1975 Jun.25/75
 (Kudjuak, Natalie R. Silverstein, Donald A. Stuart)
Contemporary Indian and Inuit Art of Canada Jan.12/84
 (Kenojuak Ashevak, Carl Beam, Simon Brascoupé, Robert Davidson, Freda Diesing,
 Janet Kigusiuq, Norval Morrisseau, Ipeelee Osuitok, Josie Papialuk, Lipa
 Pitsiulak, Michael Robinson, Allen Sapp, John Tiktak, Phillip Young)

CHILE

Guillermo Núñez of Chile: Oils Jan.29/65
Esso Salon of Young Artists Apr.21/65
 (Gracia Barrios, Sergio Castillo, Juan Egenau Moore, Guillermo Núñez)
Twenty South American Artists from the Second Bienal Americana de Arte Jun.15/65
 (Eduardo Bonati, Guillermo Núñez, Eugenio Téllez)
Juan Downey of Chile Sep.23/65
Oils by Gastón Orellana of Chile Jan.6/66
Art of the Americas Jan.18/66
 (Raúl Valdivieso, Roberto Matta, Guillermo Núñez)
Ernesto Barreda of Chile: Paintings Oct.3/66

Museum of Modern Art of Latin America Recent Acquisitions Jan.15/81
 (January 1978 - December 1980)
 (Mario Carreño, Mario Toral)
Matilde Pérez of Chile Oct.2/84

COLOMBIA

Esso Salon of Young Artists Apr.21/65
 (Fernando Botero, Feliza Bursztyn, Francisco Cardona, Alvaro Herrán, Nirma
 Zárate)
Twenty South American Artists from the Second Bienal Americana de Arte Jun.15/65
 (Alberto Gutiérrez, Nirma Zárate)
Noé León of Colombia Nov.4/65
Art of the Americas Jan.18/66
 (Edgar Negret)
Piñeross of Colombia Nov.16/67
Edgar Tafur Nov.16/67
Alicia Cajiao of Colombia: Paintings Apr.16/68
Marlene Hoffman of Colombia: Textiles Apr.16/68
Manuel Cantor of Colombia Jul.14/69
Fanny Sanín of Colombia: Paintings Jul.14/69
Gerardo Caballero of Colombia Mar.14/70
Raúl Marroquín of Colombia Aug.5/71
Margarita Lozano of Colombia Sep.6/72
The Manzur Workshop of Bogotá: Works by Its Associates Feb.22/73
 (Doris Angel, Luz Clemencia Arenas, Lydia Azout, Maggy Becerra, Teresa Bernal,
 Olga de Botero, María Eugenia Bravo, Magdalena Bravo, Gerardo Caballero, Clara
 Cervantes, Julián Delgadillo, Beatriz Echeverri, Fanny Finkelman, María Antonia
 González, Clara Gutiérrez, Ligia Hoyos, Gloria Jaramillo, Clara Kassin, Ana
 Kerpel, Ada Leary, Suzanne Liska, Sara Mekler, Vivian Moreinis, Oscar Naranjo,
 Ximena Otero, Carlos Padilla, Clara Ramírez, Yolanda Rodríguez, Clemencia
 Salazar, Ana Samper, Pedro Sandino, Maruja Shaio de Possin, Eugenia Simmonds,
 Fanny Stern, Patricia Tavera, Libia Tenorio, Marlene Troll, Ana Uribe, Eugenia
 Valencia, Amparo Vélez, Irma Wronsky, Pilar Zea)
Jaime Muñoz of Colombia May 17/73
Dora Ramírez of Colombia May 17/73
Tribute to Picasso Oct.25/73
 (David Manzur)
Rafael Penagos of Colombia: Drawings Jan.22/74
Nelly Sarmiento of Colombia: Ceramic Sculptures Jan.22/74
Art of the Americas in Washington Private Collections Mar.15/74
 (Fernando Botero, Gerardo Caballero, David Manzur, Alejandro Obregón, Omar Rayo)
Five Artists from Medellín: Graphics in Black and White Sep.9/74
 (Félix Angel, Renán Arango, Armando Londoño, Pascual Ruiz, Francisco Valderrama)
Sculptures by Beatriz Echeverri of Colombia Apr.8/75
Carlos Padilla of Colombia: Drawings Apr.8/75
Contemporary Crafts of the Americas: 1975 Jun.25/75
 (Nuria Carulla, Victoria Eugenia Robledo, Luis G. Trespalacios Meza)
Contemporary Printmakers of the Americas Feb.11/76
 (Leonel Góngora, Alfredo Guerrero, Omar Rayo)
Antonio Barrera of Colombia: Landscapes Mar.23/76
Sergio Trujillo of Colombia: Photographs Mar.23/76
Urueta of Colombia Mar.23/76
Egar: Photographs of Colombia Oct.7/76

New Painting of Costa Rica Feb.9/82
 (Martalicia Almeida, Carlos Bates, Luis Chacón, Lola Fernández, Rafa Fernández,
 Cathy Giusti, Xenia Gordienko, Oscar Méndez, Gonzalo Morales, Amparo Rivera,
 Rodolfo Stanley, Ricardo Ulloa Barrenechea, Alberto Ycaza)
Homage to Women Artists of the Americas Jun.8/82
 (Lola Fernández)
Fernando Carballo of Costa Rica Jul.10/85
Roberto Sandoval of Costa Rica Jul.10/85

CUBA

Art of the Americas Jan.18/66
 (Amelia Peláez)
Photographs and Objects from Easter Island Nov.26/68
 (Ramón G. Osuna)
Tribute to Picasso Oct.25/73
 (Cundo Bermúdez)
Art of the Americas in Washington Private Collections Mar.15/74
 (Cundo Bermúdez, Wifredo Lam, Amelia Peláez, René Portocarrero)
Contemporary Printmakers of the Americas Feb.11/76
 (Cundo Bermúdez, Hugo Consuegra)
Opening of the Museum of Modern Art of Latin America Oct.14/76
 (Cundo Bermúdez, Jorge Camacho, Mario Carreño, Hugo Consuegra, Roberto Diago,
 Roberto Estopiñán, Raúl Milián, Amelia Peláez, René Portocarrero, Thorvald
 Sánchez, Juan José Sicre)
Museum of Modern Art of Latin America: New Acquisitions Jan.18/78
 (Felipe Orlando)
Hispanic-American Artists of the United States Nov.7/78
 (Alejandro Anreus, Cundo Bermúdez, Humberto Calzada, Ramón Carulla, Hugo
 Consuegra, Roberto Estopiñán, Emilio Falero, Agustín Fernández, Enzo Gallo, Gay
 García, Eladio González, Juan González, Osvaldo Gutiérrez, Rolando Gutiérrez,
 Raquel Lázaro, Rolando López Dirube, Tony López, Alfredo Lozano, McAllister
 Kelly, José María Mijares, Roberto Montes de Oca, Tomás Oliva, Efraim Oliver,
 Dionisio Perkins, Víctor Piedra, Enrique Riverón, Manuel Rodulfo Tardo, Baruj
 Salinas, Thorvald Sánchez, Rafael Soriano, César Trasobares, Rafael Vadía)
Museum of Modern Art of Latin America Recent Acquisitions Jan.15/81
(January 1978 - December 1980)
 (Mario Bencomo, Humberto Calzada, Mario Carreño, Ramón Carulla, Roberto
 Estopiñán, Gay García, Raquel Lázaro, Fidelio Ponce de León,
 Richard Rodríguez, Daniel Serra-Badué, Rafael Soriano, Rafael Vadía)
Homage to Women Artists of the Americas Jun.8/82
 (Amelia Peláez)
María Martínez-Cañas Dec.9/82
Inauguration of Mural by Cundo Bermúdez Mar.29/84

DOMINICAN REPUBLIC

Esso Salon of Young Artists Apr.21/65
 (Cándido Bidó, Gilberto Hernández, Domingo Liz)
Art of the Americas Jan.18/66
 (Darío Suro)
Mario Villanueva of the Dominican Republic Aug.9/72
Tribute to Picasso Oct.25/73
 (Darío Suro)
Art of the Americas in Washington Private Collections Mar.15/74
 (Ada Balcácer, Norberto Santana)
Paintings by Ramón Oviedo of the Dominican Republic Nov.3/75

Mauricio Aguilar of El Salvador: Paintings	Sep.16/66
Cañas Herrera of El Salvador	Jan.12/70
Tribute to Picasso	Oct.25/73
(Mauricio Aguilar)	
Art of the Americas in Washington Private Collections	Mar.15/74
(Mauricio Aguilar, Roberto Huezo)	
Contemporary Crafts of the Americas: 1975	Jun.25/75
(Angela Girón C.)	
Contemporary Printmakers of the Americas	Feb.11/76
(Bencastro)	
Toño Salazar of El Salvador: Caricatures, 1925-1975	May 19/76
Paintings by San Avilés of El Salvador	May 19/76
Opening of the Museum of Modern Art of Latin America	Oct.14/76
(Mauricio Aguilar, Benjamín Cañas)	
Museum of Modern Art of Latin America: New Acquisitions	Jan.18/78
(Benjamín Cañas)	
Roberto Huezo of El Salvador	Jun.28/79
Museum of Modern Art of Latin America Recent Acquisitions	Jan.15/81
(January 1978 - December 1980)	
(Roberto Huezo)	
Roberto Galicia of El Salvador	Mar.3/81
José Nery of El Salvador	Mar.3/81
César Menéndez of El Salvador	Jan.14/82
Elena Castro-Morán of El Salvador	Jan.14/82
Homage to Women Artists of the Americas	Jun.8/82
(Julia Díaz)	
Contemporary Painting of El Salvador	May 7/85
(Negra Alvarez, Licry Bicard, Gil, María Kahn, Mauricio Mejía, Rodolfo Molina, Edmundo Otoniel, Tití)	

GUATEMALA

Efraín Recinos of Guatemala: Oils	Mar.9/65
Esso Salon of Young Artists	Apr.21/65
(Rodolfo Abularach, Roberto González Goyri, Efraín Recinos)	
Art of the Americas	Jan.18/66
(Carlos Mérida)	
César Izquierdo of Guatemala	Mar.4/66
Elmar Rojas of Guatemala	Feb.16/71
Tribute to Picasso	Oct.25/73
(Elmar Rojas)	
Art of the Americas in Washington Private Collections	Mar.15/74
(Rodolfo Abularach, César Izquierdo, Carlos Mérida)	
Manuel González of Guatemala	May 7/74
Contemporary Crafts of the Americas: 1975	Jun.25/75
(Delfino Pedro López Chuc)	
Contemporary Printmakers of the Americas	Feb.11/76
(Rodolfo Abularach)	
Corpus of Maya Hieroglyphic Inscriptions. Handicrafts of the Maya Region	Mar.1/76
Opening of the Museum of Modern Art of Latin America	Oct.14/76
(Rodolfo Abularach, Roberto Cabrera, Carlos Mérida, Roberto Ossaye, Marco Quiroa, Elmar Rojas)	
Sculptures by Joyce of Guatemala	May 12/77
Museum of Modern Art of Latin America: New Acquisitions	Jan.18/78
(Joyce Vourvoulias)	
Roberto González Goyri of Guatemala: Paintings	Jan.22/80

Tribute to José Antonio Velázquez 1906-1983) Apr.14/83
 (José Antonio Velázquez, Francisco Alvarado-Juárez)
Contemporary Art of Honduras Mar.1/84
 (Gustavo Armijo, Mario Castillo, Aníbal Cruz, Dino Fanconi, Elio Flores,
 Teresita Fortín, Gelasio Giménez, Benigno Gómez, Virgilio Guardiola, Juan Ramón
 Laínez, Raúl Laínez, Dante Lazzaroni, Víctor López, Mario Mejía, Oscar Mendoza,
 Lutgardo Molina, Ezequiel Padilla, Luis H. Padilla, César Rendón, Alán Roldán
 Caicedo, Miguel Angel Ruiz, María Talavera, José Antonio Velásquez,
 Pablo Zelaya Sierra, Roque Zelaya)

JAMAICA

Contemporary Art from the Caribbean Dec.14/72
 (Valerie Bloomfield, Hope Brooks, Clinton Brown, Everald Brown, Austin Campbell,
 Ralph Campbell, Karl Craig, Milton Harley, Sidney McLaren, Edna Manley, Mervin
 Palmer, Karl Parboosingh, Seya Parboosingh, Mallica [Kapo] Reynolds, George
 Rodney, Daisy Rose, Beat Schwab)
Tribute to Picasso Oct.25/73
 (Everald Brown)
Art of the Americas in Washington Private Collections Mar.15/74
 (Barry Watson)
Contemporary Crafts of the Americas: 1975 Jun.25/75
 (Pat Byer)
Contemporary Printmakers of the Americas Feb.11/76
 (Mike Auld)
Opening of the Museum of Modern Art of Latin America Oct.14/76
 (Everald Brown)
Four Primitive Painters from Jamaica: Everald Brown, Clinton Brown, Sidney McLaren, Aug.7/78
 Kapo
Mike Auld of Jamaica May 31/79
David Boxer of Jamaica May 31/79
Museum of Modern Art of Latin America Recent Acquisitions Jan.15/81
 (January 1978 - December 1980)
 (David Boxer, Clinton Brown, Everald Brown, Kapo, Sidney McLaren)
H. Lloyd Weston, Jamaica Apr.17/84

MEXICO

Esso Salon of Young Artists Apr.21/65
 (Lilia Carrillo, Guillermo Castaño, Fernando García Ponce, Olivier Seguin)
Rafael Coronel of Mexico: Oils Nov.4/65
Art of the Americas Jan.18/66
 (Rafael Coronel, José Clemente Orozco, Rufino Tamayo)
New Architecture in Mexico Apr.11/66
 (Salvador de Alba, Augusto H. Alvarez. Joaquín Alvarez Ordóñez, Francisco Artigas,
 Raúl Cacho, Félix Candela, Enrique Carral, Alejandro Caso, Enrique Castañeda
 Tamborrel, Manuel de la Colina, Eric Coufal, Agustín Hernández, Enrique Landa,
 Ricardo Legorreta, René Martínez Ostos, Héctor Mestre, Rafael Mijares, Enrique de
 la Mora y Palomar, Enrique del Moral, Mario Pani, Manuel Parra, Reynaldo Pérez
 Rayón, Alejandro Prieto, Pedro Ramírez Vázquez, Manuel La Rosa, Guillermo
 Rossel de la Lama, Joaquín Sánchez Hidalgo, Juan Sordo Madaleno, José Villagrán
 García, Enrique Yáñez de la Fuente, Alejandro Zohn)
Mexican Prints. University of Guanajuato Aug.23/66
 (Thelma Cortés, Jesús Gallardo, Roberto González, Esthela Gutiérrez, Lourdes
 Luna, Francisco Patlán, Rubén Resendiz)
Héctor Navarro of Mexico Aug.23/66
Arnaldo Coen of Mexico Jun.15/67

New Work of José Luis Cuevas Apr.2/82
Homage to Women Artists of the Americas Jun.8/82
 (Daisy Ascher, Olga Dondé, Camila Hernández, Carol Miller)
Celia Cherter of Mexico Nov.4/82
Alejandro Colunga of Mexico Nov.4/82
New Directions: Mexican Women Artists Jun.12/84
 (Maris Bustamante, Susana Campos, Lilia Carrillo, Gilda Castillo, Teresa Cito,
 Paloma Díaz Abreu, Olga Dondé, Manuela Generali, Consuelo González Salazar,
 Ofelia Márquez Huitzil, Mónica Mayer, Dulce María Núñez, Leticia Ocharán, Irma
 Palacios Flores, Anamario Pinto, Fanny Rabel, Alice Rahon, Herlinda Sánchez
 Laurel, Nunik Sauret, Susana Sierra, Isabel Vázquez, Elena Villaseñor)

NICARAGUA

Esso Salon of Young Artists Apr.21/65
 (Silvio Miranda, Orlando Sobalvarro)
Art of the Americas Jan.18/66
 (Asilia Guillén, Armando Morales)
Leoncio Sáenz of Nicaragua: Drawings Feb.15/66
Alejandro Aróstegui of Nicaragua Feb.15/66
Dino Aranda of Nicaragua Sep.3/69
Adela Vargas and Alberto Ycaza of Nicaragua: Paintings Mar.25/71
Bernard Dreyfus of Nicaragua Mar.10/72
Tribute to Picasso Oct.25/73
 (Armando Morales)
Art of the Americas in Washington Private Collections Mar.15/74
 (Alejandro Aróstegui, Asilia Guillén, Armando Morales, Adela Vargas)
Tapestries by Iván Osorio of Nicaragua Jul.15/75
Contemporary Printmakers of the Americas Feb.11/76
 (Dino Aranda)
Opening of the Museum of Modern Art of Latin America Oct.14/76
 (Dino Aranda, Alejandro Aróstegui, Bernard Dreyfus, Asilia Guillén, Armando
 Morales, Rodrigo Peñalba, Leoncio Sáenz)
Rolando Castellón of Nicaragua Oct.17/77
Museum of Modern Art of Latin America: New Acquisitions Jan.18/78
 (Dino Aranda, Rolando Castellón)
Museum of Modern Art of Latin America Recent Acquisitions Jan.15/81
 (January 1978 - December 1980)
 (Omar d'León, Bernard Dreyfus)
Homage to Women Artists of the Americas Jun.8/82
 (Asilia Guillén)
Primitive Artists of Nicaragua Nov.29/83
 (Faustino Altamirano, Fernando Altamirano, Luis Alvarado, Eduardo Arana,
 Rodolfo Arellano, Alejandro Cabrera, Julia Chavarría, Milagros Chavarría, Carlos
 García, Mercedes Graham, Miriam Guevara, Olivia Guevara, Olga Madariaga,
 Carlos Marenco, Pablo Mayorga, Rosa Pineda, Rafael, Miriana Samson, Yelba Ubau)

PANAMA

Esso Salon of Young Artists Apr.21/65
 (Antonio Alvarado, Guillermo Trujillo)
Art of the Americas Jan.18/66
 (Guillermo Trujillo)
Chong Neto of Panama: Oils and Drawings Oct.10/67
Beatrix Briceño of Panama Mar.6/69
Arts of the Cuna Indians Apr.13/69
 (molas, uchus, necklaces, and musical instruments)

PERU

Esso Salon of Young Artists	Apr.21/65
(Alberto Guzmán, Manuel Pereira, Fernando de Szyszlo, Daniel Yaya)	
Twenty South American Artists from the Second Bienal Americana de Arte	Jun.15/65
(Arturo Kubotta, Fernando de Szyszlo)	
Colonial Art of Peru	Jun.30/65
(18th century paintings)	
Art of the Americas	Jan.18/66
(Joaquín Roca Rey, Arturo Kubotta)	
Milner Cajahuaringa of Peru	Jan.27/66
Manuel and René Pereira of Peru: Sculptures	Sep.16/66
Folk Art of Peru	Apr.13/67
(Contemporary ceramics, textile, and *retablos*)	
José Casals: Photographs of Peru	Feb.20/68
Shinki of Peru	Feb.20/68
Carlos Dávila of Peru	Sep.25/68
Ciro Palacios of Peru	Nov.13/70
Eduardo Moll of Peru	Nov.13/70
Three Artists of Peru: Burela, Condeso, Ramírez	Jun.2/71
Herman Braun of Peru	Nov.5/71
Spanish Landscapes by Ornellas of Peru	Jun.8/73
Tribute to Picasso	Oct.25/73
(Fernando de Szyszlo)	
Art of the Americas in Washington Private Collections	Mar.15/74
(Joaquín Roca Rey, Fernando de Szyszlo)	
Contemporary Crafts of the Americas: 1975	Jun.25/75
(Angelino Alcántara García, Mary Fischer de Traver, Rosa Mamani, Pailo Nilca, Ecolástico Quispe, Leoncio Veli Alfaro)	
Bill Caro of Peru	Aug.19/75
Contemporary Printmakers of the Americas	Feb.11/76
(Orlando Condeso, Carlos Dávila)	
Opening of the Museum of Modern Art of Latin America	Oct.14/76
(Carlos Castillo, Orlando Condeso, Carlos Dávila, Arturo Kubotta, Ciro Palacios, Manuel Pereira, René Pereira, Joaquín Roca Rey, José Sabogal, Venancio Shinki, Fernando de Szyszlo, Armando Villegas)	
Paintings by Rainer Bineck of Peru	Feb.23/77
Silverworks from Rio de la Plata, Argentina (18th and 19th Centuries)	Apr.1/77
Víctor Delfín: Sculptures of Peru	Aug.17/78
Humberto Aquino of Peru	Dec.5/78
Huguette Franco of Peru: Works on Paper	Dec.5/78
Gilberto Rebaza of Peru	Oct.24/79
Colonial Art of Peru	Oct.7/80
(18th and 19th centuries religious painting and sculpture)	
Museum of Modern Art of Latin America Recent Acquisitions	Jan.15/81
(January 1978 - December 1980)	
(Humberto Aquino, Sérvulo Gutiérrez, Teodoro Núñez Ureta, Gilberto Rebaza)	
Retablos from Peru	Dec.14/81
(Joaquín López Antay, Julio and Jesús Urbano)	
Homage to Women Artists of the Americas	Jun.8/82
(Julia Navarrete)	
Peruvian Handicrafts	Nov.9/82
Dianderas	May 6/83
Fernando de Szyszlo. First Retrospective Exhibition in the United States	Mar.11/85

PUERTO RICO

Esso Salon of Young Artists	Apr.21/65
(Olga Albizu, Tomás Batista, Rafael Ferrer, Luis Hernández Cruz)	
Julio Rosado del Valle of Puerto Rico	May 21/65
Olga Albizu of Puerto Rico	Jun.13/66
Rafael Ferrer of Puerto Rico	Jun.13/66
María Señeriz of Puerto Rico: Cardboard Reliefs	Jul.11/67
Luis Hernández Cruz and Rafael Villamil of Puerto Rico	Jul.11/68
Rechany of Puerto Rico	Aug.16/73
Art of the Americas in Washington Private Collections	Mar.15/74
(Rafael Ferrer)	
Contemporary Crafts of the Americas: 1975	Jun.25/75
(Luis Alberto González)	
Contemporary Printmakers of the Americas	Feb.11/76
(Marcos Yrizarry)	
Opening of the Museum of Modern Art of Latin America	Oct.14/76
(Rafael Ferrer, Julio Rosado del Valle)	
Drawings by Juan Ramón Velázquez of Puerto Rico	Jan.18/77
Museum of Modern Art of Latin America: New Acquisitions	Jan.18/78
(Juan Ramón Velázquez)	
Luis Hernández Cruz of Puerto Rico	May 5/78
Museum of Modern Art of Latin America Recent Acquisitions	Jan.15/81
(January 1978 - December 1980)	
(Luis Hernández Cruz, Juan Ramón Velázquez)	
Roberto Laureano of Puerto Rico	Mar.18/82
Héctor Méndez-Caratini of Puerto Rico	Mar.18/82
Homage to Women Artists of the Americas	Jun.8/82
(Myrna Báez)	
Four Latin American Sculptors	Jul.12/83
(Charles J. Seplowin)	
Francisco Oller: A Realist Impressionist	Mar.30/84

SURINAME

Images of Suriname	Aug.13/85
(J.A. Chin A Foeng, A. Favery, R. Flu, G. Fung Loi, R. Fung Loi, K. Flijders,	
R. Getrouw, W. Grimmer, N. Hatterman, S. Irodikromo, R. Karsters,	
E.K.D. Lieveld, A. Mosis, G. Ramdjiawansingh, C. San A Jong, K. Siebert,	
M. Stuart, R. Tosari, A. Veninga)	

TRINIDAD AND TOBAGO

Contemporary Art from the Caribbean	Dec.14/72
(M.P. Alladin, Sybil Atteck, Ralph Baney, Vera Baney, Leo Basso, Patrick	
Chu-Foon, Sarah Crook, Hettie De Gannes, Holly Gayadeen, Boscoe Holder,	
Marcelio Hovell, Arthur Magin, Sonnylal Rambissoon, Noel Vaucrosson)	
Tribute to Picasso	Oct.25/73
(M.P. Alladin)	
Ralph Baney of Trinidad and Tobago	Feb.14/74
Art of the Americas in Washington Private Collections	Mar.15/74
(Ralph Baney)	
Contemporary Printmakers of the Americas	Feb.11/76
(Sonnylal Rambissoon)	
Three Artists from Trinidad and Tobago: Vera Baney, Ottway Jones, Sonnylal Rambissoon	Aug.18/76
Opening of the Museum of Modern Art of Latin America	Oct.14/76
(M.P. Alladin)	
Roslyn K. Cambridge of Trinidad and Tobago	Jul.21/81
Katherine Williams of Trinidad and Tobago	Jul.21/81
Althea Bastien of Trinidad and Tobago	Apr.6/82

Homage to Women Artists of the Americas Jun.8/82
 (Nina Squires)
Four Latin American Sculptors Jul.12/83
 (Valerie Brathwaite)

UNITED STATES

Art of the Americas Jan.18/66
 (Robert Gates, Jack Perlmutter, Ben Summerford)
A Particular Portion of Earth Jan.14/68
 (Otis Dozier, William Lester, Loren Mozley, Evaline Sellors, Everett Spruce,
 Charles Umlauf)
Florida 17 Mar.21/68
 (Harrison W. Covington, Ernest L. Cox, Arthur Deshaies, Doris Leeper, Steven
 D. Lotz, Bryn J. Manley, Eugene Massin, J. Geoffrey Naylor, William Pachner,
 Frank Rampolla, Craig Rubadoux, Donald J. Saff, Syd Solomon, Bernard F.
 Voichysonk, Vernon Voelz, Hiram D. Williams, Karl L. Zerbe)
Creative Stitchery on Handwoven Textiles from Bolivia by Nancy Hemenway Dec.11/70
Tribute to Picasso Oct.25/73
 (Jasper Johns)
Colonial Architecture of Mexico Jan.7/74
 (Photographs by Judith Hancock de Sandoval)
Luis Quintanilla of Mexico Jan.7/74
Art of the Americas in Washington Private Collections Mar.15/74
 (Gene Davis)
Contemporary Crafts of the Americas: 1975 Jun.25/75
 (Michael A. Arntz, Cornelia K. Breitenback, Linda Dalton, Palli Davene Davis,
 Judith Poxon Fawkes, Humphrey T. Gilbert, Jr., Lukman Glasgow, Wayne Hammer,
 Harold B. Helwig, Janet Luks, Alphonse Mattia, Paul Marioni, Richard Mawdsley,
 Mineo Mizuno, June Utako Morioka, Stanley J. Moskowitz, Susan Marie Mueller,
 Gordon Orear, Vernon Patrick, Nancy Rabbitt, David Moffett Snell, Susan
 Tantlinger, Janet Roush Taylor, Elizabeth Tuttle, Lynda Watson, Barbara Wilk)
Contemporary Printmakers of the Americas Feb.11/76
 (David Becker, Misch Kohn, Mauricio Lasansky, Peter Milton, Gabor Peterdi)
Corpus of Maya Hieroglyphic Inscriptions. Handcrafts of the Maya Region Mar.1/76
Hispanic-American Artists of the United States: Argentina, Bolivia, Chile, Cuba, Uruguay Nov.7/78
 (Alejandro Anreus, Cundo Bermúdez, Humberto Calzada, Ramón Carulla, Hugo Consuegra,
 Belisario Contreras, Emilio Falero, Agustín Fernández, Juan González, Osvaldo Gutiérrez,
 Miguel Jorge, McAllister Kelly, Raquel Lázaro, José María Mijares, Roberto Montes de Oca,
 Efraim Oliver, María Luisa Pacheco, Dionisio Perkins, Víctor Piedra, Enrique Riverón,
 Baruj Salinas, Thorvald Sánchez, Rafael Soriano, César Trasobares, Rafael Vadía, Roberto
 Estopiñán, Enzo Gallo, Gay García, Eladio González, Rolando Gutiérrez, Alfredo Halegua,
 Tony López, Rolando López Dirube, Alfredo Lozano, Tomás Oliva, Manuel Rodulfo Tardo)
Museum of Modern Art of Latin America Recent Acquisitions Jan.15/81
 (January 1978 - December 1980)
 (Mauricio Lasansky)
Homage to Women Artists of the Americas Jun.8/82
 (Romaine Brooke, Helen Frankenthaler)
María Martínez-Cañas Dec.9/82
Art of New Mexico Nov.1/84
 (Gero Antresian, Felipe Archuleta, Gilbert Atencio, Helen Beck, Larry Bell, David
 Bradley, Paul Caponigro, William Clift, Helen Cordero, Gloria Lopez Cordova, Blue
 Corn, Doris Cross, Dennis Culver, Rick Dillingham, John Fincher, Harry Fonseca,
 Ruben Gonzales, R.C. Gorman, Woody Gwyn, Betty Hahn, Bob Haozous, Helen Hardin,
 Alan Houser, Luis Jimenez, Gail Bird, Douglas Johnson, Yazzie Johnson, Lucy
 Lewis, Joseph Lonewolf, Bruce Lowney, Bruce Nauman, Eugene Newman, Dick Mason,
 Bernard Plossu, Eliot Porter, Eliseo Rodriguez, Johnny and Marlene Rosetta,
 Maridel Rubenstein, Ford Ruthling, Ken Saville, Fritz Scholder, Elmer Schooley,
 Jaune Quick-to-See Smith, Margaret Tafoya, Luis Tapia, Horacio Valdez, Ed Vega,
 Pablita Velarde, Frederico Vigil, Randy Lee White, Maria Vergara-Wilson)

Michael Plyler: Photographs — Dec.5/84

URUGUAY

Esso Salon of Young Artists — Apr.21/65
(Ernesto Cristiani, Hermenegildo Sabat, Ruisdael Suárez)
Twenty South American Artists from the Second Bienal Americana de Arte — Jun.15/65
(José Gamarra, Hermenegildo Sabat)
Art of the Americas — Jan.18/66
(Rafael Barradas, Pedro Figari)
María Freire and José Pedro Costigliolo of Uruguay — Oct.3/66
Oscar Meraldi of Uruguay — Dec.5/67
Roberto Morassi of Uruguay — Nov.22/71
Acosta García of Uruguay — Jun.28/73
Tribute to Picasso — Oct.25/73
(Carlos Páez Vilaró)
Art of the Americas in Washington Private Collections — Mar.15/74
(Alfredo Halegua, Joaquín Torres-García)
Contemporary Crafts of the Americas: 1975 — Jun.25/75
(Lilian Lipschitz)
Contemporary Printmakers of the Americas — Feb.11/76
(Luis Acosta García, Miguel Bresciano, Antonio Frasconi, Luis Solari)
Opening of the Museum of Modern Art of Latin America — Oct.14/76
(Luis Acosta García, Rafael Barradas, Pedro Figari, Alfredo Halegua, Carlos
Páez Vilaró, Joaquín Torres-García)
Silverworks from Río de la Plata, Argentina (18th and 19th Centuries) — Apr.1/77
Raquel Orzuj of Uruguay: Paintings — Dec.9/77
Museum of Modern Art of Latin America: New Acquisitions — Jan.18/78
(Joaquín Torres-García)
Hispanic-American Artists of the United States — Nov.7/78
(Alfredo Halegua)
Washington Barcala of Uruguay — Apr.3/79
Julio Olivera of Uruguay — Jul.29/80
Museum of Modern Art of Latin America Recent Acquisitions — Jan.15/81
(January 1978 - December 1980)
(Washington Barcala, Raúl Cattelani, José Cúneo, Vicente Martín, Lincoln Presno,
Luis A. Solari)
Cecilia Mattos of Uruguay — Jul.1/82
Lincoln Presno of Uruguay — Jul.1/82
Linda Kohen of Uruguay — Apr.9/85
Julio Testoni of Uruguay — Apr.9/85

VENEZUELA

Esso Salon of Young Artists — Apr.21/65
(Edgard Guinand, Francisco Hung, Humberto Jaimes Sánchez, Víctor Valera)
Twenty South American Artists from the Second Bienal Americana de Arte — Jun.15/65
(Jacobo Borges, Carlos Cruz-Diez, Gerd Leufert, Jesús Rafael Soto)
Teresa Casanova: Paintings and Engravings from Venezuela — Sep.2/65
Art of the Americas — Jan.18/66
(Alejandro Otero)
Alberto Collie of Venezuela: Sculptures — Mar.23/66
Carlos Eduardo Puche of Venezuela: Objeto-grafías (Image-Objects) — Mar.23/66
Venezuelan Painting Today — Oct.25/66
(Jacobo Borges, Carlos Cruz-Diez, Elsa Gramcko, Luis Guevara Moreno, Francisco
Hung, Humberto Jaimes Sánchez, Alejandro Otero, Mercedes Pardo, Héctor Poleo,
Luisa Richter, Jesús Rafael Soto, Oswaldo Vigas)
Chacón of Venezuela: The Planets — Aug.21/67
Landscape Architecture in Venezuela by Fernando Tabora and J. Godfrey Stoddart — Jul.8/68
Alirio Rodríguez — Jan.23/69

ABOUT THE EDITOR

Annick Sanjurjo (M.A. Romance Languages and Literature, Asunción, Paraguay) edited the current volume and wrote the biographical information about the artists not included in the original catalogues. Before coming to Washington, D.C., to work as an archivist at the Museum of Modern Art of Latin America, Organization of American States (1978-89), she worked at the Museum of Modern Art's International Council, Latin American Archives in New York (1977-78). In 1976, she assisted Ms. Barbara Duncan with the preparation of the traveling exhibition *Recent Latin American Drawings (1969-1976)/Lines of Vision* sponsored by the International Exhibitions Foundation, Washington, D.C.

Annick Sanjurjo was also the Contributing Editor, Books, (1981-82) and the Contributing Editor, Art, (1987-91) for *Américas* magazine. Inn 1989, she was the curator of a major exhibit, *Masters of Latin America and the Caribbeans*. She is the author of several publications and award-winning media productions on Latin American art and culture. Among them are: *Botero, Magic and Reality; Behind the Lines of José Luis Cuevas; Fernando de Szyszlo;* and *"Ñanduti, the Flower in the Spider's Web."* She is presently working on the script of a documentary about the late master, Rufino Tamayo.